1998
PHOTOGRAPHER'S
MARKET

1998
PHOTO GRAPHER'S MARKET

2,000 PLACES TO SELL YOUR PHOTOGRAPHS

EDITED BY

MICHAEL WILLINS

ASSISTED BY

ALICE P. BUENING

BARBARA KUROFF

WRITER'S DIGEST BOOKS
CINCINNATI, OHIO

The cover illustration is a detail of a painting by Berge Missakian. Missakian is a Canadian artist from Montreal. He has studied art at the American University of Beruit; Cornell University, Ithaca, NY; and Concordia University, Montreal, Canada. Illusion, imagination and fantasy appear in his paintings and set as elements which unify his compositions with explosively brilliant shapes of color. Missakian, who is listed in several books on art, including *Who's Who in American Art* (22nd edition), exhibits internationally. He celebrates passion over passivity, movement over inertia and joy over melancholic outlook. His internet URL is http://www.generation.net.studiom1

Bonjour New York
20″ × 24″
acrylic on canvas

Managing Editor, Annuals Department:
Constance J. Achabal.

International Standard Serial Number 0147-247X
International Standard Book Number 0-89879-793-4

Attention Booksellers: This is an annual directory of F&W Publications. Return deadline for this edition is December 31, 1998.

Contents

© Andy Anderson

Page 450

© Galyn Hammond

Page 260

Resources

Page 355

From the Editor

The beginning of this edition of *Photographer's Market* actually starts with an ending—mine as editor of this book. I took over *PM* in 1992, after spending two and a half years as a reporter/photographer in southeast Indiana. Instead of shooting news with my Pentax P3N, I began gathering information about every aspect of the market for photography—information that I've passed on to you—and hope it has been helpful to your career.

I feel confident that as I worked on each book and my knowledge of the market continued to expand, *PM* evolved into an even more useful tool than it was when I began. I'm also certain the next edition will be even better than this one.

Speaking of "this one," you're going to see major changes as you turn the pages. Most obvious is our switch from hardback to paperback. We also increased page size, allowing us to provide more information and make that information easier to read.

Those of you who regularly use this book will notice that the order of the sections has changed. Last year, we conducted a reader survey to determine which sections are most important to you. On the basis of that survey, the most used market sections now appear first.

We also merged Consumer Publications with Special Interest Publications, making it easier for you to locate magazine markets. Then, we expanded the Subject Index to include more sections (and nearly doubled the number of catagories). In the past, only markets in the Publications sections were included in the Subject Index. Now this resource contains markets from Paper Products, Book Publishers, Stock Agencies and Galleries as well as Publications.

As always, the articles that appear before the markets give you valuable insights into the industry and help you conduct business as a professional photographer. In Setting Up Your Stock Photo Business (page 26), I tell you how to set up and manage a successful stock photo operation. How to Put Together a Winning Portfolio (page 10), written by Allen Rabinowitz, gives step-by-step details on putting together a portfolio that sells your photos. In First Contacts and Portfolio Presentations (page 15), Charles E. Rotkin draws upon 50 years of experience and tells you how to professionally present your portfolio to photo buyers. Fresh Photographers (page 32), by Megan Lane, features informative interviews with five newcomers who have managed to break into the competitive worlds of commercial and fine art photography.

I know that whoever steps in as editor will, as I did, welcome your suggestions for improving future editions. After all, your tips and ideas have helped *PM* be the successful, useful reference book that it is.

If I can impart any last minute words of wisdom it would be these from an interview with Michael Jordan. While participating in a youth basketball camp Jordan said he didn't want kids to strive to be another Michael Jordan—he wanted them to be something better. Jordan knows that we are the ones who set limitations for ourselves. If we expect greatness—actually demand it—greatness will come.

As a photographer, don't limit yourself to the greatness of masters such as Ansel Adams, Gordon Parks, Edward Weston or Mary Ellen Mark. Set your goals higher, then achieve them.

Michael Willins
photomarket@fwpubs.com

How To Use This Book to Sell Your Photos

Every year, we attempt to turn *Photographer's Market* into a more useful tool for you. We want you to have success locating dozens of potential clients and, eventually, selling some photos. Seeing your work in print is our reward, and we hope you develop some long-lasting clients from the markets you contact. But what, exactly, is the best way to use this book to your advantage?

First, know what kinds of buyers you want to reach. This can be determined by the subjects you photograph, your location, or, perhaps, your style of living. The key is to concentrate on what you like to do and market your efforts accordingly. For instance, if you love the outdoors and often take photographs on nature walks, find markets that are interested in outdoor shots or landscapes. To simplify such searches, we have expanded our Subject Index, beginning on page 570, to include not only Publications, but also Paper Products, Book Publishers, Stock Agencies and Galleries. Then, we increased the number of categories from 24 to 46, making it even easier to find specific markets for your photos.

For more specific information about what markets prefer from freelancers, check out the "**Needs:**" subhead within listings. The information contained under this subhead lets you know exactly what photos each market wants and often gives you an estimate of how much freelance material is used by each market. For example, the listing for *New Mexico Magazine* states:

> **Needs:** Uses about 60 photos/issue; 90% supplied by freelancers. Needs New Mexico photos only—landscapes, people, events, architecture, etc. "Most work is done on assignment in relation to a story, but we welcome photo essay suggestions from photographers." Cover photos usually relate to the main feature in the magazine. Model release preferred. Captions required; include who, what, where.

After you've found potential buyers it's important to know how to submit your material. This can be investigated in several ways. If you are into digital imagery and have many of your photos in electronic format, turn to the Digital Markets Index located on page 566. This index lists those markets that are interested in acquiring photos digitally, either on CD-ROM, computer disks or via online services. If you want more specific information about how to approach markets, read the information under "**Making Contact & Terms:**" within listings. This subhead spells out submission information. For example, Reidmore Books gives this information for contacting them:

> **Making Contact & Terms:** Query with résumé of credits. Query with samples. Query with stock photo list. Provide résumé, business card, brochure, flier or tearsheets to be kept on file for possible future assignments. Accepts images in digital format for Mac (Photoshop, Illustrator, QuarkXPress). Keeps samples of tearsheets, etc. on file. Cannot return material. Reports in 1 month. Pays $50-200/color photo; $50-200/b&w photo. Credit line given. Buys one-time rights and book rights; negotiable. Simultaneous submissions and previously published work OK.

This year, we asked photo buyers if they also offer internships to photographers. Information for those who do appears at the end of this subhead. Each listing also provides information about the preferred formats that are accepted (e.g., transparencies or prints) and whether the market

accepts black and white, color, or both. One important note here: Do not submit originals unless you're sure a buyer plans to use your work and needs originals for production purposes. And, when submitting black and white images, never send the negatives. Duplicate slides, tearsheets and prints are replaceable if an image is damaged or lost. Originals aren't!

Now that you know what to send and how to send it, you should find out something about the company you are approaching. Many of the markets offer photo guidelines to freelancers who send a self-addressed stamped envelope (SASE). If you are unfamiliar with a publication, send away for a recent sample copy to see if your work is appropriate. This kind of research is essential, especially if the client is unfamiliar with your work.

For the past several years we also have included editorial comments within listings. Denoted by bullets (●), these comments give you extra information about markets, such as mergers that have taken place, company awards, and digital technology that businesses are adopting. For instance, the editorial comment for Berkshire Artisans Gallery states:

●This gallery was written up in a *Watercolors* magazine article, by Daniel Grant, on galleries that do open-jury selections.

The "**Tips:**" subheads within listings include specific information on what photo buyers say they want to see—and, sometimes, what they *don't* want to see—from photographers. These subheads contain comments that can make the difference between selling or not selling your photos to a market. Here, for example, are tips from the picture editor at *Parenting*:

Tips: "Subject area is not always most important, but 'how' a photographer approaches any subject and how well the photographer captures an original or creative image (is important). Technique is secondary often to 'vision.' Submit good samples and portfolio. Try to show quality, not the 'I can shoot anything/everything' type of book. Know who you're submitting your work to. Look at the publication and have some knowledge of how we use photography, and how your work might apply. We prefer to see your more personal work since we're more likely to use it than strictly commercial imagery."

Not all of the marketing advice comes from within the listings. You also will find helpful information in the introduction to each market section. In the first 39 pages we have articles that should improve your business knowledge, including pricing, copyright, proper ways to submit and store images, portfolios and insurance.

Finally, while payment is important, don't judge markets solely on the basis of money. You may find that stated pay ranges are flexible. This is especially true for markets who say "Payment negotiable." Variables entering into those negotiations include clients' budgets and your experience. (See Pricing Your Photos in Today's Market beginning on page 18.)

Taking Care of Business

Anyone who sells his photographic skills for a living knows that setting exposures and composing images are only part of being a professional photographer. Success comes as much from business knowledge as it does from understanding the technical aspects of the craft. Maybe even more. After all, what good is having great images if you have no idea how to market them or what they are worth to clients?

This article outlines some of photography's business basics. The goal is to provide you with some understanding of how to create standard business forms and market your work along with information about things like taxes and insurance, which must not be overlooked if you plan to sell photos. Another important aspect of running your photography business—creating a storage system for your photos—is covered in depth in Setting Up Your Stock Photo Business on page 26.

After you've read this article, consider creating a business plan for yourself. Think about what types of subjects you like to shoot and establish some goals. Ask yourself, "Who is going to buy what I'm selling?" Then scour the listings in this book and develop a client list based on the type of work you shoot. How much money do you want to make from your photography? What kind of financial commitment do you want to make toward your business in the way of self-promotion and/or equipment? Knowing where you want to end up, and periodically reminding yourself of your goals, will help you when conducting business.

ESSENTIAL BUSINESS FORMS

Proper business forms will make you appear more professional in the eyes of potential clients. Most forms can be reproduced quickly and inexpensively at most quick-print services. If you have a computer system with some graphic capabilities you can design simple and attractive forms that can be used every day.

When producing detailed contracts, remember that proper wording is imperative. You want to protect your copyright and, at the same time, be fair to clients. Therefore, it's a good idea to have a lawyer examine your contracts before using such forms.

Several photography books include sample forms if you want to get an idea what should be included in your documents. See Helpful Resources for Photographers at the back of this book and check your local library or bookstore for these resources. You also might want to order FORMS, a booklet of sample forms that was produced by the American Society of Media Photographers. To order copies of FORMS write to ASMP, Washington Park, Suite 502, Washington Rd., Princeton Junction NJ 08550-1033. (609)799-8300. The price is $19.95 plus $2 shipping and handling.

The following forms are useful when selling stock photography, as well as when shooting on assignment:

Delivery Memo—This document should be mailed to potential clients along with a cover letter when an initial submission is made. A delivery memo provides an accurate count of the images that are enclosed and it provides rules of usage. Ask clients to sign and return a copy of this form if they agree to the terms you've spelled out.

Terms & Conditions—Also known as a boilerplate, this form outlines in fine detail all aspects of usage, including copyright, client liability and a sales agreement. You also should

SAMPLE MODEL RELEASE

I hereby grant (photographer), his/her legal representatives and assigns (including any agency, client, or publication), irrevocable permission to publish photographs of me, taken at _____. These images may be published in any manner, including advertising, periodicals, greeting cards and calendars. Furthermore, I will hold harmless aforementioned photographer, his/her representatives and assigns, from any liability by virtue of any blurring, distortion or alteration that may occur in producing the finished product, unless it can be proven that such blurring, distortion or alteration was done with malicious intent toward me.

I affirm that I am more than 18 years of age and competent to sign this contract on my own behalf. I have read this release and fully understand its contents.

Please Print:
Model's Name _____
Address _____
City _____ State _____ Zip Code _____
Country _____

Model's Signature: _____
Witness: _____ Date: _____

Parent/Guardian Consent (if applicable):
I am the parent or guardian of the minor named above and have legal authority to execute this release. I consent to use of said photographs based on the contents of this release.

Parent/Guardian Name: _____
Parent/Guardian Signature: _____
Witness: _____ Date: _____

include a statement that protects you from having your work digitally stored and/or manipulated. Often this form is placed on the back of a delivery memo.

Invoice—This is the form you want to send more than any of the others, because mailing it means you have made a sale. The invoice should provide clients with your mailing address, an explanation of usage and amount due (include a due date for payment). You also should include a business tax identification number or social security number.

Model/Property Releases—Get into the habit of obtaining releases from anyone you photograph. They increase the sales potential for images and can protect you from liability. A model release is a short form, signed by the person/people in the photo, that allows you to sell the image for commercial or editorial purposes. (See sample above.) The property release does the same thing for photos of personal property. When photographing children, remember that a parent or guardian must sign before the release is legally binding. In exchange for signed releases some photographers give their subjects copies of the photos, others pay the models. Figure out a system that works best for you. Once you obtain a release, keep it on file.

You do not need a release if the image is being sold editorially. However, some magazine editors are beginning to require such forms in order to protect themselves. You always need a

release for advertising purposes or for purposes of trade and promotion. There are times when it is impossible to get a release. In those cases, remember that the image only can be used editorially.

If you shoot photographs of private property, and you want to use these photographs for commercial purposes, secure a property release from the owner of the property. If in doubt, check it out. The Volunteer Lawyers for the Arts (VLA) is a nonprofit, tax-exempt organization based in New York City, dedicated to providing all artists, including photographers, with sound legal advice. Call the VLA Art Law Line at (212)319-2910, Monday-Friday, 9:30-4:30 e.s.t., for legal information or assistance; or write to: Volunteer Lawyers for the Arts, 1 E. 53rd St., 6th Floor, New York NY 10022.

Finally, if you are traveling in a foreign country it is a good idea to carry releases written in that country's language. To translate releases into a foreign language, check with embassies or professors at a college near you.

SUBMISSION TIPS

When submitting images to potential clients, cater your submission to the needs of the market. Make it simpler for them to buy your work than reject it. Now, how can you do that?

First, don't be sloppy. Editors constantly complain about the unprofessional manner in which images are submitted. Some photographers, for example, mail photos with no explanations as to what they are or why they are being sent. Others send cover letters written in illegible script on crumpled paper. When an editor receives these types of submissions he will invariably reject them on the basis of appearance.

Invest in a professional appearance—and not just in the form of money, but in time, too. Use a typewriter or computer when putting together cover letters or query letters. For a more polished look, purchase your own stationery and business cards and use them when putting together submissions.

What should you include in your submission? We've already mentioned several pieces of the marketing puzzle, but let's break it down:

Cover Letters and Query Letters—These are slightly different approaches to the same goal—making a sale. They are used to convince photo buyers that your photography will enhance their products or services. Both of these letters are excellent opportunities to provide more information about your photographic abilities. Cover letters should include an itemized list of photos you are submitting and caption information pertinent to each image. Keep it brief.

In publishing, query letters are used to propose photo essays or photo/text packages. Ideas must sound exciting to interest buyers in your work. In the query letter you can either request permission to shoot an assignment for further consideration, submit stock photos, or ask to be considered for upcoming assignments.

Résumé and Client List—Résumés provide clients with more information about your skills and previous experience. Include job experience, photo-related education and any professional trade association memberships you have. A client list is simply a list of credits, past buyers of your work. You also should include any awards you've won and shows or exhibits you've been in.

Self-Promotion Piece—Art directors and photo editors love to keep self-promotion pieces on file as references for future assignments. Often these pieces are essential when trying to get a picture editor to review your portfolio. Tearsheets or postcards show your style and area of expertise and should be included in any direct mail to potential buyers. Make sure you include your address and phone (and fax and e-mail if you have them) directly on the piece.

Also, spend at least one day a week working on self-promotion. This may seem like a lot, but the work you do in this area can mean the difference between success and failure. Remember that each piece should show your creativity and make photo editors want to hire you for assignments.

Self-promotion can appear in numerous forms, including:

- Sourcebook advertisements in books like *The Workbook*, *Creative Black Book* and *Klik*;
- Postcards and other direct mail pieces with your best images on them;
- Press releases (for example, when you win photography awards);
- Brochures explaining the services you offer and listing past clients.

Stock Photo List—This is a detailed description of the subjects you have available. You also should include whether the images are color or black and white. A travel photographer, for example, might want to outline what countries he has photographed. Editors like to keep such resources in their files for future reference.

The package

To ensure your images' safe arrival and return, pay attention to the way you package them. Insert 8 × 10 prints into plastic pages; transparencies should be shipped in protective vinyl pages. *Do not send original transparencies or negatives unless they are requested by the client.* You do not want to risk losing or damaging originals. Slides can be duplicated at a relatively low cost and if they are damaged or lost, there is no real harm done.

To further protect your submissions it's a good idea to send your work via certified mail. That way a client must sign for the package when it is delivered. You also can use delivery services, such as UPS or Federal Express, which track packages.

When submitting material, include the following items: a cover letter or query letter, a résumé and client list, a delivery memo with terms and conditions attached, a self-addressed, stamped envelope, and, of course, your work. For proper protection of your prints and transparencies, sandwich all images between two pieces of cardboard. You also can try insulated envelopes. *Note: When mailing to countries other than your own you will need International Reply Coupons instead of stamps. Check with your local post office for IRCs.*

Finally, before you submit work, find out what editors want in the way of submissions. Most markets in this book explain their likes and dislikes when it comes to submissions. Some prefer tearsheets and self-promotion pieces instead of slides, others only want stock photo lists. Many review portfolios and want you to drop off your work on specific days. By doing a little legwork you can sell more photos.

IMPORTANT TAX INFORMATION

The financial concerns that go along with freelancing are demanding. You are the sole proprietor of your business and, therefore, must tend to tasks such as recording expenses and income. These tasks are time consuming, but necessary.

Every photographer is in a different situation. You may make occasional sales from your work or your entire livelihood may derive from your photography skills. Whatever the case, it is a good idea to consult with a tax professional. If you are just starting out, an accountant can give you solid advice for organizing financial records. If you are an established professional, an accountant can double check your system and possibly find a few more deductions.

When consulting with a tax professional, it is best to see someone who is familiar with the needs and concerns of small business people, particularly photographers. You also can conduct your own tax research by contacting the Internal Revenue Service. The IRS has numerous free booklets that provide specific information, such as allowable deductions and tax rate structures. These include: Publication 334: Tax Guide for Small Business; Publication 463: Travel, Entertainment and Gift Expense; Publication 505: Tax Withholding and Estimated Tax; Publication 525: Taxable and Nontaxable Income; Publication 533: Self-Employment Tax; Publication 535: Business Expenses; Publication 538: Accounting Periods and Methods; Publication 587: Business Use of Your Home; Publication 910: Guide to Free Tax Services. To order any of these booklets, phone the IRS at (800)829-3676. IRS forms and publications,

as well as answers to questions and links to help, are available at the IRS website: http://www.irs.ustreas.gov/basic/cover.html.

Self-employment tax

As a freelancer it's important to be aware of tax rates on self-employment income. All income you receive without taxes being taken out by an employer qualifies as self-employment income. Normally, when you are employed by someone else, your income is taxed at a lower rate and the employer shares responsibility for the taxes due. However, when you are self-employed, even if only part-time, you are taxed at a higher rate on that income, and you must pay the entire amount yourself.

Freelancers frequently overlook self-employment taxes and fail to set aside a sufficient amount of money. They also tend to forget state and local taxes are payable on self-employment income. If the volume of your photo sales reaches a point where it becomes a substantial percentage of your income, then you are required to pay estimated tax on a quarterly basis. This requires you to project what amount of sales you expect to generate in a three-month period. However burdensome this may be in the short run, it works to your advantage in that you plan for and stay current with the various taxes you are required to pay.

Deductions

Many deductions can be claimed by self-employed photographers. It's in your best interest to be aware of them. Examples of 100 percent deductible claims include production costs of résumés, business cards and brochures; photographer's rep commissions; membership dues; costs of purchasing portfolios and education/business-related magazines and books; insurance, legal and professional services.

Additional deductions may be taken if your office or studio is home-based. The catch here is that your work area must be used only on a professional basis; your office can't double as a family room after hours. The IRS also wants to see evidence that you use the work space on a regular basis via established business hours and proof of actively marketing your work. If you can satisfy these criteria then a percentage of mortgage interests, real estate taxes, rent, maintenance costs, utilities, and homeowner's insurance, plus office furniture and equipment, can be claimed on your tax form at year's end.

Some of the aforementioned deductions are available to hobbyists as well as professionals. If you are working out of your home, keep separate records and bank accounts for personal and business finances, as well as a separate business phone. Since the IRS can audit tax records as far back as seven years, it's vital to keep all paperwork related to your business. This includes invoices, vouchers, expenditures and sales receipts, canceled checks, deposit slips, register tapes and business ledger entries for this period. The burden of proof will be on you if the IRS questions any deductions claimed. To maintain professional status in the eyes of the IRS, you will need to show a profit for three years out of a five-year period.

Sales tax

Sales taxes are deceptively complicated and need special consideration. For instance, if you work in more than one state, use models or work with reps in one or more states, or work in one state and store equipment in another, you may be required to pay sales tax in each of the states that apply. In particular, if you work with an out-of-state stock photo agency which has clients over a wide geographic area, you should explore your tax liability with a tax professional.

As with all taxes, sales taxes must be reported and paid on a timely basis to avoid audits and/or penalties. In regard to sales tax, you should:
- Always register your business at the tax offices with jurisdiction in your city and state.
- Always charge and collect sales tax on the full amount of the invoice, unless an exemption applies.

- If an exemption applies because of resale, you must provide a copy of the customer's resale certificate.
- If an exemption applies because of other conditions (e.g., selling one-time reproduction rights or working for a tax-exempt, nonprofit organization) you must also provide documentation.

PROTECTING YOUR LIVELIHOOD

We've all heard the expression "Better safe than sorry," and if you plan to build a business this phrase goes doubly for you. What would happen to your business if a fire swept through your office? What if someone stole your computers? Maybe you were injured and couldn't work. Could your business withstand these setbacks?

Proper planning can keep you from taking that "major hit." Talk with financial planners and insurance agents about protecting your livelihood. From an insurance standpoint, here are a few points to consider:

● Devise an apt system of storage for transparencies, valuable papers and backup computer disks. Consider opening a safe deposit box for duplicate transparencies and other irreplaceable information. Then if disaster strikes in the office you won't be totally devastated. Some professionals place transparencies in fireproof safes.

● Make sure you have adequate liability coverage and worker's compensation. If someone is injured, perhaps a model who is hit by a falling studio light, you must be insured.

● Make sure you have adequate health/disability coverage. If you are injured or become ill and can't work, the effects on your business could be devastating. In the case of disability insurance, however, take a close look to see if you will be suitably covered. A disabled stock photographer, for example, who has a large file of images, could draw an income from stock sales even though he is unable to shoot. By selling stock he might be ineligible for disability benefits.

● Unfortunately, most insurance companies will only pay for the cost of replacing film if images are destroyed or lost. They consider the market value of an image "intangible," and, therefore, uninsurable.

● When acquiring property insurance make sure you are covered if you shoot on location. You don't want to drop a camera during an aerial shoot, for example, and then discover that your insurance only covers equipment in your studio.

● Finally, consider joining trade organizations that offer members group insurance packages. The cost of membership could be worth the insurance benefits you receive.

How to Put Together a Winning Portfolio

BY ALLEN RABINOWITZ

No marketing tool is more essential to a photographer than a top caliber portfolio. More than just a collection of images, a winning portfolio portrays a freelancer's best work and provides potential clients with some insight into the photographer's sensibilities.

When it comes to defining what makes a winning book, however, there are almost as many opinions as there are photographers. From veterans to newcomers, each shooter has a different take on the best possible portfolio. The one thing they agree upon is the need for photographers to take the time to choose the best possible photos.

"What you want to end up with is something you're not uncomfortable with showing physically to people," says legendary New York shooter Jay Maisel. "You're not trying to show that you can do everything. You're only trying to show what you can do well. You don't put in things just to show that you can do them. Put them in to show you can do them excellently."

Atlanta corporate photographer Phillip Spears feels that portfolios are key ingredients in the quest to doing good work. "The better portfolio you've got the better assignments you'll get and the better images you'll get to make," he explains.

From the potential client's perspective, the portfolio is a prime indicator that the photographer is indeed as talented and capable as he or she claims to be. "It's about reassurance," says Seattle corporate photographer Doug Plummer. "They're asking themselves, 'Can this guy do what I need?' Secondarily, they're thinking, 'Can he give something no one else can?' They want reassurance you won't make them look bad."

ONLY THE STRONG SURVIVE

The first step to a successful portfolio is selecting the photos that will make it up. What needs to be defined up front is the kind of work that will be pursued.

At the start of the process, New York-based creative consultant Elyse Weissberg says photographers should gather up every image they've taken and divide them into two piles—good photography and not good photography. "Every photographer, before he starts the editing process, needs to make a list of what he considers to be 'good photography' and then be totally honest when he looks at each image," says Weissberg.

Says photographer Reagan Bradshaw of Austin, Texas, "It's all well and good to put your favorite pictures in the portfolio, but if you're not targeted to what a potential client needs, you're wasting your time and money. You need to see what it is you've done that fits a market niche. Then you select the best work you have to approach these particular clients. If you feel

ALLEN RABINOWITZ *is a freelance writer from Atlanta, Georgia, who specializes in advertising, media and visual communications. His work has appeared in top trade publications, such as* Photo District News, Professional Photographer, Communication Arts, HOW, American Advertising, Folio *and* Photo Electronic Imaging. *He also served as an advisor to the Atlanta/Southeast Chapter of the Advertising Photographers of America and contributed two chapters to* The ASMP Business Bible, *published by the American Society of Media Photographers.*

you don't have enough depth or variety, then you need to think about creating some work that's targeted to that market."

For young shooters seeking to break into a particular market, many agree with Bradshaw on creating a body of work. Says Santa Ana, California-based creative consultant Maria Piscopo, "The best portfolios I've seen have been self assigned and had an objective to meet. Photographers should show they can solve a problem a client might have."

Piscopo stresses that this kind of shooting is separate from personal work. "Personal work doesn't have a particular reason to be shot," she explains. "Self-assigned work has a particular purpose and a problem it's solving."

Kansas City-based advertising photographer Nick Vedros says that he built up his first portfolio on self-assigned work and recommends that approach to others. "A photographer should simply go with what his best work is," he explains. "If your best work is self assigned, definitely put it in."

Just as the weakest link can destroy a chain, Plummer believes the weakest photograph in the portfolio drags the whole book down. "You need to be ruthless in the editing process," he advises. "You need to get outside of yourself in assessing images and get your feelings away from what happened when you made the image."

CARVING YOUR OWN NICHE

Along with showing an ability to solve a creative problem, the portfolio must express the photographer's vision. The book should give a viewer an idea of who you are, what your tastes are and your own unique sense of style. When beginning the editing process, you should keep in mind that you are selling your taste as well as your ability to manipulate the environment.

Defining yourself, according to Atlanta creative services consultant Morgan Shorey, is one of the portfolio's main tasks. "Because there are so many photographers in the marketplace today, and because they're so well educated and well prepared, you can't be a jack-of-all-trades and get respect," says Shorey.

Shorey suggests that photographers prepare a portfolio that is indicative of a style or a point of view. She says a style can be defined by subject matter, look or feel of the work, rather than the more conventional means that refers to a technique or technical specialty. Point of view can be shown by the way you approach a location, subject or person. It can be defined by unusual camera angles, lens selection or manipulation of light.

Once the direction is determined, the next critical decision is how to present the images. Perhaps the first question to be dealt with is the number of photos that will make up the book. In general, all agree with the dictum that less is more.

"I feel that 15 or so pieces is good," says Shorey. "Less than that is a little thin, and if you have more than that—and they're not in there for a good reason—you'll exhaust the viewer. The question you should ask yourself is not, 'Have I done the coolest thing I could do?' but rather, 'Is what I've done appropriate for the audience I'm calling on?' "

As a rule of thumb, Piscopo advises showing "fewer images to higher-end, advertising agency clients because of the way they look at photography. If you look at an ad, there's one picture, and they tend to pigeonhole photographers in a style, so they're very straightforward." For these clients, Piscopo suggests a portfolio with 10 to 12 strong images.

On the other hand, Piscopo says that editorial clients want to see multiple images and multiple stories. "If you had five or six images that told a story, that's the way editorial clients look at photography," she explains. "Portfolios need to be sensitive to what clients want to look at, more than what photographers want to look at."

Vedros also recommends inclusion of a select group of images. "Definitely show only great work," he suggests. "The difference between an amateur and a professional photographer is that the amateur shows you all his or her work. If you're a photographer who is new to the game

and you have just six great pictures, just send those six. Don't send 20 when you have 14 that dilute the impact of the six."

For corporate-oriented books, Spears says he would "tend to err on the side of fewer images. You're selling a feel and a look. Occasionally, you'll find a client who will respond to a particular image in your portfolio and say, 'I want to do something exactly like that.' But, by and large, your portfolio is selling a general style and competence. Using more and more images confuses the matter."

When presenting the images, Maisel believes in making it as easy as possible for the viewer. "There are simple rules to follow. Don't go from vertical to horizontal to vertical to horizontal. You're just making it difficult for the viewer. If you're going to change from vertical to horizontal, do it once and be finished with it. Don't make the guy a candidate for orthopedic surgery after he's finished looking at your portfolio."

PICKING YOUR PRESENTATION

When selecting a format, most photographers advise keeping the portfolio consistent by not mixing transparencies and prints. "Ideally, it should be a singular vehicle," says Vedros. "If you're going with transparencies, dupe your black and white prints into transparencies so that everything is continuous and flows freely without interruption."

If you're using transparencies, Piscopo suggests taking them out of the acetate sleeve provided by the lab and going to an art store to purchase the thickest acetate holder that can be found. She recommends something clear in front and opaque in the back. "It doesn't ripple, doesn't scratch easily and looks like a laminated transparency," she explains.

Other tips for presentation include making sure all mats are the same color and size. "That will make the portfolio look better," Piscopo explains. If mats are used, she also suggests the mat boards be sandwich mounts. That presents the client with a place to hold it and a clear finish on the back.

Plummer prefers a bound book rather than loose boards for his portfolio. "I want to control how someone experiences it. I want to establish a sequence. I'm making a statement by how I'm doing that. The limitation is that I don't have any flexibility in presenting that work."

Shorey adds that viewers prefer one way of looking at photographs. "If you have sheets of slides, prints and tearsheets, you're fumbling through several types of formats. That's unprofessional and inconvenient for the client."

When showing prints, Shorey suggests they should be mounted or affixed in some way to boards. This way, if the boards are all the same size, prints of different sizes can be shown.

Although some beginning shooters might think they need to invest in an expensive printing process to impress clients, Weissberg says it isn't necessary to do that if the budget isn't there. "I don't think you need C prints, Iris prints or digital C prints to make a beginning portfolio. You can scan them in—and it doesn't have to be a very high resolution scan—and print them out on a good color printer."

There is some disagreement about whether or not it's appropriate to make tearsheets of published work a part of the portfolio or save them for a separate marketing piece. "It depends on who you are and where you live," says Weissberg. "In New York, we don't really have to show that.

"Someone looking through a book of all tearsheets of published work might say, 'Is this the book of an art director or a photographer? So, whereas some photographers might feel that it makes them look better to show a published piece, if the published piece is low-end, you'll be pigeonholed as a beginner. Show your work in the context of how you want it to be used."

On the other hand, Bradshaw says, "You need to be able to show you've done work for clients. The best way to show that is tearsheets. Obviously, the tearsheets have got to be good work. In an ideal world, you'd have tearsheets of great work and be able to use them in a separate section in the back of the portfolio, and show prints or transparencies in the front."

Maisel is another advocate of using tearsheets. "Even though you've been in the business a few years and feel people should know you and your work," he explains, "I guarantee that someone, somewhere hasn't heard of you. It's nice if he can see that someone else has put some money down on you and you've come through."

WHAT ABOUT PORTFOLIO CASES?

The choice of a container for your photos is another critical decision. When a client calls in portfolios, there can be dozens of identical black books lined up on a table. The photographer with a distinctive-looking case that attracts notice has a slight advantage on the competition.

Seeking to stand out, New York-based editorial photographer Dorian Romer decided to showcase her photos in an oblong case that resembles an old-time photo album. The handmade portfolio features a red fabric material on the outside and patterned paper on the inside.

"Everything about it is different from other books," Romer explains. "But, it's not just attention for attention's sake. It's got to work. Photo editors don't have a lot of time, and they bang through portfolios. So, if there's any reason why yours should stick out, I think it helps."

Some photographers have put their creative powers to work in coming up with a distinctive look for their portfolios. Vedros, for example, highlighted his Midwestern homebase with a black and white cowhide covering with his name die-stamped onto it looking like a cattle brand. "Find something that's classy and represents your personality," he recommends. "Mine is quirky, so black and white cowhide worked for me."

Like Vedros, other photographers suggest customizing an otherwise standard portfolio which can be purchased at an art supply house. There are any number of materials which can be bought cheaply and applied to the outside.

"You can find interesting materials that relate to the work you do and relate to the art directors and designers you'll be soliciting," says Spears. "Designers like spending time in art supply stores and love getting interesting materials in the mail."

In an attempt to differentiate his portfolio, Plummer builds his own books. He uses silk on the outside and velvet on the inside, nice paper and fine hardware hinges. Even though his book is unique, he points out that it doesn't have to be expensive. "Just make it something that nobody else has," he recommends.

No matter what the book looks like, experts suggest that the portfolio be sized to easily fit inside a standard overnight delivery service packing case. All suggest sending the book via a reliable overnight service, so that the portfolio can be tracked and accounted for during shipping. The US Postal Service is not recommended under any circumstances.

Additionally, Weissberg adds that a plain, cardboard box doesn't work. "You don't want to send it in something makeshift," she says. "They'll take out your portfolio, leave it on a desk and the cleaning people will throw out that box because it looks discarded. When it comes to sending your portfolio back, they'll have to rummage to find a box."

In the past, photographers might have had the option of sending a tray of slides to a portfolio review, but those days are long gone. Although he'd love to make such a presentation, Maisel says, "You go to an ad agency billing $42 billion and they don't have a carousel. Or they can't get a room that's dark. Or they don't have the time. Years ago, you'd show a carousel. They'd call people in and you'd show your best stuff."

Weissberg says if a photographer wants to present a slide presentation, a good bet is to send transparencies with an individual viewer. Otherwise, they'll be viewed by looking into overhead florescence. "It's a viable alternative that will present the slides in a good light," she says.

STAYING IN CONTACT

After sending off the book, you should definitely follow up. "Whether you send or show a portfolio, the conclusion of that activity is the photographer taking charge and asking when the client wants to see more work, new work and when he or she should check back," says Piscopo.

"There's a very strong taking charge of what happens next, rather than the archaic way of waiting for the phone to ring."

Romer says she'll follow up with a phone call. Even if she can't talk to the buyer directly, she'll leave a message so they hear her name again. "I put a card in with the portfolio and I always send a thank-you card. I also send promo cards every four to six weeks."

But, be advised that there is a fine line between a friendly call to make sure the portfolio was received and being a nuisance. Be aware that if 20 portfolios were requested, that means that 19 other photographers are going to call. If you call too often, buyers will resent that.

In the end, the best portfolio proves to the client which photographer is the right shooter for the job. Says Maisel, "The best advice I can give is to show a portfolio that somebody looks at and says, 'Is that all there is?' Leave them so excited by what they see that they want more."

First Contacts and Portfolio Presentations

BY CHARLES E. ROTKIN

The thought of making first contacts can be intimidating to new photographers. Some approach them with trepidation, others with confidence. What most new photographers fail to realize is that people need to buy photographs or photographic services as much as the photographer needs to sell them. Photo buyers would not grant interviews if it were otherwise.

The goal of the photographer is to have his work seen and accepted. All other factors are secondary, and the photographer should not try any psychological ploy or approach other than simple, no-nonsense procedures of dealing directly with those interested in seeing and possibly using his photographic abilities.

The chances are that the people you will come in contact with are experienced in their fields, perhaps are older, and maybe just a little wiser, and any attempt to con them or fool them will only result in failure of the interview. While there are some photographers who are better salesmen than craftsmen there aren't too many of them around, and it is your pictures that will prove to be the ultimate measurement. Primary to any interview or bid for work is your showcase, portfolio or, in ad lingo, your "book."

Putting a portfolio together is one of the most important things you do before entering the marketplace, and your second most important professional decision (the first being the decision to become a professional). What you present, and to whom, is paramount. It is the only way you can demonstrate to the buyer what you are capable of doing and perhaps trigger ideas for work. (Read How to Put Together a Winning Portfolio on page 10.)

MAKING THE ACTUAL FIRST CONTACT AND PRESENTATION

Showing your portfolio in person can be costly and discouraging from a logistical standpoint, and there may be a tendency to want to use the mail instead. But if you consider the amount of time and money already invested in your career, the additional cost of some personal visits should be built into your general cost of getting started.

Choose a group of market possibilities in one locale and begin by making appointments either by phone or mail. Get the names, addresses and phone numbers, from *Photographer's Market* or other directories. Make your conversations or letters direct and to the point. Give your name and the fact that you are a photographer specializing in a certain area and that you think your work is worth seeing because it may be of use to them. For an out-of-town prospect, say that you are going to be in the buyer's area for a limited period of time, and since you live a distance away you would like to have an appointment to show your portfolio and meet him during that time. That's about it. If you have a mailer or some tearsheets you can spare, by all means include them in your mail contact.

It is inadvisable to mail photographs or portfolios for the first contact, without at least talking

to the prospective client. There is no sense going to the expense of preparing and shipping a presentation if the person you are addressing is not interested in seeing it, and this should be clear in your conversations.

When an out-of-town appointment is scheduled, try to arrange additional interviews with other picture buyers during the same time period given for your primary contact. Allow enough time between appointments to cover goofs in schedules others give you. If you are contacting people in a large city the most you can hope to see in any one day is four or five people—two in the morning and two or three in the afternoon.

You may not yet be at the level of the "business lunch," but if you feel you can afford it, and think it might be worthwhile to pursue this course, there is no harm in trying to take the picture user to lunch, dinner or cocktails. But I advise against it until after the first contacts are made to avoid any appearance of impropriety.

If you tell someone you are coming from out of town for the express purpose of seeing him he will probably respect this and be responsible about keeping the appointment. A few won't. Also, some picture editors and art directors set limits on the time they will spend on seeing new work and try to make you fit into their schedules. Some won't even see you at all. But these are the hazards you must face.

But for the moment, you have made an appointment. Keep it and be on time. Even if you are kept waiting for what you think is a long period, be patient. It's your work that has to be sold and you are at the potential buyer's mercy. Don't show your irritation and don't get angry, especially when you are finally called in for the interview.

DRESSING APPROPRIATELY FOR INTERVIEWS

Along with devoting attention to effective presentation of your work, remember your own appearance. For the most part you are dealing with stable and probably conservative companies or business institutions. Dress is important, if for no other reason than that it may be an indication of your personal ideas of tastefulness. Some ad agency art directors have cultivated an image to make it seem that their code of dress is strictly blue jeans and denim shirts. Don't believe it. These are for the most part affectations put on by a very few. Some clients will be personally repelled by the disreputable appearance of an artist, and who needs that? There is a definite consciousness about dress even in the supposedly casual atmosphere of the "typical" ad agency.

Appearance is even more important when dealing with conventional business firms. Large manufacturers, major publishers, financial institutions, educational organizations, etc., are apt to be less receptive to the photographer who comes in with total disrespect for his surroundings. Be aware of those you are dealing with and make your photographs the only criterion of whether you get an assignment. Do not introduce other factors that may negatively influence their decisions about your work.

I suggest that men wear a business suit or at least a sports jacket or blazer, shirt and tie. For women, simple classic dresses or skirts, pants and blouses with a jacket are wise choices.

There are other appearance factors such as personal cleanliness, and even smoking, which may have some effect on the person you are trying to see. You might ask (justifiably, perhaps) what all this has to do with your photography. You are probably right, nothing, but if the buyer takes offense and a dislike to you and you aren't that strong in experience or reputation, you may never get a chance to present your work—or at least present it in a favorable atmosphere.

I am not suggesting that if you are photographing a steel-making executive you should appear in a hard hat, nor are you expected to be wearing a business suit on a mill floor. But you should pay as much attention to your personal appearance as you can, and try to avoid offending or annoying anyone whose standards may be different from yours. It may not always be possible, but at least be aware of the possibilities and think these things out. It's all part of professionalism.

Manners, too, are important. Egos are fragile in this business, and it's very easy to feel rejected or equally easy to come on too strong. Be at ease. Be confident in your own ability and

don't let personality factors intrude. Build yourself up, but do it gracefully and with tact, don't put yourself down. It's okay to say you're the best in the world, but only if you do it some humor. Explain as briefly as possible beforehand what the photos you are showing are all about, but then let the pictures speak for themselves.

DO YOU LEAVE YOUR PORTFOLIO OR NOT?

The problems of the art buyer, art director, or picture editor having the time to review incoming work are real. Have respect for them. What happens after you have had your interview? What do you leave behind? You have to leave something. Some art directors, art buyers or picture editors may require that you leave your portfolio with them because they may want to show it to others. Do you accede to this request?

The answer is probably yes. But remember that it's absolutely essential to retain at least one duplicate, especially if you have others to show it to while waiting for return of the presentation you have left.

You should have had some business cards printed by now which you can leave. Also, some photographers have made up 3×5 index cards and even "Rolodex" file card inserts with their names and pertinent information which are useful for a secretary's file. Others leave their mailers if they have any, or extra tearsheets. Do not leave original prints, whether black and white or color, original transparencies, or any other material that is difficult, costly, or impossible to duplicate.

THE INTERVIEW FOLLOW-UP

The first thing you should do to follow up on an interview is to write a note of appreciation to the art director or picture editor who took the time to see you and/or your work. If you feel you were well received and that your work impressed your audience, a note or phone call in two or three weeks' time is absolutely in order. This is the time to start sending mailers to agencies or submitting story ideas in writing to the editorial publications you have contacted, again making certain the ideas you submit are the kind of material they can use.

Start keeping a log book or card index or computer file on calls or mail presentations, including dates, whom you saw, and perhaps a small commentary on your assessment of the interview. Were your pictures really examined? Were they liked or disliked? Criticized or praised? In what way? Was there a request for more material? If so, what did you send? Anything that's germane to the interview should be noted and logged, even your reaction to the person, and perhaps the secretary's or assistant's name. If you don't record this information, a hundred interviews later you may be hard pressed to remember what happened. And it may also help to avoid the future embarrassment of forgetting that you have already seen this person.

If you produce an exceptional set of photographs for an ad or editorial layout, even for a competing client (or magazine), and can get your hands on extra prints or tearsheets, send them in to the art buyer or picture editor. Some prolific photographers have made printed forms announcing the appearance of a specific layout and offering to provide more information.

The question of follow-up is a delicate one. Memories are short, yet you are reluctant to make a pest of yourself. Art directors and picture buyers do not object to being reminded of the photographer's existence by a flow of mailers. In fact they encourage this.

With editorial people it is easier if you have an idea or reason to call or write about other than just asking, "Do you have any work for me?" Where you have an advantage is when something happens on the local scene which has national overtones, and the local situation can be used to illustrate the piece as a microcosm of the national implications. Desirable as travel may be to you, magazines will be reluctant to send a photographer on a cross-country trek when stringers or regional staffers can put together a story to serve their national needs. But you will be recognized for initiating the idea and may draw a lot more out of it than the local shooting. Your name will become familiar, and once a fresh flow of useful ideas starts, the chances are you won't be forgotten.

Pricing Your Photos in Today's Market

BY MICHAEL WILLINS

In college I remember having to write a speech for a communication class on something I valued. I chose my alarm clock. Not being a morning person, it was important that my alarm clock was perfect. It had to wake me without jarring me out of bed. When it sounded every morning I didn't want it to wail with loud rock music. It couldn't screech with a high pitch that shattered glass. I just wanted it to simply beep, softly, so that I could slowly open my eyes and adjust to the day. I would have paid anything for it. To me, that's value.

As a professional photographer it's important to understand the meaning of value to your clients. This is one key to pricing your images. Clients will pay almost anything for images that solve their problems. Likewise, they will pay extra to work with good photographers—those who can provide quality photos, on time, without any headaches. When negotiating with clients remember this fact. Educate yourself about clients' needs so that you know how important your work is to their success. Remember, *the greater their dependency on you, the higher the price should be for your images.*

In this article we're going to talk about value, along with other vital aspects of negotiating fair prices. You'll learn how to compose a business plan. You'll discover the importance of establishing a fee based on usage. And, by the end of this article, you'll know how to properly bid projects for clients.

BUILD A BUSINESS PLAN

It's extremely important as you build your photography business to know what it costs to conduct business every day. This includes expenses for everything, from cameras and equipment to paper clips and other office supplies. Without knowing this information you may find yourself undercharging clients. Your expenses will be greater than your income and, eventually, you'll be out of business.

The best way to safeguard against financial ruin is to create a business plan. In this document you will account for your annual overhead expenses. (This does not include fees for film, processing, travel expenses or other expenditures that can be passed on to clients.) By knowing your overhead expenses you will know what it costs to open your doors each day. The following is a list of overhead expenses that ought to be accounted for in your business plan. Note that this list includes an expense for your salary. It's important to pay yourself based on the lifestyle you plan to keep.

- Studio rent or mortgage payment
- Utilities
- Insurance (for liability and your equipment)
- Equipment expenses
- Office supplies
- Postage
- Dues for professional organizations
- Workshop/seminar fees
- Self-promotion/advertising (such as soucebook ads and direct mail pieces)

- Fees for professional services (such as lawyers and accountants)
- Equipment depreciation
- Salary expenses for yourself, assistants and office help (including benefits and taxes)
- Other miscellaneous expenses

Once you know your overhead expenses, estimate the number of assignments and sales you will have each year. In order to do this you will need to know how many weeks in the year are actually "billable weeks." Assume that one day a week is going to be spent conducting office business and marketing your work. This amounts to approximately ten weeks. Add in days for vacation and sick time, perhaps three weeks, and add another week for workshops or seminars. This totals 14 weeks of nonbillable time and 38 billable weeks throughout the year.

Now estimate the number of assignments/sales you expect to complete each week and multiply that number by 38. This will give you a total for your yearly assignments/sales. Finally, divide the total overhead expenses by the total number of assignments. This will give you an average price per assignment.

As an example, let's say that your overhead expenses came to approximately $65,000 a year (this includes a $35,000 salary). If you completed two assignments each week for 38 weeks (76 assignments/year) your average price per assignment must equal approximately $855. This is what you should charge just to break even on each job.

To learn more about pricing and creating a business plan, contact the American Society of Media Photographers (609-799-8300) to inquire about the group's Strictly Business Seminar. This traveling seminar is excellent for photographers who are searching for business guidance.

ESTABLISH PHOTO USAGE

When pricing a photo or job, you also must consider the usage: What is going to be done with the photo? Too often, photographers shortchange themselves in negotiations because they do not understand how images will be used. Instead, they allow clients to set prices and prefer to accept lower fees rather than lose sales. Photographers argue that they would rather make the sale than lose it because they refused to lower their price.

Unfortunately, those photographers who look at short-term profits are actually bringing down the entire industry. Clients realize, if they shop around, they can find photographers willing to shoot assignments or sell image rights at very low rates. Therefore, prices stay depressed because buyers, not photographers, are setting usage fees.

However, there are ways to combat low prices. First, educate yourself about a client's line of work. This type of professionalism helps during negotiations because it shows buyers that you are serious about your work. The added knowledge also gives you an advantage when settling on fees because photographers are not expected to understand a client's profession.

For example, if most of your clients are in the advertising field, acquire advertising rate cards for magazines so that you know what a client pays for ad space. You also can find ad rates in the *SRDS* directory, which can be found at your local library. During negotiations it's good to know what clients pay for ads. Businesses routinely spend well over $100,000 on advertising space in national magazines. They establish budgets for such advertising campaigns, keeping the high ad rates in mind, but often restricting funds for photography. Ask yourself, "What's fair?" If the image is going to anchor a national advertisement and it conveys the perfect message for the client, don't settle for a low fee. Your image is the key to the campaign.

Some photographers, at least in the area of assignment work, operate on day rates or half-day rates. Editorial photographers will typically quote fees in the low hundreds, while advertising and corporate shooters may quote fees in the low thousands. However, photographers in both areas are finding that day rates by themselves are incomplete. Day rates only account for time and don't substantiate numerous other pricing variables. In place of day rates, photographers are assessing "creative fees," which include overhead costs, profit and varying expenses, such as assignment time, experience and image value. They also bill clients for the number of finished

pictures and rights purchased, as well as additional expenses, such as equipment rental and hiring assistants.

Keep in mind that there are all sorts of ways to negotiate sales. Some clients, such as paper product companies, prefer to pay royalties on the number of times a product is sold. Special markets, such as galleries and stock agencies, typically charge photographers a commission, from 20 to 50 percent, for displaying or representing their images. In these markets, payment on sales comes from the purchase of prints by gallery patrons, or from commission on the rental of photos by clients of stock agencies. Pricing formulas should be developed depending on your costs and current price levels in those markets, as well as on the basis of submission fees, commissions and other administrative costs charged to you.

WHAT IS A PICTURE'S WORTH TODAY?

No one can state exactly what any one client would or should pay, but please do not get so eager to get your photos published that you sell yourself, and your photos, short. On the other hand, you don't want to price yourself out of a potentially good sale.

Negotiation is an art you should cultivate. When a client calls and asks a price, it is helpful if you have some sort of list near the phone so that you can know which price to quote in starting your negotiations. The following four pages provide you such basic information.

Unfortunately, prices have not increased over the last several years. Electronic sales, however, are starting to soar. If the client wants electronic rights for a photo (and many magazines now publish issues simultaneously in print and electronically), there should be an additional fee. This should never be less than $50 and can be negotiated to as much as 100 percent of the original usage fee. The same holds true for photos which are used in Internet Home Pages. Here, duration is an issue. $100 per year is acceptable if the photo is being used on a noncommercial site.

—*Carl and Ann Purcell*

The accompanying charts were reprinted with permission from *Stock Photography: The Complete Guide*, by Carl and Ann Purcell (Writer's Digest Books). These charts should give you a starting point for negotiating fees for paper products, magazines, newsletters, book publishers and advertisements. However, only use them as guides and adjust your prices according to your experience and photographic skills.

BIDDING A JOB

As you build your business you will encounter another aspect of pricing and negotiating that can be very difficult. Like it or not, clients often ask photographers to supply "bids" for jobs. In some cases, the bidding process is merely procedural and the assignment will go to the photographer who can best complete the assignment. In other instances, the photographer who submits the lowest bid will earn the job. When contacted, it is imperative to find out which bidding process is being used. Putting together an accurate estimate takes time and you do not want to waste a lot of effort if your bid is being sought merely to meet some quota.

However, correctly working through the steps is necessary if you want to succeed. You do not want to bid too much on a project and repeatedly get turned down, but you also don't want to bid too low and forfeit income. When a potential client calls to ask for a bid there are several dos and don'ts to consider:

• Always keep a list of questions by the telephone, so that you can refer to it when bids are requested. The questions should give you a solid understanding of the project and help you in reaching a price estimate.

• Never quote a price during the initial conversation, even if the caller pushes for a "ballpark

These charts were reprinted from *Stock Photography: The Complete Guide*, by Carl and Ann Purcell. You will notice the phrasing "we" because the charts were created by the Purcells. Their charts should be used as guides and your prices should be adjusted according to your experience and skill level.

Editorial Use—Magazines, House Organs & Newsletters

We use the numbers below when we start to negotiate for *editorial use in consumer magazines* and *internal house organs* (a term used for magazines published within an organization, company or corporation for internal distribution to the employees or membership).

- We charge 50 percent (multiply the numbers below by 0.5) when negotiating for *internal house newsletters* that will be used for internal distribution only.

- We charge 75 percent (multiply the numbers below by 0.75) when negotiating for editorial use in *consumer newsletters* that will be distributed or sold to the public at large.

- We charge 170 percent (multiply the numbers below by 1.7) when negotiating for *editorial use in external house organs* (a term used for magazines published within an organization, company or corporation for both internal and external distribution to its membership).

- If the client is using the photograph as an interior shot plus a spot insertion on the Page of Contents, we charge the space fee plus 25 percent (multiply the space fee by 1.25). If the spot insertion is on the cover, we charge the space fee plus 50 percent (multiply by 1.5).

Magazines, House Organs and Newsletters—Editorial Use

Circulation	¼ page	½ page	¾ page	full page	double page	cover
Over 3M	$425	$495	$565	$700	$1,150	$1,235
1-3M	385	445	510	635	1,050	1,115
500,000-1M	345	400	460	575	945	1,000
250,000-500,000	265	310	350	445	735	775
100,000-250,000	240	280	320	400	675	710
50,000-100,000	220	250	290	365	600	640
20,000-50,000	200	235	275	350	550	625

Advertising in Magazines, House Organs or Newsletters

Advertising in magazines can be local, regional, national or specialized editions. Most of our invoices specify that we are granting the rights for one year. We charge an additional fee for longer use or repeated use and we base it on a percentage of the original billing.

- In the chart below are the prices we charge for *advertisements in consumer magazines— national exposure.*
- We charge 80 percent (multiply by 0.8) of the fees below for *regional exposure.*
- We charge 60 percent (multiply by 0.6) of the fees listed below for *local exposure.*
- We charge the same fee for *advertisements in trade magazines* as we charge for *regional advertisements in consumer magazines.*
- We charge 75 percent (multiply the numbers below by 0.75) when negotiating for *advertisements in newsletters* that will be distributed or sold to the public.

ADDITIONAL FEES:

Rights: One Year Exclusive: Subtotal plus 100 percent
Five Year Exclusive: Subtotal plus 200 percent
Unlimited use—1 year—Subtotal plus 250 percent

Insertions: 2-4: Space fee plus 25 percent
5-10: Space fee plus 50 percent

Inside Cover: We usually start negotiations halfway between the full page price and back cover price.

Advertising in Magazines—National Exposure

Circulation	¼ page	½ page	¾ page	full page	double page	back cover
Over 3M	$1,300	$1,750	$2,200	$2,600	$4,200	$3,500
1-3M	780	1,020	1,250	1,575	2,575	2,080
500,000-1M	625	810	990	1,250	2,050	1,675
250,000-500,000	520	675	835	1,050	1,720	1,400
100,000-250,000	475	625	775	950	1,550	1,280
50,000-100,000	400	525	650	750	1,200	1,000
20,000-50,000	375	440	540	675	1,125	925

Books—Textbooks, Encyclopedias, Trade Books & Paperbacks

Photo use in books is usually considered strictly editorial unless the book is a single destination promotional piece. For textbooks, guidebooks and encyclopedias, we offer a special rate if multiple sales are made.

The normal run for a book is around 10,000 copies. Rarely are books published in runs over 40,000, unless they are paperbacks. We have divided out the pricing for books, therefore, into two categories: under 40,000 and over 40,000.

If the run is for 5,000 copies, we will usually negotiate a price of approximately 80 percent (multiply by 0.8) of the under 40,000 fee.

Press Run	¼ page	½ page	¾ page	full page	double page	jacket or cover
TEXTBOOKS						
Over 40,000	$185	$200	$225	$270	$550	$550-820
Under 40,000	145	170	195	225	450	450-650
ENCYCLOPEDIAS						
Over 40,000	215	270	300	325	650	825-1,075
Under 40,000	190	215	250	275	550	435-650
TRADE BOOKS						
Over 40,000	185	200	225	270	550	550-825
Under 40,000	145	170	195	225	450	450-675
PAPERBACKS						
Over 40,000	200	220	250	285	565	510-780
Under 40,000	175	200	235	260	525	425-650

ADDITIONAL FEES:

- Reuse or revisions: We usually charge 50 percent of the original price each time a new edition comes out or the photo is reused in a foreign edition. If world rights are requested during initial negotiations, we charge 150 percent of the price listed above for a book being published in one language. We charge 200 percent for world rights for a book being published in several languages.

- For chapter openers, we usually charge 125 percent (multiply by 1.25) plus the space fee listed above.

- For wraparound covers, we start negotiations at the top listed price for covers.

- We usually charge $350 for an author head shot, plus traveling costs to get it and $15 per roll of film taken.

Paper Product uses such as: Greeting Cards, Postcards, Billboards, Murals, Decorative Prints, Calendars, etc.

Postcards and greeting cards (5,000-20,000)	$200-500
Billboards (one local for one year-one regional for one year)	$500-1,000
Murals (3′ × 5′ to full wall)	$300-2,500
Display prints for decoration (small-large)	$250-450
Bank checks (local-national)	$400-750
Place mats	$325
Key chains and charms	$300
Stationery letterheads	$375
Playing cards	$375
Stamps	$400
Plates or coffee mugs	$375
Apparel (actual photo used)	$350
Apparel (facsimile used)	$200
Telephone directory covers	$750 each (more than 4, $500 each)

CALENDARS

Calendars can be either promotional or retail. They can either have one photo visible for 12 months, use one photo per month, or have several photos per month as in the desktop appointment book style.

If we are asked to provide the single photo which is visible for 12 months, we usually ask for twice the rate which we would get for the first three photos we provide.

For a calendar cover photo, we can usually add 50% (a multiple of .5) to the rate which we get for the first three photos we provide.

Calendars are good promotional portfolios when all the photos used are those of one photographer. When we are asked for calendar pictures by a company who has always put out a fairly sophisticated, good-looking product, we offer the alternative that, if the art director chooses to use only our photos, we will give a 50% discount on the cost of the photos for an over-run of 250-3,000 calendars (depending on the size of the press run). We then mail the calendars to important current clients and potential clients. When the agreed-on over-run is very large, we ask for a certain percentage to be in finished calendars and the remainder to be in loose photo sheets (without the dates).

Press Run	Photos 1-3	Photos 4-7	Photos 8-12	Photos 13 & up
over 100,000	$1,000	$700	$500	$400
50,000-100,000	800	650	450	350
20,000-50,000	600	500	400	300
10,000-20,000	450	400	350	275
5,000-10,000	300	250	200	150

figure." A spot estimate can only hurt you in the negotiating process.
• Immediately find out what the client intends to do with the photos and ask who will own copyrights to the images after they are produced. It is important to note that many clients believe, if they hire you for a job, they own all rights to the images you create. If they want all rights make sure the price they pay is worth it to you.
• If it is an annual project, ask who completed the job last time. Then contact that photographer to see what he charged.
• Find out who you are bidding against and contact those people to make sure you received the same information about the job. While agreeing to charge the same price is illegal, sharing information on prices is not.
• Talk to photographers not bidding on the project and ask them what they would charge.
• Finally, consider all aspects of the shoot, including preparation time, fees for assistants and stylists, rental equipment and other material costs. Don't leave anything out.

OTHER PRICING RESOURCES

If you are a newcomer to negotiating, there are some extraordinary resources available that can help you when establishing usage fees. One of the best tools available is a software package called fotoQuote, produced by the CRADOC Corporation. This software is ideal for beginners and established photographers who want to earn the most money for their work.

Written by lecturer/photographer Cradoc Bagshaw, the software walks you through pricing structures in numerous fields, such as advertising markets, calendar companies and puzzle producers, and then provides negotiating tips that help you establish fees. For example, if you want to sell photos to a consumer magazine, a preliminary usage fee is given. The fee changes as you adjust factors that affect the sale price. In this case, prices increase when selling to magazines with higher circulations; common images pay less than unique photos; an aerial shot warrants higher fees than normal images.

Whatever the circumstances, you can input them and receive an estimated photo value. The pricing structures in fotoQuote also can be adapted to fit your negotiating style of sales history. For example, you may sell to companies in major metropolitan areas and find that these markets pay more than the software indicates. After a few modifications the program will operate based on your fee structures.

Additionally, fotoQuote provides coaching tips from stock photographer Vince Streano, former president of the American Society of Media Photographers. The tips give you negotiating advice. You also will find scripted telephone conversations. The cost of fotoQuote 2.0 is $129.95 plus $6 shipping and handling. For those people who own the first version of fotoQuote, software upgrade costs $49.95 plus $6 shipping and handling. Washington residents are required to pay sales tax and the program is not available in stores. For information, call or write the CRADOC Corporation, 145 Tyee Dr., Suite 286, Point Roberts WA 98281. (800)679-0202.

Besides fotoQuote, there are several books that can help with pricing. Two resources are *Pricing Photography: The Complete Guide to Assignment & Stock Prices*, by Michal Heron and David MacTavish (Allworth Press) and *The Photographer Market's Guide to Photo Submissions & Portfolio Formats*, by Michael Willins (Writer's Digest Books). See our list of Recommended Books & Publications at the back of this book for ordering information.

Setting Up Your Stock Photo Business

BY MICHAEL WILLINS

If a client called you right now and asked to use one of your photos, what are the chances you'd be able to lay your hands on that photo quickly? As a stock photographer you must be able to do just that if you plan to make money. If you can't you'll miss out on sales, not only from the immediate projects that come up, but from future sales to clients who know you can meet their deadlines.

The key to locating images is proper organization. Not only do you need a place to store your work; you also must have a filing system in place that allows you to easily retrieve images. Your filing system should simplify the process of quickly locating images and submitting them.

To create a filing system for your images you will need:

- labels,
- plastic protectors (archival quality) for transparencies, negatives and prints,
- 3-ring binders or a filing cabinet,
- an established coding system for all of your work,
- a computer with database or labeling software (optional).

Although computers are not essential for labeling images, they certainly simplify the process. Database software not only helps when labeling images; it can assist you in tracking submissions, conducting mass mailings or completing client correspondence. Plus, if you've ever labeled slides by hand you know that the process can be tedious.

CODING AND LABELING YOUR PHOTOS

Developing a coding system is not difficult. At first it may seem overwhelming, especially if you currently house thousands of photos in shoe boxes and have no established coding system. However, once you have the system in place the process becomes routine and relatively simple to maintain.

Start by creating a list of the subjects you shoot. As an example, let's suppose you photograph wildlife and nature. Make a list of everything you've photographed—birds, flowers, mountains, etc. Next, break this list down even farther into subcategories. For birds, you may end up with subcategories like waterfowl, raptors or perching birds. Flowers might be separated by seasons in which they flourish, or regions in which they are found. After you've created your list of subjects, assign three-letter codes to each one. And obviously, don't duplicate codes.

Once you establish a coding system for each subject, the next step is to use those codes in conjunction with numbers to identify each image. For example, perhaps you recently photographed a nesting site for a Bald Eagle. Your code might look something like this: 98WBR1-AKO. Translated from left to right this means you took the image in 1998; it's a Wildlife photograph of a Bird (Raptor); and it's the first photo of a raptor catalogued in 1998. The "AK" shows the photo was taken in Alaska and the "O" on the end means it is an original slide rather

than a duplicate. Replace the "O" with a "D" if the image is a duplicate. When you photograph a subject that needs a model release (see the discussion of model releases on page 5), add "MR" onto the end for further clarification.

Now, you may ask why is all this information necessary. The year shows you how recent the photo is. Clients often prefer images that are current. And it's good to update subjects after a few years. The three-letter subject code is necessary for obvious reasons. When a client needs a specific subject, the three-letter codes make it easy to find the appropriate shot. The number following the three-letter code helps you distinguish one shot from another. The next two letters are state codes that can be extremely useful when submitting work to regional publications. Clients also frequently request shots by region. And the "O" code is important to keep you from submitting original work on speculation to a client.

Along with the file number, each photo should contain your copyright notice which states the year the image was created and gives your name (e.g., © 1997 John Q. Photographer). Also include a brief explanation of the image contents. Remember with captioning software it's easy to write extensive descriptions onto labels. When shooting slides, however, too much information can clutter presentation and may actually be distracting to the viewer. Three or four words should suffice for 35mm. If you want to provide lengthier captions when submitting material, do so on a separate sheet of paper. Be certain to list slide numbers beside each caption.

If you shoot with medium or large format cameras, you can either purchase mounts for your images or place the transparencies into plastic sleeves. Labels can be attached to protective sleeves or mounts when work is mailed to potential clients. When submitting prints, place a label on the back of each photo and make sure it contains your copyright notice, image number and a brief description of each image. You also might want to include your address and telephone number.

One word of caution: never submit negatives to potential clients. You risk damaging the negatives, or worse, having them lost. Most buyers can use a print to generate a suitable image. You also can send contact sheets for their review.

SOFTWARE FOR LABELING

There are two slide captioning systems that I've found to be reasonably priced and easy to use when labeling slides, prints and transparencies. The first is The Norton Slide Captioning System. Produced by photographer Boyd Norton, the NSCS Pro was last updated in January 1997. The software allows you to track submissions, print out forms and stock lists, and of course, write detailed captions. Cost is $149 (plus s/h). The NSCS Pro is available at P.O. Box 2605, Evergreen, Colorado 80437-2605, (303)674-3009.

The second product is the CRADOC CaptionWriter, originally created in the mid-1980s by Cradoc Bagshaw of Point Roberts, Washington. This software can be used in conjunction with another software, Photo Management System, which gives users extensive database capabilities and allows them to write invoices or delivery memos and print out reports. Cost for each software is $69.95 (plus s/h). Both are distributed by Perfect Niche Software Inc., 6962 E. First Avenue #103, Scottsdale, Arizona 85251, (800)947-7155.

STORING YOUR PHOTOS

Now that you've properly labeled your work, the next step is to file images so they can easily be located. First, store them in a cool, dry location. Moisture can produce mold on your film and slide mounts. If your work isn't correctly stored, transparencies can be eaten by moths. To prevent damage, place 35mm slides in archival-quality plastic slide protectors. Each page holds up to 20 slides and can be placed inside a binder for easy storage. The binder system also works

for larger transparencies and negatives. Prints also should be kept in plastic pages.

Other storage areas do exist. File cabinets can work well for archiving, but they aren't as portable as binders. I've even heard of one photographer who stores images inside an old refrigerator. His main reason for using a refrigerator is to protect his work in the event of a fire: The insulation content of refrigerators makes them almost as useful as vaults when it comes to photo archiving.

This raises the issue of image protection. Because disasters such as fires or floods can strike at any time, it's wise to store duplicates of your best images in a different location. Safe deposit boxes work well as secondary storage facilities. The last thing you want is for all your work to be destroyed. Such disasters can ruin your business because most insurance companies will only replace the cost of the film, not the potential value of the images.

Another means of storage is digital archiving. If you are serious about your work, you probably have thousands of images in your files. Digital archiving is a great way to protect your work because compact disks, DAT tapes or hard drives can store thousands of images in small spaces.

Having images in a digital format can also help you meet client demands. As technology develops, more and more clients are using digital versions of images for things like composition layouts, inhouse newsletters or online websites. If you can provide digital images to clients, you might see your sales increase as a result.

One important point to consider if you supply images digitally is that digital images are easy to alter and, therefore, easy to steal. The growth in digital technology makes it important to protect yourself against misuse and theft of your work. To do this, add a clause in your contracts that discusses image alterations and computer storage of your work. If a client plans to make radical changes to your images, stipulate that those alterations must meet with your approval.

Also, don't let clients keep digital files of your images. Specify that any digital files of your work should be deleted once your images are published. People change jobs and the next person using a client's computer may find your work and unknowingly think it's fair game for other projects.

TRACKING YOUR IMAGES

Finally, you need a system of tracking submissions so that you know who has your images and when they were mailed to clients. You want to know who received them, and when the material is due back.

Talk to any professional photographer and you will learn that photo editors, creative directors and art directors habitually hold images for long periods of time. Sometimes this means buyers are deciding which images to use; sometimes buyers are just too busy to return photos. As a photographer, this can be extremely problematic. You don't want to offend potential clients by ordering the return of your images, but you have a business to run.

If you have a computer with database software, you can easily track images by logging in their file codes, jotting down who should have received the material, when it was sent, and when it is due back to you. Sort the file by the dates when the images are due back. If you don't receive your work by the given dates, get on the phone and make some follow-up calls.

When photo editors hold images with no intention of using them, they essentially keep you from submitting those photos to other editors who might buy them. This is one reason that having a sound filing system is so important. By tracking your submissions you can follow up with letters or phone calls to retrieve images from uninterested buyers.

Lastly, when you mail submissions make certain the work is sent via registered mail or preferably by one of the shipping services (Federal Express or UPS). The additional money needed to send trackable packages is worth the expense because it guarantees that the client received your work.

Understanding the Basics of Copyright

Photography industry leaders lecture repeatedly about the importance of maintaining control of your copyright. "Losing control of your images is verboten," they say, adding horror stories of how some unscrupulous characters steal images. With advances in digital technology taking place almost on a daily basis, these cries seem to be growing even louder.

What makes copyright so important to a photographer? First of all, there's the moral issue. Simply put, stealing someone's work is wrong and it's a joyous occasion when an infringer is caught and punished. By registering your photos with the Copyright Office in Washington DC, you are safeguarding against theft. You're making sure that if someone illegally uses one of your images they can be held accountable. By failing to register your work, it is often more costly to pursue a lawsuit than it is to ignore the fact that the image was stolen.

Which brings us to issue number two—money. You should consider theft of your images to be a loss of income. After all, the person stealing one of your photos used it for a project, their project or someone else's. That's a lost sale for which you will never be paid, especially if you never find out that the image was stolen.

THE IMPORTANCE OF REGISTRATION

There is one major misconception about copyright—many photographers don't realize that once you create a photo it becomes yours. You own the copyright, regardless of whether or not you register it. Note: You cannot copyright an idea. Simply thinking about something that would make a great photograph does not make that scene yours. You have to actually have something on film.

The fact that an image is automatically copyrighted does not mean that it shouldn't be registered. Quite the contrary. You cannot even file a copyright infringement suit until you've registered your work. Also, without timely registration of your images, you only can recover actual damages—money lost as a result of sales by the infringer plus any profits the infringer earned. For example, recovering $2,000 for an ad sale can be minimal when weighed against the expense of hiring a copyright attorney. Often this deters photographers from filing lawsuits if they haven't registered their work. They know that the attorney's fees will be more than the actual damages recovered, and, therefore, infringers go unpunished.

Registration allows you to recover certain damages to which you otherwise would not be legally entitled. For instance, attorney fees and court costs can be recovered. So too can statutory damages—awards based on how deliberate and harmful the infringement. Statutory damages can run as high as $100,000. These are the fees that make registration so important.

In order to recover these fees there are certain rules regarding registration that you must follow. The rules have to do with the timeliness of your registration in relation to the infringement:

- **Unpublished images** must be registered before the infringement takes place.
- **Published images** must be registered within three months of the first date of publication or before the infringement began.

The process of registering your work is simple. Contact the Register of Copyrights, Library of Congress, Washington DC 20559, (202)707-9100, and ask for Form VA (works of the visual arts). Registration costs $20, but you can register photographs in large quantities for that fee. If

you have any questions contact the Copyright Office. (You can get answers or forms through the Copyright Office website: http://lcweb.loc.gov/copyright.) There also are plenty of books on the subject that simplify copyright laws.

THE COPYRIGHT NOTICE

Another way to protect your copyright is to mark each image with a copyright notice. This informs everyone reviewing your work that you own the copyright. It may seem basic, but in court this can be very important. In a lawsuit, one avenue of defense for an infringer is "innocent infringement"—basically the "I-didn't-know" argument. By placing your copyright notice on your images, you negate this defense for an infringer.

The copyright notice basically consists of three elements: the symbol, the year of first publication and the copyright holder's name. Here's an example of a copyright notice for an image published in 1997—© 1997 John Q. Photographer. Instead of the symbol ©, you can use the word "Copyright" or simply "Copr." However, most foreign countries prefer © as a common designation.

Also consider adding the notation "All rights reserved." after your copyright notice. This phrase is not necessary in the U.S. since all rights are automatically reserved, but it is recommended in other parts of the world.

KNOW YOUR RIGHTS

As mentioned before, the digital era is making copyright protection more difficult. Often images are manipulated so much that it becomes nearly impossible to recognize the original version. As this technology grows, more and more clients will want digital versions of your photos. Don't be alarmed, just be careful. Not every client wants to steal your work. They often need digital versions to conduct color separations or place artwork for printers.

So, when you negotiate the usage of your work, consider adding a phrase to your contract that limits the rights of buyers who want digital versions of your photos. You might want them to guarantee that images will be removed from computer files once the work appears in print. You might say it's OK to do limited digital manipulation, and then specify what can be done. The important thing is to discuss what the client intends to do with the image and spell it out in writing.

It's essential not only to know your rights under the Copyright Law, but also to make sure that every photo buyer you deal with understands them. The following list of typical image rights should help you in your dealings with clients:

• **One-time rights.** These photos are "leased" on a one-time basis; one fee is paid for one use.
• **First rights.** This is generally the same as purchase of one-time rights, though the photo buyer is paying a bit more for the privilege of being the first to use the image. He may use it only once unless other rights are negotiated.
• **Serial rights.** The photographer has sold the right to use the photo in a periodical. It shouldn't be confused with using the photo in "installments." Most magazines will want to be sure the photo won't be running in a competing publication.
• **Exclusive rights.** Exclusive rights guarantee the buyer's exclusive right to use the photo in his particular market or for a particular product. A greeting card company, for example, may purchase these rights to an image with the stipulation that it not be sold to a competing company for a certain time period. The photographer, however, may retain rights to sell the image to other markets. Conditions should always be in writing to avoid any misunderstandings.
• **Electronic rights.** These rights allow a buyer to place your work on electronic media, such as CD-ROMs or online services. Often these rights are requested with print rights
• **Promotion rights.** Such rights allow a publisher to use the photographer's photo for promotion of a publication in which the photo appeared. The photographer should be paid for promotional use in addition to the rights first sold to reproduce the image. Another form of this—agency

promotion rights—is common among stock photo agencies. Likewise, the terms of this need to be negotiated separately.

- **Work for hire.** See sidebar below for detailed definition.
- **All rights.** This involves selling or assigning all rights to a photo for a specified period of time. This differs from work for hire, which always means the photographer permanently surrenders all rights to a photo and any claims to royalties or other future compensation. Terms for all rights— including time period of usage and compensation—should only be negotiated and confirmed in a written agreement with the client.

It is understandable for a client not to want a photo he used to appear in a competitor's ad. Skillful negotiation usually can result in an agreement between the photographer and the client that says the image(s) will not be sold to a competitor, but could be sold to other industries, possibly offering regional exclusivity for a stated time period.

A valuable tool for any photographer dealing with copyright language and various forms of the photography business is the *SPAR* Do-It-Yourself Startup Kit*. This survival package includes sample forms, explanations and checklists of all terms and questions a photographer should ask himself when negotiating a job and pricing it. It's available from SPAR (the Society of Photographer and Artist Representatives, Inc.), 60 E. 42nd St., Suite 1166, New York NY 10165, (212)779-7464. Price: $57.37.

DEFINITION OF WORK FOR HIRE

Under the Copyright Act of 1976, section 101, a "work for hire" is defined as:
"(1) a work prepared by an employee within the scope of his or her employment; or
(2) a work . . .

- specially ordered or commissioned for use as a contribution to a collective work*
- as part of a motion picture or audiovisual work*
- as a translation
- as a supplementary work*
- as a compilation
- as an instructional text
- as a test
- as answer material for a test
- or as an atlas

. . . if the parties expressly agree in a written instrument signed by them that the work shall be considered a work made for hire."

NOTE: The asterisk (*) denotes categories within the Copyright Law which apply to photography.

Fresh Photographers

BY MEGAN LANE

More than anything else, it is the desire to be successful that keeps young photographers struggling with their craft, agree five relative newcomers to the worlds of commercial and fine art photography. Each of these photographers found his or her own way into the business and all are following different paths based on their education, family responsibilities, talent and good fortune. Their stories hold lessons about what they've done wrong and what they've done right. They also hold inspiration for anyone trying to break into the competitive world of professional photography.

Artistic expression is what led **Bill Davis** to major in fine art photography in college. It also led him to travel to the Czech Republic and spend two years working as an assistant for a fine art photographer in Prague. But Davis embraces commercial photography as well. Before he went to Europe he worked as an assistant in Chicago for a commercial photographer and now he teaches photography at a technical college in Cincinnati. "I've always been a combination of both and that seems to be the best for me because they scratch each other on the back."

Commercial work, helping shoot for catalogs like Spiegel, Montgomery Ward and Sears, taught Davis how to light dimensional objects as well as the realities of studio work. Fine art photography taught him about himself. It was a learning process made possible by an incredible mentor. "I got really serious about photography and I met someone who was twice as serious as me. That was Eva Enderlaine, and at first she tore me apart. She was a very good mentor and brutally honest. I found her to be very atypical for a professor because she was absolutely blunt. After breaking me down she built me up, gave me lots of encouragement and lots of feedback." His mentor showed Davis all the natural strengths he had as a photographer and taught him how to control them. She also legitimized fine art photography in his mind. "Fine art photography is an absolutely legitimate pursuit because it is the perfect mode of expression. It has a certain quickness or efficiency that I appreciate and respect. The fact that it can also be machineless is seductive to me."

Much of Davis's recent work incorporates machineless photography, photograms, with traditional portraits and landscapes. "The photogram helps to interpret the rest of the image that I can't get in the studio." He also makes images through straight photography that appear to be photograms. *The Stranger* was created by backlighting a black paper figure posed in front of a white paper cone. The mysterious image evokes very real emotions through nothing more than paper dolls.

MEGAN LANE, *a graduate of Ohio University's Scripps School of Journalism, has written for such national magazines as* Writer's Digest, Editor & Publisher *and* Southern Accents. *She works as the production editor for two Writer's Digest Books titles,* Artist's & Graphic Designer's Market *and* Novel & Short Story Writer's Market. *She met Bill Davis while studying photography in Prague.*

© Bill Davis

This nude is a perfect example of the challenges Bill Davis had to face while working in Prague. His small studio didn't offer many interesting backgrounds for posing models, so Davis made one for himself by painting the radiator a stark black and white. The effect is a dramatic contrast between the model's soft skin and the cold metal of the radiator as well as a similarity of form between the curving body and the curving heater.

Such seemingly simple techniques are a result of his stay in Europe when equipment was hard to come by. "I had to learn how to use light instead of how to use equipment," he says. "Half my students don't understand how their cameras work." Davis is afraid this lack of understanding will end up hurting them if they refuse to learn. "I try to help people use what I was taught and what I've personally experienced. I want people to transform their complaining and their anger [into art]."

While Davis settles into his new teaching job, he is also trying to re-start his American freelance career. "I had a better freelance career in Prague than I have here. I got published in magazines in Australia, Slovenia and Germany." However, he has started to make contacts in Cincinnati and is developing new marketing strategies. "The key for self-promotion for me right now is to go and photograph the building or interior of the place I want to send [work] to. This takes a lot of time but if you show them something they are doing, as long as you get the right shot, then that is undoubtedly the tightest, most returnable self-promotion." This approach led to an assignment shooting interiors for an art consultancy and now the owners are interested in staging a show of Davis's fine art work.

It has been a struggle for Davis to reach this point but he can't imagine himself in any other profession. "It's all about a personal competition. I compete against myself and my own failure. The only success we have is the result of failure. It's entirely necessary." This attitude is what led Davis half a world away to study his craft. It's also what led him home to put what he'd learned into practice.

Jennifer Min also made a move to become a photographer. She moved from California State University, where she'd studied art for two years, to Los Angeles, where she would eventually begin an apprenticeship as a photographer's assistant. She started by calling portrait studios to ask how to get started in the business and they advised her to look in *The Workbook*, a sourcebook that lists major U.S. photographers. She began sending résumés to the photographers and offering to assist them at no charge. She ended up with two interviews for assisting positions. She worked part time without pay until she gained experience and was able to quit her day job working retail and become a full-time, paid assistant.

"The photographer I was working for said how about I match your pay [from your retail job] and you come and work for me full-time?" Min accepted because the photographer was good enough to have steady work. She says assisting is the perfect way to get the inside track on professional photography. She learned how to use different types of equipment, but she also learned the administrative side of the business. "I've been having the nerve to go freelance now as an assistant and I can charge $125 to $150 a day." But assisting on shoots for catalog fashion, products and advertising wasn't enough.

"I started to get models and tried to do work that was saleable but I realized it wasn't very satisfying." Min had her own ideas about what she wanted to shoot and didn't want to worry about having to make a model look good so the shot could be used in a portfolio. She was most inspired by the work of photographers Nan Golden and Cindy Sherman. "Right now I choose to work with people I know because we can talk about the story line. I want to get something

Jennifer Min made a gutsy move into photography by volunteering her services as an assistant until she learned the business. That sense of daring is translated into her own work, which has won attention in two gallery shows. This photograph is indicative of Min's style, influenced by artists like Cindy Sherman. Like her running girl photographs, it exemplifies her personal struggle to capture the moments between action and emotion.

going on in the photograph." She also wants to evoke an emotion in the people who view her work. "It's sort of like film, but not to that degree."

In an untitled shot of a running, frightened girl, Min wanted to get away from the prostitute look in some fashion photography so she dressed her friend up to look like she'd been on a date. The terror comes later when the date tries to attack her. The girl runs but she is frightened and exhausted. That moment is what Min tried to capture on film. A series of similar photographs are what comprised her gallery shows, "Tabularasa I and II," which literally means a blank page. For Min it signifies a state of limbo between action and emotion.

Min makes time for her own photography when she isn't working as an assistant. She shoots mostly outdoors at night and develops her film and makes prints in her bathroom darkroom. Her hard work is paying off. She already has plans for a second show and recently won two honorable mentions in the APA Photo 8 Awards Contest. The silent auction that followed resulted in the sale of two prints. "I don't want to assist anymore. I want to be somewhere soon," Min says.

Min is certainly well on her way to somewhere, but she didn't take an easy route to become a professional photographer. Although she studied art during her two years in college she didn't concentrate on photography and assisting work was made even more difficult because she is female. "You really have to prove yourself. You have to get down with the guys and carry equipment." But the photographers she works with don't doubt her for long. For Min it all comes down to action. "It doesn't matter what you talk about. It's what you do about it that matters."

Margie Duke also never had formal training in photography and has never attended an organized workshop, but she's been in love with the camera since she received her first point-and-shoot at age 13. Yet, after only a short time working with another amateur photographer, Duke has made a name for herself in her small home town of Kingstree, South Carolina.

"I'm working with a retired engineer from the local telephone corporation who has been probably messing with photography for over 40 years. Right now what I'm doing more than anything else is hand coloring black and white photographs. I'm really enjoying that." Duke colors her prints with oils and colored pencils. Her subjects are often local children and she sells the photographs to their parents. "Most folks in my area love the old-fashioned look of the tinting and appreciate the artwork in this kind of photography." Though she hasn't made any sales outside of Kingstree, Duke is beginning to think of ways to increase her sales. One such option might be greeting cards. Card companies have begun using selectively-colored, black and white photographs of children on friendship, Valentine and blank cards.

But Duke does not limit herself to one kind of photography. When people in Kingstree need a photographer for weddings, portraits or even the covers of books, they often think of Duke because everybody in town has one of her prints somewhere in his home—usually near the phone. Duke took her first professional photograph for free. But doing the phone book cover for the Farmer's Telephone Corporation spread Duke's name all over her hometown and led to paying work.

Now Duke is hired each year to photograph the phone company's annual Christmas banquet. "Usually they call me at the end of spring to make sure they can get me to do the coverage for Christmas." Other people call her to do weddings, senior portraits for the high school yearbook, and sports shots for the yearbook and parents of high school athletes.

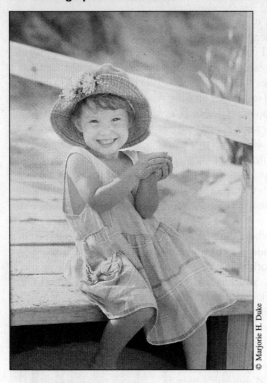

© Marjorie H. Duke

Margie Duke uses oils and colored pencils to tint her black and white portraits of children. The "old-fashioned" prints are popular in her home town and sell well. "The 'different' look is what makes this work so appealing and what provides a needed edge in the market," Duke says. "Besides, it's a lot of fun and my children are happy that I don't color in their coloring books anymore."

Although Duke works full-time at the South Carolina Department of Juvenile Justice, she is serious about one day supporting herself with her photography. "It's paid some bills for me. I would love to have my own studio. We're looking at some property out in the country to build [a darkroom]." Duke makes time for photography on the weekends and at night. "I have two small kids and I work full-time and home is a full-time job. When the kids get a little bit older I would like to drop what I'm doing and do nothing but photography."

Alan Albright feels the same way. His first priority is to spend as much time as he can with his three-year-old son, then comes his job as a sprayman for BASF in Waterford, Michigan, and finally photography. But Albright hopes to soon make the latter second on his list. He treats his "hobby" as a business, handing out business cards to anyone who might be interested in his work, going to seminars and workshops, sending transparencies to magazines and even tailoring his answering machine message to potential customers. But photography found Albright almost by accident.

"Photography started about seven years ago when my wife and I went to Aruba and I bought a [35mm] camera. I fell in love with it from there on in. I like to do landscape and nature." When Albright decided to make the move to professional photography, he bought a Mamiya R267 on the advice of nationally recognized nature photographer Jim Zuckerman. "I started out using 35mm but then I read some articles by Jim Zuckerman and I met him at a workshop in Acadia, Maine." Albright admits there are drawbacks to using such a large format. "35mm is more versatile when shooting wildlife." But the $2\frac{1}{4} \times 2\frac{3}{4}$ transparencies he shoots look better on a light table than their much smaller 35mm counterparts.

Even more important then the size of the transparency, however, is the light in the shot. Albright says the key to good landscape photography is capturing the perfect light. "You always have to be ready for it, and sometimes you miss it." But when he doesn't miss, the effect can be spectacular and lead to profitable results. "I've sold several prints. Two of them were from Death Valley, from Stove Pipe Wells sand dune, and there were some from White Sands, New Mexico."

Albright also sent some of the White Sands shots to *New Mexico* magazine. "They loved them but they had just done an article on that." He took the bad news in stride. "The rejection part is normal. What keeps me going is the love of doing it." Albright says there is no other reason to become a photographer and that his desire to be the best will be enough to get him through the hard times.

The most difficult part of Albright's nature niche is the cost involved in obtaining his spectacular shots. He spent almost $14,000 last year on travel alone, and the large format he works in is the most expensive for color work. Although he hasn't had any success yet in publishing his work, Albright continues to send transparencies to magazines like *Outdoor Photographer, Bugle* and *Arizona Highways*. He's the first to admit he's still learning how the editorial process works, and he is constantly trying to get an edge in the publishing world. One way is by scouring *Photographer's Market*. "That's a very helpful book." But Albright says the next step may be more about words than images. He's considering learning how to write or finding a writing partner in order to submit a more complete package to magazines. He believes editors will be more likely to accept his work if they don't have to come up with an article to accompany it.

Alan Albright sent several shots of White Sands, New Mexico, to *New Mexico Magazine*. Though the shots didn't fit the magazine's editorial needs, the staff let Albright know his photos were beautiful. *Grass in White Sand Dunes* is typical of Albright's gorgeous, high-contrast outdoor photography. Now that he's perfected his image-making technique, Albright is concentrating on learning more about the editorial process.

© Alan Albright

That photos plus manuscript formula has been working for **Fran Putney** for the past 15 years. Although Putney considers herself primarily a freelance writer, each article she submits is accompanied by her photography. "As a writer, that's one of my best assets—providing a whole package to an editor. It is definitely an incentive for an editor to use me." And because she writes about everything from pre-school programs to weekend getaways, Putney's photography spans a wide range of styles as well.

"It's not like I'm a portrait photographer and I'm concentrating solely on that, but I do photojournalism and I do all the photography for the articles that I write. Mostly they're feature stories. The one I'm writing right now for example is about pre-school music programs. I could end up doing pictures of people who are featured in my article. It could be anything that will illustrate an article. If I do a travel article, it might be the mountains somewhere or a resort." Putney has sold her packages to magazines including *Girls' Life, San Diego Family* and *Atlanta Parent*, and her work is regularly published in two community newspapers, *Atlanta 30306* and *Atlanta 30305*.

Putney studied photography in college to help her writing career but ended up falling in love with it. This love is leading Putney beyond photojournalism into the next phase of her career. She is just beginning to explore her talent as a home and garden photographer. She has already done public relations photography for a tour of homes in Atlanta, where she lives. She also markets her garden photography in a line of handmade stationery that she sells at craft shows and to retail stores and fine garden centers in Atlanta. Next, she plans to start contacting land-

Most of Fran Putney's photographs accompany her freelance articles. And although this shot of raspberries didn't illustrate her writing, it did turn into several sales. "The raspberry picture is a very popular image I've sold many times over on my hand-made stationery and as a framed print." Putney plans to expand her garden photography and is currently researching the market by contacting landscapers and garden-owners.

© Fran M. Putney

scape architects and homeowners to sell prints, and eventually she hopes to photograph gardens for national magazines. She plans to use the handmade cards to showcase her work to these new markets.

"[Photography] creates a good balance for me because writing is very labor-intensive, research work. It's more intellectual in a way, not to say that photography isn't, but it's much different. Photography kind of frees up my head sometimes. I can be more intuitive and not have to use words. I can just go out there and express myself more freely, artistically."

IMPORTANT INFORMATION ON MARKET LISTINGS

• The majority of markets listed in this book are those which are actively seeking new freelance contributors. Some important, well-known companies which have declined complete listings are included within their appropriate section with a brief statement of their policies. In addition, firms which for various reasons have not renewed their listings from the 1997 edition are listed, with an explanation for their absence, in the General Index at the back of this book.

• Market listings are published free of charge to photography buyers and are not advertisements. While every measure is taken to ensure that the listing information is as accurate as possible, we cannot guarantee or endorse any listing.

• *Photographer's Market* reserves the right to exclude any listing which does not meet its requirements.

• Although every buyer is given the opportunity to update his listing information prior to publication, the photography marketplace changes constantly throughout the year and between editions. Therefore, it is possible that some market information will be out of date by the time you make use of it.

• This book is edited (except for quoted material) in the masculine gender because we think "he/she," "she/he," "he or she," "him or her" is distracting.

KEY TO SYMBOLS AND ABBREVIATIONS

‡	New Markets
✤	Canadian Markets
*	Markets located outside the United States and Canada
■	Audiovisual Markets
●	Introduces special comments by the editor of *Photographer's Market*
SASE	Self-addressed stamped envelope
IRC	International Reply Coupon, for use on reply mail in markets outside of your own country
Ms, Mss	Manuscript(s)
©	Copyright

(For definitions and abbreviations relating specifically to the photographic industry, see the Glossary in the back of the book.)

COMPLAINT PROCEDURE

If you feel you have not been treated fairly by a listing in *Photographer's Market*, we advise you to take the following steps:

• First try to contact the listing. Sometimes one phone call or a letter can quickly clear up the matter.

• Document all your correspondence with the listing. When you write to us with a complaint, provide the details of your submission, the date of your first contact with the listing and the nature of your subsequent correspondence.

• We will enter your letter into our files and attempt to contact the listing.

• The number and severity of complaints will be considered in our decision whether or not to delete the listing from the next edition.

The Markets

Publications

Somewhere among the hundreds of listings in this section there's bound to be a publication right for your work. These magazines, newspapers and newsletters are far ranging in style and content and are viable markets for a wide range of photo styles and subject matter. Some, such as *Life*, *Playboy* and *Vanity Fair* require more experience from freelancers, but many publications are willing to take a chance on an unknown talent. Your task is to find your niche. Find those markets that fit your style and might be interested in your photographs.

First, do your homework. This section consists of three main categories—Consumer Publications, Newspapers & Newsletters and Trade Publications. Many of these listings offer photo guidelines and sample copies. Send for this information and use it to your advantage. Photo guidelines tell you what editors prefer in the way of formats and content. They might provide tips regarding upcoming needs and tell you when to drop off portfolios. Also, sample copies can give you a better indication of what the publication needs and they can show you how your work is likely to be presented.

Whenever possible try to get feedback regarding your work. If an editor disliked the images in your portfolio, ask him why. Also, try not to take a love-it-or-leave-it attitude regarding your work. Be willing to accept criticism and learn from the suggestions of editors. However, if you ask for an assessment of your work and an editor gives you a vague response, be a little suspicious. There are times when editors are too busy and don't look at portfolios. Without being too confrontational, see if you can submit your portfolio again in the near future.

The important thing is to be persistent without being a pest. Sending a new promotional piece often can be enough to keep your name in the mind of an editor. Constant phone calls from freelancers often bother editors who may be working on deadlines and don't have time to talk. If you get on an editor's bad side your chances of making a sale or getting an assignment for that publication drastically decrease.

To make your search for markets easier, there is a Subject Index at the back of this book. This newly expended index is now divided into 46 topics (almost doubled), and markets are listed according to the types of photographs they want to see. For example, if you shoot wildlife photos there are numerous markets wanting to receive this type of material.

Throughout this section you also will find bullets (●) inside some listings. These comments were written by the editor of *Photographer's Market* and they are designed to provide additional information about listings. The comments usually center on awards won by markets, design changes that have taken place, or specific submission requirements.

CONSUMER PUBLICATIONS

Traditionally the Consumer Publications section has been the largest in *Photographer's Market* and this year is no exception. One major change for this year, however, has been the merger of Consumer Publications with a section from last year, Special Interest Publications. Actually, there were only slight differences between the markets in these two sections and we thought the merger would simplify your research by making it easier for you to locate publications.

There are several points to consider when approaching these markets. We questioned many

of the buyers listed and found they had similar likes and dislikes when it comes to receiving work from photographers.

First, quality means everything to picture buyers at magazines. "It's amazing how poor the quality can be from experienced, professional photographers when it comes to taking photos of fish in aquariums," says Edward Bauman, editor of *Aquarium Fish Magazine*. "The ones who keep at it and master the techniques can do some really amazing stuff."

Bauman advises photographers to use a loupe to review images during the editing process. "I don't know any good photographer who doesn't use an 8X loupe to help pick only the best shots.

"All the basics—good composition and lighting, correct exposure for highlights and sharp focus with sufficient depth-of-field—are needed to make any photo that is of publication quality," he says.

Although quality is key, always remember to hold onto your original slides or negatives when submitting work on speculation. Send prints or excellent quality duplicates instead of sending originals. This will keep you from losing one-of-a-kind images in the event they are misplaced or damaged. Plus, most buyers prefer dupes over originals in order to limit their liability.

If a buyer wants to use one of your images he may request the original transparency. You can then send the original with a delivery memo that explains the client's liability in the event the images are lost or damaged. (For more on delivery memos and other forms turn to Taking Care of Business on page 4.)

Another important point to remember concerns promotional pieces and stock lists. Many buyers we contacted complained that photographers didn't provide samples of their work when they submitted stock lists. This is a major faux pas. Clients want to know that you can provide top-notch photos. Promotional pieces give them a basic understanding of your work. Without promos the stock lists mean absolutely nothing. And when you send samples make certain they are relevant to the buyer.

"I find it disappointing when a photographer sends in an example of work that would never go into *Backpacker* magazine," says Deborah Burnett Stauffer, photo editor for *Backpacker*. "You wouldn't believe how many times I've received a promotional piece of a cityscape, or a fashion shot."

Robert Moll of *Caribbean Travel & Life Magazine*, agrees that strong promo pieces can improve a photographer's chances of selling imagery. "Stock lists are always helpful, but photographers should keep in mind that they are trying to sell me a service," says Moll. "A photocopied list of destinations isn't going to impress me. Some photographers spend a lot of money courting magazines. We definitely take more notice of them. I often receive colorful, glossy cards on heavy stock. They reproduce images well and tell me a lot more about a photographer's skill and talent than how many magazines he or she has contributed to, or years they've been in the business or destinations they've been to."

If buyers are impressed by the promotional materials you send, you may be asked to submit a portfolio of your work. Remember, a portfolio should be professional in every respect. It should house only your best images. And most importantly, make certain that the contents of your portfolio match the editorial content of the magazine you are approaching. For example, don't send a fashion portfolio to a magazine that covers the auto industry. For more portfolio tips see How to Put Together a Winning Portfolio, by Allen Rabinowitz (page 10).

Finally, all buyers appreciate research. Review recent copies of the magazines you plan to approach to see what's inside. By examining sample copies you can locate names of buyers for your promotional mailings. You can see what stories are common in the magazine. Some publishers will even provide you with photo guidelines as long as you provide a self-addressed, stamped envelope.

As a good example of why it's important to do your research, consider the needs of Tom Hamilton, editor of *Balloon Life*. Hamilton says photographers who can supply photo-text pack-

ages have the best chance of selling their work to his publication. "Because of the special nature of our publication, hot air ballooning, we sometimes get as many as six submissions on an event. It's usually best for the writer/photographer to check with us first," he says.

For more help in locating markets in the magazine industry check out the following resources:

* *Standard Rate and Data Service*—Commonly referred to as SRDS this is a monthly directory that lists thousands of magazines. Since it is aimed at potential advertisers the listings usually have brief descriptions of the publications and lists their advertising rates. Check your local library for the most recent edition. Special thanks to SRDS for allowing us to use their editorial descriptions for publications that did not respond to our request for information.

* *The Guilfoyle Report*—This is a quarterly newsletter published for nature and wildlife photographers. It provides helpful tips and insight into some photography magazine markets. Call (212)929-0959 for current subscription rates.

* *The International Directory of Little Magazines and Small Presses*—For those photographers interested in approaching smaller publishers as a way of getting some clips, this directory lists thousands of potential contacts. Check your local library or write to Dustbooks, Box 100, Paradise CA 95967.

‡**ABOARD MAGAZINE**, 100 Almeria Ave., Suite 220, Coral Gables FL 33134. Fax: (305)441-9739. Contact: Lillian Calderon. Circ. 180,000. Estab. 1976. Inflight magazine for 11 separate Latin American national airlines. Bilingual bimonthly. Emphasizes travel through Central and South America. Readers are mainly Latin American businessmen, and American tourists and businessmen. Sample copy free with SASE. Photo guidelines free with SASE.
Needs: Uses 50 photos/issue; 30 supplied by freelance photographers. Needs photos of travel, scenic, fashion, sports and art. Special needs include good quality pictures of Latin American countries, particularly Chile, Guatemala, Ecuador, Bolivia, Rep. Dominicana, El Salvador, Peru, Nicaragua, Honduras, Paraguay, Uruguay. Model/property release preferred. Captions preferred.
Making Contact & Terms: Interested in receiving work from newer, lesser-known photographers. Query with samples. Provide business card, brochure, flier or tearsheets to be kept on file for possible future assignments. SASE. Reports in 2 months. Payment varies; pays $20/color photo; $150 for photo/text package. Pays on publication. Credit line given. Buys one-time rights. Previously published work OK.
Tips: If photos are accompanied by an article, chances of them being accepted are much better.

ACCENT ON LIVING, P.O. Box 700, Bloomington IL 61702. (309)378-2961. Fax: (309)378-4420. E-mail: acntlvg@aol.com. Editor: Betty Garee. Circ. 20,000. Estab. 1955. Quarterly magazine. Emphasizes successful disabled young adults (18 and up) who are getting the most out of life in every way and *how* they are accomplishing this. Readers are physically disabled individuals of all ages, socioeconomic levels and professions. Sample copy $3.50 with 5×7 SAE and 5 first-class stamps. Free photo/writers guidelines; enclose SASE.
Needs: Uses 40-50 photos/issue; 95% supplied by freelancers. Needs photos for Accent on People, "a human interest photo column on disabled individuals who are gainfully employed or doing unusual things." Also uses occasional photo features on specific occupations: art, health, etc. Manuscript required. Photos depict handicapped persons coping with problems and situations particular to them: how-to, new aids and assistive devices, news, documentary, human interest, photo essay/photo feature, humorous and travel. "All must be tied in with physical disability. We want essentially action shots of disabled individuals doing something interesting/unique or with a new device they have developed—not photos of disabled people shown with a good citizen 'helping' them." Model release preferred. Captions preferred.
Making Contact & Terms: Interested in receiving work from newer, lesser-known photographers. Query first with ideas, get an OK, and send contact sheet for consideration. Accepts images in digital format for

 MARKETS NEW TO THIS EDITION are marked with a double dagger.

Mac. Uses glossy prints and color photos, transparencies preferred. Provide letter of inquiry and samples to be kept on file for possible future assignments. Cover is usually tied in with the main feature inside. SASE. Reports in 3 weeks. Pays $50-up/color cover; pays $15-up/color inside photo; pays $10-up/b&w inside photo. Pays on publication. Credit line given if requested. Previously published work OK.

Tips: "Concentrate on improving photographic skills. Join a local camera club, go to photo seminars, etc. We find that most articles are helped a great deal with *good* photographs—in fact, good photographs will often mean buying a story and passing up another one with very poor or no photographs at all." Looking for *good* quality photos depicting what article is about. "We almost always work on speculation."

‡ADIRONDACK LIFE, Rt. 9N, P.O. Box 97, Jay NY 12941. (518)946-2191. Art Director: Ann Eastman. Circ. 50,000. Estab. 1970. Bimonthly. Emphasizes the people and landscape of the north country of New York State. Sample copy $4 with 9×12 SAE and 5 first-class stamps. Photo guidelines free with SASE.

Needs: "We use about 40 photos/issue, most supplied by freelance photographers. All photos must be taken in the Adirondacks and all shots must be identified as to location and photographer."

Making Contact & Terms: Send one sleeve (20 slides) of samples. Send b&w prints (preferably 8×10) or color transparencies in any format. SASE. Pays $300/cover photo; $50-200/color or b&w photo; $150/day plus expenses. Pays 30 days after publication. Credit line given. Buys first North American serial rights. Simultaneous submissions OK.

Tips: "Send quality work pertaining specifically to the Adirondacks. In addition to technical proficiency, we look for originality and imagination. We emphasize vistas and scenics. We are using more pictures of people and action."

ADVENTURE CYCLIST, Box 8308, Missoula MT 59807. (406)721-1776. Editor: Dan D'Ambrosio. Circ. 30,000. Estab. 1974. Publication of Adventure Cycling Association. Magazine published 9 times/year. Emphasizes bicycle touring. Readers are mid-30s, mostly male, professionals. Sample copy and photographer's guidelines free with 9×12 SAE and 4 first-class stamps.

Needs: Covers. Model release preferred. Captions required.

Making Contact & Terms: Submit portfolio for review. SASE. Reports in 3 weeks. Payment negotiable. Pays on publication. Credit line given. Buys one-time rights. Simultaneous submissions and previously published work OK.

ADVENTURE WEST MAGAZINE, P.O. Box 3210, Incline Village NV 89450. (702)832-1641. Fax: (702)832-1640. Photo Editor: Andrew Mond. Circ. 165,000. Estab. 1992. Bimonthly magazine. Emphasizes travel and adventure in the 13 western states, including Hawaii, Alaska, Western Canada and Western Mexico. Sample copy free with 10×13 SAE and 11 first-class stamps. Photo guidelines free with SASE.

Needs: Uses 65-70 photos/issue; 100% supplied by freelancers. Needs photos of action, sports, animal/wildlife, scenics. Special photo needs include scuba/underwater, hiking, camping, biking, climbing, kayaking, sailing, caving, skiing. Property release preferred. Captions preferred; include where and what.

Making Contact & Terms: Interested in receiving work from newer, lesser-known photographers. Query with stock photo list. Send unsolicited photos by mail for consideration. Send 35mm color transparencies. Keeps samples on file; "not originals but business cards and stock lists." SASE. Reports in 6 weeks. Pays $50-225/color inside; $350/cover. Pays on publication. Credit line given. Buys one-time rights. Simultanous submissions OK.

Tips: "Always ask about payment before agreeing to send photos."

‡THE ADVOCATE, 6922 Hollywood Blvd., 10th Floor, Los Angeles CA 90028. (213)871-1225. Fax: (213)467-6805. Picture Editor: Michael Matson. Circ. 74,000. Estab. 1967. Biweekly magazine. Emphasizes gay and lesbian issues. Readers are gays and lesbians, ages 21-70. Photo guidelines free with SASE.

Needs: Uses 55 photos/issue; 50% supplied by freelancers. Model release required for minors.

Making Contact & Terms: Interested in receiving work from newer, lesser-known photographers. Send promo cards. Send 35mm, 2¼×2¼, 4×5 transparencies. Keeps samples on file. SASE. Reports in 3 weeks. Payment negotiable. Pays net 30 days from delivery of assignment. Credit line given. Buys one-time rights.

Tips: "Be flexible. Have ideas to contribute. Don't bombard editors with follow-up calls. Our deadlines are tight. We'll call you if we need you."

‡AFRICAN AMERICAN CHILD MAGAZINE, P.O. Box 178, Fairfax VA 22039. (800)890-2689. Fax: (703)764-0330. Managing Editor: Judith Ferebee. Circ. 20,000. Estab. 1996. Quarterly magazine. Emphasizes African-American children, families and parenting. Readers are primarily females, ages 28-65. Sample copy $3.75. Photo guidelines free with SASE.

Needs: Uses 15-20 photos/issue; 10% supplied by freelancers. Needs photos of baby close-ups, family

travel, educational, kids' sports, parent-child interaction, computer usage. Model/property release required. Captions preferred.

Making Contact & Terms: Interested in receiving work from newer, lesser-known photographers. Send unsolicited photos by mail for consideration. Query with stock photo list. Send color and b&w prints; 35mm transparencies; digital format. Keeps samples on file. SASE. Reports in 1-2 weeks. Pays $100/color cover photo; $30/color inside photo; $40/photo/text package. **Pays on acceptance.** Credit line given. Buys one-time rights. Simultaneous submissions and/or previously published work OK.

AFSCME PUBLIC EMPLOYEE, AFSCME, 1625 L St. NW, Washington DC 20036. (202)429-1144. Production Supervisor: LeeAnn Jackson. Circ. 1,300,000. Union publication of American Federation of State, County and Municipal Employees, AFL-CIO. Color magazine published 6 times/year. Emphasizes public employees, AFSCME members. Readers are "our members."

Needs: Uses 35 photos/issue; majority supplied by freelancers. Assignment only.

Making Contact & Terms: Provide résumé, business card, brochure, flier or tearsheets to be kept on file for possible assignments. Will try to return unsolicited material if a SASE is enclosed, but no guarantee. Reports back as needed. Payment negotiable; depends on assignment, usually negotiates price. **Pays on acceptance.** Credit line usually given. Buys all rights; negotiable.

Tips: "Color transparencies, no fast film. Show strong photojournalism skills and be skilled in use of flash."

AIM MAGAZINE, P.O. Box 20554, Chicago IL 60620. (312)874-6184. Editor: Myron Apilado. Circ. 7,000. Estab. 1974. Quarterly magazine. Magazine dedicated to promoting racial harmony and peace. Readers are high school and college students, as well as those interested in social change. Sample copy for $4 with 9×12 SAE and 6 first-class stamps.

Needs: Uses 10 photos/issue. Needs "ghetto pictures, pictures of people deserving recognition, etc." Needs photos of "integrated schools with high achievement." Model release required.

Making Contact & Terms: Send unsolicited photos by mail for consideration. Send b&w prints. SASE. Reports in 1 month. Pays $25/color cover photo; $10/b&w cover photo. **Pays on acceptance.** Credit line given. Buys one-time rights. Simultaneous submissions OK.

Tips: Looks for "positive contributions."

AIR LINE PILOT, 535 Herndon Pkwy., Box 1169, Herndon VA 22070. (703)481-4460. Fax: (703)689-4370. E-mail: 73714.41@compuserve.com. Editor-in-Chief: Gary DiNunno. Circ. 65,000. Estab. 1933. Publication of Air Line Pilots Association. Monthly. Emphasizes news and feature stories for commercial airline pilots. Photo guidelines for SASE.

Needs: Uses 12-15 photos/issue; 25% comes from freelance stock. Needs dramatic 35mm transparencies, prints or IBM-compatible images on disk or CD of commercial aircraft, pilots and co-pilots performing work-related activities in or near their aircraft. "Pilots must be ALPA members in good standing. Our editorial staff can verify status." Special needs include dramatic images technically and aesthetically suitable for full-page magazine covers. Especially needs vertical composition scenes. Model release required. Captions required; include aircraft type, airline, location of photo/scene, description of action, date, identification of people and which airline they work for.

Making Contact & Terms: Interested in receiving work from newer, lesser-known photographers. Query with samples. Send unsolicited photos by mail for consideration. Accepts images in digital format for Windows. Send via compact disc or floppy disk. SASE. Pays $35/b&w photo; $35-350/color photo. **Pays on acceptance.** Buys all rights. Simultaneous submissions and previously published work OK.

Tips: In photographer's samples, wants to see "strong composition, poster-like quality and high technical quality. Photos compete with text for space so they need to be very interesting to be published. Be sure to provide brief but accurate caption information and send in only professional quality work. For our publication, cover shots do not need to tie in with current articles. This means that the greatest opportunity for publication exists on our cover."

ALABAMA LIVING, P.O. Box 244014, Montgomery AL 36124. (334)215-2732. Fax: (334)215-2733. Editor: Darryl Gates. Circ. 315,000. Estab. 1948. Publication of the Alabama Rural Electric Association. Monthly magazine. Emphasizes rural life and rural electrification. Readers are older males and females living in rural areas and small towns. Sample copy free with 9×12 SASE and 4 first-class stamps.

Needs: Uses 6-12 photos/issue; 1-3 supplied by freelancers. Needs photos of nature/wildlife, travel—southern region, some scenic and Alabama specific. Special photos needs include vertical scenic cover shots. Captions preferred; include place and date.

Making Contact & Terms: Interested in receiving work from newer, lesser-known photographers. Query with stock photo list or transparencies ("dupes are fine") in negative sleeves. Keeps samples on file. SASE. Reports in 1 month. Pays $40-50/color cover photo; $60-75/photo/text package. Pays on publication. Credit

line given. Buys one-time rights; negotiable. Simultaneous submissions OK. Previously published work OK "if previously published out-of-state."

‡**ALASKA**, 4220 B St., Suite 210, Anchorage AK 99503. (907)561-4772. Fax. (907)561-5669. Editor: Ken Marsh. Photo Editor: Donna Rae Thompson. Circ. 250,000. Estab. 1935. Monthly magazine. Readers are people interested in Alaska. Sample copy $4. Free photo guidelines.
Needs: Buys 500 photos annually, supplied mainly by freelancers. Captions required.
Making Contact & Terms: Interested in receiving work from established and newer, lesser-known photographers. Send carefully edited, captioned submission of 35mm, 2¼×2¼ or 4×5 transparencies. SASE. Reports in 4 weeks. Pays $50/b&w photo; $75-500/color photo; $300/day; $2,000 maximum/ complete job; $300/full page; $500/cover. Buys one-time rights; negotiable.
Tips: "Each issue of *Alaska* features an 8- to 10-page photo feature. We're looking for themes and photos to show the best of Alaska. We want sharp, artistically composed pictures. Cover photo always relates to stories inside the issue."

ALIVE NOW MAGAZINE, 1908 Grand Ave., P.O. Box 189, Nashville TN 37202. (615)340-7218. Associate Editor: Eli Fisher. Circ. 80,000. Estab. 1975. Bimonthly magazine published by The Upper Room. "*Alive Now* uses poetry, short prose, photography and contemporary design to present material for personal devotion and reflection. It reflects on a chosen Christian concern in each issue. The readership is composed of primarily college-educated adults." Sample copy free with 6×9 SAE and 3 first-class stamps. Themes list free with SASE; photo guidelines available.
Needs: Uses about 25-30 b&w prints/issue; 90% supplied by freelancers. Needs b&w photos of "family, friends, people in positive and negative situations, scenery, celebrations, disappointments, ethnic minority subjects in everyday situations—Native Americans, Hispanics, Asian-Americans and African-Americans." Model release preferred.
Making Contact & Terms: Query with samples. Send 8×10 glossy b&w prints by mail for consideration. Send return postage with photographs. Submit portfolio for review. SASE. Reports in 6 months; "longer to consider photos for more than one issue." Pays $25-35/b&w inside photo; no color photos. Pays on publication. Credit line given. Buys one-time rights. Simultaneous and previously published submissions OK.
Tips: Looking for high reproduction, quality photographs. Prefers to see "a variety of photos of people in life situations, presenting positive and negative slants, happy/sad, celebrations/disappointments, etc. Use of racially inclusive photos is preferred."

ALLURE, Conde Nast Publications, Inc., 360 Madison Ave., New York, NY 10017. (212)880-8800. Fax: (212)880-8287. *Allure* covers beauty and total image. It looks at the complex role beauty plays in culture and analyzes the trends in cosmetics, skincare, fashion, haircare, fitness and health. This magazine did not respond to our request for information. Query before submitting.

ALOHA, THE MAGAZINE OF HAWAII AND THE PACIFIC, P.O. Box 3260, Honolulu HI 96801. (808)593-1191. Fax: (808)593-1327. Assistant Editor: Joyce Akamine. Circ. 90,000. Estab. 1978. Bimonthly. Emphasizes culture, arts, history of Hawaii and its people. Readers are "affluent, college-educated people from all over the world who have an interest in Hawaii." Sample copy $2.95 with 9×11 SAE and 9 first-class stamps. Photo guidelines free with SASE.
Needs: Uses about 50 photos/issue; 90% supplied by freelance photographers. Needs "scenics, travel, people, florals, strictly about Hawaii. We buy primarily from stock. Assignments are rarely given and when they are, they are usually given to one of our regular local contributors. Subject matter must be Hawaiian in some way." Model release required if the shot is to be used for a cover. Captions required.
Making Contact & Terms: Interested in receiving work from newer, lesser-known photographers. Submit portfolio for review. Query with stock photo list. Send unsolicited photos by mail for consideration. Provide résumé, business card, brochure, flier or tearsheets. SASE. Reports in 3 weeks. Pays $25/b&w photo; $75/color transparency; $125/photo running across a two-page spread; $250/cover shot. Pays on publication. Credit line given. Buys one-time rights.
Tips: Prefers to see "a unique way of looking at things, and of course, well-composed images. Generally, we are looking for outstanding scenic photos that are not standard sunset shots printed in every Hawaii publication. We need to see that the photographer can use lighting techniques skillfully, and we want to see pictures that are sharp and crisp. Competition is fierce, and it helps if a photographer can first bring in his portfolio to show to our art director. Then the art director can give him ideas regarding our needs."

‡**AMELIA MAGAZINE**, 329 "E" St., Bakersfield CA 93304. (805)323-4064. Editor: Frederick A. Raborg, Jr. Circ. 1,250. Quarterly magazine. Emphasizes literary: fiction, non-fiction, poetry, reviews, fine

illustrations and photography, etc. "We span all age groups, three genders and all occupations. We are also international in scope. Average reader has college education." Sample copy $8.95 and SASE. Photo guidelines free with SASE.

● Because this is a literary magazine it very seldom uses a lot of photographs. However, the cover shots are outstanding, fine art images.

Needs: Uses 4-6 photos/issue depending on availability; all supplied by freelance photographers. "We look for photos in all areas including male and female nudes and try to match them to appropriate editorial content. We sometimes use photos alone; color photos on cover. We use the best we receive; the photos usually convince us." Model release required. Captions preferred.

Making Contact & Terms: Send unsolicited photos by mail for consideration. Send b&w or color, 5×7 and up, glossy or matte prints; 35mm or 2¼×2¼ transparencies. SASE. Reports in 2 weeks. Pays $100/ color cover photo; $50/b&w cover photo; $5-25/b&w inside photo. **Pays on acceptance.** Credit line given. Buys one-time rights or first North American serial rights. "We prefer first North American rights, but one-time is fine." Simultaneous submissions OK.

Tips: In portfolio or samples, looks for "a strong cross-section. We assume that photos submitted are available at time of submission. Do your homework. Examine a copy of the magazine, certainly. Study the 'masters of contemporary' photography, i.e., Adams, Avedon, etc. Experiment. Remember we are looking for photos to be married to editorial copy usually."

‡**AMERICA WEST AIRLINES MAGAZINE**, 4636 E. Elwood St., Suite 5, Phoenix AZ 85040. (602)997-7200. America West Airlines magazine. Circ. 125,000. Monthly. Emphasizes general interest— including: travel, interviews, business trends, food, etc. Readers are primarily business people and business travelers; substantial vacation travel audience. Photo guidelines free with SASE. Sample copy $3.

Needs: Uses about 20 photos/issue supplied by freelance photographers. "Each issue varies immensely; we primarily look for stock photography of places, people, subjects such as animals, plants, scenics—we assign some location and portrait shots. We publish a series of photo essays with brief, but interesting accompanying text." Model release required. Captions required.

Making Contact & Terms: Provide résumé, business card, brochure, tearsheets or color samples to be kept on file for possible future assignments. Pays $100-225/color inside photo, depends on size of photo and importance of story. Pays on publication. Credit line given. Buys one-time rights. Previously published work OK.

Tips: "We judge portfolios on technical quality, consistency, ability to deliver with a certain uniqueness in style or design, versatility and creativity. Photographers we work with most often are those who are both technically and creatively adept, and who can take the initiative conceptually by providing new approaches or ideas."

AMERICAN BAR ASSOCIATION JOURNAL, 750 N. Lake Shore Drive, Chicago IL 60611. (312)988-6002. Photo Editor: Beverly Lane. Publication of the American Bar Association. Monthly magazine. Emphasizes law and the legal profession. Readers are lawyers of all ages. Circ. 400,000. Estab. 1915. Photo guidelines available.

Needs: Uses 50-100 photos per month; 90% supplied by freelance photographers. Needs vary; mainly shots of lawyers and clients by assignment only.

Making Contact & Terms: Send non-returnable printed samples with résumé and two business cards with rates written on back. "If samples are good, portfolio will be requested. *ABA Journal* keeps film. However, if another publication requests photos, we will release and send the photos. Then, that publication pays the photographer." Payment negotiable. Cannot return unsolicited material. Credit line given.

Tips: "NO PHONE CALLS. The *ABA Journal* does not hire beginners."

AMERICAN CRAFT, 72 Spring St., New York NY 10012. (212)274-0630. Fax: (212)274-0650. Editor/ Publisher: Lois Moran. Managing Editor: Pat Dandignac. Circ. 45,000. Estab. 1941. Bimonthly magazine of the American Craft Council. Emphasizes contemporary creative work in clay, fiber, metal, glass, wood, etc. and discusses the technology, materials and ideas of the artists who do the work. Free sample copy with 9×12 SAE and 5 first-class stamps.

Needs: Visual art. Shots of crafts: clay, metal, fiber, etc. Captions required.

Making Contact & Terms: Arrange a personal interview to show portfolio. Uses 8×10 glossy b&w prints; 4×5 transparencies and 35mm film; 4×5 color transparencies for cover, vertical format preferred. SASE. Reports in 1 month. Pays according to size of reproduction; $40 minimum/b&w and color photos; $175-500/cover photos. Pays on publication. Buys one-time rights. Previously published work OK.

AMERICAN FITNESS, Dept. PM, 15250 Ventura Blvd., Suite 200, Sherman Oaks CA 91403. (818)905-0040. Managing Editor: Rhonda J. Wilson. Circ. 30,000. Estab. 1983. Publication of the Aerobics and Fitness Association of America. Publishes 6 issues/year. Emphasizes exercise, fitness, health, sports nutri-

tion, aerobic sports. Readers are fitness enthusiasts and professionals, 75% college educated, 66% female, majority between 20-45. Sample copy $2.50.

Needs: Uses about 20-40 photos/issue; most supplied by freelancers. Assigns 90% of work. Needs action photography of runners, aerobic classes, swimmers, bicyclists, speedwalkers, in-liners, volleyball players, etc. Special needs include food choices, youth and senior fitness, people enjoying recreation, dos and don'ts. Model release required.

Making Contact & Terms: Query with samples or with list of stock photo subjects. Send b&w prints; 35mm, 2¼ × 2¼ transparencies; b&w contact sheets by mail for consideration. SASE. Reports in 2 weeks. Pays $10-35/b&w or color photo; $50-100 for text/photo package. Pays 4-6 weeks after publication. Credit line given. Buys first North American serial rights. Simultaneous submissions and previously published work OK.

Tips: Fitness-oriented outdoor sports are the current trend (i.e. mountain bicycling, hiking, rock climbing). Over-40 sports leagues, youth fitness, family fitness and senior fitness are also hot trends. Wants high-quality, professional photos of people participating in high-energy activities—anything that conveys the essence of a fabulous fitness lifestyle. Also accepts highly stylized studio shots to run as lead artwork for feature stories. "Since we don't have a big art budget, freelancers usually submit spin-off projects from their larger photo assignments."

AMERICAN FORESTS MAGAZINE, Dept. PM, 1516 P St. NW, Washington DC 20005. (202)667-3300. Fax: (202)667-2756. E-mail: mrobbins@amfor.org. Website: http://www.amfor.org. Editor: Michelle Robbins. Circ. 25,000. Estab. 1895. Publication of American Forests. Quarterly. Emphasizes use, enjoyment and management of forests and other natural resources. Readers are "people from all walks of life, from rural to urban settings, whose main common denominator is an abiding love for trees, forests or forestry." Sample copy and free photo guidelines with magazine-sized envelope and 7 first-class stamps.

Needs: Uses about 40 photos/issue, 80% supplied by freelance photographers (most supplied by article authors). Needs woods scenics, wildlife, woods use/management and urban forestry shots. Model release preferred. Captions required; include who, what, where, when and why.

Making Contact & Terms: Interested in receiving work from newer, lesser-known photographers. Query with résumé of credits. Accepts images in digital format for Mac (TIFF or EPS; use Photoshop). Send via compact disc, SyQuest (300 dpi) or call for information. "We regularly review portfolios from photographers to look for potential images for upcoming magazines or to find new photographers to work with." SASE. Reports in 2 months. $300/color cover photo; $50-75/b&w inside; $75-150/color inside; $250-800 for text/photo package. **Pays on acceptance.** Credit line given. Buys one-time rights.

Tips: Seeing trend away from "static woods scenics, toward more people and action shots." In samples wants to see "overall sharpness, unusual conformation, shots that accurately portray the highlights and 'outsideness' of outdoor scenes."

THE AMERICAN GARDENER, (formerly *American Horticulturist*), 7931 E. Boulevard Dr., Alexandria VA 22308. (703)768-5700. Fax: (703)768-7533. E-mail: editorahs@aol.com. Editor: Kathleen Fisher. Circ. 25,000. Estab. 1927. Bi-monthly. 4-color. Emphasizes horticulture. Readers are advanced amateur gardeners. Sample copy $3. Photo guidelines free with SASE.

Needs: Uses 30-40 photos/issue, all supplied by freelancers. "Assignments are rare; 2-3/year for portraits to accompany profiles." Needs primarily close-ups of particular plant species showing detail. "We only review photos to illustrate a particular manuscript which has already been accepted." Sometimes uses seasonal cover shots. Model release preferred. Captions required, must include genus, species and/or cultivar names; "tulip" or "rose" is not enough. "We are science-based, not a garden design magazine."

Making Contact & Terms: Interested in receiving work from newer, lesser-known photographers. Query with list of stock photo subjects, photo samples. Provide résumé, business card, brochure, flier or tearsheets to be kept on file for possible future assignments or requests. Accepts images in digital format for Mac (Photoshop) TIFF. Send via compact disc, online, floppy disk, SyQuest (300 pixels/inch). SASE. Reports in 3 weeks. Pays $50/b&w photo; $50-65/color inside photo; $100/cover photo. Pays on publication. Buys one-time rights.

Tips: Wants to see "ability to identify precise names of plants, clarity and vibrant color."

AMERICAN HUNTER, 11250 Waples Mill Rd., Fairfax VA 22030-7400. (703)267-1300. Editor: Tom Fulgham. Circ. 1.4 million. Publication of the National Rifle Association. Monthly magazine. Sample copy and photo guidelines free with 9 × 12 SAE. Free writer's guidelines with SASE.

Needs: Uses wildlife shots and hunting action scenes. Photos purchased with or without accompanying ms. Seeks general hunting stories on North American game. Captions preferred.

Making Contact & Terms: Send material by mail for consideration. Uses 8 × 10 glossy b&w prints and 35mm color transparencies. (Uses 35mm transparencies for cover). Vertical format required for cover. SASE. Reports in 1 month. Pays $25/b&w print; $75-275/transparency; $300/color cover photo; $200-500

for text/photo package. Pays on publication for photos. Credit line given. Buys one-time rights.

AMERICAN MOTORCYCLIST, Dept. PM, 33 Collegeview Rd., Westerville OH 43081-6114. (614)891-2425. Vice President of Communication: Greg Harrison. Managing Editor: Bill Wood. Circ. 183,000. Publication of the American Motorcyclist Association. Monthly magazine. For "enthusiastic motorcyclists, investing considerable time in road riding or competition sides of the sport. We are interested in people involved in, and events dealing with, all aspects of motorcycling." Sample copy and photo guidelines for $1.50.
Needs: Buys 10-20 photos/issue. Subjects include: travel, technical, sports, humorous, photo essay/feature and celebrity/personality. Captions preferred.
Making Contact & Terms: Query with samples to be kept on file for possible future assignments. Reports in 3 weeks. SASE. Send 5×7 or 8×10 semigloss prints; transparencies. Pays $30-100/photo; $30-100/slide; $200 minimum/cover photo. Also buys photos in photo/text packages according to same rate; pays $7/column inch minimum for story. Pays on publication. Buys first North American serial rights.
Tips: Uses transparencies for covers. "The cover shot is tied in with the main story or theme of that issue and generally needs to be with accompanying manuscript. Show us experience in motorcycling photography and suggest your ability to meet our editorial needs and complement our philosophy."

AMERICAN SKATING WORLD, 1816 Brownsville Rd., Pittsburgh PA 15210-3908. (412)885-7600. Fax: (412)885-7617. Managing Editor: H. Kermit Jackson. Circ. 15,000. Estab. 1981. Monthly tabloid. Emphasizes ice skating—figure skating primarily, speed skating secondary. Readers are figure skating participants and fans of all ages. Sample copy $3.25 with 8×12 SAE and 3 first-class stamps. Photo guidelines free with SASE.
Needs: Uses 20-25 photos/issue; 4 supplied by freelancers. Needs performance and candid shots of skaters and "industry heavyweights." Reviews photos with or without manuscript. Model/property release preferred for children and recreational skaters. Captions required; include name, locale, date and move being executed (if relevant).
Making Contact & Terms: Interested in receiving work from newer, lesser-known photographers. Query with résumé of credits. Keeps samples on file. SASE. Report on unsolicited submissions could take 3 months. Pays $25/color cover photo; $5/b&w inside photo. Pays 30 days after publication. Buys one-time rights color; all rights b&w; negotiable. Simultaneous submissions and/or previously published work OK.
Tips: "Pay attention to what's new, the newly emerging competitors, the newly developed events. In general, be flexible!" Photographers should capture proper lighting in performances and freeze the action instead of snapping a pose.

‡**AMERICAN SURVIVAL GUIDE**, % Visionary, L.P., 265 S. Anita Dr., Suite 120, Orange CA 92868-3310. (714)939-9991 ext. 204 or 203. Fax: (714)939-9909. Editor: Jim Benson. Circ. 60,000. Estab. 1980. Monthly magazine. Emphasizes firearms, military gear, emergency preparedness, survival food storage and self-defense products. Average reader is male, mid-30s, all occupations and with conservative views. Sample copy $3.50 and SAE with 5 first-class stamps. Photo guidelines free with SASE.
Needs: Uses more than 100 photos/issue; 35-45% supplied by freelance photographers. Photos purchased with accompanying manuscript only. Model release required. Captions required.
Making Contact & Terms: Interested in receiving work from newer, lesser-known photographers. Send written query detailing article and photos. Note: Will not accept text without photos or other illustrations. Pays $80/color and b&w page rate. Pays on publication. Credit line given. Buys all rights; negotiable.
Tips: Wants to see "professional looking photographs—in focus, correct exposure, good lighting, interesting subject and people in action. Dramatic poses of people helping each other after a disaster, riots or worn torn area. Wilderness survival too. Look at sample copies to get an idea of what we feature. We only accept photos with an accompanying manuscript (floppy disk with WordPerfect or Microsoft Word files). The better the photos, the better chance you have of being published."

‡**ANCHOR NEWS**, 75 Maritime Dr., Manitowoc WI 54220. (414)684-0218. Fax: (414)684-0219. Editor: Jay Martin. Circ. 1,900. Publication of the Wisconsin Maritime Museum. Quarterly magazine. Emphasizes Great Lakes maritime history. Readers include learned and lay readers interested in Great Lakes history. Sample copy free with 9×12 SAE and $1 postage. Guidelines free with SASE.
Needs: Uses 8-10 photos/issue; infrequently supplied by freelance photographers. Needs historic/nostalgic, personal experience and general interest articles on Great Lakes maritime topics. How-to and technical pieces and model ships and shipbuilding are OK. Special needs include historic photography or photos that show current historic trends of the Great Lakes. Photos of waterfront development, bulk carriers, sailors, recreational boating, etc. Model release required. Captions required.
Making Contact & Terms: Query with samples. Send 4×5 or 8×10 glossy b&w prints by mail for consideration. SASE. Reports in 1 month. Pays in copies only on publication. Credit line given. Buys first

...erican serial rights. Simultaneous submissions and previously published work OK.

...sides historic photographs, I see a growing interest in underwater archaeology, especially on the ...s, and underwater exploration—also on the Great Lakes. Sharp, clear photographs are a must. ...tion deals with a wide variety of subjects; however, we take a historical slant with our publica-...ore photos should be related to a historical topic in some respect. Also current trends in Great ...ing. A query is most helpful. This will let the photographer know exactly what we are looking for and will help save a lot of time and wasted effort."

ANIMALS, 350 S. Huntington Ave., Boston MA 02130. (617)522-7400. Fax: (617)522-4885. Photo Editor: Detrich Gehring. Publication of the Massachusetts Society for the Prevention of Cruelty to Animals and the American Humane Education Society. Circ. 100,000. Estab. 1868. Bimonthly. Emphasizes animals, both wild and domestic. Readers are people interested in animals, conservation, animal welfare issues, pet care and wildlife. Sample copy $2.95 with 9×12 SASE. Photo guidelines free with SASE.

Needs: Uses about 45 photos/issue; approximately 95% supplied by freelance photographers. "All of our pictures portray animals, usually in their natural settings, however some in specific situations such as pets being treated by veterinarians or wildlife in captive breeding programs." Needs vary according to editorial coverage. Special needs include clear, crisp shots of animals, wild and domestic, both close-up and distance shots with spectacular backgrounds, or in the case of domestic animals, a comfortable home or backyard. Model release required in some cases. Captions preferred; include species, location.

Making Contact & Terms: Interested in receiving work from newer, lesser-known photographers. Query with résumé of credits; query with list of stock photo subjects. Provide résumé, business card, brochure, flier or tearsheets to be kept on file for possible future assignments. SASE. Reports in 6 weeks. Fees are usually negotiable; pays $50-150/b&w photo; $75-300/color photo; payment depends on size and placement. Pays on publication. Credit line given. Buys one-time rights.

Tips: Photos should be sent to Detrich Gehring, photo editor. Gehring does first screening. "Offer original ideas combined with extremely high-quality technical ability. Suggest article ideas to accompany your photos, but only propose yourself as author if you are qualified. We have a never-ending need for sharp, high-quality portraits of mixed-breed dogs and cats for both inside and cover use. Keep in mind we seldom use domestic cats outdoors; we often need indoor cat shots."

APPALACHIAN TRAILWAY NEWS, Box 807, Harpers Ferry WV 25425. (304)535-6331. Fax: (304)535-2667. Editor: Judith Jenner. Circ. 26,000. Estab. 1939. Publication of the Appalachian Trail Conference. Bimonthly. Emphasizes the Appalachian Trail. Readers are conservationists, hikers. Sample copy $3 (includes postage and guidelines). Guidelines free with SASE.

Needs: Uses about 20-30 b&w photos/issue; 4-5 supplied by freelance photographers (plus 13 color slides each year for calendar). Needs scenes from the Appalachian Trail, specifically of people using or maintaining the trail. Special needs include candids—people/wildlife/trail scenes. Photo information required.

Making Contact & Terms: Query with ideas. Send 5×7 or larger glossy b&w prints; b&w contact sheet; or 35mm transparencies by mail for consideration. SASE. Reports in 3 weeks. **Pays on acceptance.** Pays $150/cover photo; $200 minimum/color slide calendar photo; $10-50/b&w inside photo. Credit line given. Rights negotiable. Simultaneous submissions and/or previously published work OK.

‡APPALOOSA JOURNAL, P.O. Box 8403, Moscow ID 83843. (208)882-5578. Fax: (208)882-8150. Circ. 30,000. Estab. 1946. Association publication of Appaloosa Horse Club. Monthly magazine. Emphasizes Appaloosa horses. Readers are Appaloosa owners, breeders and trainers, child through adult. Sample copy $5. Photo guidelines free with SASE.

Needs: Uses 30 photos/issue; 10% supplied by freelance photographers. Needs photos (color and b&w) to accompany features and articles. Special photo needs include photographs of Appaloosas (high quality horses) in winter scenes. Model release required. Captions required.

Making Contact & Terms: Send unsolicited 8×10 b&w and color prints or 35mm and $2\frac{1}{4} \times 2\frac{1}{4}$ transparencies by mail for consideration. Reports in 3 weeks. Pays $100-300/color cover photo; $25-50/color inside photo; $25-50/b&w inside photo. **Pays on acceptance.** Credit line given. Buys first North American serial rights. Previously published work OK.

Tips: In photographer's samples, wants to see "high-quality color photos of world class, characteristic

Appaloosa horses with people in appropriate outdoor environment. We often need a freelancer to illustrate a manuscript we have purchased. We need specific photos and usually very quickly."

‡AQUARIUM FISH MAGAZINE, P.O. Box 6050, Mission Viejo CA 92690. (714)855-8822. Fax: (714)855-3045. E-mail: 76107.460@compuserve.com. Editor: Edward Bauman. Circ. 75,000. Estab. 1988. Monthly magazine. Emphasizes aquarium fish. Readers are both genders, all ages. Sample copy $3.50. Photo guidelines free with SASE.
Needs: Uses 30 photos/issue; all supplied by freelance photographers. Needs photos of aquariums and fish, freshwater and saltwater; ponds.
Making Contact & Terms: Query with list of stock photo subjects. Submit portfolio for review. Send 35mm, 2¼×2¼ transparencies by mail for consideration. SASE. Reports in 1 month. Pays $150/color cover photo; $50-75/color inside photo; $25/b&w inside photo; $75/color page rate; $25/b&w page rate. Pays on publication. Credit line given. Buys one-time rights. Previously published work OK.

‡ASPIRE, CCM Communications, 107 Kenner Ave., Nashville TN 37205. (615)386-3011. Fax: (615)386-3380. Design & Production Director: Brian Smith. Circ. 50,000. Estab. 1991. Bimonthly magazine. Emphasizes Christian lifestyle and health. Readers are female Christians, ages 30-45.
Needs: Uses 20 photos/issue; 5-8 supplied by freelancers. Needs photos of editorial concepts. Model release required. Property release preferred. Captions preferred.
Making Contact & Terms: Interested in receiving work from newer, lesser-known photographers. Send unsolicited photos by mail for consideration. Provide résumé, business card, brochure, flier or tearsheets to be kept on file for possible assignments. Send 35mm, 2¼×2¼, 4×5, 8×10 transparencies. Keeps samples on file. SASE. Reports in 1-2 weeks. Pays $50-100/hour; $500-800/day; $50-500/job; $250-750/color cover photo; $50-300/b&w cover photo; $200-500/color inside photo; $50-200/b&w inside photo. **Pays on acceptance.** Credit line given. Buys first North American serial rights; negotiable. Simultaneous submissions and/or previously published work OK.

ASTRONOMY, 21027 Crossroads Circle, Waukesha WI 53187. (414)796-8776. Fax: (414)796-1142. Photo Editor: David J. Eicher. Circ. 175,000. Estab. 1973. Monthly magazine. Emphasizes astronomy, science and hobby. Median reader: 40 years old, 85% male, income approximately $68,000/yr. Sample copy $3. Photo guidelines free with SASE.
Needs: Uses approximately 100 photos/issue; 70% supplied by freelancers. Needs photos of astronomical images. Model/property release preferred. Captions required.
Making Contact & Terms: Interested in receiving work from newer, lesser-known photographers. Send unsolicited photos by mail for consideration. Send 8×10 glossy color and b&w photos; 35mm, 2¼×2¼, 4×5, 8×10 transparencies. Keeps samples on file. SASE. Reports in 2 weeks. Pays $150/cover photo; $25 for routine uses. Pays on publication. Credit line given.

‡ATLANTA HOMES & LIFESTYLES, 1100 Johnson Ferry Rd. NE, Suite 595, Atlanta GA 30342. (404)252-6670. Fax: (404)252-6673. Editor: Barbara Tapp. Circ. 38,000. Estab. 1983. Magazine published 9 times/year. Covers residential design (home and garden); food, wine and entertaining; people, travel and lifestyle subjects. Sample copy $2.95.
Needs: Needs photos of homes (interior/exterior), people, travel, decorating ideas, products, gardens. Model/property release required. Captions preferred.
Making Contact & Terms: Interested in receiving work from newer, lesser-known photographers. Submit portfolio for review. Send unsolicited photos by mail for consideration. Provide résumé, business card, brochure, flier or tearsheets to be kept on file for possible assignments. Send 35mm, 2¼×2¼ transparencies. SASE. Reports in 2 months. Pays $50-650/job. Pays on publication. Credit line given. Buys one-time rights. Simultaneous submissions and/or previously published work OK.

ATLANTA PARENT, 4330 Georgetown Square II, Suite 506, Atlanta GA 30338. (770)454-7599. Fax: (770)454-7699. Assistant to Publisher: Peggy Middendorf. Circ. 70,000. Estab. 1983. Monthly tabloid. Emphasizes parents, families, children, babies. Readers are parents with children ages 0-16. Sample copy $2.
Needs: Uses 4-8 photos/issue; all supplied by freelancers. Needs photos of babies, children in various activities, parents with kids. Model/property release required. Captions preferred.
Making Contact & Terms: Interested in receiving work from newer, lesser-known photographers. Query with stock photos or photocopies of photos. Send unsolicited photos by mail for consideration. Send 3×5 or 4×6 b&w prints. Keeps samples on file. SASE. Reports in 3 months. Pays $20-75/color photo; $20/b&w photo. Pays on publication. Credit line given. Buys one-time rights; negotiable. Simultaneous and/or previously published work OK.

ATLANTIC CITY MAGAZINE, Dept. PM, Box 2100, Pleasantville NJ 08232. (609)272-7900. Art Director: Michael Lacy. Circ. 50,000. Monthly. Sample copy $2 plus 4 first-class stamps.
Needs: Uses 50 photos/issue; all supplied by freelance photographers. Prefers to see b&w and color portraits in photographic essays. Model release required. Captions required.
Making Contact & Terms: Query with portfolio/samples. Cannot return material. Provide tearsheets to be kept on file for possible future assignments. Payment negotiable; usually $35-50/b&w photo; $50-100/color; $250-450/day; $175-300 for text/photo package. Pays on publication. Credit line given. Buys one-time rights.
Tips: "We promise only exposure, not great fees. We're looking for imagination, composition, sense of design, creative freedom and trust."

‡**AU JUICE**, 1431 Spruce St., Berkeley CA 94709. (510)548-0697. E-mail: getjuice@aol.com. Editor: Fred Dodsworth. Circ. 50,000. Etab. 1994. Bimonthly magazine. Readers are young, hip, adventurous, into food and drink. Sample copy $5 with 8 × 11 SASE.
Needs: Uses 10-30 photos/issue; 10-20 supplied by freelancers. Needs photos of people, places and things. Reviews photos with our without a ms. Model/property release preferred. Captions preferred.
Making Contact & Terms: Interested in receiving work from newer, lesser-known photographers. Send unsolicited photos by mail for consideration. Send 3 × 5 color prints. Keeps samples on file. Cannot return material. Reports in 1 month. Pays $25-180 total/hour. Pays extra for electronic usage. Pays on publication. Credit line given. Buys one-time, first North American serial and electronic rights; negotiable.

AUDUBON MAGAZINE, National Audubon Society, 700 Broadway, New York NY 10003. (212)979-3000. Fax: (212)353-0398. *Audubon* reports on the state of the natural world and the many ways people relate to it, from culture and commerce to technology and politics. This magazine did not respond to our request for information. Query before submitting.

‡**AUTO SOUND & SECURITY**, 774 S. Placentia Ave., Placentia CA 92670. (714)572-6887. Fax: (714)572-4265. Editor: Bruce Fordyce. Estab. 1990. Monthly magazine. Emphasizes automotive aftermarket electronics. Readers are largely male students, ages 16-26. Sample copy free with SASE.
Needs: Uses 100 photos/issue; less than half supplied by freelancers. Needs photos of custom installations of aftermarket autosound systems and sub-systems. Model/property release required for vehicle owners and models (full features only).
Making Contact & Terms: Interested in receiving work from newer, lesser-known photographers. Provide résumé, business card, brochure, flier or tearsheets to be kept on file for possible assignments. Deadlines: three months prior to cover date. Keeps samples on file. SASE. Reports in 2 weeks. Pays $300-500/job; $100/color page rate. Pays on publication. Credit line given. Rights negotiable.

AUTO TRIM & RESTYLING NEWS, 6255 Barfield Rd., Suite 200, Atlanta GA 30328-4300. (404)252-8831. Fax: (404)252-4436. Editor: Gregory Sharpless. Circ. 8,503. Estab. 1951. Publication of National Association of Auto Trim and Restyling Shops. Monthly. Emphasizes automobile restyling and restoration. Readers include owners and managers of shops specializing in restyling, customizing, graphics, upholstery, trim, restoration, detailing, glass repairs, and others.
Needs: Uses about 15-20 photos/issue; 10-15 supplied by freelance photographers, all on assignment. Needs "how-to, step-by-step photos; restyling showcase photos of unusual and superior completed work." Special needs include "restyling ideas for new cars in the aftermarket area; soft goods and chrome add-ons to update Detroit." Also needs feature and cover-experienced photographers. Captions required.
Making Contact & Terms: Interested in receiving work from photographers with a minimum of 3 years professional experience. Provide résumé, business card, brochure, flier or tearsheets to be kept on file for possible future assignments. Photographer should be in touch with a cooperative shop locally. SASE. Reports in 2-3 weeks. Pays $35/b&w photo; up to $700/color cover. Assignment fees negotiable. Pays on publication. Credit line given if desired. Buys all rights.
Tips: "In samples we look for experience in shop photography, ability to photograph technical subject matter within automotive and marine industries."

AUTOGRAPH COLLECTOR MAGAZINE, 510-A S. Corona Mall, Corona CA 91719-1420. (909)734-9636. Fax: (909)371-7139. Editors: Ev Phillips. Circ. 20,000. Estab. 1986. Magazine published 12 times/year. Emphasizes autograph collecting. Readers are all ages and occupations. Sample copy $6.
Needs: Uses 30-40 photos/issue; all supplied by freelancers. Needs photos of "autograph collectors with collections, autographs and VIPs giving autographs, historical documents in museums, etc." Model/property release required. Photo captions preferred.
Making Contact & Terms: Interested in receiving work from newer, lesser-known photographers. Send

unsolicited photos by mail for consideration. Provide résumé, business card, brochure, flier or tearsheets to be kept on file for possible assignments. Send 4×5, 8×10 glossy b&w or color prints. SASE. Reports in 3 weeks. Payment negotiable. Pays on publication. Credit line given. Buys first North American serial rights; negotiable. Simultaneous submissions OK.

AUTOMOTIVE SERVICE ASSOCIATION (ASA), 1901 Airport Freeway, Bedford TX 76021. (817)283-6205. Fax: (817)685-0225. E-mail: monicab@asashop.org. Website: http://www.asashop.org. Vice President of Communication: Monica Buchholz. Circ. 15,000. Estab. 1952. Publication of Automotive Service Association. Monthly magazine. Emphasizes automotive articles pertinent to members, legislative concerns, computer technology related to auto repair. Readers are male and female, ages 25-60, automotive repair owners, aftermarket. Free sample copy; additional copies $3.
Needs: Uses 20 photos/issue; 50% supplied by freelancers. Needs cover photos, technology photos and photos pertaining to specific articles. Special cover photo needs include late model 1960s automobiles. Model/property release required. Captions required.
Making Contact & Terms: Interested in receiving work from newer, lesser-known photographers. Submit portfolio for review. Send unsolicited photos by mail for consideration. Send 4×5 medium format transparencies. Deadline: 30-40 days prior to publication. Keeps samples on file. SASE. Reports in 3 weeks. Payment negotiable. Pays on publication. Buys all rights; negotiable. Previously published work OK.

AWARE COMMUNICATIONS INC., 305 SW 140th Terrace, Newberry FL 32669. (352)332-9600. Fax: (352)332-9696. Vice President-Creative: Scott Stephens. Publishes quarterly and annual magazines and poster. Emphasizes education—medical, pre-natal, sports safety and job safety. Readers are high school males and females, medical personnel, women, home owners.
 • This company produces numerous consumer publications: *Student Aware, Technology Education, Sports Safety, Medaware, New Homeowner, Help Yourself, Perfect Prom* and *Insect Protect!*.
Needs: Uses 20-30 photos/issue; 10% supplied by freelancers. Needs photos of medical, teenage sports and fitness, pregnancy and lifestyle (of pregnant mothers), home interiors. Model/property release required.
Making Contact & Terms: Interested in reviewing work from newer, lesser-known photographers. Submit portfolio for review. Send unsolicited photos by mail for consideration. Send 35mm, 2¼×2¼, 4×5, 8×10 transparencies. Accepts images in digital format for Windows. Send via compact disc, floppy disk or SyQuest. Keeps samples on file. SASE. Reports only when interested. Pays $400/color cover photo; $100/color inside photo; $200-1,000/complete job. Pays on publication. Credit line given. Buys one time rights; negotiable. Simultaneous submissions and/or previously published work OK. Offers internships for photographers year round. Contact Creative Vice President: Scott Stephens.
Tips: Looks for quality of composition and color sharpness. "Photograph people in all lifestyle situations."

‡BABY'S WORLD MAGAZINE, P.O. Box 281, E. Hanover NJ 07936. (201)503-0700. Fax: (201)887-6801. E-mail: info@babysworld.com. Managing Editor: Taylor Scott. Circ. 100,000. Estab. 1996. Quarterly magazine. Emphasizes new and expectant parents with issues on health, safety, medicine and nutrition. Readers are females and males ages 20-45. Sample copy free with 9×12 SASE. Photo guidelines free with SASE.
Needs: Uses 30 photos/issue; 15 supplied by freelancers. Needs photos of babies, mothers with babies, mothers in hospital, mothers at doctors' office, children playing (ages 3-24 months). Model release required. Property release preferred. Captions preferred.
Making Contact & Terms: Send unsolicited photos by mail for consideration. Send 4×5 color or b&w prints; 35mm, 2¼×2¼, 4×5 transparencies. Keeps samples on file. SASE. Reports in 1 month. Pays $100-300/b&w cover photo; $25-50/color inside photo; $5-15/b&w inside photo. Pays on publication. Credit line given. Buys first North American serial rights. Previously published work OK.
Tips: "We look for photos of realism, parents and babies, and shots such as eyes, mouths, hands and feet. If you can work well with our editorial content, you will be perfect for us."

BACK HOME IN KENTUCKY, P.O. Box 681629, Franklin TN 37068-1629. (615)794-4338. Fax: (615)790-6188. Editor: Nanci Gregg. Circ. 13,000. Estab. 1977. Bimonthly magazine. Emphasizes subjects in the state of Kentucky. Readers are interested in the heritage and future of Kentucky. Sample copy $3 with 9×12 SAE and 5 first-class stamps.
 • This publication performs its own photo scans and has stored some images on Photo CD. They have done minor photo manipulation of photos for advertisers.
Needs: Uses 25 photos/issue; all supplied by freelance photographers, less than 10% on assignment. Needs photos of scenic, specific places, events, people. Reviews photos solo or with accompanying ms. Also seeking vertical cover (color) photos. Special needs include winter, fall, spring and summer in Kentucky; Christmas; the Kentucky Derby sights and sounds. Model release required. Captions required.

Making Contact & Terms: Interested in receiving work from newer, lesser-known photographers. Send any size, glossy b&w and color prints, 35mm transparencies by mail for consideration. Accepts images in digital format for Mac (TIFF or EPS). Send via compact disc, floppy disk, SyQuest 88 or Zip disk (133 line screen or better). Reports in 2 weeks. Pays $10-25/b&w photo; $20-50/color photo; $50 minimum/cover photo; $15-100/text/photo package. Pays on publication. Credit line given. Usually buys one-time rights; also all rights; negotiable. Simultaneous submissions and previously published work OK.
Tips: "We look for someone who can capture the flavor of Kentucky—history, events, people, homes, etc. Have a great story to go with the photo—by self or another."

BACKPACKER MAGAZINE, 135 N. Sixth St., Emmaus PA 18049. (610)967-8371. E-mail: dbstauffer @aol.com. Website: http://www.bpbasecomp.com. Photo Editor: Deborah Burnett Stauffer. Magazine published 9 times annually. Readers are male and female, ages 35-45. Photo guidelines free with SASE.
Needs: Uses 40 photos/issue; almost all supplied by freelancers. Needs transparencies of wildlife, scenics, people backpacking, camping. Reviews photos with or without ms. Model/property release required.
Making Contact & Terms: Interested in receiving work from newer, lesser-known photographers. Query with résumé of credits, photo list and example of work to be kept on file. Accepts images in digital format for Windows. Send via online, SyQuest or zip disk. SASE. Payment varies. Pays on publication. Credit line given. Rights negotiable. Sometimes considers simultaneous submissions and previously published work.

BALLOON LIFE, 2336 47th Ave. SW, Seattle WA 98116-2331. (206)935-3649. Fax: (206)935-3326. E-mail: blnlife@scn.org. Website: http://www.balloonlife.com. Editor: Tom Hamilton. Circ. 4,000. Estab. 1986. Monthly magazine. Emphasizes sport ballooning. Readers are sport balloon enthusiasts. Sample copy free with 9×12 SAE and 6 first-class stamps. Photo guidelines free with #10 SASE.
- 95% of artwork is scanned digitally inhouse by this publication, then color corrected and cropped for placement.
Needs: Uses about 15-20 photos/issue; 90% supplied by freelance photographers on assignment. Needs how-to photos for technical articles, scenic for events. Model/property release preferred. Captions preferred.
Making Contact & Terms: Interested in receiving work from newer, lesser-known photographers. Send b&w or color prints; 35mm transparencies by mail for consideration. "We are now scanning our own color and doing color separations in house. As such we prefer 35mm transparencies above all other photos." Accepts images in digital format for Mac (TIFF). Send via compact disc, online, floppy disk, SyQuest 44 or Zip disk (300 dpi). SASE. Reports in 1 month. Pays $50/color cover photo; $15-50/b&w or color inside photo. Pays on publication. Credit line given. Buys one-time and first North American serial rights. Simultaneous submissions and previously published work OK.
Tips: "Photographs, generally, should be accompanied by a story. Cover the basics first. Good exposure, sharp focus, color saturation, etc. Then get creative with framing and content. Often we look for one single photograph that tells readers all they need to know about a specific flight or event. We're evolving our coverage of balloon events into more than just 'pretty balloons in the sky.' I'm looking for photographers who can go the next step and capture the people, moments in time, unusual happenings, etc. that make an event unique. Query first with interest in sport, access to people and events, experience shooting balloons or other outdoor special events."

‡BALTIMORE, 1000 Lancaster St., Suite 400, Baltimore MD 21202. (410)752-4200. Fax: (410)625-0280. Associate Art Director: Erik Washam. Circ. 60,000. Estab. 1907. Monthly magazine for Baltimore region. Readers are educated Baltimore denizens, ages 35-60. Sample copy $2.95 with 9×12 SASE.
Needs: Uses 200 photos/issue; 30-50 supplied by freelancers. Needs photos of lifestyle, profile, news, food, etc. Special photo needs include photo essays about Baltimore. Model release required. Captions required; include name, age, neighborhood, reason/circumstances of photo.
Making Contact & Terms: Interested in receiving work from newer, lesser-known photographers. Provide résumé, business card, brochure, flier or tearsheets to be kept on file for possible assignments. SASE. Call for photo essays. Reports in 1 month. Pays $100-350/day. Pays 30 days past invoice. Credit line given. Buys first North American serial rights; negotiable.

BASSIN', Dept. PM, 2448 E. 81st St., 5300 CityPlex Tower, Tulsa OK 74137-4207. (918)491-6100. Executive Editor: Mark Chesnut. Circ. 275,000 subscribers, 100,000 newsstand sales. Published 8 times/year. Emphasizes bass fishing. Readers are predominantly male, adult; nationwide circulation with heavier concentrations in South and Midwest. Sample copy $2.95. Photo guidelines free.
Needs: Uses about 50-75 photos/issue; "almost all of them" are supplied by freelance photographers. "We need both b&w and Kodachrome action shots of bass fishing; close-ups of fish with lures, tackle, etc., and scenics featuring lakes, streams and fishing activity." Captions required.
Making Contact & Terms: Query with samples. SASE. Reports in 6 weeks. Pays $400-500/color cover

photo; $25/b&w inside photo; $75-200/color inside photo. Pays on publication. Credit line given. Buys first North American serial rights.

Tips: "Don't send lists—I can't pick a photo from a grocery list. In the past, we used only photos sent in with stories from freelance writers. However, we would like freelance photographers to participate."

☘BC OUTDOORS, 780 Beatty St., Suite 300, Vancouver, British Columbia V6B 2M1 Canada. (604)606-4644. Fax: (604)687-1925. Editor: Karl Bruhn. Circ. 42,000. Estab. 1945. Emphasizes fishing, both fresh water and salt; hunting; RV camping; wildlife and management issues. Published 8 times/year (January/February, March, April, May, June, July/August, September/October, November/December). Free sample copy with $2 postage (Canadian).

Needs: Uses about 30-35 photos/issue; 99% supplied by freelance photographers on assignment. "Fishing (in our territory) is a big need—people in the act of catching or releasing fish. Hunting, canoeing and camping. Family oriented. By far most photos accompany mss. We are always on lookout for good covers—fishing, wildlife, recreational activities, people in the outdoors—vertical and square format, primarily of British Columbia and Yukon. Photos with mss must, of course, illustrate the story. There should, as far as possible, be something happening. Photos generally dominate lead spread of each story. They are used in everything from double-page bleeds to thumbnails. Column needs basically supplied inhouse." Model/property release preferred. Captions or at least full identification required.

Making Contact & Terms: Interested in receiving work from newer, lesser-known photographers. Send by mail for consideration actual 5×7 or 8×10 b&w prints; 35mm, 2¼×2¼, 4×5 or 8×10 color transparencies; color contact sheet. If color negative, send jumbo prints and negatives only on request. Query with list of stock photo subjects. SASE, Canadian stamps. Reports in 1-2 weeks normally. Pays $20-75/b&w photo; $25-200/color photo; and $250/cover photo. Pays on publication. Credit line given. Buys one-time rights inside; with covers "we retain the right for subsequent promotional use." Simultaneous submissions not acceptable if competitor; previously published work OK.

Tips: "We see a trend toward more environmental/conservation issues."

‡BEARS MAGAZINE, P.O. Box 88, Tremorton UT 84337. (801)257-3634. Fax: (801)257-7341. Publisher and Photo Editor: Brad Garfield. Circ. 20,000. Quarterly magazine. Emphasizes bears and wild bears. (grizzly, black, polar bears, etc.). Readers are male and female, ages 5-80. Sample copy $3. Photo guidelines free with SASE.

Needs: Uses 30 photos/issue. Needs photos of bears and other wildlife they interact with; travel, scenics, profiles on bears and how-to articles on where and when to find bears. Reviews photos with accompanying ms only. Model/property release preferred for people. Captions preferred.

Making Contact & Terms: Query with résumé of credits. Send 35mm, 2¼×2¼, 4×5, 8×10 transparencies. Keeps samples on file. SASE. Reports in 1 month. Pays $100-200/color cover photo; $25-50/color inside photo; $25-50/color page rate; $25-50/b&w page rate; $200-400/photo/text package. Pays on publication. Buys one-time rights. Simultaneous submissions and previously published work OK.

Tips: "Do not send duplicates unless they are sharp. Send only tack-sharp slides with good exposure and composition."

BEAUTY HANDBOOK: NATIONAL WOMEN'S BEAUTY MAGAZINE, 75 Holly Hill Lane, 3rd Floor, Greenwich CT 06830. (203)869-5553, ext. 305. Fax: (203)869-3971. Editor-in-Chief: Michelle Goodman. Circ. 1.1 million. Quarterly magazine. Emphasizes beauty, health, fitness, hair, cosmetics, nails. Readers are female, ages 25-45, interested in improving appearance. Sample copy free with 9×12 SAE and 4 first-class stamps.

Needs: Uses 12-14 photos/issue; almost all supplied by freelancers. Needs photos of studio and natural setting shots of attractive young women. Model/property release preferred. Offers internships for photographers. Contact Editor: Michelle Goodman.

Making Contact & Terms: Interested in receiving work from newer, lesser-known photographers. Send unsolicited photos by mail for consideration. Contact through rep. Query with stock photo list. Send 8×10 glossy b&w or color prints; 35mm, 2¼×2¼, 4×5. Keeps samples on file. SASE. Reports in 2 weeks. Photographers must be willing to work for tearsheets only. Rights negotiable. Simultaneous submissions and previously published work OK.

BETTER NUTRITION, Intertec Publishing, 6151 Powers Ferry Rd., Atlanta GA 30339-2941. (770)955-2500. Fax: (770)618-0348. Art Director: Scott Upton. Circ. 465,000. Monthly magazine. Emphasizes

 CANADIAN LISTINGS are marked with a maple leaf.

"health food, healthy people." Readers are ages 30-60. Sample copy or editorial calendar free with 9×12 SAE and 2 first-class stamps. Free guideline sheet with SASE.

Needs: Uses 8-10 photos/issue; 6 supplied by freelancers. Needs photos of "healthy people exercising (skiing, running, etc.), food shots, botanical shots." Model release preferred.

Making Contact & Terms: Interested in receiving work from newer, lesser-known photographers. Send unsolicited photos by mail for consideration. Send 35mm transparencies. SASE. Reports in 1 month. Pays $400/color cover photo; $150/color inside photo. Pays on publication. Credit line given. Buys one-time rights. Simultaneous submissions and previously published work OK.

Tips: "We are looking for photos of healthy people (all ages) usually in outdoor settings. We work on a limited budget, so do not send submissions if you cannot work within it. Review past issues for photo style."

THE BIBLE ADVOCATE, P.O. Box 33677, Denver CO 80233. (303)452-7973. Fax: (303)452-0657. E-mail: cofgsd@denver.net. Website: http://www.denver.net/~baonline. Editor: Roy A. Marrs. Circ. 13,500. Estab. 1863. Publication of the Church of God (Seventh Day). Monthly magazine; 11 issues/year. Emphasizes Christian and denominational subjects. Sample copy free with 9×12 SAE and 4 first-class stamps.
 ● *The Bible Advocate* is using more and more CD-ROM art and less slides from photographers.

Needs: Needs scenics and some religious shots (Jerusalem, etc.). Captions preferred, include name, place.

Making Contact & Terms: Interested in receiving work from newer, lesser-known photographers. Submit portfolio for review. SASE. Reports as needed. No payment offered. Rights negotiable. Simultaneous submissions and previously published work OK.

Tips: "We especially need fall and winter slides for the front cover." Wants to see "b&w prints for inside and 35mm color transparencies for front cover—religious, nature, people." To break in, "be patient—right now we use material on an as-needed basis. We will look at all work, but please realize we don't pay for photos or cover art. Send samples and we'll review them. We are working several months in advance now. If we like a photographer's work, we schedule it for a particular issue so we don't hold it indefinitely."

BIRD WATCHER'S DIGEST, Dept. PM, Box 110, Marietta OH 45750. (614)373-5285. Editor/Photography and Art: Bill Thompson III. Circ. 99,000. Bimonthly. Emphasizes birds and bird watchers. Readers are bird watchers/birders (backyard and field, veterans and novices). Digest size. Sample copy $3.50.

Needs: Uses 25-35 photos/issue; all supplied by freelance photographers. Needs photos of North American species.

Making Contact & Terms: Query with list of stock photo subjects and samples. SASE. Reports in 2 months. Pays $50-up/color inside. Pays on publication. Credit line given. Buys one-time rights. Previously published work in other bird publications should not be submitted.

‡BIRDS & BLOOMS, 5400 S. 60th St., Greendale WI 53129. (414)423-0100. Fax: (414)423-8463. Photo Coordinator: Trudi Bellin. Estab. 1994. Bimonthly magazine. Celebrates "the beauty in your own backyard." Readers are male and female 30-50 (majority) who prefer to spend their spare time in their "outdoor living room." Heavy interest in "amateur" gardening, backyard bird-watching and bird feeding. Sample copy $2 with 9×12 SASE and 6 first-class stamps.

Needs: Uses 140 photos/issue; 25% supplied by freelancers. Needs photos of backyard flowers and birds. Special photo needs include vertical materials for cover use, must include humans or "human elements" (i.e., fence, birdhouse, birdbath). Also needs images for two-page spreads focusing on backyard birds or gardening. Model release required for private homes. Photo captions required; include season, location, common and/or scientific names.

Making Contact & Terms: Interested in receiving work from newer, lesser-known photographers. Query with résumé of credits. Query with stock photo list. Send unsolicited photos by mail for consideration. Send color prints; 35mm, $2\frac{1}{4} \times 2\frac{1}{4}$, 4×5, 8×10 transparencies. Keeps samples on file (tearsheets; no dupes). SASE. Reports in 1-3 months for first review. Pays $300/color cover; $75-300/color inside photos; $150/color page rate; $100-200/photo/text package. Pays on publication. Credit line given. Buys one-time rights. Simultaneous submissions and previously publilshed work OK.

Tips: "Technical quality is extremely important; focus must be sharp, no soft focus; colors must be vivid so they 'pop off the page.' Study our magazine thoroughly—we have a continuing need for sharp, colorful images, and those who can supply what we need can expect to be regular contributors."

BLACK CHILD MAGAZINE, Interrace Publications, P.O. Box 12048, Atlanta GA 30355. (404)350-7877. Fax: (404)350-0819. Associate Publisher: Gabe Grosz. Circ. 50,000. Estab. 1995. Bimonthly magazine. Emphasizes children of African-American heritage, with or without family, from birth to early teens. Also, transracial adoptees. Sample copies $2 with 9×12 SAE and 4 first-class stamps. Photo guidelines free with SASE.

● *Black Child* is published by Interrace Publications, publisher of *Interrace* and *Child of Colors* mini-magazine also listed in this section.

Needs: Uses 15-20 photos/issue; 12-15 supplied by freelancers. Needs photos of children and their families. Must be of African-American heritage. Special photo needs include children playing, serious shots, schooling, athletes, arts, entertainment. Model/property release preferred. Captions preferred.

Making Contact & Terms: Interested in receiving work from newer, lesser-known photographers. Submit portfolio for review. Query with résumé of credits. Query with stock photo list. Send unsolicited photos by mail for consideration. Accepts images in digital format for Mac. Send via floppy disk (133 line per inch or 2400 dpi). Provide résumé, business card, brochure, flier or tearsheets to be kept on file for possible assignments. Send 3×5, 8×10 color or b&w prints; any transparencies. Keeps samples on file. SASE. Reports in 1 month or less. Pays $20/photo for less than ½ page; $28 for ½ page; $35 for full page; $50/ cover photo. Pays on publication. Credit line given. Buys one-time rights. Simultaneous submissions and/ or previously published work OK.

Tips: "We're looking for kids in all types of settings and situations! Family settings are also needed (single parent, two-parent, grandparent, step-parent, foster or adopted parent)."

‡BLIND SPOT PHOTOGRAPHY MAGAZINE, 49 W. 23rd St., New York NY 10010. (212)633-1317. Fax: (212)691-5465. E-mail: photo@blindspot.com. Contact: Editors. Circ. 28,000. Estab. 1993. Semi-annual magazine. Emphasizes fine arts and contemporary photography. Readers are creative designers, curators, collectors, photographers, ad firms, publishers, students and media. Sample copy $14. Photo guidelines free with SASE.

● Although this publication does not pay, the image quality inside is usually superb. It might be worth submitting here just to get the tearsheet from an attractive publication.

Needs: Uses 90 photos/issue; all supplied by freelancers. Needs unpublished photos from galleries and museums. Captions required; include titles, dates of artwork.

Making Contact & Terms: Send unsolicited photos by mail for consideration. Submit portfolio for review. Send SASE with return postage. Send up to 16×20 color and b&w prints; 35mm, $2\frac{1}{4} \times 2\frac{1}{4}$, 4×5, 8×10 transparencies. Limit submission to 25 pieces or fewer. Deadlines: For May issue—late March; for November issue—late September. Does not keep samples on file. SASE. Reports in 3 weeks. No payment available. Acquires one-time and electronic rights. Simultaneous submissions OK.

‡THE BLOOMSBURY REVIEW, Dept. PM, 1762 Emerson St., Denver CO 80218. (303)863-0406. Editor: Tom Auer. Art Director: Chuck McCoy. Circ. 50,000. Published 6 times a year. Emphasizes book reviews, articles and stories of interest to book readers. Sample copy $3.50.

Needs: Uses 2-3 photos/issue; all supplied by freelance photographers. Needs photos of people who are featured in articles. Photos purchased with or without accompanying ms. Model release preferred. Captions preferred.

Making Contact & Terms: Provide brochure, tearsheets and sample print to be kept on file for possible future assignments. SASE. Reports in 1 month. Payment negotiable. Payment by the job varies. Pays on publication. Credit line and one-line bio given. Buys one-time rights.

Tips: "Send good photocopies of work to Art Director."

BLUE RIDGE COUNTRY, P.O. Box 21535, Roanoke VA 24018. (540)989-6138. Art Director: Tim Brown. Circ. 70,000. Estab. 1988. Bimonthly magazine. Emphasizes outdoor scenics of Blue Ridge Mountain region. Readers are upscale couples, ages 30-70. Sample copy free with 9×12 SAE and 7 first-class stamps. Photo guidelines free with SASE.

Needs: Uses up to 20 photos/issue; all supplied by freelance photographers; 10% assignment and 90% freelance stock. Needs photos of travel, scenics and wildlife. Seeking more scenics with people in them. Future photo needs include themes of the Blue Ridge region. Model release preferred. Captions required.

Making Contact & Terms: Query with list of stock photo subjects. Send unsolicited photos by mail for consideration. Uses 35mm, $2\frac{1}{4} \times 2\frac{1}{4}$, 4×5 transparencies. Also accepts digital images on Kodak CD. SASE. Reports in 2 months. Pays $100/color cover photo; $25-50/color photo. Pays on publication. Credit line given. Buys one-time rights.

Tips: In photographer's samples looks for "photos of Blue Ridge region, color saturated, focus required and photo abilities. Freelancer should present him/herself neatly and organized."

THE B'NAI B'RITH INTERNATIONAL JEWISH MONTHLY, 1640 Rhode Island Ave. NW, Washington DC 20036. (202)857-6645. Fax: (202)296-1092. E-mail: ijm@bnaibrith.org. Website: http://bnaibrit h.org/ijm. Editor: Glenn Garelik. Circ. 200,000. Estab. 1886. Bimonthly magazine. Specializes in social, political, historical, religious, cultural and service articles relating chiefly to the Jewish Community of the US and abroad.

Needs: Buys 200 photos/year, stock and on assignment. Occasionally publishes photo essays.

Making Contact & Terms: Present samples and text (if available). SASE. Reports in 6 weeks. Pays up to $500/color cover; $300/color full-page; $100/b&w page. Pays on publicaiton. Buys first serial rights.
Tips: "Be familiar with our format and offer suggestions or experience relevant to our needs." Looks for "technical expertise, ability to tell a story within the frame."

BODY, MIND, SPIRIT MAGAZINE, P.O. Box 701, Providence RI 02901. (401)351-4320. Fax: (401)272-5767. Publisher: Jim Valliere. Associate Publisher: Jane Kuhn. Circ. 150,000. Estab. 1982. Bi-monthly. Focuses on spirituality, meditation, alternative healing, and the body/mind connection. Targeted to all who are interested in personal transformation and growth. Sample copy free with 9×12 SAE.
Needs: Uses 10-15 photos/issue. Photographs for different areas of magazine which include; natural foods, holistic beauty and skin care, alternative healing, herbs, meditation, spirituality, and the media section which includes; reviews of books, audio tapes, videos and music. "Photos should show creativity, depth of feeling, positive energy, imagination and a light heart." Model release required. Captions required.
Making Contact & Terms: Interested in receiving work from newer, lesser-known photographers. Query with samples/portfolio. Provide résumé, business card, brochure, price requirements if available, flier or tearsheets to be kept on file for possible future assignments. SASE. Reports in 3 months. Pays up to $150/b&w photo and up to $400/color photo. Pays on publication. Credit line given. Buys one-time rights. Previously published work OK.

BODYBOARDING MAGAZINE, 950 Calle Amanecer, Suite C, San Clemente CA 92673. (714)492-7873. Fax: (714)498-6485. E-mail: surfing@netcom.com. Photo Editor: Scott Winer. Bimonthly magazine. Emphasizes hardcore bodyboarding action and bodyboarding beach lifestyle photos and personalities. Readers are 15-24 years old, mostly males (96%). Circ. 40,000. Photo guidelines free with SASE.
Needs: Uses roughly 70 photos/issue; 50-70% supplied by freelancers. Needs photos of hardcore body-boarding action, surf lineups, beach scenics, lifestyles and bodyboarding personalities. Special needs include bodyboarding around the world; foreign bodyboarders in home waves, local beach scenics.
Making Contact & Terms: Send unsolicited photos by mail for consideration. Uses 35mm and 2¼×2¼ transparencies; b&w contact sheets & negatives. SASE. Reports in 2 weeks. Pays $20-110/b&w photo; $20-575/color photo; $575/color cover photo; $40/b&w page rate; $110/color page rate. Pays on publication. Credit line given. Buys one-time rights.
Tips: "We look for clear, sharp, high-action bodyboarding photos preferably on Fuji Velvia 50. We like to see a balance of land and water shots. Be able to shoot in not so perfect conditions. Be persistent and set high standards."

BOSTONIA MAGAZINE, 10 Lenox St., Brookline MA 02146. (617)353-9711. Editor: Jerrold Hickey. Art Director: Doug Parker. Circ. 150,000. Estab. 1900. Quarterly. Sample copy $3.50.
Needs: Uses 100 photos/issue. "Most photos are supplied by University Photo Services. We use freelance photographers on occasion." Works with freelance photographers on assignment only. Needs include documentary photos and international travel photos; photo essay/photo features and human interest; and possibly art photos presented in long portfolio sections. Also seeks feature articles on people and the New England area accompanied by photos. Model releases required. Captions required.
Making Contact & Terms: Provide résumé, brochure and samples to be kept on file for possible future assignments. Call for appointment or send photos by mail for consideration; send actual 5×7 b&w glossies for inside. SASE. Reports in 2 weeks. Pays $50-400 for b&w photo; $300-600/color photo; 10¢/word or flat fee (depending on amount of preparation) for feature articles. **Pays on acceptance.** Credit line given. Buys all rights. No simultaneous submissions or previously published work.

BOWHUNTER, 6405 Flank Dr., P.O. Box 8200, Harrisburg PA 17105. (717)657-9555. Editor: M.R. James. Editorial Director: Richard Cochran. Art Director: Joelle Potts. Circ. 200,000. Estab. 1971. Published 9 times/year. Emphasizes bow and arrow hunting. Sample copy $2. Writer's guidelines free with SASE.
Needs: Buys 50-75 photos/year. Scenic (showing bowhunting) and wildlife (big and small game of North America). No cute animal shots or poses. "We want informative, entertaining bowhunting adventure, how-to and where-to-go articles." Photos purchased with or without accompanying ms.
Making Contact & Terms: Send material by mail for consideration. Query with samples. SASE. Reports on queries in 2 weeks; on material in 6 weeks. Uses 5×7 or 8×10 glossy b&w and color prints, both vertical and horizontal format; 35mm and 2¼×2¼ transparencies, vertical format; vertical format preferred for cover. Pays $50-125/b&w photo; $75-250/color photo; $300/cover photo, occasionally "more if photo warrants it." **Pays on acceptance.** Credit line given. Buys one-time publication rights.
Tips: "Know bowhunting and/or wildlife and study several copies of our magazine before submitting any material. We're looking for better quality and we're using more color on inside pages. Most purchased photos are of big game animals. Hunting scenes are second. In b&w we look for sharp, realistic light, good

contrast. Color must be sharp; early, late light is best. We avoid anything that looks staged; we want natural settings, quality animals. Send only your best, and if at all possible let us hold those we indicate interest in. Very little is taken on assignment; most comes from our files or is part of the manuscript package. If your work is in our files it will probably be used."

BOWLING MAGAZINE, 5301 S. 76th St., Greendale WI 53129. (414)423-3232. Fax: (414)421-7977. Editor: Bill Vint. Circ. 150,000. Estab. 1934. Publication of the American Bowling Congress. Bimonthly magazine. Emphasizes ten-pin bowling. Readers are males, ages 30-55, in a cross section of occupations. Sample copy free with 9×12 SAE and 5 first-class stamps. Photo guidelines free with SASE.
Needs: Uses 30-40 photos/issue; 5-10 supplied by freelancers. Needs photos of outstanding bowlers or human interest features. Model release preferred. Captions required.
Making Contact & Terms: Interested in receiving work from newer, lesser-known photographers. Provide résumé, business card, brochure, flier or tearsheets to be kept on file for possible assignments. Deadline discussed on case basis. SASE. Reports in 1-2 weeks. Pays $25-50/hour; $100-150/day; $50-150/job; $50-150/color cover photo; $25-50/color inside photo; $20-30/b&w inside photo; $150-300/photo/text package. **Pays on acceptance.** Credit line given. Buys all rights.

BOY'S LIFE, Boy Scouts of America Magazine Division, 1325 W. Walnut Hill Lane, Irving TX 75038. (972)580-2358. Fax: (972)580-2079. Director of Photography: Stephen Seeger. Circ. 1.3 million. Estab. 1910. Monthly magazine. General interest youth publication. Readers are primarily boys, ages 8-18. Photo guidelines free with SASE.
• Boy Scouts of America Magazine Division also publishes *Scouting* and *Exploring* magazines.
Needs: Uses 50-80 photos/issue; 99% supplied by freelancers. Needs photos of all categories. Captions required.
Making Contact & Terms: "We're interested in all photographers, but please do not send work." Arrange personal interview to show portfolio. Does not keep samples on file. Cannot return material. Reports in 3 weeks. Pays $400 base editorial day rate against placement fees. Pays extra for electronic usage of images. Pays on acceptance or publication. Buys one-time rights. Previously published work OK.
Tips: "A portfolio shows me 20% of a person's ability. We use new people regularly. Show an ability to work quickly with people in tough situations. Learn and read our publications before submitting anything."

‡BRAZZIL, P.O. Box 42536, Los Angeles CA 90050. (213)255-8062. Fax: (213)257-3487. E-mail: brazzil@brazzil.com. Website: http://www.brazzil.com. Editor: Rodney Mello. Circ. 12,000. Estab. 1989. Monthly magazine. Emphasizes Brazilian culture. Readers are male and female, ages 18-80, interested in Brazil. Photo guidelines free; "no SASE needed."
Needs: Uses 20 photos/issue; 12 supplied by freelancers. Needs photos of Brazilian scenes, people shots. Special photo needs include close up faces for cover. Model/property release preferred. Captions preferred; include subject identification.
Making Contact & Terms: Interested in receiving work from newer, lesser-known photographers. Contact by phone. Send 8×10 glossy b&w prints. Accepts images in digital format for Windows (TIFF). Send via online, floppy disk, zip disk. Deadlines: the 10th of each month. Keeps samples on file. SASE. Reports in 1-2 weeks. Payment negotiable. Pays on publication. Credit line given. Buys one-time rights. Simultaneous submissions and/or previously published work OK.

♣BRIARPATCH, 2138 McIntyre St., Regina, Saskatchewan S4P 2R7 Canada. (306)525-2949. Fax: (306)565-3430. Managing Editor: George Manz. Circ. 2,000. Estab. 1973. Magazine published 10 times per year. Emphasizes Canadian and international politics, labor, environment, women, peace. Readers are left-wing political activists. Sample copy $3.
Needs: Uses 15-30 photos/issue; 15-30 supplied by freelancers. Needs photos of Canadian and international politics, labor, environment, women, peace and personalities. Model/property release preferred. Captions preferred; include name of person(s) in photo, etc.
Making Contact & Terms: Interested in receiving work from newer, lesser-known photographers. Query with stock photo list. Send unsolicited photos by mail for consideration. Do not send slides! Provide résumé, business card, brochure, flier or tearsheets to be kept on file for possible assignments. Send (minimum 3×5) color and b&w prints. Keeps samples on file. SASE. Reports in 1 month. "We cannot pay photographers for their work since we do not pay any of our contributors (writers, photo, illustrators). We rely on volunteer submissions. When we publish photos, etc., we send photographer 5 free copies of magazine." Credit line given. Buys one-time rights. Simultaneous submissions and previously published work OK.
Tips: "We keep photos on file and send free magazines when they are published."

BRIDE'S, (formerly *Bride's & Your New Home*), 140 E. 45th St., New York NY 10017. (212)880-8530. Fax: (212)880-8331. Art Director: Phyllis Richmond Cox. Produced by Conde Nast Publications. Bimonthly magazine. Emphasizes bridal fashions, home furnishings, travel. Readers are mostly female, newly engaged; ages 21-35.
Needs: Needs photos of home furnishings, tabletop, lifestyle, fashion, travel. Model release required.
Making Contact & Terms: Interested in receiving work from newer, lesser-known photographers. Submit portfolio for review. Provide résumé, business card, brochure, flier or tearsheets to be kept on file for possible assignments. Keeps samples on file. SASE. Reports in 3 weeks. Payment negotiable. Pays after job is complete. Credit line given. Buys one-time rights, all rights; negotiable.

BRIGADE LEADER, P.O. Box 150, Wheaton IL 60189. (708)665-0630. Fax: (708)665-0372. Managing Editor: Deborah Christensen. Art Director: Robert Fine. Circ. 9,000. Estab. 1959. Quarterly 2-color magazine for Christian men. Seeks "to make men aware of their leadership responsibilities toward boys in their families, churches and communities." Sample copy $1.50 with 9×12 SAE and 4 first-class stamps. Photo guidelines free with SASE.
Needs: Buys 2-7 photos/issue; 50% freelance photography/issue comes from assignment and 50% from freelance stock. Needs photos of men at work, camping with their sons, with boys in sports, recreation and hobbies.
Making Contact & Terms: Interested in receiving work from newer, lesser-known photographers. Send 8×10 photos or photocopies for consideration. Reports in 6 weeks. Pays $50-100/inside b&w photo; $75-100/b&w cover photo. Pays on publication. Buys one-time rights. Simultaneous submissions and previously published work OK.
Tips: "Study the magazine before submitting. Submit sharp photos with good contrast; 8×10 prints preferred."

BRITISH CAR, Dept. PM, P.O. Box 1683, Los Altos CA 94023-1683. (415)949-9680. Fax: (415)949-9685. Editor: Gary G. Anderson. Circ. 30,000. Estab. 1985. Bimonthly magazine. Publication for owners and enthusiasts of British motor cars. Readers are US citizens, male, 40 years old and owners of multiple cars. Sample copy $5. Photo guidelines free for SASE.
Needs: Uses 100 photos/issue; 50-75% (75% are b&w) supplied by freelancers. "Photos with accompanied manuscripts required. However, sharp uncluttered photos of different British marques may be submitted for file photos to be drawn on as needed." Photo captions required that include description of vehicles, owner's name and phone number, interesting facts, etc.
Making Contact & Terms: Send unsolicited photos by mail for consideration. Send 5×7 and larger b&w prints. Does not keep samples on file unless there is a good chance of publication. SASE. "Publisher takes all reasonable precautions with materials, however cannot be held liable for damaged or lost photos." Reports in 6-8 weeks. Pays $25-100/color inside photo; $10-35/b&w inside photo. Payment negotiable, however standard rates will be paid unless otherwise agreed in writing prior to publication." Pays on publication. Buys world rights; negotiable.
Tips: "Find a journalist to work in cooperation with."

BUGLE MAGAZINE, P.O. Box 8249, Missoula MT 59807-8249. (406)523-4573. Fax: (406)523-4550. Photo Coordinator: Mia McGreevey. Circ. 200,000. Estab. 1984. Publication of the Rocky Mountain Elk Foundation. Quarterly magazine. Nonprofit organization that specializes in elk, elk habitat and hunting. Readers are 98% hunters, both male and female; 54% are 35-54; 48% have income over $50,000. Sample copy $5. Photo guidelines free with SASE.
Needs: Uses 50 photos/issue; all supplied by freelancers. "*Bugle* editor sends out quarterly letter requesting specific images for upcoming issue." Model/property release required. Captions preferred; include name of photographer, location of photo, information on what is taking place.
Making Contact & Terms: Interested in receiving work from newer, lesser-known photographers. Send unsolicited photos by mail for consideration. Send 3×5 glossy prints; 35mm, $2\frac{1}{4} \times 2\frac{1}{4}$, 4×5 transparencies. Deadlines: February 8 for summer issue; May 3 for fall issue; August 2 for winter issue; November 1 for spring issue. Does not keep samples on file. SASE. Reports in 1-2 weeks. Pays $250/cover photo; $150/spread; $100/full-page; $50/half page. Pays on publication. Credit line given. Rights negotiable. Previously published work OK.

THE DIGITAL MARKETS INDEX, located in the back of this book, lists markets that use images electronically.

Tips: "We look for high quality, unusual, dramatic and stimulating images of elk and other wildlife. Photos of elk habitat and elk in unique habitat catch our attention, as well as those depicting specific elk behavior. We are also interested in habitat project photos involving trick tanks, elk capture and release, etc. And images showing the effects of human development on elk habitat. Outdoor recreation photos are also welcome. Besides *Bugle* we also use images for billboards, brochures and displays. We work with both amateur and professional photographers, with the bulk of our editorial material donated."

BUSINESS IN BROWARD, 1301 S. Andrews Ave., Ft. Lauderdale FL 33316. (954)763-3338. Publisher: Sherry Friedlander. Circ. 25,000. Estab. 1986. Magazine published 8 times/year. Emphasizes business. Readers are male and female executives, ages 30-65. Sample copy $4.
Needs: Uses 30-40 photos/issue; 75% supplied by freelancers. Needs photos of local sports, local people, ports, activities and festivals. Model/property release required. Photo captions required.
Making Contact & Terms: Contact through rep. Submit portfolio for review. Reports in 2 weeks. Pays $150/color cover photo; $75/color inside photo. Pays on publication. Buys one-time rights; negotiable. Previously published work OK.
Tips: "Know the area we service."

CAGED BIRD HOBBYIST, 7-L Dundas Circle, Greensboro NC 27407-1645. (910)292-4047. Fax: (910)292-4272. Executive Editor: Rita Davis. Managing Editor: Karen McCullough. Bimonthly magazine. Emphasizes primarily pet birds, plus some feature coverage of birds in nature. Sample copy $5 and 9 × 12 SASE. Photo guidelines free with SASE.
Needs: Needs photos of pet birds. Special needs arise with story schedule. Write for photo needs list. Common pet birds are always in demand (cockatiels, parakeets, etc.) Captions required; include common and scientific name of bird; additional description as needed.
Making Contact & Terms: Interested in receiving work from newer, lesser-known photographers. Send unsolicited photos by mail for consideration. Query with stock photo list. "We cannot assume liability for originals." Photographers may wish to send duplicates. Send 4 × 6, 8 × 10 glossy color prints; 35mm, 2¼ × 2¼ transparencies. Deadlines: 3 months prior to issue of publication. Keeps samples on file. SASE. Reports in 2 months. Pays $150-250/color cover photo; $25-50/color inside photo. Pays on publication. Buys all rights; negotiable.
Tips: "We are looking for pet birds primarily; although we do feature some wildlife/nature/conservation bird articles. We look for good composition (indoor or outdoor). Photos must be professional and of publication quality—in focus and with proper contrast. We work regularly with a few excellent freelancers, but are always on the lookout for new contributors. Because we are a bimonthly, we do need to retain submissions on file for at least a few months."

‡CALIFORNIA NURSE, 1145 Market St., Suite 1100, San Francisco CA 94103-1545. Fax: (415)431-1011. Editor: Carl Bloice. Circ. 28,000. Estab. 1904. Publication of California Nurses Association. Monthly tabloid. Emphasizes nursing. Readers are adults, male and female nurses. Sample copy free with SASE.
Needs: Uses 15-20 photos/issue; 10% supplied by freelancers. Needs photos of nurses, medical technology and populations served by health professionals, (e.g. elderly, infants, uninsured). Model release and photo descriptions required.
Making Contact & Terms: Interested in receiving work from newer, lesser-known photographers. Send unsolicited 4 × 5 or 5 × 7 glossy b&w prints by mail for consideration. Provide résumé, business card, brochure, flier or tearsheets to be kept on file for possible assignments. Phone calls acceptable. SASE. Reports in 3 weeks. Pays $25-50/b&w cover photo; $20/b&w inside photo. Pays on publication. Buys one-time rights. Simultaneous submissions OK.
Tips: "Best choices are sensitive shots of people needing or receiving health care or RNs at work. Send sample photos, well-tailored to individual publication."

CALLIOPE, World History for Young People, Cobblestone Publishing, Inc., 7 School St., Peterborough NH 03458. (603)924-7209. Fax: (603)924-7380. Managing Editor: Denise L. Babcock. Circ. 10,500. Estab. 1990. Magazine published 9 times/year, September-May. Emphasis on non-United States history. Readers are children, ages 8-14. Sample copies $4.50 with 9 × 12 or larger SAE and 5 first-class stamps. Photo guidelines free with SASE.
Needs: Uses 40-45 photos/issue; 15% supplied by freelancers. Needs contemporary shots of historical locations, buildings, artifacts, historical reenactments and costumes. Reviews photos with or without accompanying ms. Model/property release preferred. Captions preferred.
Making Contact & Terms: Query with stock photo list. Send unsolicited photos by mail for consideration. Provide résumé, business card, brochure, flier or tearsheets to be kept on file for possible future assignments. Send b&w or color prints; 35mm transparencies. Samples kept on file. SASE. Reports in 1 month. Pays $15-100/inside; cover (color) photo negotiated. Pays on publication. Credit line given. Buys

one-time rights; negotiable. Simultaneous submissions and/or previously published work OK.

Tips: "Given our young audience, we like to have pictures which include people, both young and old. Pictures must be dynamic to make history appealing. Submissions must relate to themes in each issue."

CALYPSO LOG, 777 United Nations Plaza, New York NY 10017. (212)949-6290. Fax: (212)949-6296. American Section Editor: Lisa Rao. Circ. 200,000. Publication of The Cousteau Society. Bimonthly. Emphasizes expedition activities of The Cousteau Society; educational/science articles; environmental activities. Readers are members of The Cousteau Society. Sample copy $2 with 9 × 12 SAE and $1 postage. Photo guidelines free with SASE.

Needs: Uses 10-14 photos/issue; 1-2 supplied by freelancers; 2-3 photos/issue from freelance stock.

Making Contact & Terms: Query with samples and list of stock photo subjects. Uses color prints; 35mm and 2¼ × 2¼ transparencies (duplicates only). SASE. Reports in 5 weeks. Pays $50-200/color photo. Pays on publication. Buys one-time rights and "translation rights for our French publication." Previously published work OK.

Tips: Looks for sharp, clear, good composition and color; unusual animals or views of environmental features. Prefers transparencies over prints. "We look for ecological stories, food chain, prey-predator interaction and impact of people on environment. Please request a copy of our publication to familiarize yourself with our style, content and tone and then send samples that best represent underwater and environmental photography."

CAMPUS LIFE, 465 Gundersen Dr., Carol Stream IL 60188. Editor: Harold Smith. Art Director: Doug Johnson. Circ. 100,000. Estab. 1943. Bimonthly magazine. "*Campus Life* is a magazine for high school and college-age youth. We emphasize balanced living—emotionally, spiritually, physically and mentally." Sample copy $2. Photo guidelines free with SASE.

Needs: Buys 15 photos/issue; 10 supplied by freelancers, most are assigned. Head shots (of teenagers in a variety of moods); humorous, sport and candid shots of teenagers/college students in a variety of settings. "We look for diverse racial teenagers in lifestyle situations, and in many moods and expressions, at work, play, home and school. No travel, how-to, still life, travel scenics, news or product shots. Shoot for a target audience of 17-year-olds." Photos purchased with or without accompanying ms. Special needs include "Afro-American males/females in positive shots." Model/property release preferred for controversial stories. Captions preferred.

Making Contact & Terms: Interested in reviewing work from newer, lesser-known photographers. Submit portfolio for review. Query with résumé of credits. Provide brochure, tearsheets, résumé, business card or flier to be kept on file for possible assignments. Uses 6 × 9 glossy b&w prints and 35mm or larger transparencies. Keeps samples on file. SASE. Reports in 2 months. Pays $100-150/b&w photo; $100-300/color photo. Pays on publication. Credit line given. Buys one-time rights; negotiable. Simultaneous submissions and previously published work OK if marked as such.

Tips: "Look at a few issues to get a feel for what we choose. Ask for copies of past issues of *Campus Life*. Show work that fits our editorial approach. We choose photos that express the contemporary teen experience. We look for unusual lighting and color. Our guiding philosophy: that readers will 'see themselves' in the pages of our magazine." Looks for "ability to catch teenagers in real-life situations that are well-composed but not posed. We want technical quality in photos that communicate an overall mood or emotion or action."

✤**CANADA LUTHERAN**, 1512 St. James St., Winnipeg, Manitoba R3H 0L2 Canada. (204)786-6707. Fax: (204)783-7548. Art Director: Darrell Dyck. Editor: Kenn Ward. Circ. 22,000. Estab. 1986. Publication of Evangelical Lutheran Church in Canada. Monthly. Emphasizes faith/religious content; Lutheran denomination. Readers are members of the Evangelical Lutheran Church in Canada. Sample copy for $1.50 with 9 × 12 SAE and $1 postage (Canadian).

Needs: Uses 4-10 photos/issue; most supplied though article contributors; 1 or 2 supplied by freelancers. Needs photos of people (in worship/work/play etc.).

Making Contact & Terms: Interested in receiving work from newer, lesser-known photographers. Send 5 × 7 glossy prints or 35mm transparencies by mail for consideration. Also accepts digital files on CD-ROM or floppy ("call for particulars"). SASE. Pays $15-50/b&w photo; $40-75/color photo. Pays on publication. Credit line given. Buys one-time rights.

Tips: "Trend toward more men and women in non-stereotypical roles. Do not restrict photo submissions to just the categories you believe we need. Sometimes a surprise shot works perfectly for a subject. Give us many photos that show your range. We prefer to keep them on file for at least a year. We have a short-term turnaround and turn to our file on a monthly basis to illustrate articles or cover concepts. Changing technology speeds up the turnaround time considerably when assessing images, yet forces publishers to think farther in advance to be able to achieve promised cost savings."

‡❦**CANADIAN RODEO NEWS**, 2116 27th Ave. NE, #223, Calgary, Alberta T2E 7A6 Canada. (403)250-7292. Fax: (403)250-6926. E-mail: rodeones@iul-ccs.com. Editor: P. Kirby Meston. Circ. 4,000. Estab. 1964. Monthly tabloid. Emphasizes professional rodeo in Canada. Readers are male and female rodeo contestants and fans—all ages. Sample copy and photo guidelines free with SASE (9×12).
Needs: Uses 20-25 photos/issue; 3 supplied by freelancers. Needs photos of professional rodeo action or profiles. Captions preferred; include identity of contestant/subject.
Making Contact & Terms: Interested in receiving work from newer, lesser-known photographers. Send unsolicited photos by mail for consideration. Phone to confirm if usable. Send any color/b&w print. Keeps samples on file. SASE. Reports in 1 month. Pays $15/color cover photo; pays $10/color inside photo; pays $10/b&w inside photo; pays $60-70/photo/text package. Pays on publication. Credit line given. Rights negotiable. Simultaneous submissions and/or previously published work OK.
Tips: "Photos must be from or pertain to professional rodeo in Canada. Phone to confirm if subject/material is suitable before submitting. *CRN* is very specific in subject."

❦**CANADIAN YACHTING**, 395 Matheson Blvd. E., Mississauga, Ontario L4Z 2H2 Canada. (905)890-1846. Fax: (905)890-5769. Editor: Heather Ormerod. Circ. 15,800. Estab. 1976. Bimonthly magazine. Emphasizes sailing (no powerboats). Readers are mostly male, highly educated, high income, well read. Sample copy free with 9×12 SASE.
Needs: Uses 28 photos/issue; all supplied by freelancers. Needs photos of all sailing/sailing related (keelboats, dinghies, racing, cruising, etc.). Model/property release preferred. Captions preferred.
Making Contact & Terms: Interested in receiving work from newer, lesser-known photographers. Submit portfolio for review. Query with stock photo list. Send unsolicited photos by mail for consideration. Send transparencies. SASE. Reports in 1 month. Pays $150-250/color cover photo; $30-70/color inside photo; $30-70/b&w inside photo. Pays 60 days after publication. Buys one-time rights. Simultaneous submissions and previously published work OK.

CANOE & KAYAK, Dept. PM, P.O. Box 3146, Kirkland WA 98083. (206)827-6363. Fax: (206)827-1893. Art Director: Catherine Black. Circ. 63,000. Estab. 1973. Bimonthly magazine. Emphasizes a variety of paddle sports, as well as how-to material and articles about equipment. For upscale canoe and kayak enthusiasts at all levels of ability. Also publishes special projects/posters. Free sample copy with 9×12 SASE.
Needs: Uses 30 photos/issue: 90% supplied by freelancers. Canoeing, kayaking, ocean touring, canoe sailing, fishing when compatible to the main activity, canoe camping but not rafting. No photos showing disregard for the environment, be it river or land; no photos showing gasoline-powered, multi hp engines; no photos showing unskilled persons taking extraordinary risks to life, etc. Accompanying mss for "editorial coverage striving for balanced representation of all interests in today's paddling activity. Those interests include paddling adventures (both close to home and far away), camping, fishing, flatwater, whitewater, ocean kayaking, poling, sailing, outdoor photography, how-to projects, instruction and historical perspective. Regular columns feature paddling techniques, conservation topics, safety, interviews, equipment reviews, book/movie reviews, new products and letters from readers." Photos only occasionally purchased without accompanying ms. Model release preferred "when potential for litigation." Property release required. Captions are preferred, unless impractical.
Making Contact & Terms Interested in reviewing work from newer, lesser-known photographers. Query or send material. "Let me know those areas in which you have particularly strong expertise and/or photofile material. Send best samples only and make sure they relate to the magazine's emphasis and/or focus. (If you don't know what that is, pick up a recent issue first, before sending me unusable material.) We will review dupes for consideration only. Originals required for publication. Also, if you have something in the works or extraordinary photo subject matter of interest to our audience, let me know! It would be helpful to me if those with substantial reserves would supply indexes by subject matter." Uses 5×7 and 8×10 glossy b&w prints; 35mm, $2\frac{1}{4} \times 2\frac{1}{4}$ and 4×5 transparencies; color transparencies for cover; vertical format preferred. SASE. Reports in 1 month. Pays $300/cover color photo; $150/half to full page color photos; $100/full page or larger b&w photos; $75/quarter to half page color photos; $50/quarter or less color photos; $75/half to full page b&w photos; $50/quarter to half page b&w photos; $25/less than quarter b&w photos. Pays on publication. Credit line given. Buys one-time rights, first serial rights and exclusive rights. Simultaneous submissions and previously published work OK, in noncompeting publications.
Tips: "We have a highly specialized subject and readers don't want just any photo of the activity. We're particularly interested in photos showing paddlers' *faces*; the faces of people having a good time. We're after anything that highlights the paddling activity as a lifestyle and the urge to be outdoors." All photos should be "as natural as possible with authentic subjects. We receive a lot of submissions from photographers to whom canoeing and kayaking are quite novel activities. These photos are often clichéd and uninteresting. So consider the quality of your work carefully before submission if you are not familiar with the sport. We are always in search of fresh ways of looking at our sport."

CAPE COD LIFE INCLUDING MARTHA'S VINEYARD AND NANTUCKET, P.O. Box 1385, Pocasset MA 02559-1385. Phone/fax: (508)564-4466. E-mail: capecod@capecodlife.com. Website: http://www.capecodlife.com. Publisher: Brian F. Shortsleeve. Circ. 35,000. Estab. 1979. Bimonthly magazine. Emphasizes Cape Cod lifestyle. "Readers are 55% female, 45% male, upper income, second home, vacation homeowners." Sample copy for $3.75. Photo guidelines free with SASE.

Needs: Uses 30 photos/issue; all supplied by freelancers. Needs "photos of Cape and Island scenes, people, places; general interest of this area." Reviews photos with or without a ms. Model release required. Property release preferred. Photo captions required; include location. Reviews photos with or without a ms.

Making Contact & Terms: Interested in receiving work from newer, lesser-known photographers. Submit portfolio for review. Send unsolicited photos by mail for consideration. Send 35mm, 2¼×2¼, 4×5 transparencies. Keeps samples on file. SASE. Pays $225/color cover photo; $25-225/b&w/color photo, depending on size. Pays 30 days after publication. Credit line given. Buys one-time rights; reprint rights for *Cape Cod Life* reprints; negotiable. Simultaneous submissions and previously published work OK.

Tips: Looks for "clear, somewhat graphic slides. Show us scenes we've seen hundreds of times with a different twist and elements of surprise."

THE CAPE ROCK, Southeast Missouri State University, Cape Girardeau MO 63701. (314)651-2156. Editor-in-Chief: Harvey Hecht. Circ. 1,000. Estab. 1964. Emphasizes poetry and poets for libraries and interested persons. Semiannual. Free photo guidelines.

Needs: Uses about 13 photos/issue; all supplied by freelance photographers. "We like to feature a single photographer each issue. Submit 25-30 thematically organized b&w glossies (at least 5×7), or send 5 pictures with plan for complete issue. We favor a series that conveys a sense of place. Seasons are a consideration too: we have spring and fall issues. Photos must have a sense of place: e.g., an issue featuring Chicago might show buildings or other landmarks, people of the city (no nudes), travel or scenic. No how-to or products. Sample issues and guidelines provide all information a photographer needs to decide whether to submit to us." Model release not required "but photographer is liable." Captions not required "but photographer should indicate where series was shot."

Making Contact & Terms: Send actual b&w photos by mail for consideration. Query with list of stock photo subjects. Submit portfolio by mail for review. SASE. Reporting time varies. Pays $100 and 10 copies on publication. Credit line given. Buys "all rights, but will release rights to photographer on request." Returns unused photos.

Tips: "We don't make assignments, but we look for a unified package put together by the photographer. We may request additional or alternative photos when accepting a package."

CAR & TRAVEL, 1000 AAA Dr., Heathrow, FL 32746-5063. (407)444-8544. Fax: (407)444-8500. Editor and Publisher: Doug Damerst. Art Director: Emilie Whitcomb. Circ. 4.7million. Estab. 1995. Member publication of AAA (ABC member). Bimonthly magazine (except monthly in Metro New York and quarterly in Alabama) emphasizing how to drive, car care, how to travel and travel destinations. Readers are above average income and age. Sample copy free.

Needs: Uses 60 photos/issue; 20 supplied by freelancers. Needs photos of people enjoying domestic and international vacation settings. Model release required. Captions preferred.

Making Contact & Terms: Provide résumé, business card, brochure, flier or tearsheets to be kept on file for possible future assignments. Do not send any unsolicited photos. Will only accept queries. Cannot return material. Payment varies according to size and circulation. **Pays on acceptance.** Credit line given. Buys one-time rights.

Tips: "Our need is for travel photos, but not of places as much as of Americans enjoying travel."

CAR CRAFT MAGAZINE, 6420 Wilshire Blvd., Los Angeles CA 90048. (213)782-2320. Fax: (213)782-2263. Editor: Charles Schifsky. Circ. 500,000. Estab. 1953. Monthly magazine. Emphasizes street machines, muscle cars and modern, high-tech performance cars. Readership is mostly males, ages 18-34.

Needs: Uses 100 photos/issue. Uses freelancers occasionally; all on assignment. Model/property release required. Captions preferred.

Making Contact & Terms: Interested in receiving work from newer, lesser-known photographers. Query with résumé of credits. Provide résumé, business card, brochure, flier or tearsheets to be kept on file for possible assignments. Send 35mm and 8×10 b&w prints; 35mm and 2¼×2¼ transparencies by mail for consideration. SASE. Reports in 1 month. Pays $35-75/b&w photo; $75-250/color photo, cover or text; $60 minimum/hour; $250 minimum/day; $500 minimum/job. Payment for b&w varies according to subject and needs. Pays on publication. Credit line given. Buys all rights.

Tips: "We use primarily b&w shots. When we need something special in color or see an interesting color shot, we'll pay more for that. Review a current issue for our style and taste."

CAREER FOCUS, 1300 Broadway, Suite 660, Kansas City MO 64111-2412. (816)960-1988. Fax: (816)960-1989. Circ. 250,000. Estab. 1988. Bimonthly magazine. Emphasizes career development. Readers are male and female African-American and Hispanic professionals, ages 21-45. Sample copy free with 9×12 SAE and 4 first-class stamps. Photo guidelines free with SASE.
Needs: Uses approximately 40 photos/issue. Needs technology photos and shots of personalities; career people in computer, science, teaching, finance, engineering, law, law enforcement, government, hi-tech, leisure. Model release preferred. Captions required; include name, date, place, why.
Making Contact & Terms: Query with résumé of credits and list of stock photo subjects. Keeps samples on file. SASE. Reports in 1 month. Pays $10-50/color photo; $5-25/b&w photo. Pays on publication. Credit line given. Buys one-time rights. Simultaneous submissions and previously published work OK.
Tips: "Freelancer must be familiar with our magazine to be able to submit appropriate manuscripts and photos."

CAREERS & COLLEGES MAGAZINE, 989 Avenue of Americas, New York NY 10018. (212)563-4688. Fax: (212)967-2531. E-mail: ccmagazine@aol.com. Art Director: Michael Hofmann. Circ. 500,000. Estab. 1980. Biannual magazine. Emphasizes college and career choices for teens. Readers are high school juniors and seniors, male and female, ages 16-19. Sample copy $2.50 with 9×12 SAE and 5 first-class stamps.
Needs: Uses 4 photos/issue; 80% supplied by freelancers. Needs photos of teen situations, study or career related, some profiles. Model release preferred. Property release required. Captions preferred.
Making Contact & Terms: Interested in receiving work from newer, lesser-known photographers. Send tearsheets and promo cards. Submit portfolio for review; please call for appointment—drop off Monday-Wednesday in morning; can be picked up later in the afternoon. Keeps samples on file. SASE. Reports in 3 weeks. Pays $800-1,000/color cover photo; $350-450/color inside photo; $600-800/color page rate. **Pays on acceptance**. Credit line given. Buys one-time rights; negotiable.
Tips: "Must work well with teen subjects, hip, fresh style, not too corny. Promo cards or packets work the best, business cards are not needed unless they contain your photography."

CARIBBEAN TRAVEL AND LIFE MAGAZINE, 8403 Colesville Rd., #830, Silver Spring MD 20910. (301)588-2300. Fax: (301)588-2256. Assistant Photo Editor: Robert Moll. Circ. 125,000. Estab. 1985. Published bimonthly. Emphasizes travel, culture and recreation in islands of Caribbean, Bahamas and Bermuda. Readers are male and female frequent Caribbean travelers, age 32-52. Sample copy $4.95. Photo guidelines free with SASE.
Needs: Uses about 100 photos/issue; 90% supplied by freelance photographers: 10% assignment and 90% freelance stock. "We combine scenics with people shots. Where applicable, we show interiors, food shots, resorts, water sports, cultural events, shopping and wildlife/underwater shots. We want images that show intimacy between people and place." Captions preferred. "Provide thorough caption information. Don't submit stock that is mediocre."
Making Contact & Terms: Query with list of stock photo subjects. Uses 4-color photography. SASE. Reports in 3 weeks. Pays $600/color cover photo; $175/color full page; $150/color ¾ page; $125/color ½ page and $100/color ¼ page; $100-600/color photo; $1,200-1,500 per photo/text package. Pays after publication. Buys one-time rights. Does not pay research or holding fees.
Tips: Seeing trend toward "fewer but larger photos with more impact and drama. We are looking for particularly strong images of color and style, beautiful island scenics and people shots—images that are powerful enough to make the reader want to travel to the region; photos that show people doing things in the destinations we cover; originality in approach, composition, subject matter. Good composition, lighting and creative flair. Images that are evocative of a place, creating story mood. Good use of people. Submit stock photography for specific story needs, if good enough can lead to possible assignments. Let us know exactly what coverage you have on a stock list so we can contact you when certain photo needs arise."

CAROLINA QUARTERLY, Greenlaw Hall, CB#3520, University of North Carolina, Chapel Hill NC 27599-3520. (919)962-0244. Fax: (919)962-3520. Editor: John Black. Circ. 1,500. Estab. 1948. Emphasizes "current poetry, short fiction." Readers are "literary, artistic—primarily, though not exclusively, writers and serious readers." Sample copy $5.
Needs: Sometimes uses 1-8 photos/issue; all supplied by freelance photographers from stock. Often photos

 INTERNATIONAL MARKETS, those located outside of the United States and Canada, are marked with an asterisk.

are chosen to accompany the text of the magazine.

Making Contact & Terms: Interested in receiving work from newer, lesser-known photographers. Send b&w prints by mail for consideration. Accepts images in digital format. SASE. Reports in 3 months, depending on deadline. Pays $50/job. Credit line given. Buys one-time rights.

Tips: "Look at a recent issue of the magazine to get a clear idea of its contents and design."

CASINO PLAYER, 3100 W. Sahara Ave., Suite 207, Las Vegas NV 89102. (702)253-6230. Fax: (702)253-6804. E-mail: rgreco@casinocenter.com. Photo Editor: Rick Greco. Circ. 200,000. Estab. 1988. Monthly magazine. Emphasizes casino gambling. Readers are frequent gamblers, age 35 and up. Sample copy free with 9×12 SAE and $2 postage.

Needs: Uses 40-60 photos/issue; 5 supplied by freelancers. Needs photos of casinos, gambling, casino destinations, money, slot machines. Reviews photos with or without ms. Model release required for gamblers. Captions required; include name, hometown, titles.

Making Contact & Terms: Interested in receiving work from newer, lesser-known photographers. Query with résumé of credits. Reports in 3 months. Pays $200/color cover photo; $40/color inside photo; $20/ b&w inside photo. Pays on publication. Credit line given. Buys all rights; negotiable.

Tips: "Know the magazine before submission."

CAT FANCY, Fancy Publications, Inc., P.O. Box 6050, Mission Viejo CA 92690. (714)855-8822. Editor-in-Chief: Jane Calloway. Circ. 303,000. Estab. 1965. Readers are "men and women of all ages interested in all phases of cat ownership." Monthly. Sample copy $5.50. Photo guidelines and needs free with SASE.

Needs: Uses 20-30 photos/issue; all supplied by freelancers. "For purebred photos, we prefer shots that show the various physical and mental attributes of the breed. Include both environmental and portrait-type photographs. We also need good-quality, interesting color photos of mixed-breed cats for use with feature articles and departments." Model release required.

Making Contact & Terms: Send by mail for consideration actual 8×10 b&w photos; 35mm or 2¼×2¼ color transparencies. No duplicates. SASE. Reports in 8-10 weeks. Pays $35-100/b&w photo; $50-250/ color photo; and $50-450 for text/photo package. Credit line given. Buys first North American serial rights.

Tips: "Nothing but sharp, high contrast shots, please. Send SASE for list of specific photo needs. We prefer color photos and action shots to portrait shots. We look for photos of all kinds and numbers of cats doing predictable feline activities—eating, drinking, grooming, being groomed, playing, scratching, taking care of kittens, fighting, being judged at cat shows and accompanied by people of all ages."

CATHOLIC LIBRARY WORLD, 9009 Carter, Allen Park MI 48101. (313)388-7429. Fax: (413)592-4871. E-mail: allencg@aol.com. Editor: Allen Gruenke. Circ. 1,100. Estab. 1929. Publication of the Catholic Library Association. Quarterly magazine. Emphasizes libraries and librarians (community, school, academic librarians, research librarians, archivists). Readers are librarians who belong to the Catholic Library Association; generally employed in Catholic institutions or academic settings. Sample copy $10.

Needs: Uses 2 photos/issue. Needs photos of authors of children's books and librarians who have done something to contribute to the community at large. Special photo needs include photos of annual conference in 1998 in Los Angeles. Model release preferred for photos of authors. Captions preferred.

Making Contact & Terms: Interested in receiving work from newer, lesser-known photographers. Send 5×7 b&w prints. Accepts images in digital format for Windows. Send via compact disc, Zip disk (1200 dpi). Deadlines: January 15, April 15, July 15, September 15. SASE. Reports in 1-2 weeks. Pays with copies and photo credit. Acquires one-time rights. Previously published work OK.

CATHOLIC NEAR EAST MAGAZINE, 1011 First Ave., New York NY 10022-4195. Fax: (212)838-1344. Editor: Michael LaCività. Circ. 100,000. Estab. 1974. Bimonthly magazine. A publication of Catholic Near East Welfare Association, a papal agency for humanitarian and pastoral support. *Catholic Near East* informs Americans about the traditions, faiths, cultures and religious communities of Middle East, Northeast Africa, India and Eastern Europe. Sample copy and guidelines available with SASE.

Needs: 60% supplied by freelancers. Prefers to work with writer/photographer team. Evocative photos of people—not posed—involved in activities; work, play, worship. Also interested in scenic shots and photographs of art objects and the creation of crafts, etc. Liturgical shots also welcomed. Extensive captions required if text is not available.

Making Contact & Terms: Interested in receiving work from newer, lesser-known photographers. Query first. "Please do not send an inventory, rather, send a letter explaining your ideas." SASE. Reports in 3 weeks; acknowledges receipt of material immediately. Credit line given. "Credits appear on page 3 with masthead and table of contents." Pays $50-150/b&w photo; $75-300/color photo; $20 maximum/hour; $100 maximum/assignment. Pays on publication. Buys first North American serial rights. Simultaneous submissions and previously published work OK, "but neither is preferred. If previously published please tell us when and where."

Tips: Stories should weave current lifestyles with issues and needs. Avoid political subjects, stick with ordinary people. Photo essays are welcomed.

CEA ADVISOR, Dept. PM, Connecticut Education Association, 21 Oak St., Hartford CT 06106. (860)525-5641. Fax: (860)725-6356. Managing Editor: Michael Lydick. Circ. 30,000. Monthly tabloid. Emphasizes education. Readers are public school teachers. Sample copy free with 6 first-class stamps.
Needs: Uses about 20 photos/issue; 1 or 2 supplied by freelancers. Needs "classroom scenes, students, school buildings." Model release preferred. Captions preferred.
Making Contact & Terms: Send b&w contact sheet by mail for consideration. Provide résumé, business card, brochure, flier or tearsheets to be kept on file for possible future assignments. Cannot return material. Reports in 1 month. Pays $50/b&w cover photo; $25/b&w inside photo. Pays on publication. Credit line given. Buys all rights. Simultaneous submissions and/or previously published work OK.

CHARISMA MAGAZINE, 600 Rinehart Rd., Lake Mary FL 32746. (407)333-0600. Design Manager: Mark Poulalion. Circ. 200,000. Monthly magazine. Emphasizes Christians. General readership. Sample copy $2.50.
Needs: Uses approximately 20 photos/issue; all supplied by freelance photographers. Needs editorial photos—appropriate for each article. Model release required. Captions preferred.
Making Contact & Terms: Send unsolicited photos by mail for consideration. Provide brochure, flier or tearsheets to be kept on file for possible assignments. Send color 35mm, 2¼×2¼, 4×5 or 8×10 transparencies. Cannot return material. Reports ASAP. Pays $300/color cover photo; $150/b&w inside photo; $50-150/hour or $400-600/day. Pays on publication. Credit line given. Buys all rights; negotiable. Simultaneous submissions and previously published work OK.
Tips: In portfolio or samples, looking for "good color and composition with great technical ability. To break in, specialize; sell the sizzle rather than the steak!"

‡CHARLOTTE MAGAZINE, 120 Greenwich Rd., Charlotte NC 28211. (704)366-5000, ext. 29. Fax: (704)366-6144. Director of Design: Clifton Shaw. Circ. 30,000. Estab. 1995. Monthly magazine. Emphasizes Charlotte, North Carolina. Readers are upper-middle class, ages 30 and up. Sample copy $3.95 with 9×12 SASE and 2 first-class stamps.
Needs: Uses 15-20 photos/issue; 6-10 supplied by freelancers. Subject needs depend on editorial content. Model/property release preferred for young children. Captions preferred; include names.
Making Contact & Terms: Interested in receiving work from newer, lesser-known photographers. Submit portfolio for review. Provide résumé, business card, brochure, flier or tearsheets to be kept on file for possible assignments. Send 35mm transparencies. Keeps samples on file. SASE. Reports in 1-2 weeks. Payment negotiable. Pays on publication. Credit line given. Buys one-time rights.
Tips: "Look at the publication; get a feel for the style and see if it coincides with your photography style."

THE CHESAPEAKE BAY MAGAZINE, 1819 Bay Ridge Ave., Annapolis MD 21403. (410)263-2662, (DC)261-1323. Fax: (410)267-6924. Art Director: Karen Ashley. Circ. 37,000. Estab. 1972. Monthly. Emphasizes boating—Chesapeake Bay only. Readers are "people who use Bay for recreation." Sample copy available.
 ● *Chesapeake Bay* is CD-ROM equipped and does corrections and manipulates photos inhouse.
Needs: Uses "approximately" 45 photos/issue; 60% supplied by freelancers; 40% by freelance assignment. Needs photos that are Chesapeake Bay related (must); vertical powerboat shots are badly needed (color). Special needs include "vertical 4-color slides showing boats and people on Bay."
Making Contact & Terms: Interested in reviewing work from newer, lesser-known photographers. Query with samples or list of stock photo subjects. Send 35mm, 2¼×2¼, 4×5 or 8×10 transparencies by mail for consideration. SASE. Reports in 3 weeks. Pays $300/color cover photo; $25-75/b&w photo; $35-250/color photo; $150-1,000/photo/text package. Pays on publication. Credit line given. Buys one-time rights. Simultaneous submissions OK.
Tips: "We prefer Kodachrome over Ektachrome. Looking for: boating, bay and water-oriented subject matter. Qualities and abilities include: fresh ideas, clarity, exciting angles and true color. We're using larger photos—more double-page spreads. Photos should be able to hold up to that degree of enlargement. When photographing boats on the Bay—keep the 'safety' issue in mind. (People hanging off the boat, drinking, women 'perched' on the bow are a no-no!)"

CHESS LIFE, Dept. PM, 186 Route 9W, New Windsor NY 12553. (914)562-8350. Fax: (914)561-CHES (2437). Editor-in-Chief: Glenn Petersen. Art Director: Jami Anson. Circ. 70,000. Estab. 1939. Publication of the U.S. Chess Federation. Monthly. *Chess Life* covers news of all major national and international tournaments; historical articles, personality profiles, columns of instruction, occasional fiction, humor . . .

for the devoted fan of chess. Sample copy and photo guidelines free with SAE and 3 first-class stamps.
Needs: Uses about 10 photos/issue; 7-8 supplied by freelancers. Needs "news photos from events around the country; shots for personality profiles." Special needs include "Chess Review" section. Model release preferred. Captions preferred.
Making Contact & Terms: Interested in receiving work from newer, lesser-known photographers. Query with samples. Provide business card and tearsheets to be kept on file for possible future assignments. Prefers 35mm transparencies for cover shots. Also accepts digital images on broadcast tape, VHS and Beta. SASE. Reports in "2-4 weeks, depending on when the deadline crunch occurs." Pays $150-300/b&w or color cover photo; $25/b&w inside photo; $35/color inside photo; $15-30/hour; $150-250/day. Pays on publication. Credit line given. Buys one-time rights; "we occasionally purchase all rights for stock mug shots." Simultaneous submissions and previously published work OK.
Tips: Using "more color, and more illustrative photography. The photographer's name and date should appear on the back of all photos." Looks for "clear images, good composition and contrast—with a fresh approach to interest the viewer. Increasing emphasis on strong portraits of chess personalities, especially Americans. Tournament photographs of winning players and key games are in high demand."

❀**CHICKADEE MAGAZINE**, 370 King St. W., Suite 300, Toronto, Ontario M5V 1S9 Canada. (416)971-5275. Fax: (416)971-5294. Website: http://www.owl.on.ca. Researcher: Ekaterina Gitlin. Circ. 125,000. Estab. 1979. Published 9 times/year, 1 summer issue. A natural science magazine for children under 8 years. Sample copy for $4.28 with 9×12 SAE and $1.50 money order to cover postage. Photo guidelines free.
 • *Chickadee* has received Magazine of the Year, Parents' Choice and The Educational Association of America awards.
Needs: Uses about 3-6 photos/issue; 1-2 supplied by freelance photographers. Needs "crisp, bright, close-up shots of animals in their natural habitat." Model/property release required. Captions required.
Making Contact & Terms: Interested in receiving work from newer, lesser-known photographers. Request photo package before sending photos for review. Send 35mm transparencies; submit digital images on Zip disk or SyQuest hard disk scanned at high resolution (300 dpi) as a TIFF or EPS file (prefer CMYK format, separations included). Reports in 2-3 months. Pays $325 Canadian/color cover; $200 Canadian/color page; text/photo package negotiated separately. **Pays on acceptance.** Credit line given. Buys one-time rights. Previously published work OK.

CHILD OF COLORS, Interrace Publications, P.O. Box 12048, Atlanta GA 30355. (404)350-7877. Fax: (404)350-0819. Associate Publisher: Gabe Grosz. Circ. 5,000. Estab. 1994. Quarterly magazine. Emphasizes children, with or without family, of black, Hispanic, Asian, American-Indian and mixed-race heritage, 1 month to 17 years old. Also, transracial adoptees. Readers are parents of children of all races/ethnicity, including biracial/multiracial; transracial adoption parents. Sample copies $2 with 9×12 SAE and 4 first-class stamps. Photo guidelines free with SASE.
 • *Child of Colors* is a parenting mini-magazine included with each issue of *Interrace Magazine*. See listings for *Interrace* and *Black Child Magazine*, also published by Interrace Publications, in this section.
Needs: Uses 15-20 photos/issue; 12-15 supplied by freelancers. Needs photos of children and their families. Must be mixed-race or transracial adoptees. All racial, ethnic background. Special photo needs include children playing, serious shots, schooling, athletes, arts, entertainment. Model/property release preferred. Captions preferred.
Making Contact & Terms: Interested in receiving work from newer, lesser-known photographers. Submit portfolio for review. Query with résumé of credits. Query with stock photo list. Send unsolicited photos by mail for consideration. Provide résumé, business card, brochure, flier or tearsheets to be kept on file for possible assignments. Send 3×5, 8×10 color or b&w prints; any transparencies. Keeps samples on file. SASE. Reports in 1 month or less. Pays $15-25/hour; $15-75/job; $35/color cover photo; $35/b&w cover photo; $20/color inside photo; $20/b&w inside photo; $20-35/color page rate. Pays on publication. Credit line given. Buys one-time rights. Simultaneous submissions and/or previously published work OK.
Tips: "We're looking for kids of all ethnic/racial make up. Cute, upbeat kids are a plus. Photos with family are also needed."

● **SPECIAL COMMENTS** within listings by the editor of *Photographer's Market* are set off by a bullet.

CHILDHOOD EDUCATION, The Olney Professional Bldg., 17904 Georgia Ave., Suite 215, Olney MD 20832. (301)942-2443. Director of Publications/Editor: Anne Bauer. Assistant Editor: Bruce Herzig. Circ. 15,000. Estab. 1924. Publication for the Association for Childhood Education International. Bimonthly journal. Emphasizes the education of children from infancy through early adolescence. Readers include teachers, administrators, day-care workers, parents, psychologists, student teachers, etc. Sample copy free with 9 × 12 SAE and $1.44 postage. Photo guidelines free with SASE.

Needs: Uses 5-10 photos/issue; 2-3 supplied by freelance photographers. Subject matter includes children infancy-14 years in groups or alone, in or out of the classroom, at play, in study groups; boys and girls of all races and in all cities and countries. Wants close-ups of children, unposed. Reviews photos with or without accompanying ms. Special needs include photos of minority children; photos of children from different ethnic groups together in one shot; boys and girls together. Model release required.

Making Contact & Terms: Interested in receiving work from newer, lesser-known photographers. Send unsolicited photos by mail for consideration. Uses 8 × 10 glossy b&w and color prints and color transparencies. SASE. Reports in 1 month. Pays $75-100/color cover photo; $25-50/b&w inside photo. Pays on publication. Credit line given. Buys one-time rights. Simultaneous submissions and previously published work are discouraged but negotiable.

Tips: "Send pictures of unposed children, please."

CHILDREN'S DIGEST, P.O. Box 567, Indianapolis IN 46206. (317)636-8881. Fax: (317)684-8094. Photo Editor: Rebecca Ray. Circ. 106,000. Estab. 1950. Magazine published 8 times/year. Emphasizes health and fitness. Readers are preteens—kids 10-13. Sample copy $1.25. Photo guidelines free with SASE.

Needs: "We have featured photos of wildlife, children in other countries, adults in different jobs, how-to projects." *Reviews photos with accompanying ms only.* "We would like to include more photo features on nature, wildlife or anything with an environmental slant." Model release preferred.

Making Contact & Terms: Send complete manuscript and photos on speculation; 35mm transparencies. SASE. Reports in 10 weeks. Pays $50-100/color cover photo; $20/color inside photo; $10/b&w inside photo. Pays on publication. Buys one-time rights.

‡CHILDREN'S MINISTRY MAGAZINE, % Group Publishing, Inc., 1515 Cascade Ave., Loveland CO 80538. (970)669-3836. Fax: (970)669-1994. Art Director: Rose Anne Buerge. Circ. 50,000. Estab. 1991. Bimonthly magazine. Provides ideas and support to adult workers (professional and volunteer) with children in Christian churches. Sample copy $2 with 9 × 12 SAE. Photo guidelines free with SASE.

● This publication is interested in receiving work on Photo CD.

Needs: Uses 20-25 photos/issue; 3-6 supplied by freelancers. Needs photos of children (infancy—6th grade) involved in family, school, church, recreational activities; with or without adults; generally upbeat and happy. Reviews photos with or without a manuscript. Especially needs good portrait-type shots of individual children, suitable for cover use; colorful, expressive. Model release required. Captions not needed.

Making Contact & Terms: Interested in reviewing work from newer, lesser-known photographers, "if they meet our stated requirements." Query with list of stock photo subjects. Send unsolicited photos by mail for consideration. Send 35mm, 2¼ × 2¼, 8 × 10 transparencies. Samples filed. SASE. Reports in 1 month. Pays minimum $100/color inside photo; $50/b&w inside photo. **Pays on acceptance**. Credit line given. Buys one-time rights. Simultaneous submissions and previously published work OK.

Tips: "We seek to portray people in a variety of ethnic, cultural and economic backgrounds in our publications. We look for photographers with the ability to portray emotion in photos. Real life shots are preferable to posed ones."

THE CHRISTIAN CENTURY, 407 S. Dearborn St., Chicago IL 60605. (312)427-5380. Fax: (312)427-1302. Production Coordinator: Matthew Giunti. Circ. 32,000. Estab. 1884. Weekly journal. Emphasis on religion. Readers are clergy, scholars, laypeople, male and female, ages 40-85. Sample copy $2. Photo guidelines free with SASE.

Needs: Buys 50 photos/year; all supplied by freelancers; 75% comes from stock. People of various races and nationalities; celebrity/personality (primarily political and religious figures in the news); documentary (conflict and controversy, also constructive projects and cooperative endeavors); scenic (occasional use of seasonal scenes and scenes from foreign countries); spot news; and human interest (children, human rights issues, people "in trouble," and people interacting). Reviews photos with or without accompanying ms. For accompanying mss seeks articles dealing with ecclesiastical concerns, social problems, political issues and international affairs. Model/property release preferred. Captions preferred; include name of subject and date.

Making Contact & Terms: Interested in reviewing work from newer, lesser-known photographers. "Send crisp black and white images. We will consider a stack of photos in one submission. Send cover letter with prints. Don't send negatives or color prints." Also accepts digital files on floppy disk in Photoshop or

TIFF format (EPS also if it's not too large). Uses 8 × 10 b&w prints. Does not keep samples on file. SASE. Reports in 1 month. Pays $50-150/photo (b&w or color). Pays on publication. Credit line given. Buys one-time rights; negotiable. Simultaneous submissions and previously published work OK.

Tips: Looks for diversity in gender, race, age and religious settings. Photos should reproduce well on newsprint.

CHRISTIAN HOME & SCHOOL, 3350 E. Paris Ave. SE, Grand Rapids MI 49512-3054. (616)957-1070, ext. 239. Senior Editor: Roger Schmurr. Circ. 57,000. Estab. 1922. Publication of Christian Schools International. Published 6 times a year. Emphasizes Christian family issues. Readers are parents who support Christian education. Sample copy free with 9 × 12 SAE with 4 first-class stamps. Photo guidelines free with SASE or along with sample copy.

Needs: Uses 10-15 photos/issue; 7-10 supplied by freelancers. Needs photos of children, family activities, school scenes. Model release preferred.

Making Contact & Terms: Query with samples. Query with list of stock photo subjects. SASE. Reports in 3 weeks. Pays color: $125/inside editorial; $250/cover; $50-100/b&w inside spot usage. Pays on publication. Credit line given. Buys one-time rights. Simultaneous submissions and previously published work OK.

Tips: Assignment work is becoming rare. Freelance stock most often used. "Photographers who allow us to hold duplicate photos for an extended period of time stand more chance of having their photos selected for publication than those who require speedy return of submitted photos."

‡CHRISTIANITY AND THE ARTS, P.O. Box 118088, Chicago IL 60611. (312)642-8606. Fax: (312)266-7719. E-mail: chrnarts@aol.com. Publisher: Marci Whitney-Schenck. Circ. 4,000. Estab. 1994. Nonprofit quarterly magazine. Emphasizes "Christian expression—visual arts, dance, music, literature, film. We reach Protestant, Catholic and Orthodox readers throughout the United States and Canada." Readers are "upscale and well-educated, with an interest in several disciplines, such as music and the visual arts." Sample copy $6.

Needs: "Parting Shot" page is devoted to "arty photos."

Making Contact & Terms: "We occasionally pay a freelance photographer $100/photo. Usually, there is no pay, but the photographer gets exposure."

THE CHRONICLE OF THE HORSE, P.O. Box 46, Middleburg VA 20118. (540)687-6341. Fax: (540)687-3937. Editor: John Strassburger. Circ. 23,000. Estab. 1937. Weekly magazine. Emphasizes English horse sports. Readers range from young to old. "Average reader is a college-educated female, middle-aged, well-off financially." Sample copy for $2. Photo guidelines free with SASE.

Needs: Uses 10-25 photos/issue; 90% supplied by freelance photographers. Needs photos from competitive events (horse shows, dressage, steeplechase, etc.) to go with news story or to accompany personality profile. "A few stand alone. Must be cute, beautiful or newsworthy. Reproduced in b&w." Prefers purchasing photos with accompanying ms. Captions required with every subject identified.

Making Contact & Terms: Interested in receiving work from newer, lesser-known photographers. Query with idea. Send b&w and color prints (reproduced b&w). SASE. Reports in 3 weeks. Pays $15-100/photo/text package. Pays on publication. Credit line given. Buys one-time rights. Prefers first North American rights. Simultaneous submissions and previously published work OK.

Tips: "We do not want to see portfolio or samples. Contact us first, preferably by letter. Know horse sports."

CIRCLE K MAGAZINE, 3636 Woodview Trace, Indianapolis IN 46268. (317)875-8755. Executive Editor: Nicholas K. Drake. Circ. 15,000. Published 5 times/year. For community service-oriented college leaders "interested in the concept of voluntary service, societal problems, leadership abilities and college life. They are politically and socially aware and have a wide range of interests."

Needs: Assigns 0-5 photos/issue. Needs general interest photos, "though we rarely use a nonorganization shot without text. Also, the annual convention requires a large number of photos from that area." Prefers ms with photos. Seeks general interest features aimed at the better-than-average college student. "Not specific places, people topics." Captions required, "or include enough information for us to write a caption."

Making Contact & Terms: Works with freelance photographers on assignment only basis. Provide calling card, letter of inquiry, résumé and samples to be kept on file for possible future assignments. Send query with résumé of credits. Uses 8 × 10 glossy b&w prints or color transparencies. Uses b&w and color covers; vertical format required for cover. SASE. Reports in 3 weeks. Pays up to $225-350 for text/photo package, or on a per-photo basis—$25 minimum/b&w print and $100 minimum/cover. **Pays on acceptance.** Credit line given. Previously published work OK if necessary to text.

CIVITAN MAGAZINE, P.O. Box 130744, Birmingham AL 35213-0744. (205)591-8910. Fax: (205)592-6307. E-mail: civitan@civitan.org. Website: http://www.civitan.org/civitan. Editor: Dorothy Wellborn. Circ. 36,000. Estab. 1920. Publication of Civitan International. Bimonthly magazine. Emphasizes work with mental retardation/developmental disabilities. Readers are men and women, college age to retirement and usually managers or owners of businesses. Sample copy free with 9 × 12 SAE and 2 first-class stamps. Photo guidelines not available.
Needs: Uses 8-10 photos/issue; 50% supplied by freelancers. Always looking for good cover shots (travel, scenic and how-tos). Model release preferred. Captions preferred.
Making Contact & Terms: Send unsolicited 2¼ × 2¼ or 4 × 5 transparencies or b&w prints by mail for consideration. Provide résumé, business card, brochure, flier or tearsheets to be kept on file for possible assignments. Reports in 1 month. Pays $50/color cover photo; $10 b&w inside photo. **Pays on acceptance.** Buys one-time rights. Simultaneous submissions and previously published work OK.

CLASSIC AUTO RESTORER, P.O. Box 6050, Mission Viejo CA 92690. (714)855-8822. Fax: (714)855-3045. Editor: Dan Burger. Circ. 75,000. Estab. 1989. Monthly magazine. Emphasizes restoration of collector cars and trucks. Readers are male (98%), professional/technical/managerial, ages 35-55. Sample copy $5.50.
Needs: Uses 50 photos/issue; 95% supplied by freelancers. Needs photos of auto restoration projects and restored cars. Reviews photos with accompanying ms only. Model/property release preferred. Captions required; include year, make and model of car; identification of people in photo.
Making Contact & Terms: Interested in receiving work from newer, lesser-known photographers. Submit inquiry and portfolio for review. Provide résumé, business card, brochure, flier or tearsheets to be kept on file for possible assignments. Prefers transparencies, mostly 35mm, 2¼ × 2¼. Does not keep samples on file. SASE. Reports in 1 month. Pays $200-300/color cover photo; $100/color page rate; $100/b&w page rate; $100/page for photo/test package; $30-100/color or b&w photo. Pays on publication. Credit line given. Buys first North American serial rights; negotiable. Simultaneous submissions OK.
Tips: Looks for "technically proficient or dramatic photos of various automotive subjects, auto portraits, detail shots, action photos, good angles, composition and lighting. We're also looking for photos to illustrate how-to articles such as how-to repair a damaged fender or how-to repair a four-barrel carburetor."

COAST MAGAZINE, 943 A 33rd Ave., Gulfport MS 39501. (601)868-1182. Fax: (601)867-2986. Creative Director: Belinda Mallery. Circ. 25,000. Estab. 1993. Bimonthly magazine. Emphasizes lifestyle. Readers are mostly female (59%), ages 34-46, affluent ($35,000 plus income). Sample copy free with 10 × 13 SAE and $2.90 first-class postage.
Needs: Uses 60-80 photos/issue; 40 supplied by freelancers. Needs photos of travel, people, vacation spots, scenics. Model/property release required. Captions required; include pertinent information.
Making Contact & Terms: Interested in receiving work from newer, lesser-known photographers. Arrange personal interview to show portfolio. Query with stock photo list. Send 35mm transparencies. Does not keep samples on file. SASE. Reports in 1 month. Pays $50-500/job. Pays on publication. Credit line given.

COBBLESTONE: THE HISTORY MAGAZINE FOR YOUNG PEOPLE, Cobblestone Publishing Company, 7 School St., Peterborough NH 03458. (603)924-7209. Editor: Meg Chorlian. Circ. 36,000. Estab. 1980. Publishes 9 issues/year, September-May. Emphasizes American history; each issue covers a specific theme. Readers are children 8-14, parents, teachers. Sample copy for $4.50 and 9 × 12 SAE with 5 first-class stamps. Photo guidelines free with SASE.
Needs: Uses about 40 photos/issue; 5-10 supplied by freelance photographers. "We need photographs related to our specific themes (each issue is theme-related) and urge photographers to request our themes list." Model release required. Captions preferred.
Making Contact & Terms: Query with samples or list of stock photo subjects. Send 8 × 10 glossy prints, or 35mm or 2¼ × 2¼ transparencies. SASE. "Photos must pertain to themes, and reporting dates depend on how far ahead of the issue the photographer submits photos. We work on issues 6 months ahead of publication." Cover photo (color) negotiated; $15-100/inside b&w and color use. Pays on publication. Credit line given. Buys one-time rights. Simultaneous submissions and previously published work OK.
Tips: "In general, we use few contemporary images; most photos are of historical subjects. However, the amount varies with each monthly theme."

COLLAGES & BRICOLAGES, P.O. Box 86, Clarion PA 16214. E-mail: fontis@vaxa.clarion.edu. Editor: Marie-José Fortis. Estab. 1986. Annual magazine. Emphasizes literary works, avant-garde, poetry, fiction, plays and nonfiction. Readers are writers and the general public in the US and abroad. Sample copy $8.50.
Needs: Uses 5-10 photos/issue; all supplied by freelancers. Needs photos that make a social statement,

surrealist photos and photo collages. Reviews photos (only in fall, August-December) with or without a ms. Photo captions preferred; include title of photo and short biography of artist/photographer. "Photos should be no larger than 8½ × 11 with at least a 1-inch border."

Making Contact & Terms: Send unsolicited photos by mail for consideration. "Photos should be no larger than 8½ × 11 with at least a 1″ border." Send matte b&w prints. SASE. Reports in 3 months. Pays in copies. Simultaneous submissions and/or previously published work OK.

Tips: "*C&B* is primarily meant for writers. It will include photos if: a) they accompany or illustrate a story, a poem, an essay or a focus *C&B* might have at the moment; b) they constitute the cover of a particular issue; or c) they make a statement (political, social, spiritual)."

‡COLLECTING TOYS MAGAZINE, 21027 Crossroads Circle, Waukesha WI 53187. (414)796-8776. Fax: (414)796-1142. E-mail: thammel@toysmag.com. Website: http://www.toysmag.com. Editor: Tom Hammel. Circ. 48,000. Estab. 1993. Bimonthly magazine. Emphasizes collectible toys—no dolls. Readers are 90% male, average age 46. Sample copy $3.95. Photo guidelines free with SASE, or on website.

Needs: Uses 50 photos/issue; 15-25 supplied by freelancers. Needs photos of static or diorama shots in full color only of vintage boys' toys. Model/property release required for owner's permission to shoot toys. Captions required; include age of toy(s), maker, dimensions, actions or motors, etc.

Making Contact &I Terms: Interested in receiving work from newer, lesser-known photographers. Send unsolicited photos by mail for consideration. Provide résumé, business card, brochure, flier or tearsheets to be kept on file for possible assignments. Send 4 × 6 glossy color prints; 35mm, 4 × 5 transparencies. Accepts images in digital format for Mac. Send via online, floppy disk, zip disk. Keeps samples on file. SASE. Reports in 1 month. Pays $25-50/color inside photo; $75-100/photo/text package. **Pays on acceptance**. Credit line given. Buys first North American serial and all rights; negotiable.

‡COLLECTOR CAR & TRUCK PRICES, 41 N. Main St., N. Grafton MA 01536-1559. (508)839-6707. Fax: (508)839-6266. Production Director: Kelly Hulitzky. Circ. 20,000. Estab. 1994. Bimonthly magazine. Emphasizes old cars and trucks. Readers are primarily males, ages 30-60. Sample copy free with SASE and 6 first-class stamps.

Needs: Uses 3 photos/issue; all supplied by freelancers. Needs photos of old cars and trucks. Model/property release required. Captions required; include year, make and model. Provide résumé, business card, brochure, flier or tearsheets to be kept on file for possible assignments. Does not keep samples on file. SASE. Reports in 1 month. Pays $150-200/color cover photo; $100-125/b&w inside photo. Pays net 30 days. Buys one-time rights. Previously published work OK.

COLLEGE PREVIEW, 3100 Broadway, Suite 660, Kansas City MO 64111-2413. (816)960-1988. Fax: (816)960-1989. Editor: Neoshia Michelle Paige. Circ. 600,000. Bimonthly magazine. Emphasizes college and college-bound African-American and Hispanic students. Readers are African-American, Hispanic, ages 16-24. Sample copy free with 9 × 12 SAE and 4 first-class stamps.

Needs: Uses 30 photos/issue. Needs photos of students in class, at work, in interesting careers, on-campus. Special photo needs include computers, military, law and law enforcement, business, aerospace and aviation, health care. Model/property release required. Captions required; include name, age, location, subject.

Making Contact & Terms: Interested in receiving work from newer, lesser-known photographers. Query with résumé of credits. Query with ideas and SASE. Reports in 1 month, "usually less." Pays $10-50/color photo; $5-25/b&w inside photo. Pays on publication. Buys first North American serial rights. Simultaneous submissions and/or previously published work OK.

COLONIAL HOMES MAGAZINE, Dept. PM, 1790 Broadway, New York NY 10019. (212)830-2950. Editor: Annette Stramesi. Bimonthly. Circ. 600,000. Focuses on traditional American architecture, interior design, antiques and crafts. Sample copy available.

Needs: All photos supplied by freelance photographers. Needs photos of "American architecture and interiors of 18th century or 18th century style." Special needs include "American food and drink; private and museum homes; historic towns in America." All art must be identified.

Making Contact & Terms: Submit portfolio for review. Send 4 × 5 or 2¼ × 2¼ transparencies by mail

THE SUBJECT INDEX, located at the back of this book, lists publications, book publishers, galleries, paper product companies and stock agencies according to the subject areas they seek.

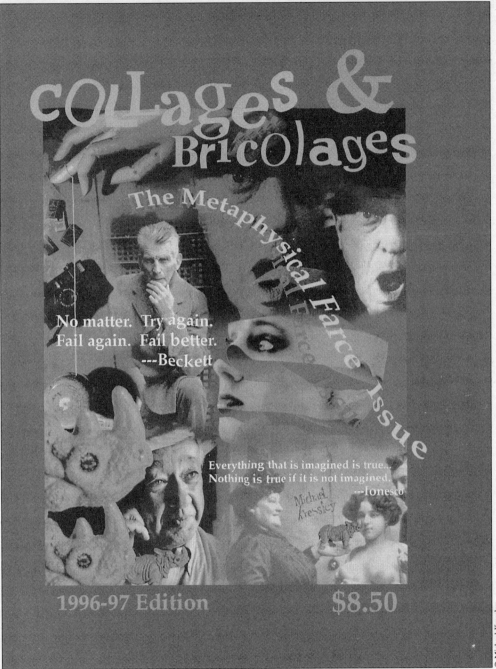

"Michael Kressley is excellent at photo collage, has a very intriguing way of exploring the human body, and can intelligently blend what could appear just as disparate elements," says *Collages & Bricolages* Editor Marie-Jose Fortis. "He also has great interpretational skills: avant-garde, yet accessible to a large audience, probably because his playfulness intervenes." This collage by Kressley appeared on the cover of *C&B's* 1996-97 issue. Kressley found the journal through *Photographer's Market*, and hopes "art directors with an imaginative bent" will want to see more of his work as a result of the piece. Fortis encourages photographic submissions like Kressley's that are non-traditional. "Remember that magazines like *C&B*, although paying only in copies, represent a good showcase for avant-garde artists, including photographers."

for consideration. Provide résumé, business card, brochure, flier or tearsheets to be kept on file for possible future assignments. SASE. Reports in 1 month. Pays a flat fee. Pays on publication. Credit line given. Buys all rights. Previously published work OK.

COMPANY: A MAGAZINE OF THE AMERICAN JESUITS, Dept. PM, 3441 N. Ashland Ave., Chicago IL 60657. (773)281-1534. Fax: (773)281-2667. Editor: Martin McHugh. Circ. 128,000. Estab. 1983. Published by the Jesuits (Society of Jesus). Quarterly magazine. Emphasizes people; "a human interest magazine about people helping people." Sample copy free with 9×12 SAE and 4 first-class stamps. Photo guidelines free with SASE.
Needs: All photos supplied by freelancers. Needs photo-stories of Jesuit and allied ministries and projects, only photos related to Jesuit works. Photos purchased with or without accompanying ms. Model release required. Captions required.
Making Contact & Terms: Interested in receiving work from newer, lesser-known photographers. Query with samples. Provide résumé, business card, brochure, flier or tearsheets to be kept on file for possible future assignments. SASE. Reports in 1 month. Pays $300/color cover photo; $100-400/job. Pays on publication. Credit line given. Buys one-time rights; negotiable.
Tips: "Avoid large-group, 'smile-at-camera' photos. We are interested in people photographs that tell a story in a sensitive way—the eye-catching look that something is happening."

COMPLETE WOMAN, 875 N. Michigan Ave., Suite 3434, Chicago IL 60611-1901. (312)266-8680. Art Director: Juli McMeekin. Estab. 1980. Bimonthly magazine. General interest magazine for women. Readers are "females, 21-40, from all walks of life."
Needs: Uses 50-60 photos/issue. Needs "high-contrast shots of attractive women, how-to beauty shots, women with men, etc." Model release required. Captions preferred.
Making Contact & Terms: Interested in receiving work from newer, lesser-known photographers. Query with list of stock photo subjects. Send unsolicited photos by mail for consideration. Provide résumé, business card, brochure, flier or tearsheets to be kept on file for possible assignments. Send b&w, color prints; 35mm transparencies. SASE. Reports in 1 month. Pays $100/color inside photo; $50-100/b&w inside photo. Pays on publication. Credit line given. Buys one-time rights. Simultaneous and previously published work OK.

COMPUTER CURRENTS, 1250 Ninth St., Berkeley CA 94710. (510)527-0333. Fax: (510)527-4106. E-mail: scullison@compcurr.com. Production Director: Sherry Scllison. Circ. 600,000. Estab. 1983. Magazine: biweekly in Bay Area; monthly in Los Angeles, New York City, Chicago, Boston, Atlanta and Texas. Emphasizes personal computing (PCs and Macs). Readers are PC and Mac users with 4-5 years experience; mostly male, 25-55. Sample copy for 10½×12½ SAE and $3 postage. Photo guidelines free with SASE.
Needs: Uses 1 cover photo/issue; all supplied by freelancers. Needs illustriave photos representing a given concept. Reviews photos purchased with accompanying ms only. Model/property release required.
Making Contact & Terms: Interested in receiving work from newer, lesser-known photographers. Send unsolicited photos by mail for consideration. Provide résumé, business card, brochure, flier or tearsheets to be kept on file for possible future assignments. Send 2¼×2¼, 4×5 transparencies; SyQuest in TIFF Photoshop, Illustrator digital formats. Keeps samples on file. SASE. Reports in 1 month. Pays $800-1,000/color cover photo. **Pays on acceptance.** Credit line given. Buys first North American serial, electronic and nonexclusive rights. Simultaneous submissions and previously published work OK.
Tips: "Photographers wishing to work with us should have Photoshop and QuarkXPress awareness or experience."

CONDE NAST TRAVELER, Conde Nast Publications, Inc., 360 Madison Ave., New York NY 10017. (212)880-8800. Fax: (212)286-9244. *Conde Nast Traveler* provides the experienced traveler with an array of diverse travel experiences encompassing art, architecture, fashion, culture, cuisine and shopping. This magazine has very specific needs and contacts a stock agency when seeking photos.

CONFRONTATION: A LITERARY JOURNAL, English Dept., C.W. Post of L.I.U., Brookville NY 11548. (516)299-2391. Fax: (516)299-2735. Editor: Martin Tucker. Circ. 2,000. Estab. 1968. Semiannual magazine. Emphasizes literature. Readers are college-educated lay people interested in literature. Sample copy $3.
Needs: Reviews photos with or without a manuscript. Captions preferred.
Making Contact & Terms: Interested in reviewing work from newer, lesser-known photographers. Query with résumé of credits. Query with stock photo list. Reports in 1 month. Pays $25-100/b&w photo; $50-100/color cover photo; $20-40/b&w page rate; $100-300/job. Pays on publication. Credit line given. Buys first North American serial rights; negotiable. Simultaneous submissions OK.

THE CONNECTION PUBLICATION OF NJ, INC., P.O. Box 2122, Teaneck NJ 07666. (201)692-1512. Fax: (201)861-0492. Contact: Editor. Weekly tabloid. Readers are male and female executives, ages 18-62. Circ. 41,000. Estab. 1982. Sample copy $1.50 with 9 × 12 SAE.
Needs: Uses 12 photos/issue; 4 supplied by freelancers. Needs photos of personalities. Reviews photos with accompanying ms only. Photo captions required.
Making Contact & Terms: Send unsolicited photos by mail for consideration. Send b&w prints. Keeps samples on file. SASE. Reports in 2 weeks. Payment negotiable. Pays on publication. Credit line given. Buys one-time rights; negotiable. Previously published work OK.
Tips: "Work with us on price."

COSMOPOLITAN, Hearst Corporation Magazine Division, 224 W. 57th St., 8th Floor, New York NY 10019. (212)649-3303. Fax: (212)265-1849. *Cosmopolitan* targets young women for whom beauty, fashion, fitness, career, relationships and personal growth are top priorities. It includes articles and columns on nutrition and food, travel, personal finance, home/lifestyle and celebrities. This magazine did not respond to our request for information. Query before submitting.

COUNTRY, 5925 Country Lane, Greendale WI 53129. (414)423-0100. Fax: (414)423-8463. Photo Coordinator: Trudi Bellin. Estab. 1987. Bimonthly magazine. "For those who live in or long for the country." Readers are rural-oriented, male and female. "*Country* is supported entirely by subscriptions and accepts no outside advertising." Sample copy $2. Photo guidelines free with SASE.
Needs: Uses 150 photos/issue; 20% supplied by freelancers. Needs photos of scenics—country only. Model/property release required. Captions preferred; include season, location.
Making Contact & Terms: Interested in receiving work from newer, lesser-known photographers. Query with list of stock photo subjects. Send unsolicited photos by mail for consideration. Send 35mm, 2¼ × 2¼, 4 × 5 and 8 × 10 transparencies. Tearsheets kept on file but not dupes. SASE. Reports within 3 months. Pays $300/color cover photo; $75-150/color inside photo; $150/color page (full-page bleed). Pays on publication. Credit line given. Buys one-time rights. Previously published work OK.
Tips: "Technical quality is extremely important: focus must be sharp, no soft focus; colors must be vivid so they 'pop off the page.' Study our magazine thoroughly—we have a continuing need for sharp, colorful images, and those who can supply what we need can expect to be regular contributors."

COUNTRY WOMAN, Dept. PM, P.O. Box 643, Milwaukee WI 53201. Managing Editor: Kathy Pohl. Emphasizes rural life and a special quality of living to which country women can relate; at work or play in sharing problems, etc. Sample copy $2. Free photo guidelines with SASE.
Needs: Uses 75-100 photos/issue, most supplied by readers, rather than freelance photographers. "We're always interested in seeing good shots of farm, ranch and country women (in particular) and rural families (in general) at work and at play." Uses photos of farm animals, children with farm animals, farm and country scenes (both with and without people) and nature. Want on a regular basis scenic (rural), seasonal, photos of rural women and their family. "We're always happy to consider cover ideas. Covers are often seasonal in nature and *always* feature a country woman. Additional information on cover needs available." Photos purchased with or without accompanying ms. Good quality photo/text packages featuring interesting country women are much more likely to be accepted than photos only. Captions are required. Work 6 months in advance. "No poor-quality color prints, posed photos, etc."
Making Contact & Terms: Send material by mail for consideration. Uses transparencies. Provide brochure, calling card, letter of inquiry, price list, résumé and samples to be kept on file for possible future assignments. SASE. Reports in 3 months. Pays $100-150 for text/photo package depending on quality of photos and number used; pays $300 for front cover; $200 for back cover; partial page inside $50-125, depending on size. Many photos are used at ¼ page size or less, and payment for those is at the low end of the scale. No b&w photos used. **Pays on acceptance.** Buys one-time rights. Previously published work OK.
Tips: Prefers to see "rural scenics, in various seasons; emphasis on farm women, ranch women, country women and their families. Slides appropriately simple for use with poems or as accents to inspirational, reflective essays, etc."

‡CRC PRODUCT SERVICES, 2850 Kalamazoo Ave SE, Grand Rapids MI 49560. (616)246-0780. Fax: (616)246-0834. E-mail: crdesign@crcna.org. Art Acquisition: Dean Heetderks. Publishes numerous magazines with various formats. Emphasizes living the Christian life. Readers are Christians ages 35-85. Photo guidelines free with SASE.

Needs: Uses 6-8 photos/issue; 6-8 supplied by freelancers. Needs photos of people, holidays and concept. Reviews photos purchased with or without a ms. Special photo needs include real people doing real activities: couples, families. Model/property release required. Captions preferred.

Making Contact & Terms: Provide résumé, business card, brochure, flier or tearsheets to be kept on file for possible assignments. Send any color or b&w prints; 35mm, $2\frac{1}{4} \times 2\frac{1}{4}$, 4×5, 8×10 transparencies; digital format. Keeps samples on file. Cannot return material. Reports in 1-2 weeks. Pays $300-600/color cover photo; $200-400/b&w cover photo; $200-300/color inside photo; $200-300/b&w inside photo. **Pays on acceptance**. Buys one-time and electronic rights. Simultaneous submissions and/or previously published work OK.

THE CREAM CITY REVIEW, University of Wisconsin-Milwaukee, English Dept., Box 413, Milwaukee WI 53201. (414)229-4708. http://www.uwm.edu/Dept/English. Art Director: Laurie Buman. Circ. 2,000. Estab. 1975. Bienniel journal. Emphasizes literature. Readers are mostly males and females with Ph.D's in English, ages 18-over 70. Sample copy $5. Photo guidelines free with SASE.

Needs: Uses 6-20 photos/issue; most supplied by freelancers. Needs photos of fine art and other works of art. Captions preferred.

Making Contact & Terms: Interested in reviewing work from newer, lesser-known photographers. Send unsolicited photos by mail for consideration. Send all sizes b&w and color prints; 35mm, $2\frac{1}{4} \times 2\frac{1}{4}$, 4×5, 8×10 transparencies. SASE. Reports in 2 months. Pays $50/color cover photo; $50/b&w cover photo; $5/b&w inside photo; $5/b&w page rate. Pays on publication. Credit line given. Buys one-time rights. Simultaneous submissions and/or previously published work OK.

Tips: "We currently receive very few unsolicited submissions, and would like to see more. Though our primary focus is literary, we are dedicated to producing a visually exciting journal. The artistic merit of submitted work is important. We have been known to change our look based on exciting work submitted. Take a look at *Cream City Review* and see how we like to look. If you have things that fit, send them."

CRUISING WORLD MAGAZINE, 5 John Clark Rd., Newport RI 02840. (401)847-1588. Fax: (401)848-5048. Art Director: William Roche. Circ. 130,000. Estab. 1974. Emphasizes sailboat maintenance, sailing instruction and personal experience. For people interested in cruising under sail. Sample copy free for 9×12 SAE.

Needs: Buys 25 photos/year. Needs "shots of cruising sailboats and their crews anywhere in the world. Shots of ideal cruising scenes. No identifiable racing shots, please." Also wants exotic images of cruising sailboats, people enjoying sailing, tropical images, different perspectives of sailing, good composition, bright colors. For covers, photos "must be of a cruising sailboat with strong human interest, and can be located anywhere in the world." Prefers vertical format. Allow space at top of photo for insertion of logo. Model release preferred. Property release required. Captions required; include location, body of water, make and model of boat.

Making Contact & Terms: Interested in receiving work from newer, lesser-known photographers "as long as their subjects are marine related." Send 35mm color transparencies. "We rarely accept miscellaneous b&w shots and would rather they not be submitted unless accompanied by a manuscript." For cover, "submit original 35mm slides. *No* duplicates. Most of our editorial is supplied by author. We look for good color balance, very sharp focus, the ability to capture sailing, good composition and action. Always looking for *cover shots*." Reports in 2 months. Pays $50-300/inside photo; $500/cover photo. Pays on publication. Credit line given. Buys all rights, but may reassign to photographer after publication; first North American serial rights; or one-time rights.

CUPIDO, % Red Alder Books, P.O. Box 2992, Santa Cruz CA 95063. (408)426-7082. Fax: (408)425-8825. E-mail: eronat@aol.com. Photo Representative: David Steinberg. Circ. 60,000. Estab. 1984. Monthly magazine. Emphasizes quality erotica. Sample copy $10 (check payable to Red Alder Books).

Needs: Uses 50 photos/issue. Needs quality erotic and sexual photography, visually interesting, imaginative, showing human emotion, tenderness, warmth, humor OK, sensuality emphasized. Reviews photos only (no manuscripts, please).

Making Contact & Terms: Contact through rep. Arrange personal interview to show portfolio or submit portfolio for review. Query with stock photo list. Send unsolicited photos by mail for consideration. Send

THE SUBJECT INDEX, located at the back of this book, lists publications, book publishers, galleries, paper product companies and stock agencies according to the subject areas they seek.

8 × 10 or 11 × 14 b&w, color prints; 35mm, 2¼ × 2¼, 4 × 5, 8 × 10 transparencies. Keeps samples on file. SASE. Reports in 1 month. Pays $500-800/color cover photo; $60-90/color or b&w inside photo. Pays on publication. Credit line given. Buys one-time rights. Simultaneous submissions and/or previously published work OK.

Tips: "Not interested in standard, porn-style photos. Imagination, freshness, emotion emphasized. Glamor OK, but not preferred."

‡**CURRENTS**, Voice of the National Organization for Rivers, 212 W. Cheyenne Mountain Blvd., Colorado Springs CO 80906. (719)579-8759. Fax: (719)576-6238. Editor: Greg Moore. Circ. 5,000. Estab. 1979. Quarterly magazine. Membership publication of National Organization for Rivers, for canoeists, kayakers and rafters. Emphasizes river conservation and river access, also techniques of river running. Sample copy $1. Writer's and photographer's guidelines free with #10 SASE.

Needs: Buys 10 photos/issue; 25% assigned, 75% unsolicited. Photo essay/photo feature (on rivers of interest to river runners). Need features on rivers that are in the news because of public works projects, use regulations, wild and scenic consideration or access prohibitions. Sport newsphotos of canoeing, kayaking, rafting and other forms of river paddling, especially photos of national canoe and kayak races; nature/river subjects, conservation-oriented; travel (river runs of interest to a nationwide membership). Wants on a regular basis close-up action shots of river running and shots of dams in progress, signs prohibiting access. Especially needs shots of rivers that are threatened by dams, showing specific stretch to be flooded and dam-builders at work. "No panoramas of river runners taken from up on the bank or the edge of a highway. We must be able to see their faces, front-on shots. We always need photos of the 20 most popular whitewater river runs around the US." Photos purchased with or without accompanying ms. "We are looking for articles on rivers that are in the news regionally and nationally—for example, rivers endangered by damming; access is limited by government decree; rivers being considered for wild and scenic status; rivers offering a setting for unusual expeditions and runs; and rivers having an interest beyond the mere fact that they can be paddled. Also articles interviewing experts in the field about river techniques, equipment and history." Captions required.

Making Contact & Terms: Interested in receiving work from newer, lesser-known photographers. Send material or photocopies of work by mail for consideration. "We need to know of photographers in various parts of the country." Provide tearsheets or photocopies of work to be kept on file for possible future assignments. Uses 5 × 7 and 8 × 10 glossy b&w prints. Vertical format photos needed more than horizontal. Occasional color prints. Query before submitting color transparencies. SASE. Reports in 2 weeks. Pays $30-50/b&w print or color prints or transparencies; $50-150 text/photo package; $35 minimum/interview article. Credit line given. Buys one-time rights. Simultaneous submissions and previously published work OK if labeled clearly as such.

Tips: "Needs more squirt boating photos, photos of women and opening canoeing photos. Looks for close-up action shots of river runners in kayaks, rafts, canoes or dories. Little or no red. Show faces of paddlers. Photos must be clear and sharp. Tell us where the photo was taken—name of river, state and name of rapid, if possible."

CYCLE WORLD MAGAZINE, Dept. PM, 1499 Monrovia Ave., Newport Beach CA 92663. (714)720-5300. Editor-in-Chief: David Edwards. VP/Editorial Director: Paul Dean. Monthly magazine. Circ. 350,000. For active motorcyclists who are "young, affluent, educated and very perceptive." For motorcycle enthusiasts.

Needs: "Outstanding" photos relating to motorcycling. Buys 10 photos/issue. Prefers to buy photos with mss. For Slipstream column see instructions in a recent issue.

Making Contact & Terms: Buys all rights. Send photos for consideration. Pays on publication. Reports in 6 weeks. SASE. Send 8 × 10 glossy prints. "Cover shots are generally done by the staff or on assignment." Uses 35mm color transparencies. Pays $50-100/b&w photo; $150-225/color photo.

Tips: Prefers to buy photos with mss. "Read the magazine. Send us something good. Expect instant harsh rejection. If you don't know our magazine, don't bother us."

DAKOTA OUTDOORS, P.O. Box 669, Pierre SD 57501. (605)224-7301. Fax: (605)224-9210. E-mail: 73613,3456@cis.com. Website: http://7313,3456@compuserve.com. Managing Editor: Rachel Engbrecht. Circ. 6,900. Estab. 1978. Monthly magazine. Emphasizes hunting and fishing in the Dakotas. Readers are sportsmen interested in hunting and fishing, ages 35-45. Sample copy free for 9 × 12 SAE and 3 first-class stamps. Photo guidelines free with SASE.

● All photos for *Dakota Outdoors* are scanned and reproduced digitally. They store photos on CD and do computer manipulation.

Needs: Uses 15-20 photos/issue; 8-10 supplied by freelancers. Needs photos of hunting and fishing. Reviews photos with or without ms. Special photo needs include: scenic shots of sportsmen. Model/property release required. Captions preferred.

Making Contact & Terms: Interested in receiving work from newer, lesser-known photographers. Send 3×5 b&w prints; 35mm b&w transparencies by mail for consideration. Accepts images in digital format for Mac. Send via compact disc, online or Zip disk. Keeps samples on file. SASE. Reports in 3 weeks. Pays $50-150/b&w cover photo; $25-75/b&w inside photo; payment negotiable. Pays on publication. Credit line given. Usually buys one-time rights; negotiable.
Tips: "We want good quality outdoor shots, good lighting, identifiable faces, etc.—photos shot in the Dakotas. Use some imagination and make your photo help tell a story. Photos with accompanying story are accepted."

DANCING USA, 10600 University Ave. NW, Minneapolis MN 55448-6166. (612)757-4414. Fax: (612)757-6605. Editor: Patti P. Johnson. Circ. 20,000. Estab. 1982. Bimonthly magazine. Emphasizes romance of ballroom, Latin and swing dance and big bands, techniques, personal relationships, dance music reviews. Readers are male and female, all backgrounds, with ballroom dancing and band interest, age over 45. Sample copy free with 9×12 SAE and 4 first-class stamps.
Needs: Uses 25 photos/issue; 1-3 supplied by freelancers. Prefer action dancing/band photos. Non-dance competitive clothing, showing romance and/or fun of dancing. Model/property release preferred. Captions preferred; include who, what, when, where, how if applicable.
Making Contact & Terms: Interested in receiving work from newer, lesser-known photographers. Send unsolicited photos by mail for consideration. Send 4×5 matte color or b&w prints. Keeps samples on file. SASE. Reports in 1 month. Pays $50-100/color cover photo; $20/color inside photo; $10/b&w inside photo; $10-50/photo/text package. Pays on publication. Credit line given. Buys one-time rights. Simultaneous submissions and previously published work OK.

DAS FENSTER, 1060 Gaines School Rd., B-3, Athens GA 30605. (706)548-4382. Fax: (706)548-8856. Owner/Business Manager: Alex Mazeika. Circ. 18,000. Estab. 1904. Monthly magazine. Emphasizes general topics written in the German language. Readers are German, ages 35 years plus. Sample copy free with SASE.
Needs: Uses 25 photos/issue; 20-25 supplied by freelancers. Needs photos of German scenics, wildlife and travel. Captions preferred.
Making Contact & Terms: Interested in receiving work from newer, lesser-known photographers. Send unsolicited photos by mail for consideration. Send 4×5 glossy b&w prints. Accepts images in digital format for Mac (TIFF). Send via floppy disk or zip disk (266 dpi). Keeps samples on file. SASE. Reports in 3 weeks. Pays $40/b&w page rate. Pays on publication. Credit line given. Buys one-time rights; negotiable. Previously published work OK.

DEER AND DEER HUNTING, 700 E. State St., Iola WI 54990. (715)445-2214. Editor: Pat Durkin. Distribution 200,000. Estab. 1977. 8 issues/year. Emphasizes white-tailed deer and deer hunting. Readers are "a cross-section of American deer hunters—bow, gun, camera." Sample copy and photo guidelines free with 9×12 SAE with 7 first-class stamps.
Needs: Uses about 25 photos/issue; 20 supplied by freelance photographers. Needs photos of deer in natural settings. Model release and captions preferred.
Making Contact & Terms: Query with résumé of credits and samples. "If we judge your photos as being usable, we like to hold them in our file. It is best to send us duplicates because we may hold the photo for a lengthy period." SASE. Reports in 2 weeks. Pays $500/color cover; $50/b&w inside; $75-250/color inside. Pays within 10 days of publication. Credit line given. Buys one-time rights. Simultaneous submissions and previously published work OK.
Tips: Prefers to see "adequate selection of b&w 8×10 glossy prints and 35mm color transparencies, action shots of whitetail deer only as opposed to portraits. We also need photos of deer hunters in action. We are currently using almost all color—very little b&w. Submit a limited number of quality photos rather than a multitude of marginal photos. Have your name on all entries. Cover shots must have room for masthead."

DEFENDERS, 1101 14th St. NW, Suite 1400, Washington DC 20005. (202)682-9400. Fax: (202)682-1331. Editor: James G. Deane. Circ. 130,000. Membership publication of Defenders of Wildlife. Quarterly magazine. Emphasizes wildlife and wildlife habitat. Sample copy free with 9×12½ SAE and 6 first-class stamps. Photo guidelines free with SASE.
Needs: Uses 35 or more photos/issue; "many" from freelancers. Captions required.
Making Contact & Terms: Query with list of stock photo subjects. In portfolio or samples, wants to see "wildlife group action and behavioral shots in preference to static portraits. High technical quality." SASE. Reports ASAP. Pays $75-450/color photo. Pays on publication. Credit line given. Buys one-time rights.
Tips: "*Defenders* focuses heavily on endangered species and destruction of their habitats, wildlife refuges

and wildlife management issues, primarily North American, but also some foreign. Images must be sharp. Think twice before submitting anything but low speed (preferably Kodachrome) transparencies."

DIRT RIDER, 6420 Wilshire Blvd., Los Angeles CA 90048-5515. (213)782-2390. Fax: (213)782-2372. Editor: Ken Faught. Moto Editor: Don Maeda. Circ. 185,000. Estab. 1982. Monthly magazine. Covers off-road motorcycles, specializing in product tests, race coverage and rider interviews. Readers are predominantly male blue-collar/white-collar, between the ages of 20-35 who are active in motorcycling. Sample copy $3.

Needs: Uses 125 photos/issue; 40 supplied by freelancers. "We need everything: technical photos, race coverage and personality profiles. Most subject matter is assigned. Any photo aside from race coverage or interview needs a release." Captions preferred.

Making Contact & Terms: Interested in receiving work from newer, lesser-known photographers. Phone Ken Faught. Deadlines vary from month to month. Keeps samples on file. Cannot return material. Reports in 2 weeks. Pays $200/color cover photo; $200/b&w cover photo; $50/color inside photo; $25/b&w inside photo; $50/color page rate; $25/b&w page rate. Pays on publication. Credit line given. Simultaneous submissions OK.

Tips: "Familiarize yourself with *Dirt Rider* before submitting photos for review or making initial contact. Pay strict attention to deadlines."

THE DIVER, Dept. PM, P.O. Box 54788, Saint Petersburg FL 33739-4788. (813)866-9856. Publisher/Editor: Bob Taylor. 6 issues/year. Emphasizes springboard and platform diving. Readers are divers, coaches, officials and fans. Circ. 1,500. Sample copy $2 with 9 × 12 SAE and 4 first-class stamps.

Needs: Uses about 10 photos/issue; 30% supplied by freelance photographers. Needs action shots, portraits of divers, team shots and anything associated with the sport of diving. Special needs include photo spreads on outstanding divers and tournament coverage. Captions required.

Making Contact & Terms: Send 4 × 5 or 8 × 10 prints by mail for consideration; "simply query about prospective projects." SASE. Reports in 1 month. Pays $35/cover photo; $5-15/inside photo; $75 for text/photo package. Pays on publication. Credit line given. Buys one-time rights. Simultaneous submissions and previously published work OK.

Tips: "Study the field; stay busy."

DIVERSION MAGAZINE, 1790 Broadway, 6th Floor, New York NY 10019. (212)969-7542. Fax: (212)969-7557. Photo Editor: Ericka Camastro. Circ. 176,000. Monthly magazine. Emphasizes travel. Readers are doctors/physicians. Sample copy free with SASE.

Needs: Uses varying number of photos/issue; all supplied by freelancers. Needs a variety of subjects, "mostly worldwide travel. Hotels, restaurants and people." Model/property release preferred. Captions preferred; include precise locations.

Making Contact & Terms: Interested in receiving work from newer, lesser-known photographers. Query with list of stock photo subjects. Keeps samples on file. SASE. Reports in 3 weeks. Pays $350/color cover photo; $135/quarter color page inside photo; $225/color full page rate; $200-250/day. Pays on publication. Credit line given. Buys one-time rights. Simultaneous submissions and/or previously published work OK.

Tips: "Send updated stock list and photo samples regularly."

DOG FANCY, P.O. Box 6050, Mission Viejo CA 92690. Editor: Betty Liddick. Circ. 270,000. Estab. 1970. Monthly. Readers are "men and women of all ages interested in all phases of dog ownership." Sample copy $5.50; photo guidelines available with SASE.

Needs: Uses 20-30 photos/issue, 100% supplied from freelance stock. Specific breed featured in each issue. Prefers "photographs that show the various physical and mental attributes of the breed. Include both environmental and portrait-type photographs. Dogs must be well groomed and, if purebred, good examples of their breed. By good example, we mean a dog that has achieved some recognition on the show circuit and is owned by a serious breeder or exhibitor. We also have a major need for good-quality, interesting photographs of any breed or mixed breed in any and all canine situations (dogs with veterinarians; dogs eating, drinking, playing, swimming, etc.) for use with feature articles." Model release required. Captions preferred (include dog's name and breed and owner's name and address).

MARKET CONDITIONS are constantly changing! If you're still using this book and it's 1999 or later, buy the newest edition of *Photographer's Market* at your favorite bookstore or order directly from Writer's Digest Books.

Making Contact & Terms: Interested in receiving work from newer, lesser-known photographers. Send by mail for consideration actual 35mm or 2¼×2¼ color transparencies. Present a professional package: 35mm slides in sleeves, labeled, numbered or otherwise identified; a run sheet listing dog's name, titles (if any) and owner's name; and a return envelope of the appropriate size with the correct amount of postage. Reports in 6 weeks. Pays $50-75/color photo; $100-400 per text/photo package. Credit line given. Buys first North American print rights and non-exclusive rights to use electronic media.

Tips: "Nothing but sharp, high contrast shots. Send SASE for list of photography needs. We're looking more and more for good quality photo/text packages that present an interesting subject both editorially and visually. Bad writing can be fixed, but we can't do a thing with bad photos. Subjects should be in interesting poses or settings with good lighting, good backgrounds and foregrounds, etc. We are very concerned with sharpness and reproducibility; the best shot in the world won't work if it's fuzzy, and it's amazing how many are. Submit a variety of subjects—there's always a chance we'll find something special we like."

DOLL READER, Cowles Magazines, 6405 Flank Dr., Harrisburg PA 17112. (717)540-6656. Fax: (717)540-6169. Managing Editor: Deborah Thompson. Estab. 1972. Magazine published 9 times/year. Emphasizes doll collecting. Photo guidelines free with SASE.

Needs: Buys 100-250 photos/year; 50 photos/year supplied by freelancers. "We need photos of specific dolls to accompany our articles." Model/property release required. Captions required; include name of object, height, medium, edition size, costume and accessory description; name, address, telephone number of artist or manufacturer; price.

Making Contact & Terms: Interested in receiving work from newer, lesser-known photographers. Send unsolicited photos by mail for consideration. Provide résumé, business card, brochure, flier or tearsheets to be kept on file for possible assignments. Submit portfolio for review. Query with stock photo list. Query with sample. Send 3½×5 glossy color prints; 35mm, 2¼×2¼, 4×5 transparencies. Transparencies are preferred. Keeps samples on file. SASE. Reports in 1 month. Payment negotiable. "If photos are accepted, we pay on receipt of invoice." Credit line given. Buys all rights. Simultaneous submissions OK.

THE DOLPHIN LOG, 777 United Nations Plaza, New York NY 10017. (212)949-6290. Fax: (212)949-6296. Editor: Lisa Rao. Circ. 80,000. Estab. 1981. Publication of The Cousteau Society, Inc., a nonprofit organization. Bimonthly magazine. Emphasizes "ocean and water-related subject matter for children ages 8 to 12." Sample copy $2.50 with 9×12 SAE and 3 first-class stamps. Photo guidelines free with SASE.

Needs: Uses about 20 photos/issue; 2-6 supplied by freelancers; 10% stock. Needs "selections of images of individual creatures or subjects, such as architects and builders of the sea, how sea animals eat, the smallest and largest things in the sea, the different forms of tails in sea animals, resemblances of sea creatures to other things. Also excellent potential for cover shots or images which elicit curiosity, humor or interest." No aquarium shots. Model release required if person is recognizable. Captions preferred, include when, where and, if possible, scientifically accurate identification of animal.

Making Contact & Terms: Query with samples or list of stock photos. Send 35mm, 4×5 transparencies or b&w contact sheets by mail for consideration. Send duplicates only. SASE. Reports in 1 month. Pays $75-200/color photo. Pays on publication. Credit line given. Buys one-time rights and worldwide translation rights. Simultaneous and previously published submissions OK.

Tips: Prefers to see "rich color, sharp focus and interesting action of water-related subjects" in samples. "No assignments are made. A large amount is staff-shot. However, we use a fair amount of freelance photography, usually pulled from our files, approximately 45-50%. Stock photos purchased only when an author's sources are insufficient or we have need for a shot not in file. These are most often hard-to-find creatures of the sea." To break in, "send a good submission of dupes in keeping with our magazine's tone/content; be flexible in allowing us to hold slides for consideration."

DOUBLETAKE MAGAZINE, 1317 W. Pettigrew St., Durham NC 27705. (919)660-3669. Fax: (919)660-3668. E-mail: dtmag@aol.com. Assistant Editor: Caroline Nasrallah. Circ. 35,000. Estab. 1995. Quarterly magazine covering all writing (fiction, nonfiction and poetry) and photography, mostly documentary. General interest, 18 and over. Sample copy for $12. Photo guidelines free with SASE.

Needs: Uses photos on approximately half of the pages (50+ pages/issue); 80% supplied by freelancers. Needs completed photo essays. "We also accept works in progress and some proposals for projects. We are usually interested in work that is in the broad photo-journalistic/humanistic tradition." Model release preferred for children. Captions preferred; date and location are helpful, but not necessary.

Making Contact & Terms: Interested in receiving work from newer, lesser-known photographers. Send unsolicited photos by mail for consideration. Send SASE for guidelines. "We prefer copy slides, no more than 40." Send 35mm transparencies. "We have an ongoing review process. We do not keep samples from every photographer." Keeps samples on file. SASE. Reports in 8-9 weeks usually (varies). Pays $250/full published page; $125/half page; etc. Minimum is $75. Pays on publication. Credit line given. Buys first North American serial rights. Simultaneous submissions OK.

DOWN BEAT MAGAZINE, Dept. PM, Jazz Blues & Beyond, 102 N. Haven Rd., Elmhurst IL 60126. (630)941-2030. Editorial Director: Frank Alkyer. Monthly. Emphasizes jazz musicians. Circ. 90,000. Estab. 1934. Sample copy available for SASE.

Needs: Uses about 30 photos/issue; 95% supplied by freelancers. Needs photos of live music performers/posed musicians/equipment, "primarily jazz and blues." Captions preferred.

Making Contact & Terms: Query with list of stock photo subjects; send 8×10 b&w prints; 35mm, 2¼×2¼, 4×5, 8×10 transparencies; b&w or color contact sheets by mail. Unsolicited samples for consideration will not be returned unless accompanied by SASE. Provide résumé, business card, brochure, flier or tearsheets to be kept on file for possible future assignments. "Send us two samples of your best work and a list of artists photographed." Reports only when needed. Pays $35/b&w photo; $75/color photo; $175/complete job. Credit line given. Buys one-time rights. Simultaneous submissions and previously published work OK.

Tips: "We prefer live shots and interesting candids to studio work."

DUCKS UNLIMITED, One Waterfowl Way, Memphis TN 38120. (901)758-3825. Photo Editor: Diane Jolie. Circ. 580,000. Estab. 1937. Association publication of Ducks Unlimited, a nonprofit organization. Bimonthly magazine. Emphasizes waterfowl conservation. Readers are professional males, ages 40-50. Sample copy $3. Guidelines free with SASE.

Needs: Uses approximately 60 photos/issue; 60% supplied by freelance photographers. Needs images of wild ducks and geese, waterfowling and scenic wetlands. Special photo needs include dynamic shots of waterfowl interacting in natural habitat.

Making Contact & Terms: Send only top quality portfolio of not more than 40 35mm or larger transparencies for consideration. SASE. Reports in 1 month. Pays $100 for images less than half page; $125/half page; $150/full page; $225/2-page spread; $400/cover photo. **Pays on acceptance.** Credit line given. Buys one-time rights plus permission to reprint in our Mexican and Canadian publications. Previously published work OK, if noted.

DUNE BUGGIES AND HOT VWS MAGAZINE, P.O. Box 2260, Costa Mesa CA 92628. (714)979-2560. Fax: (714)979-3998. Editor: Bruce Simurda. Circ. 92,000. Estab. 1967. Monthly magazine. Emphasizes Volkswagen features, technical, how-to, race events and reports, product information relating to VWs. Readers are male and female, ages 18-65, seeking general VW-related information. Sample copy $6. Photo guidelines free with SASE.

Needs: Uses 150 photos/issue; 20 supplied by freelancers. Needs photos of feature cars, technical/how-to articles and event coverage. Special photo needs include photos relating to new/cutting edge VW news and/or production of VW automobiles worldwide. Model release required; models must be over 18 years old and photos must be accompanied by a signed release form. Captions preferred.

Making Contact & Terms: Interested in receiving work from newer, lesser-known photographers. Send unsolicited photos by mail for consideration. Provide résumé, business card, brochure, flier or tearsheets to be kept on file for possible future assignments. Send 5×7 glossy b&w prints; 35mm, 2¼×2¼, 4×5 transparencies. Accepts images in digital format for Mac (TIFF). Send via compact disc, floppy disk, SyQuest. Deadlines: 10th of each month, 3 months preceeding cover date. Keeps samples on file. SASE. Reports in 2-4 weeks. Pays $125-150/color page; $125-150/b&w page. Higher rates available depending on quality. Credit line given. Buys one-time rights.

Tips: "We will not accept photos of any vehicle used in careless, dangerous, illegal or other unsafe manner."

E MAGAZINE, 28 Knight St., Dept. PM, Norwalk CT 06851. (203)854-5559. Fax: (203)866-0602. E-mail: emagazine@prodigy.com. Photo Editor: Tracey Rembert. Circ. 70,000. Estab. 1990. Nonprofit consumer magazine. Emphasizes environmental issues. Readers are environmental activists; people concerned about the environment. Sample copy for 9×12 SAE and $5. Photo guidelines free with SASE.

Needs: Uses 42 photos/issue; 55% supplied by freelancers. Needs photos of threatened landscapes, environmental leaders, people and the environment and coverage of when environmental problem figures into background of other news. Model and/or property release preferred. Photo captions required: location, identities of people in photograph, date, action in photograph.

Making Contact & Terms: Query with résumé of credits and list of stock photo subjects. Keeps printed samples on file. Reports in 6 weeks. Pays free—$150/color photo; negotiable. Pays several weeks after publication. Credit line given. Buys one-time rights. Simultaneous submissions and previously published work OK.

Tips: Wants to see "straightforward, journalistic images. Abstract or art photography or landscape photography is not used." In addition, "please do not send manuscripts with photographs. These can be addressed as queries to the managing editor."

EARTH MAGAZINE, 21027 Crossroads Circle, Waukesha WI 53186-4055. (414)796-8776. Fax: (414)796-1142. E-mail: dpinkalla@earthmag.com. Website: http://www.earthmag.com. Editorial Assistant: Diane Pinkalla. Circ. 96,000. Estab. 1992. Bimonthly magazine. Emphasizes earth science for general audience. Sample copy $6.95 ($3.95 plus $3 shipping and handling). Photo guidelines free with SASE for amateurs.
Needs: Uses 70 photos/issue; 25% supplied by freelancers. Needs photos of earth science: landforms, air and water phenomena, minerals, fossils, researchers at work, geologic processes. Model/property release preferred. Captions required; include location, feature and date.
Making Contact & Terms: Interested in receiving work from newer, lesser-known photographers. Send stock list and samples for file. Accepts images in digital format for Mac. Send via Zip disk. Pays $25-200/ color or b&w inside photo. Pays on publication. Credit line given. Buys one-time rights. Previously published work OK.
Tips: Wants to see excellent technical quality in photos of real earth science, not just pretty pictures.

EASTERN CHALLENGE, P.O. Box 14866, Reading PA 19612-4866. (610)375-0300. Fax: (610)375-6862. E-mail: osborne@imi.org. Editor: Dr. Osborne Buchanan, Jr. Circ. 22,000. Estab. 1967. Publication of the International Missions, Inc. Quarterly magazine. Emphasizes "church-planting ministry in a number of countries." Sample copy free with SASE.
 • *Eastern Challenge* is beginning to use photos that are available on CD-ROM discs.
Needs: Uses 2 + photos/issue. Needs photos of scenics and personalties. Reviews photos with or without accompanying ms. Model/property release preferred. Captions preferred.
Making Contact & Terms: Send unsolicited photos by mail for consideration. Provide résumé, business card, brochure, flier or tearsheets to be kept on file for possible assignments. Accepts images in digital format for Windows (TIFF, GIF, JPEG). Send via compact disc, floppy disk, SyQuest, Zip disk. Keeps samples on file. SASE. Reports in 1 month. Pays "minimal or nominal amount; organization is nonprofit." Pays on publication. Credit line given. Buys all rights; negotiable. Simultaneous submissions and/or previously published work OK. Would consider using photographers as interns. Contact Editor: Dr. Osborne Buchanan, Jr.
Tips: Looks for "color and contrast; relevance to program of organization."

EASYRIDERS MAGAZINE, Dept. PM, P.O. Box 3000, Agoura Hills CA 91376-3000. (818)889-8740. Fax: (818)889-1252. Editorial Director: Keith R. Ball. Estab. 1971. Monthly. Emphasizes "motorcycles (Harley-Davidsons in particular), motorcycle women, bikers having fun." Readers are "adult men who own, or desire to own, custom motorcycles—the individualist—a rugged guy who enjoys riding a custom motorcycle and all the good times derived from it." Free sample copy. Photo guidelines free with SASE.
Needs: Uses about 60 photos/issue; "the majority" supplied by freelance photographers; 70% assigned. Needs photos of "motorcycle riding (rugged chopper riders), motorcycle women, good times had by bikers, etc." Model release required. Also interested in technical articles relating to Harley-Davidsons.
Making Contact & Terms: Send b&w prints, color prints, 35mm transparencies by mail for consideration. SASE. Call for appointment for portfolio review. Reports in 3 months. Pays $30-100/b&w photo; $40-250/color photo; $30-2,500/complete package. Other terms for bike features with models to satisfaction of editors. For usage on cover, gatefold and feature. Pays 30 days after publication. Credit line given. Buys all rights. All material must be exclusive.
Tips: Trend is toward "more action photos, bikes being photographed by photographers on bikes to create a feeling of motion." In samples, wants photos "clear, in-focus, eye-catching and showing some emotion. Read magazine before making submissions. Be critical of your own work. Check for sharpness. Also, label photos/slides clearly with name and address."

EDUCATIONAL LEADERSHIP MAGAZINE, 1250 N. Pitt St., Alexandria VA 22314. (703)549-9110, ext. 430. Fax: (703)299-8637. E-mail: judiconnelly@ascd@ccmail.ascd.org. Designer: Judi Connelly. Circ. 200,000. Publication of the Association for Supervision and Curriculum Development. Magazine; 8 issues/year. Emphasizes schools and children, especially grade school and high school levels, classroom activities. Readers are teachers and educators worldwide.
Needs: Uses 30-40 photos/issue; all supplied by freelancers. Model release required. Property release preferred. Captions preferred.
Making Contact & Terms: Interested in receiving work from newer, lesser-known photographers. Provide résumé, business card, brochure, flier or tearsheets to be kept on file for possible future assignments. Send all size glossy b&w prints; 35mm, 2¼×2¼, 4×5 transparencies. Accepts images in digital format for Photoshop. Send via compact disc, floppy disk, SyQuest. Nonreturnable samples only. Keeps samples on file. Cannot return material. Reports in 3 weeks. Pays $50/b&w photo; $100/color photo; $400/day minimum. Pays on publication. Buys one-time rights. Simultaneous submissions and previously published work OK.

ENERGY TIMES, 548 Broad Hollow Rd., Melville NY 11747. (516)777-7773. Fax: (516)293-0349. Art Director: Ed Canavan. Circ. 600,000. Estab. 1992. Published 10 times/year. Emphasizes health food industry. Readers are 72% female, 28% male, average age 42.3, interested in supplements and alternative health care, exercise 3.2 times per week. Sample copy $1.25.

Needs: Uses 25 photos/issue; 5 supplied by freelancers. Needs photos of herbs, natural lifestyle, food. Model/property release required. Captions preferred.

Making Contact & Terms: Interested in receiving work from newer, lesser-known photographers. Provide résumé, business card, brochure, flier or tearsheets to be kept on file for possible assignments. Deadlines ongoing. Keeps samples on file. SASE. Reports in 2 weeks. Pays $275/color cover photo; $85/color inside photo; "inside rates negotiable based on size." Pays on publication. Rights negotiable. Previously published work OK.

Tips: "Photos must clearly illustrate the editorial context. Photos showing personal energy are highly regarded. Sharp, high-contrast photos are the best to work with. Bright but non-tacky colors will add vibrance to a publication. When shooting people, the emotion captured in the subject's expression is often as important as the composition."

ENVIRONMENT, Dept. PM, 1319 18th St. NW, Washington DC 20036. (202)296-6267. Fax: (202)296-5149. Editor: Barbara T. Richman. Editorial Assistant: Nathan Borchelt. Circ. 12,500. Estab. 1958. Magazine published 10 times/year. Covers science and science policy from a national, international and global perspective. "We cover a wide range of environmental topics—acid rain, tropical deforestation, nuclear winter, hazardous waste disposal, energy topics and environmental legislation." Readers include libraries, colleges and universities and professionals in the field of environmental science and policy. Sample copy $7.

Needs: Uses 15 photos/issue; varying number supplied by freelance photographers; 90% comes from stock. "Our needs vary greatly from issue to issue—but we are always looking for good photos showing human impact on the environment worldwide—industrial sites, cities, alternative energy sources, pesticide use, disasters, third world growth, hazardous wastes, sustainable agriculture and pollution. Interesting and unusual landscapes are also needed." Model release required. Captions required, include location and subject.

Making Contact & Terms: Interested in receiving work from newer, lesser-known photographers. Query with list of stock photo subjects. Provide business card, brochure, flier or tearsheets to be kept on file for possible future assignments. Pays $50-150/b&w photo; $50-300/color photo; $350/color cover photo. Pays on publication. Credit line given. Buys one-time rights. Simultaneous submissions and previously published work OK.

Tips: "We are looking for international subject matter—especially environmental conditions in developing countries. Provide us with a stock list, and if you are going someplace specific to shoot photos let us know. We might have some specific request."

ESQUIRE, The Hearst Corporation, 250 W. 55th St., New York NY 10019. (212)649-4050. Fax: (212)265-0938. Monthly magazine. *Esquire* is edited with a journalistic focus on how a man lives and the way he thinks. In its coverage of men's interests and their leisure pursuits, matters of style and fashion, culture and personalities, business and politics, and travel and entertaining are examined. This magazine did not respond to our request for information. Query before submitting.

EVANGELIZING TODAY'S CHILD, Child Evangelism Fellowship Inc., P.O. Box 348, Warrenton MO 63383. (314)456-4321. Fax: (314)456-2078. Editor: Mrs. Elsie Lippy. Circ. 20,000. Estab. 1975. Bimonthly magazine. Written for people who work with children, ages 5-12, in Sunday schools, Bible clubs and camps. Sample copy for $2. Photo guidelines free with SASE.

Needs: Buys 1-4 photos/issue; 20% from freelance asssignment; 80% from freelance stock. Children, ages 6-11; unique, up-to-date. Candid shots of various moods and activities. If full color, needs to include good color combination. "We use quite a few shots with more than one child and some with an adult, mostly closeups. The content emphasis is upon believability and appeal. Religious themes may be especially valuable." No nudes, scenery, fashion/beauty, glamour or still lifes.

Making Contact & Terms: Prefers to retain good-quality photocopies of selected glossy prints and duplicate slides in files for future use. Send material by mail with SASE for consideration; 35mm or larger transparencies. Publication is under no obligation to return materials sent without SASE. Pays on a per-photo basis. Pays $45 minimum/color inside photo; $125/color cover shot. Credit line given. Buys one-time rights. Simultaneous submissions and previously published work OK.

‡♥**EVENT**, Douglas College, Box 2503, New Westminster, British Columbia V3L 5B2 Canada. (604)527-5293. Fax: (604)527-5095. Editor: Calvin Wharton. Visuals Editor: Ken Hughes. Circ. 1,000. Magazine published every 4 months. Emphasizes literature (short stories, reviews, poetry). Sample copy $5.

Needs: Buys 3 photos/year intended for cover art. Documentary, fine art, human interest, nature, special effects/experimental, still life and travel. Wants any "nonapplied" photography, or photography not intended for conventional commercial purposes. Needs excellent quality. Must be a series. "No unoriginal, commonplace or hackneyed work."

Making Contact & Terms: Send material by mail for consideration. Send 8×10 color or b&w prints. Any smooth finish OK. Vertical format preferred for cover. SAE and IRC or Canadian stamps. Pays $100 on publication. Credit line given. Buys one-time rights. Simultaneous submissions OK.

Tips: "We prefer work that appears as a sequence: thematically, chronologically, stylistically. Individual items will only be selected for publication if such a sequence can be developed. Photos should preferably be composed for vertical, small format (6×9)."

FACES: The Magazine About People, Cobblestone Publishing Inc., 7 School St., Peterborough NH 03458. (603)924-7209. Fax: (603)924-7380. Editor: Lynn L. Sloneker. Circ. 13,500. Estab. 1984. 9 issues/year, September-May. Emphasizes cultural anthropology for young people ages 8-14. Sample copy $4.50 with 8×11 SASE and 5 first-class stamps. Photo guidelines free with SASE.

Needs: Uses about 30-35 photos/issue; about 75% supplied by freelancers. "Photos (color) for text must relate to themes; cover photos (color) should also relate to themes." Send SASE for themes. Photos purchased with or without accompanying ms. Model release preferred. Captions preferred.

Making Contact & Terms: Query with stock photo list and/or samples. SASE. Reports in 1 month. Pays $15-100/inside use; cover (color) photos negotiated. Pays on publication. Credit line given. Buys one-time rights. Simultaneous submissions and previously published work OK.

Tips: "Photographers should request our theme list. Most of the photographs we use are of people from other cultures. We look for an ability to capture people in action—at work or play. We primarily need photos showing people, young and old, taking part in ceremonies, rituals, customs and with artifacts and architecture particular to a given culture. Appropriate scenics and animal pictures are also needed. All submissions must relate to a specific future theme."

FAMILY CIRCLE, Gruner & Jahr USA Publishing, 375 Lexington Ave., New York NY 10017-5514. (212)499-2000. Fax: (212)463-1595. *Family Circle* is written for contemporary women, providing information on issues ranging from financial planning to food, from health to beauty and fashion to planning the perfect family outing. This magazine did not respond to our request for information. Query before submitting.

FAMILY MOTOR COACHING, Dept. PM, 8291 Clough Pike, Cincinnati OH 45244. (513)474-3622. Editor: Pamela Wisby Kay. Circ. 104,000. Estab. 1963. Publication of Family Motor Coach Association. Monthly. Emphasizes motor homes. Readers are members of national association of motor home owners. Sample copy $2.50. Writer's/photographer's guidelines free with SASE.

Needs: Uses about 45-50 photos/issue; 40-45 supplied by freelance photographers. Each issue includes varied subject matter—primarily needs travel and scenic shots and how-to material. Photos purchased with accompanying ms only. Model release preferred. Captions required.

Making Contact & Terms: Query with résumé of credits. SASE. Reports in 2 months. Pays $100-500/text/photo package. **Pays on acceptance.** Credit line given if requested. Prefers first North American rights, but will consider one-time rights on photos *only*.

‡FAMILY PUBLISHING GROUP, INC., 141 Halstead Ave., Mamaroneck NY 10543. (914)381-7474. Fax: (914)381-7672. E-mail: fpg@family.com. Senior Editor: Betsy F. Woolf. Circ. 155,000. Estab. 1986. Monthly magazine. Emphasizes parenting. Also publishes *New York Family, Westchester Family* and *Connecticut Family*. Readers are women, ages 25-50. Sample copy $3.50 with 8½×11 SASE.

Needs: Uses 10 photos/issue; 3-5 supplied by freelancers. Needs photos of children, families, depends on subject. Model release required. Photographers need to identify subjects on occasion, but rarely need captions.

Making Contact & Terms: Interested in receiving work from newer, lesser-known photographers. Query with stock photo list. Provide résumé, business card, brochure, flier or tearsheets to be kept on file for possible assignments. Send 5×7 matte or glossy color and b&w prints; digital format (Mac disc). Deadlines: 6 weeks prior to date of publication. Reporting time varies. Pays $40/color inside photo; $25-40/b&w inside photo. Pays on publication. Credit line given. Buys one-time rights with exclusivity for 2 years within readership area; negotiable.

FARM & RANCH LIVING, 5400 S. 60th St., Greendale WI 53129. (414)423-0100. Fax: (414)423-8463. Associate Editor: Trudi Bellin. Estab. 1978. Bimonthly magazine. "Concentrates on farming and ranching as a way of life." Readers are full-time farmers and ranchers. Sample copy $2. Photo guidelines free with SASE.

Needs: Uses about 130 photos/issue; about 25% from freelance stock; 45% assigned. Needs agricultural and scenic photos. "We assume you have secured releases. If in question, don't send the photos." Captions should include season, location.

Making Contact & Terms: Interested in receiving work from newer, lesser-known photographers. Query with samples or list of stock photo subjects. Send 35mm, 2¼×2¼, 4×5, 8×10 transparencies by mail for consideration. SASE. "We only want to see one season at a time; we work one season in advance." Reports within 3 months. Pays $300/color cover photo; $75-150/color inside photo; $150/color page (full-page bleed); $50-100/b&w photo. Pays on publication. Buys one-time rights. Previously published work OK.

Tips: "Technical quality extremely important. Colors must be vivid so they pop off the page. Study our magazines thoroughly. We have a continuing need for sharp, colorful images. Those who supply what we need can expect to be regular contributors."

FELLOWSHIP, Box 271, Nyack NY 10960. (914)358-4601. Fax: (914)358-4924. Editor. Richard Deats. Circ. 8,500. Estab. 1935. Publication of the Fellowship of Reconciliation. Publishes 32-page b&w magazine 6 times/year. Emphasizes peace-making, social justice, nonviolent social change. Readers are religious peace fellowships—interfaith pacifists. Sample copy free with SASE.

Needs: Uses 8-10 photos/issue; 90% supplied by freelancers. Needs stock photos of people, monuments, civil disobedience, demonstrations—Middle East, Latin America, Caribbean, prisons, anti-nuclear, children, farm crisis, gay/lesbian, the former Soviet Union. Also natural beauty and scenic; b&w only. Captions required.

Making Contact & Terms: Provide résumé, business card, brochure, flier or tearsheets to be kept on file for possible future assignments. "Call on specs." SASE. Reports in 3 weeks. Pays $27/b&w cover photo; $15/b&w inside photo. Pays on publication. Credit line given. Buys one-time rights. Simultaneous submissions and/or previously published work OK.

Tips: "You must want to make a contribution to peace movements. Money is simply token (our authors contribute without tokens)."

‡50/50 MAGAZINE, Wendy Jill York Productions, 2336 Market St., Suite 20, San Francisco CA 94114. (415)861-8210. Fax: (415)621-1703. E-mail: fift50mag@aol.com. Editor-in-Chief: Wendy Jill York. Circ. 20,000. Estab. 1995. Quarterly magazine. Emphasizes arts and entertainment, including gay and lesbian material. Readers are male and female, ages 25-45, who like arts and entertainment and are alternative in interests. Sample copy $6. Photo guidelines free with SASE.

Needs: Uses 30 photos/issue; all supplied by freelancers or PR firms. Needs photos of personalities. Model release required. Property release preferred. Captions preferred; include location of shot and names of persons in photo and clothing if it is a fashion shot.

Making Contact & Terms: Send unsolicited photos by mail for consideration. Provide résumé, business card, brochure, flier or tearsheets to be kept on file for possible assignments. Send color or b&w prints or contact sheets; 35mm, 2¼×2¼ transparencies; digital format (Mac Photoshop or Quark). Keeps samples on file. SASE. Reports in 1 month. Pays $100/color cover photo; $40/color inside photo; $25/b&w inside photo; $35/b&w page. Also offers ad trade and special promotion exposure opportunities. Pays on publication. Credit line given. Buys one-time rights; negotiable. Simultaneous submissions OK.

Tips: "If a photographer is very knowledgeable in Photoshop, it insures that the photos turned in on SyQuest reproduce the way the artist intends. It's very important to have tearsheets in your portfolio. Persevere."

FINE GARDENING, 63 S. Main St., P.O. Box 5506, Newtown CT 06470. (203)426-8171. Fax: (203)426-3434. Editor: LeeAnne White. Circ. 200,000. Estab. 1988. Bimonthly magazine. Emphasizes gardening. Readers are male and female gardeners, all ages (30-60 mostly). Sample copy $5. Photo guidelines free with SASE.

Needs: Uses 80 photos/issue; 20-30 supplied by freelancers on assignment basis. A few stock photos purchased.

Making Contact & Terms: Contact before sending portfolio for review. If you have an extensive holding of horticultural stock photos, send stock list. Photographers paid day rate upon completion of assignment. Pays $50-300 upon publication for stock photos. Credit line given. Buys one-time rights for stock photos.

FINESCALE MODELER, 21027 Crossroads Circle, P.O. Box 1612, Waukesha WI 53187-1612. (414)796-8776. Fax: (414)796-1383. E-mail: rhayden@finescale.com. Website: http://www.finescale.com. Editor: Bob Hayden. Photo Editor: Paul Boyer. Circ. 80,000. Published 10 times/year. Emphasizes "how-to-do-it information for hobbyists who build nonoperating scale models." Readers are "adult and juvenile hobbyists who build nonoperating model aircraft, ships, tanks and military vehicles, cars and figures." Sample copy $3.95. Photo guidelines free with SASE.

Needs: Uses more than 50 photos/issue; "anticipates using" 10 supplied by freelance photographers. Needs "in-progress how-to photos illustrating a specific modeling technique; photos of full-size aircraft, cars, trucks, tanks and ships." Model release required. Captions required.

Making Contact & Terms: Provide résumé, business card, brochure, flier or tearsheets to be kept on file for possible future assignments. "Phone calls are OK." Reports in 2 months. Pays $25 minimum/color cover photo; $8 minimum inside photo; $40/page; $50-500 for text/photo package. Pays for photos on publication, **for text/photo package on acceptance**. Credit line given. Buys all rights. "Will sometimes accept previously published work if copyright is clear."

Tips: Looking for "sharp contrast prints or slides of aircraft, ships, cars, trucks, tanks, figures, and science-fiction subjects. In addition to photographic talent, must have comprehensive knowledge of objects photographed and provide complete caption material. Freelance photographers should provide a catalog stating subject, date, place, format, conditions of sale and desired credit line before attempting to sell us photos. We're most likely to purchase color photos of outstanding models of all types for our regular feature, 'Showcase.' "

‡FIRST HAND LTD., P.O. Box 1314, Teaneck NJ 07666. (201)836-9177. Fax: (201)836-5055. E-mail: firsthand3@aol.com. Editor: Bob Harris. Circ. 60,000. Estab. 1980. Monthly digest. Emphasizes gay erotica and stories and letters from readers. Readers are male, gay, wide range of ages. Sample copy $5. Photo guidelines free with SASE.

Needs: Uses 1 photo/issue; all supplied by freelancers. Needs erotic male photographs for covers. "No full-frontal nudity. We especially need photos with an athletic theme." Model release required. "We need proof of age with all model releases, preferably a copy of a driver's license." Captions preferred; include model's name.

Making Contact & Terms: Send unsolicited photos by mail for consideration. Send 35mm transparencies. Does not keep samples on file. Reports in 1 month. Pays $150/color cover photo. Pays on publication. Credit line given. Buys all rights; negotiable. Previously published work OK.

FIRST OPPORTUNITY, 3100 Broadway, Suite 660, Kansas City MO 64111. (816)960-1988. Fax: (816)960-1989. Editor: Neoshia Michelle Paige. Circ. 500,000. Semi-annual magazine. Emphasizes advanced vocational/technical education opportunities, career prospects. Readers are African-American, Hispanic, ages 16-22. Sample copy free with 9×12 SAE and 4 first-class stamps.

Needs: Uses 30 photos/issue. Needs photos of students in class, at work, in vocational/technical training, in health field, in computer field, in technology, in engineering, general interest. Model/property release required. Captions required; include name, age, location, action.

Making Contact & Terms: Interested in receiving work from newer, lesser-known photographers. Query with résumé of credits. Query with ideas and SASE. Reports in 1 month, "usually less." Pays $10-50/color photo; $5-25/b&w inside photo. Pays on publication. Buys first North American serial rights. Simultaneous submissions and/or previously published work OK.

FLORIDA KEYS MAGAZINE, 3299 SW Ninth Ave., P.O. Box 22748, Ft. Lauderdale FL 33335-2748. (954)764-0604. Fax: (954)760-9949. Art Director: Callie Pyle. Circ. 10,000. Estab. 1978. Bimonthly magazine. Emphasizes Florida Keys lifestyle. Readers are male and female, Keys residents and frequent visitors, ages 30-55. Sample copy free with 9×12 SAE and 3 first-class stamps. Photo guidelines free with SASE.

Needs: Uses 20-30 photos/issue; 20% supplied by freelancers. Needs photos of wildlife, scenic, personalities, food, architecture, sports. Special photo needs include holiday and special event locations in the Keys. Model/property release preferred. Captions required; include location, names of subjects.

Making Contact & Terms: Interested in receiving work from newer, lesser-known photographers. Send unsolicited photos by mail for consideration. Send any size color or b&w prints; 35mm, 2¼×2¼, 4×5, 8×10 transparencies. Keeps samples on file. SASE. Reports in 1 month. Pays $50/color cover photo; $25/color inside photo; $25/b&w inside photo. Pays on publication. Credit line given. Buys one-time rights; negotiable. Simultaneous submissions and/or previously published work OK.

Tips: Wants to see a "fresh viewpoint on familiar subjects."

FLORIDA MARINER, P.O. Box 1220, Venice FL 34284. (941)488-9307. Fax: (941)488-9309. Publisher: Ken Brothwell. Editor: Stacey Fulgieri. Circ. 25,000. Estab. 1984. Biweekly tabloid. Readers are recreational boaters, both power and sail. Sample copy free with 9×12 SAE and 7 first-class stamps.

Needs: Uses cover photo each issue—26 a year; 100% supplied by freelance photographers. Needs photos of boating related fishing, water skiing, racing and shows. Use of swimsuit-clad model or fisherman with boat preferred. All photos must have *vertical* orientation to match our format. Model release required. Captions preferred.

Making Contact & Terms: Interested in receiving work from newer, lesser-known photographers. Send

35mm transparencies by mail for consideration. SASE. Reports in 2 weeks. Pays $50/color cover photo. **Pays on acceptance.** Credit line optional. Rights negotiable. May use photo more than once for cover. Simultaneous submissions and previously published work OK.

Tips: "We are willing to accept outtakes from other assignments which is why we pay only $50. We figure that is better than letting an unused shot go to waste or collect dust in the drawer."

FLORIDA WILDLIFE, 620 S. Meridian St., Tallahassee FL 32399-1600. (904)488-5563. Fax: (904)488-6988. Editor: Dick Sublette. Circ. 29,000. Estab. 1947. Publication of the Florida Game & Fresh Water Fish Commission. Bimonthly magazine. Emphasizes wildlife, hunting, fishing, conservation. Readers are wildlife lovers, hunters and fishermen. Sample copy $2.95. Photo guidelines free with SASE.

Needs: Uses about 20-40 photos/issue; 75% supplied by freelance photojournalists. Needs Florida fishing and hunting, all flora and fauna of Southeastern US; how-to; covers and inside illustration. Do not feature products in photographs. No alcohol or tobacco. Special needs include hunting and fishing activities in Florida scenes; showing ethical and enjoyable use of outdoor resources. "Must be able to ID species and/or provide accurate natural history information with materials." Model release preferred. Captions required; include location and species.

Making Contact & Terms: Interested in receiving work from newer, lesser-known photographers. Query with samples. Send 35mm color transparencies by mail for consideration. "Do not send negatives." SASE. Keeps materials on file, or will review and return if requested. Pays $50-75/color back cover; $100/color front cover; $20-50/color inside photos. Pays on publication. Credit line given. Buys one-time rights; "other rights are sometimes negotiated." Simultaneous submissions OK "but we prefer originals over duplicates." Previously published work OK but must be mentioned when submitted.

Tips: "Study back issues to determine what we buy from freelancers (no saltwater species as a rule, etc.) Use flat slide mounting pages or individual sleeves. Show us your best. Annual photography contest often introduces us to good freelancers. Rules printed in March-April issue. Contest form must accompany entry; available in magazine or by writing/calling; winners receive honorarium and winning entries are printed in September-October and November-December issues."

FLOWER AND GARDEN MAGAZINE, 700 W. 47th St., Suite 310, Kansas City MO 64112. (816)531-5730. Fax: (816)531-3873. Staff Editor: Brent Shepherd. Executive Editor: Doug Hall. Estab. 1957. "We publish 6 times a year and require several months of lead time." Emphasizes home gardening. Readers are male and female homeowners with a median age of 47. Sample copy $4. Photo guidelines free with SASE.

Needs: Uses 25-50 photos/issue; 75% supplied by freelancers. "We purchase a variety of subjects relating to home lawn and garden activities. Specific horticultural subjects must be accurately identified."

Making Contact & Terms: Interested in receiving work from newer, lesser-known photographers. To make initial contact, "Do not send great numbers of photographs, but rather a good selection of 1 or 2 specific subjects. We do not want photographers to call. We return photos by certified mail—other means of return must be specified and paid for by the individual submitting them. It is not our policy to pay holding fees for photographs." Pays $25-100/b&w photo; $100-200/inside usage; $300-500/color photo. Pays on publication. Buys one-time and non-exclusive reprint rights. Model/property release preferred. Captions preferred; please provide exact name of plant (botanical), variety name and common name.

Tips: Wants to see "clear shots with crisp focus. Also, appealing subject matter—good lighting, technical accuracy, depictions of plants in a home garden setting rather than individual close-ups. Let us know what you've got, we'll contact you when we need it. We see more and more freelance photographers trying to have their work published. In other words, supply is greater than demand. Therefore, a photographer who has too many conditions and provisions will probably not work for us."

FLY FISHERMAN, Cowles Enthusiast Media, 6405 Flank Dr., Harrisburg PA 17112. (717)657-9555. Editor and Publisher: John Randolph. Managing Editor: Philip Hanyok. Circ. 150,000. Published 6 times/year. Emphasizes all types of fly fishing for readers who are "100% male, 83% college educated, 98% married. Average household income is $81,800 and 49% are managers or professionals; 68% keep their copies for future reference and spend 35 days a year fishing." Sample copy $3.95 with 9×12 SAE and 4 first-class stamps. Photo/writer guidelines for SASE.

Needs: Uses about 45 photos/issue, 80% of which are supplied by freelance photographers. Needs shots of "fly fishing and all related areas—scenics, fish, insects, how-to." Captions required.

Making Contact & Terms: Send 35mm, 2¼×2¼, 4×5 or 8×10 color transparencies by mail for

THE DIGITAL MARKETS INDEX, located in the back of this book, lists markets that use images electronically.

consideration. SASE. Reports in 6 weeks. Payment negotiable. Pays on publication. Credit line given. Buys one-time rights.

FLY ROD & REEL: THE MAGAZINE OF AMERICAN FLY-FISHING, Dept. PM, P.O. Box 370, Camden ME 04843. (207)594-9544. Fax: (207)594-5144. Editor: Jim Butler. Magazine published bi-monthly. Emphasizes fly-fishing. Readers are primarily fly fishermen ages 30-60. Circ. 55,000. Estab. 1979. Free sample copy with SASE. Photo guidelines free with SASE.
Needs: Uses 25-30 photos/issue; 15-20 supplied by freelancers. Needs "photos of fish, scenics (preferrably with anglers in shot), equipment." Photo captions preferred that include location, name of model (if applicable).
Making Contact & Terms: Query with list of stock photo subjects. Send unsolicited photos by mail for consideration. Provide résumé, business card, brochure, flier or tearsheets to be kept on file for possible assignments. Send glossy b&w, color prints; 35mm, 2¼×2¼, 4×5 transparencies. Keeps samples on file. SASE. Reports in 1 month. Pays $600/color cover photo; $75/color inside photo; $75/b&w inside photo; $150/color page rate; $150/b&w page rate. Pays on publication. Credit line given. Buys one-time rights.
Tips: "Photos should avoid appearance of being too 'staged.' We look for bright color (especially on covers), and unusual, visually appealing settings. Trout and salmon are preferred for covers. Also looking for saltwater fly-fishing subjects."

FOOD & WINE, Dept. PM, 1120 Avenue of the Americas, New York NY 10036. (212)382-5600. Photo Editor: Patti Wilson. Monthly. Emphasizes food and wine. Readers are an "upscale audience who cook, entertain, dine out and travel stylishly." Circ. 850,000. Estab. 1978.
Needs: Uses about 25-30 photos/issue; freelance photography on assignment basis 85%, 15% freelance stock. "We look for editorial reportage specialists who do restaurants, food on location and travel photography." Model release and captions required.
Making Contact & Terms: Drop-off portfolio on Tuesdays. Call for pickup. Submit fliers, tearsheets, etc. to be kept on file for possible future assignments and stock usage. Pays $450/color page; $100-450 color photo. **Pays on acceptance.** Credit line given. Buys one-time world rights.

‡FOR SENIORS ONLY, 339 N. Main St., New City NY 10956. (914)638-0333. Fax: (914)634-9423. Art Director: David Miller. Circ. 350,000. Estab. 1970. Biannual publication. Emphasizes career and college guidance—with features on travel, computers, etc. Readers are male and female, ages 16-19. Sample copy free with 6½×9½ SAE and 8 first-class stamps.
Needs: Uses various number of photos/issue; 50% supplied by freelancers. Needs photos of travel, college-oriented shots and youths. Reviews photos with or without ms. Model/property release required.
Making Contact & Terms: Interested in receiving work from newer, lesser-known photographers. Send unsolicited photos by mail for consideration. Send 5½×8½ color prints; 35mm, 8×10 transparencies. SASE. Reports when needed. Payment negotiable. Pays on publication. Credit line given. Buys one-time rights; negotiable. Simultaneous submissions and/or previously published work OK.

FORTUNE, Dept. PM, Rockefeller Center, Time-Life Bldg., 1271 Avenue of the Americas, New York NY 10020. (212)522-3803. Managing Editor: John Huey. Picture Editor: Michele F. McNally. Picture Editor reviews photographers' portfolios on an overnight drop-off basis. Emphasizes analysis of news in the business world for management personnel. Photos purchased on assignment only. Day rate on assignment (against space rate): $400; page rate for space: $400; minimum for b&w or color usage: $150. Pays extra for electronic rights.

‡FOTOTEQUE, (Fine Art Photo Journal of the International Society of Fine Art Photographers), P.O. Box 735, Miami FL 33144. E-mail: fototeque@aol.com. Photo Editor/Researcher: Alex Gonzalez. Estab. 1991. Publisher. Photos used in magazine *Fototeque*, and documentary biannual book. SASE for submission guideline samples ($10 for magazine $15 book).
Needs: Buys 30 photos/month. Subjects include fine art, b&w photos. Captions preferred; include technical data (i.e., camera, lens, aperture, film). Photo essays, portfolios and fine art has annual contest.
Making Contact & Terms: Interested in receiving work from newer, lesser-known photographers. Submit portfolio for review by querying first in writing. Include a SASE for reply. "We do not return materials unless adequate return shipping and postage needs are included." Do not send unsolicited photos. Uses b&w prints no larger than 8×10. Keeps samples on file. SASE. Reports in 1 month. Pays $15-100/b&w photo. Pays 3 months after publication. Buys one-time rights.
Tips: Wants to see still life-portrait and photo essays. We need critiques, reviews (of new work and shows) and artist bios and portfolio from USA and foreign countries (must be translated). Has a special Portfolio/Gallery section in each issue."

FOUR WHEELER MAGAZINE, 3330 Ocean Park Blvd., Suite 115, Santa Monica CA 90405. (310)392-2998. Editor: John Stewart. Circ. 325,000. Monthly magazine. Emphasizes four-wheel drive vehicles and enthusiasts. Photo guidelines free with SASE.
Needs: Uses 100 color/100 b&w photos/issue; 2% supplied by freelance photographers. Needs how-to, travel/scenic/action (off-road 4×4s only) photos. Travel pieces also encouraged. Reviews photos with accompanying ms only. Model release required. Captions required.
Making Contact & Terms: Provide résumé, business card, brochure, flier or tearsheets to be kept on file for possible future assignments. Does not return unsolicited material. Reports in 1 month. Pays $10-50/inside b&w photo; $20-100/inside color photo; $100/b&w and color page; $200-600/text/photo package. Pays on publication. Credit line given. Buys all rights.

‡FOX MAGAZINE, 401 Park Ave. S., New York NY 10016-8802. Editorial Director: Marc Medoff. Photo Editor: Judy Linden. Estab. 1972. Emphasizes men's interests. Readers are male, collegiate, middle class. Photo guidelines free with SASE.
Needs: Uses 200 photos/issue; 10% supplied by freelancers (no assignments). Needs photos of nude women and celebrities, plus sports, adventure pieces. Interested in porn stars, strippers, swingers. Model release with 2 photo IDs required.
Making Contact & Terms: Send at least 200 35mm transparencies by mail for consideration. SASE. Reports in 1 month. Pays $85-100/b&w photo. Girl sets: pays $1,500-1,800; cover extra. Buys firt North American serial rights plus nonexclusive international rights.
Tips: In photographer's samples, wants to see "beautiful models and good composition. Trend in our publication is outdoor settings—avoid soft focus! Send complete layout."

***FRANCE MAGAZINE**, Dormer House, The Square, Stow-on-the-Wold, Gloucestershire GL54 1BN England. (0451)831398. Fax: (0451)830869. E-mail: francemag@btinternet. Department Editor: Jon Stackpool. Circ. 43,121. Estab. 1990. Quarterly magazine. Emphasizes France. Readers are male and female, ages over 45; people who holiday in France. Sample copy $9.
Needs: Uses 250 photos/issue; 200 supplied by freelancers. Needs photos of France and French subjects: people, places, customs, curiosities, produce, towns, cities, countryside. Captions required; include location and as much information as is practical.
Making Contact & Terms: Interested in receiving work on spec: themed sets very welcome. Send unsolicited photos by mail for consideration. Also accepts digital files on ISDN: 4sight compatible 300 DPI or similar. Send 35mm, 2¼×2¼ transparencies. Keep samples on file. SASE. Reports in 1 month. Pays £100/color cover photo; £50/color full page DPS; £25/¼ page and under. Pays quarterly following publication. Credit line given. Buys one-time rights. Previously published work OK.

GALLERY MAGAZINE, 401 Park Ave. S., New York NY 10016-8802. Editorial Director: Marc Medoff. Photo Editor: Judy Linden. Estab. 1972. Emphasizes men's interests. Readers are male, collegiate, middle class. Photo guidelines free with SASE.
Needs: Uses 200 photos/issue; 10% supplied by freelancers (no assignments). Needs photos of nude women and celebrities, plus sports, adventure pieces. Model release with photo ID required.
Making Contact & Terms: Send at least 200 35mm transparencies by mail for consideration. "We need several days for examination of photos." SASE. Reports in 1 month. Pays $85-120/b&w photo. Girl sets: pays $1,500-2,000; cover extra. Pays extra for electronic usage of images. Buys first North American serial rights plus nonexclusive international rights. Also operates Girl Next Door contest: $250 entry photo; $2,500 monthly winner; $25,000 yearly winner (must be amateur!). Photographer: entry photo/receives 1-year free subscription, monthly winner $500; yearly winner $2,500. Send *by mail* for contest information.
Tips: In photographer's samples, wants to see "beautiful models and good composition. Trend in our publication is outdoor settings—avoid soft focus! Send complete layout."

GENRE, 7080 Hollywood Blvd., Suite 1104, Hollywood CA 90028. (213)896-9778. Publisher: Richard Settles. Editor: Ron Kraft. Circ. 45,000. Estab. 1990. Monthly. Emphasizes gay life. Readers are gay men, ages 24-35. Sample copy $5.

 INTERNATIONAL MARKETS, those located outside of the United States and Canada, are marked with an asterisk.

Needs: Uses 140 photos/issue. Needs photos of fashion, celebrities, scenics. Model/property release required. Captions preferred.

Making Contact & Terms: Interested in receiving work from newer, lesser-known photographers. Provide résumé, business card, brochure, flier or tearsheets to be kept on file for possible assignments. Cannot return material. Reports only if interested. "We pay only film processing." Pays on publication. Credit line given. Buys all rights; negotiable.

GENT, 14411 Commerce Way, Suite 420, Miami Lakes FL 33016. (305)557-0071. Editor: Steve Dorfman. Circ. 150,000. Monthly magazine. Showcases "slim and stacked" D-cup nude models. Sample copy $6 (postpaid). Photo guidelines free with SASE.

Needs: Buys in sets, not by individual photos. "We publish manuscripts on sex, travel, adventure, cars, racing, sports, gambling, grooming, fashion and other topics that traditionally interest males. Nude models must be extremely large breasted (minimum 38″ bust line). Sequence of photos should start with woman clothed, then stripped to brassiere and then on to completely nude. Bikini sequences also recommended. Cover shots must have nipples covered. Full-figured models also considered if they are reasonably attractive and measure up to our 'D-Cup' image." Model release and photocopy or photograph of picture ID required.

Making Contact & Terms: Send material by mail for consideration. Send transparencies. Prefer Kodachrome or large format; vertical format required for cover. SASE. Reports in 4-6 weeks. Pays $1,200 minimum per set (first rights); $600 (second rights); $300/cover photo; $250-500 for text and photo package. Pays on publication. Credit line given. Buys one-time rights or second serial (reprint) rights. Previously published work OK.

GLAMOUR, Conde Nast Publication, Inc., 350 Madison Ave., New York NY 10017-3704. (212)880-8800. Fax: (212)880-8336. *Glamour* provides the contemporary American women information on trends, recommends how she can adapt them to her needs, and motivates her to take action. Over half of its editorial content focuses on fashion, beauty and health, and coverage of personal relationships, career, travel, food and entertainment. This magazine did not respond to our request for information. Query before submitting.

‡GOLF ILLUSTRATED, P.O. Box 5300, Jenks OK 74037-5300. (918)491-6100. Fax: (918)491-9424. Executive Editor: Mark Chesnut. Circ. 270,000. Estab. 1914. Magazine published 8 times/year. Emphasizes golf. Readers are mostly male, ages 40-60. Sample copy $2.95. Photo guidlines free with SASE.

Needs: Uses 40-60 photos/issue; 90% supplied by freelancers. Needs photos of various golf courses, golf travel, other golf-related shots. Model/property release preferred. Captions required; include who, what, when and where.

Making Contact & Terms: Interested in receiving work from newer, lesser-known photographers. Query with résumé of credits. Provide résumé, business card, brochure, flier or tearsheets to be kept on file for possible assignments. Send 35mm, 2¼×2¼ transparencies. Keeps samples on file. SASE. Reports in 3 weeks. Pays $400-600/color cover photo; $100-300/color inside photo. Pays on publication. Credit line given. Buys one-time rights. Previously published work OK.

‡GOLF TIPS, 12121 Wilshire Blvd., #1200, Los Angeles CA 90025. (310)820-1500. Fax: (310)820-2793. Art Director: Warren Keating. Circ. 300,000. Estab. 1986. Magazine published 9 times/year. Readers are hardcore golf enthusiasts. Sample copy free with SASE.

Needs: Uses 60 photos/issue; 40 supplied by freelancers. Needs photos of golf instruction (usually prearranged, on-course); equipment-studio. Reviews photos purchased with accompanying ms only. Model/property release preferred. Captions required.

Making Contact & Terms: Interested in receiving work from newer, lesser-known photographers. Query with résumé of credits. Submit portfolio for review. Send prints; 35mm, 2¼×2¼, 4×5, 8×10 transparencies; digital format. Accepts images in digital format for Mac. Send via SyQuest, Zip disk (300 dpi). Cannot return material. Reports in 1 month. Pays $400-800/day; $100-150 inside; $500-800/color cover photo; $100-400/color inside photo. Pays on publication. Buys one-time rights; negotiable.

THE GOLFER, 21 E. 40th St., New York NY 10016. (212)768-8360. Fax: (212)768-8365. Contact: Rosemary Delgado or Andrea Da Rif. Circ. 250,000. Estab. 1994. Bimonthly magazine. Emphasizes golf, resort, travel, sporting fashion. Readers are affluent males and females, ages 35 and up. Sample copy $5.50.

Needs: Uses 30-50 photos/issue; all supplied by freelancers. Needs photos of golf action, resorts, courses, and still life photography.

Making Contact & Terms: Interested in receiving work from newer, lesser-known photographers. Query with résumé of credits. Provide résumé, business card, brochure, flier or tearsheets to be kept on file for possible assignments. Query with stock photo list. Keeps samples on file. SASE. Reports in 1 month.

Payment negotiable. Pays on publication. Buys one-time rights. Simultaneous submissions and previously published work OK.

GOOD HOUSEKEEPING, Hearst Corporation Magazine Division, 959 Eighth Ave., New York NY 10019-3795. (212)649-2531. Fax: (212)977-9824. *Good Housekeeping* articles focus on food, fitness, beauty and childcare, drawing upon the resources of the Good Housekeeping Institute. Editorial includes human interest stories, and articles that focus on social issues, money management, health news and travel. This magazine did not respond to our request for information. Query before submitting.

❧**GOSPEL HERALD**, 4904 King St., Beamsville, Ontario L0R 1B6 Canada. (905)563-7503. Fax: (905)563-7503. E-mail: eperry@freenet.npiec.on.a. Co-editor: Wayne Turner. Managing Editor: Eugene Perry. Circ. 1,420. Estab. 1936. Consumer publication. Monthly magazine. Emphasizes Christianity. Readers are primarily members of the Churches of Christ. Sample copy free with SASE.
Needs: Uses 2-3 photos/issue; percentage supplied by freelancers varies. Needs scenics, shots, especially those relating to readership—moral, religious and nature themes.
Making Contact & Terms: Send unsolicited photos by mail for consideration. Send b&w, any size and any format. Payment not given, but photographer receives credit line.
Tips: "We have never paid for photos. Because of the purpose of our magazine, both photos and stories are accepted on a volunteer basis."

GRAND RAPIDS MAGAZINE, 549 Ottawa Ave. NW, Grand Rapids MI 49503-1444. (616)459-4545. Fax: (616)459-4800. Publisher: John H. Zwarensteyn. Editor: Carole R. Valade. Estab. 1963. Monthly magazine. Emphasizes community-related material of Western Michigan; local action and local people.
Needs: Animal, nature, scenic, travel, sport, fashion/beauty, photo essay/photo feature, fine art, documentary, human interest, celebrity/personality, humorous, wildlife, vibrant people shots and special effects/experimental. Wants on a regular basis western Michigan photo essays and travel-photo essays of any area in Michigan. Model release required. Captions required.
Making Contact & Terms: Interested in receiving work from newer, lesser-known photographers. Freelance photos assigned and accepted. Provide business card to be kept on file for possible future assignments; "only people on file are those we have met and personally reviewed." Arrange a personal interview to show portfolio. Query with résumé of credits. Send material by mail for consideration. Submit portfolio for review. Send 8×10 or 5×7 glossy b&w prints; contact sheet OK; 35mm, 120mm or 4×5 transparencies or 8×10 glossy color prints; Uses 2¼×2¼ and 4×5 color transparencies for cover, vertical format required. SASE. Reports in 3 weeks. Pays $25-35/b&w photo; $35-50/color photo; $100-150/cover photo. Buys one-time rights, exclusive product rights, all rights; negotiable.
Tips: "Most photography is by our local freelance photographers, so freelancers should sell us on the unique nature of what they have to offer."

GRAND RAPIDS PARENT MAGAZINE, 549 Ottawa NW, Grand Rapids MI 49503. (616)459-4545. Fax: (616)459-4800. Editor: Carole R. Valade. Circ. 12,000. Estab. 1989. Monthly magazine. Sample copy $2. Photo guidelines free with SASE.
Needs: Uses 20-50 photos/issue; all supplied by freelancers. Needs photos of families, children, education, infants, play, etc. Model/property release required. Captions preferred; include who, what, where, when.
Making Contact & Terms: Interested in receiving work from newer, lesser-known photographers. Query with résumé of credits. Query with stock photo list. Sometimes keeps samples on file. SASE. Reports in 1 month. Pays $200/color cover photo; $35/color inside photo; $25/b&w inside photo; $50 minimum/color page rate. Pays on publication. Credit line given. Buys one-time rights, all rights; negotiable. Simultaneous submissions and/or previously published work OK.
Tips: "We are not interested in 'clip art' variety photos. We want the honesty of photojournalism, photos that speak to the heart, that tell a story, that add to the story told."

‡**GREECE TRAVEL MAGAZINE**, 830 Eyrie Dr., Suite 1, Oviedo FL 32765. (407)365-0663. Fax: (407)365-6018. Publisher: Candice Ricketts. Circ. 25,000. Bimonthly magazine. Emphasizes travel in Greece (i.e. culture, history, landmarks, sites, islands, events, etc.) Readers are interested in travel to Greece. Magazine is targeted at affluent USA/Canada market. Sample copy $3.95.
Needs: Uses 80 photos/issue; 50% supplied by freelancers. Needs photos of travel/tourism. No politics or news-related shots unless related to tourism. Reviews photos with or without ms. Model/property release required. Captions required; include description of photo (i.e. location, event, etc.).
Making Contact & Terms: Interested in receiving work from newer, lesser-known photographers. Query with stock photo list. Send unsolicited photos by mail for consideration. Send color prints; 35mm, 2¼×2¼, 4×5, 8×10 transparencies. SASE. Reports in 1 month. Pays $100-300/color cover photo; $50-200/color

inside photo; $100/photo/text package. Pays on publication. Buys one-time rights. Simultaneous submissions and previously published work OK.

GREEN BAY PACKER YEARBOOK, P.O. Box 1773, Green Bay WI 54305. (414)435-5100. Fax: (414)435-5017. Publisher: John Wemple. Sample copy free with 9×12 SASE.

Needs: Needs photos of Green Bay Packer football action shots in NFL cities other than Green Bay. Captions preferred.

Making Contact & Terms: Query with résumé of credits. Query with samples. Provide résumé, business card, brochure, flier or tearsheets to be kept on file for possible future assignments. Accepts images in digital format for Mac. Send via Zip disk. Works on assignment only. SASE. Reports in 2 weeks. Pays $50 maximum/color photo. Pays on acceptance or receipt of invoice. Credit line given on table of contents page. Buys all rights.

Tips: "We are looking for Green Bay Packer pictures when they play in other NFL cities—action photos. Contact me directly." Looks for "the ability to capture action in addition to the unusual" in photos.

"This cover photo for our December 29th issue captures the country feel and tone of the publication and portrays a serene winter scene common at that time of year," says *Grit Magazine* Editor Donna Doyle. "I had seen Tim Hynds's work in the *Ft. Dodge Messenger* and loved his pastoral shots, so I asked him to submit this cover shot." The theme of the *Grit* issue was rest after the holidays and Hynds captured the quiet countryside, as the landscape lay "frozen and asleep under a blue sky, on a sunny day."

THE GREYHOUND REVIEW, P.O. Box 543, Abilene KS 67410. (913)263-4660. Contact: Gary Guccione or Tim Horan. Circ. 5,000. Publication of the National Greyhound Association. Monthly. Emphasizes greyhound racing and breeding. Readers are greyhound owners and breeders. Sample copy with SAE and 11 first-class stamps.

Needs: Uses about 5 photos/issue; 1 supplied by freelance photographers. Needs "anything pertinent to the greyhound that would be of interest to greyhound owners." Captions required.

Making Contact & Terms: Query first. After response, send b&w or color prints and contact sheets by mail for consideration. Submit portfolio for review. Provide résumé, business card, brochure, flier or tearsheets to be kept on file for possible future assignments. Can return unsolicited material if requested. Reports within 1 month. Pays $85/color cover photo; $25-100/color inside photo. **Pays on acceptance.** Credit line given. Buys one-time and North American rights. Simultaneous submissions and previously published work OK.

Tips: "We look for human-interest or action photos involving greyhounds. No muzzles, please, unless the greyhound is actually racing. When submitting photos for our cover, make sure there's plenty of cropping space on all margins around your photo's subject; full bleeds on our cover are preferred."

‡**GRIT MAGAZINE**, 1503 SW 42nd St., Topeka KS 66609. (800)678-5779. Fax: (913)274-4305. Contact: Editor. Circ. 400,000. Estab. 1882. Biweekly magazine. Emphasizes "people-oriented material which is helpful, inspiring or uplifting. Readership is national." Sample copy $2.
Needs: Buys "hundreds" of photos/year; 70% from assignment. Needs on a regular basis "photos of all subjects, provided they have up-beat themes that are so good they surprise us. Need *short*, unusual stories—heartwarming, nostalgic, inspirational, off-beat, humorous—or human interest with b&w or color photos. Be certain pictures are well composed, properly exposed and pin sharp. No cheesecake. No pictures that cannot be shown to any member of the family. No pictures that are out of focus or over-or under-exposed. No ribbon-cutting, check-passing or hand-shaking pictures. We use 35mm and up." Photos purchased with accompanying ms. Model release required. Captions required. "Single b&w photo or color slide, that stands alone must be accompanied by 50-100 words of meaningful caption information."
Making Contact & Terms: Interested in receiving work from newer, lesser-known photographers if work is good. Send material by mail for consideration. Prefer color slides/professional quality. Reports in 6 weeks. Pays $250 for cover photo; $25 for b&w; $50 minimum/color photo. Uses much more color than b&w. Buys one-time rights. SASE. Pays on publication.
Tips: "Need major-holiday subjects: Easter, Fourth of July, Christmas or New Year. Remember that *Grit* publishes on newsprint and therefore requires sharp, bright, contrasting colors for best reproduction. Avoid sending shots of people whose faces are in shadows; no soft focus. Need photos of small town, rural life; outdoor scenes with people; gardens; back roads and country life shots."

‡**GROUP MAGAZINE**, 1515 Cascade Ave., Loveland CO 80538. (970)669-3836. Fax: (970)669-1994. Art Director: Joel Armstrong. Circ. 55,000. Estab. 1974. Bimonthly magazine. Readers are Christian adults of all denominations who work with teenagers. Sample copy for $2 and 9 × 12 SAE. Photo guidelines free with SASE.
Needs: Uses 20-25 photos/issue; 3-6 supplied by freelancers. Needs photos of activities and settings related to family life; teens, adults and high school youth together. Model release required.
Making Contact & Terms: Send unsolicited photos by mail for consideration. Send color and b&w prints; 35mm, 2¼ × 2¼, 4 × 5 transparencies; digital format (Photo CD). Keeps samples on file. SASE. Reports in 1 month. Pays $100/color inside photo; $50/b&w inside photo. **Pays on acceptance**. Credit line given. Buys one-time rights. Simultaneous submissions and previously published work OK.
Tips: "We seek to portray people in a variety of ethnic, cultural and racio-economic backgrounds in our publications and look for the ability of a photographer to portray emotion in photos. Real life shots are preferable to posed ones."

GUEST INFORMANT, 21200 Erwin St., Woodland Hills CA 91367. (818)716-7484. Fax: (818)716-7583. Contact: Photo Editor. Quarterly and annual city guide books. Emphasizes city-specific photos for use in guide books distributed in upscale hotel rooms in approximately 30 U.S. cities.
Needs: "We review people-oriented, city-specific stock photography that is innovative and on the cutting edge." Categories include: major attractions, annual events, local recreation, lifestyle, pro sports, regional food and cultural color. Captions required; include city, location, event, etc.
Making Contact & Terms: Interested in seeing new as well as established photographers. Provide promo, business card and list of cities covered. Send transparencies with a delivery memo stating the number and format of transparencies you are sending. All transparencies must be clearly marked with photographer's name and caption information. They should be submitted in slide pages with similar images grouped together. To submit portfolio for review "call first." Accepts images in digital format for Mac. Send via compact disc. Rates: Cover $250. Inside $100-250, depending on size. 50% reuse rate. Pays on publication, which is about 60 days from initial submission. Credit line given. Offers internships for photographers. Contact Senior Photo Editor: Susan Warmbo.
Tips: Contact photo editor at (800)275-5885 for guidelines and submission schedule before sending your work.

GUIDE FOR EXPECTANT PARENTS, 261 Old York Rd., Suite 831, Jenkintown PA 19046-3706. (215)886-7022 or (800)220-3145. Fax: (215)886-7276. Project Coordinator: Deana C. Jamroz. Circ. 1.85 million. Estab. 1973. Biannual magazine. Emphasizes prenatal care for pregnant women and their partners. Sample copy free with 9 × 12 SAE and 4 first-class stamps. Photo guidelines free with SASE.
Needs: Uses 2-8 photos/issue; 80% supplied by freelancers. Needs photos of pregnant women with their spouses and physicians, nurses with pregnant women, pregnant women in classroom (prenatal) situations, pictures of new families. Reviews photos with or without ms. Model/property release required.

Making Contact & Terms: Interested in receiving work from newer, lesser-known photographers. Query with stock photo list. Does not keep samples on file. SASE. Reports in 3 weeks. Pays $300-600/color inside photo; $100-500/b&w inside photo. **Pays on acceptance.** Credit line not given. Buys all rights.

GUIDEPOSTS, Dept. PM, 16 E. 34th St., 21st Floor, New York NY 10016. (212)251-8124. Fax: (212)684-0679. Photo Editor: Candice Smilow. Circ. 4 million. Estab. 1945. Monthly magazine. Emphasizes tested methods for developing courage, strength and positive attitudes through faith in God. Free sample copy and photo guidelines with 6×9 SAE and 3 first-class stamps.
 ● This company also publishes *Angels on Earth*.
Needs: Uses 85% assignment, 15% stock (variable). "Photos mostly used are of an editorial reportage nature or stock photos, i.e., scenic landscape, agriculture, people, animals, sports. We work four months in advance. It's helpful to send stock pertaining to upcoming seasons/holidays. No lovers, suggestive situations or violence." Model release preferred.
Making Contact & Terms: Interested in receiving work from newer, lesser-known photographers. Send photos or arrange a personal interview. Send 35mm transparencies; vertical format required for cover, usually shot on assignment. SASE. Reports in 1 month. Pays by job or on a per-photo basis; pays $150-400/color photo; $800 and up/cover photo; $400-600/day; negotiable. **Pays on acceptance.** Credit line given. Buys one-time rights. Simultaneous submissions OK.
Tips: "I'm looking for photographs that show people in their environment. I like warm, saturated color for portraits and scenics. We're trying to appear more contemporary. We want to stimulate a younger audience and yet maintain a homey feel. For stock—scenics; graphic images with intense color. *Guideposts* is an 'inspirational' magazine. NO violence, nudity, sex. No more than 60 images at a time. Write first and ask for a photo guidelines/sample issue; this will give you a better idea of what we're looking for. I will review transparencies on a light box. I am interested in the experience as well as the photograph. I am also interested in the photographer's sensibilities—Do you love the city? Mountain climbing? Farm life?"

‡GUNGAMES MAGAZINE, P.O. Box 516, Moreno Valley CA 92556. (909)485-7986. Fax: (909)485-6628. E-mail: ggamesed@aol.com. Editor: Roni Toldanes. Circ. 125,000. Estab. 1995. Bimonthly magazine. Emphasizes shooting sports—"the fun side of guns." Readers are male and female gun owners, ages 18-90. Sample copy $3.50 plus S&H or SASE.
Needs: Uses many photos/issue; most supplied by freelancers. Needs photos of personalities, shooting sports and modern guns and equipment. "No self-defense topics; avoid hunting photos. Just shooting tournaments." Captions required.
Making Contact & Terms: Send unsolicited photos by mail for consideration. Send color prints; 35mm transparencies. Does not keep samples on file. Cannot return material. Reports in 1 month. Payment negotiable. Pays on publication. Credit line given. Buys one-time rights; negotiable.

HADASSAH MAGAZINE, 50 W. 58th St., New York NY 10019. (212)688-0558. Fax: (212)446-9521. Editorial Assistant: Leah Finkelshteyn. Circ. 300,000. Publication of the Hadassah Women's Zionist Organization of America. Monthly magazine. Emphasizes Jewish life, Israel. Readers are 85% females who travel and are interested in Jewish affairs, average age 59. Photo guidelines free with SASE.
Needs: Uses 10 photos/issue; most supplied by freelancers. Needs photos of travel and Israel. Captions preferred, include where, when, who and credit line.
Making Contact & Terms: Interested in receiving work from newer, lesser-known photographers. Submit portfolio for review. Send unsolicited photos by mail for consideration. Keeps samples on file. SASE. Reports in 1 month. Pays $400/color cover photo; $100-125/¼ page color inside photo; $75-100/¼ page b&w inside photo. Pays on publication. Credit line given. Buys one-time rights.
Tips: "We're looking for kids of all ethnic/racial make up. Cute, upbeat kids are a plus. We also need photos of families and travel photos, especially of places of Jewish interest."

***HEALTH & BEAUTY MAGAZINE**, 10 Woodford, Brewery Rd., Blackrock, Dublin, Ireland. (01)2954095. Mobile: 087-531566. Fax: (01)01-2954095. Advertising Manager: David Briggs. Circ. 11,000. Estab. 1985. Bimonthly magazine. Emphasizes all body matters. Readers are male and female, ages 17-50 (all keen on body matters). Sample copy free with A4 SASE.
Needs: Uses approximately 100 photos/issue; 50% supplied by freelancers. Needs photos related to health, hair, fashion, beauty, food, drinks. Reviews photos with or without ms. Model/property release preferred. Captions preferred; include photo description.
Making Contact & Terms: Interested in receiving work from newer, lesser-known photographers. Send unsolicited photos by mail for consideration. Provide résumé, business card, brochure, flier or tearsheets to be kept on file for possible assignments. Send any size glossy color and b&w prints; 35mm, 2¼×2¼, 4×5, 8×10 transparencies; prints preferred. Keeps samples on file. SASE. Reports in 1 month. Payment

negotiable. Credit line given. Buys all rights; negotiable. Simultaneous submissions and/or previously published work OK.

Tips: Looks for "male and female models of good body shape, shot in interesting locations with interesting body and facial features. Continue on a regular basis to submit good material for review."

HIGHLIGHTS FOR CHILDREN, Dept. PM, 803 Church St., Honesdale PA 18431. (717)253-1080. Photo Editor: Sharon Umnik. Circ. 2.5 million. Monthly magazine. For children, ages 2-12. Free sample copy.

• *Highlights* is currently expanding its photographic needs.

Needs: Buys 100 or more photos annually. "We will consider outstanding photo essays on subjects of high interest to children." Photos purchased with accompanying ms. Wants no single photos without captions or accompanying ms.

Making Contact & Terms: Interested in receiving work from newer, lesser-known photographers. Send photo essays for consideration. Prefers transparencies. SASE. Reports in 7 weeks. Pays $30 minimum/ b&w photo; $55 minimum/color photo. Pays $100 minimum for ms. Buys all rights.

Tips: "Tell a story which is exciting to children. We also need mystery photos, puzzles that use photography/collage, special effects, anything unusual that will visually and mentally challenge children."

HOCKEY ILLUSTRATED, 233 Park Ave. S., New York NY 10003. (212)780-3500. Fax: (212)780-3555. Editor: Stephen Ciacciarelli. Circ. 50,000. Published 4 times/year, in season. Emphasizes hockey superstars. Readers are hockey fans. Sample copy $3.50 with 9×12 SASE.

Needs: Uses about 60 photos/issue; all supplied by freelance photographers. Needs color slides of top hockey players in action. Captions preferred.

Making Contact & Terms: Query with action color slides. SASE. Pays $150/color cover photo; $75/ color inside photo. **Pays on acceptance.** Credit line given. Buys one-time rights.

HOME EDUCATION MAGAZINE, P.O. Box 1083, Tonasket WA 98855. (509)486-1351. E-mail: HomeEdMag@aol.com. Website: http://www.home-ed-press.com. Managing Editor: Helen Hegener. Circ. 8,900. Estab. 1983. Bimonthly magazine. Emphasizes homeschooling. Readership includes parents, educators, researchers, media, etc.—anyone interested in home schooling. Sample copy for $4.50. Photo guidelines free with SASE.

Needs: Number of photos used/issue varies based on availability; 50% supplied by freelance photographers. Needs photos of parent/child or children. Special photo needs include homeschool personalities and leaders. Model/property releases preferred. Captions preferred.

Making Contact & Terms: Interested in receiving work from newer, lesser-known photographers. Send unsolicited b&w prints by mail for consideration. Prefers b&w prints in normal print size (3×5). "Enlargements not necessary for inside only—we need enlargements for cover submissions." Accepts images in digital format for Mac. Send via compact disc, online, flopy disk, SyQuest, Zip disk (266 dpi). Uses 35mm transparencies. SASE. Reports in 1 month. Pays $50/color cover photo; $10/b&w inside photo; $50-150/photo/text package. **Pays on acceptance.** Credit line given. Buys first North American serial rights; negotiable.

Tips: In photographer's samples, wants to see "sharp clear photos of children doing things alone, in groups or with parents. Know what we're about! We get too many submissions that are simply irrelevant to our publication."

HORIZONS MAGAZINE, P.O. Box 2639, Bismarck ND 58502. (701)222-0929. Fax: (701)222-1611. E-mail: lhaluvors@btigate.com. Website: http://www.ndhorizons.com. Editor: Lyle Halvorson. Estab. 1971. Quality regional magazine. Photos used in magazines, audiovisual and calendars.

Needs: Buys 50 photos/year; offers 25 assignments/year. Scenics of North Dakota events, places and people. Examples of recent uses: "Scenic North Dakota" calendar, *Horizons Magazine* (winter edition) and "North Dakota Bad Lands." Model/property release preferred. Captions preferred.

Making Contact & Terms: Query with samples. Query with stock photo list. Accepts images in digital format. Works on assignment only. Uses 8×10 glossy b&w prints; 35mm, 2¼×2¼, 4×5 transparencies. Does not keep samples on file. SASE. Reports in 2 weeks. Pays $150-250/day; $200-300/job. Pays on usage. Credit line given. Buys one-time rights; negotiable.

Tips: "Know North Dakota events, places. Have strong quality of composition and light."

‡**THE HORSE**, 1736 Alexandria Dr., Lexington KY 40504. (606)278-2361. Fax: (606)276-4450. E-mail: tbrockhoff@thehorse.com or kherbert@thehorse.com. Website: http://www.thehorse.com. Staff Writer: Tim Brockhoff. Circ. 24,900. Estab. March 1995 (name changed from *Modern Horse Breeding* to *The Horse*). Monthly magazine. Emphasizes equine health. Readers are equine veterinarians and top-level horse

owners, trainers and barn managers. Sample copy free with SASE. Photo guidelines free with SASE.
Needs: Uses 30 photos/issue; 10-20 supplied by freelancers. Needs generic horse shots, horse health such as farrier and veterinarian shots. "We use all breeds and all disciplines." Model/property relese preferred. Captions preferred.
Making Contact & Terms: Interested in receiving work from newer, lesser-known photographers. Send unsolicited photos by mail for consideration. Send color and b&w prints; 35mm, 2¼×2¼, 4×5, 8×10 transparencies. Accepts images in digital format for Mac (JPEG or TIFF). Send via compact disc, online, floppy disk, SyQuest, Zip disk, Jazz (300 dpi 6×4). Keeps samples on file. Reports in 1-2 weeks. Pays $150/color cover photo; $150/b&w cover photo; $25-75/color inside photo; $25-75/b&w inside photo. Pays on publication. Buys one-time rights. Previously published work OK.

HORSE ILLUSTRATED, Dept. PM, P.O. Box 6050, Mission Viejo CA 92690. (714)855-8822. Fax: (714)855-3045. Editor: Moira C. Harris. Readers are "primarily adult horsewomen between 18-40 who ride and show mostly for pleasure and who are very concerned about the well being of their horses." Circ. 180,000. Sample copy $4.50; photo guidelines free with SASE.
Needs: Uses 20-30 photos/issue, all supplied by freelance photographers; 50% from assignment and 50% from freelance stock. Specific breed featured every issue. Prefers "photos that show various physical and mental aspects of horses. Include environmental, action and portrait-type photos. Prefer people to be shown only in action shots (riding, grooming, treating, etc.). We like all riders—especially those jumping—to be wearing protective headgear."
Making Contact & Terms: Send by mail for consideration actual color photos or 35mm and 2¼×2¼ color transparencies. "We generally use color transparencies and have them converted to b&w if needed." Reports in 2 months. Pays $25/b&w photo; $60-200/color photo and $100-350 per text/photo package. Credit line given. Buys one-time rights.
Tips: "Nothing but sharp, high-contrast shots. Looks for clear, sharp color shots of horse care and training. Healthy horses, safe riding and care atmosphere is the current trend in our publication. Send SASE for a list of photography needs and for photo guidelines and submit work (prefer color transparencies) on spec."

HORSE SHOW MAGAZINE, % AHSA, 220 E. 42nd St., New York NY 10017-5876. (212)972-2472, ext. 237. Fax: (212)983-7286. Editor: Cathy Raymond. Circ. 57,000. Estab. 1937. Publication of National Equestrian Federation of US. Monthly magazine. Emphasizes horses and show trade. Majority of readers are upscale women, median age 31.
Needs: Uses up to 25 photos/issue; most are supplied by equine photographers; freelance 100% on assignment only. Needs shots of competitions. Reviews photos with or without accompanying ms. Especially looking for "excellent color cover shots" in the coming year. Model release required. Property release preferred. Captions required; include name of owner, rider, name of event, date held, horse and summary of accomplishments.
Making Contact & Terms: Interested in receiving work from newer, lesser-known photographers. Pays $250/color cover photo; $30/color and b&w inside photo. **Pays on acceptance.** Credit line given. Buys one-time rights; negotiable. Previously published work OK.
Tips: "Get best possible action shots. Call to see if we need coverage of an event."

HORTICULTURE MAGAZINE, 98 N. Washington St., Boston MA 02114. (617)742-5600. Fax: (617)367-6364. Photo Editor: Tina Schwinder. Circ. 350,000. Estab. 1904. Monthly magazine. Emphasizes gardening. Readers are all ages. Sample copy $2.50 with 9×12 SAE with $2 postage. Photo guidelines free with SASE.
Needs: Uses 25-30 photos/issue; 100% supplied by freelance photographers. Needs photos of gardening, individual plants. Model release preferred. Captions required.
Making Contact & Terms: Arrange a personal interview to show portfolio. Query with samples. Send 35mm color transparencies by mail for consideration. Submit portfolio for review. Provide résumé, business card, brochure, flier or tearsheets to be kept on file for possible future assignments. SASE. Reports in 1 month. Pays $500/color cover photo; $50-250/color page. Pays on publication. Credit line given. Buys one-time rights. Simultaneous submissions OK.
Tips: Wants to see gardening images, i.e., plants and gardens.

HOST COMMUNICATIONS, INC., 904 N. Broadway, Lexington KY 40505. (606)226-4510. Fax: (606)226-4575. Production Manager: Jamie Barker. Estab. 1971. Weekly magazine. Emphasizes collegiate athletics. Includes football, basketball and Texas football sections and NCAA Basketball Championship Guide. Readers are predominantly male, ages 18-49. Sample copy free with 9×12 SAE and $2.90 postage.
Needs: Uses 30 photos/issue; 25 supplied by freelancers. Needs action photography. Model release preferred; photo captions preferred.
Making Contact & Terms: Interested in receiving work from newer, lesser-known photographers. Sub-

mit portfolio for review. Send unsolicited photos by mail for consideration. Provide résumé, business card, brochure, flier or tearsheets to be kept on file for possible future assignments. Send color prints; 35mm transparencies. Deadlines vary depending on publication. SASE. Pays $50-100/color cover photo; $50-100/color inside photo; $25-100/color page. Pays on publication. Credit line given. Buys one-time rights.
Tips: Looks for crispness, clarity of photography, action captured in photography.

HOT BOAT, 8484 Wilshire Blvd., Suite 900, Beverly Hills CA 90211. (213)651-5400. Editor: Brett Bayne. Circ. 70,000. Estab. 1964. Monthly magazine. Emphasizes performance boating. Readers are mostly male, ages 19-55. Sample copy free with SASE.
Needs: Uses 40 photos/issue; 20 supplied by freelancers. "We use photography to illustrate our tech stories. travel and boat tests, competition, too." Captions required.
Making Contact & Terms: Interested in receiving work from newer, lesser-known photographers "as long as they know the subject." Submit portfolio for review (copies OK). Send color prints; 35mm, 2¼×2¼ transparencies. Does not keep samples on file. SASE. Reports in 1-2 weeks. Pays $100-200/color page rate. Pays on publication. Credit line given. Buys first North American serial rights; negotiable. Simultaneous submissions OK.
Tips: "I look for an understanding of performance boating. We aren't interested in sailboats or fishing! The best way to break into this magazine is to shoot a feature (multiple photos—details and overall action) of a 'hot boat.' Check out the magazine if you don't know what a custom performance boat is."

HSUS NEWS, 700 Professional Dr., Gaithersburg MD 20879-3418. Art Director: T. Tilton. Circ. 500,000. Estab. 1954. Publication of The Humane Society of the US Association. Quarterly magazine. Emphasizes animals. Sample copy free with 10×14 SASE.
Needs: Uses 60 photos/issue. Needs photos of animal/wildlife shots. Model release required.
Making Contact & Terms: Query with list of stock photo subjects. Send unsolicited transparencies by mail for consideration. Provide résumé, business card, brochure, flier or tearsheets to be kept on file for possible assignments. Reports in 3 weeks. Pays $500/color cover photo; $225/color inside photo; $150/b&w inside photo. **Pays on acceptance.** Credit line given. Buys one-time rights. Previously published work OK.
Tips: To break in, "don't pester us. Be professional with your submissions."

IDAHO WILDLIFE, P.O. Box 25, Boise ID 83707. (208)334-3748. Fax: (208)334-2148. E-mail: dronayne@idfg.state.id.us. Website: http://www.state.id.us/fishgame/fishgame.html. Editor: Diane Ronayne. Circ. 20,000. Estab. 1978. Bimonthly magazine. Emphasizes wildlife, hunting, fishing. Readers are aged 25-70, 80% male, purchase Idaho hunting or fishing licenses; ½ nonresident, ½ resident. Sample copy $1. Photo guidelines free with SASE.
Needs: Uses 20-40 photos/issue; 30-60% supplied by freelancers. Needs shots of "wildlife, hunting, fishing in Idaho; habitat management." Photos of wildlife/people should be "real," not too "pretty" or obviously set up. Model release preferred. Captions required; include species and location.
Making Contact & Terms: Interested in receiving work from newer, lesser-known photographers. Query with list of stock photo subjects. SASE. Accepts images in digital format for Windows (TIFF or EPS). Send via online, floppy disk, SyQuest, Zip disk or Bernoulli (300 dpi). Reports in 1 month. Pays $80/color cover photo; $40/color or b&w inside photo; $40/color or b&w page rate. Pays on publication. Credit line given. Buys one-time rights. Simultaneous submissions and previously published work OK. Offers internship year-round. Contact: Diane Ronayne. "Need help with archiving, too. No pay but would get clips and experience photographing wildlife and wildlife and fish management."
Tips: "Write first for want list. 99% of photos published are taken in Idaho. Seldom use scenics. Love action hunting or fishing images but must look 'real' (i.e., natural light). Only send your *best* work. We don't pay as much as the 'Big Three' commercial hunting/fishing magazines but our production quality is as high or higher and we value photography and design as much as text. We began placing information, including the *Idaho Wildlife* table of contents on the Internet in early 1996. The potential use of these technologies to enhance freelancer-editor communication is great."

IDEALS MAGAZINE, Ideals Publications Incorporated, P.O. Box 305300, Nashville TN 37230-5300. (615)333-0478. Editor: Lisa Ragan. Circ. 200,000. Estab. 1944. Magazine published 6 times/year. Emphasizes an idealized, nostalgic look at America through poetry and short prose, using "seasonal themes—bright flowers and scenics for Thanksgiving, Christmas, Easter, Mother's Day, Friendship and Country—all thematically related material. Issues are seasonal in appearance." Readers are "mostly women who live in rural areas, aged 50 and up." Sample copy $4. Photo guidelines free with SASE.
Needs: Uses 20-25 photos/issue; all supplied by freelancers. Needs photos of "bright, colorful flowers, scenics, still life, children, pets, home interiors; subject-related shots depending on issue. We regularly

send out a letter listing the photo needs for our upcoming issue." Model/property release required. No research fees.

Making Contact & Terms: Submit tearsheets to be kept on file. No color copies. Will send photo needs list if interested. Do not submit unsolicited photos or transparencies. Work only with 2¼×2¼, 4×5, 8×10 transparencies; no 35mm. Keeps samples on file. Payment negotiable. Pays on publication. Credit line given. Buys one-time rights. Simultaneous and previously published work OK.

Tips: "We want to see *sharp* shots. No mood shots, please. No filters. Would suggest the photographer purchase several recent issues of *Ideals* magazine and study photos for our requirements."

"IN THE FAST LANE", ICC National Headquarters, 2001 Pittston Ave., Scranton PA 18505. (717)585-4082. Editor: D.M. Crispino. Circ. 2,000. Publication of the International Camaro Club. Bimonthly, 20-page newsletter. Emphasizes Camaro car shows, events, cars, stories, etc. Readers are auto enthusiasts/Camaro exclusively. Sample copy $2.

Needs: Uses 20-24 photos/issue; 90% assigned. Needs Camaro-oriented photos only. "At this time we are looking for photographs and stories on the Camaro pace cars 1967, 1969, 1982 and the Camaro Z28s, 1967-1981." Reviews photos with accompanying ms only. Model release required. Captions required.

Making Contact & Terms: Send 3½×5 and larger b&w or color prints by mail for consideration. SASE. Reports in 2 weeks. Pays $5-25 for text/photo package. Pays on publication. Credit line given. Buys one-time rights. Previously published work OK.

Tips: "We need quality photos that put you at the track, in the race or in the midst of the show. Magazine is bimonthly; timeliness is even more important than with monthly. We are looking for all Yenko Camaro stories especially the 1981 Yenko Turbo Z."

INCOME OPPORTUNITIES, 1500 Broadway, 6th Floor, New York NY 10036. (212)642-0631. Fax: (212)768-3769. E-mail: ioart@aol.com. Website: http://www.incomeops.com. Art Director: Andrew Bass. Circ. 300,000. Estab. 1956. Monthly magazine. Readers are individuals looking for ways to start manage and run low-cost business. Also, deals with a home-based entrepreneur.

• This publication uses Photoshop for manipulation to achieve certain effects.

Needs: Uses 10-30 photos/issue; 10-15 supplied by freelancers. Needs editorial shots with people, location shots assignment basis only. Special photo needs include special effect, location, portraiture photos.

Making Contact & Terms: Interested in receiving work from newer, lesser-known photographers. Provide résumé, business card, brochure, flier or tearsheets to be kept on file for possible assignments; or send 300 dpi Photoshop TIFF files in CMYK mode. Keeps samples on file. Cannot return material. Reports in 2 weeks. Pays maximum prices of $2,500/color cover photo; $500/color inside photo. Pays in 30 days. Credit line given. Buys first North American serial rights also, electronic usage of same editorial content.

INDIANAPOLIS BUSINESS JOURNAL, 431 N. Pennsylvania St., Indianapolis IN 46204. (317)634-6200. Fax: (317)263-5060. E-mail: ibjedit@aol.com. Picture Editor: Robin Jerstad. Circ. 17,000. Estab. 1980. Weekly newspaper/monthly magazine. Emphasizes Indianapolis business. Readers are male, 28 and up, middle management to CEO's.

Needs: Uses 15-20 photos/issue; 3-4 supplied by freelancers. Needs portraits of business people. Model release preferred. Captions required; include who, what, when and where.

Making Contact & Terms: Interested in receiving work from newer, lesser-known photographers. Query with résumé and credits. Query with stock photo list. Accepts images in digital format for Mac (EPS/TIFF). Send via compact disc, online, floppy disk or SyQuest (170 dpi). Cannot return material. Reports in 3 weeks. Pays $50-75/color inside photo; $25-50/b&w inside photo. Pays on publication. Credit line given. Buys one-time rights. Simultaneous submissions and/or previously published work OK. Offers internships for photographers during the summer. Contact Picture Editor: Robin Jerstad.

Tips: "We generally use local freelancers (when we need them). Rarely do we have needs outside the Indianapolis area."

INDIANAPOLIS MONTHLY, Dept. PM, 950 N. Meridian, Suite 1200, Indianapolis IN 46204. Art Director: Craig Arive. Monthly. Emphasizes regional/Indianapolis. Readers are upscale, well-educated. Circ. 50,000. Sample copy for $3.05 and 9×12 SASE.

● **SPECIAL COMMENTS** within listings by the editor of *Photographer's Market* are set off by a bullet.

Needs: Uses 50-60 photos/issue; 10-12 supplied by freelance photographers. Needs seasonal, human interest, humorous, regional; subjects must be Indiana- or Indianapolis-related. Model release and captions preferred.

Making Contact & Terms: Query with samples; send 5×7 or 8×10 glossy b&w prints or 35mm or 2¼×2¼ transparencies by mail for consideration. Also accepts digital files. SASE. Reports in 1 month. Pays $50-100/b&w inside photo; $75-250/color inside photo. Pays on publication. Credit line given. Buys first North American serial rights. Previously published work on occasion OK, if different market.

Tips: "Read publication. Send photo similar to those you see published. If we do nothing like what you are considering, we probably don't want to."

INDIANAPOLIS WOMAN, 9000 Keystone Crossing, Suite 939, Indianapolis IN 46240. (317)580-0939. Fax: (317)581-1329. Art Director: Amy Mansfield. Circ. 37,000. Estab. 1994. Monthly magazine. Readers are females, ages 20-55. Sample copy free with 9×12 SASE. Photo guidelines free with SASE.

Needs: Uses 48 photos/issue. Needs photos of beauty, fashion, dining out. Model relese required. Property release required. Captions preferred; include subject, date, photographer.

Making Contact & Terms: Interested in receiving work from newer, lesser-known photographers. Provide résumé, business card, brochure, flier or tearsheets to be kept on file for possible assignments. Keeps samples on file. SASE. Reports on an as needed basis. Payment negotiable. Credit line given. Rights negotiable. Previously published work OK.

INLINE: THE SKATER'S MAGAZINE, 2025 Pearl St., Boulder CO 80302. (303)440-5111. Fax: (303)440-3313. Photo Editor: Annelies Cunis. Circ. 40,000. Estab. 1991. Bimonthly tabloid. Emphasizes inline skating (street, speed, vertical, fitness, hockey, basics). Readers are male and female skaters of all ages. Sample copy free with 11×14 SASE.

Needs: Uses 20-50 photos/issue; 75% supplied by freelancers. Needs photos of skating action, products, scenics, personalities, how-to. Captions preferred; include location and model.

Making Contact & Terms: Interested in receiving work from newer, lesser-known photographers. Provide résumé, business card, brochure, flier or tearsheets to be kept on file for possible assignments. Keeps samples on file. SASE. Reports in 3 weeks. Pays $50-500/job; 200-300/color cover photo; $50-125/color inside photo; $25-100/b&w inside photo; $100/color page rate; $75/b&w page rate. Pays on publication. Credit line given. Buys one-time rights; negotiable. Simultaneous submissions and previously published work OK.

Tips: "Freelancers should get in touch to arrange any kind of submission before sending it. However, I am always interested in seeing new work from new photographers."

‡INSIDER MAGAZINE, 4124 Oakton St., Skokie IL 60076-3267. (847)673-3703. Fax: (847)329-6358. E-mail: insidermag.com. Website: http://www.incard.com. Editorial Director: David Glines. Circ. 1 million. Estab. 1984. Bimonthly magazine. Emphasizes general interest focusing on male and female readers, ages 18-29. Sample copy $1.95.

Needs: Uses 100 photos/issue. Reviews photos purchased with accompanying ms only. Model release required. Captions required.

Making Contact & Terms: Interested in receiving work from newer, lesser-known photographers. Query with résumé of credits. Query with stock photo list. Provide résumé, business card, brochure, flier or tearsheets to be kept on file for possible assignments. Send 8×10 color prints; 35mm, 4×5 transparencies. Keeps samples on file. SASE. Reports in 1 month. Offers internships for photographers. Contact Associate Publisher: Jim Chaplin.

INTERNATIONAL OLYMPIC LIFTER, Box 65855, 3602 Eagle Rock, Los Angeles CA 90065. (213)257-8762. Editor: Bob Hise III. Circ. 1,000. Estab. 1973. Bimonthly international magazine. Emphasizes Olympic-style weightlifting. Readers are athletes, coaches, administrators, enthusiasts of all ages. Sample copy $4.50 and 5 first-class stamps.

Needs: Uses 20 or more photos/issue; all supplied by freelancers. Needs photos of weightlifting action. Reviews photos with or without ms. Captions preferred.

Making Contact & Terms: Send unsolicited photos by mail for consideration. Send 5×7, 8×10 b&w prints. Does not keep samples on file. SASE. Reports in 1-2 weeks. Pays $25/b&w cover photo; $2-10/b&w inside photo. **Pays on acceptance.** Credit line given. Rights negotiable.

Tips: "Good, clear, b&w still and action photos of (preferably outstanding) Olympic-style (overhead/lifting) weightlifters. Must know sport of weightlifting, not bodybuilding or powerlifting."

INTERNATIONAL WILDLIFE, Photo Submissions, IW Publications, 8925 Leesburg Pike, Vienna VA 22184. Photo Editor: John Nuhn. Circ. 275,000. Estab. 1970. Bimonthly magazine. Emphasizes world's

wildlife, nature, environment, conservation. Readers are people who enjoy viewing high-quality wildlife and nature images, and who are interested in knowing more about the natural world and man's interrelationship with animals and environment on all parts of the globe. Sample copy $3 from National Wildlife Federation Membership Services (same address). Send separate SASE for free photo guidelines to Photo Guidelines, International Wildlife Publications (same address).

• This photo editor looks for the ability to go one step farther to make a common shot unique and creative.

Needs: Uses about 45 photos/issue; all supplied by freelance photographers; 10% on assignment, 90% from stock. Needs photos of world's wildlife, wild plants, nature-related how-to, conservation practices, conservation-minded people (tribal and individual). Special needs include single photos for various uses (primarily wildlife but also plants, scenics); story ideas (with photos) from Europe, former Soviet republics, Pacific, China. Model release preferred. Captions required.

Making Contact & Terms: "Study the magazine, and ask for and follow photo guidelines before submitting. No unsolicited submissions from photographers whose work has not been previously published or considered for use in our magazine. Instead, send nonreturnable samples (tearsheets or photocopies) to Photo Queries (same address)." Interested in seeing work from newer, lesser-known photographers with professional-quality transparencies only. If nonreturnable samples are acceptable, send 35mm or larger transparencies (magazine is 100% color) for consideration. SASE. Reports in 1 month. Pays $1,000/color cover photo; $300-750/inside photo; negotiable/photo text package. **Pays on acceptance.** Credit line given. Buys one-time rights with limited magazine promotion rights. Previously published work OK.

Tips: "While *International Wildlife* does not encourage submissions, the annual photo contest in our companion magazine, *National Wildlife*, is an excellent way to introduce your photography. The contest is open to professional and amateur photographers alike. **Rules are updated each year** and printed along with the winning photos in the December/January issue. Rules are also available on the website."

INTERRACE MAGAZINE, Interrace Publications, P.O. Box 12048, Atlanta GA 30355. (404)350-7877. Fax: (404)350-0819. Associate Publisher: Gabe Grosz. Circ. 25,000. Estab. 1989. Bimonthly magazine. Emphasizes interracial couples and families, mixed-race people. Readers are male and female, ages 18-70, of all racial backgrounds. Sample copies $2 with 9×12 SAE and 4 first-class stamps. Photo guidelines free with SASE.

• Every issue of *Interrace* includes *Child of Colors* parenting mini-magazine. See listing for *Child of Colors* in this section as well as *Black Child Magazine* also published by Interrace Publications.

Needs: Uses 20-30 photos/issue; 15-20 supplied by freelancers. Needs photos of people/couples/personalities; must be interracial couple or interracially involved; biracial/multiracial people. Model/property release optional. Captions preferred, identify subjects.

Making Contact & Terms: Interested in receiving work from newer, lesser-known photographers. Submit portfolio for review. Query with résumé of credits. Query with stock photo list. Send unsolicited photos by mail for consideration. Provide résumé, business card, brochure, flier or tearsheets to be kept on file for possible assignments. Accepts images in digital format for Mac. Send via floppy disk (133 line per inch or 2400 dpi). Send 3×5, 8×10 color or b&w prints; any transparencies. Keeps samples on file. SASE. Reports in 1 month or less. Pays $35/color cover photo; $35/b&w cover photo; $20/full page; $15/half page; $10/less than half page. Pays on publication. Credit line given. Buys one-time rights. Simultaneous submissions and/or previously published work OK.

Tips: "We're looking for unusual, candid, upbeat, artistic, unique photos. We're looking for not only black and white couples/people. All racial make ups are needed."

THE IOWAN MAGAZINE, 108 Third St., Suite 350, Des Moines IA 50309. (515)282-8220. Fax: (515)282-0125. Editor: Mark Ingebretsen. Circ. 25,000. Estab. 1952. Quarterly magazine. Emphasizes "Iowa—its people, places, events and history." Readers are over 30, college-educated, middle to upper income. Sample copy $4.50 with 9×12 SAE and 8 first-class stamps. Photo guidelines free with SASE.

Needs: Uses about 80 photos/issue; 50% by freelance photographers on assignment and 50% freelance stock. Needs "Iowa scenics—all seasons." Model/property releases preferred. Captions required.

Making Contact & Terms: Interested in receiving work from newer, lesser-known photographers. Send b&w prints; 35mm, 2¼×2¼ or 4×5 transparencies; or b&w contact sheet by mail for consideration. SASE. Reports in 1 month. Pays $25-50/b&w photo; $50-200/color photo; $200-500/day. Pays on publication. Credit line given. Buys one-time rights; negotiable.

ITE JOURNAL, 525 School St. SW, #410, Washington DC 20024. (202)554-8050. Fax: (202)863-5486. Communications Director: Susan Frensilli Williams. Circ. 14,000. Estab. 1930. Publication of Institute of Transportation Engineers. Monthly journal. Emphasizes surface transportation, including streets, highways and transit. Readers are transportation engineers and professionals.

Needs: One photo used for cover illustration per issue. Needs "strikingly scenic shots of streets, highways, bridges, transit systems." Model release required. Captions preferred, include location, name or number of road or highway and details.

Making Contact & Terms: Interested in receiving work from newer, lesser-known photographers. Query with list of stock photo subjects. Send 35mm or 2¼ × 2¼ transparencies by mail for consideration. Provide résumé, business card, brochure, flier or tearsheets to be kept on file for possible assignments. "Send originals; no dupes please." Pays $250/color cover photo; $50/b&w inside photo. Pays on publication. Credit line given. Buys multiple-use rights. Simultaneous submissions and/or previously published work OK.

JUDICATURE, 180 N. Michigan, Suite 600, Chicago IL 60601-7401. (312)558-6900, ext. 119. Fax: (312)558-9175. E-mail: ajspubs@interaccess.com. Website: http://homepage.interaccess.com/~ajs/. Editor: David Richert. Circ. 12,000. Estab. 1917. Publication of the American Judicature Society. Bimonthly. Emphasizes courts, administration of justice. Readers are judges, lawyers, professors, citizens interested in improving the administration of justice. Sample copy free with 9 × 12 SAE and 6 first-class stamps.

Needs: Uses 2-3 photos/issue; 1-2 supplied by freelancers. Needs photos relating to courts, the law. "Actual or posed courtroom shots are always needed." Model/property releases preferred. Captions preferred.

Making Contact & Terms: Interested in receiving work from newer, lesser-known photographers. Send 5 × 7 glossy b&w prints by mail for consideration. Provide résumé, business card, brochure, flier or tearsheets to be kept on file for possible future assignments. SASE. Reports in 2 weeks. Pays $250/b&w cover photo; $350/color cover photo; $125-300/color inside photo; $125-250/b&w inside photo. Pays on publication. Credit line given. Buys one-time rights. Simultaneous submissions and previously published work OK.

JUNIOR SCHOLASTIC, 555 Broadway, New York NY 10012. (212)343-6295. Editor: Lee Baier. Senior Photo Researcher: Beth Krumholz. Circ. 500,000. Biweekly educational school magazine. Emphasizes middle school social studies (grades 6-8): world and national news, US and world history, geography, how people live around the world. Sample copy $1.75 with 9 × 12 SAE.

Needs: Uses 20 photos/issue. Needs photos of young people ages 11-14; non-travel photos of life in other countries; US news events. Reviews photos with accompanying ms only. Model release required. Captions required.

Making Contact & Terms: Arrange a personal interview to show portfolio. "Please do not send samples—only stock list or photocopies of photos." Reports in 1 month. Pays $200/color cover photo; $75/b&w inside photo; $150/color inside photo. **Pays on acceptance.** Credit line given. Buys one-time rights. Simultaneous submissions OK.

Tips: Prefers to see young teenagers; in US and foreign countries, especially "personal interviews with teenagers worldwide with photos."

KALLIOPE, A Journal of Women's Art, 3939 Roosevelt Blvd., Jacksonville FL 32205. Contact: Art Editor. Circ. 1,500. Estab. 1978. Journal published 3 times/year. Emphasizes art by women. Readers are interested in women's issues. Sample copy $7. Photo guidelines free with SASE.

Needs: Uses 18 photos/issue; all supplied by freelancers. Needs art and fine art that will reproduce well in b&w. Needs photos of nature, people, fine art by excellent sculptors and painters, and shots that reveal lab applications. Model release required. Photo captions preferred. Artwork should be titled.

Making Contact & Terms: Interested in receiving work from newer, lesser-known photographers as well as established photographers. Send unsolicited photos by mail for consideration. Send 5 × 7 b&w prints. SASE. Reports in 1 month. Pays contributor 3 free issues or 1-year free subscription. Buys one-time rights. Credit line given.

Tips: "Send excellent quality photos with an artist's statement (50 words) and résumé."

KANSAS, 700 SW Harrison, Suite 1300, Topeka KS 66603. (913)296-3479. Editor: Andrea Glenn. Circ. 54,000. Estab. 1945. Quarterly magazine. Emphasizes Kansas travel, scenery, arts, recreation and people.

THE SUBJECT INDEX, located at the back of this book, lists publications, book publishers, galleries, paper product companies and stock agencies according to the subject areas they seek.

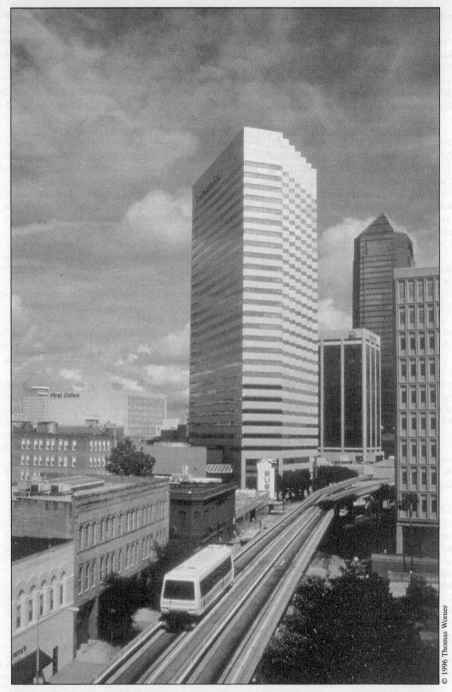

Photographer Thomas Worner has done work for *ITE Journal* since finding them in the 1992 *Photographer's Market*. A conversation between Worner and *ITE*'s editor resulted in this shot. "The editor explained that he receives lots of good images, but would really like to see something from 'above street level,'" says Worner. "It was like receiving insider trading information. When I took this shot in Jacksonville, Florida, I knew it would sell." The image, for which Worner received $250, appeared on *ITE*'s November 1996 cover.

Photos are purchased with or without accompanying ms or on assignment. Free sample copy and photo guidelines.

Needs: Buys 60-80 photos/year; 75% from freelance assignment, 25% from freelance stock. Animal, human interest, nature, photo essay/photo feature, scenic, sport, travel and wildlife, all from Kansas. No nudes, still life or fashion photos. Model/property release preferred. Captions required.

Making Contact & Terms: Interested in receiving work from newer, lesser-known photographers. Send material by mail for consideration. No b&w. Transparencies must be identified by location and photographer's name on the mount. Uses 35mm, 2¼×2¼ or 4×5 transparencies. Photos are returned after use. Pays $50 minimum/color photo; $150 minimum/cover photo. **Pays on acceptance.** Credit line given. Not copyrighted. Buys one-time rights. Previously published work OK.

Tips: Kansas-oriented material only. Prefers Kansas photographers. "Follow guidelines, submission dates specifically. Shoot a lot of seasonal scenics."

KASHRUS MAGAZINE—The Guide for the Kosher Consumer, P.O. Box 204, Parkville Station, Brooklyn NY 11204. (718)336-8544. Editor: Rabbi Yosef Wikler. Circ. 10,000. Bimonthly. Emphasizes kosher food and food technology. Readers are kosher food consumers, vegetarians and producers. Sample copy $2.

Needs: Uses 3-5 photos/issue; all supplied by freelance photographers. Needs photos of travel, food, food technology, seasonal nature photos and Jewish holidays. Model release preferred. Captions preferred.

Making Contact & Terms: Send unsolicited photos by mail for consideration. Provide résumé, business card, brochure, flier or tearsheets to be kept on file for possible future assignments. Uses 2¼×2¼, 3½×3½ or 7½×7½ matte b&w prints. SASE. Reports in 1 week. Pays $40-75/b&w cover photo; $25-50/b&w inside photo; $75-200/job; $50-200/text/photo package. Pays part on acceptance; part on publication. Buys one-time rights, first North American serial rights, all rights; negotiable. Simultaneous submissions and previously published work OK.

KEYBOARD, 411 Borel Ave., Suite 100, San Mateo CA 94402. (415)358-9500. Editor: Tom Darter. Art Director: Paul Martinez. Monthly magazine. Circ. 82,000. Emphasizes "biographies and how-to feature articles on keyboard players (pianists, organists, synthesizer players, etc.) and keyboard-related material. It is read primarily by musicians to get background information on their favorite artists, new developments in the world of keyboard instruments, etc."

Needs: Buys 10-15 photos/issue. Celebrity/personality (photos of keyboard players at their instruments). Prefers shots of musicians with their instruments. Photos purchased with or without accompanying ms and infrequently on assignment. Captions required for historical shots only.

Making Contact & Terms: Interested in receiving work from newer, lesser-known photographers. Query with list of stock photo subjects. Send first class to Paul Martinez. Uses 8×10 b&w glossy prints; 35mm color, 120mm, 4×5 transparencies for cover shots. SASE. Reports in 1 month. Pays on a per-photo basis. Pays expenses on assignment only. Pays $35-150/b&w inside photo; $300-500/photo for cover; $75-250/ color inside photo. Pays on publication. Credit line given. Buys rights to one-time use with option to reprint. Simultaneous submissions OK.

Tips: "Send along a list of artist shots on file. Photos submitted for our files would also be helpful—we'd prefer keeping them on hand, but will return prints if requested. We prefer live shots at concerts or in clubs. Keep us up to date on artists that will be photographed in the near future. Freelancers are vital to us."

KEYNOTER, 3636 Woodview Trace, Indianapolis IN 46268. (317)875-8755. Fax: (317)879-0204. Art Director: Jim Patterson. Circ. 190,000. Publication of the Key Club International. Monthly magazine through school year (7 issues). Emphasizes teenagers, above average students and members of Key Club International. Readers are teenagers, ages 14-18, male and female, high GPA, college-bound, leaders. Sample copy free with 9×12 SAE and 3 first-class stamps. Photo guidelines free with SASE.

Needs: Uses varying number of photos/issue; varying percentage supplied by freelancers. Needs vary with subject of the feature article. Reviews photos purchased with accompanying ms only. Model release required. Captions preferred.

Making Contact & Terms: Query with résumé of credits. Accepts images in digital format for Mac and Windows. Send via compact disc, floppy disk or SyQuest. Pays $700/color cover photo; $500/b&w cover photo; $400/color inside photo; $100/b&w inside photo. **Pays on acceptance.** Credit line given. Buys first North American serial rights and first international serial rights.

KIPLINGER'S PERSONAL FINANCE MAGAZINE, 1729 H St. NW, Washington DC 20006. (202)887-6492. Fax: (202)331-1206. Photography Editor: Wendy Tefenbacher. Circ. 1.2 million. Estab. 1935. Monthly magazine. Emphasizes personal finance.

Needs: Uses 15-25 photos/issue; 90% supplied by freelancers. Needs "creative business portraits and

photo illustration dealing with personal finance issues (i.e. investing, retirement, real estate). Model release required. Property release preferred. Captions required.

Making Contact & Terms: Interested in receiving work from newer, lesser-known and established photographers. Arrange personal interview to show portfolio. Provide business card, brochure, flier or tearsheets to be kept on file for possible assignments. Keeps samples on file. SASE. Reports in 2 weeks. Pays $1,200/color and b&w cover photo; $350-1,200/day against space rate per page. **Pays on acceptance.** Credit line given. Buys one-time rights.

KITE LINES, P.O. Box 466, Randallstown MD 21133-0466. (410)922-1212. Fax: (410)922-4262. E-mail: 102365.1060@compuserve.com. Publisher-Editor: Valerie Govig. Circ. 13,000. Estab. 1977. Quarterly. Emphasizes kites and kite flying exclusively. Readers are international adult kiters. Sample copy $5. Photo guidelines free with SASE.

Needs: Uses about 45-65 photos/issue; "up to about 50% are unassigned or over-the-transom—but nearly all are from *kiter*-photographers." Needs photos of "unusual kites in action (no dimestore plastic kites), preferably with people in the scene (not easy with kites). Needs to relate closely to *information* (article or long caption)." Special needs include major kite festivals; important kites and kiters. Captions required. "Identify *kites*, kitemakers and kitefliers as well as location and date."

Making Contact & Terms: Query with samples or send 2-3 b&w 8×10 uncropped prints or 35mm or larger transparencies (dupes OK) by mail for consideration. Provide relevant background information, i.e., knowledge of kites or kite happenings. SASE. Reports in "2 weeks to 2 months (varies with work load, but any obviously unsuitable stuff is returned quickly—in 2 weeks." Pays $0-30/inside photo; $0-50/color photo; special jobs on assignment negotiable; generally on basis of film expenses paid only. "We provide extra copies to contributors. Our limitations arise from our small size. However, *Kite Lines* is a quality showcase for good work." Pays within 30 days after publication. Buys one-time rights; usually buys first world serial rights. Previously published work considered.

Tips: In portfolio or samples wants to see "ability to select important, *noncommercial* kites. Just take a great kite picture, and be patient with our tiny staff. Considers good selection of subject matter; good composition—angles, light, background and sharpness. But we don't want to look at 'portfolios'—just *kite* pictures, please."

KIWANIS MAGAZINE, 3636 Woodview Trace, Indianapolis IN 46268. (317)875-8755. Fax: (317)879-0204. Website: http://kiwanismail@kiwanis.org. Managing Editor: Chuck Jonak. Art Director: Jim Patterson. Circ. 285,000. Estab. 1915. Published 10 times/year. Emphasizes organizational news, plus major features of interest to business and professional men and women involved in community service. Free sample copy and writer's guidelines with SAE and 5 first-class stamps.

Needs: Uses photos with or without ms.

Making Contact & Terms: Send résumé of stock photos. Provide brochure, business card and flier to be kept on file for future assignments. Accepts images in digital format for Mac, Windows. Send via compact disc, floppy disk, SyQuest. Assigns 95% of work. Uses 5×7 or 8×10 glossy b&w prints; accepts 35mm but prefers 2¼×2¼ and 4×5 transparencies. Pays $50-400/b&w photo; $75-1,000/color photo; $400-1,000/text/photo package. Buys one-time rights.

Tips: "We can offer the photographer a lot of freedom to work *and* worldwide exposure. And perhaps an award or two if the work is good. We are now using more conceptual photos. We also use studio set-up shots for most assignments. When we assign work, we want to know if a photographer can follow a concept into finished photo without on-site direction." In portfolio or samples, wants to see "studio work with flash and natural light."

LACMA PHYSICIAN, P.O. Box 3465, Los Angeles CA 90051-1465. (213)683-9900. Fax: (213)630-1152. E-mail: lpmag@lacmanet.org. Website: http://www.lacmanet.org. Managing Editor: Johanna M. Smith. Circ. 8,000. Estab. 1875. Published 20 times/year—twice a month except January, July, August and December. Emphasizes Los Angeles County Medical Association news and medical issues. Readers are physicians and members of LACMA.

Needs: Uses about 1-12 photos/issue; from both freelance and staff assignments. Needs photos of association meetings, physician members, association events—mostly internal coverage. Photos purchased with or without accompanying ms. Model release required.

Making Contact & Terms: Arrange a personal interview to show portfolio. Accepts images in digital format for Windows (TIFF). Send via online, floppy disk (magneto-optical disk). Does not return unsolic-

‡　**MARKETS NEW TO THIS EDITION** are marked with a double dagger.

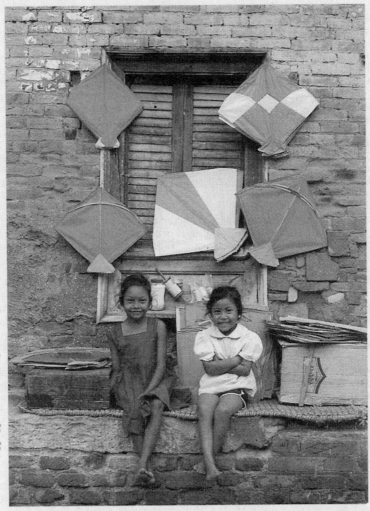

QUARTERLY JOURNAL OF THE WORLDWIDE KITE COMMUNITY

KiteLines

BONUS! POCKET KITE CALENDAR

$4.50 US WINTER-SPRING 1996, VOL. 11 NO. 4

© 1996 Stephen C. Lowe

This photo, taken in Nepal, was originally part of a submission to *Kitelines* in 1984, but the slides were returned to photographer Stephen Lowe because there was no story with them. Ten years later, editor Valerie Govig received an article about Nepal, remembered Lowe's submission, and contacted him. "This time, a gracious and helpful Mr. Lowe provided a good story to go with the slides," says Govig. "So we had two articles, different enough that we used *both* stories with Lowe's photos." The photos, including this cover shot, were finally published in the March 1996 *Kitelines*, nearly 12 years after they were first submitted, "but they were classics, still representative of Nepal, and still as strikingly beautiful as we had remembered them."

ited material. Pays by hour, day or half day; negotiable. Pays $100/hour. Pays on publication with submission of invoice. Credit line given. Buys one-time rights or first North American serial rights "depending on what is agreed upon; we buy nonexclusive rights to use work on our website."

Tips: "We want photographers who blend in well, and can get an extraordinary photo from what may be an ordinary situation. We need to see work that demonstrates an ability to get it right the first time without a lot of set-up on most shoots."

‡LACROSSE MAGAZINE, 113 W. University Pkwy., Baltimore MD 21210. (410)235-6882. Fax: (410)366-6735. E-mail: mbouchard@lacrosse.org. Editor: Marc Bouchard. Circ. 15,000. Estab. 1978. Publication of The Lacrosse Foundation. Monthly magazine during lacrosse season (March, April, May, June); bimonth off-season (July/August, September/October, November/December, January/February). Emphasizes sport of lacrosse. Readers are male and female lacrosse enthusiasts of all ages. Sample copy free with general information pack.

Needs: Uses 30-40 photos/issue; 50-75% supplied by freelancers. Needs lacrosse action shots. Captions required; include rosters with numbers for identification.

Making Contact & Terms: Interested in receiving work from newer, lesser-known photographers. Send unsolicited photos by mail for consdieration. Provide résumé, business card, brochure, flier or tearsheets to be kept on file for possible assignments. Send 4×6 glossy color and b&w prints. Keeps samples on file. SASE. Reports in 3 weeks. Pays $100/color cover photo; $50/color inside photo; $50/b&w inside photo. Pays on publication. Credit line given. Buys one-time rights. Simultaneous submissions and/or previously published work OK.

LADIES HOME JOURNAL, Dept. PM, 125 Park Ave., New York NY 10017. (212)557-6600. Fax: (212)351-3650. Contact: Photo Editor. Monthly magazine. Features women's issues. Readership consists of women with children and working women in 30s age group. Circ. 6 million.

Needs: Uses 90 photos per issue; 100% supplied by freelancers. Needs photos of children, celebrities and women's lifestyles/situations. Reviews photos only without ms. Model release and captions preferred. No photo guidelines available.

Making Contact & Terms: Provide résumé, business card, brochure, flier or tearsheet to be kept on file for possible assignment. "Do not send slides or original work; send only promo cards or disks." Reports in 3 weeks. Pays $200/b&w inside photo; $200/color page rate. **Pays on acceptance.** Credit line given. Buys one-time rights.

LAKE SUPERIOR MAGAZINE, Lake Superior Port Cities, Inc., P.O. Box 16417, Duluth MN 55816-0417. (218)722-5002. Fax: (218)722-4096. Editor: Paul L. Hayden. Circ. 20,000. Estab. 1979. Bimonthly magazine. "Beautiful picture magazine about Lake Superior." Readers are ages 35-55, male and female, highly educated, upper-middle and upper-management level through working. Sample copy $3.95 with 9×12 SAE and 5 first-class stamps. Photo guidelines free with SASE.

● This publication now uses a desktop system for color scanning and storage of high resolution files.

Needs: Uses 30 photos/issue; 70% supplied by freelance photographers. Needs photos of scenic, travel, wildlife, personalities, underwater, all photos Lake Superior-related. Photo captions preferred.

Making Contact & Terms: Interested in receiving work from newer, lesser-known photographers. Send unsolicited photos by mail for consideration. Provide résumé, business card, brochure, flier or tearsheets to be kept on file for possible assignments. Uses b&w prints; 35mm, 2¼×2¼, 4×5 transparencies. SASE. Reports in 3 weeks. Pays $75/color cover photo; $35/color inside photo; $20/b&w inside photo. Pays on publication. Credit line given. Buys first North American serial rights; reserves second rights for future use. Simultaneous submissions OK.

Tips: "Be aware of the focus of our publication—Lake Superior. Photo features concern only that. Features with text can be related. We are known for our fine color photography and reproduction. It has to be 'tops.' We try to use images large, therefore detail quality and resolution must be good. We look for unique outlook on subject, not just snapshots. Must communicate emotionally."

LAKELAND BOATING MAGAZINE, 500 Davis St., Suite 100, Evanston IL 60201. (847)869-5400. Editor: Randall W. Hess. Circ. 45,000. Estab. 1945. Monthly magazine. Emphasizes powerboating in the Great Lakes. Readers are affluent professionals, predominantly men over 35. Sample copy $6 with 9×12 SAE and 10 first-class stamps.

Needs: Needs shots of particular Great Lakes ports and waterfront communities. Model release preferred. Captions preferred.

Making Contact & Terms: Query with list of stock photo subjects. Provide résumé, business card, brochure, flier or tearsheets to be kept on file for possible assignment. SASE. Pays $20-100/b&w photo; $25-100/color photo. **Pays on acceptance.** Credit line given. Buys one-time rights.

LANDSCAPE ARCHITECTURE, 4401 Connecticut Ave. NW, 5th Floor, Washington DC 20008. (202)686-8322. Design Director: Jeff Roth. Circ. 35,000. Estab. 1910. Publication of the American Society of Landscape Architects. Monthly magazine. Emphasizes "landscape architecture, urban design, parks and recreation, architecture, sculpture" for professional planners and designers. Sample copy $7. Photo guidelines free with SASE.
Needs: Uses about 75-100 photos/issue; 80% supplied by freelance photographers. Needs photos of landscape- and architecture-related subjects as described above. Special needs include aerial photography and environmental portraits. Model release required. Credit, caption information required.
Making Contact & Terms: Query with samples or list of stock photo subjects. Provide brochure, flier or tearsheets to be kept on file for possible future assignments. SASE. Reporting time varies. Pays $400/day. Pays on publication. Credit line given. Buys one-time rights. Previously published work OK.
Tips: "We take an editorial approach to photographing our subjects."

‡**LATINA MAGAZINE**, 1500 Broadway, Suite 600, New York NY 10036. (212)642-0600. Fax: (212)997-2553. E-mail: latinamag@aol.com. Photo Editor: Laura Encinas. Circ. 300,000. Estab. 1996. Quarterly magazine in 1996; 9 issues in 1997. Emphasizes lifestyle. Readers are female hispanic, ages 25-40.
Needs: Uses 80 photographs in Fall 1996 issue; all supplied by freelancers. Needs photos of fashion, beauty, portraits, travel, food, etc. Model release required for celebrities. Captions required; include photographer's name.
Making Contact & Terms: Interested in receiving work from newer, lesser-known photographers. Submit portfolio for review. Dropoff portfolios at mailroom of *Essence* Magazine 1500 Broadway, 6th Floor, New York NY 10036. Provide résumé, business card, brochure, flier or tearsheets to be kept on file for possible assignments. "Only send your portfolio." Accepts images in digital format for Mac. Send via online, floppy disk, Zip disk (300 dpi). Keeps samples on file. Cannot return material. Reports in 1-2 weeks. Pays $100-250/b&w inside photo; $250/color page rate. Pays on publication. Credit line given. Buys one-time and all rights; negotiable.

LAW PRACTICE MANAGEMENT, Box 11418, Columbia SC 29211-1418. (803)754-3563. Editor/Art Director: Delmar L. Roberts. Circ. 22,005 (BPA). Estab. 1975. Published 8 times/year. Publication of the Section of Law Practice Management, American Bar Association. For practicing attorneys and legal administrators. Sample copy $8 (make check payable to American Bar Association).
Needs: Uses 1-2 photos/issue; all supplied by freelance photographers. Needs photos of some stock subjects such as group at a conference table, someone being interviewed, scenes showing staffed office-reception areas; *imaginative* photos illustrating such topics as time management, employee relations, trends in office technology, alternative billing, lawyer compensation. Computer graphics of interest. Abstract shots or special effects illustrating almost anything concerning management of a law practice. "We'll exceed our usual rates for exceptional photos of this latter type." No snapshots or Polaroid photos. Model release required. Captions required.
Making Contact & Terms: Uses 5×7 glossy b&w prints; 35mm, 2¼×2¼, 4×5 transparencies. Send unsolicited photos by mail for consideration. They are accompanied by an article pertaining to the lapida "if requested." SASE. Reports in 3 months. Pays $200-300/color cover photo (vertical format); $75-100/b&w inside photo; $200-300/job. Pays on publication. Credit line given. Usually buys all rights, and rarely reassigns to photographer after publication.

❦**LEISURE WORLD**, 1253 Ouellette Ave., Windsor, Ontario N8X 1J3 Canada. Fax: (519)977-1197. E-mail: ompc@nnsi.net. Editor-in-Chief: Doug O'Neil. Circ. 321,214. Estab. 1988. Bimonthly magazine. Emphasizes travel and leisure. Readers are members of the Canadian Automobile Association, 50% male, 50% female, middle to upper middle class. Sample copy $2.
Needs: Uses 20-25 photos/issue; 25-30% supplied by freelance photographers. "*Leisure World* is looking for travel and destination features that not only serve as accurate accounts of real-life experiences, but are also dramatic narratives, peopled by compelling characters. Nonfiction short stories brought home by writers who have gone beyond the ordinary verities of descriptive travel writing to provide an intimate glimpse of another culture." Model release preferred. Captions required.
Making Contact & Terms: Send unsolicited photos by mail for consideration. Provide business card, brochure, flier or tearsheets to be kept on file for possible assignments. Accepts images in digital format for Windows (TIFF, EPS). Send via compact disc, online, SyQuest (300×300 dpi minimum). Send or color 35mm slides only, 2¼×2¼, 4×5, or 8×10 transparencies. SASE. Reports in 2 weeks. Pays $100/color cover photo; $50/color inside photo; or $150-300/photo/text package. Pays on publication. Credit line given. Buys one-time rights.
Tips: "We expect that the technical considerations are all perfect—frames, focus, exposure, etc. Beyond that we look for a photograph that can convey a mood or tell a story by itself. We would like to see 50%

landscape, 50% portrait format in 35mm photographs. We encourage talented and creative photographers who are trying to establish themselves."

LIBIDO: THE JOURNAL OF SEX AND SENSIBILITY, 5318 N. Paulina St., Chicago IL 60640. (773)275-0842. Fax: (773)275-0752. E-mail: rune@mcs.com. Website: http://www.indra.com/libido. Photo Editor: Marianna Beck. Circ. 9,000. Estab. 1988. Quarterly journal. Emphasizes erotic photography. Subscribers are 60% male, 40% female, generally over 30, college educated professionals. Sample copy $8. Photo guidelines free with SASE.
Needs: Uses 30-35 photos/issue; 30 supplied by freelancers. Needs erotic photos (need not be nude, but usually it helps); nude figure-studies and couples. Reviews photos with or without ms. Model release required. "Besides dated releases, all photos taken after July 5, 1995 must comply with federal record keeping requirements."
Making Contact & Terms: Interested in receiving work from newer, lesser-known photographers. Send unsolicited photos by mail for consideration. Send 4×5, 8×10 matte or glossy b&w prints. Accepts images in digital format for Mac (JPEG). Send via online, floppy disk. Keeps samples on file. Reports in 1 month. Pays $75/b&w cover photo; $20-50/b&w inside photo. Pays on publication. Credit line given. Buys one-time and electronic rights. Previously published work OK.
Tips: "Fit your work to the style and tone of the publication."

LIFE, Time-Life Bldg., Rockefeller Center, New York NY 10020. (212)522-1212. Special Project Photo Editor: Barbara Baker Burrows. Photo Editor: Marie Schumann. Circ. 1.4 million. Monthly magazine. Emphasizes current events, cultural trends, human behavior, nature and the arts, mainly through photojournalism. Readers are of all ages, backgrounds and interests.
Needs: Uses about 100 photos/issue. Prefers to see topical and unusual photos. Must be up-to-the minute and newsworthy. Send photos that could not be duplicated by anyone or anywhere else. Especially needs humorous photos for last page article "Just One More."
Making Contact & Terms: Send material by mail for consideration to the Picture Desk. Do not send negatives or original transparencies—send prints, dupe sides or laser copies. SASE. Uses 35mm, $2\frac{1}{4} \times 2\frac{1}{4}$, 4×5 and 8×10 slides. Pays $500/page; $1,000/cover. Credit line given. Buys one-time rights.
Tips: "Familiarize yourself with the topical nature and format of the magazine before submitting photos and/or proposals."

THE LION, 300 22nd St., Oak Brook IL 60521-8842. (630)571-5466. Fax: (630)571-8890. Editor: Robert Kleinfelder. Circ. 600,000. Estab. 1918. For members of the Lions Club and their families. Monthly magazine. Emphasizes Lions Club service projects. Free sample copy and guidelines available.
Needs: Uses 50-60 photos/issue. Needs photos of Lions Club service or fundraising projects. "All photos must be as candid as possible, showing an activity in progress. Please, no award presentations, meetings, speeches, etc. Generally photos purchased with ms (300-1,500 words) and used as a photo story.We seldom purchase photos separately." Model release preferred for young or disabled children. Captions required.
Making Contact & Terms: Interested in receiving work from newer, lesser-known photographers. Works with freelancers on assignment only. Provide résumé to be kept on file for possible future assignments. Query first with résumé of credits or story idea. Send 5×7, 8×10 glossy b&w and color prints; 35mm transparencies. SASE. Reports in 2 weeks. Pays $10-25/photo; $100-600/text/photo package. **Pays on acceptance.** Buys all rights; negotiable.

THE LIVING CHURCH, 816 E. Juneau Ave., P.O. Box 92936, Milwaukee WI 53202. (414)276-5420. Fax: (414)276-7483. Managing Editor: John Schuessler. Circ. 9,000. Estab. 1878. Weekly magazine. Emphasizes news of interest to members of the Episcopal Church. Readers are clergy and lay members of the Episcopal Church, predominantly ages 35-70. Sample copies available.
Needs: Uses 8-10 photos/issue; almost all supplied by freelancers. Needs photos to illustrate news articles. Always in need of stock photos—churches, scenic, people in various settings. Captions preferred.
Making Contact & Terms: Interested in receiving work from newer, lesser-known photographers. Send unsolicited photos by mail for consideration. Send 5×7 or larger glossy b&w prints. Also accepts color/b&w TIFF files, resolution 72 and 300 dpi. SASE. Reports in 1 month. Pays $25-50/b&w cover photo; $10-25/b&w inside photo. Pays on publication. Credit line given.

LOG HOME LIVING, 4200 T Lafayette Center Dr., Chantilly VA 20151. (703)222-9411. Fax: (703)222-3209. Website: http://www.loghomeliving.com. Executive Editor: Janice Brewster. Circ. 120,000. Estab. 1989. Ten times/year magazine. Emphasizes buying and living in log homes. Sample copy $3.50/issue. Photo guidelines free with SASE.
Needs: Uses over 100 photos/issue; 10 supplied by freelancers. Needs photos of homes—living room,

dining room, kitchen, bedroom, bathroom, exterior, portrait of owners, design/decor—tile sunrooms, furniture, fireplaces, lighting, porch and decks, doors. Model release preferred. Caption required.

Making Contact & Terms: Interested in receiving work from newer, lesser-known photographers. Send unsolicited photos by mail for consideration. Keeps samples on file. SASE. Reports back only if interested. Pays $200-600/color cover photo; $50-100/color inside photo; $100/color page rate; $500-1,000/photo/text package. **Pays on acceptance.** Credit line given. Buys first North American serial rights; negotiable. Previously published work OK.

LUSTY LETTERS, OPTIONS, BEAU, Box 470, Port Chester NY 10573. Photo Editor: Wayne Shuster. Circ. 60,000. Periodical magazines. Emphasizes "sexually oriented situations. We emphasize good, clean sexual fun among liberal-minded adults." Readers are mostly male; ages 18-65. Sample copy $2.95 with 6×9 SAE and 5 first-class stamps.
Needs: Color transparencies of single girls, girl-girl and single boys for cover; "present in a way suitable for newsstand display." Also transparencies of sexual situations among gay males, lesbians, male-female. Model release required.
Making Contact & Terms: Query with samples. Send 35mm, 2¼×2¼, 4×5 transparencies by mail for consideration. SASE. Reports in 2 weeks. Pays $250 maximum/color cover photo. Pays on publication. Buys one-time rights on covers.
Tips: "Please examine copies of our publications before submitting work. In reviewing samples we consider composition of color photos for newsstand display and look for recent b&w photos for inside."

LUTHERAN FORUM, P.O. Box 327, Delhi NY 13753. (607)746-7511. Editor: Ronald Bagnall. Circ. 3,500. Quarterly. Emphasizes "Lutheran concerns, both within the church and in relation to the wider society, for the leadership of Lutheran churches in North America."
Needs: Uses cover photo occasionally. "While subject matter varies, we are generally looking for photos that include people, and that have a symbolic dimension. We use *few* purely 'scenic' photos. Photos of religious activities, such as worship, are often useful, but should not be 'cliches'—types of photos that are seen again and again." Captions "may be helpful."
Making Contact & Terms: Query with list of stock photo subjects. SASE. Reports in 2 months. Pays $15-25/b&w photo. Pays on publication. Credit line given. Buys one-time rights. Simultaneous submissions or previously published work OK.

THE LUTHERAN, 8765 W. Higgins Rd., Chicago IL 60631. (773)380-2540. Fax: (773)380-2751. E-mail: lutheran@elca.org. Website: http://www.thelutheran.org. Art Director: Michael Watson. Publication of Evangelical Lutheran Church in America. Circ. 800,000. Estab. 1988. Monthly magazine. Sample copy 75¢ with 9×12 SASE.
 • *The Lutheran*'s entire production is now digitized. They have their own inhouse network so graphics, photo and text are readily accessible to all. They have been online with a worldwide Web edition since July, 1995.
Needs: Assigns 35-40 photos/issue; 4-5 supplied by freelancers. Needs current news, mood shots. "We usually assign work with exception of 'Reflections' section." Model release required. Captions preferred.
Making Contact & Terms: Interested in receiving work from newer, lesser-known photographers. Query with list of stock photo subjects. Accepts images in digital format for Mac, Photoshop. Send via compact disc, online, floppy disk, SyQuest (300 dpi). Provide résumé, brochure, flier or tearsheets to be kept on file for possible future assignments. SASE. Reports in 3 weeks. Pays $100-250/color photo; $250/half day; $500 for full day. Pays on publication. Credit line given. Buys one-time rights.
Tips: Trend toward "more dramatic lighting. Careful composition." In portfolio or samples, wants to see "candid shots of people active in church life, preferably Lutheran. Churches-only photos have little chance of publication. Submit sharp well-composed photos with borders for cropping."

✣MACLEAN'S MAGAZINE, 777 Bay St., Toronto, Ontario M5W 1A7 Canada. (416)596-5379. Fax: (416)596-7730. E-mail: pbregg@macleans.com. Photo Editor: Peter Bregg. Circ. 500,000. Estab. 1905. Weekly magazine. Emphasizes news/editorial. Readers are a general audience. Sample copy $3 with 9×12 SASE.
Needs: Uses 50 photos/issue. Needs a variety of photos similar to *Time* and *Newsweek*. Captions required; include who, what, where, when, why.
Making Contact & Terms: Interested in receiving work from newer, lesser-known photographers. Send business card. Uses color prints; transparencies; 266 dpi, 6×8 average digital formats. Deadline each Friday. Cannot return material. Don't send originals. Reports in 3 weeks. Pays $350/day; $600/color cover photo; $200/color inside photo; $50 extra for electronic usage. Pays on publication. Credit line given. Buys one-time and electronic rights. Simultaneous submissions and previously published work OK.

THE MAGAZINE ANTIQUES, 575 Broadway, New York NY 10012. (212)941-2800. Fax: (212)941-2819. Editor: Allison E. Ledes. Circ. 64,402. Estab. 1922. Monthly magazine. Emphasizes art, antiques, architecture. Readers are male and female collectors, curators, academics, interior designers, ages 40-70. Sample copy $10.50.
Needs: Uses 60-120 photos/issue; 40% supplied by freelancers. Needs photos of interiors, architectural exteriors, objects. Reviews photos with or without ms.
Making Contact & Terms: Interested in receiving work from newer, lesser-known photographers. Submit portfolio for review; phone ahead to arrange dropoff. Send 8×10 glossy prints; 4×5 transparencies. Does not keep samples on file. SASE. Reports in 2 weeks. Payment negotiable. Pays on publication. Credit line given. Buys one-time rights; negotiable. Previously published work OK.

‡**MAGIC REALISM**, P.O. Box 922648, Sylmar CA 91392-2648. Editor: C. Darren Butler. Circ. 800. Estab. 1990. Magazine published quarterly. Emphasizes literary fiction, unusual fiction related to fantasy and magic realism. Sample copy $5.95; $4.95 (back issue). Photo guidelines free with SASE.
Needs: Uses 0-3 photos/issue; all supplied by freelancers. Special photo needs include artistic, bizarre, touched up, multiple exposures. Model/property release preferred. Captions preferred.
Making Contact & Terms: Interested in receiving work from newer, lesser-known photographers. Submit portfolio for review. Query with résumé of credits. Query with stock photo list. Send unsolicited photos by mail for consideration. Provide résumé, business card, brochure, flier or tearsheets to be kept on file for possible assignments. Send color or b&w 5×4 transparencies. Keeps samples on file. SASE. Reports in 1 month on queries; 3-6 months on submissions. Pays $50-300/b&w or color cover photo; $10-50/b&w cover photo; $2-10/b&w inside photo and contributor's copies. **Pays on acceptance**. Credit line given. Buys one-time, first North American serial, Spanish language edition rights. Simultaneous submissions and previously published work OK.

MAINSTREAM, Magazine of the Able-Disabled, 2973 Beech St., San Diego CA 92102. (619)234-3138. E-mail: editor@mainstream~mag.com. Website: http://www.mainstream~mag.com. Editor: William G. Stothers. Circ.19,400. Estab. 1975. Published 10 times per year. Emphasizes disability rights. Readers are upscale, active men and women who are disabled. Sample copy $5 with 9×12 SAE and 6 first-class stamps.
Needs: Uses 3-4 photos/issue. Needs photos of disabled people doing things—sports, travel, working, etc. Reviews photos with accompanying ms only. Model/property release preferred. Captions required.
Making Contact & Terms: Provide résumé, business card, brochure, flier or tearsheets to be kept on file for possible assignments. Keeps samples on file. SASE. Reports in 2 months. Pays $85/color cover photo; $35/b&w inside photo. Pays on publication. Credit line given. Buys all rights; negotiable. Previously published work OK "if not in one of our major competitors' publications."
Tips: "We definitely look for signs that the photographer empathizes with and understands the perspective of the disability rights movement."

MANAGEMENT ACCOUNTING, 10 Paragon Dr., Montvale NJ 07645. (201)573-9000. Fax: (201)573-0639. Editor: Kathy Williams. Circ. 95,000. Estab. 1919. Publication of Institute of Management Accountants. Monthly. Emphasizes management accounting. Readers are financial executives.
Needs: Uses about 25 photos/issue; 40% from stock houses. Needs stock photos of business, high-tech, production and factory. Model release required for identifiable people. Captions required.
Making Contact & Terms: Query with samples. Provide résumé, business card, brochure, flier or tearsheets to be kept on file for possible future assignments. Uses prints and transparencies. SASE. Reports in 2 weeks. Pays $100-200/b&w photo; $150-250/color photo. **Pays on acceptance.** Credit line given. Buys one-time rights. Simultaneous submissions and previously published work OK.
Tips: Prefers to see "ingenuity, creativity, dramatics (business photos are often dry), clarity, close-ups, simple but striking. Aim for a different slant."

✤**THE MANITOBA TEACHER**, 191 Harcourt St., Winnipeg, Manitoba R3J 3H2 Canada. (204)888-7961. Fax: (204)831-0877. Communications Officer: Janice Armstrong. Managing Editor: Raman Job. Circ. 17,000. Publication of The Manitoba Teachers' Society. Published nine times per year. Emphasizes education in Manitoba—emphasis on teachers' interest. Readers are teachers and others in education. Sample copy free with 10×14 SAE and Canadian stamps.
Needs: Uses approximately 4 photos/issue; 80% supplied by freelancers. Needs action shots of students and teachers in education-related settings. Model release required. Captions required.
Making Contact & Terms: Send 8×10 glossy b&w prints by mail for consideration. Submit portfolio for review. Provide résumé, business card, brochure, flier or tearsheets to be kept on file for possible assignments. SASE. Reports in 1 month. Pays $35/photo for single use.
Tips: "Always submit action shots directly related to major subject matter of publication and interests of

readership of that publication."

MARLIN MAGAZINE, P.O. Box 2456, Winter Park FL 32790. (407)628-4802. Fax: (407)628-7061. E-mail: marlin@worldzine.com. Editor: David Ritchie. Circ. 40,000 (paid). Estab. 1981. Bimonthly magazine. Emphasizes offshore big game fishing for billfish, sharks and tuna and other large pelagics. Readers are 94% male, 75% married, average age 43, very affluent businessmen. Free sample copy with 8×10 SAE. Photo guidelines free with SASE.
Needs: Uses 40-50 photos/issue; 98% supplied by freelancers. Needs photos of fish/action shots, scenics and how-to. Special photo needs include big game fishing action and scenics (marinas, landmarks etc.). Model release preferred. Captions preferred.
Making Contact & Terms: Interested in receiving work from newer, lesser-known photographers. Send unsolicited photos by mail for consideration. Send 35mm transparencies. Also accepts high resolution images on CD (Mac). SASE. Reports in 1 month. Pays $750/color cover photo; $50-300/color inside photo; $35-150/b&w inside photo; $150-200/color page rate. Pays on publication. Buys first North American rights. Simultaneous submissions OK, with notification.

MARTIAL ARTS TRAINING, P.O. Box 918, Santa Clarita CA 91380-9018. (805)257-4066. Fax: (805)257-3028. E-mail: rainbow@rsabbs.com. Editor: Douglas Jeffrey. Circ. 40,000. Bimonthly. Emphasizes martial arts training. Readers are martial artists of all skill levels. Sample copy free. Photo guidelines free with SASE.
Needs: Uses about 100 photos/issue; 90 supplied by freelance photographers. Needs "photos that pertain to fitness/conditioning drills for martial artists. Photos purchased with accompanying ms only. Model release required. Captions required.
Making Contact & Terms: Send 5×7 or 8×10 b&w prints; 35mm transparencies; b&w contact sheet or negatives by mail for consideration. Accepts images in digital format for Mac. SASE. Reports in 1 month. Pays $50-150 for photo/text package. Pays on publication. Credit line given. Buys all rights.
Tips: Photos "must be razor-sharp, b&w or color. Technique shots should be against neutral background. Concentrate on training-related articles and photos."

‡**MATURE LIFESTYLES NEWS MAGAZINE**, 15951 McGregor Blvd., #2-D, Ft. Myers FL 33908. (941)482-7969. Fax: (941)481-8707. Graphic Design Manager: Glenn Fraller. Circ. 254,000. Circ. 1986. Monthly tabloid. Emphasis on 50-65 age group. Readers are male and female, 50-75, employed boomers, early retirees, retirees, semi-retired executives. Free sample copy.
Needs: Uses 2 photos/issue; 2 supplied by freelancers. Needs photos of personalities, how-to. Special photo needs include cover shots.
Making Contact & Terms: Interested in receiving work from newer, lesser-known photographers. Submit portfolio for review. Query with stock photo list. Provide résumé, business card, brochure, flier or tearsheets to be kept on file for possible assignments. Send 2¼×2¼, 4×5 transparencies. Keeps samples on file. SASE. Reports in 1 month. Pays $250/color cover photo. Pays on publication. Credit line given. Buys one-time rights. Previously published work OK.

MEDIPHORS, P.O. Box 327, Bloomsburg PA 17815. Editor: Eugene D. Radice, MD. Circ. 900. Estab. 1993. Semiannual magazine. Emphasizes literary/art in medicine and health. Readers are male and female adults in the medical fields and literature. Sample copy $5.50. Photo guidelines free with SASE.
Needs: Uses 5-7 photos/issue; all supplied by freelancers. Needs artistic photos related to medicine and health. Also photos to accompany poetry, essay, and short stories. Special photo needs include single photos, cover photos, and photos accompanying literary work. Releases usually not needed—artistic work. Photographers encouraged to submit titles for their artwork.
Making Contact & Terms: Interested in receiving work from newer, lesser-known photographers. Send unsolicited photos by mail for consideration. Send minimum 3×4 any finish b&w prints. Keeps samples on file. SASE. Reports in 1 month. Pays on publication 2 copies of magazines. Credit line given. Buys first North American serial rights.
Tips: Looking for "b&w artistic photos related to medicine & health. Our goal is to give new artists an opportunity to publish their work. Prefer photos where people CANNOT be specifically identified. Examples: Drawings on the wall of a Mexican Clinic, an abandoned nursing home, an old doctor's house, architecture of an old hospital."

MENNONITE PUBLISHING HOUSE, 616 Walnut Ave., Scottdale PA 15683. (412)887-8500. Fax: (412)887-3100. Photo Secretary: Debbie Cameron. Publishes *Story Friends* (ages 4-9), *On The Line* (ages 10-14), *Christian Living*, *Gospel Herald*, *Purpose* (adults).
Needs: Buys 10-20 photos/year. Needs photos of children engaged in all kinds of legitimate childhood

activities (at school, at play, with parents, in church and Sunday School, at work, with hobbies, relating to peers and significant elders, interacting with the world); photos of youth in all aspects of their lives (school, work, recreation, sports, family, dating, peers); adults in a variety of settings (family life, church, work, and recreation); abstract and scenic photos. Model release preferred.

Making Contact & Terms: Send 8½×11 b&w photos by mail for consideration. Provide résumé, business card, brochure, flier or tearsheets to be kept on file for possible assignments. SASE. Reports in 1 month. Pays $30-70/b&w photo. Credit line given. Buys one-time rights. Simultaneous submissions and/or previously published work OK.

‡METROPOLIS PUBLICATIONS, 5670 Wilshire Blvd., #1240, Los Angeles CA 90036. (213)965-7800. Fax: (213)965-0915. E-mail: cmarkham@metropolismedia.com. Magazines. Photo Editor/Manager: Catherine Markham. Combined circulation approximately 500,000. Estab. 1994. Various monthly magazine. Emphasizes men's general interest: electronic entertainment, gaming, extreme sports, fitness. Celebrity interviews, technology, movies, music, travel, fashion, health, grooming, fiction stories, vehicles, etc. Readers are male 25-40. Sample copy $3.

● Metropolis publishes *Men's Perspective, Gamefan, Digital Diner, Megan Fan* and is growing rapidly.

Needs: Uses 100 photos/issue; 50% supplied by freelancers.

Making Contact & Terms: Contact through rep. Query with stock photo list. Provide résumé, business card, brochure, flier or tearsheets to be kept on file for possible assignments. Send transparencies. Keeps samples on file. SASE. Reports in 3 weeks. Payment negotiable. Pays on publication. Buys one-time and all rights; negotiable. Simultaneous submissions and previously published work OK.

MICHIGAN NATURAL RESOURCES MAGAZINE, 30600 Telegraph Rd., Suite 1255, Bingham Farms MI 48025-4531. (810)642-9580. Fax: (810)642-5290. Editor: Richard Morscheck. Creative Director: Michael Wagester. Circ. 65,000. Estab. 1931. Bimonthly. Emphasizes natural resources in the Great Lakes region. Readers are "appreciators of the out-of-doors; 15% readership is out of state." Sample copy $4. Photo guidelines free with SASE.

Needs: Uses about 40 photos/issue; freelance photography in given issue—25% from assignment and 75% from freelance stock. Needs photos of Michigan wildlife, Michigan flora, how-to, travel in Michigan, outdoor recreation. Captions preferred.

Making Contact & Terms: Interested in receiving work from newer, lesser-known photographers. Query with samples or list of stock photo subjects. Send original 35mm color transparencies by mail for consideration. SAE. Reports in 1 month. Pays $50-250/color page; $500/job; $800 maximum for photo/text package. Pays on publication. Credit line given. Buys one-time rights.

Tips: Prefers "Kodachrome 64 or 25 or Fuji 50 or 100, 35mm, *razor-sharp in focus!* Send about 20 slides with a list of stock photo topics. Be sure slides are sharp, labeled clearly with subject and photographer's name and address. Send them in plastic slide filing sheets. Looks for unusual outdoor photos. Flora, fauna of Michigan and Great Lakes region. Strongly recommend that photographer look at past issues of the magazine to become familiar with the quality of the photography and the overall content. We'd like our photographers to approach the subject from an editorial point of view. Every article has a beginning, middle and end. We're looking for the photographer who can submit a complete package that does the same thing."

MICHIGAN OUT-OF-DOORS, P.O. Box 30235, Lansing MI 48909. (517)371-1041. Fax: (517)371-1505. Editor: Dennis C. Knickerbocker. Circ. 130,000. Estab. 1947. Monthly magazine. For people interested in "outdoor recreation, especially hunting and fishing; conservation; environmental affairs." Sample copy $2.50; free editorial guidelines.

Needs: Use 6-12 freelance photos/issue. Animal, nature, scenic, sport (hunting, fishing and other forms of noncompetitive recreation), and wildlife. Materials must have a Michigan slant. Captions preferred.

Making Contact & Terms: Send any size glossy b&w prints; 35mm or 2¼×2¼ color transparencies. SASE. Reports in 1 month. Pays $20 minimum/b&w photo; $175/cover photo; $30/inside color photo. Credit line given. Buys first North American serial rights. Previously published work OK "if so indicated."

Tips: Submit seasonal material 6 months in advance. Wants to see "new approaches to subject matter."

THE MIDWEST MOTORIST, Dept. PM, Auto Club of Missouri, 12901 N. Forty Dr., St. Louis MO 63141. (314)523-7350. Fax: (314)523-6982. Editor: Michael Right. Circ. 428,000. Bimonthly. Emphasizes travel and driving safety. Readers are "members of the Auto Club of Missouri, ranging in age from 25-65 and older." Free sample copy and photo guidelines with SASE; use large manila envelope.

Needs: Uses 8-10 photos/issue, most supplied by freelancers. "We use four-color photos inside to accompany specific articles. Our magazine covers topics of general interest, historical (of Midwest regional interest), humor (motoring slant), interview, profile, travel, car care and driving tips. Our covers are full color photos mainly corresponding to an article inside. Except for cover shots, we use freelance photos only to accompany specific articles." Captions required.

Making Contact & Terms: Send by mail for consideration 35mm, 2¼ × 2¼ or 4 × 5 color transparencies. Query with résumé of credits. Query with list of stock photo subjects. SASE. Reports in 6 weeks. Pays $100-350/cover; $50-200/color photo; $75-350 photo/text package. **Pays on acceptance.** Credit line given. Rights negotiable. Simultaneous submissions and previously published work OK.

Tips: "Send an 8½ × 11 SASE for sample copies and study the type of covers and inside work we use."

‡MIZZOU MAGAZINE, (formerly *Missouri Alumnus*), Alumni Center, 407 Reynolds, Columbia MO 65211. (573)882-3049. Fax: (573)882-7290. Circ. 125,000. Estab. 1912. Quarterly magazine. Emphasizes University of Missouri and its alumni. Readers are professional, educated, upscale alumni and friends of MU. Sample copy free with 9 × 12 SAE and 4 first-class stamps.

Needs: Uses 37-40 photos/issue; 10% supplied by freelancers. Needs photos of technology, personalities tied to MU alumni and professors. Reviews photos with or without ms. Model release preferred. Captions required.

Making Contact & Terms: Interested in receiving work from newer, lesser-known photographers. Query with résumé of credits. SASE. Reports in 1-2 weeks. Pays $35/hour;$15-30/color inside photo; pays $15-30/b&w inside photo. Pays extra for electronic usage of images. Pays on publication. Credit line given. Buys one-time rights. Previously published works OK.

‡MODE MAGAZINE, 22 E. 49th St., 5th Floor, New York NY 10017. (212)328-0180. (212)328-0188. E-mail: modemag@aol.com. Art Director: Janine Weitenauer. Quarterly magazine. Circ. 550,000. Emphasizes beauty and fashion for women sizes 12 and up. Readers are females of all occupations, ages 18-55. Sample copy available.

Needs: Uses 75-100 photos/issue; 25 supplied by freelancers. Needs photos of fashion spreads, still lifes, personalities. Model/property release required. Captions preferred; include where photo was taken if on location, name of clothing/accessories and stores where they can be purchased.

Making Contact & Terms: Contact through rep. Provide résumé, business card, brochure, flier or tearsheets to be kept on file for possible assignments. Send 35mm, 2¼ × 2¼, 4 × 5, 8 × 10 transparencies. "No negatives." Keeps samples on file. SASE. Reports in 1-2 weeks. Payment negotiable. **Pays on acceptance.** Credit line given. Buys one-time rights.

Tips: "Be innovative, creative and have a fresh outlook—uniqueness stands out."

MODERN DRUMMER MAGAZINE, 12 Old Bridge Rd., Cedar Grove NJ 07009. (201)239-4140. Fax: (201)239-7139. Editor: Ron Spagnardi. Photo Editor: Scott Bienstock. Circ. 100,000. Magazine published 12 times/year. For drummers at all levels of ability: students, semiprofessionals and professionals. Sample copy $4.95.

Needs: Buys 100-150 photos annually. Needs celebrity/personality, product shots, action photos of professional drummers and photos dealing with "all aspects of the art and the instrument."

Making Contact & Terms: Submit freelance photos with letter. Send for consideration b&w contact sheet, b&w negatives, or 5 × 7 or 8 × 10 glossy b&w prints; 35mm, 2¼ × 2¼, 8 × 10 color transparencies. Uses color covers. SASE. Pays $200/cover; $30-150/color photo; $15-75/b&w photo. Pays on publication. Credit line given. Buys one-time international usage rights per country. Previously published work OK.

MODERN MATURITY, 601 E. St., NW, Washington DC 20049. (202)434-2277. Photo Editor: M.J. Wadolny. Circ. 20 million. Bimonthly. Readers are age 50 and older. Sample copy free with 9 × 12 SASE. Guidelines free with SASE.

Needs: Uses about 50 photos/issue; 45 supplied by freelancers; 75% from assignment and 25% from stock.

Making Contact & Terms: Arrange a personal interview to show portfolio. SASE. Pays $50-200/b&w photo; $150-1,000/color photo; $350/day. **Pays on acceptance.** Credit line given. Buys one-time and first North American serial rights.

Tips: Portfolio review: Prefers to see clean, crisp images on a variety of subjects of interest. "Present yourself and your work in a professional manner. Be familiar with *Modern Maturity*. Wants to see creativity and ingenuity in images."

MOPAR MUSCLE MAGAZINE, 3816 Industry Blvd., Lakeland FL 33811. (941)644-0449. Fax: (941)648-1187. Editor Greg Rager. Circ. 100,000. Estab. 1988. Monthly magazine. Emphasizes Chrysler products—Dodge, Plymouth, Chrysler (old and new). Readers are Chrysler product enthusiasts of all ages. Guidelines free with SASE.
Needs: Uses approximately 120 photos/issue; 50% supplied by freelancers. Needs photos of automotive personalities, automobile features. Reviews photos with or without ms. Model release required. Property release required of automobile owners. Captions required; include all facts relating to the automotive subject.
Making Contact & Terms: Interested in receiving work from newer, lesser-known photographers. Send unsolicited photos by mail for consideration. Send 35mm, 2¼×2¼, 4×5 color transparencies. Keeps samples on file. Reports in 3 weeks. Payment negotiable. Pays on publication. Credit line given. Buys all rights; negotiable.

MOTHER EARTH NEWS, Sussex Publishers, 49 E. 21st St., 11th Floor, New York NY 10010. (212)260-3214. Fax: (212)260-7445. Photo Editor: Karin Fittante. Estab. 1992. Bimonthly magazine. Readers are male and female, highly educated, active professionals. Photo guidelines free with SASE.
• Sussex also publishes *Psychology Today* and *Spy* listed in this section.
Needs: Uses 19-25 photos/issue; all supplied by freelancers. Needs photos of humor, photo montage, symbolic, environmental, portraits, conceptual. Model/property release preferred.
Making Contact & Terms: Interested in receiving work from "upcoming" photographers. Submit portfolio for review. Send promo card with photo. Also accepts Mac files. Call before you drop off portfolio. Keeps samples on file. Cannot return material. Reports back only if interested. For assignments, pays $1,000/cover plus expenses; $350-750/inside photo plus expenses; for stock, pays $150/¼ page; $300/full page.

MOTHERING MAGAZINE, P.O. Box 1690, Santa Fe NM 87504. (505)984-8116. Fax: (505)986-8335. Senior Editor: Ashisha. Circ. 70,000. Estab. 1976. Bimonthly magazine. Emphasizes parenting. Readers are progressive parents, primarily aged 25-40, with children of all ages, racially mixed. Sample copy $3. Free photo guidelines and current photo needs.
Needs: Uses about 40-50 photos/issue; nearly all supplied by freelance photographers. Needs photos of children of all ages, mothers, fathers, breastfeeding, birthing, education. Model/property release required.
Making Contact & Terms: Interested in receiving work from newer, lesser-known photographers. Please send duplicates of slides. Send only 8×10 b&w prints by mail for consideration. "Provide a well-organized, carefully packaged submission following our guidelines carefully. Send SASE for return of pictures please." Reports in 2 months. Pays $500/color cover photo; $100 for full page, $50 for less than full page/b&w inside photo. Pays on publication. Credit line given. Buys one-time rights.
Tips: "For cover: we want technically superior color slides only of sharply focused images evoking a strong feeling or mood, spontaneous and unposed; unique and compelling. Eye contact with subject will often draw in viewer. For inside: b&w prints, sharply focused, action or unposed shots; 'doing' pictures—family, breastfeeding, fathering, midwifery, birth, reading, drawing, crawling, climbing, etc. No disposable diapers, no bottles, no pacifiers. We are being flooded with submissions from photographers acting as their own small stock agency—when the reality is that they are just individual freelancers selling their own work. As a result, we are using fewer photos from just one photographer, giving exposure to more photographers."

‡**MOUNTAIN LIVING**, Wiesner Publishing, 7009 S. Potomac St., Englewood CO 80112. (303)397-7600. Fax: (303)397-7619. E-mail: rgriggs@winc.usa.com. Editor: Robyn Griggs. Circ. 35,000. Estab. 1994. Bimonthly magazine. Emphasizes shelter, lifestyle. Sample copy $3.95.
Needs: Uses 50-75 photos/issue; all supplied by freelancers. Needs photos of home interiors, sporting events, nature, travel, scenics. Reviews photos purchased with accompanying ms only. Model/property release required. Captions preferred.
Making Contact & Terms: Submit portfolio for review. Query with stock photo list. Provide resume, business card, brochure, flier or tearsheets to be kept on file for possible assignments. Send 35mm, 2¼×2¼ transparencies. Keeps samples on file. SASE. Reports in 6 weeks. Pays $500-600/day; $500-600/job. **Pays on acceptance.** Credit line given. Buys one-time and first North American serial rights; negotiable. Previously published work OK.

❁**MOVING PUBLICATIONS LIMITED**, 44 Upjohn Rd., #100, Don Mills, Ontario M3B 2W1 Canada. Administrative Assistant: Anne Laplante. Circ. 225,000. Estab. 1973. Annual magazines. Emphasizes moving to a geographic area. Readers are male and female, ages 35-55.
Needs: Uses 20 photos/issue. Needs photos of housing shots, attractions, leisure. Special photo needs include cover shots. Model/property release required. Captions should include location.
• This publisher produces guides to locations such as Alberta, San Francisco Bay area and Greater

Sacramento; Vancouver & British Columbia; Winnipeg and Manitoba; Montreal; Toronto and area; Saskatchewan; Ottawa/Hull; Southwestern Ontario area.

Making Contact & Terms: Only free photographs accepted. Do not send unsolicited material. Phone/fax to determine requirements.

Tips: "For front covers, we look for general scenic shots."

MULTINATIONAL MONITOR, P.O. Box 19405, Washington DC 20036. (202)387-8030. Fax: (202)234-5176. E-mail: monitor@essential.org. Website: http://www.essential.org/monitor. Editor: Robert Weissman. Circ. 6,000. Estab. 1978. Monthly magazine. "We are a political-economic magazine covering operations of multinational corporations." Emphasizes multinational corporate activity. Readers are in business, academia and many are activists. Sample copy free with 9×12 SAE.

Needs: Uses 12 photos/issue; number of photos supplied by freelancers varies. "We need photos of industry, people, cities, technology, agriculture and many other business-related subjects." Captions required, include location, your name and description of subject matter.

Making Contact & Terms: Interested in receiving work from newer, lesser-known photographers. Query with list of stock photo subjects. SASE. Reports in 3 weeks. Pays $0-35/color and b&w photos and transparencies. Pays on publication. Credit line given. Buys one-time rights.

♣MUSCLEMAG INTERNATIONAL, 6465 Airport Rd., Mississauga, Ontario L4V 1E4 Canada. (905)678-7311. Fax: (905)678-9236. Editor: Johnny Fitness. Circ. 300,000. Estab. 1974. Monthly magazine. Emphasizes male and female physical development and fitness. Sample copy $6.

Needs: Buys 3,000 photos/year; 50% assigned; 50% stock. Needs celebrity/personality, fashion/beauty, glamour, swimsuit, how-to, human interest, humorous, special effects/experimental and spot news. "We require action exercise photos of bodybuilders and fitness enthusiasts training with sweat and strain." Wants on a regular basis "different" pics of top names, bodybuilders or film stars famous for their physique (i.e., Schwarzenegger, The Hulk, etc.). No photos of mediocre bodybuilders. "They have to be among the top 100 in the world or top film stars exercising." Photos purchased with accompanying ms. Captions preferred.

Making Contact & Terms: Send material by mail for consideration; send $3 for return postage. Uses 8×10 glossy b&w prints. Query with contact sheet. Send 35mm, 2¼×2¼ or 4×5 transparencies; vertical format preferred for cover. Reports in 1 month. Pays $85-100/hour; $500-700/day and $1,000-3,000/complete package. Pays $20-50/b&w photo; $25-500/color photo; $500/cover photo; $85-300/accompanying ms. **Pays on acceptance.** Credit line given. Buys all rights.

Tips: "We would like to see photographers take up the challenge of making exercise photos look like exercise motion." In samples wants to see "sharp, color balanced, attractive subjects, no grain, artistic eye. Someone who can glamorize bodybuilding on film." To break in, "get serious: read, ask questions, learn, experiment and try, try again. Keep trying for improvement—don't kid yourself that you are a good photographer when you don't even understand half the attachments on your camera. Immerse yourself in photography. Study the best; study how they use light, props, backgrounds, best angles to photograph. Current biggest demand is for swimsuit-type photos of fitness men and women (splashing in waves, playing/posing in sand, etc.) Shots must be sexually attractive."

MUZZLE BLASTS, P.O. Box 67, Friendship IN 47021. (812)667-5131. Fax: (812)667-5137. Art Director: Terri Trowbridge. Circ. 25,000. Estab. 1939. Publication of the National Muzzle Loading Rifle Association. Monthly magazine emphasizing muzzleloading. Sample copy free. Photo guidelines free with SASE.

Needs: Interested in North American wildlife, muzzleloading hunting, primitive camping. Model/property release required. Captions preferred.

Making Contact & Terms: Interested in receiving work from newer, lesser-known photographers. Query with stock photo list. Deadlines: 15th of the month—4 months before cover date. Keeps samples on file. SASE. Reports in 1-2 weeks. Pays $300/color cover photo; $25/b&w inside photo. Pays on publication. Credit line given. Buys one-time rights. Simultaneous submissions OK.

‡MVP MEDIA, 1920 Highland Ave., Suite 220, Lombard IL 60504. (630)916-1744. Editor: Will Wagner. Annual magazines. "We publish 8-13 'annuals' per year prior to the start of each specific sport season." Emphasizes sports: NFL, NBA, NHL, racing, extreme sports. Readers are primarily male, ages 15-35. Sample copy free with 9×12 SAE and $2 postage.

Needs: Uses 60-120 photos/issue; all supplied by freelancers. Needs photos of sports action, including good profile shots. Reviews photos with accompanying ms only. Captions preferred; include players' names and dates.

Making Contact & Terms: Query with resume of credits. Query with stock photo list. Send 35mm transparencies; digital format (Photo CD) preferred. Keeps samples on file. Reports in 1 month. Payment

negotiable. Pays on publication. Credit line given. Buys one-time rights; negotiable. Simultaneous submissions OK.

NATIONAL GEOGRAPHIC, National Geographic Society, 1145 17th St. NW, Washington DC 20036. (202)775-6700. Fax: (202)828-5658. *National Geographic* is a source of information about the world and its people dealing with the changing universe and man's involvement in it. It reveals the people and places of the world as well as the major technological advances that impact on our lives. This magazine did not respond to our request for information. Query before submitting.

NATIONAL GEOGRAPHIC TRAVELER, National Geographic Society, 1145 17th St. NW, Washington DC 20036. (202)775-6700. Fax: (202)828-5658. *National Geographic Traveler* targets active travelers. It's filled with practical information and detailed maps that are designed to encourage readers to explore and travel the globe. Features on both foreign and domestic destinations, photography, the economics of travel, scenic drives, and weekend getaways help readers plan a variety of excursions. This magazine did not respond to our request for information. Query before submitting.

THE NATIONAL NOTARY, 8236 Remmet Ave., Box 7184, Canoga Park CA 91309-7184. (818)713-4000. Editor: Charles N. Faerber. Circ. 133,000. Bimonthly. Emphasizes "Notaries Public and notarization—goal is to impart knowledge, understanding and unity among notaries nationwide and internationally." Readers are employed primarily in the following areas: law, government, finance and real estate. Sample copy $5.
Needs: Uses about 20-25 photos/issue; 10 supplied by non-staff photographers. "Photo subject depends on accompanying story/theme; some product shots used." Unsolicited photos purchased with accompanying ms only. Model release required.
Making Contact & Terms: Query with samples. Provide business card, tearsheets, résumé or samples to be kept on file for possible future assignments. Prefers to see prints as samples. Cannot return material. Reports in 6 weeks. Pays $25-300 depending on job. Pays on publication. Credit line given "with editor's approval of quality." Buys all rights. Previously published work OK.
Tips: "Since photography is often the art of a story, the photographer must understand the story to be able to produce the most useful photographs."

NATIONAL PARKS MAGAZINE, 1776 Massachusetts Ave. NW, Washington DC 20036. (202)223-6722. Editor-in-Chief: Leslie Happ. Circ. 465,000. Estab. 1919. Bimonthly magazine. Emphasizes the preservation of national parks and wildlife. Sample copy $3. Photo guidelines free with SASE.
Needs: Photos of wildlife and people in national parks, scenics, national monuments, national recreation areas, national seashores, threats to park resources and wildlife.
Making Contact & Terms: Send stock list with example of work if possible. Do not send unsolicited photos or mss. Uses 4×5 or 35mm transparencies. SASE. Reports in 1 month. Pays $100-200/color photos; $500 full-bleed color covers. Pays on publication. Buys one-time rights.
Tips: "Photographers should be specific about national park system areas they have covered. We are a specialized publication and are not interested in extensive lists on topics we do not cover. *National Parks* photos follow editorial content. Photographers should find out our needs and arrange permission to submit photos."

THE NATIONAL RURAL LETTER CARRIER, 1630 Duke St., 4th Floor, Alexandria VA 22314-3465. (703)684-5545. Managing Editor: Kathleen O'Connor. Circ. 94,000. Biweekly magazine. Emphasizes Federal legislation and issues affecting rural letter carriers and the activities of the membership for rural carriers and their spouses and postal management. Sample copy and photo guidelines free with SASE.
 • This magazine uses a limited number of photos in each issue, usually only a cover photograph and some promotional headshots or group photos. Photo/text packages are used on occasion and if you present an interesting story you should have better luck with this market.
Needs: Photos purchased with accompanying ms. Buys 24 photos/year. Human interest; humorous; nature; scenics; photo essay/photo feature; special effects and experimental; still life; spot news; travel; and unusual mailboxes. Needs scenes that combine subjects of the Postal Service and rural America; "submit photos of rural carriers on the route." Model release required. Captions required.
Making Contact & Terms: Interested in receiving work from newer, lesser-known photographers. Send material by mail for consideration. Query with list of stock photo subjects. Uses 8×10 b&w or color glossy prints, vertical format preferred for cover. SASE. Reports in 1 month. Pays $75/photo. Pays on publication. Credit line given. Buys first serial rights. Previously published work OK.
Tips: "Please submit sharp and clear photos with interesting and pertinent subject matter. Study the publication to get a feel for the types of rural and postal subject matter that would be of interest to the

membership. We receive more photos than we can publish, but we accept beginners' work if it is good."

NATIONAL WILDLIFE, Photo Submissions, NW Publications, 8925 Leesburg Pike, Vienna VA 22184. Website: http://www.fwf.org. Photo Editor: John Nuhn. Circ. 650,000. Estab. 1962. Bimonthly magazine. Emphasizes wildlife, nature, environment and conservation. Readers are people who enjoy viewing high-quality wildlife and nature images from around the world, and who are interested in knowing more about the natural world and man's interrelationship with animals and environment. Sample copy $3; send to National Wildlife Federation Membership Services (same address). Send separate SASE only for free photo guidelines, to Photo Guidelines, National Wildlife Publications (same address).

Needs: Uses about 45 photos/issue; all supplied by freelance photographers; 90% stock, 10% assigned. Photo needs include worldwide photos of wildlife, wild plants, nature-related how-to, conservation practices. Subject needs include single photos for various uses (primarily wildlife but also plants, scenics). Captions required.

Making Contact & Terms: "Study the magazine, and ask for and follow photo guidelines before submitting. No unsolicited submissions from photographers whose work has not been previously published or considered for use in our magazine. Instead, send nonreturnable samples (tearsheets or photocopies) to Photo Queries (same address). Interested in seeing work from newer, lesser-known photographers with professional quality transparencies only. If nonreturnable samples are acceptable, send 35mm or larger transparencies (magazine is 100% color) for consideration. SASE. Reports in 1 month. Pays $1,000/cover photo; $300-750/inside photo; text/photo package negotiable. **Pays on acceptance.** Credit line given. Buys one-time rights with limited magazine promotion rights. Previously published work OK.

Tips: "While *National Wildlife* does not encourage unsolicited submissions, the annual photo contest is an excellent way to introduce your photography. The contest is open to professional and amateur photographers alike. **Rules are updated each year** and printed along with the winning photos in the December/January issue. Rules are also available on the website."

NATIVE PEOPLES MAGAZINE, 5333 N. Seventh St., Suite C-224, Phoenix AZ 85014. (602)252-2236. Fax: (602)265-3113. E-mail: native_peoples@amcolor.com. Website: http://www.atiin.com/native_peoples. Editor: Gary Avey. Circ. 115,000. Estab. 1987. Quarterly magazine. Dedicated to the sensitive protrayal of the arts and lifeways of the native peoples of the Americas. Readers are primarily upper-demographic members of affiliated museums (i.e. National Museum of the American Indian/Smithsonian). Sample copy free with SASE. Photo guidelines free with SASE.

Needs: Uses 50-60 photos/edition; 100% supplied by freelancers. Needs Native American lifeways photos. Model/property release preferred. Captions preferred; include names, location and circumstances.

Making Contact & Terms: Interested in receiving work from newer, lesser-known photographers. Submit portfolio for review. Send unsolicited photos by mail for consideration. Send transparencies, all formats. Also accepts digital files on disk with proof copy. SASE. Reports in 1 month. Pays $250/color cover photo; $250/b&w cover photo; $45-150 color inside photo; $45-150/b&w inside photo. Pays on publication. Buys one-time rights.

Tips: "We prefer to send magazine and guidelines rather than pour over general portfolio."

NATURAL HISTORY MAGAZINE, Central Park W. at 79th St., New York NY 10024. (212)769-5500. Editor: Bruce Stutz. Picture Editor: Kay Zakariasen. Circ. 520,000. Monthly magazine. For primarily well-educated people with interests in the sciences. Free photo guidelines.

Needs: Buys 400-450 photos/year. Animal behavior, photo essay, documentary, plant and landscape. "We are interested in photoessays that give an in-depth look at plants, animals, or people and that are visually superior. We are also looking for photos for our photographic feature, 'The Natural Moment.' This feature focuses on images that are both visually arresting and behaviorally interesting." Photos used must relate to the social or natural sciences with an ecological framework. Accurate, detailed captions required.

Making Contact & Terms: Query with résumé of credits. "We prefer that you come in and show us your portfolio, if and when you are in New York. Please don't send us any photographs without a query first, describing the work you would like to send. No submission should exceed 30 original transparencies or negatives. However, please let us know if you have additional images that we might consider. Potential liability for submissions that exceed 30 originals shall be no more than $100 per slide." Uses 8×10 glossy, matte and semigloss b&w prints; and 35mm, $2\frac{1}{4} \times 2\frac{1}{4}$, 4×5, 6×7 and 8×10 color transparencies. Covers are always related to an article in the issue. SASE. Reports in 2 weeks. Pays (for color and b&w) $400-

 CANADIAN LISTINGS are marked with a maple leaf.

600/cover; $350-500/spread; $300-400/oversize; $250-350/full-page; $200-300/¾ page; $150-225/½ page; $125-175/¼ page; $100-125/¹⁄₁₆ page or less. Pays $50 for usage on contents page. Pays on publication. Credit line given. Buys one-time rights. Previously published work OK but must be indicated on delivery memo.

Tips: "Study the magazine—we are more interested in ideas than individual photos. We do not have the time to review portfolios without a specific theme in the social or natural sciences."

‡❧NATURAL LIFE MAGAZINE, 7436 Fraser Park Dr., Burnaby, British Columbia V5J 5B9 Canada. (604)435-1919. Photo Editor: Siegfried Gursche. Published 11 times/year. Readers are interested in health and nutrition, lifestyle and fitness. Circ. 110,000. Sample copy $3 (Canadian) and 9½×11 SASE. Photo guidelines free with SASE.
Needs: Uses 12 photos/issue; 50% supplied by freelance photographers. Looking for photos of healthy people doing healthy things. Subjects include environment, ecology, organic farming and gardening, herbal therapies, vitamins, mineral supplements and good vegetarian food, all with a family orientation. Model release required. Captions preferred.
Making Contact & Terms: Send unsolicited photos by mail for consideration with résumé, business card, brochure, flier or tearsheets to be kept on file for possible assignments. Send color 4×5 prints and 35mm, 2¼×2¼, or 4×5 transparencies. SASE. Reports in 2 weeks. Pays $125/color cover photo; $60/color inside photo. Pays on publication. Credit line given. Buys all rights; will negotiate. Simultaneous submissions and previously published work OK.
Tips: "Get in touch with the 'Natural Foods' and 'Alternative Therapies' scene. Observe and shoot healthy people doing healthy things."

‡NATURAL LIVING TODAY, 175 Varick St., New York NY 10014. (212)924-1762. Fax: (212)691-7828. Editor-in-Chief: Alexis Tannenbaum. Circ. 150,000. Estab. 1996. Bimonthly magazine. Emphasizes natural living for women, (ex: natural beauty, alternative healing, vegetarianism, organic and macrobiotic eating). Readers are women aged 18-40, from various occupations (students, executives). Sample copy $3.95.
Needs: Uses 40-50 photos/issue; 70% supplied by freelancers. Needs photos of cosmetics, models and food. Model release required.
Making Contact & Terms: Query with résumé of credits. Only wants to work with photographers on assignment. "Send nothing unsolicited." Payment negotiable. Pays on publication. Credit line given. Rights negotiable.

‡NATURAL WAY, 566 Westchester Ave., Rye Brook NY 10573. (914)939-2111. Fax: (914)939-5138. E-mail: natway@aol.com. Art Director: Vicki Nightingale. Circ. 125,000. Estab. 1994. Bimonthly consumer magazine emphasizing alternative health. Readers are 70% female over 35. Sample copy $3.50.
Needs: Uses 40-45 photos/issue; 95% supplied by freelancers. Needs photos of food, beauty, health. Model release preferred for people. Captions preferred.
Making Contact & Terms: Interested in receiving work from newer, lesser-known photographers. Submit portfolio for review. Send unsolicited photos by mail for consideration. Provide résumé, business card, brochure, flier or tearsheets to be kept on file for possible assignments. Keeps samples on file. SASE. Reports in 1 month. Pays $75-335/color inside photo; $75-200/b&w inside photo. Pays on publication. Credit line given. Buys one-time rights. Previously published work OK.

NATURE CONSERVANCY MAGAZINE, 1815 N. Lynn St., Arlington VA 22209. (703)841-8742. Fax: (703)841-9692. E-mail: cgelb@tnc.org. Website: http://www.tnc.org. Photo Editor: Connie Gelb. Circ. 600,000. Estab. 1951. Publication of The Nature Conservancy. Bimonthly. Emphasizes "nature, rare and endangered flora and fauna, ecosystems in North and South America, the Caribbean, Indonesia, Micronesia and South Pacific and compatible development." Readers are the membership of The Nature Conservancy. Sample copy free with 9×12 SAE and 5 first-class stamps. Write for guidelines. Articles reflect work of the Nature Conservancy and its partner organizations.
Needs: Uses about 20-25 photos/issue; 70% from freelance stock. The Nature Conservancy welcomes permission to make duplicates of slides submitted to the *Magazine* for use in slide shows and online use. Captions required; include location and names (common and Latin) of flora and fauna. Proper credit should appear on slides.
Making Contact & Terms: Interested in reviewing non-returnable samples and photo-driven story ideas from newer, lesser-known photographers. Many photographers contribute the use of their slides. Accepts images in digital format for Windows. Send via website (at least 72 dpi). Uses color transparencies. Pays $150-500/hour; $300/color cover photo; $150-400/color inside photo; $75-150/b&w photo; negotiable day rate. Will occasionally pay extra for photos of rare/endangered species. Pay from $35-200 for unlimited Web use for 1 year. Pays on publication. Credit line given. Buys one-time rights; starting to consider all

rights for public relations and online purposes; negotiable. Willing to offer free hyperlinks to photographers' E-mail addresses and biographies. Offers internships for photographers during the spring and summer. Contact Photo Editor: Connie Gelb.

Tips: Seeing more large-format photography and more interesting uses of motion and mixing available light with flash and b&w. "Photographers must familiarize themselves with our organization. We only run articles reflecting our work or that of our partner organizations in Latin America and Asia/Pacific. Membership in the Nature Conservancy is only $25/year and the state newsletter will keep photographers up to date on what the Conservancy is doing in your state. Many of the preserves are open to the public. We look for rare and endangered species, wetlands and flyways, indigenous/traditional people of Latin America, South Pacific and the Caribbean."

NATURE PHOTOGRAPHER, P.O. Box 2037, West Palm Beach FL 33402. (561)622-5223. Fax: (561)622-6438. Photo Editor: Helen Longest-Slaughter. Circ. 25,000. Estab. 1990. Bimonthly 4-color high-quality magazine. Emphasizes "conservation-oriented, low-impact nature photography" with strong how-to focus. Readers are male and female nature photographers of all ages. Sample copies free with 10×13 SAE with 6 first-class stamps.

Needs: Uses 25-35 photos/issue; 90% supplied by freelancers. Needs nature shots of "all types—abstracts, animal/wildlife shots, flowers, plants, scenics, environmental images, etc." Shots must be in natural settings; no set-ups, zoo or captive animal shots accepted. Reviews photos with or without ms twice a year, May (for fall/winter issues) and November (for spring/summer). Captions required; include description of subject, location, type of equipment, how photographed. "This information published with photos."

Making Contact & Terms: Interested in receiving work from newer, lesser-known photographers. Prefers to see 35mm, $2\frac{1}{4} \times 2\frac{1}{4}$ and 4×5 transparencies. Does not keep samples on file. SASE. Reports within 4 months, according to deadline. Pays $100/color cover photo; $25-40/color inside photo; $20/b&w inside photo; $75-150/photo/text package. Pays on publication. Credit line given. Buys one-time rights. Simultaneous submissions and previously published work OK.

Tips: Recommends working with "the best lens you can afford and slow speed slide film." Suggests editing with a $4 \times$ or $8 \times$ lupe (magnifier) on a light board to check for sharpness, color saturation, etc. Color prints are not used for publication in magazine, except from photographers under the age of 18 for the "Young People's" column.

NATURIST LIFE INTERNATIONAL, P.O. Box 300-F, Troy VT 05868-0300. (802)744-6565. E-mail: naturist@together.net. Website: http://www.together.net/~naturist/nli.htm. Editor-in-chief: Jim C. Cunningham. Circ. 2,000. Estab. 1987. Quarterly magazine. Emphasizes nudism. Readers are male and female nudists, age 30-80. Sample copy $5. Photo guidelines free with SASE.

• *Naturist Life* holds yearly Vermont Naturist Photo Safaris organized to shoot nudes in nature.

Needs: Uses approximately 45 photos/issue; 80% supplied by freelancers. Needs photos depicting family-oriented, nudist/naturist work and recreational activity. Reviews photos with or without ms. Model release required. Property release preferred for recognizable nude subjects. Captions preferred.

Making Contact & Terms: Interested in receiving work from newer, lesser-known photographers. Query with résumé of credits. Send unsolicited photos by mail for consideration. Provide résumé, business card, brochure, flier or tearsheets to be kept on file for possible assignments. Send 8×10 glossy color and b&w prints; 35mm, $2\frac{1}{4} \times 2\frac{1}{4}$, 4×5, 8×10 (preferred) transparencies. Does not keep samples on file. SASE. Reports in 2 weeks. Pays $50 color photo; $25/color inside photo; $25/b&w inside photo. Only pays $10 if not transparency or 8×10 glossy. Pays on publication. Credit line given. "Prefer to own all rights but sometimes agree to one-time publication rights." Offers internships for photographers during July. Contact Editor: Jim C. Cunningham.

Tips: "The ideal *NLI* photo shows ordinary-looking people of all ages doing everyday activities, in the joy of nudism."

NAUGHTY NEIGHBORS, 4931 SW 75th Ave., Miami FL 33155. (305)662-5959. Fax: (305)662-5952. E-mail: quad@netrunner.net. Assistant Editor: Lisa Gable. Circ. 250,000. Estab. 1995. Monthly magazine. Emphasizes "nude glamor with a voyeuristic focus—amateurs and the swinging scene." Readers are male, 18 and over. Sample copy $7. Photo guidelines free with SASE.

Needs: Uses approximately 200 photos/issue; all supplied by freelancers. Needs photos of nude females; "amateurs, not professional models." Model release required.

Making Contact & Terms: Interested in receiving work from newer, lesser-known photographers. Send unsolicited photos by mail for consideration. Send 4×6 or 7×10 glossy color prints; 35mm transparancies. Keeps samples on file. SASE. Reports in 1-2 weeks. "Rates negotiated per individual sets." Pays on publication. Buys one-time and other negotiated rights. Simultaneous submissions OK.

Tips: "Study samples of the magazine for insights into what we are looking for."

NEVADA MAGAZINE, 1800 Hwy. 50 E., Suite 200, Carson City NV 89710. (702)687-6158. Fax: (702)687-6159. Art Director: Denise Barr. Estab. 1936. Circ. 100,000. Bimonthly. State tourism magazine devoted to promoting tourism in Nevada, particularly for people interested in travel, people, history, events and recreation; age 30-70. Sample copy $3.50.

Needs: Buys 40-50 photos/issue; 30-35 supplied by freelance photographers. Buys 10% freelance on assignment, 20% from freelance stock. (Nevada stock photos only—not generic). Towns and cities, scenics, outdoor recreation with people, events, state parks, tourist attractions, travel, wildlife, ranching, mining and general Nevada life. Must be Nevada subjects. Captions required; include place, date, names if available.

Making Contact & Terms: Interested in receiving work from newer, lesser-known photographers. Send samples of Nevada photos. Send 8×10 glossy prints; 35mm, 2¼×2¼, 4×5, 8×10 transparencies; prefers vertical format for cover. Send 35mm slides in 8×10 see-through slide sleeves. Must be labeled with name, address and captions on each. SASE. Reports in 4 months. Pays $35-100/inside photo; $150-300/cover photo; $50 minimum/job. Pays on publication. Credit line given. Buys first North American serial rights.

Tips: "Send variety of good-quality Nevada photos, well-labeled. Self-edit work to 20-40 slides maximum. We are increasing our use of events photos from prior years' events. We have a real need for current shots of people having fun."

NEW CHOICES LIVING EVEN BETTER AFTER 50, (formerly *New Choices for Retirement Living*), 28 W. 23rd St., New York NY 10010. (212)366-8817. Fax: (212)366-8899. Photo Editor: Regina Flanagan. Circ. 575,000. 10 issues a year (double issues—July/Aug., Dec./Jan.). Emphasizes people over 50, retired or planning to retire. Readers are 50 plus years old, male and female, interested in retirement living.

Needs: Uses 30-40 photos/issue; 50% supplied by freelancers; 50% supplied by stock. Needs photos related to health and fitness, money and finances, family values, travel and entertainment. Reviews photos with or without ms. "No unsolicited photos please!" Model release required; property release preferred. Captions required.

Making Contact & Terms: Interested in hiring newer, lesser-known photographers, as well as established photographers. Provide résumé, business card, brochure, flier or tearsheets to be kept on file for possible assignments. Reports in 1 month. Pays $200/¼ color page rate; $150/¼ b&w page rate. **Pays on acceptance** and assignment within 30 days. Credit line given. Buys one-time rights; negotiable.

Tips: "*New Choices* targets a very select market—seniors, people aged fifty and over. Our assignments are very specific concepts and the key to a successful assignment is communication. I rarely send a photographer more than 300 miles for an assignment because our budget just doesn't allow for it, so I end up calling photographers in the location of my subjects, which vary with each article. Communication is very important between the photo editor and the photographer."

NEW ERA MAGAZINE, 50 E. North Temple St., Salt Lake City UT 84150. (801)240-2951. Fax: (801)240-5997. Art Director: Lee Shaw. Circ. 203,000. Estab. 1971. Association publication of The Church of Jesus Christ of Latter-day Saints. Monthly magazine. Emphasizes teenagers who are members of the Mormon Church. Readers are male and female teenagers, who are members of the Latter-day Saints Church. Sample $1 with 9×12 SAE and 2 first-class stamps. Photo guidelines free with SASE.

Needs: Uses 60-70 photos/issue; 35-40 supplied by freelancers. Anything can be considered for "Photo of the Month," most photos of teenage Mormons and their activities. Model/property release preferred. Captions preferred.

Making Contact & Terms: Arrange personal interview to show portfolio. Submit portfolio for review. Query with stock photo list. Send unsolicited photos by mail for consideration. Send any b&w or color print; 35mm, 2¼×2¼, 4×5 transparencies. Keeps samples on file. SASE. Reports in 6-8 weeks. Pays $150-300/day; "rates are individually negotiated, since we deal with many teenagers, non-professionals, etc." Credit line given. Buys all rights; negotiable. "Rights are reassigned on request."

Tips: "Most work consists of assignments given to photographers we know and trust, or of single item purchases for 'Photo of the Month.' "

NEW MEXICO MAGAZINE, Dept. PM, 495 Old Santa Fe Trail, Santa Fe NM 87503. (505)827-7447. Fax: (505)827-6496. Art Director: John Vaughan. Circ. 123,000. Monthly magazine. For affluent people age 35-65 interested in the Southwest or who have lived in or visited New Mexico. Sample copy $2.95 with 9×12 SAE and 3 first-class stamps. Photo guidelines free with SASE.

Needs: Uses about 60 photos/issue; 90% supplied by freelancers. Needs New Mexico photos only—landscapes, people, events, architecture, etc. "Most work is done on assignment in relation to a story, but we welcome photo essay suggestions from photographers." Cover photos usually relate to the main feature in the magazine. Model release preferred. Captions required; include who, what, where.

Making Contact & Terms: Interested in receiving work from newer, lesser-known photographers. Submit portfolio to John Vaughan; uses transparencies. SASE. Pays $450/day; $300/color cover photo; $300/

b&w cover photo; $60-100/color inside photo; $60-100/b&w inside photo. Pays on publication. Credit line given. Buys one-time rights.

Tips: Prefers transparencies submitted in plastic pocketed sheets. Interested in different viewpoints, styles not necessarily obligated to straight scenic. "All material must be taken in New Mexico. Representative work suggested. If photographers have a preference about what they want to do or where they're going, we would like to see that in their work. Transparencies or dupes are best for review and handling purposes."

NEW MOON PUBLISHING, P.O. Box 3620, Duluth MN 55803-3620. (218)728-5507. Fax: (218)728-0314. E-mail: newmoon@newmoon.duluth.mn.us. Girls Editorial Board: %Tya Ward or Barbara Stretchberry. Circ. 22,000. Estab. 1993. Bimonthly magazine. Emphasizes girls, ages 8-14; *New Moon* is edited by girls for girls. Readers are girls, ages 8-14. Sample copy $6.50.

Needs: Uses 15-25 photos/issue; 5 supplied by freelancers. Needs photos for specific stories. Model/property release required. Captions required; include names, location, ages of kids.

Making Contact & Terms: Interested in receiving work from newer, lesser-known photographers. Submit portfolio for review. Accepts images in digital format for Mac. Call for details. Send 4×6 glossy color b&w prints; 35mm transparencies. Keeps samples on file. SASE. Reports in 6 months. Pays $25-50/b&w inside photo. Pays on publication. Credit line given. Buys all rights. Simultaneous submissions and previously published work OK. Offers internships for photographers. Contact Managing Editors: Tya Ward or Barbara Stretchberry.

Tips: "Read and get to know style of magazine first!"

NEW YORK OUTDOORS, Allsport Publishing Corp., 51 Atlantic Ave., Floral Park NY 11001. (516)352-9700. Fax: (516)437-6841. E-mail: hattie38@aol.com. Publisher/Editor-in-Chief: Scott Shane. Circ. 50,000. Published 8 times annually. Emphasizes technique, locations and products for all outdoor activities including: cycling, paddling, fishing, hiking, camping, climbing, diving, skiing and boating. Also features adventure outdoor locations and destinations in the northeastern US. Free sample copy and photo guidelines. "Ask to be placed on our wants list or send us your stock list."

Needs: Buys one color cover and 5-10 inside shots per issue. Photo from freelance stock. Photos purchased with accompanying ms; covers purchased separately. Captions required.

Making Contact & Terms: Interested in receiving work from newer, lesser-known photographers. Send original transparencies. Send photos for consideration. Also accepts digital files in Mac format—TIFF, GIF or EPS. SASE. Reports in 3 weeks. Pays: $25-100/color or b&w inside; $350/color cover. Pays on publication. Buys first North American serial rights.

Tips: "If it looks like fun, it's for us. Any sport, but background must be or look like Northeast United States, New York state a bonus. We are tabloid size, so pictures need to hold a blow-up. People in sport—including families—are always good."

NEW YORK SPORTSCENE, 990 Motor Pkwy., Central Islip NY 11722. (516)435-8890. Fax: (516)435-8925. Editor-in-Chief: Anthony Stoeckert. Circ. 125,000. Estab. 1995. Monthly magazine. Emphasizes professional and major college sports in New York. Readers are 95% male; median age: 30; 85% are college educated. Sample copy $3.

Needs: Uses 30 photos/issue; all supplied by freelancers. Needs photos of sports action, fans/crowd reaction.

Making Contact & Terms: Interested in receiving work from newer, lesser-known photographers. Send unsolicited photos by mail for consideration. Send color prints; 35mm transparencies. Keeps samples on file. SASE. Reports in 3 weeks. Payment negotiable. Pays several weeks after publication.

Tips: "Slides should capture an important moment or event and tell a story. There are numerous sports photographers out there—your work must stand out to be noticed."

NEW YORK STATE CONSERVATIONIST MAGAZINE, Editorial Office, NYSDEC, 50 Wolf Rd., Albany NY 12233-4502. (518)457-5547. Contact: Photo Editor. Circ. 110,000. Estab. 1946. Bimonthly nonprofit, New York State government publication. Emphasizes natural history, environmental, and outdoor interests pertinent to New York State. Readers are people interested in nature and environmental quality issues. Sample copy $3.50 and 8½×11 SASE. Photo guidelines free with SASE.

Needs: Uses 40 photos/issue; 80% supplied by freelance photographers. Needs wildlife shots, people in

THE DIGITAL MARKETS INDEX, located in the back of this book, lists markets that use images electronically.

the environment, outdoor recreation, forest and land management, fisheries and fisheries management, environmental subjects (some pollution shots), effects of pollution on plants, buildings, etc. Model release preferred. Captions required.

Making Contact & Terms: Interested in reviewing work from newer, lesser-known photographers. Query with samples. Send 35mm, 2¼×2¼, 4×5 or 8×10 transparencies by mail for consideration. Submit portfolio for review. Provide résumé, business card, brochure, flier or tearsheets to be kept on file for possible future assignments. Reports in 3 weeks. Pays $15/b&w or color photo. Pays on publication. Buys one-time rights. Simultaneous submissions and previously published work OK.

Tips: Looks for "artistic interpretation of nature and the environment, unusual ways of picturing environmental subjects (even pollution, oil spills, trash, air pollution, etc.); wildlife and fishing subjects at all seasons. Try for unique composition, lighting. Technical excellence a must."

NEWS PHOTOGRAPHER, Dept. PM, 1446 Conneaut Ave., Bowling Green OH 43402. (419)352-8175. Fax: (419)354-5435. E-mail: jgordon@bgnet.bgsu.edu. Website: http://jgordon@bgnet.bgsu.edu. Editor: James R. Gordon. Circ. 11,000. Estab. 1946. Publication of National Press Photographers Association, Inc. Monthly magazine. Emphasizes photojournalism and news photography. Readers are newspaper, magazine, television freelancers and photojournalists. Sample copy free with 9×12 SAE and 9 first-class stamps.
• *News Photographer* is 100% digital—to printer.

Needs: Uses 50 photos/issue. Needs photos of photojournalists at work; photos which illustrate problems of photojournalists. Special photo needs include photojournalists at work, assaulted, arrested; groups of news photographers at work; problems and accomplishments of news photographers. Captions required.

Making Contact & Terms: Send glossy b&w/color prints; 35mm, 2¼×2¼ transparencies by mail for consideration. Also accepts JPEG'd to Mac or DOS floppy or 44 or 88MB SyQuest cartridge. "We prefer the photos (color and/or b&w) JPEG'ed to a Mac floppy disk, Zip Disk, or a 44MB. SyQuest cartridge (indicate whether Unsharp Mask has been applied in Photoshop). We'd prefer file size for each image less than 10MB. before compression. (We do not have 'Iron Mike' software.) Prints (silver image or thermal) are always acceptable. Photos may also be sent by way of the Internet." Provide résumé, business card, brochure, flier or tearsheets to be kept on file for possible assignments; make contact by telephone. Reports in 3 weeks. Pays $75/color page rate; $50/b&w page rate; $50-150/photo/text package. **Pays on acceptance.** Credit line given. Buys one-time rights. Simultaneous submissions and previously published work OK.

NEWSWEEK, Newsweek, Inc., 251 W. 57th St., New York NY 10019-6999. (212)445-4000. *Newsweek* reports the week's developments on the newsfronts of the world and the nation through news, commentary and analysis. News is divided into National Affairs, International, Business, Lifestyle, Society and the Arts. Relevant visuals, including photos, accompany most of the articles. This magazine did not respond to our request for information. Query before submitting.

NFPA JOURNAL, 1 Batterymarch Park, Quincy MA 02169-9101. (617)984-7566. Art Director: Wendy C. Simpson. Circ. 65,000. Publication of National Fire Protection Association. Bimonthly magazine. Emphasizes fire protection issues. Readers are fire professionals, engineers, architects, building code officials, ages 20-65. Sample copy free with 9×12 SAE.

Needs: Uses 25-30 photos/issue; 25% supplied by freelance photographers. Needs photos of fires and fire-related incidents. Especially wants to use more photos for Fire Fighter Injury and Fire Fighter Fatality. Model release preferred. Captions preferred.

Making Contact & Terms: Query with list of stock photo subjects, send unsolicited photos by mail for consideration. Provide résumé, business card, brochure, flier or tearsheets to be kept on file for possible assignments. Send color prints and 35mm transparencies in 3-ring slide sleeve with date. SASE. Reports in 3 weeks or "as soon as I can." Payment negotiated. Pays on publication. Credit line given. Buys rights depending "on article and sensitivity of subject. We are not responsible for damage to photos."

Tips: "Send cover letter, 35mm color slides preferably with manuscripts and photo captions."

NORTH AMERICAN WHITETAIL MAGAZINE, P.O. Box 741, Marietta GA 30061. (404)953-9222. Fax: (404)933-9510. Photo Editor: Gordon Whittington. Circ. 170,000. Estab. 1982. Published 8 times/year (July-February) by Game & Fish Publications, Inc. emphasizing trophy whitetail deer hunting. Sample copy $3. Photo guidelines free with SASE.

Needs: Uses 20 photos/issue; 40% supplied by freelancers. Needs photos of large, live whitetail deer, hunter posing with or approaching downed trophy deer, or hunter posing with mounted head. Also use photos of deer habitat and sign. Model release preferred. Captions preferred; include where scene was photographed and when.

Making Contact & Terms: Interested in receiving work from newer, lesser-known photographers. Query with résumé of credits and list of stock photo subjects. Send unsolicited 8×10 b&w prints; 35mm transparencies (Kodachrome preferred). Will return unsolicited material in 1 month if accompanied by SASE.

Pays $250/color cover photo; $75/inside color photo; $25/b&w photo. Tearsheets provided. Pays 75 days prior to publication. Credit line given. Buys one-time rights. Simultaneous submissions not accepted.

Tips: "In samples we look for extremely sharp, well-composed photos of whitetailed deer in natural settings. We also use photos depicting deer hunting scenes. Please study the photos we are using before making submission. We'll return photos we don't expect to use and hold the remainder. Please do not send dupes. Use an $8 \times$ loupe to ensure sharpness of images and put name and identifying number on all slides and prints. Photos returned at time of publication or at photographer's request."

NORTHERN OHIO LIVE, Dept. PM, 11320 Juniper Rd., Cleveland OH 44106. (216)721-1800. Art Director: Stacy Vickroy. Circ. 35,000. Estab. 1980. Monthly magazine. Emphasizes arts, entertainment and lifestyle. Readers are upper income, ages 25-60, professionals. Sample copy $2 with 9×12 SAE.

Needs: Uses 30 photos/issue; 20-100% supplied by freelance photographers. Needs photos of people in different locations, fashion and locale. Model release preferred. Captions preferred (names only are usually OK).

Making Contact & Terms: Arrange a personal interview to show portfolio. Provide résumé, business card, brochure, flier or tearsheet to be kept on file for possible assignments. SASE. Reports in 3 weeks. Pays $250/color cover photo; $250/b&w cover photo; $100/color inside photo; $50/b&w inside photo; $30-50/hour; $250-500/day (approximate rates—rates vary per assignment). Pays on publication. Credit line given. Buys one-time rights. Previously published work OK.

Tips: In photographer's portfolio wants to see "good portraits, people on location, photojournalism strengths, quick turn-around and willingness to work on *low* budget. Mail sample of work. Portfolio review should be short—only *best quality* work!"

NORTHWEST TRAVEL, 1525 12th St., P.O. Box 18000, Florence OR 97439. (800)348-8401. Fax: (541)997-1124. E-mail: @ohwy.com. Website: http://www.ohwy.com. Art Director: Barbara Grano. Circ. 50,000. Estab. 1991. Bimonthly magazine. Emphasizes Pacific Northwest travel—Alaska, Oregon, Washington, Idaho and British Columbia (southern). Readers are middle-age male and female, upper income/middle income. Sample copy $4.50 includes postage. Photo guidelines free with SASE.

Needs: Uses 8-12 (full page) photos/issue; all supplied by freelancers. Needs photos of travel, scenics. Model release preferred. Photo captions required.

Making Contact & Terms: Send unsolicited photos by mail for consideration. Uses 35mm, $2\frac{1}{4} \times 2\frac{1}{4}$, 4×5 transparencies. SASE. Reports in 1 month. Pays $325/color cover photo; $25-75/color inside photo; $25-50/b&w inside photo; $100-250/photo/text package. Pays on publication. Credit line given. Buys one-time rights.

Tips: "Mainly interested in scenics. Avoid colored filters. Use only film that can enlarge without graininess."

NORTHWOODS PUBLICATIONS INC., 430 N. Front St., P.O. Box 90, Lemoyne PA 17043. (717)761-1400. Fax: (717)761-4579. Publishes *Pennsylvania Sportsman*, *New York Sportsman*, *Michigan Hunting & Fishing*. Publisher: Carolyn Hoffman. Circ. 120,000. Estab. 1977. Published 8 times/year. Emphasizes outdoor hunting and fishing. Readers are of all ages and backgrounds. Sample copy $2.95. Photo guidelines free with SASE.

Needs: Uses 40-70 photos/issue; 30% supplied by freelancers. Needs photos of wildlife. Special photo needs include deer, turkey, bear, trout, pike, walleye and panfish. Captions preferred.

Making Contact & Terms: Interested in receiving work from newer, lesser-known photographers. Query with stock photo list. Send unsolicited photos by mail for consideration. Send 35mm transparencies. Keeps samples on file. SASE. Pays $175/color cover photo; $25-125/color inside photo; $25-150/b&w inside photo. Pays on publication. Credit line given. Buys first North American serial rights.

Tips: "Look at the magazine to become familiar with needs."

NOR'WESTING, 6044 Seaview Ave. NW, Seattle WA 98107. (206)783-8939. Fax: (206)783-9011. Editor: Gloria Kruzner. Monthly magazine. Emphasis on cruising destinations in the Pacific Northwest. Readers are male and female boat owners ages 40-65 (on average) who own 32'-42' boats (mostly powerboats). Sample copy free with 9×12 SASE with $1.47 in postage. Photo guidelines available.

Needs: Uses 20 photos/issue; 75% supplied by freelancers. Interested in scenic Northwest destination shots, boating, slice-of-life nautical views. Model release preferred for anyone under age 18. Captions required; include location, type of boat, name of owner, crew (if available).

Making Contact & Terms: Interested in receiving work from newer, lesser-known photographers. "We're looking for active outdoor photographers in the Pacific Northwest who can capture the spirit of boating." Send unsolicited photos by mail for consideration. Provide résumé, business card, brochure, flier or tearsheets to be kept on file for possible assignments. Send 3×5 glossy b&w prints for editorial; 35mm transparencies for cover. Deadlines: the 1st of each month priot to publication. Keeps samples on file.

SASE. Reports in 2 months. Pays $100-250/color cover photo; $25-50/b&w inside photo. Pays 2 months after publication. Credit line given. Buys first North American rights; negotiable. Simultaneous submissions and/or previously published work OK.

Tips: "We want the Pacific Northwest boating scene to come alive through photography. No posed shots; wait for moment to happen."

NUGGET, 14411 Commerce Way, Suite 420, Miami Lakes FL 33016. (305)557-0071. Editor-in-Chief: Christopher James. Circ. 100,000. Magazine published 12 times a year. Emphasizes sex and fetishism for men and women of all ages. Sample copy $5 postpaid; photo guidelines free with SASE.

Needs: Uses 100 photos/issue. Interested only in nude sets—single woman, female/female or male/female. All photo sequences should have a fetish theme (sadomasochism, leather, bondage, transvestism, transsexuals, lingerie, golden showers, infantilism, wrestling—female/female or male/female—women fighting women or women fighting men, amputee models, etc.). Also seeks accompanying mss on sex, fetishism and sex-oriented products. Model release required.

Making Contact & Terms: Submit material for consideration. Buys in sets, not by individual photos. No Polaroids or amateur photography. Send 8×10 glossy b&w prints; contact sheet OK; transparencies, prefers Kodachrome or large format; vertical format required for cover. SASE. Reports in 2 weeks. Pays $250 minimum/b&w set; $400-600/color set; $200/cover photo; $250-350/ms. Pays on publication. Credit line given. Buys one-time rights or second serial (reprint) rights. Previously published work OK.

ODYSSEY, Science That's Out of This World, Cobblestone Publishing, Inc., 7 School St., Peterborough NH 03458. (603)924-7209. Fax: (603)924-7380. E-mail: edody@aol.com. Senior Editor: Elizabeth Lindstrom. Circ. 29,000. Estab. 1979. Monthly magazine, September-May. Emphasis on astronomy and space exploration. Readers are children, ages 8-14. Sample copy $4.50 with 9×12 or larger SAE and 5 first-class stamps. Photo guidelines free with SASE.

Needs: Uses 30-35 photos/issue. Needs photos covering many areas of service. Reviews photos with or without ms. Model/property release required. Captions preferred.

Making Contact & Terms: Query with stock photo list. Send unsolicited photos by mail for consideration. Accepts images in digital format for Mac. Provide résumé, business card, brochure, flier or tearsheets to be kept on file for possible future assignments. Send color prints or transparencies. Samples kept on file. SASE. Reports in 1 month. Payment negotiable for color cover and other photos; $25-100/inside color use. Pays on publication. Credit line given. Buys one-time and all rights; negotiable. Offers internships for photographers. Would consider internships for photographers. Contact Managing Editor: Denise Babcock.

Tips: "We like photos that include kids in reader-age range and plenty of action. Each issue is devoted to a single theme. Photos should relate to those themes."

OFFSHORE, 220-9 Reservoir St., Needham MA 02194. (617)449-6204, ext. 26. Fax: (617)449-9702. Editor: Peter Serratore. E-mail: oshore@aol.com. Monthly magazine. Emphasizes boating in the Northeast region, from Maine to New Jersey. Sample copy free with 9×12 SASE.

Needs: Uses 25-30 photos/issue; 25-30 supplied by freelancers. Needs photos of recreational boats and boating activities. Boats covered are mostly 20-40 feet, mostly power, but some sail, too. Especially looking for inside back page photos of a whimsical, humorous, or poignant nature, or that say "Goodbye" (all nautically themed)—New Jersey to Maine. Captions required; include location.

Making Contact & Terms: Interested in receiving work from newer, lesser-known photographers. Please call before sending photos. Cover photos should be vertical format and have strong graphics and/or color. Accepts images in digital format for Mac. Send via online, floppy disk, SyQuest. Pays $300/color cover photo; $50-200 for color inside photo. Pays on publication. Credit line given. Buys one-time rights. Simultaneous submissions and/or previously published work OK.

OHIO MAGAZINE, 62 E. Broad St., Columbus OH 43215. (614)461-5083. Art Director: Brooke Wenstrup. Estab. 1979. Magazine published 10 times/year. Emphasizes features throughout Ohio for an educated, urban and urbane readership. Sample copy $4 postpaid.

Needs: Travel, photo essay/photo feature, b&w scenics, personality, sports and spot news. Photojournalism and concept-oriented studio photography. Model/property releases preferred. Captions required.

Making Contact & Terms: Interested in receiving work from newer, lesser-known photographers. Send material by mail for consideration. Query with samples. Arrange a personal interview to show portfolio. Send 8×10 b&w glossy prints; contact sheet requested. Also uses 35mm, 2¼×2¼ or 4×5 transparencies; square format preferred for covers. SASE. Reports in 1 month. Pays $30-250/b&w photo; $30-250/color photo; $350/day; and $150-350/job. Pays within 90 days after acceptance. Credit line given. Buys one-time rights; negotiable.

Tips: "Please look at magazine before submitting to get an idea of what type of photographs we use. Send sheets of slides and/or prints with return postage and they will be reviewed. Dupes for our files are

always appreciated—and reviewed on a regular basis. We are leaning more toward well-done documentary photography and less toward studio photography. Trends in our use of editorial photography include scenics, single photos that can support an essay, photo essays on cities/towns, more use of 180° shots. In reviewing a photographer's portfolio or samples we look for humor, insight, multi-level photos, quirkiness, thoughtfulness; stock photos of Ohio; ability to work with subjects (i.e., an obvious indication that the photographer was able to make subject relax and forget the camera—even difficult subjects); ability to work with givens, bad natural light, etc.; creativity on the spot—as we can't always tell what a situation will be on location."

OKLAHOMA TODAY, P.O. Box 53384, Oklahoma City OK 73152. (405)521-2496. Fax: (405)522-4588. Editor-in-Chief: Jeanne M. Devlin. Circ. 45,000. Estab. 1956. Bimonthly magazine. "We cover all aspects of Oklahoma, from history to people profiles, but we emphasize travel." Readers are "Oklahomans, whether they live in-state or are exiles; studies show them to be above average in education and income." Sample copy $4.95. Photo guidelines free with SASE.
Needs: Uses about 50 photos/issue; 90-95% supplied by freelancers. Needs photos of "Oklahoma subjects only; the greatest number are used to illustrate a specific story on a person, place or thing in the state. We are also interested in stock scenics of the state." Other areas of focus are adventure—sport/travel, reenactment, historical and cultural activities. Model release required. Captions required.
Making Contact & Terms: Interested in receiving work from newer, lesser-known photographers. Query with samples. Send 8×10 glossy b&w prints; 35mm, 2¼×2¼, 4×5, 8×10 transparencies or b&w contact sheets by mail for consideration. No color prints. Also accepts digital files (Mac compatible). SASE. Reports in 2 months. Pays $50-200/b&w photo; $50-200/color photo; $125-1,000/job. Pays on publication. Buys one-time rights with a six-month from publication exclusive, plus right to reproduce photo in promotions for magazine, without additional payment with credit line. Simultaneous submissions and/or previously published work OK (on occasion).
Tips: To break in, "read the magazine. Subjects are normally activities or scenics (mostly the latter). I would like good composition and very good lighting. I look for photographs that evoke a sense of place, look extraordinary and say something only a good photographer could say about the image. Look at what Ansel Adams and Eliot Porter did and what Muench and others are producing and send me that kind of quality. We want the best photographs available and we give them the space and play such quality warrants."

OLD WEST, P.O. Box 2107, Stillwater OK 74076. (405)743-3370. Fax: (405)743-3374. Editor: Marcus Huff. Circ. 30,000. Estab. 1964. Quarterly magazine. Emphasizes history of the Old West (1830 to 1915). Readers are people who like to read the history of the West, mostly male, age 45 and older. Sample copy free with 9×12 SAE and 7 first-class stamps.
Needs: Uses 100 or more photos/issue; "almost all" supplied by freelance photographers. Needs mostly Old West historical subjects, some travel, some scenic (ghost towns, old mining camps, historical sites). Prefers to have accompanying ms. Special needs include western wear, cowboys, rodeos, western events. Captions required; include name and location of site.
Making Contact & Terms: Interested in receiving work from newer, lesser-known photographers. Query with samples, b&w only for inside, color covers. SASE. Reports in 1 month. Pays $75-150/color cover photos; $10/b&w inside photos. **Payment on acceptance**; cover photos on publication. Credit line given. Buys first North American serial rights.
Tips: "We are looking for transparencies of existing artwork as well as scenics for covers, pictures that tell stories associated with Old West for the inside. Most of our photos are used to illustrate stories and come with manuscripts; however, we will consider other work (scenics, historical sites, old houses). Scenics should be free of modern intrusions such as buildings, power line, highways, etc."

‡ONBOARD MEDIA, 960 Alton Rd., Miami Beach FL 33139. (305)673-0400. Fax: (305)674-9396. E-mail: onboard@netpoint.net. Photo Editor: Jessica Thomas. Circ. 792,184. Estab. 1992. Annual magazine. Emphasizes travel in the Caribbean, Far East, Mexican Riviera, Bahamas, Alaska. The publication reaches cruise vacationers or 3-1-night Caribbean, Bahamas, Mexican Riviera, Alaska and Far East itineraries. Sample copy free with 11×14 SASE. Photo guidelines free with SASE.
Needs: All photos supplied by freelancers. Needs photos of scenics, nature, prominent landmarks based

THE SUBJECT INDEX, located at the back of this book, lists publications, book publishers, galleries, paper product companies and stock agencies according to the subject areas they seek.

in Caribbean, Mexican Riviera, Bahamas and Alaska. Model/property release preferred. Captions required; include where the photo was taken and explain the subject matter.

Making Contact & Terms: Interested in receiving work from newer, lesser-known photographers. Query with stock photo list. Provide résumé, business card, brochure, flier or tearsheets to be kept on file for possible assignments. Send 35mm, 2¼×2¾₁, 4×5, 8×10 transparencies. Keeps samples on file. SASE. Reports in 3 weeks. Rates negotiable per project. Pays on publication. Previously published work OK.

OPEN WHEEL MAGAZINE, P.O. Box 715, Ipswich MA 01938. (508)463-3787. Fax: (508)463-3250. Editor: Dick Berggren. Circ. 135,000. Estab. 1981. Monthly. Emphasizes sprint car, supermodified, Indy and midget racing. Readers are fans, owners and drivers of race cars and those with business in racing. Photo guidelines free for SASE.

Needs: Uses 100-125 photos/issue supplied by freelance photographers; almost all come from freelance stock. Needs documentary, portraits, dramatic racing pictures, product photography, special effects, crash. Photos purchased with or without accompanying ms. Model release required for photos not shot in pit, garage or on track. Captions required.

Making Contact & Terms: Send by mail for consideration 8×10 glossy b&w or color prints and any size slides. Kodachrome 64 preferred. SASE. Reports in 6 weeks. Pays $20/b&w inside; $35-250/color inside. Pays on publication. Buys all rights.

Tips: "Send the photos. We get dozens of inquiries but not enough pictures. We file everything that comes in and pull 80% of the pictures used each issue from those files. If it's on file, the photographer has a good shot."

OREGON COAST MAGAZINE, P.O. Box 18000, Florence OR 97439. (800)348-8401. Fax: (541)997-1124. E-mail: @ohwy.com. Website: http://www.ohwy.com. Art Director: Barbara Grano. Circ. 50,000. Estab. 1982. Bimonthly magazine. Emphasizes Oregon coast life. Readers are middle class, middle age. Sample copy $4.50, including postage. Photo guidelines available with SASE with 2 first-class stamps.

Needs: Uses 6-10 photos/issue; all supplied by freelancers. Needs scenics. Especially needs photos of typical subjects—waves, beaches, lighthouses—but from a different angle. Needs mostly vertical format. Model release required. Captions required; include specific location and description. "Label all slides and transparencies with captions and photographer's name."

Making Contact & Terms: Interested in receiving work from newer, lesser-known photographers. Send unsolicited 35mm, 2¼×2¼, 4×5 transparencies by mail for consideration. SASE. Reports in 2 weeks; 1 month for photo/text package. Pays $325/color cover photo; pays $100 for calendar usage; pays $25-75/color inside photo; $25-50/b&w inside photo; $100-250/photo/text package. Credit line given. Buys one-time rights.

Tips: "Send only the very best. Use only slide film that can be enlarged without graininess. An appropriate submission would be 20-60 slides. Don't use color filters. Protect slides with sleeves—put in plastic holders. Don't send in little boxes."

OREGON OUTSIDE, 1525 12th St., P.O. Box 18000, Florence OR 97439. (800)348-8401. Fax: (541)997-1124. E-mail: @ohwy.com. Website: http://www.ohwy.com. Art Director: Barbara Grano. Circ. 20,000. Estab. 1991. Bimonthly magazine. Emphasizes state and national parks in Oregon. Readers are middle-age male and female, upper income/middle income. Sample copy $4.50 includes postage. Photo guidelines free with SASE.

Needs: Uses 8-12 (full page) vertical or horizontal photos/issue; all supplied by freelancers. Needs photos of outdoor activities, scenics. Model release preferred. Photo captions required.

Making Contact & Terms: Send unsolicited photos by mail for consideration. Uses 35mm, 2¼×2¼, 4×5 transparencies. SASE. Reports in 2 weeks; 1 month for photo/text packages. Pays $325/color cover photo; $25-75/color inside photo; $25-50/b&w inside photo; $100-250/photo/text package. Pays on publication. Credit line given. Buys one-time rights.

Tips: "Mainly interested in scenics and activity shots. Avoid colored filters. Use only film that can enlarge without graininess."

‡ORGANIC GARDENING, 33 E. Minor St., Emmaus PA 18098. (215)967-8770. Fax: (215)967-7846. Photo Editor: Rob Cardillo. Circ. 800,000. Magazine publishes 9 issues/year. Emphasizes the entire range of gardening topics: annual/perennial flowers, vegetables, herbs, shrubs, trees/vines. Free photo guidelines/want lists with SASE.

Needs: Uses 50-70 photos/issue; 30% supplied by freelance photographers. Needs garden plants, close-ups of perfect, disease-free vegetables, fruits, nuts, herbs, and ornamentals growing in the garden; gardening techniques, organic methods in use (i.e. straw-mulched potatoes, row-covered winter squash, companion planting, plant protection); gardening activities, real gardeners performing various gardening tasks (i.e., turning compost, harvesting rutabagas, planting peas, dividing perennials, picking cherries, weeding, etc.).

"These images are highly desired and often end up on a cover;" and garden wildlife, beneficial and pest insects in all stages, cats, dogs, gophers, moles, deer, frogs, birds, raccoons, etc. in recognizable garden settings. Model release required. Exact captions (as to plant variety) required!

Making Contact & Terms: "Submissions should be sent in clear plastic slide pages with each item identified as to subject and photographer." Uses 35mm and larger transparencies (prefer Fujichrome). Pays $125/half page; $200/page; $300/double page; $600/cover shot. Pays on publication. Credit line given. Buys one-time rights.

Tips: "Shoot using the entire range of lighting (especially early morning and late afternoon), under all weather conditions (after a frost or late spring snow, during a summer shower or early morning mist). Vary camera angles and focal lengths." To break in, "know the subject thoroughly. Know how to shoot people as well as plants."

THE OTHER SIDE, 300 W. Apsley St., Philadelphia PA 19144. (215)849-2178. Art Director: Cathleen Benberg. Circ. 17,000. Estab. 1965. Bimonthly magazine. Emphasizes social justice issues from a Christian perspective. Sample copy $4.
 ● This publication is an Associated Church Press and Evangelical Press Association award winner.
Needs: Buys 6 photos/issue; 95-100% from stock, 0-5% on assignment. Documentary, human interest and photo essay/photo feature. "We're interested in human-interest photos and photos that relate to current social, economic or political issues, both here and in the Third World." Model/property release preferred. Captions preferred.

Making Contact & Terms: Interested in receiving work from newer, lesser-known photographers. Send samples of work to be photocopied for our files and/or photos; a list of subjects is difficult to judge quality of work. Send 8×10 glossy b&w prints; transparencies for cover, vertical format required. Materials will be returned on request. SASE. Pays $20-30/b&w photo; $50-75/cover photo. Credit line given. Buys one-time rights. Simultaneous submissions and previously published work OK.

Tips: In reviewing photographs/samples, looks for "sensitivity to subject, creativity, and good quality darkroom work."

✤OUR FAMILY, P.O. Box 249, Battleford, Saskatchewan, S0M 0E0 Canada. Fax: (306)937-7644. E-mail: gregomimary@sk.sympatico.com. Editor: Nestor Gregoire. Circ. 10,000. Estab. 1949. Monthly magazine. Emphasizes Christian faith as a part of daily living for Roman Catholic families. Sample copy $2.50 with 9×12 SAE and $1.10 Canadian postage. Free photo and writer's guidelines with SAE and 52¢ Canadian postage.

Needs: Buys 5 photos/issue; cover by assignment, contents all freelance. Head shot (to convey mood); human interest ("people engaged in the various experiences of living"); humorous ("anything that strikes a responsive chord in the viewer"); photo essay/photo feature (human/religious themes); and special effects/experimental (dramatic—to help convey a specific mood). "We are always in need of the following: family (aspects of family life); couples (husband and wife interacting and interrelating or involved in various activities); teenagers (in all aspects of their lives and especially in a school situation); babies and children; any age person involved in service to others; individuals in various moods (depicting the whole gamut of human emotions); religious symbolism; and humor. We especially want people photos, but we do not want the posed photos that make people appear 'plastic,' snobbish or elite. In all photos, the simple, common touch is preferred. We are especially in search of humorous photos (human and animal subjects). Stick to the naturally comic, whether it's subtle or obvious." Photos are purchased with or without accompanying ms. Model release required if editorial topic might embarrass subject. Captions required when photos accompany ms.

Making Contact & Terms: Send material by mail for consideration or query with samples after consulting photo spec sheet. Provide letter of inquiry, samples and tearsheets to be kept on file for possible future assignments. Send 8×10 glossy b&w prints; transparencies or 8×10 glossy color prints are used on inside pages, but are converted to b&w. SAE and IRC. (Personal check or money order OK instead or IRC.) Reports in 1 month. Pays $35/b&w photo; 7-10¢/word for original mss; 5¢/word for nonoriginal mss. **Pays on acceptance.** Credit line given. Buys one-time rights and simultaneous rights. Simultaneous submissions or previously published work OK.

Tips: "Send us a sample (20-50 photos) of your work after reviewing our Photo Spec Sheet. Looks for "photos that center around family life—but in the broad sense — i.e., our elderly parents, teenagers, young adults, family activities. Our covers (full color) are a specific assignment. We do not use freelance submissions for our cover."

OUT MAGAZINE, 110 Greene St., Suite 600, New York NY 10012. (212)334-9119. Fax: (212)334-9227. E-mail: outmag@aol.com. Website: http://www.out.com. Art Director: George Karabotsos. Photo Editor: Amy Steiner. Circ. 150,000. Estab. 1992. Monthly magazine. Emphasizes gay and lesbian lifestyle. Readers are gay men and lesbians of all ages and their friends.

Needs: Uses about 100 photos/issue; about half supplied by freelancers. Needs portraits, photojournalism and fashion photos. Reviews photos with or without ms. Model release required. Captions required.

Making Contact & Terms: Submit portfolio every Wednesday for review. Also accepts digital images in SyQuest and images via the Internet. Accepts "visual dispatch" and party photos from around the country; return postage required. Unsolicited material is not returned. Payment negotiated directly with photographer. Pays on publication. Credit line given. Buys all rights; negotiable. Simultaneous submissions and/or previously published work OK.

Tips: "Don't ask to see layout. Don't call every five minutes. Turn over large portion of film."

OUTDOOR AMERICA, 707 Conservation Lane, Gaithersburg MD 20878-2983. (301)548-0150. Fax: (301)548-0146. Editor: Denny Johnson. Circ. 45,000. Estab. 1922. Published quarterly. Emphasizes natural resource conservation and activities for outdoor enthusiasts, including hunters, anglers, hikers and campers. Readers are members of the Izaak Walton League of America and all members of Congress. Sample copy $2 with 9×12 envelope. Guidelines free with SASE.

Needs: Needs vertical wildlife or shots of anglers or hunters for cover. Buys pictures to accompany articles on conservation and outdoor recreation for inside. Model release preferred. Captions required; include date taken, model info, location and species.

Making Contact & Terms: Query with résumé of photo credits. Send stock photo list. Tearsheets and non-returnable samples only. Uses 35mm and 2¼×2¼ slides. Not responsible for return of unsolicited material. SASE. Pays $200/color cover; $50-100/inside photo. **Pays on acceptance**. Credit line given. Buys one-time rights. Simultaneous and/or previously published work OK.

Tips: "*Outdoor America* seeks vertical photos of wildlife (particular game species); outdoor recreation subjects (fishing, hunting, camping or boating) and occasional scenics (especially of the Chesapeake Bay and Upper Mississippi river). We also like the unusual shot—new perspectives on familiar objects or subjects. We do not assign work. Approximately one half of the magazine's photos are from freelance sources. Our cover has moved from using a square photo format to full bleed."

♣OUTDOOR CANADA, 703 Evans Ave., Suite 202, Toronto, Ontario M9C 5E9 Canada. (416)695-0311. Fax: (416)695-0381. Editor: James Little. Circ. 95,000. Estab. 1972. Magazine published 8 times a year. Free writers' and photographers' guidelines "with SASE or SAE and IRC only."

Needs: Buys 200-300 photos annually. Needs photos of wildlife, people fishing, hiking, camping, hunting, ice-fishing, action shots. Captions required including identification of fish, bird or animal.

Making Contact & Terms: Send a selection of transparencies for consideration. No phone calls, please. For cover allow undetailed space along left side of photo for cover lines. SAE and IRC for American contributors, SASE for Canadians *must* be sent for return of materials. Reports in 3 weeks. Pays $400/cover photo; $75-250/inside color photo depending on size used. Pays on publication. Buys one-time rights.

‡OUTDOOR LIFE MAGAZINE, Dept. PM, 2 Park Ave., New York NY 10016. (212)779-5093. Design Director: Frank Rothmann. Circ. 1.35 million. Monthly. Emphasizes hunting, fishing, shooting, camping and boating. Readers are "outdoorsmen of all ages." Sample copy "not for individual requests." Photo guidelines with SASE.

Needs: Uses about 50-60 photos/issue; 75% supplied by freelance photographers. Needs photos of "all species of wildlife and fish, especially in action and in natural habitat; how-to and where-to." Captions preferred.

Making Contact & Terms: Send 5×7 or 8×10 b&w glossy prints; 35mm or 2¼×2¼ transparencies; b&w contact sheet by mail for consideration. Prefers Kodachrome 35mm slides. Prefers dupes. SASE. Reports in 1 month. Pays $35-275/b&w photo, $50-700/color photo depending on size of photos; $800-1,000/cover photo. Rates are negotiable. Pays on publication. Credit line given. Buys one-time rights.

Tips: "Have name and address clearly printed on each photo to insure return, send in 8×10 plastic sleeves. Multi subjects encouraged."

OUTDOOR TRAVELER MID-ATLANTIC, P.O. Box 2748, Charlottesville VA 22902. (804)984-0655. Fax: (804)984-0656. Editor: Marianne Marks. Circ. 30,000. Estab. 1993. Quarterly magazine. Emphasizes outdoor recreation, travel, nature—all in the mid-Atlantic region. Readers are male and female outdoor enthusiasts and travelers, ages 20-50. Sample copy $5.

Needs: Uses 20-25 photos/issue; 95% supplied by freelancers. Needs photos of outdoor recreation, nature/wildlife, travel, scenics—all in the region. Reviews photos with or without ms. Special photo needs include seasonal photos related to outdoor recreation and scenery. Property release is preferred. Captions preferred.

Making Contact & Terms: Interested in receiving work from newer, lesser-known photographers. Query with résumé of credits, slides or printed samples and a stock list. Keeps samples on file. SASE. Reports in 2 months. Pays $250/color cover photo; $50/color quarter-page; $75/color half page; $100/color full

page; $150/color spread. Pays on publication. Credit line given. Buys one-time rights. Simultaneous submissions and previously published work OK.

Tips: Interested in "action-oriented, scenic photos of people engaged in outdoor recreation (hiking, bicycling, skiing, rafting, canoeing, rock climbing, etc.)."

OVER THE BACK FENCE, P.O. Box 756, Chillicothe OH 45601. (614)772-2165. Fax: (614)773-7626. E-mail: backfencpb@aol.com. Contact: Photo Editor. Estab. 1994. Quarterly magazine. "This is a regional magazine serving Southern Ohio. We are looking for photos of interesting people, events, and history of our area." Sample copy $4. Photo guidelines free with SASE.

Needs: Uses 50-70 photos/issue; 80% supplied by freelance assignment; 20% by freelance stock. Needs photos of scenics, attractions, food (specific to each issue), historical locations in our region (call for specific counties). Model release required for identifiable people. Captions preferred; include locations, description, names, date of photo (year); and if previously published, where and when.

Making Contact & Terms: Interested in receiving work from newer, lesser-known photographers. Provide résumé, business card, brochure, flier or tearsheets to be kept on file for possible assignments. Query with stock photo list and résumé of credits. Accepts images in digital format for Windows (TIFF, EPS) Send via compact disc, floppy disk, SyQuest. Deadlines: 6 months minimum before each issue. SASE. Reports in 3 months. Pays $100/color cover photo; $100/b&w cover photo; $25-100/color inside photo; $25-100/b&w inside photo. "We pay mileage fees to photographers on assignments. Request our photographer's rates and guidelines for specifics." Pays on publication. Credit line given except in the case of ads, where it may or may not appear. Buys one-time rights. Simultaneous submissions and previously published work OK, "but must identify photos used in other publications."

Tips: "We are looking for sharp, colorful images and prefer using color transparencies over color prints when possible. Nostalgic and historical photos are usually in black & white."

♣OWL MAGAZINE, 370 King St. W., Suite 300, Toronto, Ontario M5V 1S9 Canada. (416)971-5275. Fax: (416)971-5294. Website: http://www.owl.on.ca. Researcher: Ekaterina Gitlin. Circ. 150,000. Estab. 1976. Published 9 times/year; 1 summer issue. A science and nature magazine for children ages 8-13. Sample copy $4.28 and 9×12 SAE. Photo guidelines with SAE.

- OWL's Website, OWLKids Online, has won Meckler-medias Internet IMPACT Award for changing the way people learn.

Needs: Uses approximately 15 photos/issue; 50% supplied by freelancers. Needs photos of animals/wildlife, science, technology, scientists working in the field (i.e. with animals). Model/property release preferred. Captions required.

Making Contact & Terms: Interested in receiving work from newer, lesser-known photographers. Request photo package before sending photos for review. Send 35mm transparencies. Also accepts digital files scanned on to Zip disk or SyQuest-type hard disk, at high resolution (300 dpi) as a TIFF or EPS file (prefers CMYK format, separations included). Keeps samples on file. SAE and IRCs. Reports in 2-3 months. Pays $325 Canadian/color cover photo; $100 Canadian/color inside photo; $200 Canadian/color page rate; $125-500 US/color photo. **Pays on acceptance.** Credit line given. Buys one-time rights. Previously published work OK.

Tips: "Photos should be sharply focused with good lighting showing animals in their natural environment. It is important that you present your work as professionally as possible. Become familiar with the magazine—study back issues."

PACIFIC UNION RECORDER, Box 5005, Westlake Village CA 91359. (805)497-9457. Editor: C. Elwyn Platner. Circ. 58,500. Estab. 1901. Company publication of Pacific Union Conference of Seventh-day Adventist. Monthly except twice a month in February, April, June, August, October and December. Emphasizes religion. Readers are primarily age 18-90 church members. Sample copy free with 8½×11 SAE and 3 first-class stamps. Photo guidelines free with SASE.

Needs: Uses photos for cover only; 80% supplied by freelance photographers. Needs photos of animal/wildlife shots, travel, scenics, limited to subjects within Nevada, Utah, Arizona, California and Hawaii. Model release required. Captions required.

Making Contact & Terms: Send unsolicited 35mm, 2¼×2¼, 4×5, 8×10 vertical transparencies by mail for consideration in October only. Limit of 10 transparencies or less/year per photographer. SASE. Reports in 1-2 months after contest. Pays $75/color cover photo. Pays on publication. Credit line given. Buys first one-time rights.

Tips: "Avoid the trite, Yosemite Falls, Half Dome, etc." Holds annual contest November 1 each year; submit entries in October only.

♣PACIFIC YACHTING MAGAZINE, 780 Beatty St., Suite 300, Vancouver, British Columbia V6B 2MI Canada. (604)606-4644. Fax: (604)687-1925. E-mail: op@mindlink.bc.ca. Editor: Duart Snow. Circ.

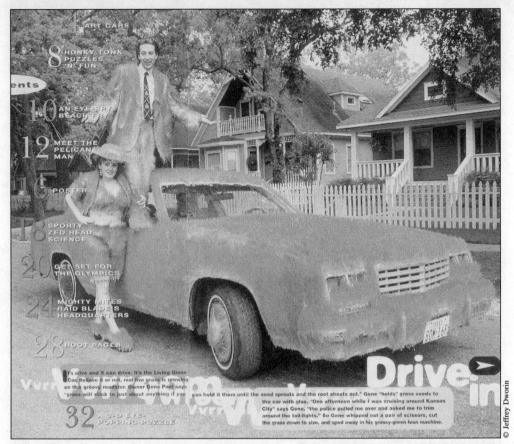

"It's alive and it can drive," says the caption accompanying this photo appearing in *OWL* magazine. Jeffrey Dworin got the shot of this rolling "lawnmobile" flanked by the grass-clad couple. His photo first appeared in *Car and Driver* magazine, and has since been published several times in magazines that contacted Dworin after seeing the shot. The owner of the green machine, Gene Pool, says he simply glues down the grass seed, and it sprouts. Dworin's photo was the first in an *OWL* series on odd autos (including one shaped like a shark, one covered with little toys and an open-air wrought iron VW Bug). He was paid $250 for the reprint, a two-page spread and background for the magazine's table of contents.

25,000. Estab. 1968. Monthly magazine. Emphasizes boating on West Coast. Readers are male, ages 35-60, boaters, power and sail. Sample copy free with 8½ × 11 SAE with IRC.
Needs: Uses 125 photos/issue; 125 supplied by freelancers. Needs photos of all kinds. Reviews photos with accompanying ms only.
Making Contact & Terms: Interested in receiving work from newer, lesser-known photographers. Keeps samples on file. Payment negotiable. Credit line given. Buys one-time rights. Simultaneous submissions and/or previously published work OK.

PADDLER MAGAZINE, P.O. Box 5450, Steamboat Springs CO 80477. Phone/fax: (970)879-1450. Editor: Eugene Buchanan. Circ. 85,000. Estab. 1990. Bimonthly magazine. Emphasizes kayaking, rafting, canoeing and sea kayaking. Sample copy $3.50. Photo guidelines free with SASE.
Needs: Uses 30-50 photos/issue; 90% supplied by freelancers. Needs photos of scenics and action. Model/property release preferred. Captions preferred; include location.
Making Contact & Terms: Interested in receiving work from newer, lesser-known photographers. Query with stock photo list. Send unsolicited photos by mail for consideration. Send 35mm transparencies. Keeps samples on file. SASE. Reports in 2 months. Pays $25-150/color photo; $150/color cover photo; $50/inset color cover photo; $75/color full page inside photo. Pays on publication. Credit line given. Buys first North American serial rights; negotiable.
Tips: "Send dupes and let us keep them on file."

PALM BEACH ILLUSTRATED MAGAZINE, 1016 N. Dixie Hwy., West Palm Beach FL 33401. (407)659-0210. Fax: (407)659-1736. Creative Director: Meg Seville. Circ. 30,000. Estab. 1952. Magazine published 10 times a year. Emphasizes upscale, first-class living. Readers are highly influential, established people, ages 35-54.

Needs: Needs photos of travel. Reviews photos with or without a ms. Model/property release required. Captions preferred.

Making Contact & Terms: Send color prints; 35mm, 2¼×2¼ transparencies. SASE. Reports in 1 month. Payment made on individual basis. Pays on publication. Credit line given. Buys one-time rights. Simultaneous submissions OK.

Tips: Looks for "travel and related topics such as resorts, spas, yacht charters, trend and lifestyle topics. Materials should appeal to affluent readers: e.g., budget travel is not of interest. Editorial material on the latest best investments in the arts would be appropriate; editorial material on investing in a mobile home would not."

‡THE PALM COURT PRESS, P.O. Box 170251, St. Louis MO 63117-7951. (314)621-6721. Fax: (314)231-6209. E-mail: greatlawn@aol.com. Publisher/Editor: David Olin Tullis. Estab. 1996. Quarterly journal. Emphasizes art and literature. Readers are gay men. Photo guidelines free with SASE.

Needs: Uses 25 photos/issue. Needs all subject matter, but elegant male nudes preferred. Model release required. Captions required; include title and copyright information.

Making Contact & Terms: Send unsolicited photos by mail for consideration. Send 5×7, 8×10 b&w prints. Does not keep samples on file. SASE. Reports in 1 month. Pays 5 contributor's copies. Credit line given. Previously published work OK.

PENNSYLVANIA, P.O. Box 576, Camp Hill PA 17011. (717)697-4660. Editor: Matthew K. Holliday. Circ. 30,000. Bimonthly. Emphasizes history, travel and contemporary issues and topics. Readers are 40-70 years old, professional and retired; average income is $59,000. Sample copy $2.95. Photo guidelines free with SASE.

● If you want to work with this publication make sure you review several past issues and obtain photo guidelines.

Needs: Uses about 40 photos/issue; most supplied by freelance photographers. Needs include travel and scenic. All photos must be in Pennsylvania. Reviews photos with or without accompanying ms. Captions required.

Making Contact & Terms: Query with samples. Send 5×7 and up color prints; 35mm and 2¼×2¼ transparencies (duplicates only, no originals) by mail for consideration. SASE. Reports in 2 weeks. Pays $100/color cover photo; $15-25/inside photo; $50-400/text/photo package. Credit line given. Buys first rights. Simultaneous submissions and previously published work OK.

PENNSYLVANIA ANGLER & BOATER, (formerly *Pennsylvania Angler*), P.O. Box 67000, Harrisburg PA 17106-7000. (717)657-4518. Fax: (717)657-4549. E-mail: 76247.624@compuserve.com. Website: http://www.state.pa.us/Fish. Editor: Art Michaels. Bimonthly. "*Pennsylvania Angler & Boater* is the Keystone State's official fishing and boating magazine, published by the Pennsylvania Fish and Boat Commission." Readers are "anglers and boaters in Pennsylvania." Sample copy and photo guidelines free with 9×12 SAE and 9 oz. postage.

Needs: Uses about 50 photos/issue; 80% supplied by freelancers. Needs "action fishing and boating shots." Model release preferred. Captions required.

Making Contact & Terms: Query with résumé of credits. Send 8×10 glossy b&w prints; 35mm or larger transparencies by mail for consideration. SASE. Reports in 2 weeks. Pays up to $400/color cover photo; $25-100/b&w inside photo; $25 up/color inside photo; $50-300 for text/photo package. **Pays on acceptance.** Credit line given. Buys variable rights.

PENNSYLVANIA GAME NEWS, 2001 Elmerton Ave., Harrisburg PA 17110-9797. (717)787-3745. Editor: Bob Mitchell. Circ. 150,000. Monthly magazine. Published by the Pennsylvania Game Commission. For people interested in hunting, wildlife management and conservation in Pennsylvania. Free sample copy with 9×12 SASE. Free editorial guidelines.

● **SPECIAL COMMENTS** within listings by the editor of *Photographer's Market* are set off by a bullet.

Needs: Considers photos of "any outdoor subject (Pennsylvania locale), except fishing and boating." Photos purchased with accompanying ms.
Making Contact & Terms: Submit seasonal material 6 months in advance. Send 8×10 glossyb&w prints. SASE. Reports in 2 months. Pays $5-20/photo. **Pays on acceptance.** Buys all rights, but may reassign after publication.

PENNSYLVANIAN MAGAZINE, Dept. PM, 2941 N. Front St., Harrisburg PA 17110. (717)236-9526. Fax: (717)236-8164. Editor: T. Michael Mullen. Circ. 7,000. Estab. 1962. Monthly magazine of Pennsylvania State Association of Boroughs (and other local governments). Emphasizes local government in Pennsylvania. Readers are officials in municipalities in Pennsylvania. Sample copy free with 9×12 SAE and 5 first-class stamps.
Needs: Number of photos/issue varies with inside copy. Needs "color photos of scenics (Pennsylvania), local government activities, Pennsylvania landmarks, ecology—for cover photos only; authors of articles supply their own photos." Special photo needs include photos of street and road maintenance work; wetlands scenic. Model release preferred. Captions preferred that include identification of place and/or subject.
Making Contact & Terms: Interested in receiving work from newer, lesser-known photographers. Query with résumé of credits. Query with list of stock photo subjects. Send unsolicited photos by mail for consideration. Provide résumé, business card, brochure, flier or tearsheets to be kept on file for possible assignments. Send color prints and 35mm transparencies. Does not keep samples on file. SASE. Reports in 1 month. Pays $25-30/color cover photo. Pays on publication. Buys one-time rights.
Tips: "We're looking for a variety of scenic shots of Pennsylvania which can be used for front covers of the magazine, especially special issues such as engineering, winter road maintenance or park and recreation. Photographs submitted for cover consideration should be vertical shots; horizontal shots receive minimal consideration."

PENTECOSTAL EVANGEL, 1445 Boonville, Springfield MO 65802. (417)862-2781. Fax: (417)862-0416. E-mail: pevangel@ao.org. Editor: Hal Donaldson. Managing Editor: Ken Horn. Circ. 250,000. Official voice of the Assemblies of God, a conservative Pentecostal denomination. Weekly magazine. Emphasizes denomination's activities and inspirational articles for membership. Free sample copy and photographer's/writer's guidelines.
 ● *Pentecostal Evangel* uses a number of images taken from the Internet and CD-ROMs.
Needs: Uses 25 photos/issue; 5 supplied by freelance photographers. Human interest (very few children and animals). Also needs seasonal and religious shots. "We are interested in photos that can be used to illustrate articles or concepts developed in articles. We are not interested in merely pretty pictures (flowers and sunsets) or in technically unusual effects or photos. We use a lot of people and mood shots." Model release preferred. Captions preferred.
Making Contact & Terms: Interested in receiving work from newer, lesser-known photographers. Send material by mail for consideration. Uses 8×10 b&w and color prints; 35mm or larger transparencies; color 2¼×2¼ to 4×5 transparencies for cover; vertical format preferred. Also accepts digital images in TIFF files. SASE. Reports in 6-8 weeks. Pays $35-50/b&w photo; $50-200/color photo; $100-300/job. **Pays on acceptance.** Credit line given. Buys one-time rights; simultaneous rights; or second serial (reprint) rights. Simultaneous submissions and previously published work OK if indicated.
Tips: "Send seasonal material six months to a year in advance—especially color."

PENTHOUSE, 277 Park Ave., 4th Floor, New York NY 10172-0003. (212)702-8000. Fax: (212)702-6262. Monthly magazine. *Penthouse* is a magazine edited for the sophisticated male. Its editorial scope ranges from outspoken contemporary comment to photography essays of beautiful women. *Penthouse* features interviews with personalities, sociological studies, humor, travel, food and wines, and fashion and grooming for men. This magazine did not respond to our request for information. Query before submitting.

PERSIMMON HILL, 1700 NE 63rd, Oklahoma City OK 73111. (405)478-6404. Fax: (405)478-4714. Editor: M. J. Van Deventer. Circ. 15,000. Estab. 1970. Publication of the National Cowboy Hall of Fame museum. Quarterly magazine. Emphasizes the West, both historical and contemporary views. Has diverse international audience with an interest in preservation of the West. Sample copy $9 with 9×12 SAE and 10 first-class stamps. Writers and photography guidelines free with SASE.
 ● This magazine has received Outstanding Publication honors from the Oklahoma Museums Association, the International Association of Business Communicators and Ad Club.
Needs: Uses 70 photos/issue; 95% supplied by freelancers; 90% of photos in each issue come from assigned work. "Photos must pertain to specific articles unless it is a photo essay on the West." Model release required for children's photos. Photo captions required including location, names of people, action. Proper credit is required if photos are of an historical nature.

Making Contact & Terms: Interested in receiving work from newer, lesser-known photographers. Submit portfolio for review. SASE. Reports in 6 weeks. Pays $350/color cover photo; $50/color inside photo; $25-100/b&w inside photo; $200/photo/text package; $40-60/hour; $250-500/day; $300-750/job. Credit line given. Buys first North American serial rights.

Tips: "Make certain your photographs are high quality and have a story to tell. We are using more contemporary portraits of things that are currently happening in the West and using fewer historical photographs. Work must be high quality, original, innovative. Photographers can best present their work in a portfolio format and should keep in mind that we like to feature photo essays on the West in each issue. Study the magazine to understand its purpose. Show only the work that would be beneficial to us or pertain to the traditional Western subjects we cover."

PETERSEN'S PHOTOGRAPHIC, 6420 Wilshire Blvd., Los Angeles CA 90048-5515. (213)782-2200. Fax: (213)782-2465. Editor: Ron Leach. Circ. 200,000. Estab. 1972. Monthly magazine. Emphasizes photography. Sample copies available on newsstands. Photo guidelines free with SASE.

Needs: No assignments. All queries, outlines and mss must be accompanied by a selection of images that would illustrate the article.

Making Contact & Terms: Interested in receiving work from newer, lesser-known photographers as well as established pros. Submit portfolio for review. Send unsolicited photos by mail for consideration. Send unmounted glossy color or b&w prints no larger than 8×10; 35mm, 2¼×2¼, 4×5, 8×10 transparencies preferred. All queries and mss must be accompanied by sample photos for the article. Deadlines: 6 months in advance for seasonal photos. SASE. Reports in 2 months. Payment negotiable. Pays per published page (text and photos). Pays on publication. Credit line given. Buys one-time rights. Previously published work OK.

Tips: "We need images that are visually exciting and technically flawless. The articles mostly cover the theme 'We Show You How.' Send great photographs with an explanation of how to create them."

‡PETS QUARTERLY MAGAZINE, 2495 Main St., P.O. Box 15, Buffalo NY 14214. (416)955-1550. Fax: (416)955-1391. Managing Editor: Richard Soren. Circ. 62,000. Estab. 1991. Quarterly consumer magazine. Emphasizes pets, dogs, cats, fish, exotic animals. Readers are mostly female (over 90%). Sample copy $2.

Needs: Uses 25 photos/issues; all supplied by freelancers. Reviews photos with or without ms. Needs humorous shots of pets; close-up portraits; pets and people. Captions required.

Making Contact & Terms: Interested in receiving work from newer, lesser-known photographers. Query with stock photo list. Send 3×5 glossy color prints. Keeps samples on file. SASE. Reports in 1 month. Pays $50/b&w cover photo; $25/color inside photo. Pays on publication. Buys one-time rights. Previously published work OK.

Tips: "We still prefer to see material in 'hard copy' format."

PHOENIX MAGAZINE, 5555 N. Seventh Ave., Suite B-200, Phoenix AZ 85013. (602)207-3750. Editor: Beth Deveny. Art Director: James Forsmo. Monthly magazine. Circ. 60,000. Emphasizes "subjects that are unique to Phoenix: its culture, urban and social achievements and problems, its people and the Arizona way of life. We reach a professional and general audience of well-educated, affluent visitors and long-term residents."

Needs: Buys 10-35 photos/issue. Wide range, all dealing with life in metro Phoenix. Generally related to editorial subject matter. Wants on a regular basis photos to illustrate features, as well as for regular columns on arts. No "random shots of Arizona scenery, etc. that can't be linked to specific stories in the magazine." Photos purchased with or without an accompanying ms.

Making Contact & Terms: Query. Works with freelance photographers on assignment basis only. Provide résumé, samples, business card, brochure, flier and tearsheets to be kept on file for possible future assignments. SASE. Reports in 3-4 weeks. Pays $25-75/b&w; $50-200/color; $400-1,000/cover photo. Pays within 2 weeks of publication. Payment for manuscripts includes photos in most cases. Payment negotiable for covers and other photos purchased separately.

Tips: "Study the magazine, then show us an impressive portfolio."

PHOTO EDITORS REVIEW, Photo Editors International, 1201 Montego Way, Suite #4, Walnut Creek CA 94598-2819. Phone/fax: (510)935-9735. Photo Editor: Bob Shepherd. Circ. 5,000. Estab. 1994. Bimonthly newsletter for the professional photo editor. Emphasis on photo editing. Readers are mostly professional photo editors and multimedia photographers. Sample copies free with #10 business envelope and 3 first-class stamps. Photo guidelines free with SASE.

Needs: Uses 6-10 photos/issue; almost all supplied by photo editors and professional photographers. About 25% supplied by talented amateur photographers. Needs all kinds of photos, but photos must meet criteria listed under Tips, below. All photographic images must include universal themes. Model/property

release required for identifiable private property and portraits. Captions required; include camera model, lens used, shutter speed; f-stop and lighting information if applicable.

Making Contact & Terms: Always interested in receiving work from newer, lesser-known photographers. Query with résumé of credits. Query with sample 3×5 to 8×10 glossy b&w prints by mail for consideration. Provide return envelope and sufficient postage if photos are to be returned. (Because of misunderstandings by some photo contributors, we must make clear that although we will take every precaution to protect your photographic images from being lost or damaged, we cannot guarantee their safe return. All photos mailed to Photo Editors International are unsolicited submissions. Therefore, only send copies of originals.) Photo samples are normally kept on file for future reference. Reports in 1 month. Pays $50-100/b&w photo; up to $200 for photo assignment. **Pays on acceptance.** Credit line given and portrait of photo editor or photographer published. Buys one-time rights; negotiable. Simultaneous submissions and previously published work OK.

Tips: "We are a trade publication that caters to the needs of professional photo editors; therefore, marketable photos that exhibit universal themes will be given top priority. Universal themes are represented by images that are meaningful to people everywhere. We look for five basic characteristics by which we judge photographic materials: sharp exposures (unless the image was intended as a soft-focus shot), impact, easily identifiable theme or subject, emphasis of the theme or subject, and simplicity."

PHOTOGRAPHER'S MARKET, 1507 Dana Ave., Cincinnati OH 45207. (513)531-2690, ext. 286. Fax: (513)531-7107. E-mail: photomarket@fwpubs.com. Contact: Editor. Circ. 30,000. Photo guidelines free with SASE.

Needs: Publishes 35-40 photos per year. Uses general subject matter. Photos must be work sold to listings in *Photographer's Market*. Photos are used to illustrate to readers the various types of images being sold to photo buyers listed in the book. "We receive a lot of photos for our Publications section. Your chances of getting published are better if you can supply images for sections other than Publications." Look through this book for examples.

Making Contact & Terms: Interested in receiving work from newer, lesser-known photographers. Submit photos for inside text usage in fall and winter to ensure sufficient time to review them by deadline (end of January). All photos are judged according to subject uniqueness in a given edition, as well as technical quality and composition within the market section in the book. Photos are held and reviewed at close of deadline. Uses color and b&w (b&w preferred) prints, any size and format; 5×7 or 8×10 preferred. Also uses tearsheets and transparencies, all sizes, color and b&w. Pays $50 plus complimentary copy of book. Pays when book goes to printer (May). Book forwarded in September upon arrival from printer. Credit line given. Buys second reprint and promotional rights. Simultaneous submissions OK. Work must be previously published.

Tips: "Send photos with brief cover letter describing the background of the sale. If sending more than one photo, make sure that photos are clearly identified. Slides should be enclosed in plastic slide sleeves, and prints should be reinforced with cardboard. Cannot return material if SASE is not included. Tearsheets will be considered disposable unless SASE is provided and return is requested. Because photos are printed in black and white on newsprint stock, some photos, especially color shots, may not reproduce well. Photos should have strong contrast and not too much fine detail that will fill in when photo is reduced to fit our small page format."

‡**PHOTORESOURCE MAGAZINE**, P.O. Box 705, Tucumcari NM 88401-0705. (505)461-6183. Fax: (505)461-6181. E-mail: photoRescr@aol.com. Editor: William Johnson. Circ. 14,000. Estab. 1994. Bimonthly magazine. Readers are male and female, ages 18-65. Sample copy $1.75 with 9×12 SASE. Photo/writers guidelines free with #10 SASE.

Needs: Uses 2-6 photos/issue; all supplied by freelancers. Model/property release required. Photo captions preferred.

Making Contact & Terms: Interested in receiving work from newer, lesser-known photographers. Query with résumé of credits. Send unsolicited photos by mail for consideration. Send 35mm, $2\frac{1}{4} \times 2\frac{1}{4}$, 4×5 transparencies. Accepts images in digital format for Windows (JPEG, TIFF). Send via compact disc, floppy disk. Does not keep samples on file. Reports in 1 month. Payment negotiable. Pays on publication. Credit line given. Buys one-time rights. Simultaneous submissions OK.

THE SUBJECT INDEX, located at the back of this book, lists publications, book publishers, galleries, paper product companies and stock agencies according to the subject areas they seek.

PLANNING, American Planning Association, 122 S. Michigan Ave, Chicago IL 60603. (312)431-9100. (312)431-9985. Editor: Sylvia Lewis. Photo Editor: Richard Sessions. Circ. 30,000. Estab. 1972. Monthly magazine. "We focus on urban and regional planning, reaching most of the nation's professional planners and others interested in the topic." Free sample copy and photo guidelines with 10×13 SAE and 4 first-class stamps. Writer's guidelines included on photo guidelines sheet.

Needs: Buys 50 photos/year, 95% from freelance stock. Photos purchased with accompanying ms and on assignment. Photo essay/photo feature (architecture, neighborhoods, historic preservation, agriculture); scenic (mountains, wilderness, rivers, oceans, lakes); housing; and transportation (cars, railroads, trolleys, highways). "No cheesecake; no sentimental shots of dogs, children, etc. High artistic quality is very important. We publish high-quality nonfiction stories on city planning and land use. Ours is an association magazine but not a house organ, and we use the standard journalistic techniques: interviews, anecdotes, quotes. Topics include energy, the environment, housing, transportation, land use, agriculture, neighborhoods and urban affairs." Captions required.

Making Contact & Terms: Interested in receiving work from newer, lesser-known photographers. Query with samples. Uses 8×10 glossy and semigloss b&w prints; contact sheet OK; 4-color prints; 35mm or 4×5 transparencies. SASE. Reports in 1 month. Pays $50-100/b&w photo; $50-200/color photo; up to $350/cover photo; $200-600/ms. Pays on publication. Credit line given. Previously published work OK.

Tips: "Just let us know you exist. Eventually, we may be able to use your services. Send tearsheets or photocopies of your work, or a little self-promo piece. Subject lists are only minimally useful. How the work looks is of paramount importance."

PLAYBOY, 680 North Lake Shore Dr., Chicago IL 60611. (312)751-8000. Fax: (312)587-9046. Photography Director: Gary Cole. Circ. 3.15 million, US Edition; 5 million worldwide. Estab. 1954. Monthly magazine. Readers are 75% male and 25% female, ages 18-70; come from all economic, ethnic and regional backgrounds.

• This is a premiere market that demands photographic excellence. *Playboy* does not use freelance photographers per se, but if you send images they like they may use your work and/or pay a finder's fee.

Needs: Uses 50 photos/issue. Needs photos of glamour, fashion, merchandise, travel, food and personalities. Model release required. Models must be at least 18 years old.

Making Contact & Terms: Interested in receiving work from newer, lesser-known photographers. Contact through rep. Submit portfolio for review. Query with résumé of credits. Send unsolicited photos by mail for consideration. Provide résumé, business card, brochure, flier or tearsheets to be kept on file for possible assignments. Send color 35mm, 2¼×2¼, 4×5, 8×10 transparencies. Reports in 1-2 weeks. Pays $300 and up/job. **Pays on acceptance.** Buys all rights.

Tips: Lighting and attention to detail is most important when photographing women, especially the ability to use strobes indoors. Refer to magazine for style and quality guidelines.

‡PLAYERS MAGAZINE, 8060 Melrose Ave., Los Angeles CA 90046. (213)653-8060. Fax: (213)655-9452. E-mail: psi@loop.com. Editor-in-Chief: David Jamison. Monthly magazine. Emphasizes black adults. Readers are black men over 18. Sample copy free with SASE. Photo guidelines free with SASE.

Needs: Number of photos/issue varies; all supplied by freelancers. Needs photos of various editorial shots and female pictorials. Reviews photos purchased with accompanying ms only. Model release required for pictorial sets. Property release preferred for pictorial sets. Captions required.

Making Contact & Terms: Interested in receiving work from newer, lesser-known photographers. Submit portfolio for review. Send 35mm, 2¼×2¼ transparencies. Keeps samples on file. SASE. Reports in 1-2 weeks. Pays $200-250/color cover photo; $100-150/color inside photo. Pays on publication. Credit line given. Buys first North American serial and all rights; negotiable. Simultaneous submissions and/or previously published work OK.

Tips: "We're interested in innovative, creative, cutting-edge work and we're not afraid to experiment."

PN/PARAPLEGIA NEWS, 2111 E. Highland Ave., Suite 180, Phoenix AZ 85016-4702. (602)224-0500. Fax: (602)224-0507. E-mail: pvapub@aol.com. Director of Art & Production: Susan Robbins. Circ. 27,000. Estab. 1946. Monthly magazine. Emphasizes all aspects of living for people with spinal-cord injuries or diseases. Readers are primarily well-educated males, 40-55, who use wheelchairs for mobility. Sample copy free with 9×12 SASE and 7 first-class stamps.

Needs: Uses 30-50 photos/issue; 10% supplied by freelancers. Articles/photos must deal with accessibility or some aspect of wheelchair living. "We do not accept photos that do not accompany manuscript." Model/property release preferred. Captions required; include who, what, when, where.

Making Contact & Terms: Interested in receiving work from newer, lesser-known photographers. Provide résumé, business card, brochure, flier or tearsheets to be kept on file for possible assignments. Accepts images in digital format for Mac (TIFF). Send via floppy disk, SyQuest (150 dpi). "OK to call regarding

possible assignments in their locales." Deadlines: will be communicated on contact. Keeps samples on file. SASE. Reports in 1 month. Pays $25-200/color cover photo; $10-25/color inside photo; $10-25/b&w inside photo; $50-200/photo/text package; other forms of payment negotiated with editor. Pays on publication. Credit line given. Buys one-time, all rights; negotiable. Simultaneous submissions and previously published work OK.

Tips: "Feature a person in a wheelchair in photos whenever possible. Person should preferably be involved in some activity."

POLO MAGAZINE, 3500 Fairlane Farms Rd., #9, Wellington FL 33414. (561)793-9524. Fax: (561)793-9576. Editor: Peter Rizzo. Circ. 7,000. Estab. 1975. Publishes monthly magazine 10 times/year with combined issues for January/February and June/July. Emphasizes the sport of polo and its lifestyle. Readers are primarily male; average age is 40. 90% of readers are professional/managerial levels, including CEO's and presidents. Sample copy free with 10×13 SASE. Photo guidelines free with SASE.

Needs: Uses 50 photos/issue; 70% supplied by freelance photographers; 20% of this by assignment. Needs photos of polo action, portraits, travel, party/social and scenics. Most polo action is assigned, but freelance needs range from dynamic action photos to spectator fashion to social events. Photographers may write and obtain an editorial calendar for the year, listing planned features/photo needs. Captions preferred, where necessary include subjects and names.

Making Contact & Terms: Query with list of stock photo subjects. Provide résumé, business card, brochure, flier or tearsheets to be kept on file for possible assignments. SASE. Reports in 2 weeks. Pays $25-150/b&w photo, $30-300/color photo, $150/half day, $300/full day, $200-500/complete package. Pays on publication. Credit line given. Buys one-time or all rights; negotiable. Simultaneous submissions and previously published work OK "in some instances."

Tips: Wants to see tight focus on subject matter and ability to capture drama of polo. "In assigning action photography, we look for close-ups that show the dramatic interaction of two or more players rather than a single player. On the sidelines, we encourage photographers to capture emotions of game, pony picket lines, etc." Sees trend toward "more use of quality b&w images." To break in, "send samples of work, preferably polo action photography."

✿POOL & SPA LIVING MAGAZINE, 270 Esna Park Dr., Unit 12, Markham, Ontario L3R 1H3 Canada. (905)513-0090. Editor: David Barnsley. Circ. 40,000. Published twice a year. Emphasizes swimming pools, spas, hot tubs, outdoor entertaining, landscaping (patios, decks, gardens, lawns, fencing). Readers are homeowners and professionals 30-55 years old. Equally read by men and women.

Needs: Uses 20-30 photos/issue; 30% supplied by freelance photographers. Looking for shots of models dressed in bathing suits, people swimming in pools/spas, patios. Plans annual bathing suit issue late in year. Model release required.

Making Contact & Terms: Send unsolicited photos by mail for consideration. Send 8×10 glossy color prints; 35mm transparencies. SASE. Reports in 2 weeks. Payment negotiable. Pays on publication. Credit line given. Buys all rights; negotiable. Simultaneous submissions and previously published work OK.

Tips: Looking for "photos of families relaxing outdoors around a pool, spa or patio. We are always in need of visual material, so send in whatever you feel is appropriate for the magazine. Photos will be returned."

‡POPULAR ELECTRONICS, 500 Bi-County Blvd., Farmingdale NY 11735. (516)293-3000. Fax: (516)293-3115. Editor: Dan Karagiannis. Circ. 87,287. Estab. 1989. Monthly magazine. Emphasizes hobby electronics. Readers are hobbyists in electronics, amateur radio, CB, audio, TV, etc.—"Mostly male, ages 13-59." Sample copy free with 9×12 SAE and 90¢ postage.

Needs: Uses about 20 photos/issue; 20% supplied by freelance photographers. Photos purchased with accompanying ms only. Special needs include regional photo stories on electronics. Model/property release required. Captions preferred.

Making Contact & Terms: Send complete ms and photo package with SASE. Reports in 2 weeks. Pays $200-350 for text/photo package. **Pays on acceptance.** Credit line given. Buys all rights; negotiable. Simultaneous submissions and previously published work OK.

‡POPULAR PHOTOGRAPHY, 1633 Broadway, New York NY 10019. (212)767-6578. Fax: (212)767-5629. Send to: Your Best Shot/Hard Knocks. Circ. 700,000. Estab. 1937. Monthly magazine. Readers are male and female photographers, amateurs to professionals of all ages. Photo guidelines free with SASE.

Needs: Uses many photos/issue; many supplied by freelancers, mostly professionals. Uses photos for monthly contest feature, Your Best Shot. Needs scenics, nature, portraits. Hard Knocks.

Making Contact & Terms: Interested in receiving work from newer, lesser-known photographers. Send unsolicited photos by mail for consideration. Send prints size 8×12 and under, color and b&w; any size transparencies. Does not keep samples on file. SASE. Reports in 3 months. Pays prize money for contest:

"I was doing a fine art series on the military in relationship to the community," says Marty Wolin, explaining how this unusual shot came about. "I was getting ready to photograph a parade in San Diego when I saw this future bride going into a church. I ran over and asked her to pose with these men—she was ecstatic." Wolin's photo appeared in *Popular Photography*'s "Your Best Shot" feature. He says he always gets comments on this photo when showing his portfolio. .

$300 (first), $200 (second), $100 (third) and honorable mention. **Pays on acceptance.** Credit line given. Buys one-time rights.

POPULATION BULLETIN, 1875 Connecticut Ave., Suite 520, Washington D.C. 20009. (202)483-1100. Fax: (202)328-3937. E-mail: shershey@prb.org. Website: http://www.prb.org/prb/. Production Managers: Sharon Hershey and Erek Dorman. Circ. 15,000. Estab. 1929. Publication of the nonprofit Population Reference Bureau. Quarterly journal. Publishes other population-related publications, including a monthly newsletter. Emphasizes demography. Readers are educators (both high school and college) of sociology, demography and public policy.
Needs: Uses 8-10 photos/issue; 70% supplied by freelancers. Needs vary widely with topic of each edition—international and US people, families, young, old, all ethnic backgrounds. Everyday scenes, close-up pictures of people in developing countries in South America, Asia, Africa and Europe. Model/property release required. Captions preferred.
Making Contact & Terms: Interested in receiving work from newer, lesser-known photographers. Query with list of stock photo subjects. Send unsolicited photos by mail for consideration. Send b&w prints or photocopies. SASE. Reports in 2 weeks. Pays $50-100/b&w photo; $150-250/color photo. **Pays on acceptance.** Buys one-time rights. Simultaneous submissions and previously published work OK.
Tips: "Looks for subjects relevant to the topics of our publications, quality photographs, composition, artistic value and price."

‡PRAIRIE DOG, P.O. Box 470757, Aurora CO 80047. Phone/fax: (303)753-0956. E-mail: jrhartcisys.net. Editor-in-Chief: John R. Hart. Circ. 600. Estab. 1995. Biannual magazine. Emphasizes literature. Readers are lovers of fiction, poetry, art and photography, ages 20-75. Sample copy $5.95 with 9×12 SAE and 4 first-class stamps. Photo guidelines free with SASE.
Needs: Uses 4-10 photos/issue; all supplied by freelancers. Needs photos of scenics, still life, wildlife and travel. Model/property release required for nudes. Captions preferred; include subject and place.
Making Contact & Terms: Send unsolicited photos by mail for consideration. Send 5×7 glossy color or b&w prints. Keeps samples on file. SASE. Reports in 3-6 months. Pays with 1 copy of magazine. Buys one-time rights; negotiable. Simultaneous submissions OK.

♣PRESBYTERIAN RECORD, 50 Wynford Dr., North York, Ontario M3C 1J7 Canada. (416)441-1111. Fax: (416)441-2825. Editor: Rev. John Congram. Circ. 60,000. Estab. 1875. Monthly magazine. Emphasizes subjects related to The Presbyterian Church in Canada, ecumenical themes and theological perspectives for church-oriented family audience. Photos purchased with or without accompanying ms. Free sample copy and photo guidelines with 9×12 SAE and $1 postage minimum.
Needs: Religious themes related to features published. No formal poses, food, nude studies, alcoholic beverages, church buildings, empty churches or sports. Captions preferred.
Making Contact & Terms: Interested in receiving work from newer, lesser-known photographers. Send photos. Uses prints only for reproduction; 8×10, 4×5 glossy b&w or color prints and 35mm and 2¼×2¼ color transparencies. Usually uses 35mm color transparency for cover or ideally, 8×10 transparency. Vertical format used on cover. SAE, IRCs for return of work. Reports in 1 month. Pays $15-35/b&w print; $60 minimum/cover photo; $30-60 for text/photo package. Pays on publication. Credit line given. Buys one-time rights; negotiable. Simultaneous submissions and/or previously published work OK.
Tips: "Unusual photographs related to subject needs are welcome."

‡PRE-VUE ENTERTAINMENT MAGAZINE, 7825 Fay Ave., La Jolla CA 92037. (619)456-5577. Fax: (619)542-0114. E-mail: PreVueMag@aol.com. Website: http://E!online.com. Photo Director/Editor: Penny Langford. Circ. 200,000. Estab. 1991. Bimonthly magazine distributed nationally in movie theaters. Emphasizes movies/celebrities. Readers are 51% male. Sample copy free with 6×9 SAE and 2 first-class stamps.
Needs: Uses 35 photos/issue; 10 supplied by freelancers. Needs photos of celebrities at play/events. Reviews photos with or without ms. Captions preferred.
Making Contact & Terms: Interested in receiving work from newer, lesser-known photographers. Send unsolicited photos by mail for consideration. Provide résumé, business card, brochure, flier or tearsheets to be kept on file for possible assignments. Send any size, 3×3 and up, matte color and b&w prints; 35mm, 2¼×2¼, 4×5, 8×10 transparencies. Keeps samples on file. SASE. Reports in 1 month. Pays $50/color photo. Pays on publication. Credit line given. Buys all rights; negotiable. Simultaneous submissions and/or previously published work OK, "if I know where it was published previously."

Tips: "We need shots of celebrities at play, working, premieres, stars traveling with family (identified). Movie stars, foreign film stars, directors, music celebrities (not in concert) are preferred. The best photos are of relaxed, friendly subjects looking straight into the lens (head and shoulders to torso and full length)."

PRIMAVERA, Box 37-7547, Chicago IL 60637. (773)324-5920. Contact: Board of Editors. Annual magazine. "We publish original fiction, poetry, drawings, paintings and photographs that deal with women's experiences." Sample copy $5. Photo guidelines free with SASE.
Needs: Uses 2-12 photos/issue; all supplied by freelancers.
Making Contact & Terms: Interested in receiving work from newer, lesser-known photographers. Send unsolicited photos or photocopies by mail for consideration. Send b&w prints. SASE. Reports in 1 month. Pays on publication 2 copies of volume in which art appears. Credit line given. Buys one-time rights.

PRIME TIME SPORTS & FITNESS, Dept. PM, P.O. Box 6097, Evanston IL 60204. (847)864-8113. Fax: (847)864-1206. E-mail: rallyden@prodigy.net. Editor: Dennis Dorner. Magazine publishes 8 times/ year. Emphasizes sports, recreation and fitness; baseball/softball, weight lifting and bodybuilding, etc. Readers are professional males (50%) and females (50%), 19-45. Photo guidelines on request.
Needs: Uses about 70 photos/issue; 60 supplied by freelancers. Needs photos concerning women's fitness and fashion, swimwear and aerobic routines. Special photo needs include women's workout and swimwear photos. Upcoming short-term needs: summer swimwear, women's aerobic wear, portraits of women in sports. "Don't send any photos that would be termed photobank access." Model/property release required. Captions preferred; include names, the situation and locations.
Making Contact & Terms: Interested in reviewing work from newer, lesser-known photographers. Send unsolicited photos by mail for consideration. Submit portfolio for review. "Contact us by fax, phone or mail and we will set appointment." May accept images in digital format for Windows via compact disc. SASE. Reports in 2 months. Pays $200/color and b&w cover photo; $20/color and b&w inside photo; $20/ color page rate; $50/b&w page rate; $30-60/hour. Time of payment negotiable. Credit line given. Buys all rights; negotiable. Simultaneous submissions and previously published work OK. Offers internships for photographers during the summer. Contact Editor: Dennis Denver.
Tips: Wants to see "tight shots of personalities, people, sports in action, but only tight close-ups." There are a "plethora of amateur photographers who have trouble providing quality action or fashion shots and yet call themselves professionals. However, bulk of photographers are sending in a wider variety of photos. Photographers can best present themselves by letting me see their work in our related fields (both published and unpublished) by sending us samples. Do not drop by or phone, it will not help."

PRINCETON ALUMNI WEEKLY, 194 Nassau St., Princeton NJ 08542. (609)258-4722. E-mail: wszola@princeton.ed. Editor-in-Chief: J.I. Merritt. Art Director: Stacy Wszola. Circ. 58,000. Biweekly. Emphasizes Princeton University and higher education. Readers are alumni, faculty, students, staff and friends of Princeton University. Sample copy $1.50 with 9 × 12 SAE and 2 first-class stamps.
Needs: Uses about 15 photos/issue (not including class notes section); 10 supplied by freelance photographers. Needs b&w photos of "people, campus scenes; subjects vary greatly with content of each issue. Show us photos of Princeton." Captions required.
Making Contact & Terms: Arrange a personal interview to show portfolio. Provide brochure to be kept on file for possible future assignments. SASE. Reports in 1 month. Pays $60-100/hour; $300-1,000/day; $50-450/color photo; $40-300/b&w photo. Pays on publication. Buys one-time rights. Simultaneous submissions and previously published work OK.

PRINCIPAL MAGAZINE, Dept. PM, 1615 Duke St., Alexandria VA 22314-3483. (703)684-3345. Editor: Lee Greene. Circ. 25,000. Estab. 1921. Publication of the National Association of Elementary School Principals. Bimonthly. Emphasizes public education—kindergarten to 8th grade. Readers are mostly principals of elementary and middle schools. Sample copy free with SASE.
Needs: Uses 5-10 b&w photos/issue; all supplied by freelancers. Needs photos of school scenes (classrooms, playgrounds, etc.), teaching situations, school principals at work, computer use and technology and science activities. The magazine sometimes has theme issues, such as back to school, technology and early childhood education. *No posed groups.* Close-ups preferred. Reviews photos with or without accompanying ms. Model release preferred. Captions preferred.
Making Contact & Terms: Interested in receiving work from newer, lesser-known photographers. Query with samples and list of stock photo subjects. Send b&w prints, b&w contact sheet by mail for consideration.

 MARKETS NEW TO THIS EDITION are marked with a double dagger.

SASE. "We hold submitted photos indefinitely for possible stock use, so send dupes or photocopies." Reports in 1 month. Pays $50/b&w photo. Pays on publication. Credit line given. Buys one-time rights; negotiable. Simultaneous submissions and previously published work OK.

PROCEEDINGS/NAVAL HISTORY, US Naval Institute, Annapolis MD 21402. (410)268-6110. Fax: (410)269-7940. Contact: Picture Editor. Circ. 110,000. Estab. 1873. Association publications. *Proceedings* is a monthly magazine and *Naval History* is a bimonthly publication. Emphasizes Navy, Marine Corps, Coast Guard. Readers are age 18 and older, male and female, naval officers, enlisted, retirees, civilians. Sample copy free with 9 × 12 SASE. Photo guidelines free with SASE.
Needs: Uses 50 photos/issue; 40% supplied by freelancers. Needs photos of foreign and US Naval, Coast Guard and Marine Corps vessels, personnel and aircraft. Captions required.
Making Contact & Terms: Send unsolicited photos by mail for consideration: 8 × 10 glossy or matte, b&w or color prints; 35mm transparencies. SASE. Reports in 1 month. Pays $200/color or b&w cover photo; $25/color inside photo; $25/b&w page rate; $250-500/photo/text package. Pays on publication. Credit line given. Buys one-time rights. Simultaneous submissions and previously published work OK.

‡**THE PROGRESSIVE**, 409 E. Main St., Madison WI 53703. Art Director: Patrick JB Flynn. Circ. 35,000. Estab. 1909. Monthly. Emphasizes "political and social affairs—international and domestic." Free sample copy and photo guidelines upon request.
Needs: Uses 10 or more b&w photos/issue; generally supplied by freelance photographers. Looking for images documenting the human condition and the social/political structures of contemporary society. Special photo needs include "Third World countries, labor activities, environmental issues and political movements." Captions (name, place, date) and credit information required.
Making Contact & Terms: Query with photocopies to be kept on file for possible future assignments. SASE. Reports once every month. Pays $300/color cover photo; $40-100/b&w inside photo; $150/b&w full-page. Pays on publication. Credit line given. Buys one-time rights. Simultaneous submissions and previously published work OK.
Tips: "Interested in photo essays and in images that make a visual statement."

‡**PROVOCATEUR MAGAZINE**, 8599 Santa Monica Blvd., West Hollywood CA 90069. (310)659-6654. Fax: (310)659-6634. Photo Editor: Tom Kurthy. Circ. 90,000. Estab. 1995. Bimonthly magazine. Emphasizes male nudes and statements on masculinity. Readers are gay men and heterosexual females. Sample copy free with 9 × 12 SASE. Photo guidelines free with SASE.
Needs: Uses 70-80 photos/issue. Model release required. Include titles.
Making Contact & Terms: Send unsolicited photos by mail for consideration. Provide résumé, business card, brochure, flier or tearsheets to be kept on file for possible assignments. Submit portfolio for review. Send 8 × 10 prints; transparencies. Keeps samples on file. SASE. Reports in 1 month. Payment negotiable. Pays on publication. Credit line given. Rights negotiable. Simultaneous submissions and previously published work OK.

PSYCHOLOGY TODAY, Sussex Publishers, 49 E. 21st St., 11th Floor, New York NY 10010. (212)260-3214, ext. 117. Fax: (212)260-7445. Photo Editor: Karin Fittante. Estab. 1992. Bimonthly magazine. Readers are male and female, highly educated, active professionals. Photo guidelines free with SASE.
 ● Sussex also publishes *Mother Earth News* and *Spy* listed in this section.
Needs: Uses 19-25 photos/issue; all supplied by freelancers. Needs photos of humor, photo montage, symbolic, environmental, portraits, conceptual. Model/property release preferred.
Making Contact & Terms: Interested in receiving work from "upcoming" photographers. Submit portfolio for review. Send promo card with photo. Also accepts Mac files but prefers photographic images. Call before you drop off portfolio. Keeps samples on file. Cannot return material. Reports back only if interested. For assignments, pays $1,000/cover plus expenses; $350-750/inside photo plus expenses; for stock, pays $150/¼ page; $300/full page. Offers internships for photographers anytime. Contact Photo Editor: Jamey O'Quinn.

PUBLIC CITIZEN NEWS, (formerly *Public Citizen*), 1600 20th St., NW, Washington DC 20009. (202)588-1000. Editor: Peter Nye. Circ. 120,000. Bimonthly. "*Public Citizen News* is the magazine of the membership organization founded by Ralph Nader in 1971. The magazine addresses topics of concern to today's socially aware and politically active consumers on issues in consumer rights, safe products and workplaces, a clean environment, campaign finance reform, safe and efficient energy, global trade and corporate and government accountability." Sample copy free with 9 × 12 SAE and 2 first-class stamps.
Needs: Uses 5-7 photos/issue; 2 usually supplied by freelancers. Needs photos to go along with articles on various consumer issues—assigns for press conference coverage or portrait shot of interview. Buys stock for other purposes.

Making Contact & Terms: Provide résumé, business card, brochure, flier or tearsheets to be kept on file for possible future assignments. Does not return unsolicited material. Pays $50-75/b&w inside photo. Pays on publication. Credit line given. Buys first North American serial rights. Simultaneous submissions and previously published work OK.

Tips: Prefers to see "good photocopies of photos and list of stock to keep on file. Common subjects: nuclear power, presidential administrations, health and safety issues, citizen empowerment, union democracy, etc."

PUBLIC POWER, 2301 M. St. NW, Third Floor, Washington DC 20037. (202)467-2948. Fax: (202)467-2910. E-mail: jlabella@his.com. Editor: Jeanne LaBella. Circ. 14,700. Publication of the American Public Power Association. Bimonthly. Emphasizes electric power provided by cities, towns and utility districts. Sample copy and photo guidelines free.

Needs: "We buy photos on assignment only."

Making Contact & Terms: Query with samples. Provide résumé, business card, brochure, flier or tearsheets to be kept on file for possible future assignments. Accepts ditigal images; call art director (James Bartlett (202)467-2983) to discuss. Reports in 2 weeks. Pay varies—$25-75/photo—more for covers. **Pays on acceptance.** Credit line given. Buys one-time rights. Simultaneous submissions and previously published work OK.

‡PUSH!, Muscle Mag International Corp. (USA), 6465 Airport Rd., Mississauga, Ontario L4V 1E4 Canada. Phone/fax: (905)678-7311. Editor-in-Chief: Robert Kennedy. Circ. 250,000. Estab. 1997. Bimonthly magazine. Emphasizes exercise and nutrition for women. Readers are women, ages 16-35. Sample copy $5.

Needs: Uses 300 photos/issue; 80% supplied by freelancers. Needs photos of women in weight training and aerobic exercising. Model release preferred. Captions preferred; include names of subjects.

Making Contact & Terms: Send unsolicited photos by mail for consideration. Send 35mm, 2¼×2¼ transparencies. Deadlines: 1st of each month. Does not keep samples on file. SASE. Reports in 3 weeks. Pays $100-200/hour; $400-600/day; $400-1,000/job; $500-600/color cover photo; $35-50/color or b&w inside photo. **Pays on acceptance.** Credit line given. Buys all rights.

PYX PRESS, Box 922648, Sylmar CA 91392-2648. Contact: C. Darren Butler. Circ. 800. Estab. 1990. Quarterly journal. Emphasizes magic-realism fiction and related creative works. Readers are a general, educated audience. Query for book catalog. Photo guidelines available.

Needs: Uses 0-2 photos/issue; all supplied by freelancers. Needs photos that are double-exposure, magic realism or lightly surreal. Model release preferred. Captions preferred.

Making Contact & Terms: Interested in receiving work from newer, lesser-known photographers. Submit portfolio for review. Query with stock photo list. Send unsolicited photos by mail for consideration. Provide résumé, business card, brochure, flier or tearsheets to be kept on file for possible assignments. Send color or b&w prints. Keeps samples on file. SASE. Reports in 1 month for queries, 2-6 months for submissions. Pays $50-300/color cover photo; $10-100/b&w cover photo; $2-10/b&w inside photo; $10/b&w page. **Pays on acceptance.** Credit line given. Buys one-time and reprint rights. Simultaneous submissions and previously published work OK.

‡Q SAN FRANCISCO MAGAZINE, 584 Castro St., Suite 521, San Francisco CA 94114. (415)764-0324. Fax: (415)626-5744. E-mail: qsf1@aol.com. Editor: Robert Adams. Circ. 47,000. Estab. 1995. Bimonthly magazine. Emphasizes city, entertainment, travel. Readers are 75% gay male, 20% lesbian, 5% straight males and females. Sample copy free with 9×12 SAE and $1.93 postage.

Needs: Uses 20 photos/issue; 10 supplied by freelancers. Needs photos of travel, personalities. Model release required. Property release preferred. Captions required; include name, place, date.

Making Contact & Terms: Provide résumé, business card, brochure, flier or tearsheets to be kept on file for possible assignments. Arrange personal interview to show portfolio. Cannot return material. Reports in 6-8 weeks. Pays $50-200/job; $100-200/color or b&w cover photo; $50-150/color inside photo; $50-100/b&w inside photo; $50-150/color or b&w page. Pays on publication. Credit line given. Rights negotiable.

RACQUETBALL MAGAZINE, 1685 W. Uintah, Colorado Springs CO 80904-2921. (719)635-5396. Fax: (719)635-0685. E-mail: rbzine@webaccess.net. Website: http://www.racqmag.com. Production Manager: Kevin Vicroy. Circ. 45,000. Estab. 1990. Publication of the United States Racquetball Association. Bimonthly magazine. Emphasizes racquetball. Sample copy $4. Photo guidelines available.

Needs: Uses 20-40 photos/issue; 20-40% supplied by freelancers. Needs photos of action racquetball. Model/property release preferred. Captions required.

Making Contact & Terms: Interested in receiving work from newer, lesser-known photographers. Provide résumé, business card, brochure, flier or tearsheets to be kept on file for possible assignments. Dead-

lines: 1 month prior to each publication date. Keeps samples on file. SASE. Reports in 1 month. Pays $200/color cover photo; $25-75/color inside photo; $3-5/b&w inside photo. Pays on publication. Credit line given. Buys all rights; negotiable. Previously published work OK.

RAG MAG, Box 12, Goodhue MN 55027. (612)923-4590. Editor: Beverly Voldseth. Circ. 300. Estab. 1982. Magazine. Emphasizes poetry and fiction, but is open to good writing in any genre. Sample copy $6 with 6¼×9¼ SAE and 4 first-class stamps.
• *Rag Mag* will only publish theme issues through 1997; request guidelines. Regular, non-theme submissions will be accepted beginning January 1998.
Needs: Uses 3-4 photos/issue; all supplied by freelancers. Needs photos that work well in a literary magazine; faces, bodies, stones, trees, water, etc. Reviews photos without a manuscript. Uses photos on covers.
Making Contact & Terms: Interested in receiving work from newer, lesser-known photographers. Send up to 8 unsolicited photocopies of photos by mail for consideration; include name on back of copies with brief bio. Always supply your name and address and add an image title or number on each photo for easy reference. Do not send originals. 6×9 vertical shots are best. Does not keep samples on file. SASE. Reports in 2 weeks-2 months. Pays in copies. Pays on publication. Buys one-time rights. Simultaneous submissions and previously published work OK.
Tips: "I do not want anything abusive, sadistic or violent."

READING TODAY, International Reading Association, 800 Barksdale Rd., P.O. Box 8139, Newark DE 19714-8139. (302)731-1600, ext. 250. Fax: (302)731-1057. E-mail: 74673.3641@compuserve.com. Editor: John Micklos, Jr. Circ. 90,000. Estab. 1983. Publication of the International Reading Association. Bimonthly newspaper. Emphasizes reading education. Readers are educators who belong to the International Reading Association. Sample copy available. Photo guidelines free with SASE.
Needs: Uses 20 photos/issue; 3 supplied by freelancers. Needs classroom shots and photos of people of all ages reading in various settings. Reviews photos with or without ms. Model/property release preferred. Captions preferred; include names (if appropriate) and context of photo.
Making Contact & Terms: Interested in receiving work from newer, lesser-known photographers. Query with résumé of credits. Query with stock photo list. Send unsolicited photos by mail for consideration. Send 3½×5 or larger color and b&w (preferred) prints. Deadline: 8 weeks prior to publication date for any given issue. SASE. Reports in 1 month. Pays $25-50/b&w inside photo. **Pays on acceptance.** Credit line given. Buys one-time rights. Simultaneous submissions and previously published work OK.

REAL PEOPLE, 450 Fashion Ave., Suite 1701, New York NY 10123-1799. (212)244-2351. Fax: (212)244-2367. Editor: Alex Polner. Circ. 100,000. Estab. 1988. Bimonthly magazine. Emphasizes celebrities. Readers are women 35 and up. Sample copy $4 with 6×9 SAE.
Needs: Uses 30-40 photo/issue; 10% supplied by freelancers. Needs celebrity photos. Reviews photos with accompanying ms. Model release preferred where applicable. Photo captions preferred.
Making Contact & Terms: Interested in receiving work from newer, lesser-known photographers. Query with résumé of credits and/or list of stock photo subjects. Provide résumé, business card, brochure, flier or tearsheets to be kept on file for possible assignments. Send samples or tearsheets, perhaps even an idea for a photo essay as it relates to entertainment field. Accepts images in digital format for Mac (EPS, TIFF, JPG). Send via compact disc, floppy disk, SyQuest, Zip disk (high). SASE. Reports only when interested. Pays $100-200/day. Pays on publication. Credit line given. Buys one-time rights.

RECREATIONAL HAIR NEWS, 138 West, Burke VT 05871. (914)647-4198. E-mail: bfitzgerald@uppercuts.com. Editor: Bob Fitzgerald. Circ. 2,000. Monthly newsletter. Emphasizes "unusual, radical, bizarre hairstyles and fashions, such as a shaved head for women, waist-length hair or extreme transformations from very long to very short." Sample copy $3. Photo guidelines free with SASE.
Needs: Celebrity/personality, documentary, fashion/beauty, glamour, head shots, nudes, photo essay/photo feature, spot news, travel, fine art, special effects/experimental, how-to and human interest "directly related to hairstyles and innovative fashions. We are also looking for old photos showing hairstyles of earlier decades—the older the better. If it's not related to hairstyles in the broadest sense, we're not interested." Model release preferred. Captions preferred.
Making Contact & Terms: Uses 5×7, 8×10 color and b&w prints; 35mm transparencies; and "accompanying manuscripts that are interviews/profiles of individuals with radical or unusual haircuts." Vertical format preferred. Accepts images in digital format for Windows. Send material by mail for consideration. Include samples of work and description of experience. SASE. Reports in 3 weeks. Pays: $10-100/b&w or color photo; $50 minimum/job; $50 minimum/manuscript. Credit line given. Buys one-time and all rights. Simultaneous submissions and previously published work OK.
Tips: "The difficulty in our publication is finding the subject matter, which is unusual and fairly rare.

Rag Mag

Childhood

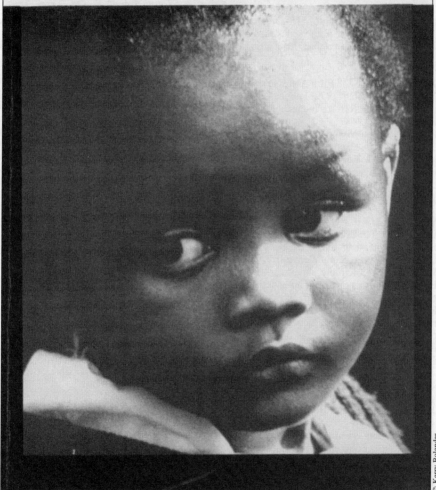

© Kerry Bolander

The theme of the fall 1996 issue of *Rag Mag* was childhood, "and this wonderful face seems the epitome of that," says Editor Beverly Voldseth of Kerry Bolander's photo. Bolander agrees that the shot portrays the innocence and frailty of childhood. "I think this is a beautiful child—partly because you're not sure what emotions she's feeling, so it's easy to have her reflect the emotion you want her to feel," the photographer says. He submitted the piece to *Rag Mag*, along with a number of other black and white photos, after reading about the publication in *Photographer's Market*.

Anyone who can overcome that hurdle has an excellent chance of selling to us."

RECREATIONAL ICE SKATING, 355 W. Dundee Rd., Buffalo Grove IL 60089-3500. (847)808-7528. Fax: (847)808-8329. E-mail: skateisi@aol.com. Art Director: Carol Davis. Circ. 40,000. Estab. 1976. A publication of Ice Skating Institute. Quarterly magazine. Emphasizes figure skating, hockey and speedskating—recreational aspects of these sports. Readers are male and female skating enthusiasts—all professions; ages 6-80. Sample copy free with 9×12 SASE and 3 first-class stamps.
Needs: Uses 50 photos/issue; 68% supplied by freelancers. Needs photos of travel (ISIA event venues); art with stories—skating, hockey. Model/property release required for skaters, bystanders, organization property (i.e. Disney World, etc.) and any photo not directly associated with story content. Captions preferred; include name(s) of person/people locations, ages of people—where they are from, skate, etc.
Making Contact & Terms: Interested in receiving work from newer, lesser-known photographers. Query with stock photo list. Provide résumé, business card, brochure, flier or tearsheets to be kept on file for possible assignments. Deadlines: July 1, September 1, January 1, February 15. Keeps samples on file. SASE. Reports in 1 month. Pays $25-50/hour; $100-200/day; $100-1,000/job; pays $10-35/color cover photo; $10-15/b&w inside photo; $15-35/color page rate; $10-35/photo/text package. Pays on publication. Credit line given. Buys one-time rights and all rights; negotiable. Previously published work OK.
Tips: "Show an ability to produce lean action photos within indoor rinks that have poor lighting conditions."

REFORM JUDAISM, 838 Fifth Ave., New York NY 10021. (212)650-4240. Managing Editor: Joy Weinberg. Circ. 300,000. Estab. 1972. Publication of the Union of American Hebrew Congregations. Quarterly magazine. Emphasizes Reform Judaism. Readers are members of Reform congregations in North America. Sample copy $3.50.
Needs: Uses 35 photos/issue; 10% supplied by freelancers. Needs photos relating to Jewish life or Jewish issues, Israel, politics. Captions required.
Making Contact & Terms: Provide résumé, business card, brochure, flier or tearsheets to be kept on file for possible assignments. Reports in 1 month. Pays on publication. Credit line given. Buys one-time rights; first North American serial rights. Simultaneous submissions and/or previously published work OK.
Tips: Wants to see "excellent photography: artistic, creative, evocative pictures that involve the reader."

RELAY MAGAZINE, P.O. Box 10114, Tallahassee FL 32302-2114. (904)224-3314. Editor: Stephanie Wolanski. Circ. 1,800. Estab. 1957. Association publication of Florida Municipal Electric. Monthly magazine. Emphasizes municipally owned electric utilities. Readers are city officials, legislators, public power officials and employees. Sample copy free with 9×12 SAE and 3 first-class stamps.
• *Relay* is purchasing more photos on CD.
Needs: Uses various amounts of photos/issue; various number supplied by freelancers. Needs b&w photos of electric utilities in Florida (hurricane/storm damage to lines, utility workers, etc.). Special photo needs include hurricane/storm photos. Model/property release preferred. Captions required.
Making Contact & Terms: Query with letter, description of photo or photocopy. Uses 3×5, 4×6, 5×7 or 8×10 b&w prints. Also accepts digital images. Keeps samples on file. SASE. Reports in 3 months. Payment negotiable. Rates negotiable. **Pays on acceptance.** Credit line given. Buys one-time rights, repeated use (stock); negotiable. Simultaneous submissions and/or previously published work OK.
Tips: "Must relate to our industry. Clarity and contrast important. Query first if possible. Always looking for good black & white hurricane, lightning-storm and Florida power plant shots."

RELIX MAGAZINE, P.O. Box 94, Brooklyn NY 11229. (718)258-0009. Fax: (718)692-4345. Editor: Phyllis Antoniello. Circ. 70,000-80,000. Estab. 1974. Bimonthly. Emphasizes rock and roll music and classic rock. Readers are music fans, ages 13-50. Sample copy $4.
Needs: Uses about 50 photos/issue; "about 30%" supplied by freelance photographers; 20% on assignment; 80% from stock. Needs photos of "music artists—in concert and candid, backstage, etc." Special needs: "photos of rock groups, especially the Grateful Dead, San Francisco-oriented groups and sixties related bands." Captions preferred.
Making Contact & Terms: Interested in receiving work from newer, lesser-known photographers. Send 5×7 or larger b&w and color prints by mail for consideration. SASE. Reports in 2 months. "We try to report immediately; occasionally we cannot be sure of use." Pays $25-75/b&w photo; $25-300/color. Pays on publication. Credit line given. Buys all rights; negotiable. Simultaneous submissions and previously published work OK.
Tips: "Black and white photos should be printed on grade 4 or higher for best contrast."

REMINISCE, 5400 S. 60th St., Greendale WI 53129. (414)423-0100. Fax: (414)423-8463. Photo Coordinator: Trudi Bellin. Estab. 1990. Bimonthly magazine. "For people who love reliving the good times."

Readers are male and female, interested in nostalgia, ages 55 and over. "*Reminisce* is supported entirely by subscriptions and accepts no outside advertising." Sample copy $2. Photo guidelines free with SASE.
Needs: Uses 130 photos/issue; 35% supplied by freelancers. Needs photos with people interest—"we need high-quality color shots with nostalgic appeal, as well as good quality b&w vintage photography." Model/property release required. Captions preferred; season, location.
Making Contact & Terms: Interested in receiving work from newer, lesser-known photographers. Query with list of stock photo subjects. Send unsolicited photos by mail for consideration. Send 35mm, 2¼×2¼, 4×5, 8×10 transparencies. Submit seasonally. Tearsheets filed but not dupes. SASE. Reports within 3 months. Pays $300/color cover photo; $75-150/color inside photo; $150/color page (full page bleed); $50-100/b&w photo. Pays on publication. Credit line given. Buys one-time rights. Previously published work OK.
Tips: "We are continually in need of authentic color taken in the '40s, '50s and '60s and b&w stock photos. Technical quality is extremely important; focus must be sharp, no soft focus; colors must be vivid so they 'pop off the page.' Study our magazine thoroughly—we have a continuing need for vintage color and b&w images, and those who can supply what we need can expect to be regular contributors."

REPTILE & AMPHIBIAN MAGAZINE, 1168 Rt. 61 Hwy. South, Pottsville PA 17901. (717)622-6050. Fax: (717)622-5858. E-mail: eramus@csrlink.net. Website: http://petstation.com/repamp.html. Editor: Erica Ramus. Circ. 14,000. Estab. 1989. Bimonthly magazine. Specializes in reptiles and amphibians only. Readers are college-educated, interested in nature and animals, familiar with basics of herpetology, many are breeders and conservation oriented. Sample copy $5. Photo guidelines with SASE.
Needs: Uses 50 photos/issue; 80% supplied by freelance photographers. Needs photos of related subjects. Photos purchased with or without ms. Model/property releases preferred. Captions required; clearly identify species with common and/or scientific name on slide mount.
Making Contact & Terms: Interested in receiving work from newer, lesser-known photographers. Send cover letter describing qualifications with representative samples. Must identify species pictured. Provide résumé, business card, brochure, flier or tearsheets to be kept on file for possible assignments. Send b&w and glossy prints; 35mm transparencies. Originals returned in 3 months. SASE. Reports in 1 month. Pays $25-50/color cover photo; $25/color inside photo; and $10/b&w inside photo. Pays on acceptance if needed immediately, or publication if the photo is to be filed for future use. Credit line given. Buys one-time rights. Previously published work OK.
Tips: In photographer's samples, looks for quality—eyes in-focus; action shots—animals eating, interacting, in motion. "Avoid field-guide type photos. Try to get shots with action and/or which have 'personality.' " All animals should be clearly identified with common and/or scientific name.

‡REQUEST MAGAZINE, 10408 Yellow Circle Dr., Minnetonka MN 55343. (612)931-8379. Fax: (612)931-8490. Art Director: Scott Anderson. Assistant Editor: David Simpson. Circ. 700,000. Estab. 1989. Monthly magazine. Emphasizes music, all types: rock, metal, rap, country, blues, world, reggae, techno/rave, blues, jazz, etc. Readers are male 54%, female 46%, median age 23.6. Free sample copy.
Needs: Uses 20-100 photos/issue; 50% supplied by freelancers. Needs music photos: color or b&w, live, studio or location. Frequent requests for archival photos. Special photo needs include more exclusive photos of well-known musicians, different styles, "arty" photos, unusual locations or processing techniques." Model release issues dealt with as they arise, no predetermined policy at this point. I.D.'s of band members, etc. required."
Making Contact & Terms: Interested in receiving work from newer, lesser-known photographers. Submit portfolio for review. Query with stock photo list. Deadlines: 2 month lead time; "we do not review concerts but frequently need live photos for features." Keeps samples on file. Cannot return material. Reports in 1-2 weeks or as photos are needed. Payment negotiable. Pays on publication. Buys one-time rights. Previously published work OK.

THE RETIRED OFFICER MAGAZINE, 201 N. Washington St., Alexandria VA 22314. (800)245-8762. Fax: (703)838-8179. Contact: Photo Editor. Circ. 400,000. Estab. 1945. Monthly. Publication represents the interests of retired military officers from the seven uniformed services: recent military history (particularly Vietnam and Korea), travel, health, second-career job opportunities, military family lifestyle and current military/political affairs. Readers are officers or warrant officers from the Army, Navy, Air Force, Marine Corps, Coast Guard, Public Health Service and NOAA. Free sample copy and photo guidelines with 9×12 SAE.
Needs: Uses about 24 photos/issue; 8 (the cover and some inside shots) usually supplied by freelancers. "We're always looking for good color slides of active duty military people and healthy, active mature adults with a young 50s look—our readers are 55-65."
Making Contact & Terms: Interested in receiving work from newer, lesser-known photographers. Query with list of stock photo subjects. Provide résumé, brochure, flier to be kept on file. "Do *not* send original

photos unless requested to do so." Uses original 35mm, 2¼×2¼ or 4×5 transparencies. Pays $300/color cover photo; $20/b&w inside photo; $50-125 transparencies for inside use (in color); $50-150/quarter-page; complimentary copies. Other payment negotiable. "Photo rates vary with size and position." Pays on publication. Credit line given. Buys one-time rights.
Tips: "A photographer who can also write and submit a complete package of story and photos is valuable to us. Much of our photography is supplied by our authors as part of their manuscript package. We periodically select a cover photo from these submissions—our covers relate to a particular feature in each issue." In samples, wants to see "good color saturation, well-focused, excellent composition."

RIDER, 2575 Vista Del Mar Dr., Ventura CA 93001. Editor: Mark Tuttle. Circ. 140,000. Monthly magazine. For dedicated motorcyclists with emphasis on long-distance touring, with coverage also of general street riding, commuting and sport riding. Sample copy $3 with 9×12 SAE. Guidelines free.
Needs: Needs human interest, novelty and technical photos; color photos to accompany feature stories about motorcycle tours. Photos are rarely purchased without accompanying ms. Captions required.
Making Contact & Terms: Query first. Send 8×10 glossy or matte prints; 35mm transparencies. SASE. Reports in 2 months. Payment negotiable. Pay is included in total purchase price with ms. Pays on publication. Buys first-time rights.
Tips: "We emphasize quality graphics and color photos with good visual impact. Photos should be in character with accompanying ms and should include motorcyclists engaged in natural activities. Read our magazine before contacting us."

RIFLE & SHOTGUN SPORT SHOOTING, 2448 E. 81st St., 5300 CityPlex Tower, Tulsa OK 74137-4207. (918)491-6100. Fax: (918)491-9424. Executive Editor: Mark Chesnut. Circ. 100,000. Estab. 1994. Bimonthly magazine. Emphasizes shooting sports, including hunting. Readers are primarily male over 35. Sample copy $2.50. Photo guidelines free with SASE.
Needs: Uses 40-50 photos/issue; all supplied by freelancers. Needs photos of various action shots of shooting sports. Special photo needs include wildlife shots for cover; skeet, trap, sporting clays, rifle shooting and hunting shots for inside use. Model/property release preferred. Captions preferred.
Making Contact & Terms: Interested in receiving work from newer, lesser-known photographers. Send unsolicited photos by mail for consideration. Send 35mm, 2¼×2¼ transparencies. Keeps samples on file. SASE. Reports in 3 weeks. Pays $400-600/color cover photo; $75-200/color inside photo; $300-450/photo/text package. **Pays on acceptance.** Credit line given. Buys first North American serial rights.

THE ROANOKER, P.O. Box 21535, Roanoke VA 24018. (540)989-6138. Fax: (540)989-7603. Editor: Kurt Rheinheimer. Circ. 14,000. Estab. 1974. Monthly. Emphasizes Roanoke and western Virginia. Readers are upper income, educated people interested in their community. Sample copy $2.50.
Needs: Uses about 40 photos/issue; most are supplied on assignment by freelance photographers. Needs "travel and scenic photos in western Virginia; color photo essays on life in western Virginia." Model/property releases preferred. Captions required.
Making Contact & Terms: Interested in receiving work from newer, lesser-known photographers. Send any size glossy b&w or color prints and transparencies (preferred) by mail for consideration. SASE. Reports in 1 month. Pays $15-25/b&w photo; $20-35/color photo; $100/day. Pays on publication. Credit line given. Rights purchased vary; negotiable. Simultaneous submissions and previously published work OK.

ROCK & ICE, P.O. Box 3595, Boulder CO 80307. (303)499-8410. E-mail: mail@rockandice.com. Website: http://www.rockandice.com. Editor-in-Chief: DeAnne Musolf. Circ. 50,000. Estab. 1984. Bimonthly magazine. Emphasizes rock and ice climbing and mountaineering. Readers are predominantly professional, ages 10-90. Sample copy for $6.50. Photo guidelines free with SASE.
 • Photos in this publication usually are outstanding action shots. Make sure your work meets the magazine's standards. Do not limit yourself to climbing shots from the U.S.
Needs: Uses 90 photos/issue; all supplied by freelance photographers; 20% on assignment, 80% from stock. Needs photos of climbing action, personalities and scenics. Buys photos with or without ms. Captions required.
Making Contact & Terms: Interested in receiving work from newer, lesser-known photographers. Query

MARKET CONDITIONS are constantly changing! If you're still using this book and it's 1999 or later, buy the newest edition of *Photographer's Market* at your favorite bookstore or order directly from Writer's Digest Books.

with list of stock photo subjects. Send unsolicited photos by mail for consideration. Send b&w prints; 35mm, 2¼×2¼ and 4×5 transparencies. Accepts images in digital format for Mac. Send via compact disc, online, floppy disk, SyQuest (175L). SASE. Pays $500/cover photo; $200/color and b&w page; $25/ Website image. Pays on publication. Credit line given. Buys one-time rights and first North American serial rights. Previously published work OK.

Tips: "Samples must show some aspect of technical rock climbing, ice climbing, mountain climbing or indoor climbing, scenics of places to climb or images of people who climb or who are indigenous to the climbing area. Climbing is one of North America's fastest growing sports."

ROCKFORD REVIEW, P.O. Box 858, Rockford IL 61105. Editor: David Ross. Association publication of Rockford Writers' Guild. Triquarterly magazine. Circ. 750. Estab. 1982. Emphasizes poetry and prose of all types. Readers are of all stages and ages who share an interest in quality writing and art. Sample copy $5.

● This publication is literary in nature and publishes very few photographs. However, the photos on the cover tend to be experimental (e.g. solarized images, photograms, etc.).

Needs: Uses 1-5 photos/issue; all supplied by freelancers. Needs photos of scenics and personalities. Model/property release preferred. Captions preferred; include when and where of the photos and biography.

Making Contact & Terms: Interested in receiving work from newer, lesser-known photographers. Send unsolicited photos by mail for consideration. Send 8×10 or 5×7 glossy b&w prints. Does not keep samples on file. SASE. Reports in 6 weeks. Pays in one copy of magazine, but work is eligible for *Review*'s $25 Editor's Choice prize. Pays on publication. Credit line given. Buys first North American serial rights. Simultaneous submissions OK.

Tips: "Experimental work with a literary magazine in mind will be carefully considered. Avoid the 'news' approach." Sees more opportunities for artsy photos.

ROLLER HOCKEY, 12327 Santa Monica Blvd., Los Angeles CA 90025. (310)442-6660. Fax: (310)442-6663. E-mail: info@rhockey. Website: http://www.rhockey.com. Editor: Greg Guss. Circ. 20,000. Estab. 1992. Magazine published 9 times/year. Emphasizes roller hockey, specifically inline hockey. Readers are male and female, ages 12-45. Sample copy $2.95. Photo guidelines free with SASE.

Needs: Uses 50 photos/issue; 35 supplied by freelancers. Needs photos of roller hockey. Special photo needs include play from local and professional roller hockey leagues. Model/property release preferred for professionals in staged settings. Captions preferred; include who, what, where, when, why, how.

Making Contact & Terms: Interested in receiving work from newer, lesser-known photographers. Send unsolicited photos by mail for consideration. Query with stock photo list. Submit portfolio for consideration. Reports within 1 week. Send 3×5, 5×7 glossy color b&w prints; 35mm transparencies. Accepts images in digital format for Mac (TIFF). Send via compact disc, floppy disk, SyQuest, Zip disk (300 dpi). Deadlines: 3 months prior to any season. SASE. Reports in 1 month. Pays $100/color cover photo; $25/color inside photo; $15/b&w inside photo. Pays on publication. Credit line given. Buys all rights; negotiable. Previously published work OK.

ROLLING STONE, Dept. PM, 1290 Avenue of the Americas, New York NY 10104. (212)484-1616. Photo Editor: Jodi Peckman. Emphasizes all forms of entertainment (music, movies, politics, news events).

Making Contact & Terms: "All our photographers are freelance." Provide brochure, calling card, flier, samples and tearsheet to be kept on file for future assignments. Needs famous personalities and rock groups in b&w and color. No editorial repertoire. SASE. Reports immediately. Pays $150-350/day.

Tips: "Drop off portfolio at mail room any Wednesday between 10 am and 3 pm. Pick up Thursday between 11 am and 3 pm. Leave a card with sample of work to keep on file so we'll have it to remember."

THE ROTARIAN, 1560 Sherman Ave., Evanston IL 60201. (847)866-3000. Fax: (847)866-9732. Editor-in-Chief: Willmon L. White. Editor: Charles W. Pratt. Photo Editor: Judy Lee. Circ. 520,439. Estab. 1911. Monthly magazine. For Rotarian business and professional men and women and their families. Free sample copy and photo guidelines with SASE.

Needs: "Our greatest need is for the identifying face or landscape, one that says unmistakably, 'This is Japan, or Minnesota, or Brazil, or France or Sierra Leone,' or any of the other states, countries and geographic regions this magazine reaches." Captions preferred.

Making Contact & Terms: Interested in receiving work from newer, lesser-known photographers. Query with résumé of credits or send photos for consideration. Uses 8×10 glossy b&w or color prints; contact sheet OK; 8×10 color glossy prints; for cover uses transparencies "generally related to the contents of that month's issue." SASE. Reports in 2 weeks. **Pays on acceptance.** Payment negotiable. Buys one-time rights; occasionally all rights; negotiable.

Tips: "We prefer vertical shots in most cases. The key words for the freelance photographer to keep in mind are *internationality* and *variety*. Study the magazine. Read the kinds of articles we publish. Think

how your photographs could illustrate such articles in a dramatic, story-telling way. Key submissions to general interest, art-of-living material."

‡**RUGBY MAGAZINE**, 2350 Broadway, New York NY 10024. (212)787-1160. Fax: (212)595-0934. E-mail: rugby@inch.com. Publisher: Ed Hagerty. Circ. 10,000. Estab. 1975. Monthly tabloid. Emphasizes rugby matches. Readers are male, wealthy, well-educated, ages 23-60. Sample copy $3 with $1.25 postage.
Needs: Uses 20 photos/issue most supplied by freelancers. Needs rugby action shots. Reviews photos purchased with accompanying ms only.
Making Contact & Terms: Interested in receiving work from newer, lesser-known photographers. Send unsolicited photos by mail for consideration. Provide résumé, business card, brochure, flier or tearsheets to be kept on file for possible assignments. Uses 3×5 color and b&w prints; $2\frac{1}{4} \times 2\frac{1}{4}$ transparencies. Keeps samples on file. SASE. Reports in 1-2 weeks. "We only pay when we assign a photographer. Rates are very low, but our magazine is a good place to get some exposure. Pays on publication. Credit line given. Buys one-time rights. Simultaneous submissions and previously published work OK.

RUNNER'S WORLD, 135 N. Sixth St., Emmaus PA 18098. (610)967-8917. Fax: (610)967-7725. E-mail: rwreap@aol.com. Executive Editor: Amby Burfoot. Photo Editor: Liz Reap. Circ. 435,000. Monthly magazine. Emphasizes running. Readers are median aged: 37, 65% male, median income $40,000, college-educated. Photo guidelines free with SASE.
Needs: Uses 100 photos/issue; 25% freelance, 75% assigned; features are generally assigned. Needs photos of action, features, photojournalism. Model release and captions preferred.
Making Contact & Terms: Query with samples. Accepts images in digital format for Mac. Contact photo editor before sending portfolio or submissions. Pays as follows: color—$350/full page, $250/half page, $210/quarter page, $600/full page spread. Cover shots are assigned. Pays on publication. Credit line given. Buys one-time rights. Simultaneous submissions and previously published work OK.
Tips: "Become familiar with the publication and send photos in on spec. Also send samples that can be kept in our source file. Show full range of expertise; lighting abilities—quality of light—whether strobe sensitivity for people—portraits, sports, etc.. Both action and studio work if applicable, should be shown." Current trend is non-traditional treatment of sports coverage and portraits. Call prior to submitting work. Be familiar with running, as well as the magazine."

RURAL HERITAGE, 281 Dean Ridge Lane, Gainesboro TN 38562-5039. (615)268-0655. E-mail: rural_heritage@echo.tfnet.org. Editor: Gail Damerow. Circ. 4,000. Estab. 1975. Bimonthly magazine in support of modern day farming and logging with draft animals. Sample copy $6 ($6.50 outside the U.S.).
Needs: "Most of the photos we purchase illustrate stories or poems. Exceptions are back cover, for which we need well-captioned, humorous scenes related to rural life, and front cover where we use draft animals in harness."
Making Contact & Terms: Interested in receiving work from newer, lesser-known photographers. "For covers we prefer color horizontal shots, 5×7 glossy (color or 35mm slide). Interior is b&w. Accepts images in digital format for Mac (TIFF, EPS). Send via compact disc, floppy disk, SyQuest (1200 line art, 300 half tones). "Do not submit photo files via e-mail please." Please include SASE for the return of your material, and put your name and address on the back of each piece. Pays $10/photo to illustrate a story or poem; $15/photo for captioned humor; $25/back cover, $50/front cover. Also provides 2 copies of issue in which work appears. Pays on publication.
Tips: "Animals usually look better from the side than from the front. We like to see all the animal's body parts, including hooves, ears and tail. For animals in harness, we want to see the entire implement or vehicle. We prefer action shots (plowing, harvesting hay, etc.). Look for good contrast that will print well in black and white (for interior shots); watch out for shadows across animals and people. Please include the name of any human handlers involved, the farm, the town (or county), state, and the animal's names (if any) and breeds."

RUSSIAN LIFE MAGAZINE, 89 Main St., #2, Montpelier VT 05602. (802)223-4955. (802)223-6105. E-mail: 74754.3234@compuserve.com. Executive Editor: Mikhail Ivanov. Estab. 1990. Monthly magazine.
Needs: Uses 25-35 photos/issue. Offers 10-15 freelance assignments annually. Needs photojournalism related to Russian culture, art and history. Model/property release preferred.
Making Contact & Terms: Interested in receiving work from newer, lesser-known photographers. Works with local freelancers only. Query with samples. Send 35mm, $2\frac{1}{4} \times 2\frac{1}{4}$, 4×5, 8×10 transparencies; 35mm film; Kodak CD digital format. SASE "or material not returned." Reports in 1 month. Pays $25-200 (color photo with accompanying story), depending on placement in magazine. Pays on publication. Credit line given. Buys one-time and electronic rights.

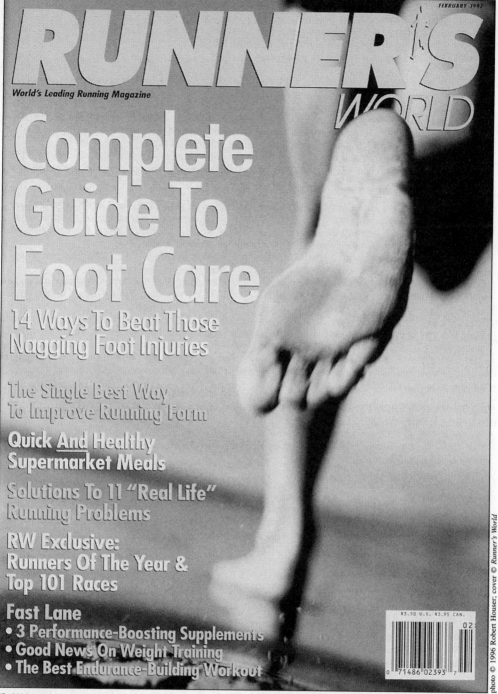

FEBRUARY 1997

RUNNER'S WORLD

World's Leading Running Magazine

Complete Guide To Foot Care

14 Ways To Beat Those Nagging Foot Injuries

The Single Best Way
To Improve Running Form

**Quick And Healthy
Supermarket Meals**

Solutions To 11 "Real Life"
Running Problems

**RW Exclusive:
Runners Of The Year &
Top 101 Races**

Fast Lane
- **3 Performance-Boosting Supplements**
- **Good News On Weight Training**
- **The Best Endurance-Building Workout**

$3.50 U.S. $3.95 CAN.

0 71486 02393 7

02

photo © 1996 Robert Houser; cover © Runner's World

"Bob Houser has a great eye for color and composition, and a knack for finding angles that make ordinary situations or people interesting," says Liz Reap, photo editor of *Runner's World*. Houser was assigned this cover shot to illustrate a story on foot pain. The cross-processed photo was the first *Runner's World* cover for the photographer, who's been shooting for the magazine for years.

SAILING, Dept. PM, 125 E. Main St., Box 248, Port Washington WI 53074. (414)284-3494. Editor: Micca L. Hutchins. Circ. 50,000. Monthly magazine. Emphasizes sailing. Our theme is "the beauty of sail." Readers are sailors with great sailing experience—racing and cruising. Sample copy free with 11×15 SAE and 9 first-class stamps. Photo guidelines free with SASE.

Needs: "We are a photo journal-type publication so about 50% of issue is photos." Needs photos of exciting sailing action, onboard deck shots; sailor-type boat portraits seldom used. Special needs include high-quality color—mainly good *sailing*. Captions required. "We must have area sailed, etc., identification."

Making Contact & Terms: Query with samples. Send 35mm transparencies by mail for consideration. "Request guidelines first—a big help." SASE. Reports in 1 month. Payment varies from $150 and up. Pays 30 days after publication. Credit line given. Buys one-time rights. Simultaneous submissions and previously published work OK "if not with other sailing publications who compete with us."

Tips: "We are looking for good, clean, sharp photos of sailing action—exciting shots are for us. Please request a sample copy to become familiar with format. Knowledge of the sport of sailing a requisite for good photos for us."

SAILING WORLD, 5 John Clarke Rd., Newport RI 02840. (401)847-1588. Fax: (401)848-5048. Asstistant Art Director: Joyce Shipman. Circ. 62,000. Estab. 1962. Monthly magazine. Emphasizes sailboat racing and performance cruising for sailors, upper income. Readers are males 35-45, females 25-35 who are interested in sailing. Sample copy $5. Photo guidelines free with SASE.

Needs: "We will send an updated photo letter listing our needs on request." Freelance photography in a given issue: 20% assignment and 80% freelance stock. Covers most sailing races.

Making Contact & Terms: Uses 35mm and 2¼×2¼ transparencies for covers. Vertical and square (slightly horizontal) formats. Reports in 1 month. Pays $500 for cover shot; regular color $50-300 (varies with use). Pays on publication. Credit line given. Buys first N.A. serial rights.

Tips: "We look for photos that are unusual in composition, lighting and/or color that feature performance sailing at its most exciting. We would like to emphasize speed, skill, fun and action. Photos must be of high quality. We prefer Fuji Velvia or Kodachrome 64 film. We have a format that allows us to feature work of exceptional quality. A knowledge of sailing and experience with on-the-water photography is really a requirement. Please call with specific questions or interests. We cover current events and generally only use photos taken in the past 30-60 days."

SALT WATER SPORTSMAN, 77 Franklin St., Boston MA 02110. (617)338-2300. Fax: (617)338-2309. Editor: Barry Gibson. Circ. 150,000. Estab. 1939. Monthly magazine. Emphasizes all phases of salt water sport fishing for the avid beginner-to-professional salt water angler. "Number-one monthly marine sport fishing magazine in the US." Sample copy free with 9×12 SAE and 7 first-class stamps. Free photo and writer's guidelines.

Needs: Buys photos (including covers) without ms; 20-30 photos/issue with ms. Needs salt water fishing photos. "Think scenery, mood, fishing action, storytelling close-ups of anglers in action. Make it come alive—and don't bother us with the obviously posed 'dead fish and stupid fisherman' back at the dock. Wants, on a regular basis, cover shots (verticals depicting salt water fishing action)." For accompanying ms needs fact/feature articles dealing with marine sportfishing in the US, Canada, Caribbean, Central and South America. Emphasis on how-to.

Making Contact & Terms: Send material by mail for consideration or query with samples. Provide résumé and tearsheets to be kept on file for possible future assignments. Holds slides for 1 year and will pay as used. Also accepts digital images on an 88mg SyQuest disk with proof of image. Uses 35mm or 2¼×2¼ transparencies; cover transparency vertical format required. SASE. Reports in 1 month. Pay included in total purchase price with ms, or pays $50-400/color photo; $1,000 minimum/cover photo; $250-up/text-photo package. **Pays on acceptance.**

Tips: "Prefers to see a selection of fishing action and mood; must be sport fishing oriented. Read the magazine! Example: no horizontal cover slides with suggestions it can be cropped, etc. Don't send Ektachrome. We're using more 'outside' photography—that is, photos not submitted with ms package. Take lots of verticals and experiment with lighting. Most shots we get are too dark."

‡SAN DIEGO FAMILY MAGAZINE, (formerly *San Diego Family Press*), P.O. Box 23960, San Diego CA 92193. (619)685-6970. Editor: Sharon Bay. Circ. 75,000. Estab. 1982. Monthly magazine. Emphasizes families with children (ages newborn to 16). Readers are mothers, ages 25-45. Sample copy 9×12 SAE and $3.50 postage/handling.

Needs: Uses 4-6 photos/issue. Needs photos of children and families participating in all activities.

Making Contact & Terms: Send unsolicited photos by mail for consideration (photocopies OK). Query with stock photo list. Send 3×5, 4×5, 5×7 color b&w prints. Deadlines: first of each month. Keeps samples on file. SASE. Reports in 1 month. Pays $5-10/b&w inside photo. Pays on publication. Credit

line given. Buys one-time rights; negotiable. Simultaneous submissions and previously published work OK.

SANDLAPPER MAGAZINE, P.O. Box 1108, Lexington SC 29071. (803)359-9941. Fax: (803)957-8226. Managing Editor: Dan Harmon. Estab. 1989. Quarterly magazine. Emphasizes South Carolina topics.
Needs: Uses about 5 photographers/issue. Needs photos of South Carolina subjects. Model release preferred. Captions required; include places and people.
Making Contact & Terms: Interested in receiving work from newer, lesser-known photographers. Query with samples. Send 8×10 color and b&w prints; 35mm, 2¼×2¼, 4×5, 8×10 transparencies. Keeps samples on file. SASE. Reports in 1 month. Pays $25-100/color inside photo; $25-75/b&w inside photo. Pays on publication. Credit line given. Buys first rights plus right to reprint.
Tips: Looking for any South Carolina topic—scenics, people, action, mood, etc.

THE SATURDAY EVENING POST SOCIETY, Dept. PM, Benjamin Franklin Literary & Medical Society, 1100 Waterway Blvd., Indianapolis IN 46202. (317)634-1100. Editor: Cory SerVaas, M.D. Photo Editor: Patrick Perry. Magazine published 6 times annually. For family readers interested in travel, food, fiction, personalities, human interest and medical topics—emphasis on health topics. Circ. 500,000. Sample copy $4; free photo guidelines with SASE.
Needs: Prefers the photo essay over single submission. Model release required.
Making Contact & Terms: Send photos for consideration; 8×10 b&w glossy prints; 35mm or larger transparencies. Provide business card to be kept on file for possible future assignments. SASE. Reports in 1 month. Pays $50 minimum/b&w photo or by the hour; pays $150 minimum for text/photo package; $75 minimum/color photo; $300/color cover photo. Pays on publication. Prefers all rights. Simultaneous submissions and previously published work OK.

SCHOLASTIC MAGAZINES, 555 Broadway, New York NY 10012. (212)343-6100. Fax: (212)343-6185. E-mail: ghow@scholastic.com. Manager of Picture Services: Grace How. Estab. 1920. Publication of magazine varies from weekly to monthly. "We publish 22 titles per year on topics from current events, science, math, fine art, literature and social studies. Interested in featuring high-quality well-composed images of students of all ages and all ethnic backgrounds." Sample copy free with 9×12 SAE with 3 first-class stamps.
Needs: Uses 15 photos/issue. Needs photos of various subjects depending upon educational topics planned for academic year. Model release preferred. Captions required. Images must be interesting, bright and lively!
Making Contact & Terms: Interested in receiving work from newer, lesser-known photographers. Query with résumé, business card, brochure, flier or tearsheets to be kept on file for possible assignments. Accepts digital images for Mac (compact disc, online, SyQuest). Material cannot be returned. Pays $400/color cover photo; $100/b&w inside photo (⅛ page); $125/color inside photo (¼ page). Pays 25% additional for electronic usage. Pays on publication. Buys one-time rights. Previously published work OK.

SCHOOL MATES, 3054 NYS Rt. 9W, New Windsor NY 12553. (914)562-8350, ext. 152. Fax: (914)561-2437. Graphic Designer: Tammy Steinman. Publication of the US Chess Federation. Bimonthly magazine. Emphasizes chess. Readers are male/female, ages 7-18. Sample copy free with 9×12 SAE and 2 first-class stamps.
Needs: Buys 5-30 photos/issue; most supplied by freelancers. Needs photos of children playing chess. Photo captions preferred.
Making Contact & Terms: Interested in receiving work from newer, lesser-known photographers. Send unsolicited photos by mail for consideration. Provide résumé, business card, brochure, flier or tearsheets to be kept on file for possible future assignments. Send color or b&w prints. Keeps samples on file. SASE. Reports in 1 month. Pays $15 minimum for b&w or color inside photo. Pays $100-150/color cover photo. Pays on publication. Credit line given. Rights negotiable.

SCIENCE AND CHILDREN, 1840 Wilson Blvd., Arlington VA 22201-3000. (703)243-7100. Assistant Editor: Katherine Marteka. Circ. 24,000. Publication of the National Science Teachers Association. Monthly (September to May) journal. Emphasizes teaching science to elementary school children. Readers are male and female elementary science teachers and other education professionals.
Needs: Uses 10 photos/issue; 1-2 supplied by freelancers. Needs photos of "a variety of science-related topics, though seasonals, nature scenes and animals are often published. Also children." Special photo needs include children doing science in all settings, especially classroom and science fairs. Model/property release required. Captions required.
Making Contact & Terms: Arrange personal interview to show portfolio. Send stock lists and photocop-

ies of b&w or color prints. Unsolicited material will not be returned. Pays $200/color cover photo; $75/color inside; $50 b&w inside. Pays on publication. Credit line given.

Tips: "We look for candid shots that are sharp in focus and show the excitement of science discovery. We also want photographs that reflect the fact that science is accessible to people of every race, gender, economic background and ability."

‡SCIENCE SCOPE, 1840 Wilson Blvd., Arlington VA 22201. (703)243-7100. Fax: (703)243-7177. E-mail: sciencescope@nsta.org. Website: http://www.nsta.org/pubs/scope. Assistant Editor: Vicki Moll. Publication of the National Science Teachers Association. Journal published 8 times/year during the school year. Emphasizes activity-oriented ideas—ideas that teachers can take directly from articles. Readers are mostly middle school science teachers. Single copy $6.25. Photo guidelines free with SASE.

Needs: Uses cover shots, about half supplied by freelancers. Needs photos of mostly classroom shots with students participating in an activity. "In some cases, say for interdisciplinary studies articles, we'll need a specialized photo." Need for photo captions "depends on the type of photo."

Making Contact & Terms: Interested in receiving work from newer, lesser-known photographers. Arrange personal interview to show portfolio. Query with stock photo list. Provide résumé, business card, brochure, flier or tearsheets to be kept on file for possible assignments. Keeps samples on file. SASE. Pays $200 for cover photos and $50 for small b&w photos. Pays on publication. Sometimes pays kill fee. Credit line given. Buys one-time rights; negotiable. Considers previously published work; "prefer not to, although in some cases there are exceptions."

Tips: "We look for clear, crisp photos of middle level students working in the classroom. Shots should be candid with students genuinely interested in their activity. (The activity is chosen to accompany manuscript.) Please send photocopies of sample shots along with listing of preferred subjects and/or listing of stock photo topics."

SCIENTIFIC AMERICAN, 415 Madison Ave., New York NY 10017. (212)754-1462. Fax: (212)755-1976. E-mail: bgerety@sciam.com. Photography Editor: Bridget Gerety. Circ. 600,000. Estab. 1854. Emphasizes science technology and people involved in science. Readers are mostly male, 15-55.

Needs: Uses 100 photos/issue; all supplied by freelancers. Needs photos of science and technology, personalities, photojournalism and how-to shots; especially "amazing science photos." Model release required. Property release preferred. Captions required.

Making Contact & Terms: Interested in receiving work from newer, lesser-known photographers. Arrange personal interview to show portfolio. "Do not send unsolicited photos." Provide résumé, business card, brochure, flier or tearsheets to be kept on file for possible assignments. Keeps samples on file. Cannot return material. Reports in 1 month. Pays $350/day; $1,000/color cover photo. Pays on publication. Credit line given. Buys one-time and electronic rights; negotiable.

Tips: Wants to see strong natural and artificial lighting, location portraits and location shooting. "Send business cards and promotional pieces frequently when dealing with magazine editors. Find a niche."

SCORE, 4931 SW 75th Ave., Miami FL 33155. (305)662-5959. Fax: (305)662-5952. E-mail: quad@netrunner.net. Editor: John Fox. Circ. 150,000. Estab. 1992. Monthly magazine. Emphasizes large-busted models. Readers are males between 18-50 years of age.

Needs: Uses 150 photos/issue; 100% supplied by freelancers. Model release required for photo identification (such as a driver's license) is also required and/or copy of model's birth certificate.

Making Contact & Terms: Interested in receiving work from newer, lesser-known photographers. Query with stock photo list. Send unsolicited photos by mail for consideration. Photo submissions should consist of a minimum of 100 transparencies of one model. Send 35mm transparencies. SASE. Reports in 3 weeks. Pays $150/color page rate; photo sets of individual models—$1,500-2,500. Pays on publication. Credit line given (if requested). Buys one-time rights; negotiable.

Tips: "Study samples of our publication. We place a premium on—and pay a premium for—new discoveries and exclusives."

‡SCOUTING MAGAZINE, Boy Scouts of America Magazine Division, 1325 W. Walnut Hill Lane, Irving TX 75038. (972)580-2358. Fax: (972)580-2079. Director of Photography: Stephen Seeger. Circ. 1 million. Bimonthly magazine. For adults within the Scouting movement. Free photo guidelines.
● Boy Scouts of America Magazine Division also publishes *Boy's Life* and *Exploring* magazines.

Needs: Assigns 90% of photos; uses 10% from stock. Needs photos dealing with success and/or personal interest of leaders in Scouting. Wants no "single photos or ideas from individuals unfamiliar with our magazine." Captions required.

Making Contact & Terms: "No assignments will be considered without a portfolio review by mail or in person." Call to arrange a personal appointment, or query with ideas. SASE. Reports in 10 working days. Pays $400 base editorial day rate against placement fees. **Pays on acceptance.** Buys one-time rights.

Tips: Study the magazine carefully. In portfolio or samples, wants to see "diversity and ability to light difficult situations."

SCRAP, 1325 G St. NW, Suite 1000, Washington DC 20005. (202)737-1770. Fax: (202)626-0900. E-mail: 76735.3461@compuserve.com. Website: http://www.isri.com. Editor: Elise Browne Hughes. Circ. 6,000. Estab. 1988. Publication of the Institute of Scrap Recycling Industries. Bimonthly magazine. Covers scrap recycling for owners and managers of private recycling operations worldwide. Sample copy $7.50.
Needs: Uses approximately 100 photos/issue; 15% supplied by freelancers. Needs operation shots of companies being profiled and studio concept shots. Model release required. Captions required.
Making Contact & Terms: Arrange personal interview to show portfolio. Query with list of stock photo subjects. Accepts images in digital format for Windows. Send via online, floppy disk or SyQuest (270 dpi). Provide résumé, business card, brochure, flier or tearsheets to be kept on file for possible assignment. Reports in 1 month. Pays $600-1,000/day. Pays on publication. Credit line given. Rights negotiable. Previously published work OK.
Tips: Photographers must possess "ability to photograph people in corporate atmosphere, as well as industrial operations; ability to work well with executives, as well as laborers. We are always looking for good color photographers to accompany our staff writers on visits to companies being profiled. We try to keep travel costs to a minimum by hiring photographers located in the general vicinity of the profiled company. Other photography (primarily studio work) is usually assigned through freelance art director."

SCUBA TIMES MAGAZINE, 14110 Perdido Key Dr., Suite 16, Pensacola FL 32507. (904)492-7805. Fax: (904)492-7807. Website: scubatimes.com. Art Director: Scott Bieberich. Circ. 42,000. Estab. 1979. Bimonthly magazine. Emphasizes scuba diving. Sample copy $3. Photo guidelines free with SASE. Provides an editorial schedule with SASE.
● The editorial staff at this magazine likes to work with photographers who can write as well as shoot outstanding images. Don't be afraid to deviate from "blue" photos when submitting work. Other vibrant colors can make you stand out.
Needs: Uses 50-60 photos/issue; all supplied by freelance photographers; 80% comes from assignments. Needs animal/wildlife shots, travel, scenics, how-to, all with an underwater focus. Model release preferred. Captions preferred; include description of subject and location.
Making Contact & Terms: Interested in receiving work from newer, lesser-known photographers. "Send a sample (20 dupes) for our stock file with each slide labelled according to location rather than creature. Send a complete list of destinations you have photographed. We will build a file from which we can make assignments and order originals." Send 35mm or large format transparencies. Accepts images in digital format for Windows (TIFF or EPS). Send via compact disc, SyQuest, Zip disk (270-300 pixels per inch). SASE. Reports in 1-2 months. Pays $150/color cover photo; $75/color page rate; $75/b&w page rate. Pays 30 days after publication. Credit line given. Buys one-time rights. Previously published work OK "under certain circumstances."
Tips: Looks for underwater and "topside" shots of dive destinations around the world, close-ups of marine creatures, divers underwater with creatures or coral. "We look for photographers who can capture the details that, when combined, create not only a physical description, but also capture the spirit of a dive destination. In portfolio or samples, likes to see "broad range of samples, majority underwater."

SEA KAYAKER, P.O. Box 17170, Seattle WA 98107. (206)789-1326. Fax: (206)781-1141. Editor: Christopher Cunningham. Circ. 20,000. Estab. 1984. Bimonthly magazine. Emphasizes sea kayaking—kayak cruising on coastal and inland waterways. Sample copy $5.75. Photo guidelines free with SASE.
Needs: Uses 50 photos/issue; 85% supplied by freelancers. Needs photos of sea kayaking locations, coastal camping and paddling techniques. Reviews photos with or without ms. Always looking for cover images (some to be translated into paintings, etc.). Model/property release preferred. Captions preferred.
Making Contact & Terms: Interested in receiving work from newer, lesser-known photographers. Submit portfolio for review. Send unsolicted photos by mail for consideration. Send 5×7 color and b&w prints; 35mm transparencies. Keeps samples on file. SASE. Reports in 1 month. Pays $250/color cover photo; $25-50/color inside photo; $15-35/b&w inside photo. Pays on publication. Credit line given. Buys one-time rights, first North American serial rights.
Tips: Subjects "must relate to sea kayaking and cruising locations."

THE SECRETARY, 2800 Shirlington Rd., Suite 706, Arlington VA 22206. (703)998-2534. E-mail: 10305 0.1446@compuserve.com. Managing Editor: Susan Fitzgerald. Circ. 45,000. Estab. 1942. Association publication of the Professional Secretaries International. Published 9 times a year. Emphasizes secretarial profession—proficiency, continuing education, new products/methods and equipment related to office administration/communications. Readers include career secretaries, 98% women, in myriad offices, with wide ranging responsibilities. Sample copy free with SASE.

Needs: Uses 1-2 feature photos and several "Product News" photos/issue; freelance photos 100% from stock. Needs secretaries (predominantly women, but occasionally men) in appropriate and contemporary office settings using varied office equipment or performing varied office tasks. Must be in good taste and portray professionalism of secretaries. Especially interested in photos featuring members of minority groups. Reviews photos with or without accompanying ms. Model release preferred.
Making Contact & Terms: Interested in receiving work from newer, lesser-known photographers. Query with samples. Send unsolicited photos by mail for consideration. Uses 3½×4½, 8×10 glossy prints; 35mm, 2¼×2¼, 4×5 and 8×10 transparencies. SASE. Reports in 1 month. Pays $150 maximum/b&w photo; $500 maximum/color photo. Pays on publication. Credit line given. Buys first North American serial rights. Simultaneous submissions and previously published work OK.

SECURE RETIREMENT, 2000 K St. NW, Washington DC 20006. (202)822-9459. Fax: (202)822-9612. E-mail: secure_retirement@ncpssm.org. Editor: Denise Fremeau. Circ. 2 million. Estab. 1992. Publication of the National Committee to Preserve Social Security and Medicare. Magazine published 6 times yearly. Emphasizes aging and senior citizen issues. Readers are male and female retirees/non-retirees, ages 50-80. Sample copy free with 9×12 SASE.
 ● *Secure Retirement* now buys all its photos from freelancers.
Needs: Uses 20-25 photos/issue; all supplied by freelancers. Needs photos of generic, healthy lifestyle seniors, intergenerational families. Model release required. Captions preferred.
Making Contact & Terms: Interested in receiving work from newer, lesser-known photographers. Arrange personal interview to show portfolio. Provide résumé, business card, brochure, flier or tearsheets to be kept on file for possible assignments. "Do not send unsolicited 35mm or 4×5 slides; color or b&w prints OK. SASE. Pays $100-500/day; $100-500/color and b&w inside photo. Pays on publication. Credit line given. Simultaneous submissions and/or previously published work OK.
Tips: "We are interested in hiring freelancers to cover events for us across the nation (approximately 3-7 events/month)."

SENTIMENTAL SOJOURN, 11702 Webercrest, Houston TX 77048. (713)733-0338. Editor: Charlie Mainze. Circ. 1,000. Estab. 1993. Annual magazine. Sample copy $12.50.
Needs: Uses photos on almost every page. Needs sensual images evocative of the sentimental, usually including at least one human being, suitable for matching with sentimental poetry. "Delicate, refined, romantic, nostalgic, emotional idealism—can be erotic, but must be suitable for a general readership." Model/property release required for any model.
Making Contact & Terms: Interested in receiving work from newer, lesser-known photographers. Send unsolicited photos by mail for consideration. Provide résumé, business card, brochure, flier or tearsheets to be kept on file for possible assignments. Send color and b&w prints; 35mm, 2¼×2¼, 4×5 transparencies. Keeps samples on file. SASE, but generally keep for a few years. Reports when need for work arises, could be 2 years. Pays $50-200/color cover photo; $50-200/b&w cover photo; $10-100/color inside photo; $10-100/b&w inside photo; also pays a percentage of page if less than full page. Credit line given. Buys one-time rights, first North American serial rights. Previously published work OK.
Tips: "Symbols of the dead and dying had better be incomparably delicate. Send a celebration of emotions."

THE SENTINEL, Industrial Risk Insurers, 85 Woodland St., Hartford CT 06102. (860)520-7300. Editor: Barbara Wierzbicki. Circ. 59,000. Quarterly magazine. Emphasizes industrial loss prevention for "insureds and all individuals interested in fire protection." Free sample copy and photo guidelines.
Needs: Uses 10-20 photos/issue; "many" supplied by freelance photographers. Needs photos of fires, explosions, floods, windstorm damage and other losses at industrial sites. Prefers to see good industrial fires and industrial process shots, industrial and commercial fire protection equipment. No photos that do not pertain to industrial loss prevention (no house fires) but can use generic shots of natural disaster damage, e.g., floods, hurricanes, tornadoes. Model release preferred.
Making Contact & Terms: Send material by mail for consideration. Uses color glossy prints or slides. Horizontal or vertical format for cover. Reports in 2 weeks. Pays $100/photo. **Pays on acceptance.** Credit line given. Buys unlimited reproduction rights for nonexclusive use. Previously published work OK.

SEVENTEEN MAGAZINE, K-III Magazines, 850 Third Ave., 9th Floor, New York NY 10022. (212)407-9700. *Seventeen* is a young women's first fashion and beauty magazine. Tailored to young women

 CANADIAN LISTINGS are marked with a maple leaf.

in their teens and early 20s, *Seventeen* covers fashion, beauty, health, fitness, food, cars, college, careers, talent, entertainment, fiction, plus crucial personal and global issues. This magazine did not repond to our request for information. Query before submitting.

SHOWBOATS INTERNATIONAL, 1600 SE 17th St., Suite 200, Ft. Lauderdale FL 33316. (954)525-8626. Fax: (954)525-7954. E-mail: showboats@aol.com. Executive Editor: Marilyn Mower. Circ. 60,000. Estab. 1981. Bimonthly magazine. Emphasizes exclusively large yachts (100 feet or over). Readers are mostly male, 40 plus years of age, incomes above $1 million, international. Sample copy $5.
 • This publication has received 20 Florida Magazine Association Awards plus two Ozzies since 1989.
Needs: Uses 90-150 photos/issue; 80-90% supplied by freelancers. Needs photos of very large yachts and exotic destinations. "Almost all shots are commissioned by us." Model/property releases required. Color photography only. Captions preferred.
Making Contact & Terms: Arrange personal interview to show portfolio. Submit portfolio for review. Query with résumé of credits. Provide résumé, business card, brochure, flier or tearsheets to be kept on file for possible assignments. Accepts images in digital format for Mac. Send via compact disc, SyQuest, Zip disk (high resolution). Does not keep samples on file. SASE. Reports in 3 weeks. Pays $500/color cover photo; $100-375/color page rate; $550-850/day. Pays on publication. Credit line given. Buys first serial rights, all rights; negotiable. Previously published work OK, however, exclusivity is important.
Tips: Looking for excellent control of lighting; extreme depth of focus; well-saturated transparencies. Prefer to work with photographers who can supply both exteriors and beautiful, architectural quality interiors. "Don't send pictures that need any excuses. The larger the format, the better. Send samples. Exotic location shots should include yachts."

SIGNPOST FOR NORTHWEST TRAILS MAGAZINE, Dept. PM, 1305 Fourth Ave., #512, Seattle WA 98101. (206)625-1367. E-mail: dnelson024@aol.com. Editor: Dan Nelson. Circ. 3,800. Estab. 1966. Publication of the Washington Trails Association. Monthly. Emphasizes "backpacking, hiking, cross-country skiing, all nonmotorized trail use, outdoor equipment and minimum-impact camping techniques." Readers are "people active in outdoor activities, primarily backpacking; residents of the Pacific Northwest, mostly Washington; age group: 9-90, family-oriented, interested in wilderness preservation, trail maintenance." Photo guidelines free with SASE.
Needs: Uses about 20-25 photos/issue; 50% supplied by freelancers. Needs "wilderness/scenic; people involved in hiking, backpacking, canoeing, skiing, wildlife, outdoor equipment photos, all with Pacific Northwest emphasis." Captions required.
Making Contact & Terms: Send 5×7 or 8×10 glossy b&w prints by mail for consideration. SASE. Reports in 1 month. No payment for inside photos. Pays $25/b&w cover photo. Pays on publication. Credit line given. Buys one-time rights. Simultaneous submissions and previously published work OK.
Tips: "We are a b&w publication and prefer using b&w originals for the best reproduction. Photos must have a Pacific Northwest slant. Photos that meet our cover specifications are always of interest to us. Familiarity with our magazine would greatly aid the photographer in submitting material to us. Contributing to *Signpost* won't help pay your bills, but sharing your photos with other backpackers and skiers has its own rewards."

SKATING, 20 First St., Colorado Springs CO 80906-3697. (719)635-5200. Fax: (719)635-9548. E-mail: skatemag@aol.com. Editor: Jay Miller. Circ. 45,000. Estab. 1923. Publication of The United States Figure Skating Association. Magazine published 10 times/year. Emphasizes competitive figure skating. Readers are primarily active skaters, coaches and officials. Sample copy $3.
Needs: Uses 25 photos/issue; 90% supplied by freelancers. Needs sports action shots of national and world-class figure skaters; also casual, off-ice shots of skating personalities. Model/property release required. Captions preferred; include who, what, when where. Send unsolicited photos by mail for consideration. Send 3½×5, 4×6, 5×7 glossy color prints; 35mm transparencies. Accepts images in digital format for Mac. Deadlines: 15th of every month. Keeps samples on file. Cannot return material. Reports in 2 weeks. Pays $50/color cover photo; $35/color inside photo; $15/b&w inside photo. Pays on publication. Credit line given. Buys one-time rights; negotiable.
Tips: "We look for a mix of full-body action shots of skaters in dramatic skating poses and tight, close-up or detail shots that reveal the intensity of being a competitor. Shooting in ice arenas can be tricky. Flash units are prohibited during skating competitions, therefore, photographers need fast, zoom lenses that will provide the proper exposure, as well as stop the action."

✿SKI CANADA, 117 Indian Rd., Toronto, Ontario M6R 2V5 Canada. (416)538-2293. Fax: (416)538-2475. E-mail: skicanada@shift.com. Editor: Iain MacMillan. Monthly magazine published 7 times/year,

September through February. Readership is 65% male, ages 25-44, with high income. Circ. 55,000. Sample copy free with SASE.

Needs: Uses 40 photos/issue; 100% supplied by freelance photographers. Needs photos of skiing—travel (within Canada and abroad), competition, equipment, instruction, news and trends. Model release required; photo captions preferred.

Making Contact & Terms: Send unsolicited photos by mail for consideration. Provide résumé, business card, brochure, flier or tearsheets to be kept on file for possible assignments. Send color and 35mm transparencies. SASE. Reports in 1 month. Pays $100/photo/page; cover $350; rates are for b&w or color. Pays within 30 days of publication. Credit line given. Simultaneous submissions OK.

Tips: "Please request in writing (or by fax), an editorial lineup, available in late fall for the following year's publishing schedule. Areas covered: travel, equipment, instruction, competition, fashion and general skiing stories and news."

‡SKIN DIVER, 6420 Wilshire Blvd., Los Angeles CA 90048. (213)782-2960. Editor/Publisher: Bill Gleason. Executive Editor: Bonnie J. Cardone. Circ. 219,035. Monthly magazine. Emphasizes scuba diving in general, dive travel and equipment. "The majority of our contributors are divers-turned-writers." Free writer's/photographer's guidelines.

Needs: Photos purchased with accompanying ms only. Buys 60 photos/year; 85% supplied by freelance photographers. Adventure; how-to; human interest; wreck diving, game diving, local diving. All photos must be related to underwater subjects. Model release required. Captions preferred.

Making Contact & Terms: Send material by mail for consideration. Uses 5×7 and 8×10 b&w glossy prints; 35mm and $2\frac{1}{4} \times 2\frac{1}{4}$ transparencies; 35mm color transparencies for cover, vertical format preferred. SASE. Pays $50/published page. Pays on publication. Credit line given. Buys one-time rights.

Tips: "Read the magazine; submit only those photos that compare in quality to the ones you see in *Skin Diver*."

SKIPPING STONES: A Multicultural Children's Magazine, P.O. Box 3939, Eugene OR 97403. (541)342-4956. Managing Editor: Arun N. Toké. Circ. 3,000. Estab. 1988. Magazine published 5 times/year. Emphasizes multicultural and ecological issues. Readers are youth ages 8-16, their parents and teachers, schools and libraries. Sample copy $6 (including postage). Photo guidelines free with SASE.

Needs: Uses 25-40 photos/issue; most supplied by freelancers. Needs photos of animals, wildlife, children 8-16, cultural celebrations, international, travel, school/home life in other countries or cultures. Model release preferred. Captions preferred; include site, year, names of people in photo.

Making Contact & Terms: Interested in receiving work from newer, lesser-known photographers. Send unsolicited photos by mail for consideration. Send 4×6, 5×7 glossy color or b&w prints. Keeps samples on file. SASE. Reports in 1 month. Pays contributor's copy; "we're a labor of love." For photo essays; "we provide 5 copies to contributors. Additional copies at a 25% discount. Sometimes, a small honorarium of up to $50. Credit line given. Buys one-time and first North American serial rights; negotiable. Simultaneous submission OK. Offers internships during the summer and fall. Contact Executive Editor: Arun Toké.

Tips: "We publish b&w inside; color on cover. Should you send color photos, choose the ones with good contrast which can translate well into b&w photos. We are seeking meaningful, humanistic and realistic photographs."

SKYDIVING, 1725 N. Lexington Ave., DeLand FL 32724. (904)736-4793. Fax: (904)736-9786. Editor: Sue Clifton. Circ. 12,400. Estab. 1979. Monthly magazine. Readers are "sport parachutists worldwide, dealers and equipment manufacturers." Sample copy $3. Photo guidelines for SASE.

Needs: Uses 50 photos/issue; 5 supplied by freelancers. Selects photos from wire service, photographers who are skydivers and freelancers. Interested in anything related to skydiving—news or any dramatic illustration of an aspect of parachuting. Model release preferred. Captions preferred; include who, what, when, how.

Making Contact & Terms: Interested in receiving work from newer, lesser-known photographers. Send actual 5×7 or larger b&w or color photos or 35mm or $2\frac{1}{4} \times 2\frac{1}{4}$ transparencies by mail for consideration. Keeps samples on file. SASE. Reports in 1 month. Pays $50-100/color cover photo; $25-50/color inside photo; $15-50/b&w inside photo. Pays on publication. Credit line given. Buys one-time rights.

SMITHSONIAN, Arts & Industrial Building, 900 Jefferson Dr., Washington DC 20560. (212)490-2510. Fax: (212)986-4259. *Smithsonian* magazine chronicles the arts, the environment, sciences and popular culture of the times for today's well-rounded individuals with diverse general interests, providing its readers with information and knowledge in an entertaining way. This magazine did not respond to our request for information. Query before submitting.

Skipping Stones

A Multicultural Children's Magazine

Volume 8, No. 5

Nov.–Dec. 1996
US: $4.75; CAN: $5.95

Let's
Celebrate!

Deep is the
Heart of Africa

photo © 1996 Tina Friedman; cover © 1996 *Skipping Stones*

"This photo is one of the best we have ever received," says Arun Toke, editor of *Skipping Stones*. "It shows an African elder who conveys the heart of what we wanted to say in this issue—respecting our elders, honoring their experiences and contributions to the society." Photographer Tina Friedman captured the image during eight months of backpacking through southern Africa with her daughter, Emily. The cover photo and several others by Friedman accompanied an article Emily wrote for *Skipping Stones* about the Tonga people, a tribe they encountered during their journey. "Emily and I spent time visiting a Tonga village, and we felt a deep connection with the people. This photo is of a woman who is sister to the chief of the village of Siachilaba," Friedman says.

SNOW COUNTRY MAGAZINE, 5520 Park Ave., Trumbull CT 06611. (203)373-7296 Fax: (203)373-7111. E-mail: smcneill@snowcountry.com. Photo Editor: Sharon McNeill. Circ. 465,000. Estab. 1988. Magazine published 8 times/year. Emphasizes skiing, mountain sports and living. Readers are 70% male, 39 years old, professional/managerial with average household income of $90,000. Sample copy $5.
Needs: Uses 90 photos/issue; 95% supplied by freelancers. Needs photos of downhill skiing, cross-country skiing, telemark skiing, snowboarding, mountain biking, in-line skating, hiking, scenic drives, ski area resorts, ice/rock climbing, people profiles, Heli skiing, snowcat skiing, rafting, camping. Special photo needs include good ski area resort shots showing family interaction, scenic drives going into white-capped mountains. Also b&w and color photos to be used as a photo essay feature in each issue. The photos should have a theme and relate to the mountains. Model/property release preferred. Captions preferred.
Making Contact & Terms: Interested in receiving work from newer, lesser-known photographers. Query with stock photo list. Provide résumé, business card, brochure, flier or tearsheets to be kept on file for possible assignments. Also accepts digital images on CD. Keeps samples on file. SASE. Reports in 1 month. Pays $250/½ day; $400/day; $800/color cover photo; $100-400/color space rate. Pays on publication. Buys first North American serial rights; negotiable. Simultaneous submissions and/or previously published work OK.
Tips: "Looking for unique shots that put our readers in snow country, a place in the mountains."

SOAP OPERA DIGEST, 45 W 25th St., New York NY 10010. (212)229-8400. Fax: (212)645-0683. Editor-in Chief: Lynn Leahey. Art Director: Catherine Connors. Photo Editor: Tammy Roth. Circ. 1 million. Estab. 1975. Biweekly. Emphasizes daytime and nighttime TV serial drama. Readers are mostly women, all ages. Sample copy free with 5×7 SAE and 3 first-class stamps.
Needs: Needs photos of people who appear on daytime and nighttime TV soap operas; special events in which they appear. Uses mostly color and some b&w photos.
Making Contact & Terms: Interested in receiving work from new photographers. Query with résumé of credits to photo editor. Provide business card and promotional material to be kept on file for possible future assignments. SASE. Reports in 1 month. Pays $50-175/b&w photo; $100-400/color photo; $350-1,000/complete package. Pays on publication. Credit line given. Buys all rights; negotiable.
Tips: "Have photos of the most popular stars and of good quality. Sharp color quality is a must. "I look for something that's unusual in a picture, like a different pose instead of head shots. We are not interested in people who happened to take photos of someone they met. Show variety of lighting techniques and creativity in your portfolio."

SOARING, Box E, Hobbs NM 88241-7504. (505)392-1177. Fax: (505)392-8154. Art Director: Steve Hines. Circ. 16,010. Estab. 1937. Monthly magazine. Emphasizes the sport of soaring in sailplanes and motorgliders. Readership consists of white collar and professional males and females, ages 14 and up. Sample copy and photo guidelines free with SASE.
Needs: Uses 25 or more photos/issue; 95% supplied by freelancers. "We hold freelance work for a period of usually six months, then it is returned. If we have to keep work longer, we notify the photographer. The photographer is always updated on the status of his or her material." Needs sharply focused transparencies, any format. Especially needs aerial photography. "We need a good supply of sailplane transparencies for our yearly calendar." Model release preferred. Captions required.
Making Contact & Terms: Send unsolicited photos by mail for consideration. Uses b&w prints, any size and format. Also uses transparencies, any format. SASE. Reports in 2 weeks. Pays $50/color cover photo. Pays $50-100 for calendar photos. Pays on publication. Credit line given. Buys one-time rights. Simultaneous submissions OK.
Tips: "Exciting air-to-air photos, creative angles and techniques are encouraged. We pay only for the front cover of our magazine and photos used in our calendars. We are a perfect market for photographers who have sailplane photos of excellent quality. Send work dealing with sailplanes only and label all material."

SOARING SPIRIT, P.O. Box 38, Malibu CA 90265. Editor: Dick Sutphen. Art Director: Jason D. McKean. Circ. 120,000. Estab. 1976. Quarterly magazine. Emphasizes metaphysical, psychic development, reincarnation, self-help with tapes. Everyone receiving the magazine has attended a Sutphen Seminar or purchased Valley of the Sun Publishing books or tapes from a line of over 300 titles: video and audio tapes, subliminal/hypnosis/meditation/New Age music/seminars on tape, etc. Sample copy free with 9×12 SAE and 5 first-class stamps.
Needs: "We purchase about 20 photos per year for the magazine and also for cassette album covers, videos and CDs. We are especially interested in surrealistic photography which would be used as covers, to illustrate stories and for New Age music cassettes. Even seminar ads often use photos that we purchase from freelancers." Model release required.
Making Contact & Terms: Interested in receiving work from newer, lesser-known photographers. Send b&w and color prints; 35mm transparencies by mail for consideration. SASE. Reports in 2 weeks. Pays

$100/color photo; $50/b&w photo. Pays on publication. Credit line given if desired. Buys one-time rights; negotiable. Simultaneous submissions and previously published work OK.

SOCCER MAGAZINE, 5211 S. Washington Ave., Titusville FL 32780. (407)268-5010. Fax: (407)267-1894. Photo Editor: J. Brett Whitesell. Circ. 30,000. Estab. 1993. Magazine published 9 times/year. Emphasizes soccer. Readers are male and female, ages 15-50, players, fans, coaches, officials. Photo guidelines free with SASE.
Needs: Uses 45-50 photos/issue; 25-30% supplied by freelancers. Needs photos of game action. Reviews photos purchased with accompanying ms only. Captions required; include player identification, event.
Making Contact & Terms: Provide résumé, business card, brochure, flier or tearsheets to be kept on file for possible assignments. Keeps samples on file. SASE. Reports in 2 weeks. Pays $300/color cover photo; $75-100/color inside photo; $50/b&w inside photo; photo/text package rate negotiated. Pays on publication. Credit line given. buys one-time rights.
Tips: "The photographers I use know the sport of soccer. They are not just sports photographers. I will know the difference. I use photographer's files who keep me informed on events they are covering. Rarely do I give specific assignments. Those that are given out go to proven photographers."

SOCIETY, Rutgers University, New Brunswick NJ 08903. (908)445-2280. Fax: (908)445-3138. E-mail: ihorowit@gardalf. Website: http://www.transactionpub.com. Editor: Irving Louis Horowitz. Circ. 31,000. Estab. 1962. Bimonthly magazine. Readers are interested in the understanding and use of the social sciences and new ideas and research findings from sociology, psychology, political science, anthropology and economics. Free sample copy and photo guidelines.
Needs: Buys 75-100 photos/annually. Human interest, photo essay and documentary. Needs photo essays—"no random photo submissions." Essays (brief) should stress human interaction; photos should be of people interacting (not a single person) or of natural surroundings. Include an accompanying explanation of photographer's "aesthetic vision."
Making Contact & Terms: Send 8 × 10 b&w glossy prints for consideration. SASE. Reports in 3 months. Pays $200-250/photo essay. Pays on publication. Buys all rights to one-time usage.

SOLDIER OF FORTUNE MAGAZINE, P.O. Box 693, Boulder CO 80306. (303)449-3750. Editor: Dwight Swift. Deputy Editor: Tom Reisinger. Monthly magazine. Emphasizes adventure, combat, military units and events. Readers are mostly male—interested in adventure and military related subjects. Circ. 175,000. Estab. 1975. Sample copy $5.
Needs: Uses about 60 photos/issue; 33% on assignment, 33% from stock. Needs photos of combat—under fire, or military units, military—war related. "We always need front-line combat photography." Not interested in studio or still life shots. Model/property release preferred. Captions required; "include as much tech information as possible."
Making Contact & Terms: Contact Tom Reisinger by phone with queries; send 8 × 10 glossy b&w, color prints, 35mm transparencies, b&w contact sheets by mail for consideration. SASE. Reports in 3 weeks. Pays $50-150/b&w photo; $50-500/color cover; $150-2,000/complete job. Will negotiate a space-rate payment schedule for photos alone. **Pays on acceptance.** Credit line given. Buys one-time rights.
Tips: "Combat action photography gets first consideration for full-page and cover layouts. Photo spreads on military units from around the world also get a serious look, but stay away from 'man with gun' shots. *Give us horizontals and verticals!* The horizontal-shot syndrome handcuffs our art director. *Get close!* Otherwise, use telephoto. Too many photographers send us long distance shots that just don't work for our audience. *Give us action!* People sitting, or staring into the lens, mean nothing. *Consider using black & white* along with color. It gives us options in regard to layout; often, black & white better expresses the combat/military dynamic."

SOUTHERN BOATING, 1766 Bay Rd., Miami Beach FL 33139. (305)532-8657. Executive Editor: David Strickland. Circ. 30,000. Estab. 1972. Monthly magazine. Emphasizes "boating (mostly power, but also sail) in the southeastern U.S. and the Caribbean." Readers are "concentrated in 30-50 age group; male and female; affluent—executives mostly." Sample copy $4.
Needs: Number of photos/issue varies; all supplied by freelancers. Needs "photos to accompany articles about cruising destinations, the latest in boats and boat technology, boating activities (races, rendezvous); cover photos of a boat in a square format (a must) in the context of that issue's focus (see editorial calendar)." Model release preferred. Captions required.
Making Contact & Terms: Query with list of stock photo subjects. Accepts images in digital format for Mac. Send via compact disc, floppy disk, SyQuest, Zip disk. SASE. Reporting time varies. Pays $150 minimum/color cover photo; $50 minimum/color inside photo; $25 minimum/b&w inside photo; $75-150/photo/text package. Pays on publication. Credit line given. Buys one-time rights. Simultaneous submissions and previously published work OK.

Tips: "Photography on the water is very tricky. We are looking for first-rate work, preferably Kodachrome or Fujichrome, and prefer to have story *and* photos together, except in the case of cover material."

SOUTHERN EXPOSURE, P.O. Box 531, Durham NC 27702. (919)419-8311. Fax: (919)419-8315. Editor: Pat Arnow. Estab. 1972. Quarterly. Emphasizes the politics and culture of the South, with special interest in women's issues, African-American affairs and labor. Sample copy $5 with 9×12 SASE. Photo guidelines free with SASE.
Needs: Uses 30 photos/issue; most supplied by freelance photographers. Needs news and historical photos; photo essays. Model/property release preferred. Captions required.
Making Contact & Terms: Interested in receiving work from newer, lesser-known photographers. Query with samples. Send glossy b&w prints by mail for consideration. SASE. Reports in 6 weeks. Pays $25-100/color photo; $100/color cover photo; $25-50/b&w inside photo. Pays on publication. Credit line given. Buys all rights "unless the photographer requests otherwise." Simultaneous submissions and previously published work OK.

SPARE TIME MAGAZINE, 5810 W. Oklahoma Ave., Milwaukee WI 53219. (414)543-8110. Fax: (414)543-9767. Editor: Peter Abbott. Circ. 301,500. Estab. 1955. Published 11 times yearly (monthly except July). Emphasizes income-making opportunities. Readers are income opportunity seekers with small capitalization. People who want to learn new techniques to earn extra income. Sample copy $2.50 with 9 first-class stamps.
● *Spare Time Magazine* has increased its publication from 9 to 11 issues.
Needs: Uses one photo/issue. Needs photos that display money-making opportunities. Model/property release required.
Making Contact & Terms: Interested in receiving work from newer, lesser-known photographers. Send unsolicited photos by mail for consideration. Send color or b&w prints; 2¼×2¼ transparencies. Keeps samples on file. Contacts photographer if photo accepted. Pays $15-50/color or b&w photo. Pays on publication. Buys one-time rights, all rights; negotiable. Simultaneous submissions and previously published work OK.

‡SPORT MAGAZINE, Dept. PM, 6420 Wilshire Blvd., Los Angeles CA 90048. (213)782-2830. Photo Director: Gladees Prieur. Monthly magazine. Emphasizes sports, both professional and collegiate. Readers are ages "9-99, male and female." Circ. 1 million. Photo guidelines free with SASE.
Needs: Uses 80 photos/issue; 20% supplied by freelance photographers. Needs photos of sports action (i.e., strobed basketball, hockey, football, baseball). "Always need good editorial (nonaction) photographers for portrait work, especially photographers who can work on location."
Making Contact & Terms: Interested in receiving work from newer, lesser-known photographers. Query with résumé of credits or stock photo subjects. "No unsolicited work accepted." Reports in 1 month. Pays $700/color cover photo or $400/day. Pays on publication. Credit line given. Buys one-time rights.
Tips: In portfolio or samples looking for "tight, sharp, action—hockey and basketball must be strobed, color transparencies preferred, well-lighted portraits or feature style and candid shots of athletes. No prints. Assignments are being given to those who continue to excel and are creative."

SPORTS CARD TRADER, 5 Nassau Blvd. S., Garden City South NY 11530. (516)292-6000. Fax: (516)292-6007. Editor: Doug Kale. Circ. 225,000. Estab. 1990. Monthly magazine. Emphasizes baseball cards, basketball, football, hockey sports cards, memorabilia, all sports. Readers are male ages 9-99. Free sample copy.
Needs: Uses 1-2 photos/issue; all supplied by freelancers. Needs photos of studio shots, action shots. Model/property release required.
Making Contact & Terms: Interested in receiving work from newer, lesser-known photographers. Send unsolicited photos by mail for consideration. Send 8×10 glossy color prints. Keeps samples on file. Cannot return material. Reports in 2 weeks. Pays $50-100/job. Pays on publication. Credit line given. Buys all rights; negotiable. Simultaneous submissions OK.

SPORTS ILLUSTRATED, Times Mirror Co., Time Life Building, 1271 Avenue of the Americas, New York NY 10020. (212)522-1212. *Sports Illustrated* reports and interprets the world of sport, recreation and

active leisure. It previews, analyzes and comments on major games and events, as well as those noteworthy for character and spirit alone. In addition, the magazine has articles on such subjects as fashion, physical fitness and conservation. This magazine did not respond to our request for information. Query before submitting.

SPORTSCAR, 1371 E. Warner, Suite E, Tustin CA 92680. (714)259-8240. Editor: Rich McCormack. Circ. 50,000. Estab. 1944. Publication of the Sports Car Club of America. Monthly magazine. Emphasizes sports car racing and competition activities. Sample copy $2.95.
Needs: Uses 75-100 photos/issue; 75% from assignment and 25% from freelance stock. Needs action photos from competitive events, personality portraits and technical photos.
Making Contact & Terms: Interested in receiving work from newer, lesser-known photographers. Query with résumé of credits or send 5×7 color or b&w glossy/borders prints or 35mm or 2¼×2¼ transparencies by mail for consideration. Provide résumé, business card, brochure, flier or tearsheets to be kept on file for possible assignments. SASE. Reports in 1 month. Pays $25/color inside photo; $10/b&w inside photo; $250/color cover. Negotiates all other rates. Pays on publication. Credit line given. Buys first North American serial rights. Simultaneous submissions OK.
Tips: To break in with this or any magazine, "always send only the absolute best work; try to accommodate the specific needs of your clients. Have a relevant subject, strong action, crystal sharp focus, proper contrast and exposure. We need good candid personality photos of key competitors and officials."

SPOTLIGHT MAGAZINE, 126 Library Lane, Mamaroneck NY 10543. (914)381-4740, ext. 20. Fax: (914)381-4641. Publisher: Susan Meadow. Circ. 350,000. Monthly magazine. Readers are largely upscale, about 60% female. Sample copy $2.50.
Needs: Uses 25-30 photos/issue; 5-10 supplied by freelancers. Model release required. Captions required.
Making Contact & Terms: Interested in receiving work from newer, lesser-known photographers. Query with résumé of credits. Accepts images for Mac (TIFF). Send via compact disc, floppy disk, SyQuest, Zip disk (high resolution). Keeps samples on file. SASE. Reports in 1 month. Pays $40-125/photo. Pays on publication. Credit line given. Buys all rights "but flexible on reuse." Offers internships for photographers all year. Contact Art Director: Kathee Casey Pennucci.

SPY, Sussex Publishers, 49 E. 21st St., 11th Floor, New York NY 10010. (212)260-3214, ext. 110. Fax: (212)260-7445. Photo Editor: Jamey O'Quinn. Estab. 1992. Bimonthly magazine. Readers are male and female, highly educated, active professionals. Photo guidelines free with SASE.
Needs: Uses 19-25 photos/issue; all supplied by freelancers. Needs photos of humor, photo montage, political, symbolic, environmental, portraits, conceptual. Model/property release preferred.
Making Contact & Terms: Interested in receiving work from "upcoming" photographers. Submit portfolio for review. Call before you drop off portfolio. Send promo card with photo. Also accepts Mac files. Keeps samples on file. Cannot return material. Reports back only if interested. For assignments, pays $1,000/cover plus expenses; $350-750/inside photo plus expenses; for stock, pays $150/¼ page; $300/full page.

STAR, 660 White Plains Rd., Tarrytown NY 10591. (914)332-5000. Editor: Phillip Bunton. Photo Director: Alistair Duncan. Circ. 2.8 million. Weekly. Emphasizes news, human interest and celebrity stories. Sample copy and photo guidelines free with SASE.
Needs: Uses 100-125 photos/issue; 75% supplied by freelancers. Reviews photos with or without accompanying ms. Model release preferred. Captions required.
Making Contact & Terms: Interested in receiving work from newer, lesser-known photographers. Query with samples and with list of stock photo subjects. Send 8×10 b&w prints; 35mm, 2¼×2¼ transparencies by mail for consideration. SASE. Reports in 2 weeks. Payment negotiable. Pays on publication. Credit line sometimes given. Simultaneous submissions and previously published work OK.

THE STATE: Down Home in North Carolina, 1915 Lendew St., P.O. Box 4552, Greensboro NC 27408-7017. (910)286-0600 or (800)948-1409. Fax: (910)286-0100. Editor: Mary Ellis. Circ. 32,000. Estab. 1933. Monthly magazine. Regional publication, privately owned, emphasizing travel, history, nostalgia, folklore, humor, all subjects regional to North Carolina for residents of, and others interested in, North Carolina. Sample copy $3. "Send for our photography guidelines."
Needs: Freelance photography used; 5% assignment and 5% stock. Photos on travel, history and human interest in North Carolina. Captions required.
Making Contact & Terms: Send material by mail for consideration. Uses 5×7 and 8×10 glossy b&w prints; also glossy color prints and slides. Uses b&w and color cover photos, vertical preferred. SASE. Pays $25/b&w photo; $25-150/cover photo; $125-150/complete job. Credit line given. Pays on publication.

Tips: Looks for "North Carolina material; solid cutline information."

STOCK CAR RACING MAGAZINE, 65 Parker St., #2, Newburyport MA 01950. (508)463-3787. Fax: (508)463-3250. Editor: Dick Berggren. Circ. 400,000. Estab. 1966. Monthly magazine. Emphasizes all forms of stock car competition. Read by fans, owners and drivers of race cars and those with racing businesses. Photo guidelines free with SASE.
Needs: Buys 50-70 photos/issue. Documentary, head shot, photo essay/photo feature, product shot, personality, crash pictures, special effects/experimental, technical and sport. No photos unrelated to stock car racing. Photos purchased with or without accompany ms and on assignment. Model release required unless subject is a racer who has signed a release at the track. Captions required.
Making Contact & Terms: Send material by mail for consideration. Uses 8×10 glossy b&w prints; 35mm or $2\frac{1}{4} \times 2\frac{1}{4}$ transparencies. Kodachrome 64 or Fuji 100 preferred. Pays $20/b&w photo; $35-250/color photo; $250/cover photo. Pays on publication. Credit line given. Buys one-time rights.
Tips: "Send the pictures. We will buy anything that relates to racing if it's interesting, if we have the first shot at it, and it's well printed and exposed. Eighty percent of our rejections are for technical reasons—poorly focused, badly printed, too much dust, picture cracked, etc. We get far fewer cover submissions than we would like. We look for full-bleed cover verticals where we can drop type into the picture and position our logo."

STRAIGHT, 8121 Hamilton Ave., Cincinnati OH 45231. (513)931-4050. Fax: (513)931-0950. Editor: Heather E. Wallace. Circ. 35,000. Estab. 1950. Weekly. Readers are ages 13-19, mostly Christian; a conservative audience. Sample copy free with SASE and 2 first-class stamps. Photo guidelines for SASE.
Needs: Uses about 4 photos/issue; all supplied by freelance photographers. Needs color photos of teenagers involved in various activities such as sports, study, church, part-time jobs, school activities, classroom situations. Outside nature shots, groups of teens having good times together are also needed. "Try to avoid the sullen, apathetic look—vital, fresh, thoughtful, outgoing teens are what we need. Any photographer who submits a set of quality color transparencies for our consideration, whose subjects are teens in various activities and poses, has a good chance of selling to us. This is a difficult age group to photograph without looking stilted or unnatural. We want to purport a clean, healthy, happy look. No smoking, drinking or immodest clothing. We especially need masculine-looking guys and minority subjects." Model release required. Photo captions preferred.
Making Contact & Terms: Interested in receiving work from newer, lesser-known photographers. Send color transparencies by mail for consideration. Enclose sufficient packing and postage for return of photos. Reports in 6 weeks. Pays $75-125/color photo. **Pays on acceptance.** Credit line given. Buys one-time rights. Simultaneous submissions and previously published work OK.
Tips: "Our publication is almost square in shape. Therefore, 5×7 or 8×10 prints that are cropped closely will not fit our proportions. Any photo should have enough 'margin' around the subject that it may be cropped square. This is a simple point, but absolutely necessary. Look for active, contemporary teenagers with light backgrounds for photos. For our publication, keep up with what teens are interested in. Subjects should include teens in school, church, sports and other activities. Although our rates may be lower than the average, we try to purchase several photos from the same photographer to help absorb mailing costs. Review our publication and get a feel for our subjects."

‡**THE STRAIN**, 1307 Diablo Dr., Crosby TX 77532-3004. (713)738-4887. For articles contact: Alicia Adler; for columns, Charlie Mainze. Circ. 1,000. Estab. 1987. Monthly magazine. Emphasizes interactive arts and 'The Arts'. Readers are mostly artists and performers. Sample copy $5 with 9×12 SAE and 7 first-class stamps. Photo guidelines free with SASE.
Needs: Uses 5-100 photos/issue; 95% supplied by freelance photographers. Needs photos of scenics, personalities, portraits. Model release required. Captions preferred.
Making Contact & Terms: Send any format b&w and color prints or transparencies by mail for consideration. SASE. The longer it is held, the more likely it will be published. Reports in 1 year. Pays $50/color cover photo; $100/b&w cover photo; $5 minimum/color inside photo; $5 minimum/b&w inside photo; $5/b&w page rate; $50-500/photo/text package. Pays on publication. Credit line given. Buys one-time rights or first North American serial rights. Simultaneous submissions and previously published work OK.

‡♣**SUB-TERRAIN MAGAZINE**, 175 E. Broadway, #204-A, Vancouver, British Columbia V5T 1W2 Canada. (604)876-8710. Fax: (604)879-2667. E-mail: subterinc.com. Photo Editor: Dirk Beck. Estab. 1988. Emphasizes literature, plays, poetry.
Needs: Uses "many" unsolicited photos. Needs "artistic" photos. Captions preferred.
Making Contact & Terms: Submit portfolio for review. Send unsolicited photos by mail for consideration. Send color or b&w prints. Keeps samples on file "sometimes." Reports in 2-4 months. Pays $200-

250/color photo (solicited material only). Also pays in contributor's copies. Pays on publication. Credit line given. Buys one-time rights. Simultaneous submissions OK.

THE SUN, 107 N. Roberson, Chapel Hill NC 27516. (919)942-5282. Editor: Sy Safransky. Circ. 29,000. Estab. 1974. Monthly magazine. Sample copy $3.50. Photo guidelines free with SASE.
• *The Sun* has doubled its payment.
Needs: Uses about 8 photos/issue; all supplied by freelance photographers. Model release preferred.
Making Contact & Terms: Interested in receiving work from newer, lesser-known photographers. Send cover letter and b&w prints by mail for consideration. SASE. Reports in 2 months. Pays $50-200/b&w cover and inside photos. Pays on publication. Credit line given. Buys one-time rights; negotiable. Previously published work OK.
Tips: Looks for "artful and sensitive photographs that are not overly sentimental. We use many photos of people. All the photographs we publish come to us as unsolicited submissions."

SUPER FORD, 3816 Industry Blvd., Lakeland FL 33811. (941)644-0449. Managing Editor: Steve Turner. Circ. 65,000. Estab. 1977. Monthly magazine. Emphasizes high-performance Ford automobiles. Readers are males, ages 18-40, all occupations. Sample copy free with 11×14 SASE and 8 first-class stamps.
Needs: Uses 75 photos/issue; 30-40 supplied by freelancers. Needs photos of high performance Fords. Model/property release preferred. Captions required.
Making Contact & Terms: Interested in receiving work from newer, lesser-known photographers. Send unsolicited photos by mail for consideration. Provide résumé, business card, brochure, flier or tearsheets to be kept on file for possible assignments. Send 5×7 glossy color or b&w prints; 35mm, $2\frac{1}{4} \times 2\frac{1}{4}$ transparencies. Does not keep samples on file. SASE. Reports in 1 month, "can be longer." Pays $200/ day; $65/color inside photo; $45/b&w inside photo. Pays on publication. Credit line given. Buys one-time rights; negotiable.
Tips: "Do not park/pose cars on grass."

THE SURGICAL TECHNOLOGIST, 7108-C S. Alton Way, Englewood CO 80112. (303)694-9130. Managing Editor: Kathy Poppen. Circ. 18,500. Publication of the Association of Surgical Technologists. Monthly. Emphasizes surgery. Readers are "20-60 years old, operating room professionals, well educated in surgical procedures." Sample copy free with 9×12 SASE and 5 first-class stamps. $1.25 postage. Photo guidelines free with SASE.
Needs: Needs "surgical, operating room photos that show members of the surgical team in action." Model release required.
Making Contact & Terms: Query with samples. Submit portfolio for review. Send 5×7 or $8\frac{1}{2} \times 11$ glossy or matte prints; 35mm, $2\frac{1}{4} \times 2\frac{1}{4}$ or 4×5 transparencies; b&w or color contact sheets; b&w or color negatives by mail for consideration. Provide résumé, business card, brochure, flier or tearsheets to be kept on file for possible future assignments. SASE. Reports in 4 weeks after review by Editorial Board. Pays $25/b&w inside photo; $50/color inside photo. **Pays on acceptance.** Credit line given. Buys one-time rights. Simultaneous submissions and previously published work OK.

TAMPA REVIEW, The University of Tampa, 19F, Tampa FL 33606-1490. (813)253-6266. Editor: Richard B. Mathews. Circ. 750. Estab. 1988. Semiannual literary magazine. Emphasizes literature and art. Readers are intelligent, college level. Sample copy $5. Photo guidelines free with SASE.
• *Tampa Review* currently reproduces all images via in-house scans, stores images on SyQuest removable hard disks and color-corrects or retouches with Photoshop.
Needs: Uses 6 photos/issue; 100% supplied by freelancers. Needs photos of artistic, museum-quality images. Photographer must hold rights, or release. "We have our own release form if needed." Photo captions required.
Making Contact & Terms: Interested in receiving work from newer, lesser-known photographers. Provide résumé, business card, brochure, flier or tearsheets to be kept on file for possible assignments. Send b&w, color prints "suitable for vertical 6×8 or 6×9 reproduction." SASE. Reports by end of April. Pays $10/image. Pays on publication. Credit line given. Buys first North American serial rights.
Tips: "We are looking for artistic photography, not for illustration, but to generally enhance our magazine. We will consider paintings, prints, drawings, photographs, or other media suitable for printed reproduction. Submissions should be made in February and March for publication the following year."

TENNIS WEEK, 341 Madison Ave., New York NY 10017. (212)808-4750. Publisher: Eugene L. Scott. Managing Editors: Heather Holland, Kim Kodl and Merrill Shafer. Circ. 80,000. Biweekly. Readers are "tennis fanatics." Sample copy $4 current issue, $5 back issue.
Needs: Uses about 16 photos/issue. Needs photos of "off-court color, beach scenes with pros, social

scenes with players, etc." Emphasizes originality. Subject identification required.

Making Contact & Terms: Send actual 8×10 or 5×7 b&w photos by mail for consideration. SASE. Reports in 2 weeks. Pays $50/b&w photo; $150/color cover. Pays on publication. Credit line given. Rights purchased on a work-for-hire basis.

TEXAS FISH & GAME, 7600 W. Tidwell, Suite 708, Houston TX 77040. (713)690-3474. Fax: (713)690-4339. Editor: Larry Bozka. Circ. 100,000. Estab. 1983. Magazine published 10 times/year; November/December and June/July are double issues. Features all types of hunting and fishing. Must be Texas only. Photo guidelines free with SASE.

Needs: Uses 20-30 photos/issue; 80% supplied by freelance photographers. Needs photos of fish: action, close up of fish found in Texas; hunting: Texas hunting and game of Texas. Model release preferred. Captions required.

Making Contact & Terms: Interested in receiving work from newer, lesser-known photographers. Query with list of stock photo subjects. SASE. Reports in 1 month. Pays $200-300/color cover photo and $50-100/color inside photos. Pays on publication. Credit line given. Buys one-time rights.

Tips: "Query first. Ask for guidelines. No black & white used. For that 'great' shot, prices will go up. Send best shots and only subjects the publication you're trying to sell uses."

TEXAS GARDENER, P.O. Box 9005, Waco TX 76714. (817)772-1270. Fax: (817)772-9696. Editor/Publisher: Chris S. Corby. Managing Editor: Vivian Whatley. Circ. 35,000. Bimonthly. Emphasizes gardening. Readers are "65% male, home gardeners, 98% Texas residents." Sample copy $2.95.

Needs: Uses 20-30 photos/issue; 90% supplied by freelance photographers. Needs "color photos of gardening activities in Texas." Special needs include "cover photos shot in vertical format. Must be taken in Texas." Model release preferred. Captions required.

Making Contact & Terms: Query with samples. SASE. Reports in 3 weeks. Pays $100-200/color cover photo; $5-15/b&w inside photo; $25-100/color inside photo. Pays on publication. Credit line given. Buys one-time rights.

Tips: "Provide complete information on photos. For example, if you submit a photo of watermelons growing in a garden, we need to know what variety they are and when and where the picture was taken. Also, ask for a copy of our editorial calendar. Then use it in selecting images to send us on speculation."

TEXAS HIGHWAYS, P.O. Box 141009, Austin TX 78714. (512)483-3675. Editor: Jack Lowry. Photo Editor: Michael A. Murphy. Circ. 380,000. Monthly. "*Texas Highways* interprets scenic, recreational, historical, cultural and ethnic treasures of the state and preserves the best of Texas heritage. Its purpose is to educate and entertain, to encourage recreational travel to and within the state, and to tell the Texas story to readers around the world." Readers are 45 and over (majority); $24,000 to $60,000/year salary bracket with a college education. Sample copy and photo guidelines free.

Needs: Uses about 60-70 photos/issue; 50% supplied by freelance photographers. Needs "travel and scenic photos in Texas only." Special needs include "fall, winter, spring and summer scenic shots and wildflower shots (Texas only)." Captions required; include location, names, addresses and other useful information.

Making Contact & Terms: Interested in receiving work from newer, lesser-known photographers. Query with samples. Provide business card and tearsheets to be kept on file for possible future assignments. "We take only color originals, 35mm or larger transparencies. No negatives." SASE. Reports in 1 month. Pays $120/half-page color inside photo; $170/full-page color photo; $400/front cover photo. Pays on publication. Credit line given. Buys one-time rights. Simultaneous submissions OK.

Tips: "Know our magazine and format. We accept only high-quality, professional level work—no snapshots. Interested in a photographer's ability to edit their own material and the breadth of a photographer's work. Look at 3-4 months of the magazine. Query not just for photos but with ideas for new/unusual topics."

TEXAS MONTHLY, P.O. Box 1569, Austin TX 78767. (512)320-6900. *Texas Monthly* is edited for the urban Texas audience and covers the state's politics, sports, business, culture and changing lifestyles. It contains lengthy feature articles, reviews and interviews and presents critical analysis of popular books, movies and plays. This magazine did not respond to our request for information. Query before submitting.

TEXAS REALTOR MAGAZINE, P.O. Box 2246, Austin TX 78768. (512)370-2286. Fax: (512)370-2390. Art Director: Lauren Levi. Circ. 43,000. Estab. 1972. Publication of the Texas Association of Realtors. Monthly magazine. Emphasizes real estate sales and related industries. Readers are male and female realtors, ages 20-70. Sample copy free with SASE.

Needs: Uses 10 photos/issue; all supplied by freelancers. Needs photos of architectural details, business,

office management, telesales, real estate sales, commercial real estate, nature. Especially wants to see architectural detail and landscape for covers. Property release required.

Making Contact & Terms: Interested in receiving work from newer, lesser-known photographers. Pays $75-300/color photo; $1,500/job. Buys one-time rights; negotiable.

THANATOS, P.O. Box 6009, Tallahassee FL 32314. (904)224-1969. Fax: (904)224-7965. Editor: Jan Scheff. Circ. 6,000. Estab. 1975. Quarterly journal. Covers death, dying and bereavement. Readers include health-care professionals, thanatologists, clergy, funeral directors, counselors, support groups, volunteers, bereaved family members, students, et al. Photo guidelines free with SASE.

Needs: Uses 6 photos/issue; all supplied by freelancers. Needs many b&w scenic and people shots to accompany articles. Also, full-color scenics to illustrate seasons for each quarterly edition. Model release required. Captions preferred.

Making Contact & Terms: Query with list of stock photo subjects. Provide résumé, business card, brochure, flier or tearsheets to be kept on file for possible assignment. Cannot return material. Reports in 2 months. Pays $100/color cover photo; $50/b&w inside photo. Buys all rights. Simultaneous submissions OK.

‡THIN AIR MAGAZINE, P.O. Box 23549, Flagstaff AZ 86002. (520)523-6743. Fax: (520)523-7074. E-mail: jdh4@dana.ucc.nau.edu. Production Editors: Lisa Biggar and Dan Crawley. Circ. 500. Estab. 1995. Biannual magazine of the Graduate Student Creative Writing Association. Emphasizes arts and literature— poetry, fiction and essays. Readers are collegiate, academic, writerly adult males and females interested in arts and literature. Sample copy $4.95.

Needs: Uses 2-4 photos/issue; all supplied by freelancers. Needs scenic/wildlife shots and b&w photos that portray a statement or tell a story. Looking for "a b&w cover shot that illustrates 'The Right Kind of Trouble,' our subtitle." Model/property release preferred for nudes. Captions preferred; include name of photographer, date of photo.

Making Contact & Terms: Send unsolicited photos by mail for consideration. Send 8×10 b&w prints. Photos accepted August-May only. Keeps samples on file. SASE. Reports in 1 month. Pays with 2 contributor's copies. Credit line given. Buys one-time rights. Simultaneous submissions and previously published work OK.

TIDE MAGAZINE, 4801 Woodway, Suite 220 W, Houston TX 77056. (713)626-4222. Fax: (713)961-3801. Editor: Doug Pike. Circ. 50,000. Estab. 1979. Publication of the Coastal Conservation Association. Bimonthly magazine. Emphasizes coastal fishing, conservation issues. Readers are mostly male, ages 25-50, coastal anglers and professionals.

Needs: Uses 16-20 photos/issue; 12-16 supplied by freelancers. Needs photos of Gulf and Atlantic coastal activity, recreational fishing and coastal scenics, tight shots of fish (saltwater only). Model/property release preferred. Captions not required, but include names, dates, places and specific equipment or other key information.

Making Contact & Terms: Interested in receiving work from newer, lesser-known photographers. Query with stock photo list. SASE. Reports in 1 month. Pays $100/color cover photo; $50/color inside photo; $25/b&w inside photo; $250/photo/text package. Pays on publication. Credit line given. Buys one-time rights; negotiable. Simultaneous submissions and/or previously published work OK.

Tips: Wants to see "fresh twists on old themes—unique lighting, subjects of interest to my readers. Take time to discover new angles for fishing shots. Avoid the usual poses, i.e. 'grip-and-grin.' We see too much of that already."

TIKKUN, 26 Fell St., San Francisco CA 94102. (415)575-1200. Fax: (415)281-0832. Production Manager: Jodi Perelman. Circ. 40,000. Estab. 1986. Bimonthly journal. Publication is a political, social and cultural Jewish critique. Readers are 75% Jewish, white, middle-class, literary people ages 30-60.

Needs: Uses 10 photos/issue; 50% supplied by freelancers. Needs political; social; commentary; Middle Eastern; US photos. Reviews photos with or without ms.

Making Contact & Terms: Send unsolicited photos by mail for consideration. Uses b&w "or good photo copy" prints. Keeps samples on file. SASE. Reporting time varies. "Turnaround is 4 months, unless artist specifies other." Pays $40/b&w inside photo. Pays on publication. Credit line given. Buys all rights; negotiable. Simultaneous submissions and/or previously published work OK.

Tips: "Read or look at magazine before sending photos."

TIME, Time Inc., Time/Life Building, 1271 Avenue of the Americas, New York NY 10020. (212)522-1212. *TIME* is edited to report and analyze a complete and compelling picture of the world, including national and world affairs, news of business, science, society and the arts, and the people who make the

news. This magazine did not respond to our request for information. Query before submitting.

‡TMB PUBLICATIONS, P.O. Box 1156, Lake Oswego OR 97035. (503)236-2524. Fax: (503)620-3808. Website: http://www.dank@touthrunner.com. Editor: Dan Kesterson. Circ. 100,000. Estab. 1996. Quarterly magazine and website. Emphasizes track and cross country and road racing for young athletes, 8-18. Sample copy free with 9×12 SASE and 5 first-class stamps. Photo guidelines free with SASE.
Needs: Uses 30-50 photos/issue. Needs action shots from track and cross country meets and indoor meets. Model release preferred. Property release required. Captions required.
Making Contact & Terms: Send unsolicited photos by mail for consideration. Provide résumé, business card, brochure, flier or tearsheets to be kept on file for possible assignments. Call. Send transparencies; digital format. Keeps samples on file. SASE. Reports in 1 month. Payment negotiable. Credit line given. Buys all and electronic rights. Simultaneous submissions OK.
Tips: "We prefer high quality digital photos. Fax to let us know what kind of equipment you're using, to see if compatible."

TODAY'S MODEL, P.O. Box 205-454, Brooklyn NY 11220. (718)651-8523. Fax: (718)651-8863. Publisher: Sumit Arya. Circ. 100,000. Estab. 1993. Monthly magazine. Emphasizes modeling and performing arts. Readers are male and female ages 13-28, parents of kids 1-12. Sample copy $3 with 9×12 SAE and 10 first-class stamps.
Needs: Uses various number photos/issue. Needs photos of fashion—studio/on location/runway; celebrity models, performers, beauty and hair—how-to; photojournalism—modeling, performing arts. Reviews photos with or without ms. Needs models of all ages. Model/property release required. Captions preferred; include name and experience (résumé if possible).
Making Contact & Terms: Interested in receiving work from newer, lesser-known photographers. Provide résumé, sample photos, promo cards, business card, brochure, flier or tearsheets to be kept on file for possible future assignments. Keeps samples on file. Reports only when interested. Payment negotiable. Pays on publication. Buys all rights; negotiable. Considers simultaneous submissions and/or previously published work.

TODAY'S PHOTOGRAPHER INTERNATIONAL, P.O. Box 18205, Washington DC 20036. (910)945-9867. Photography Editor: Vonda H. Blackburn. Circ. 131,000. Estab. 1986. Bimonthly magazine. Emphasizes making money with photography. Readers are 90% male photographers. For sample copy, send 9×12 SAE. Photo guidelines free with SASE.
Needs: Uses 40 photos/issue; all supplied by freelance photographers. Model release required. Photo captions preferred.
Making Contact & Terms: Send 35mm, 2¼×2¼, 4×5, 8×10 b&w and color prints or transparencies by mail for consideration. SASE. Reports at end of the quarter. Payment negotiable. Credit line given. Buys one-time rights, per contract. Simultaneous submissions and previously published work OK.
Tips: Wants to see "consistently fine-quality photographs and good captions or other associated information. Present a portfolio which is easy to evaluate—keep it simple and informative. Be aware of deadlines. Submit early."

TOTAL TV, 570 Lexington Ave., 17th Floor, New York NY 10022. (212)750-6116. Fax: (212)750-6235. Photo Editor: Cherie Cincilla. Weekly magazine. Emphasizes movie and TV personalities, sports figures, musicians, nature.
 • *Total TV* is online on Prodigy and has its own Website.
Needs: Uses 30 photos/issue; all supplied by freelancers. Needs photos of personalities or TV and movie coverage. Reviews photos with or without ms. Model/property release preferred. Captions preferred.
Making Contact & Terms: Interested in receiving work from newer, lesser-known photographers. Accepts digital files in SyQuest. SASE. Reports in 1-2 weeks. Pays $75 minimum/photo (b&w or color); $500-2,000/job. **Pays on acceptance.** Credit line given. Simultaneous submissions and/or previously published work OK.

TOUCH, P.O. Box 7259, Grand Rapids MI 49510. (616)241-5616. Managing Editor: Carol Smith. Circ. 15,500. Estab. 1970. Publication of Gems/Calvinettes. Monthly. Emphasizes "girls 7-14 in action. The magazine is a Christian girls' publication geared to the needs and activities of girls in the above age group." Readers are "Christian girls ages 7-14; multiracial." Sample copy and photo guidelines for $1 with 9×12 SASE. "Also available is a theme update listing all the themes of the magazine for one year."
Needs: Uses about 5-6 photos/issue. Needs "photos suitable for illustrating stories and articles: photos of girls aged 7-14 from multicultural backgrounds involved in sports, Christian service and other activities young girls would be participating in." Model/property release preferred.

Making Contact & Terms: Interested in receiving work from newer, lesser-known photographers. Send 5×7 glossy color prints by mail for consideration. SASE. Reports in 2 months. Pays $30-40/photo; $50/cover. Pays on publication. Credit line given. Buys one-time rights. Simultaneous submissions OK.

Tips: "Make the photos simple. We prefer to get a spec sheet rather than photos and we'd really like to hold photos sent to us on speculation until publication. We select those we might use and send others back. Freelancers should write for our annual theme update and try to get photos to fit the theme of each issue." Recommends that photographers "be concerned about current trends in fashions and hair styles and that all girls don't belong to 'families.' " To break in, "a freelancer can present a selection of his/her photography of girls, we'll review it and contact him/her on its usability."

TRACK & FIELD NEWS, 2570 El Camino Real, Suite 606, Mountain View CA 94040. (415)948-8417. Fax: (415)948-9445. E-mail: tfnmail@aol.com. Website: http://www.trackandfieldnews.com. Associate Editor (Features/Photography): Jon Hendershott. Circ. 35,000. Estab. 1948. Monthly magazine. Emphasizes national and world-class track and field competition and participants at those levels for athletes, coaches, administrators and fans. Sample copy free with 9×12 SAE. Free photo guidelines.

Needs: Buys 10-15 photos/issue; 75% of freelance photos on assignment, 25% from stock. Wants on a regular basis, photos of national-class athletes, men and women, preferably in action. "We are always looking for quality pictures of track and field action, as well as offbeat and different feature photos. We always prefer to hear from a photographer before he/she covers a specific meet. We also welcome shots from road and cross-country races for both men and women. Any photos may eventually be used to illustrate news stories in *T&FN*, feature stories in *T&FN* or may be used in our other publications (books, technical journals, etc.). Any such editorial use will be paid for, regardless of whether material is used directly in *T&FN*. About all we don't want to see are pictures taken with someone's Instamatic or Polaroid. No shots of someone's child or grandparent running. Professional work only." Captions required; include subject name, meet date/name.

Making Contact & Terms: Interested in receiving work from newer, lesser-known photographers. Query with samples or send material by mail for consideration. Prefers 8×10 glossy b&w prints; 35mm transparencies, although color prints are acceptable. Accepts images in digital format for Mac (limited use). Send via compact disc, online, floppy disk, Zip disk. SASE. Reports in 7-10 days. Pays $25/b&w inside photo; $60/color inside photo ($100/interior color); full pages $175/color cover photo. Payment is made bimonthly. Credit line given. Buys one-time rights.

Tips: "No photographer is going to get rich via *T&FN*. We can offer a credit line, nominal payment and, in some cases, credentials to major track and field meets to enable on-the-field shooting. Also, we can offer the chance for competent photographers to shoot major competitions and competitors up close, as well as being the most highly regarded publication in the track world as a forum to display a photographer's talents."

TRAFFIC SAFETY, 1121 Spring Lake Dr., Itasca IL 60143. (630)775-2278. Fax: (630)775-2285. Acting Publisher: John H. Kennedy. Editor: John Jackson. Circ. 17,000. Publication of National Safety Council. Bimonthly. Emphasizes highway and traffic safety, accident prevention. Readers are professionals in highway-related fields, including law-enforcement officials, traffic engineers, fleet managers, state officials, driver improvement instructors, trucking executives, licensing officials, community groups, university safety centers.

• *Traffic Safety* uses computer manipulation for cover shots.

Needs: Uses about 10 photos/issue; most supplied by freelancers. Needs photos of road scenes, vehicles, driving; specific needs vary.

Making Contact & Terms: Query with four-color and/or b&w prints. SASE. Reports in 2 weeks. Pays $100-1,000/cover. **Pays on acceptance**. Credit line given.

TRANSITIONS ABROAD, 18 Hulst Rd., P.O. Box 1300, Amherst MA 01004. Fax: (413)256-0373. E-mail: trabroad@aol.com. Editor: Clay Hubbs. Circ. 20,000. Estab. 1977. Bimonthly magazine. Emphasizes special interest travel. Readers are people interested in cultural travel and learning, living, or working abroad, all ages, both sexes. Sample copy $6.25. Photo guidelines free with SASE.

Needs: Uses 10 photos/issue; all supplied by freelancers. Needs photos of travelers in international settings or the people of other countries. Each issue has an area focus: January/February—Asia and the Pacific Rim; March/April—Europe and the former Soviet Union; May/June—The Americas and Africa (South of the Sahara); November/December—The Mediterranean Basin and the Near East. Captions preferred.

Making Contact & Terms: Interested in receiving work from newer, lesser-known photographers. Query with list of stock photo subjects. Send unsolicited 8×10 b&w prints by mail for consideration. Prefers b&w; sometimes uses color photos; rarely uses transparencies. SASE. Reports in 6 weeks. Pays $25-50/inside photo; $125/b&w cover photo. Pays on publication. Credit line given. Buys one-time rights. Simultaneous submissions and previously published work OK.

Tips: In freelance photographer's samples, wants to see "mostly people in action shots—travelers and people of other countries. We use very few landscapes or abstract shots."

TRANSPORT TOPICS, 2200 Mill Rd., Alexandria VA 22314. (703)838-1735. Fax: (703)548-3662. Website: http://www.ttnews.com. Chief Photographer: Michael James. Circ. 31,000. Estab. 1935. Publication of the American Trucking Associations. Weekly tabloid. Emphasizes the trucking industry. Readers are male executives 35-65.
Needs: Uses approximately 12 photos/issue; amount supplied by freelancers "depends on need." Needs photos of truck transportation in all modes. Model/property release preferred. Captions preferred.
Making Contact & Terms: Interested in receiving work from newer, lesser-known photographers. Send unsolicited 35mm or 2¼×2¼ transparencies by mail for consideration. Provide résumé, business card, brochure, flier or tearsheets to be kept on file for possible assignments. Does not keep samples on file. SASE. Reports in 1 month. Payment negotiable. Pays standard "market rate" for color cover photo. **Pays on acceptance.** Credit line given. Buys one-time rights; negotiable. Simultaneous submissions and previously published work OK.
Tips: "Trucks/trucking must be dominant element in the photograph—not an incidental part of an environmental scene."

TRAVEL & LEISURE, 1120 Avenue of the Americas, New York NY 10036. (212)382-5600. Editor: Nancy Novogrod. Art Director: Pamela Berry. Circ. 1.2 million. Monthly magazine. Emphasizes travel destinations, resorts, dining and entertainment.
Needs: Nature, still life, scenic, sport and travel. Does not accept unsolicited photos. Model release required. Captions required.
Making Contact & Terms: Uses 8×10 semigloss b&w prints; 35mm, 2¼×2¼, 4×5 and 8×10 transparencies, vertical format required for cover. Pays $200-500/b&w photo; $200-500/color photo; $1,000/cover photo or negotiated. Sometimes pays $450-1,200/day; $1,200 minimum/complete package. Pays on publication. Credit line given. Buys first world serial rights, plus promotional use. Previously published work OK.
Tips: Seeing trend toward "more editorial/journalistic images that are interpretive representations of a destination."

***TRAVELLER**, 45-49 Brompton Road, London SW3 1DE Great Britain. (0171)581-4130. Fax: (0171)581-1357. Managing Editor: Miranda Haines. Circ. 35,000. Quarterly. Readers are predominantly male, professional, age 35 and older. Sample copy £2.50.
Needs: Uses 30 photos/issue; all supplied by freelancers. Needs photos of travel, wildlife. Reviews photos with or without ms. Captions preferred.
Making Contact & Terms: Interested in receiving work from newer, lesser-known photographers. Send 35mm transparencies. Does not keep samples on file. SASE. Reports in 1 month. Pays £50/color cover photo; £25/color inside photo. Pays on publication. Buys one-time rights.
Tips: Looks for "original, quirky shots with impact, which tell a story."

TROUT: The Voice of America's Trout and Salmon Anglers, 1500 Wilson Blvd., Suite 310, Arlington VA 22209-2404. (703)522-0200. Fax: (703)284-9400. E-mail: trout@tu.org. Website: http://www.tu.org/trout. Editor: Peter Rafle. Circ. 98,000. Estab. 1959. Quarterly magazine. Emphasizes conservation and restoration of America's trout and salmon species and the streams and rivers they inhabit. Readers are conservation-minded anglers, primarily male, with an average age of 46. Sample copy free with 9×12 SAE and 4 first-class stamps. Photo guidelines free with SASE.
Needs: Uses 25-50 photos/issue; 100% supplied by freelancers. Needs photos of trout and salmon, trout and salmon angling, conservation issues. Special photo needs include endangered species of trout and salmon; Pacific and Atlantic salmon. Model/property release required. Captions preferred; include species of fish; if angling shot: location (river/stream, state, name of park or wilderness area).
Making Contact & Terms: Interested in receiving work from newer, lesser-known photographers. Query with résumé of credits. Deadlines: Spring, 2/1; Summer, 5/1; Fall, 8/1; Winter, 11/1. Does not keep samples

✳ INTERNATIONAL MARKETS, those located outside of the United States and Canada, are marked with an asterisk.

on file. SASE. Reports in 2 months. Pays $500/color cover photo; $500/b&w cover photo; $150-350/color inside photo; $150-350/b&w inside photo. Pays on publication. Credit line given. Buys first North American serial rights; negotiable. Simultaneous submissions OK.

Tips: "If the fish in the photo could not be returned to the water alive with a reasonable expectation it would survive, we will not run the photo. The exception is when the photo is explicitly intended to represent 'what not to do.' "

TRUE WEST, P.O. Box 2107, Stillwater OK 74076. (405)743-3370. Fax: (405)743-3374. Editor: Marcus Huff. Circ. 30,000. Estab. 1953. Monthly magazine. Emphasizes "history of the Old West (1830 to about 1915)." Readers are "people who like to read the history of the West, mostly male, age 45 and older." Sample copy $2 with 9×12 SAE. Photo guidelines free with SASE.

Needs: Uses about 50 or more photos/issue; almost all are supplied by freelance photographers. Needs "mostly Old West historical subjects, some travel, some scenic, (ghost towns, old mining camps, historical sites). We prefer photos with ms." Special needs include western wear; cowboys, rodeos, western events. Captions required; include name and location of site.

Making Contact & Terms: Interested in receiving work from newer, lesser-known photographers. Query with samples—b&w only for inside; color for covers. Query with stock photo list. Send unsolicited photos by mail for consideration. SASE. Reports in 1 month. Pays $100-175/color cover photo; $10-25/color inside photo; $10-25/b&w inside photo. **Pays on acceptance**; cover photos on publication. Credit line given. Buys first North American serial rights.

Tips: Prefers to see "transparencies of existing artwork as well as scenics for cover photos. Scenics should be free of modern intrusions such as buildings, powerlines, highways, etc. Inside photos need to tell story associated with the Old West. Most of our photos are used to illustrate stories and come with manuscripts; however, we will consider other work, scenics, historical sites, old houses. Even though we are Old West history, we do need current photos, both inside and for covers—so don't hesitate to contact us."

TURKEY CALL, P.O. Box 530, Edgefield SC 29824. Parcel services: 770 Augusta Rd. (803)637-3106. Fax: (803)637-0034. Publisher: National Wild Turkey Federation, Inc. (nonprofit). Editor: Jay Langston. Circ. 132,000. Estab. 1973. Bimonthly magazine. For members of the National Wild Turkey Federation—people interested in conserving the American wild turkey. Sample copy $3 with 9×12 SASE. Contributor guidelines free with SASE.

Needs: Buys at least 50 photos/year. Needs photos of "wild turkeys, wild turkey hunting, wild turkey management techniques (planting food, trapping for relocation, releasing), wild turkey habitat." Captions required.

Making Contact & Terms: Interested in receiving work from newer, lesser-known photographers. Send copyrighted photos to editor for consideration. Send 8×10 glossy b&w prints; color transparencies, any format; prefers originals, 35mm accepted. SASE. Reports in 6 weeks. Pays $35 minimum/b&w photo; maximum $200/inside color photo; $400/cover. **Pays on acceptance.** Credit line given. Buys one-time rights.

Tips: Wants no "poorly posed or restaged shots, mounted turkeys representing live birds, domestic turkeys representing wild birds or typical hunter-with-dead-bird shots. Photos of dead turkeys in a tasteful hunt setting are considered. Keep the acceptance agreement/liability language to a minimum. It scares off editors and art directors." Sees a trend developing regarding serious amateurs who are successfully competing with pros. "Newer equipment is partly the reason. In good light and steady hands, full auto is producing good results. I still encourage tripods, however, at every opportunity."

TV GUIDE, News America Publications, Inc., Four Radnor Corporate Center, Radnor PA 19088. (610)293-8500. Fax: (610)293-6216. *TV Guide* watches television with an eye for how TV programming affects and reflects society. It looks at the shows, the stars and covers the medium's impact on news, sports, politics, literature, the arts, science, and social issues through reports, profiles, features and commentaries. This magazine uses staff members to shoot photos.

U. THE NATIONAL COLLEGE MAGAZINE, 1800 Century Park E., Suite 820, Los Angeles CA 90067. (310)551-1381. Fax: (310)551-1659. E-mail: editor@umagazine.com; umagazine@aol.com. Website: http://www.umagazine.com. Editor: Frances Huffman. Circ. 1.5 million. Estab. 1987. Monthly magazine. Emphasizes college. Readers are college students at 400 schools nationwide. Sample copy free for 9×12 SAE with 3 first-class stamps.

Needs: Uses 15 photos/issue; all supplied by student freelancers. Needs color feature shots of students, college life and student-related shots. Model release preferred. Captions required that include name of subject, school.

Making Contact & Terms: Interested in receiving work from newer, lesser-known photographers. Send unsolicited photos by mail for consideration. Provide résumé or tearsheets to be kept on file for possible

assignments. Send any size color prints; 35mm, $2\frac{1}{4} \times 2\frac{1}{4}$, 4×5, 8×10, but prefers color slides. Also uses photo illustrations, collages, etc. Accepts digital images on disk (Mac) or via e-mail, Illustrator or Photoshop. Files should be 220 dpi minimum TIFF or EPS format, CMYK color. Must include all fonts if any used. "Send samples and we will commission shots as needed." Keeps sample on file. Reports in 3 weeks. Pays $100/color cover photo; $25/color inside photo. Pays on publication. Credit line given. Buys all rights. Simultaneous submissions and previously published work OK.

Tips: "We look for photographers who can creatively capture the essence of life on campus. Also, we need light, bright photos since we print on newspaper. We are looking for photographers who are college students."

U.S.A. SOFTBALL MAGAZINE, (formerly Amateur Softball Association), 2801 NE 50th St., Oklahoma City OK 73111. (405)425-3463. Director of Communications: Ronald A. Babb. Promotion of amateur softball. Photos used in newsletters, newspapers, association magazine.

Needs: Buys 10-12 photos/year; offers 5-6 assignments annually. Subjects include action sports shots. Model release required. Captions required.

Making Contact & Terms: Contact ASA national office first before doing any work. Uses prints or transparencies. SASE. Reports in 2 weeks. Pays $50 for previously published photo. Assignment fees negotiable. Credit line given. Buys all rights.

UNITY MAGAZINE, 1901 NW Blue Pkwy., Unity Village MO 64065. Editor: Philip White. Associate Editor: Janet McNamara. Circ. 120,000. Estab. 1889. Monthly magazine. Emphasizes spiritual, metaphysical, self-help, healing articles and poetry. Free sample copy and photo guidelines for 6×9 SASE.

Needs: Uses 6-10 photos/issue. Buys 100 photos/year, 10% from freelancers. Wants on a regular basis people and nature scenics. Model release required. Captions required, include location for scenics and ethnic clothed people. Stock numbers required.

Making Contact & Terms: Interested in receiving work from newer, lesser-known photographers. Send insured material by mail for consideration. No calls in person or by phone. Uses 4×5 or 2×2 color transparencies. Vertical format required for cover. *Send SAE and check or money order for return postage. Do not send stamps or stamped envelopes. Return postage must be included for photographs to be returned.* There is a 7-8 month lead time for seasonal material. Reports in 2 months. Pays $220/cover, $110 inside color photo. **Pays on acceptance.** Credit line given. Buys first North American serial rights.

Tips: "Don't overwhelm us with hundreds of submissions at a time. We look for nature scenics, human interest, photos of active people. We are looking for photos with a lot of color and contrast."

‡UNO MAS MAGAZINE, P.O. Box 1832, Silver Spring MD 20915. Fax: (301)770-3250. E-mail: unomasmag@aol.com. Editor: Jim Saah. Circ. 3,500. Estab. 1990. Quarterly magazine. Emphasizes pop culture: Music, film, literture, fine art drawings and photography. Readers are male and female, ages 25-40. Sample copy $3. Photo guidelines free with SASE.

Needs: Uses 15-30 photos/issue; half supplied by freelancers. We publish a wide array of photography: Fine art, documentary, photojournalism, portraiture etc. So the guidelines are wide open. We only ask that you submit b&w images no larger than 11×14. Model/property release preferred. Captions required; include names, place and dates.

Making Contact & Terms: Interested in receiving work from newer, lesser-known photographers. Query with résumé of credits. Send unsolicited photos by mail for consideration. Provide résumé, business card, brochure, flier or tearsheets to be kept on file for possible assignments. Send 11×14 or smaller b&w prints; 35mm transparencies; digital format (high-resolution scans on disk). "We will never digitally alter any photo submitted without the photographer's consent. *Uno Mas* is an arts magazine. We pay with issues of the finished magazine; 2 issues to each contributor, more for artists trying to get their work published." Pays on publication. Credit line given. Simultaneous submissions and/or previously published work OK. "We also publish photographs on our website. Please state if you rather not have your photographs appear on the web when you submit. Otherwise we may consider publishing them on our site. http://www.dallas.-net/~gregp/um/unomas.html."

♣UP HERE, P.O. Box 1350, Yellowknife, Northwest Territories X1A 2N9 Canada. (403)920-4343. Fax: (403)873-2844. E-mail: outcrop@internorth.com. Editor: R. Allerston. Circ. 35,000. Estab. 1984. Bi-monthly magazine. Emphasizes Canada's north. Readers are white collar men and women ages 30 to 60. Sample copy $3 and 9×12 SAE. Photo guidelines free with SASE.

Needs: Uses 20-30 photos/issue; 90% supplied by freelance photographers. Purchases photos with and without accompanying ms. Captions required.

Making Contact & Terms: Provide résumé, business card, brochure, flier or tearsheets to be kept on file for possible assignments. Accepts images in digital format for Mac. Send via compact disc, online, SyQuest 88, Zip disk (contact magazine for specs). SASE. Reports in 2 months. Pays $35-100/b&w photo;

$50-150/color photo; $150-500/cover. Pays on publication. Credit line given. Buys one-time rights.

Tips: "We are a *people* magazine. We need northern subjects—lots of faces. We're moving more into outdoor adventure—soft type, as they say in the industry—and wildlife. Few scenics as such. We approach local freelancers for given subjects, but are building a library. We can't always make use of photos alone, but a photographer could profit by sending sheets of dupes for our stock files." Wants to see "sharp, clear photos, good color and composition. We always need verticals to consider for the cover, but they usually tie in with an article inside."

V.F.W. MAGAZINE, 406 W. 34th St., Kansas City MO 64111. (816)756-3390. Fax: (816)968-1169. Editor: Richard Kolb. Art Director: Robert Widener. Circ. 2.2 million. Monthly magazine, except July. For members of the Veterans of Foreign Wars (V.F.W.)—men and women who served overseas, and their families. Sample copy free with SAE and 2 first-class stamps.

Needs: Photos illustrating features on current defense and foreign policy events, veterans issues and, accounts of "military actions of consequence." Photos purchased with or without accompanying ms. Present model release on acceptance of photo. Captions required.

Making Contact & Terms: Interested in receiving work from newer, lesser-known photographers. Uses mostly color prints and transparencies but will consider b&w. "Cover shots must be submitted with a ms. Price for cover shot will be included in payment of manuscript." SASE. Reports in 1 month. Pays $250 minimum. Pays $25-50/b&w photo; $35-250/color photo. **Pays on acceptance.** Buys one-time and all rights; negotiable.

Tips: "Go through an issue or two at the local library (if not a member) to get the flavor of the magazine." When reviewing samples "we look for familiarity with the military and ability to capture its action and people. We encourage military photographers to send us their best work while they're still in the service. Though they can't be paid for official military photos, at least they're getting published by-lines, which is important when they get out and start looking for jobs."

VANITY FAIR, Conde Nast Building, 350 Madison Ave., New York NY 10017. (212)880-8800. Photography Director: Susan White. Monthly magazine.

Needs: 50% of photos supplied by freelancers. Needs portraits. Model/property release required for everyone. Captions required for photographer, styles, hair, makeup, etc.

Making Contact & Terms: Interested in receiving work from newer, lesser-known photographers. Contact through rep. Submit portfolio for review. Provide résumé, business card, brochure, flier or tearsheets to be kept on file for possible assignments. Reports in 1-2 weeks. Payment negotiable. Pays on publication.

Tips: "We solicit material after a portfolio drop. So, really we don't want unsolicited material."

VERMONT LIFE, 6 Baldwin St., Montpelier VT 05602. (802)828-3241. Editor: Tom Slayton. Circ. 90,000. Estab. 1946. Quarterly magazine. Emphasizes life in Vermont: its people, traditions, way of life, farming, industry and the physical beauty of the landscape for "Vermonters, ex-Vermonters and would-be Vermonters." Sample copy $5 with 9 × 12 SAE. Free photo guidelines.

Needs: Buys 30 photos/issue; 90-95% supplied by freelance photographers, 5-10% from stock. Wants on a regular basis scenic views of Vermont, seasonal (winter, spring, summer, autumn), submitted 6 months prior to the actual season; animal; documentary; human interest; humorous; nature; photo essay/photo feature; still life; travel; and wildlife. "We are using fewer, larger photos and are especially interested in good shots of wildlife, birds." No photos in poor taste, nature close-ups, cliches or photos of places other than Vermont. Model/property releases preferred. Captions required.

Making Contact & Terms: Interested in receiving work from newer, lesser-known photographers. Query first. Send 35mm or 2¼ × 2¼ color transparencies. SASE. Reports in 3 weeks. Pays $75-200/b&w photo; $75-200/color photo; $250/day; $400-800 job. Pays on publication. Credit line given. Buys one-time rights; negotiable. Simultaneous submissions OK.

Tips: "We look for clarity of focus; use of low-grain, true film (Kodachrome or Fujichrome are best); unusual composition or subject."

VERMONT MAGAZINE, 20½ Main St., Middlebury VT 05753. (802)388-8480. Fax: (802)388-8485. E-mail: vtmag@sover.net. Photo Editor: Regan Eberhart. Circ. 50,000. Estab. 1989. Bimonthly magazine. Emphasizes all facets of Vermont and nature, politics, business, sports, restaurants, real estate, people, crafts, art, architecture, etc. Readers are people interested in Vermont, including residents, tourists and summer home owners. Sample copy $3 with 9 × 12 SAE and 5 first-class stamps. Photo guidelines free with SASE.

Needs: Uses 30-40 photos/issue; 75% supplied by freelance photographers. Needs animal/wildlife shots, travel, Vermont scenics, how-to, portraits, products and architecture. Special photo needs include Vermont activities such as skiing, ice skating, biking, hiking, etc. Model release preferred. Captions required.

Making Contact & Terms: Interested in receiving work from newer, lesser-known photographers. Query

with résumé of credits and samples of work. Send 8×10 b&w prints or 35mm or larger transparencies by mail for consideration. Submit portfolio for review. Provide tearsheets to be kept on file for possible assignments. SASE. Reports in 2 months. Pays $450/color cover photo; $200/color page rate; $75-200/ color or b&w photo; $300/day. Pays on publication. Credit line given. Buys one-time rights and first North American serial rights; negotiable. Previously published work OK, depending on "how it was previously published."

Tips: In portfolio or samples, wants to see tearsheets of published work, and at least 40 35mm transparencies. Explain your areas of expertise. Looking for creative solutions to illustrate regional activities, profiles and lifestyles. "We would like to see more illustrative photography/fine art photography where it applies to the articles and departments we produce."

‡VERNON PUBLICATIONS, 3000 Northup Way, Suite 200, Bellevue WA 98004. Editorial Director: Michele Dill. Annual guides. Emphasizes Alaska, northwestern Canada, northwest US. Sample copy $21.95 plus $6 shipping and handling. Photo guidelines free with SASE.
• This company publishes *The Milepost Travel Guide* and other publications.
Needs: Uses 400 photos/issue; 50% supplied by freelancers. Needs photos of animal/wildlife shots, travel. Model/property release required. Captions required; include location, time of day, subject, etc.
Making Contact & Terms: Interested in receiving work from newer, lesser-known photographers. Send unsolicited photos by mail for consideration. Send dupes to be safe but note they are dupes. Send 35mm, 2¼×2⅓, 4×5 transparencies. Deadlines: summer/early fall for upcoming guide. "Doesn't make promises about safe return of unsolicited materials. Does not keep samples on file. Pays $75-100/color inside photo. Pays on publication. Credit line given. Buys one-time and electronic rights. Simultaneous submissions and previously published work OK.

VICTORIA MAGAZINE, 224 W. 57th St., New York NY 10019. Fax: (212)757-6109. Photography Editor: Susan Maher. Circ. 900,000. Estab. 1987. Monthly magazine. Emphasizes women's interests, lifestyle. Readers are females, 60% married, average age 37.
Needs: Uses "hundreds" of photos/issue; most supplied by freelancers. "We hire freelancers to shoot 99% of our stories. Occasionally a photographer will submit work that we consider exceptional and wish to publish. This is rare, and an exception to the rule." Needs beauty, fashion, home furnishings, lifestyle, children's corner, gardens, food, collections. Model/property release required.
Making Contact & Terms: Interested in receiving work from newer, lesser-known photographers. Submit portfolio for review. Provide tearsheets to be kept on file for possible future assignments. SASE. Reports in 2 weeks. Pays $750-850/day. **Pays on acceptance**. Credit line given. Usually buys all rights, one-time rights; negotiable. Previously published work OK.
Tips: Looking for "beautiful photos, wonderful lighting, elegance of style, simplicity."

‡VIDEOMAKER MAGAZINE, P.O. Box 4591, Chico CA 95927. (916)891-8410. Fax: (916)891-8443. E-mail: editor@videomaker.com. Website: http://www.videomaker.com. Editor: Stephen Muratore. Art Director: Janet Souza. Circ. 150,000. Estab. 1986. Monthly magazine. Emphasizes video production from hobbyist to low-end professional level. Readers are mostly male, ages 25-40. Sample copy free with 9×12 SAE.
Needs: Uses 50-60 photos/issue; 10-15% supplied by freelancers. Subjects include tools and techniques of consumer video production, videomakers in action. Reviews photos with or without ms. Model/property release required. Captions required.
Making Contact & Terms: Send unsolicited photos by mail for consideration; any size or format, color or b&w. SASE. Reports in 1 month. Payment negotiable. Pays on publication. Credit line given. Rights negotiable. Simultaneous submissions and previously published work OK.

VIRGINIA WILDLIFE, P.O. Box 11104, Richmond VA 23230. (804)367-1000. Editor: Rich Jefferson. Art Director: Emily Pels. Circ. 55,000. Monthly magazine. Emphasizes Virginia wildlife, as well as outdoor features in general, fishing, hunting and conservation for sportsmen and conservationists. Free sample copy and photo/writer's guidelines.
Needs: Buys 350 photos/year; about 95% purchased from freelancers. Photos purchased with accompany-

• **SPECIAL COMMENTS** within listings by the editor of *Photographer's Market* are set off by a bullet.

ing ms. Good action shots relating to animals (wildlife indigenous to Virginia), action hunting and fishing shots, photo essay/photo feature, scenic, human interest outdoors, nature, outdoor recreation (especially boating) and wildlife. Photos must relate to Virginia. Accompanying mss: features on wildlife; Virginia travel; first-person outdoors stories. Pays 15¢/printed word. Model release preferred for children. Property release preferred for private property. Captions required; identify species and locations.

Making Contact & Terms: Send 35mm and 2¼×2¼ or larger transparencies. Vertical format required for cover. SASE. Reports (letter of acknowledgment) within 30 days; acceptance or rejection within 45 days of acknowledgement. Pays $30-50/color photo; $125/cover photo; $75/back cover. Pays on publication. Credit line given. Buys one-time rights.

Tips: "We don't have time to talk with every photographer who submits work to us, since we do have a system for processing submissions by mail. Our art director will not see anyone without an appointment. In portfolio or samples, wants to see a good eye for color and composition and both vertical and horizontal formats. We are seeing higher quality photography from many of our photographers. It is a very competitive field. Show only your best work. Name and address must be on each slide. Plant and wildlife species should also be identified on slide mount. We look for outdoor shots (must relate to Virginia); close-ups of wildlife."

VISIONS, 3100 Broadway, Suite 660, Kansas City MO 64111. (816)960-1988. Fax: (816)221-1112. Editor: Neoshia Michelle Paige. Circ. 100,000. Semi-annual magazine. Emphasizes Native Americans in high school, college, vocational-technical, careers. Readers are Native American students 16-22. Sample copy free with 9×12 SAE and 5 first-class stamps.

Needs: Uses 30 photos/issue. Needs photos of students in-class, at work, on campus, in vocational/technical training in health, engineering, technology, computers, law, science, general interest. Model/property release required. Captions required; include name, age, location, what's going on in photo.

Making Contact & Terms: Interested in receiving work from newer, lesser-known photographers. Query with ideas and SASE. Reports in 1 month. Pays $10-50/color photo; pays $5-25/b&w inside photo. Pays on publication. Buys first North American serial rights. Simultaneous submissions and previously published work OK.

VISTA, 999 Ponce de Leon Blvd., Suite 600, Coral Gables FL 33134. (305)442-2462. Fax: (305)443-7650. Editor: Julia Bencomo Lobaco. Circ. 1.2 million. Estab. 1985. Monthly newspaper insert. Emphasizes Hispanic life in the US. Readers are Hispanic-Americans of all ages. Sample copy available.

Needs: Uses 10-50 photos/issue; all supplied by freelancers. Needs photos mostly of personalities with story only. No "stand-alone" photos. Reviews photos with accompanying ms only. Special photo needs include events in the Hispanic American communities. Model/property release preferred. Captions required.

Making Contact & Terms: Provide résumé, business card, brochure, flier or tearsheets to be kept on file for possible assignments. Accepts images in digital format for Mac (TIFF, EPS). Send via compact disc, online, floppy disk, SyQuest, zip disk (300 dpi). Keeps samples on file. SASE. Reports in 3 weeks. Pays $300/color cover photo; $150/color inside photo; $75/b&w inside photo; day assignments are negotiated. Pays 25% extra for Web usage. Pays on publication. Credit line given. Buys one-time rights. Previously published work OK.

Tips: "Build a file of personalities and events. Hispanics are America's fastest-growing minority."

VOGUE, Conde Nast Publications, Inc., 350 Madison Ave., New York NY 10017-3799. (212)880-8800. *Vogue* reflects the changing roles and concerns of women, covering not only evolutions in fashion, beauty, and style, but the important issues and ideas of the arts, health care, politics, and world affairs. Articles about European and American fashion designers suggest concepts, create new trends—and encourage ideas that keep life exciting and modern. This magazine did not respond to our request for information. Query before submitting.

VOICE OF SOUTH MARION, P.O. Box 700, Belleview FL 34421. (904)245-3161. E-mail: vosn@aol.com. Editor: Jim Waldron. Circ. 1,800. Estab. 1969. Weekly tabloid. Readers are male and female, ages 12-65, working in agriculture and various small town jobs. Sample copy $1.

Needs: Uses 15-20 photos/issue; 2 supplied by freelance photographers. Features pictures that can stand alone with a cutline. Captions required.

Making Contact & Terms: Send b&w or color prints by mail for consideration. SASE. Reports in 2 weeks. Pays $10/b&w cover photo; $5/b&w inside photo. Pays on publication. Credit line given. Buys one-time rights.

THE WAR CRY, The Salvation Army, 615 Slaters Lane, Alexandria VA 22313. (703)684-5500. Fax: (703)684-5539. Editor-in-Chief: Lt. Colonel Marlene Chase. Circ. 300,000. Publication of The Salvation

Army. Biweekly. Emphasizes the inspirational. Readers are general public and membership. Sample copy free with SASE.

Needs: Uses about 6 photos/issue. Needs "inspirational, scenic, general photos and photos of people that match our themes (write for theme list)."

Making Contact & Terms: Send color prints or color slides by mail for consideration. Accepts images in digital format for Mac. Send via compact disc, SyQuest. SASE. Reports in 2 weeks. Pays up to $200/ color photo; payment varies for text/photo package. **Pays on acceptance.** Credit line given "if requested." Buys one-time rights. Simultaneous submissions and previously published work OK.

WASHINGTONIAN, 1828 L St. NW, Suite 200, Washington DC 20036. (202)296-3600. Fax: (202)785-1822. Photo Editor: Jay Sumner. Monthly city/regional magazine emphasizing Washington metro area. Readers are 40-50, 54% female, 46% male and middle to upper middle professionals. Circ. 160,000. Estab. 1965.

Needs: Uses 75-150 photos/issue; 100% supplied by freelance photographers. Needs photos for illustration, portraits, reportage; tabletop of products, food; restaurants; nightlife; house and garden; fashion; and local and regional travel. Model release preferred; captions required.

Making Contact & Terms: Submit portfolio for review. Provide résumé, business card, brochure, flier or tearsheets to be kept on file for possible assignments. Pays $125-250/b&w photo; $150-300/color photo; $175-$350/day. Credit line given. Buys one-time rights ("on exclusive shoots we share resale").

Tips: "Read the magazine you want to work for. Show work that relates to its needs. Offer photo-story ideas. Send samples occasionally of new work."

THE WATER SKIER, 799 Overlook Dr., Winter Haven FL 33884. (941)324-4341. Fax: (941)325-8259. E-mail: 76774.1141@compuserve. com. Website: usawaterski.org. Editor: Don Cullimore. Circ. 30,000. Estab. 1950. Publication of the American Water Ski Association. Magazine published 7 times a year. Emphasizes water skiing. Readers are male and female professionals ages 20-45. Sample copy $2.50. Photo guidelines available.

Needs: Uses 25-35 photos/issue. 1-5 supplied by freelancers. Needs photos of sports action. Model/ property release required. Captions required.

Making Contact & Terms: Interested in receiving work from newer, lesser-known photographers. Call first. Accepts images in digital format for Mac (TIFF). Send via compact disc, floppy disk or SyQuest. SASE. Reports in 1 month. Pays $25-50/b&w photo; $50-150/color photo. Pays on publication. Credit line given. Buys all rights.

WATERCRAFT WORLD, 601 Lakeshore Pkwy, #600, Minnetonka MN 55305. (612)476-2200. Fax: (612)476-8065. E-mail: editor@watercraftworld.com. Managing Editor: Glenn R. Hansen. Circ. 70,000. Estab. 1987. Published 9 times/year. Emphasizes personal watercraft (jet skis). Readers are 95% male, average age 35, boaters, outdoor enthusiasts. Sample copy $3.

● This publication is doing more storing of images on CD and computer manipulation of photos.

Needs: Uses 30-50 photos/issue; 25% supplied by freelancers. Needs photos of jet ski travel, action, technology, race coverage. Model/property release required. Captions preferred.

Making Contact & Terms: Query with résumé of credits. Provide résumé, business card, brochure, flier or tearsheets to be kept on file for possible future assignments. Also accepts digital images in SyQuest and Photo CD. SASE. Reports in 1 month. Pays $20/b&w photo; $40/color photo; $200/color cover photo. Pays on publication. Credit line given. Rights negotiable.

WATERSKI MAGAZINE, 330 W. Canton Ave., Winter Park FL 32789. (407)628-4802. Fax: (407)628-7061. Editor: Rob May. Circ. 105,000. Estab. 1978. Published 10 times/year. Emphasizes water skiing instruction, lifestyle, competition, travel. Readers are 31-year-old males, average household income $65,000. Sample copy $2.95. Photo guidelines free with SASE.

Needs: Uses 75 photos/issue; 20 supplied by freelancers. 30% of photos in each issue comes from assigned work; 30% from freelance stock. Needs photos of instruction, travel, personality. Special photo needs include travel, personality. Model/property release preferred. Captions preferred; include person, trick described.

Making Contact & Terms: Interested in receiving work from newer, lesser-known photographers. Arrange a personal interview to show portfolio. Keeps samples on file. Reports in 1 month. Pays $150-300/ day; $500/color cover photo; $75-200/color inside photo; $50-75/b&w inside photo; $75-250/color page rate; $50-75/b&w page rate. Pays on publication. Credit line given. Buys first North American serial rights.

Tips: "Clean, clear, large images. Plenty of vibrant action, colorful travel scenics and personality. Must be able to shoot action photography."

WATERWAY GUIDE, 6151 Powers Ferry Rd. NW, Atlanta GA 30339. (770)618-0313. Fax: (770)618-0349. Editor: Judith Powers. Circ. 50,000. Estab. 1947. Cruising guides with 3 annual regional editions. Emphasizes recreational boating. Readers are men and women ages 25-65, management or professional, with average income $95,000 a year. Sample copy $33.95 and $3 shipping. Photo guidelines free with SASE.

Needs: Uses 10-15 photos/issue; all supplied by freelance photographers. Needs photos of boats, Intracoastal Waterway, bridges, landmarks, famous sights and scenic waterfronts. Expects to use more coastal shots from Maine to the Bahamas; also, Hudson River, Lake Champlain and Gulf of Mexico. Model release required. Captions required.

Making Contact & Terms: Send unsolicited photos by mail for consideration. Send color prints or 35mm transparencies. SASE. Reports in 4 months. Pays $600/color cover photo; $50/color inside photo. Pays on publication. Credit line given.

WESTERN HORSEMAN, P.O. Box 7980, Colorado Springs CO 80933. (719)633-5524. Editor: Pat Close. Monthly magazine. Circ. 230,000. Estab. 1936. Readers are active participants in western horse activities, including pleasure riders, ranchers, breeders and riding club members. Model/property release preferred. Captions required; include name of subject, date, location.

Needs: Articles and photos must have a strong horse angle, slanted towards the western rider—rodeos, shows, ranching, stable plans, training. "We do not buy single photographs/slides; they must be accompanied by an article. The exception: We buy 35mm color slides for our annual cowboy calendar. Slides must depict ranch cowboys/cowgirls at work."

Making Contact & Terms: Interested in receiving work from newer, lesser-known photographers. Submit material by mail for consideration. Pays $25/b&w photo; $50-75/color photo; $400-600 maximum for articles. For the calendar, pays $125-225/slide. "We buy mss and photos as a package." Payment for 1,500 words with b&w photos ranges from $100-600. Buys one-time rights; negotiable.

Tips: "For color, we prefer 35mm slides. For b&w, either 5×7 or 8×10 glossies. We can sometimes use color prints if they are of excellent quality. In all prints, photos and slides, subjects must be dressed appropriately. Baseball caps, T-shirts, tank tops, shorts, tennis shoes, bare feet, etc., are unacceptable."

WESTERN OUTDOORS, 3197-E Airport Loop, Costa Mesa CA 92626. (714)546-4370. E-mail: woutdoors@aol.com. Editor: Jack Brown. Circ. 131,000. Estab. 1961. Magazine published 9 times/year. Emphasizes fishing and boating for Far West states. Sample copy $2 OWAA members, $1. Editorial and photo guidelines free with SASE.

Needs: Uses 80-85 photos/issue; 70% supplied by freelancers; 25% comes from assignments, 75% from stock. Cover photos of fishing in California, Oregon, Washington, Baja. "We are moving toward 100% four-color books, meaning we are buying only color photography. A special subject need will be photos of boat-related fishing, particularly small and trailerable boats and trout fishing cover photos." Most photos purchased with accompanying ms. Model/property release preferred for women and men in brief attire. Captions required.

Making Contact & Terms: Interested in receiving work from newer, lesser-known photographers. Query or send photos for consideration. Send 35mm transparencies. SASE. Reports in 3 weeks. Pays $50-150/color photo; $250/cover photo; $400-600 for text/photo package. **Pays on acceptance.** Buys one-time rights for photos only; first North American serial rights for articles; electronic rights are negotiable.

Tips: "Submissions should be of interest to Western fishermen, and should include a 1,120-1,500 word ms; a Trip Facts Box (where to stay, costs, special information); photos; captions; and a map of the area. Emphasis is on fishing and hunting how-to, somewhere-to-go. Submit seasonal material 6 months in advance. Make your photos tell the story and don't depend on captions to explain what is pictured. Avoid 'photographic cliches' such as 'dead fish with man.' Get action shots, live fish. In fishing, we seek individual action or underwater shots. For cover photos, use vertical format composed with action entering picture from right; leave enough left-hand margin for cover blurbs, space at top of frame for magazine logo. Add human element to scenics to lend scale. Get to know the magazine and its editors. Ask for the year's editorial schedule (available through advertising department) and offer cover photos to match the theme of an issue. In samples, looks for color saturation, pleasing use of color components; originality, creativity; attractiveness of human subjects, as well as fish or game; above all—sharp, sharp, sharp focus! Send

THE SUBJECT INDEX, located at the back of this book, lists publications, book publishers, galleries, paper product companies and stock agencies according to the subject areas they seek.

duplicated transparencies as samples, but be prepared to provide originals." Sees trend toward electronic imagery, computer enhancement and electronic transmission of images.

WHERE CHICAGO MAGAZINE, 1165 N. Clark St., Chicago IL 60610. (312)642-1896. Fax: (312)642-5467. Editor: Margaret Doyle. Circ. 100,000. Estab. 1985. Monthly magazine. Emphasizes shopping, dining, nightlife and entertainment available in Chicago and its suburbs. Readers are male and female traveling executives and tourists, ages 25-55. Sample copy $4.
Needs: Uses 1 photo/issue; 90% supplied by freelancers. Needs scenic, seasonal shots of Chicago; "must include architecture or landmarks that identify a photo as being shot in Chicago." Reviews photos with or without ms. "We look for seasonal shots on a monthly basis." Model/property release required. Captions required.
Making Contact & Terms: Send unsolicited photos by mail for consideration. Provide résumé, business card, brochure, flier or tearsheets to be kept on file for possible assignments. Send 35mm, 2¼×2¼, 4×5, 8×10 transparencies. SASE. Reports in 1 month. Pays $300/color cover photo. **Pays on acceptance.** Credit line given. Buys one-time rights; negotiable. Simultaneous submissions and previously published work OK.
Tips: "We only consider photos of downtown Chicago, without people in them. Shots should be colorful and current, in a vertical format. Keep our deadlines in mind. We look for covers two months in advance of issue publication."

WHERE MAGAZINE, 475 Park Ave. S., Suite 2100, New York NY 10016. (212)725-8100. Fax: (212)725-3412. Editor-in-Chief: Lois Anzelowitz-Tanner. Circ. 119,000. Estab. 1936. Monthly. Emphasizes points of interest, shopping, restaurants, theater, museums, etc. in New York City (specifically Manhattan). Readers are visitors to New York staying in the city's leading hotels. Sample copy available in hotels.
Needs: Buys cover photos only. Covers showing New York scenes; color photos only. Vertical compositions preferred. Model release preferred. Captions preferred.
Making Contact & Terms: Interested in receiving work from newer, lesser-known photographers. Arrange a personal interview to show portfolio. Does not return unsolicited material. Pays $300-500/color photo. Pays on publication. Credit line given. Rights purchased vary. Simultaneous submissions and previously published work OK.

WINDSURFING, 330 W. Canton Ave., Winter Park FL 32789. (407)628-4802. Fax: (407)628-7061. Editor: Tom James. Managing Editor: Jason Upright. Circ. 75,000. Monthly magazine published 8 times/year. Emphasizes board-sailing. Readers are all ages and all income groups. Sample copy free with SASE. Photo guidelines free with SASE.
Needs: Uses 80 photos/issue; 60% supplied by freelance photographers. Needs photos of boardsailing, flat water, recreational travel destinations to sail. Model/property release preferred. Captions required; include who, what, where, when, why.
Making Contact & Terms: Query with samples. Send unsolicited photos by mail for consideration. Provide résumé, business card, brochure, flier or tearsheets to be kept on file for possible future assignments. Send 35mm, 2¼×2¼ and 4×5 transparencies by mail for consideration. Kodachrome and slow Fuji preferred. SASE. Reports in 3 weeks. Pays $450/color cover photo; $40-150/color inside; $25-100/b&w inside. Pays on publication. Credit line given. Buys one-time rights unless otherwise agreed on. Previously published work OK.
Tips: Prefers to see razor sharp, colorful images. The best guideline is the magazine itself. "Get used to shooting on, in or under water. Most of our needs are found there."

WINE & SPIRITS, 1 Academy St., RD #6, Princeton NJ 08540. (609)921-1060. Fax: (609)921-2566. E-mail: winespir@aol.com. Art Director: John Thompson. Circ. 55,000. Estab. 1985. Bimonthly magazine. Emphasizes wine. Readers are male, ages 39-60, married, parents, children, $70,000 plus income, wine consumers. Sample copy $2.95; September and November special issues $6.50.
Needs: Uses 0-30 photos/issue; all supplied by freelancers. Needs photos of food, wine, travel, people. Captions preferred; include date, location.
Making Contact & Terms: Interested in receiving work from newer, lesser-known photographers. Submit portfolio for review. Provide résumé, business card, brochure, flier or tearsheets to be kept on file for possible assignments. Accepts images in digital format for Mac. Send via SyQuest, Zip disk (266 dpi). Reports in 1-2 weeks, if interested. Pays $200-1,000/job. Pays on publication. Credit line given. Buys one-time rights. Simultaneous submissions OK.

‡WISCONSIN TRAILS, Dept. PM, P.O. Box 5650, Madison WI 53705. (608)231-2444. Photo Editor: Nancy Mead. Circ. 35,000. Bimonthly magazine. For people interested in history, travel, recreation, person-

alities, the arts, nature and Wisconsin in general. Sample copy $4. Photo guidelines free with SASE.

Needs: Buys 300 photos/year. Seasonal scenics and photos relating to Wisconsin. Annual Calendar: uses horizontal and vertical formats; scenic photographs. Wants no color or b&w snapshots, color negatives, cheesecake, shots of posed people, b&w negatives ("proofs or prints, please") or "photos of things clearly not found in Wisconsin. We greatly appreciate caption info."

Making Contact & Terms: Query with résumé of credits. Arrange a personal interview to show portfolio. Submit portfolio or submit contact sheet or photos for consideration. Provide calling card and flier to be kept on file for possible future assignments. Send contact sheet or 5×7 or 8×10 glossy b&w prints. Send transparencies; "we use all sizes." Send 35mm, 2¼×2¼ or 4×5 transparencies for cover; "should be strong seasonal scenics or people in action." Uses vertical format; top of photo should lend itself to insertion of logo. Locations preferred and needed. SASE. Reports in 3 weeks. Pays $125-200/calendar and cover photos; $50-100/b&w photo. Pays on publication. Buys first serial rights or second serial (reprint) rights. Simultaneous submissions OK "only if we are informed in advance." Previously published work OK.

Tips: "Because we cover only Wisconsin and because most photos illustrate articles (and are done by freelancers on assignment), it's difficult to break into *Wisconsin Trails* unless you live or travel in Wisconsin." Also, "be sure you specify how you want materials returned. Include postage for any special handling (insurance, certified, registered, etc.) you request."

WITH, The Magazine for Radical Christian Youth, P.O. Box 347, Newton KS 67114. (316)283-5100. Fax: (316)283-0454. E-mail: deliag@gcmc.org. Co-editors: Eddy Hall, Carol Duerksen. Circ. 6,200. Estab. 1968. Magazine published eight times a year. Emphasizes "Christian values in lifestyle, vocational decision making, conflict resolution for US and Canadian high school students." Sample copy free with 9×12 SAE and 4 first-class stamps. Photo and writer's guidelines free with SASE.

Needs: Buys 70 photos/year; 8-10 photos/issue. Buys 65% of freelance photography from assignment; 35% from stock. Documentary (related to concerns of high school youth "interacting with each other, with family and in school environment; intergenerational"); head shot; photo essay/photo feature; scenic; human interest; humorous. Particularly interested in action shots of teens, especially of ethnic minorities. We use some mood shots and a few nature photos. Prefers candids over posed model photos. Few religious shots, e.g., crosses, steeples, etc. Photos purchased with or without accompanying ms and on assignment. For accompanying mss wants issues involving youth—school, peers, family, hobbies, sports, community involvement, sex, dating, drugs, self-identity, values, religion, etc. Model release preferred.

Making Contact & Terms: Interested in receiving work from newer, lesser-known photographers. Send material by mail for consideration. Accepts images in digital format for Mac (TIFF, EPS). Send via compact disc, floppy disk, SyQuest, Zip disk. Uses 8×10 glossy b&w prints. SASE. Reports in 2 months. Pays $40/b&w inside photo; $50/b&w cover photo; 5¢/word for text/photo packages, or on a per-photo basis. **Pays on acceptance.** Credit line given. Buys one-time rights. Simultaneous submissions and previously published work OK.

Tips: "Candid shots of youth doing ordinary daily activities and mood shots are what we generally use. Photos dealing with social problems are also often needed. Needs to relate to teenagers—either include them in photos or subjects they relate to; using a lot of 'nontraditional' roles, also more ethnic and cultural diversity. Use models who are average-looking, not obvious model-types. Teenagers have enough self-esteem problems without seeing 'perfect' teens in photos."

WOMEN'S SPORTS AND FITNESS MAGAZINE, 2025 Pearl St., Boulder CO 80302. (303)440-5111. Fax: (303)440-3313. Editorial Manager: Laurie Russo. Art Director: Theron Moore. Circ. 210,000. Estab. 1974. Published 8 times/year. Readers want to celebrate an active lifestyle through the spirit of sports. Recreational interests include participation in two or more sports, particularly cycling, running and swimming. Sample copy and photo guidelines free with SASE.

Needs: 80% of photos supplied by freelance photographers. Needs photos of indoor and outdoor fitness, product shots (creative approaches as well as straight forward), outdoor action and location. Model release preferred. Captions preferred.

Making Contact & Terms: Write before submitting material to receive photo schedule. The photographer must first send printed samples, then call to set up an appointment. Provide business card, brochure, flier or tearsheets to be kept on file for possible future assignments. "I prefer to see promo cards and tearsheets first to keep on file. Then follow up with a call for specific instructions." Accepts images in digital format for Mac (QuarkXPress, Photoshop). Send via compact disc, online, floppy disk, SyQuest, Zip disk. SASE. Reports in 1 month. Pays $125-400/b&w or color photo; $200-400/day; $200-3,000 (fees and expenses)/ job. Pays on publication. Credit line given. Buys one-time rights.

Tips: Looks for "razor sharp images and nice light. Check magazine before submitting query. We look especially for photos of women who are genuinely athletic in active situations that actually represent a particular sport or activity. We want to see less set-up, smiling-at-the-camera shots and more spontaneous, real-action shots. We are always interested in seeing new work and new styles of photography."

WOMENWISE, CFHC, Dept. PM, 38 S Main St., Concord NH 03301. (603)225-2739. Fax: (603)228-6255. Editor: Luita Spangler. Circ. 3,000. Estab. 1978. Publication of the Concord Feminist Health Center. Quarterly tabloid. Emphasizes women's health from a feminist perspective. Readers are women, all ages and occupations. Sample copy $2.95.
Needs: All photos supplied by freelancers; 80% assignment; 20% or less stock. Needs photos of primarily women, women's events and demonstrations, etc. Model release required. Captions preferred.
Making Contact & Terms: Interested in receiving work from newer, lesser-known photographers, "if it's excellent quality and supports our editorial stance." Arrange a personal interview to show portfolio. Send b&w prints. Pays $15/b&w cover photo; sub per b&w inside photo. Pays on publication. Credit line given. Buys first North American serial rights.
Tips: "We don't publish a lot of 'fine-arts' photography now. We want photos that reflect our commitment to empowerment of all women. We prefer work by women. Do not send originals to us, even with SASE. We are small (staff of three) and lack the time to return original work."

WOODENBOAT MAGAZINE, P.O. Box 78, Brooklin ME 04616. (207)359-4651. Fax: (207)359-8920. Editor: Matthew P. Murphy. Circ. 105,000. Estab. 1974. Bimonthly magazine. Emphasizes wooden boats. Sample copy $4.95. Photo guidelines free with SASE.
Needs: Uses 100-125 photos/issue; 95% supplied by freelancers. Needs photos of wooden boats: in use, under construction, maintenance, how-to. Captions required; include identifying information, name and address of photographer on each image.
Making Contact & Terms: Interested in receiving work from newer, lesser-known photographers. Query with stock photo list. Keeps samples on file. SASE. Reports in 1 month. Pays $350/day; $350/color cover photo; $25-125/color inside photo; $15-75/b&w page rate. Pays on publication. Credit line given. Buys first North American serial rights. Simultaneous submissions and/or previously published work OK with notification.

WOODMEN, 1700 Farnam St., Omaha NE 68102. (402)342-1890. Fax: (402)271-7269. Editor: Scott J. Darling. Assistant Editor: Billie Jo Foust. Circ. 507,000. Estab. 1890. Official publication for Woodmen of the World/Omaha Woodmen Life Insurance Society. Bimonthly magazine. Emphasizes American family life. Free sample copy and photographer guidelines.
Needs: Buys 15-20 photos/year. Historic, family, insurance, animal, fine art, photo essay/photo feature, scenic, human interest, humorous; nature, still life, travel, health and wildlife. Model release required. Captions preferred.
Making Contact & Terms: Send material by mail for consideration. Uses 8×10 glossy b&w prints on occasion; 35mm, 2¼×2¼ and 4×5 transparencies; 4×5 transparencies for cover, vertical format preferred. SASE. Reports in 1 month. Pays $50/b&w inside photo; $75 minimum/color inside photo; $300/cover photo. **Pays on acceptance.** Credit line given on request. Buys one-time rights. Previously published work OK.
Tips: "Submit good, sharp pictures that will reproduce well."

THE WORLD & I, 3600 New York Ave. NE, Washington DC 20002. (202)635-4037. Fax: (202)269-9353. Photo Essay Editor: Linda Forristal. Contact department editors. Circ. 30,000. Estab. 1986. Monthly magazine. Sample copy $10. Photo guidelines free with 9×12 SASE.
Needs: Uses 250 photos/issue; 50% supplied by freelancers. Needs news photos, head shots of important political figures; important international news photos of the month; scientific photos, new products, inventions, research; reviews of concerts, exhibitions, museums, architecture, photography shows, fine art; travel; gardening; adventure; food; human interests; personalities; activities; groups; organizations; anthropology, social change, folklore, Americana; photo essay: Life and Ideals, unsung heroes doing altruistic work. Reviews photos with or without ms—depends on editorial section. Model release required for special features and personalities. Captions required.
Making Contact & Terms: Interested in receiving work from newer, lesser-known photographers. "Send written query or call photo essay editor before sending photos. Photographers should direct themselves to editors of different sections (Current Issues, Natural Science, Arts, Life, Book World, Modern Thought, and Photo Essays). If they have questions, they can ask the photo director or the photo essay editor for advice. All unsolicited material must be accompanied by a SASE and unsolicited delivery memos will not be honored. We will try to give you a quick reply, within 2 weeks." For color, pays $75/¼ page, $125/½ page, $135/¾ page, $200/full page, $225/1¼ page, $275/1½ page, $330/1¾ page, $375/double page; for b&w, pays $45/¼ page, $95/½ page, $110/¾ page, $150/full page, $165/1¼ page, $175/1½ page, $185/1¾ page, $200/double page. Commissioned photo essays are paid on package deal basis. Pays on publication. Buys one-time rights. Previously published work OK.
Tips: "To be considered for the Photo Essay department, study the guidelines well and then make contact as described above. You must be a good and creative photographer who can tell a story with sufficient

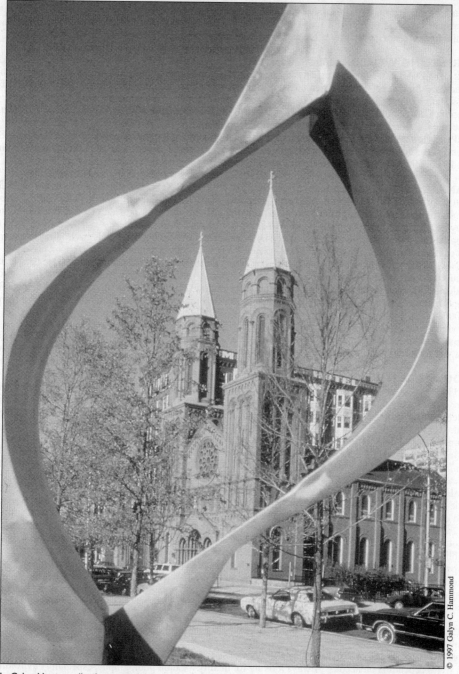

In Galyn Hammond's photo titled *Atlanta Art & Architecture*, the photographer sought to create "an artistic presentation of a mundane subject." The piece appeared in the July 1996 issue of *The World & I* magazine illustrating a special section called "The Risen South." He received $75. Hammond learned of the magazine through a *PhotoSource International* newsletter, and called for submission requirements before sending his work.

attention paid to details and the larger picture. Images must work well with the text, but all tell their own story and add to the story with strong captions. Do NOT submit travel pieces as Patterns photo essays, nor sentimental life stories as Life & Ideals photo essays."

WRESTLING WORLD, Sterling/MacFadden, 233 Park Ave. S. New York NY 10003. (212)780-3500. Fax: (212)780-3555. Editor: Stephen Ciacciarelli. Circ. 50,000. Bimonthly magazine. Emphasizes professional wrestling superstars. Readers are wrestling fans. Sample copy $3.50 with 9×12 SAE and 3 first-class stamps.
Needs: Uses about 60 photos/issue; all supplied by freelance photographers. Needs photos of wrestling superstars, action and posed, color slides and b&w prints.
Making Contact & Terms: Query with representative samples, preferably action. SASE. Reports ASAP. Pays $150/color cover photo; $75/color inside photo; $50-125/text/photo package. **Pays on acceptance.** Credit line given on color photos. Buys one-time rights.

YANKEE MAGAZINE, Main St., Dublin NH 03444. (603)563-8111. Fax: (603)563-8252. Picture Editor: Ann Card. Circ. 700,000. Estab. 1935. Monthly magazine. Emphasizes general interest within New England. Readers are of all ages and backgrounds, majority are actually outside of New England. Sample copy $1.95. Photo guidelines free with SASE.
Needs: Uses 50 photos/issue; 70% supplied by freelancers (on assignment). Needs environmental portraits, travel, food, still lifes, photojournalistic essays. "Always looking for outstanding photo packages shot in New England." Model/property release preferred. Captions required; include name, locale, pertinent details.
Making Contact & Terms: Submit portfolio for review. Keeps samples on file. SASE. Reports in 1 month. Pays $300/day; $100-400/color inside photo; $100-400/b&w inside photo; $200/color page rate; $200/b&w page rate. Credit line given. Buys one-time rights; negotiable. Simultaneous submissions and previously published work OK.
Tips: "Submit only top-notch work. I don't need to see development from student to pro. Show me you can work with light to create exciting images."

YOUR HEALTH, 5401 NW Broken Sound Blvd., Boca Raton FL 33487. (800)749-7733, (561)997-7733. Fax: (561)997-9210. E-mail: yhealth@aol.com. Editor: Susan Gregg. Photo Editor: Judy Browne. Circ. 40,000. Estab. 1963. Biweekly magazine. Emphasizes healthy lifestyles: aerobics, sports, eating, celebrity fitness plans, plus medical advances and the latest technology. Readers are consumer audience; males and females 20-70. Sample copy free with 9×12 SASE. Call for photo guidelines.
Needs: Uses 40-45 photos/issue; all supplied by freelance photographers. Needs photos depicting lifestyles, nutrition and diet, sports (runners, tennis, hiking, swimming, etc.), food, celebrities, arthritis, back pain, headache, etc. Also any photos illustrating exciting technological or scientific breakthroughs. Model release required.
Making Contact & Terms: Interested in receiving work from newer, lesser-known photographers. Provide résumé, business card, brochure, flier or tearsheets to be kept on file for possible future assignments, and call to query interest on a specific subject. Accepts images in digital format for Mac. SASE. Reports in 2 weeks. Pay depends on photo size and color. Pays $50-100/b&w photo; $75-200/color photo; $75-150/photo/text package. Pays on publication. Buys one-time rights. Simultaneous submissions and previously published work OK.
Tips: "Pictures and subjects should be interesting; bright and consumer-health oriented. We are using both magazine-type mood photos, and hard medical pictures. We are looking for different, interesting, unusual ways of illustrating the typical fitness, health nutrition story; e.g. an interesting concept for fatigue, insomnia, vitamins. Send prints or dupes to keep on file. Our first inclination is to use what's on hand."

YOUR MONEY MAGAZINE, 5705 N. Lincoln Ave., Chicago IL 60659. Art Director: Beth Ceisel. Circ. 450,000. Estab. 1979. Bimonthly magazine. Emphasizes personal finance.
Needs: Uses 18-25 photos/issue, 130-150 photos/year; all supplied by freelance assignment. Considers all styles depending on needs. "Always looking for quality location photography, especially environmental portraiture. We need photographers with the ability to work with people in their environment, especially

MARKET CONDITIONS are constantly changing! If you're still using this book and it's 1999 or later, buy the newest edition of *Photographer's Market* at your favorite bookstore or order directly from Writer's Digest Books.

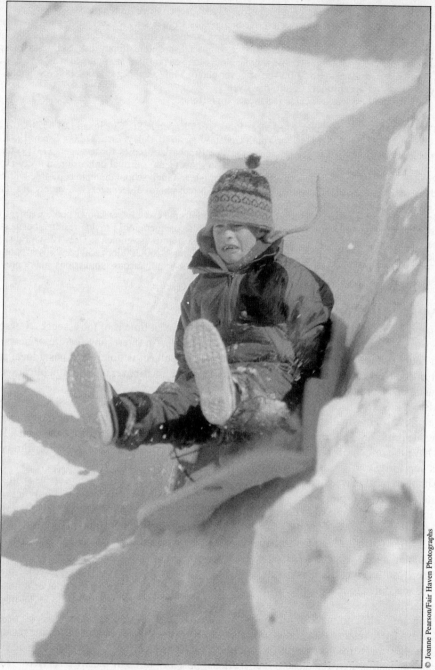

Joanne Pearson's shot of a young sledder accompanied a short piece describing the Mad River Valley Winter Carnival in the "Traveler's Journal" section of *Yankee Magazine*, a publication focusing on New England. Pearson had seen the magazine on newsstands and read their listing in *Photographer's Market* before showing her portfolio. "At their request, I sent a group of slides all taken during the same winter event," says Pearson. She received $75 for use of this photo.

people who are not used to being photographed." Model/property release required.

Making Contact & Terms: Interested in receiving work from newer, lesser-known photographers. Arrange a personal interview to show portfolio. Provide a business card, flier or tearsheets to be kept on file. Accepts images in digital format for Mac. Send via compact disc, online, floppy disk, SyQuest. Transparencies, slides, proofs or prints returned after publication. Samples not filed are returned with SASE. Reports only when interested. Pays up to $1,000/color cover photo; $450/b&w page; $200-500/b&w photo; $500/color page. **Pays on acceptance.** Credit line given.

Tips: "Show your best work. Include tearsheets in portfolio."

YOUTH UPDATE, St. Anthony Messenger Press, 1615 Republic St., Cincinnati OH 45210. (513)241-5615. Fax: (513)241-0399. Art Director/Youth Update: June Pfaff Daley. Circ. 27,000. Estab. 1982. Company publication. Monthly 4-page, 3-color newsletter. Emphasizes topics for teenagers (13-19) that deal with issues and practices of the Catholic faith but also show teens' spiritual dimension in every aspect of life. Readers are male and female teenagers in junior high and high school. Sample copy free with SASE.

Needs: Uses 2 photos/issue; 2 supplied by freelancers. Needs photos of teenagers in a variety of situations. Model/property release preferred. Captions preferred.

Making Contact & Terms: Interested in receiving work from newer, lesser-known photographers. Query with stock photo list. Send unsolicited photos by mail for consideration. Provide résumé, business card, brochure, flier or tearsheets to be kept on file for possible future assignments. Uses b&w prints. Keeps samples on file. SASE. Reports in 1 month. Pays $75-90/hour; $200-300/job; $50/b&w cover photo; $50/b&w inside photo. Pays on publication. Buys one-time rights. Simultaneous submissions and/or previously published work OK.

NEWSPAPERS & NEWSLETTERS

When working with newspapers always remind yourself that time is of the essence. Newspapers have various deadlines for each section that is produced. An interesting feature or news photo has a better chance of getting in the next edition if the subject is timely and has a local appeal. Most of the markets in this section are interested in regional coverage. Find publications near you and contact editors to get an understanding of their deadline schedules.

Also, ask editors if they prefer certain types of film or if they want color slides or black and white prints. Many smaller newspapers do not have the capability to run color images, so black and white prints are preferred. However, color slides can be converted to black and white. Editors who have the option of running color or black and white photos often prefer color film because of its versatility.

Although most newspapers rely on staff photographers, some hire freelancers as stringers for certain stories. Act professionally and build an editor's confidence in you by supplying innovative images. For example, don't get caught in the trap of shooting "grip-and-grin" photos when a corporation executive is handing over a check to a nonprofit organization. Turn the scene into an interesting portrait. Capture some spontaneous interaction between the recipient and the donor. By planning ahead you can be creative.

When you receive assignments think about the image before you snap your first photo. If you are scheduled to meet someone at a specific location, arrive early and scout around. Find a proper setting or locate some props to use in the shoot. Do whatever you can to show the editor that you are willing to make that extra effort.

Always try to retain resale rights to shots of major news events. High news value means high resale value, and strong news photos can be resold repeatedly. If you have an image with a national appeal, search for those larger markets, possibly through the wire services. You also may find buyers among national news magazines, such as *Time* or *Newsweek*.

While most newspapers offer low payment for images, they are willing to negotiate if the image will have a major impact. Front page artwork often sells newspapers, so don't underestimate the worth of your images.

■**AMERICAN SPORTS NETWORK**, Box 6100, Rosemead CA 91770. (818)292-2222. President: Louis Zwick. Associate Producer: Ron Harris. Circ. 801,773. Publishes 4 newspapers covering "general collegiate, amateur and professional sports, i.e., football, baseball, basketball, track and field, wrestling,

boxing, hockey, powerlifting and bodybuilding, fitness, health contests, etc."

Needs: Uses about 10-85 photos/issue in various publications; 90% supplied by freelancers. Needs "sport action, hard-hitting contact, emotion-filled photos. Have special bodybuilder annual calendar, collegiate and professional football pre- and post-season editions." Model release and captions preferred.

Making Contact & Terms: Send 8×10 glossy b&w prints and 4×5 transparencies or video demo reel or film work. by mail for consideration. Provide résumé, business card, brochure, flier or tearsheets to be kept on file for possible future assignments. SASE. Reports in 1 week. Pays $1,405/color cover photo; $400/inside b&w photo; negotiates rates by the job and hour. Pays on publication. Buys first North American serial rights. Simultaneous submissions and previously published work OK.

ANCHORAGE DAILY NEWS, Dept. PM, 1001 Northway Dr., Anchorage AK 99508. (907)257-4347. Editor: Kent Pollock. Photo Editor: Richard Murphy. Daily newspaper. Emphasizes all Alaskan subjects. Readers are Alaskans. Circ. 71,000 weekdays, 94,000 Sundays. Estab. 1946. Sample copy free with 11×14 SAE and 8 first-class stamps.

Needs: Uses 10-50 photos/issue; 0-5% supplied by freelance photographers; most from assignment. Needs photos of all subjects, primarily Alaskan subjects. In particular, looking for freelance images for travel section; wants photos of all areas, especially Hawaii. Model release preferred. Captions required.

Making Contact & Terms: Contact photo editor with specific ideas. SASE. Reports in 1-3 weeks. Interested only in color submissions. Pays $35 minimum/color photo: photo/text package negotiable. Pays on publication. Credit line given. Buys one-time rights. Simultaneous submissions OK.

Tips: "We, like most daily newspapers, are primarily interested in timely topics, but at times will use dated material." In portfolio or samples, wants to see "eye-catching images, good use of light and active photographs."

ARIZONA BUSINESS GAZETTE, Box 194, Phoenix AZ 85001. (602)271-7300. Fax: (602)271-7363. General Manager: Stephanie Pressly. Circ. 8,000. Estab. 1880. Weekly newspaper.

Needs: 25% of photos come from assignments. Interested in business subjects, portraits and an ability to illustrate business series and concepts. Model release preferred. Captions required; include name, title and photo description.

Making Contact & Terms: Interested in receiving work from newer, lesser-known photographers. Provide résumé, business card, brochure, flier or tearsheets to be kept on file for possible assignments. Cannot return unsolicited material. Reports when possible. Pays $95/color photo; $85/assignment; $125/day. Pays on publication. Buys one-time rights. Does not consider simultaneous submissions or previously published work.

Tips: Wants to see an "ability to shoot environmental portraits, creatively illustrate stories on business trends and an ability to shoot indoor, outdoor and studio work." Photographers should live in Arizona with some newspaper experience.

THE CALLER, P.O. Box 530, Edgefield SC 29824. (803)637-3106. Fax: (803)637-0034. E-mail: nwtf@g ab.net. Website: http://www.hooks.com/nwf. Editor: Shannon Geiger. Circ. 120,000. Estab. 1990. Publication of National Wild Turkey Federation, Inc. Quarterly tabloid. Emphasizes wildlife conservation, hunting (turkey). Sample copy free with 9×12 SASE and 4 first-class stamps. Photo guidelines available.

Needs: Uses 15 photos/issue; 50% supplied by freelancers. Accepts photos on wide range of outdoor themes—hunting, camping, wild turkeys, other wildlife, nature scenes, etc. "We have opportunities to cover photo assignments. The NWTF does approximately 1,000 habitat restoration projects each year throughout the U.S." Model release preferred. Captions preferred; include species of animals.

Making Contact & Terms: Interested in receiving work from newer, lesser-known photographers. Provide résumé, business card, brochure, flier or tearsheets to be kept on file for possible assignments. Send 35mm transparencies. Accepts images in digital format for Mac. Send via compact disc, online, SyQuest. SASE. Pays up to $300/color cover photo; $50/color inside photo; $25/b&w inside photo. **Pays on acceptance**. Credit line given. Buys one-time rights. Previously published work OK.

Tips: "We know the difference between truly wild turkeys and pen-raised birds. Don't waste any time photographing a turkey unless it's a wild bird."

MARKET CONDITIONS are constantly changing! If you're still using this book and it's 1999 or later, buy the newest edition of *Photographer's Market* at your favorite bookstore or order directly from Writer's Digest Books.

CAPPER'S, 1503 SW 42nd St., Topeka KS 66609-1265. (800)678-5779, ext. 4346. Fax: (800)274-4305. Editor: Nancy Peavler. Circ. 370,000. Estab. 1879. Biweekly tabloid. Emphasizes human-interest subjects. Readers are "mostly Midwesterners in small towns and on rural routes." Sample copy $1.50.
Needs: Uses about 20-25 photos/issue, 1-3 supplied by freelance photographers. "We make no photo assignments. We select freelance photos with specific issues in mind." Needs "35mm color slides or larger transparencies of human-interest activities, nature (scenic), etc., in bright primary colors. We often use photos tied to the season, a holiday or an upcoming event of general interest." Captions preferred.
Making Contact & Terms: Interested in receiving work from newer, lesser-known photographers. "Send for guidelines and a sample copy (SAE, 85¢ postage). Study the types of photos in the publication, then send a sheet of 10-20 samples with caption material for our consideration. Although we do most of our business by mail, a phone number is helpful in case we need more caption information. Phone calls to try to sell us on your photos don't really help." Accepts digital images through AP Leaf Desk. Reporting time varies. Pays $10-15/b&w photo; $35-40/color photo; only cover photos receive maximum payment. Pays on publication. Credit line given. Buys one-time rights.
Tips: "Generally, we're looking for photos of everyday people doing everyday activities. If the photographer can present this in a pleasing manner, these are the photos we're most likely to use. Season shots are appropriate for *Capper's*, but they should be natural, not posed. We steer clear of dark, mood shots; they don't reproduce well on newsprint. Most of our readers are small town or rural Midwesterners, so we're looking for photos with which they can identify. Although our format is tabloid, we don't use celebrity shots and won't devote an area much larger than 5×6 to one photo."

CATHOLIC HEALTH WORLD, 4455 Woodson Rd., St. Louis MO 63134. (314)427-2500. Fax: (314)427-0029. Editor: Suzy Farren. Circ. 11,500. Estab. 1985. Publication of Catholic Health Association. Semimonthly newspaper emphasizing health care—primary subjects dealing with our member facilities. Readers are hospital and long-term care facility administrators, public relations staff people. Sample copy free with 9×12 SASE.
Needs: Uses 4-15 photos/issue; 1-2 supplied by freelancers. Any photos that would help illustrate health concerns (i.e., pregnant teens, elderly). Model release required.
Making Contact & Terms: Send unsolicited photos by mail for consideration. Uses 5×7 or 8×10 b&w and color glossy prints. SASE. Reports in 2 weeks. Pays $40-60/photo. Pays on publication. Credit line given. Buys one-time rights. Simultaneous submissions OK.

♣CHILD CARE FOCUS, 364 McGregor St., Winnipeg, Manitoba R2W 4X3 Canada. (204)586-8587. Fax: (204)589-5613. Communication Officer: Debra Mayer. Circ. 2,200. Estab. 1974. Quarterly newspaper. Trade publication for the child care industry. Emphasizes anything pertaining to child care field. Readers are male and female, 18 years of age and up. Sample copy available. Photo guidelines available.
Needs: Uses 8-10 photos/issue; all supplied by freelancers; 10% from assignments; 90% from stock. Needs photos of children, life shots, how-to, personalities. Make sure work isn't too cute. Material should contain realistic interaction between adults and children. Reviews photos with or without a ms. Model release required. Property release preferred. Captions preferred.
Making Contact & Terms: Interested in receiving work from newer, lesser-known photographers. Send unsolicited photos by mail for consideration. Provide résumé, business card, brochure, flier or tearsheets to be kept on file for possible future assignments. Uses 3×5 or larger b&w prints; 35mm transparencies. Keeps samples on file. SASE. Reports in 1 month. "We do not publish photos we must pay for. We are non-profit and *may* print photos offered for free." Credit line given. Buys one-time rights. Previously published work OK.

CYCLE NEWS, Dept. PM, P.O. Box 498, Long Beach CA 90801. (310)427-7433. Editor: Paul Carruthers. Art Director: Ree Johnson. Weekly tabloid. Emphasizes motorcycle news for enthusiasts and covers nationwide races. Circ. 45,000. Estab. 1964.
Needs: Needs photos of motorcycle racing accompanied by written race reports; prefers more than one bike to appear in photo. Wants current material. Buys 1,000 photos/year. Buys all rights, but may revert to photographer after publication.
Making Contact & Terms: Send photos or contact sheet for consideration or call for appointment. Reports in 3 weeks. SASE. For b&w: send contact sheet, negatives (preferred for best reproduction) or prints (5×7 or 8×10, glossy or matte), captions required, pays $10 minimum. For color: send transparencies, captions required, pays $50 minimum. For cover shots: send contact sheet, prints or negatives for b&w, send transparencies for color, captions required, payment negotiable. "Payment on 15th of the month for issues cover-dated the previous month."
Tips: Prefers sharp action photos utilizing good contrast. Study publication before submitting "to see what it's all about." Primary coverage area is nationwide.

DAILY BUSINESS REVIEW, 1 SE Third Ave., Suite 900, Miami FL 33131. (305)347-6622. Art Director: John Rindo. Staff Photographers: Aixa Montero-Green, Melanie Bell. Circ. 11,000. Estab. 1926. Daily newspaper. Emphasizes law, business and real estate. Readers are 25-55 years old, average net worth of $750,000, male and female. Sample copy for $3 with 9×11 SASE.

Needs: Uses 8 photos/issue; 10% supplied by freelance photographers. Needs mostly portraits, however we use live news events, sports and building mugs. Photo captions "an absolute must."

Making Contact & Terms: Arrange a personal interview to show portfolio. Submit portfolio for review. Send 35mm, 8×10 b&w and color prints. Accepts all types of finishes. Cannot return unsolicited material. If used, reports immediately. Pays $75-150 for most photos; pays more if part of photo/text package. Credit line given. Buys all rights; negotiable. Previously published work OK.

Tips: In photographer's portfolio, looks for "a good grasp of lighting and composition; the ability to take an ordinary situation and make an extraordinary photograph. We work on daily deadlines, so promptness is a must and extensive cutline information is needed."

✦FARM & COUNTRY, 1 Yonge St., Suite 1504, Toronto, Ontario M5E 1E5 Canada. (416)364-5324. Fax: (416)364-5857. E-mail: agpub@inforamp.net. Website: http://www.agpub.on.ca. Managing Editor: John Muggeridge. Circ. 45,000. Estab. 1935. Tabloid published 15 times/year. Emphasizes agriculture. Readers are farmers, ages 20-70. Sample copy free with SASE. Photo guidelines available.

Needs: Uses 50 photos/issue; 5 supplied by freelancers. Needs photos of farm livestock, farmers farming, farm activities. *No rural scenes.* Special photo needs include food processing, shoppers, rural development, trade, politics. Captions preferred; include subject name, location, description of activity, date.

Making Contact & Terms: Interested in receiving work from newer, lesser-known photographers. Submit portfolio for review. Query with résumé of credits. Query with stock photo list. Send unsolicited photos by mail for consideration. Provide résumé, business card, brochure, flier or tearsheets to be kept on file for possible assignments. Send 2¼×2¼ transparencies. Also accepts images in digital format for Mac. Send via online, floppy disk, SyQuest (266 dpi). Published second and fourth Tuesdays—2 weeks earlier. Keeps samples on file. SASE. Reports in 1 month. Pays $30-50/b&w photo; $50-100/color photo; $20-40/hour; $150-350/job. Pays on publication. Buys all rights; negotiable. Previously published work OK. Offers internships for photographers. Contact Managing Editor: John Muggeridge.

Tips: Looking for "action, color, imaginative angles, vertical. Be able to offer wide range of color—on disk, if possible."

‡FISHING AND HUNTING NEWS, Dept. PM, 511 Eastlake Ave. E., Box 19000, Seattle WA 98109. (206)624-3845. Managing Editor: Patrick McGann. Published twice a month. Emphasizes how-to material, fishing and hunting locations and new products for hunters and fishermen. Circ. 133,000. Free sample copy and photo guidelines.

Needs: Buys 300 or more photos/year. Wildlife—fish/game with successful fishermen and hunters. Captions required.

Making Contact & Terms: Send samples of work for consideration. Uses 5×7 or 8×10 glossy b&w prints or negatives for inside photos. Uses color covers and some inside color photos—glossy color transparencies. When submitting 8×10 color prints, negative must also be sent. SASE. Reports in 2 weeks. Pays $5-15 minimum/b&w print, $50-100 minimum/cover and $10-20 editorial color photos. Credit line given. **Pays on acceptance.** Buys all rights, but may reassign to photographer after publication. Submit model release with photo.

Tips: Looking for fresh, timely approaches to fishing and hunting subjects. Query for details of special issues and topics. "We need newsy photos with a fresh approach. Looking for near-deadline photos from Oregon, California, Utah, Idaho, Wyoming, Montana, Colorado, Texas, Alaska and Washington (sportsmen with fish or game)."

THE FRONT STRIKER BULLETIN, P.O. Box 18481, Asheville NC 28814. (704)254-4487. Fax: (704)254-1066. E-mail: matchclub@circle.net. Owner: Bill Retskin. Circ. 800. Estab. 1986. Publication of The American Matchcover Collecting Club. Quarterly newsletter. Emphasizes matchcover collecting. Readers are male, blue collar workers, average age 55 years. Sample copy $3.50.

Needs: Uses 2-3 photos/issue; none supplied by freelancers. Needs table top photos of older match covers or related subjects. Reviews photos with accompanying ms only.

Making Contact & Terms: Interested in receiving work from newer, lesser-known photographers. Send unsolicited photos by mail for consideration. Send 5×7 matte b&w prints. Keeps samples on file. SASE. Reports in 1 month. Payment negotiable. Pays on publication. Credit line given. Buys one-time rights; negotiable.

GLOBE, Dept. PM, 5401 NW Broken Sound Blvd., Boca Raton FL 33487. (407)997-7733. Photo Editor: Ron Haines. Circ. 2 million. Weekly tabloid. "For everyone in the family. *Globe* readers are the same

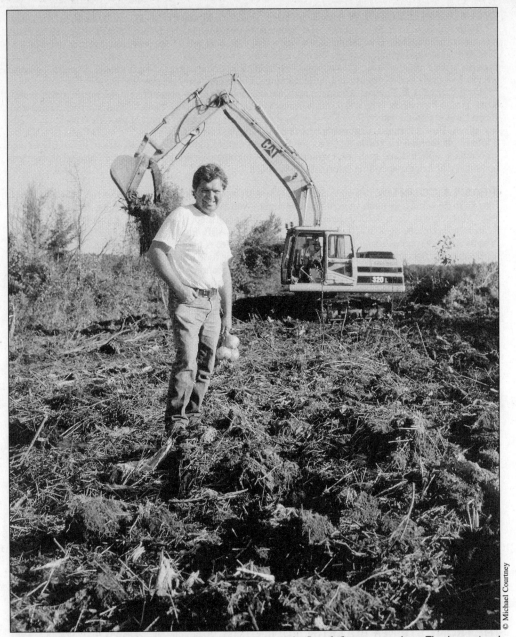

Onion grower John Horodynski poses by land-clearing equipment in this *Farm & Country* cover photo. The shot, assigned to photographer Michael Courtney, illustrates the magazine's cover story, "Farming to Feed the World." "Mike gets the job done competently and on time," says Editor John Muggeridge. "He delivers good clean work illustrating the point of the article."

people you meet on the street, and in supermarket lines—average, hard-working Americans."

Needs: Celebrity photos only!!!

Making Contact & Terms: Send transparencies or prints for consideration. Color preferred. SASE. Reports in 1 week. Pays $75/b&w photo (negotiable); $125/color photo (negotiable); day and package rates negotiable. Buys first serial rights. Pays on publication unless otherwise arranged.

Tips: "Do **NOT** write for photo guidelines. Study the publication instead."

GRAND RAPIDS BUSINESS JOURNAL, 549 Ottawa NW, Grand Rapids MI 49503. (616)459-4545. Fax: (616)459-4800. Editor: Carole Valade. Circ. 6,000. Estab. 1983. Weekly tabloid. Emphasizes West Michigan business community. Sample copy $1.

Needs: Uses 10 photos/issue; 100% supplied by freelancers. Needs photos of local community, manufacturing, world trade, stock market, etc. Model/property release required. Captions required.

Making Contact & Terms: Interested in receiving work from newer, lesser-known photographers. Query with résumé of credits. Query with stock photo list. Deadlines: two weeks prior to publication. SASE. Reports in 1 month. Pays $25-35/b&w cover photo; $35/color inside photo; $25/b&w inside photo. Pays on publication. Credit line given. Buys one-time rights, first North American serial rights; negotiable. Simultaneous submissions and previously published work OK.

GULF COAST GOLFER, 9182 Old Katy Rd., Suite 212, Houston TX 77055. (713)464-0308. Editor: Bob Gray. Circ. 35,000. Monthly tabloid. Emphasizes golf below the 31st parallel area of Texas. Readers are age 40 and older, $72,406 income, upscale lifestyle and play golf 2-5 times weekly. Sample copy free with SASE and 9 first-class stamps.

Needs: "Photos are bought only in conjunction with purchase of articles." Model release preferred. Captions preferred.

Making Contact & Terms: "Use the telephone." SASE. Reports in 2 weeks. Payment negotiable. Pays on publication. Credit line given. Buys one-time rights or all rights, if specified.

JEWISH EXPONENT, Dept. PM, 226 S. 16th St., Philadelphia PA 19102. (215)893-5740. Executive Editor: Bertram Korn, Jr. Weekly newspaper. Emphasizes news of impact to the Jewish community. Circ. 70,000.

Needs: On a regular basis, wants news and feature photos of a cultural, heritage, historic, news and human interest nature involving Jews and Jewish issues. Query as to photographic needs for upcoming year. No art photos. Photos purchased with or without accompanying mss. Captions required. Uses 8×10 glossy prints; 35mm or 4×5 transparencies. Model release required "where the event covered is not in the public domain."

Making Contact & Terms: Query with résumé of credits or arrange a personal interview. "Telephone or mail inquiries first are essential. Do not send original material on speculation." Provide résumé, business card, letter of inquiry, samples, brochure, flier and tearsheets to be kept on file. SASE. Reports in 1 week. Free sample copy. Pays $65/assignment; $10/b&w print; $25/color print; fees negotiable. Credit line given. Pays on publication. Rights purchased vary; negotiable.

Tips: "Photographers should keep in mind the special requirements of high-speed newspaper presses. High contrast photographs probably provide better reproduction under newsprint and ink conditions."

✤THE LAWYERS WEEKLY, 75 Clegg Rd., Markham, Ontario L6G 1A1 Canada. (905)479-2665. Fax: (905)479-3758. E-mail: wking@butterworths.ca. Production Assistant: Wendy King. Circ. 7,000. Estab. 1983. Weekly newspaper. Emphasizes law. Readers are male and female lawyers and judges, ages 25-75. Sample copy $8. Photo guidelines free with SASE.

Needs: Uses 12-20 photos/issue; 5 supplied by freelancers. Needs head shot photos of lawyers and judges mentioned in story.

Making Contact & Terms: Interested in receiving work from newer, lesser-known photographers. Provide résumé, business card, brochure, flier or tearsheets to be kept on file for possible assignments. Deadlines: 1-2 day turnaround time. Does not keep samples on file. SASE. Reports only when interested. Pays $50 maximum/b&w photo. **Pays on acceptance.** Credit line not given.

Tips: "We need photographers across Canada to shoot lawyers and judges on an as-needed basis. Send a résumé and we will keep your name on file. Mostly black & white work."

‡THE LOG NEWSPAPERS, 2924 Emerson, Suite 200, San Diego CA 92106. (619)226-6140. Fax: (619)226-0573. E-mail: logedit@aol.com. Editor: Susan Colby. Circ. 80,000. Estab. 1971. Biweekly newspaper. Emphasizes recreational boating. Sample copy free with $8½ \times 11$ envelope.

Needs: Uses 20-25 photos/issue; 75% supplied by freelancers. Needs photos of marine-related, historic sailing vessels, sailing/boating in general. Model/property release preferred for up-close people, private yachts. Captions required; include location, name and type of boat, owner's name, race description if applicable.

 CANADIAN LISTINGS are marked with a maple leaf.

Making Contact & Terms: Interested in receiving work from newer, lesser-known photographers. Provide résumé, business card, brochure, flier or tearsheets to be kept on file for possible assignments. Send 4×6 or 8×10 glossy color or b&w prints; 35mm transparencies; digital format on TIFF or EPS files. Keeps samples on file. SASE. Reports in 1 month. Pays $75/color cover photo; $25/b&w inside photo. Pays on publication. Credit line given. Buys all rights; negotiable. Simultaneous submissions and/or previously published work OK.

LONG ISLAND PARENTING NEWS, P.O. Box 214, Island Park NY 11558. (516)889-5510. Fax: (516)889-5513. Director: Andrew Elias. Circulation: 55,000. Estab. 1989. Monthly newspaper. Emphasizes parenting issues and children's media. Readers are mostly women, ages 25-45, with kids, ages 0-12. Sample copy $3 and 9×12 SAE with 5 first-class stamps. Model release required.
Needs: Uses 1-3 photos/issue; 1-2 supplied by freelancers. Needs photos of kids, families, parents. Model release required.
Making Contact & Terms: Interested in receiving work from newer, lesser-known photographers. Send unsolicited photos by mail for consideration. Send 5×7 or 8×10 color or b&w prints. Keeps samples on file. SASE. Reports in 6 weeks. Pays $50/color cover photo; $25-50/color inside photo; $25-50/b&w inside photo. Pays on publication. Credit line given. Buys one-time rights.

‡MILL CREEK VIEW, 16212 Bothell-Everett Hwy., Suite F-313, Mill Creek WA 98012-1219. (206)787-9529. Fax: (206)743-9882. Publisher: F.J. Fillbrook. Newspaper.
Needs: Photos for news articles and features. Captions required.
Making Contact & Terms: Submit portfolio for review. Send unsolicited photos by mail for consideration. Provide résumé, business card, brochure, flier or tearsheets to be kept on file for possible assignment. Send 4×6 matte b&w prints. Keeps samples on file. SASE. Reports in 1 month. Pays $10-25/b&w photo. Pays on publication. Credit line given.

MISSISSIPPI PUBLISHERS, INC., Dept. PM, 801 N. Congress St., P.O. Box 40, Jackson MS 39201. (601)961-7073. Photo Editors: Chris Todd and Jennifer L. Davis. Circ. 115,000. Daily newspaper. Emphasizes photojournalism: news, sports, features, fashion, food and portraits. Readers are in very broad age range of 18-70 years; male and female. Sample copy for 11×14 SAE and 54¢.
Needs: Uses 10-15 photos/issue; 1-5 supplied by freelance photographers. Needs news, sports, features, portraits, fashion and food photos. Special photo needs include food and fashion. Model release and captions required.
Making Contact & Terms: Provide résumé, business card, brochure, flier or tearsheets to be kept on file for possible assignments. Uses 8×10 matte b&w and color prints; 35mm, 2¼×2¼, 4×5, 8×10 transparencies. SASE. Reports 1 week. Pays $50-100/color cover photo; $25-50/b&w cover photo; $25/b&w inside photo; $20-50/hour; $150-400/day. Pays on publication. Credit line given. Buys one-time or all rights; negotiable.

MODEL NEWS, SHOW BIZ NEWS, 244 Madison Ave., Suite 393, New York NY 10016-2817. (212)683-0244. or (516)764-3856. Fax: (516)764-3456. Publisher: John King. Circ. 288,000. Estab. 1975. Monthly newspapers. Emphasizes celebrities and talented models, beauty and fashion. Readers are male and female, ages 15-80. Sample copy $1.50 with 8×10 SAE and 1 first-class stamp. Photo guidelines $1.50.
Needs: Uses 1-2 photos/issue; 1-2 supplied by freelancers. Review photos with accompanying ms only. Special photo needs include new celebrities, famous faces, VIP's, old and young. Model release preferred. Captions preferred.
Making Contact & Terms: Interested in receiving work from newer, lesser-known photographers. Contact through rep. Arrange personal interview to show portfolio. Submit portfolio for review. Send unsolicited photos by mail for consideration. Provide résumé, business card, brochure, flier or tearsheets to be kept on file for possible future assignments. Send 8×10 b&w prints. Keeps samples on file. SASE. Reports in 3 weeks. Pays $50/b&w photo; $60/color photo. Pays on publication. Credit line given. Buys all rights. Considers simultaneous submissions.

THE MOVING WORLD, 1611 Duke St., Alexandria VA 22314. Fax: (703)548-1845. Editor: Rose S. Talbot. Circ. 3,000. Estab. 1992. Publication of the American Movers Conference. Biweekly newspaper.

‡ **MARKETS NEW TO THIS EDITION** are marked with a double dagger.

Emphasizes the household goods moving industry. Readers are owners of businesses of all sizes associated with moving and transportation.

Needs: Uses 3-4 photos/issue. "I need shots of moving vans, transportation and affiliated shots (i.e., roads, bridges, highway signs, maps, etc.)." Reviews photos with or without ms. Also accepts digital images in TIFF files, Mac platform. Model/property release preferred.

Making Contact & Terms: Interested in receiving work from newer, lesser-known photographers. Send unsolicited photos by mail for consideration. Send 5×7 b&w prints. Keeps samples on file. SASE. Reports in 3 weeks. Pays $200/color cover photo; $25-50/b&w inside photo. Pays on publication. Credit line given. Buys one-time rights.

NATIONAL MASTERS NEWS, P.O. Box 50098, Eugene OR 97405. (503)343-7716. Fax: (503)345-2436. Editor: Al Sheahen. Circ. 8,000. Estab. 1977. Monthly tabloid. Official world and US publication for Masters (age 35 and over) track and field, long distance running and race walking. Sample copy free with 9×12 SASE.

Needs: Uses 25 photos/issue; 20% assigned and 80% from freelance stock. Needs photos of Masters athletes (men and women over age 35) competing in track and field events, long distance running races or racewalking competitions. Captions preferred.

Making Contact & Terms: Send any size matte or glossy b&w print by mail for consideration, "may write for sample issue." SASE. Reports in 1 month. Payment negotiable. Pays on publication. Credit line given. Buys one-time rights. Simultaneous submissions and previously published work OK.

NATIONAL NEWS BUREAU, P.O. Box 43039, Philadelphia PA 19129. (215)546-8088. Editor: Andy Edelman. Circ. 300 publications. Weekly syndication packet. Emphasizes entertainment. Readers are leisure/entertainment-oriented, 17-55 years old.

Needs: "Always looking for new female models for our syndicated fashion/beauty columns." Uses about 20 photos/issue; 15 supplied by freelance photographers. Captions required.

Making Contact & Terms: Arrange a personal interview to show portfolio. Query with samples. Submit portfolio for review. Send 8×10 b&w prints, b&w contact sheet by mail for consideration. SASE. Reports in 1 week. Pays $50-1,000/job. Pays on publication. Credit line given. Buys all rights.

NEW HAVEN ADVOCATE, 1 Long Wharf Dr., New Haven CT 06511. (203)789-0010. Publisher: Gail Thompson. Photographer: Kathleen Cei. Circ. 55,000. Estab. 1975. Weekly tabloid. Member of Alternative Association of News Weeklys. Readers are male and female, educated, ages 20-50.

Needs: Uses 7-10 photos/issue; 0-1 supplied by freelancers. Reviews photos with or without ms. Model release required. Captions required.

Making Contact & Terms: Interested in receiving work from newer, lesser-known photographers. Provide résumé, business card, brochure, flier or tearsheets to be kept on file for possible assignments. Does not keep samples on file. SASE. Reports in 1 month. Payment negotiable. Pays on publication. Credit line given. Buys one-time rights. Simultaneous submissions and/or previously published work OK.

NEW YORK TIMES MAGAZINE, 229 W. 43 St., New York NY 10036. (212)556-7434. Photo Editor: Kathy Ryan. Weekly. Circ. 1.8 million.

● This magazine went through a major redesign which increased the size of the editorial space and put color on nearly every page.

Needs: The number of freelance photos varies. Model release and photo captions required.

Making Contact & Terms: Drop off portfolio for review. "Please Fed Ex mailed-in portfolios." SASE. Reports in 1 week. Pays $250/b&w page rate; $300/color page rate; $225/half page; $350/job (day rates); $650/color cover photo. **Pays on acceptance.** Credit line given. Buys one-time rights.

NORTH TEXAS GOLFER, 9182 Old Katy Rd., Suite 212, Houston TX 77055. (713)464-0308. Editor: Bob Gray. Monthly tabloid. Emphasizes golf in the northern areas of Texas. Readers are age 40 and older, $72,406 income, upscale lifestyle and play golf 2-5 times weekly. Circ. 31,000. Sample copy $2.50 with SAE.

Needs: "Photos are bought only in conjunction with purchase of articles." Model release and captions preferred.

Making Contact & Terms: "Use the telephone." SASE. Reports in 2 weeks. Payment negotiable. Pays on publication. Credit line given. Buys one-time rights or all rights, if specified.

PACKER REPORT, 1317 Lombardi Access Rd., Green Bay WI 54304. (414)490-6500, ext. 227. Fax: (414)497-6519. Contact: Editor. Circ. 48,000. Estab. 1972. Weekly tabloid. Emphasizes Green Bay Packer football. Readers are 94% male, all occupations, ages. Sample copy free with SASE and 3 first-class stamps.

Needs: Uses 10-16 photos/issue; all supplied by freelancers. Needs photos of Green Bay Packer football.
Making Contact & Terms: Interested in receiving work from newer, lesser-known photographers. Query with résumé of credits. Provide résumé, business card, brochure, flier or tearsheets to be kept on file for possible assignments. Does not keep samples on file. SASE. Reports in 1 month. Pays $50/color cover photo; $10-50/color inside photo; $10-20/b&w page rate. Pays on publication. Credit line given. Buys one-time rights; negotiable. Simultaneous submissions and previously published work OK.

PITTSBURGH CITY PAPER, 911 Penn Ave., 6th Floor, Pittsburgh PA 15222. (412)560-2489. Fax: (412)281-1962. E-mail: info@pghcitypaper.com. Website: http://www.pghcitypaper.com. Editor: John Hayes. Art Director: Kevin Shepherd. Circ. 80,000. Estab. 1991. Weekly tabloid. Emphasizes Pittsburgh arts, news, entertainment. Readers are active, educated young adults, ages 29-54, with disposable incomes. Sample copy free with 12×15 SASE.
Needs: Uses 6-10 photos, all supplied by freelancers. Model/property release preferred. Captions preferred. Generally supplies film and processing. "We can write actual captions but we need all the pertinent facts."
Making Contact & Terms: Interested in receiving work from newer, lesser-known photographers. Arrange personal interview to show portfolio. Query with résumé of credits. Provide résumé, business card, brochure, flier or tearsheets to be kept on file for possible assignments. Does not keep samples on file. SASE. Reports in 2 weeks. Pays $25-125/job. Pays on publication. Credit line given. Previously published work OK.
Tips: Provide "something beyond the sort of shots typically seen in daily newspapers. Consider the long-term value of exposing your work through publication. In negotiating prices, be honest about your costs, while remembering there are others competing for the assignment. Be reliable and allow time for possible re-shooting to end up with the best pic possible."

PRORODEO SPORTS NEWS, 101 Pro Rodeo Dr., Colorado Springs CO 80919. (719)593-8840. Fax: (719)548-4889. Editor: Paul Asay. Circ. 40,000. Publication of Professional Rodeo Cowboys Association. Biweekly newspaper, weekly during summer (12 weeks). Emphasizes professional rodeo. Sample copy free with 8×10 SAE and 4 first-class stamps. Photo guidelines free with SASE.
 ● *Prorodeo* scans about 95% of their photos, so *high quality* prints are very helpful.
Needs: Uses about 25-50 photos/issue; all supplied by freelancers. Needs action rodeo photos. Also uses behind-the-scenes photos, cowboys preparing to ride, talking behind the chutes—something other than action. Model/property release preferred. Captions required, including contestant name, rodeo and name of animal.
Making Contact & Terms: Interested in receiving work from newer, lesser-known photographers. Send 5×7, 8×10 glossy b&w and color prints by mail for consideration. Also accepts images in digital format, contact for information. SASE. Pays $85/color cover photo; $35/color inside photo; $15/b&w inside photo. Other payment negotiable. Pays on publication. Credit line given. Buys one-time rights.
Tips: In portfolio or samples, wants to see "the ability to capture a cowboy's character outside the competition arena, as well as inside. In reviewing samples we look for clean, sharp reproduction—no grain. Photographer should respond quickly to photo requests. I see more PRCA sponsor-related photos being printed."

ROLL CALL NEWSPAPER, 900 Second St. NE, Suite 107, Washington DC 20002. (202)289-4900. Fax: (202)289-5337. Photo Editor: Laura Patterson. Circ. 20,000. Estab. 1955. Semiweekly newspaper. Emphasizes US Congress and politics. Readers are politicians, lobbyists and congressional staff. Sample copy free with 9×12 SAE with 4 first-class stamps.
Needs: Uses 15-25 photos/issue; up to 5 supplied by freelancers. Needs photos of anything involving current congressional issues, good or unusual shots of congressmen. Captions required.
Making Contact & Terms: Interested in receiving work from newer, lesser-known photographers. Query with samples or list of stock photo subjects. Send unsolicited photos by mail for consideration. Uses 8×10 glossy b&w prints; 35mm transparencies. Does not return unsolicited material. Reports in 1 month. Pays $50-125/b&w photo; $75-250/color photo (if cover); $50-75/hour; $200-300/day. Pays on publication. Credit line given. Buys one-time rights. Simultaneous submissions OK.
Tips: "We're always looking for unique candids of congressmen or political events. In reviewing photographer's samples, we like to see good use of composition and light for newsprint."

SENIOR VOICE OF FLORIDA, 18860 US Highway 19 N., Suite 151, Clearwater FL 34624-3106. Editor: Nancy Yost. Circ. 70,000. Estab. 1981. Monthly newspaper. Emphasizes lifestyles of senior citizens. Readers are Florida residents and tourists, 50 years old and older. Sample copy $1. Photo guidelines free with SASE.
Needs: Uses 6 photos/issue; 1-2 supplied by freelancers. Needs photos of recreational activities, travel,

seasonal, famous persons (only with story). Reviews photos purchased with accompanying ms only. Model/property release required. Captions required.

Making Contact & Terms: Send photos with manuscript. Samples kept on file. SASE. Reports in 2 months. Pays $10/color cover photo; $5/color inside photo; $5/b&w inside photo. Pays on publication. Credit line given. Buys one-time rights; negotiable. Simultaneous submissions and previously published work OK.

Tips: "We look for crisp, clean, clear prints. Photos that speak to us rate special attention. We use photos only to illustrate manuscripts."

SINGER MEDIA CORP., INC., Seaview Business Park, 1030 Calle Cordillera, Unit #106, San Clemente CA 92673. Chairman: Kurt Singer. Worldwide circulation. Estab. 1940. Newspaper syndicate (magazine, journal, books, newspaper, newsletter, tabloid). Emphasizes books and interviews.

• Singer Media is starting to store images on optical disks.

Needs: Needs photos of celebrities, movies, TV, rock/pop music pictures, top models, posters. Uses 35mm, 2¼×2¼, 4×5. Will use dupes or photocopies, cannot guarantee returns. No models. Usually requires releases on interview photos. Photo captions required and accompanying text desired.

Making Contact & Terms: Interested in receiving work from newer, lesser-known photographers, depending on subject. Query with list of stock photo subjects or tearsheets of previously published work. Color preferred. Accepts images in digital format for Windows (Photoshop). Reports in 6 weeks. Pays $25-1,000/b&w photo; $50-1,000/color photo. Pays 50/50% of all syndication sales. Pays after collection. Credit line given. Buys one-time rights, foreign rights; negotiable. Previously published work OK.

Tips: "Worldwide, mass market, text essential. Trend is toward international interest. Survey the market for ideas."

‡SLO-PITCH NEWS, VARSITY PUBLICATIONS, 13540 Lake City Way NE, Suite 3, Seattle WA 98125. (206)367-2420. Fax: (206)367-2636. Editor: Dick Stephens. Circ. 15,800. Estab. 1985. Publication of United States Slo-Pitch Softball Association (USSSA). Tabloid published 8 times/year. Emphasizes slo-pitch softball. Readers are men and women, ages 13-70. Sample copy for 10×14 SASE and $2. Photo guidelines free with SASE.

Needs: Uses 10-30 photos/issue; 90% supplied by freelancers. Needs stills and action softball shots. Special photo needs include products, tournaments, general, etc. Model/property release preferred for athletes. Captions required.

Making Contact & Terms: Interested in receiving work from newer, lesser-known photographers. Send unsolicited photos by mail for consideration. Provide résumé, business card, brochure, flier or tearsheets to be kept on file for possible assignments. Send color and b&w prints. Deadlines: 1st of every month. Keeps samples on file. Cannot return material. Reports in 1 month. Pays $10-30/b&w cover photo; $10-30/color inside photo; $10-25/b&w inside photo; $10-25/color page rate; $10-25/b&w page rate. Pays on publication. Credit line given. Rights negotiable. Simultaneous submissions and previously published work OK.

Tips: Looking for good sports action and current stock of subjects. "Keep sending us recent work and call periodically to check in."

SOUTHERN MOTORACING, P.O. Box 500, Winston-Salem NC 27102. (910)723-5227. Fax: (910)722-3757. Associate: Greer Smith. Editor/Publisher: Hank Schoolfield. Circ. 15,000. Biweekly tabloid. Emphasizes autoracing. Readers are fans of auto racing.

Needs: Uses about 10-15 photos/issue; some supplied by freelance photographers. Needs "news photos on the subject of Southeastern auto racing." Captions required.

Making Contact & Terms: Query with samples; send 5×7 or larger matte or glossy b&w prints; b&w negatives by mail for consideration. SASE. Reports in 1 month. Pays $25-50/b&w cover photo; $5-50/b&w inside photo; $50-100/page. Pays on publication. Credit line given. Buys first North American serial rights. Simultaneous submissions OK.

Tips: "We're looking primarily for *news* pictures, and staff produces many of them—with about 25% coming from freelancers through long-standing relationships. However, we're receptive to good photos from new sources, and we do use some of those. Good quality professional pictures only, please!"

THE DIGITAL MARKETS INDEX, located in the back of this book, lists markets that use images electronically.

STREETPEOPLE'S WEEKLY NEWS (Homeless Editorial), P.O. Box 270942, Dallas TX 75227-0942. E-mail: bflum@cyberkamp.net. Website: http://www.commercial~directory.com/netel/flum. Newspaper. Publisher: Lon G. Dorsey, Jr. Estab. 1977. For a copy of the paper send $5 to cover immediate handling (same day as received) and postage. Includes photo guidelines package now required. "Also contains information about our homeless website and photo gallery. See section "C" of guidelines to participate."

● *SWN* wishes to establish relationships with corporations interested in homeless issues that can also provide photography regarding what their company is doing to combat the problem.

Needs: Uses photos for newspapers. Subjects include: photojournalism on homeless or street people. Model/property release required. Captions required.

Making Contact & Terms: Interested in receiving work from newer, lesser-known photographers. "Hundreds of photographers are needed to show national view of America's homeless." Send unsolicited photos by mail for consideration with SASE for return of all materials. Accepts images in digital format (DOS). Send via 3½″ floppy disk (no unsolicited disks due to hacking possibility). Reports promptly. Payment negotiable. Pays extra for electronic usage (negotiable). Pays on acceptance or publication. Credit line sometimes given. Buys all rights; negotiable. Offers internships for photographers. Contact Traffic Manager: Bob Hostemburger.

Tips: In freelancer's demos, wants to see "professionalism, clarity of purpose, without sex or negative atmosphere which could harm purpose of paper." The trend is toward "kinder, gentler situations, the 'let's help our fellows' attitude." To break in, "find out what we're about so we don't waste time with exhausting explanations. We're interested in all homeless situations. Inquiries not answered without SASE. All persons interested in providing photography should get registered with us. Now using 'Registered photographers and Interns of *SWN*' for publishing and upcoming Internet worldwide awards competition. Info regarding competition is outlined in *SWN*'s Photoguidelines package. Photographers not registering will not be considered due to the continuous sending of improper materials, inadequate information, wasted hours of screening matter, etc. If you don't register with us please don't send anything for consideration. You'll find that many professional pubs are going this way to reduce the materials management pressures which have increased."

SUN, 5401 NW Broken Sound Blvd., Boca Raton FL 33487. (561)989-1070. Fax: (561)998-0798. Photo Editor: Bella Center. Weekly tabloid. Readers are housewives, college students, middle Americans. Sample copy free with extra large SAE and $1.70 postage.

Needs: Uses about 60 photos/issue; 50% supplied by freelance photographers. Wants varied subjects: prophesies and predictions, amazing sightings (i.e., Jesus, Elvis, angels), stunts, unusual pets, health remedies, offbeat medical, human interest, inventions, spectacular sports action; human interest and offbeat pix and stories; and celebrity photos. "Also—we are always in need of interesting, offbeat, humorous stand-alone pix." Model release preferred. Captions preferred.

Making Contact & Terms: Query with stock photo list. Send 8×10 b&w prints, 35mm transparencies, b&w contact sheet or b&w negatives by mail for consideration. Accepts digital images via Mac to Mac W Z modem, ISDN, Leaf Desk, SyQuest, floppy disk. Send through mail with SASE. Reports in 2 weeks. Pays $150-250/day; $150-250/job; $75/b&w cover photo; $125-200/color cover photo; $50-125/b&w inside photo; $125-200/color inside photo. Pays on publication. Buys one-time rights. Simultaneous submissions and previously published work OK.

Tips: "We are specifically looking for the unusual, offbeat, freakish true stories and photos. *Nothing* is too far out for consideration. We would suggest you send for a sample copy and take it from there."

SUNSHINE: THE MAGAZINE OF SOUTH FLORIDA, 200 E. Las Olas Blvd., Ft. Lauderdale FL 33301-2293. (305)356-4685. Art Director: Greg Carannante. "*Sunshine* is a Sunday newspaper magazine emphasizing articles of interest to readers in the Broward and Palm Beach counties region of South Florida." Readers are "the 800,000 readers of the Sunday edition of the *Sun-Sentinel*." Sample copy and guidelines free with SASE.

Needs: Uses about 12-20 photos/issue; 30% supplied by freelancers. Needs "all kinds of photos relevant to a South Florida readership." Photos purchased with accompanying ms. Model release sometimes required. Captions preferred.

Making Contact & Terms: Query with samples. Provide résumé, business card, brochure, flier or tearsheets to be kept on file for possible future assignments. SASE. Reports in 1 month. "All rates negotiable; the following are as a guide only." Pays $200/color cover photo; $75-150/color inside photo; $500-1,000 for text/photo package. Pays within 2 months of acceptance. Credit line given. Buys one-time rights. Simultaneous and previously published submissions OK.

❉**TORONTO SUN PUBLISHING**, 333 King St., Toronto, Ontario M5A 3X5 Canada. (416)947-2399. Fax: (416)947-3580. Director of Photography: Hugh Wesley. Circ. 300,000. Estab. 1971. Daily newspaper.

© Michael Edwards

This photo captures Clara the chicken "puppysitting" a litter of young border collies while their mother is away. English photographer Michael Edwards has sold the shot 16 times, including a recent reprint in *The Sun*. "The photo was submitted on spec and we were amused by it because it fits our paper so well," says Photo Editor Bella Center. "We are always looking for unusual, humorous, amazing photos to run by themselves or as parts of features stories." Edwards found *The Sun* through *Photographer's Market*.

Emphasizes sports, news and entertainment. Readers are 60% male, 40% female, ages 25-60. Sample copy free with SASE.

Needs: Uses 30-50 photos/issue; 20% supplied by freelancers. Needs photos of Toronto personalities making news out of town. Reviews photos with or without ms. Captions preferred.

Making Contact & Terms: Interested in receiving work from newer, lesser-known photographers. Phone. Send any size color prints; 35mm transparencies; press link digital format. Deadline: 11 p.m. daily. Does not keep samples on file. Reports in 1-2 weeks. Pays $150/job. Pays on publication. Credit line given. Buys one-time and other negotiated rights. Simultaneous submissions and previously published work OK.
Tips: "The squeeky wheel gets the grease when it delivers the goods. Don't try to oversell a questionable photo. Return calls promptly."

TRIBUNE-REVIEW, 622 Cabin Hill Dr., Greensburg PA 15601. (412)836-5454 or (800)433-3045. Fax: (412)838-5171. Chief Photographer: Tod Gombar. Circ. 150,000. Estab. 1889. Daily newspaper. Emphasizes news, features, sports, travel, consumer information and food. Sample copy 50¢.
Needs: Uses 25-35 photos/issue; 10% supplied by freelancers. Model release required; property release preferred. Captions required.
Making Contact & Terms: Interested in receiving work from newer, lesser-known photographers. Arrange personal interview to show portfolio. Provide résumé, business card, brochure, flier or tearsheets to be kept on file for possible future assignments. "All work submitted should be digitized in Mac format on floppy disks or magneto optical disks, using JPEG Photoshop." Deadlines: daily. Keeps samples on file. Reports in 1-2 weeks. Pays on publication. Buys one-time and other negotiated rights. Simultaneous submissions OK. Offers internships for photographers June-August. Contact Chief Photographer: Tod Gombar.
Tips: "Illustration photos are important to us; people-oriented subject material is a must."

VELONEWS, 1830 N. 55th St., Boulder CO 80301-2700. (303)440-0601. Fax: (303)444-6788. Senior Editor: John Rezell. Paid circ. 48,000. The journal of competitive cycling. Covers road racing, mountain biking and recreational riding. Sample copy free with 9 × 12 SAE and 4 first-class stamps.
Needs: Bicycle racing and nationally important races. Looking for action shots that show the emotion of cycling, not just finish-line photos with the winner's arms in the air. No bicycle touring. Photos purchased with or without accompanying ms. Uses news, features, profiles. Captions and identification of subjects required.
Making Contact & Terms: Send samples of work or tearsheets with assignment proposal. Query first on mss. Send glossy b&w prints and transparencies. SASE. Reports in 3 weeks. Pays $16.50-50/b&w inside photo; $33-100/color inside photo; $150/color cover; $15-100/ms. Credit line given. Pays on publication. Buys one-time rights.
Tips: "We're a newspaper; photos must be timely. Use fill flash to compensate for harsh summer light."

THE WASHINGTON BLADE, 1408 U St. NW, Washington DC 20009-3916. (202)797-7000. Fax: (202)797-7040. E-mail: news@washblade.com. Managing Editor: Mark Sullivan. Circ. 50,000. Estab. 1969. Weekly tabloid. For and about the gay community. Readers are gay men and lesbians; moderate- to upper-level income; primarily Washington DC metropolitan area. Sample copy free with 9 × 12 SAE plus 11 first-class stamps.
 • *The Washington Blade* stores images on CD; manipulating size, contrast, etc.—but not content!
Needs: Uses about 6-7 photos/issue; only out-of-town photos are supplied by freelance photographers. Needs "gay-related news, sports, entertainment events; profiles of gay people in news, sports, entertainment, other fields." Photos purchased with or without accompanying ms. Model release preferred. Captions preferred.
Making Contact & Terms: Interested in receiving work from newer, lesser-known photographers. Query with résumé of credits. Provide résumé, business card and tearsheets to be kept on file for possible future assignments. Accepts images in digital format for Windows. Send via online. SASE. Reports in 1 month. Pays $25-50/b&w photo; $50-100/color photo; $50 minimum/job. Pays within 30 days of publication. Credit line given. Buys all rights when on assignment, otherwise one-time rights. Simultaneous submissions and previously published work OK.
Tips: "Be timely! Stay up-to-date on what we're covering in the news and call if you know of a story about to happen in your city that you can cover. Also, be able to provide some basic details for a caption (*tell* us what's happening, too)." Especially important to "avoid stereotypes."

● **SPECIAL COMMENTS** within listings by the editor of *Photographer's Market* are set off by a bullet.

WATERTOWN PUBLIC OPINION, Box 10, Watertown SD 57201. (605)886-6903. Fax: (605)886-4280. Editor: Gordon Garnos. Circ. 17,500. Estab. 1887. Daily newspaper. Emphasizes general news of this area, state, national and international news. Sample copy 50¢.
Needs: Uses up to 8 photos/issue. Reviews photos with or without ms. Model release required. Captions required.
Making Contact & Terms: Interested in receiving work from newer, lesser-known photographers. Send unsolicited photos by mail for consideration. Send b&w or color prints. Does not keep samples on file. SASE. Reports in 1-2 weeks. Pays minimum $5/b&w or color cover photo; $5/b&w or color inside photo; $5/color page rate. Pays on publication. Credit line given. Buys one-time rights; negotiable. Simultaneous submissions OK.

WESTART, Box 6868, Auburn CA 95604. (916)885-0969. Editor-in-Chief: Martha Garcia. Circ. 4,000. Emphasizes art for practicing artists, artists/craftsmen, students of art and art patrons, collectors and teachers. Free sample copy and photo guidelines.
Needs: Uses 20 photos/issue, 10 supplied by freelancers. "We will publish photos if they are in a current exhibition, where the public may view the exhibition. The photos must be black & white. We treat them as an art medium. Therefore, we purchase freelance articles accompanied by photos." Wants mss on exhibitions and artists in the Western states. Captions required.
Making Contact & Terms: Send 5×7 or 8×10 b&w prints by mail for consideration. SASE. Reports in 2 weeks. Payment is included with total purchase price of ms. Pays $25 on publication. Buys one-time rights. Simultaneous and previously published submissions OK.

♣THE WESTERN PRODUCER, P.O. Box 2500, Saskatoon, Sasketchewan S7K 2C4 Canada. Fax: (306)934-2401. E-mail: newsroom@producer.com. Editor: Garry Fairbairn. Circ. 100,000. Estab. 1923. Weekly newspaper. Emphasizes agriculture and rural living in western Canada. Photo guidelines free with SASE.
 ● This publication accesses images through computer networks and is examining the storage of images on CD.
Needs: Buys up to 10 photos/issue; about 50-80% of photos supplied by freelancers. Livestock, nature, human interest, scenic, rural, agriculture, day-to-day rural life and small communities. Model/property release preferred. Captions required; include person's name and description of activity.
Making Contact & Terms: Interested in receiving work from newer, lesser-known photographers. Send material by mail for consideration. SASE. Pays $20-40/photo; $35-100/color photo; $50-250 for text/photo package. Pays on publication. Credit line given. Buys one-time rights. Previously published work OK.
Tips: Needs current photos of farm and agricultural news. "Don't waste postage on abandoned, derelict farm buildings or sunset photos. We want modern scenes with life in them—people or animals, preferably both." Also seeks mss on agriculture, rural Western Canada, history, fiction and contemporary life in rural western Canada.

YACHTSMAN, Dept. PM, 2033 Clement Ave., Suite 100, Alameda CA 94501. (510)865-7500. Editor: Hal Schell. Circ. 25,000. Estab. 1965. Monthly slick tabloid. Emphasizes recreational boating for boat owners of northern California. Sample copy $3. Writer's guidelines free with SASE.
Needs: Buys 5-10 photos/issue. Sport; power and sail (boating and recreation in northern California); spot news (about boating); travel (of interest to boaters). Seeks mss about power boats and sailboats, boating personalities, locales, piers, harbors, and how-tos in northern California. Photos purchased with or without accompanying ms. Model release required. Captions preferred.
Making Contact & Terms: Interested in receiving work from newer, lesser-known photographers. "We would love to give a newcomer a chance at a cover." Send material by mail for consideration. Uses any size b&w or color glossy prints. Uses color slides for cover. Vertical (preferred) or horizontal format. SASE. Reports in 1 month. Pays $5 minimum/b&w photo; $150 minimum/cover photo; $1.50 minimum/inch for ms. Pays on publication. Credit line given. Buys one-time rights. Simultaneous submissions or previously published work OK but must be exclusive in Bay Area (nonduplicated).
Tips: Prefers to see action b&w, color slides, water scenes. "We do not use photos as stand-alones; they must illustrate a story. The exception is cover photos, which must have a Bay Area application—power, sail or combination; vertical format with uncluttered upper area especially welcome."

TRADE PUBLICATIONS

Most trade publications are directed toward the business community in an effort to keep readers abreast of the ever-changing trends and events in their specific professions. For photographers, shooting for these professions can be financially rewarding and can serve as a stepping stone toward acquiring future jobs.

As often happens with this category, the number of trade publications produced increases or decreases as professions develop or deteriorate. In recent years, for example, magazines involving computers have flourished as the technology continues to grow.

Trade publication readers are usually very knowledgeable about their businesses or professions. The editors and photo editors, too, are often experts in their particular fields. So, with both the readers and the publications' staffs, you are dealing with a much more discriminating audience. To be taken seriously, your photos must not be merely technically good pictures, but also should communicate a solid understanding of the subject and reveal greater insights.

In particular, photographers who can communicate their knowledge in both verbal and visual form will often find their work more in demand. If you have such expertise, you may wish to query about submitting a photo/text package that highlights a unique aspect of working in that particular profession or that deals with a current issue of interest to that field.

Many photos purchased by these publications come from stock—both that of freelance inventories and of stock photo agencies. Generally, these publications are more conservative with their freelance budgets and use stock as an economical alternative. For this reason, listings in this section will often advise sending a stock list as an initial method of contact. Some of the more established publications with larger circulations and advertising bases will sometimes offer assignments as they become familiar with a particular photographer's work. For the most part, though, stock remains the primary means of breaking in and doing business with this market.

AAP NEWS, 141 Northwest Pt. Blvd., Elk Grove Village IL 60007. (847)981-6755. Fax: (847)228-5097. E-mail: Kidsdocs@aap.org. Art Director/Production Coordinator: Felicia McGurren. Estab. 1985. Publication of American Academy of Pediatrics. Monthly tabloid newspaper.
Needs: Uses 60 photos/year. 12 freelance assignments offered/year. Needs photos of children, pediatricians, health care providers—news magazine style. Model/property release required as needed. Captions required; include names, dates, location and explanation of situations.
Making Contact & Terms: Provide résumé, business card, tearsheets to be kept on file (for 1 year) for possible assignments. Also accepts digital files in SyQuest. Cannot return material. Pays $75/hour; $75-125/one-time use of photo. Pays on publication. Buys one-time or all rights; negotiable. Simultaneous submissions and previously published work OK.
Tips: "We want great photos 'real' children in 'real-life' situations, and the more diverse the better."

ABA BANKING JOURNAL, 345 Hudson St., New York NY 10014. (212)620-7256. Fax: (212)633-1165. E-mail: ababj@aol.com. Website: http://www.banking.com. Art Director: Wendy Williams. Circ. 30,000. Estab. 1909. Monthly magazine. Emphasizes "how to manage a bank better. Bankers read it to find out how to keep up with changes in regulations, lending practices, investments, technology, marketing and what other bankers are doing to increase community standing."
Needs: Buys 12-24 photos/year; freelance photography is 50% assigned, 50% from stock. Personality, and occasionally photos of unusual bank displays or equipment. "We need candid photos of various bankers who are subjects of articles." Photos purchased with accompanying ms or on assignment.
Making Contact & Terms: Query with samples. For color: uses 35mm transparencies and 2¼×2¼ transparencies. For cover: uses color transparencies. Accepts images in digital format for Mac. Send via online, SyQuest. Call and set up appointment for portfolio review. SASE. Reports in 1 month. Pays $200-500/photo. **Pays on acceptance**. Credit line given. Buys one-time rights.
Tips: "Most of our subjects are not comfortable being photographed."

A/C FLYER, Suite 260, 4 International Dr., Rye Brook NY 10573. (914)939-8787. Fax: (914)939-8824. Managing Editor: Mike Perry. Circ. 45,000. Estab. 1979. Company publication for McGraw-Hill. Monthly magazine. Emphasizes resale aircraft. Readers are aircraft owners, pilots, company pilots, company CEOs and presidents. Sample copy $2.
Needs: Uses 125 photos/issue; 1 supplied by freelancers. Needs photos of aircraft (jets, turboprop). Model/property release required for aircraft with 10 numbers showing, hangars and people.
Making Contact & Terms: Provide résumé, business card, brochure, flier or tearsheets to be kept on file for possible assignments. Deadlines: 3rd week of each month. Keeps samples on file. SASE. Reports in 1 month. Pays $1,600/color cover photo. Pays on publication. Credit line given. Buys all rights.
Tips: "Some clients may need photos taken of their aircraft listed for sale. We can refer freelancers to our clients."

ACCOUNTING TODAY, 11 Penn Plaza, New York NY 10001. (212)631-1596. Fax: (212)564-9896. Contact: Managing Editor. Circ. 35,000. Estab. 1987. Biweekly tabloid. Emphasizes finance. Readers are CPAs in public practice.
Needs: Uses 2-3 photos/issue; all supplied by freelancers. "We assign news subjects, as needed." Captions required.
Making Contact & Terms: Interested in receiving work from newer, lesser-known photographers. Provide résumé, business card, brochure, flier or tearsheets to be kept on file for possible assignments. Keeps samples on file. Cannot return material. Pays $250/shoot. **Pays on acceptance**. Credit line given. Buys all rights; negotiable.

AG PILOT INTERNATIONAL MAGAZINE, P.O. Box 1607, Mt. Vernon WA 98273. (360)336-9737. Fax: (360)336-2506. Publisher: Tom J. Wood. Circ. 7,200. Estab. 1978. Monthly magazine. Emphasizes agricultural aviation and aerial fire suppression (airborne fire fighting). Readers are male cropdusters, ages 20-70. Sample copy $3.
Needs: Uses 20-30 photos/issue; 20% supplied by freelancers. Needs photos of small, less than 400 hp,ag aircraft suitable for cover shots. Model/property release preferred. Captions preferred; include who, what, where, when, why.
Making Contact & Terms: Interested in receiving work from newer, lesser-known photographers. Send unsolicited photos by mail for consideration. Send 3×5 any finish color or b&w prints. Keeps samples on file. SASE. Usually reports in 1 month, but may be 2-3 months. Pays $30-150/color cover photo; $10-30/color inside photo; $5-20/b&w inside photo; $50-250/photo/text package. Pays on publication. Credit line given. Buys all rights; negotiable.
Tips: "Subject must be cropdusting and aerial fire suppression (airborne fire fighting). Learn about the aerial application business before submitting material."

AMERICAN AGRICULTURIST, 2389 N. Triphammer Rd., Ithaca NY 14850. (607)257-8670. Fax: (607)257-8238. E-mail: ejacobs@chilton.net. Editor: Eleanor Jacobs. Circ. 32,000. Estab. 1842. Monthly. Emphasizes agriculture in the Northeast—specifically New York and New England. Photo guidelines free with SASE.
Needs: Occasionally photos supplied by freelance photographers; 90% on assignment, 25% from stock. Needs photos of farm equipment, general farm scenes, animals. Geographic location: only New York and New England. Reviews photos with or without accompanying ms. Model release required. Captions preferred.
Making Contact & Terms: Interested in receiving work from newer, lesser-known photographers. Query with samples and list of stock photo subjects. Send 35mm transparencies by mail for consideration. Accepts images in digital format for Windows (TIFF). Send via SyQuest. SASE. Reports in 3 months. Pays $200/color cover photo and $75-150/inside color photo. **Pays on acceptance.** Credit line given. Buys one-time rights.
Tips: "We need shots of modern farm equipment with the newer safety features. Also looking for shots of women actively involved in farming and shots of farm activity. We also use scenics. We send out our editorial calendar with our photo needs yearly."

AMERICAN BANKER, Dept. PM, 1 State St. Plaza, New York NY 10004. (212)803-8313. Fax: (212)843-9600. Photo Editor: Tamara Lynas. Circ. 20,000. Estab. 1835. Daily tabloid. Emphasizes banking industry. Readers are male and female, senior executives in finance, ages 35-59.
 ● This publication scans its photos on computer.
Needs: "We are a daily newspaper and we assign a lot of pictures throughout the country. We mostly assign environmental portraits with an editorial, magazine style to them."
Making Contact & Terms: Arrange a personal interview to show portfolio. Send unsolicited b&w or color prints by mail for consideration. Provide résumé, business card, brochure, flier or tearsheets to be kept on file for possible assignments. Keeps samples on file. SASE. Pays creative fee of $300. Credit line given. Buys one-time rights.
Tips: "We look for photos that offer a creative insight to corporate portraiture and technically proficient photographers who can work well with stuffy businessmen in a limited amount of time—30 minutes or less is the norm. Photographers should send promo cards that indicate their style and ability to work with executives. Portfolio should include 5-10 samples either slides or prints, with well-presented tearsheets of published work. Portfolio reviews by appointment only. Samples are kept on file for future reference."

AMERICAN BEE JOURNAL, Dept. PM, 51 S. Second St., Hamilton IL 62341. (217)847-3324. Fax: (217)847-3660. Editor: Joe M. Graham. Circ. 13,000. Estab. 1861. Monthly trade magazine. Emphasizes beekeeping for hobby and professional beekeepers. Sample copy free with SASE.
Needs: Uses about 25 photos/issue; 1-2 supplied by freelance photographers. Needs photos of beekeeping

and related topics, beehive products, honey and cooking with honey. Special needs include color photos of seasonal beekeeping scenes. Model release preferred. Captions preferred.

Making Contact & Terms: Interested in receiving work from newer, lesser-known photographers. Query with samples. Send 5×7 or 8½×11 b&w and color prints by mail for consideration. SASE. Reports in 2 weeks. Pays $75/color cover photo; $10/b&w inside photo. Pays on publication. Credit line given. Buys all rights.

AMERICAN BREWER MAGAZINE, Box 510, Hayward CA 94543-0510. (510)538-9500. President: Bill Owens. Circ. 15,000. Estab. 1986. Quarterly magazine. Emphasizes micro-brewing and brewpubs. Readers are males ages 25-35. Sample copy $5.

Needs: Uses 5 photos/issue; 5 supplied by freelancers. Reviews photos with accompanying ms only. Captions required.

Making Contact & Terms: Contact by phone. Reports in 2 weeks. Payment negotiable per job. **Pays on acceptance.** Credit line given. Buys one-time rights; negotiable. Simultaneous submissions OK.

AMERICAN CHAMBER OF COMMERCE EXECUTIVES, 4232 King St., Alexandria VA 22302. (703)998-0072. Fax: (703)931-5624. Circ. 5,000. Monthly trade newsletter. Emphasizes chambers of commerce. Readers are chamber professionals (male and female) interested in developing chambers and securing their professional place. Free sample copy.

Needs: Uses 1-15 photos/issue; 0-10 supplied by freelancers. Special photo needs include coverage of our annual conference in October 1998 in Newport Beach, California. Model release required. Captions preferred.

Making Contact & Terms: Interested in receiving work from newer, lesser-known photographers. Query with stock photo list. Provide résumé, business card, brochure, flier or tearsheets to be kept on file for possible future assignments. Send 4×6 matte b&w prints. Keeps samples on file. SASE. Reports in 1-2 weeks. Pays $10-50/hour. **Pays on acceptance** Buys all rights.

AMERICAN FARRIERS JOURNAL, P.O. Box 624, Brookfield WI 53008-0624. (414)782-4480. Fax: (414)782-1252. Editor: Frank Lessiter. Circ. 7,000 (paid). Estab. 1974. Magazine published 7 times/year. Emphasizes horseshoeing and horse health for professional horseshoers. Sample copy free with SASE.

Needs: Looking for horseshoeing photos, documentary, how-to (of new procedures in shoeing), photo/essay feature, product shot and spot news. Photos purchased with or without accompanying ms. Captions required.

Making Contact & Terms: Interested in receiving work from newer, lesser-known photographers. Query with printed samples. Uses 4-color transparencies for covers. Vertical format. Artistic shots. SASE. Pays $25-50/b&w photo; $30-100/color photo; up to $150/cover photo. Pays on publication. Credit line given.

AMERICAN FIRE JOURNAL, Dept. PM, 9072 Artesia Blvd., Suite 7, Bellflower CA 90706. (562)866-1664. Fax: (562)867-6434. Editor: Carol Carlsen Brooks. Circ. 6,000. Estab. 1952. Monthly magazine. Emphasizes fire protection and prevention. Sample copy $3.50 with 10×12 SAE and 6 first-class stamps. Free photo and writer's guidelines.

Needs: Buys 5 or more photos/issue; 90% supplied by freelancers. Documentary (emergency incidents, showing fire personnel at work); how-to (new techniques for fire service); and spot news (fire personnel at work). Captions required. Seeks short ms describing emergency incident and how it was handled by the agencies involved.

Making Contact & Terms: Interested in receiving work from newer, lesser-known photographers. Query with samples. Provide résumé, business card or letter of inquiry. SASE. Reports in 1 month. Uses b&w semigloss prints; for cover uses 35mm color transparencies; covers must be verticals. Pays $10-25/b&w photo, negotiable; $25-100/color photo; $100/cover photo; $1.50-2/inch for ms.

Tips: "Don't be shy! Submit your work. I'm always looking for contributing photographers (especially if they are from outside the Los Angeles area). I'm looking for good shots of fire scene activity with captions. The action should have a clean composition with little smoke and prominent fire and show good firefighting techniques, i.e., firefighters in full turnouts, etc. It helps if photographers know something about firefighting so as to capture important aspects of fire scene. We like photos that illustrate the drama of firefighting—large flames, equipment and apparatus, fellow firefighters, people in motion. Write suggested captions. Give us as many shots as possible to choose from. Most of our photographers are firefighters or 'fire buffs.' "

ANIMAL SHELTERING, Humane Society of the US, 2100 L St. NW, Washington DC 20037. (202)452-1100. Fax: (301)258-3081. E-mail: asm@ix.netcom.com. Editor: Julie Miller Dowling. Circ. 4,000. Estab. 1978. Bimonthly magazine. Emphasizes animal protection. Readers are animal control and shelter workers, men and women, all ages. Sample copy free.

Needs: Uses 25 photos/issue; 75% supplied by freelance photographers. Needs photos of domestic animals interacting with people/humane workers; animals in shelters; animals during the seasons; animal care and obedience; humane society work and functions; other companion animal shots. "We do not pay for manuscripts." Model release required for cover photos only. Captions preferred.

Making Contact & Terms: Interested in receiving work from newer, lesser-known photographers. Provide résumé, business card, brochure, flier or tearsheets to be kept on file for possible assignments. SASE. Reports in 3 weeks. Pays $45/b&w cover photo; $35/b&w inside photo. "We accept color, but magazine prints in b&w." **Pays on acceptance.** Credit line given. Buys one-time rights.

Tips: "We almost always need good photos of people working with animals in an animal shelter, in the field, or in the home. We do not use photos of individual dogs, cats and other companion animals as much as we use photos of people working to protect, rescue or care for dogs, cats and other companion animals."

APPLIANCE MANUFACTURER, 5900 Harper Rd., Suite 105, Solon OH 44139. (216)349-3060. Fax: (216)498-9121. Editor: Joe Jancsurak. Circ. 38,000. Monthly magazine. Emphasizes design for manufacturing in the global consumer, commercial and business appliance industry. Primary audience is the "engineering community." Sample copy free with 10×12 SASE.

Needs: Uses 20-25 photos/issue. Needs technological photos. Reviews photos purchased with accompanying ms only. Captions preferred.

Making Contact & Terms: Interested in receiving work from newer, lesser-known photographers. Provide résumé, business card, brochure, flier or tearsheets to be kept on file for possible assignments. Keeps samples on file. SASE. Reports in 2 weeks. Payment negotiable. Payment negotiable. **Pays on acceptance.** Credit line given.

ATHLETIC BUSINESS, % Athletic Business Publications Inc., 1846 Hoffman St., Madison WI 53704. (608)249-0186. Fax: (608)249-1153. Art Directors: Kay Lum and Michael Roberts. Monthly magazine. Emphasizes athletics, fitness and recreation. "Readers are athletic, park and recreational directors and club managers, ages 30-65." Circ. 40,000. Estab. 1977. Sample copy $5.

Needs: Uses 4 or 5 photos/issue; 50% supplied by freelancers. Needs photos of sporting shots, athletic equipment, recreational parks and club interiors. Model and/or property release and photo captions preferred.

Making Contact & Terms: Send unsolicited color prints or 35mm transparencies by mail for consideration. Does not keep samples on file. SASE. Reports in 1-2 weeks. Pays $250/color cover photo; $75/color inside photos; $125/color page rate. Pays on publication. Credit line given. Buys all rights; negotiable. Simultaneous submissions and previously published work OK, but should be explained.

Tips: Wants to see ability with subject, high quality and reasonable price. To break in, "shoot a quality and creative shot from more than one angle."

ATHLETIC MANAGEMENT, 438 W. State St., Ithaca NY 14850. (607)272-0265. Fax: (607)272-2105. Editor-in-Chief: Eleanor Frankel. Circ. 30,000. Estab. 1989. Bimonthly magazine. Emphasizes the management of athletics. Readers are managers of high school and college athletic programs.

Needs: Uses 6-10 photos/issue; 50% supplied by freelancers. Needs photos of athletic events and athletic equipment/facility shots. Model release preferred.

Making Contact & Terms: Interested in receiving work from newer, lesser-known photographers. Submit portfolio for review. Keeps samples on file. SASE. Reports in 1-2 weeks. Pays $350-500/color cover photo; $100-150/b&w cover or color inside photo; $50-100/b&w inside photo. Pays on publication. Credit line given. Buys first North American serial rights; negotiable. Previously published work OK.

ATLANTIC PUBLICATION GROUP INC., 2430 Mall Dr., Suite 160, Charleston SC 29406. (803)747-0025. Fax: (803)744-0816. Editorial Coordinator: Shannon Clark. Circ. 6,500. Estab. 1985. Publication of Chambers of Commerce South of New York and North of Georgia, Visitor Products from Hawaii to the East Coast. Quarterly magazine. Emphasizes business. Readers are male, female business people who are members of chambers of commerce, ages 30-60. Sample copy free with 9×12 SAE and 7 first-class stamps.

Needs: Uses 10 photos/issue; all supplied by freelancers. Needs photos of business scenes, manufacturing, real estate, lifestyle. Model/property release required. Captions preferred.

Making Contact & Terms: Provide résumé, business card, brochure, flier or tearsheets to be kept on file for possible assignment. Query with stock photo list. Unsolicited material will not be returned. Deadlines: quarterly. Keeps samples on file. SASE. Reports in 1 month. Pays $100-400/color cover photo; $100-250/b&w cover photo; $50-100/color inside photo; $50/b&w inside photo. **Pays on acceptance.** Credit line given. Buys one-time rights; negotiable. Simultaneous submissions and previously published work OK.

AUTOMATED BUILDER, Dept. PM, P.O. Box 120, Carpinteria CA 93014. (805)684-7659. Fax: (805)684-1765. E-mail: abmag@autbldrmag.com. Website: http://www.autbldrmag.com. Editor and Publisher: Don Carlson. Circ. 26,000. Estab. 1964. Monthly. Emphasizes home and apartment construction. Readers are "factory and site builders and dealers of all types of homes, apartments and commercial buildings." Sample copy free with SASE.
Needs: Uses about 40 photos/issue; 10-20% supplied by freelance photographers. Needs in-plant and job site construction photos and photos of completed homes and apartments. Photos purchased with accompanying ms only. Captions required.
Making Contact & Terms: Interested in receiving work from newer, lesser-known photographers. "Call to discuss story and photo ideas." Send 3×5 color prints; 35mm or 2¼×2¼ transparencies by mail for consideration. Will consider dramatic, preferably vertical cover photos. Send color proof or slide. SASE. Reports in 2 weeks. Pays $300/text/photo package; $150/cover photo. Credit line given "if desired." Buys first time reproduction rights.
Tips: "Study sample copy. Query editor by phone on story ideas related to industrialized housing industry."

BARTENDER MAGAZINE, P.O. Box 158, Liberty Corner NJ 07938. (908)766-6006. Fax: (908)766-6607. Art Director: Erica DeWitte. Circ. 150,000. Estab. 1979. Quarterly magazine. *Bartender Magazine* serves full-service drinking establishments (full-service means able to serve liquor, beer and wine). "We serve single locations including individual restaurants, hotels, motels, bars, taverns, lounges and all other full-service on-premises licensees." Sample copy $2.50.
Needs: Number of photos/issue varies. Number supplied by freelancers varies. Needs photos of liquor-related topics, drinks, bars/bartenders. Reviews photos with or without ms. Model/property release required. Captions preferred.
Making Contact & Terms: Interested in receiving work from newer, lesser-known photographers. Provide résumé, business card, brochure, flier or tearsheets to be kept on file for possible assignments. SASE. Payment negotiable. Pays on publication. Credit line given. Buys all rights; negotiable. Previously published work OK.

BETTER ROADS, 6301 Gaston Ave., Suite 541, Dallas TX 75214. (214)827-4630. Fax: (214)827-4758. Associate Publisher: Ruth W. Stidger. Circ. 40,000. Estab. 1935. Monthly magazine. Emphasizes highway and street construction, repair, maintenance. Readers are mostly male engineers and public works managers, ages 30-65. Sample copy for 9×12 SAE and 4 first-class stamps.
Needs: Uses 12 photos/issue; 20% supplied by freelancers. Needs vertical 4-color shots of workers and/or equipment in bridge, street, road repair or maintenance situations. Special photo needs include work-zone photos, winter road maintenance photos, bridge painting, roadside vegetation maintenance. "Releases not needed if photos shot in public locations." Captions preferred; include names of workers in photos, location, highway department and contractor names.
Making Contact & Terms: Interested in receiving work from newer, lesser-known photographers. Send unsolicited photos by mail for consideration. Send 8×10 color prints; 35mm, 2¼×2¼, 4×5, 8×10 transparencies. Keeps samples on file. SASE. Reports in 2 weeks. Pays $200-300/color cover photo; $200-300/color inside photo. **Pays on acceptance**. Buys first North American serial rights; negotiable. Simultaneous submissions and previously published work OK.

BEVERAGE & FOOD DYNAMICS, Dept. PM, 1180 Avenue of the Americas, 11th Floor, New York NY 10036. (212)827-4700. Fax: (212)827-4720. Editor: Richard Brandes. Art Director: Paul Viola. Circ. 67,000. Magazine published 9 times/year. Emphasizes distilled spirits, wine and beer and all varieties of non-alcoholic beverages (soft drinks, bottled water, juices, etc.), as well as gourmet and specialty foods. Readers are national—retailers (liquor stores, supermarkets, etc.), wholesalers, distillers, vintners, brewers, ad agencies and media.
Needs: Uses 30-50 photos/issue; 5 supplied by freelance photographers and photo house (stock). Needs photos of retailers, product shots, concept shots and profiles. Special needs include good retail environments; interesting store settings; special effect photos. Model release required. Captions required.
Making Contact & Terms: Interested in receiving work from newer, lesser-known photographers. Query with samples and list of stock photo subjects. Send non-returnable samples, slides, tearsheets, etc. with a business card. "An idea of your fee schedule helps, as well as knowing if you travel on a steady basis to certain locations." SASE. Reports in 2 weeks. Pays $550-750/color cover photo; $450-950/job. Pays on publication. Credit line given. Buys one-time rights or all rights on commissioned photos. Simultaneous submissions OK.
Tips: "We're looking for good location photographers who can style their own photo shoots or have staff stylists. It also helps if they are resourceful with props. A good photographer with basic photographs is always needed. We don't manipulate other artists work, whether its an illustration or a photograph. If a special effect is needed, we hire a photographer who manipulates photographs."

BUILDINGS: The Facilities Construction and Management Magazine, 427 Sixth Ave. SE, P.O. Box 1888, Cedar Rapids IA 52406. (319)364-6167. Fax: (319)364-4278. Editor: Linda Monroe. Circ. 56,600. Estab. 1906. Monthly magazine. Emphasizes commercial real estate. Readers are building owners and facilities managers. Sample copy $6.
Needs: Uses 50 photos/issue; 10% supplied by freelancers. Needs photos of concept, building interiors and exteriors, company personnel and products. Model/property release preferred. Captions preferred.
Making Contact & Terms: Provide résumé, business card, brochure, flier or tearsheets to be kept on file for possible assignments. Send 3×5, 8×10, b&w or color prints; 35mm, $2\frac{1}{4} \times 2\frac{1}{4}$, 4×5 transparencies upon request only. SASE. Reports as needed. Pays $350/color cover photo; $200/color inside photo. Pays on publication. Credit line given. Rights negotiable. Simultaneous submissions OK.

BUSINESS CREDIT MAGAZINE, National Association of Credit Management, 8815 Centre Park Dr., Suite 200, Columbia MD 21045. (410)740-5560. Fax: (410)740-5574. E-mail: katherinej@nacm.org. Website: http://www.nacm.org. Vice President, Communications: Katherine Jeschke. Circ. 40,000. Estab. 1896. Publication of the National Association of Credit Management. Monthly magazine. Emphasizes business credit, finance, banking and customer financial services. Readers are male and female executives, 25-65—VPs, CEOs, CFOs, middle management—and entry-level employees. Free sample copy.
Needs: Uses 1-5 photos/issue. Needs photos of technology, industry, commerce, banking and business (general, international, concepts). Special photo needs include: international; computer technology (Internet, global village); humorous; business-related; and technology-related.
Making Contact & Terms: Interested in receiving work from newer, lesser-known photographers. "We're particularly interested in having annual convention covered, May '98, New Orleans. We're willing to use students with teacher recommendations." Query with résumé of credits. Provide résumé, business card, brochure, flier or tearsheets to be kept on file for possible future assignments. Send 4×6 glossy color and b&w prints; 35mm, $2\frac{1}{4} \times 2\frac{1}{4}$ transparencies. Accepts images in digital format for Mac. Send via floppy disk, Zip disk (low res for approval—high res for use). Deadlines: 2 months prior to publication; always 1st of month. SASE. Reports in 1 month. Pays $50-100/hour; $250-500/color cover photo; $250-375/b&w cover photo; $100-375/color inside photo; $100-275/b&w inside photo; $100-200/color page rate; $100-150/b&w page rate. **Pays on acceptance.** Credit line given. Buys one-time and all rights; negotiable. Previously published work OK. Offers internships for photographers year-round. Contact Vice President, Communications: Katherine Jeschke.
Tips: "Be familiar with publication and offer suggestions. Be available when called and be flexible with nonprofit groups such as NACM."

BUSINESS NH MAGAZINE, 404 Chestnut St., #201, Manchester NH 03101. (603)626-6354. Fax: (603)626-6359. Art Director: Nikki Bonenfant. Circ. 13,000. Estab. 1984. Monthly magazine. Emphasizes business. Readers are male and female—top management, average age 45. Sample copy free with 9×12 SAE and 5 first-class stamps.
Needs: Uses 3-6 photos/issue. Needs photos of people, high-tech, software and locations. Model/property release preferred. Captions required; include names, locations, contact phone number.
Making Contact & Terms: Interested in receiving work from newer, lesser-known photographers. Arrange personal interview to show portfolio. Provide résumé, business card, brochure, flier or tearsheets to be kept on file for possible assignments. Accepts images in digital format for Mac (TIFF). Send via compact disc, floppy disk, Zip disk (300 PPI, ISOLPI). Keeps samples on file. SASE. Reports in 3 weeks. Pays $300-500/color cover photo; $50-100/color inside photo; $50-75/b&w inside photo. Pays on publication. Credit line given. Buys one-time rights. Offers internships for photographers. Contact Art Director: Nikki Bonenfant.
Tips: Looks for "people in environment shots, interesting lighting, lots of creative interpretations, a definite personal style. If you're just starting out and want excellent statewide exposure to the leading executives in New Hampshire, you should talk to us."

CASINO JOURNAL, 8025 Black Horse Pike, #420, West Atlantic City NJ 08232. (800)394-2467. Fax: (609)645-1611. Editor: Adam Fine. Circ. 35,000. Estab. 1985. Monthly journal. Emphasizes casino operations. Readers are casino executives, employees and vendors. Sample copy free with 11×14 SAE and 9 first-class stamps.
Needs: Uses 40-60 photos/issue; 5-10 supplied by freelancers. Needs photos of gaming tables and slot machines, casinos and portraits of executives. Model release required for gamblers, employees. Captions required.
Making Contact & Terms: Interested in receiving work from newer, lesser-known photographers. Query with résumé of credits. Query with stock photo list. Reports in 2-3 months. Pays $100 minimum/color cover photo; $10-35/color inside photo; $10-25/b&w inside photo. Pays on publication. Credit line given. Buys all rights; negotiable.

Tips: "Read and study photos in current issues."

THE CHRISTIAN MINISTRY, 407 S. Dearborn St., Chicago IL 60605-1150. (312)427-5380. Fax: (312)427-1302. Managing Editor: Victoria A. Rebeck. Circ. 12,000. Estab. 1969. Bimonthly magazine. Emphasizes religion—parish clergy. Readers are 30-65 years old, 80% male, 20% female, parish clergy and well-educated. Sample copy free with 9 × 12 SAE and 4 first-class stamps. Photo guidelines free with SASE.
Needs: Uses 8 photos/issue; all supplied by freelancers; 75% comes from stock. Needs photos of clergy (especially female clergy), church gatherings, school classrooms and church symbols. Future photo needs include social gatherings and leaders working with groups. Candids should appear natural. Model release preferred. Captions preferred.
Making Contact & Terms: Interested in receiving work from newer, lesser-known photographers. Send 8 × 10 b&w prints by mail for consideration. Also accepts digital images. SASE. Reports in 3 weeks. Pays $75/b&w cover photo; $35/b&w inside photo. On solicited photography, pays $50/photo plus expenses and processing. Pays on publication. Credit line given. Buys one-time rights. Will consider simultaneous submissions.
Tips: "We're looking for up-to-date photos of clergy, engaged in preaching, teaching, meeting with congregants, working in social activities. We need photos of women, African-American and Hispanic clergy. We print on newsprint, so images should be high in contrast and sharply focused."

THE CHRONICLE OF PHILANTHROPY, 1255 23rd St. NW, 7th Floor, Washington DC 20037. (202)466-1205. Fax: (202)466-2078. E-mail: sue.lalumia@chronicle.com. Art Director: Sue LaLumia. Circ. 39,000. Estab. 1988. Biweekly tabloid. Readers come from all aspects of the nonprofit world such as charities, foundations and relief agencies such as the Red Cross. Sample copy free.
Needs: Uses 20 photos/issue; 50-75% supplied by freelance photographers. Needs photos of people (profiles) making the news in philanthropy and environmental shots related to person(s)/organization. Most shots arranged with freelancers are specific. Model release required. Captions required.
Making Contact & Terms: Arrange a personal interview to show portfolio. Send unsolicited photos by mail for consideration. Send 35mm, 2¼ × 2¼ transparencies and prints by mail for consideration. Provide résumé, business card, brochure, flier or tearsheets to be kept on file for possible assignments. Will send negatives back via certified mail. Reports in 1-2 days. Pays (color and b&w) $225 plus expenses/half day; $350 plus expenses/full day; $75/b&w reprint; $150/color reprint. Pays on publication. Buys one-time rights. Previously published work OK.

CLEANING & MAINTENANCE MANAGEMENT MAGAZINE, 13 Century Hill Dr., Latham NY 12110. (518)783-1281. Fax: (518)783-1386. E-mail: dominic@facility~maintenance.com. Website: http://facility~maintenance. Senior Editor: Tom Williams. Managing Editor: Dominic Tom. Circ. 40,000. Estab. 1963. Monthly. Emphasizes management of cleaning/custodial/housekeeping operations for commercial buildings, schools, hospitals, shopping malls, airports, etc. Readers are middle- to upper-level managers of in-house cleaning/custodial departments, and managers/owners of contract cleaning companies. Sample copy free (limited) with SASE.
Needs: Uses 10-15 photos/issue. Needs photos of cleaning personnel working on carpets, hard floors, tile, windows, restrooms, large buildings, etc. Model release preferred. Captions required.
Making Contact & Terms: Provide résumé, business card, brochure, flier or tearsheets to be kept on file for possible assignments. "Query with specific ideas for photos related to our field." SASE. Reports in 1-2 weeks. Pays $25/b&w inside photo. Credit line given. Rights negotiable. Simultaneous submissions and previously published work OK.
Tips: "Query first and shoot what the publication needs."

CLIMATE BUSINESS MAGAZINE, P.O. Box 13067, Pensacola FL 32591. (904)433-1166. Fax: (904)435-9174. Publisher: Elizabeth A. Burchell. Circ. 15,000. Estab. 1990. Bimonthly magazine. Emphasizes business. Readers are executives, ages 35-54, with average annual income of $80,000. Sample copy $4.75.
Needs: Uses 50 photos/issue; 20 supplied by freelancers. Needs photos of Florida topics: technology, government, ecology, global trade, finance, travel and life shots. Model/property release required. Captions preferred.
Making Contact & Terms: Send unsolicited photos by mail for consideration. Provide résumé, business card, brochure, flier or tearsheets to be kept on file for possible assignments. Send 5 × 7 b&w or color prints; 35mm, 2¼ × 2¼ transparencies. Keeps samples on file. SASE. Reports in 3 weeks. Pays $75/color cover photo; $25/color inside photo; $25/b&w inside photo; $75/color page. Pays on publication. Buys one-time rights.
Tips: "Don't overprice yourself and keep submitting work."

COLLISION, Box M, Franklin MA 02038. (508)528-6211. Editor: Jay Kruza. Circ. 20,000. Magazine published every 2 months. Emphasizes "technical tips and management guidelines" for auto body repairmen and dealership managers in eastern US. Sample copy $3. Photo guidelines free with SASE.

Needs: Buys 100 photos/year; 12/issue. Photos of technical repair procedures, association meetings, etc. A regular column called "Stars and Cars" features a national personality with his/her car. Prefers at least 3 b&w photos with captions as to why person likes this vehicle. If person has worked on it or customized it, photo is worth more. Special needs include: best looking body shops in US, includes exterior view, owner/manager, office, shop, paint room and any special features (about 6-8 photos). In created or set-up photos, which are not direct news, requires photocopy of model release with address and phone number of models for verification. Captions required

Making Contact & Terms: Query with résumé of credits and representational samples (not necessarily on subject) or send contact sheet for consideration. Send b&w glossy or matte contact sheet or 5×7 prints. SASE. Reports in 3 weeks. Pays $25 for first photo; $10 for each additional photo in the series; pays $50 for first photo and $25 for each additional photo for "Stars and Cars" column. Prefers to buy 5 or 7 photos per series. Extra pay for accompanying mss. **Pays on acceptance.** Buys all rights, but may reassign to photographer after publication. Simultaneous submissions OK.

Tips: "Don't shoot one or two frames; do a sequence or series. It gives us choice, and we'll buy more photos. Often we reject single photo submissions. Capture how the work is done to solve the problem."

COMMERCIAL CARRIER JOURNAL, 201 King of Prussia Rd., Radnor PA 19089. (610)964-4513. Executive Editor: Paul Richards. Managing Editor: Paul Richards. Circ. 85,600. Estab. 1911. Monthly magazine. Emphasizes truck and bus fleet maintenance operations and management.

Needs: Spot news (of truck accidents, Teamster activities and highway scenes involving trucks). Photos purchased with or without accompanying ms, or on assignment. Model release required. *Detailed* captions required.

Making Contact & Terms: Query first; send material by mail for consideration. For color photos, uses prints and 35mm transparencies. For covers, uses color transparencies. Uses vertical cover only. Needs accompanying features on truck fleets and news features involving trucking companies. SASE. Reports in 3 months. Payment varies. Pays on a per-job or per-photo basis. **Pays on acceptance.** Credit line given. Buys all rights.

‡**CONSTRUCTION BULLETIN**, 9443 Science Center Dr., New Hope MN 55428. (612)537-7730. Fax: (612)537-1363. Editor: G.R. Rekela. Circ. 5,000. Estab. 1893. Weekly magazine. Emphasizes construction in Minnesota, North Dakota and South Dakota *only*. Readers are male and female executives, ages 23-65. Sample copy $3.50.

Needs: Uses 25 photos/issue; 1 supplied by freelancers. Needs photos of construction equipment in use on Minnesota, North Dakota, South Dakota job sites. Reviews photos purchased with accompanying ms only. Captions required; include who, what, where, when.

Making Contact & Terms: Send unsolicited photos by mail for consideration. Send 8×10 matte color prints. Keeps samples on file. SASE. Reports in 1 month. Payment negotiable. Pays on publication. Credit line given. Buys one-time rights. Previously published work OK.

Tips: "Be observant, keep camera at hand when approaching construction sites in Minnesota, North Dakota and South Dakota."

✱**CONSTRUCTION COMMENT**, 920 Yonge St., 6th Floor, Toronto, Ontario M4W 3C7 Canada. (416)961-1028. Fax: (416)924-4408. Executive Editor: Katherine Goodes. Circ. 5,000. Estab. 1970. Semi-annual magazine. Emphasizes construction and architecture. Readers are builders, contractors, architects and designers in the Ottawa area. Sample copy and photo guidelines available.

Needs: Uses 25 photos/issue; 50% supplied by freelance photographers. Needs "straightforward, descriptive photos of buildings and projects under construction, and interesting people shots of workers at Ottawa construction sites." Model release preferred. Captions preferred.

Making Contact & Terms: Arrange a personal interview to show portfolio. Query with résumé of credits or list of stock photo subjects. Provide résumé, business card, brochure, flier or tearsheets to be kept on file for possible assignments. SASE (IRCs). Reports in 1 month. Pays $125/color cover photo; $75/b&w cover photo; $25/color or b&w inside photo. Pays on publication. Credit line given. Buys all rights to reprint in our other publications; rights negotiable. Simultaneous submissions and previously published work OK.

Tips: Looks for "representative photos of Ottawa building projects and interesting construction-site people shots."

CONSTRUCTION EQUIPMENT GUIDE, 2627 Mt. Carmel Ave., Glenside PA 19038. (215)885-2900 or (800)523-2200. Fax: (215)885-2910. E-mail: cegglen@aol.com. Editor: Beth Baker. Circ. 80,000.

Estab. 1957. Biweekly trade newspaper. Emphasizes construction equipment industry, including projects ongoing throughout the country. Readers are male and female of all ages. Many are construction executives, contractors, dealers and manufacturers. Free sample copy. Photo guidelines free with SASE.

Needs: Uses 75 photo/issue; 20 supplied by freelancers. Needs photos of construction job sites and special event coverage illustrating new equipment applications and interesting projects. Call to inquire about special photo needs for coming year. Model/property release preferred. Captions required for subject identification.

Making Contact & Terms: Interested in receiving work from newer, lesser-known photographers. Send unsolicited photos by mail for consideration. Provide résumé, business card, brochure, flier or tearsheets to be kept on file for possible future assignments. Send any size matte or glossy b&w prints. Keeps samples on file. SASE. Reports in 3 weeks. Payment negotiable. Pays on publication. Credit line given. Buys all rights; negotiable. Simultaneous submissions OK.

CONTEMPORARY DIALYSIS & NEPHROLOGY, 6300 Variel Ave., Suite 1, Woodland Hills CA 91367. (818)704-5555. Fax: (818)704-6500. Associate Publisher: Susan Sommer. Circ. 16,300. Estab. 1980. Monthly magazine. Emphasizes renal care (kidney disease). Readers are medical professionals involved in kidney care. Sample copy $4.

Needs: Uses various number of photos/issue. Model release required. Captions required.

Making Contact & Terms: Interested in receiving work from newer, lesser-known photographers. Contact through rep. Send unsolicited photos by mail for consideration. Send 35mm transparencies. Keeps samples on file. SASE. Reports in 2 weeks. Payment negotiable. Credit line given.

CORPORATE DETROIT MAGAZINE, 19512 Livernois, Detroit MI 48221. (313)345-3300. Fax: (313)345-5010. Editor: Tom Henderson. Circ. 26,000. Monthly independent circulated to senior executives. Emphasizes Michigan business. Readers include top-level executives. Sample copy free with 9 × 12 SASE. Call Art Director for photo guidelines.

Needs: Uses variable number of photographs; most supplied by freelance photographers; 40% come from assignments. Needs photos of business people, environmental, feature story presentation, mug shots, etc. Reviews photos with accompanying ms only. Special needs include photographers based around Michigan for freelance work on job basis. Model/property release preferred. Captions required.

Making Contact & Terms: Interested in receiving work from newer, lesser-known photographers. Arrange a personal interview to show portfolio. Query with résumé of credits and samples. SASE. Payment negotiable. Pays on publication.

THE CRAFTS REPORT, 300 Water St., Wilmington DE 19801. (302)656-2209. Fax: (302)656-4894. Art Director: Mike Ricci. Circ. 20,000. Estab. 1975. Monthly. Emphasizes business issues of concern to professional craftspeople. Readers are professional working craftspeople, retailers and promoters. Sample copy $5.

Needs: Uses 15-25 photos/issue; 0-10 supplied by freelancers. Needs photos of professionally-made crafts, craftspeople at work, studio spaces, craft schools—also photos tied to issue's theme. Model/property release required; shots of artists and their work. Captions required; include artist, location.

Making Contact & Terms: Interested in receiving work from newer, lesser-known photographers. Query with résumé of credits. Provide résumé, business card, brochure, flier or tearsheets to be kept on file for possible assignments. Keeps samples on file. SASE. Pays $250-400/color cover photo; $25-50/published photo; assignments negotiated. Pays on publication. Credit line given. Buys one-time and first North American serial rights; negotiable. Simultaneous submissions and previously published work OK.

Tips: "Shots of craft items must be professional-quality images. For all images be creative—experiment. Color, black & white and alternative processes considered."

CRANBERRIES, Dept. PM, P.O. Box 190, Rochester MA 02770. (508)866-5055. Fax: (508)866-9291. E-mail: cranzine@ultranet.com. Publisher/Editor: Carolyn Gilmore. Circ. 850. Monthly, but December/January is a combined issue. Emphasizes cranberry growing, processing, marketing and research. Readers are "primarily cranberry growers but includes anybody associated with the field." Sample copy free.

Needs: Uses about 10 photos/issue; half supplied by freelancers. Needs "portraits of growers, harvesting, manufacturing—anything associated with cranberries." Captions required.

Making Contact & Terms: Send 4×5 or 8×10 b&w or color glossy prints by mail for consideration; "simply query about prospective jobs." Accepts images in digital format for Windows (TIFF). Send via compact disc, online, floppy disk. SASE. Pays $25-60/b&w cover photo; $15-30/b&w inside photo; $35-100 for text/photo package. Pays on publication. Credit line given. Buys one-time rights. Simultaneous submissions and previously published work OK.

Tips: "Learn about the field."

DANCE TEACHER NOW, 3101 Poplarwood Court, Suite 310, Raleigh NC 27604-1010. (919)872-7888. Fax: (919)872-6888. E-mail: dancenow@aol.com. Editor: K.C. Patrick. Circ. 8,000. Estab. 1979. Magazine published 10 times per year. Emphasizes dance, business, health and education. Readers are dance instructors and other related professionals, ages 15-90. Sample copy free with 9 × 12 SASE. Guidelines free with SASE.

Needs: Uses 20 photos/issue; all supplied by freelancers. Needs photos of action shots (teaching, etc.). Reviews photos with accompanying ms only. Model/property release preferred. Model releases required for minors and celebrities. Captions preferred; include date and location.

Making Contact & Terms: Interested in receiving work from newer, lesser-known photographers. Provide résumé, business card, brochure, flier or tearsheets to be kept on file for possible assignments. Keeps samples on file. SASE. Accepts digital images; call art director for requirements. Pays $50 minimum/color cover photo; $20/color inside photo; $20/b&w inside photo. Pays on publication. Credit line given. Buys one-time rights plus publicity rights; negotiable.

■**DELTA DESIGN GROUP, INC.**, 409 Washington Ave., Box 1676, Greenville MS 38702. (601)335-6148. Fax: (601)378-2826. President: Noel Workman. Publishes magazines dealing with cotton marketing, health care, casino, travel and Southern agriculture.

Needs: Photos used for text illustration, promotional materials and slide presentations. Buys 25 photos/year; offers 10 assignments/year. Southern agriculture (cotton, rice, soybeans, sorghum, forages, beef and dairy, and catfish); California and Arizona irrigated cotton production; all aspects of life and labor on the lower Mississippi River; Southern historical (old photos or new photos of old subjects); recreation (boating, water skiing, fishing, canoeing, camping), casino gambling. Model release required. Captions preferred.

Making Contact & Terms: Query with samples or list of stock photo subjects or mail material for consideration. SASE. Reports in 1 week. Pays $50 minimum/job. Credit line given, except for photos used in ads or slide shows. Rights negotiable. Simultaneous submissions and previously published work OK.

Tips: "Wide selections of a given subject often deliver a shot that we will buy, rather than just one landscape, one portrait, one product shot, etc."

DENTAL ECONOMICS, Box 3408, Tulsa OK 74101. (918)835-3161. Editor: Dr. Joseph Blaes. Circ. 110,000. Monthly magazine. Emphasizes dental practice administration—how to handle staff, patients and bookkeeping and how to handle personal finances for dentists. Free sample copy. Photo and writer's guidelines free with SASE.

Needs: "Our articles relate to the business side of a practice: scheduling, collections, consultation, malpractice, peer review, closed panels, capitation, associates, group practice, office design, etc." Also uses profiles of dentists.

Making Contact & Terms: Send material by mail for consideration. Uses 8 × 10 b&w glossy prints; 35mm or 2¼ × 2¼ transparencies. "No outsiders for cover." SASE. Reports in 5-6 weeks. Payment negotiable. Pays in 30 days. Credit line given. Buys all rights but may reassign to photographer after publication.

Tips: "Write and think from the viewpoint of the dentist—not as a consumer or patient. If you know of a dentist with an unusual or very visual hobby, tell us about it. We'll help you write the article to accompany your photos. Query please."

DIMENSIONS, (formerly *Pickworld*), 1691 Browning, Irvine CA 92606. (714)261-7425. Fax: (714)250-8187. Editor: Denis Hill. Circ. 25,000. Estab. 1984. Quarterly magazine. Emphasizes the multidimensional database market: vendors and users. Readers are managers, technical staff of vendors or user entities in the multidimensional database market. Sample copy $8.

Needs: Uses 30 photos/issue; 10 supplied by freelancers. Needs photos of people and businesses, computers and related objects. Model release preferred.

Making Contact & Terms: Query with résumé of credits. Does not keep samples on file. SASE. Reports in 3 weeks. Pays $200/job; $300-500/color cover photo; $50/color inside photo. **Pays on acceptance**. Credit line given. Buys first North American serial rights. Simultaneous submissions and previously published work OK.

DISPLAY & DESIGN IDEAS, 6255 Barfield Rd., Suite 200, Atlanta GA 30328. (404)252-8831. Fax: (404)252-4436. Editor: Steve Kaufman. Circ. 20,000. Estab. 1988. Monthly magazine. Emphasizes retail design, store planning, visual merchandising. Readers are retail chain executives in more than 35 retail catagories. Sample copy available.

Needs: Uses 150 photos/issue; less than 5% supplied by freelancers. Needs photos of architecture, mostly interior. Property release preferred.

Making Contact & Terms: Interested in receiving work from newer, lesser-known photographers. Contact through rep. Arrange personal interview to show portfolio. Submit portfolio for review. Query with résumé of credits. Send unsolicited photos by mail for consideration. Provide résumé, business card, bro-

chure, flier or tearsheets to be kept on file for possible future assignments. Send 8×10 glossy color prints; 4×5 transparencies. Keeps samples on file. SASE. Reports in 3 weeks. Credit line given. Rights negotiable. Simultaneous submissions and/or previously published work OK.

Tips: Looks for architectural interiors, ability to work with different lighting.

‡DM NEWS, 100 Avenue of the Americas, New York NY 10013. (212)925-7300. Fax: (212)925-8754. E-mail: editor@dmnews.com. Editor-in-Chief: Jane Traulsen. Circ. 35,000. Estab. 1979. Company publication for Mill Hollow Corporation. Weekly newspaper. Emphasizes direct marketing. Readers are male and female professionals ages 25-55. Sample copy $2.

 • This publication was redesigned and now needs more photos.

Needs: Uses 20 photos/issue; 3-5 supplied by freelancers. Needs photos of news head shots, product shots. Reviews photos purchased with accompanying ms only. Captions required.

Making Contact & Terms: Interested in receiving work from newer, lesser-known photographers. Provide résumé, business card, brochure, flier or tearsheets to be kept on file for possible assignments. Does not keep samples on file. SASE. Reports in 1-2 weeks. Payment negotiable. **Pays on acceptance**. Buys one-time rights.

Tips: "News and business background are a prerequisite."

EDUCATION WEEK, Dept. PM, 4301 Connecticut Ave. NW, Suite 250, Washington DC 20008. (202)364-4114. Fax: (202)364-1039. Editor-in-Chief: Ronald A. Wolk. Photo Editor: Benjamin Tice Smith. Circ. 65,000. Estab. 1981. Weekly. Emphasizes elementary and secondary education.

Needs: Uses about 20 photos/issue; most supplied by freelance photographers; 90% on assignment, 10% from stock. Model/property release preferred. Model release usually needed for children (from parents). Captions required; include names, ages, what is going on in the picture.

Making Contact & Terms: Interested in receiving work from newer, lesser-known photographers. Query with samples. Provide résumé and tearsheets to be kept on file for possible future assignments. Cannot return material. Reports in 2 weeks. Pays $50-150/b&w photo; $100-300/day; $50-250/job. **Pays on acceptance**. Credit line given. Buys all rights; negotiable. Simultaneous submissions and previously published work OK.

Tips: "When reviewing samples we look for the ability to make interesting and varied images from what might not seem to be photogenic. Show creativity backed up with technical polish."

ELECTRIC PERSPECTIVES, 701 Pennsylvania Ave. NW, Washington DC 20004. (202)508-5714. Fax: (202)508-5759. E-mail: ericbcm@eei.org. Associate Editor: Eric Blume. Circ. 20,000. Estab. 1976. Publication of Edison Electric Institute. Bimonthly magazine. Emphasizes issues and subjects related to investor-owned electric utilities. Sample copy available on request.

Needs: Uses 20-25 photos/issue; 60% supplied by freelancers. Needs photos relating to the business and operational life of electric utilities—from customer service to engineering, from executive to blue collar. Model release required. Captions preferred.

Making Contact & Terms: Interested in receiving work from all photographers, including newer, lesser-known photographers. Query with stock photo list. Send unsolicited photos by mail for consideration. Provide résumé, business card, brochure, flier or tearsheets to be kept on file for possible assignments. Send 8×10 glossy color prints; 35mm, 2¼×2¼, 4×5 transparencies. Keeps samples on file. SASE. Reports in 1 month. Pays $200-400/color cover photo; $100-300/color inside photo; $200-350/color page rate; $750-1,500/photo/text package. Pays on publication. Buys one-time rights; negotiable (for reprints).

Tips: "We're interested in annual-report quality transparencies in particular. Quality and creativity is often more important than subject."

ELECTRICAL APPARATUS, Barks Publications, Inc., 400 N. Michigan Ave., Chicago IL 60611-4198. (312)321-9440. Associate Publisher: Elsie Dickson. Circ. 17,000. Monthly magazine. Emphasizes industrial electrical machinery maintenance and repair for the electrical aftermarket. Readers are "persons engaged in the application, maintenance and servicing of industrial and commercial electrical and electronic equipment." Sample copy $4.

Needs: "Assigned materials only. We welcome innovative industrial photography, but most of our material is staff-prepared." Photos purchased with accompanying ms or on assignment. Model release required "when requested." Captions preferred.

Making Contact & Terms: Query with résumé of credits. Contact sheet or contact sheet with negatives OK. SASE. Reports in 3 weeks. Pays $25-100/b&w or color. Pays on publication. Credit line given. Buys all rights, but exceptions are occasionally made.

ELECTRICAL WHOLESALING, 9800 Metcalf, Overland Park KS 66212-2215. (913)967-1797. Fax: (913)967-1905. E-mail: cheri_jones@intertec.com. Art Director: Cheri Jones. Monthly magazine. Empha-

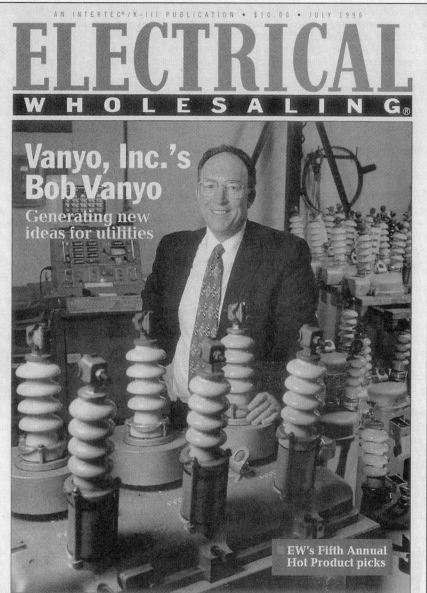

AN INTERTEC®/K-III PUBLICATION • $10.00 • JULY 1996

ELECTRICAL
WHOLESALING®

Vanyo, Inc.'s Bob Vanyo
Generating new ideas for utilities

EW's Fifth Annual Hot Product picks

photo © Eric Miller

While shooting this photo on site at Vanyo, Inc., photographer Eric Miller found that "oil leaks from transformers, and can make a mess of shooting situations." He received $1,000 for a day shoot of Vanyo employees resulting in this cover shot as well as several photos accompanying an article in the July 1996 issue of *Electrical Wholesaling*. Miller wishes, however, that art directors "would be more accepting of subtle interpretations of guys in ties with their company's widget and get away from the obvious staged picture."

sizes electrical wholesale business. Readers are male and female executives, electrical distributors and contractors, salespeople (ages 30-65) in the electrical wholesale business. Sample copy free with 9×12 SAE and 10 first-class stamps.

Needs: Uses 15 photos/issue; 3 supplied by freelancers, usually the cover photo. Needs color photos of executive portraits, photo/illustration. Special photos include executive portraits, company profile photos, photo/illustration.

Making Contact & Terms: Interested in receiving work from newer, lesser-known photographers. Provide business card, brochure or tearsheets to be kept on file for possible assignments. Keeps samples on file. SASE. Reports in 3 weeks. Pays $400-1,000/job; $800-1,000/color cover photo; $450-700/color inside photo. Credit line given. Buys one-time rights. Simultaneous submissions OK.

Tips: Looks for "a natural sense of working with people, location capability, good color sense, an ability to make mundane subjects seem interesting using mood, color, composition, etc. We only use color photos. We run a small operation, which often forces us to be ingenious and flexible and creative. We look for similar characteristics in the people we hire."

EMERGENCY, The Journal of Emergency Services, 2512 Artesia Blvd., Redono Beach CA 90278. (310)376-8788. Fax: (310)798-4598. E-mail: emergency@aol.com. Editor: Doug Fiske. Circ. 26,000. Estab. 1969. Monthly magazine. Emphasizes prehospital emergency medical and rescue services for paramedics, EMTs and firefighters to keep them informed of latest developments in the emergency medical services field. Sample copy $5.

• *Emergency* customizes photos in PhotoShop.

Needs: Buys 200 photos/year; 12 photos/issue. Documentary and spot news dealing with prehospital emergency medicine. Needs shots to accompany unillustrated articles submitted and cover photos; year's calendar of themes forwarded on request with #10 SASE. "Try to get close to the action; both patient and emergency personnel should be visible. All medics pictured *must* be wearing gloves and using any other necessary universal precautions." Photos purchased with or without accompanying ms. Model and property releases preferred. Captions required; include the name, city and state of the emergency rescue team and medical treatment being rendered in photo. Also needs color transparencies for "Action," a photo department dealing with emergency personnel in action. Accompanying mss: instructional, descriptive or feature articles dealing with emergency medical services.

Making Contact & Terms: Interested in receiving work from newer, lesser-known photographers. Uses 5×7 b&w or color glossy prints; 35mm or larger transparencies. For cover: Prefers 35mm; $2\frac{1}{4} \times 2\frac{1}{4}$ transparencies OK. Vertical format preferred. Send material by mail for consideration, especially shots of EMTs/paramedics in action. SASE. Pays $30/inside photo; $105/color cover photo; $100-400/ms; "noteworthy material will be considered for further compensation." Pays for mss/photo package, or on a per-photo basis. **Pays on acceptance.** Credit line given. Buys all rights, "nonexclusive."

Tips: Wants well-composed photos with good overall scenes and clarity that say more than "an accident happened here. We're going toward single-focus, uncluttered photos." Looking for more color photos for articles. "Good closeups of actual treatment. Also, sensitive illustrations of the people in EMS—stress, interacting with family/pediatrics etc. We're interested in rescuers, and our readers like to see their peers in action, demonstrating their skills. Make sure photo is presented with treatment rendered and people involved.

EMPIRE STATE REPORT, 4 Central Ave., 3/F, Albany NY 12210. (518)465-5502. Fax: (518)465-9822. Editor: Victor Schaffner. Circ. 15,000. Estab. 1976. Monthly magazine. Emphasizes New York state politics and public policy. Readers are state policy makers and those who wish to influence them. Sample copy with $8\frac{1}{2} \times 11$ SAE and 6 first-class stamps.

Needs: Uses 10-20 photos/issue; 5-10 supplied by freelancers. Needs photos of New York state personalities (political, government, business); issues; New York state places, cities, towns. Model/property release preferred. Captions preferred; include subject matter of photo.

Making Contact & Terms: Interested in receiving work from newer, lesser-known photographers. Send unsolicited photos by mail for consideration. Provide résumé, business card, brochure, flier or tearsheets to be kept on file for possible assignments. Keeps samples on file. SASE. Reports in 3 weeks. Pays $125-250/color cover photo; $50-75/b&w inside photo. Pays on publication. Credit line given. Buys one-time rights. Simultaneous submissions and previously published work OK.

Tips: "Subject matter is the most important consideration at ESR. The subject must have a New York connection. But, on some occasions, a state issue can be illustrated with a more general photograph."

ERGONOMICS IN DESIGN, P.O. Box 1369, Santa Monica CA 90406-1369. (310)394-1811. Fax: (310)394-2410. E-mail: 72133.1474@compuserve.com. Website: http://hfes.org. Managing Editor: Lois Smith. Circ. 6,000. Estab. 1993. Publication of Human Factors and Ergonomics Society. Quarterly magazine. Emphasizes how ergonomics research is applied to tools, equipment and systems people use. Readers

are BA/MA/PhDs in psychology, engineering and related fields. Sample copy $9.

Needs: Needs photos of technology areas such as medicine, transportation, consumer products. Model/property release preferred. Captions preferred.

Making Contact & Terms: Interested in receiving work from newer, lesser-known photographers. Query with stock photo list. Keeps samples on file. SASE. Reports in 2 weeks. Accepts digital images; inquire before submitting. Pays on publication. Credit line given. Buys one-time rights. Simultaneous submissions and previously published work OK.

Tips: Wants to see high-quality color work for strong (sometimes subtle) cover that can also be modified in b&w for lead feature opener inside book.

EUROPE, 2300 M St. NW, 3rd Floor, Washington DC 20037. (202)862-9557. Editor-in-Chief: Robert J. Guttman. Managing Editor: Peter Gwin. Photo Editor: Anne Alvarez. Circ. 25,000. Magazine published 10 times a year. Covers the Europe Union with "in-depth news articles on topics such as economics, trade, US-EU relations, industry, development and East-West relations." Readers are "business people, professionals, academics, government officials." Free sample copy.

Needs: Uses about 20-30 photos/issue, most of which are supplied by stock houses and freelance photographers. Needs photos of "current news coverage and sectors, such as economics, trade, small business, people, transport, politics, industry, agriculture, fishing, some culture, some travel. No traditional costumes. Each issue we have an overview article on one of the 15 countries in the European Union. For this we need a broad spectrum of photos, particularly color, in all sectors. If a photographer queries and lets us know what he has on hand, we might ask him to submit a selection for a particular story. For example, if he has slides or b&ws on a certain European country, if we run a story on that country, we might ask him to submit slides on particular topics, such as industry, transport or small business." Model release preferred. Captions preferred; identification necessary.

Making Contact & Terms: Interested in receiving work from newer, lesser-known photographers. Query with list of stock photo subjects. Initially, a list of countries/topics covered will be sufficient. SASE. Reports in 1 month. Pays $75-150/b&w photo; $100 minimum/color transparency for inside; $400/cover; per job negotiable. Pays on publication. Credit line given. Buys one-time rights. Simultaneous submissions and previously published work OK.

Tips: "For certain articles, especially the Member States' Reports, we are now using more freelance material than previously. We need good photo and color quality, but not touristy or stereotypical. We want to show modern Europe growing and changing. Feature business or industry if possible."

FARM CHEMICALS, Dept. PM, 37733 Euclid Ave., Willoughby OH 44094. (216)942-2000. Fax: (216)942-0662. Editorial Director: Charlotte Sine. Editor: Jim Suleuki. Circ. 32,000. Estab. 1894. Monthly magazine. Emphasizes application and marketing of fertilizers and protective chemicals for crops for those in the farm chemical industry. Free sample copy and photo guidelines with 9 × 12 SAE.

Needs: Buys 6-7 photos/year; 5-30% supplied by freelancers. Photos of agricultural chemical and fertilizer application scenes (of commercial—not farmer—applicators). Model release preferred. Captions required.

Making Contact & Terms: Query first with résumé of credits. Uses 8 × 10 glossy b&w and color prints or transparencies. SASE. Reports in 3 weeks. Pays $25-50/b&w photo; $50-125/color photo. **Pays on acceptance.** Buys one-time rights. Simultaneous submissions and previously published work OK.

FIRE CHIEF, 35 E. Wacker, Suite 700, Chicago IL 60601. (312)726-7277. Fax: (312)726-0241. E-mail: firechfmag@connectinc.com. Editor: Scott Baltic. Circ. 45,000. Estab. 1956. Monthly magazine. Emphasizes fire department management and operations. Readers are overwhelmingly fire officers and predominantly chiefs of departments. Free sample copy. Photo guidelines free with SASE.

Needs: Uses 1 photo/issue; 1 supplied by freelancers. Needs photos of a fire chief in action at an emergency scene. "Contact us for a copy of our current editorial calendar." Model/property release preferred. Captions required; include names, dates, brief description of incident.

Making Contact & Terms: Interested in receiving work from newer, lesser-known photographers. Send unsolicited photos by mail for consideration. Send any glossy color prints; 35mm, 2¼ × 2¼ transparencies. Keeps samples on file. SASE. Reports in 1 month. Pays $150/color cover photo; $20-25/color inside photo. Pays on publication. Buys first serial rights; negotiable.

Tips: "We want a photo that captures a chief officer in command at a fire or other incident, that speaks to the emotions (the burden of command, stress, concern for others). Most of our cover photographers take dozens of fire photos every month. These are the guys who keep radio scanners on in the background most of the day. Timing is everything."

FIRE ENGINEERING, Park 80 West Plaza 2, 7th Floor, Saddle Brook NJ 07663. (201)845-0800. Fax: (201)845-6275. Editor: Bill Manning. Estab. 1877. Magazine. Training magazine for firefighters. Photo guidelines free with SASE.

Needs: Uses 400 photos/year. Needs action photos of firefighters working. Captions required; include date, what is happening, location and fire department contact.

Making Contact & Terms: Interested in receiving work from newer, lesser-known photographers. Send unsolicited photos by mail for consideration. Send prints; 35mm transparencies. SASE. "We accept scans of photos as long as high-resolution version." Reports in up to 3 months. Pays $35-150/color inside photo; $300/color cover. Pays on publication. Credit line given. Rights negotiable.

Tips: "Firefighters must be doing something. Our focus is on training and learning lessons from photos."

‡**FIREFIGHTERS NEWS**, P.O. Box 100, Nassau DE 19969. (302)645-5600. (302)645-8747. Editor: Larry Stevens. Circ. 41,000. Estab. 1982. Bimonthly magazine. Emphasizes fire service suppression (not protection). Readers are male and female fire department personnel, ages 16-80. Sample copy $4. Photo guidelines free with SASE.

Needs: Uses 150-200 photos/issue; 100-150 supplied by freelancers. Needs photos of live fire, suppression, rescue, extrication and paramedic services. Property release required. Captions required; include who, when, why, where, how.

Making Contact & Terms: Interested in receiving work from newer, lesser-known photographers. Send unsolicited photos by mail for consideration. Send 3×5 or larger glossy color prints; 35mm, 2¼×2¼ transparencies. Keeps samples on file. SASE. Submissions either returned in 30 days or held for stock photos. Pays $100/color cover photo; $30/color inside photo. Pays on publication. Credit line given. Buys all rights; negotiable. Simultaneous submissions OK.

FIRE-RESCUE MAGAZINE, (formerly *Rescue Magazine*), Jems Communications, P.O. Box 2789, Carlsbad CA 92018. Fax: (619)431-8176. Editor: Jeff Berend. Circ. 25,000. Estab. 1988. Monthly. Emphasizes techniques, equipment, action stories with unique rescues; paramedics, EMTs, rescue divers, firefighters, etc. "Rescue personnel are most of our readers." Sample copy free with 9×12 SAE and 7 first-class stamps. Photo guidelines free with SASE.

● Not only has *Fire-Rescue* changed from bimonthly to monthly publication, but it also has increased the number of photos used in each issue.

Needs: Uses 50-75 photos/issue; 25-50 supplied by freelance photographers. Needs rescue scenes, transport, injured victims, equipment and personnel, training, earthquake rescue operations. Special photo needs include strong color shots showing newsworthy rescue operations, including a unique or difficult rescue/extrication, treatment, transport, personnel, etc. b&w showing same. Captions required.

Making Contact & Terms: Interested in receiving work from newer, lesser-known photographers. Query with samples. Send 5×7 or larger glossy color prints or color contacts sheets by mail for consideration. Slide/transparencies preferred format. SASE. Pays $135-150/color inside photo. Pays on publication. Credit line given. Buys one-time rights. No work previously published in competitors.

Tips: Looks for "photographs that show rescuers in action, using proper techniques and wearing the proper equipment. Submit timely photographs that show the technical aspects of firefighting and rescue. Tight shots/close-ups preferred."

FLORIDA UNDERWRITER, Dept. PM, 9887 Fourth St. N., Suite 230, St. Petersburg FL 33702. (813)576-1101. Editor: James E. Seymour. Circ. 10,000. Estab. 1984. Monthly magazine. Emphasizes insurance. Readers are insurance professionals in Florida. Sample copy free with 9×12 SASE.

Needs: Uses 10-12 photos/issue; 1-2 supplied by freelancers; 80% assignment and 20% freelance stock. Needs photos of insurance people, subjects, meetings and legislators. Captions preferred.

Making Contact & Terms: Query first with list of stock photo subjects. Send b&w prints, 35mm, 2¼×2¼, 4×5, 8×10 transparencies by mail for consideration. Provide résumé, business card, brochure, flier or tearsheets to be kept on file for possible assignments. SASE. Reports in 3 weeks. Pays $50-150/b&w cover photo; $15-35/b&w inside photo; $5-20/color page rate. Pays on publication. Credit line given. Buys all rights; negotiable. Simultaneous submissions and previously published work OK (admission of same required).

Tips: "Like the insurance industry we cover, we are cutting costs. We are using fewer freelance photos (almost none at present)."

FOOD & SERVICE, P.O. Box 1429, Austin TX 78767-1429. Art Director: Gina Wilson. Circ. 6,500. Estab. 1940. Publication of the Texas Restaurant Association. Published 8 times a year. Emphasizes restaurant owners and managers in Texas—industry issues, legislative concerns, management techniques. Readers are restaurant owners/operators in Texas. Sample copy free with 10×13 SAE and 6 first-class stamps. Photo guidelines free with SASE.

Needs: Uses 1-3 photos/issue; 1-3 supplied by freelancers. Needs editorial photos illustrating business concerns (i.e. health care issues, theft in the workplace, economic outlooks, employee motivation, etc.)

Reviews photos purchased with or without a manuscript (but prefers with). Model release required for paid models. Property release preferred for paid models.

Making Contact & Terms: Interested in receiving work from newer, lesser-known photographers. Provide résumé, business card, brochure, flier or tearsheets to be kept on file for possible assignments. Accepts digital images in Photoshop 300 DPI RGB files on magnetic optical 230 drive for Macintosh. Deadlines: 2-3 week turnaround from assignment date. Keeps samples on file. SASE. Reports in 2 months. Pays $75-450/job; $200-450/color cover photo; $200-300/b&w cover photo; $200-300/color inside photo; $100-250/b&w inside photo. **Pays on acceptance.** Credit line given. Buys one-time rights. Previously published work OK.

Tips: "Please don't send food shots—even though our magazine is called *Food & Service*. We publish articles about the food service industry that interest association members—restaurant owners and operators (i.e. legislative issues like health care; motivating employees; smokers' vs. non-smokers' rights; proper food handling; plus, occasional member profiles). Avoid clichés and over-used trends. Don't be weird for weird's sake. Photos in our magazines must communicate (and complement the editorial matter)."

FOOD DISTRIBUTION MAGAZINE, 213 N. Belcher, Clearwater FL 34625. (813)724-6400. Fax: (813)724-6303. Editor: Steve Germain. Circ. 35,000. Estab. 1959. Monthly magazine. Emphasizes gourmet and specialty foods. Readers are male and female food-industry executives, ages 30-60. Sample copy $5.
Needs: Uses 10 photos/issue; 3 supplied by freelancers. Needs photos of food, still-life, human interest, people. Reviews photos with accompanying ms only. Model release required for models only. Captions preferred; include photographer's name, subject.
Making Contact & Terms: Send unsolicited photos by mail for consideration. Send any size color prints or slides and 4×5 transparencies. SASE. Reports in 1-2 weeks. Pays $100 minimum/color cover photo; $50 minimum/color inside photo. Pays on publication. Credit line given. Buys all rights. Simultaneous submissions OK.

FOOD PRODUCT DESIGN MAGAZINE, 3400 Dundee Rd., Suite 100, Northbook IL 60062. (847)559-0385. Fax: (847)559-0389. Art Director: Barbara Weeks. Circ. 26,000. Estab. 1991. Monthly. Emphasizes food development. Readers are research and development people in food industry.
Needs: Needs food shots (4-color). Special photo needs include food shots—pastas, cheese, reduced fat, meat products, sauces, etc.; as well as group shots of people, lab shots, focus group shots.
Making Contact & Terms: Interested in receiving work from newer, lesser-known photographers. Query with stock photo list. Reports in 1-2 weeks. Pays on publication. Credit line given. Buys all rights for use in magazine. Simultaneous submissions and/or previously published work OK.
Tips: Prefers to work with local photographers.

FORD NEW HOLLAND NEWS, P.O. Box 1895, New Holland PA 17557. Editor: Gary Martin. Circ. 400,000. Estab. 1960. Published 8 times a year. Emphasizes agriculture. Readers are farm families. Sample copy and photo guidelines free with 9×12 SASE.
Needs: Buys 30 photos/year. 50% freelance photography/issue from assignment and 50% freelance stock. Needs photos of scenic agriculture relating to the seasons, harvesting, farm animals, farm management and farm people. Model release required. Captions required.
Making Contact & Terms: "Show us your work." SASE. Reports in 2 weeks. "We need photos of farm crops and animals. Collections viewed and returned quickly." Pays $50-500/color photo, depends on use and quality of photo. **Pays on acceptance.** Buys first North American serial rights. Previously published work OK.
Tips: Photographers "must see beauty in agriculture and provide meaningful caption material. It also helps to team up with a good agricultural writer and query us."

FUTURES MAGAZINE, 219 Parkade, Cedar Falls IA 50613. Fax: (319)277-5803. Website: http://www.futuresmag.com. Managing Editor: Kelly Volden. Circ. 70,000. Monthly magazine. Emphasizes futures and options trading. Readers are individual traders, institutional traders, brokerage firms, exchanges. Sample copy $4.50.
Needs: Uses 1-5 photos/issue; 80% supplied by freelance photographers. Needs mostly personality portraits of story sources, some mug shots, trading floor environment. Model release required.
Making Contact & Terms: Arrange a personal interview to show portfolio. Query with list of stock photo subjects. Provide résumé, business card, brochure, flier or tearsheets to be kept on file for possible future assignments. SASE. Reports in 2 weeks. Payment negotiable. Pays on publication. Credit line given.
Tips: All work is on assignment. Be competitive on price. Shoot good work without excessive film use.

GAS INDUSTRIES, 6301 Gaston Ave., Suite 541, Dallas TX 75214. (214)827-4630. Fax: (214)827-4758. Associate Publisher: Ruth W. Stidger. Circ. 11,000. Estab. 1956. Monthly magazine. Emphasizes

natural gas utilities and pipelines. Readers are mostly male managers and engineers, ages 30-65. Sample copy free with 9×12 SAE and 4 first-class stamps.

Needs: Uses 12 photos/issue; 20% supplied by freelancers. Needs photos of workers laying, repairing pipelines; gas utility crews on the job. Special photo needs include plastic pipe cover; new gas meter technology cover; assigned industry figure shots. Model release required. "Releases required unless photo is shot in public place." Captions required; include names of people in photos; names of contractors or utilities crews in pictures.

Making Contact & Terms: Interested in receiving work from newer, lesser-known photographers. Send unsolicited photos by mail for consideration. Send 8×10 color prints; 35mm, 2¼×2¼, 4×5, 8×10 transparencies. Does not keep samples on file. SASE. Reports in 2 weeks. Pays $200-300/color cover photo. **Pays on acceptance.** Credit line given. Buys first North American serial rights; negotiable. Simultaneous submissions and previously published work OK.

GENERAL AVIATION NEWS & FLYER, Dept. PM, P.O. Box 39099, Tacoma WA 98439-0099. (206)471-9888. Fax: (206)471-9911. Managing Editor: Kirk Gormley. Circ. 35,000. Estab. 1949. Biweekly tabloid. Emphasizes aviation. Readers are pilots and airplane owners and aviation professionals. Sample copy $3.50. Photo guidelines free with SASE.

Needs: Uses 30-40 photos/issue; 10-50% supplied by freelancers. Reviews photos with or without ms, but "strongly prefer with ms." Especially wants to see "travel and destinations, special events."

Making Contact & Terms: Interested in receiving work from newer, lesser-known photographers. Query with résumé of credits. Captions preferred. Send unsolicited prints (up to 8×10, b&w or color) or transparencies (35mm or 2¼×2¼) by mail for consideration. Does not keep samples on file. SASE. Reports in 1 month. Pays $35-50/color cover photo; $35/color inside photo; $10/b&w inside photo. Pays on publication. Credit line given. Buys one-time rights.

Tips: Wants to see "sharp photos of planes with good color, airshows not generally used."

GEOTECHNICAL FABRICS REPORT, 345 Cedar St., Suite 800, St. Paul MN 55101. (612)222-2508 or (800)225-4324. Fax: (612)222-8215. Editor: Dawn A. Sawvel. Circ. 17,000. Estab. 1983. Published 9 times/year. Emphasizes geosynthetics in civil engineering applications. Readers are civil engineers, professors and consulting engineers. Sample copies available. Photo guidelines available.

Needs: Uses 10-15 photos/issue; various number supplied by freelancers. Needs photos of finished applications using geosynthetics, photos of the applications process. Reviews photos with or without ms. Model release required. Captions required; include project, type of geosynthetics used and location.

Making Contact & Terms: Interested in receiving work from newer, lesser-known photographers. Send unsolicited photos by mail for consideration. Send any size color and b&w prints. Keeps samples on file. SASE. Reports in 1 month. Payment negotiable. Credit line given. Buys all rights; negotiable. Simultaneous submissions OK.

Tips: "Contact manufacturers in the geosynthetics industry and offer your services. We will provide a list, if needed."

GOVERNMENT TECHNOLOGY, 9719 Lincoln Village, #500, Sacramento CA 95827. (916)363-5000. Fax: (916)363-5197. Creative Director: Michelle MacDonnell. Circ. 65,000. Estab. 1988. Monthly tabloid. Emphasizes technology in state and local government—no federal. Readers are male and female state and local government executives. Sample copy free with tabloid-sized SAE and 10 first-class stamps.

Needs: Uses 20-30 photos/issue; 1-5 supplied by freelancers. Needs photos of action or aesthetic—technology in use in state and local government, e.g., fire department, city hall, etc. Model/property release required; model and government agency. Captions preferred; who, what and where.

Making Contact & Terms: Interested in receiving work from newer, lesser-known photographers. Send unsolicited photos by mail for consideration. Send 35mm, 2¼×2¼, 4×5, 8×10 transparencies. Cannot return materials. Reports back when used. Pays $100-200/color cover photo; $25-75/color inside photo; $10-50/b&w inside photo. Pays on publication. Credit line given. Buys all rights; negotiable. Simultaneous submissions and previously published work OK.

Tips: Looking for "before and after shots. Photo sequences that tell the story. Get copies of our magazine. Tell me your location if you are willing to do assignments on spec."

GRAIN JOURNAL, Dept. PM, 2490 N. Water St., Decatur IL 62526. (217)877-9660. Fax: (217)877-6647. E-mail: ed@grainnet.com. Website: www.grainnet.com. Editor: Ed Zdrojewski. Circ. 11,303. Bi-monthly. Emphasizes grain industry. Readers are "elevator managers primarily as well as suppliers and others in the industry." Sample copy free with 10×12 SAE and 3 first-class stamps.

Needs: Uses about 1-2 photos/issue. "We need photos concerning industry practices and activities. We look for clear, high-quality images without a lot of extraneous material." Captions preferred.

Making Contact & Terms: Query with samples and list of stock photo subjects. Accepts images in

digital format. Send via online, floppy disk, Zip disk. SASE. Reports in 1 week. Pays $100/color cover photo; $30/b&w inside photo. Pays on publication. Credit line given. Buys all rights; negotiable.

THE GROWING EDGE, 215 SW Second St., P.O. Box 1027, Corvallis OR 97333. (541)757-2511. Fax: (541)757-0028. E-mail: aknutson@peak.org. Website: http://www.teleport.com/~tomalex. Editor: Amy Knutson. Circ. 20,000. Estab. 1989. Published quarterly. Emphasizes "new and innovative techniques in gardening indoors, outdoors and in the greenhouse—hydroponics, artificial lighting, greenhouse operations/control, water conservation, new and unusual plant varieties." Readers are serious amateurs to small commercial growers.
Needs: Uses about 20 photos per issue; most supplied with articles by freelancers. Occasional assignment work (5%); 80% from freelance stock. Model release required. Captions preferred; include plant types, equipment used.
Making Contact & Terms: Interested in receiving work from newer, lesser-known photographers. Send query with samples. Accepts b&w or color prints; transparencies (any size); b&w or color negatives with contact sheets. Accepts images in digital format for Mac. SASE. Reports in 6 weeks or will notify and keep material on file for future use. Pays $175/cover photos; $25-50/b&w photos; $25-175/color; $75-400/text/photo package. Pays on publication. Credit line given. Buys first world and one-time anthology rights; negotiable. Simultaneous submissions and/or previously published work OK.
Tips: "Most photographs are used to illustrate processes and equipment described in text. Some photographs of specimen plants purchased. Many photos are of indoor plants under artificial lighting. The ability to deal with tricky lighting situations is important." Expects more assignment work in the future.

HEARTH AND HOME, Dept. PM, P.O. Box 2008, Laconia NH 03247. (603)528-4285. Fax: (603)524-0643. Editor: Richard Wright. Circ. 22,000. Monthly magazine. Emphasizes new and industry trends for specialty retailers and manufacturers of solid fuel and gas appliances, hearth accessories and casual furnishings. Sample copy $5.
• This publication scans images and stores them electronically.
Needs: Uses about 30 photos/issue; 30% supplied by freelance photographers. Needs "shots of energy and patio furnishings stores (preferably a combination store), retail displays, wood heat installations, fireplaces, wood stoves and lawn and garden shots (installation as well as final design), gas grill, gas fireplaces, gas installation indoor/outdoor. Assignments available for interviews, conferences and out-of-state stories." Model release required; captions preferred.
Making Contact & Terms: Interested in receiving work from newer, lesser-known photographers. Query with samples or list of stock photo subjects. Send color glossy prints, transparencies by mail for consideration. Also accepts digital images with color proof in Photoshop, CMYK and SyQuest. SASE. Reports in 2 weeks. Pays $50-300/color photo, $250-750/job. Pays within 60 days. Credit line given. Buys various rights. Simultaneous and photocopied submissions OK.
Tips: "Call and ask what we need. We're *always* on the lookout for material."

♣HEATING, PLUMBING & AIR CONDITIONING (HPAC), 1370 Don Mills Rd., Suite 300, Don Mills, Ontario M3B 3N7 Canada. (416)759-2500. Fax: (416)759-6979. Publisher: Bruce Meacock. Circ. 17,000. Estab. 1927. Bimonthly magazine plus annual buyers guide. Emphasizes heating, plumbing, air conditioning, refrigeration. Readers are predominantly male, mechanical contractors ages 30-60. Sample copy $4.
Needs: Uses 10-15 photos/issue; 2-4 supplied by freelancers. Needs photos of mechanical contractors at work, product shots. Model/property release preferred. Captions preferred.
Making Contact & Terms: Interested in receiving work from newer, lesser-known photographers. Send unsolicited photos by mail for consideration. Send 4×6, glossy/semi-matte color b&w prints; 35mm transparencies. Also accepts digital images. Cannot return material. Reports in 1 month. Payment negotiable. Pays on publication. Credit line given. Buys one-time rights; negotiable. Simultaneous submissions and/or previously published work OK.

***HELICOPTER INTERNATIONAL**, 75 Elm Tree Rd., Locking, Weston-S-Mare, Avon BS24 8EL England. (0934)822524. Editor: E. Aphees. Circ. 23,000. Bimonthly magazine. Emphasizes helicopters and autogyros. Readers are helicopter professionals. Sample copy $4.50.
Needs: Uses 25-35 photos/issue; 50% supplied by freelance photographers. Needs photos of helicopters, especially newsworthy subjects. Model release preferred. Captions required.
Making Contact & Terms: Send unsolicited photos by mail for consideration. Send 8×10 or 4×5 glossy b&w, color prints or slides. Cannot return material. Reports in 1 month. Pays $20/color cover photo; $5/b&w inside photo. Pays on publication. Credit line given. Buys one-time rights. Simultaneous submissions or previously published work OK.
Tips: Magazine is growing. To break in, submit "newsworthy pictures. No arty-crafty pix; good clear

shots of helicopters backed by newsworthy captions, e.g., a new sale/new type/new color scheme/accident with dates."

HEREFORD WORLD, (combined *Polled Hereford World* and *Hereford Journal*), P.O. Box 014059, Kansas City MO 64101. (816)842-3757. Editor: Ed Bible. Circ. 10,000. Estab. 1947. Monthly magazine. Emphasizes Hereford cattle for registered breeders, commercial cattle breeders and agribusinessmen in related fields.
Making Contact & Terms: Interested in receiving work from newer, lesser-known photographers. Query. Uses b&w prints and color transparencies and prints. Reports in 2 weeks. Pays $5/b&w print; $100/color transparency or print. Pays on publication.
Tips: Wants to see "Hereford cattle in quantities, in seasonal and/or scenic settings."

HISPANIC BUSINESS, 360 S. Hope Ave., Suite 300C, Santa Barbara CA 93105. (805)682-5843. Managing Editor: Hector Cantu. Circ. 200,000. Estab. 1979. Monthly publication. Emphasizes Hispanics in business (entrepreneurs and executives), the Hispanic market. Sample copy $5.
Needs: Uses 25 photos/issue; 20% supplied by freelancers. Needs photos of personalities and action shots. No mug shots. Captions required; include name, title.
Making Contact & Terms: Query with résumé of credits. Keeps samples on file. Reports in 2 weeks. Pays $450/color cover photo; $150/color inside photo. Pays on publication. Credit line given. Rights negotiable.
Tips: Wants to see "unusual angles, bright colors, hand activity. Photo tied to profession."

‡**HOME FURNISHINGS EXECUTIVE**, 305 W. High St., Suite 400, High Point NC 27260. (910)883-1650. Fax: (910)883-1195. E-mail: hfexec@aol.com. Editor: Trisha McBride. Monthly magazine. "We are an issue-oriented business journal that tries to provide a forum for constructive dialogue between retailers and manufacturers in the home furnishings industry. Our readers include industry retailers, manufacturers and suppliers." Sample copy and photo guidelines free with SASE.
Needs: Uses 15-20 photos/issue; 50% supplied by freelancers. Needs personality photos, shots of store interiors.
Making Contact & Terms: Query with résumé of credits. Provide résumé, business card, brochure, flier or tearsheets to be kept on file for possible assignments. Accepts images in digital format for Mac. Send via compact disc, floppy disk, SyQuest. Reports only when interested. Pays $250-1,000/photo. **Pays on acceptance.** Credit line given. Buys first North American serial rights.
Tips: Looks for "ability to capture personality in business subjects for profiles; ability to handle diverse interiors."

HOME LIGHTING & ACCESSORIES, 1011 Clifton Ave., Clifton NJ 07013. (201)779-1600. Fax: (201)779-3242. Editor-in-Chief: Linda Longo. Circ. 12,000. Estab. 1923. Monthly magazine. Emphasizes outdoor and interior lighting. Readers are small business owners, specifically lighting showrooms and furniture stores. Sample copy $6.
Needs: Uses 50 photos/issue; 10 supplied by freelancers. Needs photos of lighting applications that are unusual—either landscape for residential or some commercial and retail stores. Reviews photos with accompanying ms only. Model/property release preferred. Captions required (location and relevant names of people or store).
Making Contact & Terms: Interested in receiving work from newer, lesser-known photographers. Query with résumé of credits. Send unsolicited photos by mail for consideration. Provide résumé, business card, brochure, flier or tearsheets to be kept on file for possible future assignments. Send 5×7, 8×10 color prints; 4×5 transparencies. Keeps samples on file. SASE. Reports in 1 month. Pays $90/color cover photo; $5-10/color inside photo. Pays on publication. Credit line given. Buys one-time rights. Simultaneous submissions and/or previously published work OK.

♣**HUMAN RESOURCES PROFESSIONAL**, 2 Bloor St. W., Suite 1902, Toronto, Ontario M4W 3E2 Canada. (416)923-2324. Fax: (416)923-8956. Editor: Katherine Came. Circ. 8,200. Estab. 1985. Publication of the Human Resources Professionals Association of Ontario. Bimonthly magazine. Emphasizes human resources. Readers are male and female senior manager executives, 40-55. Free sample copy.
Needs: Uses 2-3 photos/issue; all supplied by freelancers. Needs photos of people profiles, some abstract shots. Reviews photos purchased with accompanying ms only. Model/property release preferred. Captions required.
Making Contact & Terms: Interested in receiving work from newer, lesser-known photographers. Provide tearsheets to be kept on file for possible assignments. Keeps samples on file. Cannot return materials. Reporting back depends on deadlines. Payment negotiable. Pays on publication. Credit line given. Buys one-time rights.

IB (INDEPENDENT BUSINESS): AMERICA'S SMALL BUSINESS MAGAZINE, Group IV Communications, 125 Auburn Court, Suite 100, Thousand Oaks CA 91362. (805)496-6156. Fax: (805)496-5469. E-mail: gosmallbiz@aol.com. Website: http://www.yoursource.com. Editor: Daniel Kehrer. Editorial Director: Don Phillipson. Photo Editor: Pamela Froman. Circ. 600,000. Estab. 1990. Bimonthly magazine. Emphasizes small business. All readers are small business owners throughout the US. Sample copy $4. Photo guidelines free with SASE.

Needs: Uses 25-35 photos/issue; all supplied by freelancers. Needs photos of "people who are small business owners. All pictures are by assignment; no spec photos." Special photo needs include dynamic, unusual photos of offbeat businesses and their owners. Model/property release required. Captions required; include correct spelling on name, title, business name, location.

Making Contact & Terms: Query with résumé of credits. Provide résumé, business card, brochure, flier or tearsheets to be kept on file for possible assignments. Unsolicited original art will not be returned. Pays $350/color inside photo plus expenses. **Pays on acceptance.** Credit line given. Buys first plus nonexclusive reprint rights.

Tips: "We want colorful, striking photos of small business owners that go well above-and-beyond the usual business magazine. Capture the essence of the business owner's native habitat."

IEEE SPECTRUM, 345 E. 47th St., New York NY 10017. (212)705-7568. Fax: (212)705-7453. Website: http://www.spectrum.IEEE.org. Art Director: Mark Montgomery. Circ. 300,000. Publication of Institute of Electrical and Electronics Engineers, Inc. (IEEE). Monthly magazine. Emphasizes electrical and electronics field and high technology. Readers are male/female; educated; age range: 24-60.

Need: Uses 3-6 photos/issue; 3 provided by freelancers. Special photo needs include portrait photography and high technology photography. Model/property release required. Captions preferred.

Making Contact & Terms: Interested in receiving work from newer, lesser-known photographers. Arrange personal interview to show portfolio. Provide résume, business card, brochure, flier or tearsheets to be kept on file for possible assignments. Pays $1,500-2,000/color cover photo; $200-400/color inside photo. **Pays on acceptance.** Credit line given. Buys one-time rights. Previously published work OK.

Tips: Wants photographers who are consistent, have an ability to shoot color and b&w, display a unique vision and are receptive to their subjects.

IGA GROCERGRAM, 1301 Carolina St., Greensboro NC 27401. (910)378-6065. Fax: (910)275-2864. Managing Editor: Wes Isley. Publication of the Independent Grocers Alliance. Circ. 18,000. Estab. 1926. Monthly magazine, plus special issues. Emphasizes food industry. Readers are IGA retailers, mainly male. Sample copy $2 plus postage.

Needs: Uses 25-35 photos/issue; all supplied by freelancers. Needs in-store shots, food (appetite appeal). Prefers shots of IGA stores. Model/property release preferred. Captions preferred.

Making Contact & Terms: Send unsolicited 35mm transparencies by mail for consideration. Provide résumé, business card, brochure, flier or tearsheets to be kept on file for possible assignments. Keeps samples on file. Reports in 3 weeks. Pay negotiable. **Pays on acceptance.** Credit line given. Buys one-time rights. Simultaneous submissions and previously published work OK.

INDOOR COMFORT NEWS, 454 W. Broadway, Glendale CA 91204. (818)551-1555. Fax: (818)551-1115. Managing Editor: Chris Callard. Circ. 23,000. Estab. 1955. Publication of Institute of Heating and Air Conditioning Industries. Monthly magazine. Emphasizes news, features, updates, special sections on CFC's, Indoor Air Quality, Legal. Readers are predominantly male—25-65, HVAC/R/SM contractors, wholesalers, manufacturers and distributors. Sample copy free with 10×13 SAE and 10 first-class stamps.

Needs: Interested in photos with stories of topical projects, retrofits, or renovations that are of interest to the heating, venting, and air conditioning industry. Property release required. Captions required; include what it is, where and what is unique about it.

Making Contact & Terms: Interested in receiving work from newer, lesser-known photographers. Send unsolicited photos by mail for consideration. Provide résumé, business card, brochure, flier or tearsheets to be kept on file for possible assignments. Send 3×5 glossy color and b&w prints. Deadlines: first of the month, 2 months prior to publication. Keeps samples on file. SASE. Reports in 1-2 weeks. Payment negotiable. Credit line given.

MARKET CONDITIONS are constantly changing! If you're still using this book and it's 1999 or later, buy the newest edition of *Photographer's Market* at your favorite bookstore or order directly from Writer's Digest Books.

Tips: Looks for West Coast material—projects and activities with quality photos of interest to the HVAC industry. "Familiarize yourself with the magazine and industry before submitting photos."

INFOSECURITY NEWS, 498 Concord St., Framingham MA 01702-2357. (508)879-9792. Fax: (508)879-0348. Art Director: Maureen Joyce. Circ. 30,000. Estab. 1988. Magazine published 9 times/year. Emphasizes computer security. Readers are male and female executives, managers. Sample copy $8.
Needs: Uses 5-15 photos; 1-5 supplied by freelancers. Needs photos of technology (computers), business, people. Model/property release required. Captions preferred.
Making Contact & Terms: Interested in receiving work from newer, lesser-known photographers. Arrange personal interview to show portfolio. Query with résumé of credits. Provide résumé, business card, brochure, flier or tearsheets to be kept on file for possible assignments. Keeps samples on file (printed samples or tearsheets only). Reports in 1 month. Pays $200-1,300 (depending on use, position). Pays on publication. Credit line given. Buys one-time rights.

INSIDE AUTOMOTIVES, 29355 Northwestern Hwy., Suite 200, Southfield MI 48034. (810)746-9940. Fax: (810)746-9941. E-mail: autoinfo@atlanta.com. Managing Editor: Ken Downie. Circ. 11,200. Estab. 1994. Bimonthly magazine. Emphasizes automotive interiors. Readers are engineers, designers, management OEMS and material and components suppliers. Sample copy $4. Photo guidelines free with SASE.
Needs: Uses 20 photos/issue; 10% supplied by freelancers. Needs photos of technology related to articles. Model/property release preferred for technical information. Captions required; include who and what is in photos.
Making Contact & Terms: Interested in receiving work from newer, lesser-known photographers. Provide résumé, business card, brochure, flier or tearsheets to be kept on file for possible future assignments. Contact editor by letter or fax. Send 3×5, 5×7 color and b&w photos; 35mm transparencies. Keeps samples on file. SASE. Payment negotiable. Pays on publication. Credit line given. Buys one-time rights. Simultaneous submissions OK.

INTERNATIONAL GROUND WATER TECHNOLOGY, (formerly *Ground Water Age*), 13 Century Hill Dr., Latham NY 12110. (518)783-1281. Fax: (518)783-1386. Editor: Susan Wheeler. Bimonthly magazine. Circ. 10,000. Estab. 1965. Emphasizes management, marketing and technical information. Readers are international water well drilling contractors, water pump specialists and monitoring well contractors. Free sample copy and photo guidelines.
Needs: Buys 5-10 photos/year. Needs picture stories and photos of water well drilling activity and pump installation.
Making Contact & Terms: Send 5×7 matte b&w prints; 8×10 matte color prints; transparencies; negatives. Uses vertical format for covers. SASE. Reports in 3 weeks. Payment negotiable. **Pays on acceptance**. Buys all rights, but may reassign to photographer after publication. Simultaneous submissions and/or previously published work OK.
Tips: "There is a need for quality photos of on-site, job-related activity in our industry. Many photo sites are outdoors. Some familiarity with the industry would be helpful, of course." In photographer's samples, wants to see "an ability to capture a water well contractor, pump installer or monitoring well contractor in action. We have been improving our color cover shots. We'd appreciate more contributions from freelancers."

JEMS COMMUNICATIONS, 1947 Camino Vida Roble, Suite 200, Carlsbad CA 92008. (619)431-9797. Fax: (619)431-8176. E-mail: jems.editor@mosby.com. Managing Editor: Julie Rach. Circ. 45,000. Estab. 1980. Monthly magazine. Emphasizes emergency medical services by out-of-hospital providers. Readers are EMTS and paramedics. Sample copy available. Photo guidelines free with SASE.
Needs: Uses 35-40 photos/month; 15-20 supplied by freelancers. Needs photos of paramedics and EMTs on actual calls following proper procedures with focus on caregivers, not patients. Model/property release required for EMS providers, patients and family members. Captions preferred; include city, state, incident and response organizations identified.
Making Contact & Terms: Interested in receiving work from newer, lesser-known photographers. Query with letter requesting rates and guidelines. Send 8×10 glossy color and b&w prints; 35mm 2¼×2¼, 4×5, 8×10 transparencies. Accepts photos in digital format for Mac (Photoshop). Keeps samples on file. Cannot return material. Reports in 3 weeks. Pays $200-1,100/color cover photo; $25-300/color inside photo; $25-100/b&w inside photo; pays extra for electronic usage of photos. Credit line given. Buys one-time rights.
Tips: "Study samples before submitting. We want the photos to focus on caregivers, not patients. We want providers following protocols in a variety of settings."

JOURNAL OF PROPERTY MANAGEMENT, 430 N. Michigan Ave., 7th Floor, Chicago IL 60611. (312)329-6059. Fax: (312)661-0217. Website: http://www.irem.org. Associate Editor: Kent Wadsworth. Executive Editor: Mariwyn Evans. Estab. 1934. Bimonthly magazine. Emphasizes real estate management. Readers are mid- and upper-level managers of investment real estate. Sample copy free with SASE.
Needs: Uses 6 photos/issue; 50% supplied by freelancers. Needs photos of buildings (apartments, condos, offices, shopping centers, industrial), building operations and office interaction. Model/property release preferred.
Making Contact & Terms: Accepts images in digital format for Windows (EPS, TIFF). Send via compact disc, floppy disk, SyQuest, Zip disk. Pays $200/color photo.

JOURNAL OF PSYCHOACTIVE DRUGS, Dept. PM, 612 Clayton St., San Francisco CA 94117. (415)565-1904. Fax: (415)864-6162. Editor: Richard B. Seymour. Circ. 1,400. Estab. 1967. Quarterly. Emphasizes "psychoactive substances (both legal and illegal)." Readers are "professionals (primarily health) in the drug abuse treatment field."
Needs: Uses 1 photo/issue; supplied by freelancers. Needs "full-color abstract, surreal, avant garde or computer graphics."
Making Contact & Terms: Query with samples. Send 4×6 color prints or 35mm slides by mail for consideration. SASE. Reports in 2 weeks. Pays $50/color cover photo. Pays on publication. Credit line given. Buys one-time rights. Simultaneous submissions and previously published work OK.

JR. HIGH MINISTRY MAGAZINE, 1515 Cascade Ave., Loveland CO 80539. (970)669-3836. Fax: (970)669-3269. Art Editor: Rose Anne Buerge. Published 5 times a year. Interdenominational magazine that provides ideas and support to adult workers (professional and volunteer) with junior highers in Christian churches. Sample copy $1 and 9×12 SASE. Photo guidelines free with SASE.
Needs: Uses 20-25 photos/issue; 3-6 supplied by freelancers. Needs photos of activities and settings relating to families, teenagers (junior high school age), adults and junior high youth together. Model release required.
Making Contact & Terms: Interested in receiving work from newer, lesser-known photographers. Send unsolicited photos by mail for consideration. "Must include SASE." Send 8×10 b&w prints; 35mm, 2¼×2¼, 4×5 transparencies, will also accept PhotoCD. Reports in 1 month. Pays $300 and up/color cover photo; $300 & up/b&w cover photo; $65 & up/color inside photo; $35 & up/b&w inside photo. **Pays on acceptance**. Credit line given. Buys one-time rights. Simultaneous submissions and previously published work OK.
Tips: "We seek to portray people in a variety of ethnic, cultural and racio-economic backgrounds in our publications and the ability of a photographer to portray emotion in photos. One of our greatest ongoing needs is for good contemporary photos of black, Hispanic and American and Native American, as well as photos portraying a mix of group ethnic. Also candid, real life shots are preferable to posed ones."

KITCHEN & BATH BUSINESS, One Penn Plaza, 10th Floor, New York NY 10119. (212)615-2338. Fax: (212)279-3963. E-mail: vcaruso@mfi.com. Editor: Valerie Caruso. Circ. 52,000. Estab. 1955. Monthly magazine. Emphasizes kitchen and bath design, sales and products. Readers are male and female kitchen and bath dealers, designers, builders, architects, manufacturers, distributors and home center personnel. Sample copy free with 9×12 SASE.
Needs: Uses 40-50 photos/issue; 4-8 supplied by freelancers. Needs kitchen and bath installation shots and project shots of never-before-published kitchen and baths. Reviews photos with accompanying ms only. Captions preferred; include relevant information about the kitchen or bath—remodel or new construction, designer's name and phone number.
Making Contact & Terms: Interested in receiving work from newer, lesser-known photographers. Send unsolicited photos by mail for consideration. Send any size color and b&w prints. Keeps samples on file. Reports in 3 weeks. Payment negotiable. Pays on publication. Buys one-time rights. Simultaneous submissions OK.

LAND LINE MAGAZINE, 311 R.D. Mize Rd., Grain Valley MO 64029. (816)229-5791. Fax: (816)229-0518. Managing Editor: Sandi Laxson. Circ. 110,000. Estab. 1975. Publication of Owner Operator Independent Drivers Association. Bimonthly magazine. Emphasizes trucking. Readers are male and female independent truckers, with an average age of 44. Sample copy $2.
Needs: Uses 18-20 photos/issue; 50% supplied by freelancers. Needs photos of trucks, highways, truck stops, truckers, etc. "We prefer to have truck owners/operators in photos." Reviews photos with or without ms. Model/property release preferred for company trucks, drivers. Captions preferred.
Making Contact & Terms: Interested in receiving work from newer, lesser-known photographers. Provide résumé, business card, brochure, flier or tearsheets to be kept on file for possible assignments. Send glossy color or b&w prints; 2¼×2¼ transparencies. Pays $100/color cover photo; $50/b&w cover photo;

$50/color inside photo; $30/b&w inside photo. Credit line given. Buys one-time rights. Previously published work OK.

LLAMAS MAGAZINE, P.O.Box 100, Herald CA 95638. (209)223-0469. Fax: (209)223-0466. E-mail: cdalporto@aol.com. Circ. 5,500. Estab. 1979. Publication of The International Camelid Journal. Magazine published 7 times a year. Emphasizes llamas, alpacas, vicunas, guanacos and camels. Readers are llama and alpaca owners and ranchers. Sample copy $5.75. Photo and editorial guidelines free with SASE.
Needs: Uses 30-50 photos/issue; all supplied by freelancers. Wants to see "any kind of photo with llamas, alpacas, camels in it. Always need good verticals for the cover. Always need good action shots." Model release required. Captions required.
Making Contact & Terms: Send unsolicited b&w or color 35mm prints or 35mm transparencies by mail for consideration. Provide résumé, business card, brochure, flier or tearsheets to be kept on file for possible assignments. SASE. Reports in 2 weeks. Pays $5-25/b&w photo; $25-300/color photo. Pays on publication. Credit line given. Buys one-time rights. Simultaneous submissions and previously published work OK.
Tips: "You must have a good understanding of llamas and alpacas to submit photos to us. It's a very specialized market. Our rates are modest, but our publication is a very slick 4-color magazine and it's a terrific vehicle for getting your work into circulation. We are willing to give photographers a lot of free tearsheets for their portfolios to help publicize their work."

MARKETERS FORUM, 383 E. Main St., Centerport NY 11721. (516)754-5000. Fax: (516)754-0630. Publisher: Martin Stevens. Circ. 70,000. Estab. 1981. Monthly magazine. Readers are entrepreneurs and retail store owners. Sample copy $5.
Needs: Uses 3-6 photos/issue; all supplied by freelancers. "We publish trade magazines for retail variety goods stores and flea market vendors. Items include: jewelry, cosmetics, novelties, toys, etc. (five-and-dime-type goods). We are interested in creative and abstract impressions—not straight-on product shots. Humor a plus." Model/property release required.
Making Contact & Terms: Send unsolicited photos by mail for consideration. Send color prints; 35mm, 4×5 transparencies. Does not keep samples on file. SASE. Reports in 2 weeks. Pays $100/color cover photo; $50/color inside photo. **Pays on acceptance.** Buys one-time rights. Simultaneous submissions and/or previously published work OK.

MARKETING & TECHNOLOGY GROUP, 1415 N. Dayton, Chicago IL 60622. (312)266-3311. Fax: (312)266-3363. Art Director: Scott Dreyer. Circ. 18,000. Estab. 1993. Publishes 3 magazines: *Carnetec*, *Meat Marketing & Technology*, and *Poultry Marketing & Technology*. Emphasizes meat and poultry processing. Readers are predominantly male, ages 35-65, generally conservative. Sample copy $4.
Needs: Uses 15-30 photos/issue; 1-3 supplied by freelancers. Needs photos of food, processing plant tours, product shots, illustrative/conceptual. Model/property release preferred. Captions preferred.
Making Contact & Terms: Provide résumé, business card, brochure, flier or tearsheets to be kept on file for possible assignments. Submit portfolio for review. Keeps samples on file. Reports in 1 month. Payment negotiable. Pays on publication. Credit line given. Buys all rights; negotiable. Simultaneous submissions and previously published work OK.
Tips: "Work quickly and meet deadlines. Follow directions when given; and when none are given, be creative while using your best judgment."

MASONRY MAGAZINE, 1550 Spring Rd., #320, Oak Brook IL 60521. (630)782-6767. Fax: (630)782-6786. Editor: Dick Olson. Circ. 5,200. Estab. 1960. Publication of the Mason Contractors Association of America and Canadian Masonry Contractors. Bimonthly magazine. Emphasizes masonry contracting. Readers are mason and general contractors, ages 30-70. Free sample copy. Free photo guidelines.
Needs: Uses 15-20 photos/issue; 1-2 supplied by freelancers. Needs photos of technology/how-to masonry buildings/personalities in industry. Model/property release preferred for individuals/plant technologists. Captions required.
Making Contact & Terms: Interested in receiving work from newer, lesser-known photographers. Query with stock photo list. Send unsolicited photos by mail for consideration. Provide résumé, business card, brochure, flier or tearsheets to be kept on file for possible assignments. Send 5×7 or 8×10 color or b&w matte finish prints; 35mm transparencies. SASE. Reports in 1 month. Pays $50 and up/color cover photo; $10 and up/b&w inside photo. **Pays on acceptance.** Credit line given. Buys all rights; negotiable. Simultaneous submissions and previously published work OK.
Tips: Looks for "grasp of subject; clarity; succinct illustration of points. Be available for assignment; be flexible; keep work before prospects; work and submit possibilities list; keep in constant touch."

MEXICO EVENTS & DESTINATIONS, 3445 Catalina Dr., Carlsbad CA 92008. Phone/fax: (760)434-7447. Art Director: Gabriela Flores. Circ. 25,000. Estab. 1992. Quarterly magazine. Emphasizes travel to Mexico for travel professionals and consumers. Readers are consumers, travel agents and travel industry people. Sample copy $4.50. Photo guidelines free with SASE.

Needs: Uses 30-40 photos/issue; 10 supplied by freelancers. Needs destination and travel industry shots—hotels, resorts, tourism officials, etc. in Mexico for US travel pros. Model/property release preferred. Captions required; include correct spelling of people's names, location, time of day/year. Send for Editorial Calendar before submitting.

Making Contact & Terms: Interested in receiving work from newer, lesser-known photographers. Does not keep samples on file. SASE. Reports in 1 month. Pays $200/color cover photo; $20-50/color inside photo. "We also pay in trade for travel." Pays 30 days from publication. Buys one-time rights. Previously published work OK.

Tips: Wants technically sound, inventive, creative shots.

MINORITY BUSINESS ENTREPRENEUR, 3528 Torrance Blvd., Suite 101, Torrance CA 90503. (310)540-9398. Fax: (310)792-8265. E-mail: mbewbe@ix.netcom.com. Website: http://www.mbemag.com. Executive Editor: Jeanie Barnett. Circ. 40,000. Estab. 1984. Bimonthly magazine. Emphasizes minority- and women-owned businesses. Readers are business owners of all ages and industries. Sample copy $3 with 9½×12½ SAE and 5 first-class stamps. "We have editorial guidelines and calendar of upcoming issues available."

Needs: Uses 30 feature photos/issue; 2% supplied by freelancers. Needs "good shots for cover profiles and minority features of our entrepreneurs." Model/property release required. Captions preferred; include name, title and company of subject, and proper photo credit.

Making Contact & Terms: Interested in receiving work from newer, lesser-known photographers. Query with résumé of credits. Provide résumé, business card, brochure, flier or tearsheets to be kept on file for possible assignments. Send 5×7, 8×10 matte b&w prints. "Never submit unsolicited photos. Photographers interested in showing their portfolios must make an appointment with the executive editor." Accepts images in digital format for Windows (Postscript, EPS). Send via floppy disk, SyQuest. SASE. Reports in 5 weeks. Payment negotiable. Pays on publication. Credit line given. Buys first North American serial rights; negotiable.

Tips: "We're starting to run color photos in our business owner profiles. We want pictures that capture them in the work environment. Especially interested in minority and women photographers working for us. Our cover is an oil painting composed from photos. It's important to have high quality b&ws which show the character lines of the face for translation into oils. Read our publication and have a good understanding of minority business issues. Never submit photos that have nothing to do with the magazine."

MODERN BAKING, Dept. PM, 2700 River Rd., Suite 418, Des Plaines IL 60018. (708)299-4430. Fax: (708)296-1968. Editor: Ed Lee. Circ. 27,000. Estab. 1987. Monthly. Emphasizes on-premise baking, in supermarkets, food service establishments and retail bakeries. Readers are owners, managers and operators. Sample copy for 9×12 SAE with 10 first-class stamps.

Needs: Uses 30 photos/issue; 1-2 supplied by freelancers. Needs photos of on-location photography in above-described facilities. Model/property release preferred. Captions required; include company name, location, contact name and telephone number.

Making Contact & Terms: Interested in receiving work from newer, lesser-known photographers. Provide résumé, business card, brochure, flier or tearsheets to be kept on file for possible future assignments. SASE. Reports in 2 weeks. Pays $50 minimum; negotiable. **Pays on acceptance.** Credit line given. Buys all rights; negotiable.

Tips: Prefers to see "photos that would indicate person's ability to handle on-location, industrial photography."

MORTGAGE ORIGINATOR MAGAZINE, 1360 Sunset Cliffs Blvd., San Diego CA 92107. (619)223-9989. Fax: (619)223-9943. E-mail: mtgemom@aol.com Publisher: Chris Salazar. Circ. 10,000. Estab. 1991. Monthly magazine. Emphasizes mortgage banking. Readers are sales staff. Sample copy $6.95.

Needs: Uses 8 photos/issue. Needs photos of business.

Making Contact & Terms: Interested in receiving work from newer, lesser-known photographers. Query with stock photo list. Send unsolicited photos by mail for consideration. Send color prints; 35mm transparencies. Keeps samples on file. Payment negotiable. Pays on publication. Credit line given. Buys exclusive industry rights. Simultaneous submissions and previously published work OK.

MOUNTAIN PILOT, 7009 S. Potomac St., Englewood CO 80112-4029. (303)397-7600. Fax: (303)397-7619. E-mail: ehuber@winc.usa.com. Editor: Ed Huber. Bimonthly national magazine on mountain avia-

tion. Circ. 15,000. Estab. 1985. Published by Wisner Publishing Inc. Emphasizes mountain aviation—flying, safety, education, experiences, survival, weather, location destinations. Readers are mid-life male, affluent, mobile. Sample copy free with SASE.

Needs: Uses assignment photos. Model release and photo captions required.

Making Contact & Terms: Provide résumé, business card, brochure, flier or tearsheets to be kept on file for possible assignments; contact by phone. Accepts digital format for Mac (TIFF or EPS). Send via floppy disk, SyQuest, Zip disk (300 live screen 150 for output). SASE. Reports in 1 month. Pays negotiable text package. Pays 30 days after publication. Credit line given. Buys all rights; negotiable. Simultaneous submissions and previously published work OK.

Tips: Looks for "unusual destination pictures, mountain aviation oriented." Trend is "imaginative." Make shot pertinent to an active pilot readership. Query first. Don't send originals—color copies acceptable. Copy machine reprints OK for evaluation.

MUSHING MAGAZINE, P.O. Box 149, Ester AK 99725. (907)479-0454. Fax: (907)479-3137. Publisher: Todd Hoener. Circ. 7,000. Estab. 1987. Bimonthly magazine. Readers are dog drivers, mushing enthusiasts, dog lovers, outdoor specialists, innovators and sled dog history lovers. Sample copy $5 in US. Photo guidelines free with SASE.

Needs: Uses 20 photos/issue; most supplied by freelancers. Needs action photos: all-season and wilderness; also still and close-up photos: specific focus (sledding, carting, dog care, equipment, etc). Special photo needs include skijoring, feeding, caring for dogs, summer carting or packing, 1-3 dog-sledding and kids mushing. Model release preferred. Captions preferred.

Making Contact & Terms: Interested in receiving work from newer, lesser-known photographers. Send unsolicited photos by mail for consideration. Reports in 6 months. Pays $150 maximum/color cover photo; $35 maximum/color inside photo; $15-30/b&w inside photo. Pays on publication. Credit line given. Buys first serial rights and second reprint rights.

Tips: Wants to see work that shows "the total mushing adventure/lifestyle from environment to dog house." To break in, one's work must show "simplicity, balance and harmony. Strive for unique, provocative shots that lure readers and publishers."

NAILPRO, 7628 Densmore Ave., Van Nuys CA 91406-2042. (818)782-7328. Fax: (818)782-7450. Executive Editor: Linda Lewis. Circ. 50,000. Estab. 1989. Published by Creative Age Publications. Monthly magazine. Emphasizes topics for professional manicurists and nail salon owners. Readers are females of all ages. Sample copy $2 with 9 × 12 SASE.

Needs: Uses 10-12 photos/issue; all supplied by freelancers. Needs photos of beautiful nails illustrating all kinds of nail extensions and enhancements; photographs showing process of creating and decorating nails, both natural and artificial. Model release required. Captions required; identify people and process if applicable.

Making Contact & Terms: Interested in receiving work from newer, lesser-known photographers. Send color prints; 35mm, 2¼ × 2¼, 4 × 5. Keeps samples on file. SASE. Reports in 1 month. Pays $500/color cover photo; $50-200/color inside photo; $50/b&w inside photo. **Pays on acceptance**. Credit line given. Buys one-time rights. Previously published work OK.

Tips: "Talk to the person in charge of choosing art about photo needs for the next issue and try to satisfy that immediate need; that often leads to assignments."

NATIONAL BUS TRADER, 9698 W. Judson Rd., Polo IL 61064-9049. (815)946-2341. Fax: (815)946-2347. Editor: Larry Plachno. Circ. 6,600. Estab. 1977. "The Magazine of Bus Equipment for the United States and Canada—covers mainly integral design buses in the United States and Canada." Readers are bus owners, commercial bus operators, bus manufacturers, bus designers. Sample copy free (no charge—just write or call).

Needs: Uses about 30 photos/issue; 22 supplied by freelance photographers. Needs photos of "buses; interior, exterior, under construction, in service." Special needs include "photos for future feature articles and conventions our own staff does not attend."

Making Contact & Terms: "Query with specific lists of subject matter that can be provided and mention whether accompanying mss are available." SASE. Reports in 1 week. Pays $3-5/b&w photo; $100-3,000/photo/text package. **Pays on acceptance.** Credit line given. Buys rights "depending on our need and photographer." Simultaneous submissions and previously published work OK.

Tips: "We don't need samples, merely a list of what freelancers can provide in the way of photos or ms. Write and let us know what you can offer and do. We often use freelance work. We also publish *Bus Tours Magazine*—a bimonthly which uses many photos but not many from freelancers; *The Bus Equipment Guide*—infrequent, which uses many photos; and *The Official Bus Industry Calendar*—annual full-color calendar of bus photos. We also publish historical railroad books and are looking for historical photos on midwest interurban lines and railroads. Due to publication of historical railroad books, we are purchasing

many historical photos. In photos looks for subject matter appropriate to current or pending article or book. Send a list of what is available with specific photos, locations, bus/interurban company and fleet number."

NATIONAL CASINO JOURNAL, (formerly *New Jersey Casino Journal*), 3100 W. Sahara Ave., Suite 207, Las Vegas NV 89102. (702)253-6230. Fax: (702)253-6804. E-mail: rgreco@casinocenter.com. Photo/ Graphic Editor: Rick Greco. Circ. 25,000. Estab. 1985. Monthly. Emphasizes casino operations. Readers are casino executives, employers and vendors. Sample copy free with 11×14 SAE and 9 first-class stamps.
Needs: Uses 40-60 photos/issue; 5-10 supplied by freelancers. Needs photos of gaming tables and slot machines, casinos and portraits of executives. Model release required for gamblers, employees. Captions required.
Making Contact & Terms; Interested in receiving work from newer, lesser-known photographers. Query with résumé of credits. Query with stock photo list. Accepts digital images. Reports in 3 months. Pays $100 minimum/color cover photo; $10-35/color inside photo; $10-25/b&w inside photo. Pays on publication. Credit line given. Buys all rights; negotiable.
Tips: "Read and study photos in current issues."

NATION'S BUSINESS, U.S. Chamber of Commerce, 1615 H St. NW, Washington DC 20062. (202)463-5447. Photo Editor: Laurence L. Levin. Assistant Photo Editor: Frances Borchardt. Circ. 865,000. Monthly. Emphasizes business, how to run your business better, especially small business. Readers are managers, upper management and business owners. Sample copy free with 9×12 SASE.
Needs: Uses about 40-50 photos/issue; 60% supplied by freelancers. Needs portrait-personality photos, business-related pictures relating to the story. Model release preferred. Captions required.
Making Contact & Terms: Arrange a personal interview to show portfolio. Submit portfolio for review. SASE. Reports in 3 weeks. Pays $200/b&w or color inside photo; $175-300/day. Pays on publication. Credit line given. Buys one-time rights.
Tips: In reviewing a portfolio, "we look for the photographer's ability to light, taking a static situation and turning it into a spontaneous, eye-catching and informative picture."

NEW METHODS, P.O. Box 22605, San Francisco CA 94122-0605. (415)664-3469. Art Director: Ronald S. Lippert, AHT. Circ. 5,600. Estab. 1981. Monthly. Emphasizes veterinary personnel, animals. Readers are veterinary professionals and interested consumers. Sample copy $3.20 (20% discount on 12 or more). Photo guidelines free with SASE.
Needs: Uses 12 photos/issue; 2 supplied by freelance photographers. Assigns 95% of photos. Needs animal, wildlife and technical photos. Most work is b&w. Model/property releases preferred. Captions preferred.
Making Contact & Terms: Interested in receiving work from newer, lesser-known photographers. Arrange a personal interview to show portfolio. Query with résumé of credits, samples or list of stock photo subjects. Provide résumé, business card, brochure, flier or tearsheets. SASE. Reports in 2 months. Payment is rare, negotiable; will barter. Credit line given. Simultaneous submissions and previously published work OK.
Tips: Ask for photo needs before submitting work. Prefers to see "technical photos (human working with animal(s) or animal photos (*not cute*)" in a portfolio or samples. On occasion, needs photographer for shooting new products and local area conventions.

911 MAGAZINE, P.O. Box 11788, Santa Ana CA 92711. (714)544-7776. E-mail: Magazn911@aol.com. Editor: Randall Larson. Circ. 22,000. Estab. 1988. Bimonthly magazine. Emphasizes public safety communications and response—police, fire, paramedic, dispatch, etc. Readers are ages 20-65. Sample copy free with 9×12 SAE and 7 first-class stamps. Photo guidelines free with SASE.
Needs: Uses up to 25 photos/issue; 75% supplied by freelance photographers; 20% comes from assignment, 5% from stock. "From the Field" department photos are needed of incidents involving public safety communications and emergency agencies in action from law enforcement, fire suppression, paramedics, dispatch, etc., showing proper techniques and attire. Model release preferred. Captions preferred; if possible include incident location by city and state, agencies involved, duration, dollar cost, fatalities and injuries.
Making Contact & Terms: Interested in receiving work from newer, lesser-known photographers. Query with list of stock photo subjects. Send unsolicited photos by mail for consideration. Provide résumé, business card, brochure, flier or tearsheets to be kept on file for possible assignments. Uses 35mm, $2\frac{1}{4} \times 2\frac{1}{4}$, 4×5, 8×10 glossy contacts, b&w or color prints; 35mm, $2\frac{1}{4} \times 2\frac{1}{4}$, 4×5, 8×10 transparencies. SASE. Reports in 3 weeks. Pays $100-300/color cover photo; $50-75/color inside photo; $20-50/b&w inside photo. Pays on publication. Credit line given. Buys one-time rights.
Tips: "We need photos for unillustrated cover stories and features appearing in each issue. Topics include rescue, traffic, communications, training, stress, media relations, crime prevention, etc. Calendar available. Assignments possible."

‡NORTHEAST EXPORT, 404 Chestnut St., #201, Manchester NH 03101. (603)626-6354. Fax: (603)626-6359. Art Director: Nikki Bonenfant. Circ. 12,000. Estab. 1997. Semimonthly magazine. Emphasizes international trade by northeast companies. Readers are male and female—top management, average age 45. Sample copy free with 9×12 SAE and 5 first-class stamps.
Needs: Uses 3-6 photos/issue. Needs photos of exporting, shipping and receiving, cargo, international trade zones, high-tech and manufacturing. Model/property release preferred. Captions required; include names, locations, contact phone number.
Making Contract & Terms: Interested in receiving work from newer, lesser-known photographers. Arrange personal interview to show portfolio. Provide résumé, business card, brochure, flier or tearsheets to be kep on file for possible assignments. Accepts images in digitial format for Mac (TIFF). Send via compact disc, floppy disk, zip disk (300 ppi, 150 lpi). Keeps samples on file. SASE. Reports in 3 weeks. Pays $300-500/color cover photo; $50-100/color inside photo; $50-75/b&w inside photo. Pays on publication. Credit line given. Buys one-time rights. Offers internships for photographers. Contact Art Director: Nikki Bonenfant.
Tips: Looks for "people in environment shots, interesting lighting, lots of creative interpretations, a definite personal style. We are a publishing company that has a reputation for quality, award-winning publications."

O&A MARKETING NEWS, 532 El Dorado St., Suite 200, Pasadena CA 91101. (818)683-9993. Fax: (818)683-0969. Editor: Kathy Laderman. Circ. 9,000. Estab. 1966. Bimonthly tabloid. Emphasizes petroleum marketing in the 13 Western states. Readers are active in the petroleum industry and encompass all ages, interests and genders. Sample copy free with 10×13 SAE and $2.50 postage.
Needs: Uses 150-200 photos/issue; 10 supplied by freelancers. Needs photos of interesting—and innovative—activities at gasoline stations, car washes, quick lubes and convenience stores in the 13 Western states. Model/property release preferred. Captions required (what is pictured, where it is, why it's unusual).
Making Contact & Terms: Interested in receiving work from newer, lesser-known photographers. Send unsolicited photos by mail for consideration. Send 5×7 (preferred, but others OK) matte or glossy b&w prints. SASE. Reports in 3 weeks. Pays $5/b&w inside photo; other forms of payment vary, depending on length of text submitted. Buys one-time rights. Simultaneous submissions and/or previously published work OK.
Tips: "We're looking for sharp, newspaper-style black & white photos that show our Western readers something new, something different, something they wouldn't necessarily see at a gas station or convenience store near their home."

OCULAR SURGERY NEWS, Dept. PM, 6900 Grove Rd., Thorofare NJ 08086. (609)848-1000. Fax: (609)853-5991. E-mail: cweddo@slackinc.com. Associate Editor: Conni Waddington. Circ. 18,000. Biweekly newspaper. Emphasizes ophthalmology, medical and eye care. Readers are ophthalmologists in the US. Sample copy free with 9×12 SAE and 10 first-class stamps.
Needs: Uses 30 photos/issue; less than 10% supplied by freelancers. Needs photos for business section on a monthly basis. Topics like managed care, money management, computers and technology, patient satisfaction, etc.
Making Contract & Terms: Query with list of stock photo subjects. Provide résumé, business card, brochure, flier or tearsheets to be kept on file for possible assignments. SASE. Reports in 2 weeks. Pays $300/color cover photo; $150/color inside photo; $150-250/day. Pays on publication. Credit line given. Buys one-time rights.

OHIO TAVERN NEWS, 329 S. Front St., Columbus OH 43215. (614)224-4835. Fax: (614)224-8649. Editor: Chris Bailey. Circ. 8,200. Estab. 1939. Tabloid newspaper. Emphasizes beverage alcohol/hospitality industries in Ohio. Readers are liquor permit holders: restaurants, bars, distillers, vintners, wholesalers. Sample copy free for 9×12 SASE.
Needs: Uses 1-4 photos/issue. Needs photos of people, places, products covering the beverage alcohol/hospitality industries in Ohio. Captions required; include who, what, where, when and why.
Making Contact & Terms: Interested in receiving work from newer, lesser-known photographers. Send unsolicited photos by mail for consideration. Send up to 8×10 glossy b&w prints. Deadlines: first and third Friday of each month. Keeps samples on file. SASE. Reports in 1 month. Pays $15/photo. Pays on publication. Credit line given. Buys one-time rights; negotiable. Simultaneous submissions OK.

PACIFIC BUILDER & ENGINEER, Vernon Publications Inc., 3000 Northup Way, Suite 200, Bellevue WA 98004. (206)827-9900. Fax: (206)822-9372. Editor: Carl Molesworth. Circ. 14,500. Estab. 1902. Biweekly magazine. Emphasizes non-residential construction in the Northwest and Alaska. Readers are construction contractors. Sample copy $7.
Needs: Uses 8 photos/issue; 4 supplied by freelancers. Needs photos of ongoing construction projects to accompany assigned feature articles. Reviews photos purchased with accompanying ms only. Photo cap-

tions preferred; include name of project, general contractor, important subcontractors, model/make of construction equipment, what is unusual/innovative about project.

Making Contact & Terms: Interested in receiving work from newer, lesser-known photographers. Query with résumé of credits. Accepts images in digital format for Mac (Quark, Photoshop, FreeHand). Send via floppy disk, SyQuest, Zip disk (133 line screen ERP 2438 dots/inch). Does not keep samples on file. SASE. Reports in 1 month. Pays $25-125/color cover photo; $15-50/b&w inside photo. Pays on publication. Buys first North American serial rights.

Tips: "All freelance photos must be coordinated with assigned feature stories."

PACIFIC FISHING, 1515 NW 51st, Seattle WA 98107. (206)789-5333. Fax: (206)784-5545. Editor: Brad Warren. Circ. 11,000. Estab. 1979. Monthly magazine. Emphasizes commercial fishing on West Coast—California to Alaska. Readers are 80% owners of fishing operations, primarily male, ages 25-55; 20% processors, marketers and suppliers. Sample copy free with 11×14 SAE and 8 first-class stamps. Photo guidelines free with SASE.

Needs: Uses 15 photos/issue; 10 supplied by freelancers. Needs photos of *all* aspects of commercial fisheries on West Coast of US and Canada. Special needs include "high-quality, active photos and slides of fishing boats and fishermen working their gear, dockside shots and the processing of seafood." Model/property release preferred. Captions required; include names and locations.

Making Contact & Terms: Query with résumé of credits. Query with list of stock photo subjects. Keeps samples on file. SASE. Reports in 2-4 weeks. Pays $200/color cover photo; $50-100/color inside photo; $25-50/b&w inside photo. Pays on publication. Credit line given. Buys one-time rights, first North American serial rights. Previously published work OK "if not previously published in a competing trade journal."

Tips: Wants to see "clear, close-up and active photos."

PAPER AGE, 51 Mill St., Suite 5, Hanover MA 02339-1650. (617)829-4581. Fax: (617)829-4503. Editor: John F. O'Brien Jr.. Circ. 35,000. Estab. 1884. Monthly tabloid. Emphasizes paper industry—news, pulp and paper mills, technical reports on paper making and equipment. Readers are employees in the paper industry. Sample copy free.

Needs: Uses 25-30 photos/issue; very few supplied by freelancers. Needs photos of paper mills—inside/outside; aerial; forests (environmentally appealing shots); paper recycling facilities. Property release preferred (inside shots of paper mill equipment). Photo captions required; include date, location, description of shot.

Making Contact & Terms: Interested in receiving work from newer, lesser-known photographers. Send unsolicited photos by mail for consideration. Send any size glossy prints. Keeps samples on file. SASE. Reports in 1-2 weeks. Payment negotiable. Pays on publication. Credit line given. Buys all rights; negotiable.

THE PARKING PROFESSIONAL, 701 Kenmore, Suite 200, Fredericksburg VA 22401. (540)371-7535. Fax: (540)371-8022. Editor: Marie E. Witmer. Circ. 3,000. Estab. 1984. Publication of the International Parking Institute. Monthly magazine. Emphasizes parking: public, private, institutional, etc. Readers are male and female public parking managers, ages 30-60. Free sample copy.

Needs: Uses 12 photos/issue; 4-5 supplied by freelancers. Model release required. Captions preferred, include location, purpose, type of operation.

Making Contact & Terms: Interested in receiving work from newer, lesser-known photographers. Contact through rep. Arrange personal interview to show portfolio for review. Query with résumé of credits. Provide résumé, business card, brochure, flier or tearsheets to be kept on file for possible assignments. Send 5×7, 8×10 color or b&w prints; 35mm, $2\frac{1}{4} \times 2\frac{1}{4}$, 4×5, 8×10 transparencies. Keeps samples on file. SASE. Reports in 1-2 weeks. Pays $100-300/color cover photo; $25-100/color inside photo; $25-100/b&w inside photo; $100-500/photo/text package. Pays on publication. Credit line given. Buys one-time, all rights; negotiable. Previously published work OK.

PEDIATRIC ANNALS, 6900 Grove Rd., Thorofare NJ 08086. (609)848-1000. E-mail: ped@slackinc.com. Website: http://www.slackinc.com/ped.htm. Editor: Kimberly A. Callar. Circ. 36,000. Monthly journal. Readers are practicing pediatricians. Sample copy free with SASE.

Needs: Uses 1 cover photo/issue. Needs photos of "children in medical settings, some with adults." Written release required. Captions preferred.

Making Contact & Terms: Query with samples. Provide résumé, business card, brochure, flier or tearsheets to be kept on file for possible future assignments. Pays $200-400/color cover photo. Pays on publication. Credit line given. Buys one-time North American rights including any and all subsidiary forms of publication, such as electronic media and promotional pieces. Simultaneous submissions and previously published work OK.

PERSONAL SELLING POWER, INC., Box 5467, Fredericksburg VA 22403. (540)752-7000. Editor-in-Chief: Laura B. Gschwandtner. Magazine for sales and marketing professionals. Uses photos for magazine covers and text illustration. Recent covers have featured leading personalities such as George Foreman, Gregg Lemond and Andy Grove.

Needs: Buys about 35 freelance photos/year; offers about 6 freelance assignments/year. Business, sales, motivation, etc. Subject matter and style of photos depend on the article. Most photos are business oriented, but some can also use landscape.

Making Contact & Terms: Query with résumé of credits, samples and list of stock photo subjects. Uses transparencies, or in some cases b&w; formats can vary. Report time varies according to deadlines. Payment and terms negotiable. **Pays on acceptance.** Credit line given. Buys one-time rights. Previously published work OK.

Tips: Photographers should "send only their best work. Be reasonable with price. Be professional to work with. Also, look at our magazine to see what types of work we use and think about ways to improve what we are currently doing to give better results for our readers." As for trends, "we are using more and better photography all the time, especially for cover stories."

PET BUSINESS, 7-L Dundas Circle, Greensboro NC 27407. (910)292-4047. Fax: (910)292-4272. Executive Editor: Rita Davis. Circ. 19,000. Estab. 1974. Monthly news magazine for pet industry professionals. Sample copy $3. Guidelines free with SASE.

Needs: Photos of well-groomed pet animals (preferably purebred) of any age in a variety of situations. Identify subjects. Animals: dogs, cats, fish, birds, reptiles, amphibians, small animals (hamsters, rabbits, gerbils, mice, etc.) Also, can sometimes use shots of petshop interiors—but must be careful not to be product-specific. Good scenes would include personnel interacting with customers or caring for shop animals. Model/property release preferred. Captions preferred; include essential details regarding animal species.

Making Contact & Terms: Interested in receiving work from newer, lesser-known photographers. Submit photos for consideration. Reports within 3 months with SASE. Pays $20/color print or transparency for inside use; $100 for cover use. Pays on publication. Credit line given. Buys all rights; negotiable.

Tips: Uncluttered background. Portrait-style always welcome. Close-ups best. News/action shots if timely. "Make sure your prints have good composition, and are technically correct, in focus and with proper contrast. Avoid dark pets on dark backgrounds! Send only 'pet' animal, not zoo or wildlife, photos."

PHOTO TECHNIQUES, Dept. PM, Preston Publications, 6600 W. Touhy, P.O. Box 48312, Niles IL 60714. (847)647-2900. Fax: (847)647-1155. Publisher: Tinsley S. Preston, III. Editor: Mike Johnston. Circ. 40,000. Estab. 1979. Bimonthly magazine. Covers darkroom techniques, creative camera use, photochemistry and photographic experimentation/innovation, plus general user-oriented photography articles aimed at advanced amateurs and professionals. Sample copy $4.50. Photography and writer's guidelines free with SASE.

Needs: "The best way to publish photographs in *Photo Techniques* is to write an article on photo or darkroom techniques and illustrate the article. The exceptions are: cover photographs—we are looking for striking poster-like images that will make good newsstand covers; and the Portfolio feature—photographs of an artistic nature. Most of freelance photography comes from what is currently in a photographer's stock." Model/property release preferred. Captions required if photo is used.

Making Contact & Terms: Interested in receiving work from newer, lesser-known photographers. "We do not want to receive more than 10 or 20 in any one submission. We ask for submissions on speculative basis only. Except for portfolios, we publish few single photos that are not accompanied by some type of text." Send dupe slides first. All print submissions should be 8×10. Pays $300/covers; $100/page and up for text/photo package; negotiable. Pays on publication only. Credit line given. Buys one-time rights.

Tips: "We are looking for exceptional photographs with strong, graphically startling images. No run-of-the-mill postcard shots please. We are the most technical general-interest photographic publication on the market today. Authors are encouraged to substantiate their conclusions with experimental data. Submit samples, article ideas, etc. It's easier to get photos published with an article."

PLASTICS NEWS, 1725 Merriman Rd., Akron OH 44313. (330)836-9180. Fax: (330)836-2322. Managing Editor: Don Loepp. Circ. 60,000. Estab. 1989. Weekly tabloid. Emphasizes plastics industry business news. Readers are male and female executives of companies that manufacture a broad range of plastics products; suppliers and customers of the plastics processing industry. Sample copy $1.95.

Needs: Uses 10-20 photos/issue; 1-3 supplied by freelancers. Needs photos of technology related to use and manufacturing of plastic products. Model/property release preferred. Captions required.

Making Contact & Terms: Send unsolicited photos by mail for consideration. Provide résumé, business card, brochure, flier or tearsheets to be kept on file for possible assignments. Query with stock photo list. Keeps samples on file. SASE. Reports in 2 weeks. Pays $125-175/color cover photo; $125-175/color inside

photo; $100-150/b&w inside photo. Pays on publication. Credit line given. Buys one-time and all rights. Simultaneous submissions and previously published work OK.

PLUMBING & MECHANICAL, 3150 River Rd., Suite 101, Des Plaines IL 60018. (847)297-3757. Fax: (847)297-8371. E-mail: wcalc@aol.com. Art Director: Rick Ravidson. Circ. 40,324. Estab. 1984. Monthly magazine. Emphasizes mechanical contracting, plumbing, hydronic heating, remodeling. Readers are company owners, presidents, CEOs, vice presidents, general managers, secretaries and treasurers.
Needs: Uses 10-12 photos/issue; 2-5 supplied by freelancers. Interested in showroom shots, job sites, personalities. Model/property release preferred. Captions preferred.
Making Contact & Terms: Interested in receiving work from newer, lesser-known photographers. Provide résumé, business card, brochure, flier or tearsheets to be kept on file for possible assignments. Deadlines: Photos are due during the first week of the month. Keeps samples on file. Cannot return material. Also accepts ditigal images in Photoshop TIFF images, CMYK, 300 DPI. Reports in 1 month. Pays $950/job. Pays on publication. Credit line given. Buys all rights.

POLICE MAGAZINE, 2512 Artesia Blvd., Redondo Beach CA 90278. (800)365-7827. Fax: (310)798-4598. Managing Editor: Dennis Hall. Estab. 1976. Monthly. Emphasizes law enforcement. Readers are various members of the law enforcement community, especially police officers. Sample copy $2 with 9×12 SAE and 6 first-class stamps. Photo guidelines free with SASE.
Needs: Uses about 15 photos/issue; 99% supplied by freelance photographers. Needs law enforcement related photos. Special needs include photos relating to daily police work, crime prevention, international law enforcement, police technology and humor. Model release required. Property release preferred. Captions preferred.
Making Contact & Terms: Interested in receiving work from newer, lesser-known photographers. Arrange a personal interview to show portfolio. Send b&w prints, 35mm transparencies, b&w contact sheet or color negatives by mail for consideration; prefers color photos. Also accepts digital images. SASE. Payscale available in photographer's guidelines. Payment negotiable. **Pays on acceptance.** Buys all rights. Simultaneous submissions OK.
Tips: "Send for our editorial calendar and submit photos based on our projected needs. If we like your work, we'll consider you for future assignments. A photographer we use can grasp the conceptual and the action shots."

POLICE TIMES/CHIEF OF POLICE, 3801 Biscayne Blvd., Miami FL 33137. (305)573-0070. Fax: (305)573-9819. Executive Editor: Jim Gordon. Circ. 50,000. Quarterly (*Police Times*) and bimonthly (*Chief of Police*). Readers are law enforcement officers at all levels. Sample copy $2.50. Photo guidelines free with SASE.
Needs: Buys 60-90 photos/year. Photos of police officers in action, civilian volunteers working with the police and group shots of police department personnel. Wants no shots that promote other associations. Police-oriented cartoons also accepted on spec. Model release preferred. Captions preferred.
Making Contact & Terms: Send photos for consideration. Send glossy b&w and color prints. SASE. Reports in 3 weeks. Pays $5-10 upwards/inside photo; $25-50 upwards/cover photo. **Pays on acceptance.** Credit line given if requested; editor's option. Buys all rights, but may reassign to photographer after publication; includes internet publication rights. Simultaneous submissions and previously published work OK.
Tips: "We are open to new and unknowns in small communities where police are not given publicity."

POWERLINE MAGAZINE, 1650 S. Dixie Hwy., 5th Floor, Boca Raton FL 33432. (561)750-5575. Fax: (561)750-5316. E-mail: tkgroup@earthlink.net. Website: http://home.earthlink.net/~tkgroup. Editor: James McMullen. Photos used in trade magazine of Electrical Generating Systems Association and PR releases, brochures, newsletters, newspapers and annual reports.
Needs: Buys 40-60 photos/year; gives 2 or 3 assignments/year. "Cover photos, events, award presentations, groups at social and educational functions." Model release required. Property release preferred. Captions preferred; include identification of individuals only.
Making Contact & Terms: Interested in receiving work from newer, lesser-known photographers. Provide résumé, business card, brochure, flier or tearsheets to be kept on file for possible future assignments. Solicits photos by assignment only. Uses 5×7 glossy b&w and color prints; b&w and color contact sheets; b&w and color negatives. SASE. Reports as soon as selection of photographs is made. Payment negotiable. Buys all rights; negotiable.
Tips: "Basically a freelance photographer working with us should use a photojournalistic approach, and have the ability to capture personality and a sense of action in fairly static situations. With those photographers who are equipped, we often arrange for them to shoot couples, etc., at certain functions on spec, in lieu of a per-day or per-job fee."

THE PREACHER'S MAGAZINE, E. 10814 Broadway, Spokane WA 99206. (509)226-3464. Fax: (509)926-8740. Editor: Randal E. Denny. Circ. 18,000. Estab. 1925. Quarterly professional journal for ministers. Emphasizes the pastoral ministry. Readers are pastors of large to small churches in 5 denominations; most pastors are male. No sample copy available. No photo guidelines.
Needs: Uses 1 photo/issue; all supplied by freelancers. Large variety needed for cover, depends on theme of issue. Model release preferred.
Making Contact & Terms: Send 35mm b&w/color prints by mail for consideration. Reports ASAP. Pays $25/b&w photo; $75/color cover photo. **Pays on acceptance.** Credit line given. Buys one-time rights. Simultaneous submissions and previously published work OK.
Tips: In photographer's samples wants to see "a variety of subjects for the front cover of our magazine. We rarely use photos within the magazine itself."

PRODUCE MERCHANDISING, a Vance Publishing Corp. magazine, Three Pine Ridge Plaza, 10901 W. 84th Terrace, Lenexa KS 66214. (913)438-8700. Fax: (913)438-0691. E-mail: 103423.1660.@compuserv.com. Website: http://www.rbes.com/. Managing Editor: Janice L. McCall. Circ. 12,000. Estab. 1988. Monthly magazine. Emphasizes the fresh produce industry. Readers are male and female executives who oversee produce operations in US and Canadian supermarkets. Sample copy available. Photo guidelines free with SASE.
Needs: Uses 30 photos/issue; 2-5 supplied by freelancers. Needs in-store shots, either environmental portraits for cover photos or display pictures. Captions preferred; include subject's name, job title and company title—all verified and correctly spelled.
Making Contact & Terms: Provide résumé, business card, brochure, flier or tearsheets to be kept on file for possible future assignments. Keeps samples on file. Reporting time "depends on when we will be in a specific photographer's area and have a need." Pays $500-600/color cover transparencies; $25-50/color photo inside; $50-100/color roll inside photo. **Pays on acceptance.** Credit line given. Buys all rights.
Tips: "We seek photographers who serve as our on-site 'art director,' to ensure art sketches come to life. Supermarket lighting (fluorescent) offers a technical challenge we can't avoid. The 'greening' effect must be diffused/eliminated."

‡PROFESSIONAL PHOTOGRAPHER, Suite 1600, 57 Forsyth NW, Atlanta GA 30303. (404)522-8600. Fax: (404)614-6405. E-mail: ppaeditor@aol.com. Editorial Director: Kimberly Brady. Art Director: Debbie Todd. Circ. 28,000. Estab. 1907. Monthly. Emphasizes professional photography in the fields of portrait, wedding, commercial/advertising, corporate and industrial. Readers include professional photographers and photographic services and educators. Approximately half the circulation is Professional Photographers of America members. Sample copy $5 postpaid. Photo guidelines free with SASE.
● PPA members submit material unpaid to promote their photo businesses and obtain recognition. Images sent to *Professional Photographer* should be technically perfect and photographers should include information about how the photo was produced.
Needs: Uses 25-30 photos/issue; all supplied by freelancers. "We only accept material as illustration that relates directly to photographic articles showing professional studio, location, commercial and portrait techniques. A majority are supplied by Professional Photographers of America members." Reviews photos with accompanying ms only. "We always need commercial/advertising and industrial success stories. How to sell your photography to major accounts, unusual professional photo assignments. Also, photographer and studio application stories about the profitable use of electronic still imaging for customers and clients." Model release preferred. Captions required.
Making Contact & Terms: Query with résumé of credits. "We want a story query, or complete ms if writer feels subject fits our magazine. Photos will be part of ms package." Accepts images in digital format for Mac. Send via compact disc, online, floppy disk, SyQuest, Zip disk, Jaz disk. Uses 8×10 glossy unmounted b&w or color prints; 35mm, 2¼×2¼, 4×5 and 8×10 transparencies. SASE. Reports in 2 months. Credit line given.

‡PROGRESSIVE RENTALS, 9015 Mountain Ridge Dr., Suite 220, Austin TX 78759. (512)794-0095. Fax: (512)794-0097. E-mail: tsfnrf@onr.com. Art Director: Neil Ferguson. Circ. 5,000. Estab. 1983. Member of Association of Progressive Rental Organizations. Bimonthly magazine. Emphasizes the rental-purchase industry. Readers are owners and managers of rental-purchase stores in North America. Sample copy free with 9×12 SAE and $1.50 postage. Photo guidelines free with SASE.
Needs: Uses 1-2 photos/issue; all supplied by freelancers. Needs "strongly conceptual, cutting edge photos that relate to editorial articles on business/management issues." Model/property release preferred.
Making Contact & Terms: Send unsolicited photos by mail for consideration. Provide résumé, business card, brochure, flier or tearsheets to be kept on file for possible assignments. Send glossy color and b&w prints; 2¼×2¼, 4×5 transparencies; digital format (high resolution, proper size, flattened image, saved in proper format, etc.). Keeps samples on file. SASE. Reports in 1 month "if we're interested." Pays $200-

450/job; $350-450/color cover photo; $200-450/color inside photo; $200-350/b&w inside photo. Pays on publication. Credit line given. Buys one-time and electronic rights. Simultaneous submissions and previously published work OK.

Tips: "Always ask for a copy of the publication you are interested in working with. Understand the industry and the specific editorial needs of the publication, i.e., don't send beautiful still life to a trade association publication."

PUBLIC WORKS MAGAZINE, 200 S. Broad St., Ridgewood NJ 07451. (201)445-5800. Contact: James Kircher. Circ. 60,000. Monthly magazine. Emphasizes the planning, design, construction, inspection, operation and maintenance of public works facilities (bridges, roads, water systems, landfills, etc.) Readers are predominately male civil engineers, ages 20 and up. Some overlap with other planners, including consultants, department heads, etc. Sample copy free upon request. Photo guidelines available, but for cover only.

Needs: Uses dozens of photos/issue. "Most photos are supplied by authors or with company press releases." Purchases photos with accompanying ms only. Captions required.

Making Contact & Terms: Provide résumé, business card, brochure, flier or tearsheets to be kept on file for possible assignments. SASE. Reports in 2 weeks. Payment negotiated with editor. Credit line given "if requested." Buys one-time rights.

Tips: "Nearly all of the photos used are submitted by the authors of articles (who are generally very knowledgeable in their field). They may occasionally use freelancers. Cover personality photos are done by staff and freelance photographers." To break in, "learn how to take good clear photos of public works projects that show good detail without clutter. Prepare a brochure and pass around to small and mid-size cities, towns and civil type consulting firms; larger (organizations) will probably have staff photographers."

PURCHASING MAGAZINE, 275 Washington St., Newton MA 02158. (617)964-3030. Fax: (617)558-4705. Art Director: Michael Roach. Circ. 90,000. Estab. 1993. Bimonthly. Readers are management and purchasing professionals.

Needs: Uses 0-10 photos/issue, most on assignment. Needs corporate photos and people shots. Model/property release preferred. Captions required.

Making Contact & Terms: Interested in receiving work from newer, lesser-known photographers. Arrange a personal interview to show portfolio. Provide résumé, business card, brochure, flier or tearsheets to be kept on file for possible future assignments. Cannot return material. Pays $300-500/b&w photo; $300-500/color photo; $50-100/hour; $400-800/day; $200-500/photo/text package. **Pays on acceptance.** Credit line given. Buys all rights for all media including electronic media. Simultaneous submissions and previously published work OK.

Tips: In photographer's portfolio looks for informal business portrait, corporate atmosphere.

QUICK FROZEN FOODS INTERNATIONAL, 2125 Center Ave., Suite 305, Fort Lee NJ 07024-5898. (201)592-7007. Fax: (201)592-7171. Editor: John M. Saulnier. Circ. 13,000. Quarterly magazine. Emphasizes retailing, marketing, processing, packaging and distribution of frozen foods around the world. Readers are international executives involved in the frozen food industry: manufacturers, distributors, retailers, brokers, importers/exporters, warehousemen, etc. Review copy $8.

Needs: Buys 20-30 photos/year. Plant exterior shots, step-by-step in-plant processing shots, photos of retail store frozen food cases, head shots of industry executives, product shots, etc. Captions required.

Making Contact & Terms: Query first with résumé of credits. Uses 5×7 glossy b&w and color prints. SASE. Reports in 1 month. Payment negotiable. Pays on publication. Buys all rights, but may reassign to photographer after publication.

Tips: A file of photographers' names is maintained; if an assignment comes up in an area close to a particular photographer, he may be contacted. "When submitting your name, inform us if you are capable of writing a story, if needed."

THE RANGEFINDER, 1312 Lincoln Blvd., Santa Monica CA 90401. (310)451-8506. Fax: (310)395-9058. Editor: Bill Hurter. Circ. 50,000. Estab. 1952. Monthly magazine. Emphasizes topics, developments and products of interest to the professional photographer. Readers are professionals in all phases of photography. Sample copy free with 11×14 SAE and 2 first-class stamps. Photo guidelines free with SASE.

Needs: Uses 20-30 photos/issue; 70% supplied by freelancers. Needs all kinds of photos; almost always run in conjunction with articles. "We prefer photos accompanying 'how-to' or special interest stories from the photographer." No pictorials. Special needs include seasonal cover shots (vertical format only). Model release required. Property release preferred. Captions preferred.

Making Contact & Terms: Interested in receiving work from newer, lesser-known photographers. Query with résumé of credits. Keeps samples on file. SASE. Reports in 1 month. Pays $100 minimum/printed editorial page with illustrations. Covers submitted gratis. Pays on publication. Credit line given. Buys first

North American serial rights; negotiable. Previously published work occasionally OK; give details.

RECOMMEND WORLDWIDE, 5979 NW 151st St., Suite 120, Miami Lake FL 33014. (305)828-0123. Art Director: Janet Rosemellia. Managing Editor: Rick Shively. Circ. 55,000. Estab. 1985. Monthly. Emphasizes travel. Readers are travel agents, meeting planners, hoteliers, ad agencies. Sample copy free with 8½×11 SAE and 10 first-class stamps.
Needs: Uses about 40 photos/issue; 70% supplied by freelance photographers. "Our publication divides the world up into seven regions. Every month we use travel destination-oriented photos of animals, cities, resorts and cruise lines. Features all types of travel photography from all over the world." Model/property release required. Captions preferred; identification required.
Making Contact & Terms: Interested in receiving work from newer, lesser-known photographers. "We prefer a résumé, stock list and sample card or tearsheets with photo review later." SASE. Pays $150/color cover photo; up to 20 square inches: $25; 21-35 square inches $35; 36-80 square inches $50; over 80 square inches $75; supplement cover: $75; front cover less than 80 square inches $50. Pays 30 days upon publication. Credit line given. Buys one-time rights. Simultaneous submissions and previously published work OK.
Tips: Prefers to see "transparencies—either 2¼×2¼ or 35mm first quality originals, travel-oriented."

REFEREE, P.O. Box 161, Franksville WI 53126. (414)632-8855. Fax: (414)632-5460. E-mail: refmag@ex exec.com. Photo Editor: Jeff Stern. Circ. 35,000. Estab. 1976. Monthly magazine. Readers are mostly male, ages 30-50. Sample copy free with 9×12 SAE and 5 first-class stamps. Photo guidelines free with SASE.
Needs: Uses up to 50 photos/issue; 75% supplied by freelancers. Needs action officiating shots—all sports. Photo needs are ongoing. Captions required.
Making Contact & Terms: Send unsolicited photos by mail for consideration. Any format is accepted. Accepts images in digital format for Mac (TIFF). Send via SyQuest, optical 128m (266). Reports in 2 weeks. Pays $100/color cover photo; $75/b&w cover photo; $35/color inside photo; $20/b&w inside photo. Pays on publication. Credit line given. Rights purchased negotiable. Simultaneous submissions and previously published work OK.
Tips: Prefers photos which bring out the uniqueness of being a sports official. Need photos primarily of officials at or above the high-school level in baseball, football, basketball, soccer and softball in action. Other sports acceptable, but used less frequently. "When at sporting events, take a few shots with the officials in mind, even though you may be on assignment for another reason. Don't be afraid to give it a try. We're receptive, always looking for new freelance contributors. We are constantly looking for pictures of officials/umpires. Our needs in this area have increased."

REGISTERED REPRESENTATIVE, 18818 Teller Ave., Suite 280, Irvine CA 92612. (714)851-2220. Art Director: Chuck LaBresh. Circ. 90,000. Estab. 1976. Monthly magazine. Emphasizes stock brokerage industry. Magazine is "requested and read by 90% of the nation's stock brokers."
Needs: Uses about 8 photos/issue; 5 supplied by freelancers. Needs environmental portraits of financial and brokerage personalities, and conceptual shots of financial ideas, all by assignment only. Model/property release preferred. Captions required.
Making Contact & Terms: Interested in receiving work from newer, lesser-known photographers. Provide brochure, flier or tearsheets to be kept on file for possible future assignments. Cannot return material. Pays $250-600/b&w or color cover photo; $100-250/b&w or color inside photo. Pays 30 days after publication. Credit line given. Buys one-time rights. Simultaneous submissions and previously published work OK.
Tips: "I usually give photographers free reign in styling, lighting, camera lenses, whatever. I want something that is unusual enough to provide interest but not so strange that the subject can't be identified."

RESOURCE RECYCLING, P.O. Box 10540, Portland OR 97296-0540. (503)227-1319. Fax: (503)227-6135. Editor: Jerry Powell. Circ. 16,000. Estab. 1982. Monthly. Emphasizes "the recycling of post-consumer waste materials (paper, metals, glass, plastics etc.) and composting." Readers are "recycling company managers, local government officials, waste haulers and environmental group executives." Sample copy free with 11 first-class stamps plus 9×12 SAE.
Needs: Uses about 5-15 photos/issue; 1 supplied by freelancers. Needs "photos of recycling facilities, curbside recycling collection, secondary materials (bundles of newspapers, soft drink containers), etc." Model release preferred. Captions required.
Making Contact & Terms: Send glossy color prints and contact sheet. Accepts images in digital format for Mac. Send via floppy disk, SyQuest 44mb, Zip disk (high res). SASE. Reports in 1 month. Payment "varies by experience and photo quality." Pays on publication. Credit line given. Buys first North American serial rights. Simultaneous submissions OK.
Tips: "Because *Resource Recycling* is a trade journal for the recycling and composting industry, we are

looking only for photos that relate to recycling and composting issues."

‡RESTAURANT HOSPITALITY, 1100 Superior Ave., Cleveland OH 44114. (216)931-9254. Fax: (216)696-0836. E-mail: rheditors@aol.com. Editor-in-Chief: Michael DeLuca. Art Director: Christopher Roberto. Circ. 100,000. Estab. 1919. Monthly. Emphasizes "hands-on restaurant management ideas and strategies." Readers are "restaurant owners, chefs, food service chain executives."
 ● *Restaurant Hospitality* won the Ozzie Award for best design (circulation over 50,000) in 1993 and 1994 and the *Folio* Editorial Excellence Award for best written/edited magazine in food service, 1994, 1995 and 1996.
Needs: Uses about 30 photos/issue; 50% supplied by freelancers. Needs "people with food, restaurant and food service interiors and occasional food photos." Special needs include "subject-related photos; query first." Model release preferred. Captions preferred.
Making Contact & Terms: Send résumé of credits or samples, or list of stock photo subjects. Provide résumé, business card, brochure, flier or tearsheets to be kept on file for possible future assignments. Accepts images in digital format for Mac (BMP). Send via online, floppy disk. Pays $50-275/b&w or color photo; $350/half day; $150-450/job includes normal expenses. **Pays on acceptance.** Credit line given. Buys one-time rights plus reprint rights in all media. Previously published work OK "if exclusive to food service press."
Tips: "Let us know you exist. We can't assign a story if we don't know you. Send résumé, business card, samples, etc. along with introductory letter to Art Director Christopher Roberto."

RISTORANTE MAGAZINE, P.O. Box 73, Liberty Corner NJ 07938. (908)766-6006. Fax: (908)766-6607. Art Director: Erica Lynn DeWitte. Circ. 50,000. Estab. 1994. Quarterly magazine. *Ristorante*, the magazine for the Italian connoisseur and Italian restaurants with liquor licenses; appears on newstands.
Needs: Number of photos/issue varies. Number supplied by freelancers varies. "Think Italian!" Reviews photos with or without ms. Model/property release required. Captions preferred.
Making Contact & Terms: Interested in receiving work from newer, lesser-known photographers. Provide résumé, business card, brochure, flier or tearsheets to be kept on file for possible assignments. SASE. Payment negotiable. Pays on publication. Credit line given. Buys all rights; negotiable. Previously published work OK.

SEAFOOD LEADER, 5305 Shilshole Ave. NW, #200, Seattle WA 98107. (206)789-6506. Fax: (206)789-9193. Photo Editor: Scott Wellsandt. Circ. 16,000. Estab. 1981. Published bimonthly. Emphasizes seafood industry, commercial fishing. Readers are processors, buyers and sellers of seafood. Sample copy $5 with 9×12 SASE.
Needs: Uses about 40 photos/issue; 50% supplied by freelance photographers, most from stock. Needs photos of international seafood harvesting and farming, supermarkets, restaurants, shrimp, Alaska, many more. Captions preferred; include name, place, time.
Making Contact & Terms: Interested in receiving work from newer, lesser-known photographers. Query with list of stock photo subjects. Send photos on subjects we request. SASE. "We only want it on our topics." Reports in 1 month. Pays $100/color cover photo; $50/color inside photo; $25/b&w photo. Pays on publication. Credit line given. Buys one-time rights. Previously published work OK.
Tips: "Send in slides relating to our needs—request editorial calendar." Looks for "aesthetic shots of seafood and commercial fishing, shots of people interacting with seafood in which expressions are captured (i.e. not posed shots); artistic shots of seafood emphasizing color and shape. We want clear, creative, original photography of commercial fishing, fish species, not sports fishing."

SECURITY DEALER, Dept. PM, 445 Broad Hollow Rd., Suite 21, Melville NY 11747. (516)845-2700. Fax: (516)845-7109. Associate Publisher/Editor: Susan Brady. Circ. 28,000. Estab. 1967. Monthly magazine. Emphasizes security subjects. Readers are business owners who install alarm, security, CCTV, home automation and access control systems. Sample copy free with SASE.
Needs: Uses 2-5 photos/issue; none at present supplied by freelance photographers. Needs photos of security-application-equipment. Model release preferred. Captions required.
Making Contact & Terms: Interested in receiving work from newer, lesser-known photographers. Send b&w and color prints by mail for consideration. SASE. Reports "immediately." Pays $25-50/b&w photo; $400/color cover photo; $50-100/inside color photos. Pays 30 days after publication. Credit line given. Buys one-time rights in security trade industry. Simultaneous submissions and/or previously published work OK.
Tips: "Do not send originals, dupes only, and only after discussion with editor."

SHOOTER'S RAG—THE PRACTICAL PHOTOGRAPHIC GAZETTE, 6100 Pine Cone Lane, Austell GA 30001. (770)745-4170. E-mail: 72517.2176@compuserve.com. Website: http://www.mindsprin

g.com/~havelin Editor: Michael Havelin. Circ. 2,000. Estab. 1992. Bimonthly. Emphasizes photographic techniques, practical how-tos and electronic imaging. Readers are male and female professionals, semi-professionals and serious amateurs. Sample copy $3 with 10×13 SAE and 75¢ postage. Photo guidelines free with SASE.

Needs: Uses 3-10 photos/issue; 50-75% supplied by freelancers. "Single photos are not needed. Query for text with photographs." Special photo needs include humorous b&w cover shots with photographic theme and Band-Aid and detailed description of how the shot was done with accompanying set-up shots. Model/property release preferred. Captions required.

Making Contact & Terms: Interested in reviewing work from newer, lesser-known photographers. Query with résumé of credits, ideas for text/photo packages. Do not send portfolios. Accepts images in digital format for Windows (PCX, TIFF, GIF, JPG). Send via compact disc, online, floppy disk, Zip disk. Electronic submissions preferred via website. Does not keep samples on file. Reports in 1-3 months. Payment in copies only. Credit line given. Interested in one-time rights; negotiable. Simultaneous submissions and/or previously published work OK.

Tips: "Writers who shoot and photographers who write well should query. Develop your writing skills as well as your photography. Don't wait for the world to discover you. Announce your presence."

SIGNCRAFT MAGAZINE, P.O. Box 60031, Fort Myers FL 33906. (813)939-4644. Editor: Tom McIltrot. Circ. 20,000. Estab. 1980. Bimonthly magazine. Readers are sign makers and sign shop personnel. Sample copy $5. Photo guidelines free with SASE.

Needs: Uses over 100 photos/issue; few at present supplied by freelancers. Needs photos of well-designed, effective signs. Captions preferred.

Making Contact & Terms: Query with samples. Send b&w or color prints; 35mm, $2\frac{1}{4} \times 2\frac{1}{4}$ transparencies; b&w, color contact sheet by mail for consideration. SASE. Reports in 1 month. Payment negotiable. Pays on publication. Credit line given. Buys first North American serial rights. Previously published work possibly OK.

Tips: "If you have some background or past experience with sign making, you may be able to provide photos for us."

SOCIAL POLICY, 25 W. 43rd St., Room 620, New York NY 10036. (212)642-2929. Fax: (212)642-1956. Managing Editor: Audrey Gartner. Circ. 3,500. Estab. 1970. Quarterly. Emphasizes "social policy issues—how government and societal actions affect people's lives." Readers are academics, policymakers, lay readers. Sample copy $2.50.

Needs: Uses about 9 photos/issue; all supplied by freelance photographers. Needs photos of social consciousness and sensitivity. Model release preferred.

Making Contact & Terms: Arrange a personal interview to show portfolio. Query with samples. Provide résumé, business card, brochure, flier or tearsheets to be kept on file for possible future assignments. Reports in 2 weeks. Pays $100/b&w cover photo; $30/b&w inside photo. Pays on publication. Credit line given. Buys one-time rights. Simultaneous submissions and previously published work OK.

Tips: "Be familiar with social issues. We're always looking for relevant photos."

SOUTHERN LUMBERMAN, 128 Holiday Court, Suite 116, P.O. Box 681629, Franklin TN 37068-1629. (615)791-1961. Fax: (615)790-6188. Managing Editor: Nanci Gregg. Circ. 12,000. Estab. 1881. Monthly. Emphasizes forest products industry—sawmills, pallet operations, logging trades. Readers are predominantly owners/operators of midsized sawmill operations nationwide. Sample copy $3 with 9×12 SAE and 5 first-class stamps. Photo guidelines free with SASE.

• This publication digitally stores and manipulates images for advertising purposes.

Needs: Uses about 3-4 photos/issue; 25% supplied by freelancers. "We need black and white photos of 'general interest' in the lumber industry. We need photographers from across the country to do an inexpensive black & white shoot in conjunction with a phone interview. We need 'human interest' shots from a sawmill scene—just basic 'folks' shots—a worker sharing lunch with the company dog, sawdust flying as a new piece of equipment is started; face masks as a mill tries to meet OSHA standards, etc." Looking for photo/text packages. Model release required. Captions required.

Making Contact & Terms: Interested in receiving work from newer, lesser-known photographers. Query with samples. Send 5×7 or 8×10 glossy color prints; 35mm, 4×5 transparencies, b&w contact sheets or negatives by mail for consideration. SASE. Reports in 6 weeks. Pays minimum $20-35/b&w photos; $25-50/color photo; $100-150/photo/text package. Pays on publication. Credit line given. Buys first North American serial rights.

Tips: Prefers b&w capture of close-ups in sawmill, pallet, logging scenes. "Try to provide what the editor wants—call and make sure you know what that is, if you're not sure. Don't send things that the editor hasn't asked for. We're all looking for someone who has the imagination/creativity to provide what we need. I'm not interested in 'works of art'—I want and need color feature photos capturing essence of

employees working at sawmills nationwide. I've never had someone submit anything close to what I state we need—try that. *Read* the description, shoot the pictures, send a contact sheet or a couple 5×7s."

SPEEDWAY SCENE, P.O. Box 300, North Easton MA 02356. (508)238-7016. Editor: Val LeSieur. Circ. 70,000. Estab. 1970. Weekly tabloid. Emphasizes auto racing. Sample copy free with 8½×11 SAE and 4 first-class stamps.
Needs: Uses 200 photos/issue; all supplied by freelancers. Needs photos of oval track auto racing. Reviews photos with or without ms. Captions required.
Making Contact & Terms: Send unsolicited photos by mail for consideration. Send b&w, color prints. Reports in 1-2 weeks. Payment negotiable. Credit line given. Buys all rights. Simultaneous submissions and/or previously published work OK.

STEP-BY-STEP GRAPHICS, 6000 N. Forest Park Dr., Peoria IL 61614-3592. (309)688-2300. Fax: (309)688-8515. Managing Editor: Holly Angus. Circ. 45,000. Estab. 1985. Bimonthly. How-to magazine for traditional and electronic graphics. Readers are graphic designers, illustrators, art directors, studio owners, photographers. Sample copy $7.50.
Needs: Uses 130 photos/issue; all supplied by freelancers. Needs how-to ("usually tight") shots taken in artists' workplaces. Assignment only. Model release required. Captions required.
Making Contact & Terms: Query with samples. Provide résumé, business card, brochure, flier or tearsheets to be kept on file for possible future assignments. SASE. Reports in 1 month. Pays by the job on a case-by-case basis. **Pays on acceptance.** Credit line given. Buys one-time rights or first North American serial rights.
Tips: In photographer's samples looks for "color and lighting accuracy particularly for interiors." Most shots are tight and most show the subject's hands. Recommend letter of inquiry plus samples.

‡STREET SKILLS, P.O. Box 100, Nassau DE 19969. (302)645-5600. Fax: (302)645-8747. Editor: Larry Stevens. Circ. 27,000. Estab. 1994. Bimonthly magazine. Emphasizes emergency medical services and fire/rescue. Readers are male and female, emergency medical personnel. Sample copy $3.85. Photo guidelines available.
Needs: Uses 150 photos/issue; 150 supplied by freelancers. Needs photos of action and training photos of EMS and fire service rescuers. Model/property release preferred for staged events. Captions required; include date, location, description of activity, agency involved.
Making Contact & Terms: Interested in receiving work from newer, lesser-known photographers. Query with stock photo list. Send unsolicited photos by mail for consideration. Send 3×5 or 4×6 glossy color or b&w prints; 35mm, 2¼×2¼ transparencies. Keeps samples on file. SASE. Reports in 1-2 weeks. Pays $100/cover photo; $30/inside photo. Pays on publication. Credit line given. Rights negotiable. Simultaneous submissions and/or previously published work OK.

SUCCESSFUL MEETINGS, 355 Park Ave. S., New York NY 10010. (212)592-6401. Fax: (212)592-6409. Art Director: Don Salkaln. Circ. 75,000. Estab. 1955. Monthly. Emphasizes business group travel for all sorts of meetings. Readers are business and association executives who plan meetings, exhibits, conventions and incentive travel. Sample copy $10.
Needs: Special needs include *good*, high-quality corporate portraits, conceptual, out-of-state shoots (occasionally).
Making Contact & Terms: Arrange a personal interview to show portfolio. Query with résumé of credits and list of stock photo subjects. SASE. Reports in 2 weeks. Pays $500-750/color cover photo; $50-150/inside b&w photo; $75-200/inside color photo; $150-250/b&w page; $200-300/color page; $200-600/text/photo package; $50-100/hour; $175-350/½ day. **Pays on acceptance.** Credit line given. Buys one-time rights. Simultaneous submissions and previously published work OK "only if you let us know."

TECHNOLOGY & LEARNING, 330 Progress Rd., Dayton OH 45449. (937)847-5900, ext. 112. Fax: (937)847-5910. Website: http://www.techlearning.com. Editor: Judy Salpeter. Art Director: Daved Levitan. Circ. 82,000. Monthly. Emphasizes computers in education. Readers are teachers and administrators, grades K-12. Sample copy $3.
Needs: Uses about 7-10 photos/issue; 2 or more supplied by freelance photographers. Photo needs "depend on articles concerned. No general categories. Usually photos used to accompany articles in a conceptual manner. Computer screen shots needed often." Model release required.
Making Contact & Terms: Contact Ellen Wright to arrange a personal interview to show portfolio. Query with nonreturnable samples. Provide résumé, business card, brochure, flier or tearsheets to be kept on file for possible future assignments. Accepts images in digital format for Mac (Photoshop, TIFF). Send via compact disc, online, floppy disk, SyQuest, Zip disk. SASE. Reports in 3 weeks. Pays $300-500/color

cover photo; $50-100/b&w inside photo; $100-300/color inside photo. **Pays on acceptance.** Credit line given. Buys one-time rights. Previously published work OK.

TOBACCO INTERNATIONAL, 130 W. 42 St., Suite 2200, New York NY 10036. (212)391-2060. Fax: (212)827-0945. Editor: Jane Shea. Circ. 5,000. Estab. 1886. Monthly international business magazine. Emphasizes cigarettes, tobacco products, tobacco machinery, supplies and services. Readers are executives, ages 35-60. Sample copy free with SASE.
Needs: Uses 20 photos/issue. "Prefer photos of people smoking, processing or growing tobacco products from all around the world, but any interesting news-worthy photos relevant to subject matter is considered." Model and/or property release preferred.
Making Contact & Terms: Query with photocopy of photos. Send unsolicited color positives, slides or prints by mail for consideration. Does not keep samples on file. Reports in 3 weeks. Pays $50/color photo. Pays on publication. Credit line may be given. Simultaneous submissions OK (not if competing journal).

TRUCK ACCESSORY NEWS, 6255 Barfield Rd., Suite 200, Atlanta GA 30328. (404)252-8831. Fax: (404) 252-4436. Editor: Alfreda Vaughn. Circ. 8,500. Estab. 1994. Monthly magazine. Emphasizes retail truck accessories. Readers are male and female executives. Sample copy available.
Needs: Uses 75 photos/issue; 5-10 supplied by freelancers. Needs photos of trucks and truck accessory retailers. Model/property release required. Captions required.
Making Contact & Terms: Interested in receiving work from newer, lesser-known photographers. Provide résumé, business card, brochure, flier or tearsheets to be kept on file for possible assignments. Send 5×7, 8×10 color prints; 2¼×2¼, 4×5, 8×10 transparencies. Keeps samples on file. SASE. Reports in 3 weeks. Pays $350-450/half day. Pays on publication. Credit line given. Buys all rights; negotiable.

UNDERGROUND CONSTRUCTION, (formerly *Pipeline and Utilities Construction*), P.O. Box 219368, Houston TX 77218-9368. (281)558-6930. Fax: (281)558-7029. Editor: Robert Carpenter. Circ. 35,000. Estab. 1945. Monthly. Emphasizes construction and rehabilitation of oil and gas, water and sewer underground pipelines and cable. Readers are key contractor personnel and construction company managers and owners. Sample copy $3.
Needs: "Uses photos of underground construction and rehabilitation."
Making Contact & Terms: Send unsolicited photos by mail for consideration. Accepts color prints and transparencies. SASE. Reports in 1 month. Payment negotiable. Buys one-time rights.
Tips: "Freelancers are competing with staff as well as complimentary photos supplied by equipment manufacturers. Subject matter must be unique, striking and 'off the beaten track' (i.e., somewhere we wouldn't travel ourselves to get photos)."

UTILITY AND TELEPHONE FLEETS, P.O. Box 183, Cary IL 60013. (847)639-2200. Fax: (847)639-9542. Editor/Associate Publisher: Alan Richter. Circ. 18,000. Estab. 1987. Magazine published 8 times a year. Emphasizes equipment and vehicle management and maintenance. Readers are fleet managers, maintenance supervisors, generally 35 and older in age and primarily male. Sample copy free with SASE.
Needs: Uses 30 photos/issue; 3-4% usually supplied by a freelance writer with an article. Needs photos of vehicles and construction equipment. Special photo needs include alternate fuel vehicles and eye-grabbing colorful shots of utility vehicles in action as well as utility construction equipment. Model release preferred. Captions required; include person's name, company and action taking place.
Making Contact & Terms: Interested in receiving work from newer, lesser-known photographers. Provide résumé, business card, brochure, flier or tearsheets to be kept on file for possible assignments. SASE. Reports in 2 weeks. Pays $50/color cover photo; $10/b&w inside photo; $50-200/photo/text package ($50/published page). Pays on publication. Credit line given. Buys one-time rights; negotiable.
Tips: "Be willing to work cheap and be able to write; the only photos we have paid for so far were part of an article/photo package. Looking for shots focused on our market with workers interacting with vehicles, equipment and machinery at the job site."

UTILITY CONSTRUCTION AND MAINTENANCE, P.O. Box 183, Cary IL 60013. (847)639-2200. Fax: (847)639-9542. Editor: Alan Richter. Circ. 25,000. Estab. 1990. Quarterly magazine. Emphasizes equipment and vehicle management and maintenance. Readers are fleet managers, maintenance supervisors, generally 35 and older in age and primarily male. Sample copy free with SASE. No photo guidelines.
Needs: Uses 80 photos/issue; 1-2% usually supplied by a freelance writer with an article. Needs photos of vehicles and construction equipment. Special photo needs include eye-grabbing colorful shots of utility construction equipment. Model release preferred. Captions required.
Making Contact & Terms: Provide résumé, business card, brochure, flier or tearsheets to be kept on file for possible assignments. SASE. Reports in 2 weeks. Pays $50/color cover photo; $10/b&w inside

TECHNOLOGY & LEARNING

NOVEMBER/DECEMBER 1996 • VOLUME 17 NUMBER 3 • $3.00

PRESENTING THE 1996-97 SOFTWARE AWARD WINNERS

Plus:
- Networking Solutions
- Electronic Field Trips
- School-Grown Web Projects

Each year *Technology & Learning* magazine gives Software Awards. Beyond the publication's task of deciding the winners, Art Director Daved Levitan is annually faced with picturing the actual awards on the magazine's cover. "It's a challenge every year to show the awards in a unique way. We'd done it in a number of situations. This was the latest way we presented them," says Levitan. The cover was assigned to Bob Winner, a photographer *Technology & Learning* has a long-standing relationship with. Winner photographed the award through a prism, and the photo was digitally manipulated by *T&L's* art department using Photoshop.

photo; $50-200/photo/text package ($50/published page). Pays on publication. Credit line given. Buys one-time rights.

Tips: "Be willing to work cheap and be able to write as the only photos we have paid for so far were part of an article/photo package."

VEHICLE LEASING TODAY, 800 Airport Blvd., Suite 506, Burlingame CA 94010. Fax: (415)548-9155. Art Director: Deborah Dembek. Circ. 4,000. Estab. 1979. Publication of National Vehicle Leasing Association. Bimonthly magazine. Emphasizes leasing industry. Readers are leasing companies and their affiliates, financial institutions, dealers. Sample copy free with SASE.

Needs: Uses 3-5 photos/issue; 1-3 supplied by freelancers. Interested mostly in automotive photos, some conceptual, legislative, city views and local conferences. Captions preferred.

Making Contact & Terms: Query with stock photo list. Keeps samples on file. SASE. Reports in 2 weeks. Pays $400/color cover photo; $75/color inside photo. Pays on publication. Credit line given. Rights negotiable. Previously published work OK.

WALLS & CEILINGS MAGAZINE, 3225 S. Macdill Ave., Suite 129-242, Tampa FL 33629-8171. (800)533-5653. Fax: (800)746-4926. E-mail: greg@wconline.com; paula@wconline.com; julie@wconline.com. Website: http://www.wconline.com. Editor: Greg Campbell. Circ. 24,000. Monthly magazine. Emphasizes wall and ceiling construction, drywall, lath, plaster, stucco and exterior specialty finishes. Readership consists of 98% male, wall and ceiling contractors. Sample copy $6.

Needs: Uses 15-20 photos/issue; 30% supplied by freelancers. Needs photos of interior/exterior architectural shots, contractors and workers on job (installing drywall and stucco). Model release required.

Making Contact & Terms: Query with résumé of credits. Send unsolicited photos by mail. Send glossy b&w or color prints, any size, or 35mm, 2¼×2¼ or 4×5 transparencies. Accepts images in digital format for Mac, Windows. Send via compact disc, floppy disk, SyQuest. SASE. Reports in 1 month. Pays $150/color cover photo; $50/color inside photo; $25/b&w inside photo; $50-150/photo/text package. Pays on publication. Credit line given. Buys exclusive, one-time and "our industry" rights. Simultaneous submissions and previously published work OK, if not submitted to or published by competitors.

WATER WELL JOURNAL, 601 Dempsey Rd., Westerville OH 43081. (614)882-8179. Fax: (614)898-7786. E-mail: h2o@h2o~ngwa.org. Website: http://www.h2o~ngwa.org. Senior Editor: Gloria J. Swanson. Circ. 26,002. Estab. 1947. Monthly. Emphasizes construction of water wells, development of ground water resources and ground water cleanup. Readers are water well drilling contractors, manufacturers, suppliers and ground water scientists. Sample copy $6 (US); $10.50 (foreign).

Needs: Uses 1-3 freelance photos/issue plus cover photos. Needs photos of installations and how-to illustrations. Model release preferred. Captions required.

Making Contact & Terms: Interested in receiving work from newer, lesser-known photographers. Contact with résumé of credits; inquire about rates. "We'll contact." Pays $10-50/hour; $200/color cover photo; $50/b&w inside photo; "flat rate for assignment." Pays on publication. Credit line given "if requested." Buys all rights.

THE WHOLESALER, 1838 Techny Court, Northbrook IL 60062. (847)564-1127. Fax: (847)564-1264. Editor: John Schweizer. Circ. 29,600. Estab. 1946. Monthly news tabloid. Emphasizes wholesaling, distribution in the plumbing, heating, air conditioning, piping (inc. valves), fire protection industry. Readers are owners and managers of wholesale distribution businesses, also manufacturers and manufacturer representatives. Sample copy free with 11×15½ SAE and 5 first-class stamps.

Needs: Uses 1-5 photos/issue; 3 supplied by freelancers. Interested in field and action shots in the warehouse on the loading dock, at the job site. Property release and captions preferred. "Just give the facts."

Making Contact & Terms: Interested in receiving work from newer, lesser-known photographers. Query with stock photo list. Send unsolicited photos by mail for consideration. Send any size glossy print, color and b&w. SASE. Reports in 2 weeks. Pays on publication. Buys one-time rights. Simultaneous and/or previously published work OK.

WINES & VINES, 1800 Lincoln Ave., San Rafael CA 94901. (415)453-9700. Fax: (415)453-2517. E-mail: geninfo@winesandvines.com. Contact: Dottie Kubota-Cordery. Circ. 5,000. Estab. 1919. Monthly magazine. Emphasizes winemaking in the US for everyone concerned with the wine industry, including winemakers, wine merchants, suppliers, consumers, etc.

- *Wines & Vines* has more than doubled its payment for photography.

Needs: Wants color cover subjects on a regular basis.

Making Contact & Terms: Interested in receiving work from newer, lesser-known photographers. Query or send material by mail for consideration. Will call if interested in reviewing photographer's portfolio.

Provide business card to be kept on file for possible future assignments. Accepts images in digital format for Mac or Windows (Adobe, Aldus, Quark). Send via compact disc, SyQuest, Zip disk (150-200). SASE. Reports in 3 months. Pays $50/b&w print; $100-300/color cover photo. Pays on publication. Credit line given. Buys one-time rights. Previously published work OK.

WISCONSIN ARCHITECT, 321 S. Hamilton St., Madison WI 53703. (608)257-8477. Managing Editor: Brenda Taylor. Circ. 3,700. Estab. 1931. Publication of American Institute of Architects Wisconsin. Bimonthly magazine. Emphasizes architecture. Readers are design/construction professionals.
Needs: Uses approximately 35 photos/issue. "Photos are almost exclusively supplied by architects who are submitting projects for publication. Of these, approximately 65% are professional photographers hired by the architect."
Making Contact & Terms: "Contact us through architects." Keeps samples on file. SASE. Reports in 1-2 weeks when interested. Pays $50-100/color cover photo when photo is specifically requested. Pays on publication. Credit line given. Rights negotiable. Simultaneous submissions and/or previously published work OK.

WOODSHOP NEWS, 35 Pratt St., Essex CT 06426. (860)767-8227. Senior Editor: Thomas Clark. Circ. 100,000. Estab. 1986. Monthly tabloid. Emphasizes woodworking. Readers are male, ages 20-60, furniture makers, cabinetmakers, millworkers and hobbyist woodworkers. Sample copy and photo guidelines free with 11×13 SAE.
Needs: Uses 40 photos/issue; less than 5% supplied by freelancers. Needs photos of people working with wood. Model release required. Captions required.
Making Contact & Terms: Provide résumé, business card, brochure, flier or tearsheets to be kept on file for possible assignments. SASE. Reports in 1 month. Pays $300/color cover photo; $35/b&w inside photo. Pays on publication. Credit line given. Buys one-time rights.

WRITER'S DIGEST/WRITER'S YEARBOOK, 1507 Dana Ave., Cincinnati OH 45207. (513)531-2690, ext. 384. Fax: (513)531-1843. Managing Editor: Peter Blocksom. Circ. 250,000. Estab. 1920. Monthly magazine. Emphasizes writing and publishing. Readers are "writers and photojournalists of all description: professionals, beginners, students, moonlighters, bestselling authors, editors, etc." Sample copy $3.50 ($3.70 in Ohio). Guidelines free with SASE.
Needs: Buys 15 photos/year. Uses about 10% freelance material each issue. Purchases about 75% of photos from stock or on assignment; 25% of those with accompanying ms. Primarily celebrity/personality ("to accompany profiles"); some how-to, human interest and product shots. All must be writer-related. Submit model release with photo. Captions required.
Making Contact & Terms: Query with résumé of credits, list of photographed writers, or contact sheet. Provide brochure and samples (print samples, not glossy photos) to be kept on file for possible future assignments. "We never run photos without text." Also accepts digital files—JPEG and TIFF acceptable; EPS preferred. Uses 8×10 glossy prints; send contact sheet. "Do *not* send negatives." Pays $75-200. "Freelance work is rarely used on the cover." **Pays on acceptance.** Credit line given. Buys first North American serial rights, one-time use only. Simultaneous submissions OK if editors are advised. Previously published work OK.
Tips: "We most often use photos with writers' profiles; in fact, we only buy the profile if we can get photos. The story, however, is always our primary consideration, and we won't buy photos unless they are related to an article in the works. We sometimes use humorous shots in our Writing Life column. Shots should not *look* posed, even though they may be. Photos with a sense of place, as well as persona, preferred. Have a mix of tight and middle-distance shots of the subject. Avoid the stereotyped writer-at-typewriter; go for an array of settings. We're also interested in articles on how a writer earned extra money with photos, or how a photographer works with writers on projects, etc."

YALE ROBBINS, INC., 31 E. 28th St., 12th Floor, New York NY 10016. (212)683-5700. Fax: (212)545-0764. Managing Editor: Peg Rivard. Circ. 10,500. Estab. 1983. Annual magazine and photo directory. Emphasizes commercial real estate (office buildings). Readers are real estate professionals—brokers, developers, potential tenants, etc. Sample copy $69.
Needs: Uses 150-1,000 photos/issue. Needs photos of buildings. Property release required.
Making Contact & Terms: Interested in receiving work from newer, lesser-known or established photographers. Provide résumé, business card, brochure, flier or tearsheets to be kept on file for possible future assignments. Send 35mm transparencies. Keeps samples on file. SASE. Reports in 1 month. Pays $35-45/color slide; payment for color covers varies. Pays on publication. Credit line given. Buys all rights; negotiable. Simultaneous submissions and previously published work OK.

Book Publishers

There are diverse needs for photography in the book publishing industry. Publishers need photos for the obvious covers, jackets, text illustration and promotional materials, but now may also need them for use on CD-ROMs and even websites. Generally, though, publishers either buy individual or groups of photos for text illustration, or they publish entire books of photography.

Those in need of text illustration use photos for cover art and interiors of textbooks, travel books and nonfiction books. For illustration, photographs may be purchased from a stock agency or from a photographer's stock or the publisher may make assignments. Publishers usually pay for photography used in book illustration or on covers on a per-image or per-project basis. Some pay photographers on hourly or day rates, if on an assignment basis. No matter how payment is made, however, the competitive publishing market requires freelancers to remain flexible.

To approach book publishers for illustration jobs, send a query letter and photographs or slides and a stock photo list with prices, if available. If you have published work, tearsheets are very helpful in showing publishers how your work translates to the printed page.

Publishers who produce photography books usually publish themed books featuring the work of one or several photographers. It is not always necessary to be well-known to publish your photographs as a book. What you do need, however, is a unique perspective, a saleable idea and quality work.

For entire books, publishers may pay in one lump sum or with an advance plus royalties (a percentage of the book sales). When approaching a publisher for your own book of photographs, query first with a brief letter describing the project and samples. If the publisher is interested in seeing the complete proposal, photographers can send additional information in one of two ways depending on the complexity of the project.

Prints placed in sequence in a protective box, along with an outline, will do for easy-to-describe, straight-forward book projects. For more complex projects, you may want to create a book dummy. A dummy is basically a book model with photographs and print arranged as they will appear in finished book form. Book dummies show exactly how a book will look including the sequence, size, format and layout of photographs and accompanying text. The quality of the dummy is important, but keep in mind the expense can be prohibitive.

To find the right publisher for your work first check the newly expanded Subject Index to help narrow your search, then read the appropriate listings carefully. Send for catalogs and guidelines for those publishers that interest you. Also, become familiar with your local bookstore. By examining the books already published, you can find those publishers who produce your type of work. Check for both large and small publishers. While smaller firms may not have as much money to spend, they are often more willing to take risks, especially on the work of new photographers.

AAIMS PUBLISHERS COMPANY, 11000 Wilshire Blvd., P.O. Box 241777, Los Angeles CA 90024-9577. (213)968-1195. Fax: (213)931-7217. E-mail: aaims1@aol.com. Personnel Manager: Samuel P. Elliott. Estab. 1969. Publishes adult trade, "how-to," description and travel, sports, adventure, fiction and poetry. Photos used for text illustration, promotional materials and book covers. Examples of recently published titles: *Family Reunions: How To Plan Yours*; *A Message From Elvis Presley*; and *U.S. Marines Force Recon: A Black Hero's Story*.
Needs: Offers 4 or 5 freelance assignments annually. Shots of sports figures and events. Reviews stock photos. Model/property release required.
Making Contact & Terms: Interested in receiving work from newer, lesser-known photographers. Arrange personal interview to show portfolio. Query with samples. Uses 3×5 glossy b&w/prints. SASE.

Reports in 3 weeks. Pays $10-50/b&w photo; $50/hour. Credit line may be given. Buys all rights; negotiable. Offers internships for photographers. Contact Assistant Director: Olatunde Master.

‡ABBEVILLE PRESS, 488 Madison Ave., New York NY 10022. (212)888-1969. Fax: (212)644-5085. Director of Photography: Laura Straus. Publishes art books, travel books, cookbooks, children's books, calendars, stylebooks. Photos used for text illustration, promotional materials, book covers, dust jackets. Examples of recently published titles: *History of Women in Photography* (illustrations); *Empire* (interior illustrations). Photo guidelines free with SASE.
Needs: Buys 500-5,000 photos annually; offers 5-10 freelance assignments annually. Wants focused material that is well-lit. Prefers large format. Reviews stock photos of wildflowers (North American). Model/ property release required for people or artwork. Captions required.
Making Contact & Terms: Provide résumé, business card, brochure, flier or tearsheets to be kept on file for possible future assignments. Uses up to 11 × 14 matte or glossy b&w prints; "2¼ × 2¼, 4 × 5 and 8 × 10 transparencies preferred, but we will take 35mm." Keeps samples on file. SASE. Reports in 1 month. Pays per picture rated range from $25-150. Pays on receipt of invoice. Credit line given. Rights purchased depends upon project and whether there was a work-for-hire arrangement; negotiable.
Tips: "We prefer not to review portfolios (except food photography and some specific product work for fashion or objects). We love to receive good ideas for books. Otherwise, you can submit materials on the following subjects: art, travel, nature, food, animals."

ADAMS-BLAKE PUBLISHING, 8041 Sierra St., Fair Oaks CA 95628. Phone/fax: (916)962-9296. Editorial Assistant: Monica Blane. Estab. 1992. Publishes business, career and reference material. Photos used for text illustration, promotional materials and book covers. Examples of published titles: *Computer Money* (promo); *Core 911* (cover/promo); and *Complete Guide to TV Movies* (promo).
Needs: Buys 10-15 photos annually; offers 5 freelance assignments annually. Wants photos of people in office situations. Model/property release required. Captions required; include where and when.
Making Contact & Terms: Interested in receiving work from newer, lesser-known photographers. Query with résumé of credits. Provide résumé, business card, brochure, flier or tearsheets to be kept on file for possible future assignments. Uses 5 × 7 and 8 × 10 glossy b&w prints; 35mm transparencies. Keeps samples on file. SASE. Reports in 1 month. Pays $50-100/color photo; $50-100/b&w photo. **Pays on acceptance.** Credit line given. Buys one-time and book rights; negotiable. Simultaneous submissions and previously published work OK.
Tips: "We publish business books and look for subjects using office equipment in meetings and at the desk/work site. Don't send a whole portfolio. We only want your name, number and a few samples. Having an e-mail address and fax number will help you make a sale. Don't phone or fax us. We also look for b&w book covers. They are cheaper to produce and, if done right, can be more effective than color."

‡AERIAL PHOTOGRAPHY SERVICES, 2511 S. Tryon St., Charlotte NC 28203. (704)333-5143. Fax: (704)333-5148. Photography/Lab Manager: Joe Joseph. Estab. 1960. Publishes pictorial books, calendars, postcards, etc. Photos used for text illustration, book covers. Examples of recently published titles: *Blue Ridge Parkway Calendar*, *Great Smoky Mountain Calendar*, *North Carolina Calendar*, all depicting the seasons of the year. Photo guidelines free with SASE.
Needs: Buys 100 photos annually. Landscapes, scenics, mostly seasons (fall, winter, spring). Reviews stock photos. Model/property release preferred. Captions required; include location.
Making Contact & Terms: Interested in receiving work from newer, lesser-known photographers. Send unsolicited photos by mail for consideration. Works with local freelancers on assignment only. Uses 5 × 7, 8 × 10 matte color prints; 35mm, 2¼ × 2¼, 4 × 5 transparencies; c-41 120mm film mostly. SASE. Reports in 3 weeks. Payment negotiable. **Pays on acceptance.** Credit line given. Buys all rights; negotiable. Simultaneous submissions OK.
Tips: Looking for "fresh looks, creative, dynamic, crisp images. We use a lot of nature photography, scenics of the Carolinas area including Tennessee and the mountains. We like to have a nice variety of the four seasons. We also look for good quality chromes good enough for big reproduction. Only submit images that are very sharp and well exposed. We get a lot of useless photos and that takes a lot of our time, so please be considerate on that particular aspect. Seeing large format photography the most (120mm-

THE SUBJECT INDEX, located at the back of this book, lists publications, book publishers, galleries, paper product companies and stock agencies according to the subject areas they seek.

4×5). If you would like to submit images in a CD, that is acceptable too. The industry is looking for fast action/response and computers are promising a lot."

AGRITECH PUBLISHING GROUP, 95 Court St., Unit A, Exeter NH 03833-2621. (603)773-9823. Executive Vice President: Eric C. Lightin' Horse. Estab. 1988. Publishes adult trade, juvenile, textbooks. Subject matter includes horses, pets, farm animals/management, gardening, Western art/Americana and agribusiness. Photos used for text illustration, promotional materials, book covers and dust jackets.
Needs: Number of purchases and assignments varies. Reviews stock photos. Model/property release required. Captions preferred.
Making Contact & Terms: Interested in receiving work from newer, lesser-known photographers. Submit portfolio for review. Query with samples. Provide résumé, business card, brochure, flier, duplicates or tearsheets to be kept on file for possible future assignments. Keeps samples on file. SASE. Subject matter varies. Payment negotiable. Pays on publication. Credit line sometimes given depending upon subject and/ or photo. Buys book rights and all rights.
Tips: "Limit queries to what we look for and need."

ALLYN AND BACON PUBLISHERS, 160 Gould St., Needham MA 02194. Fax: (617)455-1294. Photography Director: Susan Duane. Textbook publisher (college). Photos used in textbook covers and interiors.
Needs: Offers 4 assignments plus 80 stock projects/year. Multi-ethnic photos in education, health and fitness, business, social sciences and good abstracts. Reviews stock photos. Model/property release required.
Making Contact & Terms: Provide self-promotion piece or tearsheets to be kept on file for possible future assignments. "Do not call or send stock lists." Uses 8×10 or larger, matte b&w prints; 35mm, 2¼×2¼, 4×5, 8×10 transparencies. Keeps samples on file. Cannot return material. Reports back in "24 hours to 4 months." Pays $50-225/photo; negotiable/day or complete job. Pays on usage. Credit line given. Buys one-time rights; negotiable. Offers internships for photographers January-June. Contact Photography Director: Susan Duane.
Tips: "Send tearsheets and promotion pieces. Need bright, strong, clean abstracts and unstaged, nicely lit people photos."

ALPINE PUBLICATIONS, INC., 225 S. Madison Ave., Loveland CO 80537. (303)667-9317. Publisher: B.J. McKinney. Estab. 1975. Publishes how-to, training and breed books for dogs, cats, horses, pets. Photos used for text illustration and book covers.
Needs: Wants photos of dogs, horses, cats, (singly and in combination), working and training photos, how-to series on assignment. Reviews stock photos. Model release required for people and animals. Captions preferred; include breed and registered name.
Making Contact & Terms: Interested in receiving work from newer, lesser-known photographers. Query with samples. Query with stock photo list. Works on assignment only. Uses 5×7, 8×10 glossy color and b&w prints; 35mm, 2¼×2¼, 4×5 transparencies. Keeps samples on file. SASE. Reports in 1 month. Pays $25-300/color photo; $15-50/b&w photo. Pays on publication. Credit line given. Buys book rights; negotiable. Simultaneous submissions and previously published work OK.
Tips: "We look for clear, very sharp-focused work and prefer purebred, excellent-quality specimens. Natural behavior-type shots are very desirable. Be flexible in rates—we're small and growing. We actively seek lesser-known talents, believing your work will sell our product, not your name. Be patient."

AMERICAN & WORLD GEOGRAPHIC PUBLISHING, P.O. Box 5630, Helena MT 59604. (406)443-2842. Fax: (406)443-5480. Photo Librarian: Patty White. Estab. 1973. Publishes material relating to geography, weather, photography—scenics and adults and children at work and play. Photos used for text illustration, promotional materials, book covers and dust jackets (inside: alone and with supporting text). Examples of published titles: *Wisconsin from the Sky* (aerial coffee table book); *The Quad-Cities and the People* (text, illustration); and *Oklahoma: The Land and Its People* (text, illustration). Photo guidelines free with SASE.
Needs: Buys 1,000 photos annually; offers 1-10 freelance assignments annually. Looking for photos that are clear with strong focus and color—scenics, wildlife, people, landscapes. Captions required; include name and address on mount. Package slides in individual protectors, then in sleeves.
Making Contact & Terms: Interested in receiving work from newer, lesser-known photographers. Query with samples. Query with stock photo list. Uses 35mm, 2¼×2¼, 4×5 and 8×10 transparencies. SASE. Reporting time depends on project. Pays $75-350/color photo. Pays on publication. Buys one-time rights. Simultaneous submissions and/or previously published work OK.
Tips: "We seek bright, heavily saturated colors. Focus must be razor sharp. Include strong seasonal looks, scenic panoramas, intimate close-ups. Of special note to *wildlife* photographers, specify shots taken in the

wild or in a captive situation (zoo or game farm). We identify shots taken in the wild."

AMERICAN ARBITRATION ASSOCIATION, 140 W. 51st St., New York NY 10020-1203. (212)484-4000. Editorial Director: Jack A. Smith. Publishes law-related materials on all facets of resolving disputes in the labor, commercial, construction and insurance areas. Photos used for text illustration. Examples of published titles: *Dispute Resolution Journal* (cover and text); *Dispute Resolution Times* (text); and *AAA Annual Report* (text).
Needs: Buys 10 photos annually; assigns 5 freelance projects annually. General business and industry-specific photos. Reviews stock photos. Model release and photo captions preferred.
Making Contact & Terms: Provide résumé, business card, brochure, flier or tearsheets to be kept on file for possible future assignments. Uses 8×10 glossy b&w prints; 35mm transparencies. SASE. Reports "as time permits." Pays $250-400/color photo, $75-100/b&w photo, $75-100/hour. Credit lines given "depending on usage." Buys one-time rights. Also buys all rights "if we hire the photographer for a shoot." Simultaneous submissions and previously published work OK.

AMERICAN BAR ASSOCIATION PRESS, 750 N. Lake Shore Dr., Chicago IL 60611. (312)988-6094. Fax: (312)988-6081. Photo Service Coordinator: Craig Jobson. "The ABA Press publishes 10 magazines, each addressing various aspects of the law. Readers are members of the sections of the American Bar Association." Photos used for text illustration, promotional materials, book covers. Examples of published titles: *Business Law Today*, portrait shot of subject of story; *Criminal Justice*, photo for story on crack. Photo guidelines free with SASE.
Needs: Buys 3-5 photos/issue. Rarely gives freelance assignments. "We are looking for serious photos that illustrate various aspects of the law, including courtroom scenes and still life law concepts. Photos of various social issues are also needed, e.g., crime, AIDS, homelessness, families, etc. Photos should be technically correct. Photos should show emotion and creativity. Try not to send any gavels or Scales of Justice. We have plenty of those." Reviews stock photos. Model/property release preferred; "required for sensitive subjects." Photo captions preferred.
Making Contact & Terms: Interested in receiving work from newer, lesser-known photographers. Query with stock photo list. Send unsolicited photos by mail for consideration. Provide résumé, business card, brochure, flier or tearsheets with SASE to be kept on file for possible future assignments. Uses 5×7, 8×10 b&w prints; 35mm, 2¼×2¼, 4×5, 8×10 transparencies. Keeps samples on file. Reports in 4-6 weeks. Pays $100-350. Assignment fees will be negotiated. When photos are given final approval, photographers will be notified to send an invoice. Credit line given. Buys one-time rights; negotiable. "We reserve the right to republish if publication is used on the Internet." Simultaneous submissions and/or previously published works OK.
Tips: "Be patient, present only what is relevant."

AMERICAN BIBLE SOCIETY, 1865 Broadway, New York NY 10023. (212)408-1441. Fax: (212)408-1435. Product Development: Christina Murphy. Estab. 1816. Publishes Bibles, New Testaments and illustrated scripture booklets and leaflets on religious and spiritual topics. Photos used for text illustration, promotional materials and book covers. Examples of published titles: *Hospital Scripture Tray Cards*, series of 7 (covers); *God Is Our Shelter and Strength*, booklet on natural disasters; and *God's Love for Us Is Sure and Strong*, booklet on Alzheimer's disease (cover and text).
Needs: Buys 10-25 photos annually; offers at least 10 freelance assignments annually. Needs scenic photos, people (multicultural), religious activities, international locations (particularly Israel, Jerusalem, Bethlehem, etc.). Reviews stock photos. Model release required. Property release preferred. Releases needed for portraits and churches. Captions preferred; include location and names of identifiable persons.
Making Contact & Terms: Interested in receiving work from new, lesser-known photographers. Query with samples. Provide résumé, business card, brochure, flier or tearsheets to be kept on file for possible future assignments. Uses any size glossy color and b&w prints; 35mm, 2¼×2¼, 4×5, 8×10 transparencies. Keeps samples on file. SASE. Reports within 2 months. Pays $100-800/color photo; $50-500/b&w photo. **Pays on receipt of invoice.** Credit line sometimes given depending on nature of publication. Buys one-time and all rights; negotiable. Simultaneous and/or previously published work OK.
Tips: Looks for "special sensitivity to religious and spiritual subjects and locations; contemporary, multicultural people shots are especially desired."

‡**AMERICAN COLLEGE OF PHYSICIAN EXECUTIVES**, 4890 W. Kennedy Blvd., Suite 200, Tampa FL 33609-2575. (813)287-2000. Fax: (813)287-8993. E-mail: ssasenick@acp.org. Editor: Susan Sasenick. Estab. 1979. Publishes adult trade for physician executives. Photos used for text illustration. Example of recently published title: *Physician Executive Journal*.
Needs: Buys 10 photos annually. Looking for photos of abstracts and still lifes. Reviews stock photos.
Making Contact & Terms: Interested in receiving work from newer, lesser-known photographers. Query

with samples. Query with stock photo list. Provide résumé, business card, brochure, flier or tearsheets to be kept on file for possible future assignments. Accepts all formats, including prints, transparencies, film and videotape and digital. Keeps samples on file. SASE. Reports in 1 month. Payment negotiable. Pays on publication, receipt of invoice. Credit line given. Buys one-time rights and electronic rights; negotiable. Simultaneous submissions and previously published work OK.

AMERICAN MANAGEMENT ASSOCIATION, 1601 Broadway, New York NY 10019. (212)903-8058. Fax: (212)903-8083. E-mail: snewton@amanet.org. Art & Production Director: Seval Newton. Estab. 1923. Publishes trade books and magazines on management. Photos used for text illustration, book covers, magazine articles and covers. Examples of recently published titles: *Management Review*, July '95 issue (cover, inside journalistic photos) and February '96 issue (cover photo, ergonomics article).
Needs: Buys 10 photos annually; offers 3-5 freelance assignments annually. Needs business and office photos. Reviews stock photos of management, business, office and professions. Model/property release required for people and locations. Captions required; include name, title of person, location and date.
Making Contact & Terms: Provide résumé, business card, brochure, flier or tearsheets to be kept on file for possible future assignments. Works with freelancers on assignment only. Uses 35mm slides, 8 × 10 color prints; 2¼ × 2¼, 4 × 5 transparencies. Negatives and Kodak digital format OK. Keeps samples on file. SASE. Reports only if interested. Pays $350-500/day; 25% more for electronic usage. Pays on publication. Credit line given. Buys all rights; negotiable. Simultaneous submissions OK.
Tips: "We appreciate photographers who know and use Photoshop for enhancement and color correction. Delivery on a Kodak CD with color correction is a big plus."

AMERICAN PLANNING ASSOCIATION, 122 S. Michigan, Suite 1600, Chicago IL 60603. (312)431-9100. Fax: (312)431-9985. Art Director: Richard Sessions. Publishes planning and related subjects. Photos used for text illustration, promotional materials, book covers, dust jackets. Photo guidelines and sample for $1 postage.
Needs: Buys 100 photos annually; offers 8-10 freelance assignments annually. Needs planning related photos. Captions required; include what's in the photo and credit information.
Making Contact & Terms: Interested in receiving work from newer, lesser-known photographers. Provide résumé, business card, brochure, flier or tearsheets to be kept on file for possible future assignments. "Do not send original work—slides, prints, whatever—with the expectation of it being returned." Uses 8 × 10 glossy color or b&w prints. Keeps samples on file. SASE. Reports in 1-2 weeks. Pays $80-100 for existing stock photos. **Pays on receipt of invoice.** Credit line given. Buys one-time and electronic rights (CD-ROM and online). Simultaneous submissions and previously published work OK.

‡AMERICAN SCHOOL HEALTH ASSOCIATION, P.O. Box 708, Kent OH 44240. (330)678-1601. Fax: (330)678-4526. Managing Editor: Thomas M. Reed. Estab. 1927. Publishes professional journals. Photos used for book covers.
Needs: Looking for photos of school-age children. Model/property release required. Captions preferred; include photographer's full name and address.
Making Contact & Terms: Interested in receiving work from newer, lesser-known photographers. Query with samples. Uses 35mm transparencies. Does not keep samples on file. SASE. Reports as soon as possible. Payment negotiable. Pays on publication. Credit line given. Buys one-time rights. Simultaneous submissions and previously published work OK.

AMHERST MEDIA INC., P.O. Box 586, Amherst NY 14226. (716)874-4450. Fax: (716)874-4508. Publisher: Craig Alesse. Estab. 1979. Publishes how-to photography. Photos used for text illustration and book covers. Examples of published titles: *The Freelance Photographer's Handbook*; *Wedding Photographer's Handbook* (illustration); and *Lighting for Imaging* (illustration).
Needs: Buys 25 photos annually; offers 6 freelance assignments annually. Model release required. Property release preferred. Captions preferred.
Making Contact & Terms: Interested in receiving work from newer, lesser-known photographers. Query with résumé of credits. Uses 5 × 7 prints; 35mm transparencies. Does not keep samples on file. SASE. Reports in 1 month. Pays $30-100/color photo; $30-100/b&w photo. Pays on publication. Credit line sometimes given depending on photographer. Rights negotiable. Simultaneous submissions OK.

AMPHOTO BOOKS, 1515 Broadway, New York NY 10036. (212)764-7300. Senior Editor: Robin Simmen. Publishes instructional and how-to books on photography. Photos usually provided by the author of the book.
Needs: Submit model release with photos. Photo captions explaining photo technique required.
Making Contact & Terms: Query with résumé of credits and book idea, or submit material by mail for

consideration. SASE. Reports in 1 month. Payment negotiable. Pays on royalty basis. Buys one-time rights. Simultaneous submissions and previously published work OK.

Tips: "Submit focused, tight book ideas in form of a detailed outline, a sample chapter, and sample photos. Be able to tell a story in photos and be aware of the market."

ARDSLEY HOUSE PUBLISHERS INC., 320 Central Park West, New York NY 10025. (212)496-7040. Fax: (212)496-7146. Publishing Assistant: Karen Bianco. Estab. 1981. Publishes college textbooks—music, film, history, philosophy, mathematics. Photos used for text illustration and book covers. Examples of published titles: *Ethics in Thought and Action* (text illustration); *Music Melting Round* (text illustration, book cover); and *Greek & Latin Roots of English* (text illustration).

Needs: Buys various number of photos annually; offers various freelance assignments annually. Needs photos that deal with music, film and history. Reviews stock photos. Model/property release preferred.

Making Contact & Terms: Interested in receiving work from newer, lesser-known photographers. Query with samples. Query with stock photo list. Provide résumé, business card, brochure, flier or tearsheets to be kept on file for possible future assignments. Uses color and b&w prints. Keeps samples on file. SASE. Reports in 1 month. Pays $25-50/color photo; $25-50/b&w photo. **Pays on acceptance.** Credit line given. Buys book rights; negotiable.

ARJUNA LIBRARY PRESS, 1025 Garner St., D, Space 18, Colorado Springs CO 80905. Director: Prof. Joseph A. Uphoff, Jr. Estab. 1979. Publishes proceedings and monographs, surrealism and metamathematics (differential logic, symbolic illustration) pertaining to aspect of performance art (absurdist drama, martial arts, modern dance) and culture (progressive or mystical society). Photos used for text illustration and book covers. Example of published title: *The Poet's Universe* (small photos with poetry).

Needs: Surrealist (static drama, cinematic expressionism) suitable for a general audience, including children. Model release and photo captions preferred.

Making Contact & Terms: Interested in receiving work from newer, lesser-known photographers as well as experienced photographers. Query with samples. Send unsolicited photos by mail for consideration. Submit portfolio for review. Provide résumé, business card, brochure, flier or tearsheets to be kept on file for possible future assignments. Uses 5×7 glossy (maximum size) b&w and color prints. Cannot return material. Reports in "one year." Payment is 1 copy of published pamphlet. Credit line given. Rights dependent on additional use. Simultaneous submissions and previously published work OK.

Tips: "Realizing that photography is expensive, it is not fair to ask the photographer to work for free. Nevertheless, it should be understood that, if the publisher is operating on the same basis, a trade might establish a viable business mode, that of advertising through contributions of historic significance. We are not soliciting the stock photography market. We are searching for examples that can be applied as illustrations to conceptual and performance art. Elegance in a photograph will convey the abstract qualities of figuration, gesture or expression. Contrast will emphasize the contours of a geometry. These simple ideas work well with poetry. This material is presented in a forum for symbolic announcements, *The Journal of Regional Criticism*. We prefer conservative and general audience compositions." It's helpful "to translate color photographs in order to examine the way they will appear in black & white reproduction of various types. Make a photocopy."

■❧**ARNOLD PUBLISHING LTD.**, 10301-104 St., #101, Edmonton, Alberta T5J 1B9 Canada. (403)426-2998. Fax: (403)426-4607. E-mail: info@arnold.ca. Contact: Production Coordinator. Publishes social studies textbooks and related materials. Photos used for text illustration and CD-ROM. Examples of recently published titles: *Japan* (textbook); *Russia—A Landscape and People* (educational CD-ROM); and *Marooned-Resource Explorer* (educational CD-ROM).

Needs: Buys hundreds of photos annually; offers 2-3 freelance assignments annually. Looking for photos of history of Canada, world geography, geography of Canada. Reviews stock photos. Model/property release required. Captions preferred; include description of photo and setting.

Making Contact & Terms: Interested in receiving work from newer, lesser-known photographers. Query with stock photo list. Provide résumé, business card, brochure, flier or tearsheets to be kept on file for possible future assignments. Uses 2¼×2¼ transparencies and broadcast quality videotape. Does not keep samples on file. Cannot return material. Reports in 1 month. Payment negotiable. **Pays on receipt of invoice.** Credit line given. Buys book and all rights; negotiable. Simultaneous submissions and previously published work OK.

 MARKETS USING AUDIOVISUAL MATERIAL, such as slides, film or videotape, are marked with a solid, black square.

ART DIRECTION BOOK CO., INC., 456 Glenbrook Rd., Stamford CT 06906. (203)353-1441 or (203)353-1355. Fax: (203)353-1371. Contact: Art Director. Estab. 1939. Publishes advertising art, design, photography. Photos used for dust jackets.
Needs: Buys 10 photos annually. Needs photos for advertising.
Making Contact & Terms: Submit portfolio for review. Works on assignment only. SASE. Reports in 1 month. Pays $200 minimum/b&w photo; $500 minimum/color photo. Credit line given. Buys one-time and all rights.

ASSOCIATION OF BREWERS, INC., 736 Pearl St., Boulder CO 80302. (303)447-0816. Fax: (303)447-2825. E-mail: vicki@aob.org. or stephanie@aob.org. Website: http://www.beertown.org. Graphic Production Manager: Tyra Segars. Art Directors: Vicki Hopewell and Stephanie Johnson. Estab. 1978. Publishes beer how-to, cooking with beer, adult trade, hobby, brewing and beer-related books. Photos used for text illustration, promotional materials, books, magazines. Examples of published magazines: *Zymurgy* (front cover and inside) and *The New Brewer* (front cover and inside). Examples of published book titles: *Great American Beer Cook Book* (front/back covers and inside); *Scotch Ale* (cover front/back).
Needs: Buys 15-50 photos annually; offers 20 freelance assignments annually. Needs still lifes, people, beer and events. Reviews stock photos. Model/property release preferred.
Making Contact & Terms: Interested in receiving work from newer, lesser-known photographers. Submit portfolio for review. Query with samples. Provide résumé, business card, brochure, flier or tearsheets to be kept on file for possible future assignments. Uses color and b&w prints, 35mm transparencies. Keeps samples on file. SASE. Reports in 1-2 weeks. Payment negotiable; all jobs done on a quote basis. Pays 30 days after receipt of invoice. Credit line given. Preferably buys one-time usage rights, but negotiable. Simultaneous submissions and previously published works OK.
Tips: "Send samples for us to keep in our files which depict whatever their specialty is plus some samples of beer-related objects, equipment, events, people, etc."

AUGSBURG FORTRESS, PUBLISHERS, P.O. Box 1209, Minneapolis MN 55440. (612)330-3300. Fax: (612)330-3455. Contact: Photo Secretary. Publishes Protestant/Lutheran books (mostly adult trade), religious education materials, audiovisual resources and periodicals. Photos used for text illustration, book covers, periodical covers and church bulletins. Guidelines free with SASE.
Needs: Buys 1,000 color photos and 250 b&w photos annually. No assignments. People of all ages, variety of races, activities, moods and unposed. "Always looking for church scenarios—baptism, communion, choirs, acolites, ministers, Sunday school, etc." In color, wants to see nature, seasonal, church year and mood. Model release required.
Making Contact & Terms: Send material by mail for consideration. "We are interested in stock photos." Provide tearsheets to be kept on file for possible future assignments. Uses 8×10 glossy or semiglossy b&w prints, 35mm and $2\frac{1}{4} \times 2\frac{1}{4}$ color transparencies. SASE. Reports in 6-8 weeks. "Write for guidelines, then submit on a regular basis." Pays $25-75/b&w photo; $40-125/color photo. Credit line nearly always given. Buys one-time rights. Simultaneous submissions and previously published work OK.

AUTONOMEDIA, P.O. Box 568, Brooklyn NY 11211. Phone/fax: (718)963-2603. E-mail: autonobook @aol.com. Website: http://www.autonomedia.org. Editor: Jim Fleming. Estab. 1974. Publishes books on radical culture and politics. Photos used for text illustration and book covers. Examples of recently published titles: *TAZ* (cover illustration); *Cracking the Movement* (cover illustration); and *Zapatistas* (cover and photo essay).
Needs: The number of photos bought annually varies, as does the number of assignments offered. Model/property release preferred. Captions preferred.
Making Contact & Terms: Interested in receiving work from newer, lesser-known photographers. Query with samples. Send unsolicited photos by mail for consideration. Works on assignment only. Does not keep samples on file. SASE. Reports in 1 month. Payment negotiable. Pays on publication. Buys one-time and electronic rights.

BEACON PRESS, 25 Beacon St., Boston MA 02108. (617)742-2110. Fax: (617)742-2290. Art Director: Sara Eisenman. Estab. 1854. Publishes adult nonfiction trade and scholarly books; African-American, Jewish, Asian, Native American, gay and lesbian studies; anthropology; philosophy; women's studies; environment/nature. Photos used for book covers and dust jackets. Examples of published titles: *Straight Talk about Death for Teenagers* (½-page cover photo, commissioned); *The Glory and the Power* (full-bleed cover photo, stock); and *Finding Home* (full-bleed cover photo, stock).
Needs: Buys 5-6 photos annually; offers 1-2 freelance assignments annually. "We look for photos for specific books, not any general subject or style." Model/property release required. Captions preferred.
Making Contact & Terms: Interested in receiving work from newer, lesser-known photographers. Provide résumé, business card, brochure, flier or tearsheets to be kept on file for possible future assignments.

Uses 8×10 glossy b&w prints; 35mm, 2¼×2¼ transparencies. Keeps samples on file. SASE. Reports in 1 month. Pays $500-750/color photo; $150-250/b&w photo. **Pays on receipt of invoice.** Credit line given. Buys English-language rights for all (paperback and hardcover) editions; negotiable. Previously published work OK.

Tips: "I only contact a photographer if his area of expertise is appropriate for particular titles for which I need a photo. I do not 'review' portfolios because I'm looking for specific images for specific books. Be willing to negotiate. We are a nonprofit organization, so our fees are not standard for the photo industry."

BEAUTIFUL AMERICA PUBLISHING COMPANY, 9725 SW Commerce Circle, P.O. Box 646, Wilsonville OR 97070. (503)682-0173. Librarian: Shari Adams-Hanson. Estab. 1986. Publishes nature, scenic and pictorial. Photos used for text illustration, pictorial. Examples of recently published titles: *Beautiful America's Alaska*, by George Wuerthner (cover); *Beautiful America's Atlanta*, by Dennis Engleman (cover and text); and calendars (regional scenic).

Needs: Assigns 12-15 freelance projects annually; buys small number of additional freelance photos. Nature and scenic. Model release required. Captions required; include location, correct spelling of topic in caption.

Making Contact & Terms: Provide résumé, business card, brochure, flier or tearsheets to be kept on file for possible future assignments. Uses 35mm, 2¼×2¼, 4×5, and 8×10 transparencies. Payment varies based on project. Credit line given. Buys one-time rights. Simultaneous submissions and previously published work OK.

Tips: "Do not send unsolicited photos! Please do not ask for guidelines. We are using some freelance plus complete book and calendar projects."

BEHRMAN HOUSE INC., 235 Watchung Ave., West Orange NJ 07052. (201)669-0447. Fax: (201)669-9769. Editor: Adam Siegel. Estab. 1921. Publishes Judaica textbooks. Photos used for text illustration, promotional materials and book covers.

Needs: Interested in stock photos of Jewish content, particularly holidays, with children. Model/property release required.

Making Contact & Terms: Interested in receiving work from newer, lesser-known photographers. Query with résumé of credits. Query with samples. Provide résumé, business card, brochure, flier or tearsheets to be kept on file for possible future assignments. Interested in stock photos. SASE. Reports in 3 weeks. Pays $50-500/color photo; $20-250/b&w photo. Credit line given. Buys one-time rights; negotiable.

Tips: Company trend is increasing use of photography.

BLACKBIRCH PRESS, INC., 260 Amity Rd., Woodbridge CT 06525. Contact: Sonja Glassman. Estab. 1979. Publishes juvenile nonfiction. Photos used for text illustration, promotional materials, book covers and dust jackets. Example of published titles: *Nature Close-Up: Earthworms*.

Needs: Buys 300 photos annually. Interested in set up shots of kids, studio product/catalog photos and location shots. Reviews stock photos of nature, animals and geography. Model release required. Property release preferred. Captions required.

Making Contact & Terms: Interested in receiving work from newer, lesser-known photographers. Query with résumé of credits. Query with samples. Query with stock photo list. Works on assignment only. Uses 35mm, 2¼×2¼, 4×5 transparencies. Keeps samples on file. Cannot return material. Reports in 1 month. Pays $50-100/hour; $500-800/day; $100-200/color photo; $60-80/b&w photo. Pays on acceptance or publication. Credit line given. Buys one-time, book, all rights; negotiable. Simultaneous submissions and previously published work OK.

Tips: "We're looking for photos of people, various cultures and nature."

BLUE BIRD PUBLISHING, 2266 S. Dobson, Mesa AZ 85202. Publisher: Cheryl Gorder. Estab. 1985. Publishes adult trade books on home education, home business, social issues (homelessness), etc. Photos used for text illustration. Examples of recently published titles: *Road School* and *Divorced Dad's Handbook*. In both, photos used for text illustration.

Needs: Buys 40 photos annually; offers 3 freelance assignments annually. Types of photos "depends on subject matter of forthcoming books." Reviews stock photos. Model release required; photo captions preferred.

Making Contact & Terms: Query with list of stock photo subjects. Provide résumé, business card, brochure, flier or tearsheets to be kept on file for possible future assignments. Pays $25-150/color photo, $25-150/b&w photo; also pays flat fee for bulk purchase of stock photos. Buys book rights. Simultaneous submissions and previously published work OK.

Tips: "We will continue to grow rapidly in the coming years and will have a growing need for stock photos and freelance work. Send a list of stock photos for our file. If a freelance assignment comes up in your area, we will call."

‡BLUE DOLPHIN PUBLISHING, INC., P.O. Box 8, Nevada City CA 95959. (916)265-6925. Fax: (916)265-0787. President: Paul M. Clemens. Estab. 1985. Publishes comparative spiritual traditions, self-help, lay psychology, humor, cookbooks, children's books, natural living and healing. Photos used for text illustration, promotional materials, book covers and dust jackets. Examples of recently published titles: *Mary's Message of Hope*; *My Summer with the Leprechauns: A True Story*; and *UFO's: A Great New Dawn for Humankind*. All photos used throughout text.

Needs: Buys 1-25 photos annually; offers 1-3 freelance assignments annually. Subject needs New Age, spiritual/psychological or regional. Model release preferred; property release required. Captions preferred.

Making Contact & Terms: Interested in receiving work from newer, lesser-known photographers. Query with a few samples. Provide résumé, business card, brochure, flier or tearsheets to be kept on file for possible future assignments. Works on assignment only. Uses 3×5, 5×7 color and/or b&w prints; 35mm, 2¼×2¼, 4×5, 8×10 transparencies. "We can scan images into our system and output directly to color separations." Keeps samples on file. SASE. Reports in 1 month. Pays $20-200/b&w photo; $20-300/color photo; $20/hour, or by arrangement per project. Pays on receipt of invoice. Credit line given. Buys one-time and book rights; prefers all rights; negotiable. Simultaneous submissions and previously published work OK.

Tips: Looks for "clarity, composition. Do 'different' things in life. Shoot the unique perspective. We're getting more electronic—looking for the unusual perspective."

‡BLUEWOOD BOOKS, P.O. Box 689, San Mateo CA 94401. (415)548-0754. Fax: (415)548-0654. Director: Richard Michaels. Estab. 1990. Publishes young adult nonfiction. Photos used for text illustration and book covers. Examples of recently published titles: *100 Authors Who Shaped World History* (text); *100 Explorers Who Shaped World History* (text); and *The Revolutionary War* (cover/text).

Needs: Buys 50-150 photos annually; offers 3-5 assignments annually. Photos of historical nature (i.e. places, people, artifacts, buildings, etc. . . .). Reviews historical stock photos. Model/property release required. Captions required; identify subject completely.

Making Contact & Terms: Interested in receiving work from newer, lesser-known photographers. Arrange personal interview to show portfolio. Query with résumé of credits. Provide résumé, business card, brochure, flier or tearsheets to be kept on file for possible assignments. Works on assignment only. Uses 5×7, 8×10 glossy color and b&w prints; 35mm, 2¼×2¼, 4×5, 8×10 transparencies; digital format. Keeps samples on file. SASE. Reports in 1 month. Negotiates flat fee. Credit line given. Buys all rights.

BONUS BOOKS, INC., 160 E. Illinois St., Chicago IL 60611. (312)467-0580. Fax: (312)467-9271. Managing Editor: Rachel Drzewicki. Estab.1980. Publishes adult trade: sports, consumer, self-help, how-to and biography. Photos used for text illustration and book covers. Examples of recently published titles: *Stuck in the 70s* (cover); *What Will My Mother Say* (cover, interior); and *Hanging Out on Halsted* (cover).

Needs: Buys 1 freelance photo annually; gives 1 assignment annually. Model release required. Property release preferred with identification of location and objects or people. Captions required.

Making Contact & Terms: Interested in receiving work from newer, lesser-known photographers. Query with résumé of credits, query with samples. Provide résumé, business card, brochure, flier or tearsheets to be kept on file for possible future assignments. Uses 8×10 matte b&w prints and 35mm transparencies. Solicits photos by assignment only. Does not return unsolicited material. Reports in 1 month. Pays in contributor's copies and $150 maximum for color transparency. Credit line given if requested. Buys one-time rights.

Tips: "Don't call. Send written query. In reviewing a portfolio, we look for composition, detail, high quality prints, well-lit studio work. We are not interested in nature photography or greeting-card type photography."

✤BOSTON MILLS PRESS, 132 Main St., Erin, Ontario N0B 1T0 Canada. (519)833-2407. Fax: (519)833-2195. Publisher: John Denison. Estab. 1974. Publishes coffee table books, local guide books. Photos used for text illustration, book covers and dust jackets. Examples of recently published titles: *Union Pacific: Salt Lake Route*; *Gift of Wings*; and *Superior: Journey on an Inland Sea*.

Needs: "We're looking for book length ideas *not* stock. We pay a royalty on books sold plus advance."

Making Contact & Terms: Interested in receiving work from established and newer, lesser-known photographers. Query with résumé of credits. Uses 35mm transparencies. Does not keep samples on file. SASE and IRC. Reports in 3 weeks. Payment negotiated with contract. Credit line given. Simultaneous submissions OK.

‡ **MARKETS NEW TO THIS EDITION** are marked with a double dagger.

‡**BRISTOL FASHION PUBLICATIONS**, P.O. Box 20, Enola PA 17025-0020. Publisher: John P. Kaufman. Estab. 1993. Publishes marine, how-to and boat repair books. Photos used for front and back covers and text illustration. Photo guidelines free with SASE.

Needs: Buys 10-50 photos annually. Looking for b&w photos of hands using tools for boat repair (before and after cosmetic repairs). Reviews stock photos. Model/property release preferred for identifiable people and boats. "If the job being photographed needs an explanation, we cannot use the photo. When we review photos it should be obvious what job is being done."

Making Contact & Terms: Interested in receiving work from newer, lesser-known photographers. Query with samples. Send unsolicited photos by mail for consideration. Provide résumé, business card, brochure, flier or tearsheets to be kept on file for possible future assignments. No calls. Uses 3½×5 to 5×7 glossy color (cover) and b&w (inside) prints; 35mm, 2¼×2¼, 4×5 transparencies; color and b&w scanned images in TIFF, JPEG and BMP. Prefers JPEG. Submit via floppy disk (300 dpi or better). May keep samples on file or will return with SASE. Reports in 1 month. Pays $25-100/color photo; $15-30/b&w photo; will assign specific shots and pay stock amounts for photos used. If photos are supplied on disk in JPEG and usable, will pay $5 additional. Disks returned with SASE. Pays on publication. Credit line given. Buys book rights. Simultaneous submissions and/or previously published work OK.

Tips: "We are more apt to use a scanned image supplied by the photographer. We want to see the photos (prints, slides) first. We make copies of the photos we may use and note the photographers name and phone number on the copy. If we want an image for a book, we will call and ask for a disk to be sent within seven days. We scan all photos for our books. Obviously, photographers who can save us this step have a good chance of selling us their photos. Mail at least 20 new submissions each month if possible. Our editors use more photos because the disk or photo is in their hands. Good contrast and sharp images are recommended, but neither help if we do not have the image to use. We would use more interior photos to replace line drawings but we cannot acquire them easily."

THE BUREAU FOR AT-RISK YOUTH, 135 Dupont St., P.O. Box 760, Plainview NY 11803-0760. (516)349-5520. Editor-in-Chief: Sally Germain. Estab. 1990. Publishes educational materials for teachers, mental health professionals, social service agencies on children's issues such as building self-esteem, substance abuse prevention, parenting information, etc. Photos used for text illustration, promotional materials, book covers, dust jackets. Began publishing books that use photos in 1994.

Needs: Interested in photos for use as posters of children and adults in family and motivational situations. Model release required.

Making Contact & Terms: Interested in receiving work from newer, lesser-known photographers. Send unsolicited photos by mail for consideration. Provide résumé, business card, brochure, flier or tearsheets to be kept on file for possible future assignments. "Please call if you have questions." Uses 2¼×2¼ transparencies. Keeps samples on file. SASE. Reports in 3-6 months. Payment negotiable; "Fees have not yet been established." Will pay on a per project basis. Pays on publication or receipt of invoice. Credit line sometimes given, depending upon project. Rights purchased depend on project; negotiable. Simultaneous submissions and/or previously published work OK.

‡**CAPSTONE PRESS**, 818 N. Willow St., Mankato MN 56001. (507)388-6650. Fax: (507)625-4662. E-mail: m.norstad@mail.capstone~press.com. Contact: Photo Researcher. Estab. 1991. Publishes juvenile nonfiction and educational books; subjects include animals, ethnic groups, vehicles, sports and scenics. Photos used for text illustration, promotional materials and book covers. Examples of recently published titles: *The Golden Retriever; Monster Trucks;* and *Rock Climbing* (covers and interior illustrations). Photo "wish lists" for projects are available on request.

Needs: Buys 1,000-2,000 photos annually. "Our subject matter varies (usually 100 or more different subjects/year; no artsy stuff." Model/property release preferred. Captions are preferred; "basic description; if people of color, state ethnic group; if scenic, state location."

Making Contact & Terms: Query with stock photo list. Provide résumé, business card, brochure, flier or tearsheets to be kept on file for possible future assignments. Uses various sizes color prints and b&w prints (if historical); 35mm, 2¼×2¼, 4×5 transparencies; digital format. Keeps samples on file. Reports in 6 months. Pays $50/interior photo; $150/cover photo. **Pays on receipt of invoice.** Credit line given. Buys one-time rights; North American rights negotiable. Simultaneous submissions and previously published work OK.

Tips: "Be flexible. Book publishing usually takes at least six months. Capstone does not pay holding fees. Be prompt. The first photos in are considered for covers first."

CELO VALLEY BOOKS, 346 Seven Mile Ridge Rd., Burnsville NC 28714. Production Manager: D. Donovan. Estab. 1987. Publishes all types of books. Photos used for text illustration, book covers and dust jackets. Examples of published titles: *Foulkeways: A History* (text illustraton and color insert); *Tomorrow's Mission* (historical photos); *River Bends and Meanders* (cover and text photos).

Making Contact & Terms: Provide résumé, business card, brochure, flier or tearsheets to be kept on file for possible future assignments. Keeps samples on file. Uses various sizes b&w prints. Reports only as needed. Payment negotiable. Credit line given. Buys one-time rights and book rights. Simultaneous submissions OK.

Tips: "Send listing of what you have. We will contact you if we have a need."

CENTER PRESS, Box 16473, Encino CA 91416-6473. (818)754-4410. Art Director: Richelle Bixler. Estab. 1980. Publishes mostly little/literary, some calendars, and a joint venture European *"Esquire*-type*"* magazine. Photos used for text illustration, promotional, magazine, posters and calendars. Example of recently published title: *La Lectrice* (cultural/literary magazine distributed in Europe for liberal men and women).

Needs: Buys hundreds of photos annually. Looking for female erotica and art photos. Model/property release required prior to payment and use. Captions required; editors create this from a questionnaire the photographer supplies.

Making Contact & Terms: Interested in receiving work from newer, lesser-known photographers. Query with samples. Send unsolicited photos by mail for consideration. Uses 5×7, 8×10 glossy color and b&w prints; 35mm, 2¼×2¼, 4×5, 8×10 transparencies; VHS videotape. Keeps samples on file if requested and résumé included. SASE; doesn't return photos without adequate postage. Reporting time depends on workload. Pays $10-100/color photo; $10-50/b&w photo. Pays on publication. Credit line given. Buys one-time, book and all rights; negotiable. Simultaneous submissions and previously published work OK.

Tips: "The photos we use are primarily female nudes, art-type and erotic. We'd like to see more photos of women by women and even self-portraits."

CENTERSTREAM PUBLICATION, P.O. Box 17878, Anaheim CA 92807. Phone/fax: (714)779-9390. Owner: Ron Middlebrook. Estab. 1982. Publishes music history (guitar—drum), music instruction all instruments, adult trade, juvenile, textbooks. Photos used for text illustration, book covers. Examples of published titles: *Dobro Techniques*, *History of Leedy Drums*, *History of National Guitars*.

Needs: Reviews stock photos of music. Model release preferred. Captions preferred.

Making Contact & Terms: Interested in receiving work from newer, lesser-known photographers. Query with samples. Query with stock photo list. Send unsolicited photos by mail for consideration. Provide résumé, business card, brochure, flier or tearsheets to be kept on file for possible future assignments. Works on assignment only. Uses color b&w prints; 35mm, 2¼×2¼, 4×5 transparencies. Keeps samples on file. Reports in 1 month. Payment negotiable. **Pays on receipt of invoice.** Credit line given. Buys all rights. Simultaneous submissions and/or previously published work OK.

CHATHAM PRESS, Box A, Old Greenwich CT 06870. (203)531-7755. Editor: Roger Corbin. Estab. 1971. Publishes New England and ocean-related topics. Photos used for text illustration, book covers, art and wall framing.

Needs: Buys 25 photos annually; offers 5 freelance assignments annually. Preferably New England and ocean-related topics. Model release preferred; photo captions required.

Making Contact & Terms: Query with samples. Uses b&w prints. SASE. Reports in 1 month. Payment negotiable. Credit line given. Buys all rights.

Tips: To break in with this firm, "produce superb b&w photos. There must be an Ansel Adams-type of appeal—which is instantaneous to the viewer!"

CLEANING CONSULTANT SERVICES, P.O. Box 1273, Seattle WA 98111. (206)682-9748. Fax: (206)622-6876. Publisher: William R. Griffin. "We publish books on cleaning, maintenance and self-employment. Examples are related to janitorial, housekeeping, maid services, window washing, carpet cleaning, etc." Photos are used for text illustration, promotional materials, book covers and all uses related to production and marketing of books. Photo guidelines free with SASE. Sample issue $3.

Needs: Buys 20-50 freelance photos annually; offers 5-15 freelance assignments annually. Photos of people doing cleaning work. "We are always looking for unique cleaning-related photos." Reviews stock photos. Model release preferred. Captions preferred.

Making Contact & Terms: Query with résumé of credits, samples, list of stock photo subjects or send unsolicited photos by mail for consideration. Provide résumé, business card, brochure, flier or tearsheets to be kept on file for possible future assignments. Uses 5×7 and 8×10 glossy b&w and color prints. SASE. Reports in 3 weeks. Pays $5-50/b&w photo; $5/color photo; $10-30/hour; $40-250/job; negotiable depending on specific project. Credit lines generally given. Buys all rights; depends on need and project; rights negotiable. Simultaneous submissions and previously published work OK.

Tips: "We are especially interested in color photos of people doing cleaning work in other countries, for use on the covers of our quarterly magazine, *Cleaning Business*. Be willing to work at reasonable rates. Selling two or three photos does not qualify you to earn top-of-the-line rates. We expect to use more

photos, but they must be specific to our market, which is quite select. Don't send stock sample sheets. Send photos that fit our specific needs. Call if you need more information or would like specific guidance."

CLEIS PRESS, Box 14684, San Francisco CA 94114. (415)864-3385. Fax: (415)864-5602. E-mail: sfcleis @aol.com. Art Director: Frédérique Delacoste. Estab. 1979. Publishes fiction, nonfiction, trade and lesbian/ gay erotica. Photos used for book covers. Examples of recently published titles: *Best Lesbian Erotica 1997*, *Best Gay Erotica 1997*, *Food For Life* and *Dark Angels* (all fiction collections).
Needs: Buys 20 photos annually. Reviews stock photos.
Making Contact & Terms: Interested in receiving work from newer, lesser-known photographers. Provide résumé, business card, brochure, flier or tearsheets to be kept on file for possible future assignments. Works with local freelancers on assignment only. Uses color and b&w prints; 35mm transparencies. Keeps samples on file. SASE. Reports in 3 weeks. Pays $150/photo for all uses in conjunction with book. **Pays on acceptance**. Credit line given. Buys book rights; negotiable.

‡COMMUTERS LIBRARY, P.O. Box 3168, Falls Church VA 22043. (703)847-6355. Fax: (703)827-8937. E-mail: commlib@aol.com. Editor: Joseph Langenfeld. Estab. 1992. Publishes audiobooks (literature). Photos used for promotional materials, book covers and dust jackets. Examples of recently published titles: *Classic Poe* (cover) and *The Eyes* (cover).
Needs: Buys 5 photos annually; offers 2 freelance assignments annually. Reviews stock photos of authors' portraits and book-related scenes. Model/property release preferred.
Making Contact & Terms: Query with stock photo list. Uses 8×10 prints. SASE. Reports in 3 weeks. Payment negotiable. Pays on publication. Credit line given. Buys book rights. Previously published work OK.

COMPASS AMERICAN GUIDES, 5332 College Ave., Oakland CA 94618. (510)547-7233. Fax: (510)547-2145. Creative Director: Christopher C. Burt. Estab. 1990. Publishes travel guide series for every state in the U.S. and 15 major cities, also Canadian provinces and cities. Photos used for text illustration and book covers. Examples of recently published titles: *Compass American Guide to Alaska*, *Compass American Guide to Boston*, and *Compass American Guide to Minnesota*.
Needs: Buys 1,000-1,500 photos annually; offers 8-10 freelance assignments annually. Reviews stock photos (depends on project). Model release required, especially with prominent people. Property release preferred. Captions required.
Making Contact & Terms: Interested in receiving work from newer, lesser-known photographers as well as seasoned professionals. Provide résumé, business card, brochure, flier or tearsheets to be kept on file for possible future assignments. "Do not phone; fax OK." Works on assignment only. Uses 35mm, $2\frac{1}{4} \times 2\frac{1}{4}$, 4×5, 8×10 transparencies. Keeps samples on file. Cannot return unsolicited material. Reports in "one week to five years." Pays $5,000/job. Pays ⅓ advance, ⅓ acceptance, ⅓ publication. Buys one-time and book rights. Photographer owns copyright to images. Simultaneous submissions and previously published work OK.
Tips: "Our company works only with photographers native to, or currently residing in, the state or city in which we are publishing the guide. We like creative approaches that capture the spirit of the place being covered. We need a mix of landscapes, portraits, things and places."

CONSERVATORY OF AMERICAN LETTERS, P.O. Box 298, Thomaston ME 04861. (207)354-0998. Fax: (207)354-8953. E-mail: alrob@midcoast.com. President: Robert Olmsted. Estab. 1986. Publishes "all types of books except porn and evangelical." Photos used for promotional materials, book covers and dust jackets. Examples of recently published titles: *Dan River Stories* and *Dan River Anthology* (cover); *After the Light* (covers).
Needs: Buys 2-3 photos annually. Model release required if people are identifiable. Photo captions preferred.
Making Contact & Terms: Uses 3×5 to 8×10 b&w glossy prints, also 5×7 or 6×9 color prints, vertical format. SASE. Reports in 1 week. Pays $5-50/b&w photo; $20-200/color photo; per job payment negotiable. Credit line given. Buys one-time and all rights; negotiable.
Tips: "We are a small market. We need *few* photos, but can never find them when we do need them."

‡THE CONSULTANT PRESS LTD., 163 Amsterdam Ave., #201, New York NY 10023. (212)838-8640. Fax: (212)873-7065. Estab. 1980. Publishes how-to, art and photography business. Photos used for book covers. Examples of recently published titles: *Art of Displaying Art* (cover); *Publishing Your Art as Cards, Posters and Calendars* (cover/art); and *Art of Creating Collectors* (text).
Needs: Buys 20 photos annually (usually from author of text). Model release required.
Making Contact & Terms: Interested in receiving work from newer, lesser-known photographers. Query

Provide résumé, business card, brochure, flier or tearsheets to be kept on file for possible ...ments. Uses 35mm, 2¼×2¼ transparencies; digital format. Does not keep samples on file. ...orts in 1-2 weeks. Payment factored into royalty payment for book. Pays on publication. Credit ... Buys book rights.

...ERSTONE PRODUCTIONS INC., P.O. Box 55229, Atlanta GA 30308. (770)621-2514. Presi-...EO: Ricardo A. Scott J.D. Estab. 1985. Publishes adult trade, juvenile and textbooks. Photos used for ...illustration, promotional materials and book covers. Examples of published titles: *A Reggae Education* (illustrative); and *Allied Health Risk-Management* (illustrative).

Needs: Buys 10-20 photos annually; offers 50% freelance assignments annually. Photos should show life in all its human and varied forms—reality! Reviews stock photos of life, nature, medicine, science, the arts. Model/property release required. Captions required.

Making Contact & Terms: Interested in receiving work from newer, lesser-known photographers. Submit portfolio for review. Send unsolicited photos by mail for consideration. Uses 5×7, 10×12 glossy color and b&w prints; 4×5, 8×10 transparencies; VHS videotape. Keeps samples on file. SASE. Reports in 1 month. Payment negotiable. Pays on publication. Credit line sometimes given depending upon the particular projects and arrangements, done on an individual basis. Buys all rights; negotiable. Simultaneous submissions and previously published work OK.

Tips: "The human aspect and utility value is of prime importance. Ask 'How can this benefit the lives of others?' Let your work be a reflection of yourself. Let it be of some positive value and purpose towards making this world a better place."

CRABTREE PUBLISHING COMPANY, 350 Fifth Ave., Suite 3308, New York NY 10118. (905)262-5814. Fax: (905)262-5890. Contact: Editorial (Dept.). Estab. 1978. Publishes juvenile nonfiction, library and trade—natural science, history, geography (including cultural geography), 18th and 19th-century America. Photos used for text illustration, book covers. Examples of recently published titles: *Vietnam: the Land* (text illustration, cover); *Spanish Missions* (text illustration); and *How a Plant Grows* (text illustration, cover).

● When reviewing a portfolio, this publisher looks for bright, intense color and clarity.

Needs: Buys 400-600 photos annually. Wants photos of children, cultural events around the world, animals (exotic and domestic). Model/property release required for children, photos of artwork, etc. Captions preferred; include place, name of subject, date photographed, animal behavior.

Making Contact & Terms: Interested in receiving work from newer, lesser-known photographers. Unsolicited photos will be considered but not returned without SASE. Provide résumé, business card, brochure, flier or tearsheets to be kept on file for possible future assignments. Uses color prints; 35mm, 2¼×2¼, 4×5, 8×10 transparencies. Keeps samples on file. SASE. Reports in 1-2 weeks. Pays $40-75/color photo. Pays on publication. Credit line given. Buys non-exclusive rights. Simultaneous submissions and/or previously published works OK.

Tips: "Since books are for younger readers, lively photos of children and animals are always excellent." Portfolio should be "diverse and encompass several subjects, rather than just one or two; depth of coverage of subject should be intense, so that any publishing company could, conceivably, use all or many of a photographer's photos in a book on a particular subject."

‡CREATIVE WITH WORDS PUBLICATIONS, P.O. Box 223226, Carmel CA 93922. (408)655-8627. Editor: Brigitta Geltrich. Estab. 1975. Publishes poetry and prose anthologies according to set themes. Photos used for text illustration and book covers. Examples of recently published titles: humor; sports and hobbies; and sky, space, heaven.

Needs: Looking for theme-related b&w photos. Model/property release preferred.

Making Contact & Terms: Query with samples. Request theme list, then query with photos. Uses any size b&w photos. "We will reduce to fit the page." Does not keep samples on file. SASE. Reports in 2-3 weeks after deadline if submitted for a specific theme. Payment negotiable. Pays on publication. Credit line given. Buys one-time rights.

CROSS CULTURAL PUBLICATIONS, INC., P.O. Box 506, Notre Dame IN 46556. (219)272-0889. Fax: (219)273-5973. General Editor: Cy Pullapilly. Estab. 1980. Publishes nonfiction, multicultural books. Photos used for book covers and dust jackets. Examples of published titles: *Night Autopsy Room*, *Red Rum Punch*, and *Boots from Heaven*.

Needs: Buys very few photos annually; offers very few freelance assignments annually. Model release preferred. Captions preferred.

Making Contact & Terms: Interested in receiving work from newer, lesser-known photographers. Provide résumé, business card, brochure, flier or tearsheets to be kept on file for possible future assignments. Works on assignment only. Does not keep samples on file. Cannot return material. Reports in 3 weeks.

Payment negotiable; varies depending on individual agreements. **Pays on acceptance.** Credit line given. Simultaneous submissions and previously published work OK.

CROSSING PRESS, P.O. Box 1048, Freedom CA 95019. (408)722-0711. Fax: (408)722-2749. Publisher: Elaine Gill. Art Director: Karen Narita. Estab. 1971. Publishes adult trade, cooking, calendars, health, humor and New Age books. Photos used for text illustration, book covers. Examples of recently published titles: *Healing with Chinese Herbs* (cover); *Homestyle Italian Cooking* (cover); and Crossing Press Specialty Cookbooks (covers).
Needs: Buys 70-100 photos annually; offers 3-6 freelance assignments annually. Looking for photos of food, people, how-to steps for health books. Reviews stock photos of food, people, avant-garde material (potential book covers). Model/property release required. Captions preferred.
Making Contact & Terms: Interested in receiving work from newer, lesser-known photographers. Submit portfolio for review. Query with samples. Provide résumé, business card, brochure, flier or tearsheets to be kept on file for possible future assignments. Works on assignment only. Uses color and b&w. Keeps samples on file. SASE. Payment negotiable. Buys one-time and book rights; negotiable. Simultaneous submissions and previously published works OK.
Tips: Looking for photos which are "unique, stylish but not overdone—tight closeups of food—portraits of interesting everyday people—quirky scenes that can be utilized for different reasons. We are a mid-size independent press with limited budgets, but can offer unique opportunities for photographers willing to work closely with us. Increasing rapidly—a desire for style without predictability."

■**CRUMB ELBOW PUBLISHING**, P.O. Box 294, Rhododendron OR 97049. Publisher: Michael P. Jones. Estab. 1979. Publishes juvenile, educational, environmental, nature, historical, multicultural, travel and guidebooks. Photos used for text illustration, promotional materials, book covers, dust jackets and educational videos. "We are just beginning to use photos in books and videos." Examples of recently published titles: *Oregon Trail* (b&w prints); *Northwest Indians* (b&w prints); and slide show Portland Shanghi Tunnels (b&w and color slides). Photo guidelines free with SASE.
Needs: Looking for nature, wildlife, historical, environmental, folklife, historical re-enactments, ethnicity and natural landscapes. Model/property release preferred for individuals posing for photos. Captions preferred.
Making Contact & Terms: Submit portfolio for review. Query with résumé of credits. Query with samples. Query with stock photo list. Send unsolicited photos by mail for consideration. Provide résumé, business card, brochure, flier or tearsheets to be kept on file for possible future assignments. Works on assignment only. Uses 3×5, 5×7, 8×10 color or b&w prints; 35mm transparencies; videotape. Keeps samples on file. SASE. Reports in 1 month depending on work load. Pays in contributor's copies. Pays on publication. Credit line given. Buys one-time rights. Simultaneous submissions OK. Offers internships for photographers year round. Contact Publisher: Michael P. Jones.
Tips: "Publishers are still looking for black & white photos due to high production costs for color work. Don't let opportunities slip by you. Use two cameras—one for black & white and one for color. Multimedia is the coming thing and more opportunities for freelancers will result. Slide work is perfect for still photography in videos, for which the need is growing."

DIAL BOOKS FOR YOUNG READERS, 375 Hudson St., New York NY 10014. (212)366-2803. Fax: (212)366-2020. Senior Editor: Toby Sherry. Publishes children's trade books. Photos used for text illustration, book covers. Examples of published titles: *How Many* (photos used to teach children how to count); and *Jack Creek Cowboy*.
Making Contact & Terms: Photos are only purchased with accompanying book ideas. Works on assignment only. Does not keep samples on file. Payment negotiable. Credit line given.

DOCKERY HOUSE PUBLISHING INC., 1720 Regal Row, Suite 228, Dallas TX 75235. (214)630-4300. Fax: (214)638-4049. Art Director: Janet Todd. Photos used for text illustration, promotional material, book covers, magazines. Example of recently published title: *Celebration of America* (scenery of travel spots).
Needs: Looking for food, scenery, people. Needs vary. Reviews stock photos. Model release preferred.
Making Contact & Terms: Interested in receiving work from newer, lesser-known photographers. Query with samples. Provide résumé, business card, brochure, flier or tearsheets to be kept on file for possible future assignments. Works on assignment only. Uses all sizes and finishes of color, b&w prints; 35mm, 2¼×2¼, 4×5 transparencies. Keeps samples on file. Cannot return material. Payment negotiable. Payment varies. Pays net 30 days. Credit line sometimes given depending upon type of book. Buys all rights; negotiable.

‡**DOWN THE SHORE PUBLISHING CORP.**, P.O. Box 3100, Harvey Cedars NJ 08008. (609)978-1233. Fax: (609)597-0422. Publisher: Raymond G. Fisk. Estab. 1984. Publishes regional calendars; regional books (specific to the mid-Atlantic shore and New Jersey). Photos used for text illustration, scenic calendars (New Jersey and mid-Atlantic only). Example of recently published titles: *Great Storms of the Jersey Shore* (text illustration). Photo guidelines free with SASE.

Needs: Buys 30-50 photos annually. Scenic coastal shots, photos of beaches and New Jersey lighthouses (New Jersey and mid-Atlantic region). Reviews stock photos. Model release required. Property release preferred. Captions preferred; *specific location* identification essential.

Making Contact & Terms: Interested in receiving work from newer, lesser-known photographers. Query with stock photo list. Provide résumé, business card, brochure, flier or tearsheets to be kept on file for possible future requests. "We have a very limited use of prints." 35mm, 2¼×2¼, 4×5 transparencies, preferred. Does not keep samples on file. SASE. Reports in 2-6 weeks. Pays $10-150/b&w photo; $20-175/color photo. Pays 90 days from publication. Credit line given. Buys one-time or book rights; negotiable. Previously published work OK.

Tips: "We are looking for an honest depiction of familiar scenes from an unfamiliar and imaginative perspective. Images must be specific to our very regional needs. Limit your submissions to your best work. Edit your work very carefully."

DUSHKIN/McGRAW HILL, (formerly DPG/Brown & Benchmark), Sluice Dock, Guilford CT 06437. (203)453-4351. Managing Art Editor: Pamela Carley. Estab. 1971. Publishes college textbooks. Photos used for text illustration, book covers. Examples of published titles: *Sexuality Today*, *Cultural Anthropology*, *International Politics on the World Stage*.

Needs: Varies according to subject. "I tend to use the work of freelance photographers I see in other sources and in some cases, the work of those who contact me." Reviews stock photos. Model release preferred. Captions preferred.

Making Contact & Terms: Interested in receiving work from newer, lesser-known photographers. Query with stock photo list. Send unsolicited photocopies or tearsheets by mail for consideration. Provide résumé, business card, brochure, flier or tearsheets to be kept on file for possible future assignments. Uses 8×10 glossy b&w prints; 35mm, 2¼×2¼, 4×5, 8×10 transparencies. Keeps samples on file. Reporting time "varies from project to project. Often takes 2-3 months if we seriously consider. If not interested we can respond quickly." Payment negotiable. Pays on publication. Credit line given. Buys one-time rights; negotiable. Previously published works OK.

Tips: "Subjects include: psychology, anthropology, education, human sexuality, international politics, American government, health. Looking for good quality current material. Mostly b&w, but some color. Looking especially for good, recent people shots that relate to the above subjects. Ethnic variety."

EASTERN PRESS, INC., P.O. Box 881, Bloomington IN 47402. Publisher: Don Lee. Estab. 1981. Publishes university-related Asian subjects: language, linguistics, literature, history, archaeology. Teaching English as Second Language (TESL); Teaching Korean as Second Language (TKSL); Teaching Japanese as Second Language (TJSL); Chinese, Arabic. Photos used for text illustration. Examples of recently published titles: *An Annotated Bibliography on South Asia* and *An Annotated Prehistoric Bibliography on South Asia*.

Needs: Depends upon situation. Looking for higher academic. Captions for photos related to East Asia/Asian higher academic.

Making Contact & Terms: Interested in receiving work from newer, lesser-known photographers. Provide résumé, business card, brochure, flier or tearsheets to be kept on file for possible future assignments. Uses 6×9 book b&w prints. Keeps samples on file. Reports in 1 month (sometimes 1-2 weeks). Payment negotiable. **Pays on acceptance.** Credit line sometimes given. Rights negotiable.

Tips: Looking for "East Asian/Arabic textbook-related photos. However, it depends on type of book to be published. Send us résumé and about two samples. We keep them on file. Photos on, for example, drama, literature or archaeology (Asian) will be good, also TESL."

‡**EMC/PARADIGM PUBLISHING**, (formerly Paradigm Publishing Inc.), 375 Montreal Way, St. Paul MN 55102. (612)215-7681. Fax: (612)290-2828. E-mail: jsilver@emcp.com. Art Director: Joan Silver.

MARKET CONDITIONS are constantly changing! If you're still using this book and it's 1999 or later, buy the newest edition of *Photographer's Market* at your favorite bookstore or order directly from Writer's Digest Books.

Estab. 1989. Publishes textbooks on business, office and computer information systems. Photos used for text illustration, promotional materials and book covers. Examples of recently published titles: *Psychology: Realizing Human Potential* (250 photos); *Business Communication* (120 photos); and *Business Math* (70 photos).

Needs: Buys 500 photos annually; offers 10 freelance assignments annually. Needs photos of people in high-tech business settings. Model/property release preferred. Captions preferred; technical equipment may need to be tagged.

Making Contact & Terms: Interested in receiving work from newer, lesser-known photographers. Provide résumé, business card, brochure, flier or tearsheets to be kept on file for possible future assignments. Uses 35mm transparencies. Keeps samples on file. SASE. Reports in 1 month. Pays $25-300/color photo; $25-300/b&w photo. **Pays on receipt of invoice.** Credit line given. Buys one-time, book and all rights; negotiable. Simultaneous submissions and previously published work OK. Offers internships for photographers during August. Contact Art Director: Joan Silver.

ENCYCLOPAEDIA BRITANNICA, 310 S. Michigan Ave., 3rd Floor, Chicago IL 60604. (312)347-7000. Fax: (312)347-7914. Art Director: Bob Ciano. Estab. 1768. Publishes encyclopedia/yearbooks. Photos used for text illustration, promotional materials. Examples of published titles: *Encyclopedia Britannica* (text illustration); *Britannica Book of the Year* (text illustration); *Yearbook of Science and the Future* (text illustration); *Medical & Health Annual*; Britannica On-Line; Britannica CD.

 • Encyclopaedia Britannica has begun seeking nonexclusive world print and electronic rights. For these added rights they have paid $300 per image.

Needs: Buys hundreds of photos annually. Needs photos of current events, natural history, personalities, breakthroughs in science and medicine, art, geography, history, architecture. Reviews stock photos. Captions required. "This is very important to us! Captions must be very detailed."

Making Contact & Terms: Interested in receiving work from newer, lesser-known photographers. "Please do not request photo guidelines." Query only with stock photo list. Uses any size or finish color and b&w prints; 35mm, 2¼×2¼, 4×5, 8×10 transparencies. Accepts images in digital format for Mac. Send via SyQuest or Zip disk. Keeps samples on file. Cannot return unsolicited material. "We only contact when needed." Payment negotiable. **Pays on receipt of invoice.** Credit line given. Buys one-time world rights; negotiable. "Photographers and agencies must be willing to sell electronic rights for the Britannica On-Line and Britannica CD products."

Tips: "Photos must be well-lighted and sharply focused. The subject must be clearly visible. We prefer photographers who have a solid knowledge of their subject matter. Submissions should be tightly edited. Loosely edited submissions take up valuable time! Ultimately, the photos must be informative. Space is limited, so pictures must literally speak a thousand words! Stock lists and samples will be routed through the department. We are always looking for new sources of material."

ENTRY PUBLISHING, INC., 27 W. 96th St., New York NY 10025. (212)662-9703. Fax: (212)622-0549. President: Lynne Glasner. Estab. 1981. Publishes education/textbooks, secondary market. Photos used for text illustrations.

Needs: Number of freelance photos bought and freelance assignments given vary. Often looks for shots of young teens in school settings. Reviews stock photos. Model release required. Captions preferred.

Making Contact & Terms: Interested in receiving work from newer, lesser-known photographers. Query with list of stock photo subjects. Provide résumé, business card, brochure, flier or tearsheets to be kept on file for possible future assignments. Uses b&w prints. SASE. Reports in 3 weeks. Payment depends on job requirements. Credit line given if requested. Buys one-time rights; negotiable. Simultaneous submissions and previously published work OK.

Tips: "Have wide range of subject areas for review and use. Stock photos are most accessible and can be available quickly during the production of a book."

‡FERGUSON PUBLISHING COMPANY, (formerly Standard Educational Corp.), 200 W. Madison, Suite 300, Chicago IL 60606. (312)346-7440. Fax: (312)346-5081. Picture Editor: Irene L. Ferguson. Publishes the New Standard Encyclopedia and other reference books. Photos used for text illustration. To see style/themes used, look at encyclopedias in library, especially New Standard Encyclopedia.

Needs: Buys 50 photos annually (stock photos only). Major cities and countries, points of interest, agricultural and industrial scenes, plants and animals. Model release preferred. Captions required.

Making Contact & Terms: Query with stock photo list. Do not send unsolicited photos. Uses 8×10 glossy b&w prints; contact sheet OK; uses transparencies. SASE. Reports in 1 month. Pays $75-125/b&w photo; $135-300/color photo. Credit line given. Buys one-time rights. Simultaneous submissions and previously published work OK.

‡❧FIFTH HOUSE PUBLISHERS, #9, 6125-11th St. SE, Calgary, Alberta T2H 2L6 Canada. (403)571-5230. Fax: (403)571-5235. E-mail: 5thhouse@cadvision.com. Managing Editor: Charlene Dobmeier. Estab. 1982. Publishes calendars, history, biography, Western Canadiana. Photos used for text illustration, book covers, dust jackets and calendars. Examples of recently published titles: *The Canadian Weather Trivia Calendar*, *The Canadian Skywatchers Calendar* and *Once Upon a Tomb: Stories from Canadian Graveyards*.
Needs: Buys 15-20 photos annually. Looking for photos of Canadian weather and astronomy. Model/property release preferred. Captions required; include location and identification.
Making Contact & Terms: Query with samples. Query with stock photo list. Uses 5×7 color prints; 8×10 transparencies. Keeps samples on file. SASE. Reports in 3 weeks. Pays $300 (Canadian)/calendar image. Pays on publication. Credit line given. Buys one-time rights.

‡FINE EDGE PRODUCTIONS, Box 303, Route 2, Bishop CA 93514. (619)387-2412. Fax: (619)387-2286. E-mail: fineedgepr@aol.com. Website: http://www.fineedge.com. Contact: Don Douglass. Estab. 1986. Publishes outdoor guide and how-to books; custom topographic maps—mostly mountain biking and sailing. Publishes 6 new titles/year. Photos used for text illustration, promotional materials, book covers. Examples of recently published titles: *Mountain Biking Southern California's Best 100 Trails*; *Mountain Biking The San Bernadino Mountains*; *Eastern High Sierra Recreation Topo Map*. "Call to discuss" photo guidelines.
Needs: Buys 200 photos annually; offers 1-2 freelance assignments annually. Looking for area-specific mountain biking (trail usage), northwest cruising photos. Model release required. Captions preferred with place and activity.
Making Contact & Terms: Interested in receiving work from newer, lesser-known photographers. Query with samples. Uses 3×5, 4×6 glossy b&w prints; color for covers. SASE. Reports in 1-2 months. Pays $150-500/color photo; $10-50/b&w photo. Pays on publication. Credit line given. Rights purchased vary. Simultaneous submissions and/or previously published works OK.
Tips: Looking for "photos which show activity in realistic (not artsy) fashion—want to show sizzle in sport. Increasing—now going from disc directly to film at printer."

‡❧FISHER HOUSE PUBLISHERS, 10907 34 A Ave., Edmonton, Alberta T6J 2T9 Canada. (403)988-0321. Fax: (403)468-2058. E-mail: fisher@ocii.com. Website: http://www.ocii.com/~fisher/fhp.htm. Editor: John R. Fisher. Estab. 1991. Publishes textboks, biographies, histories, government/politics, how-to. Photos used for text illustration, book covers, dust jackets and artwork in poetry books. Example of recently published title: *Reflections at Christmas* (cover photography).
Needs: Looking for photos of nature and human interest. Model release preferred. Captions preferred.
Making Contact & Terms: Query with samples. Query with stock photo list. Uses color and b&w prints. SASE. Reports in 1 month. Credit line given. Rights negotiable. Simultaneous submissions and previously published work OK.
Tips: "We prefer to work with beginning photographers who are building a portfolio."

FIVE CORNERS PUBLICATIONS, HCR 70 Box 2, Plymouth VT 05056. (802)672-3868. Fax: (802)672-3296. E-mail: editor@fivecorners.com. Website: http://www.fivecorners.com. Editor: Donald Kroitzsh. Estab. 1990. Publishes adult trade (such as coffee table photo books), a travel newsletter and how-to books about travel. Photos used for text illustration. Examples of published titles: *American Photographers at the Turn of the Century: People & Our World*; *American Photographers at the Turn of the Century: Nature & Landscape; and The Curiosity Book* (text illustration using 35mm b&w prints).
Needs: Buys 20 photos annually. Interested in complementary photos to articles, showing technical matter and travel scenes. Model release preferred. Captions required.
Making Contact & Terms: Interested in receiving work from newer, lesser-known photographers. Query with résumé of credits. Works with freelancers only. Uses color and b&w prints; 35mm, 2¼×2¼, 4×5, 8×10 transparencies. Accepts images in digital format for Windows (TIFF, GIF, JBG). Send via compact disc, online, floppy disk, SyQuest or Zip disk. SASE. Reports in 1-2 weeks. Pays $25/color photo; $25/b&w photo. Pays on publication. Credit line given. Buys one-time rights. Simultaneous submissions and/or previously published work OK.

GASLIGHT PUBLICATIONS, 2809 Wilmington Way, Las Vegas NV 89102-5989. (702)221-8495. Fax: (702)221-8297. E-mail: 71604.511@compuserve.com. Publisher: Jack Tracy. Estab. 1979. Publishes adult trade and Victorian literature studies books. Photos used for text illustration, promotional materials, book covers and dust jackets.
Needs: Buys very few photos annually. Uses some copy photography; very rarely a cover photo. Model/property release required. Captions preferred.
Making Contact & Terms: Interested in receiving work from newer, lesser-known photographers. Query.

Works on assignment only. Uses 8 × 10 glossy b&w prints; 35mm, 2¼ × 2¼, 4 × 5 transparencies. Keeps samples on file. Reports in 1-2 weeks. Pays $200/color photo; copy photography batch jobs negotiable. **Pays on receipt of invoice.** Acknowledgements sometimes given. Buys all rights; negotiable.

GLENCOE PUBLISHING/MCGRAW HILL, 15319 Chatsworth St., Mission Hills CA 91345. Attention: Photo Editor. Publishes elementary and high school textbooks, religion, careers, business, office automation, social studies and fine arts. Photos used for text illustration and book covers. Examples of published titles: *Art Talk*, *Career Skills* and *Marketing Essentials*.
Needs: Buys 500 photos annually. Occasionally offers assignments. Children and teens at leisure, in school, in Catholic church; interacting with others: parents, siblings, friends, teachers; Catholic church rituals; young people (teens, early 20s) working, especially in jobs that go against sex-role stereotypes. Model release preferred.
Making Contact & Terms: Send stock photo list. List kept on file for future assignments. Uses 8 × 10 glossy b&w prints and 35mm slides. Pays $50/b&w photo, $100/color photo (¼ page). Buys one-time rights, but prefers to buy all rights on assignment photography with some out takes available to photographer. Simultaneous submissions and previously published work OK.
Tips: "A good ethnic mix of models is important. We look for a contemporary, unposed look."

GRAPHIC ARTS CENTER PUBLISHING COMPANY, P.O. Box 10306, Portland OR 97296-0306. (503)226-2402. Fax: (503)223-1410. Photo Editor: Diana Eilers. Publishes adult trade photo essay books and state, regional recreational calendars. Examples of published titles: *Crossing Alaska*; *Indiana II*; and *Oregon Coast*.
Needs: Offers 5-10 freelance assignments annually. Needs photos of landscape, nature, people, historic architecture and destiny attractions.
Making Contact & Terms: Uses 35mm, 2¼ × 2¼ and 4 × 5 transparencies (35mm as Kodachrome 25 or 64). Accepts images in digital format for Mac. Send via compact disc, floppy disk, SyQuest or Zip disk. Pays by royalty—amount varies based on project; minimum, but advances against royalty are given. Pays $2,200-4,000/calendar fees. Credit line given. Buys book rights.
Tips: "Photographers must be previously published and have a minimum of five years fulltime professional experience to be considered. Call first to present your book or calendar proposal before you send in a submission. Topics proposed must have strong market potential."

GRAPHIC ARTS PUB INC., 3100 Bronson Hill Rd., Livonia NY 14487. Estab. 1979. Publishes textbooks, adult trade—how-to quality and reproduction of color for printers and publishers. Photos used for text illustration, promotional materials, book covers. Examples of published titles: *Color Separation on the Desktop* (cover and illustrations); *Quality & Productivity in the Graphic Arts*.
Needs: Varies; offers 1-2 freelance assignments annually. Looking for technical photos. Model release preferred.
Making Contact & Terms: Works on assignment only. Uses color prints; 35mm transparencies.

GREAT QUOTATIONS PUBLISHING CO., 1967 Quincy Court, Glendale Heights IL 60139. (630)582-2800. Fax: (630)582-2813. Senior Marketing Manager: Patrick Caton. Estab. 1985. Publishes gift books.
Needs: Buys 10-20 photos annually; offers 10 freelance assignments annually. Looking for inspirational or humorous. Reviews stock photos of inspirational, humor, family. Model/property release preferred.
Making Contact & Terms: Interested in receiving work from newer, lesser-known photographers. Provide résumé, business card, brochure, flier or tearsheets to be kept on file for possible future assignments. Works on assignment only. Uses color and b&w prints; 35mm, 2¼ × 2¼, 4 × 5 transparencies. Keeps samples on file. SASE. "We prefer to maintain a file of photographers and contact them when appropriate assignments are available." Payment negotiable. Pays on publication. "We will work with artist on rights to reach terms all agree on." Simultaneous submissions and previously published work OK.
Tips: "We intend to introduce 30 new books per year. Depending on the subject and book format, we may use photographers or incorporate a photo image in a book cover design. Unfortunately, we decide on new product quickly and need to go to our artist files to coordinate artwork with subject matter. Therefore, more material and variety of subjects on hand is most helpful to us."

GROLIER, INC., 6 Park Lawn Dr., Bethel CT 06801. (203)797-3500. Fax: (203)797-3344. Director of Photo Research: Lisa Grize. Estab. 1829. Publishes encyclopedias and yearbooks. Examples of published titles: *The New Book of Knowledge Annual*; *Academic American Encyclopedia*; and *Health and Medicine Annual*. All photo use is text illustration unless otherwise negotiated.
● This publisher is using more color images, but they also see a decrease in quality news photos as

a result of digital transmission of images. "We also are saddled with shorter deadlines and therefore we rely on those photographers and agencies who put together tight edits in no time. We have less time to track down specialists."

Needs: Buys 3,000 stock photos/year; offers no assignments/year. Interested in unposed photos of the subject in its natural habitat that are current and clear. Model/property release preferred for any photos used in medical articles, education articles, etc. Captions mandatory; include dates, specific locations and natural history subjects should carry Latin identifications.

Making Contact & Terms: Interested in working with newer, lesser-known photographers. Query with list of stock photo subjects. Provide résumé, business card, brochure, flier or tearsheets to be kept on file for future reference. Uses 8 × 10 glossy b&w/color prints; 35mm, 4 × 5, 8 × 10 (reproduction quality dupes preferred) transparencies. Cannot return unsolicited material. Pays $65-100/b&w photo; $150-200/color photo. Very infrequent freelance photography is negotiated by the job. Credit line given "either under photo or on illustration credit page." Buys one-time and foreign language rights; negotiable.

Tips: "Send subject lists and small selection of samples for file. Printed samples *only* please. In reviewing samples we consider the quality of the photographs, range of subjects and editorial approach. Keep in touch but don't overdo it."

GRYPHON HOUSE, P.O. Box 207, Beltsville MD 20704. (301)595-9500. Fax: (301)595-0051. E-mail: rosanna@ghbooks.com. Editor-in-Chief: Kathy Charner. Estab. 1970. Publishes educational resource materials for teachers and parents of young children. Examples of recently published titles: *Crisis Manual for Teachers* (text illustration); and *Toddlers Together* (book cover).

Needs: Looking for b&w and color photos of young children, (birth-6 years.) Reviews stock photos. Model release required.

Making Contact & Terms: Query with samples. Query with stock photo list. Uses 5 × 7 glossy color (cover only) and b&w prints. Accepts photographs in digital format for Mac. Send via compact disc, SyQuest or Zip disk. Keeps samples on file. Reports in 1 month. Payment negotiable. **Pays on receipt of invoice.** Credit line given. Buys book rights. Simultaneous submissions OK.

♣GUERNICA EDITIONS, INC., P.O. Box 117, Station P, Toronto, Ontario M5S 2S6 Canada. (416)657-8885. Editor: Antonio D'Alfonso. Estab. 1978. Publishes adult trade (literary). Photos used for book covers. Examples of recently published titles: *How to Sing to a Dago* (cover); *My Father, Marconi* (cover).

Needs: Buys various number of photos annually; "often" assigns work. Life events, including characters; houses. Photo captions required. "We use authors' photo everywhere."

Making Contact & Terms: Interested in receiving work from newer, lesser-known photographers. Query with samples. Uses color and/or b&w prints. Sometimes keeps samples on file. Cannot return material. Reports in 1-2 weeks. Pays $100-150 for cover. Pays on publication. Credit line given. Buys book rights. "Photo rights go to photographers. All we need is the right to reproduce the work."

‡HANCOCK HOUSE PUBLISHERS, 1431 Harrison Ave., Blaine WA 98231-0959. (800)938-1114. Fax: (800)983-2262. President: David Hancock. Estab. 1968. Publishes trade books. Photos used for text illustration, promotions, book covers. Examples of recently published titles: *Antarctic Splendor*, by Frank S. Todd, (over 250 color images); *Pheasants of the World* (350 color photos). Photos used for text illustration.

Needs: Birds/nature. Model release and photo captions preferred. Reviews stock photos.

Making Contact & Terms: SASE. Reports in 1 month. Payment negotiable. Credit line given. Buys non-exclusive rights. Simultaneous submissions and previously published work OK.

HARMONY HOUSE PUBLISHERS, P.O. Box 90, Prospect KY 40059 or 1008 Kent Rd., Goshen KY 40026. (502)228-4446. Fax: (502)228-2010. Owner: William Strode. Estab. 1984. Publishes photographic books on specific subjects. Photos used for text illustration, promotion materials, book covers and dust jackets. Examples of published titles: *Christmas Collections* (35mm/4 × 5 photos); *Appalachian Trail* (35mm); *The Saddlebred-American Horse of Distinction* (35mm).

Needs: Number of freelance photos purchased varies. Assigns 30 shoots each year. Captions required.

Making Contact & Terms: Query with résumé of credits along with business card, brochure, flier or tearsheets to be kept on file for possible future assignments. Query with samples or stock photo list. Submit

● SPECIAL COMMENTS within listings by the editor of *Photographer's Market* are set off by a bullet.

portfolio for review. Works on assignment mostly. Uses 35mm, 2¼×2¼, 4×5 or 8×10 transparencies. Payment negotiable. Credit line given. Buys one-time rights and book rights. Simultaneous submissions and previously published work OK.

Tips: To break in, "send in book ideas to William Strode, with a good tray of slides to show work."

‡**HARPERCOLLINS SAN FRANCISCO**, 1160 Battery St., San Francisco CA 94111. (415)477-4400. Creative Director: Michele Wetherbee. Estab. 1928. Publishes adult trade—spirituality, philosophical and cultural-nonfiction. Photos used for promotional materials, book covers and dust jackets. Examples of recently published titles: *Undercurrents* by Martha Manning (4-color, custom, full-bleed, wrap around); *Our Share of Night* by Nancy Fuchs (inset duotone, stock image); and *Confessions* by Matthew Fox (4-color, custom, full-bleed, wrap around).

 • All design at HarperCollins is produced digitally, but photography is still reviewed and used traditionally.

Needs: Buys 15-20 stock photos annually; offers 6-10 freelance assignments annually. Needs unexpected and conceptual religious/spiritual subjects. Model release preferred.

Making Contact & Terms: Interested in receiving work from newer, lesser-known photographers. Query with non-returnable samples (fliers or tearsheets). Do not call! "We will contact you if appropriate." Works on assignment only. Uses color and b&w prints; 35mm, 2¼×2¼, 4×5 transparencies. Keeps samples on file. SASE. Will contact only if there is an appropriate project. Pays $800-1,200/color photo (on assignment); $500-800/color stock photo. Pays 30 days after invoice and acceptance. Credit line given. Buys one-time rights for that cover to include all printings, and nonexclusive English language/world rights. Simultaneous submissions and/or previously published work OK.

Tips: "We look for the unusual and inspired image to make the book unique. We are not interested in standard 'stock' or corporate photography."

HERALD PRESS, 616 Walnut Ave., Scottdale PA 15683. (412)887-8500. Fax: (412)887-3111. Contact: James Butti. Estab. 1908. Photos used for book covers and dust jackets. Examples of published titles: *Lord, Teach Us to Pray*; *Starting Over*; and *Amish Cooking* (all cover shots).

Needs: Buys 5 photos annually; offers 10 freelance assignments annually. Subject matter varies. Reviews stock photos of people and other subjects. Model/property release required. Captions preferred (identification information).

Making Contact & Terms: Interested in receiving work from newer, lesser-known photographers. Query with samples. Provide résumé, business card, brochure, flier or tearsheets to be kept on file for possible future assignments. Works on assignment only or select from file of samples. Uses varied sizes of glossy color and/or b&w prints; 35mm transparencies. Keeps samples on file. SASE. Reports in 1 month. Pays $150-200/color photo. **Pays on acceptance.** Credit line given. Buys book rights; negotiable. Simultaneous submissions and previously published work OK.

Tips: "Put your résumé and samples on file."

HOLLOW EARTH PUBLISHING, P.O. Box 1355, Boston MA 02205-1355. Phone/fax: (603)433-8735. President/Publisher: Helian Yvette Grimes. Publishes adult trade, mythology, computers (Macintosh), science fiction and fantasy. Photos used for text illustration, promotional materials, book covers, dust jackets and magazines. Examples of published titles: *Complete Guide to B&B's and Country Inns (USA)*, *Complete Guide to B&B's and Country Inns (worldwide)*, and *Software Guide for the Macintosh Power Book*. Photo guidelines free with SASE.

Needs: Buys 150-300 photos annually. Needs photos of bed & breakfasts, country inns, Macintosh Powerbook and computer peripherals. Reviews stock photos. Model/property release required. Captions required; include what it is, where and when.

Making Contact & Terms: Interested in receiving work from newer, lesser-known photographers. Query with samples. No unsolicited photographs. Works with local freelancers on assignment only. Uses 5×7, 8½×11 glossy or matte color and b&w prints; 35mm, 2¼×2¼, 4×5 transparencies. Also accepts images on disk in EPS, TIFF, or Adobe Photoshop formats. Keeps samples on file. SASE. Reports in 1 month. Pays $50-600/color photo; $50-600/b&w photo. **Pays on acceptance.** Credit line given. Buys all rights "but photographer can use photographs for other projects after contacting us." Rights negotiable. No simultaneous submissions.

Tips: Wants to see portfolios with strong content, impact, graphic design. "Be unique and quick in fulfilling assignments, and pleasant to work with."

HOLT, RINEHART AND WINSTON, 1120 Capital of Texas Hwy. S., Austin TX 78746. (512)314-6500. Fax: (512)314-6590. Manager of Photo Research: Tim Taylor. Estab. 1866. "The Photo Research Department of the HRW School Division in Austin obtains photographs for textbooks in subject areas taught in secondary schools." Photos are used for text illustration, promotional materials and book covers.

Examples of published titles: *Elements of Writing*, *Science Plus*, *People and Nations*, *World Literature*, *Biology Today* and *Modern Chemistry*.

Needs: Buys 3,500 photos annually. Photos to illustrate mathematics, the sciences—life, earth and physical—chemistry, history, foreign languages, art, English, literature, speech and health. Reviews stock photos. Model/property releases preferred. Photo captions required that include scientific explanation, location and/or other detailed information.

Making Contact & Terms: Interested in receiving work from newer, lesser-known photographers. Query with résumé of credits. Query with stock photo list. Query with samples. Send a letter and printed flier with a sample of work and a list of subjects in stock. Do not call! Uses any size glossy b&w prints and color transparencies. Cannot return unsolicited material. Reports as needed. Pays $125-180/b&w photo; $150-225/color photo; $75-125/hour and $700-1,000/day. Credit line given. Buys one-time rights.

Tips: "We use a wide variety of photos, from portraits to studio shots to scenics. We like to see slides displayed in sheets. We especially like photographers who have specialties . . . limit themselves to one or two subjects." Looks for "natural looking, uncluttered photographs, labeled with exact descriptions, technically correct, and including no evidence of liquor, drugs, cigarettes or brand names." Photography should be specialized, with photographer showing competence in 1 or more areas.

HOME PLANNERS, A Division of Hanley-Wood, Inc., 3275 W. Ina Road, Suite 110, Tucson, AZ 85741. (602)297-8200. Fax: (602)297-6219. Art Director: Cindy J. Coatsworth Lewis. Estab. 1946. Publishes material on home building and planning and landscape design. Photos used for text illustration, promotional materials and book covers. Examples of recently published titles: *Home Planners Gold*; *Country Houses*; and *Easy-Care Landscape Plans*. In all 3, photos used for cover and text illustrations.

Needs: Buys 25 freelance photos annually; offers 10 freelance assignments annually. Homes/houses—"but for the most part, it must be a specified house built with one of our plans." Property release required.

Making Contact & Terms: Provide résumé, business card, brochure, flier or tearsheets to be kept on file for possible assignments. Works on assignment only. Uses 4×5 transparencies. SASE. Reports in 1 month. Pays $25-100/color photo; $500-750/day; maximum $500/4-color cover shots. Credit line given. Buys all rights. Simultaneous submissions and previously published work OK.

Tips: Looks for "ability to shoot architectural settings and convey a mood. Looking for well-thought, professional project proposals."

HOMESTEAD PUBLISHING, Box 193, Moose WY 83012. Editor: Carl Schreier. Publishes 20-30 titles per year in adult and children's trade, natural history, guidebooks, fiction, Western American and art. Photos used for text illustration, promotional, book covers and dust jackets. Examples of published titles: *Yellowstone: Selected Photographs*; *Field Guide to Yellowstone's Geysers; Hot Springs and Fumaroles*; *Field Guide to Wildflowers of the Rocky Mountains*; *Rocky Mountain Wildlife*; and *Grand Teton Explorers Guide*.

Needs: Buys 100-200 photos annually; offers 6-8 freelance assignments annually. Natural history. Reviews stock photos. Model release preferred. Photo captions required; accuracy very important.

Making Contact & Terms: Query with samples. Provide résumé, business card, brochure, flier or tearsheets to be kept on file for possible future assignments. Uses 8×10 glossy b&w prints; 35mm, 2¼×2¼, 4×5 and 6×7 transparencies. SASE. Reports in 4-6 weeks. Pays $70-300/color photo, $50-300/b&w photo. Credit line given. Buys one-time and all rights; negotiable. Simultaneous submissions and previously published work OK.

Tips: In freelancer's samples, wants to see "top quality—must contain the basics of composition, clarity, sharp, in focus, etc. Looking for well-thought out, professional project proposals."

HOWELL PRESS, INC., 1147 River Road, Suite 2, Charlottesville VA 22901. (804)977-4006. Fax: (804)971-7204. President: Ross A. Howell, Jr. Estab. 1986. Publishes illustrated books. Examples of recently published titles: *Mustang: North American P-51*; *Corvette GTP*; and *Stuck on Cactus: A Beginning Grower's Guide* (photos used for illustration, jackets and promotions for all books).

Needs: Aviation, military history, gardening, maritime history, motorsports, cookbooks only. Model/property release preferred. Captions required; clearly identify subjects.

Making Contact & Terms: Interested in receiving work from newer, lesser-known photographers. Photographer's guidelines available; query. Uses b&w and color prints. Keeps samples on file. SASE. Reports in 1 month. Payment negotiable. Buys one-time rights. Simultaneous submissions and previously published work OK.

Tips: When submitting work, please "provide a brief outline of project, including cost predictions and target market for project. Be specific in terms of numbers and marketing suggestions."

✿I.G. PUBLICATIONS LTD., 1311 Howe St., Suite 601, Vancouver, British Columbia V6Z 2D3 Canada. (604)691-1749. Fax: (604)691-1748. Property Coordinator: Elizabeth Hrappstead. Estab. 1977.

Publishes travel magazines/books of local interest to include areas/cities of Vancouver, Victoria, Banff/Lake Louise, Calgary. Photos used for text illustration, book covers. Examples of published titles: *International Guide* and *Visitor's Choice*, text illustration and covers. Photo guidelines free with SASE.

Needs: Buys 50-100 photos annually. Looking for photos of mountains, lakes, views, lifestyle, buildings, festivals, people, sports and recreation, specific to each area as mentioned above. Reviews stock photos. Model release required. Property release is preferred. Captions required "detailed but brief."

Making Contact & Terms: Interested in receiving work from newer, lesser-known photographers. Query with samples. Works with local freelancers only. Uses 4×5 to 8×10 color prints; 35mm transparencies. Keeps digital images on file. SASE. Reports in 3 weeks. Pays $65/color photo. Pays 30-60 days. Credit line given. Previously published works OK.

Tips: "Please submit photos that are relative to our needs only. Photos should be specific, clear, artistic, colorful."

ICS BOOKS INC., 1370 E. 86th Place, Merrillville IN 46410. (219)769-0585. Fax: (219)769-6085. E-mail: adventure@icsbook.com. Website: http://www.icsbooks.com. Art Director: James Putrus. Estab. 1980. Publishes adult trade, camping, rock climbing, water sports, outdoor. Photos used for book covers. Examples of recently published titles: *Climbing Back* (cover); *Golfer's Little Book of Wisdom* (cover); *Golf Shot* (cover); and *Hiking Shot* (cover).

Needs: Buys 5-10 photos annually; offers 1-2 freelance assignments annually. Wants outdoor photos. Model release required. Captions required.

Making Contact & Terms: Interested in receiving work from newer, lesser-known photographers. Send unsolicited photos by mail for consideration. Provide résumé, business card, brochure, flier or tearsheets to be kept on file for possible future assignments. Uses color prints; 35mm, 2¼×2¼, 4×5 transparencies. Keeps samples on file. Cannot return material. Reports in 1-2 weeks. Pays $45-60/hour; $400-500/day; $150-300/color photo. Pays on publication or within 30 days receipt of invoice. Credit line given. Buys all rights; negotiable. Simultaneous submissions and previously published work OK.

Tips: "Send tearsheets with photo in ad or book cover."

INTERNATIONAL VOYAGER MEDIA, 11900 Biscayne Blvd., #300, Miami FL 33181. (305)892-6644. Fax: (305)892-1005. Photography Director: Robin Hill. Estab. 1975. Publishes travel books, cruise line magazines, commemorative books. "We publish 120 different travel publications annually." Photos used for text illustration and book covers. Example of recently published title: *Carribean Vacation Planner*. Photo guidelines free with SASE.

Needs: Buys thousands of photos annually; offers 10 freelance assignments annually. Needs photos that promote a destination in a positive light. Reviews stock photos. Captions required; include where, who, what, when.

Making Contact & Terms: Interested in receiving work from newer, lesser-known photographers. Arrange personal interview to show portfolio. Submit portfolio for review. Query with résumé of credits. Query with stock photo list. Provide résumé, business card, brochure, flier or tearsheets to be kept on file for possible future assignments. Uses 35mm, 2¼×2¼, 4×5 transparencies. Keeps samples on file. Cannot return material. Reports in 3 weeks. Pays $75-1,000/color photo. **Pays on receipt of invoice.** Credit line given. Buys one-time rights. Simultaneous submissions OK.

Tips: "There are only two criteria in succeeding: talent and tenacity. Both are needed in large quantities to succeed in a very competitive marketplace. I look for original ideas and consider it very important to evaluate work of new/less-known photographers."

‡JUDICATURE, 180 N. Michigan Ave., Suite 600, Chicago IL 60601. (312)558-6900 ext 119. Fax: (312)558-9175. E-mail: ajspubs@interaccess.com. Editor: David Richert. Estab. 1917. Publishes legal journal, court and legal books. Photos are used for text illustration and cover of bimonthly journal.

Needs: Buys 10-12 photos annually; rarely offers freelance assignments. Looking for photos relating to courts, the law. Reviews stock photos. Model/property release preferred. Captions preferred.

Making Contact & Terms: Interested in receiving work from newer, lesser-known photographers. Query with samples. Works on assignment only. Uses 5×7 color and b&w prints; 35mm transparencies. Keeps samples on file. SASE. Reports in 1-2 weeks. Pays $150-200/color photo; $150-200/b&w photo; cover use $200-300. **Pays on receipt of invoice.** Credit line given. Buys one-time rights. Simultaneous and/or previously published work OK.

B. KLEIN PUBLICATIONS., P.O. Box 6578, Delray Beach FL 33482. (561)496-3316. Fax: (561)496-5546. President: Bernard Klein. Estab. 1953. Publishes adult trade, reference and who's who. Photos used for text illustration, promotional materials, book covers, dust jackets. Examples of published titles: *1933 Chicago World's Fair*, *1939 NY World's Fair* and *Presidential Ancestors*.

Needs: Reviews stock photos.

Making Contact & Terms: Interested in receiving work from newer, lesser-known photographers. Query with résumé of credits. Query with samples. Send unsolicited photos by mail for consideration. Works on assignment only. Cannot return material. Reports in 1-2 weeks. Payment negotiable.

Tips: "We have several books in the works that will need extensive photo work in the areas of history and celebrities."

KREGEL PUBLICATIONS, 733 Wealthy SE, P.O. Box 2607, Grand Rapids MI 49501-2607. (616)451-4775. Fax: (616)451-9330. E-mail: kregelpub@aol.com. Director of Graphic & Print Production: Alan G. Hartman. Publishes books for Christian and Bible colleges, reference works and commentaries, sermon helps and adult trade books. Photos used for book covers and printed jackets. Examples of recently published titles: *Biblical Manhood & Womanhood*, (cover, digital-photo disc); *Honey from the Rock*, (scenic, full bleed, 35mm); and *Master's Plan of Prayer*, (scenic, full bleed, 4×5).

• Kregel received the Gold Medallion ECPA award for *Spanish Romanos Commentary*.

Needs: Buys 12-40 photos annually. Scenic and/or biblical. Holy Land, scenery and inhabitants sometimes used; religious symbols, stained glass and church activities of non-Catholic origin may be submitted. Reviews stock photos. Model release preferred.

Making Contact & Terms: Query with phone call to approve photo submission before sending. Uses 35mm, 2¼×2¼ and 4×5 transparencies. Accepts images in digital format for Mac (TIFF or EPS). Send via compact disc, 44m6 SyQuest, Zip disk or 230, 128 MO. Keeps duplicates on file. SASE. Reports in 3 months. Pays $200-400/color photo. Credit line given. Buys book rights and one-time rights with allowances for reproductions. Prefers purchase of photos for unlimited use. Previously published work OK.

Tips: "Prior submission approval a must! High quality scenics of 'inspirational calendar' type preferred."

LAYLA PRODUCTION INC., 340 E. 74, New York NY 10021. (212)879-6984. Fax: (212)879-6399. Manager: Lori Stein. Estab. 1980. Publishes adult trade, how-to gardening and cooking books. Photos used for text illustration and book covers. Example of recently published title: *American Garden Guides*, 12 volumes (commission or stock, over 4,000 editorial photos).

Needs: Buys over 150 photos annually; offers 6 freelance assignments annually. Gardening and cooking. Buys all rights.

Making Contact & Terms: Provide résumé, business card, brochure, flier or tearsheets to be kept on file for possible future assignments. Specifications for submissions are very flexible. SASE. Reports in 1 month; prefers no unsolicited material. Pays $25-200/color photo; $10-100/b&w photo; $30-75/hour; $250-400/day. Other methods of pay depends on job, budget and quality needed. Simultaneous submissions and previously published work OK.

Tips: "We're usually looking for a very specific subject. We *do* keep all résumés/brochures received on file—but our needs are small, and we don't often use unsolicited material. We will be working on gardening books through 1999."

LERNER PUBLICATIONS COMPANY, 241 First Ave. N., Minneapolis MN 55401. (612)332-3344 or (800)328-4929. Fax: (612)332-7615. Senior Photo Researcher: Lynn Olsen. Estab. 1959. Publishes educational books for young people covering a wide range of subjects, including animals, biography, history, geography and sports. Photos used for text illustration, promotional materials, book covers, dust jackets. Examples of recently published titles: *Aung San Suu Kyi* (text and cover); *A Bosnian Family* (text and cover); and *Barry Bonds* (text and cover).

Needs: Buys over 1,000 photos annually; rarely offers assignments. Model/property release preferred when photos are of social issues (i.e., the homeless). Captions required; include who, where, what and when.

Making Contact & Terms: Interested in receiving work from newer, lesser-known photographers. Query with stock photo list. Provide résumé, business card, brochure, flier or tearsheets to be kept on file. "No calls, please." Uses any size glossy color and b&w prints; 35mm, 2¼×2¼, 4×5 transparencies. Cannot return material. Reports only when interested. Pays $50-125/color photo; $35-75/b&w photo; negotiable. **Pays on receipt of invoice.** Credit line given. Buys one-time rights. Previously published works OK.

Tips: Prefers crisp, clear images that can be used editorially. "Send in as detailed a stock list as you can, and be willing to negotiate use fees. We are using freelance photographers more and more."

‡**LIFETIME BOOKS**, 2131 Hollywood Blvd., Hollywood FL 33020. (954)925-5242. Fax: (954)925-5244. Senior Editor: Brian Feinblum. Estab. 1943. Publishes nonfiction business, health, cookbooks, self-help, how-to and psychology. Photos are used for text illustration, book covers and dust jackets.

Needs: Reviews stock photos. Model release required. Captions preferred.

Making Contact & Terms: Interested in receiving work from newer, lesser-known photographers. Query with samples. Query with stock photo list. Uses color prints. Keeps samples on file. SASE. Payment

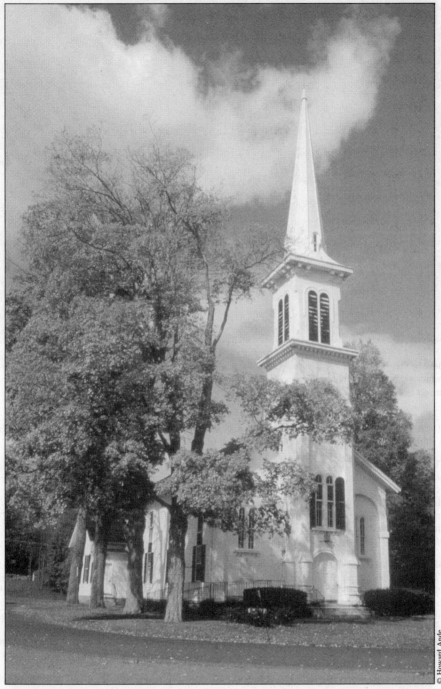

© Howard Ande

Howard Ande's striking photo of a church in New Preston, Connecticut appeared in an educational children's book on towers published by Lerner Publications Company. "They wanted a tall church steeple to use as an illustration and selected this shot," says Ande on the solicited photo for which he was paid $50. In addition to the tower book, Ande has had work in a number of Lerner's nonfiction children's titles including a book about bridges and a book about roads. He learned of them through *Photographer's Market*.

© Galyn Hammond

Galyn Hammond's photo titled "Santiago de Compostela in the Rain" was one of five of the photographer's shots purchased by Lerner Publications Company for the book *Spain in Pictures*. Hammond has sold other work to Lerner as well, including three photos used in a book on California missions. He discovered Lerner through a listing in a *PhotoSource International* newsletter.

negotiable. **Pays on acceptance.** Credit line given. Non-exclusive, multiple-use rights; negotiable. Simultaneous submissions and/or previously published work OK.

LITTLE, BROWN & CO., 1271 Avenue of the Americas, New York NY 10020. (212)522-1793. Fax: (212)467-4502. Art Department Coordinator: Scott Richards. Publishes adult trade. Photos used for book covers and dust jackets.
Needs: Reviews stock photos. Model release required.
Making Contact & Terms: Provide tearsheets to be kept on file for possible future assignments. "Samples should be nonreturnable." SASE. Reporting time varies. Payment negotiable. Credit line given. Buys one-time rights.

LITURGY TRAINING PUBLICATIONS, 1800 N. Hermitage, Chicago IL 60622. (773)486-8970. Fax: (773)486-7094. Prepress Director: Diana Kodner. Estab. 1964. Publishes materials that assist parishes, institutions and households in the preparation, celebration and expression of liturgy in Christian life. Photos used for text illustration, book covers. Examples of published titles: *Infant Baptism, a Parish Celebration* (text illustration); *The Postures of the Assembly During the Eucharistic Prayer* (cover); and *Teaching Christian Children about Judaism* (text illustration).
Needs: Buys 30 photos annually; offers 5 freelance assignments annually. Needs photos of processions, assemblies with candles in church, African-American worship, sacramental/ritual moments. Reviews stock photos. Model/property release preferred. Captions preferred.
Making Contact & Terms: Interested in receiving work from newer, lesser-known photographers. Arrange personal interview to show portfolio. Submit portfolio for review. Query with résumé of credits. Query with samples. Query with stock photo list. Send unsolicited photos by mail for consideration. Provide résumé, business card, brochure, flier or tearsheets to be kept on file for possible future assignments. Uses 5×7 glossy b&w prints; 35mm transparencies. Keeps samples on file. SASE. Reports in 1-2 weeks. Pays $50-225/color photo; $25-200/b&w photo. Pays on publication. Credit line given. Buys one-time rights; negotiable. Simultaneous submissions; previously published work.
Tips: "Please realize that we are looking for very specific things—people of mixed age, race, socio-economic background; shots in focus; post-Vatican II liturgical style; candid photos; photos that are not

dated. We are not looking for generic religious photography. We're trying to use more photos, and will if we can get good ones at reasonable rates."

LLEWELLYN PUBLICATIONS, P.O. Box 64383, St. Paul MN 55164. Art Director: Lynne Menturweck. Publishes consumer books (mostly adult trade paperback) with astrology, wiccan, occult, self-help, health and New Age subjects, geared toward an educated audience. Uses photos for book covers. Examples of recently published titles: *Complete Book of Incense, Oils & Brews*; *Sarava!, Mother Nature's Herbal* and *Advanced Candle Magic* (all covers).
Needs: Buys 5-10 freelance photos annually. Science/fantasy, sacred sites, gods and goddesses (statues, etc.), nature, high-tech and special effects. Reviews stock photos. Model release preferred.
Making Contact & Terms: Query with samples. Uses 8×10 glossy color prints; 35mm or 4×5 transparencies. Provide slides, brochure, flier or tearsheets to be kept on file for possible future assignments. SASE. Reports in 5 weeks. Pays $125-600/color cover photo. Pays on publication. Credit line given. Buys all rights.
Tips: "Send materials that can be kept on file."

LOOMPANICS UNLIMITED, P.O. Box 1197, Port Townsend WA 98368. (360)385-5087. Fax: (360)385-7785. E-mail: loompseditor@olympus.net Editorial Director: Dennis P. Eichhorn. Estab. 1975. Publishes how-to and nonfiction for adult trade. Photos used for book covers. Examples of published titles: *Free Space!* (color photos on cover and interior); *Secrets of a Superhacker* (photo collage on cover); and *Stoned Free* (interior photos used as line-drawing guide).
Needs: Buys 2-3 photos annually; offers 1-2 freelance assignments annually. "We're always interested in photography documenting crime and criminals." Reviews stock photos. Model/property release preferred. Captions preferred.
Making Contact & Terms: Query with samples. Query with stock photo list. Provide tearsheets to be kept on file for possible future assignments. Uses b&w prints. Samples kept on file. SASE. Reports in 1 month. Pays $10-250 for cover photo; $5-20 interior photo. Credit lines given. Buys all rights. Simultaneous submissions and previously published work OK.
Tips: "We look for clear, high contrast b&w shots that *clearly* illustrate a caption or product. Find out as much as you can about what we are publishing and tailor your pitch accordingly."

‡**LUCENT BOOKS**, P.O. Box 289011, San Diego CA 92128. (619)485-7424. Fax: (619)485-9549. Production Coordinator: Tracey Engel. Estab. 1987. Publishes juvenile nonfiction—social issues, biographies and histories. Photos used for text illustration and book covers. Examples of recently published titles: *The Importance of Winston Churchill*, *The Ancient Near East* and *Child Abuse*.
Needs: Buys hundreds of photos annually, including many historical and biographical images, as well as controversial topics such as euthanasia. Reviews stock photos. Model/property release required; photo captions required.
Making Contact & Terms: Submit portfolio for review. Query with résumé of credits. Query with samples. Uses 5×7, 8½×11 b&w prints. Provide résumé, business card, brochure, flier or tearsheets to be kept on file for possible future assignments. Keeps samples on file. SASE. Reports in 1 month. Pays $25-75/b&w photo. Credit lines given on request. Simultaneous submissions and previously published work OK.

‡✤■**LYNX IMAGES INC.**, P.O. Box 5961, Station A, Toronto, Ontario M5W 1P4 Canada. (416)535-4553. Fax: (416)535-3665. Contact: Russell Floren. Estab. 1988. Publishes travel, history. Photos used for text illustration, promotional materials, book covers and dust jackets. Examples of recently published titles: *Alone In The Night* (cover, promotional materials); *Ghosts of the Boy* (cover, promotional materials); and *North Channel* (cover and promotional materials).
Needs: Buys 10-20 photos annually; offers 10 freelance assignments annually. Looking for photos of mood, style to fit book. Reviews stock photos of the Great Lakes and other travel images. Model release preferred for people and ships. Property release required for people and ships. Captions required; include date, location and site.
Making Contact & Terms: Interested in receiving work from newer, lesser-known photographers. Query with samples. Works with local freelancers only. Uses 16mm film and Betacame SP videotape. Keeps samples on file. Reports in 1 month. Pays a negotiated flat fee for work. **Pays on receipt of invoice.** Credit

line sometimes given depending upon work. Buys all rights. Simultaneous submissions OK.

METAMORPHOUS PRESS, Box 10616, Portland OR 97210. (503)228-4972. Editor: Lori Vannorsdel. "We publish books and tapes in the subject areas of communication, health and fitness, education, business and sales, psychology, women and children. Photos used for text illustration, promotional materials, book covers and dust jackets. Examples of published titles: *The Challenge of Excellence*; *Re-Creating Your Self*; and *The Professional ACT: Acting, Communication, Technique*. Photos used for cover and/or text illustration.

Needs: Reviews stock photos.

Making Contact & Terms: Query with list of stock photo subjects. Provide résumé, business card, brochure, flier or tearsheets to be kept on file for possible future assignments. Works on assignment only. Cannot return material. Reports as soon as possible. Payment negotiable. Credit line given. Buys one-time and book rights. Also buys all rights, but willing to negotiate. Simultaneous submissions and previously published work OK.

Tips: "Let us have samples of specialties so we can match contents and styles to particular projects."

‡**MILKWEED EDITIONS**, 430 First Ave., Suite 400, Minneapolis MN 55401-1743. (612)332-3192. Managing Editor: B. Olson. Estab. 1979. Publishes fiction (adult and children), nonfiction and poetry. Photos used for text illustration, book covers and dust jackets. Examples of recently published titles: *Confidence of the Heart*; *A Keeper of Sheep*; *Homestead* (color photos for cover illustrations).

Needs: Interested in high-quality photos, able to stand on own; "should not be journalistic." Model release required; photo captions preferred.

Making Contact & Terms: Query with samples. Provide résumé, business card, brochure, book list, flier or tearsheets to be kept on file. Uses b&w glossy prints and color transparencies. SASE. Reports in 1 month. Pays $10-500/b&w photo; $50-600/color photo; $10-650/job. "We buy piece work. We are a nonprofit publisher of poetry, fiction, children's fiction, and adult nonfiction. Photographers who are willing to work with us in keeping down our costs and in reviewing a manuscript to determine the best possible cover image are welcome to send a letter and book list." Credit line given. Buys one-time rights. Simultaneous submissions and previously published work OK.

Tips: Would like to see series works. "Look at our books for use. Then send in a fairly good color copy to keep on file."

MOON PUBLICATIONS, INC., P.O. Box 3040, Chico CA 95927-3040. (916)345-5473. Fax: (916)345-6751. Photo Buyer: Dave Hurst. Estab. 1973. Publishes travel material. Photos used for text illustration, promotional materials and book covers. Examples of recently published titles: *Indonesia Handbook*, 6th Edition; *Nepal Handbook*, (2nd Edition) and *Tasmania Handbook* (1st Edition). All photos used for cover and text illustration. Photo guidelines free with SASE.

Needs: Buys 25-30 photos annually. People, clothing and activity typical of area being covered, landscape or nature. Reviews stock photos. Photo captions preferred; include location, description of subject matter.

Making Contact & Terms: Interested in receiving work from newer, lesser-known photographers. Query with stock photo list. Provide résumé, business card, brochure, flier or tearsheets to be kept on file for possible future assignments. Uses 35mm, 2¼×2¼, 4×5, 8×10 transparencies. Keeps samples on file. SASE. Pays $200-300/cover photo. Pays on publication. Credit line given. Buys book rights; negotiable. Previously published work OK.

Tips: Wants to see "sharp focus, visually interesting (even unusual) compositions portraying typical activities, styles of dress and/or personalities of indigenous people of area covered in handbook. Unusual land or seascapes. Don't send snapshots of your family vacation. Try to look at your own work objectively and imagine whether the photograph you are submitting really deserves consideration for the cover of a book that will be seen worldwide. We continue to refine our selection of photographs that are visually fascinating, unusual."

‡**MOREHOUSE PUBLISHING**, 871 Ethan Allen Hwy., Ridgefield CT 06877. (203)431-3927. Fax: (203)431-3964. Senior Editor: Deborah Grahame. Estab. 1884. Publishes adult trade, some juvenile, some gift, some reference—all "religious" (Christian). Photos used for text illustration, book covers.

● Morehouse Publishing has increased its pay rates in all categories.

Needs: Buys 4-5 photos annually; offers 4 freelance assignments annually. Reviews stock photos of any subject with spiritual/contemplative overtones.

Making Contact & Terms: Interested in receiving work from newer, lesser-known photographers. Query with samples. Query with stock photo list. Uses 5×7, 8×10 glossy or matte color and b&w prints; 35mm, 2¼×2¼, 4×5 transparencies. Accepts images in digital format for Windows. Send via compact disc or SyQuest. Keeps samples on file. SASE. Reports in 3 weeks. Pays $300-400/job; $200-350/color photo;

$100-200/b&w photo. **Pays on receipt of invoice.** Credit line given. Buys one-time and book rights. Simultaneous submissions OK.

Tips: "Be creative when keeping up with contemporary religious trends. Concentrate on subjects that reflect concerns, questions in today's society."

■**MOUNTAIN AUTOMATION CORPORATION**, P.O. Box 6020, Woodland Park CO 80866. (719)687-6647. Fax: (719)687-2448. E-mail: mtnauto@compuserve.com. President: Claude Wiatrowski. Estab. 1976. Publishes souvenir books. Photos used for text illustration, promotional materials and book covers. Examples of published titles: *Colorado's Black Canyon* (throughout); *Pike's Peak By Rail* (extra illustrations in video) and *Georgetown Loop RR* (extra illustrations in video).

Needs: Complete projects for illustrated souvenir books and videos, not individual photos. Model release required. Property release preferred. Captions required.

Making Contact & Terms: Interested in receiving work from newer, lesser-known photographers. Query with book project. Uses 35mm, 2¼×2¼, 4×5 transparencies. "Although we will deal with larger formats if necessary, we prefer 35mm for transfer to Kodak Photo CD." Accepts images in digital format for Windows (TIFF and PCD preferred). Send via compact disc or floppy disk. Keeps samples on file. SASE. Reports in 1 month. Pays royalty on complete book projects. Credit lines given. Buys all rights. Simultaneous submissions OK.

Tips: "Provide a contact with a tourist attraction, chamber of commerce or other entity willing to purchase souvenir books. We *only* are interested in complete illustrated book or video projects for the souvenir market with very targeted markets."

JOHN MUIR PUBLICATIONS, P.O. Box 613, Santa Fe NM 87504. Graphics Editor: Tom Gaukel. Estab. 1969. Publishes adult travel (trade), juvenile nonfiction (science, inter-cultural). Photos used for text illustration and book covers. Examples of recently published titles: Travel Smart Trip Planner Series, City Smart Guidebook Series and Kidding Around Series.

• This publisher scans photos and places them electronically and outputs from disk.

Needs: Buys more than a thousand photos annually. Reviews stock photos. Model/property release preferred.

Making Contact & Terms: Query with samples. Query with stock photo list. Uses 35mm, medium and 4×5 transparencies. Accepts images in digital format for Mac (TIFF, Photoshop) for preview only. Submit via Zip disk. Provide résumé, business card, brochure, flier or tearsheets to be kept on file for possible future assignments. Keeps samples on file. SASE. Reports back "only if we wish to use material or photographer." Payment negotiable. Credit line given. Buys one-time rights; rights negotiable. Simultaneous submissions and previously published work OK.

‡**MUSEUM OF NORTHERN ARIZONA**, 3101 N. Fort Valley Rd., Flagstaff AZ 86001. (520)774-5213. Fax: (520)779-1527. Editor: Carol Haralson. Estab. 1928. Publishes biology, geology, archaeology, anthropology and history. Photos used for *Plateau Journal* magazine, published twice a year. Examples of recently published title: *Canyon Journal* article illustration (slides, 4×5 b&w prints). Forty b&w and color photos used for text in each.

Needs: Buys approximately 80 photos annually. Biology, geology, history, archaeology and anthropology—subjects on the Colorado Plateau. Reviews stock photos. Photo captions preferred, include location, description and context.

Making Contact & Terms: Interested in receiving work from newer, lesser-known photographers. Uses 8×10 glossy b&w prints; also 35mm, 2¼×2¼, 4×5 and 8×10 transparencies. Prefers 2¼×2¼ transparencies or larger. Possibly accepts images in digital format for Mac. Submit via Zip disk. SASE. Reports in 1 month. Pays $55-250/color photo; $55-250/b&w photo. Credit line given. Buys one-time and all rights; negotiable. Simultaneous submissions and previously published work OK. Offers internships for photographers. Contact Photo Archivist: Tony Marinella.

Tips: Wants to see top-quality, natural history work. To break in, send only pre-edited photos.

‡**MUSIC SALES CORP.**, 257 Park Ave. S., New York NY 10010. (212)254-2100. Contact: Daniel Earley. Publishes instructional music books, song collections and books on music. Recent titles include: *Bob Dylan 30th Anniversary Concert Celebration*; *Stone Temple Pilots: Purple*; and *10,000 Maniacs: MTV Unplugged*. Photos used for cover and/or interiors.

Needs: Buys 200 photos annually. Present model release on acceptance of photo. Captions required.

Making Contact & Terms: Query first with résumé of credits. Provide business card, brochure, flier or tearsheet to be kept on file for possible future assignments. Uses 8×10 glossy prints; 35mm, 2×2 or 5×7 transparencies. SASE. Reports in 2 months. Pays $50-75/b&w photo, $250-750/color photo. Simultaneous submissions and previously published work OK.

Tips: In samples, wants to see "the ability to capture the artist in motion with a sharp eye for framing the

Portraits must reveal what makes the artist unique. We need rock, jazz, classical—on stage and shots. Please send us an inventory list of available stock photos of musicians. We rarely send ...ers on assignment and buy mostly from material on hand." Send "business card and tearsheets ...amped 'proof' across them. Due to the nature of record releases and concert events, we never ...tly when we may need a photo. We keep photos on permanent file for possible future use."

VE CAPABILITY, 62 Ridgelawn Dr. E., Mobile AL 36608. (334)343-6163. Fax: (334)344-8478. Editor: S. Walker. Estab. 1981. Publishes books of poetry, fiction, essays and articles. Photos used for text illustration, book covers and dust jackets. Examples of recently published titles: *Negative Capability* (journal) and *Little Dragons* (book).
Needs: Buys over 10 photos annually. Captions required.
Making Contact & Terms Interested in receiving work from newer, lesser-known photographers. Query with samples. Send unsolicited photos by mail for consideration. Provide résumé, business card, brochure, flier or tearsheets to be kept on file for possible future assignments. Uses 5×7 b&w prints. Keeps samples on file. SASE. Reports in 1 month. Pays in copies or by arrangement for covers. Credit line given. Buys one-time rights.

NEW LEAF PRESS, INC., Box 726, Green Forest AR 72638. (501)438-5288. Production Manager: Janell Robertson. Publishes adult trade, cooking, fiction of religious nature, catalogs and general trade. Photos used for book covers and dust jackets. Example of published title: *Moments for Friends*.
Needs: Buys 20 freelance photos annually. Landscapes, dramatic outdoor scenes, "anything that could have an inspirational theme." Reviews stock photos. Model release required. Captions preferred.
Making Contact & Terms: Query with samples and list of stock photo subjects. Does not assign work. Uses 35mm slides. SASE. Reports in 4-6 weeks. Pays $100-175/color photo and $50-100/b&w photo. Credit line given. Buys one-time and book rights. Simultaneous submissions and previously published work OK. "Not responsible for submitted slides and photos from queries. Please send copies, no originals unless requested."
Tips: In order to contribute to the company, send "quality, crisp photos." Trend in book publishing is toward much greater use of photography.

‡**NORTHLAND PUBLISHING**, P.O. Box 1389, Flagstaff AZ 86002. (520)774-5251. Fax: (520)774-0592. E-mail: rudy@northlandpub.com. Senior Designer: Rudy Ramos. Estab. 1966. Southwest themes—native American cowboy, hispanic culture—all in trade, juvenile, cookbooks, fiction. Photos used for text illustration, promotional materials, book covers and dust jackets. Examples of recently published titles: *Pronghorn* (cover/interior); *Mountains and Mesas* (cover/interior); and *Healthy Southwest Cooking* (interior).
Needs: Buys 10-50 photos annually; offers 6-8 freelance assignments annually. Looking for photos with creative interesting angles—"try not to use computer-aided material." Reviews stock photos of natural history. Model/property release required. Captions preferred.
Making Contact & Terms: Interested in receiving work from newer, lesser-known photographers. Query with samples. Works on assignment only. Uses 2¼×2¼, 4×5 transparencies. Keeps samples on file. SASE. Reports in 1-2 weeks. Payment negotiable. **Pays on receipt of invoice.** Credit line given. Buys one-time and all rights. Previously published work OK.
Tips: "We do not prefer to work with digital imagery, but will use digital information after an image is produced. Often we look for specific images, but we frequently have done a new book with an idea from a photographer."

THE OLIVER PRESS, Charlotte Square, 5707 W. 36th St., Minneapolis MN 55416-2510. (612)926-8981. Fax: (612)926-8965. Associate Editor: Teresa Faden. Estab. 1991. Publishes history books and collective biographies for the school and library market. Photos used for text illustration, promotional materials and book covers. Examples of published titles: *Women of the U.S. Congress* (9 freelance photos in the book, 1 on the back cover); *Women Who Reformed Politics* (7 freelance photos in the book); and *Amazing Archaeologists and Their Finds* (8 freelance photos in the book, 3 on the front cover).
Needs: Buys 15 freelance photos annually, but "we would like to increase this number." Photographs of people in the public eye: politicians, business people, activists, etc. Reviews stock photos. Captions re-

THE DIGITAL MARKETS INDEX, located in the back of this book, lists markets that use images electronically.

quired; include the name of the person photographed, the year, and the place/event at which the picture was taken.

Making Contact & Terms: Interested in receiving work from newer, lesser-known photographers. Query with stock photo list. Uses 8×10 glossy b&w prints. Keeps samples on file. SASE. Reports in 1 month. Pays $35-50/b&w photo. Pays on publication. Credit line given. Buys book rights, including the right to use photos in publicity materials; negotiable. Simultaneous submissions and previously published work OK.

Tips: "We are primarily interested in photographs of public officials, or people in other fields (science, business, law, etc.) who have received national attention. We are not interested in photographs of entertainers. Do not send unsolicited photos. Instead, send us a list of the major subjects you have photographed in the past."

C. OLSON & CO., P.O. Box 100-PM, Santa Cruz CA 95063-0100. (408)458-9004. E-mail: clayolson@a ol.com. Editor: C. L. Olson. Estab. 1977. Examples of published titles: *World Health; Carbon Dioxide & the Weather* (cover).

Needs: Uses 2 photos/year—b&w or color; all supplied by freelance photographers. Photos of fruit and nut trees (in blossom or with fruit) in public access locations like parks, schools, churches, streets, businesses. "You should be able to see the fruits up close with civilization in the background." Also needs photos of people under stress from loud noise, photos relating to male circumcision, photos showing people (children and/or adults) wounded in war. Model/property release required for posed people and private property. Captions preferred.

Making Contact & Terms: Interested in receiving work from newer, lesser-known photographers. Query with samples. SASE, plus #10 window envelope. Reports in 2 weeks. Payment negotiable. Pays on acceptance or publication. Credit line given on request. Buys all rights. Simultaneous submissions and previously published work OK.

Tips: Open to both amateur and professional photographers. "To ensure that we buy your work, be open to payment based on a royalty for each copy of a book we sell."

‡OUTDOOR EMPIRE PUBLISHING, INC., Box C-19000, Seattle WA 98109. (206)624-3845. Art Director: Maggie Sellars. Publishes how-to, outdoor recreation and large-sized paperbacks. Photos used for text illustration, promotional materials, book covers and newspapers.

Needs: Buys 6 photos annually; offers 2 freelance assignments annually. Wildlife, hunting, fishing, boating, outdoor recreation. Model release preferred. Captions preferred.

Making Contact & Terms: Query with samples or send unsolicited photos by mail for consideration. Provide résumé, business card, brochure, flier or tearsheets to be kept on file for possible future assignments. Works on assignment only. Uses 8×10 glossy b&w and color prints; 35mm, $2\frac{1}{4} \times 2\frac{1}{4}$ and 4×5 transparencies. SASE. Reports in 3 weeks. Payment "depends on situation/publication." Credit line given. Buys all rights. Simultaneous submissions OK.

Tips: Prefers to see slides or contact sheets as samples. "Be persistent; submit good quality work. Since we publish how-to books, clear informative photos that tell a story are very important."

RICHARD C. OWEN PUBLISHERS, INC., P.O. Box 585, Katonah NY 10536. (914)232-3903. Fax: (914)232-3977. Editor (Children's Books): Janice Boland. Editor (Professional Books): Amy Haggblom. Publishes picture/storybook fiction and nonfiction for 5- to 7-year-olds; author autobiographies for 7- to 10-year-olds; professional books for educators. Photos used for text illustration, promotional materials and book covers of professional books. Examples of recently published titles: *Meet the Author; Books for Young Learners* (children's).

Needs: Number of photos bought annually varies; offers 3-10 freelance assignments annually. Needs unposed people shots and nature photos that suggest storyline. "For children's books, must be child-appealing with rich, bright colors and scenes, no distortions or special effects. For professional books, similar, but often of classroom scenes, including teachers. Nothing posed, should look natural and realistic." Reviews stock photos of children involved with books and classroom activities, age ranging from kindergarten to sixth grade, "not posed or set up, not portrait type photos. Realistic!" Model release required for children and adults. Children (under the age of 21) must have signature of legal guardian. Property release preferred. Captions required. Include "any information we would need for acknowledgements, including if special permission was needed to use a location."

Making Contact & Terms: Interested in receiving work from newer, lesser-known photographers. Submit portfolio by mail for review. Provide résumé, business card, brochure, flier, or tearsheets to be kept on file for possible future assignments. Include a cover letter with name, address, and daytime phone number, and indicate *Photographer's Market* as a source for correspondence. Works with freelancers on assignment only. "For samples, we like to see any size color prints (or color copies). For materials that are to be used, we need 35mm mounted transparencies. We usually use full-color photos." Keeps samples

on file "if appropriate to our needs." Reports in 1 month. Pays $50-150/color photo; $500-2,000/job; $400/day (2-day maximum). "Each job has its own payment rate and arrangements." **Pays on acceptance.** Credit line given sometimes, depending on the project. "Photographers' credits appear in children's books, and in professional books, but not in promotional materials for books or our company." For children's books, publisher retains ownership, possession and world rights, and applies to first and all subsequent editions of a particular title, and to all promotional materials. Simultaneous submissions OK.

Tips: Wants to see "real people in natural, real life situations. No distortion or special effects. Bright, clear images with jewel tones and rich colors. Keep in mind what would appeal to children. Be familiar with what the publishing company has already done. Listen to the needs of the company."

PAPIER-MACHÉ PRESS, 627 Walker St., Watsonville CA 95076. (408)763-1420. Fax: (408)763-1421. Acquisitions Editor: Shirley Coe. Estab. 1984. Publishes adult trade paperbacks and hardcovers focusing on issues of interest to midlife and older women and for men and women on aging. Photos used for text illustration and promotional materials. Examples of published titles: *When I Am an Old Woman I Shall Wear Purple* (19 photos); *If I Had My Life to Live Over I Would Pick More Daisies* (17 photos); and *Time for Love* (6 photos). "Guidelines for current theme anthologies are available with #10 SASE."

Needs: Buys 20-40 photos annually. Human interest, usually women in "doing" role; sometimes couples, families, etc. Sometimes reviews stock photos. Model/property release preferred. "Generally we do not caption photos except for photographer's name."

Making Contact & Terms: Interested in receiving work from newer, lesser-known photographers. Query with samples (including photocopies). Provide résumé, business card, brochure, flier or tearsheets to be kept on file for possible future assignments. Uses 8×10 semigloss b&w prints. Keeps samples on file. SASE. Reports in 3-6 months. Pays $25-50/b&w photo; $300-500/job; photographers also receive "copies of books, generous discount on books." Credit line given. Buys one-time rights and rights to use photos in promo material for books, e.g. fliers, ads, etc.; negotiable. Simultaneous submissions and previously published work OK.

Tips: "We are generally looking for photos to complement a specific theme anthology or poetry collection. It is essential for photographers to know what those current themes are."

PELICAN PUBLISHING CO., 1101 Monroe St., Gretna LA 70053. (504)368-1175. Fax: (504)368-1195. Production Manager: Tracey Clements. Publishes adult trade, juvenile, textbooks, how-to, cooking, fiction, travel, science and art books. Photos used for book covers. Examples of published titles: *Maverick Hawaii* (cover), *Maverick Berlin* and *Coffee Book*.

Needs: Buys 8 photos annually; offers 3 freelance assignments annually. Wants to see travel (international) shots of locations and people and cooking photos of food. Reviews stock photos of travel subjects. Model/property release required. Captions required.

Making Contact & Terms: Interested in receiving work from newer, lesser-known photographers. Query with stock photo list. Provide résumé, business card, brochure, flier or tearsheets to be kept on file for possible future assignments. Uses 8×10 glossy color prints; 35mm, 4×5 transparencies. Keeps samples on file. SASE. Reports as needed. Pays $100-500/color photo; negotiable with option for books as payment. **Pays on acceptance.** Credit line given. Buys one-time rights and book rights; negotiable.

Tips: "Be flexible on price. Keep publisher up on new materials."

THE PHOTOGRAPHIC ARTS CENTER, 163 Amsterdam Ave., #201, New York NY 10023. (212)838-8640. Fax: (212)873-7065. Publisher: Robert S. Persky. Estab. 1980. Publishes books on photography and art, emphasizing the business aspects of being a photographer, artist and/or dealer. Photos used for book covers. Examples of recently published titles: *Publishing Your Art as Cards, Posters & Calendars* (cover illustration); *The Photographer's Complete Guide to Getting & Having an Exhibition*; and *Creating Successful Advertising* (text illustration).

Needs: Business of photography and art. Model release required.

Making Contact & Terms: Query with samples and text. Uses 5×7 glossy b&w or color prints; 35mm transparencies. SASE. Reports in 3 weeks. Pays $25-100/b&w and color photos. Credit line given. Buys one time rights.

Tips: Sees trend in book publishing toward "books advising photographers how to maximize use of their images by finding business niches such as gallery sales, stock and cards and posters." In freelancer's submissions, looks for "manuscript or detailed outline of manuscript with submission."

PLAYERS PRESS INC., P.O. Box 1132, Studio City CA 91614. Vice President: David Cole. Estab. 1965. Publishes entertainment books including theater, film and television. Photos used for text illustration, promotional materials, book covers and dust jackets. Examples of recently published titles: *Period Costume for Stage and Screen: Medieval-1500*; *Men's Garments 1830-1900*; and *Clown Tales*.

Needs: Buys 50-1,000 photos annually. Needs photos of entertainers, actors, directors, theaters, produc-

tions, actors in period costumes, scenic designs and clowns. Reviews stock photos. Model release required for actors, directors, productions/personalities. Photo captions preferred for names of principals and project/production.

Making Contact & Terms: Interested in receiving work from newer, lesser-known photographers. Query with list of stock photo subjects. Send unsolicited photos by mail for consideration. Uses 8×10 glossy or matte b&w prints; 5×7 glossy color prints; 35mm, $2\frac{1}{4} \times 2\frac{1}{4}$ transparencies. SASE. Reports in 3 weeks. Pays $100 maximum/color photo; $100 maximum/b&w photo. Credit line sometimes given, depending on book. Buys all rights; negotiable in "rare cases." Simultaneous submissions and previously published work OK.

Tips: Wants to see "photos relevant to the entertainment industry. Do not telephone; submit only what we ask for."

‡♥**POLESTAR BOOK PUBLISHERS**, 1011 Commercial Dr., 2nd Floor, Vancouver, British Columbia V5L 3X1 Canada. (604)251-9718. Fax: (604)251-9738. E-mail: polestar@direct.ca. Publisher: Michelle Benjamin. Estab. 1981. Publishes sports, fiction, poetry, junior/YA fiction. Photos are used for book covers and dust jackets. Examples of recently published titles: *Cadillac Kind* (covers); *Long Shot* (text, illustration); and *Celebrating Excellence* (text and cover).

Needs: Buys 50 photos annually. Reviews stock photos of sports and general. Model/property release preferred.

Making Contact & Terms: Interested in receiving work from newer, lesser-known photographers. Provide résumé, business card, brochure, flier or tearsheets to be kept on file for possible future assignments. Uses color and b&w prints; 35mm, $2\frac{1}{4} \times 2\frac{1}{4}$ transparencies; digital format. Keeps samples on file. SAE and IRC. Pays $20-300/color photo; $20-100/b&w photo. Pays on publication. Credit line given. Buys book rights; negotiable. Simultaneous submissions and/or previously published work OK.

PRAKKEN PUBLICATIONS, INC., 275 Metty Dr., Suite 1, P.O. Box 8623, Ann Arbor MI 48107. (313)769-1211. Fax: (313)769-8383. Production & Design Manager: Sharon K. Miller. Estab. 1934. Publishes *The Education Digest* (magazine), *Tech Directions* (magazine for technology and vocational/technical educators), text and reference books for technology and vocational/technical education and general education reference. Photos used for text illustration, promotional materials, book covers, magazine covers and text. Examples of published titles: *Chisels on a Wheel: Modern Woodworking Tools and Materials* (cover and text, marketing); *Managing the Occupational Education Laboratory* (text and marketing); and *The Education Digest, Tech Directions* (covers and marketing). No photo guidelines available.

Needs: Education "in action" and especially technology and vocational-technical education. Photo captions necessary; scene location, activity.

Making Contact & Terms: Query with samples. Send unsolicited photos by mail for consideration. Uses any size image and all media. Keeps sample on file. SASE. Payment negotiable. Methods of payment to be arranged. Credit line given. Rights negotiable.

Tips: Wants to see "experience in education and knowledge of high-tech equipment" when reviewing portfolios. Send inquiry with relevant samples to be kept on file. "We buy very few freelance photographs."

PROSTAR PUBLICATIONS LTD., 13468 Beach Ave., Marina del Rey CA 90292. (310)577-1975. Fax: (310)577-9272. Editor: Peter L. Griffes. Estab. 1989. Publishes how-to, nonfiction. Photos used for book covers. Examples of published titles: *Pacific Boating Almanac* (aerial shots of marinas); and *Pacific Northwest Edition*. Photo guidelines free with SASE.

Needs: Buys less than 100 photos annually; offers very few freelance assignments annually. Reviews stock photos of nautical (sport). Model/property release required. Captions required.

Making Contact & Terms: Interested in receiving work from newer, lesser-known photographers. Query with stock photo list. Uses color and b&w prints. Does not keep samples on file. SASE. Reports in 1 month. Pays $10-50/color or b&w photo. Pays on publication. Credit line given. Buys book rights; negotiable. Simultaneous submissions and previously published work OK.

*****QUARTO PUBLISHING PLC.**, 6 Blundell St., London N7 9BH England. (0171)700-6700. Fax: (0171)700-4191. Contact: Picture Manager. Publishes nonfiction books on a wide variety of topics including art, craft, natural history, home and garden and reference. Photos used for text illustration. Examples of recently published titles: *Birdhouses Around the World*; *Amazing Bugs*; *Great Battlefields Then and Now*; and *Regional Cuisine: Normandy*. Photo guidelines free when projects come up.

‡ **MARKETS NEW TO THIS EDITION** are marked with a double dagger.

Needs: Buys 1,000 photos annually. "Subjects depend on books being worked on." Model/property release required. Photo captions required; include full details of subject and name of photographer.

Making Contact & Terms: Interested in receiving work from newer, lesser-known photographers. Provide résumé, business card, brochure, flier or tearsheets to be kept on file for future reference. Uses all types of prints. Pays $30-60/b&w photo; $60-100/color photo. Pays on publication. Credit line given. Buys one-time rights; negotiable. Simultaneous submissions and/or previously published work OK.

Tips: "Be prepared to negotiate!"

❦REIDMORE BOOKS INC., 10109 106th St., Suite 1200, Edmonton, Alberta T5J 3L7 Canada. (403)424-4420. Fax: (403)441-9919. E-mail: reidmore@compusmart.ab.ca. Website: http://www.reidmore.com. Contact: Visuals Editor. Estab. 1979. Publishes textbooks for K-12; textbooks published cover all subject areas. Photos used for text illustration and book covers. Examples of recently published titles: *The Northern Circumpolar World*; *Japan: Its People and Culture,* 2nd edition; and *Beginnings: From the First Nations to the Great Migration.* Photo guidelines available.

Needs: Buys 250 photos annually; offers 1-3 freelance assignments annually. "Photo depends on the project, however, images should contain unposed action." Reviews stock photos. Model/property release preferred. Captions required; "include scene description and photographer's control number."

Making Contact & Terms: Interested in receiving work from newer, lesser-known photographers. Query with résumé of credits. Query with samples. Query with stock photo list. Provide résumé, business card, brochure, flier or tearsheets to be kept on file for possible future assignments. Accepts images in digital format for Mac (Photoshop, Illustrator, QuarkXPress). Keeps samples of tearsheets, etc. on file. Cannot return material. Reports in 1 month. Pays $50-200/color photo; $50-200/b&w photo. Credit line given. Buys one-time rights and book rights; negotiable. Simultaneous submissions and previously published work OK.

Tips: "I look for unposed images which show lots of action. Please be patient when you submit images for a project. The editorial process can take a long time and it is in your favor if your images are at hand when last minute changes are made."

‡REIMAN PUBLICATIONS, L.P., 5400 S. 60th St., Greendale WI 53129. (414)423-0100. Fax: (414)423-8463. Photo Coordinator: Trudi Bellin. Estab. 1965. Publishes adult trade—cooking, people-interest, country themes. Examples of recently published titles: *This Old Barn* (covers, text illustration); *A Day in the Life of the Amish* (covers, text illustration); and *From Flappers to Flivvers* (covers, text illustration).

Needs: Buys "hundreds" of photos/annually. Looking for vintage color photos; nostalgic b&w photos, and colorful, sharp-focus agricultural, scenic and backyard beauty photos. Reviews stock photos of nostalgia, agriculture, rural, scenics, birds, flowers and flower gardens. Model/property release required for children and private homes. Photo captions preferred; include season, location, era (when appropriate).

Making Contact & Terms: Query with résumé of credits. Query with stock photo list. Send unsolicited photos by mail for consideration. Uses color and b&w prints; 35mm, $2\frac{1}{4} \times 2\frac{1}{4}$, 4×5, 8×10 transparencies. Keeps samples on file ("tearsheets; no duplicates"). SASE. Reports in 3 months for first review. Pays $75-300/color photo; $25-100/b&w photo. Pays on publication. Credit line given. Buys one-time rights. Simultaneous submissions and previously published work OK.

Tips: "Our nostalgic books need authentic color taken in the '40s, '50s, and '60s and b&w stock photos. All projects require technical quality: focus must be sharp, no soft focus; colors must be vivid so they 'pop off the page.' "

THE ROSEN PUBLISHING GROUP, INC., 29 E. 21st St., New York NY 10010. (212)777-3017. Fax: (212)777-0277. E-mail: rosenpub@tribeca.ios.com. Art Director: Kim Sonsky. Estab. 1950. Publishes juvenile and young adult nonfiction books. Photos used for text illustration and book covers. Examples of recently published titles: *Drugs and Your Friends*; *Everything You Need to Know About Sports Injuries*; and *Let's Talk About Your Parents' Divorce.*

Neeeds: Buys 2,000 photos annually; offers 80-100 freelance assignments annually. Needs photos of teens or juveniles in coping and self-help situations; also religious photos. Reviews stock photos. Model release required for subjects in photo. Captions preferred.

Making Contact & Terms: Interested in receiving work from newer, lesser-known photographers. Arrange personal interview to show portfolio. Query with résumé of credits. Provide résumé, business card, brochure, flier or tearsheets to be kept on file for possible future assignments. Works with freelancers on assignment only. Buys 5×7, 8×10 color and b&w prints; 35mm, $2\frac{1}{4} \times 2\frac{1}{4}$ transparencies; 35mm or medium format film. Keeps samples on file. SASE. Reports in 1-2 weeks. Pays $250-1,000/job. **Pays on acceptance**. Credit line given. Buys all rights; negotiable. Simultaneous submissions and previously published work OK.

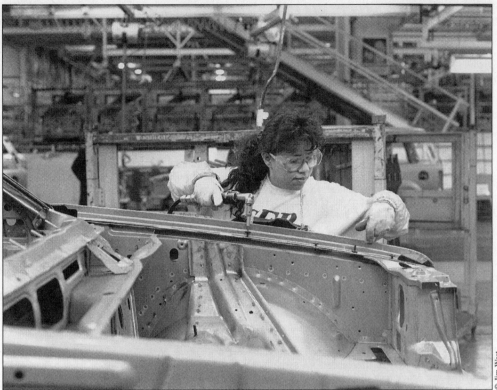

© Jim West

Jim West took this photo of a Latina worker on the assembly line at Chrysler's Jefferson North Assembly plant in Detroit during a tour for journalists. He's since sold it about half a dozen times. Salem Press used it in their *Latino Encyclopedia* to illustrate an article on affirmative action. "This photo is very representative of the concept and application of affirmative action," says Salem Press Photo Editor Mark Rehn. West feels his sale to Salem shows the value of specializing. "Most of my photography deals with labor and social issues. The fact that I have a large number of images in their subject area probably makes Salem Press more willing to call me and send want lists for their projects. Although their pay per photo is low, Salem often buys six, eight, ten or more per project, making it financially worthwhile to work for them, while it would not be for just an occasional isolated sale."

‡**SALEM PRESS**, 131 N. El Molino Ave., Suite 350, Pasadena, CA 91101. Photo Editor: Mark Rehn. Associate Photo Editor: Karrie Hyatt. Publisher of reference sets, encyclopedic series, history, science, social science, literary, biography. Examples of recently published titles: *Ready Reference: Women's Issues*; *Great Events from History: North America*; *The Twentieth Century: Great Scientific Achievement*.
Needs: Varied. Primarily people/event-oriented shots related to American social issues, including minority and multicultural photos. Model release preferred.
Making Contact & Terms: Query with stock photo list. "When sending stock lists, please be as detailed as possible regarding your holdings. Notate any areas of specialty or out-of-the-ordinary shots." The vast majority of photos used are b&w 8×10 shots, with the use of color photos on rare occasion. Accepts images in digital format for Windows (GIF, JPEG). Send via compact disc or floppy disk. Pays $75-100/color photo; $30-50/b&w photo. Credit lines will appear with the photo and/or as a contributor list at the beginning or end of the publication. Rights are primarily one-time, North American. Simultaneous submissions and/or previously published work OK.
Tips: Looks for "clarity, composition, unposed/natural looks." Experienced photo researchers in major metropolitan areas will also be considered.

‡**SILVER MOON PRESS**, 160 Fifth Ave., Suite 622, New York NY 10010. (212)242-6499. Fax: (212)242-6799. Editor: David Katz. Estab. 1991. Publishes juvenile fiction and general nonfiction. Photos used for text illustration, book covers, dust jackets. Examples of published titles: *Police Lab* (interiors); *Drums at Saratoga* (interiors); *A World of Holidays* (interiors).
Needs: Buys 5-10 photos annually; offers 1 freelance assignment annually. Looking for general children,

subject-specific photos. Reviews general stock photos. Captions preferred.

Making Contact & Terms: Interested in receiving work from newer, lesser-known photographers. No samples. Provide résumé, business card, brochure, flier or tearsheets to be kept on file for possible future assignments. Uses vary greatly. Keeps samples on file. SASE. Reports in 1 month. Pays $25-100/b&w photo. Pays on publication. Credit line given. Buys all rights; negotiable. Simultaneous submissions and/ or previously published works OK.

‡**THE SPEECH BIN INC.**, 1965 25th Ave., Vero Beach FL 32960. (561)770-0007. Fax: (561)770-0006. Senior Editor: Jan J. Binney. Estab. 1984. Publishes textbooks and instructional materials for occupational and physical therapists, speech-language pathologists, audiologists and special educators. Photos used for book covers, instructional materials and catalogs. Example of published title: *Talking Time* (cover); also catalogs.

Needs: Scenics are currently most needed photos. Also needs children; children with adults; school scenes; elderly adults; handicapped persons of all ages. Model release required.

Making Contact & Terms: Interested in receiving work from newer, lesser-known photographers. Provide résumé, business card, brochure, flier or tearsheets to be kept on file for possible future assignments. Works on assignment plus purchases stock photos from time to time. Uses 8×10 glossy b&w prints. Full-color scenics for catalog. SASE. Reports in 3 weeks. Payment negotiable. Credit line given. Buys all rights; negotiable. Previously published work OK.

SPINSTERS INK, 3201 Columbus Ave. S., Minneapolis MN 55407-2030. (612)827-6177. Fax: (612)827-4417. E-mail: tufte004@gold.tc.umn.edu. Production Manager: Liz Tufte. Estab. 1978. Publishes feminist books by women. Photos used for book covers. Example of recently published title: *Give Me Your Good Ear* (cover). Photo guidelines free on request.

Needs: Buys 1 photo annually; offers 6 freelance assignments annually. Wants positive images of women in all their diversity. "We work with photos of women by women." Model release required. Captions preferred.

Making Contact & Terms: Interested in receiving work from newer, lesser-known photographers. Query with samples. Works with freelancers on assignment only. Uses 5×7, 8×10 color or b&w prints; 4×5 transparencies; Macintosh disk; 88 or 44mb SyQuest; photo CD. Keeps samples on file. SASE. Reports in 3 weeks. Pays $150-250/job. **Pays on acceptance.** Credit line given. Buys book rights; negotiable. Simultaneous submissions OK.

Tips: "Spinsters Ink books are produced electronically, so we prefer to receive a print as well as a digital image when we accept a job. Please ask for guidelines before sending art."

STAR PUBLISHING COMPANY, 940 Emmett Ave., Belmont CA 94002. (415)591-3505. Fax: (415)591-3898. E-mail: hoffman@starpublishing.com. Website: http://www.starpublishing.com. Managing Editor: Stuart Hoffman. Estab. 1978. Publishes textbooks, regional history, professional reference books. Photos used for text illustration, promotional materials and book covers. Examples of recently published titles: *Applied Food Microbiology* and *Medical Mycology.*

Needs: Biological illustrations, photomicrographs, business, industry and commerce. Reviews stock photos. Model release required. Captions required.

Making Contact & Terms: Query with samples and list of stock photo subjects. Provide résumé, business card, brochure, flier or tearsheets to be kept on file for possible future assignments. Uses 5×7 minimum b&w and color prints; 35mm transparencies. SASE. Reports within 90 days when a response is appropriate. Payment negotiable "depending on publication, placement and exclusivity." Credit line given. Buys one-time rights; negotiable. Previously published submissions OK.

Tips: Wants to see photos that are technically (according to book's subject) correct, showing photographic excellence.

STRANG COMMUNICATIONS COMPANY, 600 Rinehart Rd., Lake Mary FL 32746. (407)333-0600. Fax: (407)333-7100. E-mail: markp@strang.mhs.compuserve.com. Design Assistant: Donna Morano. Estab. 1975. Publishes religious magazines and books for Sunday School and general readership. Photos used for text illustration, promotional materials, book covers and dust jackets. Examples of recently published titles: *Charisma Magazine*; *New Man Magazine*; *Ministries Today Magazine*; and *Vida Cristiana* (all editorial, cover). Photo guidelines free with SASE.

Needs: Buys 50-75 photos annually; offers 50-75 freelance assignments annually. People, environmental portraits, situations. Reviews stock photos. Model/property release preferred for all subjects. Captions preferred; include who, what, when, where.

Making Contact & Terms: Interested in receiving work from newer, lesser-known photographers. Arrange personal interview to show portfolio. Submit portfolio for review. Query with samples. Provide résumé, business card, brochure, flier or tearsheets to be kept on file for possible future assignments. Call

and arrange to send portfolio. Works with freelancers on assignment only. Uses 8×10 prints; 35mm, $2\frac{1}{4} \times 2\frac{1}{4}$, 4×5 transparencies. Accepts photographs in digital format for Mac (Photoshop). Send via compact disc, online, floppy disk, SyQuest or Zip disk. Keeps samples on file. SASE. Pays $5-75/b&w photo; $50-550/color photo; negotiable with each photographer. Pays on publication and receipt of invoice. Credit line given. Buys one-time, first-time, book, electronic and all rights; negotiable. Simultaneous submissions and previously published work OK. Offers internships for photographers. Contact Design Manager: Mark Poulalion.

Tips: "Be flexible. Listen to the needs of the client and cultivate a long-term relationship."

♣**THISTLEDOWN PRESS LTD.**, 633 Main St., Saskatoon, Saskatchewan S7H 0J8 Canada. (306)244-1722. Fax: (306)244-1762. Director of Production: A.M. Forrie. Publishes adult/young adult fiction and poetry. Photos used for text illustration, promotional materials, book covers.

Needs: Looking for realistic color or b&w photos.

Making Contact & Terms: Query with samples. Include SAE and IRCs. "Project oriented—rates negotiable."

‡**THORSON & ASSOCIATES**, P.O. Box 94135, Washington MI 48094. (810)781-0907. New Product Development: Timothy D. Thorson. Estab. 1988. Technical publisher and book producer creating trade and specialized projects for a variety of clients.

- This publisher is very interested in photographers with multimedia experience such as CD-ROM, Macromedia Director, etc.

Needs: Offers 2-3 freelance assignments annually. Needs aviation/military, automotive and architectural subjects. Reviews stock photos of aviation/military, automotive, architecture and the arts. Captions preferred; include subject, location, rights offered.

Making Contact & Terms: Interested in receiving work from newer, lesser-known photographers. Query with stock photo list. Provide résumé, business card, brochure, flier or tearsheets to be kept on file for possible future assignments. Works on assignment only. Keeps samples on file. SASE. Reports in 1 month. Payment negotiable. Pays on usage. Credit line sometimes given depending upon customer. Rights vary based on project; negotiable.

Tips: "We need reliable, self-motivated photographers to provide photos for assigned books in a wide range of fields. Thorson & Associates is also open to original book proposals suggested by a photographer's work or experience; special access to museums or collections, collections of old aircraft, military equipment, classic automobiles, or significant historical buildings. I anticipate a considerable increase in our needs over the next 12-24 months."

‡**TRANSPORTATION TRAILS**, 9698 W. Judson Rd., Polo IL 61064. (815)946-2343. Editor: Larry Plachno. Estab. 1977. Publishes historical transportation titles. Photos used for text illustration, promotional materials, book covers, dust jackets and condensed articles in magazines. Examples of published titles: *The Longest Interurban Charter* (text and cover); *Sunset Lines—The Story of The Chicago Aurora & Elgin Railroad* (text); *The Steam Locomotive Directory of North America* (text).

Needs: Buys over 500 photos annually. Transportation, mainly bus or interurban, mainly historical.

Making Contact & Terms: Query with samples of historical transportation photos. Uses glossy b&w prints; 35mm transparencies. SASE. Reports in 1 week. Rates vary depending on needs; $2.50-150/b&w photo. Credit line given. Buys one-time, book and all rights; negotiable. Simultaneous submissions and previously published work OK.

Tips: In photographer's samples, "quality is not as important as location and date." Looks for "historical photos of buses and interurbans. Don't bother us with photos less than 30 years old."

TRUTH CONSCIOUSNESS/DESERT ASHRAM, 3403 W. Sweetwater Dr., Tucson AZ 85745-0384. (520)743-8821. Editor: Sita Stuhlmiller. Estab. 1974. Publishes books and a periodical, *Light of Consciousness, A Journal of Spiritual Awakening*.

Needs: Buys/assigns about 45 photos annually. Looking for people in prayer or meditation, "universal spiritual, all traditions that in some way illustrate or evoke upliftment, reverence, devotion or other spiritual qualities." Art is used that relates to or supports a particular article.

Making Contact & Terms: Send b&w and color slides, cards, prints. Include self-addressed, stamped mailer for return of work. Payment negotiable; prefers gratis. Model release preferred. Captions preferred. Credit line given; also, artist's name/address/phone (if wished) printed in separate section in magazine.

‡**2M COMMUNICATIONS LTD.**, 121 W. 27 St., New York NY 10001. (212)741-1509. Fax: (212)691-4460. President: Madeleine Morel. Estab. 1982. Publishes adult trade biographies. Photos used for text illustration. Examples of previously published titles: *Diane Keaton, Magic and the Bird* and *The Princess and the Duchess;* all for text illustration.

Needs: Buys approximately 200 photos annually. Candids and publicity. Reviews stock photos. Model release required. Captions preferred.
Making Contact & Terms: Query with stock photo list. Uses b&w prints; 35mm transparencies. Reports in 1 month. Payment negotiable. Credit line given. Buys one-time, book and world English language rights. Simultaneous submissions OK.

‡**ULYSSES PRESS**, P.O. Box 3440, Berkeley CA 94703. (510)601-8301. Fax: (510)601-8307. Publisher: Leslie Henriques. Estab. 1983. Publishes trade paperbacks, including travel guidebooks and health books. Photos used for book covers. Examples of previously published titles: *Hidden Hawaii* (cover photos on front and back); *New Key to Costa Rica* (color signature) and *Hidden Southwest* (cover photos).
• Ulysses Press has more than doubled its freelance photo needs.
Needs: Buys hundreds of photos annually. Wants scenic photographs of destinations covered in guidebooks and covers for health books. Some use of portraits for back cover. Model release required. Property release preferred.
Making Contact & Terms: Interested in receiving work from newer, lesser-known photographers. Query with stock photo list. Provide résumé, business card, brochure, flier or tearsheets to be kept on file for possible future assignments. Uses 35mm, 2¼×2¼ transparencies. Accepts images in digital format for Windows. Send via compact disc or Zip disk. Does not keep samples on file. Cannot return material. Reports as needed. Payment depends on placement and size of photo: $150-350 non-agency color photo. Pays on publication. Credit line given. Buys one-time rights. Simultaneous submissions and previously published work OK.

U.S. NAVAL INSTITUTE, 118 Maryland Ave., Annapolis MD 21402. (410)268-6110. Fax: (410)269-7940. Contact: Photo Editor. Estab. 1873. Publishes naval and maritime subjects, novels. Photos used for text illustration, promotional materials, book covers and dust jackets. Examples of published titles: *The Hunt for Red October* (book cover); *The U.S.N.I. Guide to Combat Fleet* (70% photos); and *A Year at the U.S. Naval Academy* (tabletop picture book). Photo guidelines free with SASE.
Needs: Buys 240 photos annually; offers 12 freelance assignments annually. "We need dynamic cover-type images that are graphic and illustrative." Reviews stock photos. Model release preferred. Captions required.
Making Contact & Terms: Interested in receiving work from newer, lesser-known photographers. Query with résumé of credits. Uses 8×10 glossy color and b&w prints; 35mm, 2¼×2¼, 4×5, 8×10 transparencies. Keeps samples on file. SASE. Reports in 1-2 weeks. Pays $25-200/color and b&w photos. Pays on publication or receipt of invoice. Credit line given. Buys one-time rights; negotiable. Simultaneous submissions and previously published work OK.
Tips: "Be familiar with publications *Proceedings* and *Naval History* published by U.S. Naval Institute."

UNITY SCHOOL OF CHRISTIANITY, 1901 NW Blue Pkwy., Unity Village MO 64065-0001. (816)524-3550. Fax: (816)251-3552. Product Publicist: Terri Springer. Estab. 1889. Publishes books on adult and juvenile spirituality, *Unity Magazine* and *Daily Word Magazine*. Photos used for book and magazine covers, audio packaging, dust jackets. Examples of recently published titles: *Creating Healthier Relationships*; *UP Thoughts for Down Moments*; and *Open the Doors to Your Soul* (all audio packaging).
Needs: Buys 10 photos annually for book covers and hundreds of photos annually for magazine covers. Needs inspirational photos of happy people, landscapes, nature, etc. Reviews stock photos. Model/property release is required for individuals and identifiable institutions or locations. Captions preferred.
Making Contact & Terms: Interested in receiving work from newer, lesser-known photographers. Query with stock photo list. Provide résumé, business card, brochure, flier or tearsheets to be kept on file for possible future assignments. Prefers 35mm, 2¼×2¼, 4×5 transparencies. Keeps samples on file. SASE. Reports in 1 month. Payment negotiable. **Pays on receipt of invoice.** Credit line given. Rights negotiable. Simultaneous submissions and previously published work OK.

UNIVELT, INC., P.O. Box 28130, San Diego CA 92198. (619)746-4005. Manager: Robert H. Jacobs. Estab. 1970. Publishes technical books on astronautics. Photos used for text illustration, book covers and

MARKET CONDITIONS are constantly changing! If you're still using this book and it's 1999 or later, buy the newest edition of *Photographer's Market* at your favorite bookstore or order directly from Writer's Digest Books.

dust jackets. Examples of recently published titles: *History of Rocketry and Astronautics* and *Strategies for Mars: A Guide to Human Exploration*.

Needs: Uses astronautics; most interested in photographer's concept of space, and photos depicting space flight and related areas. Reviews stock photos; space related only. Captions required.

Making Contact & Terms: Generally does not use freelance photos. Call before submitting. Uses 6×9 or $4\frac{1}{2} \times 6$ b&w photos. Reports in 1 month. Pays $25-100/b&w photo. Credit line given, if desired. Buys one-time rights. Simultaneous submissions and previously published work OK.

Tips: "Photos should be suitable for front cover or frontispiece of space books."

VERNON PUBLICATIONS INC., 3000 Northup Way, Suite 200, Bellevue WA 98004. Fax: (206)822-9372. Editorial Director: Michele A. Dill. Estab. 1960. Publishes travel guides, a travel magazine for RVers, relocation guides, homeowner guides. Photos used for text illustration, promotional materials and book covers. Examples of published titles: *The Milepost*; *RV West* (magazine); and *Info Guide* (annual guide). Photo guidelines free with SASE, specify which publication you want guidelines for.
● This publisher likes to see high-resolution, digital images.

Needs: Buys 200-300 photos annually. Model release required. Property release preferred. Captions required; include place, time, subject, and any background information.

Making Contact & Terms: Interested in receiving work from newer, lesser-known photographers. Query with samples. "Tearsheets or duplicates are fine for queries. Don't send originals." Provide résumé, business card, brochure, flier or tearsheets to be kept on file for possible future assignments. Include SASE for return. Uses b&w prints; 35mm, $2\frac{1}{4} \times 2\frac{1}{4}$ transparencies. SASE. Reporting time varies. Payment negotiable. Pays on publication. Credit line given. Buys one-time, book and all rights; negotiable. Simultaneous submissions and previously published work OK; however, it depends on where the images were previously published.

VICTOR BOOKS, 1825 College Ave., Wheaton IL 60187. (630)260-6472. Fax: (603)668-3806. Senior Graphic Designer: Scott Rattray. Estab. 1934. Publishes CBA trade fiction, nonfiction, children's juvenile and reference books. Photos used for book covers and dust jackets. Examples of recently published titles: *Rediscovering the Soul of Leadership*, *Desert Water* and *Truth Seed Series*.

Needs: Buys 20 photos annually; offers 20 freelance assignments annually. Creative concepts, people, backgrounds. Reviews stock photos. Model/property relese required.

Making Contact & Terms: Submit portfolio for review. Query with stock photo list. Uses $2\frac{1}{4} \times 2\frac{1}{4}$, 4×5 transparencies. Keeps samples on file. Reports in 1-2 weeks. Payment negotiable. **Pays on receipt of invoice.** Credit line given. Buys book rights.

Tips: "Keep subject matter simple and with cutting edge style."

VICTORY PRODUCTIONS, 581 Pleasant St., Paxton MA 01612. (508)755-0051. Fax: (508)755-0025. E-mail: victoryprod@aol.com. Website: http://members.aol.com/victoryprod. Contact: S. Littlewood. Publishes children's books. Examples of recently published titles: a children's reference book (36mm, $4\frac{1}{4}$ and 4×5); and a 6-volume encyclopedia (36mm).

Needs: Children and animals. Model/property release required.

Making Contact & Terms: Interested in receiving work from newer, lesser-known photographers. Provide résumé, business card, brochure, flier or tearsheets to be kept on file for possible future assignments. Works on assignment only. Accepts images in digital format for Mac. Send via compact disc, online, floppy disk, SyQuest or Zip disk. Keeps samples on file. Reports in 1-2 weeks. Payment negotiable; varies by project. Credit line usually given, depending upon project. Rights negotiable.

VOYAGEUR PRESS, 123 N. Second St., Stillwater MN 55082. Fax: (612)430-2211. E-mail: books@voyageurpress.com. Editor: Todd R. Berger. Estab. 1972. Publishes mostly adult trade books; specializes in natural history and travel guides. Photos used for text illustration, book covers, dust jackets, calendars. Examples of recently published titles: *Master Training Series: Gun Dogs* (interior/cover); *Buffalo Nation: History and Legend of the North American Bison* (interior/cover); and *The Freshwater Fish Cookbook* (interior/cover). Photo guidelines free with SASE.

Needs: Buys 300 photos annually. Primarily natural history; artistic angle is crucial—books often emphasize high-quality photos. Model/property release required. Captions preferred; include location, species, interesting nuggets, depending on situation.

Making Contact & Terms: Interested in receiving work from newer, lesser-known photographers. Query with résumé of credits. Query with nonreturnable samples. Query with stock photo list. Provide résumé, business card, brochure, flier or tearsheets to be kept on file for possible future assignments. Uses 35mm, $2\frac{1}{4} \times 2\frac{1}{4}$, 4×5, some 8×10 transparencies. Keeps samples on file. SASE. Reports in 1 month. Payment negotiable. Pays on publication. Credit line given. Buys one-time or all rights; negotiable.

Tips: "We are often looking for specific material (crocodile in the Florida Keys; farm scenics in the

Southwest; wolf research in Yellowstone) so subject matter is important. But outstanding color and angles, interesting patterns and perspectives, are strongly preferred whenever possible. If you have the capability and stock to put together an entire book, your chances with us are much better. Though we use some freelance material, we publish many more single-photographer works."

WAITE GROUP PRESS, 200 Tamal Plaza, Corte Madera CA 94925. (415)924-2575. Fax: (415)924-8738. Production Director: Julianne Ososke. Estab. 1991. Publishes computer programming books. Photos used for book covers. Examples of recently published titles: *Delphi How-to*; *Master C#*; *Visual Basic Database How-to* (all book covers).
Needs: Buys 25-50 photos annually; offers 25-50 freelance assignments annually. Needs abstract photos. Model/property release preferred. Captions preferred; include photographer's name.
Making Contact & Terms: Interested in receiving work from newer, lesser-known photographers. Query with samples. Query with stock photo list. Provide résumé, business card, brochure, flier or tearsheets to be kept on file for possible future assignments. Works on assignment only. Uses 4×5 transparencies. Keeps samples on file. SASE. Reports in 1 month. Pays $600-1,000/color photo. **Pays on receipt of invoice.** Buys book rights; negotiable. Simultaneous submissions and previously published work OK.
Tips: "Make sure the image is submitted in the correct format. Do your homework before you approach a publication—look at cover images used on previous titles."

WARNER BOOKS, 1271 Avenue of the Americas, 9th Floor, New York NY 10020. (212)522-7200. Vice President & Creative Director/Warner Books: Jackie Merri Meyer. Publishes "everything but text books." Photos used for book covers and dust jackets.
Needs: Buys approximately 50 freelance photos annually; offers approximately 30 assignments annually. Needs photos of people, food still life, women and couples. Reviews stock photos. Model release required. Captions preferred.
Making Contact & Terms: Send brochure, flier or tearsheets to be kept on file for possible future assignments. Cannot return unsolicited material. Uses color prints/transparencies; also some b&w and hand-tinting. Pays $800 and up/color photo; $1,200 and up/job. Credit line given. Buys one-time rights. Simultaneous submissions and previously published work OK.
Tips: "Printed and published work (color copies are OK, too) are very helpful. Do not call, we do not remember names—we remember samples. Be persistent."

WAVELAND PRESS, INC., P.O. Box 400, Prospect Heights IL 60070. (847)634-0081. Fax: (847)634-9501. Photo Editor: Jan Weissman. Estab. 1975. Publishes college textbooks. Photos used for text illustration and book covers. Examples of published titles: *Our Global Environment*, Fourth Edition (inside text); *Africa & Africans*, Fourth Edition (chapter openers and cover); and *Principles of Agribusiness Management*, Second Edition (chapter openers).
Needs: Number of photos purchased varies depending on type of project and subject matter. Subject matter should relate to college disciplines: criminal justice, anthropology, speech/communication, sociology, archaeology, etc. Model/property release required. Captions preferred.
Making Contact & Terms: Interested in receiving work from newer, lesser-known photographers. Query with stock photo list. Provide résumé, business card, brochure, flier or tearsheets to be kept on file for possible future assignments. Uses 5×7, 8×10 glossy b&w prints. Keeps samples on file. SASE. Reports in 2-4 weeks. Pays $25-200/color photo; $25-100/b&w photo. Pays on publication. Credit line given. Buys one-time and book rights. Simultaneous submissions and previously published work OK.

✸**WEIGL EDUCATIONAL PUBLISHERS LIMITED**, 1902 11th St. SE, Calgary, Alberta T2G 3G2 Canada. (403)233-7747. Fax: (403)233-7769. E-mail: weigl@mail.telusplanet.net. Website: http://www.weigl.com. Attention: Editorial Department. Estab. 1979. Publishes textbooks and educational resources: social studies, life skills, environment/science studies, multicultural, language arts and geography. Photos used for text illustration and book covers. Example of published titles: *Career Connections* (cover and inside); *Alberta, Its People in History* (cover and inside); *The Untamed World Series*.
Needs: Buys 25-50 photos annually. Social issues and events, politics, education, technology, people gatherings, multicultural, environment, science, agriculture, life skills, landscape, wildlife and people doing daily activities. Reviews stock photos. Model/property release required. Captions required.
Making Contact & Terms: Interested in receiving work from newer, lesser-known photographers. Query with samples. Query with stock photo list. Provide tearsheets to be kept on file for possible future assignments. Tearsheets or samples that don't have to be returned are best. Keeps samples on file. Uses 5×7, 3×5, 4×6, 8×10 color/b&w prints; 35mm, 2¼×2¼ transparencies. SASE. "We generally get in touch when we actually need photos." Payment is negotiable. Credit line given (photo credits as appendix). Buys one-time, book and all rights; negotiable. Simultaneous submissions and previously published work OK.
Tips: Needs "clear, well-framed shots that don't look posed. Action, expression, multicultural representa-

tion are important, but above all, education value is sought. People must know what they are looking at. Please keep notes on what is taking place, where and when. As an educational publisher, our books use specific examples as well as general illustrations."

SAMUEL WEISER INC., P.O. Box 612, York Beach ME 03910-0612. (207)363-4393. Fax: (207)363-5799. E-mail: weiserbooks@worldnet.att.net. Vice President: B. Lundsted. Estab. 1956. Publishes books on esoterica, Oriental philosophy, alternative health and mystery traditions. Photos used for book covers. Examples of published titles: *Modern Mysticism*, by Micheal Gellert (Nicolas Hays imprint); *Foundations of Personality*, by Hamaker-Zondag. Photo guidelines free with SASE.
Needs: Buys 2-6 photos annually. Needs photos of flowers, abstracts (such as sky, paths, roads, sunsets) and inspirational themes. Reviews stock photos.
Making Contact & Terms: Interested in receiving work from newer, lesser-known photographers. Query with samples. Query with stock photo list. Send unsolicited photos by mail for consideration. Provide résumé, business card, brochure, flier or tearsheets to be kept on file for possible future assignments. "We'll take color snapshots to keep on file, or color copies." Accepts images in digital format for Mac. Send via compact disc, floppy disc, SyQuest or Zip disk. Keeps samples on file. Uses color prints. SASE. Reports in 1 month. Pays $100/b&w and color. Credit line given. Buys one-time rights. "We pay once for life of book because we do small runs." Simultaneous submissions and previously published work OK.
Tips: "We don't pay much and we don't ask a lot. We have to keep material on file or we won't use it. Color photocopies, cheap Kodak prints, something that shows us an image that we assume is pristine on a slide and we can call you or fax you for it. We do credit line on back cover, and on copyright page of book, in order to help artist/photographer get publicity. We like to keep inexpensive proofs because we may see a nice photo and not have anything to use it on now. We search our files for covers, usually on tight deadline. We don't want to see goblins and Halloween costumes."

✦WHITECAP BOOKS LTD., 351 Lynn Ave., North Vancouver, British Columbia V7J 2C4 Canada. (604)980-9852. Fax: (604)980-8197. E-mail: robinr@pinc.com. Editorial Director: Robin Rivers. Estab. 1978. Publishes adult trade, color books, natural history, scenic, gardening, some juvenile nonfiction. Photos used for text illustration, book covers, dust jackets, calendars. Examples of published titles: *Eagles* (interior and cover); *Discover Canada* (interior and cover); and *Welcome to the World of Whales* (interior).
Needs: Buys 250-500 photos annually. Looking for scenics, wildlife, calendar material. Model release required. Captions required; include basic identification, photographer's name.
Making Contact & Terms: Interested in receiving work from newer, lesser-known photographers. Query with stock photo list. Provide résumé, business card, brochure, flier or tearsheets to be kept on file for possible future assignments. Uses 35mm, 2¼×2¼, 4×5 transparencies. SASE; international postal voucher if submitting from the US. Pays $90-100/color photo. Pays on publication. Credit line sometimes given (not usually in text—always a photo credit page). Buys one-time and book rights; negotiable. Simultaneous submissions and/or previously published works OK.
Tips: "We look for wildlife and scenics with good composition, color and a creative approach to conventional subjects. We need images which are clear and crisp. We prefer descriptive style shots to more interpretive ones suitable for art books. Don't expect to be paid the same rates as in other industries. We are continuing to use freelance photographers on a regular basis."

JOHN WILEY & SONS, INC., 605 Third Ave., New York NY 10158. (212)850-6731. Fax: (212)850-6450. Director, Photo Department: Majorie Graham. Estab. 1807. Publishes college texts in hard sciences. Photos used for text illustration. Examples of published titles: *Dynamic Earth*, by Skinner; *Physical Geography*, by Strahler; *Genetics*, by Snustad; *Physics*, by Cutnell/Johnson; and *Phychology*, by Western (all covers and interior photos).
Needs: Buys 4,000 photos/year; 200 photos used for text and cover illustration. Uses b&w and color photos for textbooks in psychology, business, computer science, biology, physics, chemistry, geography, geology and foreign languages. Captions required.
Making Contact & Terms: Query with list of stock photo subjects. Uses 8×10 glossy and semigloss b&w prints; also 35mm, electronic, and large format transparencies. SASE. "We return all photos securely wrapped between double cardboard by FedX." Pays $100-150/b&w print and $100-225/color transparency. Credit line given. Buys one-time rights. Simultaneous submissions and previously published work OK.
Tips: "Initial contact should spell out the material photographer specializes in, rather than a general inquiry about our photo needs. Tearsheets and fliers welcome."

‡WISCONSIN TRAILS BOOKS, P.O. Box 5650, Madison WI 53705. (608)231-2444. Photo Editor: Nancy Mead. Estab. 1960. Publishes adult nonfiction, guide books and photo essays. Photos used for text illustration and book covers. Recently published: *Ah Wisconsin* (all photographs) and *Best Wisconsin Bike Trips* (cover and ⅓ inside-photos). Photo guidelines free on request with SASE.

● This publisher also needs material for calendars and a bimonthly magazine. Check the Wisconsin Trails' listings in the Paper Products and Consumer Publications sections.

Needs: Buys many photos and gives large number of freelance assignments annually. Wisconsin nature and historic scenes and activities. Captions preferred, include location information.

Making Contact & Terms: Query with samples or stock photo list. Send unsolicited photos by mail for consideration. Provide résumé to be kept on file for possible assignments. Uses 5×7 or 8×10 b&w prints and any size transparencies. SASE. Reports in 1 month. Pays $25-100/b&w photo; $50-200/color photo. Credit line given. Buys one-time rights. Simultaneous submissions and previously published work OK.

WORD PUBLISHING, 1501 LBJ Freeway, Suite 650, Dallas TX 75234. (214)488-9673. Senior Art Director: Tom Williams. Estab. 1951. Publishes Christian books. Photos used for book covers, publicity, brochures, posters and product advertising. Examples of recently published titles: *The End of the Age*, by Pat Robertson; *Angels*, by Billy Graham; and *Miracle Man: Nolan Ryan Autobiography*. Photos used for covers. "We do not provide want lists or photographer's guidelines."

Needs: People and studio shots and special effects. Model release required; property release preferred.

Making Contact & Terms: Provide brochure, flier or tearsheets to be kept on file for possible future assignments. "Please don't call." SASE. Reports in 1 month. Assignment photo prices determined by the job. Pays for stock $350-1,000. Credit line given. Rights negotiable.

Tips: In portfolio or samples, looking for strikingly lighted shots, good composition, clarity of subject. Something unique and unpredictable. "We use the same kinds of photos as the secular market. I don't need crosses, church windows, steeples, or wheat waving in the sunset. Don't send just a letter. Give me something to look at, not to read about."

❦WUERZ PUBLISHING LTD., 895 McMillan Ave., Winnipeg, Manitoba R3M 0T2 Canada. (204)453-7429. Fax: (204)453-6598. Director: Steve Wuerz. Estab. 1989. Publishes university-level science textbooks, especially in environmental sciences (chemistry, physics and biology). Photos used for text illustration, book covers to accompany textbooks in diskettes or CD-ROM materials. Examples of published titles: *Mathematical Biology*; *Energy Physics & the Environment*; and *Environmental Chemistry* (all cover and text illustration). Photo guidelines free with SASE.

Needs: Buys more than 100 photos annually; offers 4 assignments with research combined. Reviews stock photos. Model/property release "as appropriate." Captions required; include location, scale, genus/species.

Making Contact & Terms: Interested in receiving work from newer, lesser-known photographers. Query with résumé of credits. Query with samples. Query with stock photo list. Provide résumé, business card, brochure, flier or tearsheets to be kept on file for possible future assignments. Works on assignment only. SAE and IRCs. Reports usually in 1 month. Payment negotiable. Credit line given. Buys book rights. Simultaneous submissions and previously published work OK.

Tips: "The scientific principle or the instrument being displayed must be clearly shown in the photo. In the past we have used photos of smog in Los Angeles, tree frogs from Amazonia, wind turbines from California, a plasma reactor at Harwell United Kingdom, and about 50 different viruses. Summarize your capabilities and your collection of 'stock' photos, preferably with quantities. Outline your 'knowledge level,' or how your collection is organized, so that searches will yield answers in reasonable time."

ZOLAND BOOKS, 384 Huron Ave., Cambridge MA 02138. Design Director: Lori K. Pease. Publishes adult trade, some juvenile, mostly fiction, some photography, poetry. Photos used for book covers and dust jackets. Examples of recently published titles: *Gas Station*, by Joseph Torra; *Furthering My Education*, by William Corbett. Photo guidelines free with SASE.

Needs: Buys 3-5 photos annually; offers 3-5 freelance assignments annually. Subject matter varies greatly with each book. "Please keep in mind we are a literary book publisher distributed to the book trade."

Making Contact & Terms: Query with samples. Provide résumé, business card, brochure, flier or tearsheets to be kept on file for possible future assignments. Mostly works with freelancers. Use 4×5 glossy, b&w prints; 2¼×2¼, 4×5 transparencies. Keeps samples on file. SASE. Reports in 1-2 months. Payment negotiable. **Pays on acceptance**. Credit lines given. Rights vary with project; negotiable. Simultaneous submissions and previously published work OK.

THE SUBJECT INDEX, located at the back of this book, lists publications, book publishers, galleries, paper product companies and stock agencies according to the subject areas they seek.

Paper Products

The greeting card industry takes in close to $7 billion a year—80 percent through giants American Greetings, Gibson Greetings and Hallmark Cards. Naturally, the "big three" are difficult companies to break into, but there is plenty of room for photo sales to smaller companies.

There are more than 1,000 greeting card companies in the United States, many of which produce low-priced cards that fill a niche in the market, focusing on anything from the cute to the risqué to seasonal topics. A number of listings in this section produce items like calendars and posters, as well as greeting cards.

Before approaching greeting card, poster or calendar companies, it's important to research the industry to see what's being bought and sold. Start by checking out card, gift and specialty stores that carry greeting cards and posters. Pay attention to the selections of calendars, especially the large seasonal displays during December. Studying what you see on store shelves will give you an idea of what types of photos are marketable.

There is also a brand new greeting card industry publication available. The Greeting Card Association debuted *Greetings Today* in July, 1997. This publication for marketers, publishers, designers and retailers of greeting cards offers industry news, and information on trends, new products and trade shows. (For more information on this magazine, see Helpful Resources for Photographers.)

APPROACHING THE MARKET

After your initial research, query companies you are interested in working with and send a stock photo list. You can help narrow your search by consulting our newly expanded Subject Index, now including Paper Products. Check the index for companies interested in the topics you shoot.

Since these companies receive large volumes of submissions, they often appreciate knowing what is available rather than actually receiving samples. This kind of query can lead to future sales even if your stock inventory doesn't meet their immediate needs. Buyers know they can request additional submissions as their needs change. Some listings in this section advise sending quality samples along with your query while others specifically request only a list. As you plan your queries, follow their instructions. It will help you establish a better rapport with companies from the start.

Some larger companies have staff photographers for routine assignments, but also look for freelance images. Usually, this is in the form of stock, and images are especially desirable if they are of unusual subject matter or remote scenic areas for which assignments—even to staff shooters—would be too costly. Freelancers are usually offered assignments once they have established track records and demonstrated a flair for certain techniques, subject matter or locations. Smaller companies are more receptive to working with freelancers, though they are less likely to assign work because of smaller budgets for photography.

The pay in this market can be quite lucrative if you provide the right image at the right time for a client in need of it, or if you develop a working relationship with one or a few of the better paying markets. You should be aware, though, that one reason for higher rates of payment in this market is that these companies may want to buy all rights to images. But with changes in the copyright law, many companies are more willing to negotiate sales which specify all rights for limited time periods or exclusive product rights rather than complete surrender of copyright.

ACME GRAPHICS, INC., Box 1348, Cedar Rapids IA 52406. (319)364-0233. Fax: (319)363-6437. President: Stan Richardson. Estab. 1913. Specializes in printed merchandise for funeral directors.

Needs: Religious, nature. Reviews stock photos.
Making Contact & Terms: Interested in receiving work from newer, lesser-known photographers. Query with samples. Send unsolicited photos by mail for consideration. Uses 35mm transparencies; color contact sheets; color negatives. SASE. Reports in 2 weeks. Pays $50/b&w photo; $50/color photo. Also, pays according to price set by photographer. **Pays on acceptance.** Buys all rights.

ADVANCED GRAPHICS, P.O. Box 8517, 941 Garcia Ave., Pittsburg CA 94565. (510)432-2262. Fax: (510)432-9259. Photo Editor: Steve Henderson. Estab. 1985. Specializes in life-size standups and cardboard displays.
Needs: Buys 20 images annually; number supplied by freelancers varies. Interested in celebrities (movie and TV stars, entertainers). Reviews stock photos.
Making Contact & Terms: Interested in receiving work from newer, lesser-known photographers. Query with stock photo list. Uses 4 × 5, 8 × 10 transparencies. Keeps samples on file. SASE. Reports in 1 month. NPI; negotiable. **Pays on acceptance.** Credit line given. Buys exclusive product rights; negotiable. Simultaneous submissions and/or previously published work OK.
Tips: "We specialize in publishing life-size standups which are cardboard displays of celebrities. Any pictures we use must show the entire person, head to toe. We must also obtain a license for each image that we use from the celebrity pictured or from that celebrity's estate. The image should be vertical and not too wide."

‡**ALFRESCO PUBLICATIONS**, P.O. Box 14191, Tulsa OK 74159. President: Jim Bonner. Estab. 1989. Specializes in posters, framing prints and print sets. Photo guidelines $1 with SASE.
Needs: Buys 300-400 images annually; all supplied by freelancers. Interested in glamour, semi-nude, nude. Model release required.
Making Contact & Terms: Interested in receiving work from newer, lesser-known photographers. Send for guidelines. Uses color prints. Does not keep samples on file. SASE. Reports in 1 week. **Pays on acceptance.** Credit line sometimes given depending upon usage. Buys all rights; negotiable. Simultaneous submissions and/or previously published work OK.
Tips: "We like working with beginners using amateur models, so we don't have to teach them how to avoid the professional posed look. If you are looking for your first sale, we want to see your work."

AMERICAN GREETINGS, 10500 American Rd., Cleveland OH 44144. Prefers not to share information.

‡❀**ART IN MOTION**, 2000 Hartley Ave., Coquitlam, British Columbia V3K 6W5 Canada. (604)525-3900. Fax: (604)525-6166. Submissions Director: Lynn Harrison. Specializes in greeting cards, postcards, posters, framing prints and wall decor.
Needs: "We are publishers of fine art reproductions, so we have not been involved in the use of photographs until now."
Making Contact & Terms: Interested in receiving work from newer, lesser-known photographers. Submit portfolio for review. Does not keep samples on file. SASE. Reports in 1-2 weeks. Payment negotiable. Pays on usage. Credit line given. Buys all rights; negotiable. Simultaneous submissions OK.

ART RESOURCE INTERNATIONAL LTD./BON ART, Fields Lane, Brewster NY 10509. (914)277-8888. Fax: (914)277-8602. E-mail: bonartinc.@aol.com. Vice President: Robin Bonnist. Estab. 1980. Specializes in posters and fine art prints. Photo guidelines free with SASE.
Needs: Buys 500 images/year. Interested in all types but does not wish to see regional. Accepts seasonal material anytime. Model release required. Captions preferred.
Making Contact & Terms: Interested in receiving work from newer, lesser-known photographers. Send unsolicited photos by mail for consideration. Submit portfolio for review. Works on assignment only. Uses 35mm, 4 × 5 and 8 × 10 transparencies. SASE. Reports in 1 month. Pays $50-250/photo. Pays on publication. Credit line given if required. Buys all rights; exclusive reproduction rights. Simultaneous submissions and previously published work OK.
Tips: Looks for "new and exciting material; subject matter with universal appeal."

‡**ASHTON-DRAKE GALLERIES**, 9200 N. Maryland Ave., Niles IL 60714. (847)581-8035. Fax: (847)966-3026. Artist Relations Manager: Andrea Ship. Estab. 1985. Specializes in collectible dolls and ornaments.

Needs: Interested in children and babies. Does not want anything not containing babies or children. Model release required.

Making Contact & Terms: Submit portfolio for review. Works with freelancers on assignment only. Uses color prints; 8×10 transparencies. Keeps samples on file. Reports in 1 month or more. Pays flat fee for job. **Pays on acceptance.** Buys all rights.

THE AVALON HILL GAME CO., 4517 Harford Rd., Baltimore MD 21214. (410)254-9200. Fax: (410)254-0991. E-mail: j4d@1x.netcom.com. President: Jack Dott. Estab. 1949. Specializes in playing cards.

Needs: Buys 50 images annually; 50% supplied by freelancers. Offers 15 assignments annually. Specializes in military subjects. Submit seasonal material 3 months in advance. Reviews stock photos of military subjects. Model/property release required for models, etc. Captions preferred.

Making Contact & Terms: Interested in receiving work from newer, lesser-known photographers. Query with stock photo list. Works on assignment only. Uses 5×8, 8½×11 color and b&w prints; 35mm, 4×5 transparencies. Keeps samples on file. SASE. Reports in 3 weeks. Pays $50-500/job. Pays on usage. Credit line given. Buys exclusive product rights. Simultaneous submissions and/or previously published work OK.

AVANTI PRESS INC., 134 Spring St., Suite 602, New York NY 10012. (212)941-9000. Fax: (212)941-8008. Attention: Art Submissions. Estab. 1980. Specializes in photographic greeting cards, posters and note cards. Photo guidelines free with SASE.

Needs: Buys approximately 250 images annually; all supplied by freelancers. Offers assignments annually. Interested in humorous, narrative, colorful, simple, to the point; also babies, children, animals (in humorous situations). Has specific deadlines for seasonal material. Does NOT want travel, sunsets, landscapes, nudes, high-tech. Reviews stock photos. Model/property release required. Now have an alternative, multi-occasion line—4U. Personal, artistic, expressive, friendly, intimate, mysterious are words which describe the types of images needed for this line.

Making Contact & Terms: Interested in receiving work from newer, lesser-known photographers. Arrange personal interview to show portfolio. Query with stock photo list. Please do not submit original material. Will work with all mediums and formats. Reports quarterly. Payment negotiable. Pays on license. Credit line given. Buys 5-year worldwide, exclusive card rights.

Tips: "Know our card lines. Stretch the boundaries of creativity."

BEAUTYWAY, Box 340, Flagstaff AZ 86002. (520)526-1812. President: Kenneth Schneider. Estab. 1979. Specializes in postcards, note cards and posters.

Needs: Buys 100-200 freelance photos/year (fee pay and Joint Venture). "Joint Venture is a program within Beautyway in which the photographer invests in his own images and production costs and works more closely in overall development. Through Joint Venture, photographers may initiate new lines or subjects with Beautyway." Interested in (1) nationwide landscapes emphasizing subjects of traveler interest and generic scenes of sea, lake and river; (2) animals, birds and sealife, with particular interest in young animals, eyes and interaction; (3) air, water and winter sports; (4) the most important attractions and vistas of major cities, emphasizing sunset, storm, cloud and night settings. Model release required.

Making Contact & Terms: Query with samples, stock list and statement of interests or objectives. All transparency formats OK. Ship in protective sleeves with photographer's name, title and location of image on frame. SASE. First report averages 2 weeks, others vary. Pays $45 for up to 2,400 postcards; $70 for up to 4,800 postcards; $120 for up to 9,600 postcards; $8 per 1,200 postcards thereafter. Previously published work OK if not potentially competitive.

Tips: Looks for "very sharp photos with bright colors and good contrast. Subject matter should be easily identified at first glance. We seek straightforward, basic scenic or subject shots. Obvious camera manipulation such as juxtaposing shots or unnatural filter use is almost always rejected. When submitting transparencies, the person's name, address and name and location of subject should be upon each transparency sleeve."

✳ INTERNATIONAL MARKETS, those located outside of the United States and Canada, are marked with an asterisk.

‡**BEPUZZLED**, 22 E. Newberry Rd., Bloomfield CT 06002. (800)874-6556. Fax: (860)769-5799. Creative Service Manager: Sue Tyska. Estab. 1986. Specializes in mystery, puzzles and games.
Needs: Buys 10-20 images annually; 10% supplied by freelancers. Offers 50-70 assignments annually. Interested in humorous and seasonal. Submit seasonal material 3 months in advance. Reviews stock photos. Model/property release required.
Making Contact & Terms: Interested in receiving work from newer, lesser-known photographers. Arrange personal interview to show portfolio. Provide résumé, business card, self-promotion piece or tearsheets to be kept on file for possible future assignments. Works with local freelancers only. Uses $2\frac{1}{4} \times 2\frac{1}{4}$, 4×5, 8×10. Keeps samples on file. SASE. Cannot return material. Call to follow up. Pays $1,000-1,500/job. Pays on usage. Credit line sometimes given. Buys all rights, exclusive product rights and world-wide rights. Simultaneous submissions OK.
Tips: "We use very little digital photography. We prefer local photographers (but have used stock or other photos). We have two cycles a year for development of new products—timing is everything."

‡**BILLIARD LIBRARY COMPANY**, (formerly Billboard Library Company), 1570 Seabright Ave., Long Beach CA 90813. (310)437-5413. Fax: (310)436-8817. Production Manager: Darian Baskin. Estab. 1973. Specializes in posters and wall decor relating to billiards.
Needs: Buys 3-7 images annually; all supplied by freelancers. "We specialize in leisure sports, specifically billiards, but also bowling and darts." Model/property release preferred.
Making Contact & Terms: Interested in receiving work from newer, lesser-known photographers. Query with samples. Uses any size color and b&w prints; 35mm, $2\frac{1}{4} \times 2\frac{1}{4}$, 4×5, 8×10 transparencies. Keeps samples on file. SASE. Reports in 1 month. Pays royalty on images based on prints sold. Pays on usage. Credit line given. Simultaneous submissions and/or previously published work OK.

BLUE SKY PUBLISHING, 6395 Gunpark Dr., M, Boulder CO 80301. (303)530-4654. Fax: (303)530-4627. Art Director: Theresa Brown. Estab. 1989. Specializes in greeting cards.
Needs: Buys 12-24 images annually; all supplied by freelancers. Interested in Rocky Mountain winter landscapes, dramatic winter scenes featuring wildlife in mountain settings, winter scenes from the Southwest, unique and creative Christmas still life images, and scenes that express the warmth and romance of the holidays. Submit seasonal material 1 year in advance. Reviews stock photos. Model/property release preferred.
Making Contact & Terms: Interested in receiving work from newer, lesser-known photographers. Submit 24-48 of best images for review. Query with samples. Provide résumé, business card, self-promotion piece or tearsheets to be kept on file for possible future assignments. Uses 35mm, 4×5 (preferred) transparencies. Keeps samples on file. SASE. "We try to respond within one month—sometimes runs two months." Pays $150-250/color photo; 3-5% royalties. **Pays on acceptance.** Credit line given. Buys exclusive product rights for 5 years; negotiable. Simultaneous submissions and/or previously published work OK.
Tips: "We choose photos with expressive use of color and composition, and strong emotional impact."

BRISTOL GIFT CO. INC., P.O. Box 425, Washingtonville NY 10992. (914)496-2821. Fax: (914)496-2859. E-mail: bristol@ny.frontiercomm.net. President: Matthew Ropiecki. Estab. 1988. Specializes in framing prints and wall decor.
Needs: Interested in religious, nature, still life. Submit seasonal material 6 months in advance. Reviews stock photos. Model/property release preferred.
Making Contact & Terms: Interested in receiving work from newer, lesser-known photographers. Query with samples. Uses 4×5, 8×10 color prints; 4×5 transparencies. Accepts images in digital format for Windows. Send via compact disc or floppy disk. Keeps samples on file. SASE. Reports in 1 month. Payment negotiable; depends on agreement. Buys exclusive product rights. Previously published work OK.

CARDMAKERS, High Bridge Rd., P.O. Box 236, Lyme NH 03768. (603)795-4422. Fax: (603)795-4222. Owner: Peter D. Diebold. Estab. 1978. Specializes in greeting cards (Christmas).
• This company expects photo cards to be a growing portion of their business.
Needs: Buys stock and assigns work. Nautical scenes which make appropriate Christmas and everyday card illustrations. Model/property release preferred.
Making Contact & Terms: Interested in receiving work from newer, lesser-known photographers. Provide self-promotion piece to be kept on file for possible future assignments. Uses color prints; 35mm, 4×5, 8×10 transparencies. Keeps samples on file. SASE. Reports in 3 weeks. Pays $100/b&w and color photos. **Pays on acceptance.** Credit line negotiable. Buys exclusive product rights and all rights; negotiable. Simultaneous submissions and previously published work OK.
Tips: "We are seeking photos primarily for our nautical Christmas and everyday card line but would also be interested in any which might have potential for business to business Christmas greeting cards. Emphasis

David Stoecklein's photo of a Christmas carriage ride was submitted to Blue Sky Publishing by his stock agency, F-Stock Inc. Blue Sky's want list included "wintry, moody scenes with people," says F-Stock President Kate Ryan. The photo has sold about 20 times through the stock agency, Stoecklein's own marketing, and his other agents.

is on humorous situations. A combination of humor and nautical scenes is best. Please do not load us up with tons of stuff. We have yet to acquire/publish designs using photos but are very active in the market presently. The best time to approach us is during the first nine months of the year (when we can spend more time reviewing submissions)."

CEDCO PUBLISHING CO., 2955 Kerner Blvd., San Rafael CA 94901. (415)457-3893. Fax: (415)457-1226. E-mail: sales@cedco.com. Website: http://www.cedco.com. Contact: Art Dept. Estab. 1980. Specializes in calendars and picture books. Photo guidelines free with SASE.
Needs: Buys 1,500 images/year; 1,000 supplied by freelancers. Wild animals, domestic animals, America, Ireland, inspirational, beaches, islands, whales, Israel, Buddhas, men in swimsuits on the beach, Australian wildlife, dolphins, surfing, general stock and studio stock. Especially needs 4×5 photos of the East Coast and South—beaches, flowers. New ideas welcome. Model/property release required. Captions required.
Making Contact & Terms: Interested in receiving work from newer, lesser-known photographers. Query with non-returnable samples and a list of stock photo subjects. "Do not send any returnable material unless requested." Uses 35mm, 2¼×2¼, 4×5, 8×10 transparencies. Keeps samples on file. Reports as needed. Pays $200/b&w photo; $200/color photo; payment negotiable. Pays the December prior to the year the calendar is dated (i.e., if calendar is 1999, photographers are paid in December 1998). Credit line given. Buys one-time rights. Simultaneous submissions and previously published work OK.
Tips: No phone calls.

‡CENTRIC CORPORATION, 6712 Melrose Ave., Los Angeles CA 90038. (213)936-2100. Fax: (213)936-2101. E-mail: centric@juno.com. President: Sammy Okdot. Estab. 1986. Specializes in gift products: T-shirts, clocks, watches, pens, mugs and frames.
Needs: Interested in humor, nature and thought-provoking images. Submit seasonal material 5 months in advance. Reviews stock photos.
Making Contact & Terms: Interested in receiving work from newer, lesser-known photographers. Submit portfolio for review. Query with résumé of credits. Provide résumé, business card, self-promotion piece or tearsheets to be kept on file for possible future assignments. Works with local freelancers only. Uses 8½×11 color and b&w prints; 35mm transparencies. Keeps samples on file. SASE. Reports in 1-2 weeks. Pays by the job; negotiable. **Pays on acceptance.** Rights negotiable.

‡CLASS PUBLICATIONS, INC., 71 Bartholomew Ave., Hartford CT 06106. (203)951-9200. Contact: Scott Moynihan. Specializes in posters.

Needs: Buys 50 images/year. Creative photography, especially humorous, cars, semi-nudes, guys, girls, etc. Interested in stock photos. Model release preferred. Captions preferred.

Making Contact & Terms: Query with samples. Submit portfolio for review. Uses b&w and color prints, contact sheets, negatives; 35mm, 2¼×2¼, 4×5 and 8×10 transparencies. SASE. Reports in 2 weeks. Payment negotiable. Pays per photo or royalties on sales. Pays on acceptance or publication. Credit line sometimes given. Buys one-time and exclusive poster rights. Simultaneous submissions and previously published work OK.

Tips: Looks for "creativity that would be widely recognized and easily understood."

‡CLAY ART, 239 Utah Ave., San Francisco CA 94080. (415)244-4970. Fax: (415)244-4979. Art Director: Thomas Biela. Estab. 1976. Specializes in home accessories.

Needs: Buys 40 images annually; 100% supplied by freelancers. Offers 6-10 assignments annually. Interested in all subjects. Submit seasonal material 6 months in advance. Reviews stock photos. Model/property release required. Captions preferred.

Making Contact & Terms: Interested in receiving work from newer, lesser-known photographers. Provide résumé, business card, self-promotion piece or tearsheets to be kept on file for possible future assignments. Works with local freelancers on assignment only. Uses color prints; 4×5 transparencies. Keeps samples on file. SASE. Reports in 1 month. Payment negotiable. Pays on usage. Credit line given. Buys exclusive product rights. Simultaneous submissions and/or previously published work OK.

COMSTOCK CARDS, 600 S. Rock Blvd., #15, Reno NV 89502. Phone/fax: (702)856-9400. Contact: Production Manager. Estab. 1986. Specializes in greeting cards, invitations, notepads, magnets. Photo guidelines free with SASE.

Needs: Buys/assigns 20 photos/year. Wild, outrageous and shocking adult humor; seductive hot men or women images. Definitely does not want to see traditional, sweet, cute, animals or scenics. "If it's appropriate to show your mother, we don't want it!" Submit seasonal material 9-10 months in advance. Model/property release required.

Making Contact & Terms: Interested in receiving work from newer, lesser-known photographers. Query with samples. Uses 35mm, 6cm×6cm, 6cm×7cm or 4×5 color transparencies. SASE. Reports in 3 weeks. Pays $50-150/color photo. **Pays on acceptance.** Credit line given if requested. Buys all rights; negotiable. Simultaneous submissions OK.

Tips: "Submit with SASE if you want material returned."

‡CONCORD LITHO CO. INC., 92 Old Turnpike Rd., Concord NH 03301. (603)225-3328. Fax: (603)225-6120. Vice President/Creative Services: Lester Zaiontz. Estab. 1958. Specializes in greeting cards, calendars, postcards, posters, framing prints, stationery, gift wrap and wall decor. Photo guidelines free with SASE.

Needs: Buys 150 images annually. Does not offer assignments. Interested in nature, seasonal, domestic animals, dogs and cats, religious, inspirational, florals and scenics. Submit seasonal material minimum 6-8 months in advance. Does not want nudes, comedy or humorous—nothing wild or contemporary. Model/property release required for historical/nostalgia, homes and gardens, dogs and cats. Captions preferred; include accurate information pertaining to image (location, dates, species, etc.).

Making Contact & Terms: Submit portfolio for review. Query with samples. Query with stock photo list. Uses 8×10 satin color prints; 35mm, 2¼×2¼, 4×5, 8×10 transparencies; anything on Macintosh platform. Keeps samples on file. SASE. Reporting time may be as long as 6 months. Pays $150 minimum for one-time usage. Pays on usage. Credit line sometimes given depending upon client and/or product. Buys one-time rights. Simultaneous submissions and/or previously published work OK.

‡THE CRYSTAL TISSUE COMPANY, 3120 S. Verity Parkway, Middletown OH 45042. Art Director: Mary Jo Recker. Estab. 1894. Specializes in gift wrap, gift bags, gift wrapping tissues, sacks and decorative items.

Needs: Buys 300 images annually; all supplied by freelancers. Offers 20 assignments annually. Interested in product photography for catalogs. 5% is for product-floral, Christmas party, nature. Does not want anything not listed above. Submit seasonal material at any time. Reviews stock photos of nature, Christmas, animals, floral, patterns, product, children and abstract (if appropriate for giftwrap).

Making Contact & Terms: Interested in receiving work from newer, lesser-known photographers. Query with samples. Works on assignment only. Uses 35mm, 2¼×2¼, 4×5, 8×10 transparencies. Keeps samples on file. SASE. Reports in 1-2 weeks. Pays $600-900 depending on rights purchased for product shots. Price varies for catalog work. **Pays on acceptance.** Credit line given for product shots, but not on catalog

"Dunes" is the title of this sensual image by William Carter. The fine art print intended to show "the body as a spiritual document" is sold via dealers and galleries. "Dunes" appeared on the cover of *Illuminations*, a book of the photographer's work published by Custom & Limited Editions. "The book publicizes me widely, helping with direct sales of prints and raises print prices," says Carter. The piece, which sells for $1,500, has sold 20 times.

work. Buys one-time rights and exclusive product rights. Simultaneous submissions and/or previously published work.

Tips: "Study the market! Submit images appropriate for prospective product (in our case—giftwrap). Must be colorful, upbeat, gift-giving occasions. Look at how photography is currently being used in this catagory in the market place."

‡CUSTOM & LIMITED EDITIONS, 41 Sutter St. #1634, San Francisco CA 94104. Phone/fax: (415)337-0177. E-mail: rfwoody@aol.com. Publisher: Ron Fouts. Estab. 1987. Specializes in prints and custom books.

Needs: Buys hundreds of images annually; 60% supplied by freelancers. "We look for a focused pattern of development in a portfolio. We are interested in the photographer's statement." Interested in reviewing stock photos only in the context of a series or statement. Model release required. Captions preferred; include title and date of photograph.

Making Contact & Terms: Interested in receiving work from newer, lesser-known photographers. Query with résumé, business card, self-promotion piece or tearsheets to be kept on file for possible future assign-

ments. Uses 8×10 glossy preferred color and b&w prints; 35mm, 2¼×2¼ transparencies. Accepts images in digital format for Mac. Send via compact disc or SyQuest. Samples sometimes kept on file depending on the nature of the work. SASE. Reports in 3 weeks. "All of our work is custom and payments are negotiated in each case." Negotiated terms. Credit is given somewhere in the publication. Rights negotiable. Simultaneous submissions and/or previously published work OK.

Tips: "Be able to articulate the purpose, or reason, for the work, subject matter, focus, etc. Be able to demonstrate commitment in the work."

DeBOS PUBLISHING COMPANY, P.O. Box 36182, Canton OH 44735. Phone/fax: (216)833-5152. Editor of Photography: Brian Gortney. Estab. 1990. Specializes in calendars, posters and aviataion reference books. Photo guidelines free with SASE.

Needs: Buys 24 images/year. Offers 24 assignments/year. Interested in civilian and military helicopters, in operation, all seasons. "We promote public interest in the helicopter industry." Reviews stock photos of any helicopter relating to historical or newsworthy events. Model/property release required (owner of the helicopter, property release; pilot of aircraft, model release). Captions preferred; include name and address of operation and pilot (optional); date and location of photograph(s) are recommended. DeBos Publishing Company will supply all releases.

Making Contact & Terms: Interested in receiving work from newer, lesser-known photographers. Provide résumé, business card, self-promotion piece or tearsheets to be kept on file for possible future assignments. Works with freelancers on assignment only. Uses color prints; 35mm, 2¼×2¼, 4×5 and 6×7 transparencies. Keeps samples on file. Pays $10-175/color photo. Pays when proper releases returned. Credit line given. Buys all rights; negotiable.

Tips: "Every company in the market for photography has its own view on what photographs should look like. Their staff photographers have their favorite lens, angle and style. The freelance photographer is their answer to a fresh look at the subject. Shoot the subject in your best point-of-view, and shoot it in a different way, a way people are not used to seeing. Everyone owns a camera, but the one who puts it to use is the one who generates the income. The amount of money made should not take priority at first, but the quality and amount of work published should be your goal. If your work is good, your client will call on you again. Due to today's economy, companies are keeping fewer photographers on staff and buying less photographs from the high priced stock photo agencies. *Photographer's Market* allows us to successfully do so, using freelance photographers for some of our needs. This also gives experience and income to photographers who like to work independently and on numerous subjects. This is an essential tool to both employer and employee."

DESIGN DESIGN, INC., P.O. Box 2266, Grand Rapids MI 49501. (616)774-2448. Fax: (616)774-4020. Creative Director: Tom Vituj. Estab. 1986. Specializes in greeting cards, gift wrap, T-shirts, gift bags and invitations.

Needs: Licenses stock images from freelancers and assigns work. Specializes in humorous, seasonal and traditional topics. Submit seasonal material 1 year in advance. Model/property release required.

Making Contact & Terms: Submit portfolio for review. Provide résumé, business card, self-promotion piece or tearsheets to be kept on file for possible future assignments. Do not send original work. Accepts images in digital format for Mac. Send via SyQuest or Zip disk. SASE. Pays 8% royalties. Pays upon sales. Credit line given.

‡DODO GRAPHICS INC., P.O. Box 585, Plattsburgh NY 12901. (518)561-7294. Fax: (518)561-6720. President: Frank How. Estab. 1979. Specializes in posters and framing prints.

Needs: Buys 50-100 images annually; 100% supplied by freelancers. Offers 25-50 assignments annually. Needs all subjects. Submit seasonal material 3 months in advance. Reviews stock photos. Model/property release preferred. Captions preferred.

Making Contact & Terms: Interested in receiving work from newer, lesser-known photographers. Submit portfolio for review. Query with samples. Query with stock photo list. Works on assignment only. Uses color and b&w prints; 35mm, 4×5 transparencies. Keeps samples on file. SASE. Reports in 1 month. Payment negotiable. **Pays on acceptance.** Credit line given. Buys all rights; negotiable. Simultaneous submissions OK.

MARKET CONDITIONS are constantly changing! If you're still using this book and it's 1999 or later, buy the newest edition of *Photographer's Market* at your favorite bookstore or order directly from Writer's Digest Books.

‡DREAM PUBLISHING, 5408 Blue Sapphire Way, Elk Grove CA 95758. (916)684-2391. Fax: (916)684-2391. E-mail: 102043.1467@compuserve.com. President: Lynn Y. Beaudoin. Estab. 1996. Specializes in greeting cards and postcards. Photo guidelines free with SASE.
Needs: Buys 20-25 images annually; 10-15 supplied by freelancers. Interested in scenics, nature, humorous and romantic images. Submit seasonal material 1 year in advance. Does not want pornographic. Model/property release required. Captions preferred; include where the picture was taken.
Making Contact & Terms: Interested in receiving work from newer, lesser-known photographers. Query with samples. Query with stock photo list. Provide résumé, business card, self-promotion piece or tearsheets to be kept on file for possible future assignments. Uses 8×10 color and b&w prints; 35mm, $2\frac{1}{4} \times 2\frac{1}{4}$, 4×5 transparencies. Accepts images in digital format for Windows. Keeps samples on file. SASE. Reports in 1 month. Pays $50/color photo. **Pays on acceptance.** Rights negotiable. Simultaneous submissions OK.
Tips: "Interested in receiving nature, scenic shots from all areas of the U.S.A. and worldwide."

‡ELEGANT GREETING, 2330 Westwood Blvd., Suite 102, Los Angeles CA 90064. (310)446-4929. Fax: (310)446-4819. Owner: Sheldon Steier. Estab. 1991. Specializes in greeting cards, calendars, postcards, posters, framing prints, stationery, mugs and T-shirts.
Needs: Interested in all types of subject matter. Reviews stock photos of adults and children.
Making Contact & Terms: Submit portfolio for review. Works with local freelancers only. SASE Reports in 1-2 weeks. Payment negotiable. Credit line given.
Tips: "Basically, my company provides sales and marketing services for a wide variety of publishers of cards, and boxed stationery and gift items. If I see something I like, I submit it to a manufacturer."

FLASHCARDS, INC., 1211A NE Eighth Ave., Fort Lauderdale FL 33304. (954)467-1141. Photo Researcher: Micklos Huggins. Estab. 1980. Specializes in postcards, greeting cards, notecards and posters.
Needs: Buys 500 images/year. Humorous, human interest, animals in humorous situations, nostalgic looks, male nudes, Christmas material, valentines, children in interesting and humorous situations. No traditional postcard material; no florals or scenic. "If the photo needs explaining, it's probably not for us." Submit seasonal material 8 months in advance. Reviews stock photos. Model release required.
Making Contact & Terms: Interested in receiving work from newer, lesser-known photographers. Query with samples. Send photos by mail for consideration. Provide résumé, business card, brochure, flier or tearsheets to be kept on file for possible future assignments. Uses any size color or b&w prints, transparencies and color or b&w contact sheets. SASE. Reports in 5 weeks. Pays $100 for exclusive product rights. Pays on publication. Credit line given. Buys exclusive product rights. Simultaneous and previously published submissions OK.

‡FLAVIA STUDIOS, 25 E. De La Guerra St., Santa Barbara CA 93101. (805)564-6905. Fax: (805)966-9175. Art Director: Michael Haggler. Estab. 1986. Specializes in greeting cards, calendars, stationery.
Needs: Buys 300 images annually; 50% supplied by freelancers. Offers 10 assignments annually. Interested in nature, seasonal, still life, inspirational, occasion-oriented (wedding, baby, etc.), floral, children. Submit seasonal material 18 months in advance. Reviews stock photos. Model/property release preferred for children.
Making Contact & Terms: Interested in receiving work from newer, lesser-known photographers. Query with samples. Works with local freelancers on assignment only. Uses $2\frac{1}{4} \times 2\frac{1}{4}$ transparencies. Keeps samples on file. SASE. Reports back in 1 month. Pays royalties on sales. Pays on usage. Credit line given. Buys exclusive product rights; negotiable. Considers previously published work (with sales data).
Tips: Wants to see multiple images that form a theme for general usage.

‡FOTOFOLIO, INC., 536 Broadway, New York NY 10012. (212)226-0923. Fax: (212)226-0072. Contact: Editorial Department. Estab. 1976. Specializes in greeting cards, postcards, posters, T-shirts and notecards. The Fotofolio line of over 5,000 images comprises the complete history of photography, and includes the work of virtually every major photographer, from past masters such as Walker Evans, Berenice Abbott, Brassai, Philippe Halsman and Paul Strand to contemporary artists including William Wegman, Richard Avedon, Andres Serrano, Cindy Sherman, Herb Ritts and Sandy Skoglund. Photo guidelines free with SASE.
Needs: Specializes in humorous, seasonal material. Submit seasonal material 9 months in advance. Reviews stock photos. Captions required; include name, date and title.
Make Contact & Terms: Interested in receiving work from newer, lesser-known photographers. Send for guidelines. Uses up to 11×14 color and b&w prints; 35mm, $2\frac{1}{4} \times 2\frac{1}{4}$, 4×5, 8×10 transparencies. Accepts images in digital format. Does not keep samples on file. SASE. Reports in 1 month. Pays royalties. Pays on usage. Credit line given. Buys exclusive product rights (only for that item—eg., postcard rights). Simultaneous submissions and/or previously published work OK.

‡**GALISON BOOKS/MUDPUPPY PRESS**, 35 W. 44th St., #910, New York NY 10036. (212)354-8840. Fax: (212)391-4037. Design Director: Heather Zschock. Estab. 1980. Specializes in greeting cards, address books, journals, jigsaw puzzles, guest books, etc. Photo guidelines free with SASE.
Needs: Buys 10-20 images annually; 100% supplied by freelancers. Offers 10-20 assignments annually. Interested in nature, gardening, floral, seasonal, cats and animals. Submit seasonal material 9 months in advance. Does not want people. Reviews stock photos. Captions preferred.
Making Contact & Terms: Interested in receiving work from newer, lesser-known photographers. Query with samples. Provide résumé, business card, self-promotion piece or tearsheets to be kept on file for possible future assignments. Uses 35mm, 4×5 transparencies. Keeps samples on file. SASE. Reports in 1 month. Payment varies and depends on the project. Pays on signing of contract. Credit line given. Buys one-time rights; negotiable. Simultaneous submissions and/or previously published work OK.
Tips: "Keep sending material so we can keep our files up to date."

‡**GALLANT GREETINGS CORP.**, P.O. Box 308, Franklin Park IL 60131. (847)671-6500. Fax: (847)671-7500. Vice President-Sales & Marketing: Chris Allen. Estab. 1966. Specializes in greeting cards.
Needs: Produces material for Christmas, Easter, Mother's Day, Father's Day, graduation, Halloween, Thanksgiving, Valentine's Day, birthday, and most other card-giving occasions.
Making Contact & Terms: Interested in receiving work from newer, lesser-known photographers. Contact Brandywine Art at phone: (415)435-6533. Does not keep samples on file. Cannot return material. Reports back only if interested.

GIBSON GREETINGS, 2100 Section Rd., Cincinnati OH 45222. Prefers not to share information.

‡**GLITTERWRAP, INC.**, 701 Ford Rd., Rockaway NJ 07866. (201)625-4200. Fax: (201)625-9641. Art Director: Danielle Grassi. Estab. 1987. Specializes in gift wrap, tote bags and accessories.
Needs: Buys 30-50 images annually for product design; 80-90% supplied by freelancers. Offers 2 assignments annually. Selection periods are January-March and May-June. Product design shots supplied by freelancers. Offers 2-3 catalog assignments, 2-4 flysheets annually. Interested in seasonal material; currently purchases only product photography; have expanded line to include photo subjects (i.e., wedding/Valentine's/Christmas/baby shower). Submit seasonal material 1 year in advance. Does not want to see fashion, landscape, nudes, architectural or industrial shots. Reviews stock photos. Model/property release required.
Making Contact & Terms: Interested in receiving work from newer, lesser-known photographers. Query with samples. Provide résumé, business card, self-promotion piece or tearsheets to be kept on file for possible future assignments. Works on assignment only. Uses 2¼×2¼, 4×5, 8×10 transparencies. Keeps samples on file. SASE. Reports in 3 weeks. Requires estimates based on job for product fliers; and pays $200-500 for product designs. Pays upon usage for totes and wraps; within 30 days for catalog and flysheet work. Credit line given "if used on totes or wrap." Buys all rights; negotiable. Simultaneous submissions and/or previously published work OK.
Tips: "Our product is occasion specific. The best-selling area of our line is birthday with baby following as a close second. Valentines and weddings are additional areas where we've had success with photographic images. We're looking for images that evoke an emotional response, tug on the heartstrings. Black and white, sepia, color and slightly handcolored are all considered. In the past few years, we've seen an increase in the use of b&w hand-tinted images on products, not just paper products. Expect growth in this area to continue for at least another one or two years."

‡**GOES CALENDARS**, 42 W. 61st St., Chicago IL 60621-3999. (773)684-6700. Fax: (773)684-2065. Contact: Dave Smith. Estab. 1879. Specializes in calendars, posters and stationery. Photo guidelines free with SASE.
Needs: Buys 3-10 images annually. Interested in photos of mountains, fall, streams and wildlife. Submit seasonal material any time. Does not want nudes. Reviews stock photos. Model/property release required. Captions preferred.
Making Contact & Terms: Interested in receiving work from newer, lesser-known photographers. Submit portfolio for review. Uses 2¼×2¼, 4×5, 8×10 transparencies. Does not keep samples on file. SASE. Reports in 1 month. Payment negotiable. **Pays on acceptance.** Credit line sometimes given depending upon calendar it is used on. Buys the right to publish in the future; negotiable.
Tips: "Do not send work with washed-out color or not in focus—this is a waste of our time."

‡**GRAPHIQUE DU JOUR, INC.**, 1710 Defoor Ave., Atlanta GA 30318. (404)350-7190. Fax: (404)350-7195. President: Daniel Deljou. Estab. 1980. Specializes in wall decor, fine art.
Needs: All images supplied by freelancers. Specializes in artistic images for reproduction for high-end art market. Work sold through art galleries as photos or prints. Needs nature photos. Reviews stock photos of graphics, b&w photos.

Making Contact & Terms: Interested in receiving work from newer, lesser-known photographers. Submit portfolio for review. Uses color and b&w prints; 35mm, 2¼×2¼, 4×5, 8×10 transparencies. SASE. Reports in 1 month. Pays royalties on sales. Credit line sometimes given depending upon the product. Rights negotiable. Simultaneous submissions and previously published work OK.
Tips: "Abstract-looking photographs OK. Hand-colored b&w photographs needed."

***GREETWELL**, D-24, M.I.D.C., Satpur., Nasik 422 007 India. Phone: 253-350181. Fax: 253-351381. Chief Executive: Ms. V.H. Sanghavi. Estab. 1974. Specializes in greeting cards and calendars.
Needs: Buys approx. 50 photos/year. Landscapes, wildlife, nudes. No graphic illustrations. Submit seasonal material anytime throughout the year. Reviews stock photos. Model release preferred.
Making Contact & Terms: Query with samples. Uses any size color prints. SASE. Reports in 1 month. Pays $25/color photo. Pays on publication. Credit line given. Previously published work OK.
Tips: In photographer's samples, "quality of photo is important; would prefer nonreturnable copies. No originals please."

HALLMARK CARDS, INC., 2501 McGee, Drop #152, Kansas City MO 64108. Not accepting freelance submissions at this time.

HEALTHY PLANET PRODUCTS INC., 1700 Corporate Circle, Petaluma CA 94954. (707)778-2280. Fax: (707)778-7518. E-mail: hppi@aol.com. Vice President/Sales and Marketing: M. Scott Foster. Specializes in greeting cards, stationery, and gift products such as magnets and journals.
Needs: "We have expanded several of our Healthy Planet Products lines. Our Sierra Club line of wildlife and wilderness cards has been a great success and we continue to look for more shots to expand this line. Wildlife in pairs, interacting in a nonthreatening manner is popular, as well as dramatic shots of man in nature. Non-West Coast shots are always in demand, as well as shots that could be used in our boxed Christmas line. Our underwater line, Sea Dreams, is comprised of only sea-related shots. We just released our new Nature Baby line of cards and gifts featuring images of baby animals. Vibrant colors are a real plus. Sea mammals are very popular." Submit seasonal material 1 year in advance; all-year-round review; "include return postage."
Making Contact & Terms: Submit by mail. Provide business card and tearsheets to be kept on file for possible future assignments. "Due to insurance requirements, we cannot accept responsibility for original transparencies so we encourage you to submit dupes. Should we select a shot from your original submission for further review, we will at that time request the original and accept responsibility for that original up to $1,500 per transparency." Uses 35 mm, 2¼×2¼, 4×5 transparencies. SASE. Reports in 4-6 weeks. Simultaneous submissions and previously published work OK. Buys 5-year, worldwide greeting card rights which include electronic online greeting cards; separate fees for other rights. "We do not pay research fees." Credit line given. Buys exclusive product rights.
Tips: "Please hold submissions for our Healthy Planet Products line to your best 100-120 shots. A portion of the proceeds from the sales of our lines goes to the Sierra Club and/or other environmentally conscious organizations."

‡HIGH RANGE GRAPHICS, P.O. Box 3302, 365 N. Glenwood, Jackson WY 83001. (307)733-8723. Art Director: J.L. Stuessl. Estab. 1989. Specializes in screen printed T-shirts.
Needs: Buys 5-10 images annually; all supplied by freelancers. May offer one assignment annually. Interested in mountain biking, skiing (speed or Big Air), whitewater rafting. Submit seasonal material 6 months in advance. Reviews stock photos. Captions preferred, "just so we can identify the image in conversation."
Making Contact & Terms: Interested in receiving work from newer, lesser-known photographers. Query with samples. Uses 8×10 maximum color prints; 35mm transparencies. Keeps samples on file. SASE. "We reply in fall or spring." Pays $50-100/color photo; flat fee (plus one T-shirt). Pays on usage. Buys exclusive product rights for screen printed garments only. Simultaneous submissions and/or previously published work OK.
Tips: "We often graphically alter the image (i.e., posterize) and incorporate it as part of a design."

***** **INTERNATIONAL MARKETS**, those located outside of the United States and Canada, are marked with an asterisk.

IMAGE CONNECTION AMERICA, INC., 456 Penn St., Yeadon PA 19050. (610)626-7770. Fax: (610)626-2778. President: Michael Markowicz. Estab. 1988. Specializes in postcards and posters.
Needs: Contemporary. Model release required. Captions preferred.
Making Contact & Terms: Query with samples. Send unsolicited photos by mail for consideration. Uses 8 × 10 b&w prints and 35mm transparencies. SASE. Payment negotiable. Pays quarterly or monthly on sales. Credit line given. Buys exclusive product rights; negotiable.

IMPACT, 4961 Windplay Dr., El Dorado Hills CA 95762. (916)939-9333. Fax: (916)939-9334. Estab. 1975. Specializes in calendars, bookmarks, magnets, postcard packets, postcards, posters and books for the tourist industry. Photo guidelines and fee schedule free with SASE.
• This company sells to specific tourist destinations; their products are not sold nationally. They need material that will be sold for at least a 6-8 year period.
Needs: Buys stock and assigns work. Buys 3,000 photos/year. Offers 10-15 assignments/year. Wildlife, scenics, US travel destinations, national parks, theme parks and animals. Submit seasonal material 4-5 months in advance. Model/property release required. Captions preferred.
Making Contact & Terms: Query with samples. Query with stock photo list. Provide résumé, business card, self-promotion piece or tearsheets to be kept on file for possible future assignments. Uses 35mm, 2¼ × 2¼, 4 × 5, 8 × 10 transparencies. Keeps samples on file. SASE. Reports in 1 month. Payment negotiable; request fee schedule; rates vary by size. Pays on usage. Credit line and printed samples of work given. Buys one-time and nonexclusive product rights; negotiable. Simultaneous submissions and previously published work OK.

‡**INSPIRATIONART & SCRIPTURE**, P.O. Box 5550, Cedar Rapids IA 52406. (319)365-4350. Fax: (319)366-2573. E-mail: lisa@inspirationart.com. Website: http://www.inspirationart.com. Contact: Lisa Edwards. Estab. 1996. Specializes in Christian posters (all contain scripture and are geared towards teens and young adults). Photo guidelines free with SASE.
Needs: Buys 5-6 images annually; all supplied by freelancers. "We've used sports, nature, etc. . . . All images must be able to work with scripture." Submit seasonal material 6 months in advance. Reviews stock photos. Model/property release required.
Making Contact & Terms: Interested in receiving work from newer, lesser-known photographers. Query with samples. Request catalog for $3. Works with local freelancers on assignment only. Uses 35mm, 2¼ × 2¼, 4 × 5, 8 × 10 transparencies. Prefers 2¼ × 2¼ or 4 × 5 but can work with 35mm. ("We go up to 24 × 36.") Keeps samples on file. SASE. Reports in 3-4 months. Art acknowledgement is sent upon receipt. Pays $100-200/color photo. Pays on usage. Credit line given. Buys exclusive rights to use as a poster only.
Tips: "We do not use digital imagery at this time because we go to a 24 × 36 final format and conventional scanning is less expensive than 24 × 36 digital outputting. Photographers interested in having their work published by InspirationArt & Scripture should consider obtaining a catalog of the type of work we do prior to sending submissions. Also remember that we review art only three or four times per year and will take that long to return submissions."

‡**INTERCONTINENTAL GREETINGS**, 176 Madison Ave., New York NY 10016. (212)683-5830. Fax: (212)779-8564. Art Director: Robin Lipner. Estab. 1967. Specializes in greeting cards, calendars, post cards, posters, framing prints, stationery, gift wrap and playing cards. Photo guidelines free with SASE.
Needs: Buys 20-50 photos/year. Graphics, sports, occasions (i.e. baby, birthday, wedding), "soft-touch" romantic themes, graphic studio photography. No nature, landscape or cute children. Accepts seasonal material any time. Model release preferred.
Making Contact & Terms: Interested in receiving work from newer, lesser-known photogaphers. Query with samples. Send unsolicited photos by mail for consideration. Submit portfolio for review. Provide résumé, business card, brochure, flier or tearsheets to be kept on file for possible future assignments. Works with freelancers only. Uses glossy color prints; 35mm, 2¼ × 2¼, 4 × 5 and 8 × 10 transparencies. SASE. Reports in 3 weeks. Pays 20% royalties on sales. Pays on publication. No credit line given. Buys one-time rights and exclusive product rights. Simultaneous submissions and previously published work OK.
Tips: In photographer's portfolio samples, wants to see "a neat presentation, perhaps thematic in arrangement." The trend is toward "modern, graphic studio photography."

‡**JII SALES PROMOTION ASSOCIATES, INC.**, 545 Walnut St., Coshocton OH 43812. (614)622-4422. Photo Editor: Walt Andrews. Estab. 1940. Specializes in advertising calendars and greetings. Photo guidelines free with SASE.
Needs: Buys 200 photos/year. Interested in traditional scenics, mood/inspirational scenics, human interest, special interest (contemporary homes in summer and winter, sailboats, hot air balloons), animals, plants. Reviews stock photos. Model release required. Captions with location information only required.
Making Contact & Terms: Query with stock photo list. Send unsolicited photos by mail for consider-

ation. Uses 4×5, 8×10 transparencies. SASE. Reports in 2 weeks. Payment negotiable; pays by the job. **Pays on acceptance.** Buys all time advertising, calendar, greeting and direct mail rights, exclusive product rights, some special 1 year rights.

Tips: "Our calendar selections are nearly all horizontal compositions. Greeting photos may be either horizontal or vertical."

‡JILLSON & ROBERTS GIFT WRAPPINGS, 5 Watson Ave., Irvine CA 92618. (714)859-8781. Fax: (714)859-0257. Art Director: Joshua J. Neufeld. Estab. 1974. Specializes in gift wrap, totes, printed tissues, accessories. Photo guidelines free with SASE.

Needs: Needs vary. Specializes in everyday and holiday products. Submit seasonal material 3-6 months in advance.

Making Contact & Terms: Submit portfolio for review. Query with samples. Provide résumé, business card, self-promotion piece or tearsheets to be kept on file for possible future assignments. Reports in 3 weeks. Pays average flat fee of $250; or royalties.

ARTHUR A. KAPLAN CO., INC., 460 W. 34th St., New York NY 10001. (212)947-8989. Art Director: Elizabeth Tuckman. Estab. 1956. Specializes in posters, wall decor and fine prints and posters for framing.

Needs: Buys 50-100 freelance photos/year. Flowers (no close-ups), scenics, animals, still life, Oriental motif, musical instruments, Americana, hand-colored and *unique* imagery. Reviews stock photos. Model release required.

Making Contact & Terms: Send unsolicited photos or transparencies by mail for consideration. Uses any size color prints; 35mm, $2\frac{1}{4} \times 2\frac{1}{4}$, 4×5 and 8×10 transparencies. Reports in 1-2 weeks. Royalty 5-10% on sales. Offers advances. Pays on publication. Buys exclusive product rights. Simultaneous submissions OK.

Tips: "Our needs constantly change, so we need diversity of imagery. We are especially interested in images with international appeal."

© 1996 Kogle Cards, Inc.

Kogle Cards' Patricia Koller can't reveal the name of the photographer of this amusing image, as their contracts are exclusive and private. She will say the humor in the photo attracted her to it. "It's a unique composition—eye catching (no pun intended!)." The inside reads "Just Keeping an Eye on You!"

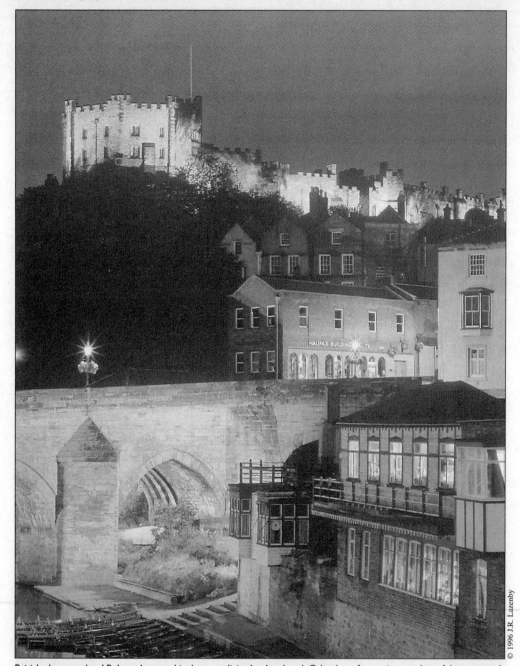

© 1996 J.R. Lazenby

British photographer J.R. Lazenby sent this shot unsolicited to Landmark Calendars after seeing another of the company's publications. "I noticed a calendar sitting around at work that listed a castles calendar amongst its publications," he says. "I thought a night shot of Durham Castle had a sense of drama and atmosphere that the calendar could use." The photo ended up as the December 1997 image in Landmark's *Castles Calendar*. "It has given me a lot of confidence to know that I can get some work published in America as well as in England."

KOGLE CARDS, INC., 1498 S. Lipan St., Denver CO 80223. (303)698-9007. Fax: (303)698-9242. President: Patricia Koller. Send submissions Attn: Art Director. Estab. 1982. Specializes in greeting cards and postcards for all business occasions.

Needs: Buys about 300 photos/year. Thanksgiving, Christmas and other holidays, also humorous. Submit seasonal material 9 months in advance. Reviews stock photos. Model release required.
Making Contact & Terms: Query with 6 color copies. Send slides or color photocopies with SASE. Sizes: postcards, 4¼×6; greeting cards, 5×7. "When artwork is finished, be sure it is in proportion to the sizes listed. Allow ¼" bleed when bleed is used." Will work with color only. SASE. Reports in 1 month. Offers "no compete" contract which means you can't work for another greeting card company. Payment negotiable; pays royalty for the life of the card with no advance. "The photographer makes more that way." Monthly royalty check. Buys all rights; negotiable.

LANDMARK CALENDARS, 51 Digital Dr., P.O. Box 6105, Novato CA 94948-6105. (415)883-1600. Fax: (415)382-3357. Contact: Photo Editor. Estab. 1979. Specializes in calendars.
● Images for this market must be super quality. Landmark plans to implement digital pre-press of images and line art. They encourage freelancers to submit images on CD.
Needs: Buys/assigns 3,000 photos/year. Interested in scenic, nature, travel, sports, automobiles, collectibles, animals, food, people, miscellaneous. No nudes. "We accept *solicited* submissions only, from November through March two years prior to the calendar product year. Photos must be accompanied by our submission agreement, and be sent only within the terms of our guidelines." Reviews stock photos. Model/property release required especially when shooting models and photos containing trademarked property or logos. Captions required; include specific breed of animal, if any; specific location of scene (i.e. gray wolf, Kalispell, Montana).
Making Contact & Terms: Unsolicited submissions are not accepted. Send list of published credits and/or non-returnable samples. Uses transparencies from 35mm to 8×10. Pays $50-200/photo depending on product. Pays in April of year preceding product year (i.e. would pay in April 1998 for 1999 product). Credit line given. Buys one-time and exclusive product rights, plus rights to use photo in sales material and catalogs. Previously published work OK.
Tips: Looks for "tack-sharp focus, good use of color, interesting compositions, correct exposures. Most of our calendars are square or horizontal, so work should allow cropping to these formats. For 35mm slides, film speeds higher than ASA 100 are generally unacceptable due to the size of the final image (up to 12×12)."

‡LESLIE LEVY FINE ART PUBLISHING, INC., 1505 N. Hayden Rd., Suite J10, Scottsdale AZ 85257. (602)945-8491. Fax: (602)945-8104. Website: http://www.leslielevy.com. Director: Leslie Levy. Estab. 1976. Publishes posters and limited edition prints.
Needs: Buys 50-75 images annually. Interested in landscape, gardenscape, animals, farm scenes, figurative, Southwest, children and much more. Reviews stock photos and slides. Model/property release required. Captions preferred; include location, date, subject matter or special information.
Making Contact & Terms: Interested in receiving work from newer, lesser-known photographers. Submit portfolio for review. Send SASE. Do not call. Uses 16×20, 22×28, 18×24, 24×30, 24×36 color and b&w prints; 4×5 transparencies. Keeps samples on file. SASE. Reports in 4-6 weeks. Pays royalties quarterly based upon sales. Buys exclusive product rights. Simultaneous submissions and previously published work OK.

LOVE GREETING CARDS, INC., 1717 Opa Locka Blvd., Opa Locka FL 33054. (305)685-LOVE. Fax: (305)685-8473. Vice President: Norman Drittel. Specializes in greeting cards, postcards and posters.
Needs: Buys 75-100 photos/year. Nature, flowers, boy/girl (contemporary looks). Submit seasonal material 6 months in advance. Reviews stock photos. Model release preferred.
Making Contact & Terms: Query with samples or stock photo list. Send unsolicited photos by mail for consideration. Provide résumé, business card, brochure, flier or tearsheets to be kept on file for possible future assignments. Uses 5×7 or 8×10 color prints; 35mm, 2¼×2¼ and 4×5 transparencies; color contact sheets, color negatives. SASE. Reports in 1 month. Pays minimum $100/color photo. Pays extra for electronic usage of photos. Pays on publication. Credit line given. Buys exclusive product rights. Previously published work OK.
Tips: "We are looking for outstanding photos for greeting cards and New Age posters." There is a "larger use of photos in posters for commercial sale."

THE DIGITAL MARKETS INDEX, located in the back of this book, lists markets that use images electronically.

‡BRUCE McGAW GRAPHICS, INC., 389 W. Nyack Rd., West Nyack NY 10994. (914)353-8600. Fax: (914)353-3155. Director of Purchasing/Acquisitons: Martin Lawlor. Estab. 1979. Specializes in posters, framing prints, wall decor.

Needs: 150-200 images in a variety of media are licensed annually; 10-15% in photography. Interested in b&w: still life, floral, figurative, landscape. Color: landscape, still life, floral. Does not want images that are too esoteric or too commercial. Model/property release required for figures, personalities, images including logos or copyrighted symbols. Captions required; include artist's name, title of image, year taken.

Making Contact & Terms: Interested in receiving work from newer, lesser-known photographers. Submit portfolio for review. Provide résumé, business card, self-promotion piece or tearsheets to be kept on file for possible future assignments. Include SASE for return of materials. Do not send originals! Uses color and b&w prints; 35mm, 2¼×2¼, 4×5, 8×10 transparencies. SASE. Reports in 1 month. Pays royalties on sales. Pays quarterly following first sale and production expenses. Credit line given. Buys exclusive product rights for image, exclusive product rights for all wall decor. Simultaneous submissions and/or previously published work OK.

Tips: "Work must be accessible without being too commercial. Our posters/prints are sold to a mass audience worldwide who are buying art prints. Images that relate a story typically do well for us. The photographer should have some sort of unique style or look that separates him from the commercial market."

MARCEL SCHURMAN COMPANY, 2500 N. Watney Way, Fairfield CA 94533. (800)333-6724 ext. 3060 or (707)428-0200 ext. 3060. Fax: (707)428-0425. Contact: Creative Department. Estab. 1950. Specializes in greeting cards, stationery, gift wrap. Guidelines free with SASE.

Needs: Buys 75 images annually; all supplied by freelancers. Offers 50 assignments annually. Interested in humorous, seasonal, art/contemporary, some nature, still life. Submit seasonal material 1 year in advance. Does not want technical, medical, or industrial shots. Model/property release required. Captions preferred.

Making Contact & Terms: Interested in receiving work of newer photographers. Submit portfolio for review. Query with samples. Provide résumé, business card, self-promotion piece or tearsheets to be kept on file for possible future assignments. Works with local freelancers only. Uses 8×10, 11×14 matte b&w prints; 35mm, 2¼×2¼, 4×5 transparencies. Keeps samples on file. SASE. Reports in 6 weeks. Pays flat fee or royalties on sales in some cases. **Pays on acceptance.** Credit line given. Buys 3-5 year worldwide exclusive rights to greeting cards/gift wraps. Simultaneous submissions OK.

Tips: "In terms of greeting cards, I advise any interested artists to familiarize themselves with the company's line by visiting a retailer. It is the fastest and most effective way to know what kind of work the company is willing to purchase or commission. Photography, in all forms, is very marketable now, specifically in different areas of technique, such as hand-colored, sepia/etc. toning, Polaroid transfer, b&w art photography."

BRUCE MINER POSTER CO. INC., Box 709, Peabody MA 01960. (508)741-3800. Fax: (508)741-3880. President: Bruce Miner. Estab. 1971. Photos used in posters.

Needs: Number of photos bought "varies." Wildlife photos. Reviews stock photos of wildlife. Model release preferred.

Making Contact & Terms: Interested in receiving work from newer, lesser-known photographers. Query with stock photo list. Provide résumé, business card, brochure, flier or tearsheets to be kept on file for possible future assignments. Uses 8×10 prints; 2¼×2¼ transparencies. Keeps samples on file. SASE. Reports in 1 month. Payment negotiable. Pays advance against royalties. Pays on usage. Credit line given. Buys one-time and all rights; negotiable.

Tips: Looking for "quality" submissions.

‡MODERN ART, 100 Snake Hill Rd., West Nyack NY 10994-1612. (914)358-7605. Fax: (914)358-3208. Art Coordinator: Jim Nicoletti. Specializes in posters, wall decor. Photo guidelines free with SASE.

Needs: Interested in nature, seasonal landscapes, seascapes, European scenes. Reviews stock photos. Model/property release required.

Making Contact & Terms: Interested in receiving work from newer, lesser-known photographers. Submit portfolio for review. Uses 16×20 and larger color and b&w prints; 35mm, 2¼×2¼, 4×5, 8×10 transparencies. Keeps samples on file "if the artist will let us." SASE. Reports in 3 weeks. Pays on usage. Credit line given. Buys one-time, all and exclusive product rights. Simultaneous submissions OK.

‡NEW YORK GRAPHIC SOCIETY, 33 River Rd., Cos Cob CT 06807. (203)661-2400. Fax: (203)661-2480. Contact: Helen Redfield. Estab. 1925. Specializes in posters, framing prints.

Needs: Buys 150 images annually; 125 supplied by freelancers. Interested in nature and sports. "However, we wish to expand our selections."

Making Contact & Terms: Query with samples. Uses 4×5 transparencies. Does not keep samples on

file. SASE. Reports in 1 month. Payment negotiable. Pays on usage. Credit line given. Buys exclusive product rights.

‡NOVA MEDIA INC., 1724 N. State St., Big Rapids MI 49307. Phone/fax: (616)796-7539. E-mail: trund@ripro.com. Website: http://www.nov.com. President: Thomas J. Rundquist. Estab. 1981. Specializes in posters. Photo guidelines free with SASE.
Needs: Buys 100 images annually; most supplied by freelancers. Offers 20 assignments annually. Interested in art, factory photos. Submit seasonal material 2 months in advance. Reviews stock photos. Model release required. Photo captions preferred.
Making Contact & Terms: Interested in receiving work from newer, lesser-known photographers. Query with samples. Works on assignment only. Uses color and b&w prints. Digital format for website, requires submissions on 3.5″ disks (IBM compatible) or CD-ROM. SASE. Reports in 1 month. Payment negotiable. Pays extra for electronic usage of photos. Pays on usage. Credit line given. Buys electronic rights; negotiable. Simultaneous submissions and/or previously published work OK.

PALM PRESS, INC., 1442A Walnut St., Berkeley CA 94709. (510)486-0502. Fax: (510)486-1158. E-mail: palmpress@aol.com. Photo Editor: Theresa McCormick. Estab. 1980. Specializes in greeting cards.
 ● Palm Press has received Louie Awards from the Greeting Card Association.
Needs: Buys stock images from freelancers. Buys 200 photos/year. Humor, nostalgia, unusual and interesting b&w and color, Christmas and Valentine, wildlife. Does not want abstracts or portraits. Submit seasonal material 1 year in advance. Model/property release required. Captions required.
Making Contact & Terms: Query with résumé of credits. Query with samples. Uses b&w and color prints; 35mm transparencies. SASE. Reports in 2-3 weeks. Pays royalty on sales. Credit line given. Buys one-time and exclusive worldwide product rights; negotiable.
Tips: Sees trend in increased use of "occasion" photos.

‡PORTAL PUBLICATIONS LTD., Dept. PM, 770 Tamalpais Dr., Suite 400, Corte Madera CA 94925. (415)924-5652. Fax: (415)924-7439. Submissions to: Art Department. Estab. 1954. Specializes in greeting cards, calendars, posters, wall decor, framing prints, gift bags, apparel and note cards. Photo guidelines free with SASE.
Needs: Gives up to 400 or more assignments annually. Contemporary photography (florals, landscapes, b&w and hand-tinted b&w). Nostalgia, nature and wildlife, endangered species, humorous, animal photography, scenic, inspirational, tinted b&w children's photography, still life, garden themes and dance. Sports, travel, food and youth-oriented popular icons such as celebrities, movie posters and cars. Nothing too risqué. Reviews stock photos. Model release required; captions preferred.
Making Contact & Terms: Query with samples. Submit portfolio for review. "Please limit submission to a maximum of 40 images showing the range and variety of work. All slides and transparencies should be clearly labeled and marked." Uses 35mm, $2\frac{1}{4} \times 2\frac{1}{4}$, 4×5 and 8×10 transparencies. No originals; dupes only. SASE. Reports in 3 months. Payment negotiable. Payment determined by the product format. Pays on acceptance or publication. Credit line given. Buys one-time and exclusive product rights. Simultaneous submissions and previously published work OK.
Tips: "Ours is an increasingly competitive business, so we look for the highest quality and most unique imagery that will appeal to our diverse market of customers."

‡PORTERFIELD'S FINE ART IN LIMITED EDITIONS, 12 Chestnut Pasture Rd., Concord NH 03301. (603)228-1864. Fax: (603)228-1888. E-mail: ljklass@aol.com. President: Lance J. Klass. Estab. 1994. Specializes primarily in limited-edition collectibles. Photo guidelines free with SASE.
Needs: Buys 12-15 images annually. Interested only in photos of children ages 1½-4, with 1 or 2 children in each photo. Submit seasonal material as soon as available. "We are seeking excellent color or black and white photographs on early childhood that can be used as photo references and conceptual materials by one of America's leading portraitists, whose paintings will then be used as the basis for collectible products, principally collector plates and related material. We are seeking high-quality photographs, whether prints, slides or digital images, which show the wonder and joy, and occasionally even the sad moments, of real children in real-life settings. No posed images, no man-made toys, no looking 'at the camera,' but only photos which provide the viewer with a window into a special, perhaps magical moment of early childhood. Each image should be of one or two children engaged in some purposeful activity which is reminiscent of our own childhood or of the years when our own children or grandchildren were small, or which depicts a typical, lovely, charming or emotional activity or event in the life of a small child." Reviews stock photos. Model release required for children.
Making Contact & Terms: Interested in receiving work from newer, lesser-known photographers. Query with samples. Uses color and b&w prints; transparencies; TIFF or JPEG. Keeps samples on file. SASE. Reports in 1-2 weeks. "We pay $150 or more for single-use rights, but will negotiate. No foreign submis-

sions accepted, other than Canadian. We'll work one on one with photographers." **Pays on acceptance.** Credit line not given. Buys single-use rights. "Porterfield's seeks the exclusive right to use a particular photo only to create derivative works, such as paintings, from which further derivative works such as collector plates may be made and sold. We have no desire to and never will reproduce a licensed photograph in its original form for any commercial use, thereby leaving the photographer free to continue to market the photo in its current form for direct reproduction in any medium other than derivative works." Simultaneous submissions and previously published work OK.

‡**PORTFOLIO GRAPHICS, INC.**, 4060 S. 500 West, Salt Lake City UT 84123. (801)266-4844. Fax: (801)263-1076. Art Director: Kent Barton. Estab. 1986. Specializes in greeting cards, posters and framing prints. Photo guidelines free with SASE.
Needs: Buys 50 images annually; nearly all supplied by freelancers. Interested in photos with a fine art/decorative look. Submit seasonal material on an ongoing basis.
Making Contact & Terms: Interested in receiving work from newer, lesser-known photographers. Send slides, transparencies, tearsheets with SASE. Works with local freelancers only. Uses prints, 4×5 transparencies. Does not keep samples on file. SASE. Reports in 1 month. Pays 10% royalty on sales. Quarterly royalties paid per pieces sold. Buys exclusive product rights license per piece.

‡**PRATT & AUSTIN CO., INC.**, P.O. Box 587, Holyoke MA 01041. (413)532-1491. Fax: (413)536-2741. Product Manager: Lorilee Costello. Estab. 1937. Specializes in stationery.
Needs: Buys 60 images annually; all supplied by freelancers. Offers 30 assignments annually. Interested in cute photos, florals and children. Does not want animals or aerials. Reviews stock photos.
Making Contact & Terms: Interested in receiving work from newer, lesser-known photographers. Provide résumé, business card, self-promotion piece or tearsheets to be kept on file for possible future assignments. Works on assignment only. Uses 4×5 color prints. Keeps samples on file. SASE. Reports in 3-6 months. Payment negotiable. **Pays on acceptance.** Credit line given. Buys exclusive product rights; negotiable.

‡**THE PRESS CHAPEAU**, P.O. Box 4591, Baltimore MD 21212. Director: Elspeth Lightfoot. Estab. 1976. Specializes in fine art originals for corporate facilities. Photo guidelines free with SASE.
 ● Press Chapeau maintains an image bank of 40,000 images.
Needs: Buys 40-70 images annually; 20% supplied by freelancers. Offers 10-20 assignments annually. Reviews stock photos. Model/property release required. Captions required.
Making Contact & Terms: Interested in receiving work from newer, lesser-known photographers. Query with samples. Provide résumé, business card, self-promotion piece or tearsheets to be kept on file for possible future assignments. "No artist's statements please." Uses 8×10, 24×30 matte b&w prints; 35mm, 2¼×2¼, 8×10 transparencies. Accepts images in digital format for Mac. Submit via disk or CD-ROM. Keeps samples on file. SASE. Reports in 1-2 weeks. Photographer determines rate. Pays extra for electronic usage of photos. **Pays on acceptance.** Credit line given. Buys all rights; negotiable. Simultaneous submissions and/or previously published work OK.
Tips: "Your work is more important than background, résumé or philosophy. We judge solely on the basis of the image before us."

‡**PRODUCT CENTRE-S.W. INC., THE TEXAS POSTCARD CO.**, P.O. Box 860708, Plano TX 75086. (214)423-0411. Art Director: Susan Hudson. Estab. 1980. Specializes in postcards.
Needs: Buys approximately 100 freelance photos/year. Texas, Oklahoma, Louisiana, Arkansas, Kansas, Missouri, New Mexico and Mississippi towns/scenics; regional (Southwest only) scenics, humorous, inspirational, nature (including animals), staged studio shots—model and/or products. No nudity. Submit seasonal material 1 year in advance. Model release required.
Making Contact & Terms: Interested in receiving work from newer, lesser-known photographers. Send insured samples with return postage/insurance. Include Social Security number and telephone number. Uses "C" print 8×10; 35mm, 2¼×2¼, 4×5 transparencies. SASE. No material returned without postage. Reports in usually 3-4 months, depending on season. Pays $50-100/photo. Pays on publication. Buys all rights.

THE SUBJECT INDEX, located at the back of this book, lists publications, book publishers, galleries, paper product companies and stock agencies according to the subject areas they seek.

Tips: "Submit slides only for viewing. Must be in plastic slide sleeves and each labeled with photographer's name and address. Include descriptive material detailing where and when photo was taken. Follow the guidelines—nine out of ten submissions rejected are rejected due to noncompliance with submission guidelines."

PUNKIN' HEAD PETS, 1025 N. Central Expy., Suite 300-349, Plano TX 75075-8806. (972)208-4061. E-mail: phpets@aol.com. Owner: Lyn Skaggs. Estab. 1995. Specializes in greeting cards and gift wrap. Photo guidelines free.
Needs: Interested in cat and dog photos. Submit seasonal material 3 months in advance.
Making Contact & Terms: Interested in receiving work from newer, lesser-known photographers. Query with samples. Uses 3×5 (any finish) color prints; 4×5 transparencies. Accepts images in digital format for Windows. Send via compact disc, online or floppy disk. Keeps samples on file. SASE. Reports in 1 month. Pays $20-50/color photo. Credit line given. Buys all rights; negotiable. Simultaneous submissions OK.
Tips: "Send cute and creative photos of cats and dogs. I do not want pictures with people in them."

‡QUALITY ARTWORKS, INC., 2262 N. Penn Rd., Hatfield PA 19440-0369. (215)822-0125. Contact: Creative Director. Estab. 1985. Specializes in bookmarks and decorative scrolls. Photo guidelines free with SASE.
Needs: Buys up to 50 images annually; 25% supplied by freelancers. Offers up to 10 assignments annually. Interested in nature, religious, animal and scenic. Does not want sports. Reviews stock photos. Model/property release required. Captions preferred.
Making Contact & Terms: Interested in receiving work from newer, lesser-known photographers. Query with samples. Works on assignment only. Uses 4×5 transparencies. Keeps samples on file. SASE. Reports in 1 month. Pays $50-400/color or b&w photo. Pays on usage. Credit line given. Buys all and exclusive product rights. Simultaneous submissions and previously published work OK.
Tips: "We are looking for creative, fresh looks with strong color and design. Study our product and the market. Design with our consumer in mind—for the most part, a high-end female (age: late teens—senior years). Freelancers must be able to work within a narrow vertical format (bookmarks)."

‡RECYCLED PAPER GREETINGS, INC., Art Dept., 3636 N. Broadway, Chicago IL 60613. (773)348-6410. Art Director: Melinda Gordon. Specializes in greeting cards and postcards.
Needs: Buys 30-50 photos/year. "Primarily humorous photos for postcards and greeting cards. Photos must have wit and a definite point of view. Unlikely subjects and offbeat themes have the best chance, but will consider all types." Model release required.
Making Contact & Terms: Send for artists' guidelines. Uses 4×5 b&w and color prints; b&w or color contact sheets. Please do not submit slides. SASE. Reports in 1 month. Pays $250/b&w or color photo. **Pays on acceptance.** Credit line given. Buys all rights; negotiable. Simultaneous submissions OK.
Tips: Prefers to see "up to ten samples of photographer's best work. Cards are printed 5×7 vertical format. Please include messages. The key word for submissions is wit."

‡REEDPRODUCTIONS, 2175 Francisco Blvd., Suite B, San Rafael CA 94901. (415)456-8267. Art Director: Susie Reed. Estab. 1978. Specializes in postcards, key rings, address books, date books, magnets, pins, etc.
Needs: Number of freelancers assigned varies. Celebrity portraits, Hollywood images and rock photographs. Model release preferred.
Making Contact & Terms: Query with samples or send unsolicited photos by mail for consideration. Include résumé, business card, brochure, flier or tearsheets to be kept on file for possible future assignments. Uses 8×10 glossy b&w or color prints or contact sheets. SASE. Reports in 1 month. Pays one-time fee. Credit line negotiable. Buys one-time rights. Simultaneous submissions and previously published work OK.
Tips: "We're looking for classic celebrity portraits, b&w or color, shot in clean style."

‡REIMAN PUBLICATIONS, L.P., 5400 S. 60th St., Greendale WI 53129. (414)423-0100. Fax: (414)423-8463. Photo Coordinator: Trudi Bellin. Estab. 1965. Specializes in calendars and occasionally posters and cards. Photo guidelines free with SASE.
Needs: Buys more than 72 images annually; all supplied by freelancers. Interested in humorous cow, pig and chicken photos as well as scenic country images including barns and churches. Also need backyard birds and flower photos as well as vintage car shots both color and b&w. Unsolicited calendar work must arrive between September 1-15. Does not want smoking, drinking, nudity. Reviews stock photos. Model/property release required for children, private homes. Captions required; include season, location; birds and flowers must include common and/or scientific names.

Making Contact & Terms: Interested in receiving work from newer, lesser-known photographers. Query with résumé of credits. Query with stock photo list. Uses color, b&w prints; 35mm, 2¼×2¼, 4×5, 8×10 transparencies. Tearsheets are kept on file but not dupes. Reports in 3 months for first review. Pays $50-300/ color photo; $25-75/b&w photo. Pays on publication. Credit line given. Buys one-time rights. Simultaneous submissions and previously published work OK.

Tips: "Tack-sharp focus is a must if we are to consider photo for enlargement. Horizontal format is preferred. The subject of the calendar theme must be central to the photo composition. All projects look for technical quality. Focus has to be sharp—no soft focus and colors must be vivid so they 'pop off the page.'"

RENAISSANCE GREETING CARDS, INC., P.O. Box 845, Springvale ME 04083-0845. (207)324-4153. Fax: (207)324-9564. Photo Editor: Wendy Crowell. Estab. 1977. Photo guidelines free with SASE.
● Renaissance is doing more manipulation of images and adding of special effects.
Needs: Buys/assigns 25-50 photos/year. "We're interested in photographs that are artsy, quirky, nostalgic, dramatic, innovative and humorous. Very limited publication of nature/wildlife photos at this time. Special treatment such as hand-tinted b&w images are also of interest." No animals in clothing, risqué or religious. Reviews occur in November and June. Limit slides/images to less than 50 per submission. Reviews stock photos. Model release preferred. Captions required; include location and name of subject.
Making Contact & Terms: Interested in receiving work from newer, lesser-known photographers. Uses b&w 35mm, 2¼×2¼, 4×5 transparencies; b&w, color contact sheets. SASE. Reports in 2 months. Rates negotiable. Pays $175-350 flat fee/color or b&w photo, or $150 advance against royalties. Credit line given. Buys all rights or exclusive product rights; negotiable.
Tips: "We strongly suggest starting with a review of our guidelines, which indicate what we are looking for during the November and June submission reviews."

‡RIGHTS INTERNATIONAL GROUP, 463 First St., Suite 3C, Hoboken NJ 07030. (201)963-3123. Fax: (201)420-0679. President: Robert Hazaga. Estab. 1996. Manufacturers include greeting cards, calendars, posters and gift wrap companies. Rights International Group is a licensing agency specializing in representing photographers and artists to manufacturers for licensing purposes.
Needs: Interested in all subjects. Submit seasonal material 9 months in advance. Reviews stock photos. Model/property release required.
Making Contact & Terms: Submit portfolio for review. Uses prints; transparencies. Keeps samples on file. SASE. Reports in 1-2 weeks. Payment negotiable. Pays on license deal. Credit line given. Buys exclusive product rights. Simultaneous submissions and/or previously published work OK.

ROCKSHOTS, INC., 632 Broadway, New York NY 10012. Fax: (212)353-8756. Art Director: Bob Vesce. Estab. 1978. Specializes in greeting cards.
Needs: Buys 20-50 photos/year. Sexy (including male and female nudes and semi-nudes), outrageous, satirical, ironic, humorous photos. Submit seasonal material at least 6 months in advance. Model release required.
Making Contact & Terms: Interested in receiving work from newer, lesser-known photographers. Send SASE requesting photo guidelines. Provide flier and tearsheets to be kept on file for possible future assignments. Uses b&w and color prints; 35mm, 2¼×2¼ and 4×5 slides. "Do not send originals!" SASE. Reports in 8-10 weeks. Pays $50-125/b&w, $125-300/color photo; other payment negotiable. **Pays on acceptance.** Rights negotiable. Simultaneous submissions and previously published work OK.
Tips: Prefers to see "greeting card themes, especially birthday, Christmas, Valentine's Day. Remember, male and female nudes and semi-nudes are fantasies. Models should definitely be better built than average folk. Also, have fun with nudity, take it out of the normal boundaries. It's much easier to write a gag line for an image that has a theme and/or props. We like to look at life with a very zany slant, not holding back because of society's imposed standards. We are always interested in adding freelance photography because it broadens the look of the line and showcases different points of view. We shoot extensively inhouse."

SUNRISE PUBLICATIONS, INC., P.O. Box 4699, Bloomington IN 47402. (812)336-9900. Fax: (812)336-8712. Estab. 1974. Specializes in greeting cards, posters, stationery. Photo guidelines free with SASE.
Needs: Buys approximately 30 images/year supplied by freelancers. Interested in interaction between people/children/animals evoking a mood/feeling, nature, endangered species (color or b&w photography). Does not want to see sexually suggestive or industry/business photos. Reviews stock photos. Model release required. Property release preferred.
Making Contact & Terms: Interested in receiving work from newer, lesser-known photographers. Submit portfolio for review. Uses 35mm; 4×5 transparencies. Keeps samples on file. Reports in 3 months.

Jan Phillips captured *Dark Elegy* on film during its installation on the campus of Syracuse University. This moving sculpture by Suse Lowenstein, portrays women in a moment of immense grief—as they heard the horrible news that their husbands and children had been killed in the 1989 terrorist bombing of Pan Am flight 103 over Lockerbie, Scotland. Lowenstein lost her son in the crash. The Syracuse Cultural Workers used Phillips photo in "Carry It On—1997 Peace Calendar" and their 1997 women artists datebook, "In Praise of the Muse." The photographer felt she "added an important image to the collective consciousness" by having the photo published.

Payment negotiable. **Pays on acceptance.** Credit line given. Buys exclusive product rights; negotiable. Simultaneous submissions and previously published work OK.
Tips: "Look for Sunrise cards in stores; familiarize yourself with quality and designs before making a submission."

SYRACUSE CULTURAL WORKERS, Box 6367, Syracuse NY 13217. (315)474-1132. Fax: (315)475-1277. Research/Development Director: Dik Cool. Art Director: Karen Kerney. Specializes in posters, cards and calendars.
Needs: Buys 15-25 freelance photos/year. Images of social content, reflecting a consciousness of peace/social justice, environment, liberation, etc. Model release preferred. Captions preferred.
Making Contact & Terms: Interested in receiving work from newer, lesser-known photographers. Send unsolicited photos by mail for consideration. Uses any size b&w; 35mm, 2¼×2¼, 4×5 or 8×10 color transparencies. SASE. Reports in 2-4 months. Pays $75-100/b&w or color photo plus free copies of item. Credit line given. Buys one-time rights.
Tips: "We are interested in photos that reflect a consciousness of peace and social justice, that portray the experience of people of color, disabled, elderly, gay/lesbian—must be progressive, feminist, non-sexist. Look at our catalog (available for $1)—understand our philosophy and politics. Send only what is appropriate and socially relevant. We are looking for positive, upbeat and visionary work."

✿TELDON CALENDARS, A Division of Teldon International Inc., 3500 Viking Way, Richmond, British Columbia, V6V 1N6 Canada. (604)272-0556. Fax: (604)272-9774. Photo Editor: Monika Vent. Estab. 1968. Publishes high quality scenic and generic advertising calendars. Photos used for one time use

in calendars. Photo guidelines free with SAE (9×11) and IRCs or stamps only for return postage.
Needs: Buys 800-1,000 photos annually. Looking for travel (world), wildlife (North America), classic automobiles, golf, scenic North America photos and much more. Reviews stock photos. Model/property release required for residential houses, people. Photo captions required that include complete detailed description of destination, i.e., Robson Square, Vancouver, British Columbia, Canada. "Month of picture taken also required as we are 'seasonal driven.' "
Making Contact & Terms: Interested in receiving work from newer, lesser-known photographers. Query with stock photo list. Works with freelancers and stock agencies. Uses 35mm, 2¼×2¼, 4×5, 6×7, 8×10 horizontal only transparencies. "We are making duplicates of what we think is possible material and return the originals within a given time frame. Originals are recalled once final selection has been made." SASE. Reports in 1 month, depending on work load. Pays $100 for one-time use. Pays in September of publication year. Credit line and complementary calendar copies given. Simultaneous submissions and/or previously published works OK.
Tips: Horizontal transparencies only, dramatic and colorful nature/scenic/wildlife shots. City shots to be no older than 1 year. For scenic and nature pictures avoid "man made" objects, even though an old barn captured in the right moment can be quite beautiful. "Examine our catalogs and fliers carefully and you will see what we are looking for. Capture the beauty of nature and wildlife as long as it's still around—and that's the trend."

TIDE MARK PRESS, Box 280311, East Hartford CT 06128-0311. Editor: Scott Kaeser. Art Director: C. Cote. Estab. 1979. Specializes in calendars.
Needs: Buys 400-500 photos/year; few individual photos; all from freelance stock. Complete calendar concepts which are unique, but also have identifiable markets; groups of photos which could work as an entire calendar; ideas and approach must be visually appealing and innovative but also have a definable audience. No general nature or varied subjects without a single theme. Submit seasonal material in spring for next calendar year. Reviews stock photos. Model release preferred. Captions required.
Making Contact & Terms: "Contact us to offer specific topic suggestion which reflect specific strengths of your stock." Uses 35mm, 2¼×2¼, 4×5 and 8×10 transparencies. SASE. Reports in 1 month. Pays $125-150/color photo; royalties on sales if entire calendar supplied. Pays on publication or per agreement. Credit line given. Buys one-time rights.
Tips: "We tend to be a niche publisher and we rely on niche photographers to supply our needs."

VAGABOND CREATIONS, INC., 2560 Lance Dr., Dayton OH 45409. (937)298-1124. President: George F. Stanley, Jr. Specializes in greeting cards.
Needs: Buys 2 photos/year. Interested in general Christmas scenes . . . non-religious. Submit seasonal material 9 months in advance. Reviews stock photos.
Making Contact & Terms: Query with stock photo list. Uses 35mm transparencies. SASE. Reports in 1 week. Pays $100/color photo. **Pays on acceptance.** Buys all rights. Simultaneous submissions OK.

‡VINTAGE IMAGES, P.O. Box 4699, Silver Spring MD 20914. (301)879-6522. Fax: (301)879-6524. President: Brian Smolens. Estab. 1986. Specializes in postcards, framing prints and wall decor. Photo guidelines free with SASE
Needs: Buys 20 images annually; 75% supplied by freelancers. Interested in scenics: landscapes, cityscapes, castles/mansions in landscape, stained glass. Reviews stock photos.
Making Contact & Terms: "Request our guidelines." Send nonreturnable proof sheets or photocopies. Uses 2¼×2¼ or 4×5 photos. SASE. Reports in 2-3 months. Pays $125-150/color photo; royalties on sales. Credit line given. Buys one-time rights. Simultaneous submissions and previously published work OK.
Tips: "Link up with a writer or designer so you can present a finished concept or line. This is not applicable to our needs, but may be helpful with other firms."

‡WATERMARK, P.O. Box 1037, Kennebunk ME 04043. (207)985-6134. Fax: (207)985-7633. E-mail: watermrk@ime.net. Publisher: Alexander Bridge. Estab. 1982. Specializes in posters.
Needs: Buys 6 images annually; 50% supplied by freelancers. Offers 2 assignments annually. Interested in rowing/crew and sailing. Submit seasonal material 6-12 months in advance. Does not want only rowing photos. Reviews stock photos of sports. Model release required. Photo captions preferred.

🍁 **CANADIAN LISTINGS** are marked with a maple leaf.

Making Contact & Terms: Interested in work from newer, lesser-known photographers. Query with samples. Works on assignment only. Uses 4×5 transparencies. Keeps samples on file. SASE. Reports in 3 weeks. Payment negotiable. Pays on usage. Credit line given. Buys all rights. Offers internships for photographers during summer. Contact President: Alexander Bridge.

WISCONSIN TRAILS, Box 5650, Madison WI 53705. (608)231-2444. Fax: (608)231-1557. E-mail: wistrail@mailbag.com. Photo Editor: Nancy Mead. Estab. 1960. Specializes in calendars (horizontal and vertical) portraying seasonal scenics, some books and activities from Wisconsin.
Needs: Buys 35 photos/issue. Needs photos of nature, landscapes, wildlife and Wisconsin activities. Makes selections in January for calendars, 6 months ahead for issues. Captions required.
Making Contact & Terms: Submit material by mail for consideration or submit portfolio. Uses 35mm, $2\frac{1}{4} \times 2\frac{1}{4}$ and 4×5 transparencies. Accepts images in digital format for Mac (Photoshop). Send via compact disc, floppy disk, SyQuest, Zip disk, jazz disk (300 dpi output 1250 dpi). Reports in 1 month. Pays $50-100/b&w photo; $50-200/color photo. Buys one-time rights. Simultaneous submissions OK "if we are informed, and if there's not a competitive market among them." Previously published work OK.
Tips: "Be sure to inform us how you want materials returned and include proper postage. Calendar scenes must be horizontal to fit $8\frac{1}{2} \times 11$ format, but we also want vertical formats for engagement calendars. See our magazine and books and be aware of our type of photography. Submit only Wisconsin scenes."

Stock Photo Agencies

If you are unfamiliar with how stock agencies work, the concept is easy to understand. Stock agencies house large files of images for contracted photographers and market the photos to potential buyers. In exchange for selling the images agencies typically extract a 50 percent commission from each sale. The photographer receives the other 50 percent.

In the past 15-20 years the stock industry has witnessed enormous growth, with agencies popping up worldwide. Many of these agencies, large and small, are listed in this section. However, as more and more agencies compete for sales there has been a trend toward partnerships among some small to mid-size agencies. In order to match the file content and financial strength of larger stock agencies, small agencies have begun to combine efforts when putting out catalogs and other promotional materials. In doing so they've pooled their financial resources to produce top-notch catalogs, both print and CD-ROM.

Other agencies have been acquired by larger agencies and essentially turned into subsidiaries. Often these subsidiaries are strategically located to cover different portions of the world. Typically, smaller agencies are bought if they have images that fill a need for the parent company. For example, a small agency might specialize in animal photographs and be purchased by a larger agency that needs those images but doesn't want to search for individual wildlife photographers.

The stock industry is extremely competitive and if you intend to sell stock through an agency you must know how they work. Below are seven ideas that can help you land a contract with an agency:

- Build a solid base of quality images before contacting any agency. If you send an agency a package of 50-100 images they are going to want more if they're interested. You must have enough quality images in your files to withstand the initial review and get a contract.
- Be prepared to supply new images on a regular basis. Most contracts stipulate that photographers must send additional submissions periodically—perhaps quarterly, monthly, or annually. Unless you are committed to shooting regularly, or unless you have amassed a gigantic collection of images, don't pursue a stock agency.
- Make sure all of your work is properly cataloged and identified with a file number. Start this process early so that you're prepared when agencies ask for this information. They'll need to know what is contained in each photograph so that the images can be properly referenced in catalogs and on CD-ROMs.
- Research those agencies that might be interested in your work. Often smaller agencies are more receptive to newcomers because they need to build their image files. When larger agencies seek new photographers, they usually want to see specific subjects in which photographers specialize.

 If you specialize in a certain subject area, be sure to check out our newly expanded Subject Index now including stock agencies. The index consists of 46 categories, listing companies according to the types of images they need.
- Conduct reference checks on any agencies you plan to approach to make sure they conduct business in a professional manner. Talk to current clients and other contracted photographers to see if they are happy with the agency. Remember you are interviewing them, too.

 Also, some stock agencies are run by photographers who market their own work through their own agencies. If you are interested in working with such an agency, be certain that your work will be given fair marketing treatment.
- Once you've selected a stock agency, write a brief cover letter explaining that you are

searching for an agency and that you would like to send some images for review. It's usually OK to include some samples (20-40 slides), but do not send originals. Only send duplicates for review so that important work won't get lost or damaged. You also might be asked to submit a portfolio, so be prepared to do so. And always include a SASE.

- Finally, don't expect sales to roll in the minute a contract is signed. It usually takes a few years before initial sales are made. Most agency sales come from catalogs and often it takes a while for new images to get printed in a catalog.

SIGNING AN AGREEMENT

When reviewing stock agency contracts there are several points to consider. First, it's common practice among many agencies to charge photographers fees, such as catalog insertion rates or image duping. Don't be alarmed and think the agency is trying to cheat you when you see these clauses. Besides, it might be possible to reduce or eliminate these fees through negotiation.

Another important item in most contracts deals with exclusive rights to market your images. Some agencies require exclusivity to sales of images that they are marketing for you. In other words, you can't market the same images they have on file. This prevents photographers from undercutting agencies on sales. Such clauses are fair to both sides as long as you can continue marketing images that are not in the agency's files.

An agency also may restrict your rights to sign with another stock house. Usually such clauses are merely designed to keep you from signing with a competitor. Be certain your contract allows you to work with other agencies. This may mean limiting the area of distribution for each agency. For example, one agency may get to sell your work in the United States, while the other gets Europe. Or it could mean that one agency sells only to commercial clients, while the other handles editorial work.

Finally, be certain you understand the term limitations of your contract. Some agreements renew automatically with each submission of images. Others renew automatically after a period of time unless photographers. terminate their contracts in writing. This might be a problem if you and your agency are at odds for any reason. So, be certain you understand the contractual language before signing anything.

AVAILABLE RESOURCES

There are numerous resources available for photographers who want to learn about the stock industry.

—PhotoSource International (800)223-3860. Owned by author/photographer Rohn Engh, this company produces several newsletters that can be extremely useful for stock photographers. A few of these include *PhotoStockNotes*, *PhotoMarket*, *PhotoLetter* and *PhotoBulletin*.

—*Taking Stock* (301)251-0720. This newsletter is published by one of the photo industry's leading insiders, Jim Pickerell. He gives plenty of behind-the-scenes information about agencies and is a huge advocate for stock photographers.

—The Picture Agency Council of America (800)457-7222. Anyone researching an American agency should check to see if the agency is a member of this organization. PACA members are required to practice certain standards of professionalism in order to maintain membership.

—British Association of Picture Libraries and Agencies (081)883-2531. This is PACA's counterpart in the United Kingdom and is a quick way to examine the track record of many foreign agencies.

■✽AAA IMAGE MAKERS, 337 W. Pender St., Suite 301, Vancouver, British Columbia V6B 1T3 Canada. (604)688-3001. Owner: Reimut Lieder. Art Director: Larry Scherban. Estab. 1981. Stock photo agency. Has 250,000 photos. Clients include: advertising agencies, public relations firms, audiovisual firms, businesses, book/encyclopedia publishers, magazine and textbook publishers, postcard publishers, calendar companies and greeting card companies.

Needs: Model-released lifestyles, high-tech, medical, families, industry, computer-related subjects, active middle age and seniors, food, mixed ethnic groups, students, education, occupations, health and fitness, extreme and team sports, and office/business scenes. "We provide our photographers with a current needs list on a regular basis."

Specs: Uses 8×10 glossy or pearl b&w prints; 35mm, 2¼×2¼, 4×5 and 8×10 transparencies.

Payment & Terms: Pays 50% commission on color and b&w. Average price per image (to clients): $400-800/b&w and color. Enforces minimum prices. Offers volume discount to customers; terms specified in photographer's contract. Discount sales terms not negotiable. Works on contract basis only. Offers limited regional exclusivity, guaranteed subject exclusivity. Charges 50% duping fee, 50% catalog insertion fee. Statements issued quarterly. Payment made quarterly. Photographers allowed to review account records. Rights negotiated by client needs. Does not inform photographer or allow him to negotiate when client requests all rights. Model releases required. "All work must be marked 'MR' or 'NMR' for model release or no model release. Photo captions required.

Making Contact: Interested in receiving work from established, especially commercial, photographers. Arrange personal interview to show portfolio or submit portfolio for review. Query with résumé of credits. Query with samples. Send SASE (IRCs) with letter of inquiry, résumé, business card, flier, tearsheets or samples. Expects minimum initial submission of 200 images. Reports in 2-3 weeks. Photo guideline sheet free with SASE (IRC). Market tips sheet distributed quarterly to all photographers on contract; free with SASE (IRCs).

Tips: "As we do not have submission minimums, be sure to edit your work ruthlessly. We expect quality work to be submitted on a regular basis. Research your subject completely and shoot shoot shoot!!"

■✽ACE PHOTO AGENCY, Satellite House, 2 Salisbury Rd., Wimbledon, London SW19 4EZ United Kingdom. (181)944-9944. Fax: (181)944-9940. Chief Editor: John Panton. Stock photo agency. Has approximately 300,000 photos. Clients include: ad agencies, audiovisual firms, businesses, book/encyclopedia publishers, magazine publishers, postcard companies, calendar companies, greeting card companies, design companies and direct mail companies.

Needs: People, sport, corporate, industrial, travel (world), seas and skies, still life and humor.

Specs: Uses 35mm, 2¼×2¼, 4×5 and 8×10 transparencies.

Payment & Terms: Pays 50% commission on color photos, 30% overseas sales. General price range: $135-1,800. Works on contract basis only; offers limited regional exclusivity contracts. Contracts renew automatically for 2 years with each submission. Charges catalog insertion fee, $100 deducted from first sale. Statements issued quarterly. Payment made quarterly. Photographers permitted to review sales records with 1 month written notice. Offers one-time rights, first rights or mostly non-exclusive rights. Informs photographers when client requests to buy all rights, but agency negotiates for photographer. Model/property release required for people and buildings. Photo captions required; include place, date and function.

Making Contact: Arrange a personal interview to show portfolio. Query with samples. SASE (IRCs). Reports in 2 weeks. Photo guidelines free with SASE. Distributes tips sheet twice yearly to "ace photographers under contract."

Tips: Prefers to see "total range of subjects in collection. Must be commercial work, not personal favorites. Must show command of color, composition and general rules of stock photography. All people must be mid-Atlantic to sell in UK. Must be sharp and also original. No dupes. Be professional and patient. We are now fully digital. Scanning and image manipulation is all done inhouse. We market CD-ROM stock to existing clients. Photographers are welcome to send CD, SyQuest, cartridge or diskette for speculative submissions. Please provide data for Mac only."

ADVENTURE PHOTO, 24 E. Main St., Ventura CA 93001. (805)643-7751. Fax: (805)643-4423. Estab. 1987. Stock agency. Member of Picture Agency Council of America (PACA). Has 250,000 photos. Clients include: advertising agencies, public relations firms, businesses, magazine publishers, calendar and greeting card companies.

Needs: Adventure Photo offers its clients 5 principal types of images: adventure sports (sailing, windsurf-

 MARKETS USING AUDIOVISUAL MATERIAL, such as slides, film or videotape, are marked with a solid, black square.

ing, rock climbing, skiing, mountaineering, mountain biking, etc.), adventure travel (all 50 states as well as Third World and exotic locations.), landscapes, environmental and wildlife.

Specs: Uses 35mm, $2\frac{1}{4} \times 2\frac{1}{4}$ and 4×5 transparencies.

Payment & Terms: Pays 50% commission on color photos. Works on contract basis only. Offers nonexclusive contract. Contracts renew automatically with each submission; time period not specified. Statements issued monthly. Payment made monthly. Photographers allowed to review sales figures. Offers one-time rights; occasionally negotiates exclusive and unlimited use rights. "We notify photographers and work to settle on acceptable fee when client requests all rights." Model and property release required. Captions required, include description of subjects, locations and persons.

Making Contact: Write to photo editor for copy of submission guidelines. SASE. Reports in 1 month. Photo guidelines free with SASE.

Tips: In freelancer's portfolio or samples, wants to see "well-exposed, well-lit transparencies (reproduction quality). Unique outdoor sports, travel and wilderness images. We love to see shots of subject matter that portray metaphors commonly used in ad business (risk taking, teamwork, etc.)." To break in, "we request new photographers send us 40-80 images they feel are representative of their work. Then when we sign a photographer, we pass ideas to him regularly about the kinds of shots our clients are requesting, and we pass any ideas we get too. Then we counsel our photographers always to look at magazines and advertisements to stay current on the kinds of images art directors and agencies are using."

‡**AGSTOCKUSA**, 25315 Arriba Del Mundo Dr., Carmel CA 93923. (408)624-8600. Fax: (408)626-3260. E-mail: agstockusa@aol.com. Website: http://www.agstockusa.com. Owner: Ed Young. Estab. 1996. Stock photo agency. Has 100,000 photos. Clients include: advertising agencies, businesses, public relations firms, book/encyclopedia publishers, calendar companies, magazine publishers and greeting card companies.

Needs: Photos should cover all aspects of agriculture worldwide—agricultural scenes; fruits, vegetables and grains in various growth stages, studio work, aerials, harvesting, processing, irrigation, insects, weeds, farm life, agricultural equipment, livestock, plant damage and plant disease.

Specs: Uses 35mm, $2\frac{1}{4} \times 2\frac{1}{4}$, 4×5, 6×7 and 6×17 transparencies.

Payment & Terms: Pays 50% on color photos. Enforces minimum price of $200. Offers volume discounts to customers; inquire about specific terms. Photographers can choose not to sell images on discount terms. Works on contract basis only. Offers nonexclusive contracts. Contracts renew automatically with additional submissions for two years. Charges 50% catalog insertion fee; 50% for production costs for direct mail and CD-ROM advertising. Statements issued monthly. Payment made monthly. Photographers allowed to review account records. Offers one-time rights and buyouts if photographer agrees to sale. Informs photographer and allows him to negotiate when client requests all rights; final decision made by agency. Model/property release preferred. Captions required; include location of photo and all technical information (what, why, how, etc.).

Making Contact: Interested in receiving work from talented, motivated, newer, lesser-known photographers, as well as veteran photographers. Submit portfolio for review. Call first. Keeps samples on file. SASE. Expects minimum initial submission of 100 images. Reports in 3 weeks. Photo guidelines free with SASE. Market tip sheet distributed yearly to contributors under contract; free upon request.

Tips: "Build up a good file (quantity and quality) of photos before approaching any agency. A portfolio of images is currently displayed on our website. We plan to issue a CD-ROM."

ALASKA STOCK IMAGES, 2505 Fairbanks St., Anchorage AK 99503. (907)276-1343. Fax: (907)258-7848. Website: http://www.alaska.net/~akstock. Owner: Jeff Schultz. Stock photo agency. Member of the Picture Agency Council of America (PACA). Has 200,000 transparencies. Clients include: advertising agencies, businesses, newspapers, postcard publishers, book/encyclopedia publishers and calendar companies.

• Alaska Stock Images is currently represented by Picture Network International (PNI) and has a home page on the World Wide Web.

Needs: Outdoor adventure, wildlife, recreation—images which were or could have been shot in Alaska.

Specs: Uses 35mm, $2\frac{1}{4} \times 2\frac{1}{4}$, 4×5, 6×17 panoramic transparencies.

Payment & Terms: Pays 50% commission on color photos; minimum use fee $125. Offers volume discounts to customers; inquire about specific terms. Photographers can choose not to sell images on discount terms. Works on contract basis only. Offers nonexclusive contract; exclusive contract for images in promotions. Contracts renew automatically with additional submissions; nonexclusive for 3 years. Charges variable catalog insertion fee. Statements issued monthly. Payment made monthly. Photographers allowed to review account records. Offers negotiable rights. Informs photographer and negotiates rights for photographer when client requests all rights. Model/property release preferred for any people and recognizable personal objects (boats, homes, etc.). Captions required; include who, what, when, where.

Making Contact: Interested in receiving work from newer, lesser-known photographers. Query with

samples. Samples not kept on file. SASE. Expects minimum initial submission of 20 images with periodic submission of 100-200 images 1-4 times/year. Reports in 3 weeks. Photo guidelines free on request. Market tips sheet distributed 2 times/year to those with contracts.

■**AMERICAN STOCK PHOTOGRAPHY**, Dept. PM, 6255 Sunset Blvd., Suite 716, Hollywood CA 90028. (213)469-3900. Fax: (213)469-3909. President: Christopher C. Johnson. Manager: Sandra Capelli. Stock photo agency. Has 2 million photos. Clients include: advertising agencies, public relations firms, audiovisual firms, businesses, book/encyclopedia publishers, magazine publishers, newspapers, postcard companies, calendar companies, greeting card companies and TV and movie production companies.
 ● American Stock Photography is a subsidiary of Camerique, which is also listed in this section.
Needs: General stock, all categories. Special emphasis on California scenics and lifestyles.
Specs: Uses 35mm, 2¼×2¼, 4×5 transparencies; b&w contact sheets; b&w negatives.
Payment & Terms: Buys photos outright; pays $5-20. Pays 50% commission. General price range (to clients): $100-750. Works on contract basis only. Offers nonexclusive contracts. Contracts renew automatically with additional submissions. Charges 50% for catalog insertion, advertising, CD disks. Statements issued monthly. Payment made monthly. Photographers allowed to review account records. Offers one-time, electronic and multi-use rights. Informs photographer and allows him to negotiate when client requests all rights. Model/property release required for people, houses and animals. Captions required: include date, location, specific information on image.
Making Contact: Contact Camerique Inc., 1701 Skippack Pike., P.O. Box 175, Blue Bell, PA 19422. (610)272-4000. SASE. Reports in 1 week. Photo guidelines free with SASE. Tips sheet distributed quarterly to all active photographers with agency; free with SASE.

*****THE ANCIENT ART & ARCHITECTURE COLLECTION**, 410-420 Rayners Lane, Suite 7, Pinner, Middlesex, London HA5 5DY England. (181)429-3131. Fax: (181)429-4646. Contact: The Librarian. Picture library. Has 200,000 photos. Clients include: public relations firms, audiovisual firms, book/encyclopedia publishers, magazine publishers and newspapers.
Specs: Uses 35mm, 2¼×2¼, 4×5 or 8×10 transparencies.
Payment & Terms: Pays 50% commission. Works with photographers on contract basis only. Offers nonexclusive contracts. Contracts renew automatically with additional submissions. Statements issued quarterly. Payment made quarterly. Photographers allowed to review account records. Offers one-time rights. Fully detailed captions required.
Making Contact: Query with samples and list of stock photo subjects. SASE. Reporting time not specified.
Tips: "Material must be suitable for our specialist requirements. We cover historical and archeological periods from 25,000 BC to the 19th century AD, worldwide. All civilizations, cultures, religions, objects and artifacts as well as art are includable. Pictures with tourists, cars, TV aerials, and other modern intrusions not accepted."

■*****ANDES PRESS AGENCY**, 26 Padbury Ct., London E2 7EH England. (0171)613-5417 Fax: (0171)739-3159. E-mail: photos@andespress.demon.co.uk. Director: Carlos Reyes. Picture library and news/feature syndicate. Has 500,000 photos. Clients include: audiovisual firms, book/encyclopedia publishers, magazine publishers and newspapers.
Needs: "We have a large collection of photographs on social, political and economic aspects of Latin America, Africa, Asia, Europe and Britain, specializing in contemporary world religions."
Specs: Uses 8×10 glossy b&w prints; 35mm and 2¼×2¼ transparencies; b&w contact sheets and negatives.
Payment & Terms: Pays 50% commission for b&w and color photos. General price range (to clients): £50-200/b&w photo; £50-300/color photo; (British currency). Enforces minimum prices. Works on contract basis only. Offers nonexclusive contract. Statements issued quarterly. Payment made quarterly. Photographers allowed to review account records to verify sales figures. Offers one-time rights and, if requested, electronic rights. Informs photographer and allows him to negotiate when client requests all rights. "We never sell all rights; photographer has to negotiate if interested." Model/property release preferred. Captions required.
Making Contact: Interested in receiving work from newer, lesser-known photographers. Query with samples. Send stock photo list. SASE. Reports in 1 week. Photo guidelines free with SASE.
Tips: "We want to see that the photographer has mastered one subject in depth. Also, we have a market for photo features as well as stock photos."

■**ANIMALS ANIMALS/EARTH SCENES**, 17 Railroad Ave., Chatham NY 12037. (518)392-5500. Branch office: 580 Broadway, Suite 1102, New York NY 10012. (212)925-2110. President: Eve Kloepper. Contact: Deborah Culmer. Member of Picture Agency Council of America (PACA). Has 850,000 photos.

Clients include: ad agencies, public relations firms, businesses, audiovisual firms, book publishers, magazine publishers, encyclopedia publishers, newspapers, postcard companies, calendar companies and greeting card companies.

● This agency has joined the Kodak Picture Exchange, an online photo network.
Needs: "We specialize in nature photography with an emphasis on all animal life."
Specs: Uses 8×10 glossy or matte b&w prints; 35mm and some larger format color transparencies.
Payment & Terms: Pays 50% commission. Works on contract basis only. Offers exclusive contracts. Contracts renew automatically for 5 years. Charges catalog insertion fee of 50%. Photographers allowed to review account records to verify sales figures "if requested and with proper notice and cause." Statements issued quarterly. Payment made quarterly. Offers one-time and electronic media rights; other uses negotiable. Informs photographer and allows him to negotiate when client requests all rights. Model release required if used for advertising. Captions required, include Latin names, and "they must be correct!"
Making Contact: Interested in receiving work from newer, lesser-known photographers. Send material by mail for consideration. SASE. Reports in 1-2 months. Free photo guidelines with SASE. Tips sheet distributed regularly to established contributors.
Tips: "First, pre-edit your material. Second, know your subject."

‡■*(APL) ARGUS PHOTOLAND, LTD., Room 2106 Goldmark, 502 Hennessy Rd., Hong Kong. (852)2890-6970. Fax: (852)2881-6979. Director: Joan Li. Estab. 1992. Stock photo agency. Has 120,000 photos. Has one branch office. Clients include: advertising agencies, graphic houses, public relations firms, book/encyclopedia publishers, magazine publishers, postcard publishers, calendar companies, greeting card companies and mural printing companies, trading firms/manufacturers.
Needs: "We cover general subject matters with urgent needs of people images (baby, children, woman, couple, family and man, etc.) in all situations; business and finance; industry; science & technology; living facilities; flower arrangement/bonsai; waterfall/streamlet; securities; interior (including office/hotel lobby and shopping mall); cityscape and landscape; and highlight of Southeast Asian countries."
Specs: Any of 120mm and 4×5 transparencies.
Payment & Terms: Pays 50% commission. Offers volume discounts to customers. Works on contract basis only. Offers regional exclusivity. Contracts renew automatically with additional submissions. Statements issued quarterly. Payment made quarterly. Photographers allowed to review account records. Offers one-time rights, agency promotion rights. Informs photographer and allows him to negotiate when client requests all rights. Model/property releases a must. Photo captions required: include name of event(s), name of building(s), location and geographical area.
Making Contact: Interested in receiving work from newer, lesser-known photographers. Submit portfolio for review. Expects minimum initial submission of 200 pieces with submission of at least 300 images quarterly. Reports in 1-2 weeks.

APPALIGHT, Griffith Run Rd., Clay Rt. Box 89-C, Spencer WV 25276. Phone/fax: (304)927-2978. Director: Chuck Wyrostok. Estab. 1988. Stock photo agency. Has 20,000 photos. Clients include advertising agencies, public relations firms, businesses, book/encyclopedia publishers, magazine publishers, calendar companies, greeting card companies and graphic designers.
Needs: General subject matter with emphasis on child development and natural history, inspirational, cityscapes, travel in the eastern mountains and eastern shore. "Presently we're building comprehensive sections on animals, birds, flora and on positive solutions to environmental problems of all kinds."
Specs: Uses 8×10, glossy b&w prints; 35mm, 2¼×2¼, 4×5 transparencies.
Payment & Terms: Pays 50% commission. General price range: $150 and up. Works on contract basis only. Contracts renew automatically for 2-year period with additional submissions. Charges 100% duping rate. Statements issued monthly. Payment made monthly. Photographers allowed to review account records during regular business hours or by appointment. Offers one-time rights, electronic media rights. "When client requests all rights photographer is contacted for his consent, but we handle all negotiations." Model release preferred. Captions required.
Making Contact: Interested in receiving work from newer, lesser-known photographers. Expects minimum initial submission of 300-500 images with periodic submissions of 200-300 several times/year. Reports in 1 month. Photo guidelines free with SASE. Market tips sheet distributed "periodically" to contracted photographers.
Tips: "We look for a solid blend of topnotch technical quality, style, content and impact contained in

 MARKETS NEW TO THIS EDITION are marked with a double dagger.

images that portray metaphors applying to ideas, moods, business endeavors, risk-taking, teamwork and winning."

ARMS COMMUNICATIONS, 1517 Maurice Dr., Woodbridge VA 22191. (703)690-3338. Fax: (703)490-3298. President: Jonathan Arms. Estab. 1989. Stock photo agency. Has 80,000 photos. Clients include: advertising agencies, public relations firms, businesses and magazine publishers.
Needs: Interested in photos of military/aerospace—US/foreign ships, foreign weapon systems (land, air and sea), weaponry being fired.
Specs: Uses 35mm transparencies.
Payment & Terms: Pays 50% commission on b&w and color photos. Average price per image (to clients): $200. Enforces minimum price of $100. Offers volume discounts to customers; terms specified in photographer's contract. Discount terms not negotiable. Works on contract basis only. Offers nonexclusive contracts. Contracts renew automatically with additional submissions for 3 years. Payment made within 60 days of invoice payment. Photographers allowed to review account records. Offers one-time rights. Does not negotiate when client requests all rights. Model release preferred. Captions required.
Making Contact: Interested in receiving work from newer, lesser-known photographers. Reports in 1-2 weeks.

PETER ARNOLD, INC., 1181 Broadway, New York NY 10001. (212)481-1190 or (800)289-7468. Fax: (212)481-3409. Estab. 1975. Contact: Anbreen Quershi or Peter Arnold. Stock photo agency. Member of the Picture Agency Council of America (PACA). Has 500,000 photos. Clients include: ad agencies, public relations firms, audiovisual firms, businesses, book/encyclopedia publishers, magazine publishers, newspapers, calendar companies, greeting card companies, postcard publishers, CD-ROM publishers and anyone else who would buy stock photography.
Needs: Nature, wildlife, science, medical, travel, astronomy, geology, adventure sports, archaeology and weather.
Specs: Uses 35mm, 2¼ × 2¼ transparencies.
Payment & Terms: Pays 50% commission on b&w and color photos. Average price per image (to clients): $150-400/b&w; $180-450/color. "We attempt to hold minimum at $100 for editorial and $300 for commercial. However, increased competition and new technologies have driven fees down." Offers volume discounts to customers; terms specified in photographer's contract. Photographers can choose not to sell images on discount terms. Works with or without contract. Offers exclusive only, limited regional exclusivity or nonexclusive contracts; varies according to photographer. Charges 50% duping fee; 50% catalog insertion fee; 50% for CD-ROMs and industry sourcebooks. Statements issued quarterly. Payment made quarterly. Photographers allowed to review account records. Offers one-time and electronic media rights. "Exclusivity/nonexclusivity is also an option for clients, whether regionally, nationally or industry-wide." Informs photographer and allows him to negotiate when client requests all rights. Model/property release preferred for images depicting identifiable people, private property and pets. Captions required; include exact location, model release information, species name, approximate date of photo and specific information which will help researchers understand significance of photo.
Making Contact: Arrange personal interview to show portfolio. Query with résumé of credits. Query with samples. "Call first." Works with local freelancers only. Samples kept on file. SASE. Expects initial submission of 200 images with later submissions of 200 images quarterly. Reports in 1-2 months. Market tips sheet distributed biannually.
Tips: "We have a UNIX-based database where we archive all of our images. This system allows us to search for images by caption information. We are currently reviewing options for possible future on-line and CD-ROM projects. Speak with the owner of each agency you are soliciting. Try and get a feel about the agency through the personality of the owner. If the owner is aggressive and smart, chances are so will the salespersons and editors. This will help increase your sales. Know something about the agency before you contact them—subjects, needs, clientele and other photographers represented."

■**ART RESOURCE**, 65 Bleecker St., 9th Floor, New York NY 10012. (212)505-8700. Fax: (212)420-9286. Permissions Director: Joanne Greenbaum. Estab. 1970. Stock photo agency specializing in fine arts. Member of the Picture Agency Council of America (PACA). Has access to 3 million photos. Clients include: advertising agencies, public relations firms, audiovisual firms, businesses, book/encyclopedia publishers, magazine publishers, newspapers, postcard publishers, calendar companies, greeting card companies and all other publishing and scholarly businesses.
Needs: Painting, sculpture, architecture *only.*
Specs: Uses 8 × 10 b&w prints; 35mm, 4 × 5, 8 × 10 transparencies.
Payment & Terms: Payment negotiable. Average price per image (to client): $75-500/b&w photo; $185-10,000/color photo. Negotiates fees below standard minimum prices. Offers volume discounts to customers; terms specified in photographer's contract. Discount sales terms not negotiable. Offers exclusive only or

nonexclusive rights. Contracts renew automatically with additional submissions. Statements issued quarterly. Payment made quarterly. Photographers allowed to review account records. Offers one-time rights, electronic media rights, agency promotion and other negotiated rights. Photo captions required.
Making Contact: Query with stock photo list. "Only fine art!"
Tips: "We only represent European fine art archives and museums in U.S and Europe, but occasionally represent a photographer with a specialty in certain art."

***AUSTRALIAN PICTURE LIBRARY**, 2 Northcote St., St. Leonards NSW 2065 Australia, (02)9438-3011. Fax: (02)4939-6527. E-mail: pictures@apl.aust.com. Managing Director: Jane Symons. Estab. 1979. Stock photo agency and news/feature syndicate. Has over 1 million photos. Clients include: advertising agencies, public relations firms, audiovisual firms, businesses, book/encyclopedia publishers, magazine publishers, newspapers, postcard publishers, calendar companies and greeting card companies.
Needs: Photos of Australia—sports, people, industry, personalities.
Specs: Uses 8×10 b&w prints; 35mm, 2¼×2¼ and 6×7cm transparencies.
Payment & Terms: Pays 50% commission. Offers volume discounts to customers. Works on contract basis only; offers exclusive contracts. Statements issued quarterly. Payment made quarterly. Offers one-time rights. Informs photographer and allows him to negotiate when client requests all rights. Model/property release required. Captions required.
Making Contact: Submit portfolio for review. Expects minimum initial submission of 400 images with minimum yearly submissions of at least 1,000 images. Images can be digitally transmitted using modem and ISDN. Reports in 1 month. Photo guidelines free with SASE. Catalog available. Market tips sheet distributed quarterly to agency photographers.
Tips: Looks for formats larger than 35mm in travel, landscapes and scenics with excellent quality. "There must be a need within the library that doesn't conflict with existing photographers too greatly."

■*BARNABY'S PICTURE LIBRARY, Barnaby House, 19 Rathbone St., London W1P 1AF England. (0171)636-6128. Fax: (0171)637-4317. Contact: Mrs. Mary Buckland. Stock photo agency and picture library. Has 4 million photos. Clients include: ad agencies, public relations firms, audiovisual firms, businesses, book/encyclopedia publishers, magazine publishers, newspapers, film production companies, BBC, all TV companies, record companies, etc.
Specs: Uses 8×10 b&w prints; 35mm, 2¼×2¼, 4×5 and 8×10 transparencies.
Payment & Terms: Pays 50% commission on b&w and color photos. Works on contract basis only. Offers nonexclusive contracts. "Barnaby's does not mind photographers having other agents as long as there are not conflicting rights." Statements issued semi-annually. Payment made semi-annually. "Very detailed statements of sales for photographers are given to them biannually and tearsheets kept." Offers one-time rights. "The photographer must trust and rely on his agent to negotiate best price!" Model release required. Captions required.
Making Contact: Interested in receiving work from newer, lesser-known photographers. Arrange a personal interview to show portfolio. Send unsolicited photos by mail for consideration. Submit portfolio for review. SASE. "Your initial submission of material must be large enough for us to select a minimum of 200 pictures in color or b&w and they must be your copyright." Reports in 3 weeks. Photo guidelines free with SASE. Tips sheet distributed quarterly to anyone for SASE.
Tips: "Please ask for 'photographer's information pack' which (we hope) tells it all!"

■ROBERT J. BENNETT, INC., 310 Edgewood St., Bridgeville DE 19933. (302)337-3347, (302)270-0326. Fax: (302)337-3444. President: Robert Bennett. Estab. 1947. Stock photo agency.
Needs: General subject matter.
Specs: Uses 8×10 glossy b&w prints; 35mm, 2¼×2¼ and 4×5 transparencies.
Payment & Terms: Pays 50% commission US; 40-60% foreign. Pays $5-50/hour; $40-400/day. Pays on publication. Works on contract basis only. Offers limited regional exclusivity. Charges filing fees and duping fees. Statements issued monthly. Payment made monthly. Photographers allowed to review account records to verify sales figures. Buys one-time, electronic media and agency promotion rights. Informs photographer and allows him to negotiate when client requests all rights. Model/property release required. Captions required.
Making Contact: Interested in receiving work from newer, lesser-known photographers. Query with résumé of credits. Query with stock photo list. Provide résumé, business card, brochure or tearsheets to be kept on file for possible future assignments. Works on assignment only. Keeps samples on file. Reports in 1 month.

BIOLOGICAL PHOTO SERVICE, P.O. Box 490, Moss Beach CA 94038. Phone/fax: (415)359-6219. E-mail: bpsterra@aol.com. Photo Agent: Carl W. May. Stock photo agency. Estab. 1980. Has 90,000 photos. Clients include: ad agencies, businesses, book/encyclopedia publishers and magazine publishers.

● This agency may begin CD storage of images, but May says he is uncertain whether his agency will get involved with networking of images. The network situation is still too unproven for them, he says.

Needs: All subjects in the life sciences, including agriculture, natural history and medicine. Stock photographers must be scientists. Subject needs include: electron micrographs of all sorts; biotechnology; modern medical imaging; animal behavior; tropical biology; and biological conservation. All aspects of general and pathogenic microbiology. All aspects of normal human biology and the basic medical sciences, including anatomy, human embryology and human genetics. Computer-generated images of molecules (structural biology).

Specs: Uses 4×5 through 11×14 glossy, high-contrast b&w prints; 35mm, 2¼×2¼, 4×5, 8×10 transparencies. "Dupes acceptable for rare and unusual subjects, but we prefer originals."

Payment & Terms: Pays 50% commission on b&w and color photos. General price range (for clients): $90-500, sometimes higher for advertising uses. Works with or without contract. Offers exclusive contracts. Statements issued quarterly. Payment made quarterly; "one month after end of quarter." Photographers allowed to review account records to verify sales figures "by appointment at any time." Offers one-time, electronic media, promotion rights; negotiable. Informs photographer and allows him veto authority when client requests all rights. "Photographer is consulted during negotiations for 'buyouts,' etc." Model or property release required for photos used in advertising and other commercial areas. Thorough photo captions required; include complete identification of subject and location.

Making Contact: Interested in receiving work from newer, lesser-known photographers if they have the proper background. Query with list of stock subjects and résumé of scientific and photographic background. SASE. Reports in 2 weeks. Photo guidelines free with query, résumé and SASE. Tips sheet distributed intermittently to stock photographers only.

Tips: "When samples are requested, we look for proper exposure, maximum depth of field, adequate visual information and composition, and adequate technical and general information in captions. Requests fresh light and electron micrographs of traditional textbook subjects; applied biology such as biotechnology, agriculture, industrial microbiology, and medical research; biological careers; field research. We avoid excessive overlap among our photographer/scientists. We are experiencing an ever-growing demand for photos covering environmental problems of all sorts—local to global, domestic and foreign. Tropical biology, marine biology, and forestry are hot subjects. Our three greatest problems with potential photographers are: 1) inadequate captions; 2) inadequate quantities of *fresh* and *diverse* photos; 3) poor sharpness/ depth of field/grain/composition in photos."

BLACK STAR PUBLISHING CO., INC., 116 E. 27th St., New York NY 10016. Prefers not to share information.

■D. DONNE BRYANT STOCK PHOTOGRAPHY (DDB STOCK), P.O. Box 80155, Baton Rouge LA 70898. (504)763-6235. Fax: (504)763-6894. E-mail: dougbryant@aol.com. President: Douglas D. Bryant. Stock photo agency. Currently represents 110 professional photographers. Has 500,000 photos. Clients include: ad agencies, audiovisual firms, book/encyclopedia publishers, magazine publishers, CD-ROM publishers and a large number of foreign publishers.

● This agency uses imagers to make up Kodak CD sample disks, and is setting up a web server/ ISDN speed with home page and hyperlinks to allow customers to sample photos by subject category.

Needs: Specializes in picture coverage of Latin America with emphasis on Mexico, Central America, South America, the Caribbean Basin and the Southern USA. Eighty percent of picture rentals are for editorial usage. Important subjects include agriculture, anthropology/archeology, art, commerce and industry, crafts, education, festivals and ritual, geography, history, indigenous people and culture, museums, parks, political figures, religion, scenics, sports and recreation, subsistence, tourism, transportation, travel and urban centers.

Specs: Accepts 35mm, 2¼×2¼ and 4×5 color transparencies.

Payment & Terms: Pays 50% commission; 30% on foreign sales through foreign agents. General price range: $85-5,000. Works with or without a signed contract, negotiable. Offers nonexclusive contracts. Statements issued monthly. Payment made immediately after lease. Does not allow photographers to review account records to verify sales figures. "We are a small agency and do not have staff to oversee audits." Offers one-time, electronic media, world and all language rights. Informs photographer and allows him to negotiate when client requests all rights. Offers $1,500 per image for all rights. Model/property release preferred, especially for ad set-up shots. Captions required; include location and brief description. "Must have good captions."

Making Contact: Interested in receiving work from professional photographers who regularly visit Latin America. Query with résumé of credits and list of stock photo subjects. SASE. Reports in 1 month. Photo guidelines free with SASE. Tips sheet distributed every 3 months to agency photographers.

Tips: "Speak Spanish and spend one to six months shooting in Latin America every year. Follow our

needs list closely. Shoot Fuji transparency film and cover the broadest range of subjects and countries. We have an active duping service where we provide European and Asian agencies with images they market in film and on CD."

■**CALIFORNIA VIEWS/MR. PAT HATHAWAY HISTORICAL COLLECTION**, 469 Pacific St., Monterey CA 93940-2702. (408)373-3811. Website: http://www.caviews.com. Photo Archivist: Mr. Pat Hathaway. Picture library; historical collection. Has 70,000 b&w images, 8,000 35mm color. Clients include: ad agencies, public relations firms, audiovisual firms, book/encyclopedia publishers, magazine publishers, museums, postcard companies, calendar companies, television companies, interior decorators, film companies.
Needs: Historical photos of California from 1860-1995.
Payment & Terms: Payment negotiable.
Making Contact: "We accept donations of photographic material in order to maintain our position as one of California's largest archives." Does not return unsolicited material. Reports in 3 months.

■*****CAMERA PRESS LTD.**, 21 Queen Elizabeth Street, London SE1 2PD England. (0171)378-1300. Fax: (0171)278-5126. Modem: (0171)378 9064. ISDN: (Planet) (0171)378 6078 or (0171)378 9141. Operations Director: Roger Eldridge. Picture library, news/feature syndicate. Clients include: ad agencies, public relations firms, audiovisual firms, book/encyclopedia publishers, magazine publishers, newspapers, postcard companies, calendar companies, greeting card companies and TV stations. Clients principally press, but also advertising, publishers, etc.
● Camera Press has a fully operational electronic picture desk to receive/send digital images via modem/ISDN lines.
Needs: Celebrities, world personalities (e.g. politics, sports, entertainment, arts, etc.), features, news/documentary, scientific, human interest, humor, women's features, stock.
Specs: Uses prints; 35mm, 2¼×2¼ and 4×5 transparencies; b&w contact sheets and negatives.
Payment & Terms: Pays 50% commission for color or b&w photos. "Top rates in every country." Contracts renewable every year. Statements issued every 2 months. Payment made every 2 months. Photographers allowed to review account records. Offers one-time rights. Informs photographers and permits them to negotiate when a client requests to buy all rights. Model release preferred. Captions required.
Making Contact: SASE.
Tips: "Camera Press celebrated 50 years in the pictures business in 1997. We represent some of the top names in the photographic world, but also welcome emerging talents and gifted newcomers. We seek lively, colorful features which tell a story and individual portraits of world personalities, both established and up-and-coming. We specialize in world-wide syndication of news stories, human interest, features, show business personalities 'at home' and general portraits of celebrities. Good accompanying text and/or interviews are an advantage; accurate captions are essential. Remember there is a big world-wide demand for premieres, openings and US celebrity-based events. Other needs include: scientific development and novelties; beauty, fashion, interiors, food and women's interests; humorous pictures featuring the weird, the wacky and the wonderful. Camera Press is also developing a top-quality stock image service (model release essential). In general, remember that subjects which seem old-hat and clichéd in America may have considerable appeal overseas. Try to look at the US with an outsider's eye."

■**CAMERIQUE INC. INTERNATIONAL**, Main office: Dept. PM, 1701 Skippack Pike, P.O. Box 175, Blue Bell PA 19422. (610)272-4000. Fax: (610)272-7651. Representatives in Boston, Los Angeles, Chicago, New York City, Montreal, Sarasota, Florida and Tokyo. Photo Director: Christopher C. Johnson. Estab. 1973. Has 1 million photos. Clients include: advertising agencies, public relations firms, audiovisual firms, businesses, book/encyclopedia publishers, magazine publishers, newspapers, postcard companies, calendar companies, greeting card companies.
● Don't miss the listing in this section for American Stock Photography, which is a subsidiary of Camerique.
Needs: General stock photos, all categories. Emphasizes people activities all seasons. Always need large format color scenics from all over the world. No fashion shots. All people shots, including celebrities, must have releases.

MARKET CONDITIONS are constantly changing! If you're still using this book and it's 1999 or later, buy the newest edition of *Photographer's Market* at your favorite bookstore or order directly from Writer's Digest Books.

Specs: Uses 35mm, 2¼×2¼, 4×5 transparencies; b&w contact sheets; b&w negatives; "35mm accepted if of unusual interest or outstanding quality."
Payment & Terms: Sometimes buys photos outright; pays $10-25/photo. Also pays 50-60% commission on b&w/color after sub-agent commissions. General price range (for clients): $300-500. Works on contract basis only. Offers nonexclusive contracts. Contracts are valid "indefinitely until canceled in writing." Charges 50% of cost of catalog insertion fee; for advertising, CD and online services. Statements issued monthly. Payment made monthly; within 10 days of end of month. Photographers allowed to review account records. Offers one-time rights, electronic media and multi-rights. Informs photographer and allows him to negotiate when client requests all rights. Model/property release required for people, houses, pets. Captions required; include "date, place, technical detail and any descriptive information that would help to market photos."
Making Contact: Query with list of stock photo subjects. Send unsolicited photos by mail for consideration. "Send letter first, we'll send our questionnaire and spec sheet." SASE. Reports in 2 weeks. "You must include correct return postage for your material to be returned." Tips sheet distributed periodically to established contributors.
Tips: Prefers to see "well-selected, edited color on a variety of subjects. Well-composed, well-lighted shots, featuring contemporary styles and clothes. Be creative, selective, professional and loyal. Communicate openly and often."

✦CANADA IN STOCK INC., 109 Vanderhoof Ave., Suite 214, Toronto, Ontario M4G 2H7 Canada. (416)425-8215. Fax: (416)425-6966. E-mail: 102223.2016. Director: Ottmar Bierwagen. Estab. 1994. Stock photo agency. Member of the Picture Agency Council of America (PACA). Has 125,000 photos. Clients include: ad agencies, public relations firms, businesses, book/encyclopedia publishers, magazine publishers, calendar companies, government and graphic designers.
Needs: Photos of people, industry, Europe, Asia, sports and wildlife. "Our needs are model-released people, lifestyles and medical."
Specs: Uses 35mm, 2¼×2¼, 4×5, 8×10 transparencies.
Payment & Terms: Pays 50% commission on color photos. Average price per image (to clients): $400/ color photo. Enforces minimum prices. Offers volume discounts to customers; inquire about specific terms. Photographers can choose not to sell images on discount terms. Works on contract basis only. Offers exclusive or limited regional exclusivity contracts. Contracts renew automatically with additional submissions. Charges 50% duping and catalog insertion fees. Statements issued quarterly. Payment made quarterly. Photographers allowed to review account records. Offers one-time rights; exclusivity and/or buyouts negotiated. "We negotiate with client, but photographer is made aware of the process." Model release required; property release preferred. Captions required; include location, detail, model release, copyright symbol and name (no date).
Making Contact: Interested in receiving work from newer, lesser-known photographers. Query with samples. Query with stock photo list. Works with local freelancers on assignment only. Samples kept on file. SASE. Expects minimum initial submission of 3-500 images with 300 more annually. Reports in 3 weeks. Photo guidelines free with SASE. Market tips sheet distributed monthly via fax to contracted photographers.
Tips: "Ask hard questions and expect hard answers. Examine a contract in detail. Accepting work is becoming more difficult with generalists; specialty niche photographers have a better chance."

CATHOLIC NEWS SERVICE, 3211 Fourth St. NE, Washington DC 20017-1100. (202)541-3251. Fax: (202)541-3255. E-mail: cnspix@aol.com. Photos/Graphics Manager: Nancy Wiechec. Photos/Graphics Researcher: Bob Roller. Wire service transmitting news, features and photos to Catholic newspapers and stock to Catholic publications.
Needs: News or feature material related to the Catholic Church or Catholics; head shots of Catholic newsmakers; close-up shots of news events, religious activities. Also interested in photos aimed toward a general family audience and photos depicting modern lifestyles, e.g., family life, human interest, teens, poverty, active senior citizens, families in conflict, unusual ministries, seasonal and humor.
Specs: Uses 8×10 color glossy prints/slides. Accepts images in digital format for Mac or Windows (JPEG high quality, 8×10, 170 ppi). Send via compact disc, online, floppy disk, Zip disk (8×10 inch @ 170 ppi).
Payment & Terms: Pays $35/photo; $75-200/job. Charges 50% on stock sales. Statements never issued. Payment made monthly. Offers one-time rights. Informs photographer and allows him to negotiate when client requests all rights. Model/property release preferred. Captions preferred; include who, what, when, where, why.
Making Contact: Send material by mail for consideration. SASE.
Tips: Submit 10-20 good quality prints covering a variety of subjects. Some prints should have relevance to a religious audience. "Knowledge of Catholic religion and issues is helpful. Read a Diocesan newspaper

for ideas of the kind of photos used. Photos should be up-to-date and appeal to a general family audience. No flowers, no scenics, no animals. As we use more than 1,000 photos a year, chances for frequent sales are good. Send only your best photos."

***CEPHAS PICTURE LIBRARY**, Hurst House, 157 Walton Rd., E. Molesey, Surrey KTB 0DX United Kingdom. (0181)979-8647. Fax: (0181)224-8095. Director: Mick Rock. Picture library. Has 120,000 photos. Clients include: ad agencies, public relations firms, businesses, book/encyclopedia publishers, magazine publishers, postcard companies and calendar companies.
Needs: "We are a general picture library covering all aspects of all countries. Wine industry, food and drink are major specialties."
Specs: Prefers 2¼×2¼ transparencies, 35mm accepted.
Payment & Terms: Pays 50% commission for color photos. General price range: £50-500 (English currency). Works on contract basis only. Offers global representation. Contracts renew automatically after 3 years. Photographers allowed to review account records. Statements issued quarterly with payments. Offers one-time rights. Informs photographers when a client requests to buy all rights. Model release preferred. Captions required.
Making Contact: Send best 40 photos by mail for consideration. SASE. Reports in 1 week. Photo guidelines for SASE.
Tips: Looks for "transparencies in white card mounts with informative captions and names on front of mounts. Only top-quality, eye-catching transparencies required."

■CHARLTON PHOTOS, INC., 11518 N. Port Washington Rd., Mequon WI 53092. (414)241-8634. Fax: (414)241-4612. E-mail: charlton@mail.execpc.com. Website: http://www.charlton.com. Director of Research: Anbreen Quershi. Estab. 1981. Stock photo agency. Has 475,000 photos; 200 hours film. Clients include: ad agencies, public relations firms, audiovisual firms, businesses, book/encyclopedia publishers, magazine publishers, newspapers and calendar companies.
Needs: "We handle photos of agriculture, senior citizens, environment, scenics, people and pets."
Specs: Uses b&w prints and color photos; 35mm, 2¼×2¼, 4×5 transparencies.
Payment & Terms: Pays 50% commission on color photos. Average price per image (to clients): $500-650/color photo. Offers volume discounts to customers; terms specified in photographer's contract. Works on contract basis only. Prefers exclusive contract, but negotiable based on subject matter submitted. Contracts renew automatically with additional submissons for 2 years minimum. Charges duping fee, 50% catalog insertion fee and materials fee. Statements issued monthly. Payment made monthly. Photographers allowed to review account records which relate to their work. Offers one-time rights. Informs photographer and allows him to negotiate when client requests all rights. Model/property release required for identifiable people and places. Captions required; include who, what, when, where.
Making Contact: Interested in receiving work from newer, lesser-known photographers. Query by phone before sending any material. SASE. No minimum number of images expected in initial submission. Reports in 1-2 weeks. Photo guidelines free with SASE. Market tips sheet distributed quarterly to contract freelance photographers; free wtih SASE.
Tips: "Provide our agency with images we request by shooting a self-directed assignment each month. Visit our website."

CHINASTOCK, (formerly Chinastock Photo Library), 2506 Country Village, Ann Arbor MI 48103-6500. (313)996-1440. Fax: (313)996-1481 or (800)315-4462. Director: Dennis Cox. Estab. 1993. Stock photo agency. Has 35,000 photos. Has branch office in Beijing and Shanghai, China. Clients include: advertising agencies, public relations firms, book/encyclopedia publishers, magazine publishers, newspapers, calendar companies.
Needs: Only handles photos of China (including Hong Kong and Taiwan) including tourism, business, historical, cultural relics, etc. Needs hard-to-locate photos of all but tourism and exceptional images of tourism subjects.
Specs: Uses 5×7 to 8×10 glossy b&w prints; 35mm, 2¼ transparencies. Pays 50% commission on b&w and color photos. Occasionally negotiates fees below standard minimum prices. "Prices are based on usage and take into consideration budget of client." Offers volume discounts to customers. Photographers can choose not to sell images on discount terms. Works with or without a signed contract. "Will negotiate contract to fit photographer's and agency's mutual needs." Photographers are paid quarterly. Photographers allowed to review account records. Offers one-time rights and electronic media rights. Informs photographer and allows him to negotiate when client requests all rights. Model/property release preferred. Captions required; include where image was shot and what is taking place.
Making Contact: Query with stock photo list. "Let me know if you have unusual material." Keeps samples on file. SASE. Agency is willing to accept 1 great photo and has no minimum submission requirements. Reports in 1-2 weeks. Market tips sheet available upon request.

Tips: Agency "represents mostly veteran Chinese photographers and some special coverage by Americans. We're not interested in usual photos of major tourist sites. We have most of those covered. We need more photos of festivals, modern family life, joint ventures, and all aspects of Taiwan."

■**BRUCE COLEMAN PHOTO LIBRARY**, 117 E. 24th St., New York NY 10010. (212)979-6252. Fax: (212)979-5468. Photo Director: Linda Waldman. Estab. 1970. Stock photo agency. Member of Picture Agency Council of America (PACA). Has 1 million photos. Clients include: advertising agencies, public relations firms, audiovisual firms, businesses, book/encyclopedia publishers, magazine publishers, newspapers, postcard publishers, calendar companies, greeting card companies, zoos (installations), TV.
Needs: Nature, travel, science, people, industry.
Specs: Uses 35mm, 2¼×2¼, 4×5 color transparencies.
Payment & Terms: Pays 50% commission on color film. Average price per image (to clients): color $175-975. Works on exclusive contract basis only. Contracts renew automatically for 5 years. Statements issued quarterly. Payment made quarterly. Does not allow photographer to review account records; any deductions are itemized. Offers one-time rights. Model/property release preferred for people, private property. Captions required; location, species, genus name, Latin name, points of interest.
Making Contact: Query with résumé of credits. SASE. Expects minimum initial submission of 300 images with annual submission of 2,000. Reports in 3 months on completed submission; 1 week acknowledgement. Photo guidelines free with SASE. Catalog available. Want lists distributed to all active photographers monthly.
Tips: "We look for strong dramatic angles, beautiful light, sharpness. No gimmicks (prism, color, starburst filters, etc.). We like photos that express moods/feelings and show us a unique eye/style. We like work to be properly captioned. Caption labels should be typed or computer generated and they should contain all vital information regarding the photograph." Sees a trend "toward a journalistic style of stock photos. We are asked for natural settings, dramatic use of light and/or angles. Photographs should not be contrived and should express strong feelings toward the subject. We advise photographers to shoot a lot of film, photograph what they really love and follow our want lists."

‡***EDUARDO COMESANA-AGENCIA DE PRENSA**, Casilla de Correo 178 (Suc.26), Buenos Aires 1426 Argentina. (541)771-9418, 773-5943. Fax: (541)777-3719. Director: Eduardo Comesana. Stock photo agency, picture library and news/feature syndicate. Has 500,000 photos. Clients include: ad agencies, book/encyclopedia publishers, magazine publishers and newspapers.
Needs: Personalities, entertainment, politics, science and technology, expeditions, archeology, travel, industry, nature, human interest, education, medicine, foreign countries, agriculture, space, ecology, leisure and recreation, couples, families and landscapes. "We have a strong demand for science-related subjects like shown in *Discover*, *Smithsonian* and *National Geographic* magazines."
Specs: Uses 8×10 glossy b&w prints; 35mm, 2¼×2¼ and 4×5 transparencies.
Payment & Terms: Pays $80/b&w photo; $100-300/color photo; 60% commission. Works with or without contract; negotiable. Offers limited regional exclusivity. Contracts continue "indefinitely unless terminated by either party with not less than 90 days written notice." Statements issued quarterly. Payment made quarterly. Photographers allowed to review account records to verify sales figures. Offers one-time and electronic media rights. Informs photographer and allows him to negotiate when client requests all rights. Model/property release preferred. Photo captions required; include "who, what, where, when, why and how."
Making Contact: "Send introductory letter or fax stating what photographer wants to syndicate. Do not send unsolicited material without previous approval. We would like to know as much as possible about the prospective contributor. A complete list of subjects will be appreciated." Include IRCs or check for postage in US dollars. Reports in 1 month.
Tips: Represents Black Star in South America; Woodfin Camp & Associates, Outline Press Syndicate from New York City; and Shooting Star from Los Angeles. "We would like to review magazine-oriented stories with a well-written text and clear captions. In case of hot news material, please fax or phone before sending anything. Freelancer should send us an introductory letter stating the type of photography he intends to sell through us. In our reply we will request him to send at least 5 stories of 10 to 20 colors each, for review. We would like to have some clippings of his photography."

COMPIX PHOTO AGENCY, 3621 NE Miami Court, Miami FL 33137. (305)576-0102. Fax: (305)576-0064. President: Alan J. Oxley. Estab. 1986. News/feature syndicate. Has 1 million photos. Clients include: advertising agencies, public relations firms, book/encyclopedia publishers, magazine publishers and newspapers.
Needs: Wants news photos and news/feature picture stories, human interest, celebrities and stunts.
Specs: Uses 35mm, 2¼×2¼, 4×5, 8×10 transparencies.
Payment & Terms: Pays 50% commission. Price per image (to clients) $175 and up. Will sometimes

negotiate fees below standard minimum, "if client is buying a large layout." Works with or without contract. Statements issued monthly. Payment made monthly. Photographers allowed to review account records "if showing those records does not violate privacy of other photographers." Offers one-time or negotiated rights based on story, quality and exclusivity. Photographer will be consulted when client wants all rights, but agency does negotiating. Photo captions required; include basic journalistic info.

Making Contact: "Send us some tearsheets. Don't write asking for guidelines."

Tips: "This is an agency for the true picture journalist, not the ordinary photographer. We are an international news service which supplies material to major magazines and newspapers in 30 countries, and we shoot hard news, feature stories, celebrities, royalty, stunts, animals and things bizarre. We offer guidance, ideas and assignments but work *only* with experienced, aggressive photojournalists who have good technical skills and can generate at least some of their own material."

‡■CUSTOM MEDICAL STOCK PHOTO, Dept. PM, 3821 N. Southport Ave., Chicago IL 60613. (773)248-3200. Fax: (773)248-7427. E-mail: info@cmsp.com. Website: http://www.cmsp.com. Medical Archivists: Mike Fisher, Henry Schleichkorn. Member of Picture Agency Council of America (PACA). Clients include: ad agencies, magazines, journals, textbook publishers, design firms, audiovisual firms, hospitals and Web designers—all commercial and editorial markets that express interest in medical and scientific subject area.

Needs: Biomedical, scientific, health care environmentals and general biology for advertising illustrations, textbook and journal articles, annual reports, editorial use and patient education.

Specs: Uses 35mm, 2¼×2¼ and 4×5 transparencies. Negatives for electron microscopy. 4×5 copy transparencies of medical illustrations or flat art. Digital files accepted with Preview in Mac or Windows. Send via compact disc, online, floppy disk, SyQuest or Zip disk.

Payment & Terms: Pays per shot or commission. Per-shot rate depends on usage. Commission: 40-50% on domestic leases; 30% on foreign leases. Works on contract basis only. Offers guaranteed subject exclusivity contract. Contracts renew automatically with additional submissions for 1 year. Administrative costs charged based on commission structure. Statements issued bimonthly. Payment made bimonthly. Credit line given if applicable, client discretion. Offers one-time, electronic media and agency promotion rights; other rights negotiable. Informs photographer but does not permit him to negotiate when a client requests all rights.

Making Contact: Query with list of stock photo subjects and request current want list and submission packet. "PC captioning disk available for database inclusion; please request. Do not send uncaptioned unsolicited photos by mail." SASE. Reports on average 1 month. Monthly want list available by US mail, and by fax. Model and property release copies required. "Information to contributors is available through our own online system. Windows or Macintosh dial (312)975-4262; download software for Mac or PC." Website available for contributors.

Tips: "Our past want lists are a valuable guide to the types of images requested by our clients. Past want lists are available on the Web. Environmentals of researchers hi-tech biomedicine, physicians, nurses and patients of all ages in situations from neonatal care to mature adults are requested frequently. Almost any image can qualify to be medical if it touches an area of life: breakfast, sports, etc. Trends also follow newsworthy events found on newswires. Photos should be good clean images that portray a single idea, whether it is biological, medical, scientific or conceptual. Photographers should possess the ability to recognize the newsworthiness of subjects. Put together a minimum of 50 images for submission. Call before shipping to receive computer disk and caption information and return information. Contributing to our agency can be very profitable if a solid commitment can exist."

‡CYR COLOR PHOTO AGENCY, Box 2148, Norwalk CT 06852. (203)838-8230. Contact: Judith A. Cyr. Has 125,000 transparencies. Clients include: ad agencies, businesses, book publishers, magazine publishers, encyclopedia publishers, calendar companies, greeting card companies, poster companies and record companies.

Needs: "As a stock agency, we are looking for all types. There has been a recent interest in family shots (with parents and children) and people in day-to-day activities. Also modern offices with high-tech equipment and general business/professional settings. Mood shots, unusual activities, etc. are always popular—anything not completely 'standard' and common. Photos must be well-exposed and sharp, unless mood shots."

Specs: Uses 35mm to 8×10 transparencies.

Payment & Terms: Pays 50% commission. Works on contract basis only. Offers nonexclusive contract. Statements are never issued. Payment made upon payment from client. Photographers can inquire about their own accounts only. Offers one-time rights, all rights, first rights or outright purchase; price depending upon rights and usage. Informs photographer and allows him to negotiate when client requests all rights. Model release preferred. Captions required; include location and, if it is a flower or animal, include species.

Making Contact: Interested in receiving work from newer, lesser-known photographers. Send material

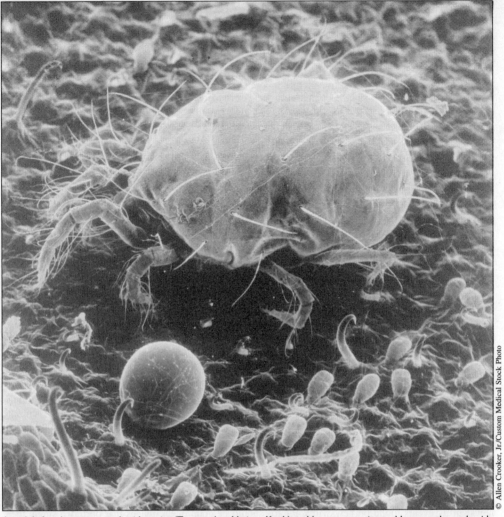

An adult female two-spotted spider mite (Tetranychus Urticae Koch) and her egg are pictured here on the underside of a bean leaf. The microscopic pest, a hazard of household plants, was captured with electron microscopy by Allen Crooker, Jr. The piece is on file with Custom Medical Stock Photo who had the black and white image hand colored by a retoucher. "The idea is to give a bit of realism to the microscopic world that usually is only seen in black and white," says Mike Fisher, CMSP CEO. "Electron microscopy of insects is a file area we are always increasing in numbers and quality." This particular image, which has sold 17 times, was chosen for CMSP's catalog because of the positioning of the mite and the hair.

by mail for consideration. SASE. "Include postage for manner of return desired." Reports in 1 month. Distributes tips sheet periodically to active contributors; "usually when returning rejects."

Tips: Each submission should be accompanied by an identification sheet listing subject matter, location, etc., for each photo included in the submission. All photos should be in vinyl holders and properly numbered, with photographer's initials. "We have received more requests from clients to use 35mm in a slide presentation only (i.e., one time) and/or in a video presentation. Thus, there are more uses of a photo with limited copyright agreements."

***JAMES DAVIS TRAVEL PHOTOGRAPHY**, 65 Brighton Rd., Shoreham, Sussex BN43 6RE England. (+44)1273-452252. Fax: (+44)1273-440116. Contact: Paul Seheult. Estab. 1975. Travel picture library. Has 200,000 photos. Clients include: ad agencies, public relations firms, businesses, book/encyclo-

pedia publishers, magazine publishers, newspapers, calendar companies, greeting card companies and postcard publishers.

Needs: Photos of worldwide travel.

Specs: Uses 2¼×2¼, 4×5 transparencies; Fuji and Kodak film.

Payment & Terms: Pays 50% commission. Offers volume discounts to customers; inquire about specific terms. Discount sales terms not negotiable. Works on contract basis only. Offers exclusive, limited regional exclusivity and nonexclusive contracts. Contracts renew automatically with additional submissions. Charges to photographer negotiable. Statements issued "if there have been sales." Photographers allowed to review account records. Offers one-time, electronic media and agency promotion rights; negotiable. Does not inform photographer or allow him to negotiate when client requests all rights. Model/property release preferred for people. Captions required; include where, what, who, why.

Making Contact: Interested in receiving work from newer, lesser-known photographers. Submit portfolio for review. Works with local freelancers only. Samples kept on file. No minimum number of images expected in initial submission. Reports "when we have time." Photo guidelines free with SASE. Market tips sheet distributed to all contributors "when we can."

DEVANEY STOCK PHOTOS, 755 New York Ave., Suite 306, Huntington NY 11743. (516)673-4477. Fax: (516)673-4440. President: William Hagerty. Photo Editors: Carole Boccia and Kathleen Bob. Has over 500,000 photos. Clients include: ad agencies, book publishers, magazines, corporations and newspapers. Previous/current clients: Young & Rubicam, BBD&O, Hallmark Cards, *Parade* Magazine, Harcourt Brace & Co.

Needs: Accidents, animals, education, medical, artists, elderly, scenics, assembly lines (auto and other), entertainers, schools, astronomy, factory, science, automobiles, family groups, aviation, finance, babies, fires, shipping, movies, shopping, flowers, food, beaches, oceans, skylines, foreign, office, birds, sports, gardens, operations, still life, pets, business, graduation, health, police, teenagers, pollution, television, children, history, hobbies, travel, churches, holidays, cities, weddings, communications, houses, women, writing, zoos, computers, housework, recreation, religion, couples, crime, crowds, dams, industry, laboratories, law, lawns, lumbering, restaurants, retirement, romance, etc.—virtually all subjects.

Specs: Uses all sizes of transparencies.

Payment & Terms: Does not buy photos outright. Pays 50% commission on color. Works with photographers with a signed contract. Contracts automatically renew for a 3-year period. Offers nonexclusive contract. Statements issued upon sale. Payment made monthly. Offers one-time rights. Model/property release preferred. Captions required. "Releases from individuals and homeowners are most always required if photos are used in advertisements."

Making Contact: Interested in receiving work from newer, lesser-known photographers. Query with list of stock photo subjects or send material by mail for consideration. SASE. Reports in 1 month. Free photo guidelines with SASE. Distributes monthly tips sheet free to any photographer.

Tips: "An original submission of 200 original transparencies in vinyl sheets is required. We will coach."

***DIANA PHOTO PRESS,** Box 6266, S-102 34 Stockholm Sweden. (46)8 314428. Fax: (46)8 314401. Manager: Diana Schwarcz. Estab. 1973. Clients include: magazine publishers and newspapers.

Needs: Personalities and portraits of well-known people.

Specs: Uses 18×24 b&w prints; 35mm transparencies. "No CD-ROM; no computerising; no electronics."

Payment & Terms: Pays 30% commission on b&w and color photos. Average price per image (to clients): $150/b&w and color image. Enforces minimum prices. Works on contract basis only. Statements issued monthly. Payment made in 2 months. Offers one-time rights. Informs photographer and allows him to negotiate when client requests all rights. Captions required.

Making Contact: Query with samples. Samples kept on file. SASE. Does not report; "Wait for sales report."

‡*MICHAEL DIGGIN PHOTOGRAPHY, 5 Castle St., Tralee, County Kerry, Ireland. Phone/fax: 353-66-22201. Managing Director/Owner: Michael Diggin. Estab. 1984. Has 30,000 images. Clients include:

 INTERNATIONAL MARKETS, those located outside of the United States and Canada, are marked with an asterisk.

ad agencies, public relations firms, audiovisual firms, book/encyclopedia publishers, magazine publishers, newspapers, calendar companies, greeting card companies and postcard publishers.

Needs: Landscapes and historical; nature and geological photos of Ireland, Switzerland, France, Spain, Russia, China, Indonesia, Malaysia, Borneo, South Africa, Maldives, Seychelles, Azores, Vietnam, Ecuador, Mexico, US (California), Canada, Nepal, Northern India, West Indies, Austria, England (London), Scotland, Egypt, Kenya, Tanzania, South Africa, Holland, Gibralter, Spain and Sri Lanka. Stock list available on request.

Specs: Uses 36×24, 4×5 glossy Cibachrome color prints; 35mm, 4×5 transparencies; Fujichrome Velvia film.

Payment & Terms: Pays 50% commission. Average price per image (to clients): $25-200/color photo. Photographers can choose not to sell images on discount terms. Works on contract basis only. Offers exclusive contracts. Statements issued quarterly. Payment made monthly. Photographers allowed to review account records. Offers one-time rights. Does not inform photographer and allow him to negotiate if client requests all rights. Model/property release required for people who are dominant in picture and for private dwellings. Captions required; include location and time of year.

Making Contact: Arrange personal interview to show portfolio. Submit portfolio for review. Samples kept on file. SASE. Expects minimum initial submission of 250 images with regular submissions at least twice yearly. Reports in 3 weeks. Catalog available on CD-ROM.

Tips: "Edit material thoroughly. Composite and exposure must be 100% and images must be on transparency (Fuji Velvia) larger than 35mm."

■*DINODIA PICTURE AGENCY**, 13 Vithoba Lane, Vithalwadi, Kalbadevi, Bombay India 400 002. (91)22-2018572. Fax: (91)22-2067675. E-mail: jagagarwal@giasbmol•usnl•net•in. Owner: Jagdish Agarwal. Estab. 1987. Stock photo agency. Has 500,000 photos. Clients include: advertising agencies, public relations firms, audiovisual firms, businesses, book/encyclopedia publishers, magazine publishers, newspapers, postcard companies, calendar companies and greeting card companies.

Needs: "We specialize in photos on India—people and places, fairs and festivals, scenic and sports, animals and agriculture."

Specs: Uses 35mm, 2¼×2¼ and 4×5 transparencies.

Payment & Terms: Pays 50% commission on b&w and color photos. General price range (to clients): US $100-600. Negotiates fees below stated minimum prices. Offers volume discounts to customers; inquire about specific terms. Discount sales terms not negotiable. Works on contract basis only. Offers limited regional exclusivity. "Prefers exclusive for India." Contracts renew automatically with additional submissions for 5 years. Statement issued monthly. Payment made monthly. Photographers permitted to review sales figures. Informs photographer and allows him to negotiate when client requests all rights. Offers one-time rights. Model release preferred. Captions required.

Making Contact: Interested in receiving work from newer, lesser-known photographers. Query with résumé of credits, samples and list of stock photo subjects. SASE. Reports in 1 month. Photo guidelines free with SASE. Market tips sheet distributed monthly to contracted photographers.

Tips: "We look for style, maybe in color, composition, mood, subject-matter; whatever, but the photos should have above-average appeal." Sees trend that "market is saturated with standard documentary-type photos. Buyers are looking more often for stock that appears to have been shot on assignment."

■**DRK PHOTO**, 265 Verde Valley School Rd., Sedona AZ 86351. (520)284-9808. Fax: (520)284-9096. President: Daniel R. Krasemann. "We handle only the personal best of a select few photographers—not hundreds. This allows us to do a better job aggressively marketing the work of these photographers." Member of Picture Agency Council of America (PACA) and A.S.P.P. Clients include: ad agencies; PR and AV firms; businesses; book, magazine, textbook and encyclopedia publishers; newspapers; postcard, calendar and greeting card companies; branches of the government, and nearly every facet of the publishing industry, both domestic and foreign.

Needs: "Especially need marine and underwater coverage." Also interested in S.E.M.'s, African, European and Far East wildlife, and good rainforest coverage.

Specs: Uses 35mm, 2¼×2¼ and 4×5 transparencies.

Payment & Terms: Pays 50% commission on color photos. General price range (to clients): $100 "into thousands." Works on contract basis only. Offers nonexclusive contracts. Contracts renew automatically. Statements issued quarterly. Payment made quarterly. Offers one-time rights; "other rights negotiable between agency/photographer and client." Model release preferred. Captions required.

Making Contact: "With the exception of established professional photographers shooting enough volume to support an agency relationship, we are not soliciting open submissions at this time. Those professionals wishing to contact us in regards to representation should query with a brief letter of introduction and tearsheets."

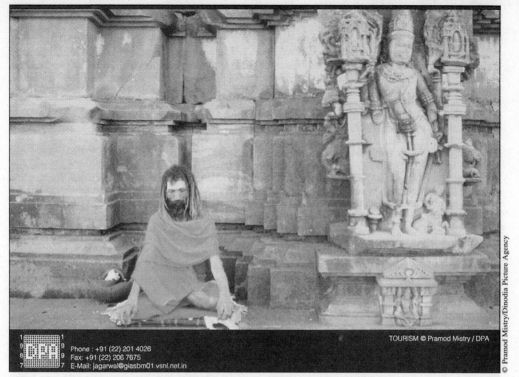

Phone : +91 (22) 201 4026
Fax: +91 (22) 206 7675
E-Mail: jagarwal@giasbm01.vsnl.net.in

TOURISM © Pramod Mistry / DPA

© Pramod Mistry/Dinodia Picture Agency

Jagdish Agarwal, owner of Dinodia Picture Agency, Bombay, India, is always looking for photos that show his country in a "different" way. The color, along with the juxtaposition of the figure and the sculpture, attracted him to this shot by photographer Pramod Mistry. The work was featured in a desk calendar created by Dinodia to help market its photo list.

‡■**DYNAMIC GRAPHICS INC., CLIPPER & PRINT MEDIA SERVICE**, 6000 N. Forest Park Dr., Peoria IL 61614. (309)688-8800. Photo Editor: Kim Gittrich. Clients include: ad agencies, printers, newspapers, companies, publishers, visual aid departments, TV stations, etc.
Needs: Generic stock photos (all kinds). "Our needs are somewhat ambiguous and require that a large number of photos be submitted for consideration. We will send a 'photo needs list' and additional information if requested."
Specs: Majority of purchases are b&w. Send 8×10 prints, contact sheets and high contrast conversions. Minimal use of 35mm and 4×5 transparencies.
Payment & Terms: Pays $50 and up/b&w photo (negotiable and competitive); $100 and up/color photo. **Pays on acceptance.** Rights are specified in contract. Model release required.
Making Contact: Interested in receiving work from newer, lesser-known photographers. Send tearsheets or folio of 8×10 b&w photos by mail for consideration; supply phone number where photographer may be reached during working hours. Reports in 6-8 weeks.

EARTH IMAGES, P.O. Box 10352, Bainbridge Island WA 98110. (206)842-7793. Managing Director: Terry Domico. Estab. 1977. Picture library specializing in worldwide outdoor and nature photography. Member of the Picture Agency Council of America (PACA). Has 150,000 photos; 2,000 feet of film. Has 2 branch offices; contact above address for locations. Clients include: ad agencies, public relations firms, audiovisual firms, businesses, book/encyclopedia publishers, magazine publishers, newspapers, calendar companies, greeting card companies, postcard publishers and overseas news agencies.
Needs: Natural history and outdoor photography (from micro to macro and worldwide to space); plant and animal life histories, natural phenomena, conservation projects and natural science.
Specs: Uses 35mm, 4×5 transparencies.
Payment & Terms: Pays 50% commission. Enforces minimum prices. Offers volume discounts to customers. Works on contract basis only. Offers nonexclusive contract. Contracts renew automatically with

additional submissions. Buys one-time and electronic media rights. Model release preferred. Captions required; include species, place, pertinent data.

Making Contact: Interested in receiving work from newer, lesser-known photographers. "However, unpublished photographers need not apply." Query with resume of credits. "Do not call for first contact." Samples kept on file. SASE. Expects minimum initial submission of 100 images. "Captions must be on mount." Reports in 3-6 weeks. Photo guidelines free with SASE.

Tips: "Sending us 500 photos and sitting back for the money to roll in is poor strategy. Submissions must be continuing over years for agencies to be most effective. Specialties sell better than general photo work. Animal behavior sells better than portraits. Environmental (such as illustrating the effects of acid rain) sells better than pretty scenics. 'Nature' per se is not a specialty; macro and underwater photography are."

■**EARTHVIEWS, A Subsidiary of the Marine Mammal Fund**, Fort Mason Center, E205, San Francisco CA 94123. (415)775-0124. Fax: (415)921-1302. Librarian: Marilyn Delgado. Estab. 1971. Nonprofit stock photo agency. Has 8,000 photos. Clients include: advertising agencies, book/encyclopedia publishers, magazine publishers, newspapers, postcard publishers, calendar companies, exhibits and advocacy groups.

Needs: Wildlife (no captive animals) with emphasis on marine mammals.

Specs: Uses 35mm, $2\frac{1}{4} \times 2\frac{1}{4}$, 4×5 transparencies; 16mm, 35mm film, Betacam SP, Hi-8, S-VHS videotape.

Payment & Terms: Pays 50% commission. Offers nonexclusive contract. Statements issued upon request. Payment made semiannually. Offers one-time rights. Informs photographer and allows him to negotiate when client requests all rights. Captions required; include species, location.

Making Contact & Terms: Interested in receiving work from newer, lesser-known photographers. Query with samples. Does not keep samples on file. SASE. Expects minimum initial submission of 20 images. Reports in 1-2 weeks.

Tips: "We do not hold originals. EarthViews will produce repro-quality duplicates and return all originals to the photographer. Contact us for more information."

■**ECLIPSE AND SUNS**, 316 Main St., Box 669, Haines AK 99827-0669. (907)766-2670. Call for fax number. President and CEO: Erich von Stauffenberg. Estab. 1973. Photography, video and film archive. Has 1.3 million photos, 8,000 hours film. Clients include: advertising agencies, public relations firms, audiovisual firms, businesses, book/encyclopedia publishers, magazine publishers, calendar companies, greeting card companies, postcard publishers, film/television production companies and studios.

Needs: Uses 35mm transparencies; 8mm Super 8, 16 mm, 35mm film; Hi8, $\frac{3}{4}$ SP, Beta SP videotape.

Payment & Terms: Buys photos/film outright. Pays $25-500/color photo; $25-500/b&w photo; $50-1,000/minute film; $50-1,000/minute videotape. Negotiates individual contracts. Works on contract basis only. Offers exclusive contract. Charges 2% filing fee and 5% duping fee. Statements issued when work is requested, sent, returned, paid for. Payment made immediately after client check clears. Photographers allowed to review account records. Offers negotiable rights, "determined by photographer in contract with us." Informs photographer and allows him to negotiate when client requests all rights. "We encourage our photographers to never sell all rights to images." Model/property release required for all recognizable persons, real and personal property, pets. Captions required; include who, what, where, why, when; camera model, lens F/stop, shutter speed, film ASA/ISO rating.

Making Contact: Interested in hearing from newer, lesser-known photographers. Query with résumé of credits. Query with stock photo list. Samples kept on file. SASE. Expects minimum initial submission of 25-50 images; 30-minute reel. Reports in 3 weeks; foreign submissions at rate of mail transit. Photo guidelines available for $5 US funds. Catalog available (on CD-ROM) for $29.95. Market tips sheet distributed quarterly; $5 US.

Tips: Uses Adobe Photo Shop, Kodak CD-ROMs, Nikon Scanner; multimedia authoring, Sanyo CD-ROM Recording Drives and Digital Workstation. "We only provide low res watermarked (with photographer's copyright) materials to clients for comps and pasteups. Images are sufficiently degraded that no duplication is possible; any enlargement is totally pixel-expanded to render it useless. Video footage is similarily degraded to avert copying or unauthorized use. Film footage is mastered on SP Beta returned to photo and degraded to an uncopyable condition for demo reels. We are currently seeking photographers from China, Japan, Korea, Southeast Asia, Europe, Middle East, Central and South America and Australia. Photos must be bracketed by $\frac{1}{2}$ stops over and under each image, must be razor sharp, proper saturation, density with highlight detail and shadow detail clearly visible. We will accept duplicates for portfolio review only. Selected images for deposit must be originals with brackets, $\frac{1}{2}$ stop plus and minus. All images submitted for final acceptance and deposit must be copyrighted by photographer prior to our marketing works for sale or submissions."

*****ECOSCENE**, The Oasts, Headley Lane, Passfield, Liphook, Hants AV30 7RX United Kingdom. (144)1428 751056. Fax: (144)1428 751057. E-mail: ecoscene.@photosource.co.uk. Website: http://www.p

hotosource.co.uk/photosource/ecoscene.htm. Owner: Sally Morgan. Estab. 1988. Stock photo agency and picture library. Has 80,000 photos. Clients include: audiovisual firms, book/encyclopedia publishers, magazine publishers, newspapers and multimedia.

Needs: Ecology, environment, pollution, habitats, conservation, energy, transport, polar habitats, agricultural, industrial, clean-up operations and any environmental topics in the news, especially ecological disasters.

Specs: Uses 35mm, $2\frac{1}{4} \times 2\frac{1}{4}$, 4×5 transparencies.

Payment & Terms: Pays 55% commission on color photos. Average price per image (to clients): $100-300/color photo. Negotiates fees below stated minimum prices, depending on quantity reproduced by a single client. Offers volume discounts to customers; terms specified in photographer's contract. Discount sales terms not negotiable. Works on contract basis only. Offers nonexclusive contract. Statements issued quarterly. Payment made quarterly. Offers one-time and electronic media rights. Informs photographer and allows him to negotiate when client requests all rights. Model/property release preferred. Captions required; include common and Latin names of wildlife and as much detail as possible.

Making Contact: Interested in receiving work from newer, lesser-known photographers. Query with résumé of credits. Samples kept on file. SASE. Expects initial submission of at least 100 images with submission of at least 50 images 2 times a year. Reports in 1-2 weeks. Photo guidelines free with SASE. Catalog available. Market tips sheet distributed quarterly to anybody who requests and to all contributors.

‡**EDGEWOOD IMAGES, INC.**, 2922 U.S. Hwy. 45 N, P.O. Box 566, Metropolis IL 62960. (618)524-1320. Fax: (618)524-1050. Owner: Jim Carter. Estab. 1995. Stock photo agency. Has 2,500 photos. Clients include: advertising agencies, newspapers, postcard publishers, public relations firms, book/encyclopedia publishers, calendar companies, magazine publishers and greeting card companies.

Needs: General stock agency interested in all subjects. "We want good quality images of any subject of your choice. We want to be aggressive in all markets."

Specs: Uses 35mm, $2\frac{1}{4} \times 2\frac{1}{4}$, 4×5, 8×10 transparencies.

Payment & Terms: Pays 50% commission on b&w and color prints. Average price per image (to clients): $40-100/b&w; $100-1,000/color. Offers volume discounts to customers; terms specified in photographer's contract. Photographers can choose not to sell images on discount terms. Works on contract basis only. Offers exclusive and nonexclusive contracts. Contracts renew automatically with additional submissions. Charges 100% duping fee; 50% catalog insertion fee. Statements issued quarterly. "When we get paid, you get paid (within 3 days after we receive payment)." Photographers allowed to review account records. Offers one-time rights. Informs photographer when client requests all rights, but "we do not allow direct negotiating with customer." Model/property release required. Captions required; include who, what, where, etc.

Making Contact: Interested in receiving work from newer, lesser-known photographers. Query with samples. Keeps samples on file. SASE. Expects minimum initial submission of 100-200 images, with periodic submission of at least 100-200 images per quarter. Reports in 1 month. Photo guidelines free with SASE. Market tips sheet distributed; free with SASE upon request.

Tips: "Make sure you have all necessary releases. We are a new stock agency that is aggressive and goes after business. We want our photographers to have the same attitude."

ENP IMAGES, (formerly Ellis Nature Photography), 4045-A N. Massachusetts Ave., Portland OR 97227-1035. (503)287-4179. Fax: (503)287-5087. E-mail: enpimages@aol.com. Contact: Cyrena Schroeder. Estab. 1991. Stock photo library. Has 400,000 images. Clients include: ad agencies, design firms, businesses, book/electronic publishers, magazine publishers, calendar companies, greeting card companies and postcard companies.

Needs: All nature-related; the environment, wildlife, underwater, micro, ecotourism, traditional culture. "In-depth collections given highest consideration."

Specs: Uses 35mm, $2\frac{1}{4} \times 2\frac{1}{4}$, 4×5, 8×10 transparencies and b&w historical material.

Payment & Terms: Pays standard 50% commission on b&w and color photos. Works on contract basis only. Offers guaranteed subject exclusivity contracts. Contracts renew automatically with additional submissions after 1 year. Statements/payments issued monthly. Photographers allowed to review account

THE SUBJECT INDEX, located at the back of this book, lists publications, book publishers, galleries, paper product companies and stock agencies according to the subject areas they seek.

records. Offers negotiable rights. Informs photographer and allows him to negotiate when client requests all rights. Captions and scientific identification required.

Making Contact: Write or e-mail for contact information sheet. Reports in up to 1 month. *Do not submit photography.* Interested in receiving work from newer, lesser-known photographers "who have large in-depth files of single subjects or geographic areas."

***■ENVIRONMENTAL INVESTIGATION AGENCY**, 15 Bowling Green Lane, London ECIR OBD England. (71)490-7040. Fax: (71)490-0436. E-mail: eiauk@gr.apc.org. Communications Manager: Ben Rogers. Estab. 1986. Conservation organization with picture and film library. Has 5,000 photos, 13,000 hours film. Clients include: book/encyclopedia publishers, magazine publishers and newspapers.

Needs: Photos about conservation of animals and the environment; trade in endangered species and endangered wildlife; and habitat destruction.

Specs: Uses 7×5 color prints; 35mm transparencies; 16mm film; BetaSP and HI-8 videotape.

Payment & Terms: Average price per image (to clients): $100/b&w photo; $200/color photo; $800/videotape. Negotiates fees below standard minimum prices. Offers volume discounts to customers; terms specified in photographer's contract. Offers one-time rights; will "negotiate on occasions in perpetuity or 5-year contract." Does not inform photographer or allow him to negotiate when client requests all rights. Captions required; include "full credit and detail of investigation/campaign where possible."

Making Contact: Interested in receiving work from newer, lesser-known photographers. Query with samples. Query with stock photo list. Works with local freelancers only. Samples kept on file. SASE. Expects minimum initial submission of 10 images with periodic submission of additional images. Reports in 1-2 weeks.

■ENVISION, 220 W. 19th St., New York NY 10011. (212)243-0415. Director: Sue Pashko. Estab. 1987. Stock photo agency. Member of the Picture Agency Council of America (PACA). Has 150,000 photos. Clients include: advertising agencies, public relations firms, businesses, book/encyclopedia publishers, magazine publishers, newspapers, calendar and greeting card companies and graphic design firms.

Needs: Professional quality photos of food, commercial food processing, fine dining, American cities (especially the Midwest), crops, Third World lifestyles, marine mammals, European landmarks, tourists in Europe and Europe in winter looking lovely with snow, and anything on Africa and African-Americans.

Specs: Uses 35mm, 2¼×2¼, 4×5 or 8×10 transparencies. "We prefer large and medium formats."

Payment & Terms: Pays 50% commission on b&w and color photos. General price range (to clients): $200 and up. Works on contract basis only. Statements issued monthly. Payment made monthly. Offers one-time rights; "each sale individually negotiated—usually one-time rights." Model/property release required. Captions required.

Making Contact: Arrange personal interview to show portfolio. Query with résumé of credits "on company/professional stationery." Regular submissions are mandatory. SASE. Reports in 1 month.

Tips: "Clients expect the very best in professional quality material. Photos that are unique, taken with a very individual style. Demands for traditional subjects *but* with a different point of view; African- and Hispanic-American lifestyle photos are in great demand. We have a need for model-released, professional quality photos of people with food—eating, cooking, growing, processing, etc."

■EWING GALLOWAY, 100 Merrick Rd., Rockville Centre NY 11570. (516)764-8620. Fax: (516)764-1196. Photo Editor: Tom McGeough. Estab. 1920. Stock photo agency. Member of Picture Agency Council of America (PACA), American Society of Media Photographers (ASMP). Has 3 million photos. Clients include: advertising agencies, public relations firms, audiovisual firms, businesses, book/encyclopedia publishers, magazine publishers, newspapers, postcard companies, calendar companies, greeting card companies and religious organizations.

Needs: General subject library. Does not carry personalities or news items. Lifestyle shots (model released) are most in demand.

Specs: Uses 8×10 glossy b&w prints; 35mm, 2¼×2¼ and 4×5 transparencies.

Payment & Terms: Pays 30% commission on b&w photos; 50% on color photos. General price range: $400-450. Charges catalog insertion fee of $400/photo. Statements issued monthly. Payment made monthly. Offers one-time rights; also unlimited rights for specific media. Model/property release required. Photo captions required; include location, specific industry, etc.

Making Contact: Interested in receiving work from newer, lesser-known photographers. Query with samples. Send unsolicited photos by mail for consideration; **must include return postage**. SASE. Reports in 3 weeks. Photo guidelines with **SASE (55¢)**. Market tips sheet distributed monthly; **SASE (55¢)**.

Tips: Wants to see "high quality—sharpness, subjects released, shot only on best days—bright sky and clouds. Medical and educational material is currently in demand. We see a trend toward photography related to health and fitness, high-tech industry, and mixed race in business and leisure."

***EYE UBIQUITOUS**, 65 Brighton Rd., Shoreham, Sussex BN43 6RE England. (+44)1273-440113. Fax: (+44)1273-440116. Owner: Paul Seheult. Estab. 1988. Picture library. Has 300,000 photos. Clients include: ad agencies, public relations firms, businesses, book/encyclopedia publishers, magazine publishers, newspapers and television companies.

Needs: Worldwide social documentary and general stock.

Specs: Uses 35mm, 2¼×2¼, 4×5 transparencies; Fuji and Kodak film.

Payment & Terms: Charges 50% commission. Offers volume discounts to customers; inquire about specific terms. Discount sales terms not negotiable. Works on contract basis only. Offers exclusive, limited regional exclusivity and nonexclusive contracts. Contracts renew automatically with additional submissions. Charges to photographers "discussed on an individual basis." Payment made quarterly. Photographers allowed to review account records. Buys one-time, electronic media and agency promotion rights; negotiable. Does not inform photographer or allow him to negotiate when client requests all rights. Model/property release preferred for people, "particularly Americans." Captions required: include where, what, why, who.

Making Contact: Interested in receiving work from newer, lesser-known photographers. Submit portfolio for review. Works with local freelancers only. Samples kept on file. SASE. No minimum number of images expected in initial submission but "the more the better." Reports as time allows. Photo guidelines free with SASE. Catalog free with SASE. Market tips sheet distributed to contributors "when we can"; free with SASE.

Tips: "Find out how picture libraries operate. This is the same for all libraries worldwide. Amateurs can be very good photographers but very bad at understanding the industry after reading some irresponsible and misleading articles. Research the library requirements."

■FINE PRESS SYNDICATE, Box 22323, Ft. Lauderdale FL 33335. Vice President: R. Allen. Has 49,000 photos and more than 100 films. Clients include: ad agencies, public relations firms, businesses, audiovisual firms, book publishers, magazine publishers, postcard companies and calendar companies worldwide.

Needs: Nudes, figure work and erotic subjects (female only).

Specs: Uses glossy color prints; 35mm, 2¼×2¼ transparencies; 16mm film; videocasettes: VHS and Beta.

Payment & Terms: Pays 50% commission on color photos and film. Price range "varies according to use and quality." Enforces minimum prices. Works on contract basis only. Offers exclusivity only. Statements issued monthly. Payment made monthly. Offers one-time rights. Does not inform photographer or permit him to negotiate when client requests all rights. Model/property release preferred.

Making Contact: Interested in receiving work from newer, lesser-known photographers. Send unsolicited material by mail for consideration or submit portfolio for review. SASE. Reports in 2 weeks.

Tips: Prefers to see a "good selection of explicit work. Currently have European and Japanese magazine publishers paying high prices for very explicit nudes. Clients prefer 'American-looking' female subjects. Send as many samples as possible. Foreign magazine publishers are buying more American work as the value of the dollar makes American photography a bargain. More explicit poses are requested."

FIRST IMAGE WEST, INC., 104 N. Halsted St., #200, Chicago IL 60661. (312)733-9875. Contact: Tom Neiman. Estab. 1985. Stock photo agency. Member of Picture Agency Council of America (PACA). Clients include: advertising agencies, public relations firms, businesses, book/encyclopedia publishers, magazine publishers and newspapers. Clients include: Bank of America, Wrangler Jeans, Jeep, America West Airlines.

Needs: Needs photos of lifestyles and scenics of the West and Midwest, model-released lifestyles.

Specs: Uses 35mm to panoramic.

Payment & Terms: Pays 50% commission on domestic photos. General price range (to clients): editorial, $185 and up; advertising, $230 base rate. Works on contract basis only. Offers limited regional exclusive and catalog exclusive contracts. Statements issued when payment is due. Payment made monthly. Photographers allowed to review account records to verify sales figures. Offers one-time rights and specific print and/or time usages. When client requests all rights, "we inform photographer and get approval of 'buyout' but agency is sole negotiator with client." Model/property release required for people, homes, vehicles, animals. Photo captions required.

Making Contact: Contact by mail for photographer's package. SASE. Reports in 1 month. Photo guidelines free with SASE.

‡■✤FIRST LIGHT ASSOCIATED PHOTOGRAPHERS, Suite 204, 1 Atlantic Ave., Toronto, Ontario M6K 3E7 Canada. (416)532-6108. President: Pierre Guevremont. Estab. 1984. Stock and assignment agency. Has 450,000 photos. Clients include: advertising agencies, public relations firms, audiovisual firms,

businesses, book/encyclopedia publishers, magazine publishers, newspapers, postcard companies, calendar companies and greeting card companies.

Needs: Natural history, international travel, commercial imagery in all categories. Special emphasis upon model-released people, high tech, industry and business. "Our broad files require variety of subjects."

Specs: Uses 35mm, 2¼×2¼ and 4×5 transparencies.

Payment & Terms: Pays 50% commmission. General price range: $150-5,000. Works on contract basis only. Offers limited regional exclusivity. Charges variable catalog insertion fees. Statements issued monthly. Payment made monthly. Offers one-time rights. Informs photographers and permits them to negotiate when client requests all rights. Model release preferred. Captions required.

Making Contact: Query with list of stock photo subjects. SASE. Reports in 1 month. Photo guidelines free with SASE. Tips sheet distributed every 6 weeks.

Tips: Wants to see "tight, quality edit and description of goals and shooting plans."

FOLIO, INC., 3417½ M St., Washington DC 20007. President: Susan Soroko. Estab. 1983. Stock photo agency. Types of clients: newspapers, textbooks, education, industrial, retail, fashion, finance.

Needs: Photos used for billboards, consumer magazines, trade magazines, direct mail, P-O-P displays, catalogs, posters, signage and newspapers.

Specs: Uses 35mm, 2¼×2¼ and 4×5 transparencies.

Payment & Terms: Pays "50% of sales." Pays on publication or on receipt of invoice. Works on contract basis only. Offers one-time rights. Model release required. Photo captions required.

Making Contact: Arrange a personal interview to show portfolio. Provide résumé, business card, brochure, flier or tearsheets to be kept on file for possible future assignments. SASE. Reports in 3 weeks. Credit line given.

Tips: "Call first, then send in requested information."

■❧**FOTO EXPRESSION INTERNATIONAL (Toronto)**, Box 1268, Station "Q," Toronto, Ontario M4T 2P4 Canada. (416)441-0166. Fax: (416)445-4953. E-mail: fotopres@ican.net. Website: http://home.ic an.net/~fotopres. Director: John Milan Kubik. Selective archive of photo, film and audiovisual materials. Clients include: ad agencies; public relations and audiovisual firms; TV stations and networks; film distributors; businesses; book, encyclopedia, trade and news magazine publishers; newspapers; postcard, calendar and greeting card companies.

Needs: City views, aerial, travel, wildlife, nature/natural phenomena and disasters, underwater, aerospace, weapons, warfare, industry, research, computers, educational, religions, art, antique, abstract, models, sports. Worldwide news and features, personalities and celebrities.

Specs: Uses 8×10 b&w prints; 35mm and larger transparencies; 16mm, 35mm film; VHS, Beta and commercial videotapes (AV). Motion picture, news film, film strip and homemade video. Accepts images in digital format for Windows. Send via compact disc, floppy disk or Zip disk.

Payment & Terms: Sometimes buys transparencies outright. Pays 40% for b&w; 50% for color and 16mm, 35mm films and AV (if not otherwise negotiated). Statements issued semi-annually. Payment made monthly. Offers one-time rights. Model release required for photos. Captions required.

Making Contact: Submit portfolio for review. The ideal portfolio for 8×10 b&w prints includes 10 prints; for transparencies include 60 selections in plastic slide pages. With portfolio you must send $4 US money order or $4.50 Canadian money order for postage—no personal checks, no postage stamps. Reports in 3 weeks. Photo guidelines free with SASE. Tips sheet distributed twice a year only "on approved portfolio."

Tips: "We require photos, slides, motion picture films, news film, homemade video and AV that can fulfill the demand of our clientele." Quality and content is essential. Photographers, cameramen, reporters, writers, correspondents and representatives are required worldwide by FOTOPRESS, Independent News Service International, (416)441-1405, Fax: (416)445-4953.

■***FOTO-PRESS TIMMERMANN**, Speckweg 34A, D-91096 Moehrendorf, Germany. 499131/42801. Fax: 499131/450528. E-mail: timmermann.foto@t~online.dc. Contact: Wolfgang Timmermann. Stock photo agency. Has 750,000 slides. Clients include: ad agencies, audiovisual firms, businesses, book/encyclopedia publishers, magazine publishers, newspapers and calendar companies.

Needs: All themes: landscapes, countries, travel, tourism, towns, people, business, nature.

Specs: Uses 2¼×2¼, 4×5 and 8×10 transparencies.

 CANADIAN LISTINGS are marked with a maple leaf.

Payment & Terms: Pays 50% commission on color prints. Works on nonexclusive contract basis (limited regional exclusivity). First period: 3 years, contract automatically renewed for 1 year. Photographers allowed to review account records. Statements issued quarterly. Payment made quarterly. Offers one-time rights. Informs photographers and permits them to negotiate when a client requests to buy all rights. Model/property release preferred. Captions required; include state, country, city, subject, etc.
Making Contact: Interested in receiving work from newer, lesser-known photographers. Query with list of stock photo subjects. Send unsolicited photos by mail for consideration. SASE. Reports in 1 month.

■**FOTOS INTERNATIONAL**, 10410 Palms Blvd., Suite 9, Los Angeles CA 90034-4812. (818)508-6400. Fax: (818)762-2181. E-mail: entertainment@earthlink.net or fotos@mail.org. Manager: Max B. Miller. Has 4 million photos. Clients include: ad agencies, public relations firms, businesses, book publishers, magazine publishers, encyclopedia publishers, newspapers, calendar companies, TV and posters.
Needs: "We are the world's largest entertainment photo agency. We specialize exclusively in motion picture, TV and popular music subjects. We want color only! The subjects can include scenes from productions, candid photos, rock, popular or classical concerts, etc., and must be accompanied by full caption information."
Specs: Uses 35mm color transparencies only.
Payment & Terms: Buys photos outright; no commission offered. Pays $5-200/photo. Works with or without contract. Offers nonexclusive contract and guaranteed subject exclusivity (within files). Offers one-time rights and first rights. Offers electronic media and agency promotion rights. Model release optional. Captions required.
Making Contact: "We prefer e-mails or faxes." Query with list of stock photo subjects. Reports "promptly which could be one hour or two months, depending on importance and whatever emergency project we're on."

FPG INTERNATIONAL CORP., 32 Union Square E., New York NY 10003. (212)777-4210. Fax: (212)475-8542. Director of Photography: Rebecca Taylor. Affiliations Manager: Claudia Micare. A full service agency with emphasis on images for the advertising, corporate, design and travel markets. Member of Picture Agency Council of America (PACA).
Needs: High-tech industry, model-released human interest, foreign and domestic scenics in medium formats, still life, animals, architectural interiors/exteriors with property releases.
Specs: Minimum submission requirement per year—1,000 original color transparencies, exceptions for large format, 250 b&w full-frame 8×10 glossy prints.
Payment & Terms: Pays 50% commission upon licensing of reproduction rights. Works on contract basis only. Offers exclusive contract only. Contracts renew automatically upon contract date; 5-year contract. Charges catalog insertion fee; rate not specified. Statements issued monthly. Payment made monthly. Photographers allowed to review account records to verify sales figures. Licenses one-time rights. "We sell various rights as required by the client." When client requests all rights, "we will contact a photographer and obtain permission."
Making Contact: "Initial approach should be by mail. Tell us what kind of material you have, what your plans are for producing stock and what kind of commercial work you do. Enclose reprints of published work." Photo guidelines and tip sheets provided for affiliated photographers. Model/property releases required and must be indicated on photograph. Captions required.
Tips: "Submit regularly; we're interested in committed, high-caliber photographers only. Be selective and send only first-rate work. Our files are highly competitive."

FRANKLIN PHOTO AGENCY, 85 James Otis Ave., Centerville MA 02632. President: Nelson Groffman. Has 35,000 transparencies. Clients include: publishers, advertising and industrial.
Needs: Scenics, animals, horticultural subjects, dogs, cats, fish, horses, antique and classic cars, and insects.
Specs: Uses 35mm, 2¼×2¼ and 4×5 color transparencies. "More interest now in medium size format—2¼×2¼." Accepts images in digital format.
Payment & Terms: Pays 50% commission. General price range (to clients): $100-300; $60/b&w photo; $100/color photo. Works with or without contract, negotiable. Offers nonexclusive contract. Statements issued when pictures are sold. Payment made within a month after sales "when we receive payment." Offers one-time, electronic media, agency promotion and 1-year exclusive rights. Informs photographer and allows him to negotiate when client requests all rights. Model/property release required for people, houses; present release on acceptance of photo. Captions preferred.
Making Contact: Interested in receiving work from newer, lesser-known photographers. Query first with résumé of credits. SASE. Reports in 1 month.
Tips: Wants to see "clear, creative pictures—dramatically recorded."

***FRONTLINE PHOTO PRESS AGENCY**, P.O. Box 162, Kent Town, South Australia 5071 Australia. 18 Wall St., Norwood, South Australia 5067 Australia. 61-8-8333-2691. Fax: 61-8-8364-0604. E-mail: fppa@tne.net.au. Website: http://www.tne.net.au/fppa. Director: Carlo Irlitti. Estab. 1988. Stock photo agency, picture library and photographic press agency. Has 350,000 photos. Clients include: advertising agencies, marketing/public relations firms, book/encyclopedia publishers, magazine publishers, newspapers, postcard publishers, calendar companies, poster companies, multimedia/audiovisual firms, graphic designers, corporations, private and government institutions.

● This agency markets images via low resolution watermarked CD-ROM catalogs. Digital picture transmission service available.

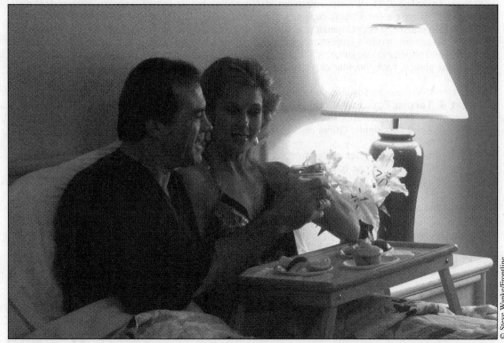

© Steve Wanke/Frontline

Working through Frontline Photo Press Agency, South Australia, the Scouts Association licensed this shot and two other photos by Steve Wanke. "The warm, appealing, light and romantic setting which gave a feeling the couple were away from the children and enjoying each other was relevant to the message we wanted to put across," says Frontline's Director Carlo Irlitti. Wanke received 60 percent commission, standard for the stock agency.

Needs: People (all walks of life, at work and at leisure), lifestyles, sports, cities and landscapes, travel, industrial and agricultural, natural history, enviromental, celebrities and important people, social documentary, concepts, science and medicine.

Specs: Uses 8½×12 glossy color and b&w prints; 35mm color and b&w negatives; 35mm, 2¼×2¼, 4×5, 8×10 transparencies; CD-ROMs in ISO 9660 Format, Kodak Photo/Pro Photo CD Masters (Base×16 and Base×64). Accepts images in digital format for Mac and Windows (JPEG, TIFF and most other types PhotoCD). Submit via compact disc, online, floppy disk, Zip disk or on Internet: 72 dpi and up (thumbnails), 2000 dpi and up (high-resolution).

Payment & Terms: Pays 60% commission on all stock images. Assignment rates negotiable. Average price per stock image: b&w $AUD125, color $AUD200 paid to the photographer; overall $AUD50-$AUD6,000. Prices vary considerably depending on use, market and rights requested. Enforces minimum prices. Discounts only on bulk sales. Prefers to work on contract basis but can work without if necessary. Offers exclusive, nonexclusive and tailored contracts to suit the individual photographer. Contracts are for a minimum of 3 years and are automatically renewed 6 months before the expiration date (if not advised in writing) or renewed automatically with additional submissions. Contracts concerning sports and celebrity images are for a minimum of 1 year and are renewable at expiration date. No charges for filing or duping. No charge on in-house produced low and high resolution CD-ROM catalog insertions but charges a once only 50% Photo CD insertion rate on Photo CD Base × 64 high resolution scans. Statements issued monthly. Payment made monthly and within 15 days (quarterly and within 15 days outside Australia). Photographers allowed to review account records as stipulated in contract. Offers one-time and first-time

rights, but also promotional, serial, exclusive and electronic media rights. Photographers informed and allowed to negotiate when client requests all rights. Agency will counsel, but if photographer is unable to negotiate agency will revert to broker on his behalf. Model/property release required. Accepts accompanying mss or extended captions with images submitted; commission on copy negotiable.

Making Contact: Interested in receiving work from competent amateur and professional photographers only. Query with samples or list of stock subjects. Send unsolicited photos (negatives with proofs, transparencies, CD-ROMs ISO 9660), Zip disks and images by e-mail for consideration. Works mostly with local freelancers but is willing to work with overseas freelancers on assignment. Samples kept on file with permission. SASE (include insurance and IRC). Expects minimum initial submission of 100-200 images with periodic submissions of 250-1,000 images/year. Reports in 1-3 weeks. Photo guidelines free with SAE and IRCs. Market tips sheet distributed 2 times/year to photographers on contract; free upon request.

Tips: "We look for creative photographers who are dedicated to their work, who can provide unique and technically sound images. We prefer our photographers to specialize in their subject coverage in fields they know best. All work submitted must be original, well-composed, well-lit (depending on the mood), sharp and meticulously edited with quality in mind. In the initial submission we prefer to see 100-200 of the photographer's best work. Send slides in clear plastic files and not in glass mounts or loose in boxes. All material must be captioned or attached to an information sheet; indicate if model/property released. Model and property releases are mostly requested for advertising and are essential for quick, hassle-free sales. Please package work appropriately; we do not accept responsibility for losses or damage. We would like all subjects covered equally but the ones most sought are: environmental issues, science and medicine, people (occupations, life-style and leisure), dramatic landscapes, general travel and conceptual images. We also need more pictures of sports (up-and-coming and established athletes who make the news worldwide), celebrities and entertainers, important people, social documentary (contemporary issues) including captioned photo-essays for our editorial clients. Feature articles on topical issues, celebrity gossip, sport, travel, lifestyle, fashion, beauty, women's interests, general interest etc., are welcomed and will help sell images in editorial markets, but inquire first before sending any copy. Write, call or fax for complete subject list. We also provide regular advice for our contributors and will direct freelancers to photograph specific, market-oriented subjects as well as help in coordinating their own private assignments to assure saleable subjects."

■**FROZEN IMAGES, INC.**, 400 First Ave. N., Suite 512, Minneapolis MN 55401. (612)339-3191. Director of Photo Services: David Niebergall. Stock photo agency. Has approximately 175,000 photos. Clients include: ad agencies, public relations firms, audiovisual firms, graphic designers, businesses, book/encyclopedia publishers, magazine publishers, newspapers and calendar companies.

Needs: All subjects including abstracts, scenics, industry, agriculture, US and foreign cities, high tech, businesses, sports, people and families.

Specs: Uses transparencies.

Payment & Terms: Pays 50% commission on color photos. Works on contract basis only. Offers limited regional exclusivity. Contracts renew automatically with each submission; time period not specified. Charges catalog insertion fee; rate not specified. Statements issued monthly. Payment made monthly; within 10 days of end of month. Photographers allowed to review account records to verify sales figures "with notice and by appointment." Offers one-time rights. Informs photographers when client requests all rights, but agency negotiates terms. Model/property release required for people and private property. Photo captions required.

Making Contact: Query with résumé of credits. Query with list of stock photo subjects. SASE. Reports in 1 month or ASAP (sometimes 6 weeks). Photo guidelines free with SASE. Tips sheet distributed quarterly to photographers in the collection.

Tips: Wants to see "technical perfection, graphically strong, released (when necessary) images in all subject areas."

F-STOCK INC.
 ● In 1997, F-Stock was purchased by Uniphoto Picture Agency (see listing in this section).

F/STOP PICTURES INC., P.O. Box 359, Springfield VT 05156. (802)885-5261. Fax: (802)885-2625. E-mail: fstoppic@vermontel.com. President: John Wood. Estab. 1984. Stock photo agency. Has 140,000 photos. Clients include: advertising agencies, public relations firms, audiovisual firms, businesses, book/encyclopedia publishers, magazine publishers, newspapers, postcard companies, calendar companies and greeting card companies.

Needs: "We specialize in New England and rural America, but we also need worldwide travel photos and model-released people and families."

Specs: Uses 35mm, $2\frac{1}{4} \times 2\frac{1}{4}$, 4×5, 8×10 transparencies.

Payment & Terms: Pays 50% commission on color photos. Average price per image (to clients): $225.

Enforces minimum prices, minimum of $100, exceptions for reuses. Works on contract basis only. Offers non-exclusive contract, exclusive contract for some images only. Contracts renew automatically for 4 years. Statements issued monthly. Payment made monthly by 31st of statement month. Photographers allowed to review account records to verify sales figures. Offers one-time rights. Informs photographer and allows him to negotiate when client requests all rights. Model/property release required for recognizable people and private property. Captions required; include complete location data and complete identification (including scientific names) for natural history subjects.

Making Contact: *Currently not taking new photographers.* Arrange a personal interview to show portfolio. Query with list of stock photo subjects. Submit portfolio for review. SASE. Reports in 2 weeks. Photo guidelines free with SASE. Market tips sheet distributed quarterly to contracted photographers only.

Tips: Especially wants to work with "professional fulltime photographers willing to shoot what we need." Send minimum of 500 usable photos in initial shipment, and 500 usable per quarter thereafter." Sees trend toward "more realistic people situations, fewer staged-looking shots; more use of electronic manipulation of images."

FUNDAMENTAL PHOTOGRAPHS, Dept. PM, 210 Forsyth St., New York NY 10002. (212)473-5770. Fax: (212)228-5059. E-mail: 70214.3663@compuserve.com. Partner: Kip Peticolas. Estab. 1979. Stock photo agency. Applied for membership into the Picture Agency Council of America (PACA). Has 100,000 photos. Clients include: advertising agencies, book/encyclopedia publishers.

Needs: Science-related topics.

Specs: Uses 35mm, 2¼×2¼, 4×5 and 8×10 transparencies.

Payment & Terms: Pays on commission basis; b&w 40%, color 50%. General price range (to clients): $100-500/b&w photo; $150-1,200/color photo, depends on rights needed. Enforces minimum prices. Offers volume discount to customers. Informs photographer but does not allow him to negotiate when client requests all rights. Works on contract basis only. Offers guaranteed subject exclusivity. Contracts renew automatically with additional submissions for 1 or 2 years. Charges 50% duping fees ($25/4×5 dupe). Statements issued quarterly. Payment made quarterly. Photographers allowed to review account records with written request submitted 1 month in advance. Offers one-time and electronic media rights. Informs photographer when client requests all rights; negotiation conducted by Fundamental (the agency). Model release required. Captions required; include date and location.

Making Contact: Interested in receiving work from newer, lesser-known photographers. Arrange a personal interview to show portfolio. Submit portfolio for review. Query with résumé of credits, samples or list of stock photo subjects. Keeps samples on file. SASE. Expects minimum initial submission of 100 images. Reports in 1-2 weeks. Photo guidelines free with SASE. Tips sheet distributed.

Tips: "Our primary market is science textbooks. Photographers should research the type of illustration used and tailor submissions to show awareness of saleable material. We are looking for science subjects ranging from nature and rocks to industrials, medicine, chemistry and physics; macrophotography, stroboscopic; well-lit still life shots are desirable. The biggest trend that affects us is the increased need for images that relate to the sciences and ecology."

■*GEOSLIDES & GEO AERIAL (Photography), 4 Christian Fields, London SW16 3JZ England. Phone/fax: (0181)764-6292. Library Directors: John Douglas (Geoslides); Kelly White (Geo Aerial). Picture library. Has approximately 120,000 photos. Clients include: ad agencies, public relations firms, audiovisual firms, businesses, book/encyclopedia publishers, magazine publishers, newspapers, calendar companies and television.

Needs: Only from: Africa (South of Sahara); Asia; Arctic and Sub-Arctic; Antarctic. Anything to illustrate these areas. Accent on travel/geography and aerial (oblique) shots.

Specs: Uses 8×10 glossy b&w prints; 35mm and 2¼×2¼ transparencies.

Payment & Terms: Pays 50% commission. General price range (to clients) $70-1,000. Works with or without contract; negotiable. Offers nonexclusive contract. Statements issued monthly. Payment made upon receipt of client's fees. Offers one-time rights and first rights. Does not inform photographer or allow him to negotiate when client requests all rights. Model release required. Photo captions required; include description of location, subject matter and sometimes the date.

Making Contact: Query with résumé of credits and list of stock photo subjects. SASE. Reports in 1 month. Photo guidelines for SASE (International Reply Coupon). No samples until called for. Leaflets available.

● **SPECIAL COMMENTS** within listings by the editor of *Photographer's Market* are set off by a bullet.

Tips: Looks for "technical perfection, detailed captions, must suit lists (especially in areas). Increasingly competitive on an international scale. Quality is important. Need for large stocks with frequent renewals." To break in, "build up a comprehensive (i.e., in subject or geographical area) collection of photographs which are well documented."

GLACIER BAY PHOTOGRAPHY, P.O. Box 97, Gustavus AK 99826-0097. (907)697-2416. Contact: Pamela Jean Miedtke.
Needs: Alaska scenics, people in nature and wildlife. "We deal only with natural subjects in their natural habitats. No filters or manipulation of any sort is used."
Specs: Uses 35mm, $2\frac{1}{4} \times 2\frac{1}{4}$, 4×5, 8×10 transparencies.
Payment & Terms: Usually charges 50% commission. Terms negotiated with photographer.
Making Contact: Query by mail only with list of stock photo subjects, samples and dupe slides to be kept on hand for future reference. Slides returned only if requested and SASE is enclosed.
Tips: When applying, dupes must be individually labeled. Originals must be readily available, razor sharp and free from distortions. "Be realistic. Expect rejection. Everyone is a photographer. If you are as good or better than what you are seeing published, and are consistent, plus enjoy what you are doing, stick with it. Someday it will happen."

‡GLOBE PHOTOS, INC., 275 Seventh Ave., New York NY 10001. (212)645-9292. Fax: (212)627-8932. General Manager (celebrity photos): Ray Whelan Sr. Stock Photography Editor: Bob Shamis. Estab. 1939. Stock photo agency. Member of the Picture Agency Council of America. Has 10 million photos. Clients include: ad agencies, public relations firms, audiovisual firms, businesses, book/encyclopedia publishers, magazine publishers, newspapers and calendar companies.
Needs: General stock photography, celebrity photos and coverage of the entertainment industry.
Specs: Uses 8×10 b&w prints; 35mm, $2\frac{1}{4} \times 2\frac{1}{4}$, 4×5, 8×10 transparencies.
Payment & Terms: Pays 50% commission on b&w and color photos. Negotiates fees below stated minimum prices for certain markets outside US and not-for-profit organizations on a by-case basis. Offers volume discounts to customers; inquire about specific terms. Discount sales terms not negotiable. Works on contract basis only. Offers nonexclusive and exclusive contracts. Contracts renew automatically with additional submissions for 3 years. Charges 50% catalog insertion fee. Statements issued monthly, when there is sales activity in photographer's account. Payment made monthly. Photographers allowed to review account records once a year, after request in writing stating reasons. Offers one-time or electronic media rights and exclusivity upon negotiation. Does not inform photographers and permit them to negotiate when a client requests to buy all rights. "Exclusivity is negotiated by the agency. The photographer is consulted and must approve terms for exclusivity of one year or more." Model/property release required for recognizable people, commercial establishments and private homes.
Making Contact: Interested in receiving work from newer, lesser-known photographers. Arrange personal interview to show portfolio. Query with résumé of credits. Query with stock photo list. "Résumé or stock list appreciated but not required." Samples kept on file. SASE. Expects minimum initial submission of 150-200 images (depends on medium). Reports in 3 weeks. Photo guidelines free with SASE. Market tips sheet distributed periodically to contributing photographers upon request.
Tips: "We transmit images digitally via modem and ISDN lines to affiliates and clients."

‡GEORGE HALL/CHECK SIX, 426 Greenwood Beach, Tiburon CA 94920. (415)381-6363. Fax: (415)383-4935. E-mail: george@code-red.com. Website: WWW.CODE_RED.COM/. Owner: George Hall. Estab. 1980. Stock photo agency. Member of the Picture Agency Council of America (PACA). Has 50,000 photos. Clients include advertising agencies, public relations firms, businesses, magazine publishers, calendar companies.
Needs: All modern aviation and military.
Specs: Uses 35mm, $2\frac{1}{4} \times 2\frac{1}{4}$, 4×5 transparencies.
Payment & Terms: Pays 50% commission on color photos. Average price per stock sale: $1,000. Has minimum price of $300 (some lower fees with large bulk sales, rare). Offers volume discounts to customers; terms specified in photographer's contract. Photographers can choose not to sell images on discount terms. Works on contract basis only. Offers nonexclusive contract. Payment made within 5 days of each sale. Photographers allowed to review account records. Offers one-time and electronic media rights. Does not inform photographer or allow him to negotiate when client requests all rights. Model release preferred. Captions preferred; include basic description.
Making Contact: Interested in receiving work from newer, lesser-known photographers. Call or write. SASE. Reports in 3 days. Photo guidelines available.

GEORGE HALL/CODE RED, 426 Greenwood Beach, Tiburon CA 94920. (415)381-6363. Fax: (415)383-4935. Owner: George Hall. Stock photo agency. Member of the Picture Agency Council of

America (PACA). Has 5,000 photos (just starting). Clients include: advertising agencies, public relations firms, businesses, book/encyclopedia publishers, magazine publishers, calendar companies.

Needs: Interested in firefighting, emergencies, disasters, hostile weather: hurricanes, quakes, floods, etc.

Specs: Uses color prints; 35mm, $2\frac{1}{4} \times 2\frac{1}{4}$, 4×5 transparencies.

Payment & Terms: Pays 50% commission. Average price (to clients) $1,000. Enforces minimum prices of $300. Offers volume discounts to customers; terms specified in photographer's contract. Photographers can choose not to sell images on discount terms. Works on contract basis only. Offers nonexclusive contract. Payment made within 5 days of each sale. Photographers allowed to review account records. Offers one-time rights. Does not inform photographer or allow him to negotiate when client requests all rights. Model release preferred. Captions required.

Making Contact: Interested in receiving work from newer, lesser-known photographers. Call or write with details. SASE. Reports in 3 days. Photo guidelines available.

HAVELIN COMMUNICATIONS, INC., 6100 Pine Cone Lane, Austell GA 30001. (770)745-4170. Website: http://www.mindspring.com/~havelin. Contact: Michael F. Havelin. Has 30,000 b&w and color photos. Clients include: advertising agencies, public relation firms, audiovisual firms, businesses, book/ encyclopedia publishers, magazine publishers, newspapers, postcard companies, calendar companies and greeting card companies.

Subject Needs: "We stock photos of pollution and its effects; animals, insects, spiders, reptiles and amphibians; solar power and alternative energy sources; and guns, hunting and motorcycle roadracing."

Specs: Uses b&w prints; 35mm, $2\frac{1}{4} \times 2\frac{1}{4}$, 8×10 and 4×5 transparencies.

Payment & Terms: Pays 50% commission. General price range: highly variable. Offers nonexclusive contract. Statements issued after sales. Payment made quarterly upon sales and receipt of client payment. Photographers allowed to review account records to verify sales figures upon request. Offers one-time rights. Informs photographer and allows him to negotiate when client requests all rights. Model release preferred for recognizable people. Photo captions required; include who, what, where, when, why and how.

Making Contact: Photo guidelines free with SASE. Tips sheet distributed intermittently; free with SASE.

Tips: "We are not seeking to represent more photographers. We stock well-exposed, informative images that have impact, as well as photo essays or images which tell a story on their own, and photo illustrated articles. Slicker work is selling better than isolated 'record' shots." To break in, "act professionally. People who work in visual media still need to write coherent business letters and intelligent, informative captions. Don't take rejection personally. It may not be the right time for the editor to use your material. Don't give up. Be flexible."

■‡**HILLSTROM STOCK PHOTO, INC.**, Dept. PM, 5483 N. Northwest Hwy., (Box 31100), Chicago IL 60630 (60631 for Box No.). (773)775-4090. Fax: (773)775-3557. President: Ray F. Hillstrom, Jr. Stock photo agency. Has 1 million color transparencies; 50,000 b&w prints. "We have a 22-agency network." Clients include: ad agencies, public relations firms, audiovisual firms, businesses, book/encyclopedia publishers, magazine publishers, newspapers, calendar companies, greeting card companies and sales promotion agencies.

Needs: "We need hundreds of 35mm color model-released sports shots (all types); panoramic 120mm format worldwide images. Model-released: heavy industry, medical, high-tech industry, computer-related subjects, family-oriented subjects, foreign travel, adventure sports and high-risk recreation, Midwest festivals (country fairs, parades, etc.), the Midwest. We need more color model-released family, occupation, sport, student, senior citizen, high tech and on-the-job shots."

Specs: Uses 8×10 b&w prints; 35mm, $2\frac{1}{4} \times 2\frac{1}{4}$ and 4×5 transparencies.

Payment & Terms: Pays $50-5,000/b&w and color photo. Pays 50% commission on b&w and color photos. Works with or without contract, negotiable. Offers non-exclusive contracts. Statements issued quarterly. Payment made quarterly. Photographers allowed to review account records to verify sales figures. Offers one-time rights. Informs photographer and allows him to negotiate when client requests all rights. Model/property release required for people and private property. Captions required; include location, subject and description of function.

Making Contact: Interested in receiving work from newer, lesser-known photographers. Include 3 business cards and detailed stock photo list. Call or write before submitting slides or prints. Reports in 3 weeks. Photo guidelines free with SASE.

Tips: Prefers to see good professional images, proper exposure, mounted, and name IDs on mount. In photographer's samples, looks for "large format, model and property release, high-tech, people on the job, worldwide travel and environment. Show us at least 200 different images with 200 different subjects."

*****HOLT STUDIOS INTERNATIONAL, LTD.**, The Courtyard, 24 High St., Hungerford, Berkshire, RG17 0NF United Kingdom. (01488)683523. Fax: (01488)6835111. E-mail: library@holt~studios.co.uk. Website: http://www.holt~studios.co.uk/library. Director: Nigel D. Cattlin. Picture library. Has 70,000 pho-

tos. Clients include: ad agencies, public relations firms, audiovisual firms, businesses, book/encyclopedia publishers, magazines, newspapers and commercial companies.

Needs: Photographs of world agriculture associated with crop production and crop protection including healthy crops and relevant weeds, pests, diseases and deficiencies. Farming, people and machines throughout the year including good landscapes. Livestock and livestock management, horticulture, gardens, ornamental plants and garden operations. Worldwide assignments undertaken.

Specs: Uses 35mm, 2¼×2¼ and 4×5 transparencies.

Payment & Terms: Occasionally buys photos outright. Pays 50% commission. General price range: $100-1,500. Offers photographers nonexclusive contract. Contracts renew automatically with additional submissions for 3 years. Photographers allowed to review account records. Statements issued quarterly. Payment made quarterly. Offers one-time rights. Model release preferred. Captions required; "identity of biological organisms is critically important."

Making Contact: Interested in receiving work from newer, lesser-known photographers. Send unsolicited photos by mail for consideration. SAE (with sufficient return postage). Reports in 2 weeks. Photo guidelines free with SASE. Distributes tips sheets every 3 months to all associates.

Tips: "Holt Studios looks for high quality, technically well-informed and fully labeled color transparencies of subjects of agricultural and horticultural interest." Currently sees "expanding interest, particularly in conservation and the environment, gardening and garden plants."

‡■❧**HOT SHOTS STOCK SHOTS, INC.**, 341 Lesmill Rd., Toronto, Ontario M3B 2V1 Canada. (416)441-3281. Fax: (416)441-1468. Attention: Editor. Member of Picture Agency Council of America (PACA). Clients include: advertising and design agencies, publishers, major printing houses and product manufacturers.

Needs: People and human interest/lifestyles, business and industry, wildlife, historic and symbolic Canadian.

Specs: Color transparency material any size.

Payment & Terms: Pays 50% commission, quarterly upon collection; 30% for foreign sales through sub-agents. Price ranges: $200-5,000. Works on contract basis only. Offers exclusive, limited regional exclusivity and nonexclusive contracts. Most contracts renew automatically for 3-year period with each submission. Statements issued quarterly. Payment made quarterly. Photographers allowed to review account to verify sales figures. Offers one-time, electronic media, and other rights to clients. Allows photographer to negotiate when client requests all rights. Requests agency promotion rights. Model/property release preferred. Photo captions required, include where, when, what, who, etc.

Making Contact: Must send a minimum of 300 images. Unsolicited submissions must have return postage. Reports in 1 week. Photo guidelines free with business SASE.

Tips: "Submit colorful, creative, current, technically strong images with negative space in composition." Looks for people, lifestyles, variety, bold composition, style, flexibility and productivity. "People should be model released for top sales. Prefer medium format." Photographers should "shoot for business, not for artistic gratification; tightly edited, good technical points (exposure, sharpness, etc.), professionally mounted, captioned/labeled and good detail."

■***THE HUTCHISON LIBRARY**, 118B Holland Park Ave., London W11 4UA England. (071)229-2743. Fax: (0171)792-0259. Director: Michael Lee. Stock photo agency, picture library. Has around 500,000 photos. Clients include: ad agencies, public relations firms, audiovisual firms, businesses, book/encyclopedia publishers, magazine publishers, newspapers, postcard companies, calendar companies, television and film companies.

Needs: "We are a general, documentary library (no news or personalities, no modeled 'set-up' shots). We file mainly by country and aim to have coverage of every country in the world. Within each country we cover such subjects as industry, agriculture, people, customs, urban, landscapes, etc. We have special files on many subjects such as medical (traditional, alternative, hospital etc.), energy, environmental issues, human relations (relationships, childbirth, young children, etc. but all *real people*, not models). We are a color library,"

Specs: Principally 35mm transparencies.

Payment & Terms: Pays 50% commission for color photos. Statements issued semiannually. Payment

MARKET CONDITIONS are constantly changing! If you're still using this book and it's 1999 or later, buy the newest edition of *Photographer's Market* at your favorite bookstore or order directly from Writer's Digest Books.

made semiannually. Sends statement with check in June and January. Offers one-time rights. Model release preferred. Captions required.

Making Contact: Only very occasionally accepts a new collection. "The general rule of thumb is that we would consider a collection which had a subject we did not already have coverage of or a detailed and thorough specialist collection." Arrange a personal interview to show portfolio. Send letter with brief description of collection and photographic intentions. Reports in about 2 weeks, depends on backlog of material to be reviewed. "We have letters outlining working practices and lists of particular needs (they change)." Distributes tips sheets to photographers who already have a relationship with the library.

Tips: Looks for "collections of reasonable size (rarely less than 1,000 transparencies) and variety; well captioned (or at least well indicated picture subjects, captions can be added to mounts later); sharp pictures (an out of focus tree branch or whatever the photographer thinks adds mood is not acceptable; clients must not be relied on to cut out difficult areas of any picture), good color, composition and informative pictures. Prettiness is rarely enough. Our clients want information, whether it is about what a landscape looks like or how people live, etc."

***THE IMAGE FACTORY**, 7 Green Walks, Prestwich, Manchester M25 1DS England. (061)798-0435. Fax: (0161)247-6394. Principal: Jeff Anthony. Estab. 1988. Picture library. Has 350,000 photos. Has 2 branch offices. Clients include: advertising agencies, public relations firms, audiovisual firms, businesses, book/encyclopedia publishers, magazine publishers, newspapers, postcard publishers, calendar companies and greeting card companies.

● The Image Factory recently merged with an agency in Warsaw, Poland (Flash Media).

Needs: Photos from all over the world. Currently looking for good glamour, nude and humor as well as shots of the Bahamas—but will look at anything of good quality.

Specs: Uses 35mm, 2¼×2¼, 4×5, 8×10 transparencies.

Payment & Terms: Pays 40-60% commission. Works on contract basis only. Offers exclusive contracts. Contracts renew automatically with additional submissions; originally for 3 years and then annually. Statements issued annually. Payment made quarterly. Photographers allowed to review account records. Offers one-time rights. Informs photographer and allows him to negotiate when client requests all rights. Model/property release preferred. Captions required, include as many details as possible.

Making Contact: Interested in receiving work from newer, lesser-known photographers. Submit portfolio for review. SASE. Expects minimum initial submission of 100 images. Reports in 1 month. Photo guidelines free with SASE. Market tips sheet distributed annually; free with SASE.

Tips: "We will look at anything if the quality is good: good color saturation, clarity and good description. All mounts should be clearly captioned."

THE IMAGE FINDERS, 2003 St. Clair Ave., Cleveland OH 44114. (216)781-7729. Fax: (216)443-1080. E-mail: 75217.106@compuserve. Owner: Jim Baron. Estab. 1988. Stock photo agency. Has 150,000 photos. Clients include: advertising agencies, public relations firms, audiovisual firms, businesses, book/encyclopedia publishers, magazine publishers, calendar companies, greeting card companies.

Needs: General stock agency. Needs more people images. Always interested in good Ohio images.

Specs: Uses 35mm, 2¼×2¼. 4×5 transparencies.

Payment & Terms: Pays 50% commission on b&w and color photos. Average price per image (to clients): $250-350/color. "This is a small agency and we will, on occasion, go below stated minimum prices." Offers volume discounts to customers; terms specified in photographer's contract. Works on contract basis only. Contracts renew automatically with additional submissions for 2 years. Statements issued monthly if requested. Payment made monthly. Photographers allowed to review account records. Offers one-time rights; negotiable depending on what the client needs and will pay for. Informs photographer and allows him to negotiate when client requests all rights. "This is rare for us. I would inform photographer of what client wants and work with photographer to strike best deal." Model release required. Property release preferred. Captions required; include location, city, state, country, type of plant or animal, etc.

Making Contact: Interested in receiving work from newer, lesser-known photographers. Query with stock photo list. Call before you send anything. SASE. Expects minimum initial submission of 100 images with periodic submission of at least 100-500 images. Reports in 3 weeks. Photo guidelines free with SASE. Market tips sheet distributed 2-4 times/year to photographers under contract.

Tips: Photographers must be willing to build their file of images. "We need more people images, industry, lifestyles, medical, etc. Scenics and landscapes must be outstanding to be considered."

■THE IMAGE WORKS, P.O. Box 443, Woodstock NY 12498. (914)246-8800. Fax: (914)246-0383. E-mail: mantman@theimageworks.com. Website: http://www.theimageworks.com. Directors: Mark Antman, Vice President of ASPP, and Alan Carey, President of PACA. Stock photo agency. Member of Picture

Agency Council of America (PACA). Has 650,000 photos. Clients include: ad agencies, audiovisual firms, book/encyclopedia publishers, magazine publishers and newspapers.

• The Image Works is marketing the Kodak Picture Exchange and is also in the process of producing a CD-ROM.

Needs: "We specialize in documentary style photography of worldwide subject matter. People in real life situations that reflect their social, economic, political, leisure time and cultural lives." Topic areas include health care, education, business, family life and environment.

Specs: Uses 8×10 glossy/semi-glossy b&w prints; 35mm and 2¼×2¼ transparencies. Accepts images in digital format for Mac and Windows. Send via compact disc, online, floppy disk, SyQuest or Zip disk.

Payment & Terms: Pays 50% commission on b&w and color photos. General price range: $160-900. Works on contract basis only. Offers nonexclusive contract. Offers guaranteed subject exclusivity (within files). Contracts renew automatically with additional submissions; 3-year renewal. Charges 100% duping fee. Charges catalog insertion fee of 50%. Statements issued monthly. Payment made monthly. Photographers allowed to review account records to verify sales figures by appointment. Photographer must also pay for accounting time. Offers one-time and electronic media rights. Informs photographer and allows him to negotiate when client requests all rights. Model release preferred. Captions required.

Making Contact: Query with list of stock photo subjects or samples. SASE. Reports in 1 month. Tips sheet distributed monthly to contributing photographers.

Tips: "We want to see photographs that have been carefully edited, that show technical control and a good understanding of the subject matter. All photographs must be thoroughly captioned and indicate if they are model released. The Image Works is known for its strong multicultural coverage in the United States and around the world. Photographs should illustrate real-life situations, but not look contrived. They should have an editorial/photojournalistic feel, but be clean and uncluttered with strong graphic impact for both commercial and editorial markets. Photographers who work with us must be hard workers. They have to want to make money at their photography and have a high degree of self-motivation to succeed. As new digital-based photographic and design technology forces changes in the industry, there will be a greater need for experienced photo agencies who know how to service a broad range of clients with very different needs. The agency personnel must be versed, not only in the quality and subject matter of its imagery, but also in the various new options for getting photos to picture buyers. As new uses of photography in new media continue to evolve, the need for agencies from the perspective of both photographers and picture buyers will continue to grow."

IMAGES PICTURES CORP., Dept. PM, 89 Fifth Ave., New York NY 10003. (212)675-3707. Fax: (212)243-2308. Managers: Peter Gould and Barbara Rosen. Has 100,000 photos. Clients include: public relations firms, book publishers, magazine publishers and newspapers.

Needs: Current events, celebrities, feature stories, pop music, pin-ups and travel.

Specs: Uses b&w prints, 35mm transparencies, b&w contact sheets and b&w negatives.

Payment & Terms: Pays 50% commission on b&w and color photos. General price range: $50-1,000. Offers one-time rights or first rights. Captions required.

Making Contact: Query with résumé of credits or with list of stock photo subjects. Also send tearsheets or photocopies of "already published material, original story ideas, gallery shows, etc." SASE. Reports in 2 weeks.

Tips: Prefers to see "material of wide appeal with commercial value to publication market; original material similar to what is being published by magazines sold on newsstands. We are interested in ideas from freelancers that can be marketed and assignments arranged with our clients and sub-agents." Wants to see "features that might be of interest to the European or Japanese press, and that have already been published in local media. Send copy of publication and advise rights available." To break in, "be persistent and offer fresh perspective."

■INDEX STOCK PHOTOGRAPHY, 23 W. 18th, 3rd Floor, New York NY 10011. (212)929-4644. Fax: (212)633-1914. Senior Photo Editor: Lindsey Nicholson. Has 500,000 tightly edited photos. Branch Office: Suite 500, 6500 Wilshire Blvd., Los Angeles CA 90048. (213)658-7707. Fax: (213)651-4975. Clients include: ad agencies; corporate design firms; graphic design and in-house agencies; direct mail production houses; magazine publishers; audiovisual firms; calendar, postcard and greeting card companies.

• Index Stock is an information provider to Kodak Picture Exchange, PressLink and CompuServe. The agency markets images for use in multimedia projects, software packages and other electronic uses, and has taken care to arrange contracts that protect photographers' rights. Agency photographers are given the option to participate or not in these electronic ventures.

Needs: Up-to-date, model-released, images of people, lifestyles, corporate and business situations. Also looking for industry, technology, science and medicine, sports, family, travel and location and nature images. "We are seeking stock photography with a fresh look. Be sure to keep up with current advertising themes."

Barbara Rosen, photographer and co-founder of Images Stock Pictures Inc., has been shooting ready-to-wear runway shows in Europe and New York City for more than a decade. This shot features a Calvin Klein runway model. Images usually sells fashion photos to newspapers immediately after the season then recycles them as magazine illustrations in *Cosmopolitan*, *Harper's Bazaar*, *Vanity Fair* and others, and occasionally sells images as book illustrations. "The most lucrative market for runway fashion material is the magazines, but to break into this market, it's important to have newspaper experience," says Images's Peter Gould. "A number of freelance photographers either make their living or supplement their income with coverage of seasonal shows. Some cover the entire fashion industry, including the men's wear shows and haute couture shows held twice a year in Paris."

Specs: Uses all sizes; 35mm, 2¼×2¼, 4×5 and 8×10 transparencies, including panoramas.
Payment & Terms: Pays 50% commission on general file images; 25% on catalog shots. General price range: $125-5,000. Sells one-time rights plus some limited buyouts (all rights) and exclusives. Model/property releases required. Captions required.
Making Contact: Query with list of stock photo subjects. Reports in 2 weeks with submission guidelines. All portfolios done on mail in or drop off basis. "We like to see 200 originals representing your best work."
Tips: "The stock photography industry has become increasingly more competitive. Keep up with current trends in advertising and print photography. Educate yourself to the demands and realities of the stock photography marketplace. Find out where your own particular style and expertise fit in, edit your work tightly. Index offers worldwide representation through its many overseas affiliates as well as an East Coast office."

INTERNATIONAL COLOR STOCK, INC., Dept. PM, 3841 NE Second Ave., Suite 304, Miami FL 33137. (305)573-5200. Contact: Dagmar Fabricius or Randy Taylor. Estab. 1987. Stock photo syndicate. Clients include: foreign agencies distributing to all markets.
Needs: "We serve as a conduit, passing top-grade, model-released production stock to foreign agencies." Currently promotes its images via the Internet and CD-ROM.
Specs: Uses 35mm, 2¼×2¼ transparencies.
Payment & Terms: Pays 70% commission. Works on contract basis only. Offers exclusive foreign contract only. Contracts renew automatically on annual basis. Charges duping fee of 100%/image. Also charges catalog insertion fee of 100%/image. Statements issued monthly. Payment made monthly. Photographers allowed to review account records to verify sales figures "upon reasonable notice, during normal business hours." Offers one-time rights. Requests agency promotion rights. Informs photographer and allows him to negotiate when client requests all rights, "if notified by subagents." Model/property release required. Captions preferred; include "who, what, where, when, why and how."
Making Contact: Query with résumé of credits. Reports "only when photographer is of interest." Photo guidelines sheet not available. Tips sheet not distributed.
Tips: Has strong preference for experienced photographers. "Our percentages are extremely low. Because of this, we deal only with top shooters seeking long-term success. If you are not published 20 times a month or have not worked on contract for two or more photo agencies or have less than 15 years experience, please do not call us."

INTERNATIONAL SPORTS, 1078 Route 33, P.O. Box 614, Farmingdale NJ 07727. (908)938-3533. Director: Robert J. Hack. Estab. 1993. Stock photo agency. Clients include: advertising agencies, public relations firms, book/encyclopedia publishers, magazine publishers and calendar companies.
Needs: Model released action, leisure and adventure sports, all professional and college sports.
Specs: Uses 35mm, 2¼×2¼, 4×5, 8×10 transparencies.
Payment & Terms: Pays 50% commission on color photos. Average price per image (to clients): $150-4,000/color photo. Works on contract basis only Offers exclusive and nonexclusive contracts. Statements issued quarterly. Payment made quarterly. Photographers allowed to review account records. Offers one-time rights. Informs photographer and allows him to negotiate when client requests all rights. Model/property release preferred for all subjects except professional athletes.
Making Contact: Interested in receiving work from newer, lesser-known photographers. Query with samples. SASE. Expects minimum initial submission of 500 images. Reports in 1-2 weeks. Photo guidelines free with SASE. Market tips sheets distributed quarterly to contracted photographers free upon request.

INTERPRESS OF LONDON AND NEW YORK, 400 Madison Ave., New York NY 10017. Editor: Jeffrey Blyth. Has 5,000 photos. Clients include: magazine publishers and newspapers.
Needs: Offbeat news and feature stories of interest to European editors. Captions required.
Specs: Uses 8×10 b&w prints and 35mm color transparencies.
Payment & Terms: Payment negotiable. Offers one-time rights.
Making Contact: Send material by mail for consideration. SASE. Reports in 1 week.

BRUCE IVERSON PHOTOMICROGRAPHY, 31 Boss Ave., Portsmouth NH 03801. Phone/fax: (603)433-8484. Owner: Bruce Iverson. Estab. 1981. Stock photo agency. Has 10,000 photos. Clients include: advertising agencies, book/encyclopedia publishers.
● This agency uses Kodak Photo CD for demos/portfolios.
Needs: Currently only interested in submission of scanning electron micrographs and transmission electron micrographs—all subjects.
Specs: Uses 8×10 glossy or matte color and b&w prints; 35mm, 2¼×2¼, 4×5 transparencies; 6×17 panoramic.

Payment & Terms: Pays 50% commission on b&w and color photos. There is a minimum use fee of $175; maximum 10% discount. Terms specified in photographer's contract. Works on contract basis only. Offers nonexclusive contracts. Photographer paid within 1 month of agency's receipt of payment. Offers one-time rights. Captions required; include magnification and subject matter.

Making Contact: "Give us a call first. Our subject matter is very specialized." SASE. Reports in 1-2 weeks.

Tips: "We are a specialist agency for science photos and technical images taken through the microscope."

***JAYAWARDENE TRAVEL PHOTO LIBRARY**, 7A Napier Rd., Wembley, Middlesex HA0 4UA United Kingdom. (0181)902-3588. Fax: (0181)902-7114. Contact: Rohith or Marion Jayawardene. Estab. 1992. Stock photo agency and picture library. Has 100,000 photos. Clients include: ad agencies, businesses, book/encyclopedia publishers, magazine publishers, newspapers, greeting card companies, postcard publishers and tour operators/travel companies.

Needs: Travel and tourism-related images worldwide, particularly of the US, the Caribbean and South America; couples/families on vacation and local lifestyle. "Pictures, especially of city views, must not be out of date."

Specs: Uses 35mm, 2¼×2¼, 6×4½ cm, 6×7 cm transparencies.

Payment & Terms : Pays 50% commission. Average price per image (to clients): $125-1,000. Enforces minimum prices of $80-100, "but negotiable on quantity purchases." Offers volume discounts to customers; inquire about specific terms. Discount sales terms not negotiable. Works on contract basis only. Offers limited regional exclusivity contract. Statements issued semiannually. Payment made semiannually, within 30 days of payment received from client. Offers one-time and exclusive rights for fixed periods. Does not inform photographer or allow him to negotiate when client requests all rights. Model/property release preferred. Captions required; include country, city/location, subject description.

Making Contact: Interested in receiving work from newer, lesser-known photographers. Arrange personal interview to show portfolio. Query with samples. Query with stock photo list. SASE. Expects minimum initial submission of 300 images with periodic submission of at least 100 images on quarterly basis. Reports in 3 weeks. Photo guidelines free with SASE. Market tips sheet free with SASE.

JEROBOAM, 120-D 27th St., San Francisco CA 94110. (415)824-8085. Call for fax number. E-mail: jeroboam@inreach.com. Contact: Ellen Bunning. Estab. 1972. Has 150,000 b&w photos, 150,000 color slides. Clients include: text and trade books, magazine and encyclopedia publishers and editorial.

Needs: "We want people interacting, relating photos, artistic/documentary/photojournalistic images, especially ethnic and handicapped. Images must have excellent print quality—contextually interesting and exciting, and artistically stimulating." Needs shots of school, family, career and other living situations. Child development, growth and therapy, medical situations. No nature or studio shots.

Specs: Uses 8×10 double weight glossy b&w prints with a ¾″ border. Also uses 35mm transparencies.

Payment & Terms: Works on consignment only; pays 50% commission. Works without a signed contract. Statements issued monthly. Payment made monthly. Photographers allowed to review account records to verify sales figures. Offers one-time and electronic media rights. Informs photographer and allows him to negotiate when client requests all rights. Model/property release preferred for people in contexts of special education, sexuality, etc. Captions preferred; include "age of subject, location, etc."

Making Contact: Interested in receiving work from newer, lesser-known photographers. Call if in the Bay area; if not, query with samples; query with list of stock photo subjects; send material by mail for consideration or submit portfolio for review. SASE. Reports in 2 weeks.

Tips: "The Jeroboam photographers have shot professionally a minimum of five years, have experienced some success in marketing their talent and care about their craft excellence and their own creative vision. Jeroboam images are clear statements of single moments with graphic or emotional tension. We look for people interacting, well exposed and printed with a moment of interaction. New trends are toward more intimate, action shots; more ethnic images needed. Be honest in regards to subject matter (what he/she *likes* to shoot)."

■KEYSTONE PRESS AGENCY, INC., 202 East 42nd St., New York NY 10017. (212)924-8123. E-mail: balpert@onldnet.att.net. Managing Editor: Brian F. Alpert. Types of clients: book publishers, magazines and major newspapers.

 MARKETS USING AUDIOVISUAL MATERIAL, such as slides, film or videotape, are marked with a solid, black square.

Needs: Uses photos for slide sets. Subjects include: photojournalism. Reviews stock photos/footage. Captions required.

Specs: Uses 8×10 glossy b&w and color prints; 35mm and 2¼×2¼ transparencies.

Making Contact & Terms: Cannot return material. Reports upon sale. Payment is 50% of sale per photo. Credit line given.

‡■*KEYSTONE PRESSEDIENST GMBH**, Kleine Reichenstr. 1, 20457 Hamburg 11, 2 162 408 Germany. (040)33 66 97-99. Fax: (040)32 40 36. E-mail: keystonede@aol.com. Website: http://www.members. aol.com/keystonede/. President: Constanze Martin. Stock photo agency, picture library and news/feature syndicate. Has 3.5 million color transparencies and b&w photos. Clients include: ad agencies, public relations firms, audiovisual firms, businesses, book/encyclopedia publishers, magazine publishers, newspapers, postcard companies, calendar companies, greeting card companies and TV stations.

Needs: All subjects excluding sports events.

Specs: Uses b&w prints; 35mm, 2¼×2¼, 4×5 and 8×10 transparencies.

Payment & Terms: Pays 50% commission on b&w and color photos. General price range: $30-1,000. Works on contract basis only. Offers guaranteed subject exclusivity (within files). Contracts renew automatically for one year with additional submissions. Does not charge duping, filing or catalog insertion fees. Payment made one month after photo is sold. Offers one-time and agency promotion rights. "We ask the photographer if client requests exclusive rights." Model release preferred. Captions required; include who, what, where, when and why.

Making Contact: Interested in receiving work from newer, lesser-known photographers. Send unsolicited photos by mail for consideration. Deals with local freelancers by assignment only. SASE. Reports in 2 weeks. Distributes a monthly tip sheet.

Tips: Prefers to see "American way of life—people, cities, general features—human and animal, current events—political, show business, scenics from the USA—travel, touristic, personalities—politics, TV. An advantage of working with KEYSTONE is our wide circle of clients and very close connections to all leading German photo users." Especially wants to see skylines of all US cities. Send only highest quality works.

KIDSTOCK, P.O. Box 21505, Lehigh Valley PA 18002. Phone/fax: (610)559-0968. Editor: Anne Raisner. Estab. 1995. Stock photo agency. Clients include: ad agencies, public relations firms, businesses, book/ encyclopedia publishers, magazine publishers, newspapers, calendar companies, greeting card companies and postcard publishers.

Needs: Photos of children (from newborn to teenagers) of all ethnic groups in all situations. "We are looking for interesting and impressive pictures and good technique."

Specs: Uses 35mm, 2¼×2¼, and other medium format transparencies; 8×10 b&w prints.

Payment & Terms: Pays 50% commission. Offers volume discounts to customers. Photographers can choose not to sell images on discount terms. Works on contract basis only. Offers nonexclusive contract. Contracts renew automatically with additionally submissions for 4 years. Statements issued quarterly. Payment made quarterly. Photographers allowed to review account records. Offers one-time rights; other rights negotiable. Model/property releases "highly" preferred. Captions required.

Making Contact: Interested in receiving work from newer, lesser-known photographers. Query with samples. Samples kept on file. Samples returned with SASE. Reports in 1-2 weeks. Photo guidelines free with SASE. Market tips sheet distributed to affiliated photographers.

■JOAN KRAMER AND ASSOCIATES, INC.**, 10490 Wilshire Blvd., Suite 1701, Los Angeles CA 90024. (310)446-1866. Fax: (310)446-1856. President: Joan Kramer. Member of Picture Agency Council of America (PACA). Has 1 million b&w and color photos dealing with travel, cities, personalities, animals, flowers, lifestyles, underwater, scenics, sports and couples. Clients include: ad agencies, magazines, recording companies, photo researchers, book publishers, greeting card companies, promotional companies and AV producers.

Needs: "We use any and all subjects! Stock slides must be of professional quality."

Specs: Uses 8×10 glossy b&w prints; any size transparencies.

Payment & Terms: Pays 50% commission. Offers all rights. Model release required.

Making Contact: Query or call to arrange an appointment. Do not send photos before calling. SASE.

KYODO PHOTO SERVICE, 250 E. First St., Suite 1107, Los Angeles CA 90012. (213)680-9448. Fax: (213)680-3547. E-mail: kyodonews@earthlink.net. Business Manager: Shige Higashi. Estab. 1946. Sales representative of a national news agency in Japan. Has 4 million photos in Tokyo. Clients include: newspapers.

Needs: News photos.

Specs: Uses any size prints and transparencies.

Payment & Terms: Buys photos/film outright. Pays $50-500/color photo; $50-500/b&w photo. Works with or without a signed contract. Offers nonexclusive contract. Offers one-time and electronic media rights. Captions required.

Making Contact: Query with samples. Works with local freelancers only. Cannot return material. Reports in 1 month. Catalog free, but not always available.

LANDMARK STOCK EXCHANGE, 51 Digital Dr., Novato CA 94949. (415)883-1600. Fax: (415)382-6613. Photo Library Manager: Jeff Downey. Estab. 1979. Stock photo agency and licensing agents. Clients include: advertising agencies; design firms; book publishers; magazine, postcard, greeting card and poster publishers; T-shirts; design firms and "many" gift manufacturers.

Needs: Cats, dogs, puppies, kittens, horses, pigs, wildlife and nature, model-released glamour photos of women and men, decorative art and folk art, hand-colored photography, illustration and cars.

Specs: Uses 35mm, 2¼×2¼, 4×5 transparencies.

Payment & Terms: Pays 50% commission for licensed photos. Enforces minimum prices. "Prices are based on usage." Payment made monthly. Offers one-time rights. Model/property release required. Captions preferred for scenics and animals.

Making Contact: Submit portfolio for review. Query with nonreturnable samples. Query with stock photo list. Samples kept on file. SASE. Photo guidelines free on request. Call for submission guidelines.

Tips: "We are always looking for innovative, creative images in all subject areas, and strive to set trends in the photo industry. Many of our clients are gift manufacturers. We look for images that are suitable for publication on posters, greeting cards, etc. We consistently get photo requests for outstanding scenics, swimsuit shots (men and women), cats and dogs and wildlife."

LIGHT SOURCES STOCK, 23 Drydock Ave., Boston MA 02210. (617)261-0346. Fax: (617)261-0358. E-mail: lsources@tiac.net or lsources@aol.com. Editor: Sonja L. Rodrigue. Estab. 1989. Stock photo agency. Has 200,000 photos. Clients include: advertising agencies, textbook/editorial publishers, magazine publishers, calendar companies, greeting card companies, corporations.

Needs: Children, families, lifestyles, educational, medical, scenics (travel), conceptual/creative and New England settings.

Specs: Uses 35mm, 2¼×2¼, 4×5 transparencies/digital files. Accepts images in digital format for Mac (any file type). Send via compact disc, online, floppy disk, SyQuest or Zip disk (72 dpi for viewing only; 40-75 mb for permanent submission).

Payment & Terms: Pays 50% commission. Average price per image (to clients): $100-2,000/ color photo. Enforces minimum prices. Offers volume discounts to customers; inquire about specific terms. Photographers can choose not to sell images on discount terms. Works on contract basis only. Offers nonexclusive contracts. Contracts renew automatically with additional submissions. Statements issued annually. "Payment is made when agency is paid by the client." Rights negotiated at time of purchase. Informs photographer and allows him to negotiate when client requests all rights. Model/property release preferred. Captions required.

Making Contact: SASE. Send SASE to receive guidelines. Expects minimum initial submission of 200 images with periodic submission of at least 100 images every 6 months. Fewer required for conceptual work or digital work. Reports in 1-2 weeks.

LIGHTWAVE, 170 Lowell St., Arlington MA 02174. Phone/fax: (617)646-1747. (800)628-6809 (outside 617 area code). E-mail: lightwav@tiac.net. Website: http://www.tiac.net/users/lightwav. Contact: Paul Light. Has 250,000 photos. Clients include: ad agencies and textbook publishers.

● Paul Light offers photo workshops over the Internet. Check out his website for details.

Needs: Candid photos of people in school, work and leisure activities.

Specs: Uses 35mm color transparencies.

Payment & Terms: Pays $210/photo. 50% commission. Works on contract basis only. Offers nonexclusive contract. Contracts renew automatically each year. Statements issued annually. Payment made "after each usage." Offers one-time rights. Informs photographer and allows him to negotiate when client requests all rights. Model/property release preferred. Captions preferred.

Making Contact: Send SASE or e-mail for guidelines.

Tips: "Photographers should enjoy photographing people in everyday activities. Work should be carefully edited before submission. Shoot constantly and watch what is being published. We are looking for photographers who can photograph daily life with compassion and originality."

LINEAIR FOTOARCHIEF, B.U., van der Helllaan 6, Arnhem 6824 HT Netherlands. (00.31)26.4456713. Fax: (00.31)26.3511123. E-mail: lineair@worldonline.nl. Manager: Ron Giling. Estab. 1990. Stock photo agency. Has 150,000 photos. Clients include advertising agencies, public relations firms,

book/encyclopedia publishers, magazine publishers. Library specializes in images from Asia, Africa, Latin America and Eastern Europe.

● This agency has been examining the possibilities of marketing its images via computer networks.

Needs: Interested in everything that has to do with the development of countries in Asia, Africa and Latin America.

Specs: Uses 8 × 10 b&w prints; 35mm, 2¼ × 2¼ transparencies. Pays 50% commission on color and b&w prints. Average price per image (to clients): $75-125/b&w; $100-400/color. Enforces minimum prices. Offers volume discounts to customers; inquire about specific terms. Photographers can choose not to sell images on discount terms. Works with or without a signed contract; negotiable. Offers limited regional exclusivity. Charges 50% duping fees. Statements issued quarterly. Payment made quarterly. Photographers allowed to review account records. "They can review bills to clients involved." Offers one-time rights. Informs photographer and allows him to negotiate when client requests all rights. Captions required; include country, city or region, description of the image.

Making Contact: Interested in receiving work from newer, lesser-known photographers. Submit portfolio for review. SASE. There is no minimum for initial submissions. Reports in 3 weeks. Brochure free with SASE (IRC). Market tips sheet available upon request.

Tips: "We like to see high-quality pictures in all aspects of photography. So we'd rather see 50 good ones, than 500 for us to select the 50 out of."

✤MACH 2 STOCK EXCHANGE LTD., #204-1409 Edmonton Tr NE, Calgary, Alberta T2E 3K8 Canada. (403)230-9363. Fax: (403)230-5855. E-mail: m2stock@net.500.com. Manager: Pamela Varga. Estab. 1986. Stock photo agency. Member of Picture Agency Council of America (PACA). Clients include: advertising agencies, public relations firms, audiovisual firms and corporations.

Needs: Corporate, high-tech, lifestyle, industry. In all cases, prefer people-oriented images.

Specs: Uses 35mm, 2¼ × 2¼, 4 × 5, 8 × 10 transparencies.

Payment & Terms: Pays 50% commission on color photos. Average sale: $300. Works on contract basis only. Offers limited regional exclusivity. Contracts renew automatically with additional submissions. Charges 50% duping and catalog insertion fees. Statements issued monthly. Payment made monthly. "All photographers' statements are itemized in detail. They may ask us anything concerning their account." Offers 1-time and 1-year exclusive rights; no electronic media rights for clip art type CD's. Informs photographer and allows him to negotiate when client requests all rights. "We generally do not sell buy-out." Model/property release required. Captions required.

Making Contact: Query with samples and list of stock photo subjects. SASE. Reports in 1 month. Market tips sheet distributed 4 times/year to contracted photographers.

Tips: "Please call first. We will then send a basic information package. If terms are agreeable between the two parties then original images can be submitted pre-paid." Sees trend toward more photo requests for families, women in business, the environment and waste management. Active vibrant seniors. High-tech and computer-generated or manipulated images, minorities (Asians mostly).

MAJOR LEAGUE BASEBALL PHOTOS, 350 Park Ave., New York NY 10022. (212)339-8290. Fax: (212)750-3345. E-mail: rpilling@mlbp.com. Manager: Rich Pilling. Estab. 1994. Stock photo agency. Has 500,000 photos. Clients include: ad agencies, public relations firms, businesses, book/encyclopedia publishers, magazine publishers, newspapers, calendar companies, greeting card companies, postcard publishers and MLB licensees.

Needs: Photos of any subject for major league baseball—action, feature, fans, stadiums, umpires, still life.

Specs: Uses 8 × 10 glossy color prints; 35mm, 2¼ × 2¼ transparencies; CD-ROM digital format.

Payment & Terms: Buys photos outright; payment varies according to assignment. Pays 60% commission on color photos. Enforces minimum prices. Offers volume discounts to customers; inquire about specific terms. Discount sales terms not negotiable. Works on contract basis only. Offers exclusive contract only. Statements issued monthly. Payment made monthly. Photographers allowed to review account records. Offers one-time rights. Informs photographer and allows him to negotiate when client requests all rights. Captions preferred.

Making Contact: Interested in receiving work from newer, lesser-known photographers. Arrange personal interview to show portfolio. Works with local freelancers on assignment only. Samples kept on file. SASE. No minimum number of images expected with initial submission. Reports in 1-2 weeks. Photo guidlines available.

✤MASTERFILE, 175 Bloor St. E., South Tower, 2nd Floor, Toronto, Ontario M4W 3R8 Canada. (416)929-3000. Fax: (416)929-2104. E-mail: inquiries@masterfile.com. Website: http://www.masterfile.com. Artist Liaison: Linda Crawford. Stock photo agency. Has 250,000 photos. Clients include: advertising agencies, public relations firms, audiovisual firms, book/encyclopedia publishers, magazine publishers,

newspapers, postcard publishers, calendar companies, greeting card companies, all media.

● This agency has "complete electronic imaging capabilities," including scanning, manipulation and color separations. Masterfile is also researching CD-ROM technology as a storage and cataloging medium.

Specs: Uses 35mm, 2¼ × 2¼, 4 × 5, 8 × 10 transparencies.

Payment & Terms: Pays 40-50% commission. Enforces minimum prices. Offers volume discounts to customers; terms specified in photographer's contract. Discount sales terms not negotiable. Works on contract basis only. Offers exclusive contract only. Contracts renew automatically with additional submissions for 1 year. Charges duping and catalog insertion fees. Statements issued monthly. Payments made monthly. Photographers allowed to review account records. Informs photographer of price being negotiated; photographer given right to refuse sale. Offers one-time and electronic media rights and allows him to negotiate when client requests all rights. Model release required. Property release preferred. Captions required.

Making Contact: Ask for submission guidelines. Keeps samples on file. SASE. Expects maximum initial submission of 200 images. Reports in 1-2 weeks on portfolios; same day on queries. Photo guidelines free with SASE. Catalog $20. Market tips sheet distributed to contract photographers only.

■**MICHELE MATTEI PRODUCTIONS**, (formerly Mega Productions, Inc.), 1714 N. Wilton Place, Los Angeles CA 90028. (213)462-6342. Fax: (213)462-7572. Director: Michele Mattei. Estab. 1974. Stock photo agency and news/feature syndicate. Has "several thousand" photos. Clients include: book/encyclopedia publishers, magazine publishers, television, film.

Needs: Needs television, film, studio, celebrity, paparazzi, feature stories (sports, national and international interest events, current news stories). Written information to accompany stories needed. "We do not wish to see fashion and greeting card-type scenics."

Specs: Uses 35mm, 2¼ × 2¼ transparencies.

Payment & Terms: Pays 50% commission on color photos. General price range (to clients): $100-20,000; 50% commission of sale. Offers one-time rights. Model release preferred. Captions required.

Making Contact: Query with résumé of credits. Query with samples. Query with list of stock photo subjects. Works with local freelancers. Occasionally assigns work.

Tips: "Studio shots of celebrities, and home/family stories are frequently requested." In samples, looking for "marketability, high quality, recognizable personalities and current newsmaking material. Also, looks for paparazzi celebrities at local and national events. We deal mostly in Hollywood entertainment stories. We are interested mostly in celebrity photography and current events. Written material on personality or event helps us to distribute material faster and more efficiently."

MEDICAL IMAGES INC., 44B Sharon Rd., P.O. Box 141, Lakeville CT 06039. (860)435-8878. Fax: (860)435-8890. E-mail: medimag@aol.com. President: Anne Richardson. Estab. 1990. Stock photo agency. Has 50,000 photos. Clients include: advertising agencies, public relations firms, corporate accounts, book/encyclopedia publishers, magazine publishers and newspapers.

Needs: Medical and health-related material, including commercial-looking photography of generic doctor's office scenes, hospital scenarios and still life shots. Also, technical close-ups of surgical procedures, diseases, high-tech colorized diagnostic imaging, microphotography, nutrition, exercise and preventive medicine.

Specs: Uses 8 × 10 glossy b&w prints; 35mm, 2¼ × 2¼, 4 × 5 and 8 × 10 transparencies.

Payment & Terms: Pays 50% commission on b&w and color photos. Average price per image (to clients): $175-3,500. Enforces minimum prices. Works with or without contract. Offers nonexclusive contract. Contracts renew automatically. Statements and checks issued bimonthly. "If client pays within same period, photographer gets check right away; otherwise, in next payment period." Photographer's accountant may review records with prior appointment. Offers one-time and electronic media rights. Model/property release preferred. Captions required; include medical procedures, diagnosis when applicable, whether model released or not, etc.

Making Contact: Interested in receiving work from newer, lesser-known photographers. Query with list of stock photo subjects or telephone with list of subject matter. SASE. Reports in 2 weeks. Photo guidelines available. Market tips sheet distributed quarterly to contracted photographers.

Tips: Looks for "quality of photograph—focus, exposure, composition, interesting angles; scientific value; and subject matter being right for our markets." Sees trend toward "more emphasis on editorial or realistic

❦ **CANADIAN LISTINGS** are marked with a maple leaf.

looking medical situations. Anything too 'canned' is much less marketable."

■**MEDICHROME**, 232 Madison Ave., New York NY 10016. Manager: Ivan Kaminoff. Has 1 million photos. Clients include: advertising agencies, design houses, publishing houses, magazines, newspapers, in-house design departments, and pharmaceutical companies.
Needs: Everything that is considered medical or health-care related, from the very specific to the very general. "Our needs include doctor/patient relationships, surgery and diagnostics processes such as CAT scans and MRIs, physical therapy, home health care, micrography, diseases and disorders, organ transplants, counseling services, use of computers by medical personnel and everything in between."
Specs: "We accept b&w prints but prefer color, 35mm, 2¼×2¼, 4×5 and 8×10 transparencies."
Payment & Terms: Pays 50% commission on b&w and color photos. All brochures are based on size and print run. Ads are based on exposure and length of campaign. Offers one-time or first rights; all rights are rarely needed—very costly. Model release preferred. Captions required.
Making Contact: Query by "letter or phone call explaining how many photos you have and their subject matter." SASE. Reports in 2 weeks. Distributes tips sheet every 6 months to Medichrome photographers only.
Tips: Prefers to see "loose prints and slides in 20-up sheets. All printed samples welcome; no carousel, please. Lots of need for medical stock. Very specialized and unusual area of emphasis, very costly/difficult to shoot, therefore buyers are using more stock."

❀**MEGAPRESS IMAGES**, 5352 St. Laurent Blvd., Montreal, Quebec H2T 1S5 Canada. (514)279-9859. Fax: (514)279-1971. Estab. 1992. Stock photo agency. Half million photos. Has 2 branch offices. Clients include: book/encyclopedia publishers, magazine publishers, postcard publishers, calendar companies, greeting card companies.
Needs: Photos of people (couples, children, beauty, teenagers, people at work, medical); animals including puppies in studio; industries; celebrities and general stock.
Specs: Uses 35mm, 2¼×2¼, 4×5 transparencies.
Payment & Terms: Pays 50-60% commission on color photos. General price range (to client): $60-500/image. Enforces minimum prices. Will not negotiate below $60. Works with or without a signed contract. Offers limited regional exclusivity. Statements issued semiannually. Payments made semiannually. Offers one-time rights. Model release required for people and controversial news. Captions required. Each slide must have the name of the photographer and the subject.
Making Contact: Submit portfolio for review. Query with stock photo list. Samples not kept on file. SASE. Expects minimum initial submission of 250 images with periodic submission of at least 500 pictures per year. Photo guidelines free with SASE. Market tips sheet distributed semiannually to all photographers; free with SASE.
Tips: "Pictures must be very sharp. Work must be consistent. We also like photographers who are specialized in particular subjects."

MIDWESTOCK, 1925 Central, Suite 200, Kansas City MO 64108. (816)474-0229. Fax: (816)474-2229. E-mail: photogs@midwestock.com. Website: http://www.midwestock.com. Director: Susan L. Anderson. Estab. 1991. Stock photo agency. Has 100,000 photos. Clients include: advertising agencies, public relations firms, businesses, book/encyclopedia publishers, magazine publishers, newspapers, postcard publishers, calendar companies, greeting card companies.
● Midwestock currently uses CD-ROM discs to showcase categories of work and to provide economical scans for certain projects at standard stock prices. They do not distribute photo clip discs but are developing an online portfolio of selective photographers.
Needs: "We need more quality people shots depicting ethnic diversity." Also general interest with distinct emphasis on "Heartland" themes.
Specs: "Clean, stylized business and lifestyle themes are biggest sellers in 35mm and medium formats. In scenics, our clientele prefers medium and large formats." Uses 35mm, 4×5, 6×6, 6×7, 8×10 transparencies. Accepts images in digital format for Mac and Windows. Send via compact disc.
Payment & Terms: Pays 50% commission. Average price per image (to clients): $300/color. Enforces minimum prices of $195, except in cases of reuse or volume purchase. Offers volume discounts to customers; inquire about specific terms. Works on contract basis only. "We negotiate with photographers on an individual basis." Prefers exclusivity. Contracts renew automatically after 2 years and annually thereafter, unless notified in writing. Charges 50% duping and catalog insertion fees and mounting fee. Statements issued monthly. Payment made monthly. Model release required. Offers one-time and electronic media rights; negotiable. Property release preferred. Captions required.
Making Contact: Interested in receiving work from newer, lesser-known photographers. Query with stock photo list. Request submittal information first. Expects minimum initial submission of 1,000 in 35mm

format (less if larger formats). Reports in 3 weeks. Photo guidelines free with SASE. Market tips sheet distributed quarterly to photographers on contract.

Tips: "We prefer photographers who can offer a large selection of medium and large formats and who are full-time professional photographers who already understand the value of upholding stock prices and trends in marketing and shooting stock."

MODEL IMAGE RESOURCES, P.O. Box 21506, Lehigh Valley PA 18002. Phone/fax: (610)559-0968. Director: Richard Raisner. Estab. 1995. Specialized subject agency. Has 10,000 photos. Clients include: ad agencies, book/encyclopedia publishers, magazine publishers, calendar companies, greeting card companies, postcard publishers and international magazine publishers.

Needs: "All aspects of erotica, glamour and nudes, including abstract, couples, creative, explicit, mood and sets; photos covering desirable women of all ethnic groups for the mens' publishing industry."

Specs: Uses 8×10 semigloss b&w prints; 35mm, medium formats, 8×10 transparencies.

Payment & Terms Pays 50% commission. Enforces minimum prices. Works on contract basis only. Contracts renew automatically with additional submissions for 3 years. Charges 50% duping fee; 50% catalog insertion fee. Statements issued quarterly. Payment made quarterly. Photographers allowed to review account records. Offers one-time rights; negotiates all other types of rights except exclusive rights. Will "negotiate as intermediary for photographer when client requests all rights, but this is not a preferred option." Model release required; property release preferred. "Due to the nature of the photos we need, additional forms of identification with the release is highly desirable." Captions preferred.

Making Contact: Interested in receiving work from newer, lesser-known photographers. Query with samples. Samples kept on file. SASE. Expects minimum initial submission of 100-160 images with periodic submission of at least 1,000 images annually (bimonthly). Reports in 1-2 weeks. Photo guidelines free with SASE. Market tips sheet distributed quarterly to contracted photographers; "normally sent with statements or returned photographs."

Tips: "Seek out an agency that parallels your picture interests and strengths. We need more highly creative and conceptual material along with ethnic layouts and shots which are 'cover quality' and studio made. Exhibit professionalism: follow the tips sheets provided by the agent, use attractive models, master your lighting, provide interesting and varied backgrounds, pay attention to details and shoot, again and again and again. . . ."

MONKMEYER, 118 E. 28th St., New York NY 10016. (212)689-2242. Fax: (212)779-2549. Owner: Sheila Sheridan. Estab. 1930s. Has 500,000-800,000 photos. Clients include: book/encyclopedia publishers.

Needs: General human interest and educational images with a realistic appearance.

Specs: Uses 8×10 matte b&w prints; 35mm transparencies.

Payment & Terms: Pays 50% commission on b&w and color photos. Average price per image (to clients): $140/b&w, $185/color. "We hold to standard rates." Offers volume discounts to customers; terms specified in photographer's contract. Discount sales terms not negotiable. Offers nonexclusive contract. "We have very few contracts—negotiable." Statements issued monthly. Payment made monthly. Photographers allowed to review account records. Buys one-time rights. Informs photographer and allows him to negotiate when client requests all rights. Model/property release preferred. Captions preferred.

Making Contact: Arrange personal interview to show portfolio. Submit portfolio for review. Keeps samples on file. SASE. Expects minimum initial submission of 200 images. Reports in 1-2 weeks. Publishes tip sheet.

Tips: "Dealing with publishers, we need specific images that will make an impact on students."

MOTION PICTURE AND TV PHOTO ARCHIVE, 16735 Saticoy St., Van Nuys CA 91406. (818)997-8292. Fax: (818)997-3998. President: Ron Avery. Estab. 1988. Stock photo agency. Has 500,000 photos. Clients include: advertising agencies, book/encyclopedia publishers, magazine publishers, newspapers, postcard publishers, calendar companies, greeting card companies.

Needs: Color shots of current stars and old TV and movie stills.

Specs: Uses 8×10 b&w/color prints; 35mm, $2\frac{1}{4} \times 2\frac{1}{4}$, 4×5 and 8×10 transparencies.

Payment & Terms: Buys photos/film outright. Pays 50% commission on b&w and color photos. Average price per image (to clients): $180-1,000/b&w image; $180-1,500/color image. Enforces minimum prices. Offers volume discounts to customers; terms specified in photographer's contract. Works on contract basis only. Offers exclusive contract. Contracts renew automatically with additional submissions. Statements issued monthly. Payment made monthly. Photographers allowed to review account records. Rights negotiable; "whatever fits the job."

Making Contact: Reports in 1-2 weeks.

■MOUNTAIN STOCK PHOTO & FILM, P.O. Box 1910, Tahoe City CA 96145. (916)583-6646. Fax: (916)583-5935. Contact: Paul Vatistas or Meg de Vire. Estab. 1986. Stock photo agency. Member of

Picture Agency Council of America (PACA). Has 60,000 photos; minimal films/videos. Clients include: ad agencies, public relations firms, audiovisual firms, businesses, book/encyclopedia publishers, magazine publishers, newspapers, calendar companies, greeting card companies.

Needs: "We specialize in and always need action sports, scenic and lifestyle images."

Specs: Uses 35mm, 2¼×2¼, 4×5, transparencies.

Payment & Terms: Pays 50% commission on color photos. Enforces minimum prices. "We have a $100 minimum fee." Offers volume discounts to customers; inquire about specific terms. Discount sales terms not negotiable. Works on contract basis only. Some contracts renew automatically. Charges 50% catalog insertion fee. Statements issued quarterly. Payment made quarterly. Photographers are allowed to review account records with due notice. Offers unlimited and limited exclusive rights. Informs photographer and allows him to negotiate when client requests all rights. Model/property release required. Captions required.

Making Contact: Query with résumé of credits. Query with samples. Query with stock photo list. Samples kept on file. SASE. Expects minimum initial submission of 500 images. Reports in 1 month. Photo guidelines free with SAE and 58¢ postage. Market tips sheet distributed quarterly to contracted photographers upon request.

Tips: "I see the need for images, whether action or just scenic, that evoke a feeling or emotion."

■*NATURAL SCIENCE PHOTOS**, 33 Woodland Dr., Watford, Hertfordshire WD1 3BY England. 01923-245265. Fax: 01923-246067. Partners: Peter and Sondra Ward. Estab. 1969. Stock photo agency and picture library. Members of British Association of Picture Libraries and Agencies. Has 175,000 photos. Clients include: ad agencies, public relations firms, audiovisual firms, businesses, book/encyclopedia publishers, magazine publishers, newspapers, postcard companies, calendar companies, greeting card companies and television.

Needs: Natural science of all types, including wildlife (terrestrial and aquatic), habitats (including destruction and reclamation), botany (including horticulture, agriculture, pests, diseases, treatments and effects), ecology, pollution, geology, primitive peoples, astronomy, scenics (mostly without artifacts), climate and effects (e.g., hurricane damage), creatures of economic importance (e.g., disease carriers and domestic animals and fowl). "We need all areas of natural history, habitat and environment from South and Central America, also high quality marine organisms."

Specs: Uses 35mm, 2¼×2¼ original color transparencies.

Payment & Terms: Pays 33-50% commission. General price range: $55-1,400. "We have minimum fees for small numbers, but negotiate bulk deals sometimes involving up to 200 photos at a time." Works on contract basis only. Offers nonexclusive contract. Statements issued semiannually. Payment made semiannually. "We are a private company; as such our books are for tax authorities only." Offers one-time and electronic media rights; exclusive rights on calendars. Informs photographers and permits them to negotiate when a client requests all rights. Copyright not sold without written permission. Captions required include English and scientific names, location and photographer's name.

Making Contact: Interested in receiving work from newer, lesser-known photographers. Arrange a personal interview to show a portfolio. Submit portfolio for review. Query with samples. Send unsolicited photos by mail for consideration. "We require a sample of at least 20 transparencies together with an indication of how many are on offer, also likely size and frequency of subsequent submissions." Samples kept on file. SASE. Reports in 1-4 weeks, according to pressure on time.

Tips: "We look for all kinds of living organisms, accurately identified and documented, also habitats, environment, weather and effects, primitive peoples, horticulture, agriculture, pests, diseases, etc. Animals, birds, etc., showing action or behavior particularly welcome. We are not looking for 'arty' presentation, just straightforward graphic images, only exceptions being 'moody' scenics. There has been a marked increase in demand for really good images with good color and fine grain with good lighting. Pictures that would have sold a few years ago that were a little 'soft' or grainy are now rejected, particularly where advertising clients are concerned."

NATURAL SELECTION STOCK PHOTOGRAPHY INC., 183 St. Paul St., Rochester NY 14604. (716)232-1502. Fax: (716)232-6325. E-mail: nssp@netacc.net. Manager: Deborah A. Free. Estab. 1987. Stock photo agency. Member of the Picture Agency Council of America (PACA). Has over 350,000 photos.

 INTERNATIONAL MARKETS, those located outside of the United States and Canada, are marked with an asterisk.

Clients include: advertising agencies, public relations firms, businesses, book/encyclopedia publishers, magazine publishers, newspapers, postcard publishers, calendar companies, greeting card companies.

Needs: Interested in photos of nature in all its diversity.

Specs: All formats.

Payment & Terms: Pays 50% commission on color photos. Works on contract basis only. Offers nonexclusive contracts. Contracts renew automatically with additional submissions for 3 years. Charges 50% duping fee. Statements issued quarterly. Payment made monthly on fees collected. Offers one-time rights. "Informs photographer when client requests all rights." Model/property release required. Captions required; include photographer's name, where image was taken and specific information as to what is in the picture.

Making Contact: Query with résumé of credits; include types of images on file, number of images, etc. SASE. Expects minimum initial submission of 200 images, with periodic submission of at least 200 images. Reports in 1 month. Photo guidelines free with SASE. Market tips sheet distributed quarterly to all photographers under contract.

Tips: "All images must be completely captioned, properly sleeved, and of the utmost quality."

NAWROCKI STOCK PHOTO, P.O. Box 16565, Chicago IL 60616. (312)427-8625. Fax: (312)427-0178. Director: William S. Nawrocki. Stock photo agency, picture library. Member of Picture Agency Council of America (PACA). Has over 300,000 photos and 500,000 historical photos. Clients include: ad agencies, public relations firms, editorial, businesses, book/encyclopedia publishers, magazine publishers, newspapers, postcard companies, calendar companies and greeting card companies.

Needs: Model-released people, all age groups, all types of activities; families; couples; relationships; updated travel, domestic and international; food.

Specs: Uses 35mm, 2¼×2¼, 2¼×2¾, 4×5 and 8×10 transparencies. "We look for good composition, exposure and subject matter; good color." Also, finds large format work "in great demand." Medium format and professional photographers preferred.

Payment & Terms: Buys only historical photos outright. Pays variable percentage on commission according to use/press run. Commission depends on agent—foreign or domestic 50%/40%/35%. Works on contract basis only. Contracts renew automatically with additional submissions for 5 years. Offers limited regional exclusivity and nonexclusivity. Charges duping and catalog insertion fees. Statements issued quarterly. Payment made quarterly. Offers one-time media and some electronic rights; other rights negotiable. Requests agency promotion rights. Informs photographer when client requests all rights. Model release required. Captions required. Mounted images required.

Making Contact: Interested in receiving work from newer, lesser-known photographers. Arrange a personal interview to show portfolio. Query with résumé of credits, samples and list of stock photo subjects. Submit portfolio for review. Provide return Federal Express. SASE. Reports ASAP. Allow 2 weeks for review. Photo guidelines free with SASE. Tips sheet distributed "to our photographers." Suggest that you call first—discuss your photography with the agency, your goals, etc. "NSP prefers to help photographers develop their skills. We tend to give direction and offer advice to our photographers. We don't take photographers on just for their images. NSP prefers to treat photographers as individuals and likes to work with them." Label and caption images. Has network with domestic and international agencies.

Tips: "A stock agency uses just about everything. We are using more people images, all types—family, couples, relationships, leisure, the over-40 group. Looking for large format—variety and quality. More images are being custom shot for stock with model releases. Model releases are very, very important—a key to a photographer's success and income. Model releases are the most requested for ads/brochures."

NETWORK ASPEN, 319 Studio N, Aspen Business Center, Aspen CO 81611. (970)925-5574. Fax: (970)925-5680. E-mail: images@networkaspen.com. Founder/Owner: Jeffrey Aaronson. Studio Manager: Becky Green. Photojournalism and stock photography agency. Has 250,000 photos. Clients include: advertising agencies, public relations, businesses, book/encyclopedia publishers, magazine publishers, newspapers, calendar companies.

Needs: Reportage, world events, travel, cultures, business, the environment, sports, people, industry.

Specs: Uses 35mm transparencies.

Payment & Terms: Pays 50% commission on color photos. Works on contract basis only. Offers nonexclusive and guaranteed subject exclusivity contracts. Statements issued quarterly. Payments made quarterly. Photographers allowed to review account records. Offers one-time and electronic media rights. Model/property release preferred. Captions required.

Making Contact: Query with résumé of credits. Query with samples. Query with stock photo list. Keeps samples on file. SASE. Expects minimum initial submission of 250 duplicates. Reports in 3 weeks.

Tips: "Our agency focuses on world events, travel and international cultures, but we would also be interested in reviewing other subjects as long as the quality is excellent."

NEW ENGLAND STOCK PHOTO, 2389 Main St., Dept. PM, Glastenbury CT 06033. (860)659-3737. Fax: (860)659-3235. President: Rich James. Estab. 1985. A full service agency with emphasis toward serving advertising, corporate, editorial and design companies. Member of the Picture Agency Council of America (PACA). Stock photo agency.

• New England Stock Photo participated in: Stock Workbook Print Catalogues (10 & 11); Stock Workbook CD-ROM's (5, 6 and specialty disks); Blackbook CD-ROM's (3 & 4); and is producing catalogue 4 and CD-ROM.

Needs: "We are a general interest agency with a growing variety of clients and subjects. Always looking for great people shots—(especially multicultural, business, children, teenagers, couples, families, middle age and senior citizens) engaged in every day life situations (business, home, travel, recreation, outdoor activities and depicting ethnicity). Other needs include U.S. and international coverage, ideas/concepts occupations in both business and industry, sports and recreation, architecture (cities and towns), transportation, nature (animals and wildlife) birds, waterfowl, technology, energy and communications. We get many requests for particular historical sites, annual events and need more coverage of towns/cities, main streets and tourist spots."

Specs: Uses 35mm, $2\frac{1}{4} \times 2\frac{1}{4}$, 4×5 transparencies.

Payment & Terms: Pays 50% commission; 75% to photographer on assignments obtained by agency. Average price per image (to client): $100-5,000. Works with photographers on contract basis only. Offers nonexclusive contract. Charges catalog insertion fee. Statements issued monthly. Payments made monthly. Photographers allowed to review account records to verify sales figures. Offers one-time rights; postcard, calendar and greeting card rights. Informs photographer and allows him to negotiate when client requests all rights. Model/property release preferred (people and private property). Captions required; include who, what, where.

Making Contact: Query with list of stock photo subjects or send unsolicited photos by mail for consideration with check or money order for $9.95 to cover return postage. Reports as soon as possible. Distributes newsletter and tips sheet regularly. "We provide one of the most comprehensive photo guideline packages in the business. Please write for it, including $4.95 for shipping and handling."

Tips: "There is an increased use of stock. Submissions must be high quality, in sharpest focus, perfectly composed and with strongest composition. Whether you are a picture buyer or photographer, we will provide the personalized service you need to succeed."

■**NEWS FLASH INTERNATIONAL, INC.**, Division of Observer Newspapers, P.O. Box 407, Bellmore NY 11710. (516)679-9888. Fax: (516)731-0338. Editor: Jackson B. Pokress. Has 25,000 photos. Clients include: ad agencies, public relations firms, businesses and newspapers.

Needs: "We handle news photos of all major league sports: football, baseball, basketball, boxing, wrestling, hockey. We are now handling women's sports in all phases, including women in boxing, basketball, softball, etc." Some college and junior college sports. Wants emphasis on individual players with dramatic impact. "We are now covering the Washington DC scene. There is currently an interest in political news photos."

Specs: Super 8 and 16mm documentary and educational film on sports, business and news; 8×10 glossy b&w prints or contact sheet; transparencies.

Payment & Terms: Pays 40-50% commission/photo and film. Pays $5 minimum/photo. Works with or without contract. Offers nonexclusive contracts. Informs photographer and allows him to negotiate when client requests all rights. Statements issued quarterly. Payment made monthly or quarterly. Photographers allowed to review account records. Offers one-time, agency promotion or first rights. Informs photographer and allows him to negotiate when client requests all rights. Model release required. Captions required.

Making Contact: Interested in receiving work from newer, lesser-known photographers. Query with samples. Send material by mail for consideration or make a personal visit if in the area. SASE. Reports in 1 month. Free photo guidelines and tips sheet on request.

Tips: "Exert constant efforts to make good photos—what newspapers call grabbers. Make them different than other photos, look for new ideas. There is more use of color and large format chromes." Special emphasis on major league sports. "We cover Mets, Yankees, Jets, Giants, Islanders on daily basis. Rangers and Knicks on weekly basis. We handle bios and profiles on athletes in all sports. There is an interest in women athletes in all sports."

NONSTOCK, 5 W. 19th St., 6th Floor, New York NY 10011. (212)633-2388. Fax: (212)989-9079. E-mail: nonstock1@aol.com. Vice President: Jerry Tavin. Stock photo agency. Clients include: advertising agencies, public relations firms, audiovisual firms, businesses, book/encyclopedia publishers, magazine publishers, newspapers, postcard publishers, calendar companies, greeting card companies.

Needs: Interested in images that are commercially applicable.

Specs: Uses 35mm transparencies.

Payment & Terms: Pays 50% commission. All fees are negotiated, balancing the value of the image

with the budget of the client. Offers volume discounts to customers; inquire about specific terms. Photographers can choose not to sell images on discount terms. Works on contract basis only. Offers nonexclusive contracts. Statements issued quarterly. Payment made quarterly. Photographers allowed to review account records. Offers all rights, "but we negotiate." Model/property release required. Captions preferred; include industry standards.

Making Contact: Interested in receiving work from newer, lesser-known photographers. Submit portfolio for review. Keeps samples on file. SASE. Expects minimum initial submission of 50 images. Reports in 1-2 weeks. Photo guidelines free with SASE. Catalog free with SASE.

***OKAPIA K.G.**, Michael Grzimek & Co., D-60 385 Frankfurt/Main, Roderbergweg 168 Germany 01149/ 69/449041. Fax: 001149/69/498449; or Constanze Presse-haus, Kurfürstenstr. 72 -74 D-10787 Berlin Germany. 01149/30/26400180. Fax: 01149/30/26400182; or Bilder Pur Kaiserplatz 8 D-80803 München Germany. 01149/89/339070. Fax: 01149/89/366435. Website: http://www.okapia.com. President: Grzimek. Stock photo agency and picture library. Has 700,000 photos. Clients include: ad agencies, book/encyclopedia publishers, magazine publishers, newspapers, postcard companies, calendar companies, greeting card companies and school book publishers.

Needs: Natural history, medical, science and technology, and general interest.

Specs: Uses 35mm, $2\frac{1}{4} \times 2\frac{1}{4}$, 4×5 and 8×10 transparencies.

Payment & Terms: Pays 50% commission on b&w and color photos. Works on contract basis only. Offers nonexclusive and guaranteed subject exclusivity (within files). Contracts renew automatically for 5 years with additional submissions. Charges catalog insertion fee. Statements issued quarterly, semi-annually or annually, depending on money photographers earn. Payment made quarterly, semi-annually or annually with statement. Photographers allowed to review account records in the case of disagreements. Offers onetime, electronic media rights (if requested). Does not permit photographer to negotiate when client requests all rights. Model release required. Captions required.

Making Contact: Interested in receiving work from newer, lesser-known photographers. Send unsolicited material by mail for consideration. SASE. Expects minimum initial submission of 300 slides. Distributes tips sheets on request.

Tips: "We need every theme which can be photographed." For best results, "send pictures continuously." Work must be of "high standard quality."

‡■OMEGA NEWS GROUP/USA, P.O. Box 309, Lehighton PA 18235-0309. (610)377-6420. Managing Editor: Marta Rubel. Stock photo agency and news/feature syndicate. Clients include: newspapers and magazines, book/encyclopedia publishers, audiovisual producers, paper product companies (calendars, postcards, greeting cards).

Needs: News, sports, features, personalities/celebrities, human interest, conflicts/wars. Wants material from Eastern Europe, primarily from Ukraine.

Specs: Prefers transparencies, however, all formats accepted. For film/tape, send VHS for review. Captions required. Model release, if available, should be submitted with photos.

Payment & Terms: Pays 60% commission on color and 50% on b&w. General price range: $75 and up, depending on usage. Offers first North American serial rights; other rights can be procured on negotiated fees.

Making Contact: Interested in receiving work from newer, lesser known photographers. "Submit material for consideration, preferably transparencies we can keep on file, by mail." Submissions should be made on a trial and error basis. Include return postage for material submitted if you want it returned. Provide résumé, business card, brochure, flier or tearsheet to be kept on file for possible future assignments. Photo guidelines not available. Tip sheets sometimes distributed to photographers on file.

Tips: Looking for quality and content, color saturation, clarity and good description. Comprehensive story material welcomed. "We will look at anything if the quality is good. Think vertical for covers."

‡■OMNI-PHOTO COMMUNICATIONS, 10 E. 23rd St., New York NY 10010. (212)995-0805. Fax: (212)995-0895. E-mail: rguerette@aol.com. President: Roberta Guerette. Estab. 1979. Stock photo agency. Has 100,000 photos. Clients include: advertising agencies, public relations firms, audiovisual firms, businesses, book/encyclopedia publishers, magazine publishers, postcard publishers, calendar companies, greeting card companies.

Needs: Travel, multicultural and people.

Specs: Uses 8×10 b&w prints; 35mm, $2\frac{1}{4} \times 2\frac{1}{4}$, 4×5, 8×10 transparencies.

Payment & Terms: Pays 50% commission on b&w and color photos. Works on contract basis only. Offers limited regional exclusive contracts. Contracts renew automatically with additional submissions for 4 years. Charges catalog insertion fee. Statements issued with payment on a quarterly basis. Offers onetime rights. Informs photographer and allows him to negotiate when client requests all rights. Model/ property release required. Captions required.

Making Contact: Interested in receiving work from newer, lesser-known photographers. Query with résumé of credits. Query with samples. SASE. Expects minimum initial submission of 200-300 images. Photo guidelines free with SASE.

Tips: "Spontaneous-looking, yet professional quality photos of people interacting with each other. Carefully thought out backgrounds, props and composition, commanding use of color. Stock photographers must produce high quality work at an abundant rate. Self-assignment is very important, as is a willingness to obtain model releases, caption thoroughly and make submissions regularly."

■**OUTLINE**, Dept. PM, 596 Broadway, 11th Floor, New York NY 10012. (212)226-8790. President: Jim Roehrig. Personality/portrait stock photo agency. Has 250,000 photos. Clients include: advertising agencies, public relations firms, magazine publishers, newspapers and production/film companies.

Needs: Heavy emphasis on personalities, film, TV, political feature stories.

Payment & Terms: General price range: negotiable. Rights negotiable. Model release preferred. Captions required.

Making Contact: Query with résumé of credits. Works with local freelancers by assignment only. Cannot return material. Reports in 3 weeks.

Tips: Prefers a photographer who can create situations out of nothing. "The market seems to have a non-ending need for celebrities and the highest-quality material will always be in demand."

■*****OXFORD SCIENTIFIC FILMS**, Lower Road, Long Hanborough, Oxfordshire OX8 8LL England. +44 (993)881881. Fax: +44 (993)882808. E-mail: 101573.163@compuserve.com. Senior Account Manager/Photo Library: Suzanne Aitzetmuller. Senior Account Manager/Film and Photo Libraries: Sandra Berry. Stock Footage Library Manager: Jane Mulleneux. Film unit and stills and film libraries. Has 350,000 photos; over one million feet of stock footage on 16mm, and 40,000 feet on 35mm. Clients include: ad agencies, design companies, audiovisual firms, book/encyclopedia publishers, magazine and newspaper publishers, merchandising companies, multimedia publishers, film production companies.

Needs: Natural history: animals, plants, behavior, close-ups, life-histories, histology, embryology, electron microscopy, scenics, geology, weather, conservation, country practices, ecological techniques, pollution, special-effects, high speed, time-lapse.

Specs: Uses 35mm and larger transparencies; 16 and 35mm film and videotapes.

Payment & Terms: Pays 40-50% commission on b&w and color photos. Enforces minimum prices. Offers volume discounts to regular customers; inquire about specific terms. Discount sale terms not negotiable. Works on contract basis only; prefers exclusivity, but negotiable by territory. Contracts renew automatically with additional submissions. "All contracts reviewed after two years initially, either party may then terminate contract, giving three months notice in writing." Statements issued quarterly. Payment made quarterly. Photographers permitted to review sales figures. Offers one-time rights and electronic media rights. Informs photographer and allows him to negotiate when client requests all rights. Photo captions required, Captions required; include common name, Latin name, behavior, location and country, magnification where appropriate.

Making Contact: Interested in receiving high quality, creative, inspiring work from both amateur and professional photographers. Enquire for stock photo list plus photographers pack. SASE. Reports in 1 month. Distributes want lists every 6 months to all photographers.

Tips: Prefers to see "good focus, composition, exposure, rare or unusual natural history subjects and behavioral and action shots."

OZARK STOCK, 333 Park Central E., Suite 712, Springfield MO 65806. Phone/fax: (417)890-5600. E-mail: ozstock@dialus.com. Director: John S. Stewart. Estab. 1991. Stock photo agency. Has 45,000 photos. Clients include: advertising agencies, public relations firms, businesses, book/encyclopedia publishers, magazine publishers, newspapers, postcard publishers, calendar companies.

Needs: "People at work, at play, in the workplace, interacting with other people young and old and interacting with pets. Children/toddlers through teens interacting with others younger and older and racially mixed. Agriculture and farm and relaxed subjects. Health care and people doing 'healthy' things like exercise and eating and shopping for healthy foods. Also, images of the Ozarks showing the scenic beauty of this fast-growing area, travel destinations of the area and the people who live there."

Specs: Uses 35mm, 120mm, 4×5 color negatives or transparencies or b&w film.

Payment & Terms: Pays 50% commission on all usage fees. "Photographer retains all original negatives and chromes and is free to sell elsewhere. The photographer's name is attached to each image in our file. Each photographer is assigned an account number. The computer keeps track of the sales activity for that account number and checks are written monthly."

Making Contact: "You may submit photos any way possible. This includes original color transparencies or black and white and color negatives with contact sheets. Ozark Stock does not keep your originals. We do a scan of the images we want on file and use low resolution watermarked versions to market your

images. The original images are returned to you. Include SASE or postage or shipping account number for their return. Photographers may also submit photo CDs. Include postage for their return. Photos and CDs are returned within 2 weeks. If model or property releases are available, please indicate which photos apply. Copies of the release may be requested later."

Tips: "Include caption information. The more information, like where photo was taken, the better. Sales are sometimes lost because not enough specific information is known and there just is not time to call up the photographer."

■**PACIFIC STOCK**, 758 Kapahulu Ave., Suite 250, Honolulu HI 96816. (808)735-5665. Fax: (808)735-7801. E-mail: pics@pacstock.com. Website: http://pacstock.com. Owner/President: Barbara Brundage. Estab. 1987. Stock photo agency. Member of Picture Agency Council of America (PACA). Has 150,000 photos. Clients include advertising agencies, public relations firms, audiovisual firms, businesses, book/encyclopedia publishers, magazine publishers, postcard companies, calendar companies and greeting card companies. Previous/current clients: American Airlines, *Life* magazine (cover), Eveready Battery (TV commercial).

Needs: "Pacific Stock is the *only* stock photo agency worldwide specializing exclusively in Pacific- and Asia-related photography. Locations include North American West Coast, Hawaii, Pacific Islands, Australia, New Zealand, Far East, etc. Subjects include: people, travel, culture, sports, marine science and industrial."

Specs: Uses 35mm, $2\frac{1}{4} \times 2\frac{1}{4}$, 4×5 and 8×10 (all formats) transparencies.

Payment & Terms: Pays 50% commission on color photos. Works on contract basis only. Offers limited regional exclusivity. Charges catalog insertion rate of 50%/image. Statements issued monthly. Payment made monthly. Photographers allowed to review account records to verify sales figures. Offers one-time or first rights; additional rights with photographer's permission. Informs photographer and allows him to negotiate when client requests all rights. Model and property release required for all people and certain properties, i.e., homes and boats. Photo captions are required; include: "who, what, where."

Making Contact: Query with résumé of credits and list of stock photo subjects. SASE. Reports in 2 weeks. Photo guidelines free with SASE. Tips sheet distributed quarterly to represented photographers; free with SASE to interested photographers.

Tips: Looks for "highly edited shots preferably captioned in archival slide pages. Photographer must be able to supply minimum of 1,000 slides (must be model released) for initial entry and must make quarterly submissions of fresh material from Pacific and Asia area destinations and from areas outside Hawaii." Major trends to be aware of include: "increased requests for 'assignment style' photography so it will be resellable as stock. The two general areas (subjects) requested are: tourism usage and economic development. Looks for focus, composition and color. As the Asia/Pacific region expands, more people are choosing to travel to various Asia/Pacific destinations while greater development occurs, i.e., tourism, construction, banking, trade, etc. Be interested in working with our agency to supply what is on our want lists."

PAINET, 466 Loring Place, El Paso TX 79927. (915)852-4840. Fax: (915)852-3343. E-mail: photogs@painetworks.com. Website: http://www.painetworks.com. Owner: Mark Goebel. Estab. 1985. Picture library. Has 80,000 photos. Clients include: advertising agencies and magazine publishers.

Needs: "We publish catalogs to market our photos and market on the Internet. Our primary emphasis is on 'people' pictures. However, we would review animals and graphic scenics."

Specs: Uses 35mm transparencies, 35mm b&w negatives with contact sheet and 8×10 b&w prints. Accepts images in digital format for Mac (TIFF, JPEG). Send via compact disc, floppy disk or Jaz disk.

Payment & Terms: Pays 50-60% "depending on how much assistance photographers give in documenting image descriptions." Works with or without signed contract. Offers nonexclusive contract. Statements issued quarterly. Payment made monthly. Photographers allowed to review account records. Offers one-time rights. Informs photographer and allows him to negotiate when client requests all rights.

Making Contact: Interested in receiving work from newer, lesser-known photographers as well as established professionals. Query with samples. Samples not kept on file. SASE. Submit 20 of your best dupes in a 35mm slide preserver sheet. Include return postage. Reports in 1-2 weeks.

Tips: "Selected photographers can have their images placed on our Website in the gallery section. No original transparencies are kept by Painet, enabling photographers to market their images elsewhere. Painet markets color and b&w images electronically or by contact with the photographer. Because images and image descriptions are scanned and entered into a database from which searches are made, we encourage other photographers to include lengthy descriptions which improve their chances of finding their images during a database search."

PHOTO AGORA, Hidden Meadow Farm, Keezletown VA 22832. Phone/fax: (540)269-8283. E-mail: photoagora@aol.com. Contact: Robert Maust. Estab. 1972. Stock photo agency. Has 25,000 photos. Clients

include: businesses, book/encyclopedia and textbook publishers, magazine publishers and calendar companies.

Needs: Families, children, students, Virginia, Africa, work situations, etc.

Specs: Uses 8×10 matte and glossy b&w prints; 35mm, 2¼×2¼, 4×5 transparencies.

Payment & Terms: Pays 50% commission on b&w and color photos. Average price per image (to clients): $40-100/b&w photo; $125-250/color photo. Negotiates fees below standard minimum prices. Offers volume discounts to customers; inquire about specific terms. Photographers can choose not to sell images on discount terms. Works with or without a signed contract. Offers nonexclusive contract. Statements issued quarterly. Payment made quarterly. Photographer allowed to review account records. Offers one-time rights. Informs photographer and allows him to negotiate when client requests all rights. Model/property release preferred. Captions required; include location, important dates, names etc.

Making Contact: Interested in receiving work from newer, lesser-known photographers. Call. Samples not kept on file. SASE. No minimum number of images required in initial submission. Reports in 3 weeks. Photo guidelines free with SASE.

PHOTO ASSOCIATES NEWS SERVICE, 7010 Brookfield Plaza, #806, Springfield VA 22150. (703)451-9204. Fax: (703)451-0332. Bureau Manager: Peter Heimsath. Estab. 1970. News/feature syndicate. Has 15,000 photos. Clients include: public relations firms, book/encyclopedia publishers, magazine publishers, newspapers.

Needs: Needs feature and immediate news for worldwide distribution, also celebrities doing unusual things.

Specs: Uses 8×10 glossy or matte b&w or color prints; 35mm transparencies.

Payment & Terms: Pays $175-500/color photo; $125-250/b&w photo. Pays 50% commission on b&w and color photos. Average price per image (to clients): $150-750/b&w photo; $100-500/color photo. Negotiates fees at standard minimum prices depending on subject matter and need; reflects monies to be charged. Offers discounts to customers; terms specified in photographer's contract. Photographers can choose not to sell images on discount terms. Works on contract basis only. Offers nonexclusive contract. Statements issued monthly. Payment made "as we are paid. Photographers may review records to verify sales, but don't make a habit of it. Must be a written request." Offers one-time rights. Informs photographer and allows him to negotiate when client requests all rights. Photo Associates News Service will negotiate with client request of all rights purchase. Model/property release required. Captions required; include name of subject, when taken, where taken, competition and process instructions.

Making Contact: Interested in receiving work from newer, lesser-known photographers. Query with résumé of credits, samples or stock photo list. Samples kept on file. SASE. Expects minimum initial submission of 20 images with periodic submission of at least 50 images every two months. Reports in 1 month. Photo guidelines free with SASE. Market tips sheet distributed to those who make serious inquiries with SASE.

Tips: "Put yourself on the opposite side of the camera, to grasp what the composition has to say. Are you satisfied with your material before you submit it? More and more companies seem to take the short route to achieve their visual goals. They don't want to spend real money to obtain a new approach to a possible old idea. Too many times, photographs lose their creativity because the process isn't thought out correctly."

■*PHOTO INDEX, 2 Prowse St., West Perth 6005 Western Australia. (08)948-10375. Fax: (08)948-16547. Manager: Lyn Woldendorp. Estab. 1979. Stock photo agency. Has 100,000 photos. Clients include: advertising agencies, public relations firms, audiovisual firms, businesses, book/encyclopedia publishers, magazine publishers, postcard publishers, calendar companies.

Needs: Generic stock photos, especially lifestyle, sport and business with people.

Specs: Uses 35mm, 2¼×2¼, 4×5 transparencies.

Payment & Terms: Pays 50% commission on color photos. Offers volume discounts to customers. Works on exclusive contract basis only. Five-year contract renewed automatically. Statements issued quarterly. Payment made quarterly. Photographers permitted to review account records to verify sales figures or account for various deductions "within reason." Offers one-time rights. Informs photographer and allows him to negotiate when client requests all rights. Model/property release required. Captions required.

Making Contact: Interested in receiving work from professional stock photographers. Query with samples. Expects minimum initial submission of 1,000 images with periodic submission of at least several hundred quarterly. Reports in 1-2 weeks. Photo guidelines free with SASE. Catalog available. Market tips sheet distributed quarterly to contributing photographers.

 MARKETS NEW TO THIS EDITION are marked with a double dagger.

Tips: "A photographer working in the stock industry should treat it professionally. Observe what sells of his work in each agency, as one agency's market can be very different to another's. Take agencies' photo needs lists seriously. Treat it as a business."

***THE PHOTO LIBRARY** (Photographic Library of Australia, Ltd.), Level 1, No. 7 West St., North Sydney 2060 N.S.W. Australia. (02)9929-8511. Fax: (02)9923-2319. Editor: Lucette Moore. General photo library. Has over 500,000 photos. Clients include: advertising agencies, book/magazine publishers, government departments and corporate clients.
Needs: Good-quality, strong images.
Specs: Uses 35mm, 120 roll film and 4×5 transparencies.
Payment & Terms: Pays 50% commission for photos. Works on contract basis only. Offers exclusive contract and regional exclusivity in Australia and New Zealand. Contract continues until photographer wants to withdraw images. Charges filing fee and duping fees. Statements issued quarterly. Photographers allowed to verify sales figures once a year. Payment made quarterly; 10 days after end of quarter. Offers one-time and electronic media rights. Requires model release (held by photographer) and accurate photo captions.
Making Contact: Send submission of photos (including return postage) by mail for consideration to Lucette Moore. Guidelines free with SASE.
Tips: Notes "35mm does not sell as well as the medium and large formats but will accept 35mm if other formats are included."

■PHOTO NETWORK, Dept. PM, 1415 Warner Ave., Suite B, Tustin CA 92780. (714)259-1244. Fax: (714)259-0645. E-mail: photonetwork@worldnet.att.net. Website: http://worldnet.att.net. Owner: Cathy Aron. Stock photo agency. Member of Picture Agency Council of America (PACA). Has 500,000 photos. Clients include: ad agencies, AV producers, textbook companies, graphic artists, public relations firms, newspapers, corporations, magazines, calendar companies and greeting card companies.
Needs: Needs shots of personal sports and recreation, industrial/commercial, high-tech, families, couples, ethnics (all ages), animals, travel and lifestyles. Special subject needs include people over 55 enjoying life, medical shots (patients and professionals), children and domestic animals.
Specs: Uses 35mm, 2¼×2¼, 4×5 transparencies. Accepts images in digital format for Mac.
Payment & Terms: Pays 50% commission. Works on contract basis only. Offers limited regional exclusivity. Contracts automatically renew with each submission for 3 years. Statements issued monthly. Payment made monthly. Photographers allowed to review account records to verify sales figures. Offers one-time rights. Informs photographer and allows him to negotiate when client requests all rights. Model/property release preferred. Captions preferred; "include places—parks, cities, buildings, etc. No need to describe the obvious, i.e., mother with child."
Making Contact: Query with list of stock photo subjects. Send a sample of 200 images for review. SASE. Reports in 1 month.
Tips: Wants to see a portfolio "neat and well-organized and including a sampling of photographer's favorite photos." Looks for "clear, sharp focus, strong colors and good composition. We'd rather have many very good photos rather than one great piece of art. Would like to see photographers with a specialty or specialties and have it covered thoroughly. You need to supply new photos on a regular basis and be responsive to current trends in photo needs. Contract photographers are supplied with quarterly 'want' lists and information about current trends."

PHOTO RESEARCHERS, INC., 60 E. 56th St., New York NY 10022. (212)758-3420. Fax: (212)355-0731. E-mail: photorsch@aol.com. Stock photography agency representing over 1 million images specializing in science, wildlife, medicine, people and travel. Member of Picture Agency Council of American (PACA). Clients include: ad agencies, graphic designers, publishers of textbooks, encyclopedias, trade books, magazines, newspapers, calendars, greeting cards and annual reports in US and foreign markets.
 ● Photo Researchers has 10,000 images on CD-ROM categorized by subject with The Picture Exchange online service.
Needs: All aspects of natural history, science, astronomy, medicine, people (especially contemporary shots of teens, couples and seniors). Particularly needs model-released people, European wildlife, up-to-date travel and scientific subjects.
Specs: Any size transparencies.
Payment & Terms: Rarely buys outright; works on 50% stock sales and 30% assignments. General price range (to clients): $150-7,500. Works on contract basis only. Offers limited regional exclusivity. Contracts renew automatically with additional submissions for 5 years initial term/1 year thereafter. Charges 50% foreign duping fee for subagents; 50% catalog insertion fee; placement cost when image sells (if no sales or sales less than 50% placement amount, 0-49%). Photographers allowed to review account records upon reasonable notice during normal business hours. Statements issued monthly, bimonthly or quarterly,

depending on volume. Offers one-time, electronic media and one-year exclusive rights. Informs photographer and allows him to negotiate when a client requests to buy all rights, but does not allow direct negotiation with customer. Model/property release required for advertising; preferred for editorial. Captions required; include who, what, where, when. Indicate model release on photo.

Making Contact: Interested in receiving work from newer, lesser-known photographers. Query with description of work, type of equipment used and subject matter available. Send to Bug Sutton, Creative Director. Submit portfolio for review when requested. SASE. Reports in 1 month maximum.

Tips: "When a photographer is accepted, we analyze his portfolio and have consultations to give the photographer direction and leads for making sales of reproduction rights. We seek the photographer who is highly imaginative or into a specialty and who is dedicated to technical accuracy. We are looking for serious photographers who have many hundreds of photographs to offer for a first submission and who are able to contribute often."

PHOTO RESOURCE HAWAII, 116 Hekili St., #204, Kaiwa HI 96734. (808)599-7773. Fax: (808)599-7754. E-mail: photohi@lava.net. Website: http://www.photoresourceHawaii.com. Owner: Tami Dawson. Estab. 1983. Stock photo agency. Has 75,000 photos. Clients include: ad agencies, audiovisual firms, businesses, book/encyclopedia publishers, magazine publishers, calendar companies, greeting card companies and postcard publishers.

Needs: Photos mainly of Hawaii and some of the South Pacific.

Specs: Uses 35mm, $2\frac{1}{4} \times 2\frac{1}{4}$, 4×5 transparencies.

Payment & Terms: Pays 50% commission. Enforces minimum prices. Offers volume discounts to customers. Discount sales terms not negotiable. Works on contract basis only. Offers nonexclusive contract. Contracts renew automatically with additional submissions. Statements issued bimonthly. Payment made bimonthly. Photographers allowed to review account records. Offers one-time and other negotiated rights. Does not inform photographer or allow him to negotiate when client requests all rights. Model/property release preferred. Captions required.

Making Contact: Interested in receiving work from newer, lesser-known photographers. Query with samples. Samples kept on file. SASE. Expects minimum initial submission of 100 images with periodic submissions at least 5 times a year. Reports in 3 weeks.

■❀PHOTO SEARCH LTD., 10130 103rd St., #107, Edmonton, Alberta T5J 3N9 Canada. Phone/fax: (403)425-3766. E-mail: gerryb@photosearch.com. Website: http://www. photosearch.com. Photo Editor: Gerry Boudrias. Estab. 1991. Stock photo agency. Has 75,000 photos. Clients include: advertising agencies, public relations firms, audiovisual firms, businesses, book/encyclopedia publishers, magazine publishers, newspapers, postcard publishers, calendar companies, graphic designers, government agencies.

Needs: "We are looking for, almost exclusively, top-notch lifestyle images: couples, families, business people, industrial, and any other images that show people at work and at play. Good-looking models are a must, as are ethnic diversity, a variety of ages of models, and positive images of the disabled."

Specs: Uses 35mm, $2\frac{1}{4} \times 2\frac{1}{4}$, 4×5 color transparencies. Prefers medium and large format.

Payment & Terms: Pays 50% commission on color photos. Average price per image (to clients): $100-400/color photo; editorial work ranges from $100-200; advertising work ranges from $200-500. Works on limited regional exclusivity contract basis only. "All contracts are automatically renewed for a one-year period, unless either party provides written notice." Statements issued quarterly. Payment made quarterly. Photographers allowed to review account records. Offers one-time, agency promotion and electronic media rights; "will negotiate rights to meet clients' needs." Informs photographer and allows him to negotiate when client requests all rights. "While we reserve the right to final judgment, we confer with photographers about all-rights sales. We insist on doing what we feel is right for the agency and the photographer." Model/property release required. "Model releases are imperative for photographers who wish to make sales in the advertising field." Captions required. "Point out information that could be important that may not be evident in the image."

Making Contact: Interested in receiving work from newer, lesser-known photographers who have adequate size collections. Submit portfolio for review. Query with samples. Query with stock photo list. SASE. Expects minimum initial submission of 200 images. Reports in 1 month. Photo guidelines free with SASE. "Enquiries outside Canada *must* include international postage coupon. General list for anybody on request."

Tips: "Show as broad a range of subjects as possible, not just your best shots. Versatility is an important quality in stock photographers. Photographers should contact several agencies in the hope of finding one that can meet their needs and financial expectations. Who you sign with is a *very* important decision that could affect your career for many years to come. Marketing methods are constantly changing, due in part to the advent of electronic imaging. The way we serve our clientele, their needs, and the way we supply our images and services will continue to change in the near future. Only photographers with collections of lifestyle images should contact us. It is practically the only section of the collection in which the demand for material outweighs the supply."

PHOTO 20-20, 435 Brannan St., San Francisco CA 94107. (415)543-8983. Fax: (415)543-2199. Principal Editor: Ted Streshinsky. Estab. 1990. Stock photo agency. Has 350,000 photos. Clients include: advertising agencies, public relations firms, book/encyclopedia publishers, magazine publishers, newspapers, calendar companies, greeting card companies, design firms.
 • This agency also markets images via the Picture Network International.
Needs: Interested in all subjects.
Specs: Uses 35mm, 2¼×2¼, 4×5, 6×7, 8×10 transparencies.
Payment & Terms: Pays 50% commission on b&w and color photos; "25% to agency on assignment." Average price per image (to clients): $300/b&w; $300/color. Enforces minimum prices. Photographers can choose not to sell images on discount terms. Works on contract basis only. Offers nonexclusive contract. Contract renews automatically. "As payment for their work arrives checks are sent with statements." Photographers allowed to review account records. Offers one-time rights; negotiable. Requests photographer's permission to negotiate when client requests buy out. Model/property release preferred. Captions essential; include location and all pertinent information.
Making Contact: Interested in receiving queries from photographers. Query with stock photo list. Expects minimum initial submission of 300 images with periodic submission of at least 300 images every 3 months. Market tips sheet distributed every 2 months to contracted photographers.
Tips: "Our agency's philosophy is to try to avoid competition between photographers within the agency. Because of this we look for photographers who are specialists in certain subjects and have unique styles and approaches to their work. Photographers must be technically proficient, productive, and show interest and involvement in their work."

■**PHOTOBANK, INC.**, 17952 Skypark Circle, Suite B, Irvine CA 92614. (714)250-4480. Fax: (714)752-5495. E-mail: photobank@earthlink.net. Photo Editor: Kristi Bressert. Stock photo agency. Has 750,000 transparencies. Clients include: ad agencies, public relations firms, audiovisual firms, book/encyclopedia publishers, magazine publishers, postcard companies, calendar publishers, greeting card companies, corporations and multimedia users.
Needs: Emphasis on active couples, lifestyle, medical, family, multiethnic, multigenerational and business. High-tech shots are always needed. These subjects are highly marketable, but model releases are a must.
Specs: Uses all formats: 35mm, 2¼×2¼, 4×5, 6×7 and 8×10 transparencies; color only. Accepts images in digital format for Mac (PICT, JPEG). Send via compact disc, SyQuest or Zip disk (high resolution only if used; low resolution OK for review).
Payment & Terms: Pays 50% commission. Average price per image (to clients): $275-500/color photo. Negotiates fees below minimum prices. Offers volume discounts to customers; terms specified in photographer's contract. Photographers can choose not to sell images on discount terms. Works on contract basis only. Offers exclusive, limited regional exclusive, nonexclusive and guaranteed subject exclusivity contracts. Contracts renew automatically with additional submissions. Statements issued quarterly. Payment made quarterly. Photographers permitted to review account records to verify sales figures or account for various deductions. Offers one-time rights, electronic media rights and agency promotion rights. Informs photographer and allows him to negotiate when client requests all rights. Model/property release required. Captions preferred.
Making Contact: Query with samples and list of stock photos. SASE. Reports in 2 weeks. Photo guidelines free with SASE.
Tips: "Clients are looking for assignment quality and are very discerning with their selections. Only your best should be considered for submission. Please tightly edit your work before submitting. Model-released people shots in all subjects sell well. Multiethnic and multigenerational images are 'key.' "

PHOTOGRAPHIC RESOURCES INC., 6633 Delmar, St. Louis MO 63130. (314)721-5838. Fax: (314)721-0301. E-mail/Website: http://www.photographic~resources.com. President: Ellen Curlee. Estab. 1986. Stock photo agency. Member of the Picture Agency Council of America (PACA). Has 250,000 photos. Clients include: ad agencies, public relations firms, businesses, greeting card companies and postcard publishers.
Needs: Lifestyles, sports and medical.
Specs: Uses 8×10 glossy b&w prints; 35mm, 2¼×2¼, 4×5, 8×10 transparencies.
Payment & Terms: Pays 50% commission; 25% on assignment work. Works on contract basis only. Offers exclusive and guaranteed subject exclusivity contracts. Contracts renew automatically with additional submissions. Charges catalog insertion fee. Statements issued monthly. Payment made monthly. Offers one-time and electronic media rights; negotiable. Informs photographer when a client requests all rights. Model/property release required. Captions required.
Making Contact: Interested in receiving work from newer, lesser-known photographers. Query with samples. Reports in 3 weeks. Catalog free with SASE. Market tips sheet distributed quarterly to photographers on contract.

■**PHOTOPHILE**, 2400 Kettner Blvd., Studio 250, San Diego CA 92101. (619)595-7989. Fax: (619)595-0016. Website: http://www.vsii.com/portfolio/photophile. Owner: Nancy Likins-Masten. Clients include: ad agencies, public relations firms, audiovisual firms, businesses, publishers, postcard and calendar producers, and greeting card companies.

Needs: Lifestyle, vocations, sports, industry, entertainment, business, computer graphics, medical and travel.

Specs: Uses 35mm, $2\frac{1}{4}\times2\frac{1}{4}$, 4×5 and 6×7 original transparencies. Accepts images in digital format for Mac. Send via compact disc or Zip disk.

Payment & Terms: Pays 50% commission. Payment negotiable. Works on contract basis only. Offers limited regional exclusivity. Contracts renew automatically for 5 years. Statements issued quarterly. Payment made quarterly; photographers paid 30 days after payment is received from client. Photographers are allowed to review account records. Offers one-time and electronic media rights; negotiable. Informs photographer and allows him to negotiate when client requests all rights. Model/property release required. Captions required, include location or description of obscure subjects; travel photos should be captioned with complete destination information.

Making Contact: Write with SASE for photographer's information. "Professionals only, please." Expects a minimum submission of 500 saleable images and a photographer must be continuously shooting to add new images to files.

Tips: "Specialize, and shoot for the broadest possible sales potential. Get releases!" Points out that the "greatest need is for model-released people subjects; sharp-focus and good composition are important." If photographer's work is saleable, "it will sell itself."

‡■**PHOTOTAKE, INC.**, 224 W. 29th St., 9th Floor, New York NY 10001. (212)736-2525. (800)542-3686. Fax: (212)736-1919. Director: Leila Levy. Stock photo agency; "fully computerized photo agency specializing in science and technology in stock and on assignment." Has 500,000 photos. Clients include: ad agencies, businesses, newspapers, public relations and AV firms, book/encyclopedia and magazine publishers, and postcard, calendar and greeting card companies.

Needs: General science and technology photographs, medical, high-tech, computer graphics, special effects for general purposes, health-oriented photographs, natural history, people and careers.

Specs: Uses 8×10 prints; 35mm, $2\frac{1}{4}\times2\frac{1}{4}$, 4×5 or 8×10 transparencies; contact sheets or negatives.

Payment & Terms: Pays 50% commission on b&w and color photos. Works on contract basis only. Offers guaranteed subject exclusivity. Contracts renew automatically with additional submissions. Charges 50¢ duping fee. Charges $75-125 catalog insertion fees. Statements issued quarterly. Payment made quarterly. Photographers allowed to review account records. Offers one-time or first rights (world rights in English language, etc.). Informs photographer when client requests all rights, but agency negotiates the sale. Model/property release required. Captions required.

Making Contact: Interested in receiving work from newer, lesser-known photographers. Arrange a personal interview to show portfolio. Query with samples or with list of stock photo subjects. Submit portfolio for review. *SASE*. Reports in 1 month. Photo guidelines "given on the phone only." Tips sheet distributed monthly to "photographers that have contracted with us at least for a minimum of 500 photos."

Tips: Prefers to see "at least 100 color photos on general photojournalism or studio photography and at least 5 tearsheets—this, to evaluate photographer for assignment. If photographer has enough in medical, science, general technology photos, send these also for stock consideration." Using more "illustration type of photography. Topics we currently see as hot are: general health, computers, news on science. Photographers should always look for new ways to illustrate concepts generally."

‡**PHOTOWEB INC.**, 500 E. 11th St., Studio West, New York NY 10009. (212)677-5950. Fax: (212)533-6795. E-mail: psychner@panix.com. or klando@aol.com. Website: http://www.photography.com. Founder: Steve Eichner. Photographer Relations: Kathy Lando. Estab. 1996. Digital stock photo agency. Currently researching PACA membership. Has 20,000 images. "We have an office in San Francisco that is currently uploading images on a test basis. The New York office is the main contact." Provides services primarily to editorial clients (magazines, newspapers, book/encyclopedia publishers and television). "We have not targeted other areas as of yet due to the fact that our library consists of mostly non-released subjects."

Needs: Specializes in images of people in the entertainment and fashion industries, but plans to expand into more general areas. Looking for photographers specializing in: celebrity sessions, paparazzi, backstage at fashion shows, news/politics and general stock.

Specs: Uses 35mm transparencies; digital format (SyQyest, Zip disc and Photo CD).

Payment & Terms: Receives 50% commission on each sale. Works on contract basis only. Offers nonexclusive contracts. Statements issued monthly. Photographers are paid within 30 days of receipt of client payment. Photographers allowed to review account records. Offers one-time, electronic media or

agency promotion rights. Informs photographer and allows him to negotiate when client requests all rights. Captions required; include name, date and location.
Making Contact: Arrange personal interview to show portfolio. Query with samples. Samples not kept on file. SASE. Expects minimum initial submission of 25 images. Reports in 3 weeks.

■**PHOTRI INC.**, 3701 S. George Maxon Dr., Suite C2 North, Falls Church VA 22041. (703)931-8600. Fax: (703)998-8407. President: Jack Novak. Member of Picture Agency Council of America (PACA). Has 1 million b&w photos and color transparencies of all subjects. Clients include: book and encyclopedia publishers, ad agencies, record companies, calendar companies, and "various media for AV presentations."
Needs: Military, computer graphics, space, science, technology, energy, environment, romantic couples, people doing things, humor, picture stories, major sports events. Special needs include calendar and poster subjects. Needs ethnic mix in photos. Has sub-agents in 10 foreign countries interested in photos of USA in general.
Specs: Uses 8×10 glossy b&w prints; 35mm and larger transparencies.
Payment & Terms: Seldom buys outright; pays 35-50% commission. Pays: $45-65/b&w photo; $100-1,500/color photo; $50-100/ft. for film. Negotiates fees below standard minimums. Offers volume discounts to customers; terms specified in photographer's contract. Discount sale terms not negotiable. Works with or without contract. Offers nonexclusive contract. Charges $150 catalog insertion fee. Statements issued quarterly. Payment made quarterly. Photographers allowed to review records. Offers one-time, electronic media and agency promotion rights. Informs photographer and allows him to negotiate when client requests all rights. Model release required if available and if photo is to be used for advertising purposes. Property release required. Captions required.
Making Contact: Interested in receiving work from newer, lesser-known photographers. Call to arrange an appointment or query with résumé of credits. SASE. Reports in 2-4 weeks.
Tips: "Respond to current needs with good quality photos. Take, other than sciences, people and situations useful to illustrate processes and professions."

■*****PICTOR INTERNATIONAL, LTD.**, Lymehouse Studios, 30-31 Lyme St., London NW1 0EE England. (171)482-0478. Fax: (171)267-5759. Creative Director: Alberto Sciama. Stock photo agency and picture library with 17 offices including London, Paris, Munich, Milan, Vienna, Atlanta, New York, Santa Monica and Washington DC. Clients include: advertising agencies, public relations firms, audiovisual firms, businesses, book/encyclopedia publishers, magazine publishers, postcard companies, calendar companies, greeting card companies, jigsaw companies and travel plus decorative poster companies.
Needs: "Pictor is a general stock agency. We accept *all* subjects." Needs primarily people shots (released): business, families, couples, children, etc. Criteria for acceptance: "photos which are technically and aesthetically excellent."
Specs: Uses 35mm, 6×6cm, 6×7cm and 4×5 transparencies.
Payment & Terms: Pays 50% commission for color photos. General price range: $100-$15,000. Statements issued monthly. Offers one-time, first and all rights. Requires model release and photo captions. Buys photos outright depending on subject.
Making Contact: Arrange a personal interview to show portfolio. Query with list of stock photo subjects. Send unsolicited photos by mail for consideration. Photo guidelines sheet available for SASE. Publishes annual catalog. Tips sheet for "photographers we represent only."
Tips: Looks for "photographs covering all subjects. Clients are getting more demanding and expect to receive only excellent material. Through our marketing techniques and PR, we advertise widely the economic advantages of using more stock photos. Through this technique we're attracting 'new' clients who require a whole different set of subjects."

■**THE PICTURE CUBE INC.**, Dept. PM, 67 Broad St., Boston MA 02109. (617)443-1113. Fax: (617)443-1114. E-mail: piccube@shore.net. President: Sheri Blaney. Member of Picture Agency Council of America (PACA). Has 300,000 photos. Clients include: ad agencies, public relations firms, businesses, audiovisual firms, textbook publishers, magazine publishers, encyclopedia publishers, newspapers, postcard companies, calendar companies, greeting card companies and TV. Guidelines available with SASE.
Needs: US and foreign coverage, contemporary images, agriculture, industry, energy, high technology, religion, family life, multicultural, animals, transportation, work, leisure, travel, ethnicity, communications, people of all ages, psychology and sociology subjects. "We need lifestyle, model-released images of families, couples, technology and work situations. We emphasize New England/Boston subjects for our ad/design and corporate clients. We also have a growing vintage collection."
Specs: Uses 8×10 prints; 35mm, 2¼×2¼, 4×5 and larger slides. "Our clients use both color and b&w photography."
Payment & Terms: Pays 50% commission. General price range (to clients): $150-400/b&w; $175-500/color photo. "We negotiate special rates for nonprofit organizations." Offers volume discounts to custom-

ers; inquire about specific terms. Discount sales terms not negotiable. Works on contract basis only. Offers limited regional exclusivity contract. Contracts renew automatically for 3 years. Charges 50% catalog insertion fee. Payment made bimonthly with statement. Photographers allowed to review account records to verify sales figures. Offers one-time rights. Model/property release preferred. Captions required; include event, location, description, if model-released.

Making Contact: Request guidelines before sending any materials. Arrange a personal interview to show portfolio. SASE. Reports in 1 month.

Tips: "Black & white photography is being used more and we will continue to stock it." Serious freelance photographers "must supply a good amount (at least 1,000 images per year, sales-oriented subject matter) of material, in order to produce steady sales. All photography submitted must be high quality, with needle-sharp focus, strong composition, correctly exposed. All of our advertising clients require model releases on all photos of people, and often on property (real estate)."

■**PICTURE LIBRARY ASSOCIATES**, 4800 Hernandez Dr., Guadalupe CA 93434. (805)343-1844. Fax: (805)343-6766. E-mail: pla@terminus.com. Website: http://www.terminus.com/~pla/. Director of Marketing: Robert A. Nelson. Estab. 1991. Stock photo agency. Has 32,000 photos. Clients include: ad agencies, public relations firms, audiovisual firms, businesses, book/encyclopedia publishers, magazine publishers, newspapers, postcard publishers, calendar companies, greeting card companies, electronic publishing companies.

Needs: All subjects. Specifically senior activities, health-related subjects; black, Hispanic, Asian and other ethnic people in everyday activities, animals, birds (other than North American). Write with SASE for want lists.

Specs: Uses 8×10 glossy b&w prints; 35mm, $2\frac{1}{4} \times 2\frac{1}{4}$, 4×5 transparencies; videotape (contact agency for specifics).

Payment & Terms: Photographer specifies minimum amount to charge. Pays 50% commission on b&w, color photos and videotape. Negotiates fees based on both media's published price schedule, minimum stated in photographer's contract, if any, and type of usage. This agency uses ASMP contract. Offers volume discounts to customers; terms specified in photographer's contract. Photographers can choose not to sell images on discount terms. Works on contract basis only. All renewal clauses are tailored to meet needs of a specific client, usually 1 time renewal option at a stated price. Charges 100% duping fees. Catalog insertion rate being determined. Charges shipping costs of images to and from Picture Library Associates and photographer. Statements issued bimonthly under terms listed in photographer/agency contract. Payment made within a few days of agency's receipt of payment. Photographers may review their sales records at any time during business hours. Offers electronic media rights, one-time North American rights, one-time world-wide rights, renewal rights based on original license fee. Photographer and agency negotiate with client on requests to buy all rights. Model/property release required for recognizable persons and recognizable property. Captions required; include who, what, common name, Latin name of principal subject in each image.

Making Contact: Interested in receiving work from newer, lesser-known photographers as well as established ones. Submit portfolio for review. Contact agency for guidelines before submission. Samples not kept on file. SASE. Expects minimum initial submission of 40-60 images. No required minimum. Prefer frequency of 60 days or less. Reports in 3 weeks. Photo guidelines with SAE and 78¢ postage. Computer printout of subject categories to clients on request. Publishes newsletter. No regular schedule. Distributed to photographers under contract and anyone requesting it; free with SASE. Established photographers asked to consider PLA as an additional agency.

Tips: "Primarily look at technical quality for reproduction, subject matter, similars with varied composition, color choices. Increased need for ethnic people. Need people doing things. Need senior citizen activity. Need health-related subject matter with people involved. Shoot for a theme when possible. Submit new stock regularly. Every image must be numbered. Arrange images on a slide page. Group images by category. Pre-edit images to include only technically excellent ones."

‡■**PICTURE PERFECT**, (formerly Picture Perfect USA, Inc.), 254 W. 31st St., New York NY 10001. (212)279-1234. Fax: (212)279-1241. Contact: Denise Childs or Robert Tod. Estab. 1991. Stock photo agency. Has 500,000 photos. Clients include: ad agencies, graphic design firms, public relations firms, audiovisual firms, businesses, book/encyclopedia publishers, magazine publishers, newspapers, postcard publishers, calendar companies, greeting card companies, corporations.

Needs: General—people, lifestyles, business, industry, travel, recreation, sports.

Specs: Uses 35mm, 4×5, $6 \times 4\frac{1}{2}$, 6×6, 6×7, 6×9 transparencies.

Payment & Terms: Pays 50% commission. Average price per image (to clients): varies by usage. Enforces minimum prices. Offers volume discounts to customers. Works on contract basis only. Offers nonexclusive contract. Contracts renew automatically with additional submissions; usually same as original contract. Catalog insertion rate varies according to project. Statements issued quarterly on paid up accounts.

Payment made quarterly. Photographers allowed to review account records. Offers one-time rights. "We negotiate on photographer's behalf." Model/property release required. Captions required.

Making Contact: Interested in receiving work from established commercial photographers only. Submit portfolio for review. "Phone/write—first." SASE. Expects minimum initial submission of 1,000-2,000 images with submissions of 500-2,000 images 2 times/year. Photo guidelines free with SASE.

Tips: "All subjects, commercial applications, sharp, well composed, colorful—any format—color only. Business situations, lifestyles, model-released people shots in particular. We market photos nationally and are heavily involved in catalog distribution worldwide."

■**PICTURESQUE STOCK PHOTOS**, 1520 Brookside Drive #3, Raleigh NC 27604. (919)828-0023. Fax: (919)828-8635. E-mail: picturesque@mindspring.com. Website: http://www.picturesque.com. Manager: Syd Jeffrey. Estab. 1987. Stock photo agency. Member of Picture Agency Council of America (PACA). Has 250,000 photos. Clients include: ad agencies, design firms, corporations, book/encyclopedia publishers and magazine publishers.

Needs: Model-released people, lifestyle, business, industry and general topics.

Specs: Uses 35mm, 2¼×2¼, 4×5 transparencies. Accepts images in digital format for Mac (TIFF). Send via compact disc or Zip disk.

Payment & Terms: Pays 50% commission. Works on contract basis only. Offers nonexclusive contract. Contracts renew automatically. Statements issued monthly. Payment made monthly. Photographers allowed to review account records. Offers one-time, electronic media and various rights depending on client needs. Contacts photographer for authorization of sale when client requests all rights. Model/property release required. Captions required.

Making Contact: Contact by telephone or Website for submissions guidelines. SASE. Tips sheet distributed quarterly to member photographers.

■***PLANET EARTH PICTURES**, The Innovation Centre, 225 Marsh Wall, London E14 9FX England. (0171)293-2999. Fax: (0171)293-2998. Director: Gillian Lythgoe. Has 200,000 photos. Clients include: ad agencies, public relations and audiovisual firms, businesses, book/encyclopedia and magazine publishers, and postcard and calendar companies.

Needs: "Marine—surface and underwater photos covering all marine subjects, marine natural history, seascapes, natural history. All animals and plants: interrelationships and behavior, landscapes, natural environments, pollution and conservation." Special subject needs: polar and rainforest animals and scenery, animal behavior.

Specs: Uses any size transparencies.

Payment & Terms: Pays 50% commission on color photos. General price range: £50 (1 picture/1 AV showing), to over £1,000 for advertising use. Prices negotiable according to use. Charges £100 per page catalog insertion fee. Works on contract basis only. Offers exclusive and nonexclusive contracts and limited regional exclusivity. Statements issued quarterly. Payment made quarterly. Photographers allowed to review account records. Offers one-time rights. Informs photographer and allows him to negotiate when client requests all rights. Model release preferred. Captions required.

Making Contact: Arrange a personal interview to show portfolio. Send photos by mail for consideration. SASE. Reports ASAP. Distributes tips sheet every 6 months to photographers.

Tips: "We like photographers to receive our photographer's booklet and current color brochure that gives details about photos and captions. In reviewing a portfolio, we look for a range of photographs on any subject—important for the magazine market—and the quality. Trends change rapidly. There is a strong emphasis that photos taken in the wild are preferable to studio pictures. Advertising clients still like larger format photographs. Exciting and artistic photographs used even for wildlife photography, protection of environment."

POSITIVE IMAGES, 89 Main St., Andover MA 01810. (508)749-9901. Fax: (508)749-2747. Manager: Pat Bruno. Stock photo agency. Member ASPP. Clients include ad agencies, public relations firms, book/encyclopedia publishers, magazine publishers, greeting card companies, sales/promotion firms, design firms.

● This agency has images on *The Stock Workbook* CD-ROM.

Needs: Garden/horticulture, insects, plant damage, health, nutrition, nature, human nature—all suitable for advertising and editorial publication.

Payment & Terms: Pays 50% commission. "3% of all our stock sales are donated to charity. Our photographers decide to whom the money should go." Works on contract basis only. Offers limited regional exclusivity. Charges fee for CD insertion, 100% of which is refunded when photo sells. Statements issued quarterly. Payment issued monthly. Photographers allowed to review account records. Offers one-time and electronic media rights. "We never sell all rights."

Making Contact: Query letter. Call to schedule an appointment. Reports in 2 weeks.

Tips: "We take on only one or two new photographers per year. We respond to everyone who contacts us and have a yearly portfolio review. Positive Images accepts only fulltime working professionals who can contribute regular submissions."

■*PRO-FILE, 2B Winner Commercial Building, 401-403 Lockhart Rd., Wanchai, Hong Kong. (852)2574-7788. Fax: (852)2574-8884. E-mail: nfarrin@hk.linkage.net. Website: http://www.profilephoto.com.hk. Director: Neil Farrin. Stock photo agency. Has 100,000 photos. Clients include: ad agencies, public relations firms, audiovisual firms, businesses, book/encyclopedia publishers, magazine publishers and calendar companies.

● Pro-File is using computer networks and CD-ROMs to market and store images.

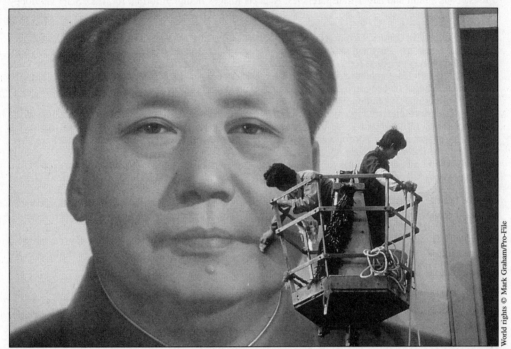

World rights © Mark Graham/Pro-File

Chairman Mao—way bigger than life on this billboard—receives a sponge bath from two workers in a cherry picker in this almost surreal photo by Mark Graham. The "unusual take on a tried and tested image" makes the shot right for Pro-File's stock list which emphasizes Asian-related images. Graham's photo has sold about 10 times for various editorial uses.

Needs: General stock, emphasis on Asian destinations and Asian model-released pictures.
Specs: Uses 35mm, 2¼×2¼ and 4×5 transparencies. Accepts images in digital format for Windows. Send via SyQuest (as high resolution as possible).
Payment & Terms: Pays 50% commission. Works on contract basis only. Offers guaranteed subject exclusivity (within files) and limited regional exclusivity. Charges duping and catalog insertion fees. Statements issued quarterly. Payment made quarterly. Photographers allowed to review account records to verify sales figures. Offers one-time, electronic media and agency promotion rights. Requests agency promotion rights. Informs photographer and allows him to negotiate when client requests all rights. Model/property release required. Captions required.
Making Contact: Interested in receiving work from newer, lesser-known photographers. Query with résumé of credits and list of stock photo subjects. SASE. Reports in 3 months. Distributes tips sheet "as necessary" to current photographers on file.
Tips: Has offices in Singapore and Thailand; contact main office for information.

■RAINBOW, Dept. PM, P.O. Box 573, Housatonic MA 01236. (413)274-6211. Fax: (413)274-6689. E-mail: rainbow@bcn.net. Website: http://www.rainbowimages.com. Director: Coco McCoy. Library Manager: Maggie Leonard. Estab. 1976. Stock photo agency. Member of Picture Agency Council of America (PACA). Has 195,000 photos. Clients include: ad agencies, public relations firms, design agencies, audiovi-

sual firms, book/encyclopedia publishers, magazine publishers and calendar companies. 20% of sales come from overseas.

• Rainbow offers its own CD-ROM discs with 4,500 images on-line at publishersdepot.com and over 200 at rainbowimages.com.

Needs: Although Rainbow is a general coverage agency, it specializes in high technology images and is continually looking for computer graphics, pharmaceutical and DNA research, photomicrography, communications, lasers and space. "We are also looking for graphically strong and colorful images in physics, biology and earth science concepts; also active children, teenagers and elderly people. Worldwide travel locations are always in demand, showing people, culture and architecture. Our rain forest file is growing but is never big enough!"

Specs: Uses 35mm and larger transparencies. Accepts images in digital format for Mac. Send via floppy disk or Zip disk.

Payment & Terms: Pays 50% commission. Works with or without contract, negotiable. Offers limited regional exclusivity contract. Contracts renew automatically with each submission; no time limit. Statements issued quarterly. Payment made quarterly. Photographers allowed to review account records to verify sales figures. Offers one-time rights. Informs photographer and allows him to negotiate when client requests all rights. Model release is required for advertising, book covers or calendar sales. Photo captions required for scientific photos or geographic locations, etc.; include simple description if not evident from photo, Prefers both Latin and common names for plants and insects to make photos more valuable.

Making Contact: Interested in receiving work from published photographers. "Photographers may write or call us for more information. We may ask for an initial submission of 150-300 chromes." Arrange a personal interview to show portfolio or query with samples. SASE. Reports in 2 weeks. Guidelines sheet for SASE. Distributes a tips sheet twice a year.

Tips: "The best advice we can give is to encourage photographers to carefully edit their photos before sending. No carefully agency wants to look at grey rocks backlit on a cloudy day! With no caption!" Looks for luminous images with either a concept illustrated or a mood conveyed by beauty or light. "Clear captions help our researchers choose wisely and ultimately improve sales. As far as trends in subject matter go, health issues and strong, simple images conveying the American Spirit—families together, farming, scientific research, winning marathons, hikers reaching the top—are the winners. Females doing 'male' jobs, black scientists, Hispanic professionals, Oriental children with a blend of others at play, etc. are also in demand. The importance of model releases for editorial covers, selected magazine usage and always for advertising/corporate clients cannot be stressed enough!"

RANGEFINDER, (formerly Photoreporters, Inc.), Dept. PM, 275 Seventh Ave., 14th Floor, New York NY 10001. (212)807-0192. Fax: (807)622-8939. Contact: Mariah Aguier. Estab. 1950. Stock photo agency. Has 2 million photos. Member of the Picture Agency Council of America (PACA). Clients include: advertising agencies, public relations firms, book/encyclopedia publishers, magazine publishers, newspapers and calendar companies.

Needs: Celebrities, politics, news and photo stories such as human interest.

Specs: Uses up to 8 × 10 glossy color and b&w prints; 2¼ × 2¼ and 35mm transparencies. Accepts images in digital format. Send via floppy disk or SyQuest.

Payment & Terms: Pays 50% commission on b&w and color photos. General price range (to clients): minimum $175/b&w; minimum $200/color; rate based on usage. Enforces minimum prices. Offers volume discounts. Photographers can choose not to sell images on discount terms. Works with or without contract; exclusive, negotiable. Contracts renew automatically with additional submissions. Statements issued monthly. Payment made monthly. Photographers are allowed to review account records to verify sales figures. Offers one-time and negotiated rights. "We consult with photographer on buying of all rights and price." Model release preferred. Captions required.

Making Contact: Interested in working with newer, lesser-known photographers. Arrange personal interview to show portfolio. Keeps samples on file. SASE. Expects minimum initial submission of 40 images. Reports in 3 weeks. Market tips sheet available on request.

■✦**REFLEXION PHOTOTHEQUE**, 1255 Square Phillips, Suite 307, Montreal, Quebec H3B 3G1 Canada. (514)876-1620. Fax: (514)876-3957. President: Michel Gagne. Estab. 1981. Stock photo agency. Has 100,000 photos. Clients include: ad agencies, public relations firms, audiovisual firms, businesses, book/encyclopedia publishers, magazine publishers, newspapers, postcard companies, calendar companies and greeting card companies.

• Reflexion Phototheque sells mostly by catalog.

Needs: Model-released people of all ages in various activities. Also, beautiful homes, recreational sports, North American wildlife, industries, US cities, antique cars, hunting and fishing scenes, food, and dogs and cats in studio setting.

Specs: Uses 35mm, 2¼ × 2¼, 4 × 5, 8 × 10 transparencies.

Payment & Terms: Pays 50% commission on color photos. Average price per image: $150-500. Enforces minimum prices. Offers volume discounts to customers; inquire about specific terms. Discount sales terms not negotiable. Works on contract basis only. Offers limited regional exclusivity. Contracts renew automatically for 5 years. Charges 50% duping fee and 100% catalog insertion fee. Statements issued quarterly. Payment made monthly. Offers one-time rights. Model/property release preferred. Photo captions required; include country, place, city, or activity.

Making Contact: Interested in receiving work from newer, lesser-known photographers. Arrange a personal interview to show portfolio. Query with list of stock photo subjects. Submit portfolio for review. SASE. Reports in 1 month. Photo guidelines available.

Tips: "Limit your selection to 200 images. Images must be sharp and well exposed. Send only if you have high quality material on the listed subjects."

RETNA LTD., 18 E. 17th St., 4th Floor, New York NY 10003. (212)255-0622. Contact: Julie Grahame. Estab. 1979. Member of the Picture Agency of America (PACA). Stock photo agency, assignment agency. Has 1 million photos. Clients include advertising agencies, public relations firms, book/encyclopedia publishers, magazine publishers, newspapers and record companies.
 • Retna wires images worldwide to sub agents.

Needs: Handles photos of musicians (pop, country, rock, jazz, contemporary, rap, R&B) and celebrities (movie, film, television and politicians). Covers New York, Milan and Paris fashion shows; has file on royals.

Specs: Uses 8×10 b&w prints; 35mm and $2\frac{1}{4} \times 2\frac{1}{4}$ transparencies; b&w contact sheets; b&w negatives.

Payment & Terms: Pays 50% commission on b&w and color photos. General price range (to clients): $125-1,500. Works on contract basis only. Contracts renew automatically with additional submissions for 5 years. Statements issued monthly. Payment made monthly. Offers one-time rights; negotiable. When client requests all rights photographer will be consulted, but Retna will negotiate. Model/property release required. Captions required.

Making Contact: Works on contract basis only. Arrange a personal interview to show portfolio. Primarily concentrating on selling stock, but do assign on occasion. Does not publish "tips" sheets, but makes regular phone calls to photographers.

Tips: Wants to see a variety of musicians/actors shot in studio, as well as concert. Photography must be creative, innovative and of the highest aesthetic quality possible.

■**REX USA LTD**, 351 W. 54th St., New York NY 10019. (212)586-4432. Fax: (212)541-5724. Manager: Charles Musse. Estab. 1935. Stock photo agency, news/feature syndicate. Affiliated with Rex Features in London. Member of Picture Agency Council of America (PACA). Has 1.5 million photos. Clients include: ad agencies, public relations firms, audiovisual firms, businesses, book/encyclopedia publishers, magazine publishers, newspapers, postcard companies, calendar companies, greeting card companies and TV, film and record companies.

Needs: Primarily editorial material: celebrities, personalities (studio portraits, candid, paparazzi), human interest, news features, movie stills, glamour, historical, geographic, general stock, sports and scientific.

Specs: Uses all sizes and finishes of b&w and color prints; 35mm, $2\frac{1}{4} \times 2\frac{1}{4}$, 4×5, and 8×10 transparencies; b&w and color contact sheets; b&w and color negatives; VHS videotape.

Payment & Terms: Pays 50-65% commission; payment varies depending on quality of subject matter and exclusivity. "We obtain highest possible prices, starting at $100-100,000 for one-time sale." Pays 50% commission on b&w and color photos. Works with or without contract. Offers nonexclusive contracts. Statements issued monthly. Payment made monthly. Photographers allowed to review account records. Offers one-time rights, first rights and all rights. Informs photographer and allows him to negotiate when client requests all rights. Model release required. Captions required.

Making Contact: Interested in receiving work from newer, lesser-known photographers. Arrange a personal interview to show portfolio. Query with samples. Query with list of stock photo subjects. If mailing photos, send no more than 40; include SASE. Reports in 1-2 weeks.

■**H. ARMSTRONG ROBERTS**, Dept. PM, 4203 Locust St., Philadelphia PA 19104. (800)786-6300. Fax: (800)786-1920. President: Bob Roberts. Estab. 1920. Stock photo agency. Member of the Picture Agency Council of America (PACA). Has 2 million photos. Has 2 branch offices. Clients include: advertising agencies, public relations firms, audiovisual firms, businesses, book/encyclopedia publishers, magazine publishers, newspapers, postcard publishers, calendar companies and greeting card companies.

Needs: Uses images on all subjects in depth except personalities and news.

Specs: Uses b&w negatives only; 35mm, $2\frac{1}{4} \times 2\frac{1}{4}$, 4×5 and 8×10 transparencies.

Payment & Terms: Buys only b&w negatives outright. Payment negotiable. Pays 35% commission on b&w photos; 45-50% on color photos. Works with or without a signed contract, negotiable. Offers various contracts including exclusive, limited regional exclusivity, and nonexclusive. Guarantees subject exclusivity

within files. Charges duping fee 5%/image. Charges .5%/image for catalog insertion. Statements issued monthly. Payment made monthly. Payment sent with statement. Photographers allowed to review account records to verify sales figures "upon advance notice." Offers one-time rights. Informs photographer and allows him to negotiate when client requests all rights. Model release and captions required.

Making Contact: Interested in receiving work from newer, lesser-known photographers. Query with résumé of credits. Does not keep samples on file. SASE. Expects minimum initial submission of 250 images with quarterly submissions of 250 images. Reports in 1 month. Photo guidelines free with SASE.

■**RO-MA STOCK**, 1003 S. Los Robles Ave., Pasadena CA 91106-4332. (818)799-7733. Fax: (818)799-6622. E-mail: romastock@aol.com. Owner: Robert Marien. Estab. 1989. Stock photo agency. Member of Picture Agency Council of America (PACA). Has more than 150,000 photos. Clients include: ad agencies, multimedia firms, corporations, graphic design and film/video production companies.
 ● RO-MA STOCK markets its best images on-line through its affiliated domestic agency, Index Stock Photography, Inc. located in New York City. CD-ROM catalog.

Needs: Looking for fictional images of Earth and outerspace, microscopic and electromicrographic images of insects, micro-organisms, cells, etc. General situations in sciences (botany, ecology, geology, astronomy, weather, natural history, medicine). Also extreme close-up shots of animal faces including baby animals. Very interested in people (young adults, elderly, children and babies) involved with nature and/or with animals and outdoor action sports involving every age range. People depicting their occupations as technicians, workers, scientists, doctors, executives, etc. Most well-known landmarks and skylines around the world are needed.

Specs: Primarily uses 35mm. "When submitting medium and large formats, these images should have a matching 35mm slide for scanning purposes. This will speed up the process of including selected images in their marketing systems. All selected images are digitized and stored on Photo-CD." Accepts images in digital format for Mac (TIFF, no JPEG). Send via compact disc (photo CD formats up to 2048×3072, 18.9 MB or more).

Payment & Terms: Pays 50% commission on b&w and color; international sales, 40% of gross. General price range: $200. Offers volume discounts to customers; terms specified in photographer's contract. Works on contract basis only. Offers limited regional exclusivity and nonexclusive contracts. Contract renews automatically with each submission (of 1,000 images) for 1 year. Charges 50% duping fees; 50% catalog insertion fee from commissions and $3.50/each image in the CD-ROM catalog to cover half of digitizing cost. Statements issued quarterly. Payment made quarterly. Offers one-time rights and first rights. Informs photographer when client requests all rights for approval. Model/property release required for recognizable people and private places "and such photos should be marked with 'M.R.' or 'N.M.R.' respectively." Captions required for animals/plants; include common name, scientific name, habitat, photographer's name; for others include subject, location, photographer's name.

Making Contact: Interested in receiving work from newer, lesser-known photographers. Query with résumé of credits, tearsheets or samples and list of specialties. No unsolicited original work. Responds with tips sheet, agency profile and questionnaire for photographer with SASE. Photo guidelines and tips distributed periodically to contracted photographers.

Tips: Wants photographers with "ability" to produce excellent competitive photographs for the stock photography market on specialized subjects and be willing to learn, listen and improve agency's file contents. Looking for well-composed subjects, high sharpness and color saturation. Emphasis in medical and laboratory situations; people involved with the environment, manufacturing and industrial. Also, photographers with collections of patterns in nature, art, architecture and macro/micro imagery are welcome.

‡■*S & I WILLIAMS POWER PIX**, Castle Lodge, Wenvoe, Cardiff CF5 6AD Wales, United Kingdom. (01222) 595163. Fax: (01222)593905. President: Steven Williams. Picture library. Has 100,000 photos. Clients include: ad agencies, public relations firms, audiovisual firms, businesses, book/encyclopedia publishers, magazine publishers, postcard companies, calendar companies, greeting card companies and music business, i.e., records, cassettes and CDs.

Specs: Uses 35mm, 2¼×2¼, 4×5 and 8×10 transparencies.

Payment & Terms: Pays 50% commission on b&w and color photos. General price range: £50-£500 (English currency). Model release required. Captions required.

Making Contact: Arrange a personal interview to show portfolio. Query with résumé of credits, samples

● **SPECIAL COMMENTS** within listings by the editor of *Photographer's Market* are set off by a bullet.

or stock photo list. SASE. Reports in 1-2 weeks. Photo guidelines available for SASE. Distributes a tips sheet every 3-6 months to photographers on books.

Tips: Prefers to see "a photographer who knows his subject and has done his market research by looking at pictures used in magazines, record covers, books, etc.—bright, colorful images and an eye for something just that little bit special."

■**S.K. STOCK**, P.O. Box 460880, Garland TX 75046-0880. (972)494-5915. Photo Manager: Sam Copeland. Estab. 1985. Stock photo agency. Has 6,000 photos. Clients include: public relations firms, book/encyclopedia publishers, magazine publishers, calendar companies and greeting card companies.

Needs: Wants to see nudes, flowers, landscapes.

Specs: Uses 4×6, 4×4 color prints; 35mm, $2\frac{1}{4} \times 2\frac{1}{4}$, 4×5 and 8×10 transparencies; film; VHS videotape.

Payment & Terms: Buys photos when needed; pays $50/color photo; $50/b&w photo; $80/minute of videotape footage. Pays 50% commission on color photo, film and videotape. Average price per image (to clients): $100-300/color; $100-400/film. Negotiates fees below standard minimum prices. Works on contract basis only. Offers nonexclusive contract. Charges $5 catalog insertion fee. Statements issued quarterly. Payment made to photographer when agency receives payment. Photographers allowed to review account records. Offers one-time rights. Informs photographer and allows him to negotiate when client requests all rights "as long as I get 10 percent." Model/property release required. Captions required; include title, what, when, where and send a list of all work.

Making Contact: Interested in receiving work from newer, lesser-known photographers. Query with samples. Query with stock photo list. Keeps samples on file. SASE. Expects minimum initial submission of 200 images with periodic submission of at least 100 images every other month. Reports in 3 weeks. Photo guidelines free with SASE. Market tips sheet distributed every 3 months; free with SASE upon request.

Tips: "Your work must be sharp. We need people who will submit work all the time, clear and sharp."

■*SCIENCE PHOTO LIBRARY, LTD.**, 112 Westbourne Grove, London W2 5RU England. (0171)727-4712. Fax: (0171)727-6041. Research Director: Rosemary Taylor. Stock photo agency. Has 100,000 photos. Clients include: ad agencies, public relations firms, audiovisual firms, businesses, book/encyclopedia publishers, magazine publishers, newspapers, postcard companies, calendar companies and greeting card companies.

Needs: SPL specializes in all aspects of science, medicine and technology. "Our interpretation of these areas is broad. We include earth sciences, landscape and sky pictures; and animals. We have a major and continuing need of high-quality photographs showing science, technology and medicine *at work*: laboratories, high-technology equipment, computers, lasers, robots, surgery, hospitals, etc. We are especially keen to sign up American freelance photographers who take a wide range of photographs in the fields of medicine and technology. We like to work closely with photographers, suggesting subject matter to them and developing photo features with them. We can only work with photographers who agree to our distributing their pictures throughout Europe, and preferably elsewhere. We duplicate selected pictures and syndicate them to our agents around the world."

Specs: Uses color prints and 35mm, $2\frac{1}{4} \times 2\frac{1}{4}$, 4×5, 6×7, 6×5 and 6×9 transparencies.

Payment & Terms: Pays 50% commission for b&w and color photos. General price range (to clients): $80-1,000; varies according to use. Only discounts below minimum for volume or education. Offers volume discounts to customers; inquire about specific terms. Discount sales terms not negotiable. Works on contract basis only. Offers exclusivity; exceptions are made; subject to negotiation. Agreement made for 4 years; general continuation is assured unless otherwise advised. Statements issued quarterly. Payment made quarterly. Photographers allowed to review account records to verify sales figures; fully computerized accounts/commission handling system. Offers one-time and electronic media rights. Model release required. Captions required.

Making Contact: Query with samples or query with list of stock photo subjects. Send unsolicited photos by mail for consideration. Returns material submitted for review. Reports in 1 month.

Tips: Prefers to see "a small (20-50) selection showing the range of subjects covered and the *quality*, style and approach of the photographer's work. Our bestselling areas in the last two years have been medicine and satellite imagery. We see a continuing trend in the European market towards very high-quality, carefully-lit photographs. This is combined with a trend towards increasing use of medium and large-format photographs and decreasing use of 35mm (we make medium-format duplicates of some of our best 35mm); impact of digital storage/manipulation; problems of copyright and unpaid usage. The emphasis is on an increasingly professional approach to photography."

SHARPSHOOTERS, INC., 4950 SW 72nd Ave., Suite 114, Miami FL 33155. (305)666-1266. Fax: (305)666-5485. Manager, Photographer Relations: Edie Tobias. Estab. 1984. Stock photo agency. Member

of Picture Agency Council of America (PACA). Has 500,000 photos. Clients include: ad agencies.
Needs: Model-released people for advertising use. Well-designed, styled photographs that capture the essence of life: children; families; couples at home, at work and at play; also beautiful landscapes and wildlife geared toward advertising. Large format preferred for landscapes.
Specs: Uses transparencies only, all formats.
Payment & Terms: Pays 50% commission on color photos. General price range (to clients): $275-15,000. Works on contract basis only. Offers exclusive contract only. Statements issued monthly. Payments made monthly. Photographers allowed to review account records; "monthly statements are derived from computer records of all transactions and are highly detailed." Offers one-time and electronic media rights usually, "but if clients pay more they get more usage rights. We never offer all rights on photos." Model/property release required. Photo captions preferred.
Making Contact: Interested in receiving work from newer, lesser-known photographers. Query along with nonreturnable printed promotion pieces. Cannot return unsolicited material. Reports in 1 week.
Tips: Wants to see "technical excellence, originality, creativity and design sense, excellent ability to cast and direct talent and commitment to shooting stock." Observes that "photographer should be in control of all elements of his/her production: casting, styling, props, location, etc., but be able to make a photograph that looks natural and spontaneous."

SILVER IMAGE PHOTO AGENCY, INC., 4104 NW 70th Terrace, Gainesville FL 32606. (352)373-5771. Fax: (352)374-4074. E-mail: silverimag@aol.com. Website: http://www.silver~image.com. President/Owner: Carla Hotvedt. Estab. 1988. Stock photo agency. Assignments in Florida/S. Georgia. Has 20,000 color/b&w photos. Clients include: public relations firms, book/encyclopedia publishers, magazine publishers and newspapers.
Needs: Florida-based travel/tourism, Florida cityscapes and people, nationally oriented topics such as drugs, environment, recycling, pollution, etc. Humorous people, animal photos and movie/TV celebrities.
Specs: Uses 35mm transparencies and prints.
Payment & Terms: Pays 50% commission on b&w/color photos. General price range (to clients): $150-600. Works on contract basis only. Offers nonexclusive contract. Statements issued monthly. Payment made monthly. Photographers allowed to review account records. Offers one-time rights. Informs photographer and allows him to negotiate when client requests all rights. Model release preferred. Captions required: include name, year shot, city, state, etc.
Making Contact: Query with list of stock photo subjects. SASE; will return if query first. Reports on queries in 1 month; material up to 2 months. Photo guidelines free with SASE. Tips sheets distributed as needed. SASE. Do not submit material unless first requested.
Tips: Looks for ability to tell a story in 1 photo. "I will look at a photographer's work if it seems to have images outlined on my stock needs list which I will send out after receiving a query letter with SASE. Because of my photojournalistic approach my clients want to see people-oriented photos, not just pretty scenics. I also get many calls for drug-related photos and unique shots from Florida."

‡SILVER VISIONS, P.O. Box 2679, Aspen CO 81612. (970)923-3137. E-mail: jjohnson@rof.net. Website: http://www.aspenlink.com/jjohnson. Owner: Joanne M. Johnson. Estab. 1987. Stock photo agency. Has 10,000 photos. Clients include: book/encyclopedia publishers, magazine publishers, postcard companies, calendar companies and greeting card companies.
 ● Silver Visions is in the process of creating a CD-ROM catalog of low resolution images for distribution to publishers.
Needs: Emphasizes lifestyles—people, families, children, couples involved in work, sports, family outings, pets, etc. Also scenics of mountains and deserts, horses, dogs, cats, cityscapes—Denver, L.A., Chicago, Baltimore, NYC, San Francisco, Salt Lake City, capitol cities of the USA.
Specs: Uses 8×10 or 5×7 glossy or semigloss b&w prints; 35mm, 2¼×2¼ or 4×5 transparencies. Accepts images in digital format for Windows. Send via compact disc, online or floppy disk.
Payment & Terms: Pays 40-50% commission on b&w and color photos. General price range: $35-750. Offers nonexclusive contract. Charges $15/each for entries in CD-ROM catalog. Statements issued semiannually. Payment made semiannually. Offers one-time rights and English language rights. Informs photographer and allows him to negotiate when client requests all rights. Model/property release required for pets, people, upscale homes. Captions required; include identification of locations, species.
Making Contact: Query with samples. SASE. Reports in 2 weeks. Photo guidelines free with SASE.
Tips: Wants to see "emotional impact or design impact created by composition and lighting. Photos must evoke a universal human interest appeal. Sharpness and good exposures—needless to say." Sees growing demand for "minority groups, senior citizens, fitness."

■SIPA PRESS/SIPA IMAGE, 30 W. 21st St., 6th Floor, New York NY 10010. Prefers not to share information.

***THE SLIDE FILE**, 79 Merrion Square, Dublin 2 Ireland. (0001)6766850. Fax: (0001)66224476. Picture Editor: Ms. Carrie Fonseca. Stock photo agency and picture library. Has 100,000 photos. Clients include: ad agencies, public relations firms, businesses, book/encyclopedia publishers, magazine publishers, newspapers and designers.

Needs: Overriding consideration is given to Irish or Irish-connected subjects. Has limited need for overseas locations, but is happy to accept material depicting other subjects, particularly people.

Specs: Uses 35mm, 2¼ × 2¼ and 4 × 5 transparencies.

Payment & Terms: Pays 50% commission on color photos. General price range: £60-1,000 English currency ($90-1,500). Works on contract basis only. Offers exclusive contracts and limited regional exclusivity. Contracts renew automatically with additional submissions. Statements issued quarterly. Payment made quarterly. Photographers allowed to review account records. Offers one-time rights and electronic media rights. Informs photographer when client requests all rights, but "we take care of negotiations." Model release preferred. Captions required.

Making Contact: Interested in receiving work from newer, lesser-known photographers. Query with list of stock photo subjects. Works with local freelancers only. Does not return unsolicited material. Expects minimum initial submission of 250 transparencies; 1,000 images annually. "A return shipping fee is required: important that all similars are submitted together. We keep our contributor numbers down and the quantity and quality of submissions high. Send for information first." Reports in 1 month.

Tips: "Our affiliation with international picture agencies provides us with a lot of general material of people, overseas travel, etc. However, our continued sales of Irish-oriented pictures need to be kept supplied. Pictures of Irish-Americans in Irish bars, folk singing, Irish dancing, would prove to be useful. They would be required to be beautifully lit, carefully composed and good-looking, model-released people."

■SOVFOTO/EASTFOTO, INC., 48 W. 21 St., 11th Floor, New York NY 10010. (212)727-8170. Fax: (212)727-8228. Director: Victoria Edwards. Estab. 1935. Stock photo agency. Has 1 million photos. Clients include: audiovisual firms, book/encyclopedia publishers, magazine publishers, newspapers.

● This agency markets images via the Picture Network International.

Needs: Interested in photos of Eastern Europe, Russia, China, CIS republics.

Specs: Uses 8 × 10 glossy b&w and color prints; 35mm transparencies.

Payment & Terms: Pays 50% commission. Average price per image (to clients): $150-250/b&w photo; $150-250/color photo. Negotiates fees below standard minimum prices. Offers exclusive contracts, limited regional exclusivity and nonexclusivity. Statements issued quarterly. Payment made quarterly. Photographers permitted to review account records to verify sales figures or account for various deductions. Offers one-time, electronic media and nonexclusive rights. Model/property release preferred. Captions required.

Making Contact: Arrange personal interview to show portfolio. Query with samples. Query with stock photo list. Samples kept on file. SASE. Expects minimum initial submission of 50-100 images. Reports in 1-2 weeks.

Tips: Looks for "news and general interest photos (color) with human element."

‡■*SPORTING PICTURES (UK), LTD., 7A Lambs Conduit Passage, London WC1R 4RG England. (0171)405-4500. Fax: (0171)831-7991. Picture Editor: Dustin Downing. Estab. 1972. Stock photo agency, picture library. Has 3 million photos. Clients include: advertising agencies, public relations firms, audiovisual firms, businesses, book/encyclopedia publishers, magazine publishers, newspapers, postcard companies, calendar companies and greeting card companies.

Needs: Sport photos: gridiron, basketball, baseball, ice hockey, boxing and athletics, especially leisure sports, children in sports, amateur sports, adventure sports.

Specs: Uses 35mm transparencies.

Payment & Terms: Pays 50-60% commission. Enforces minimum prices. Works with or without a signed contract, negotiable; offers guaranteed subject exclusivity. Statements issued quarterly. Payment made quarterly. Does not inform photographer or allow him to negotiate when client requests all rights. Model/property release preferred. Captions preferred.

Making Contact: Interested in receiving work from newer, lesser-known photographers. Submit portfolio for review. Samples kept on file "if pictures are suitable." SASE. Expects minimum initial submission of 50 images. Reports ASAP.

SPORTSLIGHT PHOTO, 127 W. 26 St., Suite 800, New York NY 10001. Website: http://www.fotosho w.com/fotoshow/sportslight/. Director: Roderick Beebe. Stock photo agency. Has 500,000 photos. Clients include: ad agencies, public relations firms, corporations, book publishers, magazine publishers, newspapers, postcard companies, calendar companies, greeting card companies and design firms.

Needs: "We specialize in every sport in the world. We deal primarily in the recreational sports such as skiing, golf, tennis, running, canoeing, etc., but are expanding into pro sports, and have needs for all pro

sports, action and candid close-ups of top athletes. We also handle adventure-travel photos, e.g., rafting in Chile, trekking in Nepal, dogsledding in the Arctic, etc.''

Specs: Uses 35mm transparencies.

Payment & Terms: Pays 50% commission. General price range (to clients): $100-6,000. Contract negotiable. Offers limited regional exclusivity. Contract is of indefinite length until either party (agency or photographer) seeks termination. Charges fees for catalog and CD-ROM promotions. Statements issued quarterly. Payment made quarterly. Photographers allowed to review account records to verify sales figures ''when discrepancy occurs.'' Offers one-time rights, rights depend on client, sometimes exclusive rights for a period of time. Informs photographer and consults with him/her when client requests all rights. Model release required for corporate and advertising usage. (Obtain releases whenever possible.) Strong need for model-released ''pro-type'' sports. Captions required; include who, what, when, where, why.

Making Contact: Interested in receiving work from newer and known photographers. Query with list of stock photo subjects, ''send samples *after* our response.'' SASE must be included. Cannot return unsolicited material. Reports in 2-4 weeks. Photo guideline sheet free with SASE.

Tips: In reviewing work looks for ''range of sports subjects that shows photographer's grasp of the action, drama, color and intensity of sports, as well as capability of capturing great shots under all conditions in all sports. Well edited, perfect exposure and sharpness, good composition and lighting in all photos. Seeking photographers with strong interests in particular sports. Shoot variety of action, singles and groups, youths, male/female—all combinations. Plus leisure, relaxing after tennis, lunch on the ski slope, golf's 19th hole, etc. Clients are looking for all sports these days. All ages, also. Sports fashions change rapidly, so that is a factor. Art direction of photo shoots is important. Avoid brand names and minor flaws in the look of clothing. Attention to detail is very important. Shoot with concepts/ideas such as teamwork, determination, success, lifestyle, leisure, cooperation and more in mind. Clients look not only for individual sports, but for photos to illustrate a mood or idea. There is a trend toward use of real-life action photos in advertising as opposed to the set-up slick ad look. More unusual shots are being used to express feelings, attitude, etc.''

■**TOM STACK & ASSOCIATES**, 103400 Overseas Hwy., Suite 238, Key Largo FL 33037. (305)453-4344. Fax: (305)453-3868. Contact: Jamie Stack. Member of the Picture Agency Council of America (PACA). Has 1.5 million photos. Clients include: ad agencies, public relations firms, businesses, audiovisual firms, book publishers, magazine publishers, encyclopedia publishers, postcard companies, calendar companies and greeting card companies.

Needs: Wildlife, endangered species, marine-life, landscapes, foreign geography, people and customs, children, sports, abstract/art and mood shots, plants and flowers, photomicrography, scientific research, current events and political figures, Native Americans, etc. Especially needs women in ''men's'' occupations; whales; solar heating; up-to-date transparencies of foreign countries and people; smaller mammals such as weasels, moles, shrews, fisher, marten, etc.; extremely rare endangered wildlife; wildlife behavior photos; current sports; lightning and tornadoes; hurricane damage. Sharp images, dramatic and unusual angles and approach to composition, creative and original photography with impact. Especially needs photos on life science, flora and fauna and photomicrography. No run-of-the-mill travel or vacation shots. Special needs include photos of energy-related topics—solar and wind generators, recycling, nuclear power and coal burning plants, waste disposal and landfills, oil and gas drilling, supertankers, electric cars, geothermal energy.

Specs: Uses 35mm transparencies. Accepts images in digital format for Mac (TIFF). Send via compact disc, SyQuest or Zip disk.

Payment & Terms: Pays 50-60% commission. General price range (to clients): $150-200/color; as high as $7,000. Works on contract basis only. Contracts renew automatically with additional submissions for 3 years. Charges duping and catalog insertion fees. Statements issued quarterly. Payment made quarterly. Offers one-time and electronic media rights. Informs photographer and allows him to negotiate when client requests all rights. Model release preferred. Captions preferred.

Making Contact: Query with list of stock photo subjects or send at least 800 transparencies for consideration. SASE or mailer for photos. Reports in 2 weeks. Photo guidelines with SASE.

Tips: ''Strive to be original, creative and take an unusual approach to the commonplace; do it in a different and fresh way.'' Have ''more action and behavioral requests for wildlife. We are large enough to market worldwide and yet small enough to be personable. Don't get lost in the 'New York' crunch—try us. Shoot quantity. We try harder to keep our photographers happy. We attempt to turn new submissions around within two weeks. We take on only the best so we can continue to give more effective service.''

‡■**THE STOCK BROKER**, Dept. PM, Suite 110, 450 Lincoln St., Denver CO 80203. (303)698-1734. Fax: (303)698-1964. E-mail: quality@tsbroker.com. Website: http://www.tsbroker.com. Contact: Dawn Fink or Garth Gibson. Estab. 1981. Stock photo agency. Member of Picture Agency Council of America (PACA). Has 300,000 photos. Clients include: advertising agencies, public relations firms, audiovisual

firms, businesses, book/encyclopedia publishers, magazine publishers and calendar companies.

Needs: Recreational and adventure sports, travel, nature, business/industry, people and lifestyles.

Specs: Uses 8×10 glossy b&w prints; 35mm, $2\frac{1}{4} \times 2\frac{1}{4}$, 4×5 or 8×10 transparencies.

Payment & Terms: Pays 50% commission on color and b&w photos. General price range: $200-4,000. Works on contract basis only. Offers guaranteed subject exclusivity (within files). Statements issued quarterly. Payment made monthly. Offers one-time rights. Informs photographer and allows him to negotiate when client requests all rights. Model release required.

Making Contact: Query with samples. SASE. Reports in 1 month. Photo guidelines free with SASE. Market tips sheet distributed to contract photographers.

Tips: "Since we rarely add new photographers we look for outstanding work both aesthetically and technically. Photos that are conceptual, simple, graphic, and bright and work well for advertising are selected over those that are simply documentary, busy or subtle. Clients are getting more daring and creative and expect better quality. Each year this has caused our standards to go up and our view of what a stock photo is to expand."

STOCK IMAGERY, L.L.C., (formerly Stock Imagery, Inc.), 1822 Blake St.. Suite A, Denver CO 80202. (303)293-0202. Fax: (303)293-3140. E-mail: stocimage@aol.com. Contact: Yunhee Pettibone. Estab. 1981. Stock photo agency. Member of Picture Agency Council of America (PACA). Has over 250,000 photos. "With representation in over 40 countries worldwide, our catalogs receive maximum exposure. Monthly correspondence and biannual newsletter gives market tips, industry information and a requst list."

Needs: Alternative processes and creative styles.

Specs: Transparencies and b&w prints only; no color prints.

Payment & Terms: Pays 50% commission on image sales. "We have competitive prices, but under special circumstances we contact photographer prior to negotiations." Works on contract basis only. Offers nonexclusive contracts. Statements and payments issued monthly. Photographers allowed to review account records. Offers one-time and electronic media rights. Informs photographer and allows him to negotiate when client requests all rights. Model/property release required. Captions required.

Making Contact: "We are always willing to review new photographers' work. Please call for submission guidelines. Photographer must have 50-150 images on file to be put under contract. Submit a well-edited sample of your work. Selection must be a good representation of the type and caliber of work that you can supply on a regular basis. Because of our location, we are saturated with nature, scenics and travel photos. We welcome any unique and visionary images that separate you as an artist from the highly competitive industy."

STOCK OPTIONS®, Dept. PM, 4602 East Side Ave., Dallas TX 75226. (214)823-6262. Fax: (214)826-6263. Owner: Karen Hughes. Estab. 1985. Stock photo agency. Member of Picture Agency Council of America (PACA). Has 200,000 photos. Clients include: ad agencies, public relations firms, audiovisual firms, corporations, book/encyclopedia and magazine publishers, newspapers, postcard companies, calendar and greeting card companies.

• This agency hopes to market work on CD-ROM in the near future.

Needs: Emphasizes the southern US. Files include Gulf Coast scenics, wildlife, fishing, festivals, food, industry, business, people, etc. Also western folklore and the Southwest.

Specs: Uses 35mm, $2\frac{1}{4} \times 2\frac{1}{4}$ and 4×5 transparencies.

Payment & Terms: Pays 50% commission on color photos. General price range (to clients): $300-3,000. Works on contract basis only. Offers nonexclusive contract. Contract automatically renews with each submission to 5 years from expiration date. When contract ends photographer must renew within 60 days. Charges catalog insertion fee of $300/image and marketing fee of $6/hour. Statements issued upon receipt of payment from client. Payment made immediately. Photographers allowed to review account records to verify sales figures. Offers one-time and electronic media rights. "We will inform photographers for their consent only when a client requests all rights, but we will handle all negotiations." Model/property release preferred for people, some properties, all models. Captions required; include subject and location.

Making Contact: Interested in receiving work from full-time commercial photographers. Arrange a personal interview to show portfolio. Query with list of stock photo subjects. Contact by "phone and submit 200 sample photos." Tips sheet distributed annually to all photographers.

THE SUBJECT INDEX, located at the back of this book, lists publications, book publishers, galleries, paper product companies and stock agencies according to the subject areas they seek.

Tips: Wants to see "clean, in focus, relevant and current materials." Current stock requests include: industry, environmental subjects, people in up-beat situations, minorities, food, cityscapes and rural scenics.

■**STOCK PILE, INC.**, Main office: Dept. PM, 2404 N. Charles St., Baltimore MD 21218. (410)889-4243. Branch: P.O. Box 30168, Grand Junction CO 81503. (303)243-4255. Vice President: D.B. Cooper. Picture library. Has 28,000 photos. Clients include: ad agencies, art studios, slide show producers, etc.
Needs: General agency looking for well-lit, properly composed images that will attract attention. Also, people, places and things that lend themselves to an advertising-oriented marketplace.
Specs: Transparencies, all formats. Some b&w 8×10 glossies.
Payment & Terms: Pays 50% commission on b&w and color photos. Works on contract basis only. Contracts renew automatically with additional submissions. Payment made monthly. Offers one-time rights. Informs photographer and permits him to negotiate when client requests all rights. Model release preferred. Captions required.
Making Contact: Interested in receiving work from newer, lesser-known photographers. Inquire for guidelines, submit directly (minimum 200) or call for personal interview. All inquiries and submissions must be accompanied by SASE. *Send all submissions to Colorado address.* Periodic newsletter sent to all regular contributing photographers.

■**THE STOCKHOUSE, INC.**, Box 540367, Houston TX 77254-0367. (713)942-8400. Fax: (713)526-4634. Sales and Marketing Director: Celia Jumonville. Stock photo agency. Member of Picture Agency Council of America (PACA). Has 500,000 photos. Clients include: ad agencies, public relations firms, audiovisual firms, businesses, book/encyclopedia publishers, magazine publishers, newspapers, postcard companies, calendar companies and greeting card companies.
Needs: Needs photos of general topics from travel to industry, lifestyles, nature, US and foreign countries. Especially interested in Texas and petroleum and medical.
Specs: Uses 35mm, 2¼×2¼, 4×5, 8×10 transparencies; "originals only."
Payment & Terms: Pays 50% commission on color photos. General price range (to clients): $200-1,000. Works on contract basis only. Offers limited regional exclusivity. Statements issued monthly. Payment made following month after payment by client. Photographers allowed to review account records to verify sales figures by appointment. Offers one-time rights; other rights negotiable. Informs photographer when client requests all rights; negotiating must be handled through the agency only. Model/property release preferred for people and personal property for advertising use; photographer retains written release. Photo captions required; include location, date and description of activity or process.
Making Contact: Interested in receiving work from newer, lesser-known photographers. Query with samples; request guidelines and tipsheet. Send submissions to 3301 W. Alabama, Houston TX 77098. SASE. Photo guidelines free with SASE. Tips sheet distributed quarterly to contract photographers.
Tips: In freelancers' samples, wants to see "quality of photos—color saturation, focus and composition. Also variety of subjects and 200-300 transparencies on the first submission. Trends in stock vary depending on the economy and who is needing photos. Quality is the first consideration and subject second. We do not limit the subjects submitted since we never know what will be requested next. Industry and lifestyles and current skylines are always good choices."

■**SUPERSTOCK INC.**, 7660 Centurion Pkwy, Jacksonville FL 32256. (904)565-0066. Photographer Liaison: Dawn Hendel. Photo Editor: Vincent Hobbs. International stock photo agency represented in 38 countries. Extensive vintage and fine art collection available for use by clients. Clients include: ad agencies, public relations firms, audiovisual firms, businesses, book/encyclopedia publishers, magazine publishers, newspapers, postcard companies, calendar companies, greeting card companies and major corporations.
Needs: "We are a general stock agency involved in all markets. Our files are comprised of all subject matter."
Specs: Uses b&w prints; 35mm, 2¼×2¼, 4×5, 8×10 transparencies.
Payment & Terms: "We work on a contract basis." Statements issued monthly. Photographers allowed to review account records to verify sales figures. Rights offered "vary, depending on client's request." Informs photographer and allows him to negotiate when client requests all rights. Model release required. Captions required.
Making Contact: Query with résumé of credits. Query with tearsheets only. Query with list of stock photo subjects. "When requested, we ask that you submit a portfolio of a maximum of 200 original transparencies, duplicate transparencies or prints as your sample. If we need to see additional images, we will contact you." Reports in 3 weeks. Photo guidelines sheet free if requested via phone or mail. Newsletter distributed quarterly to contracted photographers.
Tips: "We do not want to tell you what to shoot; we want to see what you can shoot. We are interested in images that are on the cutting edge of photography. We are particularly interested in seeing lifestyles,

people, sports, still-life, travel, business and industry, as well as other images that show the range of your photography."

SWANSTOCK AGENCY INC., P.O. Box 2350, Tucson AZ 85702. (520)622-7133. Fax: (520)622-7180. Contact: Submissions. Estab. 1991. Stock photo agency. Has 100,000 photos. Clients include: ad agencies, public relations firms, book/encyclopedia publishers, magazine publishers, newspapers, postcard publishers, calendar companies, greeting card companies, design firms, record companies and inhouse agencies.

Needs: Swanstock's image files are artist-priority, not subject-driven. Needs range from photo-illustration to realistic family life in the '90s. (Must be able to provide releases upon request.)

Specs: Uses 8×10 or smaller color and b&w prints; 35mm, $2\frac{1}{4} \times 2\frac{1}{4}$, 4×5, 8×10 transparencies. *Send dupes only.*

Payment & Terms: Pays 50% commission on stock sale; 75% commission otherwise. Average price per image (to clients): $200-1,000. Negotiates fees below standard minimum prices if agreeable to photographer in exchange for volume overrun of piece for promotional needs. Offers volume discounts to customers; terms specified in photographer's contract. Photographers can choose not to sell images on discount terms. Works on contract basis only. Offers nonexclusive contracts. Photographers provide all dupes for agency files. Charges editing fee. Statements issued upon sales only, within 1 month of payment by client. Photographers allowed to review account records by appointment only. "We sell primarily one-time rights, but clients frequently want one of the following arrangements: one year, domestic only; one year, international; one year with an option for an immediate second year at a predetermined price; one year, unlimited usage for a specific market only; one year, unlimited usages within ALL markets; all rights for the life of that specific edition only (books) and so forth." Informs photographer when client requests all rights and allows photographer to negotiate if they have experience with negotiation and have a prior relationship with the client. Model release often required. Captions preferred; include where and when.

Making Contact: Interested in receiving work from lesser-known photographers with accomplished work. Query with samples. Include SASE to receive submission details. Keeps samples on file. SASE. Reporting time may be longer than 1 month.

Tips: "We look for bodies of work that reflect the photographer's consistent vision and sense of craft—whether their subject be the landscape, still lifes, family, or more interpretive illustration. Alternative processes are encouraged (i.e., Polaroid transfer, hand-coloring, infrared films, photo montage, pinhole and Diana camera work, etc.). Long-term personal photojournalistic projects are of interest as well. We want to see the work that you feel strongest about, regardless of the quantity. Artists are not required to submit new work on any specific calendar, but rather are asked to send new bodies of work upon completion. We do not house traditional commercial stock photography, but rather work that was created by fine art photographers for personal reasons or for the gallery/museum arena. The majority of requests we receive require images to illustrate an emotion, a gesture, a season rather than a specific place geographically or a particular product. Our goal with each submission to clients is to send as many different photographers' interpretations of their need, in as many photographic processes as possible. We communicate with our clients in order to keep the usages within the original intent of the photographer (i.e., submitting proofs of desired placement of copy, wrapping an image around a book jacket, etc.) and frequently place the artist in communication with the client with regard to creative issues. Swanstock offers a nonexclusive contract and encourages photographers to place specific bodies of their work with the appropriate agency(s) for maximum return. We do NOT publish a catalog and ask that photographers supply us with appropriate promotional materials to send to clients. Under no circumstances should artists presume they will make a living on fine art stock in the way that commercial stock shooters do. However, we are confident that this 'niche' market will continue to improve, and encourage artists who previously felt there was no market for their personal work to contact us."

✦TAKE STOCK INC., 307, 319 Tenth Ave. SW, Calgary, Alberta T2R 0A5 Canada. (403)261-5128. Fax: (403)261-5723. Estab. 1987. Stock photo agency. Clients include: ad agencies, public relations firms, audiovisual firms, corporate, book/encyclopedia publishers, magazine publishers, newspapers, postcard companies, calendar companies and greeting card companies.

Needs: Model-released people, lifestyle images (all ages), Asian people, Canadian images, arts/recreation, industry/occupation, business, high-tech, beach scenics with and without model release.

Specs: Uses 35mm, medium to large format transparencies.

Payment & Terms: Pays 50% commission on transparencies. General price range (to clients): $300-700. Works on contract basis only. Offers limited regional exclusivity. Contracts renew automatically with additional submissions for 3 years." Charges 100% duping and catalog insertion fees. Statements issued monthly. Payment made monthly. Photographers allowed to review account records to verify sales figures, "with written notice and at their expense." Offers one-time, exclusive and some multi-use rights; some buy-outs with photographer's permission. Model/property release required. Captions required.

Making Contact: Query with list of stock photo subjects. SASE. Reports in 3 weeks. Photo guidelines free with SASE. Tips sheet distributed every 2 months to photographers on file.

TERRAPHOTOGRAPHICS, Box 490, Moss Beach CA 94038. Phone/fax: (415)359-6219. E-mail: bpsterra@aol.com. Photo Agent: Carl May. Estab. 1985. Stock photo agency. Has 30,000 photos on hand. Clients include: ad agencies, businesses, book/encyclopedia publishers and magazine publishers.
Needs: All subjects in the earth sciences: geological features seen from space, paleontology, volcanology, seismology, petrology, oceanography, climatology, mining, petroleum industry, meteorology, physical geography. Stock photographers must be scientists. "Currently, we need more on energy conservation, gems, economic minerals, volcanic eruptions, earthquakes, floods and severe weather."
Specs: Uses 8×10 glossy b&w prints; 35mm, $2\frac{1}{4} \times 2\frac{1}{4}$, 4×5 and 8×10 transparencies.
Payment & Terms: Pays 50% commission on all photos. General price range (to clients): $90-500. Works with or without a signed contract, negotiable. Offers exclusive contract only. Statements issued quarterly. Payment quarterly within 1 month of end of quarter. Photographers allowed to review account records to verify sales figures. Offers one-time rights and electronic media rights for specific projects only; other rights negotiable. Informs photographer and allows participation when client requests all rights. Model release required for any commercial use, but not purely editorial. Thorough photo captions required; include "all information necessary to identify subject matter and give geographical location."
Making Contact: Will consider work from newer, lesser-known scientist-photographers as well as established professionals. Query with list and résumé of scientific and photographic background. SASE. Reports in 2 weeks. Photo guidelines free with query, résumé and SASE. Tips sheet distributed intermittently only to stock photographers.
Tips: Prefers to see "proper exposure, maximum depth of field, interesting composition, good technical and general information in caption, scientists at work using modern equipment. We are a suitable agency only for those with both photographic skills and sufficient technical expertise to identify subject matter. We only respond to those who provide a rundown of their scientific and photographic background and at least a brief description of coverage. Captions must be neat and contain precise information on geographical locations. Don't waste your time submitting images on grainy film. Our photographers should be able to distinguish between dramatic, compelling examples of phenomena and run-of-the-mill images in the earth and environmental sciences. We need more on all sorts of weather phenomena; the petroleum and mining industries from exploration through refinement; problems and management of toxic wastes; environmental problems associated with resource development; natural areas threatened by development; and oceanography."

THIRD COAST STOCK SOURCE, 740 N. Plankinton Ave, Suite 824, Milwaukee WI 53203-2403. (414)765-9442. Fax: (414)765-9342. Director: Paul Henning. Managing Editor: Mary Ann Platts. Member of Picture Agency Council of America (PACA) and the American Society of Picture Professionals (ASPP). Has over 150,000 photos. Clients include: ad agencies, public relations firms, audiovisual firms, corporations, book/encyclopedia publishers, magazine publishers, graphic designers, calendar companies and greeting card companies.
 • Third Coast is affiliated with the Picture Cube in Boston and also has affiliates in Japan, Argentina, Canada and Europe. They have images on *The Stock Workbook* CD-ROM.
Needs: People in lifestyle situations, business, industry, sports and recreation, medium format scenics (domestic and foreign), traditional stock photo themes with a new spin.
Specs: Uses 35mm, $2\frac{1}{4} \times 2\frac{1}{4}$, 4×5 and 8×10 transparencies (slow and medium speed color transparency film preferred). Accepts images in digital format for Windows for review only (JPEG, GIFF). Send via floppy disk or as e-mail attachment.
Payment & Terms: Pays 50% commission on all photos. General price range (to clients): $200 and up. Enforces minimum prices. Works on contract basis only. Offers various levels regional and image exclusivity. Contracts with photographers renew automatically for 2 or 3 years. Charges duping and catalog insertion fees; print and electronic promotions costs are shared with contributors. Statements issued bimonthly. Payment made bimonthly. Photographers allowed to review account records to verify sales figures. Offers one-time and electronic media rights. Informs photographer when client requests all rights; "we will consult

MARKET CONDITIONS are constantly changing! If you're still using this book and it's 1999 or later, buy the newest edition of *Photographer's Market* at your favorite bookstore or order directly from Writer's Digest Books.

with the photographer, but all negotiations are handled by the agency." Model release required. Captions required.

Making Contact: Interested in receiving work from any photographer with professional-quality material. Submit 200-300 images for review. SASE. Reports in 1 month. Photo guidelines free with SASE. Tips sheet distributed 2 times/year to "photographers currently working with us."

Tips: "We are looking for technical expertise; outstanding, dramatic and emotional appeal. We are anxious to look at new work. Learn what stock photography is all about. Our biggest need is for photos of model-released people: couples, seniors, business situations, recreational situations, etc. Also, we find it very difficult to get great winter activity scenes (again, with people) and photos which illustrate holidays: Christmas, Thanksgiving, Easter, etc."

***TROPIX PHOTOGRAPHIC LIBRARY**, 156 Meols Parade, Meols, Merseyside L47 6AN England. Phone/fax: 151-632-1698. Website: http://www.connect.org.uk/merseymall/Tropix. Proprietor: Veronica Birley. Picture library specialist. Has 60,000 transparencies. Clients include: book/encyclopedia publishers, magazine publishers, newspapers, government departments, public relations firms, businesses, calendar/ card companies and travel agents.

Needs: "All aspects of the developing world and the natural environment. Detailed and accurate captioning according to Tropix guidelines is essential. Tropix documents the developing world from its economy and environment to its society and culture. Education, medicine, agriculture, industry, technology and other developing world topics. Particularly keep to show positive, modern aspects. Plus the full range of environmental topics worldwide."

Specs: Uses 35mm and medium format transparencies; some large format.

Payment & Terms: Pays 50% commission. General price range (to clients): £60-250 (English currency). Works on contract basis only. Offers guaranteed subject exclusivity. Charges cost of returning photographs by insured/registered post, if required. Statements made quarterly with payment. Photographers allowed to have qualified auditor review account records to verify sales figures in the event of a dispute but not as routine procedure. Offers one-time, electronic media and agency promotion rights. Other rights only by special written agreement. Informs photographer when a client requests all rights but agency handles negotiation. Model release preferred, for medical images. Full photo captions required; accurate, detailed data, to be supplied on disk. Guidelines are available from agency.

Making Contact: Interested in receiving work from both established and newer, lesser-known photographers. Query with list of stock photo subjects and destinations, plus SASE (International Reply Paid Coupon to value of £3). "*No* unsolicited photographs, please." Reports in 1 month, sooner if material is topical. "On receipt of our leaflets, a very detailed reply should be made by letter. Transparencies are requested only after receipt of this letter, if the collection appears suitable. When submitting transparencies, always screen out those which are technically imperfect."

Tips: Looks for "special interest topics, accurate and informative captioning, sharp focus always, correct exposure, strong images and an understanding of and involvement with specific subject matters. Travel scenes, views and impressions, however artistic, are not required except as part of a much more informed, detailed collection. Not less than 150 saleable transparencies per country photographed should be available." Sees a trend toward electronic image grabbing and development of a pictorial data base.

UNICORN STOCK PHOTO LIBRARY, 7809 NW 86th Terrace, Kansas City MO 64153-1769. (816)587-4131. Fax: (816)741-0632. President/Owner: Betts Anderson. Has 300,000 color slides. Clients include: ad agencies, corporate accounts, textbooks, magazines, calendars and religious publishers.

Needs: Ordinary people of all ages and races doing everyday things: at home, school, work and play. Current skylines of all major cities, tourist attractions, historical, wildlife, seasonal/holiday, and religious subjects. "We particularly need images showing two or more races represented in one photo and family scenes with BOTH parents. There is a critical need for more minority shots including Hispanics, Orientals and blacks. We also need ecology illustrations such as recycling, pollution and people cleaning up the earth."

Specs: Uses 35mm color slides.

Payment & Terms: Pays 50% commission. General price range (to clients): $50-400. Works on contract basis only. Offers nonexclusive contract. Contracts renew automatically with additional submissions for 3 years. Charges duping fee; rate not specified. Statement issued quarterly. Payment made quarterly. Offers one-time rights. Informs photographer and allows him to negotiate when client requests all rights. Model release preferred; increases sales potential considerably. Photo captions required; include: location, ages of people, dates on skylines.

Making Contact: Write first for guidelines. "We are looking for professionals who understand this business and will provide a steady supply of top-quality images. At least 500 images are required to open a file. Contact us by letter including $10 for our 'Information for Photographers' package."

Tips: "We keep in close, personal contact with all our photographers. Our monthly newsletter is a very

popular medium for doing this. Our biggest need is for minorities and interracial shots. If you can supply us with this subject, we can supply you with checks. Because UNICORN is in the Midwest, we have many requests for farming/gardening/agriculture/winter and general scenics of the Midwest."

‡**UNIPHOTO PICTURE AGENCY**, a Pictor Group company, 3307 M St. NW, Suite 300, Washington DC 20007. (202)333-0500. Fax: (202)338-5578. Art Director: Page Carr. Estab. 1977. Stock photo agency. Has more than 750,000 photos. Has 22 other branch offices worldwide. US photographers contact Washington DC. European photographers please see Pictor International in this section. Clients include: advertising agencies, public relations firms, audiovisual firms, businesses, book/encyclopedia publishers, magazine publishers, postcard publishers, calendar companies, greeting card companies and travel agencies.
 • In 1997, Uniphoto acquired the photo library of F-Stock, Inc. and has moved the F-Stock library and roster to the Uniphoto West Office.
Needs: Uniphoto is a general library and requires all stock subjects.
Specs: Uses 35mm, 2¼×2¼, 4×5 transparencies.
Payment & Terms: Buys photos outright only occasionally. Payment "depends on the pictures." Takes 50% commission on licensing revenues received by Uniphoto. Average fee per image (to clients): $250-30,000. Enforces minimum prices. Works on contract basis only. Offers exclusive contract. "Under special circumstances, contract terms may be negotiated." Contracts renew automatically with additional submissions for 5 years. Charges various rates for catalog insertion fees. Statements issued monthly. Payment made monthly within 3½ months. Offers one-time and all other commercial rights. When client requests all rights we negotiate with photographer's permission. Model/property release required. Captions required.
Making Contact: Interested in receiving work from newer, lesser-known photographers. Query with résumé of credits and non-returnable samples. Keeps samples on file. SASE. Reports in 4 months on queries; up to 2 weeks on portfolio submissions. Portfolio submission guidelines free with SASE. Market tips sheet distributed to Uniphoto photographers only.
Tips: "Portfolios should demonstrate the photographer's creative and technical range. We seek professional photographers and accomplished fine artists with commercial potential as well as experienced stock photographers."

U.S. NAVAL INSTITUTE, 118 Maryland Ave., Annapolis MD 21402. (410)268-6110. Fax: (410)269-7940. Contact: Photo Editor. Picture library. Has 450,000 photos. Clients include: public relations firms, audiovisual firms, businesses, book/encyclopedia publishers, magazine publishers, newspapers, calendar companies, greeting card companies. "Anyone who may need military photography. We are a publishing press, as well."
Needs: US and foreign ships, aircraft, equipment, weapons, personalities, combat, operations, etc. "Anything dealing with military."
Specs: Uses 5×7, 8×10 color and/or b&w prints; 35mm transparencies.
Payment & Terms: Payment made 1 month after usage. Offers rights on a case-by-case basis. Informs photographer and allows him to negotiate when client requests all rights, "if requested in advance by photographer." Model/property release preferred. Captions required; include date taken, place, description of subject.
Making Contact: Interested in receiving work from newer, lesser-known photographers. Query with samples. Samples kept on file. SASE and Social Security number. Expects minimum initial submission of 5 images. Reports in 1 month. Photo guidelines free with SASE.
Tips: "We do not look for posed photography. We want dramatic images or those that tell a story. The U.S. Naval Institute is a nonprofit agency and purchases images outright on a very limited basis. However, we do pay for their use within our own books and magazines. Prices are somewhat negotiable, but lower than what the profit-making agencies pay."

■**VIESTI ASSOCIATES, INC.**, P.O. Box 20424, New York NY 10021. (212)787-6500. Fax: (212)595-6303. President: Joe Viesti. Estab. 1987. Stock photo agency. Has 30 affiliated foreign subagents. Clients include: ad agencies, businesses, book/encyclopedia publishers, magazine publishers, calendar companies, greeting card companies, design firms.
 • Viesti is involved with CD-ROM and modem transmission of images. The images contain a watermark to protect copyright. Viesti is "dead set against clip art sales."
Needs: "We are a full service agency."
Specs: Uses 35mm, 2¼×2¼, 4×5, 6×7, 8×10 transparencies; both color and b&w transparencies; all film formats.
Payment & Terms: Charges 50% commission. "We negotiate fees above our competitors on a regular basis." Works on contract basis only. "Catalog photos are exclusive." Contract renews automatically upon expiration for 5 years. Charges duping fees "at cost. Many clients now require submission of dupes only." Statements issued monthly. "Payment is made the month after payment is received. Photographers'

accountants may review records upon proper notice, and without disrupting office operations." R̶ᵍ̶ vary. Informs photographer and allows him to negotiate when client requests all rights. Model/property release preferred. Captions required.

Making Contact: Interested in receiving work from newer, lesser-known (but serious) photographers as well as from established photographers. Query with samples. Send no originals. Send dupes or tearsheets only with bio info and size of available stock; include return postage if return desired. Samples kept on file. Expects minimum submissions of 500 edited images; 100 edited images per month is average. Submissions edited and returned usually within one week. Catalog available for fee, depending upon availability.

Tips: There is an "increasing need for large quantities of images from interactive, multimedia clients and traditional clients. No need to sell work for lower prices to compete with low ball competitors. Our clients regularly pay higher prices if they value the work."

‡VISIONQUEST, P.O. Box 8005, Charlotte NC 28203. (704)525-4800; (800)801-6717. Fax: (704)525-7030. E-mail: 74203,3051@compuserve.com. Owner: Pamela Brackett. Estab. 1994. Has 200,000 photos. Clients include: advertising agencies, businesses, newspapers, postcard publishers, public relations firms, book/encyclopedia publishers, calendar companies, audiovisual firms, magazine publishers and greeting card companies.

Needs: Uses transparencies.

Payment & Terms: Pays 50% commission on b&w and color photos. Offers volume discounts to customers; terms specified in photographer's contract. Works on contract basis only. Offers limited regional exclusivity contracts. Contracts renew automatically with additional submissions after 3 years. Photographer pays duping and catalog insertion fees. Statements issued quarterly. Payment made quarterly. Photographers allowed to review account records. Offers one-time rights. "If client pays more they can get more usage rights." Informs photographer and allows him to negotiate when client requests all rights. This is not recommended, but we will negotiate with client if approved by photographer. Model release required. Property release preferred. Captions required.

Making Contact: Interested in receiving work from newer, lesser-known photographers. Query with résumé of credits. Query with samples. Query with stock photo list. Keeps samples on file. SASE. Expects minimum intial submission of 200 images. Reports in 1-2 weeks. Photo guidelines free with SASE. Catalog available. Market tips sheet distributed weekly to photographers with agency; free by fax.

Tips: Looking for "professional photographers with excellence, creativity and personal style who are committed to shooting stock."

❦VISUAL CONTACT, 67 Mowat Ave., Suite 241, Toronto, Ontario M6K 3E3 Canada. (416)532-8131. Fax: (416)532-3792. E-mail: viscon@interlog.com. Website: http://www.interlog.com/~viscon. President: Thomas Freda. Library Administrator: Laura Chen. Estab. 1990. Stock photo agency. Has applied to become PACA member. Has 30,000 photos. Clients include: ad agencies, public relations firms, businesses, book/encyclopedia publishers, magazine publishers, calendar companies, greeting card companies.

Needs: Interested in photos of people/lifestyle, people/corporate, industry, nature, travel, science and technology, medical, food.

Specs: Uses transparencies.

Payment & Terms: Pays 50% commission on color photos. Offers volume discounts to customers; inquire about specific terms. Works with or without signed contract, negotiable. Offers exclusive only, limited regional, nonexclusive, or guaranteed subject exclusivity contracts. Contracts renew automatically with additional submissions for 1 year (after first 5 years). Charges 100% duping fee, 100% mounting, 100% CD/online service. Statements issued quarterly. Payment made quarterly. Photographers allowed to review account records in cases of discrepancies only. Offers one-time rights. Informs photographer and allows him to negotiate when client requests all rights. Model/property release required. Captions required; include location, specific names, i.e., plants, animals.

Making Contact: Interested in receiving work from newer, lesser-known photographers. Arrange personal interview to show portfolio. Submit portfolio for review. Query with résumé of credits. Query with samples. Query with stock photo list. Keeps samples on file. SASE. Expects minimum initial submission of 100-200 images. Reports in 4-6 weeks. Photo guidelines free with SASE. Market tips sheet distributed free with SASE; also available, along with periodic newsletter, at website.

VISUALS UNLIMITED, Dept. PM, P.O. Box 10246, East Swanzey NH 03446-0146. (603)352-6436. Fax: (603)357-7931. President: Dr. John D. Cunningham. Stock photo agency and photo research service. Has 500,000 photos. Clients include: ad agencies, public relations firms, audiovisual firms, businesses, book/encyclopedia publishers, magazine publishers, CD-ROM producers, television and motion picture companies, postcard companies, calendar companies and greeting card companies.

Needs: All fields: biology, environmental, medical, natural history, geography, history, scenics, chemistry, geology, physics, industrial, astronomy and "general."

Specs: Uses 5×7 or larger b&w prints; 35mm, 2¼×2¼, 4×5 and 8×10 transparencies.
Payment & Terms: Pays 50% commission for b&w and color photos. Negotiates fees based on use, type of publication, user (e.g., nonprofit group vs. publisher). Average price per image (to clients): $30-90/b&w photo; $50-190/color photo. Offers volume discounts to customers; terms specified in contract. Photographers can choose not to sell images on discount terms. Works on contract basis only. Offers nonexclusive contract. Contracts renew automatically for an indefinite time unless return of photos is requested. Statements issued monthly. Payment made monthly. Photographers not allowed to review account records to verify sales figures; "All payments are exactly 50% of fees generated." Offers one-time rights. Informs photographer and allows him to negotiate when client requests all rights. Model release preferred. Captions required.
Making Contact: Interested in receiving work from newer, lesser-known photographers. Query with samples or send unsolicited photos for consideration. Submit portfolio for review. SASE. Reports in 2 weeks. Photo guidelines free with SASE. Distributes a tips sheet several times/year as deadlines allow, to all people with files.
Tips: Looks for "focus, composition and contrast, of course. Instructional potential (e.g., behavior, anatomical detail, habitat, example of problem, living conditions, human interest). Increasing need for exact identification, behavior, and methodology in scientific photos; some return to b&w as color costs rise. Edit carefully for focus and distracting details; submit anything and everything from everywhere that is geographical, biological, geological, environmental, and people oriented."

‡■**WESTLIGHT**, 2223 S. Carmelina Ave., Los Angeles CA 90064. (310)820-7077. Owner: Craig Aurness. Estab. 1978. Stock photo agency. Member of Picture Agency Council of America (PACA). Has 2½ million photos. Clients include: advertising agencies, public relations firms, audiovisual firms, corporations, book/encyclopedia publishers, magazine publishers, newspapers, postcard companies, calendar companies, greeting card companies and TV.
Needs: Needs photos of all top quality subjects.
Specs: Uses 35mm, 2¼×2¼, 4×5 transparencies.
Payment & Terms: Pays 50% commission. General price range: $600 and up. Offers exclusive contract. Contracts renew automatically for 1 year at the end or 5 years if no notice is given. Charges duping fees of 100%/image. Also charges catalog insertion fee 50%/image. Statements issued quarterly. Payment made quarterly; within 45 days of end of quarter. Photographers allowed to review account records to verify sales figures. Offers one-time rights, electronic media and agency promotion rights. Informs photographer and allows him to negotiate when client requests all rights. Model/property release required for recognizable people and private places. Captions required.
Making Contact: Query with résumé of credits. Query with tearsheet samples. Query with list of stock photo subjects; show a specialty. Cannot return material. Reports in 1 month. Photo guidelines free with SASE. Tips sheet distributed monthly to contract photographers. Send tearsheets only, no unsolicited photos.
Tips: Photographer must have "ability to regularly produce the best possible photographs on a specialized subject, willingness to learn, listen and fill agency file needs. Photographers must request application in writing only. All other approaches will not be answered."

THE WILDLIFE COLLECTION, Division of Cranberry Press Inc., 69 Cranberry St., Brooklyn NY 11201. (718)935-9600. Fax: (718)935-9031. E-mail: office@wildlifephoto.com. Website: http://www.wildlifephoto.com. Director: Sharon A. Cohen. Estab. 1987. Stock photo agency. Has 250,000 photos. Clients include: ad agencies, public relations firms, businesses, book/encyclopedia publishers, magazine publishers, newspapers, postcard companies, calendar companies, greeting card companies, zoos and aquariums.
 • The Wildlife Collection has scanned thousands of images onto CD-ROM which they use for promotion.
Needs: "We handle anything to do with nature—animals, scenics, vegetation, underwater. We are in particular need of coverage from India, the Caribbean, Europe, Western Africa and the Middle East, as well as endangered animals, in particular chimpanzees, bonobos and California Condors. We also need pets and farm animals."
Specs: Uses 35mm, 2¼×2¼, 4×5, 6×4½ transparencies.
Payment & Terms: Pays 50% commission on color photos. General price range (to clients): $100-6,000. Works on contract basis only. Minimum US exclusivity but prefers world exclusivity. Contracts renew automatically for 1 year. There are no charges to be included in catalogs or other promotional materials. Statements issued monthly. Payment made monthly. Photographers allowed to review sales figures. Offers one-time rights. Informs photographers when client requests all rights, "but they can only negotiate through us—not directly." Model release "not necessary with nature subjects." Photo captions required; include common, scientific name and region found.
Making Contact: Interested in receiving work from newer, lesser-known photographers, as well as more

established photographers. Query with samples. Printed samples kept on file. SASE. Expects minimum initial submission of 200 images. "We would like 2,000 images/year; this will vary." Reports in 2 weeks. Photo guidelines and free catalog with 6½×9½ SAE with 78¢ postage. Market tips sheet distributed quarterly to signed photographers only.

Tips: In samples wants to see "great lighting, extreme sharpness, *non-stressed* animals, large range of subjects, excellent captioning, general presentation. Care of work makes a large impression. The effect of humans on the environment is being requested more often as are unusual and endangered animals."

THE DIGITAL MARKETS INDEX, located in the back of this book, lists markets that use images electronically.

Advertising, Public Relations and Audiovisual Firms

When examining most ads today it becomes obvious that creativity and technical excellence are musts for photographers wanting to crack the advertising market. Ads that sport digitally manipulated images are common, as are beautiful black and white photos. There also has been a rise in "realistic" images—those taken of events or situations involving real people rather than models. Much of this realism comes from the cameras of editorial photographers who are being hired by art directors for advertising assignments. Photojournalists are appealing to art directors because they can create believable scenes and tell stories.

Many of the people who produce cutting-edge concepts can be found in the markets in this section. They range in stature from the very small, one- or two-person operations to the corporate giants, such as Ammirati Puris Lintas in New York City.

In some listings you will notice figures for annual billing and total number of employees. While researching we found that readers appreciate this type of information when assessing markets. If you are a beginning photographer trying to get your feet wet in the advertising arena, consider approaching smaller houses. They may be more willing to work with newcomers. On the flip side, if you have a sizable list of advertising credits, larger firms might be receptive to your work.

We also have information about changes that are taking place as a result of new technologies. Many of the art directors/creative directors we contacted said they are now digitally storing and manipulating photos. They also are beginning to search online networks for stock images.

Along with advertising and public relations firms you will find audiovisual companies listed in this section. Markets with audiovisual, film or video needs have been designated with a solid, black square (■) before them. These listings also contain detailed information under the subhead "Audiovisual Needs."

Whatever your skill level, be professional in the way you present yourself. Organize your portfolio into an attractive showpiece. Also create some innovative self-promotion pieces that can be sent to art directors once your portfolio presentations are over.

For information on portfolio development and presentation, see How to Put Together a Winning Portfolio (page 10) and First Contacts and Portfolio Presentations (page 15). For additional names and addresses of advertising agencies, but no market information, see *Standard Directory of Advertising Agencies* (Reed Reference Publishing Co.).

Alabama

‡■**CORPORATE RESOURCE ASSOCIATES, INC.**, 3082 Dauphin Square Connector, Mobile AL 36607. (334)473-4942. Fax: (334)473-1220. E-mail: cramobal@aol.com. President: David Wagner. Estab. 1985. Member of AMA, AdFed. Ad agency, PR firm, AV firm. Approximate annual billing: $1.5 million. Types of clients: industrial, financial, fashion, retail, food. Examples of recent projects: "Ask for ICI," International Converters, Inc. (all media); "ZEBA," Bay City Pasta Co.
Needs: Works with 5 photographers and 2 videographers/month. Uses photos for consumer magazines, trade magazines, P-O-P displays, catalogs, posters, signage and audiovisual. Subjects include: industrial, food and catalog product. Model release required. Property release preferred.
Audiovisual Needs: Uses slides and video.
Specs: Uses 8×10 glossy color and b&w prints; 35mm, 2¼×2¼, 4×5 transparencies; 100 ISO film;

digital format (Mac).

Making Contact & Terms: Submit portfolio for review. Query with résumé of credits. Provide résumé, business card, brochure, flier or tearsheets to be kept on file for possible future assignments. Works on assignment only. Keeps samples on file. SASE. Reports in 3 weeks. Payment negotiable. **Pays on receipt of invoice.** Credit line not given. Buys electronic and all rights.

■**HUEY, COOK & PARTNERS**, 3800 Colonnade Pkwy., Suite 450, Birmingham AL 35243. (205)969-3200. Fax: (205)969-3136. Art Directors: Mike Macon/Shane Paris. Estab. 1972. Ad agency. Types of clients: retail and sporting goods.

Needs: Works with 6-10 freelance photographers/month. Uses photos for consumer magazines, trade magazines, P-O-P displays, catalogs, posters and audiovisuals. Subjects include: fishing industry, water sports. Model release preferred. Captions preferred.

Audiovisual Needs: Uses AV for product introductions, seminars and various presentations.

Specs: Uses 5×7 b&w prints; 35mm, $2\frac{1}{4} \times 2\frac{1}{4}$, 4×5 and 8×10 transparencies.

Making Contact & Terms: Submit portfolio for review. Provide business card, brochure, flier or tearsheets to be kept on file for possible future assignments. Works on assignment basis only. Pays $50-400/b&w photo; $85-3,000/color photo; $500-1,600/day; $150-20,000/job. Payment is made on acceptance plus 90 days. Buys all rights.

Tips: Prefers to see "table top products with new, exciting lighting, location, mood images of various forms of fishing and boating."

■**J.H. LEWIS ADVERTISING, INC.**, 1668 Government St., Mobile AL 36604. (334)476-2507. Fax: (334)470-9658. President Mobile Office: Emil Graf; Birmingham Office: Larry Norris. Creative Director; Birmingham Office: Spencer Till. Senior Art Directors Mobile Office: Ben Jordan and Helen Savage. Ad agency. Uses photos for billboards, consumer and trade magazines, direct mail, foreign media, newspapers, P-O-P displays, radio and TV. Serves industrial, entertainment, financial, agricultural, medical and consumer clients. Commissions 25 photographers/year.

Specs: Uses b&w contact sheets and 8×10 b&w glossy prints; uses 8×10 color prints and 4×5 transparencies; produces 16mm documentaries.

Making Contact & Terms: Payment negotiable. Pays per job, or royalties on 16mm film sales. Buys all rights. Model release preferred. Arrange a personal interview to show portfolio; submit portfolio for review; or send material, "preferably slides we can keep on file," by mail for consideration. SASE. Reports in 1 week.

■**TOWNSEND, BARNEY & PATRICK**, 5909 Airport Blvd., Mobile AL 36608. (334)343-0640. Ad agency. Vice President/Creative Services: George Yurcisin. Types of clients: industrial, financial, medical, retail, fashion, fast food, tourism, packaging, supermarkets and food services.

Needs: Works with 1-3 freelance photographers/month. Uses photos for consumer magazines, trade magazines, direct mail, brochures, P-O-P displays, audiovisuals, posters and newspapers. Model release required.

Audiovisual Needs: Works with freelance filmmakers to produce audiovisuals.

Specs: Uses 8×10 and 11×17 glossy b&w prints; 35mm, $2\frac{1}{4} \times 2\frac{1}{4}$, 4×5 and 8×10 transparencies; 16mm, 35mm film and videotape.

Making Contact & Terms: Arrange a personal interview to show portfolio. Query with samples and list of stock photo subjects. Provide résumé, business card, brochure, flier or tearsheets to be kept on file for possible future assignments. Does not return unsolicited material. Reports as needed. Payment "varies according to budget." Pays net 30. Buys all rights.

Alaska

THE NERLAND AGENCY, 808 E St., Anchorage AK 99501. (907)274-9553. Ad agency. Contact: Curt Potter. Types of clients: retail, hotel, restaurant, fitness, health care. Client list free with SASE.

Needs: Works with 3 freelance photographers/month. Uses photos for consumer magazines, trade maga-

zines, newspaper ads, direct mail and brochures and collateral pieces. Subjects include people and still lifes.

Specs: Uses 11×14 matte b&w prints; 35mm, 2¼×2¼ and 4×5 transparencies.

Making Contact & Terms: Query with samples. Provide résumé, business card, brochure, flier or tearsheets to be kept on file for possible future assignments. Does not return unsolicited material. Pays $500-800/day or minimum $100/job (depends on job). **Pays on receipt of invoice.** Buys all rights or one-time rights. Model release and captions preferred.

Tips: Prefers to see "high technical quality (sharpness, lighting, etc). All photos should capture a mood—good people, expression on camera. Simplicity of subject matter. Keep sending updated samples of work you are doing (monthly). We are demanding higher technical quality and looking for more 'feeling' photos than still life of product."

Arizona

‡■ARIZONA CINE EQUIPMENT INC., 2125 E. 20th St., Tucson AZ 85719. (520)623-8268. Contact: Linda Oliver. Estab. 1972. AV firm. Types of clients: industrial and retail.

Needs: Works with 6 photographers, filmmakers and/or videographers/month. Uses photos for audiovisual. Model/property release required. Captions preferred.

Audiovisual Needs: Uses slides, film and videotape.

Specs: Uses color prints; 35mm, 4×5 transparencies.

Making Contact & Terms: Query with résumé of credits. Query with list of stock photo subjects. Send unsolicited photos by mail for consideration. Query with samples. Works with freelancers on assignment only. Keeps samples on file. SASE. Reports in 3 weeks. Pays $15-30/hour; $250-500/day; or per job. **Pays on receipt of invoice.** Buys all rights; negotiable. Credit line sometimes given.

■PAUL S. KARR PRODUCTIONS, 2925 W. Indian School Rd., Phoenix AZ 85017. (602)266-4198. Contact: Kelly Karr. Film and tape firm. Types of clients: industrial, business and education. Works with freelancers on assignment only.

Needs: Uses filmmakers for motion pictures. "You must be an experienced filmmaker with your own location equipment, and understand editing and negative cutting to be considered for any assignment." Primarily produces industrial films for training, marketing, public relations and government contracts. Does high-speed photo instrumentation. Also produces business promotional tapes, recruiting tapes and instructional and entertainment tapes for VCR and cable. "We are also interested in funded co-production ventures with other video and film producers."

Specs: Uses 16mm films and videotapes. Provides production services, including sound transfers, scoring and mixing and video production, post production, and film-to-tape services.

Making Contact & Terms: Query with résumé of credits and advise if sample reel is available. Payment negotiable. Pays/job; negotiates payment based on client's budget and photographer's ability to handle the work. Pays on production. Buys all rights. Model release required.

Tips: Branch office in Utah: Karr Productions, 1045 N. 300 East, Orem UT 84057. (801)226-8209. Contact: Mike Karr.

WALKER AGENCY, #160, 15855 N. Greenway Hayden Loop, Scottsdale AZ 85260-1726. (602)483-0185. Fax: (602)948-3113. E-mail: 76167,301compuserve. Website: 76167.301@compuserve.comwalker48@aok. President: Mike Walker. Estab. 1982. Member Outdoor Writers Association of America, Public Relations Society of America. Marketing communications firm. Number of employees: 8. Types of clients: banking, marine industry, shooting sports and outdoor recreation products.

Needs: Uses photos for consumer and trade magazines, posters and newspapers. Subjects include outdoor recreation scenes: fishing, camping, etc. "We also publish a newspaper supplement, 'Escape to the Outdoors,' which goes to 11,000 papers." Model/property release required.

Specs: Uses 8×10 glossy b&w prints with borders; 35mm, 2¼×2¼, 4×5 and 8×10 transparencies.

Making Contact & Terms: Query with résumé of credits. Query with list of stock photo subjects. Provide résumé, business card, brochure, flier or tearsheets to be kept on file for possible future assignments. Reports in 1 week. Pays $25/b&w or color photo; $150-500/day; also pays per job. Pays on receipt of invoice. Buys all rights; other rights negotiable.

Tips: In portfolio/samples, prefers to see a completely propped scene. "There is more opportunity for photographers within the advertising/PR industry."

Arkansas

BLACKWOOD, MARTIN, AND ASSOCIATES, 3 E. Colt Square Dr., P.O. Box 1968, Fayetteville AR 72703. (501)442-9803. Ad agency. Creative Director: Gary Weidner. Types of clients: food, financial, medical, insurance, some retail. Client list provided on request.
Needs: Works with 3 freelance photographers/month. Uses photos for direct mail, catalogs, consumer magazines, P-O-P displays, trade magazines and brochures. Subject matter includes "food shots—fried foods, industrial."
Specs: Uses 8×10 high contrast b&w prints; 35mm, 4×5 and 8×10 transparencies.
Making Contact & Terms: Arrange a personal interview to show portfolio; query with samples; provide résumé, business card, brochure, flier or tearsheets to be kept on file for possible future assignments. Works with freelance photographers on assignment basis only. Does not return unsolicited material. Reports in 1 month. Payment negotiable. Payment depends on budget—"whatever the market will bear." Buys all rights. Model release preferred.
Tips: Prefers to see "good, professional work, b&w and color" in a portfolio of samples. "Be willing to travel (we have been doing location shots) and willing to work within our budget. We are using less b&w photography because of newspaper reproduction in our area. We're using a lot of color for printing."

■**CEDAR CREST STUDIO**, P.O. Box 28, Mountain Home AR 72653. (800)488-5777. Fax: (870)488-5255. E-mail: cedarcrest@oznet.com. Website: http://www.oznet.com/cedarcrest. Owner: Bob Ketchum. Estab. 1972. AV firm. Number of employees: 4. Types of clients: corporate, industrial, financial, broadcast, fashion, retail, food. Examples of recent projects: "T-Lite, T-Slumber," Williams Pharmaceuticals (national TV spots); "Christmas," Peoples Bank and Trust (regional TV spots); CBM demo, Baxter Healthcare Corp. (corporate sales).
 ● Cedar Crest is using computers for photo manipulation.
Needs: Works with 4 freelancers/month. Uses photos for covers on CDs and cassettes.
Audiovisual Needs: Uses slides, film and videotape.
Specs: Uses ½″, 8mm and ¾″ videotape.
Making Contact & Terms: Works with local freelancers only. Does not keep samples on file. Cannot return material. Pays $75 maximum/hour; $200 minimum/day. Pays on publication. Credit line sometimes given. Buys one-time rights; negotiable.

‡■**KIRKPATRICK WILLIAMS ASSOCIATES**, 8201 Cantrell Rd., Little Rock AR 72227. (501)225-8833. Fax: (501)225-3433. E-mail: kwa@aristotle.net. Creative Director: Kirby Williams. Estab. 1977. Member of AAAA, AAF, PRSA. Ad agency. Approximate annual billing: $6.2 million. Number of employees: 17. Types of clients: industrial, financial, retail, food, tourism. Examples of recent projects: "Christmas," City of Eureka Springs (regional TV); "Cardiac Care," Northwest Health (local TV); Little Rock Public Schools (national services brochure).
Needs: Works with 2-5 photographers, 1-2 filmmakers and 1-2 videographers/month. Uses photos for billboards, consumer magazines, trade magazines, direct mail, P-O-P displays, catalogs, posters, newspapers and audiovisual. Subjects include: people. Reviews stock photos. Model/property release required.
Audiovisual Needs: Uses slides, film and video for people and products.
Specs: Uses 8×10 glossy color prints; 2¼×2¼ transparencies; 16mm film; digital format (compact disc).
Making Contact & Terms: Query with samples. Works on assignment only. Keeps samples on file. SASE. Pays $500-1,500/day. Buys all rights; negotiable.

‡■**THE MEDIA MARKET, INC.**, 285 College St., P.O. Box 2692, Batesville AR 72503-2692. (501)793-6902. Fax: (501)793-7603. Art Director: Barth Boyd. Estab. 1980. Ad agency. Approximate annual billing: $500,000. Number of employees: 4. Types of clients: industrial, financial, retail, health care and tourism. Examples of recent projects: "See the Ozark Gateway," Ozark Gateway Tourist Council (television promotion); "Appreciation," Union Planters Bank (newspaper); and "People-Hometown Choice," Citizens Bank of Batesville (varied media).
Needs: Works with 1-3 freelance photographers, 1-3 filmmakers and 1-3 videographers/month. Uses photos for billboards, consumer magazines, trade magazines, direct mail, P-O-P displays, catalogs, posters, newspapers, signage and audiovisual. Subjects include: tourism and financial. Reviews stock photos. Model/property release required. Captions preferred.
Audiovisual Needs: Uses slides, film and videotape for business-to-business and business-to-consumer.
Specs: Uses all sizes glossy color and b&w prints; 35mm, 2¼×2¼, 4×5 transparencies; ¾″ film; VHS videotape.
Making Contact & Terms: Provide résumé, business card, brochure, flier or tearsheets to be kept on file for possible future assignments. Works on assignment only. Keeps samples on file. SASE. Reports in 1-2 weeks. Pays $25-50/hour; $200-400/day; $50-400/job; $25-200/color or b&w photo. Pays on publica-

tion. Credit line sometimes given depending upon terms. Buys all rights; negotiable.

■**WILLIAMS/CRAWFORD & ASSOCIATES, INC.**, P.O. Box 789, Ft. Smith AR 72901. (501)782-5230. Fax: (501)782-6970. Creative Director: Branden Sharp. Estab. 1983. Types of clients: financial, health care, manufacturing, tourism. Examples of ad campaigns: Touche-Ross, 401K and employee benefits (videos); Cummins Diesel Engines (print campaigns); and Freightliner Trucks (sales promotion and training videos).

Needs: Works with 2-3 freelance photographers, filmmakers or videographers/month. Uses photos for consumer magazines, trade magazines, direct mail, P-O-P displays, catalogs, posters, newspapers and audiovisual uses. Subjects include: people, products and architecture. Reviews stock photos, film or video of health care and financial.

Audiovisual Needs: Uses photos/film/video for 30-second video and film TV spots; 5-10-minute video sales, training and educational.

Specs: Uses 5×7, 8×10 b&w prints; 35mm, 2¼×2¼ and 4×5 transparencies.

Making Contact & Terms: Query with samples, provide résumé, business card, brochure, flier or tearsheets to be kept on file for possible future assignments. Works with freelancers on assignment basis only. Cannot return material. Reports in 1-2 weeks. Pays $500-1,200/day. Pays on receipt of invoice and client approval. Buys all rights (work-for-hire). Model release required; captions preferred. Credit line given sometimes, depending on client's attitude (payment arrangement with photographer).

Tips: In freelancer's samples, wants to see "quality and unique approaches to common problems." There is "a demand for fresh graphics and design solutions." Freelancers should "expect to be pushed to their creative limits, to work hard and be able to input ideas into the process, not just be directed."

California

‡■**THE AD AGENCY,** P.O. Box 470572, San Francisco CA 94147. President: Michael Carden. Estab. 1970. Member of NCAAA, San Francisco Ad Club. Ad agency. Number of employees: 14. Types of clients: industrial, financial, retail and food.

Needs: Number of photographers, filmmakers and videographers used on a monthly basis varies. Uses photos for billboards, consumer magazines, trade magazines, direct mail, catalogs, posters and newspapers. Subject matter varies. Reviews stock photos. Model/property release preferred. Captions preferred.

Audiovisual Needs: Uses film and videotape for commercials.

Making Contact & Terms: Submit portfolio for review. Query with samples. Keeps samples on file. SASE. Reports in 1 month. Payment negotiable. Rights negotiable.

ADVANCE ADVERTISING AGENCY, 606 E. Belmont, #202, Fresno CA 93701. (209)445-0383. Manager: Martin Nissen. Ad and PR agency and graphic design firm. Types of clients: industrial, commercial, retail, financial. Examples of projects: Spyder Autoworks (direct mail, trade magazines); Windshield Repair Service (radio, TV, newspaper); Mr. G's Carpets (radio, TV, newspaper); Fresno Dixieland Society (programs and newsletters).

Needs: Model release required.

Specs: Uses color and b&w prints.

Making Contact & Terms: Send unsolicited photos by mail for consideration. Provide business card, brochure, flier to be kept on file for possible future assignments. Keeps samples on file. Reports in 1-2 weeks. Payment negotiated per job. Pays 30 days from invoice. Credit line given. Buys all rights.

Tips: In samples, looks for "not very abstract or overly sophisticated or 'trendy.' Stay with basic, high quality material." Advises that photographers "consider *local* market target audience."

‡■**THE ADVERTISING CONSORTIUM,** 10536 Culver Blvd., Suite D., Culver City, CA 90232. (310)287-2222. Fax: (310)287-2227. President: Kim Miyade. Ad agency. Approximate annual billing: $1 million. Number of employees: 2. Types of clients: industrial, fashion and retail. Examples of recent projects: "Strong Fragrance" for Bernini-Beverly Hills (billboards/print); "40th Anniversary" for Meridian Communications (print ads-magazines); and "Lend Us Your Ears" for Royal-Pedic Mattresses (cassette direct mailer).

Needs: Number of photographers used on a monthly basis varies. Uses photos for billboards, consumer

‡ **MARKETS NEW TO THIS EDITION** are marked with a double dagger.

magazines, trade magazines, direct mail, posters, newspapers and signage. Subjects include: product shots and model and stock photographs. Reviews stock photos. Model release required. Property release preferred.

Audiovisual Needs: Uses slides and film.

Specs: Uses color and b&w prints.

Making Contact & Terms: Interested in receiving work from newer, lesser-known photographers. Send unsolicited photos by mail for consideration. Provide résumé, business card, brochure, flier or tearsheets to be kept on file for possible future assignments. Works with local freelancers only. Keeps samples on file. Notification dependent upon opportunity. Payment negotiable. Pays half on invoice, half upfront. Credit line sometimes given. Buys all rights.

■AMERTRON-AMERICAN ELECTRONIC SUPPLY, 1200 N. Vine St., Hollywood CA 90038-1600. (213)462-1200. Fax: (213)871-0127. General Manager: Fred Rosenthal. Estab. 1953. AV and electronics distributing firm; also sales, service and rentals. Approximate annual billing: $5 million. Number of employees: 35. Types of clients: industrial, financial, fashion and retail. "We participate in shows and conventions throughout the country."

Needs: Most photos used for advertising purposes.

Audiovisual Needs: Uses slides, film and videotape.

Making Contact & Terms: Interested in receiving work from newer, lesser-known photographers. Query with samples. Provide résumé, business card, brochure, flier or tearsheets to be kept on file for possible future assignments. Cannot return material. Reports in 6 months. Payment negotiable.

‡■BELL & ROBERTS, INC., 1275 N. Manassero St., Anaheim Hills CA 92807. (714)777-8600. Fax: (714)777-9571. President/Creative Director: Thomas Bell. Estab. 1980. Ad agency. Number of employees: 6. Types of clients: retail, food, sporting companies. Examples of recent projects: annual campaigns for Van-K Engineering, Total Food Management and Cornell Computers.

Needs: Works with 1 freelancer and 1 videographer/month. Uses photos for consumer magazines, trade magazines, direct mail, P-O-P displays, catalogs and newspapers. Subjects include various product shots. Reviews stock images. Model release required. Property release preferred.

Audiovisual Needs: Uses ½″ videotape for internal reviewing.

Specs: Uses 8×10 or larger b&w prints; 2¼×2¼, 4×5 transparencies. Accepts images in digital format for Windows. Send via compact disc or Online.

Making Contact & Terms: Provide résumé, business card, brochure, flier or tearsheets to be kept on file for possible future assignments. Do not submit photos. Works with freelancers on assignment only. Keeps samples on file. Cannot return material. Payment negotiable. Pays on receipt of invoice. Credit line not given. Rights purchased depend on usage.

■BRAMSON + ASSOCIATES, 7400 Beverly Blvd., Los Angeles CA 90036. (213)938-3595. Fax: (213)938-0852. Principal: Gene Bramson. Estab. 1970. Ad agency. Approximate annual billing: $2 million. Number of employees: 8. Types of clients: industrial, financial, food, retail, health care. Examples of recent projects: Hypo Tears ad, 10 Lab Corporation (people shots); brochure, Chiron Vision (background shots).

Needs: Works with 2-5 freelance photographers and 1 videographer/month. Uses photos for trade magazines, direct mail, catalogs, posters, newspapers, signage. Subject matter varies. Reviews stock photos. Model/property release required. Captions preferred.

Audiovisual Needs: Uses slides and/or videotape for industrial, product.

Specs: Uses 11×15 color and b&w prints; 35mm, 2¼×2¼, 4×5, 8×10 transparencies. Accepts submissions in digital format for Mac. Send via SyQuest cartridge with high resolution.

Making Contact & Terms: Interested in receiving work from newer, lesser-known photographers. Submit portfolio for review. Send unsolicited photos by mail for consideration. Provide résumé, business card, brochure, flier or tearsheet to be kept on file for possible future assignments. Works with local freelancers on assignment only. Keeps samples on file. SASE. Reports in 3 weeks. Payment negotiable. Pays on receipt of invoice. Payment varies depending on budget for each project. Credit line not given. Buys one-time and all rights.

Tips: "Innovative—crisp—dynamic—unique style—different—otherwise we'll stick with our photographers. If it's not great work, don't bother."

CHIAT-DAY, 340 Main St., Venice CA 90291. (310)314-5000. Contact: Art Buyer. Types of clients: industrial, financial, fashion, retail, food. Examples of recent projects: Nissan, Sony, Taco Bell, Infiniti and Eveready Battery Company.

Needs: Works with 10-50 freelancers/month. Uses photos for billboards, consumer and trade magazines, direct mail, P-O-P displays, catalogs, posters, newspapers, signage and audiovisual uses. Subjects used depend on the company. Model/property release required.

Specs: Uses 8×10 and 11×14 matte b&w prints; 35mm, $2\frac{1}{4} \times 2\frac{1}{4}$, 4×5, 8×10 transparencies (prefers 4×5 and 8×10).

Making Contact & Terms: Interested in receiving work from newer, lesser-known photographers. Contact through rep. Arrange personal interview to show portfolio. Submit portfolio for review. Query with samples. Leave promo sheet. Provide résumé, business card, brochure, flier or tearsheets to be kept on file for possible future assignments. Reporting time depends; can call for feedback. Payment negotiable. Pays on receipt of invoice. Rights purchased vary; negotiable.

COAKLEY HEAGERTY, 1155 N. First St., San Jose CA 95112. (408)275-9400. Fax: (408)995-0600. Art Directors: Ray Bauer, Tundra Alex, JD Keser. Estab. 1960. Member of MAAN. Ad agency. Approximate annual billing: $25 million. Number of employees: 25. Types of clients: industrial, financial, retail, food and real estate. Examples of recent projects: Valley Medical Center (hospital); Florsheim Homes (real estate); and ABHOW (senior care).
Needs: Works with 2-3 freelance photographers, 1 filmmaker and 1 videographer/month. Uses photos for consumer magazines, trade magazines, direct mail and newspapers. Subjects vary. Model release required.
Specs: Uses b&w prints; 35mm, $2\frac{1}{4} \times 2\frac{1}{4}$, 4×5, 8×10, transparencies; 16 mm, 35mm film; and Beta SP D-2 videotape.
Making Contact & Terms: Interested in receiving work from newer, lesser-known photographers. Send unsolicited photos by mail for consideration. Keeps samples on file. Cannot return material. Reports as needed. Pays on receipt of invoice; 60 days net. Credit line not given. Buys all rights; negotiable.

■EVANS & PARTNERS, INC., 55 E. G St., Encinitas CA 92024-3615. (619)944-9400. Fax: (619)944-9422. President/Creative Director: David R. Evans. Estab. 1989. Ad agency. Approximate annual billing: $1.2 million. Number of employees: 7. Types of clients: industrial, financial, medical. Examples of recent projects: "Total Water Management," U.S. Filter Corporation (15-minute laptop presentation and 4 electronic modules); Baxter Healthcare Corporation (annual report, corporate literature); "Expander," Ortho Organizer (direct mail/advertising).
 • This agency is utilizing photo manipulation technologies, which gives photographers the latitude to create.
Needs: Works with 2-3 freelance photographers, 1-6 videographers/month. Uses photos for billboards, trade magazines, direct mail, P-O-P displays, catalogs, posters, newspapers, signage and audiovisual uses. Subjects include: medical, medical high tech, real estate. Reviews stock photos. Model release required for people. Property release preferred. Captions preferred; include name of photographer.
Audiovisual Needs: Uses slides and video for presentations, educational.
Specs: Uses 35mm, $2\frac{1}{4} \times 2\frac{1}{4}$, 4×5 transparencies; $\frac{1}{2}''$ VHS-SVHS videotape.
Making Contact & Terms: Interested in receiving work from newer, lesser-known photographers. Query with stock photo list and samples. Provide résumé, business card, brochure, flier or tearsheets to be kept on file for possible future assignments. Works with local freelancers on assignment only. Keeps samples on file. SASE. Will notify if interested. Pays $700-2,000/day; $175 and up/job. Pays upon receipt of payment from client. Credit line given depending upon nature of assignment, sophistication of client. Buys first, one-time, all, exclusive product, electronic rights; negotiable.
Tips: Looking for "ability to see structure, line tensions, composition innovation; finesse in capturing people's energy; ability to create visuals equal to the level of sophistication of the business or product."

■KEN FONG ADVERTISING, INC., 178 W. Adams St., Stockton CA 95204-5338. (209)466-0366. Fax: (209)466-0387. Art Director: Donna Yee. Estab. 1953. Ad agency. Number of employees: 9. Types of clients: industrial, financial, fashion, retail and food.
Needs: Uses photos for billboards, consumer and trade magazines, direct mail, P-O-P displays, catalogs, posters, newspapers, signage and audiovisual. Subject matter varies. Reviews stock photos of diverse, "real" and business-type people, lifestyle/leisure, nature, commerce, sports/recreation. Model/property release required.
Audiovisual Needs: Uses laptop computers, slides and video.
Specs: Uses 8×10 and larger glossy color and b&w prints; 35mm, $2\frac{1}{4} \times 2\frac{1}{4}$, 4×5 transparencies; $\frac{1}{2}''$ VHS videotape, CD-ROM.
Making Contact & Terms: Interested in receiving work from newer, lesser-known photographers. Provide résumé, business card, brochure, flier or tearsheets to be kept on file for possible future assignments. Works on assignment only. Keeps samples on file. SASE. Reports in 1 month. **Pays on receipt of invoice.** Credit line not given. Buys one-time and all rights; negotiable.

‡GATEWAYS/MIND TOOLS INC., (formerly Gateways Institute), Box 1706, Ojai CA 93024. (805)646-0267. Fax: (805)646-0980. Website: http://www.mindtools2000.com. Executive Vice President: Sylvia Thompson. Types of clients: retail, corporate.

Needs: Uses photographers for catalog work. "Work must be creative." Sample of catalog will be sent upon request. Property release required.
Specs: Uses color prints; 35mm and 2¼×2¼ transparencies. Accepts images in digital format for Mac. Send via SyQuest or Zip disk.
Making Contact & Terms: Interested in receiving work from newer, lesser-known photographers. Submit portfolio by mail, query with samples. Reviews stock photos. SASE. Reports in 2-3 weeks. Pays minimum $100/color photo. Pays on publication. Buys one-time and exclusive product rights; negotiable.
Tips: Looks for "people, high tech graphics, symbolic messages, inspirational photos."

‡**GORDON GELFOND ASSOCIATES, INC.**, Suite 350, 11500 Olympic Blvd., Los Angeles CA 90064. (213)478-3600. Fax: (213)477-4825. Ad agency. Art Director: Barry Brenner. Types of clients: retail, financial, hospitals and consumer electronics.
Needs: Works with 1-2 photographers/month. Uses freelance photographers for billboards, consumer magazines, trade magazines, direct mail and newspapers. Subject matter varies.
Specs: Uses b&w and color prints; 35mm, 2¼×2¼ and 4×5 transparencies.
Making Contact & Terms: Reps only to show portfolio, otherwise drop off portfolio on Thursdays only. Send unsolicited photos by mail for consideration. Submit portfolio for review. Provide résumé, business card, brochure, flier or tearsheets to be kept on file for possible future assignments. Works with local freelance photographers on assignment basis only. Cannot return material. Reports ASAP. Payment negotiable/job. "Works within a budget." Payment is made 30 days after receipt of invoice. Buys all rights. Model release required. Credit line sometimes given.

■**HAYES ORLIE CUNDALL INC.**, 46 Varda Landing, Sausalito CA 94965. (415)332-7414. Fax: (415)332-5924. Art Director: Krista Young. Estab. 1991. Ad agency. Uses all media except foreign. Types of clients: industrial, retail, fashion, finance, computer and hi-tech, travel, healthcare, insurance and real estate.
Needs: Works with 1 freelance photographer/month on assignment only. Model release required. Captions preferred.
Making Contact & Terms: Provide résumé, business card and brochure to be kept on file for future assignments. "Don't send anything unless it's a brochure of your work or company. We keep a file of talent—we then contact photographers as jobs come up." Payment negotiable. Pays on a per-photo basis; negotiates payment based on client's budget, amount of creativity required and where work will appear. "We abide by local photographer's rates."
Tips: "Most books are alike. I look for creative and technical excellence, then how close to our offices; cheap versus costly; personal rapport; references from friends in agencies who've used him/her. Call first. Send samples and résumé if I'm not able to meet with you personally due to work pressure. Keep in touch with new samples." Produces occasional audiovisual for industrial and computer clients; also produces a couple of videos a year.

THE HITCHINS COMPANY, 22756 Hartland St., Canoga Park CA 91307. Phone/fax: (818)715-0510. E-mail: hitchins@soca.com. President: W.E. Hitchins. Estab. 1985. Ad agency. Approximate annual billing: $350,000. Number of employees: 2. Types of clients: industrial, retail (food) and auctioneers. Examples of recent projects: Electronic Expediters (brochure showing products).
Needs: Uses photos for trade magazines, direct mail and newspapers. Model release required.
Specs: Uses b&w and color prints. "Copy should be flexible for scanning."
Making Contact & Terms: Provide résumé, business card, brochure, flier or tearsheets to be kept on file for possible future assignments. Works on assignment only. Cannot return material. Payment negotiable depending on job. Pays on receipt of invoice (30 days). Rights purchased negotiable; "varies as to project."
Tips: Wants to see shots of people and products in samples.

■**BERNARD HODES ADVERTISING**, 11755 Wilshire Blvd., Suite 1600, Los Angeles CA 90025. (310)575-4000. Ad agency. Creative Director: Steve Mitchell. Produces "recruitment advertising for all types of clients."
Needs: Uses photos for billboards, trade magazines, direct mail, brochures, catalogs, posters, newspapers and internal promotion. Model release required.
Making Contact & Terms: Query with samples "to be followed by personal interview if interested." Does not return unsolicited material. Reporting time "depends upon jobs in house; I try to arrange appointments within three-four weeks." Payment negotiable. Payment "depends upon established budget and subject." **Pays on acceptance** for assignments; on publication per photo. Buys all rights.
Tips: Prefers to see "samples from a wide variety of subjects. No fashion. People-oriented location shots. Nonproduct. Photos of people and/or objects telling a story—a message. Eye-catching." Photographers must have "flexible day and ½-day rates, work fast and be able to get a full day's (or ½) work from a

model or models. Excellent sense of lighting. Awareness of the photographic problems with newspaper reproduction."

■**IMAGE INTEGRATION**, 2418 Stuart St., Berkeley CA 94705. (510)841-8524. Owner: Vince Casalaina. Estab. 1971. Specializes in material for TV productions. Approximate annual billing: $100,000. Examples of projects: "Ultimate Subscription" for *Sailing World* (30 second spot); "Road to America's Cup" for ESPN (stock footage); and "Sail with the Best" for US Sailing (promotional video).
Needs: Works with 1 freelance photographer and 1 videographer/month. Reviews stock photos of sailing. Property release preferred. Captions required; include regatta name, regatta location, date.
Audiovisual Needs: Uses videotape. Subjects include: sailing.
Specs: Uses 4×5 or larger matte color or b&w prints; 35mm transparencies; 16mm film and Betacam videotape.
Making Contact & Terms: Interested in receiving work from newer, lesser-known photographers. Send unsolicited photos by mail for consideration. Works on assignment only. Keeps samples on file. SASE. Reports in 1-2 weeks. Payment depends on distribution. Pays on publication. Credit line sometimes given, depending upon whether any credits included. Buys nonexclusive rights; negotiable.

JB WEST, P.O. Box 66895, Los Angeles CA 90066. (800)393-9278. Creative Director: John Belletti. Estab. 1979. Ad agency. Approximate annual billing: $500,000. Number of employees: 7. Types of clients: industrial, financial and food. Examples of recent projects: "Train of Values" for Coca-Cola (promotion); and "Game of Credit" for N.Y. Credit (book project).
Needs: Works with 1 or 2 freelancers/month. Uses photos for consumer magazines, trade magazines, direct mail, P-O-P displays, catalogs, posters. Subjects include: food and people. Reviews stock photos of business and finance.
Audiovisual Needs: Uses slides for slide shows.
Specs: Uses 35mm, 2¼×2¼, 4×5 transparencies.
Making Contact & Terms: Interested in receiving work from newer, lesser-known photographers. Arrange personal interview to show portfolio. Works with freelancers on assignment only. Keeps samples on file. Cannot return material. Reports in 1-2 weeks. Payment negotiable. Pays on receipt of invoice after 30 days. Credit line sometimes given depending upon project. Buys all rights; negotiable.

LEVINSON ASSOCIATES, 1440 Veteran Ave., Suite 650, Los Angeles CA 90024. (213)460-4545. Fax: (213)663-2820. E-mail: leviinc@aol.com. Assistant to President: Jed Leland, Jr. Estab. 1969. PR firm. Types of clients: industrial, financial, entertainment. Examples of recent projects: Cougar Records; Beyond Shelter; Temple Hospital; Health Care Industries, Inc. (sales brochure); *CAL Focus Magazine*; U4EA!; and "Hello, Jenny" for Hollywood Press Club (national promotion).
Needs: Works with varying number of freelancers/month. Uses photos for trade magazines and newspapers. Subjects vary. Model release required. Property release preferred. Captions preferred.
Making Contact & Terms: Works with local freelancers only. Keeps samples on file. Cannot return material. Payment negotiable. Buys all rights; negotiable.

‡**RICHARD BOND LEWIS & ASSOCIATES**, 1112 W. Cameron Ave., West Covina CA 91790. (818)962-7727. Creative Director: Dick Lewis. Estab. 1971. Ad agency. Types of clients: industrial, consumer products manufacturer, real estate, autos. Client list free with SASE.
Needs: Works with 1-2 freelance photographers/month. Uses photos for billboards, consumer and trade magazines, direct mail, catalogs and newspapers. Subjects include: product photos. Model release required. Captions preferred.
Specs: Uses 4×5 color prints and 4×5 transparencies.
Making Contact & Terms: Arrange a personal interview to show portfolio. Provide résumé, business card, brochure, flier or tearsheets to be kept on file for possible future assignments. Works on assignment only. Cannot return material. "Will return upon request." Payment negotiable. Pays "usually 10 days from receipt of invoice—no later than 30 days." Credit line given "if client approves." Buys all rights; "we request negatives on completion of job."
Tips: Prefers to see a variety—people, industrial, product, landscape, some fashion. "Bring in portfolio and leave some samples which best show your capabilities."

■**LINEAR CYCLE PRODUCTIONS**, Box 2608, Sepulveda CA 91393-2608. Production Manager: R. Borowy. Estab. 1980. Member of Internation United Photographer Publishers, Inc. Ad agency, PR firm. Approximate annual billing: $5 million. Number of employees: 10. Types of clients: industrial, commercial, advertising. Examples of recent projects: "The Sam Twee," Bob's Bob-O-Bob (ad); "Milk the Milk," Dolan's (ad); "Faster . . . not better," Groxnic, O'Fopp & Pippernatz (ad).

Needs: Works with 7-10 freelance photographers, 8-12 filmmakers, 8-12 videographers/month. Uses photos for billboards, consumer magazines, direct mail, P-O-P displays, posters, newspapers, audiovisual uses. Subjects include: candid photographs. Reviews stock photos, archival. Model/property release required. Captions required; include description of subject matter.

Audiovisual Needs: Uses slides and/or film or video for television/motion pictures. Subjects include: archival-humor material.

Specs: Uses 8×10 color and b&w prints; 35mm, 8×10 transparencies; 16mm-35mm film; ½", ¾", 1" videotape.

Making Contact & Terms: Interested in receiving work from newer, lesser-known photographers. Submit portfolio for review. Query with résumé of credits. Query with stock photo list. Send unsolicited photos by mail for consideration. Provide résumé, business card, brochure, flier or tearsheets to be kept on file for possible future assignments. Works with local freelancers on assignment only. Keeps samples on file. Reports in 1 month. Pays $100-500/b&w photo; $150-750/color photo; $100-1,000/job. Prices paid depend on position. Pays on publication. Credit line given. Buys one-time rights; negotiable.

Tips: "Send a good portfolio with color pix shot in color (not b&w of color). No sloppy pictures or portfolios!! The better the portfolio is set up, the better the chances that we would consider it . . . let alone look at it!!" Seeing a trend toward "more archival/vintage, and a lot of humor pieces!!!"

■**MARKEN COMMUNICATIONS**, 3375 Scott Blvd., Suite 108, Santa Clara CA 95054-3111. (408)986-0100. Fax: (408)986-0162. E-mail: marken@cerfnet.com. President: Andy Marken. Production Manager: Leslie Posada. Estab. 1977. Ad agency and PR firm. Approximate annual billing: $4.5 million. Number of employees: 8. Types of clients: furnishings, electronics and computers. Examples of recent ad campaigns include: Burke Industries (resilient flooring, carpet); Boole and Babbage (mainframe software); Maxar (PCs).

Needs: Works with 3-4 freelance photographers/month. Uses photos for trade magazines, direct mail, publicity and catalogs. Subjects include: product/applications. Model release required.

Audiovisual Needs: Slide presentations and sales/demo videos.

Specs: Uses color and b&w prints; 35mm, 2¼×2¼ and 4×5 transparencies.

Making Contact & Terms: Arrange a personal interview to show portfolio. Query with samples. Submit portfolio for review. "Call." Works with freelancers on assignment basis only. SASE. Reports in 1 month. Pays $50-1,000/b&w photo; $100-1,800/color photo; $50-100/hour; $500-1,000/day; $200-2,500/job. Pays 30 days after receipt of invoice. Credit line sometimes given. Buys one-time rights.

■**NEW & UNIQUE VIDEOS**, 2336 Sumac Dr., San Diego CA 92105. (619)282-6126. Fax: (619)283-8264. E-mail: videos@concentric.net. Website: http://www.concentric.net/~videos. Director of Acquisitions: Candace Love. Estab. 1981. AV firm. Number of employees: 4. Types of clients: industrial, financial, fashion, retail and special interest video distribution. Examples of recent projects: "Full-Cycle: A World Odyssey" (special-interest video); "Ultimate Mountain Biking," Raleigh Cycle Co. of America (special interest video); "John Howard's Lessons in Cycling," John Howard (special interest video); and "Battle at Durango: First-Ever World Mountain Bike Championships," *Mountain & City Biking Magazine* (special interest video).

Needs: Works with 8-10 photographers and/or videographers/year. Subjects include "new and unique" special interest, such as cycling and sports. Reviews stock footage: cycling, sports, comedy, romance, "new and unique." Model/property release preferred.

Audiovisual Needs: Uses VHS videotape, Hi-8 and Betacam SP. Accepts images in digital format for Mac. Submit via compact disc, online, floppy disk or SyQuest.

Making Contact & Terms: Query with list of video subjects. Works on assignment only. Keeps samples on file. SASE. Reports in 3 weeks. Payment negotiable. **Pays on acceptance.** Credit line given. Buys exclusive and nonexclusive rights.

Tips: In samples looks for "originality, good humor and timelessness. We are seeing an international hunger for action footage, good wholesome adventure, comedy, educational, how-to and special interest. The entrepreneurial, creative and original video artiste—with the right attitude—can always feel free to call us."

■**ON-Q PRODUCTIONS INC.**, 618 E. Gutierrez St., Santa Barbara CA 93103. (805)963-1331. President: Vincent Quaranta. Estab. 1984. Producers of multi-projector slide presentations and computer graphics. Types of clients: industrial, fashion and finance.

Needs: Buys 100 freelance photos/year; offers 50 assignments/year. Uses photos for brochures, posters, audiovisual presentations, annual reports, catalogs and magazines. Subjects include: scenic, people and general stock. Model release required. Captions required.

Specs: Uses 35mm, 2¼×2¼ and 4×5 transparencies.

Making Contact & Terms: Provide stock list, business card, brochure, flier or tearsheets to be kept on

file for possible future assignments. Pays $100 minimum/job. Buys rights according to client's needs.
Tips: Looks for stock slides for AV uses.

POINT BLANK MARKETING, (formerly Austin/Kerr Marketing), 307 Orchard City Dr., Campbell CA 95008-2948. Ad agency. Art Director: Nate Digre. Serves travel, high technology and consumer technology clients. Examples of recent projects: Back Country Active Vacations (catalog and direct mail website); "Ours Is Legal" campaign, Logic Associates (spread/page ads).
Needs: Works with 3 photographers/month. Uses work for billboards, consumer magazines, trade magazines, direct mail, P-O-P displays, newspapers. Subject matter of photography purchased includes: conceptual shots of people and table top (tight shots of electronics products).
Specs: Uses 8×10 matte b&w and color prints; 35mm, 2¼×2¼, 4×5 or 8×10 transparencies. Accepts images in ditigal format for Mac. Send via compact disc, online, floppy disk, SyQuest or Zip disk.
Making Contact & Terms: Arrange a personal interview to show portfolio. Send unsolicited photos by mail for consideration. Provide résumé, business card, brochure, flier or tearsheets to be kept on file for possible future assignments. Works on assignment basis only. Does not return unsolicited material. Reports in 3 weeks. Pays $100-5,000/b&w photo; $100-8,000/color photo; maximum $5,000/day; $200-2,000 for electronic usage (Web banners, etc.), depending on budget. **Pays on receipt of invoice.** Buys one-time, exclusive product, electronic and all rights (work-for-hire); negotiable. Model release required, captions preferred.
Tips: Prefers to see "originality, creativity, uniqueness, technical expertise" in work submitted. There is more use of "photo composites, dramatic lighting, and more attention to detail" in photography.

PURDOM PUBLIC RELATIONS, 395 Oyster Point Blvd., Suite 319, San Francisco CA 94080. (415)588-5700. Fax: (415)588-1643. E-mail: purdom@purdompr.com. President: Paul Purdom. Estab. 1965. Member of IPREX, Public Relations Society of America. PR firm. Approximate annual billing: $1.75 million. Number of employees: 17. Types of clients: computer manufacturers, software, industrial, general high-technology products. Examples of recent PR campaigns: Sun Microsystems, Autodesk, Vanian Assoc., Acuron Corporation (all application articles in trade publications).
Needs: Works with 4-6 freelance photographers/month. Uses photos for trade magazines, direct mail and newspapers. Subjects include: high technology and scientific topics. Model release preferred.
Specs: Uses 35mm and 2¼×2¼ transparencies; film: contact for specs.
Making Contact & Terms: Query with résumé of credits, list of stock photo subjects. Provide résumé, business card, brochure, flier or tearsheets to be kept on file for possible future assignments. Works on assignment only. Cannot return material. Reports as needed. Pays $50-150/hour, $400-1,500/day. Pays on receipt of invoice. Buys all rights; negotiable.

■RED HOTS ENTERTAINMENT, 634 N. Glenoaks Blvd., Suite 374, Burbank CA 91502-2024. (818)954-0092. President/Creative Director: Chip Miller. Estab. 1987. Motion picture, music video, commercial, and promotional trailer film production company. Types of clients: industrial, fashion, entertainment, motion picture, TV and music.
Needs: Works with 2-6 freelance photographers/month. Uses freelancers for TV, music video, motion picture stills and production. Model release required. Property release preferred. Captions preferred.
Making Contact & Terms: Provide business card, résumé, references, samples or tearsheets to be kept on file for possible future assignments. Payment negotiable "based on project's budget." Rights negotiable.
Tips: Wants to see minimum of 2 pieces expressing range of studio, location, style and model-oriented work. Include samples of work published or commissioned for production.

‡■RON TANSKY ADVERTISING CO., Suite 111, 14852 Ventura Blvd., Sherman Oaks CA 91403. (818)990-9370. Fax: (818)990-0456. Consulting Art Director: Norm Galston. Estab. 1976. Ad agency and PR firm. Serves all types of clients.
Needs: Uses photos for billboards, consumer and trade magazines, direct mail, P-O-P displays, brochures, catalogs, signage, newspapers and AV presentations. Subjects include: "mostly product—but some without product as well." Special subject needs include: industrial electronics, nutrition products and over-the-counter drugs. Model release required.
Audiovisual Needs: Works with freelance filmmakers to produce TV commercials.
Specs: Uses b&w or color prints; 2¼×2¼, 4×5 transparencies; 16mm film and videotape. Accepts images in digital format for Mac "if that is the only way it can be delivered." Send via online, floppy disk or on SyQuest.
Making Contact & Terms: Query with résumé of credits. Provide résumé, business card, brochure, flier or tearsheets to be kept on file for possible future assignments. SASE. Payment "depends on subject and client's budget." Pays $50-250/b&w photo; $100-1,500/color photo; $500-1,500/day; $100-1,500/complete job. Pays in 30 days. Buys all rights.

Tips: Prefers to see "product photos, originality of position and lighting" in a portfolio. "We look for creativity and general competence, i.e., focus and lighting as well as ability to work with models." Photographers should provide "rate structure and ideas of how they would handle product shots." Also, "don't use fax unless we make request."

■**VARITEL**, One Union, San Francisco CA 94111. (415)693-1111. Senior Post Producer: Blake Padilla. Types of clients: advertising agencies.
Needs: Works with 10 freelance photographers/month. Uses freelance photos for filmstrips, slide sets and videotapes. Also works with freelance filmmakers for CD-ROM, Paint Box.
Specs: Uses color prints; 35mm transparencies; 16mm, 35mm film; VHS, Beta, U-matic ¾″ or 1″ videotape. Also, D2.
Making Contact & Terms: Provide résumé, business card, self-promotion piece or tearsheets to be kept on file for possible future assignments. Does not return unsolicited material. Reports in 1 week. Pays $50-100/hour; $200-500/day. **Pays on acceptance.** Rights vary.
Tips: Apply with résumé and examples of work to Julie Resing, general manager.

■**VISUAL AID MARKETING/ASSOCIATION**, Box 4502, Inglewood CA 90309-4502. (310)399-0696. Manager: Lee Clapp. Estab. 1965. Ad agency. Number of employees: 3. Types of clients: industrial, fashion, retail, food, travel hospitality. Examples of projects: "Robot Show, Tokyo" (magazine story) and "American Hawaii Cruise" (articles).
Needs: Works with 1-2 freelance photographers, 1-2 filmmakers and 1-2 videographers/month. Uses photos for billboards, consumer magazines, trade magazines, direct mail, P-O-P displays, catalogs, posters, newspapers, signage. Model/property release required for models and copyrighted printed matter. Captions required; include how, what, where, when, identity.
Audiovisual Needs: Uses slides for travel presentations.
Specs: Uses 8×10, glossy color and b&w prints; 35mm, 2¼×2¼, 4×5, 8×10 transparencies; Ektachrome film; Beta/Cam videotape.
Making Contact & Terms: Interested in receiving work from newer, lesser-known photographers. Query with résumé of credits. Query with stock photo list. Provide résumé, business card, brochure, flier or tearsheets. Works with local freelancers on assignment only. Cannot return material. Reports in 1-2 weeks. Payment negotiable upon submission. **Pays on acceptance,** publication or **receipt of invoice.** Credit line given depending upon client's wishes. Buys first and one-time rights; negotiable.

■**DANA WHITE PRODUCTIONS, INC.**, 2623 29th St., Santa Monica CA 90405. (310)450-9101. Full-service audiovisual, multi-image, photography and design, video/film production studio: President: Dana White. Estab. 1977. Types of clients: corporate, government and educational. Examples of productions: Southern California Gas Company/South Coast AQMD (Clean Air Environmental Film Trailers in 300 LA-based motion picture theaters); Glencoe/Macmillan/McGraw-Hill (textbook photography and illustrations, slide shows); Pepperdine University (awards banquets presentations, fundraising, biographical tribute programs); US Forest Service (slide shows and training programs); Venice Family Clinic (newsletter photography); Johnson & Higgins (brochure photography).
Needs: Works with 2-3 freelance photographers/month. Uses photos for catalogs, audiovisual and books. Subjects include: people, products, still life and architecture. Interested in reviewing 35mm stock photos by appointment. Signed model release required for people and companies.
Audiovisual Needs: Uses all AV formats including slides for multi-image presentations using 1-9 projectors.
Specs: Uses color and b&w prints; 35mm, 2¼×2¼ transparencies.
Making Contact & Terms: Interested in receiving work from newer, lesser-known photographers. Arrange a personal interview to show portfolio and samples. Works with freelancers on assignment only. Will assign certain work on spec. Do not submit unsolicited material. Cannot return material. Pays when images are shot to White's satisfaction—never delays until acceptance by client. Pays according to job: $25-100/hour, up to $500/day; $20-50/shot; or fixed fee based upon job complexity and priority of exposure. Hires according to work-for-hire and will share photo credit when possible.
Tips: In freelancer's portfolio or demo, Mr. White wants to see "quality of composition, lighting, saturation, degree of difficulty and importance of assignment. The trend seems to be toward more video, less AV.

 MARKETS USING AUDIOVISUAL MATERIAL, such as slides, film or videotape, are marked with a solid, black square.

Clients are paying less and expecting more. To break in, freelancers should diversify, negotiate, be flexible, go the distance to get and keep the job. Don't get stuck in thinking things can be done just one way. Support your co-workers."

Colorado

‡EVANSGROUP, 1050 17th St., Suite 700, Denver CO 80202. (303)534-2343. Creative Director: Gary Christlieb. Ad agency. Types of clients: consumer, franchises, financial, health care, brewing, business-to-business.
Needs: Works with approximately 25 freelance photographers/year on assignment only basis. Uses photos for consumer and trade magazines, direct mail, P-O-P displays, brochures, catalogs, posters, newspapers, AV presentations and TV.
Making Contact & Terms: Arrange interview to show portfolio. Payment negotiable according to job.

■FRIEDENTAG PHOTOGRAPHICS, 356 Grape St., Denver CO 80220. (303)333-7096. Manager: Harvey Friedentag. Estab. 1957. AV firm. Serves clients in business, industry, government, trade and union organizations. Produces slide sets, motion pictures and videotape.
Needs: Works with 5-10 freelancers/month on assignment only. Buys 1,000 photos and 25 films/year. Reviews stock photos of business, training, public relations and industrial plants showing people and equipment or products in use. Model release required.
Audiovisual Needs: Uses freelance photos in color slide sets and motion pictures. "No posed looks." Also produces mostly 16mm Ektachrome and some 16mm b&w; ¾" and VHS videotape. Length requirement: 3-30 minutes. Interested in stock footage on business, industry, education and unusual information. "No scenics please!"
Specs: Uses 8×10 glossy b&w and color prints; 35mm, 2¼×2¼ or 4×5 color transparencies.
Making Contact & Terms: Send material by mail for consideration. Provide flier, business card and brochure and nonreturnable samples to show clients. SASE. Reports in 3 weeks. Pays $400/day for still; $600/day for motion picture plus expenses; $50/b&w photo; $100/color photo. **Pays on acceptance.** Buys rights as required by clients.
Tips: "More imagination needed—be different, and above all, technical quality is a must. There are more opportunities now than ever, especially for new people. We are looking to strengthen our file of talent across the nation."

Connecticut

‡■DONAHUE ADVERTISING & PUBLIC RELATIONS, INC., 227 Lawrence St., Hartford CT 06106. (860)728-0000. Fax: (860)247-9247. Ad agency and PR firm. Creative Director: Jim Donahue. Estab. 1980. Types of clients: industrial, high-tech, food/beverage, corporate and finance.
Needs: Works with 1-2 photographers and/or videographers/month. Uses photos for trade magazines, catalogs and posters. Subjects include: products.
Audiovisual Needs: Uses videotape—infrequently.
Specs: Uses 8×10 matte and glossy color or b&w prints; 4×5 transparencies. Accepts images in digital format for Mac (EPS). Send via CD, floppy disk or SyQuest cartridge (300 dpi or better).
Making Contact & Terms: Contact through rep. Arrange personal interview to show portfolio. Send unsolicited photos by mail for consideration. Provide résumé, business card, brochure, flier or tearsheets to be kept on file for possible future assignments. Keeps samples on file. Cannot return material. Reports in 1-2 weeks. Pays $1,200-1,500/day. **Pays on receipt of invoice with purchase order.** Buys all rights. Model/property release required. Credit line not given.

‡■GUILFORD MARKETING, 6 Paddock Lane, Suite 201, Guilford CT 06437-2809. Phone/fax: (203)453-6261. E-mail: guilmark@aol.com. Owner/Creative Director: R.S. Eaton. Estab. 1990. Ad/PR agency and public affairs. Number of employees: 1 full-time, 1 part-time. Types of clients: industrial, fast food, professions and financial. Examples of recent projects: new store launch for Dunkin' Donuts; integrated condo marketing for Contracting Advisors; and newsletter for the Board of Realtors.
Needs: Works with 1-2 freelancers/month. Connecticut/New York area photographers only. Uses photos for billboards, consumer magazines, direct mail, P-O-P displays, posters, newspapers, signage, brochures and other collateral, TV. Subjects include: people, scenes, products (heavy real estate). Reviews stock photos. Model release required. Property release preferred. Caption preferred; include location, subject, date, file code/source/photographer credit.

Audiovisual Needs: Uses slides and video for meetings, sales promotion and TV. Subjects include: real estate products, low-cost PR shots, some head and shoulder portraits, some situational.
Specs: Uses color and b&w prints; 35mm, 2¼×2¼, 4×5 transparencies. Accepts images in digital format for Mac or Windows. Send via compact disc, online or floppy disk (minimum 600 dpi for b&w).
Making Contact & Terms: Interested in receiving work from newer, lesser-known photographers. Query with stock photo list. Query with samples. Works on assignment only. Keeps samples on file. SASE. Will contact if future work is anticipated or if need is immediate. Otherwise, will not contact. Payment negotiable. Prefer fee for job. Pays within 30 days of invoice. Credit line sometimes given depending on job, client and, sometimes, available space or other design criteria. Buys first, one-time and all rights; negotiable.
Tips: "No kinky, off-beat material. Generally, sharp focus, good depth of field, good use of light. In real estate, most have swing back camera to correct distortions. Retouch capability is a plus. For PR, need extremely fast turn-around and low pricing schedule."

THE MORETON AGENCY, P.O. Box 749, East Windsor CT 06088. (203)627-0326. Art Director: Todd M. Lemieux. Ad agency. Types of clients: industrial, sporting goods, corporate and consumer.
Needs: Works with 3-4 photographers/month. Uses photos for consumer and trade magazines, direct mail, catalogs, newspapers and literature. Subjects include: people, sports, industrial, product and fashion. Model release required.
Specs: Uses b&w prints; 35mm, 2¼×2¼, 4×5 and 8×10 transparencies.
Making Contact & Terms: Provide business card, brochure, flier or tearsheets to be kept on file for possible future assignments. Works with freelance photographers on assignment only. Cannot return material. Payment negotiable. Credit line negotiable. Buys all rights.

District of Columbia

MORRIS BEECHER, INC., 1000 Potomac St. NW, Washington DC 20007. (202)337-5300. Fax: (202)333-2659. Contact: Diane Beecher. Estab. 1983. Ad agency. Specializes in publications, P-O-P, display design, direct mail, signage, collateral, ads and billboards. Types of clients: sports, health and nutrition, the environment, real estate, resorts, shopping centers and retail.
Needs: Works with 3-4 freelancers/ month. Uses photos for billboards, direct mail, posters, signage, ads and collateral materials. Subjects include real estate, fashion and lifestyle. Reviews stock photos. Model release required. Captions preferred.
Specs: Uses any size or finish of color and b&w prints; 35mm transparencies.
Making Contact & Terms: Arrange personal interview to show portfolio. Provide business card, brochure, flier or tearsheets to be kept on file for possible future assignments. Works on assignment only. Keeps samples on file. SASE. Usually pays per job. Credit line not given. Buys all rights.
Tips: Wants to see "very high quality work." Uses a lot of stock.

‡**CHARITABLE CHOICES**, 1804 "S" St. NW, Washington DC 20009. (202)483-2906. Fax: (202)328-0627. E-mail: charitablechoices@juno.com. Managing Partner: Robert Minnich. Estab. 1984. PR firm. Approximate annual billing: $250,000. Number of employees: 10. Types of clients: industrial, financial, charities, nonprofit groups and government.
Needs: Uses photos for catalogs and newspapers. Subjects include environment, international, children, civil and human rights and social services. Reviews stock photos.
Specs: Uses b&w prints.
Making Contact & Terms: Submit portfolio for review. Query with stock photo list. Send unsolicited photos by mail for consideration. Works with local freelancers only. SASE. Reports in 3 months. Pays $50-100/b&w photo. **Pays on acceptance.** Buys one-time rights.

■**HILLMANN & CARR INC.**, 2121 Wisconsin Ave. NW, Washington DC 20007. (202)342-0001. Art Director: Michal Carr. Estab. 1975. Types of clients: museums, corporations, industrial, government and associations.
Needs: Releases required. Captions preferred.
Audiovisual Needs: Uses film and videotape. "Subjects are extremely varied and range from the historical to current events. We do not specialize in any one subject area. Style also varies greatly depending upon subject matter."
Specs: Uses video, 16mm and 35mm film.
Making Contact & Terms: Provide résumé, business card, self-promotion pieces, video samples to be kept on file for possible future assignments. Works on assignment only. Cannot return material. "If material

has been unsolicited and we do not have immediate need, material will be filed for future reference." Payment negotiable. Rights negotiable.

Tips: Looks for photographers with artistic style.

■**WORLDWIDE TELEVISION NEWS (WTN)**, 1705 DeSales St. NW, Suite 300, Washington DC 20036. (202)222-7889. Fax: (202)222-7891. Bureau Manager, Washington: Paul C. Sisco. Estab. 1952. AV firm. "We basically supply news on tape for TV networks and stations. At this time, most of our business is with foreign nets and stations."

Needs: Buys "dozens of news stories per year, especially sports." Works with 6 freelance photographers/month on assignment only. Generally hard news material, sometimes of documentary nature and sports.

Audiovisual Needs: Produces motion pictures and videotape.

Making Contact & Terms: Send name, phone number, equipment available and rates with material by mail for consideration. Provide business card to be kept on file for possible future assignments. Fast news material generally sent counter-to-air shipment; slower material by air freight. SASE. Reports in 2 weeks. Pays $100 minimum/job. Pays on receipt of material; nothing on speculation. Video rates about $500/half day, $900/full day. Negotiates payment based on amount of creativity required from photographer. Buys all video rights. Dupe sheets for film required.

Florida

■**AD CONSULTANT GROUP INC.**, 3111 University Dr., #408, Coral Springs FL 33065. (954)340-0883. President: B. Weisblum. Estab. 1994. Ad agency. Approximate annual billing: $3 million. Number of employees: 3. Types of clients: fashion, retail and food.

Needs: Works with 1 freelancer and 1 videographer/month. Uses photos for consumer magazines, trade magazines, direct mail, catalogs and newspapers. Reviews stock photos. Model/property release required.

Audiovisual Needs: Uses videotape.

Making Contact & Terms: Interested in receiving work from newer, lesser-known photographers. Query with stock photo list. Send unsolicited photos by mail for consideration. Provide résumé, business card, brochure, flier or tearsheets to be kept on file for possible future assignments.

Works with freelancers on assignment only. Cannot return material. Reports in 3 weeks. Payment negotiable. **Pays on acceptance.** Credit line sometimes given. Buys all rights; negotiable.

■**STEVEN COHEN MOTION PICTURE PRODUCTION**, 1182 Coral Club Dr., Coral Springs FL 33071. (954)346-7370. Contact: Steven Cohen. Examples of productions: TV commercials, documentaries, 2nd unit feature films and 2nd unit TV series.

Needs: Model release required.

Specs: Uses 16mm, 35mm film; ½" VHS, Beta videotape, S/VHS videotape.

Making Contact & Terms: Query with résumé. Provide business card, self-promotion piece or tearsheets to be kept on file for possible future assignments. Works on assignment only. Cannot return material. Reports in 1 week. Payment negotiable. **Pays on acceptance** or publication. Credit line given. Buys all rights (work-for-hire).

‡**CREATIVE RESOURCES, INC.**, 2000 S. Dixie Highway, Miami FL 33133. Fax: (305)856-3151. Chairman and CEO: Mac Seligman. Estab. 1970. PR firm. Handles clients in travel (hotels, resorts and airlines).

Needs: Works with 1-2 freelance photographers/month on assignment only. Buys 10-20 photos/year. Photos used in PR releases. Model release preferred.

Specs: Uses 8×10 glossy prints; contact sheet OK. Also uses 35mm or 2¼×2¼ transparencies and color prints.

Making Contact & Terms: Provide résumé to be kept on file for possible future assignments. Query with résumé of credits. No unsolicited material. SASE. Reports in 2 weeks. Pays $50 minimum/hour; $200 minimum/day; $100/color photo; $50/b&w photo. Negotiates payment based on client's budget. For assignments involving travel, pays $60-200/day plus expenses. **Pays on acceptance.** Buys all rights.

Tips: Most interested in activity shots in locations near clients.

THE DIGITAL MARKETS INDEX, located in the back of this book, lists markets that use images electronically.

HACKMEISTER ADVERTISING & PUBLIC RELATIONS, INC., 2631 E. Oakland, Suite 204, Ft. Lauderdale FL 33306. (954)568-2511. President: Dick Hackmeister. Estab. 1979. Ad agency and PR firm. Serves industrial, electronics manufacturers who sell to other businesses.
Needs: Works with 1 freelance photographer/month. Uses photos for trade magazines, direct mail, catalogs. Subjects include: electronic products. Model release and captions required.
Specs: Uses 8×10 glossy b&w and color prints and 4×5 transparencies.
Making Contact & Terms: "Call on telephone first." Does not return unsolicited material. Pays by the day and $200-2,000/job. Buys all rights.
Tips: Looks for "good lighting on highly technical electronic products—creativity."

■**STEVE POSTAL PRODUCTIONS**, P.O. Box 428, 108 Carraway St., Bostwick FL 32007. (904)325-9356. Director: Steve Postal. Estab. 1957. Member of SMPTE. AV firm. Approximate annual billing: $1 million plus. Number of employees: 10-48. Types of clients: distributors. Examples of recent projects: "The Importance of Going Amtrak," Washington DC AMTRAK (overseas info film); and many feature films on video for release (distributed to many countries).
Needs: Works with 2-3 freelance photographers, 2-3 filmmakers and 3-4 videographers/month. Uses photos for billboards, consumer magazines, trade magazines, direct mail and audiovisual. Subjects include: feature film publicity. Reviews stock photos of travel, food, glamour modeling and industrial processes. Model/property release preferred for glamour modeling. Captions required; include name, address, telephone number, date taken and equipment used.
Audiovisual Needs: Uses slides and/or film or video.
Specs: Uses 4×5, 8×10 glossy color and/or b&w prints; 35mm, 2¼×2¼ transparencies; 16mm film; VHS (NTSC signal) videotape.
Making Contact & Terms: Interested in receiving work from newer, lesser-known photographers. Send unsolicited photos by mail for consideration. Query with samples. Provide résumé, business card, brochure, flier or tearsheets to be kept on file for possible future assignments. Works with freelancers on assignment only. Keeps samples on file. Photographers should call in 3 weeks for report. Pays per job or feature film; negotiable. **Pays on acceptance.** Credit line given. Buys all rights.
Tips: Looks for "sharpness of image, trueness of color, dramatic lighting or very nice full lighting."

PRODUCTION INK, 2826 NE 19 Dr., Gainesville FL 32609-3391. (352)377-8973. Fax: (352)373-1175. President: Terry Van Nortwick. Ad agency, PR, marketing and graphic design firm. Types of clients: hospital, industrial, computer.
Needs: Works with 1 freelance photographer/month. Uses photos for ads, billboards, trade magazines, catalogs and newspapers. Reviews stock photos. Model release required.
Specs: Uses b&w prints and 35mm, 2¼×2¼ and 4×5 transparencies.
Making Contact & Terms: Arrange personal interview to show portfolio. Submit portfolio for review. Provide résumé, business card, brochure, flier or tearsheets to be kept on file for possible future assignments. Keeps samples on file. Payment negotiable. **Pays on receipt of invoice.** Credit line sometimes given; negotiable. Buys all rights only.

Georgia

■**FRASER ADVERTISING**, 1201 George C. Wilson Dr. #B, Augusta GA 30909. (706)855-0343. President: Jerry Fraser. Estab. 1980. Ad agency. Approximate annual billing: $800,000. Number of employees: 5. Types of clients: automotive, industrial, manufacturing, residential. Examples of recent projects: Pollock Company (company presentation); STV Corp. (national ads).
Needs: Works with "possibly one freelance photographer every two or three months." Uses photos for consumer and trade magazines, catalogs, posters and AV presentations. Subject matter: "product and location shots." Also works with freelance filmmakers to produce TV commercials on videotape. Model release required. Property release preferred.
Specs: Uses glossy b&w and color prints; 35mm, 2¼×2¼ and 4×5 transparencies; videotape and film. "Specifications vary according to the job."
Making Contact & Terms: Interested in receiving work from newer, lesser-known photographers. Provide résumé, business card, brochure, flier or tearsheets to be kept on file for possible future assignments. Works with freelance photographers on assignment only. Cannot return unsolicited material. Reports in 1 month. Payment negotiable according to job. Pays on publication. Buys exclusive/product, electronic, one-time and all rights; negotiable.
Tips: Prefers to see "samples of finished work—the actual ad, for example, not the photography alone. Send us materials to keep on file and quote favorably when rate is requested."

■**GRANT/GARRETT COMMUNICATIONS**, P.O. Box 53, Atlanta GA 30301. Phone/fax: (404)755-2513. President/Owner: Ruby Grant Garrett. Estab. 1979. Ad agency. Types of clients: technical. Examples of ad campaigns: Simons (help wanted); CIS Telecom (equipment); Anderson Communication (business-to-business).
Needs: Uses photos for trade magazines, direct mail and newspapers. Interested in reviewing stock photos/video footage of people at work. Model/property release required. Photo captions preferred.
Audiovisual Needs: Uses stock video footage.
Specs: Uses 4×5 b&w prints; VHS videotape.
Making Contact & Terms: Interested in receiving work from newer, lesser-known photographers. Query with résumé of credits. Query with list of stock photo subjects. Provide résumé, business card, brochure, flier or tearsheets to be kept on file for possible future assignments. Works with freelancers on an assignment basis only. SASE. Reports in 1 week. Payment negotiable per job. **Pays on receipt of invoice**. Credit line sometimes given, depending on client. Buys one-time and other rights; negotiable.
Tips: Wants to see b&w work in portfolio.

■**MYRIAD PRODUCTIONS**, 4923 Four Oaks Court, Atlanta GA 30360. (770)698-8600. President: Ed Harris. Estab. 1965. Primarily involved with sports productions and events. Works with freelance photographers on assignment only basis.
Needs: Uses photos for portraits, live-action and studio shots, special effects, advertising, illustrations, brochures, TV and film graphics, theatrical and production stills. Model/property release required. Captions preferred; include name(s), location, date, description.
Specs: Uses 8×10 b&w glossy prints, 8×10 color prints; and 2¼×2¼ transparancies.
Making Contact & Terms: Provide brochure, résumé and samples to be kept on file for possible future assignments. Send material by mail for consideration. Cannot return material. Reporting time "depends on urgency of job or production." Payment negotiable. Credit line sometimes given. Buys all rights.
Tips: "We look for an imaginative photographer; one who captures all the subtle nuances, as the photographer is as much a part of the creative process as the artist or scene being shot. Working with us depends almost entirely on the photographer's skill and creative sensitivity with the subject. All materials submitted will be placed on file and not returned, pending future assignments. Photographers should not send us their only prints, transparencies, etc., for this reason."

Idaho

CIPRA AD AGENCY, 314 E. Curling Dr., Boise ID 83702. (208)344-7770. Fax: (208)344-7794. President: Ed Gellert. Estab. 1979. Ad agency. Types of clients: agriculture (regional basis) and real estate.
Needs: Works with 1 freelance photographer/month. Uses photos for trade magazines. Subjects include: electronic, agriculture and garden. Reviews general stock photos. Model release required.
Specs: Uses 4×5, 8×10, 11×14 glossy or matte, color and b&w prints; 35mm, 4×5 transparencies.
Making Contact & Terms: Provide résumé, business card, brochure, flier or tearsheets to be kept on file for possible future assignments. Usually works with local freelancers only. Keeps samples on file. Cannot return material. Reports as needed. Pays $75/hour. Pays on publication. Buys all rights.

Illinois

BRAGAW PUBLIC RELATIONS SERVICES, 800 E. Northwest Hwy., Suite 1040, Palatine IL 60067. (847)934-5580. Fax: (847)934-5596. Contact: Richard S. Bragaw. Estab. 1981. Member of Public Relations Society of America, Publicity Club of Chicago. PR firm. Number of employees: 3. Types of clients: professional service firms, high-tech entrepreneurs.
Needs: Works with 1 freelance photographer/month. Uses photos for trade magazines, direct mail, brochures, newspapers, newsletters/news releases. Subjects include: "products and people." Model release preferred. Captions preferred.
Specs: Uses 3×5, 5×7 and 8×10 glossy prints.
Making Contact & Terms: Provide résumé, business card, brochure, flier or tearsheets to be kept on file for possible future assignments. Works with freelance photographers on assignment basis only. SASE. Pays $25-100/b&w photo; $50-200/color photo; $35-100/hour; $200-500/day; $100-1,000/job. **Pays on receipt of invoice.** Credit line "possible." Buys all rights; negotiable.

Tips: "Execute an assignment well, at reasonable costs, with speedy delivery."

JOHN CROWE ADVERTISING AGENCY, 2319½ N. 15th St., Springfield IL 62702-1226. (217)528-1076. President: Bryan J. Crowe. Ad agency. Serves clients in industry, commerce, aviation, banking, state and federal government, retail stores, publishing and institutes.
Needs: Works with 1 freelance photographer/month on assignment only. Uses photos for billboards, consumer and trade magazines, direct mail, newspapers and TV. Model release required.
Specs: Uses 8×10 glossy color and b&w prints; 2¼×2¼ transparencies.
Making Contact & Terms: Send material by mail for consideration. Provide letter of inquiry, flier, brochure and tearsheet to be kept on file for future assignments. SASE. Reports in 2 weeks. Pays $50 minimum/job or $18 minimum/hour. Payment negotiable based on client's budget. Buys all rights.

■**DARBY GRAPHICS, INC.**, 4015 N. Rockwell St., Chicago IL 60618. (773)583-5090. Production Manager: Dennis Cyrier. Types of clients: corporate and agency.
Needs: Uses photographers for filmstrips, slide sets, multimedia productions, videotapes, print and publication uses.
Making Contact & Terms: Provide résumé, business card, self-promotion piece or tearsheets to be kept on file for possible future assignments. Works on assignment only; interested in stock photos/footage. Payment negotiable. Payment is made to freelancers net 30 days. Captions preferred; model release required.

DEFRANCESCO/GOODFRIEND, 444 N. Michigan Ave., Suite 1000, Chicago IL 60611. (312)644-4409. Fax: (312)644-7651. E-mail: office@dgpr.com. Partner: John DeFrancesco. Estab. 1985. PR firm. Approximate annual billing: $750,000. Number of employees: 9. Types of clients: industrial, consumer products. Examples of recent projects: publicity campaigns for Promotional Products Association International and S-B Power Tool Company, and a newsletter for Teraco Inc.
Needs: Works with 1-2 freelancers/month. Uses photos for consumer magazines, trade magazines, direct mail, newspapers, audiovisual. Subjects include: people, equipment. Model/property release required. Captions preferred.
Audiovisual Needs: Uses slides and video for publicity, presentation and training.
Specs: Uses 5×7, 8×10, glossy color and b&w prints; 35mm transparencies; ½" VHS videotape.
Making Contact & Terms: Interested in receiving work from newer, lesser-known photographers. Query with résumé of credits. Provide résumé, business card, brochure, flier or tearsheets to be kept on file for possible future assignments. Works with freelancers on assignment only. Keeps samples on file. SASE. Reports in 1-2 weeks. Pays $25-100/hour; $500-1,500/day; $250-850/job; payment negotiable. Pays in 30 days. Credit line sometimes given.
Tips: "Because most photography is used in publicity, the photo must tell the story. We're not interested in high-style, high-fashion techniques."

‡**KAUFMAN RYAN STRAL INC.**, 650 North Dearborn, Suite 700, Chicago IL 60610. (312)467-9494. Fax: (312)467-0298. E-mail: krs@chi.il.us. Website: http://www.bworld.com. President: Robert Ryan. Estab. 1993. Member of BMA, BPA, AICE. Ad agency. Approximate annual billing: $4.5 million. Number of employees: 5. Types of clients: industrial and trade shows.
Needs: Works with 1 photographer and 1 videographer/month. Uses photos for trade magazines, direct mail, catalogs, posters, newspapers, signage and audiovisual. Model/property release preferred.
Audiovisual Needs: Uses slides and videotape.
Making Contact & Terms: Query with résumé of credits. Provide résumé, business card, brochure, flier or tearsheets to be kept on file for possible future assignments. Keeps samples on file. SASE. Reports in 3 weeks. Pays $900-1,500/day. Pays on receipt of invoice. Credit line sometimes given depending upon project. Buys all rights.

■**MSR ADVERTISING, INC.**, P.O. Box 10214, Chicago IL 60610-0214. (312)573-0001. Fax: (312)573-1907. E-mail: zoe@msradv.com. Website: http://www.msradv.com. President: Marc S. Rosenbaum. Vice President: Barry Waterman. Creative Director: Indiana Wilkins. Estab. 1983. Ad agency. Number of em-

THE SUBJECT INDEX, located at the back of this book, lists publications, book publishers, galleries, paper product companies and stock agencies according to the subject areas they seek.

ployees: 7. Types of clients: industrial, fashion, financial, retail, food, aerospace, hospital, legal and medical. Examples of recent projects: "Back to Basics," MPC Products; "Throw Mother Nature a Curve," New Dimensions Center for Cosmetic Surgery; and "Innovative Strategies Practical Solutions," Becker & Pouakoff (full identity).

Needs: Works with 4-6 freelance photographers and 1-2 videographers/month. Uses photos for billboards, consumer and trade magazines, direct mail, P-O-P displays, catalogs, posters and signage. Subject matter varies. Reviews stock photos. Model/property release required.

Audiovisual Needs: Uses slides and videotape for business-to-business seminars, consumer focus groups, etc. Subject matter varies.

Specs: Uses 35mm, 2¼×2¼, 4×5 and 8×10 transparencies. Accepts images in digital format for Mac. Send via compact disc, SyQuest or Zip disk (low and high resolution).

Making Contact & Terms: Interested in receiving work from newer, lesser-known photographers. Submit portfolio for review. Send unsolicited photos by mail for consideration. Query with samples. Provide résumé, business card, brochure, flier or tearsheets to be kept on file for possible future assignments. Works on assignment only. Keeps samples on file. SASE. Reports in 1-2 weeks. Pays $750-1,500/day. Payment terms stated on invoice. Credit line sometimes given. Buys all rights; negotiable.

QUALLY & COMPANY, INC., Suite 3, 2238 Central St., Evanston IL 60201-1457. (847)864-6316. Creative Director: Robert Qually. Ad agency and graphic design firm. Types of clients: finance, package goods and business-to-business.

Needs: Works with 4-5 freelance photographers/month. Uses photos for billboards, consumer and trade magazines, direct mail, P-O-P displays, posters and newspapers. "Subject matter varies, but is always a 'quality image' regardless of what it portrays." Model release required.

Specs: Uses b&w and color prints; 35mm, 2¼×2¼, 4×5 and 8×10 transparencies.

Making Contact & Terms: Query with samples or submit portfolio for review. Provide résumé, business card, brochure, flier or tearsheets to be kept on file for possible future assignments. Works with local freelance photographers on assignment only. Cannot return material. Reports in 2 weeks. Payment negotiable. **Pays on acceptance** or net 45 days. Credit line sometimes given, depending on client's cooperation. Rights purchased depend on circumstances.

‡**RUDER FINN**, 444 N. Michigan Ave., Chicago IL 60611. (312)644-8600. Senior Vice President: Mike Adams. Estab. 1948. PR firm. Handles accounts for corporations, trade and professional associations, institutions and other organizations.

Needs: Works with 4-8 freelance photographers/month nationally on assignment only. Buys over 100 photos/year. Uses photos for publicity, AV presentations, annual stockholder reports, brochures, books, feature articles and industrial ads. Uses industrial photos to illustrate case histories; commercial photos for ads; and consumer photos—food, fashion, personal care products. Present model release on acceptance of photo.

Making Contact & Terms: Provide résumé, flier, business card, tearsheets and brochure to be kept on file for possible future assignments. Query with résumé of credits or call to arrange an appointment. Pays $25 minimum/hour, or $200 minimum/day. Negotiates payment based on client's budget and photographer's previous experience/reputation.

Tips: Prefers to see publicity photos in a portfolio. Will not view unsolicited material.

SANDRA SANOSKI COMPANY, INC., 166 E. Superior St., Chicago IL 60611. (312)664-7795. President: Sandra Sanoski. Estab. 1974. Marketing communications and design firm specializing in display and publication design, packaging and web/internet design. Types of clients: retail and consumer goods.

Needs: Works with 3-4 freelancers/month. Uses photos for catalogs and packaging. Subject matter varies. Reviews stock photos. Model/property release required.

Specs: Uses 35mm, 2¼×2¼, 4×5, 8×10 transparencies. Accepts digital images.

Making Contact & Terms: Interested in receiving work from newer, lesser-known photographers. Query with list of stock photo images. Arrange personal interview to show portfolio. Works on assignment only. Keeps samples on file. SASE. Payment negotiable. Pays net 30 days. Credit line not given. Buys all rights.

■**VIDEO I-D, INC.**, 105 Muller Rd., Washington IL 61571. (309)444-4323. Fax: (309)444-4333. E-mail: videoid@videoid.com. Website: http://www.videoid.com. President: Sam B. Wagner. Number of employees: 6. Types of clients: health, education, industry, service, cable and broadcast.

Needs: Works with 5 freelance photographers/month to shoot slide sets, multimedia productions, films and videotapes. Subjects "vary from commercial to industrial—always high quality." "Somewhat" interested in stock photos/footage. Model release required.

Specs: Uses 35mm transparencies; 16mm film; U-matic ¾″ and 1″ videotape, Beta SP. Accepts images in

digital format for Windows ("inquire for file types"). Send via compact disc, online, floppy disk or on Zip disk.

Making Contact & Terms: Provide résumé, business card, self-promotion piece or tearsheets to be kept on file for possible future assignments; "also send video sample reel." Works with freelancers on assignment only. SASE. Reports in 3 weeks. Pays $10-65/hour; $160-650/day. Usually pays by the job; negotiable. **Pays on acceptance.** Credit line sometimes given. Buys all rights; negotiable.

Tips: Sample reel—indicate goal for specific pieces. "Show good lighting and visualization skills. Show me you can communicate what I need to see—and willingness to put out effort to get top quality."

Indiana

■**KELLER CRESCENT COMPANY**, 1100 E. Louisiana, Evansville IN 47701. (812)426-7551 or (812)464-2461. Manager Still Photography: Cal Barrett. Ad agency, PR and AV firm. Serves industrial, consumer, finance, food, auto parts and dairy products clients. Types of clients: Old National Bank, Fruit of the Loom and Eureka Vacuums.

Needs: Works with 2-3 freelance photographers/month on assignment only basis. Uses photos for billboards, consumer and trade magazines, direct mail, newspapers, P-O-P displays, radio and TV. Model release required.

Specs: Uses 8×10 b&w prints; 35mm, 4×5 and 8×10 transparencies.

Making Contact & Terms: Query with résumé of credits, list of stock photo subjects. Send material by mail for consideration. Provide business card, tearsheets and brochure to be kept on file for possible future assignments. Prefers to see printed samples, transparencies and prints. Cannot return material. Pays $200-2,500/job; negotiates payment based on client's budget, amount of creativity required from photographer and photographer's previous experience/reputation. Buys all rights.

■**OMNI PRODUCTIONS**, 12955 Old Meridian St., P.O. Box 302, Carmel IN 46032-0302. (317)844-6664. Fax: (317)573-8189. President: Winston Long. AV firm. Types of clients: industrial, corporate, educational, government and medical.

Needs: Works with 6-12 freelance photographers/month. Uses photographers for AV presentations. Subject matter varies. Also works with freelance filmmakers to produce training films and commercials.

Specs: Uses b&w and color prints; 35mm transparencies; 16mm and 35mm film and videotape.

Making Contact & Terms: Provide résumé, business card, brochure, flier or tearsheets to be kept on file for possible future assignments. Works with freelance photographers on assignment basis only. Cannot return unsolicited material. Payment negotiable. **Pays on acceptance.** Buys all rights "on most work; will purchase one-time use on some projects." Model release required. Credit line given "sometimes, as specified in production agreement with client."

Iowa

■**PHOENIX ADVERTISING CO.**, W. Delta Park, Hwy. 18 W., Clear Lake IA 50428. (515)357-9999. Fax: (515)357-5364. Ad agency. Estab. 1986. Types of clients: industrial, financial and consumer. Examples of projects: "Western Tough," Bridon (print/outdoor/collateral); "Blockbuster," Video News Network (direct mail, print); and "Blue Jeans," Clear Lake Bank & Trust (TV/print/newspaper).

Needs: Works with 2-3 photographers or videographers/month. Uses photos for billboards, consumer and trade magazines, direct mail, P-O-P displays, catalogs, posters, newspapers, signage, audiovisual uses. Subjects include: people/products. Reviews stock photos and/or video.

Audiovisual Needs: Uses slides and videotape.

Specs: Uses 8×10 color and b&w prints; 35mm, 2¼×2¼, 4×5, 8×10 transparencies; ½″ or ¾″ videotape.

Making Contact & Terms: Contact through rep. Submit portfolio for review. Provide résumé, business card, brochure, flier or tearsheets to be kept on file for possible future assignments. Works on assignment only. Keeps samples on file. SASE. Reports in 3 weeks. Pays $1,000-10,000/day. **Pays on receipt of invoice.** Buys first rights, one-time rights, all rights and others; negotiable. Model/property release required. Credit line sometimes given; no conditions specified.

Kansas

MARKETAIDE, INC., Dept. PM, 1300 E. Iron, P.O. Box 500, Salina KS 67402-0500. (800)204-2433. (913)825-7161. Fax: (913)825-4697. Copy Chief: Ted Hale. Art Director: Pamela Harris. Ad agency. Uses

all media. Serves industrial, retail, financial, nonprofit organizations, political, agribusiness and manufacturing clients.

Needs: Needs industrial photography (studio and on site), agricultural photography, and photos of banks, people and places.

Making Contact & Terms: Call to arrange an appointment. Provide résumé and tearsheets to be kept on file for possible future assignments. Reports in 3 weeks. SASE. Buys all rights. "We generally work on a day rate ranging from $200-1,000/day." Pays within 30 days of invoice.

Tips: Photographers should have "a good range of equipment and lighting, good light equipment portability, high quality darkroom work for b&w, a wide range of subjects in portfolio with examples of processing capabilities." Prefers to see "set-up shots, lighting, people, heavy equipment, interiors, industrial and manufacturing" in a portfolio. Prefers to see "8×10 minimum size on prints, or 35mm transparencies, preferably unretouched" as samples.

PATON & ASSOCIATES, INC./PAT PATON PUBLIC RELATIONS, P.O. Box 7350, Leawood KS 66207. (913)491-4000. Contact: N.E. (Pat) Paton, Jr. Estab. 1956. Ad agency. Clients: medical, financial, home furnishings, professional associations, vacation resorts, theater and entertainment.

Needs: Uses photos for billboards, consumer and trade magazines, direct mail, newspapers, P-O-P displays and TV. Model release required. Captions required.

Making Contact & Terms: Interested in receiving work from newer, lesser-known photographers. Call for personal appointment to show portfolio. Works on assignment only. Payment negotiable according to amount of creativity required from photographer.

‡■**UNELL COMMUNICATIONS**, 6740 Antioch, Suite 155, Merriam KS 66204. (913)722-1090. Fax: (913)722-1767. Art Director: Cindy Himmelberg. Estab. 1984. Member of Kansas City Ad Club, Missouri-Kansas NAMA, Council of Growing Companies. Ad agency. Number of employees: 15. Types of clients: industrial, financial, retail and agriculture. Recent clients include: Golden Harvest Seeds, Inc., Interconnect Devices, Inc., and Copaken, White & Blitt.

Needs: Works with 5 freelance photographers and 1 videographer/month. Uses photos for trade magazines, direct mail, catalogs, posters and signage. Subjects include: agriculture (on location); studio (technology). Reviews stock photos. Model release required. Property release preferred. Photo captions preferred.

Audiovisual Needs: Uses slides and videotape.

Specs: Uses color prints; 35mm, 2¼×2¼, 4×5 transparencies.

Making Contact & Terms: Interested in receiving work from newer, lesser-known photographers. Query with résumé of credits. Query with samples. Provide résumé, business card, brochure, flier or tearsheets to be kept on file for possible future assignments. Keeps samples on file. SASE. Reports in 1 month. Payment negotiable. **Pays on receipt of invoice.** Credit line given. Rights negotiable.

Maryland

■**MARC SMITH COMPANY, INC.**, P.O. Box 5005, Severna Park MD 21146. (410)647-2606. Art Director: Ed Smith. Estab. 1963. Ad agency. Types of clients: industrial. Client list on request with SASE.

Needs: Uses photos for trade magazines, direct mail, catalogs, slide programs and trade show booths. Subjects include: products, sales literature (still life), commercial buildings (interiors and exteriors). Model release required for building owners, designers, incidental persons. Captions required.

Specs: Vary: b&w and color prints and transparencies.

Making Contact & Terms: Provide résumé, business card, brochure, flier or tearsheets to be kept on file for possible future assignments. Works with freelance photographers on assignment only. Cannot return material. Reports in 1 month. Payment negotiable by the job. Pays when client pays agency, usually 30-60 days. Buys all rights.

Tips: Wants to see "proximity, suitability, cooperation and reasonable rates."

Massachusetts

■**CRAMER PRODUCTION CENTER**, 425 University Ave., Norwood MA 02062. (617)255-8400. Fax: (617)255-0721. Film/video production and event staging company. Operations Manager: Marty Sheldon. Estab. 1982. Types of clients: industrial, corporate, financial, fashion, retail and food. Examples of recent projects: CD-ROM for Meredith & Grew; video and booth support for Cabletron; commercials for Jordan's Furniture; marketing video for J. Baker; and retail video for Boston Red Sox.

Audiovisual Needs: Works with 2-3 freelance filmmakers and/or videographers/month. Subjects include: industrial to broadcast/machines to people. Reviews stock film or video footage. Uses film and videotape (Beta SP, Beta).

Making Contact & Terms: Send demo of work, ¾″ or VHS videotape. Query with résumé of credits. Works on assignment only. Keeps samples on file. Reports in 1 month. Pays $225-600/day, depending on job and level of expertise needed. Pays 30 days from receipt of invoice. Buys all rights. Model/property release required. Credit line sometimes given, depending on how the program is used.

Tips: Looks for experience in commercial video production. "Don't be discouraged if you don't get an immediate response. When we have a need, we'll call you."

DAVID FOX PHOTOGRAPHY, 59 Fountain St., Framingham MA 01701. (508)820-1130. Fax: (508)820-0558. President: David Fox. E-mail: davidfox@virtmall.com. Website: http://www.virtmall.david foxphotographer. Estab. 1983. Member of Professional Photographers of America, Professional Photographers of Massachusetts. Video production/post production photography company. Approximate annual billing: $150,000. Number of employees: 2. Types of clients: consumer, industrial and corporate. Examples of recent projects: Wayside Community Projects (brochures, newsletter); Holiday Manufacturing (catalog).

Needs: Works with 2-4 freelance photographers/videographers/year. Subjects include: executive portraiture, fine art, stock, children, families. Reviews area footage. Model/property release required. Captions preferred.

Audiovisual Needs: Uses videotape; photos, all media related materials. "We are primarily producers of photographic and video images."

Specs: Uses 35mm and 2¼×2¼ transparencies, slides and ½″, SVHS, Hi 8mm and 8mm formats of videotape. Accepts images in digital format for Mac and Windows (PICT, TIFF, Photoshop EPS). Send 4×5 electronic digital photos via floppy disk or SyQuest.

Making Contact & Terms: Arrange personal interview to show portfolio. Provide résumé, business card, brochure, flier or tearsheets to be kept on file for possible future assignments. Portfolio and references required. Works on assignment only. Looking for wedding photographers and freelancers. Works closely with freelancers. Buys all rights; negotiable.

Tips: Looks for style, abilities, quality and commitment similar to ours. "We have expanded our commercial photography. We tend to have more need in springtime and fall, than other times of the year. We're very diversified in our services—projects come along and we use people on an as-need basis. We are scanning and delivering images on disk to our clients. Manipulation of images enables us to create new images for stock use."

FUESSLER GROUP INC., 288 Shawmut Ave., Boston MA 02118. (617)451-9383. Fax: (617)451-5950. E-mail: fuessler@fuessler.com. President: Rolf Fuessler. Estab. 1984. Member of Society for Marketing Professional Services, Public Relations Society of America. Marketing communications firm. Types of clients: industrial, professional services. Has done work for Ogden Yorkshire, Earth Tech Inc.

Needs: Works with 2 freelancers/month; rarely works with videographers. Uses photos for trade magazines, collateral advertising and direct mail pieces. Subjects include: industrial and environmental. Reviews stock photos. Model/property release required, especially with hazardous waste photos. Captions preferred.

Specs: Uses 35mm transparencies.

Making Contact & Terms: Interested in receiving work from newer, lesser-known photographers. Query with résumé of credits. Query with samples. Works with local freelancers on assignment only. Keeps samples on file. SASE. Reports in 3 weeks. Payment negotiable. Pays on receipt of invoice. Credit line given. Buys first rights, one-time rights, all rights and has purchased unlimited usage rights for one client; negotiable.

GRAPHIC COMMUNICATIONS, 3 Juniper Lane, Dover MA 02030-2146. (508)785-1301. Fax: (508)785-2072. Owner: Richard Bertucci. Estab. 1970. Member of Art Directors Club, Graphic Artists Guild. Ad agency. Approximate annual billing: $1 million. Number of employees: 5. Types of clients: industrial, consumer, finance. Examples of recent projects: campaigns for Avant Incorporated; Bird Incorporated; and Ernst Asset Management.

Needs: Works with 3 freelancers/month. Uses photos for consumer magazines, trade magazines, catalogs, direct response and annual reports. Subjects include: products, models. Reviews stock photos. Model/property release required. Captions preferred.

Specs: Uses 8×10 glossy color and b&w prints; 2¼×2¼, 4×5 transparencies.

Making Contact & Terms: Interested in receiving work from newer, lesser-known photographers. Query with stock photo list. Provide résumé, business card, brochure, flier or tearsheets to be kept on file for possible future assignments. Works with local freelancers on assignment only. Keeps samples on file. Cannot return material. Reports as needed. Payment negotiable. **Pays on receipt of invoice**. Credit line not given. Buys all rights.

■**JEF FILMS INC**, 143 Hickory Hill Circle, Osterville MA 02655-1322. (508)428-7198. Fax: (508)428-7198. President: Jeffrey H. Aikman. Estab. 1973. AV firm. Member of American Film Marketing Association, National Association of Television Programmers and Executives. Types of clients: retail. Examples of projects: "Yesterday Today & Tomorrow," JEF Films (video box); "M," Aikman Archive (video box).
Needs: Works with 5 freelance photographers, 5-6 filmmakers and 5-6 videographers/month. Uses photos for billboards, consumer magazines, trade magazines, direct mail, P-O-P displays, catalogs, posters, newspapers and audiovisual. Subjects include glamour photography. Reviews stock photos of all types. Model release preferred. Property release required. Captions preferred.
Audiovisual Needs: Uses slides, films and/or video for videocassette distribution at retail level.
Specs: Uses 35mm transparencies.
Making Contact & Terms: Interested in receiving work from newer, lesser-known photographers. Submit portfolio for review. Works on assignment only. Keeps samples on file. Cannot return material. Reports in 1 month. Pays $25-300/job. Pays on publication. Credit line is not given. Buys all rights.

■**RUTH MORRISON ASSOCIATES**, 246 Brattle St., Cambridge MA 02138. (617)354-4536. Fax: (617)354-6943. Account Executive: Marinelle Hervas. Estab. 1972. PR firm. Types of clients: specialty foods, housewares, home furnishings and general business.
Needs: Works with 1-2 freelance photographers and/or videographers/month. Uses photos for consumer and trade magazines, P-O-P displays, posters, newspapers, signage and audiovisual.
Audiovisual Needs: Uses photos and videotape.
Specs: Specifications vary according to clients' needs. Typically uses b&w prints and transparencies.
Making Contact & Terms: Arrange personal interview to show portfolio. Provide résumé, business card, brochure, flier or tearsheets to be kept on file for possible future assignments. Works with freelancers on assignment only. Reports "as needed." Pays $100-1,000 depending upon client's budget. Credit line sometimes given, depending on use. Rights negotiable.

‡■**THE PHILIPSON AGENCY**, 241 Perkins St., Suite B201, Boston MA 02130. (617)566-3334. E-mail: tpa@ziplink.net. Owner/Creative Director: Joe Philipson. Estab. 1977. Ad Agency. Number of employees: 4. Types of clients: financial and retail. Examples of recent projects: BASF (direct mail); Colgate Oral Pharmaceutical Division (new product introduction); Servolift Eastern Corporation (new product introduction literature).
Needs: Works with 1 photographer/month. Uses photos for trade magazines, direct mail, P-O-P displays, catalogs and posters. Subjects include: product shots. Reviews stock photos. Model/property release preferred.
Audiovisual Needs: Uses slides for presentations of sales development product shots.
Specs: Uses all sizes and finishes color and b&w prints; 35mm, 2¼×2¼, 4×5, 8×10 transparencies; film; and digital format.
Making Contact & Terms: Query with samples. Provide résumé, business card, brochure, flier or tearsheets to be kept on file for possible future assignments. Works on assignment only. Keeps samples on file. Cannot return material. Calls photographer when work needed. Payment negotiable. **Pays on receipt of invoice**. Credit line sometimes given depending on client. Buys all rights.

RSVP MARKETING, INC., 450 Plain St., Marshfield MA 02050. (617)837-2804. Fax: (617)837-5389. E-mail: rsvpmktg@aol.com. President: Edward G. Hicks. Estab. 1981. Member of NEDMA, DMA, AMA. Ad agency and AV firm. Types of clients: industrial, financial, fashion, retail and construction. Examples of recent projects: "Landfill Reclamation," RETECH (trade shows); "Traffic," Taylor (print media); and "Fund Raising," CHF (newsletter).
Needs: Works with 1-2 freelance photographers and 1-2 videographers/month. Uses photos for trade magazines, direct mail, catalogs, newspapers and audiovisual. Subjects include: environment and people. Model release required.
Audiovisual Needs: Uses slides and videotape for advertising and trade shows.
Specs: Uses 5×7 color and b&w prints; 35mm, 2¼×2¼, 4×5, 8×10 transparencies.
Making Contact & Terms: Query with stock photo list. Query with samples. Works with freelancers on assignment only. Keeps samples on file. Reports in 1 month. Payment negotiable. Pays net 30. Buys all rights.

■**TR PRODUCTIONS**, 1031 Commonwealth Ave., Boston MA 02215. (617)783-0200. Executive Vice President: Ross P. Benjamin. Types of clients: industrial, commercial and educational.
Needs: Works with 1-2 freelance photographers/month. Uses photographers for slide sets and multimedia productions. Subjects include: people shots, manufacturing/sales and facilities.
Specs: Uses 35mm transparencies.
Making Contact & Terms: Provide résumé, business card, self-promotion piece or tearsheets to be kept

on file for possible future assignments. Works with local freelancers on assignment only; interested in stock photos/footage. Cannot return unsolicited material. Reports "when needed." Pays $600-1,500/day. Pays "14 days after acceptance." Buys all AV rights.

Michigan

COMMUNICATIONS ELECTRONICS JOURNAL, P.O. Box 1045-PM, Ann Arbor MI 48106. (313)996-8888. Fax: (313)663-8888. Editor-in-Chief: Ken Ascher. Estab. 1969. Ad agency. Approximate annual billing: $7 million. Number of employees: 38. Types of clients: industrial, financial, retail. Examples of recent projects: Super Disk (computer ad); Eaton Medical (medical ad); Ocean Tech Group (scuba diving ad); and Weather Bureau (weather poster ad).
Needs: Works with 45 freelance photographers, 4 filmmakers and 5 videographers/month. Uses photos for consumer magazines, trade magazines, direct mail, P-O-P displays, catalogs, posters and newspapers. Subjects include: merchandise. Reviews stock photos of electronics, hi-tech, scuba diving, disasters, weather. Model/property release required. Captions required; include location.
Audiovisual Needs: Uses videotape for commercials.
Specs: Uses various size glossy color prints; 35mm, 2¼×2¼, 4×5 transparencies.
Making Contact & Terms: Interested in receiving work from newer, lesser-known photographers. Query with résumé of credits. Provide résumé, business card, brochure, flier or tearsheets to be kept on file for possible future assignments. Cannot return material. Reports in 1 month. Pays $100-2,000/job; $15-1,000/color photo. Pays on publication. Credit line sometimes given depending on client. Buys one-time rights.

■**CREATIVE HOUSE ADVERTISING, INC.**, 30777 Northwestern Hwy., Suite 301, Farmington Hills MI 48334. (810)737-7077. Executive Vice President/Creative Director: Robert G. Washburn. Senior Art Director: Denise McCormick. Art Director: Amy Hepner. Ad agency. Types of clients: retail, industry, finance and commercial products.
Needs: Works with 4-5 freelance photographers/year on assignment only. Also produces TV commercials and demo film. Uses photos for brochures, catalogs, annual reports, billboards, consumer and trade magazines, direct mail, newspapers, P-O-P displays, radio and TV. Model release required.
Audiovisual Needs: Uses 35mm and 16mm film.
Specs: Uses b&w and color prints; transparencies.
Making Contact & Terms: Arrange personal interview to show portfolio. Query with résumé of credits, samples or list of stock photo subjects. Submit portfolio for review. "Include your specialty and show your range of versatility." Send material by mail for consideration. Provide résumé, business card, brochure, flier and anything to indicate the type and quality of photos to be kept on file for future assignments. Local freelancers preferred. SASE. Reports in 2 weeks. Pays $100-200/hour or $800-1,600/day; negotiates payment based on client's budget and photographer's previous experience/reputation. Pays in 1-3 months, depending on the job. Does not pay royalties. Buys all rights.

HEART GRAPHIC DESIGN, 501 George St., Midland MI 48640. (517)832-9710. Owner: Clark Most. Estab. 1982. Ad agency. Approximate annual billing: $250,000. Number of employees: 3. Types of clients: industrial.
Needs: Works with 1 freelancer/month. Uses photos for consumer magazines, catalogs and posters. Subjects include: product shots. Reviews stock photos. Model/property release preferred. Captions preferred.
Specs: Uses 8×10, 11×14 color and b&w prints; 2¼×2¼, 4×5 and 8×10 transparencies.
Making Contact & Terms: Interested in receiving work from newer, lesser-known photographers. Send unsolicited photos by mail for consideration. Provide résumé, business card, brochure, flier or tearsheets to be kept on file for possible future assignments. Works with local freelancers only. Keeps samples on file. SASE. Reports in 1-2 weeks. Pays $200-2,500/job. **Pays on receipt of invoice.** Credit line not given. Rights negotiated depending on job.
Tips: "Display an innovative eye, ability to creatively compose shots and have interesting techniques."

■**MESSAGE MAKERS**, 1217 Turner St., Lansing MI 48906. (517)482-3333. Fax: (517)482-9933. Executive Director: Terry Terry. Estab. 1977. Member of LRCC, NSPI, AIVF, ITVA. AV firm. Number of employees: 4. Types of clients: broadcast, industrial and retail.
Needs: Works with 2 freelance photographers, 1 filmmaker and 2 videographers/month. Uses photos for direct mail, posters and newspapers. Subjects include: people or products. Model release preferred. Property release required. Captions preferred.
Audiovisual Needs: Uses slides, film, video and CD.
Specs: Uses 4×5 color and b&w prints; 35mm, 2¼×2¼ transparencies; Beta SP videotape.

Making Contact & Terms: Interested in receiving work from newer, lesser-known photographers. Provide résumé, business card, brochure, flier or tearsheets to be kept on file for possible future assignments. Keeps samples on file. Cannot return material. Reports only if interested. Payment negotiable. **Pays on receipt of invoice.** Credit line sometimes given depending upon client. Buys all rights; negotiable.

■**PHOTO COMMUNICATION SERVICES, INC.**, 6055 Robert Dr., Traverse City MI 49684-8645. (616)943-8800. E-mail: lesnmore@aol.com. President: M'Lynn Hartwell. Estab. 1970. Commercial/Illustrative and AV firm. Types of clients: commercial/industrial, fashion, food, general, human interest.
Needs: Works with variable number of freelance photographers/month. Uses photos for catalogs, P-O-P displays, AV presentations, trade magazines and brochures. Photos used for a "large variety of subjects." Sometimes works with freelance filmmakers. Model release required.
Audiovisual Needs: Primarily industrial multi-image and video.
Specs: Uses 8×10 (or larger) gloss and semigloss b&w and color prints; 35mm, $2\frac{1}{4}\times2\frac{1}{4}$, 4×5 and 8×10 transparencies; 16mm film; VHS/SVHS; Hi8 and ¾" videotape.
Making Contact & Terms: Query with résumé of credits, samples or list of stock photo subjects. Works with freelance photographers on assignment basis only. SASE. Reports in 1 month. Payment determined by private negotiation. Pays 30 days from acceptance. Credit line given "whenever possible." Rights negotiated.
Tips: Looks for professionalism in portfolio or demos. "Be professional and to the point. If I see something I can use I will make an appointment to discuss the project in detail. We also have a library of stock photography."

VARON & ASSOCIATES, INC., 31333 Southfield Rd., Beverly Hills MI 48025. (810)645-9730. Fax: (810)642-1303. President: Shaaron Varon. Estab. 1963. Ad agency. Approximate annual billing: $1 million. Number of employees: 6. Types of clients: industrial and retail.
Needs: Uses photos for trade magazines, catalogs and audiovisual. Subjects include: industrial. Reviews stock photos. Model/property release required. Captions preferred.
Audiovisual Needs: Uses slides and videotape for sales and training. Subjects include: industrial.
Specs: Uses 8×10 color prints; 4×5 transparencies. Accepts images in digital format for Mac and Windows.
Making Contact & Terms: Interested in receiving work from newer, lesser-known photographers. Arrange personal interview to show portfolio. Works with freelancers on assignment only. Keeps samples on file. Cannot return material. Reports in 1-2 weeks. Pays $1,000/day. **Pays on acceptance.** Credit line sometimes given. Buys all rights.

Minnesota

TAKE I PRODUCTIONS, 5325 W. 74th St., Minneapolis MN 55439. (612)831-7757. Fax: (612)831-2193. E-mail: take1@take1productions.com. Producer: Bob Hewitt. Estab. 1985. Member of ITVA, IICS. AV firm. Approximate annual billing: $1 million. Number of employees: 10. Types of clients: industrial. Examples of recent projects: USWest; Kraft (industrial); Paramount (broadcast).
Needs: Works with 2 photographers and 4 videographers/month. Uses photos for direct mail and audiovisual. Subjects include: industrial. Reviews stock photos. Model/property release required. Captions preferred.
Audiovisual Needs: Uses slides and/or video.
Specs: Uses 35mm transparencies; Betacam videotape.
Making Contact & Terms: Interested in receiving work from newer, lesser-known photographers. Provide résumé, business card, brochure, flier or tearsheets to be kept on file for possible future assignments. Works with freelancers on assignment only. Keeps samples on file. Cannot return material. Reports in 1 month. Payment negotiable. **Pays on receipt of invoice**, net 30 days. Credit line not given. Buys all rights.

Missouri

‡■**ANGEL FILMS NATIONAL ADVERTISING**, 967 Highway 40, New Franklin MO 65274-9778. Phone/fax: (314)698-3900. Vice President Marketing & Advertising: Linda G. Grotzinger. Estab. 1980. Ad agency, AV firm. Approximate annual billing: $10 million. Number of employees: 31. Types of clients: fashion, retail, film, TV and records. Examples of recent projects: Stephanie Gee informercial (background); Lelinda album, One Records (cover); and "G-String Murders," Zion Productions (poster).

Needs: Works with 4 freelance photographers, 1 filmmaker and 1 videographer/month. Uses photos for billboards, consumer and trade magazines, direct mail, catalogs, posters, newspapers and audiovisual. Subjects include: attractive women in swimwear and lingerie. Glamour type shots of both Asian and non-Asian women needed. Reviews stock photos of attractive women and athletic men with attractive women. Model release required.

Audiovisual Needs: Uses slides and video for fill material in commercial spots.

Specs: Uses all sizes color and b&w prints; 35mm transparencies; 16mm film; ½" videotape. Accepts images in digital format for Windows (JPG, TIFF). Send via compact disc, online or floppy disk (300 dpi or better).

Making Contact & Terms: Interested in receiving work from newer, lesser-known photographers. Provide résumé, business card, brochure, flier or tearsheets to be kept on file for possible future assignments. Works on assignment only. Keeps samples on file. SASE. Reports in 1 month. Payment negotiable based upon budget of project. Pays within 30 days of receipt of invoice. Credit line sometimes given depending upon the project. Buys all rights.

Tips: "Our company does business both here and in Asia. We do about six record covers a year and accompanying posters using mostly glamour photography."

EVERETT, KLAMP & BERNAUER, INC., 3535 Broadway, Suite 300, Kansas City MO 64111. (816)753-0200. Fax: (816)421-1069. Contact: James A. Everett. Estab. 1967. Member Public Relations Society of America. Ad agency. Approximate annual billing: $1.3 million. Number of employees: 6. Types of clients: construction, finance, industrial, auto dealership, agribusiness, insurance, health services, schools, pet food accounts. Examples of recent projects: "School Services and Learning" (4-color brochure); "Extended Care/Retirement Americare" (ads); and Public Radio and Jack Miller Auto (magazine and newspaper ads).

Needs: Works with 1-2 freelance photographers/month on assignment basis only. Buys 25 photos/year. Uses photos in brochures, newsletters, annual reports, PR releases, AV presentations, sales literature, consumer and trade magazines. Model release required.

Specs: Uses 5×7 b&w and color prints; transparencies.

Making Contact & Terms: Interested in receiving work from newer, lesser-known photographers. Arrange a personal interview to show portfolio. Provide résumé and business card to be kept on file for possible future assignments. Prefers to work with local freelancers. SASE. Reports in 1 week. Payment negotiable "based on client's budget and amount of creativity required from photographer." Buys all rights; negotiable.

Tips: "We have a good working relationship with three local photographers and would rarely go outside of their expertise unless work load or other factors change the picture."

■GEILE/REXFORD CREATIVE ASSOCIATES, 135 N. Meramec, St. Louis MO 63105. (314)727-5850. Fax: (314)727-5819. Creative Director: David Geile. Estab. 1989. Member of American Marketing Association, BPAA. Ad agency. Approximate annual billing: $3 million. Number of employees: 12. Types of clients: industrial and financial. Recent clients include: Texas Boot Company; First Bank; and Monsanto.

Needs: Works with 2-3 freelance photographers/month, 3 filmmakers and 5 videographers/year. Uses photos for billboards, consumer and trade magazines, direct mail, P-O-P displays, catalogs, posters and newspapers. Subjects include: product shots. Model/property release preferred.

Audiovisual Needs: Uses slides and video for sales meetings.

Specs: Uses color and b&w prints; 35mm, 2¼×2¼, 4×5 transparencies; 16mm film; 1" videotape.

Making Contact & Terms: Interested in receiving work from newer, lesser-known photographers. Provide résumé, business card, brochure, flier or tearsheets to be kept on file for possible future assignments. Keeps samples on file. Cannot return material. Reports when approval is given from client. Pays $800-1,200/day; $300-500/b&w photo; also accepts bids for jobs. Pays net 30-45 days. Buys one-time and all rights.

KUPPER PARKER COMMUNICATIONS INC., 8301 Maryland Ave., St. Louis MO 63105. (314)727-4000. Fax: (314)727-3034. Advertising, public relations and direct mail firm. Executive Creative Director: Peter A.M. Charlton. Creative Directors: Lew Cohn and Joe Geis. Estab. 1992. Types of clients: retail, fashion, automobile dealers, consumer, broadcast stations, health care marketing, sports and entertainment, business-to-business sales and direct marketing.

Needs: Works with 12-16 freelance photographers/month. Uses photos for billboards, consumer and trade magazines, direct mail, P-O-P displays, catalogs, posters, signage and newspapers. Model release required; captions preferred.

Making Contact & Terms: Query with résumé of credits or with list of stock photo subjects. Provide résumé, business card, brochure, flier or tearsheets to be kept on file for possible future assignments. Works on assignment only. Does not return unsolicited material. Reports in 2 weeks. Pays $50-2,500/b&w photo;

$250-5,000/color photo; $50-300/hour; $400-2,500/day. Buys one-time rights, exclusive product rights, all rights, and limited-time or limited-run usage. Pays upon receipt of client payment.

‡■**MEDIA CONSULTANTS INC.**, P.O. Box 130, Sikeston MO 63801-0130. (573)472-1116. Fax: (573)472-3299. E-mail: media@ldd.net. President: Rich Wrather. Estab. 1980. Ad agency. Number of employees: 10. Types of clients: industrial, financial, fashion, retail and food.
Needs: Works with 2-4 photographers and 1-2 videographers/month. Uses photos for billboards, consumer magazines, trade magazines, direct mail, P-O-P displays, catalogs, posters, newspapers, signage and audio-visual. Subject matter varies. Reviews stock photos. Model/property release required. Photo captions preferred.
Audiovisual Needs: Uses film and videotape for audiovisual presentations and commercials. Subject includes stock.
Specs: Uses color and b&w prints; 35mm, 2¼×2¼ transparencies; ¾"-½" film.
Making Contact & Terms: Interested in receiving work from newer, lesser-known photographers. Send unsolicited photos by mail for consideration. Query with samples. Provide résumé, business card, brochure, flier or tearsheets to be kept on file for possible future assignments. Works on assignment only. Keeps samples on file. Cannot return material. Reports in 3 weeks. Payment negotiable. Pays on publication. Credit line not given. Buys first and all rights; negotiable.

Montana

‡■**GIBSON ADVERTISING & DESIGN**, P.O. Box 21697, Billings MT 59104. (406)248-3555. Fax: (406)248-9998. E-mail: gibco@imt.net. President: Bill Gibson. Estab. 1984. Ad agency. Number of employees 3. Types of clients: industrial, financial, retail, food.
Needs: Works with 1-3 freelance photographers and 1-2 videographers/month. Uses photos for direct mail, P-O-P displays, catalogs, posters, newspapers, signage and audiovisual. Subjects vary with job. Reviews stock photos. "We would like to see more Western photos." Model release required. Property release preferred.
Audiovisual Needs: Uses slides and videotape.
Specs: Uses color and b&w prints; 35mm, 2¼×2¼, 4×5, 8×10 transparencies; 16mm, VHS, Betacam videotape; and digital format.
Making Contact & Terms: Query with résumé of credits, Query with samples. Provide résumé, business card, brochure, flier or tearsheets to be kept on file for possible future assignments. Works with local freelancers on assignment only. Keeps samples on file. Cannot return material. Reports in 1-2 weeks. Pays $75-150/job; $150-250/color photo; $75-150/b&w photo; $100-150/hour for video. **Pays on receipt of invoice**, net 30 days. Credit line sometimes given. Buys one-time and electronic rights. Right negotiable.

‡■**THOMAS PRINTING, INC.**, 38 Sixth Ave. W., Kalispell MT 59901. (406)755-5447. Fax: (406)755-5449. E-mail: tpi@digisys.net. CEO: Frank Thomas. Estab. 1962. Member of NAPL. Commercial printer, graphic design firm, prepress house. Approximate annual billing: $3 million. Number of employees: 21. Types of clients: industrial and financial. Examples of recent projects; "Boots," Talga (graphics, commercial printing); "Sleds," Grizzly Sled (graphics, commercial printing); and "Golf." Northern Pines (graphics, commercial printing).
Needs: Works with 1-5 freelancers/month. Uses photos for direct mail, P-O-P displays, catalogs and posters. Subjects include: mostly product photo and outdoor shots. Reviews stock photos. Model/property release required.
Audiovisual Needs: Uses slides.
Specs: Uses 8×10 color prints; 35mm, 2¼×2¼, 4×5, 8×10 transparencies.
Making Contact & Terms: Provide résumé, business card, brochure, flier or tearsheets to be kept on file for possible future assignments. Works on assignment only. Keeps samples on file. SASE. Reports depending on project. Payment negotiable. **Pays on acceptance.** Credit line sometimes given depending upon project. Rights negotiable.

Nebraska

‡■**PORTWOOD MARTIN JONES ADVERTISING**, 800 W. Third St., Hastings NE 68901. (402)463-0588. Fax: (402)463-2187. E-mail: pmjadv@tcgcs.com. Vice President/Creative Director: Sherma Jones. Estab. 1982. Member of Lincoln Ad Federation. Ad agency. Approximate annual billing: $850,000. Number of employees: 7. Types of clients: industrial, financial, tourism and retail.

Needs: Works with 1-2 freelance photographers and 1 videographer/month. Uses photos for direct mail, catalogs, posters and newspapers. Subjects include people and product. Reviews stock photos. Model release required. Property release preferred.

Audiovisual Needs: Uses slides and videotape for presentations.

Specs: Uses 5×7 glossy color and b&w prints.

Making Contact & Terms: Provide résumé, business card, brochure, flier or tearsheets to be kept on file for possible future assignments. Works with freelancers on assignment only. Keeps samples on file. SASE. Reports in 1-2 weeks. Pays $75-125/hour; $650-1,000/day. **Pays on acceptance** with receipt of invoice. Credit line sometimes given depending on client and project. Buys all rights; negotiable.

‡■**SWANSON RUSSELL ASSOCIATES**, 9140 W. Dodge Rd., Suite 402, Omaha NE 68114. (402)393-4940. Fax: (402)393-6926. E-mail: paul_b@oma.sramarketing.com. Senior Art Director: Paul Berger. Estab. 1963. Member of NAMA, PRSA, DMA, Ad Club, AIGA, 4-As. Ad agency. Approximate annual billing: $30 million. Number of employees: 80. Examples of recent projects: "Nuflor Product Launch"; "Orbax Product Launch," Schering-Plough Animal Health (print, direct mail); and "Branding Campaign," Alegent Health System (print and TV).

Needs: Works with 2 photographers/month; 3-4 filmmakers/year and 1 videographer/year. Uses photos for billboards, trade magazines, direct mail, P-O-P displays, newspapers and audiovisual. Subjects include human health, animal health, pharmaceuticals and agriculture (cattle, hogs, crops, rural life). Model/property release preferred. Captions preferred.

Audiovisual Needs: Uses slides, film and video for training videos, etc.

Making Contact & Terms: Submit portfolio for review. Query with samples. Provide résumé, business card, brochure, flier or tearsheets to be kept on file for possible future assignments. Works with local freelancers on assignment only. Keeps samples on file. SASE. Reports in 1-2 weeks. Pays $100-150/hour; $800-1,500/day; $400-1,000/color photo. **Pays on receipt of invoice.** Credit line sometimes given. Buys first, one-time, electronic and all rights; negotiable.

Tips: "We have begun to use photographers who also have the skills and tools to digitally manipulate their images."

Nevada

■**DAVIDSON & ASSOCIATES**, 3940 Mohigan Way, Las Vegas NV 89119-5147. (702)871-7172. President: George Davidson. Full-service ad agency. Types of clients: beauty, construction, finance, entertainment, retailing, publishing, travel.

Needs: Photos used in brochures, newsletters, annual reports, PR releases, AV presentations, sales literature, consumer and trade magazines.

Making Contact & Terms: Arrange a personal interview to show portfolio. Query with samples or submit portfolio for review. Provide résumé, brochure and tearsheets to be kept on file for possible future assignments. Offers 150-200 assignments/year. Pays $15-50/b&w photo; $25-100/color photo; $15-50/hour; $100-400/day; $25-1,000 by the project. Pays on production. Buys all rights. Model release required.

‡■**GUSTIN & NAKAMOTO**, 549 Court St., Reno NV 89501. Fax: (702)333-9396. Art Director: Skot Meyer. Estab. 1982. Member of Reno Ad Club, Second Wind, RWA. Ad agency. Approximate annual billing: $5.2 million. Number of employees: 10. Types of clients: industrial, financial. Examples of recent projects: Norwest Bank (TV, billboard, radio, print ads); Hamilton Corporation (annual reports, print ads); and Carson Valley Inn (outdoor print ads, collateral).

Needs: Works with 3-4 freelance photographers, 2-3 filmmakers and 2-5 videographers/month. Uses photos for billboards, consumer magazines, trade magazines, direct mail, P-O-P displays, posters, newspapers, signage, audiovisual, collateral, annual reports. Reviews stock photos. Model/property release preferred. Captions preferred.

Audiovisual Needs: Uses slides and video for clients' annual reports and conferences. Subjects include: medical and financial. Uses 2¼×2¼, 4×5 transparencies; film; videotape; digital format (Macintosh, compact disk).

Making Contact & Terms: Send unsolicited photos by mail for consideration. Provide résumé, business card, brochure, flier or tearsheets to be kept on file for possible future assignments. Keeps samples on file. SASE. Reports if work is needed. Payment negotiable. Pays on publication and receipt of invoice. Credit line not given. Buys one-time rights for stock use and all rights.

Tips: Looks for "style and unusual or different approaches to subject matter."

‡■**SHARP ADVERTISING**, 4701 Decatur #C-4, Las Vegas NV 89103. (702)253-1565. Fax (702)253-1566. President: Jeff Pilcher. Ad agency. Number of employees: 5. Examples of recent projects: Oasis Dog

Fair; Terrible Herbst Car Wash (Easter theme); Roadrunner/Boomtown Casino (Easter theme).
Needs: Works with 2 photographers, 2 filmmakers and 2 videographers/month. Uses photos for billboards, consumer magazines, trade magazines, P-O-P displays, posters, newspapers and signage. Reviews stock photos. Model release required. Captions preferred.
Audiovisual Needs: Uses slides, film and video.
Specs: Uses color and b&w prints; 35mm, 2¼×2¼, 8×10 transparencies.
Making Contact & Terms: Arrange personal interview to show portfolio. Works on assignment only. Keeps samples on file. Reports in 1-2 weeks. Payment negotiable. **Pays on receipt of invoice.** Credit line not given. Buys first rights.

New Jersey

■**AM/PM ADVERTISING, INC.**, 196 Clinton Ave., Newark NJ 07108. (201)824-8600. Fax: (201)824-6631. President: Robert A. Saks. Estab. 1962. Member of Art Directors Club, Illustrators Club, National Association of Advertising Agencies and Type Directors Club. Ad agency. Approximate annual billing: $250 million. Number of employees: 1,100. Types of clients: food, pharmaceuticals, health and beauty aids and entertainment industry. Examples of recent projects: AT&T (TV commercials); Nabisco (print ads for Oreo cookies); and Revlon (prints ads for lipstick colors).
Needs: Works with 6 freelance photographers/month. Uses photos for consumer and trade magazines, direct mail, P-O-P displays, catalogs, posters, newspapers and audiovisual. Subjects include: fashion, still life and commercials. Reviews stock photos of food and beauty products. Model release required. Captions preferred.
Audiovisual Needs: "We use multimedia slide shows and multimedia video shows."
Specs: Uses 8×10 color and/or b&w prints; 35mm, 2¼×2¼, 4×5, 8×10 transparencies; 8×10 film; broadcast videotape.
Making Contact & Terms: Arrange personal interview to show portfolio. Send unsolicited photos by mail for consideration. Provide résumé, business card, brochure, flier or tearsheets to be kept on file for possible future assignments. Works on assignment only. Keeps samples on file. Reports in 1-2 weeks. Pays $50-250/hour; $500-2,000/day; $2,000-5,000/job; $50-500/color or b&w photo. **Pays on receipt of invoice.** Credit line sometimes given, depending upon client and use. Buys one-time, exclusive product, electronic and all rights; negotiable.
Tips: In portfolio or samples, wants to see originality. Sees trend toward more use of special lighting.

‡**MICHAEL D. BECKERMAN & ASSOCIATES**, 35 Mill St., Bernardsville NJ 07924. (908)766-9238. Ad agency. Contact: Jay Zukus. Types of clients: real estate, banks, retail, miscellaneous.
Needs: Works with 2 photographers/month. Uses photos for advertisements, posters and brochures.
Specs: Uses b&w prints and 2¼×2¼ transparencies.
Making Contact & Terms: Arrange a personal interview to show portfolio. Provide résumé, business card, brochure, flier or tearsheets to be kept on file for possible future assignments. Works with freelance photographers on assignment only. Does not return unsolicited material. Reports as needed. Payment negotiable; maximum $1,500/day. Pays on receipt of invoice. Buys all rights. Model release required.
Tips: Looks for "the ability to think conceptually and solve a problem in a strong, fresh way."

■**CREATIVE ASSOCIATES**, 44 Park Ave., Madison NJ 07940. (201)377-4440. Producer: Harrison Feather. Estab. 1975. AV firm. Types of clients: industrial, cosmetic and pharmaceutical.
Needs: Works with 1-2 photographers, filmmakers and/or videographers/month. Uses photos for trade magazines and audiovisual uses. Subjects include product and general environment. Reviews stock photos or videotape. Model release required. Property release preferred. Captions preferred.
Audiovisual Needs: Uses photos/video for slides and videotape.
Specs: Uses 35mm, 4×5 and 8×10 transparencies; videotape.
Making Contact & Terms: Provide résumé, business card, brochure, flier or tearsheets to be kept on file for possible future assignments. Works on assignment only. Reports as needed. Pays $500-1,000/day; $1,500-3,000/job. Pays on publication. Credit line sometimes given, depending on assignment. Rights negotiable; "depends on budget."

DIEGNAN & ASSOCIATES, 3 Martens, Lebanon NJ 08833. President: N. Diegnan. Ad agency/PR firm. Types of clients: industrial, consumer.
Needs: Commissions 15 photographers/year; buys 20 photos/year from each. Uses photos for billboards, trade magazines and newspapers. Model release preferred.
Specs: Uses b&w contact sheet or glossy 8×10 prints. For color, uses 5×7 or 8×10 prints; also 2¼×2¼

transparencies.

Making Contact & Terms: Arrange a personal interview to show portfolio. Local freelancers preferred. SASE. Reports in 1 week. Payment negotiable. Negotiates payment based on client's budget and amount of creativity required from photographer. Pays by the job. Buys all rights.

■**INSIGHT ASSOCIATES,** 14 Rita Lane, Oak Ridge NJ 07438. (201)697-0880. Fax: (201)697-6904. President: Raymond Valente. Types of clients: major industrial companies, public utilities. Examples of recent projects: "Savety on the Job" for Ecolab, Inc.; "Handling Gases" for Matheson Gas; and "Training Drivers" for Suburban Propane (all inserts to videos).
Needs: Works with 4 freelancers/month. Uses freelancers for slide sets, multimedia productions, videotapes and print material—catalogs. Subjects include: industrial productions. Examples of clients: Matheson (safety); Witco Corp. (corporate image); Volvo (sales training); P.S.E.&G.; Ecolab Inc. Interested in stock photos/footage. Model release preferred.
Specs: Uses 35mm, 2¼×2¼ and 4×5 transparencies.
Making Contact & Terms: Arrange a personal interview to show portfolio. SASE. Reports in 1 week. Pays $450-750/day. **Pays on acceptance.** Credit line given. Buys all rights.
Tips: "Freelance photographers should have knowledge of business needs and video formats. Also, versatility with video or location work. In reviewing a freelancer's portfolio or samples we look for content appropriate to our clients' objectives. Still photographers interested in making the transition into film and video photography should learn the importance of understanding a script."

■**JANUARY PRODUCTIONS,** P.O. Box 66, 210 Sixth Ave., Hawthorne NJ 07507. (201)423-4666. Fax: (201)423-5569. Art Director: Karen Sigler. Estab. 1973. AV firm. Number of employees: 12. Types of clients: schools, teachers and public libraries. Audience consists of primary, elementary and intermediate-grade school students. Produces children's books, videos and CD-ROM. Subjects are concerned with elementary education—science, social studies, math and conceptual development.
Audiovisual Needs: Uses 35mm color transparencies and b&w photographs of products for company catalogs.
Making Contact & Terms: Interested in receiving work from newer, lesser-known photographers. Call or send résumé and samples of work "for us to keep on file." SASE. Payment negotiable. Payment amounts "depend on job." Buys all rights.
Tips: Wants to see "clarity, effective use of space, design, etc. We need clear photographs of our products for catalog use. The more pictures we have in the catalogs, the better they look and that helps to sell the product."

■**KJD TELEPRODUCTIONS, INC.,** 30 Whyte Dr., Voorhees NJ 08043. (609)751-3500. Fax: (609)751-7729. E-mail: mactoday@ios.com. President: Larry Scott. Estab. 1989. Member of National Association of Television Programming Executives. AV firm. Approximate annual billing: $600,000. Number of employees: 6. Types of clients: industrial, fashion, retail, professional, service and food. Examples of projects: Marco Island Florida Convention, ICI Americas (new magazine show); "More Than Just a Game" (TV sports talk show); and "Rukus," Merv Griffin Productions (TV broadcast).
Needs: Works with 2 photographers, filmmakers and/or videographers/month. Uses photos for trade magazines and audiovisual. Model/property release required.
Audiovisual Needs: Primarily videotape; also slides and film.
Specs: Uses ½", ¾", Betacam/SP 1" videotape. Accepts images in digital format for Mac (any medium). Send via compact disc, online, floppy disk, SyQuest or Zip disk.
Making Contact & Terms: Send unsolicited photos by mail for consideration. Works on assignment only. Keeps samples on file. Reports in 1 month. Pays $50-300/day. **Pays on acceptance.** Credit lines sometimes given. Buys one-time, exclusive product, all and electronic rights; negotiable.
Tips: "We are seeing more use of freelancers, less staff. Be visible!"

■**KOLLINS COMMUNICATIONS, INC.,** 425 Meadowlands Pkwy., Secaucus NJ 07094. (201)617-5555. Fax: (201)319-8760. Manager: R.J. Martin. Estab. 1992. Types of clients: Fortune 1000 pharmaceuticals, consumer electronics. Examples of projects: Sony (brochures); CBS Inc. (print ads); TBS Labs (slides).
Needs: Works with 1-2 freelance photographers/month. Uses photos for product shots, multimedia productions and videotapes. Subjects are various. Model release required.
Specs: Uses 35mm, 2¼×2¼, 4×5, 8×10 transparencies; Hi 8, ½" Betacam, SP, S-VHS. Accepts images in digital format for Mac. Submit via compact disc, floppy disk, SyQuest or Zip disk.
Making Contact & Terms: Interested in receiving work from newer, lesser-known photographers. Submit portfolio by mail. Provide résumé, business card, self-promotion piece or tearsheets to be kept on file for possible future assignments. Works on assignment only. Cannot return material. Reports in 2 weeks.

Payment negotiable. Pays per day or per job. Pays by purchase order 30 days after work completed. Credit line given "when applicable." Buys all rights.
Tips: "Be specific about your best work (what areas), be flexible to budget on project—represent our company when on business."

■**SORIN PRODUCTIONS, INC.**, 919 Hwy. 33, Suite 46, Freehold NJ 07728. (908)462-1785. President: David Sorin. Type of client: corporate.
Needs: Works with 2 freelance photographers/month. Uses photographers for slide sets, multimedia productions, films and videotapes. Subjects include people and products.
Specs: Uses b&w and color prints; 35mm and 2¼×2¼ transparencies.
Making Contact & Terms: Query with stock photo list. Provide résumé, business card, self-promotion piece or tearsheets to be kept on file for possible future assignments. Works with freelancers by assignment only; interested in stock photos/footage. Does not return unsolicited material. Reports in 2 weeks. Payment negotiable. Pays per piece or per job. **Pays on acceptance.** Buys all rights. Captions and model releases preferred. Credit line given by project.

New Mexico

■**FOCUS ADVERTISING, INC.**, 4002 Silver Ave. SE, Albuquerque NM 87108. (505)255-4355. Fax: (505)266-7795. President: Al Costanzo. Member of Nikon Professional Services, New Mexico Professional Photographer's Association. Ad agency. Approximate annual billing: $350,000. Number of employees: 3-5. Types of clients: industry, electronics, software, government, law. Produces overhead transparencies, slide sets, motion pictures, sound-slide sets, videotape, print ads, trade show displays and brochures. Examples of recent projects: "S.O.P." for Xynatech, Inc.; and "Night Sights" for Innovative Weaponry (brochures/ads/trade show displays).
Needs: Works with 1-2 freelance photographers/month on assignment only basis. Buys 70 photos and 5-8 films/year: health, business, environment and products. No animals or flowers. Length requirements: 80 slides or 15-20 minutes, or 60 frames, 20 minutes.
Specs: Produces ½″ and ¾″ video for broadcasts; also b&w photos or color prints and 35mm transparencies, "and a lot of 2¼ transparencies and some 4×5 transparencies." Accepts images in digital format for Windows. Send via Zip disk or Bernoulli.
Making Contact & Terms: Arrange personal interview or query with résumé. Provide résumé, flier and brochure to be kept on file for possible future assignments. Prefers to see a variety of subject matter and styles in portfolio. Does not return unsolicited material. Pays minimum $75/b&w or color photo; $40-75/hour; $350-750/day; $100-1,000/job. Negotiates payment based on client's budget and photographer's previous experience/reputation. Pays on job completion. Buys all rights. Model release required.

New York

AMMIRATI PURIS LINTAS, 1 Dag Hammarskjold Plaza, New York NY 10017. (212)605-8000. Art Buyers: Jean Wolff, Julie Rosenoff, Betsy Thompson, Leslie D'Acri, Helaina Buzzeo. Member of AAAA. Ad agency. Approximate annual billing: $500 million. Number of employees: 750. Types of clients: financial, food, consumer goods. Examples of recent projects: Four Seasons Hotels, Compaq Computers, RCA, Burger King, Epson, Johnson & Johnson.
Needs: Works with 50 freelancers/month. Uses photos for billboards, trade magazines, direct mail, P-O-P displays, catalogs, posters, newspapers. Reviews stock photos. Model/property release required for all subjects.
Specs: Accepts images in digital format for Mac. Send via online, floppy disk, SyQuest or Zip disk.
Making Contact & Terms: Interested in receiving work from newer, lesser-known photographers. Contact through rep. Arrange personal interview to show portfolio. Submit portfolio for review. Provide résumé, business card, brochure, flier or tearsheets to be kept on file for possible future assignments. Works on assignment only. Keeps samples on file. SASE. Reports in 1-2 weeks. Payment negotiable. Pays extra for electronic usage of images. **Pays on receipt of invoice.** Credit line not given. Buys all rights.

■**A-1 FILM AND VIDEO WORLD WIDE DUPLICATION**, 4650 Dewey Ave., Rochester NY 14612. (716)663-1400. Fax: (716)663-0246. President: Michael Gross Ordway. Estab. 1976. AV firm. Approximate annual billing: $1 million. Number of employees: 7. Types of clients: industrial and retail.
Needs: Works with 4 freelance photographers, 1 filmmaker and 4 videographers/month. Uses photos for

trade magazines, direct mail, catalogs and audiovisual uses. Reviews stock photos or video. Model release required.
Audiovisual Needs: Uses slides, film and video.
Specs: Uses color prints; 35mm transparencies; 16mm film and all types of videotape.
Making Contact & Terms: Fax or write only. Works with local freelancers only. Pays $12/hour; $96/day. **Pays on receipt of invoice.** Credit line not given. Buys all rights.

■**ANITA HELEN BROOKS ASSOCIATES**, 155 E. 55th St., New York NY 10022. (212)755-4498. Contact: Anita Helen Brooks. PR firm. Types of clients: beauty, entertainment, fashion, food, publishing, travel, society, art, politics, exhibits and charity events.
Needs: Photos used in PR releases, AV presentations and consumer and trade magazines. Buys "several hundred" photos/year. Most interested in fashion shots, society, entertainment and literary celebrity/personality shots. Model release preferred.
Specs: Uses 8×10 glossy b&w or color prints; contact sheet OK.
Making Contact & Terms: Provide résumé and brochure to be kept on file for possible future assignments. Query with résumé of credits. No unsolicited material; cannot return unsolicited material. Works on assignment only. Pays $50 minimum/job; negotiates payment based on client's budget. Credit line given.

■**CL&B ADVERTISING, INC.**, 100 Kinloch Commons, Manlius NY 13104-2484. (315)682-8502. Fax: (315)682-8508. President: Richard Labs. Creative Director: Adam Rozum. Estab. 1937. Advertising, PR and research. Types of clients: industrial, fashion, finance and retail. Examples of recent projects: "Charges, Choices and Familiar Faces" (ads and literature); "Girl, dogs, Volvo, fall foliage classics" (posters for retail); and "Glamor shots of donuts" (point of purchase).
Needs: Works with 4-6 freelance photographers/year. Uses photos for billboards, consumer and trade magazines, P-O-P displays, catalogs and newspapers. Subjects include: industrial, consumer, models, location and/or studio. Model/property release required.
Audiovisual Needs: "Wish we could find a low cost, high quality 35mm panavision film team."
Specs: Uses all formats.
Making Contact & Terms: "Send bio and proof sheet (if available) first; we will contact you if interested." Works on assignment only. Also uses stock photos. Does not return unsolicited material. Pays $10-1,000/b&w photo; $10-2,500/color photo; $10-100/hour; $200-3,000/day; $100-10,000/job. Pays in 30 days. Credit line seldom given. Buys all rights.
Tips: "We review your work and will call if we think a particular job is applicable to your talents."

■**COX ADVERTISING**, 379 W. Broadway, New York NY 10012. (212)334-9141. Fax: (212)334-9179. Ad agency. Associate Creative Director: Marc Rubin. Types of clients: industrial, retail, fashion and travel.
Needs: Works with 2 freelance photographers or videographers/month. Uses photographers for billboards, consumer magazines, trade magazines, direct mail, P-O-P displays, catalogs, posters, newspapers, signage and audiovisual. Reviews stock photos or video.
Audiovisual Needs: Uses photos for slide shows; also uses videotape.
Specs: Uses 16×20 b&w prints; 35mm, 2¼×2¼, 4×5 and 8×10 transparencies.
Making Contact & Terms: Arrange personal interview to show portfolio. Works on assignment only. Cannot return material. Reports in 1-2 weeks. Pays minimum of $1,500/job; higher amounts negotiable according to needs of client. Pays within 30-60 days of receipt of invoice. Buys all rights when possible. Model release required. Credit line sometimes given.

■**D.C.A./DENTSU CORPORATION OF AMERICA**, 666 Fifth Ave., New York NY 10103. (212)261-2668. Fax: (212)261-2360. Art Buyer: Hedy Sikora. Estab. 1971. Ad agency. Types of clients: Canon, U.S.A., Shiseido (skin care products), Sanyo, Lorus (watches); and Butler (oral hygiene products).
Needs: Works with 5-10 freelance photographers, 1-2 filmmakers. Uses photos for billboards, consumer magazines, trade magazines, direct mail, P-O-P displays, catalogs, posters, newspapers, signage for annual reports, sales and marketing kits. Reviews stock photos. All subjects with a slant on business and sports. Model/property release required. Captions preferred; include location, date and original client.
Audiovisual Needs: Uses slides and videotape for presentations.
Specs: Uses 8×10 to 16×20 color and b&w prints; 35mm, 4×5, 8×10 transparencies. Accepts images in digital format for Mac. Send via compact disc, floppy disk, SyQuest or Zip disk.
Making Contact & Terms: Interested in receiving work from newer, lesser-known photographers. Query with samples. Provide résumé, business card, brochure, flier or tearsheets to be kept on file for possible future assignments. Works with local freelancers on assignment only. Keeps samples on file. Reporting time depends on the quality of work; calls will be returned as they apply to ongoing projects. Payment negotiable. Pays 60 days from assignment completion. Credit line sometimes given depending on placement of work. Buys one-time and all rights.

Tips: "Your capabilities must be on par with top industry talent. We're always looking for new techniques."

■**RICHARD L. DOYLE ASSOC., INC., RLDA COMMUNICATIONS**, 15 Maiden Lane, New York NY 10038. (212)349-2828. Fax: (212)619-5350. Ad agency. Client Services: R.L. Stewart, Jr. Estab. 1979. Types of clients: primarily insurance/financial services and publishers. Client list free with SASE.
Needs: Works with 3-4 freelance photographers/month. Uses photographers for consumer and trade magazines, direct mail, newspapers, audiovisual, sales promotion and annual reports. Subjects include people—portrait and candid. Model release required. Captions required.
Audiovisual Needs: Typically uses prepared slides—in presentation formats, video promotions and video editorials.
Specs: Uses b&w and color prints; 35mm and 2¼ × 2¼ transparencies.
Making Contact & Terms: Query with résumé of credits and samples. Prefers résumé, business card, brochure, flier or tearsheets to be kept on file for possible future assignments. SASE. Reports in 2 weeks. Payment negotiable. **Pays on acceptance** or receipt of invoice. Buys all rights.
Tips: Prefers to see photos of people; "good coverage/creativity in presentation. Be perfectly honest as to capabilities; be reasonable in cost and let us know you'll work *with us* to satisfy the client."

EPSTEIN & WALKER ASSOCIATES, #5A, 65 W. 55 St., New York NY 10019. Phone/fax: (212)246-0565. President/Creative Director: Lee Epstein. Member of Art Directors Club of New York. Ad agency. Approximate annual billing: $2 million. Number of employees: 3. Types of clients: retail, publication, consumer. Examples of ad campaigns: *Woman's World Magazine* (trade campaign to media buyers); Northville Gas (radio campaign); and Bermuda Shop (woman's retail-image/fashion).
Needs: Works with 2-3 freelance photographers/year. Uses photos for consumer and trade magazines, direct mail and newspapers. Subjects include still life, people, etc.; "depends on concept of ads." Model release required.
Specs: Any size or format b&w prints; also 35mm, 2¼ × 2¼ transparencies.
Making Contact & Terms: Arrange personal interview to show portfolio. Provide résumé, business card, brochure, flier or tearsheets to be kept on file for possible future assignments. Works with local freelancers on assignment only. Cannot return material. Reports "as needed." Pays minimum of $250/b&w photo or negotiates day rate for multiple images. Pays 30-60 days after receipt of invoice. Credit line not given. Usually buys rights for "1 year usage across the board."
Tips: Trend within agency is "to solve problems with illustration, and more recently with type/copy only, more because of budget restraints regarding models and location expenses." Is receptive to working with new talent. To break in, show "intelligent conceptual photography with exciting ideas and great composition."

■**FINE ART PRODUCTIONS, RICHIE SURACI PICTURES, MULTI MEDIA, INTERACTIVE**, 67 Maple St., Newburgh NY 12550-4034. Phone/fax: (914)561-5866. E-mail: rs7.fapamhv.net. Websites: http://ww2.audionet.com/pub/books/fineart/fineart.htm; http://www.funslut.com; http://www.mhv.net~rs7. fap/networkerotica.html. Résumé Website: http://www.lookup.com/homepages/61239/home.html. Director: Richie Suraci. Estab. 1989. Ad agency, PR firm and AV firm. Types of clients: industrial, financial, fashion, retail, food—all industries. Examples of previous projects: "Great Hudson River Revival," Clearwater, Inc. (folk concert, brochure); feature articles, Hudson Valley News (newspaper); "Wheel and Rock to Woodstock," MS Society (brochure); and Network Erotica (Website).
Needs: Uses photos for billboards, consumer and trade magazines, direct mail, P-O-P displays, catalogs, posters, Web Pages, brochures, newspapers, signage and audiovisual. Especially needs erotic art, adult erotica, science fiction, fantasy, sunrises, waterfalls, beautiful nude women and men, futuristic concepts. Reviews stock photos. Model/property release required. Captions required; include basic information.
Audiovisual Needs: Uses slides, film (all formats) and videotape.
Specs: Uses color and b&w prints, any size or finish; 35mm, 2¼ × 2¼, 4 × 5, 8 × 10 transparencies; film, all formats; ½″, ¾″ or 1″ Beta videotape. Accepts images in digital format for Mac (2HD). Send via online or floppy disk (highest resolution).
Making Contact & Terms: Submit portfolio for review. Query with résumé of credits. Query with list of stock photo subjects. Send unsolicited photos by mail for consideration. Query with samples. Provide résumé, business card, brochure, flier or tearsheets to be kept on file for possible future assignments. Keeps samples on file. SASE. Reports in 1 month or longer. "All payment negotiable relative to subject matter." Pays on acceptance, publication or on receipt of invoice; "varies relative to project." Credit line sometimes given, "depending on project or if negotiated." Buys first, one-time and all rights; negotiable.
Tips: "We are also requesting any fantasy, avant-garde, sensuous or classy photos, video clips, PR data, short stories, adult erotic scripts, résumé, fan club information, PR schedules, etc. for use on our Website. Nothing will be posted unless accompanied by a release form. We will post this free of charge on the Website and give you free advertising for the use of your submissions We will make a separate agreement

for usage for any materials besides ones used on the Website and/or any photos or filming sessions we create together in the future. If you would like to make public appearances in our network and area, send a return reply and include PR information for our files."

HARRINGTON ASSOCIATES INC., 57 Fairmont Ave., Kingston NY 12401-5221. (914)331-7136. Fax: (914)331-7168. E-mail: gharring@aol.com. President: Gerard Harrington. Estab. 1988. Member of Hudson Valley Area Marketing Association, Hudson Valley Direct Marketing Association. PR firm. Types of clients: industrial, high technology, retail, fashion, finance, transportation, architectural, artistic and publishing. Examples of recent clients include: Ulster Performing Arts Center (PR, brochures, advertising); Smith Barney, Inc. (office relocation, investment product/service brochures); Woodstock Communications, Inc. (corporate ID campaign, investor relations program, product/service brochure).
- This company has received the Gold Eclat Award, Hudson Valley Area Marketing Association, for best PR effort.

Needs: Number of photographers used on a monthly basis varies. Uses photos for consumer and trade magazines, P-O-P displays, catalogs and newspapers. Subjects include: general publicity including head shots and candids. Also still lifes. Model release required.
Specs: Uses b&w prints, any size and format. Also uses 4×5 color transparencies; and ¾" videotape.
Making Contact & Terms: Interested in receiving work from newer, lesser-known photographers. Provide résumé, business card, brochure, flier or tearsheets to be kept on file for possible future assignments. Works with freelancers on assignment only. Cannot return material. Reports only when interested. Payment negotiable. Pays on receipt of invoice. Credit line given whenever possible, depending on use. Buys all rights; negotiable.

■**IMAGE ZONE, INC.**, 101 Fifth Ave., New York NY 10003. (212)924-8804. Fax: (212)924-5585. Managing Director: Doug Ehrlich. Estab. 1986. AV firm. Approximate annual billing: $2.5 million. Number of employees: 12. Types of clients: industrial, financial, fashion, pharmaceutical. Examples of recent projects: Incentive meeting for Monsanto (to record event); awards presentation for Lebar Friedman (holiday celebration); managers presentation for Pfizer (video tribute).
Needs: Works with 1 freelance photographer, 2 filmmakers and 3 videographers/month. Uses photos for audiovisual projects. Subjects vary. Reviews stock photos. Model/property release preferred. Captions preferred.
Audiovisual Needs: Uses slides, film and videotape. Subjects include: "original material."
Specs: Uses 35mm transparencies; ¾" or ½" videotape. Accepts images in digital format for Mac (various formats).
Making Contact & Terms: Query with résumé of credits. Provide résumé, business card, brochure, flier or tearsheets to be kept on file for possible future assignments. Works with local freelancers on assignment only. Keeps samples on file. Cannot return material. Reports when needed. Pays $500-1,500/job; also depends on size, scope and budget of project. Pays within 30 days of receipt of invoice. Credit line not given. Buys one-time rights; negotiable.

■**LIPPSERVICE**, 305 W. 52nd St., New York NY 10019. (212)956-0572. President: Ros Lipps. Estab. 1985. Celebrity consulting firm. Types of clients: industrial, financial, fashion, retail, food; "any company which requires use of celebrities." Examples of recent projects: Projects for United Way of Tri-State, CARE, AIDS benefits, Child Find of America, League of American Theatres & Producers, *Celebrate Broadway*.
Needs: Works with 6 freelance photographers and/or videographers/month. Uses photos for billboards, trade magazines, P-O-P displays, posters, audiovisual. Subjects include: celebrities only. Model/property release required.
Audiovisual Needs: Uses videotape.
Making Contact & Terms: Provide résumé, business card, brochure, flier or tearsheets to be kept on file for possible future assignments. Works on assignment only. Keeps samples on file. Cannot return material. Reports in 3 weeks. Payment negotiable. Credit line given. Rights purchased depend on job; negotiable.
Tips: Looks for "experience in photographing celebrities. *Contact us by mail only.*"

 SPECIAL COMMENTS within listings by the editor of *Photographer's Market* are set off by a bullet.

■**McANDREW ADVERTISING CO.**, 2125 St. Raymond Ave., P.O. Box 254, Bronx NY 10462. Phone/fax: (718)892-8660. Contact: Robert McAndrew. Estab. 1961. Ad agency, PR firm. Approximate annual billing: $250,000. Number of employees: 2. Types of clients: industrial and technical. Examples of recent projects: trade advertising and printed material illustrations. Trade show photography.
Needs: Works with 1 freelance photographer/month. Uses photos for trade magazines, direct mail, brochures, catalogs, newspapers, audiovisual. Subjects include: technical products. Reviews stock photos of science subjects. Model release required for recognizable people. Property release required.
Audiovisual Needs: Uses slides and videotape.
Specs: Uses 8×10 glossy b&w or color prints; 35mm, 4×5 transparencies.
Making Contact & Terms: Interested in working with local photographers. Query with résumé of credits. Provide résumé, business card, brochure, flier, tearsheets or non-returnable samples to be kept on file for possible future assignments. Reports when appropriate. Pays $65/b&w photo; $150/color photo; $700/day. "Prices dropping because business is bad." Pays 30 days after receipt of invoice. Credit line sometimes given. Buys all rights; negotiable.
Tips: Photographers should "let us know how close they are, and what their prices are. We look for photographers who have experience in industrial photography." In samples, wants to see "sharp, well-lighted" work.

■**ROGER MALER, INC.**, 161 St. Andrews Circle, South Hampton NY 11968-3819. Ad agency. President: Roger Maler. Types of clients: industrial, pharmaceutical.
Needs: Works with 3 freelance photographers/month. Uses photographers for trade magazines, direct mail, P-O-P displays, brochures, catalogs, newspapers and AV presentations.
Audiovisual Needs: Works with freelance filmmakers.
Making Contact & Terms: Send résumé, business card, brochure, flier or tearsheets to be kept on file for possible future assignments. Works with freelance photographers on assignment only. Does not return unsolicited material. Payment negotiable. Pays on publication. Model release required. Credit line sometimes given.

‡**MEDIA LOGIC, INC.**, 1520 Central Ave., Albany NY 12205. (518)456-3015. Fax: (518)456-4279. E-mail: jhoe@mlinc.com. Production Manager: Jennifer Hoehn. Estab. 1984. Ad agency. Number of employees: 28. Types of clients: industrial, financial, fashion and retail.
Needs: Works with 2 freelancers/month. Uses photos for billboards, consumer magazines, trade magazines, direct mail, P-O-P displays, catalogs, posters, newspapers and signage. Subject matter varies. Reviews stock photos. Model release required. Property release preferred.
Specs: Uses transparencies.
Making Contact & Terms: Interested in receiving work from newer, lesser-known photographers. Send unsolicited photos by mail for consideration. Provide résumé, business card, brochure, flier or tearsheets to be kept on file for possible future assignments. Keeps samples on file. SASE. Reports in 1-2 weeks. Pays $600/day. **Pays on receipt of invoice.** Credit line not given. Buys all rights; negotiable.

MIZEREK ADVERTISING INC., 318 Lexington Ave., New York NY 10016. (212)689-4885. President: Leonard Mizerek. Estab. 1974. Types of clients: fashion, jewelry and industrial.
Needs: Works with 2 freelance photographers/month. Uses photographs for trade magazines. Subjects include: still life and jewelry. Reviews stock photos of creative images showing fashion/style. Model release required. Property release preferred.
Specs: Uses 8×10 glossy b&w prints; 4×5 and 8×10 transparencies.
Making Contact & Terms: Interested in receiving work from newer, lesser-known photographers. Submit portfolio for review. Provide résumé, business card, brochure, flier or tearsheets to be kept on file for possible future assignments. SASE. Reports in 2 weeks. Pays $500-1,500/job; $1,500-2,500/day; $600/color photo; $400/b&w photo. **Pays on acceptance.** Credit line sometimes given.
Tips: Looks for "clear product visualization. Must show detail and have good color balance." Sees trend toward "more use of photography and expanded creativity." Likes a "thinking" photographer.

■**NATIONAL TEACHING AIDS, INC.**, 1845 Highland Ave., New Hyde Park NY 11040. (516)326-2555. Fax: (516)326-2560. President: A. Becker. Estab. 1960. AV firm. Types of clients: schools. Produces filmstrips and CD-ROMs.
Needs: Buys 20-100 photos/year. Subjects include: science; needs photomicrographs and space photography.
Specs: Uses 35mm transparencies.
Making Contact & Terms: Cannot return material. Pays $50 minimum. Buys one-time rights; negotiable.

NOSTRADAMUS ADVERTISING, #1128A, 250 W. 57th, New York NY 10107. (212)581-1362. Fax: (212)581-1369. President: Barry Sher. Estab. 1974. Ad agency. Types of clients: politicians, nonprofit organizations and small businesses.
Needs: Uses freelancers occasionally. Uses photos for consumer and trade magazines, direct mail, catalogs and posters. Subjects include: people and products. Model release required.
Specs: Uses 8×10 glossy b&w and color prints; transparencies, slides.
Making Contact & Terms: Provide résumé, business card, brochure. Works with local freelancers only. Cannot return material. Pays $50-100/hour. Pays 30 days from invoice. Credit line sometimes given. Buys all rights (work-for-hire).

■PARAGON ADVERTISING, 43 Court St., Suite 1111, Buffalo NY 14202. (716)854-7161. Fax: (716)854-7163. Senior Art Director: Leo Abbott. Estab. 1988. Ad agency. Types of clients: industrial, retail, food and medical.
Needs: Works with 0-5 photographers, 0-1 filmmakers and 0-1 videographers/month. Uses photos for billboards, consumer and trade magazines, P-O-P displays, catalogs, posters, newspapers, signage and audiovisual. Subjects include: location. Reviews stock photos. Model release required. Property release preferred.
Audiovisual Needs: Uses film and videotape for on-air.
Specs: Uses 8×10 prints; 2¼×2¼ or 4×5 transparencies; 16mm film; and ¾″, 1″ Betacam videotape.
Making Contact and Terms: Interested in receiving work from newer, lesser-known photographers. Submit portfolio for review. Query with stock photo list. Send unsolicited photos by mail for consideration. Works on assignment only. Keeps samples on file. SASE. Reports in 1-2 weeks. Pays $500-2,000 day; $100-5,000 job. **Pays on receipt of invoice.** Credit line sometimes given. Buys all rights; negotiable.

PRO/CREATIVES, 25 W. Burda Place, New City NY 10956-7116. President: David Rapp. Ad agency. Uses all media except billboards and foreign. Types of clients: package goods, fashion, men's entertainment and leisure magazines, sports and entertainment.
Specs: Send any size b&w prints. For color, send 35mm transparencies or any size prints.
Making Contact & Terms: Submit material by mail for consideration. Reports as needed. SASE. Payment negotiable based on client's budget.

PETER ROTHHOLZ ASSOCIATES, INC., 360 Lexington Ave., 3rd Floor, New York NY 10017. (212)687-6565. Contact: Peter Rothholz. PR firm. Types of clients: pharmaceuticals (health and beauty), government, travel.
Needs: Works with 2 freelance photographers/year, each with approximately 8 assignments. Uses photos for brochures, newsletters, PR releases, AV presentations and sales literature. Model release required.
Specs: Uses 8×10 glossy b&w prints; contact sheet OK.
Making Contact & Terms: Provide letter of inquiry to be kept on file for possible future assignments. Query with résumé of credits or list of stock photo subjects. Local freelancers preferred. SASE. Reports in 2 weeks. Payment negotiable based on client's budget. Credit line given on request. Buys one-time rights.
Tips: "We use mostly standard publicity shots and have some 'regulars' we deal with. If one of those is unavailable we might begin with someone new—and he/she will then become a regular."

SAATCHI & SAATCHI ADVERTISING, 375 Hudson St., 15th Floor, New York NY 10014-3660. (212)463-2000. Fax: (212)463-2216. Senior Art Buyer: Francis Timoney. Art Buyers: Kari Nouhan, Janice Fitzgibbon.
● This market says its photo needs are so varied that photographers should contact individual art buyers about potential assignments.

JACK SCHECTERSON ASSOCIATES, 5316 251 Place, Littleneck NY 11362-1711. (718)225-3536. Fax: (718)423-3478. Principal: Jack Schecterson. Estab. 1965. Ad agency and design studio specializing in package graphic design. Types of clients: industrial, food, HBA, hardware, housewares and leisure.
Needs: Uses photos for trade magazines, catalogs and package design. Subjects vary depending on work

MARKET CONDITIONS are constantly changing! If you're still using this book and it's 1999 or later, buy the newest edition of *Photographer's Market* at your favorite bookstore or order directly from Writer's Digest Books.

inhouse. Reviews stock photos. Model/property release required. Captions preferred.

Specs: Uses color and b&w prints; 35mm, 2¼×2¼, 4×5, 8×10 transparencies.

Making Contact & Terms: Interested in receiving work from newer, lesser-known photographers. Provide résumé, business card, brochure, flier or tearsheets to be kept on file for possible future assignments. Works with local freelancers only. Keeps samples on file. Reports ASAP once given clients OK. Payment negotiable based on job budget. **Pays on receipt of invoice.** Credit line sometimes given depending on client's preference. Buys all rights.

■**SPENCER PRODUCTIONS, INC.**, 736 West End Ave., New York NY 10025. General Manager: Bruce Spencer. Estab. 1961. PR firm. Types of clients: business, industry. Produces motion pictures and videotape.

Needs: Works with 1-2 freelance photographers/month on assignment only. Buys 2-6 films/year. Satirical approach to business and industry problems. Freelance photos used on special projects. Length: "Films vary—from a 1-minute commercial to a 90-minute feature." Model/property release required. Captions required.

Specs: 16mm color commercials, documentaries and features.

Making Contact & Terms: Interested in receiving work from newer, lesser-known photographers. Provide résumé and letter of inquiry to be kept on file for possible future assignments. Query with samples and résumé of credits. "Be brief and pertinent!" SASE. Reports in 3 weeks. Pays $50-150/color and b&w photos (purchase of prints only; does not include photo session); $5-15/hour; $500-5,000/job. Payment negotiable based on client's budget. Pays a royalty of 5-10%. **Pays on acceptance.** Buys one-time rights and all rights; negotiable.

Tips: "Almost all of our talent was unknown in the field when hired by us. For a sample of our satirical philosophy, see paperback edition of *Don't Get Mad . . . Get Even* (W.W. Norton), by Alan Abel which we promoted, or *How to Thrive on Rejection* (Dembner Books, Inc.), or rent the home video *Is There Sex After Death?*, an R-rated comedy featuring Buck Henry."

■**TALCO PRODUCTIONS**, 279 E. 44th St., New York NY 10017. (212)697-4015. Fax: (212)697-4827. E-mail: alaw@enet.com. President: Alan Lawrence. Vice President: Marty Holberton. Estab. 1968. Public relations agency and TV, film, radio and audiovisual production firm. Number of employees: 5. Types of clients: industrial, legal, political and nonprofit organizations. Produces motion pictures, videotape and radio programs.

Needs: Works with 1-2 freelancers/month. Model/property release required.

Audiovisual Needs: Uses 16mm and 35mm film, Beta videotape. Filmmaker might be assigned "second unit or pick-up shots."

Making Contact & Terms: Query with résumé of credits. Provide résumé, flier or brochure to be kept on file for possible future assignments. Prefers to see general work or "sample applicable to a specific project we are working on." Works on assignment only. SASE. Reports in 3 weeks. Payment negotiable according to client's budget and where the work will appear. **Pays on receipt of invoice.** Buys all rights.

Tips: Filmmaker "must be experienced—union member is preferred. We do not frequently use freelancers except outside the New York City area when it is less expensive than sending a crew. Query with résumé of credits only—don't send samples. We will ask for specifics when an assignment calls for particular experience or talent."

■**TOBOL GROUP, INC.**, 14 Vanderventer Ave., Port Washington NY 11050. (516)767-8182. Fax: (516)767-8185. Ad agency/design studio. President: Mitch Tobol. Estab. 1981. Types of clients: high-tech, industrial, business-to-business and consumer. Examples of ad campaigns: Weight Watchers (in-store promotion); Eutectic & Castolin; Mainco (trade ad); and Light Alarms.

Needs: Works with up to 4 photographers/videographers/month. Uses photos for billboards, consumer and trade magazines, direct mail, P-O-P displays, catalogs, posters, newspapers and audiovisual. Subjects are varied; mostly still-life photography. Reviews business-to-business and commercial video footage. Model release required.

Audiovisual Needs: Uses videotape.

Specs: Uses 4×5, 8×10, 11×14 b&w prints; 35mm, 2¼×2¼ and 4×5 transparencies; and ½″ videotape.

Making Contact & Terms: Send unsolicited photos by mail for consideration. Query with samples. Provide résumé, business card, brochure, flier or tearsheets to be kept on file for possible future assignments: follow-up with phone call. Works on assignment only. SASE. Reports in 3 weeks. Pays $100-10,000/job. Pays net 30. Credit line sometimes given, depending on client and price. Rights purchased depend on client.

Tips: In freelancer's samples or demos, wants to see "the best they do—any style or subject as long as it is done well. Trend is photos or videos to be multi-functional. Show me your *best* and what you enjoy

shooting. Get experience with existing company to make the transition from still photography to audiovisual."

■**VISUAL HORIZONS**, 180 Metro Park, Rochester NY 14623. (716)424-5300 or (800)424-1011. Fax: (716)424-5313 or (800)424-5411. E-mail: 73730.2512@compuserve.com. or slides1@aol.com. Website: http://www.btb.com/vh. President: Stanley Feingold. AV firm. Types of clients: industrial.
Audiovisual Needs: Works with 1 freelance photographer/month. Uses photos for AV presentations. Also works with freelance filmmakers to produce training films. Model release required. Captions required.
Specs: Uses 35mm transparencies and videotape.
Making Contact & Terms: Provide résumé, business card, brochure, flier or tearsheets to be kept on file for possible future assignments. Works on assignment only. Reports as needed. Payment negotiable. Pays on publication. Buys all rights.

■**WOLFF ASSOCIATES INC.**, 500 East Ave., Rochester NY 14607. (716)461-8300. Fax: (716)461-0835. Creative Services Manager: Adele Simmons. Promotional communications agency. Types of clients: industrial, fashion, consumer, packaged goods.
Needs: Works with 3-4 freelance photographers/month. Uses photos for billboards, consumer magazines, direct mail, P-O-P displays, brochures, catalogs, posters, newspapers, AV presentations. Also works with freelance filmmakers to produce TV commercials.
Making Contact & Terms: Provide résumé, business card, brochure, flier or tearsheets to be kept on file for possible future assignments. Does not return unsolicited material. Pays $800-3,500/day.

‡■**ZELMAN STUDIOS, LTD.**, 623 Cortelyou Rd., Brooklyn NY 11218. (718)941-5500. General Manager: Jerry Krone. Estab. 1966. AV firm. Types of clients: industrial, retail, fashion, public relations, fundraising, education, publishing, business and government.
Needs: Works on assignment only. Uses photographers for corporate, industrial and candid applications. Releasing work formats include print, transparency, slide sets, filmstrips, motion pictures and videotape. Subjects include: people, machines and aerial. Model release required. Property release preferred. Captions preferred.
Specs: Produces 16mm and 35mm documentary, educational and industrial video films and slide/sound shows. Uses 8×10 color prints; 35mm transparencies.
Making Contact & Terms: Interested in receiving work from newer, lesser-known photographers. Query with samples. Send material by mail for consideration. Submit portfolio for review. Provide résumé, samples and calling card to be kept on file for possible future assignments. Pays $50-100/color photo; $250-800/job. **Pays on acceptance.** Buys all rights.

North Carolina

■**EPLEY ASSOCIATES**, 6302 Fairview Rd., Suite 200, Charlotte NC 28210. (704)442-9100. Fax: (704)442-9903. E-mail: epley~pr.com. Vice President: Lamar Gunter. Estab. 1968. Number of employees: 36. Types of clients: industrial and others.
Needs: Works with 1-2 freelance photographers and/or videographers/month. Subjects include: photojournalism. Model/property release required.
Audiovisual Needs: Uses slides and videotape.
Specs: "Specifications depend on situation."
Making Contact & Terms: Works on assignment only. Payment negotiable. **Pays on receipt of invoice.** Buys various rights. Credit line sometimes given, "depends on client circumstance."

■**HODGES ASSOCIATES, INC.**, P.O. Box 53805, 912 Hay St., Fayetteville NC 28305. (910)483-8489. Fax: (910)483-7197. Art Director: Jeri Allison. Estab. 1974. Ad agency. Types of clients: industrial, financial, retail, food. Examples of projects: House of Raeford Farms (numerous food packaging/publication ads); The Esab Group, welding equipment (publication ads/collateral material).
Needs: Works with 1-2 freelancers/month. Uses photos for consumer magazines, trade magazines, direct mail, P-O-P displays, catalogs, posters, newspapers, signage, audiovisual uses. Subjects include: food,

 MARKETS NEW TO THIS EDITION are marked with a double dagger.

welding equipment, welding usage, financial, health care, industrial fabric usage, agribusiness products, medical tubing. Reviews stock photos. Model/property release required.

Audiovisual Needs: Uses slides and video. Subjects include: slide shows, charts, videos for every need.

Specs: Uses 4×5, 11×14, 48×96 color and b&w prints; 35mm, 2¼×2¼, 4×5, 8×10 transparencies.

Making Contact & Terms: Interested in receiving work from newer, lesser-known photographers. Submit portfolio for review. Keeps samples on file. SASE. Reports in 1-2 weeks. Pays $100/hour; $800/day. **Pays on receipt of invoice.** Credit line given depending upon usage PSAs, etc. but not for industrial or consumer ads/collateral. Buys all rights; negotiable.

Tips: Looking for "all subjects and styles." Also, the "ability to shoot on location in adverse conditions (small cramped spaces). For food photography a kitchen is a must, as well as access to food stylist. Usually shoot both color and b&w on assignment. For people shots . . . photographer who works well with talent/models." Seeing "less concern about getting the 'exact' look, as photo can be 'retouched' so easily in Photoshop or on system at printer. Electronic retouching has enabled art director to 'paint' the image he wants. But by no means does this mean he will accept mediocre photographs."

HOWARD, MERRELL & PARTNERS ADVERTISING, INC., 8521 Six Forks Rd., Raleigh NC 27615. (919)848-2400. Fax: (919)845-9845. Art Buyer/Broadcast Business Supervisor: Jennifer McFarland. Estab. 1976. Member of Affiliated Advertising Agencies International, American Association of Advertising Agencies, American Advertising Federation. Ad agency. Approximate annual billing: $83 million. Number of employees: 83. Types of clients: various.

Needs: Works with 10-20 freelancers/month. Uses photos for consumer and trade magazines, direct mail, catalogs and newspapers. Reviews stock photos. Model/property release required.

Specs: Uses 8×10 glossy b&w prints; 35mm, 2¼×2¼, 4×5, 8×10 transparencies.

Making Contact & Terms: Interested in receiving work from newer, lesser-known photographers. Provide résumé, business card, brochure, flier or tearsheets to be kept on file for possible future assignments. Works on assignment only. Keeps samples on file. SASE. Reports in 3 weeks. Payment individually negotiated. **Pays on receipt of invoice.** Buys one-time and all rights (1-year or 2-year unlimited use); negotiable.

MERRELL CHISHOLM, (formerly Chisholm & Associates), 4505 Falls of Neuse Rd., Suite 650, Raleigh NC 27609. (919)876-2065. Fax: (919)876-2344. E-mail: chisassoc@aol.com. Vice President: David Markovsky. Estab. 1993. Ad agency. Approximate annual billing: $10 million. Number of employees: 20. Types of clients: industrial, financial and food. Example of recent projects: Coopertools Worldwide.

Needs: Works with 2-4 freelancers/month and 2 filmmakers/year. Uses photos for consumer magazines, trade magazines, direct mail, P-O-P displays, posters, newspapers and audiovisual. Model/property release preferred.

Audiovisual Needs: Uses slides and film or video. Subjects include health care and industrial.

Specs: Uses color prints; 4×5 transparencies; Mac CD digital format.

Making Contact & Terms: Interested in receiving work from newer, lesser-known photographers. Query with résumé of credits. Provide résumé, business card, brochure, flier or tearsheets to be kept on file for possible future assignments. Works with freelancers on assignment only. Keeps samples on file. Cannot return material. Reports in 3-4 weeks. Payment negotiable. **Pays on receipt of invoice.** Credit line sometimes given depending upon piece, price, etc. Buys first, one-time, electronic and all rights; negotiable.

North Dakota

∎**FLINT COMMUNICATIONS,** 101 10th St. N., Fargo ND 58102. (701)237-4850. Fax: (701)234-9680. Art Director: Gerri Lien. Estab. 1946. Ad agency. Approximate annual billing: $9 million. Number of employees: 30. Types of clients: industrial, financial, agriculture and health care.

Needs: Works with 2-3 freelance photographers, 1-2 filmmakers and 1-2 videographers/month. Uses photos for direct mail, P-O-P displays, posters and audiovisual. Subjects include: agriculture, health care and business. Reviews stock photos. Model release preferred.

Audiovisual Needs: Uses slides and film.

Specs: Uses 35mm, 2¼×2¼, 4×5 transparencies; CD-ROM digital format.

Making Contact & Terms: Interested in receiving work from newer, lesser-known photographers. Submit portfolio for review. Query with stock photo list. Provide résumé, business card, brochure, flier or tearsheets to be kept on file for possible future assignments. Keeps samples on file. Reports in 1-2 weeks. Pays $50-100/hour; $400-800/day; $100-1,000/job. **Pays on receipt of invoice.** Buys one-time rights.

Ohio

■**AD ENTERPRISE ADVERTISING AGENCY**, 6617 Maplewood Dr., Suite 203, Cleveland OH 44124. (216)449-1333. Art Director: Jim McPherson. Estab. 1953. Ad agency and PR firm. Types of clients: industrial, financial, retail and food.

Needs: Works with 1 freelance photographer, 1 filmmaker and 1 videographer/month. Uses photos for consumer and trade magazines, direct mail, P-O-P displays, catalogs and newspapers. Subjects vary to suit job. Reviews stock photos. Model release required with identifiable faces. Captions preferred.

Audiovisual Needs: Uses slides, film and videotape.

Specs: Uses 4×5, 8×10 glossy color and b&w prints; 35mm, $2\frac{1}{4} \times 2\frac{1}{4}$ and 4×5 transparencies.

Making Contact & Terms: Interested in receiving work from newer, lesser-known photographers. Provide résumé, business card, brochure, flier or tearsheets to be kept on file for possible future assignments. Works with freelancers on assignment only. Keeps samples on file. SASE. Reports in 1-2 weeks. Pays $50-100/hour; $400-1,000/day. Pays after billing client. Credit line sometimes given, depending on agreement. Buys one-time rights and all rights; negotiable.

Tips: Wants to see industrial, pictorial and consumer photos.

■**BARON ADVERTISING, INC.**, 1422 Euclid Ave., Suite 645, Cleveland OH 44115-1901. (216)621-6800. President: Selma Baron. Incorporated 1973. Ad agency. Types of clients: food, industrial, electronics, telecommunications, building products, architectural. In particular, serves various manufacturers of tabletop and food service equipment.

Needs: Uses 20-25 freelance photographers/month. Uses photos for direct mail, catalogs, newspapers, consumer magazines, P-O-P displays, posters, trade magazines, brochures and signage. Subject matter varies. Model/property release required.

Audiovisual Needs: Works with freelance filmmakers for AV presentations.

Making Contact & Terms: Arrange a personal interview to show portfolio. Query with list of stock photo subjects. Provide résumé, business card, brochure, flier or tearsheets to be kept on file for possible future assignments. Works with freelancers on assignment only. Cannot return material. Payment negotiable. Payment "depends on the photographer." Pays on completion. Buys all rights.

Tips: Prefers to see "food and equipment" photos in the photographer's samples. "Samples not to be returned."

‡■**BRIGHT LIGHT PRODUCTIONS**, 602 Main St., Suite 810, Cincinnati OH 45202. (513)721-2574. Fax: (513)721-3329. President: Linda Spalazzi. Film and videotape firm. Types of clients: national, regional and local companies in the governmental, educational, industrial and commercial categories. Examples of productions: Health Power (image piece); Procter & Gamble (quarterly video); and Martiny & Co. (corporate image piece). Produces 16mm and 35mm films and videotape, including Betacam.

Needs: Model/property release required. Captions preferred.

Audiovisual Needs: 16mm and 35mm documentary, industrial, educational and commercial films.

Making Contact & Terms: Interested in receiving work from newer, lesser-known photographers. Provide résumé, flier and brochure to be kept on file for possible future assignments. Call to arrange appointment or query with résumé of credits. Works on assignment only. Pays $100 minimum/day for grip; payment negotiable based on photographer's previous experience/reputation and day rate (10 hours). Pays within 30 days of completion of job. Buys all rights.

Tips: Sample assignments include camera assistant, gaffer or grip. Wants to see sample reels or samples of still work. Looking for sensitivity to subject matter and lighting. "Show a willingness to work hard. Every client wants us to work smarter and provide quality at a good value."

GRISWOLD-ESHLEMAN INC., 101 Prospect Ave. W., Cleveland OH 44115. (216)696-3400. Creative Director: Joseph M. McNeil. Ad agency. Types of clients: consumer and industrial firms; client list provided upon request.

Needs: Works with freelance photographers on assignment only. Uses photographers for billboards, consumer and trade magazines, direct mail, P-O-P displays, brochures, catalogs, posters, newspapers out-of-home and AV presentations.

Making Contact & Terms: Provide brochure to be kept on file for possible future assignments. Works primarily with local freelancers but occasionally uses others. Arrange interview to show portfolio. Payment negotiable according to client's budget. Payment is per day or project. Pays on production.

■**JONES, ANASTASI, BIRCHFIELD ADVERTISING INC.**, 6065 Frantz Rd., Suite 204, Dublin OH 43017. (614)764-1274. Creative Director/VP: Joe Anastasi. Ad agency. Types of clients: telecommunications, hospitals, insurance, food and restaurants and financial.

Needs: Works on assignment basis only. Uses photographers for billboards, consumer and trade magazines,

brochures, posters, newspapers and AV presentations.

Making Contact & Terms: Arrange interview to show portfolio. Payment negotiable. per hour, per day, and per project according to client's budget.

LERNER ET AL, INC., 392 Morrison Rd., Columbus OH 43213. (614)864-8554. Fax: (614)755-5402. President: Frank Lerner. Estab. 1987. Ad agency and design firm with inhouse photography. Approximate annual billing: $1.5 million. Number of employees: 10. Types of clients: industrial, financial and manufacturers.
Needs: Works with 1-2 freelancers/month. Uses photos for consumer magazines, trade magazines, direct mail, P-O-P displays, catalogs, posters, annual reports and packaging. Subjects include: commercial products. Reviews stock photos of all subjects—medical, industrial, science, lifestyles. Model release required. Property release preferred. Captions preferred.
Spec: Uses all sizes color and b&w prints; 35mm, 2¼×2¼, 4×5 transparencies.
Making Contact & Terms: Interested in receiving work from newer, lesser-known photographers. Arrange personal interview to show portfolio. Submit portfolio for review. Send unsolicited photos by mail for consideration. Query with samples. Provide résumé, business card, brochure, flier or tearsheets to be kept on file for possible future assignments. Keeps samples on file. SASE. Reports depending on the job. Pays $150-350/day (in-studio). Pays net 30 days. Credit line not given. Buys all rights.
Tips: Looks for skill with lifestyles (people), studio ability, layout/design ability, propping/setup speed and excellent lighting techniques.

LOHRE & ASSOCIATES INC., 2330 Victory Pkwy., Suite 701, Cincinnati OH 45206. (513)961-1174. Ad agency. President: Charles R. Lohre. Types of clients: industrial.
Needs: Works with 1 photographer/month. Uses photographers for trade magazines, direct mail, catalogs and prints. Subjects include: machine-industrial themes and various eye-catchers.
Specs: Uses 8×10 glossy b&w and color prints; 4×5 transparencies.
Making Contact & Terms: Query with résumé of credits. Provide résumé, business card, brochure, flier or tearsheets to be kept on file for possible future assignments. Works with local freelancers only. SASE. Reports in 1 week. Pays $60/b&w photo; $250/color photo; $60/hour; $275/day. Pays on publication. Buys all rights.
Tips: Prefers to see eye-catching and thought-provoking images/non-human. Need someone to take 35mm photos on short notice in Cincinnati plants.

‡■ART MERIMS COMMUNICATIONS, 600 Superior Ave., Suite 1300, Cleveland OH 44114. (216)522-1909. Fax: (216)479-6801. President: Art Merims. Estab. 1981. Member of Public Relations Society of America. Ad agency and PR firm. Approximate annual billing: $900,000. Number of employees: 4. Types of clients: industrial, financial, fashion, retail and food.
Needs: Works with 1 freelancer/month. Uses photo for consumer magazines, trade magazines and newspapers. Model/property release preferred. Captions preferred.
Audiovisual Needs: Uses videotape for advertising.
Specs: Uses prints.
Making Contact & Terms: Interested in receiving work from newer, lesser-known photographers. Query with résumé of credits. Works with local freelancers on assignment only. Cannot return material. Payment negotiable. **Pays on receipt of invoice.** Credit line sometimes given. Rights negotiable.

■OLSON AND GIBBONS, INC., 1501 Euclid Ave., Suite 518, Cleveland OH 44115-2108. (216)623-1881. Fax: (216)623-1884. E-mail: olsgi@aol.com. Executive Vice-President/Creative Director: Barry Olson. Estab. 1991. Ad agency, PR/marketing firm. Types of clients: industrial, financial, medical, retail and food. Examples of recent projects: The Sinai Health System (ads, collateral); Home Bank (outdoor and TV ads, collateral); Lake View Cemetery (direct mail).
Needs: Works with 10 freelancers/month. Uses photos for billboards, trade magazines, consumer newspapers and magazines, direct mail and P-O-P displays. Model/property release required.
Audiovisual Needs: Uses film and videotape.
Specs: Uses color and/or b&w prints; 35mm, 2¼×2¼, 4×5, 8×10 transparencies; 16mm, 35mm film.
Making Contact & Terms: Interested in receiving work from newer, lesser-known photographers. Ar-

 MARKETS USING AUDIOVISUAL MATERIAL, such as slides, film or videotape, are marked with a solid, black square.

range personal interview to show portfolio. Provide résumé, business card, brochure, flier or tearsheets to be kept on file for possible future assignments. Works with local freelancers on assignment only. Keeps samples on file. SASE. Reports in 1-2 weeks. Payment negotiable. **Pays on receipt of invoice,** payment by client. Credit line not given. Buys onc-time or all rights; negotiable.

■**PIHERA ADVERTISING ASSOCIATES, INC.**, 1605 Ambridge Rd., Dayton OH 45459. (937)433-9814. President: Larry Pihera. Estab. 1970. Ad agency. Number of employees: 4. Types of clients: industrial, fashion and retail. Examples of recent projects: Arkay Industries (20-page brochure); The Elliott Company (series of brochures); Remodeling Designs for Elegance in Remodeling (newspaper/TV campaign).
Needs: Works with 3 freelance photographers and filmmakers or videographers/month. Uses photos for consumer magazines, trade magazines, direct mail, catalogs and newspapers. Subjects include: people and industrial/retail scenes with glamour. Reviews stock photos. Model/property release required.
Audiovisual Needs: Uses slides and film or video for corporate films (employee orientation/training). Subjects include: all types.
Specs: Uses 8 × 10 color and b&w prints; 35mm, 2¼ × 2¼, 4 × 5 transparencies.
Making Contact & Terms: Interested in receiving work from newer, lesser-known photographers. Query with stock photo. Works with freelancers on assignment only. Cannot return material. Reports in 1-2 weeks. Payment negotiable. Pays on receipt of invoice. Credit line given. Buys all rights.

SMILEY/HANCHULAK, INC., 47 N. Cleveland-Massillon Rd., Akron OH 44333. (330)666-0868. Fax: (330)666-5762. Ad agency. V.P./Associate Creative Director: Dominick Sorrent, Jr. Clients: all types.
Needs: Works with 1-2 photographers/month. Uses freelance photos for consumer and trade magazines, direct mail, P-O-P displays, catalogs, posters and sales promotion. Model release required. Captions preferred.
Specs: Uses 11 × 14 b&w and color prints, finish depends on job; 35mm or 2¼ × 2¼ (location) or 4 × 5 or 8 × 10 (usually studio) transparencies, depends on job.
Making Contact & Terms: Arrange a personal interview to show portfolio. Query with résumé of credits, list of stock photo subjects or samples. Send unsolicited photos by mail for consideration or submit portfolio for review. Provide résumé, business card, brochure, flier or tearsheets to be kept on file for possible future assignments. If a personal interview cannot be arranged, a letter would be acceptable. Works with freelance photographers on assignment basis only. SASE. Report depends on work schedule. Payment negotiable. Pays per day or per job. Buys all rights unless requested otherwise.
Tips: Prefers to see studio product photos. "Jobs vary—we need to see all types with the exception of fashion. We would like to get more contemporary, but photo should still do the job."

WATT, ROOP & CO., 1100 Superior Ave., Cleveland OH 44114. (216)566-7019. Vice President/Manager of Design Operations: Thomas Federico. Estab. 1981. Member of AIGA, PRSA, Press Club of Cleveland, Cleveland Ad Club. PR firm. Approximate annual billing: $3 million. Number of employees: 30. Types of clients: industrial, manufacturing and health care. Examples of recent projects: AT&T (magazine insert); City of Cleveland Division of Water (annual report); Cleveland State University (development publication); MicroXperts (ad sales).
Needs: Works with 4 freelance photographers/month. Uses photos for magazines and corporate/capabilities brochures, annual reports, catalogs and posters. Subjects include: corporate. Reviews stock photos. Model/property release required. Captions preferred.
Specs: Uses 35mm, 2¼ × 2¼, 4 × 5 transparencies.
Making Contact & Terms: Interested in receiving work from newer, lesser-known photographers. Provide résumé, business card, brochure, flier or tearsheets to be kept on file for possible future assignments. Works with local freelancers on assignment only. Reports "as needed." Pays $50-1,500/b&w photo; $100-2,500/color photo; $50-200/hour; $150-2,000/day. **Pays on receipt of invoice**. Credit line sometimes given. Buys all rights (work-for-hire); one-time rights; negotiable.
Tips: Wants to see "variety, an eye for the unusual. Be professional."

Oklahoma

‡■**HUMPHREY ASSOCIATES**, 233 S. Detroit, Suite 201, Tulsa OK 74120. (918)584-4774. Fax: (918)584-4733. E-mail: humpass@earthlink.net. Art Director: Jeff VanAusdall. Estab. 1986. Ad agency. Approximate annual billing: $2 million. Types of clients: industrial, financial, retail. Examples of recent projects: Ramsey Winch (consumer ad campaign); Flare/Duct Burner campaign, Callidus Technologies (direct mail and trade magazines).
Needs: Works with 3-6 freelance photographers, 1 filmmaker and 1 videographer/month. Uses photos for

billboards, consumer magazines, trade magazines, direct mail, P-O-P displays, catalogs, posters, newspapers, signage. Subjects include vehicles in rugged setting with Ramsey Winch. Reviews stock photos. Model release required.

Audiovisual Needs: Uses slides and video.

Specs: Uses 8×10 color and b&w prints; 35mm, 2¼×2¼, 4×5 transparencies; digital format (any Mac format).

Making Contact & Terms: Query with stock photo list. Send unsolicited photos by mail for consideration. Query with samples. Provide résumé, business card, brochure, flier or tearsheets to be kept on file for possible future assignments. Works with local freelancers on assignment only. Keeps samples on file. SASE. Reports depending upon projects. Payment negotiable. Credit line sometimes given. Buys first, one-time, electronic and all rights; negotiable.

Oregon

■**ADFILIATION ADVERTISING**, 323 W. 13th, Eugene OR 97401. E-mail: adfil@rio.com. Website: http://www.rio.com/~adfil/. Creative Director: Gary Schubert. Estab. 1976. Ad agency. Types of clients: industrial, food, computer, medical.

Needs: Works with 2 freelance photographers, filmmakers and/or videographers/month. Uses photos for billboards, consumer and trade magazines, P-O-P displays, catalogs and posters. Interested in reviewing stock photos/film or video footage. Model/property release required. Captions preferred.

Audiovisual Needs: Uses slides, film and videotape. Accepts images in digital format for Mac. Send via online, SyQuest or optical (300 dpi).

Specs: Uses color and b&w prints and 35mm transparencies.

Making Contact & Terms: Submit portfolio for review. Query with résumé of credits. Query with stock photo list. Provide résumé, business card, brochure, flier or tearsheets to be kept on file for possible future assignments. Works on assignment only. Keeps samples on file. SASE. Reports in 1-2 weeks. Payment negotiable based on job and location. **Pays on receipt of invoice.** Credit line sometimes given, depending on project and client. Rights purchased depends on usage; negotiable.

■**CREATIVE COMPANY**, 3276 Commercial St. SE, Salem OR 97302. (503)363-4433. Fax: (503)363-6817. E-mail: cr8ivity@open.org. President: Jennifer L. Morrow. Creative Director: Rick Yurk. Estab. 1978. Member of American Institute of Graphic Artists, Portland Ad Federation. Marketing communications firm. Approximate annual billing: $750,000. Number of employees: 10. Types of clients: food products, manufacturing, business-to-business. Examples of recent projects: church extension plan sales inquiry materials (brochures, postcards, mailers); Norpac Foods (Soup Supreme packaging); Tec Lab's Oak'n Ivy Brand; and Tec Labs (collateral direct mail).

Needs: Works with 1-2 freelancers/month. Uses photos for direct mail, P-O-P displays, catalogs, posters, audiovisual and sales promotion packages. Model release preferred.

Specs: Uses 5×7 and larger glossy color or b&w prints; 2¼×2¼, 4×5 transparencies. Accepts images in digital format for Mac. Send via compact disc, online, floppy disk, SyQuest or Zip disk.

Making Contact & Terms: Arrange personal interview to show portfolio. Provide résumé, business card, brochure, flier or tearsheets to be kept on file for possible future assignments. Works with local freelancers only. SASE. Reports "when needed." Pays $75-300/b&w photo; $200-1,000/color photo; $20-75/hour; $700-2,000/day, $200-15,000/job. Credit line not given. Buys one-time, one-year and all rights; negotiable.

Tips: In freelancer's portfolio, looks for "product shots, lighting, creative approach, understanding of sales message and reproduction." Sees trend toward "more special effect photography, manipulation of photos in computers." To break in with this firm, "do good work, be responsive and understand what color separations and printing will do to photos."

Pennsylvania

ADVERTEL, INC., (formerly Bellmedia Corporation), P.O. Box 18053, Pittsburgh PA 15236-0053. (412)469-0307, ext. 107. Fax: (800)470-4290 or (412)469-8244. President: Paul Beran. Estab. 1994. Member of MMTA (Multimedia Telecommunications Association). Specialized production house. Approximate annual billing: $500,000-1 million. Types of clients: all, including airlines, utility companies, manufacturers, distributors and retailers.

Needs: Uses photos for direct mail, P-O-P displays, catalogs, signage and audiovisual. Subjects include:

communications, telecommunications and business. Reviews stock photos. Model release preferred. Property release required.

Audiovisual Needs: Uses slides and printing and computer files.

Specs: Uses 4×5 matte color and b&w prints; 4×5 transparencies; VHS videotape; PCX, TIFF digital format.

Making Contact & Terms: Interested in receiving work from newer, lesser-known photographers. Query with stock photo list. Send unsolicited photos by mail for consideration. Query with samples. Provide résumé, business card, brochure, flier or tearsheets to be kept on file for possible future assignment. Works with local freelancers only. Keeps samples on file. Cannot return material. Reporting time varies; "I travel a lot." Payment negotiable. **Pays on receipt of invoice,** net 30 days. Rights negotiable.

Tips: Looks for ability to mix media—video, print, color, b&w.

‡THE CONCEPTS CORPORATION, 120 Kedron Ave., Holmes PA 19043. (610)461-1600. Fax: (610)461-1650. E-mail: jhigg93296@aol.com. President: James Higgins. Estab. 1962. Company specializes in graphic arts/visual communications. Approximate annual billing: $360,000. Number of employees: 5. Types of clients: industrial, financial, retail and food. Examples of recent projects: Avox Technologies (marketing material); Creations (direct mail brochure); and Urban Entertainers (year-end presentation).

Needs: Number of photographers used on a monthly basis varies. Uses photos for trade magazines and catalogs. Subjects include: industrial equipment. Reviews stock photos in all subject matter.

Audiovisual Needs: Uses slides for presentations. Subjects include: corporate/industrial.

Specs: Uses color and b&w prints; 35mm, 2¼×2¼, 4×5 transparencies. Accepts images in digital format for Windows (TIFF). Send via compact disc, online, floppy disk, SyQuest or Zip disk.

Making Contact & Terms: Interested in receiving work from newer, lesser-known photographers. Provide résumé, business card, brochure, flier or tearsheets to be kept on file for possible future assignments. Keeps samples on file. Cannot return material. Reporting time varies. Payment negotiable. Pays net 30 days. Credit line sometimes given depending upon circumstances. Buys one-time and all rights; negotiable.

■DZP VIDEO/MULTIMEDIA, (formerly Zoetrope Productions), 300 N. Pottstown Pike, Suite 250, Exton PA 19341. (610)524-1580. E-mail: dzp@aol.com. Producer: David Speace. Types of clients: corporate.

Needs: Subject depends on client.

Specs: Uses all media, including 35mm transparencies; videotape; 16mm and 35mm film.

Making Contact & Terms: Arrange a personal interview to show portfolio. Provide résumé, business card, self-promotion piece or tearsheets to be kept on file for possible future assignments. Works with freelancers on assignment only. Cannot return material. Reports in 1 week. Payment negotiable. Pays per day. **Pays on acceptance**. Credit line sometimes given. Buys all rights.

Tips: "Make your approach straight forward. Don't expect an assignment because someone looked at your portfolio. We are interested in photographers who have experience with digital images and digital applications for video, multimedia and 3-D logo animation. They must be able to shoot from varied angles and present sequences that tell a story."

KEENAN-NAGLE ADVERTISING, 1301 S. 12th St., Allentown PA 18103-3814. (610)797-7100. Fax: (215)797-8212. Ad agency. Art Director: Patt Bassert. Types of clients: industrial, retail, finance, health care and high-tech.

Needs: Works with 7-8 freelance photographers/month. Uses photos for billboards, consumer magazines, trade magazines, direct mail, posters, signage and newspapers. Model release required.

Specs: Uses b&w and color prints; 35mm, 2¼×2¼, 4×5 and 8×10 transparencies.

Making Contact & Terms: Query with samples. Provide résumé, business card, brochure, flier or tearsheets to be kept on file for possible future assignments. Does not return unsolicited material. Payment negotiable. Pays on receipt of invoice. Credit line sometimes given.

‡■MUDERICK MEDIA, 101 Earlington Rd., Havertown PA 19083. (610)449-6970. Owner: Michael Muderick. Estab. 1984. Types of clients: industrial and financial.

Needs: Works with 4 photographers and/or videographers/month. Uses photos for audiovisual.

Audiovisual Needs: Uses slides and videotape.

THE DIGITAL MARKETS INDEX, located in the back of this book, lists markets that use images electronically.

Specs: Uses Betacam ¾″ videotape, VHS for demo.

Making Contact & Terms: Provide résumé, business card, brochure, flier or tearsheets to be kept on file for possible future assignments. Works with local freelancers only. Keeps samples on file. Does not report on unsolicited material. "Payment negotiable depending on budget." **Pays on acceptance or receipt of invoice.** Buys all rights; negotiable. Model/property release required. Credit line not given.

■**PERCEPTIVE MARKETERS AGENCY, LTD.**, 1100 E. Hector St., Suite 301, Conshohocken PA 19428. (610)825-8710. Fax: (610)825-9186. E-mail: perceptmkt@aol.com. Contact: Jason Solovitz. Estab. 1972. Member of Advertising Agency Network International, Philadelphia Ad Club, Philadelphia Direct Marketing Association. Ad agency. Number of employees: 8. Types of clients: health care, business, industrial, financial, fashion, retail and food. Examples of recent projects: TCM direct mail campaign, Opex Compass product launch; Saint Barnabas Healthcare System, *Today Magazine*; and AT&T Call Center quarterly newsletter.

Needs: Works with 3 freelance photographers, 1 filmmaker and 1 videographer/month. Uses photos for consumer magazines, trade magazines, direct mail, P-O-P displays, catalogs, posters, newspapers, signage and audiovisual. Reviews stock photos. Model release required; property release preferred. Captions preferred.

Audiovisual Needs: Uses slides and film or video.

Specs Uses 8×12 and 11×14 glossy color and b&w prints; 2¼×2¼, 4×5 transparencies.

Making Contact & Terms: Interested in receiving work from newer, lesser-known photographers. Query with stock photo list. Provide résumé, business card, brochure, flier or tearsheets to be kept on file for possible future assignments. Works on assignment only. Keeps samples on file. Pays minimum $75/hour; $800/day. **Pays on receipt of invoice.** Credit line not given. Buys all rights; negotiable.

ROSEN-COREN AGENCY, 2381 Philmont Ave., Suite 117, Huntingdon PA 19006. (215)938-1017. Fax: (215)938-7634. Office Administrator: Ellen R. Coren. PR firm. Types of clients: industrial, retail, fashion, finance, entertainment, health care.

Needs: Works with 4 freelance photographers/month. Uses photos for PR shots.

Specs: Uses b&w prints.

Making Contact & Terms: "Follow up with phone call." Works with local freelancers only. Reports when in need of service. Pays $35-85/hour for b&w and color photos. Pays when "assignment completed and invoice sent—45 days."

‡■**STEWART DIGITAL VIDEO**, 525 Mildred Ave., Primos PA 19018. (610)626-6500. Fax: (610)626-2638. Studio and video facility. Director of Sales: David Bowers. Estab. 1970. Types of clients: corporate, commercial, industrial, retail.

Audiovisual Needs: Uses 15-25 freelancers/month for film and videotape productions.

Specs: Reviews film or video of industrial and commercial subjects. Film and videotape (specs vary).

Making Contact & Terms: Provide résumé, business card, brochure to be kept on file for possible future assignments. Works with freelancers on assignment basis only. Reports as needed. Pays $250-800/day; also pays "per job as market allows and per client specs." Photo captions preferred.

Tips: "The industry is really exploding with all types of new applications for film/video production." In freelancer's demos, looks for "a broad background with particular attention paid to strong lighting and technical ability." To break in with this firm, "be patient. We work with a lot of freelancers and have to establish a rapport with any new ones that we might be interested in before we will hire them." Also, "get involved on smaller productions as a 'grip' or assistant, learn the basics and meet the players."

Rhode Island

■**MARTIN THOMAS, INC.**, Advertising & Public Relations, 26 Bosworth St., Unit 4, Barrington RI 02806. (401)245-8500. Fax: (401)245-1242. E-mail: mti1@ma.ultranet.com. President: Martin K. Pottle. Estab. 1987. Ad agency, PR firm. Approximate annual billing: $6 million. Number of employees: 6. Types of clients: industrial and business-to-business. Examples of ad campaigns: "Bausch & Lomb" for GLS Corporation (magazine cover); "Soft Bottles" for McKechnie (booth graphics); and "Perfectly Clear" for ICI Acrylics (brochure)..

Needs: Works with 3-5 freelance photographers/month. Uses photos for trade magazines. Subjects include: location shots of equipment in plants and some studio. Model release required.

Audiovisual Needs: Uses videotape for 5-7 minute capabilities or instructional videos.

Specs: Uses 8×10 color and b&w prints; 35mm and 4×5 transparencies. Accepts images in digital format for Windows (call first). Send via compact disc, on line or floppy disk.

Making Contact & Terms: Send stock photo list. Provide résumé, business card, brochure, flier or tearsheets to be kept on file for possible future assignments. Send materials on pricing, experience. "No unsolicited portfolios will be accepted or reviewed." Works with local freelancers on assignment only. Cannot return material. Pays $1,000-1,500/day; $300-900/b&w photo; $400-1,000/color photo. Pays 30 days following receipt of invoice. Buys exclusive product rights; negotiable.

Tips: To break in, demonstrate you "can be aggressive, innovative, realistic and can work within our clients' parameters and budgets. Be responsive, be flexible."

South Carolina

■**BROWER, LOWE & HALL ADVERTISING, INC.**, 215 W. Stone Ave., P.O. Box 3357, Greenville SC 29602. (864)242-5350. Fax: (864)233-0893. President: Ed Brower. Estab. 1945. Ad agency. Uses photos for billboards, consumer and trade magazines, direct mail, newspapers, P-O-P displays, radio and TV. Types of clients: consumer and business-to-business.

Needs: Commissions 6 freelancers/year; buys 50 photos/year. Model release required.

Specs: Uses 8×10 b&w and color semigloss prints; also videotape.

Making Contact & Terms: Interested in receiving work from newer, lesser-known photographers. Arrange personal interview to show portfolio or query with list of stock photo subjects; will review unsolicited material. SASE. Reports in 2 weeks. Payment negotiable. Buys all rights; negotiable.

■**SOUTH CAROLINA FILM OFFICE**, P.O. Box 7367, Columbia SC 29202. (803)737-0490. Director: Isabel Hill. Types of clients: motion picture and television producers.

Needs: Works with 8 freelance photographers/month. Uses photos to recruit feature films/TV productions. Subjects include location photos for feature films, TV projects, and national commercials.

Specs: Uses 3×5 color prints; 35mm film.

Making Contact & Terms: Submit portfolio by mail. Provide résumé, business card, self-promotion piece or tearsheets to be kept on file for possible future assignments. Works with local freelancers on assignment only. Does not return unsolicited material. Payment negotiable. Pays per yearly contract, upon completion of assignment. Buys all rights.

Tips: "Experience working in the film/video industry is essential. Ability needed to identify and photograph suitable structures or settings to work as a movie location."

South Dakota

LAWRENCE & SCHILLER, 3932 S. Willow Ave., Sioux Falls SD 57105. (605)338-8000. Ad agency. Senior Art Director: Dan Edmonds. Types of clients: industrial, financial, manufacturing, medical.

Needs: Works with 3-4 freelance photographers/month. Uses photographers for consumer and trade magazines, direct mail, P-O-P displays, catalogs, posters and newspapers.

Specs: Uses 8×10 b&w prints; 35mm, 2¼×2¼ and 4×5 transparencies.

Making Contact & Terms: Arrange a personal interview to show portfolio; submit portfolio for review. Provide résumé, business card, brochure, flier or tearsheets to be kept on file for possible future assignments. Works with freelance photographers on assignment basis only. Cannot return material. Reports as needed. Pays $500 maximum/day plus film and processing. **Pays on acceptance.** Buys all rights. Model release required. Captions preferred.

Tips: In reviewing photographer's portfolios wants to see a "good selection of location, model, tabletop/ studio examples—heavily emphasizing their forté. The best way for freelancers to begin working with us is to fill a void in an area in which we have either underqualified or overpriced talent—then handle as many details of production as they can. We see a trend in using photography as a unique showcase for products—not just a product (or idea) display."

Tennessee

■**K.P. PRODUCTIONS**, 3369 Joslyn St., Memphis TN 38128. (901)726-1928. (901)722-5895. AV firm. Creative Director: Michael Porter. Estab. 1990. Types of clients: industrial. Examples of recent projects: "Powership," for Federal Express, (training video); Redwing Grain Nozzle, for Redwing Technical Systems, (sales video); and Big Bend Ranch, for Kossman/Klein Advertising, (sales video).

Needs: Occasionally works with freelance filmmaker or videographer. Model/property release required.

Audiovisual Needs: Uses film and videotape.

Specs: Uses 35mm motion picture film and Betacam videotape.

Making Contact & Terms: Arrange personal interview to present demo reels or cassettes. Works on assignment only. Keeps samples on file. SASE. Reports in 1-2 weeks. Pays $350-400/day. **Pays on acceptance or receipt of invoice.** Buys all rights; negotiable. Credit line sometimes given.

Tips: Primarily looks for good composition and a "leading edge look." To break in with this firm, "have a good attitude and work within budget."

‡■**LAVIDGE AND ASSOCIATES**, 409 Bearden Park Circle, Knoxville TN 37919. (615)584-6121. Fax: (615)584-6756. President: Arthur Lavidge. Estab. 1950. Ad agency. Types of clients: tourism, finance, food, resort, transportation, home furnishing. Examples of projects: Great Smoky Mountains (tourist brochure); Oldsmobile Dealer Association (ad campaign).

Needs: Works with freelancers "when need applies." Subjects include scenics and people. Interested in reviewing stock photos/video footage of people. Model release required. Captions preferred.

Audiovisual Needs: Uses slides and videotape.

Specs: Uses 35mm transparencies; videotape.

Making Contact & Terms: Provide résumé, business card, brochure, flier or tearsheets to be kept on file for possible future assignments. Works with freelancers on assignment only. Cannot return material. Reports in 1-2 weeks. Pays $50 minimum/b&w photo; $90 minimum/color photo; $95 minimum/hour; $490 minimum/day. Pays according to job and client's budget. **Pays on receipt of invoice** or on publication. Credit line given sometimes, depending on client. Buys all rights (work-for-hire).

Texas

‡■**THE ATKINS AGENCY**, Suite 1100, 1777 N.E. Loop 410, San Antonio TX 78217. Associate Creative Director: Becky Benavides. Estab. 1963. Ad agency. Types of clients: telecommunications, tourism, healthcare. Examples of recent projects: San Antonio Convention & Visitors Bureau; *Express-News* (daily newspaper in San Antonio); Cellular One; Mother Frances Regional Hospital; Mexico tourism.

Needs: Works with 2-3 freelance photographers, 1 filmmaker and 2-3 videographers/month. Uses photos for billboards, consumer magazines, trade magazines, direct mail, P-O-P displays, catalogs, posters, newspapers, audiovisual uses. Subject matter is too varied to define. Reviews stock photos related to tourism, healthcare, telecommunications. Model/property release required.

Audiovisual Needs: Uses slides and/or film or video.

Making Contact & Terms: Interested in receiving work from newer, lesser-known photographers as well as established photographers. Query with stock photo list. Send unsolicited photos by mail for consideration. Query with samples. Provide résumé, business card, brochure, flier or tearsheets to be kept on file for possible future assignments. Works with local freelancers on assignment only. Keeps samples on file. Cannot return material. Payment negotiable. Credit line sometimes given depending upon "prior arrangement we make with our clients." Rights negotiable.

Tips: "We are always looking for fresh, original looks/ways to see things. This is particularly true with our tourism accounts. We all appreciate innovative photography techniques."

■**DYKEMAN ASSOCIATES INC.**, 4115 Rawlins, Dallas TX 75219. (214)528-2991. Fax: (214)528-0241. E-mail: adykeman@airmail.net. Website: http://www.dykemanassoc.com. Contact: Alice Dykeman. Estab. 1974. Member of Public Relations Society of America. PR and AV firm. Types of clients: industrial, financial, sports, varied.

Needs: Works with 4-5 photographers and/or videographers. Uses photos for publicity, billboards, consumer and trade magazines, direct mail, P-O-P displays, catalogs, posters, newspapers, signage, and audiovisual uses. "We handle model and/or property releases."

Audiovisual Needs: "We produce and direct video. Just need crew with good equipment and people and ability to do their part."

Specs: Uses 8½×11 and glossy b&w transparencies or color prints; ¾" or Beta videotape. Accepts images

THE SUBJECT INDEX, located at the back of this book, lists publications, book publishers, galleries, paper product companies and stock agencies according to the subject areas they seek.

in digital format for Windows. Send via floppy disk, SyQuest or on Zip disk.

Making Contact & Terms: Arrange personal interview to show portfolio. Provide résumé, business card, brochure, flier or tearsheets to be kept on file for possible future assignments. Works on assignment only. Cannot return material. Pays $800-1,200/day; $250-400/1-2 days. "Currently we work only with photographers who are willing to be part of our trade dollar network. Call if you don't understand this term." Pays 30 days after receipt of invoice. Credit line sometimes given, "maybe for lifestyle publications—especially if photographer helps place." Buys exclusive product rights.

Tips: Reviews portfolios with current needs in mind. "If PSA, we would want to see examples. If for news story, we would need to see photojournalism capabilities. Show portfolio, state pricing, remember that either we or our clients will keep negatives or slide originals."

■**EDUCATIONAL VIDEO NETWORK**, 1401 19th St., Huntsville TX 77340. (409)291-2860. E-mail: pop123@mail.lcc.net. Chief Executive Officer: George H. Russell. Estab. 1953. AV firm. Number of employees: 70. Types of clients: "We produce for ourselves in the education market." Examples of recent projects: catalogs to illustrate EVD video titles.

Needs: Works with 2-3 videographers/month.

Audiovisual Needs: Uses videotape for all projects; slides.

Specs: Uses ½" videotape. Accepts images in digital format for Mac (PICT, TIFF). Send via online, Zip disk or Jaz disk (300 dpi or better).

Making Contact & Terms: Query with program proposal. SASE. Reports in 3 weeks. Payment negotiable. Pays in royalties or flat fee based on length, amount of post-production work and marketability; royalties paid quarterly. Credit line given. Buys all rights; negotiable.

Tips: In freelancer's demos, looks for "literate, visually accurate, curriculum-oriented video programs that could serve as a class lesson in junior high, high school or college classroom. The switch from slides and filmstrips to video is complete. The schools need good educational material."

■**GK&A ADVERTISING, INC.**, 8200 Brookriver Dr., Suite 510, Dallas TX 75247. (214)634-9486. Fax: (214)634-9490 or (214)638-4984. Production Manager: Tracy Rotter. Estab. 1982. Member of AAAA. Ad agency, PR firm. Approximate annual billing: $3 million. Number of employees: 4. Types of clients: financial, service, retail.

 • This agency is using computer manipulation and stock photos on CD.

Needs: Works with 1 freelance photographer, 2 filmmakers and 2 videographers/month. Uses photos for billboards, direct mail, P-O-P displays, posters, newspapers, audiovisual uses. Reviews stock photos. Model/property release required. Captions preferred.

Audiovisual Needs: Uses slides, film and video.

Specs: Uses 35mm transparencies; ½" VHS videotape.

Making Contact & Terms: Submit portfolio for review. Works on assignment only. Keeps samples on file. Cannot return material. Reports in 3 weeks. Payment negotiable. Pays net 30 days. Credit line not given. Buys one-time rights.

‡**GROUP 400 ADVERTISING**, 11202 Disco Dr., San Antonio TX 78216. (210)495-6777. Fax: (210)495-1319. E-mail: jaguillard@saami. General Manager: John A. Aguillard. Estab. 1984. Ad agency. Approximate annual billing: $9.75 million. Number of employees: 4. Types of clients: industrial. Examples of recent projects: Superior Auctioneers & Marketing; Dan Kruse Classic Car Productions; and Pyramis Companies.

Needs: Works with 2-3 freelance photographers/month. Uses photos for trade magazines, direct mail and special projects (special effects photography). Subjects include auction activity/equipment. Model release required.

Specs: Uses 3×5 color prints; 35mm, 2¼×2¼ and 4×5 transparencies. Accepts images in digital format for Mac. Send via floppy disk, SyQuest or Zip disk.

Making Contact & Terms: Interested in receiving work from newer, lesser-known photographers. Query with résumé of credits and list of stock photo subjects. Provide résumé, business card, brochure, flier or tearsheets to be kept on file for possible future assignments. Works with freelance photographers on assignment basis only. SASE. Reports in 3 weeks. Payment negotiable. **Pays on receipt of invoice,** usually net 30 days. Credit line sometimes given. Buys all rights; negotiable.

Tips: "Location is important for specific photo assignments. We use a substantial amount of photography for main auction company client—much internal production—freelance for special projects."

■**HEPWORTH ADVERTISING CO.**, 3403 McKinney Ave., Dallas TX 75204. (214)220-2415. Fax: (214)220-2416. President: S.W. Hepworth. Estab. 1952. Ad agency. Uses all media except P-O-P displays. Types of clients: industrial, consumer and financial. Examples of recent projects: Houston General Insurance, Holman Boiler, Hillcrest State Bank.

Needs: Uses photos for trade magazines, direct mail, P-O-P displays, newspapers and audiovisual. Model/property release required. Captions required.

Specs: Uses 8×10 glossy color prints, 35mm transparencies.

Making Contact & Terms: Submit portfolio by mail. Works on assignment only. Cannot return material. Reports in 1-2 weeks. Pays $350 minimum/job; negotiates payment based on client's budget and photographer's previous experience/reputation. **Pays on acceptance.** Credit line sometimes given. Buys all rights.

Tips: "For best relations with the supplier, we prefer to seek out a photographer in the area of the job location." Sees trend toward machinery shots. "Contact us by letter or phone."

TED ROGGEN ADVERTISING AND PUBLIC RELATIONS, 5858 Westheimer, Suite 630, Houston TX 77057. (713)789-0999. Fax: (713)465-0625. Contact: Ted Roggen. Estab. 1945. Ad agency and PR firm. Types of clients: construction, entertainment, food, finance, publishing and travel.

Needs: Buys 25-50 photos/year; offers 50-75 assignments/year. Uses photos for billboards, direct mail, radio, TV, P-O-P displays, brochures, annual reports, PR releases, sales literature and trade magazines. Model release required. Captions required.

Specs: Uses 5×7 glossy or matte b&w prints; 4×5 transparencies; 5×7 color prints. Contact sheet OK.

Making Contact & Terms: Interested in receiving work from newer, lesser-known photographers. Provide résumé to be kept on file for possible future assignments. Pays $75-250/b&w photo; $125-300/color photo; $150/hour. **Pays on acceptance.** Rights negotiable.

■SANDERS, WINGO, GALVIN & MORTON ADVERTISING, 4050 Rio Bravo, Suite 230, El Paso TX 79902. (915)533-9583. E-mail: swgm@swgm.com. Creative Director: Kerry Jackson. Member of American Association of Advertising Agencies. Ad agency. Approximate annual billing: $14 million. Number of employees: 30. Uses photos for billboards, consumer and trade magazines, direct mail, foreign media, newspapers, P-O-P displays, radio and TV. Types of clients: finance, retail and apparel industries. Examples of recent projects: "Marketbook," Farah USA, Inc. (ads, posters, outdoor); "Write Your Own Ticket," Sears (ads, posters). Free client list.

Needs: Works with 5 photographers/year. Model release required.

Specs: Uses b&w photos and color transparencies. Works with freelance filmmakers in production of slide presentations and TV commercials. Accepts images in digital format for Mac (all file types). Send via compact disc, online, floppy disk, SyQuest or Zip disk.

Making Contact & Terms: Query with samples, list of stock photo subjects. Send material by mail for consideration. Submit portfolio for review. SASE. Reports in 1 week. Pays $65-500/hour, $600-3,500/day, negotiates pay on photos. Buys all rights.

■EVANS WYATT ADVERTISING & PUBLIC RELATIONS, 346 Mediterranean Dr., Corpus Christi TX 78418. (512)939-7200. Owner: E. Wyatt. Estab. 1975. Ad agency, PR firm. Types of clients: industrial, technical, distribution and retail. Examples of recent projects: H&S Construction Co. (calendars); L.E.P.C. Industrial (calendars and business advertising); The Home Group (newspaper advertising).

Needs: Works with 3-5 freelance photographers and/or videographers/month. Uses photos for consumer and trade magazines, direct mail, catalogs, posters and newspapers. Subjects include: people and industrial. Reviews stock photos/video footage of any subject matter. Model release required. Captions preferred.

Audiovisual Needs: Uses slide shows and videos.

Specs: Uses 5×7 glossy b&w and color prints; 35mm, 2¼×2¼ transparencies; ½" videotape (for demo or review), VHS format.

Making Contact & Terms: Query with résumé of credits, list of stock photo subjects and samples. Submit portfolio for review. Provide résumé, business card, brochure, flier or tearsheets to be kept on file for possible future assignments. Works on assignment only. Reports in 1 month. Pays $500-1,000/day; $100-700/job; negotiated in advance of assignment. Pays on receipt of invoice. Credit line sometimes given, depending on client's wishes. Buys all rights.

Tips: "Resolution and contrast are expected." Especially interested in industrial photography. Wants to see "sharpness, clarity and reproduction possibilities." Also, creative imagery (mood, aspect, view and lighting). Advises freelancers to "do professional work with an eye to marketability. Pure art is used only rarely."

Utah

■BROWNING ADVERTISING, One Browning Place, Morgan UT 84050. (801)876-2711, ext. 289. Fax: (801)876-3331. Art Director: John Gibby. Estab. 1878. Ad agency. Approximate annual billing: $4 million. Number of employees: 18. Types of clients: retail sporting goods and outdoor recreation (hunting,

camping). Examples of recent projects: "Live the Legend," Winchester Firearms (national ads); "Quail Are Fast," Browning Firearms (4-color, full-page ads); Browning Archery (4-color catalog cover).
Needs: Works with 1-2 photographers, 1-2 filmmakers, 1-2 videographers/month. Uses photos for consumer magazines, trade magazines, catalogs, posters and audiovisual. Subjects include: wildlife, hunting, outdoor. Reviews stock photos. Model/property release required for people. Captions preferred; include location, species, season.
Audiovisual Needs: Uses slides, film and videotape for corporate and dealer training and motivation.
Specs: Uses 35mm, 2¼×2¼, 4×5 transparencies, 16 and 35mm film, Beta SP and D2 videotape.
Making Contact & Terms: Interested in receiving work from newer, lesser-known photographers. Provide résumé, business card, brochure, flier or tearsheets to be kept on file for possible future assignments. Keeps samples on file. SASE. Reports in 1-2 weeks. Payment negotiable. Pays within 30 days of receipt of invoice. Buys first, one-time, electronic and all rights; negotiable.
Tips: Looking for "unusual and real-world situations."

‡**EVANSGROUP**, 110 Social Hall Ave., Salt Lake City UT 84111. (801)364-7452. Ad agency. Art Director: Michael Cullis. Types of clients: industrial, finance.
Needs: Works with 2-3 photographers/month. Uses photos for billboards, consumer and trade magazines, direct mail, P-O-P displays, posters and newspapers. Subject matter includes scenic and people. Model release required; captions preferred.
Specs: Uses color prints and 35mm, 2¼×2¼ and 4×5 transparencies.
Making Contact & Terms: Query with list of stock photo subjects. Submit portfolio for review. Provide résumé, business card, brochure, flier or tearsheets to be kept on file for possible future assignments. Works with freelance photographers on assignment only. SASE. Reports in 1-2 weeks. Payment negotiable. **Pays on receipt of invoice**. Credit live given when possible. Buys one-time rights.

■**HARRIS & LOVE, INC.**, 630 E. South Temple, Salt Lake City UT 84102. (801)532-7333. Fax: (801)532-6029. Senior Art Director: Preston Wood. Art Directors: Kathy Kunz and Dan Murray. Estab. 1938. Member of AAAA. Approximate annual billing: $8 million. Number of employees: 35. Types of clients: finance, tourism, industrial, retail, fashion, health care, winter sports. Examples of recent projects: Utah travel summer campaign (national magazines); "HMO Blue," Blue Cross & Blue Shield (regional newspaper).
• This agency is storing images on CD, using computer manipulation and accessing images through computer networks.
Needs: Works with 4 freelance photographers, filmmakers or videographers/month. Uses photos for billboards, consumer magazines, trade magazines, newspapers and audiovisual. Needs mostly images of Utah (travel and winter sports) and people. Interested in reviewing stock photos/film or video footage on people, science, health care and industrial.
Audiovisual Needs: Contact Creative Director, Bob Wassom, by phone or mail.
Specs: Uses 35mm, 2¼×2¼, 4×5 transparencies.
Making Contact & Terms: Interested in receiving work from newer, lesser-known photographers. Send unsolicited photos by mail for consideration. Submit portfolio for review. Provide résumé, business card, brochure, flier or tearsheets to be kept on file for possible future assignments. Works with freelancers on assignment basis only. Pays $150-1,000/b&w photo; $200-2,000/color photo; $600-1,200/day. Rights negotiable depending on project. Model and property releases required. Credit line given sometimes, depending on client, outlet or usage.
Tips: In freelancer's portfolio or demos, wants to see "craftsmanship, mood of photography and creativity." Sees trend toward "more abstract" images in advertising. "Most of our photography is a total buy out (work-for-hire). Photographer can only reuse images in his promotional material."

‡■**PAUL S. KARR PRODUCTIONS, UTAH DIVISION**, 1024 N. 250 East, Orem UT 84057. (801)226-8209. Vice President & Manager: Michael Karr. Types of clients: education, business, industry, TV-spot and theatrical spot advertising. Provides inhouse production services of sound recording, looping, printing and processing, high-speed photo instrumentation as well as production capabilities in 35mm and 16mm.
Needs: Same as Arizona office but additionally interested in motivational human interest material—film stories that would lead people to a better way of life, build better character, improve situations, strengthen families.
Making Contact & Terms: Query with résumé of credits and advise if sample reel is available. Payment negotiable. Pays per job, negotiates payment based on client's budget and ability to handle the work. Pays on production. Buys all rights. Model release required.

■**SOTER ASSOCIATES INC.**, 209 N. 400 West, Provo UT 84601. (801)375-6200. Fax: (801)375-6280. Ad agency. President: N. Gregory Soter. Types of clients: industrial, financial, hardware/software and other. Examples of projects: boating publications ad campaign for major boat manufacturer; consumer brochures for residential/commercial mortgage loan company; private school brochure; software ads for magazine use; various direct mail campaigns.
Needs: Uses photos for consumer and trade magazines, direct mail and newspapers. Subjects include product, editorial or stock. Reviews stock photos/videotape. Model/property release required.
Audiovisual Needs: Uses photos for slides and videotape.
Specs: Uses 8×10 b&w prints; 2¼×2¼, 4×5 transparencies; videotape.
Making Contact & Terms: Arrange personal interview to show portfolio. Query with samples. Provide résumé, business card, brochure, flier or tearsheets to be kept on file for possible future assignments. Works on assignment only. Keeps samples on file. SASE. Reports in 1-2 weeks. Payment negotiable. **Pays on receipt of invoice.** Credit line not given. Buys all rights; negotiable.

Virginia

■**AMERICAN AUDIO VIDEO**, 2862 Hartland Rd., Falls Church VA 22043. (703)573-6910. Fax: (703)573-3539. President: John Eltzroth. Estab. 1972. Member of ICIA and MPI. AV firm. Types of clients: industrial, information systems and financial.
Needs: Works with 1 freelance photographer and 2 videographers/month. Uses photos for catalogs and audiovisual uses. Subjects include: "inhouse photos for our catalogs and video shoots for clients." Reviews stock photos.
Audiovisual Needs: Uses slides and videotape.
Specs: Uses 35mm transparencies; ¾" Beta videotape.
Making Contact & Terms: Interested in receiving work from newer, lesser-known photographers. Arrange personal interview to show portfolio. Send unsolicited photos by mail for consideration. Provide résumé, business card, brochure, flier or tearsheets to be kept on file for possible future assignments. SASE. Reports in 1 month. Payment negotiable. **Pays on acceptance and receipt of invoice.** Credit line not given. Buys all rights; negotiable.

DEADY ADVERTISING, 17 E. Cary St., Richmond VA 23219. (804)643-4011. Fax: (804)643-4043. E-mail: jdeadyo.richmond.infi.net. Website: http://www.deady.com. President: Jim Deady. Member of Richmond Ad Club, Chesterfield Business Council, Richmond Public Relations Association, Marketing Communications Agency Network. Approximate annual billing: $2 million. Number of employees 5. Types of clients: industrial, financial and food. Examples of recent projects: "Reynolds Food Service," Reynolds Metals (brochures, trade journal ads); "Holiday 1996," The Peanut Roaster (Christmas catalog); and "OK Foundry" (presentation folder with direct sales and information requests).
Needs: Works with 3-5 freelancers/month. Uses photos for billboards, consumer magazines, trade magazines, direct mail, catalogs, posters, newspapers and exhibit signage. Subjects include: equipment, products and people. Reviews stock photos. Model/property release preferred.
Audiovisual Needs: Uses video for custom corporate videos.
Specs: Uses color and b&w prints; 35mm, 4×5 transparencies.
Making Contact & Terms: Interested in receiving work from newer, lesser-known photographers. Arrange personal interview to show portfolio. Query with stock photo list. Works on assignment only. Keeps samples on file. Cannot return material. Reports in 1-2 weeks. Payment negotiable. **Pays on receipt of invoice.** Credit line sometimes given. Buys all rights.

Washington

‡**AL DOYLE ADVERTISING DIRECTION**, 4926 McDonald Ave. NE, Bainbridge Island WA 98110. (206)718-2121. Fax: (206)842-1618. E-mail: aldoyle@aol.com. Creative Director: Al Doyle. Estab. 1981.

 INTERNATIONAL MARKETS, those located outside of the United States and Canada, are marked with an asterisk.

Ad agency. Number of employees: 1-10. Types of clients: industrial, financial, retail, food. Examples of recent projects; Sky Island Ranch Planned Community (billboard, collateral print); Daniel's Ranch Planned Community (collateral, print); Shoreside Townhomes (collateral, print).

Needs: Works with 3-5 freelance photographers and varying numbers of filmmakers and videographers/month. Uses photos for billboards, trade magazines and signage. Subjects include: lifestyle, people and families, active recreation and home life. Reviews stock photos. Model release required.

Audiovisual Needs: Uses slides and video for video presentations and brochures.

Specs: Uses color prints; 35mm, 2¼×2¼ transparencies; digital format.

Making Contact & Terms: Works with freelancers on assignment only. Does not keep samples on file. SASE. Reports in 1-2 weeks. Payment negotiable. Rights negotiable.

Tips: "We use over 50% digital images from stock sources."

MATTHEWS ASSOC. INC., 603 Stewart St., Suite 1018, Seattle WA 98101. (206)340-0680. Ad agency. President: Dean Matthews. Types of clients: industrial.

Needs: Works with 0-3 freelance photographers/month. Uses photographers for trade magazines, direct mail, P-O-P displays, catalogs and public relations. Frequently uses architectural photography; other subjects include building products.

Specs: Uses 8×10 b&w and color prints; 35mm, 2¼×2¼ and 4×5 transparencies.

Making Contact & Terms: Arrange a personal interview to show portfolio if local. If not, provide résumé, business card, brochure, flier or tearsheets to be kept on file for possible future assignments. SASE. Works with freelance photographers on assignment only. Payment negotiable. Pays per hour, day or job. **Pays on receipt of invoice.** Buys all rights. Model release preferred.

Tips: Samples preferred depends on client or job needs. "Be good at industrial photography."

Wisconsin

■AGA COMMUNICATIONS, 2557C N. Terrace Ave., Milwaukee WI 53211-3822. (414)962-9810. E-mail: agacom@juns.com. CEO: Arthur Greinke. Estab. 1984. Member of Public Relations Society of America, International Association of Business Communicators, Society of Professional Journalists. Number of employees: 9. Ad agency, PR firm and marketing firm. Types of clients: entertainment, special events, music business, adult entertainment, professional sports, olympic sports. Examples of recent projects: "Brett Farve Chase Football," Fomation, Green Bay Packers, Ad Cetra Sports (display ads, newspaper PR, sales, P.O.P); "IBM Aptiva," IBM (display, newspaper PR, catalog); and "Adult Maid Service," Bare Bottom Maids (display ad, flyers).

Needs: Works with 6-12 freelance photographers, 2 filmmakers, 4-8 videographers/year. Uses photos for billboards, direct mail, P-O-P displays, posters, newspapers, signage, audiovisual. Most photos come from special events. Reviews stock photos of anything related to entertainment/music industry, model photography. Model/property release preferred. Captions preferred; include who, what, where, why, how.

Audiovisual Needs: Uses slides, film, videotape. Subjects include: special events and model work.

Specs: Uses 5×7 or 8×10 color and b&w prints; 2¼×2¼, 4×5 transparencies; 16mm and 35mm film; ½″ and ¾″ videotape.

Making Contact & Terms: Interested in receiving work from newer, lesser-known photographers. Query with résumé of credits. Query with stock photo list. Query with samples. Provide résumé, business card, brochure, flier or tearsheets to be kept on file for possible future assignments. Keeps samples on file. Cannot return material. "We respond when we need a photographer or a job becomes available for their special skills." Payment negotiable. **Pays on acceptance.** Credit line sometimes given depending on client. Buys all rights; negotiable.

Tips: "Search for a specific style or look, and make good use of light and shade."

BVK/MCDONALD, INC, 250 W. Coventry Court, Milwaukee WI 53217. (414)228-1990. Ad agency. Art Directors: Lisa Kunzelmann, Brian Marconnet, Brent Goral, Mike Lyons, Leigh Matz. Estab. 1984. Types of clients: travel, health care, financial, industrial and fashion clients such as Funjet Vacations, Flyjet Vacations, Covenant HealthCare, Waukesha Memorial Hospital, United Vacations, Budgetel, Tenet Health Systems, Airadigm Communications.

Needs: Uses 5 freelance photographers/month. Uses photos for billboards, consumer magazines, trade magazines, direct mail, catalogs, posters and newspapers. Subjects include travel and health care. Interested in reviewing stock photos of travel scenes in Carribean, California, Nevada, Mexico and Florida. Model release required.

Specs: Uses 35mm, 2¼×2¼, 4×5, 8×10 transparencies.

Making Contact & Terms: Arrange a personal interview to show portfolio or query with résumé of

credits or list of stock photo subjects. Provide résumé, business card, brochure, flier or tearsheets to be kept on file for possible future assignments. Cannot return material. Payment negotiable. Buys all rights.
Tips: Looks for "primarily cover shots for travel brochures; ads selling Florida, the Caribbean, Mexico, California and Nevada destinations."

■**NELSON PRODUCTIONS, INC.,** 1533 N. Jackson St., Milwaukee WI 53202. (414)271-5211. Fax: (414)271-5235. E-mail: dnelson130@aol.com. President: David Nelson. Estab. 1968. Produces motion pictures and videotapes. Types of clients: industry, advertising.
Needs: Industrial, graphic art and titles.
Audiovisual Needs: Video stock, slides, computer graphics.
Specs: Uses transparencies, computer originals.
Making Contact & Terms: Interested in receiving work from newer, lesser-known photographers. Query with résumé of credits or send material by mail for consideration. "We're looking for high quality photos with an interesting viewpoint." Pays $250-1,200/day. Buys one-time rights. Model release required. Captions preferred.
Tips: "Send only top quality images."

Wyoming

‡■**BRIDGER PRODUCTIONS, INC.,** P.O. Box 8131, Jackson Hole WY 83002. Phone/fax: (307)733-7871. President: Mike Emmer. Estab. 1990. Operates as a freelancer for ESPN, Prime Network. AV firm. Number of employees: 3. Types of clients: industrial, financial, fashion, retail, food and sports. Examples of recent projects: national TV ads for Michelin, ESPN and Dark Light Pictures.
Needs: Works with 1-2 freelance photographers, 1-2 filmmakers and 1-2 videographers/month. Uses photos for billboards, trade magazines, P-O-P displays, catalogs, posters, video covers and publicity. Subjects include: sports. Model/property release required for sports. Captions required; "include name of our films/programs we are releasing."
Audiovisual Needs: Uses slides, film, videotape and digital mediums for promotion of national broadcasts. Subjects include: sports.
Specs: Uses 8×10 glossy color prints; 16 or 35mm film; Beta or Digital (IFF-24) videotape.
Making Contact & Terms: Interested in receiving work from newer, lesser-known photographers. Query with résumé of credits. Query with stock photo list. Works with local freelancers on assignment only. SASE. Reporting time "depends on our schedule and how busy we are." Pays for assignments. **Pays on acceptance.** Credit line given. Buys one-time and electronic rights; negotiable.

Canada

■✽**CABER COMMUNICATIONS,** 266 Rutherford Rd. S., #22, Brampton, Ontario L6W 3N3 Canada. (905)454-5141. Fax: (905)454-5936. E-mail: caber@orbonline.net. Producers: Chuck Scott and Christine Rath. Estab. 1988. AV firm, film and video producer. Types of clients: industrial, financial, retail. Examples of recent projects: "Inhaled Steroids," Glaxo Canada (educational); "Access Control," Chubb Security (sale promotion); "A Day in the Country" (television series).
Needs: Works with 2-3 freelance photographers and 3-5 videographers/month. Uses photos for posters, newsletters, brochures. Model/property release required.
Audiovisual Needs: Uses film or video. "We mainly shoot our own material for our projects."
Specs: 35mm, 2¼×2¼, 4×5 transparencies; videotape (Betacam SP quality or better).
Making Contact & Terms: Interested in receiving work from newer, lesser-known photographers. Contact through rep. Query with résumé of credits. Provide résumé, business card, brochure, flier or tearsheets to be kept on file for possible future assignments. Works with local freelancers on assignment only. Keeps samples on file. SASE. Reports in 1-2 weeks. Pays $250/3-hour day. **Pays on receipt of invoice.** Rights negotiable.

 CANADIAN LISTINGS are marked with a maple leaf.

■❧**CHISHOLM STOCK FOOTAGE**, (formerly Jack Chisholm Film Productions Ltd.), 99 Atlantic Ave., #50, Toronto, Ontario M6K 3J8 Canada. (416)588-5200. Fax: (416)588-5324. E-mail: chisholm@istar.ca. President: Mary Di Tursi. Estab. 1956. Production house and stock shot, film and video library. Types of clients: finance, industrial, government, TV networks and educational TV/multimedia.
Needs: Supplies stock film and video footage.
Making Contact & Terms: Works with freelancers on an assignment basis only. Rights negotiable.
Tips: "We are seeing more CD-ROM and multimedia applications, i.e. Internet."

■❧**WARNE MARKETING & COMMUNICATIONS**, 111 Avenue Rd., Suite 810, Toronto, Ontario M5R 3J8 Canada. (416)927-0881. Fax: (416)927-1676. President: Keith Warne. Estab. 1979. Ad agency. Types of clients: business-to-business.
Needs: Works with 5 photographers/month. Uses photos for trade magazines, direct mail, P-O-P displays, catalogs and posters. Subjects include: in-plant photography, studio set-ups and product shots. Special subject needs include in-plant shots for background use. Model release required.
Audiovisual Needs: Uses both videotape and slides for product promotion.
Specs: Uses 8×10 glossy b&w prints; 4×5 transparencies and color prints.
Making Contact & Terms: Send letter citing related experience plus 2 or 3 samples. Works on assignment only. Cannot return material. Reports in 2 weeks. Pays $1,000-1,500/day. Pays within 30 days. Buys all rights.
Tips: In portfolio/samples, prefers to see industrial subjects and creative styles. "We look for lighting knowledge, composition and imagination." Send letter and three samples, and wait for trial assignment.

Foreign

■***AWY ASSOCIATES**, Peten 91, Col. Narvarte, D.F. 03020 Mexico. (525)530-3439. Fax: (525)530-3479. E-mail: iaw@compuserve.com. Creative Director: Isaac Ajzen. Estab. 1982. Ad agency and PR firm. Number of employees: 6. Types of clients: industrial, financial, fashion, retail, food. Examples of recent projects: ads and printing for Grupo Textil Mazal and MCM de Mexico; TV ads for Teatra La Hora.
Needs: Works with 2-3 photographers and 1 videographer/month. Uses photos for comsumer magazines, direct mail, catalogs, posters. Subjects include: fashion, food, science and technology. Reviews stock photos. Model/property release preferred. Captions preferred.
Audiovisual Needs: Uses slides for technology product presentations.
Specs: Uses prints; 35mm, 4×5 transparencies; VHS videotape. Accepts images in digital format for Mac and Windows. Submit via compact disc, online, floppy disk or Zip disk.
Making Contact & Terms: Interested in receiving work from newer, lesser-known photographers. Submit portfolio for review. Send unsolicited photos by mail for consideration. Provide resume, business card, brochure, flier or tearsheets to be kept on file for possible future assignments. Works on assignment only. Keeps samples on file. SASE. Reports in 3 weeks. Payment negotiable. Pays 2 weeks after photo session. Credit line sometimes given, depending on client and kind of work. Buys one-time rights; negotiable.
Tips: Looks for "creativity, new things, good focus on the subject and good quality."

Art/Design Studios

Image is everything for corporations in need of design work for annual reports, inhouse publications, catalogs, package design, brochures and other collateral pieces. Company CEOs know that a positive image portrayed to shareholders, employees or clients can stem from the visual appeal of a well-thought-out design. Therefore, many companies hire top studios to conceptualize and execute projects.

For photographers this opens doors to a lot of design jobs. But if you intend to work in the design field, it is important to understand how the industry operates. For example, many designers perform tasks, such as buying media space, that used to be in the domain of ad agencies. The practice has created a rivalry for jobs and removed boundary lines between the two industries. It used to be that the two industries worked hand-in-hand with each other on projects.

Trade magazines such as *HOW*, *Print*, *Communication Arts* and *Graphis* are good places to start when learning about design firms. These magazines not only provide information about how designers operate, but they also explain how creatives use photography. You can find these magazines in bookstores or flip to the section Helpful Resources for Photographers in the back of this book. The section provides addresses for all of these periodicals if you wish to order them.

For photographers, finding work with studios is much like seeking work with advertising agencies. When preparing your portfolio, concentrate on strengths and find those studios which have an interest in your area of expertise. Photographers who have mastered computer software, such as Adobe Photoshop or programs involving 3-D imaging, also should seriously consider approaching design firms. Studios are quickly adapting these image manipulating programs to their everyday jobs and freelancers can benefit greatly from such computer knowledge.

A.T. ASSOCIATES, 63 Old Rutherford Ave., Charlestown MA 02129. (617)242-8595. Fax: (617)242-0697. Contact: Dan Kovacevic. Estab. 1980. Member of IDSA. Design firm. Approximate annual billing: $200,000. Number of employees: 30. Specializes in publication design, display design, packaging, signage and product. Types of clients: industrial, financial and retail. Examples of recent projects: real estate brochures (city scapes); and sales brochure (bikes/bikers).
Needs: Works with 1 freelancer/month. Uses photos for catalogs, packaging and signage. Reviews stock photos as needed. Model/property release preferred. Captions preferred.
Specs: Uses 35mm, 4×5 transparencies; and film (specs vary).
Making Contact & Terms: Interested in receiving work from newer, lesser-known photographers. Provide résumé, business card, brochure, flier or tearsheets to be kept on file for possible future assignments. Works with local freelancers only. Keeps samples on file. Cannot return material. Reports only if interested. Payment negotiable. **Pays on receipt of invoice.** Credit line sometimes given. Buys all rights; negotiable.

ELIE ALIMAN DESIGN, INC., 134 Spring St., New York, NY 10012. (212)925-9621. Fax: (212)941-9138. Creative Director: Elie Aliman. Estab. 1981. Design firm. Specializes in annual reports, publication design, display design, packaging, direct mail. Types of clients: industrial, financial, publishers, nonprofit. Examples of projects: First Los Angeles Bank, Equitable Capital Investment and NYU State Business School.
Needs: Works with 4 freelancers/month. Uses photos for annual reports, consumer and trade magazines, direct mail, posters. Model release required. Property release preferred. Photo captions preferred.
Specs: Uses 35mm, 2¼×2¼, 4×5, 8×10 color transparencies.
Making Contact & Terms: Interested in receiving work from newer, lesser-known photographers. Query with résumé of credits. Provide résumé, business card, brochure, flier or tearsheets to be kept on file for possible future assignments. Keeps samples on file. Cannot return material. Reports in 1-2 weeks. Payment negotiable. **Pays on receipt of invoice.** Credit line sometimes given. Buys first rights, one-time rights and all rights; negotiable.

Tips: Looking for "creative, new ways of visualization and conceptualization."

ART ETC., 316 W. Fourth St., Cincinnati OH 45202. (513)621-6225. Fax: (513)621-6316. Art Director: Doug Carpenter. Estab. 1971. Art Studio. Specializes in industrial, financial, food and OTC drugs.
Needs: Works with 1-2 freelance photographers/month. Uses photos for consumer and trade magazines, direct mail, P-O-P displays, catalogs and posters. Subjects include: musical instruments, OTC drugs, pet food, people and skin products. Reviews stock photos. Model/property release required. Photo captions preferred.
Specs: Uses 4×5, 8×10 color and b&w prints; 35mm, 2¼×2¼, 4×5, 8×10 transparencies.
Making Contact & Terms: Contact through rep. Arrange personal interview to show portfolio. Query with list of stock photo subjects. Provide résumé, business card, brochure, flier or tearsheets to be kept on file for possible future assignments. Works with local freelancers on assignment only. Keeps samples on file. SASE. Reports in 1-2 weeks. Pays $40-250/hour; $600-2,000/day; $150-3,500/job; $150/color photo; $50/b&w photo. **Pays on receipt of invoice.** Buys all rights; negotiable. Credit line sometimes given depending upon marketing target.
Tips: Wants to see food, people and product shots.

AYERS/JOHANEK PUBLICATION DESIGN, INC., 4750 Rolling Hills Dr., Bozeman MT 59715. (406)585-8826. Fax: (406)585-8837. E-mail: johanek@aol.com. Partner: John Johanek. Estab. 1986. Design firm. Number of employees: 8. Specializes in publication design. Types of clients: trade, consumer and association publications. Examples of recent projects: issue design for *Professional Safety* (cover and inside); *Chicago Home & Garden* (cover and inside); *Bird Watcher's Digest* (inside design); *Mining and Engineering* (redesign); and *JMNR* (on-going art direction).
 • This design firm has won Ozzies and Creativity and Apex awards.
Needs: Works with 4-6 freelancers/month. Uses photos for magazines. Reviews stock photos. Model release required. Property release preferred.
Specs: Uses all sizes/any finish color and b&w prints; 35mm, 2¼×2¼ transparencies.
Making Contact & Terms: Interested in receiving work from newer, lesser-known photographers. Query with résumé of credits. Query with stock photo list. Query with samples. Keeps samples on file. SASE. Reports in 1 month. Pays $25-150/b&w photo; $50-300/color photo; $300-650/day; $250-700/job. Payment for electronic usage varies by client. **Pays on receipt of invoice.** Credit line given. Rights vary by client.

BACHMAN DESIGN GROUP, 6001 Memorial Dr., Dublin OH 43017. (614)793-9993. Fax: (614)793-1607. E-mail: bachmand.@aol.com. Principal: Deb Miller. Estab. 1988. Member of American Bankers Association, Bank Administration Institute, Bank Marketing Association, American Center of Design, Design Management Institute. Design firm. Approximate annual billing: $2 million. Number of employees: 15. Specializes in display design, packaging, retail environments. Types of clients: financial, retail. Examples of recent projects: Corestates Financial Corp.; Wells Fargo Bank (print, P-O-P materials); Fidelity Investments (investment account opening package); Nationwide Insurance (catalog, print materials); and Western Canada Lottery.
Needs: Works with 1 freelancer/month. Uses photos for P-O-P displays, posters. Subjects include: lifestyle, still. Reviews stock photos. Model/property release required. Photo captions preferred.
Specs: Uses color and b&w prints; 2¼×2¼, 4×5 transparencies.
Making Contact & Terms: Interested in receiving work from newer, lesser-known photographers. Query with résumé of credits and samples. Provide résumé, business card, brochure, flier or tearsheets to be kept on file for possible future assignments. Works on assignment only. Keeps samples on file. Cannot return material. Reports in 1-2 weeks. Payment negotiable. **Pays on receipt of invoice.** Credit line sometimes given depending on clients' needs/requests. Buys one-time, electronic and all rights; negotiable.

BOB BARRY ASSOCIATES, 4109 Goshen Rd., Newtown Square PA 19073. Phone: (610)353-7333. Fax: (610)356-5759. Contact: Bob Barry. Estab. 1964. Design firm. Approximate annual billing: $300,000. Number of employees: 5. Specializes in annual reports, publication design, displays, packaging, exhibitions, museums, interiors and audiovisual productions. Types of clients: industrial, financial, commercial and government. Examples of recent projects: corporate profile brochure, Zerodec 1 Corporation (text illustration); marketing program, Focht's Inc. (ads, brochures and direct mail); and Mavic Inc. exhibit (large color transparencies in display installations).
Needs: Works with 2-3 freelancers per month. Uses photos for annual reports, consumer and trade maga-

 MARKETS NEW TO THIS EDITION are marked with a double dagger.

zines, direct mail, P-O-P displays, catalogs, posters, packaging and signage. Subjects include: products, on-site installations, people working. Reviews stock images of related subjects. Model release preferred for individual subjects.

Specs: Uses matte b&w and color prints, "very small to cyclorama (mural) size;" 35mm, 2¼×2¼, 4×5, 8×10 transparencies.

Making Contact & Terms: Provide résumé, business card, brochure, flier or tearsheets to be kept on file for possible future assignments. Works on assignment only. Keeps samples on file. SASE. Reports as needed; can be "days to months." Pays $50-150/hour; $600-1,200/day; other payment negotiable. Pays on variable basis, according to project. Credit lines sometimes given, depending upon "end use and client guidelines." Buys all rights; negotiable.

Tips: Wants to see "creative use of subjects, color and lighting. Also, simplicity and clarity. Style should not be too arty." Points out that the objective of a photo should be readily identifiable. Sees trend toward more use of photos within the firm and in the design field in general. To break in, photographers should "understand the objective" they're trying to achieve. "Be creative within personal boundaries. Be my eyes and ears and help me to see things I've missed. Be available and prompt."

BERSON, DEAN, STEVENS, 65 Twining Lane, Wood Ranch CA 93065. (805)582-0898. Owner: Lori Berson. Estab. 1981. Design firm. Specializes in annual reports, display design, packaging and direct mail. Types of clients: industrial, financial and retail.

Needs: Works with 1 freelancer/month. Uses photos for billboards, trade magazines, direct mail, P-O-P displays, catalogs, posters, packaging and signage. Subjects include: product shots and food. Reviews stock photos. Model/property release required.

Specs: Uses 8×10 b&w prints; 35mm, 2¼×2¼, 4×5, 8×10 transparencies.

Making Contact & Terms: Interested in receiving work from newer, lesser-known photographers. Provide résumé, business card, brochure, flier or tearsheets to be kept on file for possible future assignments. Works on assignment only. Keeps samples on file. SASE. Reports in 1-2 weeks. Payment negotiable. Pays within 30 days after receipt of invoice. Credit line not given. Rights negotiable.

BODZIOCH DESIGN, 30 Robbins Farm Rd., Dunstable MA 01827. (508)649-2949. Fax: (508)649-2969. Art Director: Leon Bodzioch. Estab. 1986. Design firm. Specializes in annual reports, publication design and direct mail. Types of clients: industrial. Examples of recent projects: direct mail, Analog Devices (electronic circuit photography); product brochure/fact sheet, Genrad Inc. (product photography); and direct mail, Nebs, Inc. (background textures).

Needs: Uses 4 freelancers/month. Uses photos for annual reports and direct mail. Subjects include: high tech issues. Reviews stock photos. Model/property release preferred. Captions required; identify whether straight or computer-manipulated photography.

Specs: Uses 2¼×2¼, 4×5 transparencies and Photoshop CMYX files.

Making Contact & Terms: Interested in receiving work from newer, lesser-known photographers. Query with stock photo list. Query with samples. Send unsolicited photos by mail for consideration. Keeps samples on file. SASE. Reports when need arises. Pays based on project quote or range of $1,200-2,200/day. Pays net 30 days. Credit line sometimes given depending upon agreement. Buys one-time and all rights; negotiable.

Tips: Looks for "strong artistic composition and unique photographic point-of-view without being trend driven imagery. Photographer's ability to provide digital images on disk is also a benefit."

BOB BOEBERITZ DESIGN, 247 Charlotte St., Asheville NC 28801. (704)258-0316. Owner: Bob Boeberitz. Estab. 1984. Member of American Advertising Federation, Asheville Area Chamber of Commerce, National Federation of Independent Business, National Academy of Recording Arts & Sciences. Graphic design studio. Number of employees: 1. Types of clients: management consultants, retail, recording artists, mail-order firms, industrial, restaurants, hotels and book publishers.

- Awards include the 1995 Arts Alliance/Asheville Chamber Business Support of the Arts Award; Citation of Excellence in Sales Promotion/Packaging; 1995 3rd District AAF ADDY Competition; 1 Addy and 3 Citations of Excellence in the 1995 Greenville Addy Awards.

Needs: Works with 1 freelance photographer every 2 or 3 months. Uses photos for consumer and trade magazines, direct mail, brochures, catalogs and posters. Subjects include: studio product shots, some location, some stock photos. Model/property release required.

Specs: Uses 8×10 b&w glossy prints; 35mm or 4×5 transparencies.

Making Contact & Terms: Interested in receiving work from newer, lesser-known photographers. Provide résumé, business card, brochure, flier or tearsheets to be kept on file for possible future assignments. Cannot return unsolicited material. Reports "when there is a need." Pays $50-200/b&w photo; $100-500/ color photo; $50-100/hour; $350-1,000/day. Pays on per-job basis. Buys all rights; negotiable.

Tips: "I usually look for a specific specialty. No photographer is good at everything. I also consider studio

space and equipment. Show me something different, unusual, something that sets you apart from any average local photographer. If I'm going out of town for something it has to be for something I can't get done locally."

BRAINWORKS DESIGN GROUP, 2 Harris Court, Suite A-7, Monterey CA 93940. (408)657-0650. Fax: (408)657-0750. E-mail: brainwk@aol.com. President: Al Kahn. Estab. 1986. Design firm. Approximate annual billing: $1 million. Number of employees: 6. Specializes in publication design and direct mail. Types of clients: education.
Needs: Works with 2 freelancers/month. Uses photographs for direct mail, catalogs and posters. Wants conceptual images. Model release required.
Specs: Uses 35mm, 4×5 transparencies.
Making Contact & Terms: Interested in receiving work from newer, lesser-known photographers. Arrange personal interview to show portfolio. Send unsolicited photos by mail for consideration. Works with freelancers on assignment only. Keeps samples on file. Cannot return material. Reports in 1 month. Pays $200-400/b&w photo; $400-600/color photo; $100-150/hour; $750-1,200/day; $2,500-4,000/job. Pays on receipt of invoice. Credit line sometimes given, depending on client. Buys first rights, one-time rights and all rights; negotiable.

‡CARLA S. BURCHETT DESIGN CONCEPT, Box 5A, 104 Main St., Unadilla NY 13849. (607)369-4709. Owner: Carla Burchett. Estab. 1972. Member of Packaging Designers Council. Design firm. Number of employees: 2. Specializes in packaging. Types of clients: manufacturers, houses and parks. Example of recent project: Footlets (direct on package).
Needs: Works with "very few" freelancers. Uses photos for posters, packaging and signage. Subjects include: food. Interested in reviewing stock photos of children and animals. Model release required.
Specs: Uses 35mm, 4×5 transparencies.
Making Contact & Terms: Interested in receiving work from newer, lesser-known photographers. Send unsolicited photos by mail for consideration. Works with local freelancers only. Keeps samples on file. SASE. Will respond same week if not interested. Payment negotiable. Credit line given. Buys first rights; negotiable.

CAMBRIDGE PREPRESS, 215 First St., Cambridge MA 02142. (617)354-1991. Fax: (617)494-6575. E-mail: cindyd@cindydavis.com. Creative Director: Cynthia Davis. Estab. 1968. Design firm. Approximate annual billing: $3.5 million. Number of employees: 50. Specializes in publication design and packaging. Types of clients: financial and publishers. Examples of recent projects: "Fidelity Focus," Fidelity Investments (editorial); Goldhirsh Group (editorial); and "Dragon Dictate" Dragon Systems (packaging).
Needs: Works with 5-10 freelancers/month. Uses photos for consumer magazines, trade magazines, catalogs and packaging. Subjects include: people. Reviews stock photos. Model release preferred.
Specs: Uses 35mm, 2¼×2¼ transparencies; film appropriate for project.
Making Contact & Terms: Interested in receiving work from newer, lesser-known photographers. Query with samples. Works on assignment only. Keeps samples on file. Do not submit originals. Payment negotiable. Pays 30 days net. Credit line given. Rights purchased depend on project; negotiable.

‡CAREW DESIGN, 49 Sunset Way, San Rafael CA 94901. (415)454-1989. Fax: (415)457-7916. President: Jim Carew. Estab. 1977. Design firm. Specializes in publication design, packaging, direct mail and signage. Types of clients: industrial, publishers.
Needs: Works with 2 freelancers/month. Uses photos for consumer and trade magazines, catalogs and packaging. Reviews stock photos. Model/property release required. Captions preferred.
Specs: Uses 8×10, 11×17 semigloss color and/or b&w prints; 2¼×2¼, 4×5 transparencies.
Making Contact & Terms: Interested in receiving work from newer, lesser-known photographers. Provide résumé, business card, brochure, flier or tearsheets to be kept on file for possible future assignments. Works with local freelancers only. Keeps samples on file. SASE. Responds in 3 weeks. Payment negotiable. Credit line sometimes given depending on use. Buys first rights; negotiable.

‡CLIFF AND ASSOCIATES, 715 Fremont Ave., South Pasadena CA 91030. (818)799-5906. Fax: (818)799-9809. Owner: Greg Cliff. Estab. 1984. Design firm. Specializes in annual reports, display design, direct mail, signage. Types of clients: industrial, financial, corporate. Examples of recent projects: international brochure for ARCO.
Needs: Works with 1-2 freelancers/month. Uses photos for annual reports, direct mail, P-O-P displays, catalogs. Subjects include: people and food. Reviews stock photos. Model/property release preferred. Captions preferred.
Specs: Uses all glossy color prints.

Making Contact & Terms: Interested in receiving work from newer, lesser-known photographers. Provide résumé, business card, brochure, flier or tearsheets to be kept on file for future assignments. Works with local freelancers on assignment only. Keeps samples on file. SASE. Reports in 1-2 weeks. Pays $600-3,500/day. Pays on receipt of invoice. Credit line sometimes given. Rights negotiable.

SANDY CONNOR ART DIRECTION, 90 Ship St., Providence RI 02903. (401)831-5796. Fax: (401)831-5797. Owner: Sandy Connor. Estab. 1992. Member of Providence Chamber of Commerce. Design firm, advertising/design. Number of employees: 1. Specializes in annual reports, publication design, direct mail. Types of clients: industrial, financial, nonprofit. Examples of recent projects: Washington Trust Company (annual report); Arconium (brochures); and Handy & Hamon (corporate brochures).
Needs: Works with 1 freelancer/month. Uses photos for annual reports, trade magazines, direct mail, P-O-P displays, catalogs. Subjects include: industrial, location and product. Reviews stock photos. Model release required.
Specs: Uses b&w prints; 35mm, 2¼×2¼, 4×5, 8×10.
Making Contact & Terms: Interested in receiving work from newer, lesser-known photographers. Submit portfolio for review. Query with samples. Send unsolicited photos by mail for consideration. Provide résumé, business card, brochure, flier or tearsheets to be kept on file for possible future assignments. Works on assignment only. Keeps samples on file. Reports as need for work arises. Pays $50-200/hour; $1,000-2,000/day. Pays on acceptance; 30 days from receipt of invoice. Buys first, one-time and all rights; negotiable.

CSOKA/BENATO/FLEURANT, INC., 134 W. 26th St., Room 903, New York NY 10001. President: Bob Fleurant. Estab. 1969. Design firm. Number of employees: 5. Specializes in annual reports, packaging and direct mail. Types of clients: industrial, financial and music. Examples of recent projects: "Wonders of Life," Met Life (Epcot Center souvenir); "Power of Music," RCA/BMG (sales kit); and "Booster Cables," Standard Motor Products (package design).
Needs: Uses photos for direct mail, packaging, music packages. Subjects include: still life, holidays, memorabilia, lifestyles and health care. Interested in reviewing stock photos of still life, holidays, memorabilia, lifestyles and health care. Model release required for families, lifestyle, business and health care. Property release preferred.
Specs: Uses 8×10 or larger color and b&w prints; 35mm, 2¼×2¼, 4×5, 8×10 transparencies.
Making Contact & Terms: Interested in receiving work from newer, lesser-known photographers. Query with stock photo list. Provide résumé, business card, brochure, flier or tearsheets to be kept on file for possible future assignments. "Only select material is kept on file." Works on assignment only. Cannot return material. Reports only when interested. Payment negotiable. Pays 30 days from receipt of invoice. Credit line sometimes given depending on client requirements, usage. Buys one-time, exclusive product and all rights; negotiable.

DESIGN & MORE, 1222 Cavell, Highland Park IL 60035. (847)831-4437. Fax: (847)831-4462. Principal Creative Director: Burt Bentkover. Estab. 1989. Design and marketing firm. Approximate annual billing: $350,000. Number of employees: 2. Specializes in food advertising, annual reports, packaging, signage, publication design, brochures and promotions. Types of clients: foodservice and business-to-business.
Needs: Works with 1 freelancer/month. Uses photos for annual reports, consumer and trade magazines and sales brochures. Subjects include abstracts and food. Reviews stock photos of concepts and food. Property release required.
Specs: Uses 35mm and 2¼×2¼ transparencies.
Making Contact & Terms: Interested in receiving work from newer, lesser-known photographers. Provide résumé, business card, brochure, flier or tearsheets to be kept on file for possible future assignments. Never send originals. Keeps samples on file. Cannot return material. Reports in 1-2 weeks. Pays $500-1,000/day. Pays in 45 days. Cannot offer photo credit. Buys negotiable rights.

‡DESIGN CONCEPTS-CARLA SCHROEDER BURCHETT, 104 Main St., Box 5A, Unadilla NY 13849-9701. (607)369-4709. Owner: Carla Schroeder. Estab. 1972. Number of employees: 2. Specializes in direct mail. Types of clients: industrial, manufacturers. Examples of recent projects: "Used Footlets" (marketing firm).
Needs: Uses photos for catalogs. Subjects include: wild nature to still life and houses. Model release preferred. Captions required.
Specs: Uses prints; 35mm transparencies.
Making Contact & Terms: SASE. Reports in 1-2 weeks. Payment negotiable. **Pays on acceptance.** Credit line given. Buys first rights; negotiable.

DESIGNATION, (formerly Mike Quon Design Office, Inc.), 53 Spring St., New York NY 10012. (212)226-6024. Fax: (212)219-0331. President/Creative Director: Mike Quon. Design firm. Specializes in packaging, direct mail, signage, illustration. Types of clients: industrial, financial, retail, publishers, nonprofit.
Needs: Works with 1-3 freelancers/month. Uses photos for direct mail, P-O-P displays, packaging, signage. Model/property release preferred. Captions required; include company name.
Specs: Uses color, b&w prints; 2¼×2¼, 4×5 transparencies.
Making Contact & Terms: Interested in receiving work from newer, lesser-known photographers. Submit portfolio for review. Send unsolicited photos by mail for consideration. Works on assignment only. Keeps samples on file. Cannot return material. Reports only when interested. Pays $1,000-3,000/day. Pays net 30 days. Credit line given when possible. Buys first rights, one-time rights; negotiable.

✦DUCK SOUP GRAPHICS, INC., 257 Grandmeadow Crescent, Edmonton, Alberta T6L 1W9 Canada. (403)462-4760. Fax: (403)463-0924. Creative Director: William Doucette. Estab. 1980. Design firm. Specializes in annual reports, publication design, corporate literature/identity, packaging and direct mail. Types of clients: industrial, government, institutional, financial and retail.
Needs: Works with 2-4 freelancers/month. Uses photos for annual reports, billboards, consumer and trade magazines, direct mail, posters and packaging. Subject matter varies. Reviews stock photos. Model release preferred.
Specs: Uses color and b&w prints; 35mm, 4×5, 8×10 transparencies.
Making Contact & Terms: Interested in receiving work from newer, lesser-known photographers. Provide résumé, business card, brochure, flier or tearsheets to be kept on file for possible future assignments. Works on assignment only. Keeps samples on file. SAE and IRC. Reports in 1-2 weeks. Pays $100-150/hour; $800-1,000/day; $500-10,000/job. **Pays on receipt of invoice**. Credit line sometimes given depending on number of photos in publication. Buys first rights; negotiable.

‡emdash inc., 588 Broadway, Suite 610, New York NY 10012. (212)343-1451. Fax: (212)274-0545. Creative Director: Andrea Meyer. Estab. 1992. Approximate annual billing: $100,000. Number of employees: 4. Specializes in annual reports, publication design, display design and direct mail. Types of clients: financial, publishers and nonprofit.
Needs: Works with 1 freelancer/month. Uses photos for annual reports, direct mail, catalogs, posters and packaging. Subjects include: portraits, architecture and product shots. Reviews stock photos. Model/property release required. Captions preferred.
Specs: Uses prints, transparencies and digital format.
Making Contact & Terms: Interested in receiving work from newer, lesser-known photographers. Query with samples. Provide résumé, business card, brochure, flier or tearsheets to be kept on file for possible future assignments. Keeps samples on file. SASE. Reports in 1 month. Payment negotiable.

‡FORDESIGN GROUP LTD., 87 Dayton Rd., Redding CT 06896. (203)938-0008. Fax: (203)938-0805. E-mail: fordsign@webquill.com. Website: http://www.Fordesign.com. Creative Director: Steven Ford. Estab. 1990. Member of AIGA, P.D.C. Design firm. Specializes in packaging. Types of clients: industrial, retail. Examples of recent projects: Talk Xpress for AT&T Wireless (location, people); Packaging for SONY (product); and KAME Chinese Food for Liberty Richter (food).
Needs: Works with 2 freelancers/month. Uses photos for packaging. Subjects include: food. Reviews stock photos. Model release required. Location preferred.
Specs: Uses 4×5 transparencies. Accepts images in digital format for Mac (EPS, Photoshop, TIFF). Send via compact disc, online, floppy disk, SyQuest or Zip disk.
Making Contact & Terms: Interested in receiving work from newer, lesser-known photographers. Submit portfolio for review. Query with samples. Send unsolicited photos by mail for consideration. Keeps samples on file. SASE. Reports in 1-2 weeks. Pays "typical" day rate. **Pays on receipt of invoice.** Credit line given. Rights negotiable.

‡FRANZ DESIGN GROUP, 115 Fifth Ave. S., Suite 401, LaCrosse WI 54601. (608)791-1020. Fax: (608)791-1021. Design firm. Creative Director: Alan Franz. Estab. 1990. Specializes in publication design, display design and packaging. Types of clients: industrial, retail. Examples of recent projects: "In Line in Life" video, Rollerblade, Inc. (cover photo for video); Schmidt Loon Search, G. Heileman Brewing Co. (point of purchase display); and Burros Promotional Products (catalog).
Needs: Works with 2 freelance photographers/month. Uses photos for trade magazines, P-O-P displays, catalogs and packaging. Subjects include: models, products and food. Reviews stock photos of studio-food and location-models. Model/property release preferred; usually needs model shots. Captions preferred.
Specs: Uses 2¼×2¼, 4×5 transparencies.
Making Contact & Terms: Provide tearsheets to be kept on file for possible future assignments. Works

with freelancers on assignment only. Keeps samples on file. SASE. Reports in 1-2 weeks. Pays $100-3,500/job. **Pays on receipt of invoice**. Credit lines sometimes given depending on the project; "yes, if we can make the decision." Buys all rights; negotiable.

Tips: Interested in "general quality of portfolio and specifically the design and styling of each photo. We like to work with photographers who can suggest solutions to lighting and styling problems—no 'yes' men/women!"

‡FUSION INTERNATIONAL, 420-B Wharfside Way, Jacksonville FL 32207. E-mail: mocando@aol.com. Design firm. Creative Director: Michael O'Connell. Estab. 1991. Specializes in annual reports, publication design, display design, direct mail and corporate communications/music industry. Types of clients: industrial, financial, sports retail, publishers, nonprofit and environmental/music. Examples of recent projects: First Union National Bank of Florida (photos used in ads and fliers); Advanced Sports Marketing (professional sports); *First Coast Parent* (parenting publication); and video album packaging.

Needs: Works with 0-4 freelance photographers/month. Uses photographs for trade magazines, direct mail, catalogs, posters. Subjects include: editorial for publications. Reviews stock photos of entertainment and medical. Model/property release required. Captions preferred.

Specs: Uses 8×10 color and b&w prints; 35mm, 2¼×2¼ transparencies. Accepts images in digital format for Mac. Send via compact disc, online, SyQuest or jaz disk (3000 dpi or better).

Making Contact & Terms: Interested in receiving work from newer, lesser-known photographers. Provide résumé, business card, brochure, flier or tearsheets to be kept on file for possible future assignments. Works with freelancers on assignment only. Keeps samples on file. SASE. Reports in 2-4 weeks. Payment negotiable. Pays on publication. Credit line sometimes given depending on project/client specification. Rights negotiable.

Tips: "I am looking for two kinds of styles. I need financial and traditional for use with financial institutions and avant-garde styles used in sports and music."

GEREW GRAPHIC DESIGN, 4403 Wickford Rd., Baltimore MD 21210-2809. (410)366-5429. Fax: (410)366-6123. E-mail: clgggd1@aol.com. Owner: Cynthia Gerew. Estab. 1988. Design firm. Approximate annual billing: $150,000. Number of employees: 3. Specializes in publication design and direct mail. Types of clients: financial, publishers and insurance.

Needs: Uses photos for direct mail. Subjects include: families, health, real estate, senior market and credit card usage. Model/property release required.

Specs: Uses 8×10 glossy b&w prints; 35mm, 2¼×2¼, 4×5 transparencies.

Making Contact & Terms: Interested in receiving work from newer, lesser-known photographers. Arrange personal interview to show portfolio. Send unsolicited photos by mail for consideration. Provide résumé, business card, brochure, flier or tearsheets to be kept on file for possible future assignments. Works on assignment only. Keeps samples on file. SASE. Responds if an appropriate assignment is available. Pays $300-900/shot depending on usage. Pays 30 days from receipt of invoice. Credit line not given. Buys one-time rights.

Tips: "I like everyday-type people in the shots with a good cross-market representation."

■GOLD & ASSOCIATES, INC., 100 Executive Way, Ponte Verde Beach FL 32082. (904)285-5669. Fax: (904)285-1579. Creative Director: Keith Gold. Estab. 1988. Member of AIGA. Marketing/design firm. Approximate annual billing: $12 million in capitalized billings. Number of employees: 16. Specializes in music, publishing, health care and entertainment industries. Examples of recent projects: Time-Warner (video and video packaging); Harcourt General (book and collateral design); and *Sony V* (music packaging).

Needs: Works with 1-4 freelance photographers and 1-2 filmmakers/month. Uses photos for video, television spots, films and CD packaging. Subjects vary. Reviews stock photos. Tries to buy out images.

Specs: Uses transparencies, film and disks.

Making Contact & Terms: Interested in receiving work from newer, lesser-known photographers. Contact through rep. Provide flier or tearsheets to be kept on file for possible future assignments. Works with freelancers from across the US. Cannot return material. Only reports to "photographers being used." Payment negotiable. **Pays on receipt of invoice.** Credit line given only for original work where the photograph is the primary design element; never for spot or stock photos. Buys all rights.

‡GRAFICA, 7053 Owensmouth Ave., Canoga Park CA 91303. (818)712-0071. Fax: (818)348-7582. E-mail: graficaeps@aol.com. Owner: Larry Girardi. Estab. 1974. Member of Apple Developer Group, Adobe Authorized Imaging Center, Quark Service Alliance, Corel Approved Service Bureau. Design Studio and Service Bureau. Approximate annual billing: $150,000. Number of employees: 3-5. Specializes in annual reports, publication design, display design and video graphics-titling. Types of clients: industrial, financial, retail, publishers and entertainment. Examples of recent projects: Reed's "Wet" Table Tent for Reed's

Original Beverage Corporation (photo behind product); and recruitment brochure for CA State University, Northridge (campus/student photos).

Needs: Works with 1-2 freelancers/month. Uses photos for annual reports, billboards, consumer magazines, trade magazines, P-O-P displays, catalogs, posters and packaging. Reviews stock photos. Model release required. Property release preferred.

Specs: Uses 35mm, 2¼ × 2¼, 4 × 5 transparencies.

Making Contact & Terms: Interested in receiving work from newer, lesser-known photographers. Query with samples. Provide résumé, business card, brochure, flier or tearsheets to be kept on file for possible future assignments. Keeps samples on file. SASE. Reports in 1-2 weeks. Payment negotiable. Credit line sometimes given. Buys first, one-time, electronic and all rights; negotiable.

GRAPHIC ART RESOURCE ASSOCIATES, 257 W. Tenth St., New York NY 10014-2508. (212)929-0017. Fax: (212)255-3574 (phone first). E-mail: rlassen@mail.idt.net. Principal: Robert Lassen. Estab. 1980. Design firm, photography studio, ad agency, printing brokerage, etc. Approximate annual billing: $80,000. Number of employees: 1. Specializes in publication design. Types of clients: industrial, financial and academic. Examples of recent projects: Annual Picture Book, Executive Programs Directory and MBA Student Directory for New York University.

Needs: Works with 2-3 freelancers/year. Uses photos for books. Subjects include: people, table top product, location.

Specs: Uses 35mm b&w contact sheets or 11 × 14 color prints; 35mm transparencies. Accepts images in digital format for Mac (Photoshop 4.0). Send via SyQuest (300 dpi or better).

Making Contact & Terms: "Just call. If I'm not too busy, I may see you. I'm not interested in dealing with reps." Works on assignment only. Keeps samples on file (but only a few). Will not return material. "If I'm interested I'll call when I have something." Pays $50-75/hour; $250-600/day. Pays "when I get paid." Credit lines sometimes given. Buys all rights, may negotiate, depends on client requirements.

Tips: "We supply all film and lab. I myself am a photographer, and virtually all photographic services are done inhouse. Once in a while I need help." Looks for "professional competence, understanding of merchandising and the right equipment for the job. I look at Polaroids for approval. We can scan negatives directly into computer for electronic retouching and electronic output directly to litho film."

GRAPHIC DESIGN CONCEPTS, 4123 Wade St., Suite 2, Los Angeles CA 90066. (310)306-8143. President: C. Weinstein. Estab. 1980. Design firm. Specializes in annual reports, publication design, display design, packaging, direct mail and signage. Types of clients: industrial, financial, retail, publishers and nonprofit. Examples of recent projects: "Cosmo Package," Amboy, Inc. (product/package photo); "Aircraft Instruments," General Instruments, Inc. (product/package photo); and "Retirement Residence," Dove, Inc. (pictorial brochure).

Needs: Works with 10 freelancers/month. Uses photos for annual reports, billboards, consumer and trade magazines, direct mail, P-O-P displays, catalogs, posters, packaging and signage. Subjects include: pictorial, scenic, product and travel. Reviews stock photos of pictorial, product, scenic and travel. Model/property release required for people, places, art. Captions required; include who, what, when, where.

Specs: Uses 8 × 10 glossy, color and b&w prints; 35mm, 2¼ × 2¼, 4 × 5, 8 × 10 transparencies.

Making Contact & Terms: Interested in receiving work from newer, lesser-known photographers. Provide résumé, business card, brochure, flier or tearsheets to be kept on file for possible future assignments. Works with freelancers on assignment only. Keeps samples on file. SASE. Reports as needed. Pays $15 minimum/hour; $100 minimum/day; $100 minimum/job; $50 minimum/color photo; $25 minimum/b&w photo. **Pays on receipt of invoice.** Credit line sometimes given depending upon usage. Buys rights according to usage.

Tips: In samples, looks for "composition, lighting and styling." Sees trend toward "photos being digitized and manipulated by computer."

H. GREENE & COMPANY, 230 W. Huron, Chicago IL 60610. (312)642-0088. Fax: (312)642-0028. President: Howard Greene. Estab. 1985. Member of AIGA. Design firm. Approximate annual billing: $5 million. Number of employees: 11. Specializes in annual reports, publication design, direct mail, signage and technology. Types of clients: industrial, financial and nonprofit. Examples of recent clients: Rand McNally, Motorola, Nalco and Comdisco.

 MARKETS USING AUDIOVISUAL MATERIAL, such as slides, film or videotape, are marked with a solid, black square.

Needs: Works with 1 freelancer/month. Uses photos for direct mail, catalogs and posters. Subjects include: people and locations. Reviews stock photos. Model/property release required.
Specs: Uses 35mm, $2\frac{1}{4} \times 2\frac{1}{4}$, 4×5 transparencies.
Making Contact & Terms: Interested in receiving work from newer, lesser-known photographers. Send unsolicited photos by mail for consideration. Provide résumé, business card, brochure, flier or tearsheets to be kept on file for possible future assignments. Works on assignment only. Keeps samples on file. Cannot return material. Payment negotiable. **Pays on receipt of invoice.** Credit line given. Buys one-time and electronic rights; negotiable.

HAMMOND DESIGN ASSOCIATES, 79 Amherst St., Milford NH 03055. (603)673-5253. Fax: (603)673-4297. President: Duane Hammond. Estab. 1969. Design firm. Specializes in annual reports, publication design, display design, packaging, direct mail, signage and non-specialized. Types of clients: industrial, financial, publishers and nonprofit. Examples of projects: Resonetics Capabilities brochure, Micro Lasering (product photos, cover and inside); golf courses yardage guides; Granite Bank (advertising literature); and Cornerstone Software (collateral material).
Needs: Works with 1 freelancer/month. Uses photos for annual reports, trade magazines, direct mail, catalogs and posters. Subject matter varies. Reviews stock photos. Model release required. Property release preferred. Captions preferred.
Specs: Uses 8×10 and 4×5 matte or glossy, color and b&w prints; 35mm, $2\frac{1}{4} \times 2\frac{1}{4}$, 4×5 transparencies.
Making Contact & Terms: Interested in receiving work from newer, lesser-known photographers. Send unsolicited photos by mail for consideration. Provide résumé, business card, brochure, flier or tearsheets to be kept on file for possible future assignments. Works with freelancers on assignment only. Cannot return unsolicited material. Pays $25-100/hour; $450-1,000/day; $25-2,000/job; $50-100/color photo; $25-75/b&w photo. Pays on receipt of invoice net 30 days. Credit line sometimes given. Buys one-time, exclusive product and all rights; negotiable.
Tips: Wants to see creative and atmosphere shots, "turning the mundane into something exciting."

‡**HARD BALL**, (formerly Advanced Sports Marketing), 420-B Wharfside Way, Jacksonville FL 32207. Contact: Creative Director. Estab. 1991. Design and marketing firm. Specializes in sports promotion, retail products, publication design, corporate communications and direct mail. Types of clients: professional sports organizations, corporate clients, publishers, nonprofit and music.
Needs: Works with up to 4 photographers/month. Uses photos for promotional use, advertising and trade magazines. Subjects include: sports, entertainment and editorial. Reviews stock photos of sports and entertainment. Model/property release required.
Specs: Uses 35mm, $2\frac{1}{4} \times 2\frac{1}{4}$ transparencies.
Making Contact & Terms: Provide tearsheet, brochure and business card to be kept on file for possible future assignments. Payment negotiable. Pays upon publication. Credit line sometimes given depending on project/client specification. Rights negotiable.
Tips: "I'm looking for exciting, 'extreme' style images."

‡**DAVID HIRSCH DESIGN GROUP, INC.**, 205 W. Wacker Drive, Chicago IL 60606. (312)329-1500. Art Director: Peter Dugan. Estab. 1976. Design firm. Specializes in annual reports, publication design, direct mail and signage. Types of clients: industrial, financial and nonprofit. Examples of recent projects: employee annual report, Keebler Company; healthy children, Blue Cross/Blue Shield; and annual report, Baker Fentress Management Company.
Needs: Works with a various number of freelancers/month. Uses photos for annual reports and catalogs. Subject matter varies. Model release required; property release preferred. Captions preferred.
Specs: Uses 8×10 color/b&w prints; 35mm, $2\frac{1}{4} \times 2\frac{1}{4}$ and 4×5 transparencies.
Making Contact & Terms: Interested in receiving work from newer, lesser-known photographers. Send unsolicited photos by mail for consideration. Provide résumé, business card, brochure, flier or tearsheets to be kept on file for possible future assignments. Keeps samples on file. Sometimes returns material. "Reports as soon as we know something." Pays by contract with photographer. **Pays on receipt of invoice.** Credit line not given. Buys all rights; negotiable.

HOWRY DESIGN ASSOCIATES, 354 Pine St., Suite 600, San Francisco CA 94104. (415)433-2035. Fax: (415)433-0816. Office Manager: Laura Huberman. Estab. 1987. Design firm. Number of employees: 8. Specializes in annual reports. Types of clients: industrial, financial and publishers. Examples of recent projects: San Francisco International Airport (annual report); Solectron (annual report); and Cygnus (annual report).
Needs: Works with 2-4 freelancers/month. Uses photos for annual reports. Subjects vary. Reviews stock photos. Model/property release preferred. Captions preferred.
Specs: Uses 35mm, $2\frac{1}{4} \times 2\frac{1}{4}$, 4×5, 8×10 transparencies.

Making Contact & Terms: Interested in receiving work from newer, lesser-known photographers. Query with samples. Provide résumé, business card, brochure, flier or tearsheets to be kept on file for possible future assignments. Works on assignment only. Keeps samples on file. Reports in 1-2 weeks. Payment negotiable. **Pays on receipt of invoice.** Buys one-time rights.

‡HULSEY GRAPHICS, 500 Jesse Jewell Pkwy., Suite 301, Gainesville GA 30501. (404)534-6624. Fax: (404)536-6858. President: Clay Hulsey. Estab. 1989. Design firm. Specializes in annual reports, publication design, packaging, direct mail. Types of clients: industrial, financial, retail.
Needs: Uses photos for annual reports, consumer magazines, trade magazines, direct mail, catalogs, posters, packaging, advertising, newspaper ads. Subject matter varies. Reviews stock photos. Model/property release required.
Specs: Uses 35mm, 4×5 transparencies.
Making Contact & Terms: Interested in receiving work from newer, lesser-known photographers. Query with résumé of credits. Query with stock photo list. Provide résumé, business card, brochure, flier or tearsheets to be kept on file for possible future assignments. Works with freelancers on assignment. Keeps samples on file. Cannot return material. Reports only if interested. Payment negotiable. **Pays on acceptance.** Buys all rights.

HUTCHINSON ASSOCIATES, INC., 1147 W. Ohio St., Suite 305, Chicago IL 60622-5874. (312)455-9191. Fax: (312)455-9190. E-mail: hutch@hutchinson.com. Website: http://www.hutchinson.com. Design firm. Contact: Jerry Hutchinson. Estab. 1988. Member of American Center for Design, American Institute of Graphic Arts. Number of employees: 3. Specializes in annual reports, marketing brochures, etc. Types of clients: industrial, finance, real estate and medical. Examples of recent projects: annual reports (architectural) and capabilities brochures, multimedia and web page design.
Needs: Works with 1 freelance photographer/month. Uses photographs for annual reports, brochures, consumer and trade magazines, direct mail, catalogs and posters. Reviews stock photos. Subjects include: still life, real estate.
Specs: Uses 35mm, 2¼×2¼, 4×5, color and b&w prints; 35mm, 4×5 transparencies.
Making Contact & Terms: Send unsolicited photos by mail for consideration. Query with samples. Keeps samples on file. SASE. Reports "when the right project comes." Payment rates depend on the client. Pays within 30 days. Buys one-time, exclusive product and all rights; negotiable. Credit line sometimes given.
Tips: In samples "quality and composition count." Sees a trend toward "more abstraction."

ICONS, 76 Elm St., Suite 313, Boston MA 02130. Phone: (617)522-0165. Fax: (617)524-5378. Principal: Glenn Johnson. Estab. 1984. Design firm. Approximate annual billing: $250,000. Number of employees: 2. Specializes in annual reports, publication design, packaging, direct mail and signage. Types of clients: high-tech. Examples of recent clients: SQA Inc., Leaf Systems, Picturetel.
Needs: Works with 2 freelancers/month. Uses photos for annual reports, trade magazines, packaging, direct mail and posters. Subjects include: portraits, photo montage and products. Reviews unusual abstract, non-conventional stock photos. Model/property release preferred for product photography. Captions preferred; include film and exposure information and technique details.
Specs: Uses 4×5 transparencies.
Making Contact & Terms: Interested in receiving work from newer, lesser-known photographers. Query with samples. Works with local freelancers only. Keeps samples on file. SASE. Reports in 3 weeks. Pays $1,200-1,800/day; $750-5,000/job. **Pays on receipt of invoice.** Credit line given. Buys first rights.

‡IMPACT MEDIA GROUP, 1920 Franklin St., Suite 7, San Francisco CA 94109. (415)563-9083. Fax: (415)563-7637. E-mail: impactmg@aol.com. Partner: Garner Moss. Estab. 1993. Member of American Advertising Association, Art Directors of America, Robot Warrior Association-IRWA. Digital design firm. Approximate annual billing: $250,000-1 million. Number of employees: 8. Specializes in annual reports, publication design, display design, packaging, direct mail, signage, website design/corporate identities and logos. Types of clients: industrial, financial, retail, publishers, nonprofit, political, high-tech, virtual reality and Internet/intranet. Examples of recent projects: Cisco TV for Cisco Systems (direct mail piece/photos); Christmas 96.com for AT&T (photographic website for Christmas); and LA Kings.com for Los Angeles Kings Hockey Team (sports photography, fully integrated website).
Needs: Works with 2-3 freelancers/month. Uses photos for annual reports, billboards, consumer magazines, direct mail, P-O-P displays, packaging, signage, website and political mail. Subjects include: still life and portraits. Reviews stock photos. Model/property release preferred. Captions preferred.
Specs: Uses 5×7, 8×10 prints; 35mm transparencies; videotape. Accepts images in digital format. Send via Zip files.
Making Contact & Terms: Interested in receiving work from newer, lesser-known photographers. Ar-

range personal interview to show portfolio. Send unsolicited photos by mail for consideration. Provide résumé, business card, brochure, flier or tearsheets to be kept on file for possible future assignments. Send disk with samples on it. Keeps samples on file. SASE. Reports in 3 weeks. Payment negotiable. **Pays on receipt of invoice.** Credit line sometimes given depending upon publication or website. Rights negotiable.

‡INNOVATIVE DESIGN AND ADVERTISING, 1424 Fourth St., #702, Santa Monica CA 90401. (310)395-4332. Fax: (310)394-9633. E-mail: idawest@earthlink.net. Design firm. Partners: Susan Nickey and Kim Crossett. Estab. 1991. Specializes in annual reports, publication design, corporate identity. Types of clients: industrial, financial, retail, nonprofit and corporate. Examples of recent projects: Children's Hospital, Killer Tracks.
Needs: Works with less than 1 freelance photographer/month. Uses photographs for trade magazines, direct mail and brochures. Subjects include: people and studio. Reviews stock photos on a per-assignment basis. Model/property release required for models, any famous works.
Specs: Uses 35mm, 2¼×2¼, 4×5 transparencies. Accepts images in digital format for Mac. Send via compact disc, online, floppy disk, SyQuest or jaz disk.
Making Contact & Terms: Provide résumé, business card, brochure, flier or tearsheets to be kept on file for possible future assignments. Works with freelancers on assignment only. Keeps samples on file. SASE. Reports in 1 month. "When we receive a job in-house we request photographers." NPI; payment "on a per-job basis as budget allows." Pays within 30 days. Credit lines sometimes given depending on client. "We like to give credit where credit is due!" Payment negotiable. "No calls."
Tips: "Be punctual and willing to work within our client's budget."

PETER JAMES DESIGN STUDIO, 7495 NW Fourth St., Plantation FL 33317-2204. (954)587-2842. Fax: (954)587-2866. President/Creative Director: Jim Spangler. Estab. 1980. Design firm. Specializes in advertising design, packaging, direct mail. Types of clients: industrial, corporate. Example of recent project: VSI International (packaging/print).
Needs: Works with 1-2 freelancers/month. Uses photos for consumer and trade magazines, direct mail, P-O-P displays, catalogs, posters and packaging. Subjects include: lifestyle shots and products. Reviews stock photos. Model release required. Captions preferred.
Specs: Uses 8×10, glossy, color prints; 35mm, 2¼×2¼, 4×5 transparencies.
Making Contact & Terms: Arrange personal interview to show portfolio. Query with résumé of credits. Query with samples. Provide résumé, business card, brochure, flier or tearsheets to be kept on file for possible future assignments. Works with freelancers on assignment only. Keeps samples on file. SASE. Reports as needed. Pays $150 minimum/hour; $1,200 minimum/day. Pays net 30 days. Credit line sometimes given depending upon usage.
Tips: Wants to see "specific style, knowledge of the craft, innovation."

‡BRENT A. JONES DESIGN, 328 Hayes St., San Francisco CA 94102. (415)626-8337. Fax: (415)626-8337. Contact: Brent A. Jones. Estab. 1983. Design firm. Specializes in annual reports and publication design. Types of clients: industrial, financial, retail, publishers and nonprofit.
Needs: Works with 1 freelancer/month. Uses photos for annual reports, consumer magazines, catalogs and posters. Reviews stock photos as needed. Model/property release required. Captions preferred.
Specs: Uses color and b&w prints; no format preference. Also uses 35mm, 4×5, 8×10 transparencies.
Making Contact & Terms: Query with résumé of credits. Query with samples. Provide résumé, business card, brochure, flier or tearsheets to be kept on file for possible future assignments. Works with local freelancers only. Keeps samples on file. Cannot return material. Reports in 1 month. Pays on per hour basis. **Pays on receipt of invoice.** Credit line sometimes given. Buys one-time rights; negotiable.

LIEBER BREWSTER CORPORATE DESIGN, 211 W. 61st St., 6th Floor, New York NY 10023. (212)459-9099. Principal: Anna Lieber. Estab. 1988. Design firm. Specializes in corporate communications and marketing promotion. Types of clients: health care, financial, publishers and nonprofit.
Needs: Works with freelancers on a per project basis. Uses photos for direct mail, catalogs, brochures, annual report and ads. Subjects include: food and wine, flowers, people, location, still life and corporate.
Specs: Uses 8×10 b&w prints; 35mm, 2¼×2¼, 4×5, 8×10 transparencies.
Making Contact & Terms: Interested in receiving work from newer, lesser-known photographers. Provide résumé, business card, brochure, flier or tearsheets to be kept on file for possible future assignments. Works with freelancers on assignment only. Keeps samples on file. SASE. Reports only on solicited work. Pays $75-150/hour; $250-700/day; $500-2,000/job. **Pays on acceptance or receipt of invoice.** Credit line given. Rights negotiable.
Tips: Wants to see an "extremely professional presentation, well-defined style and versatility. Send professional mailers with actual work for clients, as well as creative personal work."

LORENC DESIGN, 724 Longleaf Dr., Atlanta GA 30342. (404)266-2711. Fax: (404)233-5619. Manager: Alicia Cacci. Estab. 1978. Member of SEGD, AIGA, AIA. Design firm. Approximate annual billing: $750,000. Number of employees: 7. Specializes in display design and signage. Types of clients: industrial, financial and retail. Examples of recent projects: "Holiday Inn Worldwide Headquarters," Holiday Inn (exhibit); and "Georgia Pacific Sales Center," Georgia-Pacific (exhibit).
Needs: Works with 1 freelancer/month. Uses photos for P-O-P displays, posters, signage and exhibits. Subjects include: architectural photography, scenery and people. Reviews stock photos.
Specs: Uses 8×10 glossy color and b&w prints; 35mm, 4×5 transparencies.
Making Contact & Terms: Interested in receiving work from newer, lesser-known photographers. Contact through rep. Submit portfolio for review. Keeps samples on file. SASE. Reports in 1-2 weeks. **Pays on receipt of invoice.** Credit line given. Buys all rights; negotiable.

‡McGUIRE ASSOCIATES, 1234 Sherman Ave., Evanston IL 60202. (847)328-4433. Fax: (847)328-4425. Owner: James McGuire. Estab. 1979. Design firm. Specializes in annual reports, publication design, direct mail, corporate materials. Types of clients: industrial, retail, nonprofit.
Needs: Uses photos for annual reports, consumer magazines, trade magazines, direct mail, catalogs, brochures. Reviews stock photos. Model release required.
Specs: Uses color, b&w prints; 35mm, $2\frac{1}{4} \times 2\frac{1}{4}$, 4×5, 8×10 transparencies.
Making Contact & Terms: Interested in receiving work from newer, lesser-known photographers. Provide résumé, business card, brochure, flier or tearsheets to be kept on file for possible future assignments. Works on assignment only. Keeps samples on file. Cannot return material. Pays $600-1,800/day. Pays on receipt of invoice. Credit line sometimes given depending upon client or project. Buys all rights; negotiable.

MASI GRAPHICA LTD., N. Justine, Chicago IL 60607. (312)421-7858. Fax: (312)421-7866. Designer: Eric or Kevin Masi. Estab. 1989. Design firm. Approximate annual billing: $200,000-300,000. Number of employees: 4. Specializes in publication design and direct mail. Types of clients: industrial, retail and publishers. Recent clients include: Prime Retail, Spiegal, Kemper, Border's Books.
Needs: Works with 1-2 freelancers/month. Uses photos for direct mail, catalogs, posters and corporate collateral. Reviews stock photos. Model/property release preferred. Captions preferred.
Specs: Uses 4×5 and 8×10 transparencies.
Making Contact & Terms: Interested in receiving work from newer, lesser-known photographers. Query with samples. Provide résumé, business card, brochure, flier or tearsheets to be kept on file for possible future assignments. Works on assignment only. Keeps samples on file. Cannot return material. Reports generally in 1 month. Pays $1,000-1,800/day. **Pays on receipt of invoice.** Credit line sometimes given. Buys one-time rights; negotiable.
Tips: Wants to see conceptual content in the photographer's work. "Style can be just about anything. We're looking for a mind behind the lens."

‡MAUCK & ASSOCIATES, 516 Third St., Suite 200, Des Moines IA 50309. (515)243-6010. Fax: (515)243-6011. President: Kent Mauck. Estab. 1986. Design firm. Specializes in annual reports and publication design. Types of clients: industrial, financial, retail, publishers and nonprofit. Examples of recent projects: Meredith Corporation, annual report; Blue Cross Blue Shield, annual report; and Allied Group Insurance, annual report.
Needs: Works with 3 freelancers/month. Uses photos for annual reports, billboards, consumer and trade magazines and posters. Subject matter varies. Reviews stock photos. Model release required.
Specs: Uses 35mm, $2\frac{1}{4} \times 2\frac{1}{4}$, 4×5 transparencies.
Making Contact & Terms: Interested in receiving work from newer, lesser-known photographers. Arrange personal interview to show portfolio. Query with stock photo list. Query with samples. Provide résumé, business card, brochure, flier or tearsheets to be kept on file for possible future assignments. Keeps samples on file. SASE. Reports only when interested. Pays $700-900/day. **Pays on receipt of invoice.** Credit line given. Rights negotiable.

MIRANDA DESIGNS INC., 745 President St., Brooklyn NY 11215. (718)857-9839. Owner: Mike Miranda. Estab. 1970. Design firm and publisher. Specializes in publication design, direct mail and product development. Types of clients: industrial, financial, retail and nonprofit.

MARKET CONDITIONS are constantly changing! If you're still using this book and it's 1999 or later, buy the newest edition of *Photographer's Market* at your favorite bookstore or order directly from Writer's Digest Books.

Needs: Works with 1 freelancer/month. Uses photos for annual reports, consumer magazines, direct mail and catalogs. Subjects include: product and reportage. Model/property release required.
Specs: Uses 8×10, matte, b&w prints; 35mm transparencies.
Making Contact & Terms: Interested in receiving work from newer, lesser-known photographers. Provide résumé, business card, brochure, flier or tearsheets to be kept on file for possible future assignments. Works on assignment only. Keeps samples on file. Cannot return material. Reports in 1-2 weeks. Payment negotiable. Credit line sometimes given depending upon client. Rights bought depend on client's needs.

MITCHELL STUDIOS DESIGN CONSULTANTS, 1111 Fordham Lane, Woodmere NY 11598. (516)374-5620. Fax: (516)374-6915. E-mail: msdesign@aol.com. Principal: Steven E. Mitchell. Estab. 1922. Design firm. Number of employees: 8. Types of clients: corporations with consumer products. Examples of projects: Lipton Cup-A-Soup, Thomas J. Lipton, Inc.; Colgate Toothpaste, Colgate Palmolive Co.; and Chef Boy-Ar-Dee, American Home Foods—all three involved package design.
Needs: Works with variable number of freelancers/month. Uses photographs for direct mail, P-O-P displays, catalogs, posters, signage and package design. Subjects include: still life/product. Reviews stock photos of still life/people. Model release required. Property release preferred. Captions preferred.
Specs: Uses all sizes and finishes of color and b&w prints; 35mm, 2¼×2¼, 4×5, 8×10 transparencies. Accepts images in digital format for Mac (EPS). Send via floppy disk or SyQuest (300 dpi).
Making Contact & Terms: Interested in receiving work from newer, lesser-known photographers. Submit portfolio for review. Provide résumé, business card, brochure, flier or tearsheets to be kept on file for possible future assignments. Cannot return material. Reports as needed. Pays $35-75/hour; $350-1,500/ day; $500 and up/job. **Pays on receipt of invoice.** Credit line sometimes given depending on client approval. Buys all rights.
Tips: In portfolio, looks for "ability to complete assignment." Sees a trend toward "tighter budgets." To break in with this firm, keep in touch regularly.

‡STEWART MONDERER DESIGN, INC., 10 Thacher St., Suite 112, Boston MA 02113, (617)720-5555. Fax: (617)720-5558. E-mail: monderer@shore.net. President: Stewart Monderer. Estab. 1981. Member of AIGA. Design firm. Number of employees: 3. Specializes in annual reports, publication design and packaging. Types of clients: industrial, financial and nonprofit. Examples of recent projects: Aspen Technology Annual Report for Aspen Technology (metaphorical imagery); Techgnosis, SequeLink Brochure for Techgnosis (metaphorical imagery); and Ariad Annual Report for Ariad Pharmaceuticals (closeup b&w faces).
Needs: Works work 2 freelancers/month. Uses photos for annual reports, catalogs, posters and brochures. Subjects include: conceptual, site specific, product shots, people on location. Model release preferred. Property release sometimes required.
Specs: Uses 8½×11 b&w prints; 35mm, 2¼×2¼, 4×5 transparencies. Accepts images in digital format.
Making Contact & Terms: Interested in receiving work from newer, lesser-known photographers. Send unsolicited photos by mail for consideration. Keeps samples on file. SASE. Follow up from photographers recommended. Payment negotiable. **Pays on receipt of invoice.** Credit line sometimes given depending upon client. Rights always negotiated depending on use.

‡NASSAR DESIGN, 560 Harrison Ave., Boston MA 02146. (617)482-1464. Fax: (617)426-3604. President: Nélida Nassar. Estab. 1980. Member of American Institute of Graphic Arts, Art Guild, Boston Spanish Association. Design firm. Approximate annual billing: $1.5 million. Number of employees: 3. Specializes in publication design, signage. Types of clients: publishers, nonprofit and colleges. Examples of recent projects: The Chinese Porcelain Company (photography of all objects); Metropolitan Museum of Art (photography of all sculptures); and Harvard University (photography of the campus and the architecture).
Needs: Works with 1-2 freelancers/month. Uses photos for catalogs, posters, signage. Subjects include art objects, architectural sites and products. Reviews stock photos. Model release required; property release preferred. Captions required.
Specs: Uses 8×10 glossy color and b&w prints; 4×5 transparencies.
Making Contact & Terms: Interested in receiving work from newer, lesser-known photographers. Submit portfolio for review. Query with samples. Keeps samples on file. SASE. Reports in 1-2 weeks. Pays $1,200-1,500/day; $45/color or b&w photo; $150-175/hour; $3,000-6,000/job. **Pays on receipt of invoice.** Credit line given. Buys all rights.
Tips: "We always look for the mood created in a photograph that will make it interesting and unique."

■LOUIS NELSON ASSOCIATES INC., 80 University Place, New York NY 10003. (212)620-9191. Fax: (212)620-9194. Design firm. Estab. 1980. Types of clients: corporate, retail, not-for-profit and government agencies.
Needs: Works with 3-4 freelance photographers/year. Uses photographs for consumer and trade magazines,

catalogs and posters. Reviews stock photos only with a specific project in mind.

Audiovisual Needs: Occasionally needs visuals for interactive displays as part of exhibits.

Making Contact & Terms: Submit portfolio for review. Provide résumé, business card, brochure, flier or tearsheets to be kept on file for possible future assignments. Works on assignment only. Cannot return material. Does not report; call for response. Payment negotiable. **Pays on receipt of invoice.** Credit line sometimes given depending upon client needs.

Tips: In portfolio, wants to see "the usual . . . skill, sense of aesthetics that doesn't take over and ability to work with art director's concept." One trend is that "interactive videos are always being requested."

NOVUS VISUAL COMMUNICATIONS, INC., 18 W. 27th St., New York NY 10001-6904. (212)689-2424. Fax: (212)696-9676. President: Robert Antonik. Estab. 1988. Creative marketing and communications firm. Specializes in advertising, annual reports, publication design, display design, multimedia, packaging, direct mail, signage and website and Internet development. Types of clients: industrial, financial, retail, health care, telecommunications, entertainment and nonprofit.

Needs: Works with 1 freelancer/month. Uses photos for annual reports, billboards, consumer and trade magazines, direct mail, P-O-P displays, catalogs, posters, packaging and signage. Reviews stock photos. Model/property release required. Captions preferred.

Specs: Uses color and b&w prints; 35mm, $2\frac{1}{4} \times 2\frac{1}{4}$, 4×5, 8×10 transparencies.

Making Contact & Terms: Interested in receiving work from newer, lesser-known photographers. Arrange personal interview to show portfolio. Works on assignment only. Keeps samples on file. Material cannot be returned. Reports in 1-2 weeks. Payment negotiable. Pays upon client's payment. Credit line given. Buys negotiable rights.

LINDA PATTERSON DESIGN, 55 Laurel Dr., Needham MA 02192. (617)444-1517. Fax: (617)444-8310. Owner: Linda Patterson. Estab. 1982. Member of New England Women's Business Owners, Women's Business Network. Design firm. Approximate annual billing: $80,000. Number of employees: 1. Specializes in annual reports, publication design and direct mail. Types of clients: industrial, financial, nonprofit and real estate. Examples of recent projects: Inso Corporation annual report (portraits); Property Capital Trust annual report (buildings); and John Hancock Investment and Pension Group calendar (people).

Needs: Works with 6 freelancers/year. Uses photos for annual reports, direct mail, catalogs and brochures. Subjects include: people and buildings. Reviews stock photos. Model/property release required. Captions required.

Specs: Uses 8×10 b&w prints; 35mm transparencies.

Making Contact & Terms: Interested in receiving work from newer, lesser-known photographers. Provide résumé, business card, brochure, flier or tearsheets to be kept on file for possible future assignments. Keeps samples on file. Reports when interested. Payment negotiable. Pays net 30 days. Credit line not given. Buys one-time and all rights; negotiable.

THE PHOTO LIBRARY, INC., P.O. Box 606, Chappaqua NY 10514. (914)238-1076. Fax: (914)238-3177. Vice President: M. Berger. Estab. 1982. Member of ISDA, NCA, ASI. Photo library. Specializes in product design. Types of clients: industrial, retail. Examples of current clients: Canetti Design Group, Atwood Richards, Inc., Infomobile (France).

Needs: Works with 1-2 freelancers/month. Uses photos for annual reports, trade magazines and catalogs. Model/property release required. Captions required.

Making Contact & Terms: Interested in receiving work from newer, lesser-known photographers. Provide résumé, business card, brochure, flier or tearsheets to be kept on file for possible future assignments. Works with local freelancers only. Payment negotiable. Pays on publication. Buys all rights.

‡PIKE AND CASSELS, INC., 300 S. Liberty St., Suite 100, Winston-Salem NC 27101. (910)723-9219. Fax: (919)723-9249. Art Director: Keith Vest. Estab. 1985. Design and advertising firm. Specializes in publication design, display design, packaging, graphic standards and fashion. Types of clients: industrial, financial, retail and nonprofit.

Needs: Works with 1 freelancer/month. Uses photos for consumer and trade magazines, direct mail, P-O-P displays, catalogs, posters and packaging. Subjects include: tabletop-food and product. Model release preferred. Property release required. Captions preferred; include technique.

Specs: Uses color 35mm, $2\frac{1}{4} \times 2\frac{1}{4}$, 4×5 transparencies.

Making Contact & Terms: Interested in receiving work from newer, lesser-known photographers. Provide résumé, business card, brochure, flier or tearsheets to be kept on file for possible future assignments. Works with freelancers on assignment only. Keeps samples on file. SASE. Reports in 1 month. Payment negotiable. **Pays on receipt of invoice**. Credit line not given. Buys all rights; negotiable.

Tips: Wants to see "flexibility in subjects and technique, fashion photography, processing control and organization of shoots."

RICHARD PUDER DESIGN, 2 W. Blackwell St., P.O. Box 1520, Dover NJ 07801. (201)361-1310. Fax: (201)361-1663. E-mail: strongtype@aol.com. Owner: Richard Puder. Estab. 1985. Member of Type Directors Club. Design firm. Approximate annual billing: $250,000. Number of employees: 3. Specializes in annual reports, publication design, packaging and direct mail. Types of clients: publishers, corporate and communication companies. Examples of recent projects: AT&T (cover head shots); and Prentice Hall (desk shots).

Needs: Works with 1 freelancer/month. Uses photos for annual reports, trade magazines, direct mail, posters and packaging. Subjects include: corporate situations and executive portraits. Reviews stock photos. Model/property release preferred.

Specs: Uses 8×10 glossy color and b&w prints; 2¼×2¼, 4×5 transparencies, digital images.

Making Contact & Terms: Interested in receiving work from newer, lesser-known photographers. Send unsolicited photos by mail for consideration. Provide résumé, business card, brochure, flier or tearsheets to be kept on file for possible future assignments. Works on assignment only. Keeps samples on file. Cannot return material. "We reply on an as needed basis." Pays $500-1,200/day. Pays in 30 days upon receipt of invoice. Credit line sometimes given depending upon client needs and space availability. Buys one-time rights; negotiable.

PATRICK REDMOND DESIGN, P.O. Box 75430-PM, St. Paul MN 55175-0430. (612)646-4254. Designer/Owner/President: Patrick Michael Redmond, M.A. Estab. 1966. Design firm. Specializes in publication design, book covers, books, packaging, direct mail, posters, logos, trademarks, annual reports. Number of employees: 1. Types of clients: publishers, financial, retail, advertising, marketing, education, nonprofit, arts, industrial. Examples of recent projects: Irish Books and Media, Inc. (design consulting and advertising design); Mid-List Press (book cover design); Hauser Artists (graphic design).

● Patrick Redmond Design listed in the *Marquis® Who's Who in the Midwest 1996-1997* 25th Anniversary Edition. Books designed by Redmond won awards from Midwest Independent Publishers Association, Midwest Book Achievement Awards, Publishers Marketing Association Benjamin Franklin Awards.

Needs: Uses photos for books and book covers, direct mail, P-O-P displays, catalogs, posters, packaging, annual reports. Subject varies with client—may be editorial, product, how-to, etc. May need custom b&w photos of authors (for books/covers designed by PRD). "Poetry book covers provide unique opportunities for unusual images (but typically have miniscule budgets)." Reviews stock photos; subject matter varies with need—like to be aware of resources. Model/property release required; varies with assignment/project. Captions required; include correct spelling and identification of all factual matters, re: images; i.e., names, locations, etc.—to be used optionally—if needed.

Specs: Uses 5×7, 8×10 glossy prints; 35mm, 2¼×2¼, 4×5 transparencies. Accepts images in digital format for Mac; type varies with need, production requirements, budgets. Send via compact disc, online, floppy disk, SyQuest, zip disk or as requested. "Do not send digital formats unless requested."

Making Contact & Terms: Interested in receiving work from newer, lesser-known photographers, as well as leading, established talent. "Non-returnable—no obligation." Contact through rep. Arrange personal interview to show portfolio. Query with résumé of credits. Query with stock photo list. Provide résumé, business card, brochure, flier, or tearsheets to be kept on file for possible future assignments. "Patrick Redmond Design will not reply unless specific photographer may be needed for respective project." Works with local freelancers on assignment only. Keeps samples on file. Cannot return material. Payment negotiable. "Client typically pays photographer directly even though PRD may be involved in photo/photographer selection and photo direction." Payment depends on client. Credit line sometimes given depending upon publication style/individual projects. Rights purchased vary with project; negotiable. "Clients typically involved with negotiation of rights directly with photographer."

Tips: Needs are "open—vary with project . . . location work; studio; table-top; product; portraits; travel; etc." Seeing "use of existing stock images when image/price are right for project and use of b&w photos in low-to-mid budget/price books."

ARNOLD SAKS ASSOCIATES, 350 E. 81st St., New York NY 10028. (212)861-4300. Fax: (212)535-2590. Photo Librarian: Patricia Chan. Estab. 1968. Member of AIGA. Graphic design firm. Number of employees: 15. Types of clients: industrial, financial, legal, pharmaceutical and utilities. Clients include: 3M, Siemens, Alcoa, Goldman Sachs and MCI.

 SPECIAL COMMENTS within listings by the editor of *Photographer's Market* are set off by a bullet.

• This firm conducts many stock photo searches using computer networks. They also scan images onto CD-ROM.

Needs: Works with approximately 15 photographers during busy season. Uses photos for annual reports and corporate brochures. Subjects include corporate situations and portraits. Reviews stock photos; subjects vary according to the nature of the annual report. Model release required. Captions preferred.

Specs: Uses b&w prints; 35mm, 2¼×2¼, 4×5, 8×10 transparencies.

Making Contact & Terms: Interested in receiving work from newer, lesser-known photographers. "Appointments are set up during the spring for summer review on a first-come only basis. We have a limit of approximately 30 portfolios each season." Call to arrange an appointment. Works on assignment only. Reports as needed. Payment negotiable, "based on project budgets. Generally we pay $1,250-2,250/day." Pays on receipt of invoice and payment by client; advances provided. Credit line sometimes given depending upon client specifications. Buys one-time and all rights; negotiable.

Tips: "Ideally a photographer should show a corporate book indicating his success with difficult working conditions and establishing an attractive and vital final product. Our company is well known in the design community for doing classic graphic design. We look for solid, conservative, straightforward corporate photography that will enhance these ideals."

HENRY SCHMIDT DESIGN, 3141 Hillway Dr., Boise ID 83702. (208)385-0262. President: Henry Schmidt. Estab. 1976. Design firm. Approximate annual billing: $150,000. Number of employees: 1. Specializes in display design, packaging, signage and catalog/sales literature. Types of clients: industrial and manufacturers. Examples of recent projects: Marinco-AFI (marine products catalog); Colorado Leisure (headwear catalog); and Cotney Peak (bath products catalog).

Needs: Works with 1-2 freelancers/month. Uses photos for P-O-P displays, catalogs, posters, packaging and signage. Model/property release required. Captions required.

Specs: Uses digital photography for almost all projects. Uses 35mm, 2¼×2¼, 4×5 transparencies as well (mostly stock). Accepts images in digital format for Mac (TIFF for b&w, EPS for color). Send via compact disc, floppy disk, SyQuest, Jaz or Bernoulli 230.

Making Contact & Terms: Interested in receiving work from newer, lesser-known photographers. Submit portfolio for review. Query with samples. Provide résumé, business card, brochure, flier or tearsheets to be kept on file for possible future assignments. Works with freelancers on assignment only. Keeps samples on file. SASE. Payment negotiable. Pays on receipt of invoice, net 30 days. Credit line sometimes given. Buys all rights.

Tips: "I shoot with digital photographers almost exclusively. Images are stored on CD or Jaz cartridges. Almost all photos are 'tuned up' in Photoshop."

SELBERT PERKINS DESIGN, (formerly Clifford Selbert Design Collaborative), 2067 Massachusetts Ave., Cambridge MA 02140. (617)497-6605. Fax: (617)661-5772. Second location: 2016 Broadway, Santa Monica CA 90404. (310)453-1093. Fax: (310)453-9419. Estab. 1982. Member of AIGA, SEGD. Design firm. Number of employees: 50. Specializes in strategic corporate identity design, environmental communications design, product and packaging design, landscape architecture and urban design, multimedia design. Types of clients: architecture, institutional, entertainment, consumer products, sports, high tech and financial. Examples of current clients: JP Morgan, MCA/Universal, University of Southern California, Polaroid.

Needs: Number of photos bought each month varies. Uses photos for annual reports, billboards, consumer and trade magazines, direct mail, P-O-P displays, catalogs, posters, packaging and signage. Reviews stock photos.

Making Contact & Terms: Interested in receiving work from newer, lesser-known photographers. Submit portfolio for review. Provide résumé, business card, brochure, flier or tearsheets to be kept on file for possible future assignments. "We have a drop off policy." Keeps samples on file. SASE. Payment negotiable. Credit line given.

‡STEVEN SESSIONS, INC., 5177 Richmond Ave, Suite 500, Houston TX 77056. Phone: (713)850-8450. Fax: (713)850-9324. President: Steven Sessions. Estab. 1982. Design firm. Specializes in annual reports, packaging and publication design. Types of clients: industrial, financial, women's fashion, cosmetics, retail, publishers and nonprofit.

Needs: Always works with freelancers. Uses photos for annual reports, consumer and trade magazines, P-O-P displays, catalogs and packaging. Subject matter varies according to need. Reviews stock photos. Model/property release preferred.

Specs: Uses b&w and color prints; no preference for format or finish. Prefers 35mm, 2¼×2¼, 4×5, 8×10 transparencies.

Making Contact & Terms: Submit portfolio for review. Send unsolicited photos by mail for consideration. Provide résumé, business card, brochure, flier or tearsheets to be kept on file for possible future

assignments. Keeps samples on file. SASE. Reports in 1-2 weeks. Pays $1,800-5,000/day. **Pays on receipt of invoice**. Credit line given. Sometimes buys all rights; negotiable.

SIGNATURE DESIGN, 2101 Locust St., St. Louis MO 63103. (314)621-6333. Fax: (314)621-0179. Contact: Therese McKee. Estab. 1988. Design firm. Specializes in print graphics and exhibit design and signage. Types of clients: corporations, museums, botanical gardens and government agencies. Examples of projects: Center for Biospheric Education and Research exhibits, Huntsville Botanical Garden; walking map of St. Louis, AIA, St. Louis Chapter; Flood of '93 exhibit, U.S. Army Corps of Engineers; brochure, U.S. Postal Service; Center for Home Gardening exhibits, Missouri Botanical Garden; Hawaii exhibits, S.S. Independence; Delta Queen Steamboat Development Co.
Needs: Works with 1 freelancer/month. Uses photos for posters, copy shots, brochures and exhibits. Reviews stock photos.
Specs: Uses prints and 35mm, 2¼×2¼ and 4×5 transparencies.
Making Contact & Terms: Interested in receiving work from newer, lesser-known photographers. Arrange personal interview to show portfolio. Send unsolicited photos by mail for consideration. Provide résumé, business card, brochure, flier or tearsheets to be kept on file for possible future assignments. Keeps samples on file. Reports in 1-2 weeks. Payment negotiable. Pays 30 days from receipt of invoice. Credit line sometimes given. Buys all rights; negotiable.

SPIRIT CREATIVE SERVICES INC., 412 Halsey Rd., Annapolis MD 21401. (410)974-9377. E-mail: spiritcs@infi.net. Website: http://www.infi.net/~spiritcs/. President: Alice Yeager. Design firm. Number of employees: 2-4. Types of clients: government, business, associations.
Needs: Works with 1-2 freelancers/year. Subjects vary.
Specs: Uses prints, slides and digital format. Accepts images in digital format for Mac (TIFF or JPEG). Send via zip disk.
Making Contact & Terms: Arrange personal interview to show portfolio. Works with Annapolis area freelancers only. Keeps samples on file. Reports in 1-2 weeks. Payment negotiable. Credit line sometimes given, depending upon client.

‡STUDIO GRAPHICS, 7337 Douglas St., Omaha NE 68114-4625. (402)397-0390. Fax: (402)558-3717. Owner: Leslie Hanson. Estab. 1971. Design firm. Specializes in publication design, packaging, direct mail, signage. Types of clients: industrial, financial, retail. Examples of recent projects: Wimmer's Packaging, Wimmer's Meat Products (retail packaging); Print Ad Series, Co. Bluffs Savings Bank (newspaper/ad series); Halocide Manual, Ross Chemical Co. (product introduction manual).
Needs: Works with 1 freelancer/month. Uses photos for billboards, consumer magazines, trade magazines, direct mail, P-O-P displays, catalogs, posters, packaging, signage. Subjects include: product, staged personnel settings. Reviews stock photos. Model/property release preferred.
Specs: Uses 5×7, 11×14 color and b&w prints; 35mm, 2¼×2¼, 4×5, 8×10 transparencies.
Making Contact & Terms: Interested in receiving work from newer, lesser-known photographers. Provide résumé, business card, brochure, flier or tearsheets to be kept on file for possible future assignments. Works on assignment only. Keeps samples on file. SASE. Reports in 3 weeks. Payment negotiable; rates by quotation. Credit line sometimes given; negotiable. Buys first rights, one-time rights and all rights; negotiable.

STUDIO WILKS, 2148-A Federal Ave., Los Angeles CA 90025. Fax: (310)478-0013. E-mail: teri@graphic.com. Owners: Teri and Richard Wilks. Estab. 1991. Member of American Institute of Graphic Arts. Design firm. Number of employees: 3. Specializes in annual reports, publication design, packaging, signage. Types of clients: corporate, retail.
Needs: Works with 1-2 freelancers/month. Uses photos for annual reports, trade magazines, catalogs, packaging, signage. Reviews stock photos.
Specs: Uses 8×10 prints.
Making Contact & Terms: Interested in receiving work from newer, lesser-known photographers. Provide résumé, business card, brochure, flier or tearsheets to be kept on file for possible future assignments. Works with local freelancers only. Keeps samples on file. SASE. Reports in 3 weeks. Pays $300-750/day. **Pays on receipt of invoice.** Credit line given. Buys one-time, exclusive and all rights; negotiable.
Tips: Looking for "interesting, conceptual, experimental."

TRIBOTTI DESIGNS, 22907 Bluebird Dr., Calabasas CA 91302. (818)591-7720. Fax: (818)591-7910. E-mail: bob4149@aol.com. Contact: Bob Tribotti. Estab. 1970. Design firm. Approximate annual billing: $200,000. Number of employees: 2. Specializes in annual reports, publication design, display design, packaging, direct mail and signage. Types of clients: educational, industrial, financial, retail, government,

publishers and nonprofit. Examples of projects: school catalog, SouthWestern University School of Law; magazine design, *Knitking*; signage, city of Calabasas.

Needs: Uses photos for annual reports, consumer and trade magazines, direct mail, catalogs and posters. Subjects vary. Reviews stock photos. Model/property release required. Captions preferred.

Specs: Uses 8×10, glossy, color and b&w prints; 35mm, 2¼×2¼, 4×5, 8×10 transparencies.

Making Contact & Terms: Interested in receiving work from newer, lesser-known photographers. Contact through rep. Query with résumé of credits. Provide résumé, business card, brochure, flier or tearsheets to be kept on file for possible future assignments. Works with local freelancers only. Keeps samples on file. Cannot return material. Reports in 3 weeks. Pays $500-1,000/day; $75-1,000/job; $50 minimum/b&w photo; $50 minimum/color photo; $50 minimum/hour. **Pays on receipt of invoice.** Credit line sometimes given. Buys one-time, electronic and all rights; negotiable.

UNIT ONE, INC., 950 S. Cherry St., Suite G-16, Denver CO 80222. (303)757-5690. Fax: (303)757-6801. President: Chuck Danford. Estab. 1968. Design firm. Number of employees: 4. Specializes in annual reports, publication design, display design, corporate identity, corporate collateral and signage. Examples of projects: corporate identity, plant signage, corporate brochures and marketing materials for companies in the construction industry; advanced technology, medical, gold mining and others.

Needs: Works with 1 freelancer/month. Uses photos for annual reports, trade magazines, direct mail, P-O-P displays, catalogs, posters and corporate brochures/ads. Subjects include: construction, architecture, engineering, people and oil and gas. Reviews stock photos "when needed." Model/property release required.

Specs: Reviews 2¼×2¼, 4×5 transparencies, prints or slides.

Making Contact & Terms: Interested in receiving work from newer, lesser-known photographers. Query with résumé of credits. Provide résumé, business card, brochure, flier or tearsheets to be kept on file for possible future assignments. Works with local freelancers only. Keeps samples on file. SASE. Reports as needed. Pays $500-1,500/day; $300-450/location for 4×5 building shots. Pays within 30-45 days of completion. Credit line sometimes given, depending on the job, client and price. Buys all rights; negotiable.

Tips: Looks for "quality, style, eye for design, color and good composition."

VISUAL CONCEPTS, 5410 Connecticut Ave., Washington DC 20015. (202)362-1521. Owner: John. Estab. 1980. Design firm, 3-D. Specializes in display design, signage. Types of clients: industrial, retail.

Needs: Works with 3 freelancers/month. Uses photos for annual reports, P-O-P displays, catalogs, posters. Subjects include: fashion and objects. Reviews stock photos of vintage fashion, b&w. Model release preferred.

Specs: Uses prints and transparencies.

Making Contact & Terms: Interested in receiving work from newer, lesser-known photographers. Query with stock photo list. Provide résumé, business card, brochure, flier or tearsheets to be kept on file for possible future assignments. Works on assignment only. Keeps samples on file. Cannot return material. Payment negotiable. **Pays on receipt of invoice.** Credit line not given. Rights negotiable.

Tips: Looking for "people, building, postcard style photos, fun. NO landscapes, NO animals."

WATKINS ADVERTISING DESIGN, 621 W. 58th Terrace, Kansas City MO 64113-1157. (816)333-6600. Fax: (816)333-6610. E-mail: unicom.net@aol.com. Creative Director: Phil Watkins III. Estab. 1991. Member of Kansas City Advertising Club. Design firm. Number of employees: 1. Specializes in publication design, packaging, direct mail, collateral. Types of clients: industrial, retail, nonprofit, business-to-business. Examples of recent projects: "Italian Feast," Mr Goodcents (posters, in-store promotion). California Health Vitamins, products brochure (shots of product line); Sprint, 1995 international invitation (invitation/golf . . . shots); Met Life, agricultural investments brochure (direct mail/people shots).

Needs: Works with 1 freelancer/month. Uses photos for trade magazines, direct mail, P-O-P displays, catalogs, packaging, newspaper, newsletter. Subjects include: location photographs, people. Reviews stock photos. Model release preferred for locations, people shots for retail.

Specs: Uses 8×10 matte b&w prints; 35mm, 2¼×2¼ transparencies.

Making Contact & Terms: Interested in receiving work from newer, lesser-known photographers. Arrange personal interview to show portfolio. Works with freelancers on assignment only. Keeps samples on file. SASE. Reports in 1-2 weeks. Pays $1,000-1,500/day. Pays on publication. Credit line sometimes given. Buys one-time or all rights "if usage to span one or more years."

WAVE DESIGN WORKS, 560 Harrison Ave., Boston MA 02118. (617)482-4470. Fax: (617)482-2356. Office Manager: Penelope Harrison. Estab. 1986. Member of AIGA. Design firm. Approximate annual billing: $650,000-800,000. Number of employees: 5. Specializes in display design, packaging and identity/collateral/product brochures. Types of clients: biotech, medical instrumentation and software manufacturing. Examples of recent projects: brochure, Siemens Medical (to illustrate benefits of medical technology);

annual report, United South End Settlements (to illustrate services, clientele); and 1996 catalog, New England Biolabs (environmental awareness).

Needs: Works with 2 freelancers/year. Uses photos for annual reports, trade magazines, catalogs, signage and product brochures. Subjects include product shots. Reviews stock photos, depending upon project. Model/property release preferred. Captions preferred.

Specs: Uses 2¼×2¼, 4×5 transparencies.

Making Contact & Terms: Interested in receiving work from newer, lesser-known photographers. Provide résumé, business card, brochure, flier or tearsheets to be kept on file for possible future assignments. Works with local freelancers only. SASE. Reports on unsolicited material only if asked; 1-2 weeks for requested submissions. Payment negotiable. Pays on receipt of payment of client. Credit line sometimes given depending on client and photographer. Rights negotiable depending on client's project.

Tips: "Since we use product shots almost exclusively, we look for detail, lighting and innovation in presentation."

WEYMOUTH DESIGN INC., 332 Congress St., Boston MA 02210. (617)542-2647. Fax: (617)451-6233. Office Manager: Judith Benfari. Estab. 1973. Design firm. Specializes in annual reports, new media, publication design, packaging and signage. Types of clients: industrial, financial, retail and nonprofit.

Needs: Uses photos for annual reports and catalogs. Subjects include executive portraits, people pictures or location shots. Subject matter varies. Model/property release required. "Photo captions are written by our corporate clients."

Specs: Uses 35mm, 2¼×2¼, 4×5 transparencies.

Making Contact & Terms: Interested in receiving work from newer, lesser-known photographers. Submit portfolio for review. Portfolio reviews May-August only; otherwise send/drop off portfolio for review. Works with freelancers on assignment only. "Mike Weymouth shoots most of the photographs for our clients." Keeps samples on file. SASE. Pays $125-200/hr.; $1,250-2,000/day. "We give our clients 10-hour days on our day-rate quotes." **Pays on receipt of invoice.** Buys one-time rights; negotiable.

‡YAMAGUMA & ASSOC./DESIGN 2 MARKET, 255 N. Market St., #120, San Jose CA 95110. (408)279-0500. Fax: (408)293-7819. E-mail: sayd2m@aol.com. Operations Manager: Donna Shin. Design firm. Approximate annual billing: $750,000. Number of employees: 3. Specializes in publication design, display design, packaging, direct mail and advertising. Types of clients: industrial, retail, nonprofit and technology. Examples of recent projects: Compro & Ads poster for ACS; calendar-race cars for ORBIT Semiconductor; and ad, poster for Chem USA/5D.

Needs: Works with 6 freelancers/month. Uses photos for trade magazines, direct mail, P-O-P displays, catalogs, posters, packaging and advertising. Subjects include: people, computers, equipment. Reviews stock photos. Model/property release required.

Specs: Uses 35mm, 2¼×2¼, 4×5 transparencies; Mac formats. Accepts images in digital format for Mac.

Making Contact & Terms: Send unsolicited photos by mail for consideration. Provide résumé, business card, brochure, flier or tearsheets to be kept on file for possible future assignments. Works on assignment only. Keeps samples on file. SASE. Payment negotiable. Credit line sometimes given. Buys all rights.

‡YASVIN DESIGNERS, P.O. Box 116, Hancock NH 03449. (603)525-3065. Estab. 1989. Member of N.H. Creative Club. Design firm. Number of employees: 3. Specializes in annual reports, publication design and packaging. Types of clients: industrial, financial and nonprofit. Recent projects include work on annual reports, college view books and display graphics for trade shows.

Needs: Works with 2-5 freelancers/month. Uses photos for annual reports, consumer magazines, trade magazines, P-O-P displays, catalogs, posters and packaging. Subject matter varies. Reviews stock photos. Model release required.

Specs: Image specifications vary.

Making Contact & Terms: Interesting in receiving work from newer, lesser-known photographers. Query with résumé of credits. Query with samples. Provide résumé, business card, brochure, flier or tearsheets to be kept on file for possible future assignments. Keeps samples on file. SASE. Reporting time varies. Payment negotiable. Buys first and all rights; negotiable.

‡SPENCER ZAHN & ASSOCIATES, 2015 Sansom St., Philadelphia PA 19103. (215)564-5979. Fax: (215)564-6285. President: Spencer Zahn. Estab. 1970. Member of GPCC. Marketing, advertising and design firm. Approximate annual billing: $3 million. Number of employees: 10. Specializes in direct mail and print ads. Types of clients: financial and retail. Examples of recent projects: Whiter Shade of Pale for Procol Harum (portrait); Stored Value Cards for First Union National Bank (portraits and action sports); and direct mail piece for National City Card Services (sky/sunset).

Needs: Works with 1-2 freelancers/month. Uses photos for billboards, consumer magazines, trade maga-

zines, direct mail, P-O-P displays, posters and signage. Subjects include: people. Reviews stock photos. Model/property release required.

Specs: Uses 8×10 glossy color prints; 4×5 transparencies.

Making Contact & Terms: Interested in receiving work from newer, lesser-known photographers. Submit portfolio for review. Query with résumé of credits. Query with stock photo list. Query with samples. Provide résumé, business card, brochure, flier or tearsheets to be kept on file for possible future assignments. Keeps samples on file. SASE. Reports in 1 month. **Pays on publication**. Credit line sometimes given. Buys one time and all rights; negotiable.

ZEROONE DESIGN, (formerly Heideman Design), 16229 S. 34th Way, Phoenix AZ 85044-7245. (602)706-8520. Fax: (602)706-8513. E-mail: heidesign@aol.com. Estab. 1986. Member of Art Directors Club of Indiana and AIGA. Design firm. Approximate annual billing: $175,000. Number of employees: 3. Specializes in annual reports, publication design, display design, packaging, direct mail and vehicles. Types of clients: industrial, technical and medical. Examples of recent projects: capabilities brochure for Insect's Limited (print production); promotional poster for Courtlands Aerospace (print production); technical brochure for Methodist Hospital (print production).

Needs: Works with 2-3 freelancers/year. Uses photos for annual reports, trade magazines, direct mail, P-O-P displays, catalogs, posters, packaging and vehicles. Reviews stock photos. Model/property release required. Captions preferred.

Specs: Uses 5×7 and 8×10 prints; 35mm, $2\frac{1}{4} \times 2\frac{1}{4}$ and 4×5 transparencies. Accepts images in digital format for Mac. Send via compact disc, online, floppy disk, SyQuest or Zip disk.

Making Contact & Terms: Interested in receiving work from newer, lesser-known photographers. Provide résumé, business card, brochure, flier or tearsheets to be kept on file for possible future assignments. Keeps samples on file. SASE. Payment negotiable. Pays when payment is received from client. Credit line given.

Businesses & Organizations

You will find a wide range of markets in this section, from major corporations such as insurance companies to catalog producers to universities and arts organizations. The types of photography these listings require overlap somewhat with advertising markets. However, unlike that work which is largely directed toward external media or audiences, the photography for listings in this section tends to be more for specialized applications. Among these are employee or membership commmunications, annual reports, and documentary purposes such as recording meetings, group functions or theatrical presentations.

A number of these listings are receptive to stock images, while many have specific needs for which they assign photographers. These projects will sometimes require studio-type skills (again similar to the advertising/PR market), particularly in shooting corporate interiors and portraits of executives for annual reports. However, much of the coverage of meetings, events and performances calls for a different set of skills involving use of available light and fill flash. In particular, coverage of sporting events or theatrical performances may require agility with extreme or rapidly changing light conditions.

Unless these businesses and organizations are active at the national level, they typically prefer to work with local freelancers. Rates vary widely depending upon the individual client's budget. We have tried to list current rates of payment where possible, but some listings only indicate "negotiable terms," or a per-shot, per-hour or per-day basis. When quoting a price, especially for assigned work, remember to start with a basic day rate plus expenses and negotiate for final number of images, types of usage and time period for usage.

In particular, many of these clients wish to buy all rights to the images since they are often assigned for specific needs. In such cases, negotiate so that these clients get all the rights they need but that you ultimately retain copyright.

■**ABBY LOU ENTERTAINMENT**, 1411 Edgehill Place, Pasadena CA 91103. (818)795-7334. Fax: (818)795-4013. President: George LeFave. Estab. 1987. Children's TV, toys, video production. Photos used in brochures, posters, catalogs and video production.
Needs: Buys 10-110 photos/year; offers 5-10 freelance assignments/year. Uses freelancers for children, toys. Examples of recent uses: video, catalog, brochure. Model/property release required. Captions preferred.
Audiovisual Needs: Uses slides and videotape. Subjects include: children and toys.
Making Contact & Terms: Interested in receiving work from newer, lesser-known photographers. Query with samples. Provide résumé, business card, brochure, flier or tearsheets to be kept on file for possible future assignments. Works with local freelancers only. Uses transparencies and videotape. Keeps samples on file. Cannot return material. Reports in 1 month. Payment negotiable. Pays on acceptance or usage. Credit lines sometimes given; "depends on job." Buys all rights; negotiable.
Tips: "Know your craft. Be flexible in negotiations." Concerned that "quality is not what it used to be."

‡**ALFRED PUBLISHING CO., INC.**, P.O. Box 10003, Van Nuys CA 91410-0003. Art Director: Ted Engelbart. Estab. 1922.
Needs: Photos of musical instruments. Examples of recent uses: educational music book covers (4×5); Yamaha Band Student ad campaign (2¼×2¼) and brochures for sales promotions (35mm and 2¼×2¼). Reviews stock photos/footage of musical instruments. Model/property release required for people and music halls.
Making Contact & Terms: Provide résumé, self-promotion piece or tearsheets to be kept on file for possible future assignments. Works on assignment only. Uses 35mm, 2¼×2¼, 4×5 transparencies. Does not report back, keeps on file. Payment negotiable. Buys all rights (unless stock); negotiable.
Tips: "Send requested profile. Do not call. Provide any price or release requirements." Looks for "graphic or mood presentation of musical instruments; general interest such as fireworks, Americana, landscapes."

■**AMERICAN ALLIANCE FOR HEALTH, PHYSICAL EDUCATION, RECREATION AND DANCE**, 1900 Association Dr., Reston VA 20191. (703)476-3400. Fax: (703)476-9527. E-mail: pubs@aa hperd.org. Website: www.aahperd.org. Contact: Director of Publications. Estab. 1885. Photos used in brochures, newsletters, magazines and catalogs.
Needs: Buys 50 photos/year; offers 2-3 assignments/year. Wants photos of sports, recreation, outdoor activities, health practices, physical education and other education-specific settings; also interested in people with disabilities and special populations. Reviews stock photos. Model/property release preferred, especially for children.
Audiovisual Needs: Uses slides.
Making Contact & Terms: Query with stock photo list. Provide résumé, business card, self-promotion piece or tearsheets to be kept on file for possible future assignments. Call. Accepts images in digital format. Send via compact disc or Zip disk. Keeps samples on file. SASE. Reports in 1-2 weeks. Pays $100/color photo; $25/b&w photo. Pays upon usage. Credit line given. Buys one-time rights; negotiable.
Tips: "We are always looking for strong action or emotion. We usually need vertical formats for magazine covers with color work."

■**AMERICAN FUND FOR ALTERNATIVES TO ANIMAL RESEARCH**, 175 W. 12th St., Suite 16-G, New York NY 10011. Phone/fax: (212)989-8073. Contact: Dr. E. Thurston. Finances studies to develop research methods which will not need live animals. Also informs the public of this and about current methods of experimentation. Photos used in reports, advertising and publications.
Needs: Buys 10 freelance photos/year; offers 5 freelance assignments/year. Needs b&w or color photos of laboratory animal experimentation and animal use connected with fashions (trapping) and cosmetics (tests on animals). Model release preferred.
Making Contact & Terms: Arrange a personal interview to show portfolio. Query with samples and list of stock photo subjects. Provide brochure and flier to be kept on file for possible future assignments. Notifies photographer if future assignments can be expected. Uses 5×7 b&w prints; also uses 16mm film for educational films. SASE. Reports in 2 weeks. Pays $5 minimum/b&w photo; $5 or more/color photo; $30 minimum/job. Credit line given. Buys one-time rights and exclusive product rights; arranged with photographer.
Tips: In portfolios or samples wants to "see clear pictures of animals in cosmetic tests or testing labs, or fur ranches, and in the wilds."

AMERICAN MUSEUM OF NATURAL HISTORY LIBRARY, PHOTOGRAPHIC COLLECTION, Library Services Department, Central Park West, 79th St., New York NY 10024. (212)769-5419. Fax: (212) 769-5009. E-mail: speccol@amnh.org. Senior Special Collections Librarian: Thomas Baione. Estab. 1869. Provides services for advertisers, authors, film and TV producers, general public, government agencies, picture researchers, publishers, scholars, students and teachers who use photos for brochures.
Needs: Model release required. Captions required.
Making Contact & Terms: "We accept only donations with full rights (nonexclusive) to use; we offer visibility through credits." Credit line given. Buys all rights.
Tips: "We do not review portfolios. Unless the photographer is willing to give up rights and provide images for donation with full rights (credit lines are given), the museum is not willing to accept work."

■**AMERICAN POWER BOAT ASSOCIATION**, 17640 E. Nine Mile Rd., Box 377, Eastpointe MI 48021. (810)773-9700. Fax: (810)773-6490. Executive and Publications Editor: Michele Weston. Estab. 1903. Sanctioning body for US power boat racing; monthly magazine. Majority of assignments made on annual basis. Photos used in monthly magazine, brochures, audiovisual presentations, press releases and programs.
● All photos used by APBA are scanned for placement in electronic page file.
Needs: Power boat racing—action and candid. Captions required.
Making Contact & Terms: Interested in receiving work from newer, lesser-known photographers. Initial personal contact preferred. "Suggests initial contact by phone possibly to be followed by evaluating samples." Send unsolicited photos by mail for consideration; provide résumé, business card, brochure, flier or tearsheets to be kept on file for possible future assignments. Uses 5×7 and up, b&w prints and b&w contact sheets. 35mm slides for cover. Accepts images in digital format for Mac. Submit via compact disc, floppy disk or SyQuest. SASE. Reports in 2 weeks when needed. Payment varies. Standard is $50/cover;

 MARKETS NEW TO THIS EDITION are marked with a double dagger.

$15/b&w inside; $25/color. Credit line given. Buys one-time rights; negotiable. Photo usage must be invoiced by photographer within the month incurred.

Tips: Prefers to see selection of shots of power boats in action or pit shots, candids, etc., (all identified). Must show ability to produce clear b&w action shots of racing events.

AMERICAN SOCIETY FOR THE PREVENTION OF CRUELTY TO ANIMALS (ASPCA), 424 E. 92nd St., New York NY 10128. (212)876-7700, ext. 4449. Fax: (212)410-0087. Photo Editor: Barbara Stmad. Estab. 1866. Photos used in quarterly color magazine, pamphlets, booklets. Publishes *ASPCA Animal Watch Magazine*.

Needs: Photos of animals (domestic and wildlife): farm, domestic, lab, stray and homeless animals, endangered, trapped, injured, fur animals, marine and wildlife, rain forest animals. Example of recent uses: *ASPCA Animal Watch Magazine*. Model/property release preferred.

Making Contact & Terms: Interested in receiving work from newer, lesser-known photographers. Please send a detailed, alphabetized stock list that can be kept on file for future reference. SASE. Reports when needed. Pays $50/b&w photo (inside use); $50/color photo (inside use); $200/cover. Prefers color. Credit line given. Buys one-time rights; negotiable.

Tips: "We prefer exciting pictures: strong colors, interesting angles, unusual light."

ARISTOPLAY, 450 S. Wagner Rd., Ann Arbor MI 48103. (313)995-4353. Fax: (313)995-4611. Product Development Director: John Thompson. Estab. 1979. Publishes educational board and card games. Photos used for catalogs and board and card games.

Needs: Bought 50-100 photos in last two years; purchase volume varies depending on game subjects. Offers 6-10 freelance assignments/year for local photographers. Has assigned photos dealing with science, kids playing Aristoplay games, product shots and others. Reviews stock photos. "We will send out wish lists. Do not send unsolicited photos and please do not call; fax with questions or queries." Model release required for children; get permission from parents. Photo captions preferred; identify science subjects.

Making Contact & Terms: Interested in receiving work from newer, lesser-known photographers. Query with stock photo list. Provide résumé, business card, self-promotion piece or tearsheets to be kept on file for possible future assignments. Works on assignment only. Uses 35mm, 2¼×2¼ transparencies. Keeps samples on file. Cannot return material. Reports in 1 month. Pays $35-65/color photo; other rates vary. Credit line given. Buys one-time rights.

Tips: "We publish 2-9 products per year. Each one is very different and may or may not require photos. If you are local, tell us your hourly, half day and day rate, and whether you've worked with children."

‡ASBO INTERNATIONAL, 11401 N. Shore Dr., Reston VA 22090. (703)478-0405. Fax: (703)478-0205. Contact: Production Coordinator. Estab. 1924. Professional association. Photos used in newspapers, magazines, press releases and catalogs.

Needs: Buys 12 photos/year; offers 12 assignments/year. School or business-related photos. Reviews stock photos.

Making Contact & Terms: Interested in receiving work from newer, lesser-known photographers. Query with samples. Works with local freelancers only. Uses 5×7 glossy b&w prints; 2¼×2¼ and 4×5 transparencies. Keeps samples on file. SASE. Reports in 3 weeks. Payment negotiable. Pays on acceptance depending upon usage. Buys one-time or all rights; negotiable.

■BETHUNE THEATREDANSE, 8033 Sunset Blvd., Suite 221, Los Angeles CA 90046. (213)874-0481. Fax: (213)851-2078. Managing Director: Beatrice Ballance. Estab. 1979. Dance company. Photos used in posters, newspapers, magazines.

Needs: Number of photos bought annually varies; offers 2-4 freelance assignments annually. Photographers used to take shots of dance productions, dance outreach classes (disabled children's program) and performances, and graphics and scenic. Examples of uses: promotional pieces for the dance production "Cradle of Fire" and for a circus fundraiser performance (all shots in 35mm format). Reviews stock photos if they show an ability to capture a moment. Captions preferred; include company or name of subject, date, and equipment shown in photo.

Audiovisual Needs: Uses slides and videotape. "We are a multimedia company and use videos and slides within our productions. We also use video for archival purposes." Subject matter varies.

Making Contact & Terms: Interested in receiving work from newer, lesser-known photographers. Provide résumé, business card, self-promotion piece or tearsheets to be kept on file for possible future assignments. Uses 8×10 color or b&w prints; 35mm transparencies and videotape. Keeps samples on file. Cannot return material. Reports only when in need of work. Payment for each job is negotiated differently. Credit line sometimes given depending on usage. "We are not always in control of newspapers or magazines that may use photos for articles." Buys all rights; negotiable.

Tips: "We need to see an ability to see and understand the aesthetics of dance—its lines and depth of

field. We also look for innovative approaches and personal signature to each individual's work. Our productions work very much on a collaborative basis and a videographer's talents and uniqueness are very important to each production. It is our preference to establish ongoing relationships with photographers and videographers."

BROWNING, One Browning Place, Morgan UT 84050. (801)876-2711, ext. 289. Fax: (801)876-3331. Art Director: John Gibby. Estab. 1878. Photos used in posters, magazines, catalogs. Uses photos to promote sporting good products.
Needs: Works with 2 freelancers/month. Outdoor, wildlife, hunting, shooting sports and archery. Reviews stock photos. Model/property release required. Captions preferred; include location, types of props used, especially brand names (such as Winchester and Browning).
Making Contact & Terms: Interested in receiving work from outdoor and wildlife photographers. Query with samples. Provide résumé, business card, self-promotion piece or tearsheets to be kept on file for possible future assignments. Works on assignment only. Uses 35mm, 2¼×2¼, 4×5, 8×10 transparencies. Keeps samples on file. Reports in 1 month. Payment within 30 days of invoice. Buys one-time rights, all rights; negotiable.
Tips: "We look for dramatic lighting, exceptional settings and believable interactions."

CALIFORNIA REDWOOD ASSOCIATION, 405 Enfrente Dr., Suite 200, Novato CA 94949. (415)382-0662. Fax: (415)382-8531. Publicity Manager: Pamela Allsebrook. Estab. 1916. "We publish a variety of literature, a small black and white periodical, run color advertisements and constantly use photos for magazine and newspaper publicity. We use new, well-designed redwood applications—residential, commercial, exteriors, interiors and especially good remodels and outdoor decks, fences, shelters."
Needs: Gives 40 assignments/year. Prefers photographers with architectural specialization. Model release required.
Making Contact & Terms: Send query material by mail for consideration for assignment or send finished speculation shots for possible purchase. Uses b&w prints. For color, uses 2¼×2¼ and 4×5 transparencies; contact sheet OK. Reports in 1 month. Payment based on previous use and other factors. Credit line given whenever possible. Usually buys all but national advertising rights. Simultaneous submissions and previously published work OK if other uses are made very clear.
Tips: "We like to see any new redwood projects showing outstanding design and use of redwood. We don't have a staff photographer and work only with freelancers. We generally look for justified lines, true color quality, projects with style and architectural design, and tasteful props. Find and take 'scout' shots or finished pictures of good redwood projects and send them to us."

■**CASCADE GEOGRAPHIC SOCIETY**, P.O. Box 294, Rhododendron OR 97049. Curator: Michael P. Jones. Estab. 1979. "Our photographs are for exhibits, educational materials, fliers, posters, etc., including historical artifact catalogs. We are a nonprofit organization." Photo guidelines free with SASE.
Needs: Buys 20 photos annually; offers 20 freelance assignments annually. Needs American history, wildlife, old buildings, Civil War, Revolutionary War, Indian Wars, Oregon Trail, pioneer history, living history, historical re-enactment, nature and environmental. Examples of recent uses: "Enola Hill" (American Indian sacred site); "Oregon Trail" (educational exhibit); wild mushroom exhibit (species and habitat). Reviews stock photos of American history and nature subjects. Model release preferred. Captions preferred.
Making Contact & Terms: Interested in receiving work from newer, lesser-known photographers. Query with résumé of credits. Send unsolicited photos by mail for consideration. Submit portfolio for review. Provide résumé, business card, brochure, flier or tearsheets to be kept on file for possible future assignments. Works on assignment only. Uses 5×7, 8×10 b&w or color prints; 35mm, 2¼×2¼, 4×5, 8×10 transparencies; videotape. Keeps samples on file. SASE. Reports in 3 weeks. Pays in contributor's copies. Offers copies of published images in place of payment. Credit line given. Buys one-time rights. Simultaneous submissions and previously published work OK. Offers internships for photographers year-round. Contact Curator: Michael P. Jones.
Tips: "We want photos that bond people to the earth and history. Send us enough samples so that we can really understand you and your work. Be patient. More and more doors are being opened for photographers due to multimedia. We are moving in that direction."

THE DIGITAL MARKETS INDEX, located in the back of this book, lists markets that use images electronically.

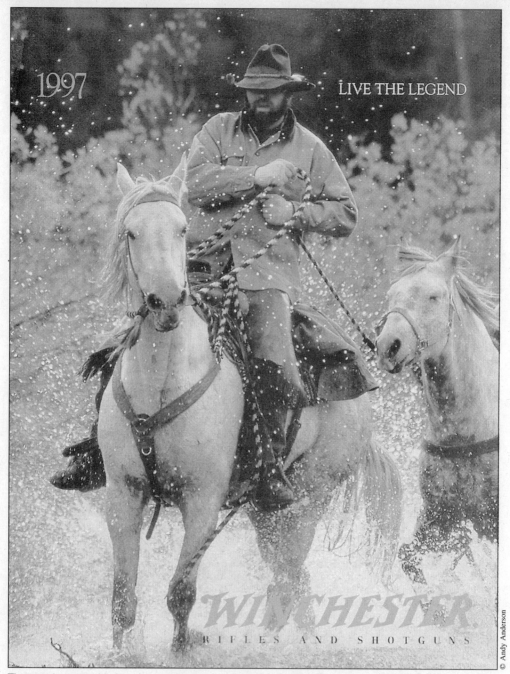

The rugged, emotional feeling of the outdoors comes through in this photo by Andy Anderson appearing on the cover of the 1997 *Winchester Rifle and Shotgun Catalog* produced by Browning. This shot was one of a group of images submitted by Anderson, who has a long and established working relationship with the company. "I love the feel of the horses in the water, the mystery of the rider," says Browning's John Gibby. "I initially requested some action shots for an ad. When I saw this image, I knew we had a winner for a catalog cover as well."

‡**CREATIF LICENSING**®, 31 Old Town Crossing, Mt. Kisco NY 10549. (914)241-6211. E-mail: creatifl ic@aol.com. Website: http://members.aol.com/creatiflic. President: Paul Cohen. Estab. 1975. Licenses artwork to manufacturers. Photos of general merchandise in the gift industry.

Needs: "Our company has shifted focus to illustrative, art-based licensing. The interest we have in photographic submissions is only if the creative content of the photography lends itself to licensing. We need new looks that are not available in general stock photography inventories." Examples of recent uses: T-shirts, posters, bookmarks, address books, picture frames, calendars. Reviews stock photos. Model/property release required for any copyright or protected design. Captions preferred.

Making Contact & Terms: Query with samples and SASE. "Submissions and requests for info will not be returned unless accompanied by a SASE." Uses 35mm, 4×5 transparencies and prints. Reports in 3 weeks. Payment negotiable. Pays royalties on sales. Pays upon receipt of royalties, advances, guarantees. Rights purchased are "license for contracted time period for specific merchandising categories."

Tips: "We look for designs that would work well on calendars, posters and printed media for the gift and stationery market."

‡**DALOIA DESIGN**, P.O. Box 140268, Howard Beach NY 11414. (718)835-7641. Owner/Creative Director: Peter Daloia. Estab. 1983. Design, develop and market novelty and gift products. Photos used for paper products, stationery, novelty and gift items.

Needs: Uses freelancers for humorous, abstract, odd shots, backgrounds, collage, montage, patterns, scenics, nature, textures. Reviews stock photos. Model/property release required.

Making Contact & Terms: Interested in receiving work from newer, lesser-known photographers. Query with samples. Provide résumé, business card, samples to be kept on file for possible future assignments. Works with freelancers on assignment only. Uses 8×10, 5×7, 4×6 color and b&w prints; 35mm slides. Keeps samples on file. Cannot return material. Reports only when interested. Pays "prevailing rates or royalties." Pays upon usage. Credit line sometimes given depending on use. Buys one-time rights and exclusive product rights.

Tips: "Show everything, even what you don't think is good."

‡**DUNCRAFT, INC.**, 102 Fisherville Rd., Concord NH 03303-2086. (603)224-0200. Fax: (603)226-3735. Marketing Coordinator: Terry Lovejoy. Estab. 1952. Manufactures and markets products for enjoying backyard birds. Photos used in catalogs.

Needs: Buys 12-15 photos/year; offers 2 assignments/year. Uses "stunning and artful close-ups of living wild song birds in the natural world, preferably amidst flowers, vegetation or water. Birds that visit backyards are mostly desired, since our catalog features specialties for bird feeding." Examples of recent uses: Duncraft catalog covers. Photo captions required; include bird's common name, gender, location of shot, name of vegetation, e.g., "male cardinal in Douglas Fir."

Making Contact & Terms: Query with samples. Uses 35mm transparencies. Does not keep samples on file. SASE. Reports in 1-2 months. Pays $200 minimum/35mm slide. Pays on usage. Credit line given. Buys first rights; negotiable.

Tips: "Please request a sample of our catalog covers. Develop a *clear* idea of our specific needs."

INTERNATIONAL PUBLISHING MANAGEMENT ASSOCIATION, 1205 W. College St., Liberty MO 64068-3733. (816)781-1111. Fax: (816)781-2790. E-mail: ipmainfo@ipma.org. Website: http://www.ipma.org. Membership association for corporate publishing professionals. Photos used in brochures and newsletters.

Needs: Buys 5-10 photos/year. Subject needs: equipment photos, issues (i.e., soy ink, outsourcing), people. Reviews stock photos. Captions preferred (location).

Making Contact & Terms: Interested in receiving work from newer, lesser-known photographers. Query with stock photo list. Provide résumé, business card, brochure, flier or tearsheets to be kept on file for possible future assignments. Uses 5×7 b&w prints. Keeps samples on file. SASE. Reports in 3 weeks. Payment negotiable. Pays on usage. Credit line given. Buys one-time rights.

■**INTERNATIONAL RESEARCH & EDUCATION (IRE)**, 21098 IRE Control Center, Eagan MN 55121-0098. (612)888-9635. Fax: (612)888-9124. IP Director: George Franklin, Jr. IRE conducts in-depth research probes, surveys, and studies to improve the decision support process. Company conducts market research, taste testing, brand image/usage studies, premium testing, and design and development of product/service marketing campaigns. Photos used in brochures, newsletters, posters, audiovisual presentations, annual reports, catalogs, press releases, and as support material for specific project/survey/reports.

© Sam Maxwell

This image was one of six photos in Sam Maxwell's "The Heartland" series licensed through Creatif Licensing for use in musical picture frames. The frame featuring this young girl munching watermelon plays the tune "My Favorite Things." The photo has been licensed for use on a variety of other products including calendars, planners and T-shirts. Maxwell is paid on a royalty basis with an advance for the usage.

Needs: Buys 75-110 photos/year; offers 50-60 assignments/year. "Subjects and topics cover a vast spectrum of possibilities and needs." Model release required.

Audiovisual Needs: Uses freelance filmmakers to produce promotional pieces for 16mm or videotape.

Making Contact & Terms: Provide résumé, business card, brochure, flier or tearsheets to be kept on file for possible future assignments. "Materials sent are put on optic disk for options to pursue by project managers responsible for a program or job." Works on assignment only. Uses prints (15% b&w, 85% color), transparencies and negatives. Cannot return material. Reports when a job is available. Payment negotiable; pays on a bid, per job basis. Credit line given. Buys all rights.

Tips: "We look for creativity, innovation and ability to relate to the given job and carry out the mission accordingly."

■NEAL MARSHAD PRODUCTIONS, 145 Avenue of the Ameircas, New York NY 10013. (212)292-8910. E-mail: neal@marshad.com. Website: http://www.marshad.com. Owner: Neal Marshad. Estab. 1983. Video, motion picture and multimedia production house.

Needs: Buys 20-50 photos/year; offers 5-10 assignments/year. Freelancers used for food, travel, production stills for publicity purposes. Examples of recent uses: "Conspiracy of Silence" (TV documentary/website using 35mm film); BBC Website (35mm); Estee Lauder (35mm video). Model release required. Property release preferred. Captions preferred.

Audiovisual Needs: Uses slides, film, video, Photo CD for multimedia CD-ROM. Subjects include: travel and food.

Making Contact & Terms: Provide résumé, business card, self-promotion piece or tearsheets to be kept on file for possible future assignments. "No calls!" Works with local freelancers on assignment only. Uses 35mm, 2¼×2¼, 4×5 prints; 16mm film; Beta SP, 1″ videotape. Keeps samples on file. SASE. Pays $50-100/hour; $150-300/day; $300-500/job; $10-100/color photo. Pays on usage. Credit line depends on client. Buys all rights; negotiable.

Tips: "Show high quality work, be on time, expect to be hired again if you're good." Expects "explosive growth in photography in the next two to five years as in the past five years."

MASEL INDUSTRIES, 2701 Bartram Rd., Bristol PA 19007. (215)785-1600. Fax: (215)785-1680. E-mail: goldberg@masel.com. Website: http://www.masel.com. Marketing Manager: Richard Goldberg. Estab. 1906. Catalog producer. Photos used in posters, magazines, press releases, catalogs and trade shows.
 ● This company scans all photos and stores them. Photos are manipulated on PhotoShop.

Needs: Buys over 250 photos/year; offers 15-20 assignments/year. Examples of recent uses: Internet Dictionary of Orthodontic Terms (website); "Gold Denture Teeth" (postcard); assorted catalog work for mail order houses. Reviews stock photos. Needs children and adults with braces on their teeth. Model release required.

Making Contact & Terms: Interested in receiving work from newer, lesser-known photographers. Provide résumé, business card, self promotion piece or tearsheets to be kept on file for possible future assignments. Works with local freelancers on assignment only. Uses 4×5 glossy b&w prints; 35mm, 2¼×2¼, 4×5 transparencies. Accepts images in digital format for Mac. Send via compact disc, online, floppy disk, SyQuest or Zip disk. "Call for specs." Keeps samples on file. SASE. Reports in 2 weeks if interested. Pays $100/color or b&w photo; $250-500/cover shot; $800 maximum/day. Volume work is negotiated. **Pays on acceptance.** Credit line depends on terms and negotiation. Buys all rights.

Tips: "We're an interesting company with great layouts. We are always looking for new ideas. We invite input from our photographers and expect them to get involved."

‡METALFORMING MAGAZINE/PMA SERVICES, INC., 27027 Chardon Rd., Richmond Heights OH 44143. (216)585-8800. Fax: (216)585-3126. Art Director: Beth Formica. Estab. 1942. Publishes trade magazine serving those who create precision metal products using stamping, fabricating and other value-added processes. Photos used in brochures and magazine.

Needs: Buys 10 photos/year; offers 4 assignments/year. Photos of stamping presses, press brakes, roll formers, washers, turret presses and items produced by this machinery, product shots and location shots. Reviews stock photos of metalformings—stampings, presses, etc. Model/property release required. Captions required; include details about manufacturers and location.

Making Contact & Terms: Provide résumé, business card, self-promotion piece or tearsheets to be kept

 MARKETS USING AUDIOVISUAL MATERIAL, such as slides, film or videotape, are marked with a solid, black square.

on file for possible future assignments. Works on assignment only. Uses 2¼×2¼, 4×5 transparencies. Keeps samples on file. Cannot return material. Reports in 6 months. Pays $250/editorial photo; $800/ editorial cover photo. **Pays on acceptance.** Credit line given. Buys all rights.

MID AMERICA DESIGNS, INC., P.O. Box 1368, Effingham IL 62401. (217)347-5591. Fax: (217)347-2952. Catalog Production Manager: Cheryl Habing. Estab. 1975. Provides mail order catalog for Corvette parts & accessories.
Needs: Buys 300 freelance photos/year; offers 6 freelance assignments/year. Apparel and automotive parts. Reviews stock photos. Model release required. Property release preferred.
Making Contact & Terms: Provide résumé, business card, brochure, flier or tearsheets to be kept on file for possible future assignments. Works on assignment. Uses 2¼×2¼, 4×5 and 8×10 transparencies. Cannot return material. Reports in 2 weeks. Pays $75/b&w or color photo. Buys all rights; negotiable.

THE MINNESOTA OPERA, 620 N. First St., Minneapolis MN 55401. (612)333-2700. Marketing: Kaylen Whitmore. Produces 4 opera productions, including 1-2 new works each year. Photos used in brochures, posters and press releases/publicity.
Needs: Buys 50 photos/year; offers 10 assignments/year. Operatic productions. Model release preferred.
Making Contact & Terms: Send unsolicited photos by mail for consideration. Provide résumé, business card, brochure, flier or tearsheets to be kept on file for possible future assignments. Works with local freelancers only. Uses 5×7 glossy b&w prints and 35mm slides. Cannot return material. Reporting time depends on needs. Pays $6-12/b&w photo; $8-15/color photo; $60-85/hour. Credit line given. Buys all rights; negatives remain with photographer.
Tips: "We look for photography that dynamically conveys theatrical/dramatic quality of opera with clear, crisp active pictures. Photographers should have experience photographing theater and have a good sense of dramatic timing."

‡■**MIRACLE OF ALOE**, 521 Riverside Ave., Westport CT 06880. (203)454-1919. Fax: (203)226-7333. Vice President: Jess F. Clarke, Jr. Estab. 1980. Manufacturers of aloe products for mail order buyers of healthcare products. Photos used in newsletters, catalogs, direct mail, consumer magazines, TV spots and infomercials.
Needs: Works with 2 freelancers per month. Uses testimonial photos and aloe vera plants. Model release preferred.
Making Contact & Terms: Provide résumé, business card, self-promotion piece or tearsheets to be kept on file for possible future assignments. Works on assignment only. Uses 4×5 b&w or color prints and 35mm transparencies. SASE. Reports in 1 month. Pays $30-45/photo. **Pays on receipt of invoice.** Credit line given. Buys one-time rights.
Tips: In freelancer's samples, looks for "older folks, head shots and nice white-haired ladies. Also show Aloe Vera plants in fields or pots; shoot scenes of southern Texas aloe farms. We need video photographers to do testimonials of aloe users all around the country for pending 30-minute infomercial."

NATIONAL BLACK CHILD DEVELOPMENT INSTITUTE, 1023 15th St. NW, Suite 600, Washington DC 20005. (202)387-1281. Fax: (202)234-1738. Deputy Director: Vicki D. Pinkston. Estab. 1970. Photos used in brochures, newsletters, annual reports and annual calendar.
Needs: Candid action photos of black children and youth. Reviews stock photos. Model release required.
Making Contact & Terms: Query with samples. Send unsolicited photos by mail for consideration. Uses 5×7 or 8×10 color and glossy b&w prints and color slides or b&w contact sheets. SASE. Reports in 1 month. Pays $70/cover photo and $20/inside photo. Credit line given. Buys one-time rights.
Tips: "Candid action photographs of one black child or youth or a small group of children or youths. Color photos selected are used in annual calendar and are placed beside an appropriate poem selected by organization. Therefore, photograph should communicate a message in an indirect way. Black & white photographs are used in quarterly newsletter and reports. Obtain sample of publications published by organization to see the type of photographs selected."

■**NORTHERN VIRGINIA YOUTH SYMPHONY ASSOCIATION**, 4026 Hummer Rd., Annandale VA 22003. (703)642-8051, ext. 21. Fax: (703)642-8054. Director of Public Relations: Paco Martinez. Estab. 1964. Nonprofit organization that promotes and sponsors 4 youth orchestras. Photos used in newsletters, posters and audiovisual uses and other forms of promotion.
Needs: Photographers usually donate their talents. Offers 8 assignments annually. Photos taken of orchestras, conductors and soloists. Captions preferred.
Audiovisual Needs: Uses slides and videotape.
Making Contact & Terms: Interested in receiving work from newer, lesser-known photographers. Ar-

range a personal interview to show portfolio. Works with local freelancers on assignment only. Uses 5×7 glossy color and b&w prints. Keeps samples on file. SASE. Payment negotiable. "We're a résumé-builder, a nonprofit that can cover expenses but not service fees." **Pays on acceptance**. Credit line given. Rights negotiable.

NORTHWORD PRESS, INC., 6211 Hwy. 51 S., P.O. Box 1360, Hazelhurst WI 54531. (715)356-9800. Fax: (715)356-6066. Photo Editor: Lin Stenz. Estab. 1984. Specializes in nature and wildlife books, calendars, nature audio (CD and tape covers).
Needs: Buys more than 1,500 photos/year. World nature, wildlife and outdoor related activities. Tack-sharp images. All transparency formats and 70mm repro-quality dupes. Model/property releases where needed are photographer's responsibility. Detailed captions required.
Making Contact & Terms: Photo guidelines with SASE. Guidelines require the following: photographer's bio, published credits, stock list, tearsheets (will return, but to photographer's benefit to have on file). Business cards not needed. Can read Photo CD, Zip disk or SyQuest 44 meg type disks. Quick return on outs. Published work is duped for printer use. Pays $100-2,000/color photo. Pays within 30 days of publication. Credit line and sample copies given. Buys one-time rights and project rights. Simultaneous submissions and previously published work OK.
Tips: "Tack-sharp, well-composed images. Do not include multiples. Edit submissions carefully. Credit line on slide. Put slides in Kimac-type sleeves, please." Photographers are contacted by mail, fax or phone on upcoming projects. Update your tearsheets and stocklist regularly. "Newer photographers please present a professional, well-packaged submission that is pertinent to our product."

‡PALM SPRINGS DESERT RESORT CONVENTION AND VISITORS BUREAU, 69-930 Highway 111, Rancho Mirage CA 92270. (619)770-9000. Fax: (619)770-9001. Vice President of Communications: Laurie Armstrong. "We are the tourism promotion bureau for Palm Springs and the entire Coachella Valley." Photos used in brochures, posters, newspapers, audiovisual presentations, magazines and PR releases.
Needs: Buys 20 freelance photos/year; gives 5 assignments/year. "Photos of tourism interest . . . specifically in Coachella Valley." Model release required. Captions required.
Making Contact & Terms: Query with résumé of credits or stock photo list. Provide résumé, business card, brochure, flier, and tearsheets to be kept on file for possible future assignments. Prefers to work with local freelancers or photographers who know the area. Uses 8×10 b&w prints; 35mm slides; b&w contact sheet and negatives OK. "We buy only 35mm transparencies." Notifies photographer if future assignments can be expected. SASE. Reports in 2 weeks. Pays $25/b&w photo; $40-75/hour. Buys all rights/all exposures from the job. "On assignment, we provide film and processing. We own all exposures."
Tips: "We will discuss only photographs of the Coachella Valley, California. No generic materials will be considered."

PHI DELTA KAPPA, Eighth & Union Sts., P.O. Box 789, Bloomington IN 47402. Website: http://www.pdkintl.org/kappam.htm. Design Director: Carol Bucheri. Estab. 1915. Produces *Phi Delta Kappan* magazine and supporting materials. Photos used in magazine, fliers and subscription cards.
Needs: Buys 10 photos/year; offers 1 assignment/year. Education-related subjects: innovative school programs, education leaders at state and federal levels, social conditions as they affect education. Reviews stock photos. Model release required. Photo captions required; include who, what, when, where.
Making Contact & Terms: Query with list of education-related stock photo subjects before sending samples. Provide photocopies, brochure or flier to be kept on file for possible future assignments. Uses 8×10 b&w prints, b&w contact sheets. Accepts images in digital format for Mac. Send via floppy disk or SyQuest (600 dpi minimum). SASE. Reports in 3 weeks. Pays $20-100/b&w photo; $30-400/color photo; $30-500/job. Credit line and tearsheets given. Buys one-time rights.
Tips: "Don't send photos that you wouldn't want to hang in a gallery. Just because you do a photo for publications does not mean you should lower your standards. Spots should be touched up (not with a ball point pen), the print should be good and carefully done, subject matter should be in focus. Send me photocopies of your b&w prints that we can look at. We don't convert slides and rarely use color."

THE SUBJECT INDEX, located at the back of this book, lists publications, book publishers, galleries, paper product companies and stock agencies according to the subject areas they seek.

PHILADELPHIA T-SHIRT MUSEUM, 235 N. 12th St., Philadelphia PA 19107. (215)625-9230. Fax: (215)625-0740. Contact: Louis Leof. Estab. 1972. Specializes in T-shirts.
Needs: Number of images bought varies; most supplied by freelancers. Interested in humor, resorts and nature. Model/property release required.
Making Contact & Terms: Interested in receiving work from newer, lesser-known photographers. Query with samples. Uses color and b&w prints. Keeps samples on file. SASE. Reports in 1-2 weeks. Pays 6% royalties on sales. Pays on usage. Credit line given. Buys exclusive product rights; negotiable.

POSEY SCHOOL OF DANCE, INC., Box 254, Northport NY 11768. (516)757-2700. E-mail: 74534.1 660@compuserve.com. President: Elsa Posey. Estab. 1953. Sponsors a school of dance and a regional dance company. Photos used in brochures, news releases and newspapers.
Needs: Buys 10-12 photos/year; offers 4 assignments/year. Special subject needs include children dancing, ballet, modern dance, jazz/tap (theater dance) and classes including women and men. Reviews stock photos. Model release required.
Making Contact & Terms: Interested in receiving work from newer, lesser-known photographers. "Call us." Works on assignment only. Uses 8×10 glossy b&w prints. Accepts images in digital format for Windows. SASE. Reports in 1 week. Pays $25-200/b&w or color photo. Credit line given if requested. Buys one-time rights; negotiable.
Tips: "We are small, but interested in quality (professional) work. Capture the joy of dance in a photo of children or adults. We prefer informal action photos, not 'posed pictures.' We need photos of REAL dancers doing dance."

■PROMOTIVISION, INC., 5929 Baker Rd., Suite 460, Minnetonka MN 55345. (612)933-6445. Fax: (612)933-7491. President: Daniel G. Endy. Estab. 1984. Photos used in TV commercials, sports, corporate image and industrial.
Audiovisual Needs: Uses film and video. Subjects include legal, medical, industrial and sports.
Making Contact & Terms: Interested in receiving work from professional photographers. Provide résumé, business card, self-promotion piece or tearsheets to be kept on file for possible future assignments. Works with freelancers on occasion. Uses 16mm color neg; Betacam SP videotape. Keeps samples on file. SASE. Pays $500-1,000/day. **We pay immediately.** Weekly shows we roll credits." Buys all rights; negotiable.
Tips: "We are only interested in quality work. At times, in markets other than ours, we solicit help and send a producer/director to work with local photo crew. Film is disappearing and video continues to progress. We are only 12 years old and started as an all film company. Now film comprises less than 5% of our business."

THE QUARASAN GROUP, INC., 214 W. Huron, Chicago IL 60610-3616. (312)787-0750. Fax: (312)787-7154. E-mail: quarasan@aol.com. Photography Coordinator: Renee Calabrese. A complete book publishing service and design firm. Offers design of interiors and covers to complete editorial and production stages, art and photo procurement. Photos used in brochures, books and other print products.
Needs: Buys 1,000-5,000 photos/year; offers 75-100 assignments/year. "Most products we produce are educational in nature. The subject matter can vary. For textbook work, male-female/ethnic/handicapped/minorities balances must be maintained in the photos we select to ensure an accurate representation." Reviews stock photos and CD-ROM. Model release required. Captions required.
Making Contact & Terms: Interested in receiving work from new, lesser-known photographers. Query with stock photo list or nonreturnable samples (photocopies OK). Provide résumé, business card, brochure, flier or tearsheets to be kept on file for possible future assignments. Prefers 8×10 b&w glossy prints; 35mm, 2¼×2¼, 4×5, or 8×10 transparencies, or b&w contact sheets. Cannot return material. "We contact once work/project requires photos." Payment based on final use size. Pays on a per photo basis or day rate. Credit line given, but may not always appear on page. Usually buys all rights or sometimes North American rights.
Tips: "Learn the industry. Analyze the products on the market to understand *why* those photos were chosen. Clients still prefer work-for-hire, but this is changing. We are always looking for experienced photo researchers and top-notch photographers local to the Chicago area."

■RIPON COLLEGE, P.O. Box 248, Ripon WI 54971. (414)748-8364. Contact: Director of College Relations. Estab. 1851. Photos used in brochures, newsletters, posters, newspapers, audiovisual presentations, annual reports, magazines and press releases.
Needs: Offers 3-5 assignments/year. Formal and informal portraits of Ripon alumni, on-location shots, architecture. Model/property release preferred. Captions preferred.
Making Contact & Terms: Interested in receiving work from newer, lesser-known photographers. Provide résumé, business card, brochure, flier or tearsheets to be kept on file for possible future assignments.

Works on assignment only. SASE. Reports in 1 month. Pays $10-25/b&w photo; $10-50/color photo; $30-40/hour; $300-500/day; $300-500/job; negotiable. Buys one-time and all rights; negotiable.

‡**RSVP MARKETING, INC.**, 450 Plain St., Suite 5, Marshfield MA 02050. President: Edward C. Hicks. Direct marketing consultant/agency. Photos used in brochures, catalogs and magazines.
Needs: Buys 50-100 photos/year; offers 5-10 assignments/year. Industrial equipment, travel/tourism topics and modeled clothing, sports events. Reviews stock photos. Model release preferred.
Making Contact & Terms: Query with list of stock photo subjects. Provide résumé, business card, brochure, flier or tearsheets to be kept on file for possible future assignments. Works on assignment only. Uses 2×2 and 4×6 b&w and color prints, and transparencies. Reports as needed. Payment negotiable per photo and per job. Buys all rights.
Tips: "We look for photos of industrial and office products, high-tech formats and fashion."

SAN FRANCISCO CONSERVATORY OF MUSIC, 1201 Ortega St., San Francisco CA 94122. (415)564-8086. Publications Coordinator: Mark Nichol. Estab. 1917. Provides publications about Conservatory programs, concerts and musicians. Photos used in brochures, posters, newspapers, annual reports, catalogs, magazines and newsletters.
Needs: Offers 10-15 assignments/year. Musical photos—musicians. Prefers to see in-performance shots and studio shots of musicians connected to the Conservatory. "Rarely uses stock shots."
Making Contact & Terms: Interested in working with newer, lesser-known photographers. "Contact us only if you are experienced in photographing performing musicians." Works with local freelancers only. Uses 5×7 b&w prints and color slides. Payment varies by photographer; "credit line" to $25/b&w photo; $100-300/job. Credit line given "most of the time." Buys one-time rights and all rights; negotiable.

■**SCAN VIDEO ENTERTAINMENT**, P.O. Box 183, Willernie MN 55090-0183. (612)426-8492. Fax: (612)426-2022. President: Mats Ludwig. Estab. 1981. Distributors of Scandinavian video films, books, calendars, cards.
Needs: Buys 100 photos; 5-10 films/year. Wants any subject related to the Scandinavian countries. Examples of recent uses: travel videos, feature films and Scandinavian fairy tales, all VHS. Reviews stock photos. Model/property release required.
Audiovisual Needs: Uses videotape for marketing and distribution to retail and video stores. Subjects include everything Scandinavian: travel, history, feature, children's material, old fashion, art, nature etc.
Making Contact & Terms: Interested in receiving work from newer, lesser-known photographers. Query with stock photo list. Uses color prints; 35mm transparencies; film and videotape. Does not keep samples. Cannot return material. Replies only if interested. Pays royalties on sales. Pays upon usage. Credit line not given. Buys all rights; negotiable.
Tips: Wants professionally made and edited films with English subtitles or narrated in English. Seeks work which reflects an appreciation of Scandinavian life, traditions and history.

■**SPECIAL OLYMPICS INTERNATIONAL**, 1325 G St. NW, Suite 500, Washington DC 20005. (202)628-3630. Fax: (202)824-0200. Visual Communications Manager: Jill Dixon. Estab. 1968. Provides sports training/competition to people with mental retardation. Photos used in brochures, newsletters, posters, annual reports, media and audiovisual.
Needs: Buys 500 photos/year; offers 3-5 assignments/year. Sports action and special events. Examples of recent uses: awards banquet (prints used in newsletters and momentos); sports training clinic (slides used for training presentation); sports exhibition (prints used for newsletter and momentos). Model/property release preferred for athletes and celebrities.
Audiovisual Needs: Uses slides and videotape.
Making Contact & Terms: Interested in receiving work from newer, lesser-known photographers. Provide résumé, business card, self-promotion piece or tearsheets to be kept on file for possible future assignments. Uses 3×5, 5×7 and 8×10 glossy color or b&w prints; 35mm transparencies; VHS, U-matic, Betacam, 1″ videotape. Keeps samples on file. SASE. Reports in 1 month. Pays $50-100/hour; $300-500/job. Processing additional. "Many volunteer time and processing because we're a not-for-profit organization." **Pays on acceptance.** Credit line depends on the material it is used on (no credit on brochure; credit in magazines). Buys one-time and all rights; negotiable.
Tips: Specific guidelines can be given upon request. Looking for "good action and close-up shots. Send example of work related to our organization's needs (i.e. sports photography, etc.). The best way to judge a photographer is to see the photographer's work."

❖■**SUN.ERGOS, A Company of Theatre and Dance**, 2203, 700 Ninth St., SW, Calgary, Alberta T2P 2B5 Canada. (403)264-4621. Fax: (403)269-1896. E-mail: sunergos@nucleus.com. Website: http://

www.sunergos.com. Artistic and Managing Director: Robert Greenwood. Estab. 1977. Company established in theater and dance, performing arts, international touring. Photos used in brochures, newsletters, posters, newspapers, annual reports, magazines, press releases, audiovisual uses and catalogs.

Needs: Buys 10-30 photos/year; offers 3-5 assignments/year. Performances. Examples of recent uses: "Birds of Stones" (8×10 b&w slides); "A Christmas Gift" (8×10 b&w slides); "Pearl Rain/Deep Thunder" (8×10 b&w slides). Reviews theater and dance stock photos. Property release required for performance photos for media use. Captions required; include subject, date, city, performance title.

Audiovisual Needs: Uses slides, film and videotape for media usage, showcases and international conferences. Subjects include performance pieces/showcase materials.

Making Contact & Terms: Interested in receiving work from newer, lesser-known photographers. Arrange a personal interview to show portfolio. Query with résumé of credits. Provide résumé, business card, self-promotion piece or tearsheets to be kept on file for possible future assignments. Works on assignment only. Uses 8×10, 8½×11 color and b&w prints; 35mm, 2¼×2¼ transparencies; 16mm film; NTSC/PAL/SECAM videotape. Keeps samples on file. SASE. Reporting time depends on project. Pays $100-150/day; $150-300/job; $2.50-10/color photo; $2.50-10/b&w photo. Pays on usage. Credit line given. Buys all rights.

Tips: "You must have experience shooting dance and *live* theater performances."

TOPS NEWS, % TOPS Club, Inc., Box 07360, Milwaukee WI 53207. Editor: Kathleen Davis. Estab. 1948. TOPS is a nonprofit, self-help, weight-control organization. Photos used in membership magazine.
Needs: "Subject matter to be illustrated varies greatly." Reviews stock photos.
Making Contact & Terms: Query with stock photo list. Provide résumé, business card, brochure, flier or tearsheets to be kept on file for possible future assignments. Uses any size transparency or print. SASE. Reports in 1 month. Pays $75-135/color photo. Buys one-time rights.
Tips: "Send a brief, well-composed letter along with a few selected samples with a SASE."

■**UNION INSTITUTE**, 440 E. McMillan St., Cincinnati OH 45206. (513)861-6400. Fax: (513)861-0779. Director of University Communications: Anu Mitra. Provides alternative higher education, baccalaureate and doctoral programs. Photos used in brochures, newsletters, magazines, posters, audiovisual presentations, annual reports, catalogs and news releases.
Needs: Uses photos of the Union Institute community involved in their activities. Also, photos that portray themes. Model release required.
Making Contact & Terms: Arrange a personal interview to show portfolio. Uses 5×7 glossy b&w and color prints; b&w and color contact sheets. SASE. Reports in 3 weeks. Payment negotiable. Credit line given.
Tips: Prefers "good closeups and action shots of alums/faculty, etc. Our quarterly alumni magazine reaches an international audience concerned with major issues. Illustrating its stories with quality photos involving our people is our constant challenge. We welcome your involvement."

UNITED AUTO WORKERS (UAW), 8000 E. Jefferson Ave., Detroit MI 48214. (313)926-5291. Fax: (313)331-1520. E-mail: 71112.363@compuserv.com. Editor: David Elsila. Trade union representing 800,000 workers in auto, aerospace, and agricultural-implement industries. Publishes *Solidarity* magazine. Photos used for brochures, newsletters, posters, magazines and calendars.
 ● The publications of this organization have won International Labor Communications Association journalism excellence contest and two photography awards.
Needs: Buys 85 freelance photos/year and offers 12-18 freelance assignments/year. Needs photos of workers at their place of work and social issues for magazine story illustrations. Reviews stock photos. Model releases preferred. Captions preferred.
Making Contact & Terms: Arrange a personal interview to show portfolio. In portfolio, prefers to see b&w and color workplace shots. Query with samples and send material by mail for consideration. Prefers to see published photos as samples. Provide résumé and tearsheets to be kept on file for possible future assignments. Uses 8×10 prints; contact sheets OK. Notifies photographer if future assignments can be expected. SASE. Reports in 2 weeks. Pays $50-100/b&w or color photo; $250/half-day; $475/day. Credit line given. Buys one-time rights and all rights; negotiable.

● **SPECIAL COMMENTS** within listings by the editor of *Photographer's Market* are set off by a bullet.

UNITED STATES SAILING ASSOCIATION, 15 Maritime Dr., P.O. Box 1260, Portsmouth RI 02871. (401)683-0800. Fax: (401)683-0840. Editor: Mr. Chris Mussler. Estab. 1897. *American Sailor Magazine* provided to members of United States Sailing Association. Photos used in brochures, posters, magazines, instructional and training manuals, and *Learning Curve*, USSA's training newsletter (color preferred, slides).
Needs: Buys 20-30 photos/year. Examples of uses: *American Sailor* (cover, color slide); "US Sailing Directory" (cover); and membership brochure, (b&w and color). Reviews stock photos, action sailing/racing shots; close-up face shots. Captions preferred; include boat type/name, regatta name.
Making Contact & Terms: Prefers slides, accepts prints, color only. Pays $25-100/color cover. Buys one-time rights.

■**WORCESTER POLYTECHNIC INSTITUTE**, 100 Institute Rd., Worcester MA 01609. (508)831-5609. Fax: (508)831-6004. University Editor: Michael Dorsey. Estab. 1865. Publishes periodicals and promotional, recruiting and fund-raising printed materials. Photos used in brochures, newsletters, posters, audiovisual presentations, annual reports, catalogs, magazines and press releases.
Needs: On-campus, comprehensive and specific views of all elements of the WPI experience. Relations with industry, alumni. Reviews stock photos. Captions preferred.
Making Contact & Terms: Interested in receiving work from newer, lesser-known photographers. Arrange a personal interview to show portfolio or query with stock photo list. Provide résumé, business card, brochure, flier or tearsheets to be kept on file for possible future assignments. "No phone calls." Uses 5×7 (minimum) glossy b&w prints; 35mm, 2¼×2¼, 4×5 transparencies; b&w contact sheets. SASE. Reports in 2 weeks. Payment negotiable. Credit line given in some publications. Buys one-time or all rights; negotiable.

‡**YEAR ONE INC.**, 4820 Hammermill Rd., Tucker GA 30084. (770)493-6568. Fax: (770)723-3498. Graphics Manager: Michael DePetro. Estab. 1981. Mail order catalog company for automotive restoration parts. Photos used in catalogs.
Needs: Buys 75 photos/year. Subjects include historic photos of car-related themes (1955-1975) or photos with muscle-car theme. "We are mainly looking for historic photos from Muscle Car Era 60s and 70s. The photos can be b&w or color. The photos will represent the era by showing normal daily occurences that highlight or accent the American muscle car. These photos can be of racing themes, gas stations, drive-ins, traffic scenes, street scenes, car dealerships, factory assembly lines, or other related photos."
Making Contact & Terms: Query with samples. Query with stock photo list. Provide résumé, business card, self-promotion piece or tearsheets to be kept on file for possible future assignments. Uses 5×7, 8×10 b&w or color prints; 35mm, 2¼×2¼, 4×5, 8×10 transparencies. Keeps samples on file. SASE. Reports in 1 month. **Pays on acceptance**; net 30 days of invoice. Buys first, one-time, electronic and all rights. Rights negotiable.

‡**ZOLAN FINE ARTS, LTD.**, (formerly Zolan Fine Art Studio), Dept. PM, P.O. Box 656, Hershey PA 17033-2173. (717)534-2446. Fax: (717)534-1095. E-mail: donaldz798@aol.com. President/Art Director: Jennifer Zolan. Commercial and fine art business. Photos used for artist reference in oil paintings.
Needs: Buys 16-24 photos/year; assignments vary on need. Interested in candid, heart-warming, and endearing photos of children with high emotional appeal between the ages of 2-5 capturing the golden moments of early childhood. Reviews stock photos. Model release preferred.
Making Contact & Terms: Interested in receiving work from newer, lesser-known photographers. Write and send for photo guidelines by mail, fax or America Online. Uses any size color or b&w prints; 35mm, 2¼×2¼, 4×5, 8×10 transparencies. Accepts images in digital format for Mac (TIFF, GIF). Submit via online or floppy disk. Does not keep samples on file. SASE. Queries on guidelines 3-4 weeks; photo returns or acceptances up to 60 days. Pays $200-500/b&w or color photo; pays up to $1,000 to buy exclusive rights for artist reference. **Pays on acceptance**. Buys exclusive rights only for use as artist reference; negotiable.
Tips: "Photos should have high emotional appeal and tell a story. Children should be involved with activity or play. Photos should look candid and capture a child's natural mannerisms. Write for free photo guidelines before submitting your work. We are happy to work with amateur and professional photographers. We are always looking for human interest type of photographs on early childhood, ages two to five. Photos should evoke pleasant and happy memories of early childhood."

Galleries

The popularity of photography as a collectible art form has improved the market for fine art photographs over the last decade. Viewers now recognize the investment value of prints by Ansel Adams, Irving Penn and Henri Cartier-Bresson, and therefore frequently turn to galleries for stirring photographs to place in their private collections.

The gallery/fine art market is one that can make money for many photographers. However, unlike commercial and editorial markets, galleries seldom generate quick income for artists. Galleries should be considered venues for important, thought-provoking imagery, rather than markets through which you can make a substantial living.

More than any other market, this area is filled with photographers who are interested in delivering a message. Whole shows often focus on one overriding theme by a single artist. Group shows also are popular for galleries that see promise in the style of several up-and-coming photographers.

It might be easiest to think of the gallery market as you would book publishing. The two are similar in that dozens of pictures are needed to thoroughly tell a story or explore a specific topic. Publishers and gallery directors are interested in the overall interpretation of the final message. And they want artists who can excite viewers, make them think about important subjects and be willing to pay for photographs that pique their emotions.

As with picture buyers and art directors, gallery directors love to see strong, well-organized portfolios. Limit your portfolio to 20 top-notch images. When putting together your portfolio focus on one overriding theme. A director wants to be certain that, if you are given a solo exhibition, you have enough quality work to carry an entire show. After the portfolio review, if the director likes your style, then you might discuss future projects or past work that you've done.

Directors who see promise in your work, but don't think you're ready for a solo exhibition, may place your material inside a group exhibition. In group shows, numerous artists display work at the same time. You might even see different mediums, such as photography, illustration or abstract sculptures, on display during group exhibitions. The emphasis of a group show is to explore an overriding theme from various perspectives. Such shows can be juried, which means participants have been accepted by a review committee, or non-juried.

HOW GALLERIES OPERATE

In exchange for brokering images a gallery often receives a commission of 40-50 percent. They usually exhibit work for a month, sometimes longer, and hold openings to kick off new shows. And they frequently provide pre-exhibition publicity. Something to be aware of is that some smaller galleries require exhibiting photographers to help with opening night reception expenses. Galleries also may require photographers to appear during the show or opening. Be certain that such policies are put in writing before you allow them to show your work.

Gallery directors who foresee a bright future for you might want exclusive rights to represent your work. This type of arrangement forces buyers to get your images directly from the gallery that represents you. Such contracts are quite common, usually limiting the exclusive rights to specified distances. For example, a gallery in Tulsa, Oklahoma, may have exclusive rights to distribute your work within a 200-mile radius of the gallery. This would allow you to sign similar contracts with galleries outside the 200-mile range.

Galleries vary widely in how they operate. The largest group is made up of retail, for-profit

operations. These galleries usually cater to both private and corporate collectors. Depending on the location, the clientele may include everyone from tourists and first-time buyers, to sophisticated, long-time collectors and professional interior designers. The emphasis is on what sells and these galleries are interested only in work they feel will fit the needs of their clientele. Before approaching a retail gallery, be sure you have a very clear understanding of its clientele's interests and needs.

Art consultancies work primarily with professional art buyers, including interior decorators, interior designers, developers, architects and corporate art collectors. Some include a viewing gallery open to the public, but they are most interested in being able to show their clients a wide variety of work. Consultancies maintain extensive slide files to match the needs of their clients in almost any situation. Photographers interested in working with consultants must have a body of work readily available.

Nonprofit galleries and alternative spaces offer photographers the most opportunities, especially if their work is experimental. Often sponsored by an educational facility or by a cooperative, the aim of these galleries is to expose the public to a variety of art forms and new artists. Since sales are secondary, profits from sales in these galleries will be lower than in retail outlets. Cooperatives offer artists (and photographers) the opportunity to have a say in how the gallery is operated. Most require a small membership fee and a donation of time. In exchange they take a very low commission on sales.

Read the listings carefully to determine which galleries interest you most. Some provide guidelines or promotional information about the gallery's recent exhibits for a self-addressed, stamped envelope. Galleries are now included in our newly expanded Subject Index. Check this index to help you narrow your search for galleries interested in your type of work. Whenever possible, visit those galleries that interest you to get a real feel for their particular needs, philosophy and exhibition capabilities. Do not, however, try to show a portfolio without first making an appointment.

A.O.I. GALLERY, One Columbus Plaza, Apt. N-29E, New York NY 10019. Director: Frank Aoi. Estab. 1992.
Exhibits: Requirements: Must be involved with fine art photography. No students' work. Interested in contemporary/avant-garde photography or videos. Very coherent content and professional presentation. Examples of recent exhibitions: "A Box of Ku," by Masao Yamamoto (silver prints with mixed media); "Unique Exhibits of Contemporary Japanese Photographic Artists," by various artists; and "Rediscovery of a New Vision," by Ernst Haas (dye-transfer prints). Presents 5 shows/year. Shows last 1 month. Sponsors openings. Photographer's presence at opening and during show preferred.
Making Contact & Terms: Commission varies. Buys photos outright. General price range: $500-15,000. Call for size limits. Cannot return material.
Tips: "Be extremely polite and professional."

‡**A.R.C. GALLERY**, 1040 W. Huron, 2nd Floor, Chicago IL 60622. (312)733-2787. President: Julia M. Morrisroe. Estab. 1973.
Exhibits: Requirements: Must send slides, résumé and statement to gallery for review. All styles considered. Contemporary fine art photography, documentary and journalism. Examples of exhibitions: "Presence of Mind," by Jane Stevens (infrared photographs, b&w); "Take Away the Pictures . . . ," by Barbara Thomas (C-prints); "Watershed Investigations . . . ," by Mark Abrahamson (cibachrome prints). Presents 5-8 shows/year. Shows last 1 month. Sponsors openings. Photographer's presence at opening and during show preferred.
Making Contact & Terms: Interested in receiving work from newer, lesser-known photographers. Charges no commission. General price range: $100-600. Reviews transparencies. Interested in seeing slides for review. No size limits or other restrictions. Send material by mail for consideration. SASE. Reports in 1 month.

‡ **MARKETS NEW TO THIS EDITION** are marked with a double dagger.

Tips: Photographers "should have a consistent body of work. Show emerging and experimental work."

‡**ANSEL ADAMS CENTER FOR PHOTOGRAPHY**, 250 Fourth St., San Francisco CA 94103. (415)495-7000. Fax: (415)495-8517. Attention: Portfolio Review. The Center was established in 1989. The Friends of Photography, the parent organization which runs the center, was founded in 1967.
Exhibits: Requirements: "Photographers are welcome to submit exhibition proposals through our portfolio review system. Generally this entails sending 15-26 slides, a brief artist's statement, a brief résumé (optional), and a SASE for return of submission. Call for future info." Interested in all styles and subjects of photography. Examples of recent exhibitions: "Size of Earth: Illuminated Photoworks," by Doug and Mike Starn; "The Inaugural Ball: An Open Space Installation," by Margaret Crane and Jon Winet; and Ansel Adams, A Legacy. Presents 15-18 exhibits/year. Shows last 2-2½ months. Sponsors openings; includes informal receptions, refreshments, exhibition preview. Photographer's presence at opening and at show preferred.
Making Contact & Terms: Interested in receiving work from newer, lesser-known photographers. Payment negotiable. Reviews transparencies. Interested in unframed, mounted or unmounted, matted or unmatted work. Submit portfolio for review. Send material by mail for consideration. Call for details on portfolio review. SASE. Reports back on portfolio reviews in 1-2 weeks; submitted work in 1 month.
Tips: "We are a museum, not a gallery. We don't represent artists, and usually *exhibit* only established artists (locally or nationally). We are, however, very open to seeing/reviewing new work, and welcome exhibition proposals so long as artists follow the guidelines (available if a SASE is sent)."

ADIRONDACK LAKES CENTER FOR THE ARTS, Rt. 28, P.O. Box 205, Blue Mt. Lake NY 12812. (518)352-7715. Fax: (518)352-7333. E-mail: alca@netheaven.con. Program Coordinator: Daisy Kelley. Estab. 1967.
Exhibits: Requirements: Send résumé, artist's statement, slides or photos. Interested in contemporary Adirondack and nature photography. Examples of recent exhibitions: "Loving the Landscape-Adirondacks and Western Mountain States," by Janet Friauf; "Rt. 30," by Mark Kurtz (hand-colored panoramic photographs); "Abstract Florals," by Walter Carstens. Presents 6-8 exhibits/year. Shows last 1 month. Sponsors openings. Provides wine and cheese receptions, bulk mailings of announcements may also be arranged if artist can provide postcard. Photographer's presence at opening preferred.
Making Contact & Terms: Interested in receiving work from newer, lesser-known photographers. Charges 40% commission. General price range: $100-250. "Pricing is determined by photographer. Payment made to photographer at end of exhibit." Reviews transparencies. Interested in framed and matted work. Send material by mail for consideration. SASE. Reports in 1 month.
Tips: "Our gallery is open during all events taking place at the Arts Center, including concerts, films, workshops and theater productions. Guests for these events are often customers seeking images from our gallery for their own collections or their places of business. Customers are often vacationers who have come to enjoy the natural beauty of the Adirondacks. For this reason, landscape and nature photographs sell well here."

AKRON ART MUSEUM, 70 E. Market St., Akron OH 44308. (330)376-9185. Website: http://www.winc .com/~aam. Curator: Barbara Tannenbaum.
 ● This gallery annually awards the Knight Purchase Award to a living artist working with photographic media.
Exhibits: Requirements: To exhibit, photographers must possess "a notable record of exhibitions, inclusion in publications, and/or a role in the historical development of photography. We also feature local photographers (northeast Ohio)." Interested in innovative works by contemporary photographers; any subject matter. Example of recent exhibitions: "Dorothea Lange, A Retrospective"; "A History of Women Photographers"; "William Christenberry"; and "Merry Christmas, America" (photographs of yard decorations by Christina Patoski). Presents 3-5 exhibits/year. Shows last 2 months. Sponsors openings; provides light food, beverages and sometimes entertainment. Photographer's presence at opening preferred. Presence during show is not required, but willingness to give a gallery talk is appreciated.
Making Contact & Terms: Payment negotiable. Buys photography outright. Will review transparencies. Send material by mail for consideration. SASE. Reports in 1-2 months, "depending on our workload."
Tips: "Prepare a professional-looking packet of materials including high-quality slides, and always send a SASE. Never send original prints."

‡**ALBANY CENTER GALLERIES**, 23 Monroe St., Albany NY 12210. (518)462-4775. Associate Director: Rebecca Harriman. Estab. 1977.
Exhibits: Requirements: Photographer must live within 75 miles of Albany for regular exhibit and within 100 miles for Photography Regional which is held at the Albany Center Galleries on even-numbered years. Interested in all subjects. Examples of recent exhibitions: 18th Annual Photography Regional (Bruce

Davidson, juror); Martin Benjamin; and Mark McCarty. Presents at least 1 show/year. Shows last 6-8 weeks. Sponsors opening; provides refreshments and hors d'oeuvres. Photographer's presence at opening required, presence during show preferred.

Making Contact & Terms: Charges 30% commission. General price range: $100-1,000. Reviews transparencies. Interested in framed work only for photography regional and slides of work. "Work must be framed and ready to hang." Send material by mail for consideration. SASE. Reports in 1 month, sometimes longer.

THE ALBUQUERQUE MUSEUM, 2000 Mountain Rd. NW, Albuquerque NM 87104. (505)243-7255. Fax: (505)764-6546. Curator of Art: Ellen Landis. Estab. 1967.
Exhibits: Requirements: Send photos, résumé and artist's statement. Interested in all subjects. Examples of previous exhibitions: "Gus Foster," by Gus Foster (panoramic photographs); "Santiago," by Joan Myers (b&w 16×20); and "Frida Kahlo," by Lola Alvaraz Bravo (b&w various sizes). Presents 3-6 shows/year. Shows last 8-12 weeks. Photographer's presence at opening preferred, presence during show preferred.
Making Contact & Terms: Buys photos outright. Reviews transparencies. Interested in framed or unframed work, mounted or unmounted work, matted or unmatted work. Arrange a personal interview to show portfolio. Submit portfolio for review. Send material by mail for consideration. "Sometimes we return material; sometimes we keep works on file." Reports in 1 month.

AMERICAN SOCIETY OF ARTISTS, INC., Box 1326, Palatine IL 60078. (847)991-4748 or (312)751-2500. Membership Chairman: Helen Del Valle.
Exhibits: Members and nonmembers may exhibit. "Our members range from internationally known artists to unknown artists—quality of work is the important factor. We have about 25 shows throughout the year which accept photographic art."
Making Contact & Terms: Payment negotiable. Interested in framed, mounted or matted work only. Send SASE for membership information and application (state media). Reports in 2 weeks. Accepted members may participate in lecture and demonstration service. Member publication: *ASA Artisan*.

‡ANN ARBOR ART ASSOCIATION ART CENTER, 117 W. Liberty, Ann Arbor MI 48104. (313)994-8004. Fax: (313)994-3610. Galleries Shop Director: Liz Lemire. Exhibition Gallery Director: Sharon Currey. Estab. 1909.
Exhibits: Requirements: each artist must be a Michigan resident. Interested in any type of photography. "We are open to new ideas." Examples of exhibitions: "Inner Iconography," by Loralei R. Byatt (enlarged portrait close-ups), and works by Chris Coffey (slice of life photography) and Leslie Adiska (large, landscape scenes). Presents 10-15 shows/year. Shows last 1 month up to 1 year. Sponsors openings. Provides opening reception with refreshments, and "postcards announcing the show to our members as well as artist's mailing list. We also show in our retail gallery shop in addition to our rotating gallery exhibits." Photographer's presence at opening preferred.
Making Contact & Terms: Interested in receiving work from newer, lesser-known photographers. Charges 30% commission for members, 50% for non-members; membership available to everyone. General price range: $200-500. Reviews transparencies. Interested in framed work only. Requires exclusive representation locally. All work must be framed and behind glass or Plexiglas. Arrange a personal interview to show portfolio. SASE for return of slides. Reports in 3 weeks.
Tips: Advises photographers to "become familiar with common business practices. Be prepared. Be prompt. Keep accurate records. Have work professionally framed. Have your b&w promo photos prepared. Update résumé and bio and have them professionally typeset."

‡ARIZONA STATE UNIVERSITY ART MUSEUM, Nelson Fine Arts Center, Tempe AZ 85287-2911. (602)965-2787. Fax: (602)965-5254. E-mail: artmuse@asuvm.inre.asu.edu. Website: http://www.asu am.fa.asu.edu. Curator: Heather Lineberry. Estab. 1950.
Exhibits: Requirements:Work must be approved by curatorial staff as meeting museum criteria. Examples of recent exhibitions: "Big Sister/Little Sister," by Annie Lopez (photography and installation); "The Curtain Falls: Russian American Stories," by Tamarra Kaida (photography and installation); and "Here and Now II (Arizona artists)," by Kenneth Shorr (silver gelatin and ink jet prints). Shows last 6-8 weeks. Sponsors openings. Invitations usually sent out for opening. Receptions include beverages and snacks. Photographer's presence at opening preferred.
Making Contact & Terms: Sometimes buys photography outright for collection. Reviews transparencies. Interested in framed, mounted, matted work. Query with samples. Send material by mail for consideration. SASE. Reports "depending on when we can review work."

ARKANSAS RIVER VALLEY ARTS CENTER, P.O. Box 2112, 1001 E. B St., Russellville AR 72811. (501)968-2452. Fax: (501)968-6181. E-mail: arvac@aol.com. Executive Director: Stephanie Schultze.

Exhibits: Requirements: Work must be reviewed by the Visual Arts Committee. Considers anything except nudes. Examples of recent exhibitions: "Landscapes," by Walter Carr (photo b&w); "Assortment," by Russ Hancock (mixed and photo); and "Styles," by Dan Pierce (b&w). Presents 1-2 shows/year. Shows last 1 month. Sponsors openings; provides all arrangements. Photographer's presence at opening preferred.
Making Contact & Terms: Interested in receiving work from newer, lesser-known photographers. Charges 25% commission. General price range: $100-500. Reviews transparencies. Interested in framed work only. Query with samples. Send material by mail for consideration. Reports in 3 weeks.

THE ART CENTER, 125 Macomb Place, Mount Clemens MI 48043. (810)469-8666. Fax: (810)469-4529. Exhibit Coordinator: Donna Juras. Executive Director: Jo-Anne F. Wilkie.
Exhibits: Interested in landscapes, still life, portraiture, abstracts, architecture and fashion. Examples of recent exhibitions: "Through the Lens," by Steve Jensen and Fernando Diaz (male nudes and nature scenes); Mary Keithan (barns and school houses); and G.L. Klayman (solarized silver prints). Presents 1 show/year. Shows last 3-4 weeks. Sponsors openings. Provides refreshments and food, publicity for opening reception. Photographer's presence at opening and during show preferred. Juried work accepted in the gift shop. Outdoor Fair held on Mother's Day weekend. Holiday Fair held inside November 23 to December 23.
Making Contact & Terms: Interested in receiving work from newer, lesser-known and well-known photographers. Charges 30% commission. General price range: $175-300. Reviews slides. Interested in framed work only. Large scale submissions accepted based on available gallery space. Query with samples. Send material by mail for consideration. SASE. Reports in 1-2 months.

‡ART CENTER OF BATTLE CREEK, 265 E. Emmett St., Battle Creek MI 49017. (616)962-9511. Curator: Carol Snapp. Estab. 1962.
Exhibits: Interested in "experimentation; technical/compositional skill; originality and personal statement—avoid clichés." Examples of recent exhibitions: "Midwest Focus '96 Regional Juried Photo Competition," 75 works accepted from 450 entries; "Mental States," intimate portraits by Kalamazoo artist, Mary Whalen; and "Kidsfocus," photographs resulting from an 8-week photography workshop with area school children. All subjects, formats and processes represented. Occasionally presents one-person exhibits and 1 competition every other year (on the even years). Shows last 6 weeks. Sponsors openings; press releases are mailed to area and appropriate media. Photographer's presence at opening is preferred.
Making Contact & Terms: Interested in receiving work from newer, lesser-known photographers. Primarily interested in Michigan and Midwestern artists. Charges 40% commission. "We also accept gifts of photography by Michigan artists into the collection." General price range: $100-500. Will review transparencies if artist wants a solo exhibit. Interested in seeing framed or unframed, mounted or unmounted, matted work only. Send material by mail for consideration. SASE. Reports after exhibits committee has met (1-2 months).
Tips: Sees trend toward "experimentation with older formats and processes, use of handtinting and an increase in social commentary. All photographers are invited to apply for exhibitions. The Center has a history of showing the work of emerging artists. Send examples of your best and most recent work. Be honest in your work and in presentation." Traditional landscapes are most popular with buying public.

‡THE ART DIRECTORS CLUB, 250 Park Ave., S., New York NY 10003. (212)674-0500. Fax: (212)460-8506. E-mail: adcny@interport.net. Associate Director: Olga Grisaitis. Estab. 1920.
Exhibits: Requirements: Must be a group show with theme and sponsorship. Interested in work for advertising and editorial design. Examples of recent exhibitions: "Young Guns NYC," by Kenneth Willardt and various others; "Japan Festival," by Tohru Ohe; and "Best of *Rolling Stone*," by various photographers. Presents 1-3 shows/year. Shows last 1-4 weeks. Photographer's presence at opening preferred.
Making Contact & Terms: Query with samples. Cannot return material. Reports depending on review committee's schedule.

ART FORMS, 16 Monmouth St., Red Bank NJ 07701. (908)530-4330. Fax: (908)530-9791. Director: Charlotte T. Scherer. Estab. 1985.
Exhibits: Requirements: work must be original. Examples of recent exhibitions: works by Vincent Serbin (b&w manipulative photography); Valentine (b&w photography); Joseph Paduano (infra red photography); Jeff Gross (Polaroid image transfers/Cibachrome prints); and Michael Neuhaus (platinum prints). Photography is exhibited all year long. Shows last 6 weeks. Photographer's presence at opening and during show preferred.
Making Contact & Terms: Interested in receiving work from newer, lesser-known photographers. Charges 50% commission. General price range: $250-1,500. Reviews transparencies. Interested in framed or unframed, mounted or unmounted, matted or unmatted work. Requires exclusive representation locally. Query with samples. SASE. Reports in 1 month.

‡ART INDEPENDENT GALLERY, 623 Main, Lake Geneva WI 53147. (414)248-3612. Fax: (414)248-2227. Owner: Betty Sterling. Estab. 1968.
Exhibits: Requirements: Should be "beautiful—nothing overtly sexual or political. Contemporary styles are best." Interested in landscapes, florals and architectural details. Examples of recent exhibitions: Ray Hartl (landscapes, architectural details); Gail Jung-Kuffel (floral, fantasy); and David Roth (b&w landscapes). Presents 2-4 shows/year. Shows last several weeks. "Photography is always part of the mix." Sponsors openings; sends out invitations, provides entertainment and refreshments, hangs and sets up the show. Photographer's presence at opening preferred.
Making Contact & Terms: Charges 50% commission. General price range: $145-950. Reviews transparencies. Interested in framed or unframed work. Requires exclusive representation in 10 mile radius. Works are limited to those that are not "outrageously large—4′ × 5′ is not acceptable." Arrange a personal interview to show portfolio. Query with résumé of credits. Send slides for review. SASE. Reports in 1 month.

ART INSTITUTE OF PHILADELPHIA, 1622 Chestnut St., Philadelphia PA 19103. (215)567-7080. Fax: (215)246-3339. Gallery Director: Alicia A. Marrone. Estab. 1973.
Exhibits: Requirements: All work must be ready to hang under glass or Plexiglas; no clip frames. Interested in fine and documentary art. Examples of recent exhibitions: George Krause (fine art, b&w); Lisa Goodman (commercial, b&w/color); Enrique Bostelmann (documentary, b&w/color). Presents 1 exhibit/year. Shows last 30 days. Photographer's presence at opening and during show is preferred.
Making Contacts & Terms: Interested in receiving work from established photographers. Sold in gallery. General price range: $150-2,000. Reviews transparencies. Interested in matted or unmatted work. Query with samples. Include 10-20 slides and a résumé. SASE. Reports in 1 month.

‡ART SOURCE L.A., INC., 11901 Santa Monica Blvd., Suite 555, Los Angeles CA 90025. (310)479-6649. Fax: (310)479-3400. E-mail: ellman@aol.com. President: Francine Ellman. In Maryland: 182 Kendrick Place, Suite 32, North Potomac MD 20878. (301)208-9201. Fax: (301)208-8855. E-mail: bkogodART @aol.com. Director: Bonnie Kogod. Estab. 1980.
Exhibits: "We do projects worldwide, putting together fine art for public spaces, hotels, restaurants, corporations, private collections." Interested in all types of quality work. "We use a lot of photography." Examples of previous exhibitions: works by Alan Levy (large scale cibachrome prints), and Corinne Whittaker (digital photography). Number of exhibitions varies. Shows last 1 week to 3 months. Photographer's presence at opening preferred.
Making Contact & Terms: Interested in receiving work from emerging and established photographers. Charges 50% commission. General price range: $300-15,000. Reviews transparencies. Interested in unframed, mounted or matted work. Submit portfolio for review. Include for consideration visuals, résumé, SASE. Reports in 1-2 months.
Tips: "We review actuals, video, CD ROM, photo disk transparencies, photographs, laser color and/or black and white, as well as pieces created through digital imagery or other high-tech means. Show a consistent body of work, well-marked and presented so it may be viewed to see its merits."

‡ARTBEAT GALLERY, 3266 21st St., San Francisco CA 94110-2423. Phone/fax: (415)452-1104. Business Manager: Ana Montano. Estab. 1997.
Exhibits: Requirements: Complete and professional presentation—résumé; bio, samples of work; slides are fine. Interested in b&w, all subject matter. Examples of recent exhibitions: Jeffrey Smith (b&w); and Sa 'Longo Lee (b&w). Presents 1-3 shows/year. Shows last 5-8 weeks. Sponsors openings; provides publicity and hosts a reception with the artist. Photographer's presence at opening and during show preferred.
Making Contact & Terms: Charges 40% commission. General price range: $75-300. Reviews transparencies. Interested in framed or unframed matted work only. Works are limited to no larger than 36 × 42. Query with samples. SASE. Reports in 1 month.

‡ARTEMISIA GALLERY, 700 N. Carpenter, Chicago IL 60622. (312)226-7323. Contact: Search Committee. Not-for-profit, cooperative, women artist-run alternative art gallery established in 1973. Interested in innovative, leading edge work and very receptive to newer, lesser-known, fine-art photographers demonstrating quality work and concept.
Exhibits: Examples of photo exhibitions: Cooper Spivey; Sungmi Naylor. Huge gallery with 5 separate spaces. Presents 60 shows a year; each lasts 1 month. Approximately 15 exhibits are photography. Concurrently showcases major women artists, sponsors lectures.
Making Contact & Terms: Interested in receiving work from newer, lesser-known photographers. Sells works; does not charge commission. General price range: $150-500. No size limits or restrictions on photography. Sponsors opening reception with cash bar, provides gallery sitters, 1,300-name mailing list. Exhibitor provides announcements and postage, mailing service fee if using the gallery's list, ad fee, rental

fee, installs show. Jurying requirements: send 15-20 slides of a consistent body of work, résumé and SASE. Returns in 4-6 weeks.

Tips: Opportunities for photographers in galleries are "fair to good." Photo exhibitions are treated as fine art. Buying public is most interested in work that is "innovative, finely composed, or concerned with contemporary issues. We encourage artists of color and/or members of minority groups, along with those interested in feminist issues, to apply. Please submit professional quality slides marked 'top' of a consistent body of work."

ARTISTS' COOPERATIVE GALLERY, 405 S. 11th St., Omaha NE 68102. (402)342-9617. President: Pam King. Estab. 1974.

Exhibits: Requirements: Fine art photography only. Artist must be willing to work 13 days per year at the gallery or pay another member to do so. "We are a member-owned and -operated cooperative. Artist must also serve on one committee." Interested in all types, styles and subject matter. Examples of exhibitions: works by Ulla Gallagher (sabattier, hand coloring), Pam King (photograms), and Margie Schimenti (Cibachrome prints). Presents 14 shows/year. Shows last one month. Sponsors openings. Gallery sponsors 1 all-member exhibit and outreach exhibits, individual artists sponsor their own small group exhibits throughout the year. Photographer's presence at opening and during show required.

Making Contact & Terms: Interested in receiving work from newer, lesser-known photographers. Charges no commission. General price range: $100-300. Reviews transparencies. Interested in framed work only. Query with résumé of credits. SASE. Reports in 2 months.

Tips: "Write for membership application. Membership committee screens applicants August 1-15 each year. Reports back by September 1. New membership year begins October 1. Members must pay annual fee of $300. Will consider well-known artists of regional or national importance for one of our community outreach exhibits. Membership is not required for outreach program and gallery will host one-month exhibit with opening reception."

ARTSPACE, INC., 201 East Davie St., Raleigh NC 27601. (919)821-2787. Fax: (919)821-0383. E-mail: artspace10@aol.com. Website: www.citysearch.com/rdu/artspace. Executive Director: Megg Rader. Estab. 1986.

Exhibits: Works are reviewed by the Artspace Gallery Committee for invitational exhibitions; Artspace sponsors juried shows periodically that are open to all artists and photographers. Send slides, résumé and SASE. Interested in all types, styles and subjects. Shows last 5-7 weeks. Sponsors openings; provides reception, invitations, refreshments, publicity, exhibition, installation. Photographer's presence at opening and during show preferred.

Making Contact & Terms: Interested in receiving work from newer, lesser-known photographers. Charges 30% commission. General price range: $100-600. Reviews transparencies. Send material by mail for consideration. SASE. Reports in 60 days.

‡ARTWORKS GALLERY, 233 Pearl St., Hartford CT 06103. Phone/fax: (860)247-3522. Executive Director: Judith Green. Estab. 1976.

Exhibits: "We have juried shows; members must be voted in after interview." Interested in contemporary work. Examples of recent exhibitions: Roger Crossgrove, John Bryan and Alison Carey. Shows last 1 month. Sponsors openings. Photographer's presence at opening required, presence during show preferred.

Making Contact & Terms: Charges 30-40% commission. General price range: $100-2,000. Reviews transparencies. Send for membership application. SASE. Reports in 1 month.

Tips: "Have a close relationship with the gallery director. Be involved; go to events. Work!"

ASCHERMAN GALLERY/CLEVELAND PHOTOGRAPHIC WORKSHOP, 23500 Mercantile Rd., Suite D, Beachwood OH 44122. (216)464-4944. Fax: (216)464-3188. E-mail: herbasch@apk.net. Director: Herbert Ascherman, Jr. Estab. 1977. Sponsored by Cleveland Photographic Workshop. Subject matter: all forms of photographic art and production. "Membership is not necessary. A prospective photographer must show a portfolio of 40-60 slides or prints for consideration. We prefer to see distinctive work—a signature in the print, work that could only be done by one person, not repetitive or replicative of others."

Exhibits: Presents 5 shows/year. Shows last about 10 weeks. Openings are held for some shows. Photogra-

MARKET CONDITIONS are constantly changing! If you're still using this book and it's 1999 or later, buy the newest edition of *Photographer's Market* at your favorite bookstore or order directly from Writer's Digest Books.

Rev. Kent Organ was caught in action by photographer and gallery director Herbert Ascherman as part of a documentary survey done for the Cleveland Bicentennial for which he photographed 70 religious leaders on location throughout the city. Note the Jewish star in the photo—the minister hung it to remind his congregation of their religious and cultural origins. "This captures the essence of religion: the initial heritage (Judaism) from which Western thought flows, and its major offspring (Christianity)," says Ascherman.

phers are expected to contribute toward expenses of publicity. Photographer's presence at show "always good to publicize, but not necessary."

Making Contact & Terms: Interested in receiving work from newer, lesser-known photographers. Charges 25-40% commission, depending on the artist. Sometimes buys photography outright. Price range: $100-1,000. "Photos in the $100-300 range sell best." Will review transparencies. Matted work only for show.

Tips: "Photographers should show a sincere interest in photography as fine art. Be as professional in your presentation as possible; identify slides with name, title, etc.; matte, mount, box prints. We are a Midwest gallery and we are always looking for innovative work that best represents the artist (all subject matter). We enjoy a variety of images and subject matters. Know our gallery; call first; find out something about us, about our background or interests. Never come in cold."

‡**ASIAN AMERICAN ARTS CENTER**, 26 Bowery, 3rd Floor, New York NY 10013. (212)233-2154. Fax: (212)766-1287. Director: Robert Lee. Estab. 1982.

Exhibits: Requirements: Must be Asian or related to Asian culture and must be entered into the archive. Interested in "creative art pieces." Examples of recent exhibitions: work by Dinh Le, Monica Chau and Wing Young Huie. Shows last 6 weeks. Sponsors openings. Photographer's presence at opening preferred.
Making Contact & Terms: Charges 20% "donation" on works sold. Sometimes buys photos outright. Reviews transparencies. Interested in slides. Send material by mail for consideration. Cannot return material; it is entered in the archive. Reports in 1 month.

TAMARA BANC GALLERY, 460 N. Rodeo, Beverly Hills CA 90210. (310)205-0555. Fax: (310)205-0794. Vice President: Tamara Banc. Estab. 1983.
Exhibits: Requirements: Must be experienced and published photographer. Examples of recent exhibitions: work of Dean Karr and Todd Friedman. Interested in nudes or erotic/provocative work. Also represents various vintage erotic photography. Presents 2 shows/year. Shows last 6 weeks. Sponsors openings; provides invitations, advertising, beverages and food. Photographer's presence at opening required; presence during show preferred.
Making Contact & Terms: Charges 50% commission. Buys photos outright. General price range: $200-5,000. Reviews transparencies. Interested in framed or unframed work. Requires exclusive representation locally. Submit portfolio for review. Query with résumé of credits. Query with samples. Send material by mail for consideration. SASE. Reports in 1 month.

‡BANNISTER GALLERY, Dept. of Art, Rhode Island College, Providence RI 02908. (401)456-9765. Fax: (401)456-8379. Website: http://www.ric.edu/home/buildings/barrister bannister.html. Director: Dennis O'Malley. Estab. 1978.
Exhibits: Requirements: Photographer must pass review by gallery committee. The committee changes yearly, consequently interests/requirements change. Interested in socio-political documentary/manipulated darkroom images/large format and digital imaging. Examples of recent exhibitions: "Farewell to Bosnia," by Gilles Peress; "Raised by Wolves," by Jim Goldberg; "Living with AIDS-HIV," by Tom McGovern. Presents 1 show/year. Shows last 3 weeks. Sponsors openings; provides refreshments, as budget allows. Photographer's presence at opening is preferred, lecture during show preferred.
Making Contact & Terms: Exhibits are for teaching purposes. Reviews transparencies. SASE. Reports 1-3 months, held for review by committee.

BARLETT FINE ARTS GALLERY, 77 W. Angela St., Pleasanton CA 94566. (510)846-4322. Owner: Dorothea Barlett. Estab. 1982.
Exhibits: Interested in landscape, dramatic images. Example of exhibitions: "Photography 1994," by Al Weber. Shows last 1 month. Sponsors openings. Artists contribute a fee to cover printing, mailing and reception. Group exhibits keep cost low. Photographer's presence at opening preferred.
Making Contact & Terms: Photography sold in gallery. General price range: $125-500. Reviews transparencies. Interested in matted work only. Requires exclusive representation locally. Works are limited to 8×10 (smallest). Query with samples. Send material by mail for consideration. SASE.
Tips: Submit work that has high marketable appeal, as well as artistic quality."

BARRON ARTS CENTER, 582 Rahway Ave., Woodbridge NJ 07095. (908)634-0413. Director: Stephen J. Kager. Estab. 1975.
Exhibits: Examples of recent exhibitions: New Jersey Print Making Council. Photographer's presence at opening required.
Making Contact & Terms: Photography sold in gallery. Charges 20% commission. General price range: $150-400. Reviews transparencies but prefers portfolio. Submit portfolio for review. SASE. Reports "depending upon date of review, but in general within a month of receiving materials."
Tips: "Make a professional presentation of work with all pieces matted or treated in a like manner. In terms of the market, we tend to hear that there are not enough galleries existing that will exhibit photography."

BATON ROUGE GALLERY, INC., 1442 City Park Ave., Baton Rouge LA 70808. (504)383-1470. Fax: (504)336-0943. E-mail: brgal@intersurf.com. Director: Kitty Pheney. Estab. 1966.
● This gallery is the oldest artist co-op in the US.
Exhibits: Professional artists with established exhibition history—must submit 20 slides and résumé to programming committee for approval. Open to all types, styles and subject matter. Examples of recent exhibitions: "Stories of the Truth," by Jennifer Simmons (portraits of everyday life); and "Animal Dance," by Lori Waselchuk (photographic essay on Cajun Mardi Gras). Presents approximately 3 exhibits/year. Shows last 4 weeks. Sponsors openings; provides publicity, liquid refreshments. Photographer's presence at opening is preferred.

Making Contact & Terms: Interested in receiving work from newer, lesser-known photographers. Charges 33.3% commission. General price range: $200-600. Reviews transparencies and artwork on CD-ROM. Interested in "professional presentation." Send material by mail for consideration. SASE. Reports in 2-3 months. Accepts submissions in March and September.

BENHAM STUDIO GALLERY, 1216 First Ave., Seattle WA 98101. (206)622-2480. Fax: (206)622-6383. E-mail: benham@halcyon.com. Website: http://www.halcyon.com/benham. Owner: Marita Holdaway. Estab. 1987.
Exhibits: Requirements: Call in December for review appointment in February. Examples of recent exhibitions: works by Paul Dahlquist (b&w nudes); b&w landscapes by Bruce Barnbaum; and "Uncommon Perspectives" (group show). Presents 12 shows/year. Shows last 1 month. Photographer's presence at opening preferred.
Making Contact & Terms: Interested in receiving work from newer to mid-career photographers. Charges 40% commission. Accepts images in digital format for Mac. Send via online or Zip disk. General price range: $175-2,000.

‡BONNI BENRUBI GALLERY, 52 E. 76th St., New York NY 10021. (212)517-3766. Fax: (212)288-7815. Director: Karen Marks. Estab. 1992.
Exhibits: Requirements: Portfolio review is the first Thursday of every month. Out-of-towners can send slides with SASE and work will be returned. Interested in 19th and 20th century photography, mainly contemporary. Examples of recent exhibitions: "Home & the World," by Abe Morell (b&w photography); "Inside," by Jean Kallina (b&w photography); and "A Voice for Change," by Lewis Hine (vintage photography). This gallery represents numerous photographers, including Merry Alpern, Dick Arentz, Andreas Feininger, Rena Bass Forman, Jean Kallina, Joel Meyerowitz and Abelardo Morell. Presents 7-8 shows/year. Shows last 6 weeks. Sponsors openings; provides announcements, wine and bartenders. Photographer's presence at opening required.
Making Contact & Terms: Interested in receiving work from newer, lesser-known photographers. Charges commission. Buys photos outright. General price range: $400-80,000. Reviews transparencies. Interested in mounted or unmounted work. Requires exclusive representation locally. No manipulated work. Submit portfolio for review. SASE. Reports in 1-2 weeks.

BERKSHIRE ARTISANS GALLERY, Lichtenstein Center for the Arts, 28 Renne Ave., Pittsfield MA 01201. (413)499-9348. Fax: (413)442-8043. E-mail: berkart@taconic.com. Artistic Director: Daniel M. O'Connell. Estab. 1975.
● This gallery was written up in a *Watercolors* magazine article, by Daniel Grant, on galleries that do open-jury selections.
Exhibits: Requirements: Professionalism in portfolio presentation, professionalism in printing photographs, professionalism. Examples of recent exhibitions: b&w portraits by Lisa Bartle; b&w prints by Angelique Antionue; and "Radicals," by David Ricci (color prints). Presents 10 shows/year. Sponsors openings; "We provide publicity announcements, artist provides refreshments." Artist's presence at opening and during shows preferred.
Making Contact & Terms: Interested in receiving work from newer, lesser-known photographers. Charges $25 fee plus 20% commission on sales. General price range: $50-1,500. Will review transparencies of photographic work. Interested in seeing framed, mounted, matted work only. "Photographer should send SASE with 20 slides or prints and résumé by mail only to gallery." SASE.
Tips: To break in, "Send portfolio, slides and SASE. We accept all art photography. Work must be professionally presented. Send in by July 1, each year. Expect exhibition 4-6 years from submission date. We have a professional juror look at slide entries once a year (usually July-September). Expect that work to be tied up for 6-8 months in jury." Sees trend toward "b&w and Cibachrome architectural photography."

MONA BERMAN FINE ARTS, 78 Lyon St., New Haven CT 06511. (203)562-4720. E-mail: mbfineart @snet.com. Director: Mona Berman. Estab. 1979.
● "We are primarily art consultants serving corporations, architects and designers. We also have private clients. We hold very few exhibits; we mainly show work to our clients for consideration and sell a lot of photographs."
Exhibits: Requirements: "Photographers must have been represented by us for over two years. Interested in all except figurative, although we do use some portrait work." Example of previous exhibit: "Suite Juliette," by Tom Hricko (b&w still life). Presents 0-1 exhibits/year. Shows last 1 month. Sponsors openings; provides all promotion. Photographer's presence at opening is required.
Making Contact & Terms: Interested in receiving work from newer, lesser-known photographers. Charges 50% commission. "Payment to artist 30 days after receipt of payment from client." General price range: $300 and up. Reviews 35mm transparencies only. Interested in seeing unframed, unmounted,

unmatted work only. Accepts images in digital format for Windows. Send via online or Zip disk. Submit portfolio for review (35mm slides only). Query with résumé of credits. Send material by mail for consideration (35mm slides with retail prices and SASE). Reports in 1 month.
Tips: "Have a variety of sizes, consistency, quality and a good amount of work available."

‡**JESSE BESSER MUSEUM**, 491 Johnson St., Alpena MI 49707. (517)356-2202. Chief of Resources: Robert Haltiner. Estab. 1965.
Exhibits: Interested in a variety of photos suitable for showing in general museum. Examples of exhibitions: "Ophthalmic Images," extreme color close-ups of the eye and its problems, by Csaba L. Martonyi; "One-Percent—To The Right," by Scott J. Simpson (color photography); "Fall-En Leaves: Primal Maps Home," by David Ochsner (Ilfochrome photography). Presents 1-2 shows/year. Shows last 6-8 weeks.
Making Contact & Terms: Interested in receiving work from newer, lesser-known photographers. Charges 20% sales commission. "However, being a museum, emphasis is not placed on sales, per se." Price range: $25-500. Reviews transparencies. Submit samples to Chief of Resources, Robert Haltiner. Framed work only. SASE for return of slides. Reports in 2 weeks. "All work for exhibit must be framed and ready for hanging. Send *good* slides of work with résumé and perhaps artist's statement. Trend is toward manipulative work to achieve the desired effect."
Tips: Most recently, northern Michigan scenes sell best.

‡**BLACKFISH GALLERY**, 420 NW Ninth Ave., Portland OR 97209. (503)224-2634. New Members Committee: Greg Conyne and Bob Swan. Estab. 1979.
Exhibits: Requirements: "Applicant must be willing to join the gallery. BlackFish is a cooperative gallery. Invitation fee is $150; monthly dues are $70, and member must be able to sit at the gallery 12-5 p.m. once per month." Interested in all types, subject to approval by membership. Examples of recent exhibitions: Tina Dworakowski (photos); and Nancy Helmsworth (photos, collage). Shows last 1 month. Sponsors openings; "Members greet guests so artist is free to talk with people." Photographer's presence at opening and during show required.
Making Contact & Terms: Charges 40% commission. General price range: $300. Interested in framed or unframed, mounted or unmounted, matted or unmatted work. Submit portfolio for review. Send material by mail for consideration. Include résumé of credits and galleries. SASE.
Tips: "Make sure the body of work submitted represents your most recent work."

‡**BOOK BEAT GALLERY**, 26010 Greenfield, Oak Park MI 48237. (810)968-1190. Fax: (810)968-3102. E-mail: bookbeat@aol.com. Director: Cary Lorey. Estab. 1982.
Exhibits: Requirements: Submit résumé, artist's statement, slide sheets and SASE for return of slides. Examples of recent exhibitions: "Male Nudes," by Bruce of Los Angeles; "Stills from Andy Warhol," by Billy Name (films); "Mr. Lotus Smiles," by Jeffrey Silverthorne (still life). Presents 6-8 shows/year. Shows last 1-2 months. Sponsors openings, provides invitations, press releases, food and wine. Photographer's presence at opening preferred.
Making Contact & Terms: Interested in receiving work from newer, lesser-known photographers. Charges 50% commission. Buys photos outright. General price range: $200-5,000. Reviews transparencies. Interested in framed or unframed, mounted or unmounted, matted or unmatted work. Arrange a personal interview to show portfolio. Query with samples. Send material by mail for consideration. SASE. Reports in 1-2 months.
Tips: "We have just published our first catalog and are marketing some of our photographers internationally. Photographers should display a solid portfolio with work that is figurative, documentary, surrealistic, off-beat, mythological or theatrical."

BOSTON CORPORATE ART, 470 Atlantic Ave., Boston MA 02210. Contact: Assistant to the Gallery Director. Estab. 1987. "The gallery shows group shows and doesn't follow conventional formats. We are an art consulting firm with a large open gallery space that is accessible to the public and our clients." Number of shows varies. Length of shows varies.
Making Contact & Terms: Charges 50% commission. General price range: $150-6,000. "In the event of a sale, the artist will be issued a purchase order which indicates to whom the art was sold. Payment will be issued in full when BCA receives payment from our client." Prefers slides. "When reviewing slides we look for work in all media, sizes and price ranges. We look for work that is appropriate for our corporate client market." Send slides by mail for consideration. Provide all necessary information with slides including all the sizes you can produce and the corresponding artist's price in writing for each dimension. SASE. Reports in 6-8 weeks.
Tips: "We curate some of the largest and most prestigious collections in New England and can provide terrific opportunities for artists." Boston Corporate Art is an advisory and consulting firm working with the corporate community in the areas of acquisition of fine art and commissioning of site-specific work.

Boston Corporate Art's client listing is diverse, representing large and small corporate collections, academic, restaurant and health care communities, as well as private collectors.

BROMFIELD ART GALLERY, (formerly Bromfield Gallery), 560 Harrison Ave., Boston MA 02118. (617)451-3605. Director of Exhibitions: Pennie Brantley.
Exhibits: Requirements: Usually shows New England artists. Interested in "programs of diversity and excellence." Presents 12 shows/year. Shows last 1 month.
Making Contact & Terms: Interested in receiving work from newer, lesser-known photographers. Rents gallery to artists ($650-750). Charges 50% commission. General price range: $200-2,000. Reviews transparencies. Interested in framed or unframed, mounted or unmounted, matted or unmatted work. Submit portfolio for review. Send material by mail for consideration. Reports in 1 month.
Tips: "We are looking to expand our presentation of photographers." There is a "small percentage of galleries handling photographers."

J.J. BROOKINGS GALLERY, 669 Mission St., San Francisco CA 94105. (415)546-1000. Director: Timothy C. Duran.
Exhibits: Requirements: Professional presentation, realistic pricing, numerous quality images. Interested in photography created with a painterly eye. Examples of exhibitions: James Crable, Lisa Gray, Duane Michals, Eberhard Grames, Misha Grodin, Irving Penn, Ben Schonzeit, Sandy Skoglund, Robert Glenn Ketchum and Todd Watts. Presents rotating group shows. Sponsors openings. Photographer's presence at opening preferred.
Making Contact & Terms: Charges 50% commission. General price range: $500-8,000. Reviews transparencies. Send material by mail for consideration. Reports in 3-5 weeks; "if not acceptable, reports immediately."
Tips: Interested in "whatever the artist thinks will impress us the most. 'Painterly' work is best. No documentary or politically-oriented work."

CALIFORNIA MUSEUM OF PHOTOGRAPHY, University of California, Riverside CA 92521. (909)787-4787. Fax: (909)787-4797. Website: http://www.cmp.ucr.edu. Director: Jonathan Green.
Exhibits: The photographer must have the "highest quality work." Examples of recent exhibitions: "How Great Thou Art: Photographs From Graceland," by Ralph Burns; "Beyond Light: the X-ray Photography of Albert C. Koetsler"; "Strange Eden," by Dean McNeil (large scale photographs of sculpture done as portraits). Presents 12-18 shows/year. Shows last 6-8 weeks. Sponsors openings; inclusion in museum calendar, reception.
Making Contact & Terms: Curatorial committee reviews transparencies and/or matted or unmatted work. Query with résumé of credits. Accepts images in digital format for Mac. Send via compact disc, or Zip disk. SASE. Reports in 90 days.
Tips: "This museum attempts to balance exhibitions among historical, technology, contemporary, etc. We do not sell photos but provide photographers with exposure. The museum is always interested in newer, lesser-known photographers who are producing interesting work. We're especially interested in work relevant to underserved communities. We can show only a small percent of what we see in a year. The CMP has moved into a renovated 23,000 sq. ft. building. It is the largest exhibition space devoted to photography in the West."

‡**WILLIAM CAMPBELL CONTEMPORARY ART**, Dept. PM, 4935 Byers Ave., Ft. Worth TX 76107. (817)737-9566. Owner/Director: William Campbell. Estab. 1974.
Exhibits: Requirements: An established record of exhibitions. "Primarily interested in photography which has been altered or manipulated in some form." Examples of previous exhibitions: A group show, "The Figure In Photography: An Alternative Approach," by Patrick Faulhaber, Francis Merritt-Thompson, Steven Sellars, Dottie Allen and Glenys Quick. Presents 8-10 shows/year. Shows last 5 weeks. Sponsors openings; provides announcements, press releases, installation of work, insurance, cost of exhibition. Photographer's presence during show preferred.
Making Contact & Terms: Charges 50% commission. General price range: $300-1,500. Reviews transparencies. Interested in framed or unframed work; mounted work only. Requires exclusive representation within metropolitan area. Send slides and résumé by mail. SASE. Reports in 1 month.

THE CANTON MUSEUM OF ART, 1001 Market Ave., Canton OH 44702. (216)453-7666. Executive Director: M.J. Albacete.
Exhibits: Requirements: "The photographer must send preliminary letter explaining desire to exhibit; send samples of work (upon our request); have enough work to form an exhibition; complete *Artist's Form* detailing professional and academic background, and provide photographs for press usage. We are interested

in exhibiting all types of quality photography, preferably using photography as an art medium, but we will also examine portfolios of other types of photography work as well: architecture, etc." Presents 2-5 shows/year. Shows last 6 weeks. Sponsors openings. Major exhibits (in galleries), postcard or other type mailer, public reception.

Making Contact & Terms: Charges commission. General price range: $50-500. Interested in exhibition-ready work. No size limits. Query with samples. Submit letters of inquiry first, with samples of photos. SASE. Reports in 2 weeks.

Tips: "We look for photo exhibitions which are unique, not necessarily by 'top' names. Anyone inquiring should have some exhibition experience, and have sufficient materials; also, price lists, insurance lists, description of work, artist's background, etc. Most photographers and artists do little to aid galleries and museums in promoting their works—no good publicity photos, confusing explanations about their work, etc. We attempt to give photographers—new and old—a good gallery exhibit when we feel their work merits such. While sales are not our main concern, the exhibition experience and the publicity can help promote new talents. If the photographer is really serious about his profession, he should design a press-kit type of package so that people like me can study his work, learn about his background, and get a pretty good concept of his work. This is generally the first knowledge we have of any particular artist, and if a bad impression is made, even for the best photographer, he gets no exhibition. How else are we to know? We have a basic form which we send to potential exhibitors requesting all the information needed for an exhibition. My article, 'Artists, Get Your Act Together If You Plan to Take it on the Road,' shows artists how to prepare self-promoting kits for potential sponsors, gallery exhibitors, etc. Copy of article and form sent for $2 and SASE."

CAPITOL COMPLEX EXHIBITIONS, Florida Division of Cultural Affairs, Department of State, The Capitol, Tallahassee FL 32399-0250. (904)487-2980. Fax: (904)922-5259. Arts Consultant: Katie Dempsey.

Exhibits: "The Capitol Complex Exhibitions Program is designed to showcase Florida artists and art organizations. Exhibition spaces include the Capitol Gallery (22nd floor), the Cabinet Meeting Room, the Old Capitol Gallery, and the Secretary of State's Reception Room. Exhibitions are selected based on quality, diversity of medium, and regional representation." Examples of recent exhibitions: Rick Wagner (b&w); Lee Dunkel (b&w); and Barbara Edwards (color). Shows last 3 months. Provides announcements and staff assistance for openings.

Making Contact & Terms: Interested in receiving work from newer, lesser-known photographers. Does not charge commission. Interested in framed work only. Request an application. SASE. Reports in 3 weeks.

SANDY CARSON GALLERY, 1734 Wazee, Denver CO 80202. (303)297-8585. Fax: (303)297-8933. Director: Denise Gleser. Estab. 1975.

Exhibits: Requirements: Professional, committed, body of work and continually producing new work. Interests vary. Examples of recent exhibitions: "We the People," by Rimma & Valeriy Gerlovin (color); "Recent Exposures," by Peter de Lory and others (b&w and color); photography by Thomas Harris, Carolyn Krieg, David Teplica, Rimma & Valeriy Gerlovin, Gary Isaacs (June 1996); Teresa Camozzi (photo collage). Shows last 6 weeks. Sponsors openings; reception and invitations. Photographer's presence at opening preferred; "Doesn't matter."

Making Contact & Terms: Interested in receiving work from newer, lesser-known photographers. Charges 50% commission. Reviews transparencies. Interested in framed or unframed, matted or unmatted work. Requires exclusive representation locally. Send material by mail for consideration. SASE. Reports in 1 month.

Tips: "We like an original point of view. Properly developed prints. Seeing more photography being included in gallery shows."

KATHARINE T. CARTER & ASSOCIATES, P.O. Box 2449, St. Leo FL 33574. (352)523-1948. Fax: (352)523-1949. New York: 24 Fifth Ave., Suite 703, New York NY 10011. Phone/fax: (212)533-9530. Website: http://www.ktcasso.com/ktcassoc.@icanect.net. Executive Director: Katharine T. Carter. Estab. 1985.

Exhibits: Requirements: Strong body of work, thematically developed over 2-year period; 30-40 works minimum in 1 area of investigation. Prefers "mature (40+) artists with statewide/regional reputations." Interested in all subject matter—traditional to innovative/experimental. Examples of recent exhibitions: James Hughson (b&w); Joan Rough (Cibachrome); and Sally Crooks (Polaroid). Presents 4 shows/year. Shows last 2-3 months. Sponsors openings; provides press and color announcement mailed to over 1,000 art professionals and collectors statewide/regionally. Artist must cover all round-trip shipping and insurance costs. Photographer's presence at opening preferred, not required.

Making Contact & Terms: Interested in reviewing work from lesser-known photographers. Charges

50% commission. Buys photos outright. General price range: $500-2,000. Reviews transparencies. Send résumé and slides. SASE.

Tips: "Katharine T. Carter & Associates is committed to the development of the careers of their artist/ clients. Gallery space is primarily used to exhibit the work of artists with whom long standing relationships have been built over several years."

CENTER FOR EXPLORATORY AND PERCEPTUAL ART, 700 Main St., 4th Floor, Buffalo NY 14202. (716)856-2717. Fax: (716)856-2720. E-mail: cepa@aol.com. Website: http://cepa.buffnet.net. Curator: Robert Hirsch. Estab. 1974. "CEPA is an artist-run space dedicated to presenting photographically based work that is under-represented in traditional cultural institutions."
- CEPA conducts an annual Emerging Artist Exhibition for its members. You must join the gallery in order to participate.

Exhibits: Requirements: Slides with detailed and numbered checklist, résumé, artist's statement, project proposal and SASE. The total gallery space is approximately 5,000 square feet. Interested in political, culturally diverse, contemporary and conceptual works. Examples of recent exhibitions: "Multiple Affinities: A Group Show," by 15 artists (convergence of printmaking and photographic practice); 3rd biennial photography auction exhibition; "Chambers of Enchantment: Recovery and Loss" a group show by 11 artists. Presents 5-6 shows/year. Shows last 6 weeks. Sponsors openings; reception with lecture. Photographer's presence at opening and during show preferred.

Making Contact & Terms: Extremely interested in exhibiting work of newer, lesser-known photographers. Charges 25% commission. General price range: $200-3,500. Reviews 10-20 transparencies. Interested in framed or unframed, mounted or unmounted, matted or unmatted work. Query with résumé of credits. Send artist's statement and material by mail for consideration. Accepts images in digital format for Mac (PICT or TIFF). Send via compact disc, floppy disk, or Zip disk. SASE. Reports in 3 months.

Tips: "We review CD-ROM portfolios and encourage digital imagery. We will be showcasing work on our website."

CENTER FOR PHOTOGRAPHY AT WOODSTOCK, 59 Tinker St., Woodstock NY 12498. (914)679-9957. Fax: (914)679-6337. Exhibitions Director: Kathleen Kenyon. Estab. 1977.

Exhibits: Interested in all creative photography. Examples of previous exhibitions: "Social Studies/Public Monument"; "Mirror-Mirror"; and "Picturing Ritual" (all were group shows). Presents 5 shows/year. Shows last 6 weeks. Sponsors openings.

Making Contact & Terms: Interested in receiving work from newer, lesser-known photographers. Charges 25% sales commission. Send 20 slides plus cover letter, résumé and artist's statement by mail for consideration. SASE. Reports in 4 months.

Tips: "We are closed Mondays and Tuesdays. Interested in contemporary and emerging photographers."

THE CENTRAL BANK GALLERY, Box 1360, Lexington KY 40590. In U.S. only (800)637-6884. In Kentucky (800)432-0721. Fax: (606)253-6244. Curator: John G. Irvin. Estab. 1987.

Exhibits: Requirements: No nudes and only Kentucky photographers. Interested in all types of photos. Examples of recent exhibitions: "Covered Bridges of Kentucky," by Jeff Rogers; "The Photography of John W. Snell"; and "The Desert Storm Series," by Brother Paul of the Abbey of Gethsemane. Presents 2-3 photography shows/year. Shows last 3 weeks. Sponsors openings. "We pay for everything, invitations, receptions and hanging. We give the photographer 100 percent of the proceeds."

Making Contact & Terms: Interested in receiving work from newer, lesser-known photographers. Charges no commission. General price range: $75-1,500. Query with telephone call. Reports back probably same day.

Tips: "We enjoy encouraging artists."

‡**CENTRAL CALIFORNIA ART LEAGUE GALLERY**, 1402 "I" St., Modesto CA 95354. (209)529-3369. Fax: (209)529-9002. E-mail: ccal@alnet.com. Gallery Director: Mary Gallagher. Estab. 1951.

Exhibits: Requirements: "Five members of the League judge submitted art work every other Wednesday of the month. New artists must submit five pieces, three of which must be accepted to have artist enter gallery." Interested in landmarks, landscapes and personalities of Central California. Photographer's presence at opening and during show preferred.

Making Contact & Terms: Charges 30% commission. Interested in framed or unframed, mounted, matted or unmatted work. Cannot return material.

‡**CHAPMAN ART CENTER GALLERY**, Cazenovia College, Cazenovia NY 13035. (315)655-9446. Fax: (315)655-2190. Director: John Aistars. Estab. 1978.

Exhibits: Requirements: Submit work by March 1. "Artist is responsible for delivery and pick-up of work

and for hanging of show." Photographer should submit résumé and other publicity information pertaining to the exhibition 3 weeks before opening date and statement of total insurance value of exhibit 3 days before opening; exhibit will be fully insured during exhibition. Interested in "a diverse range of stylistic approaches." Examples of recent exhibitions: "Bridge of Transparent Hours," by Leslie Yudelson (b&w surrealistic photos); Jeri Robinson (Cibachrome prints); Vera Scalingi (photo collage). Presents 1-2 shows/year. Shows last 3-4 weeks. Photographer's presence at opening and during show preferred. "The Cazenovia College Public Relations Office will publicize the exhibition to the news media and the Cazenovia College community, but if the artist wishes to schedule an opening or have printed invitations, it will have to be done by the artist at his/her own expense. College food service will provide a reception for a fee."

Making Contact & Terms: Charges no commission. General price range: $150-300. Reviews transparencies. Interested in framed or unframed, mounted or unmounted, matted or unmatted work. Send material by mail for consideration. SASE. Reports approximately 3 weeks after exhibitions committee meeting.

CHARLENE'S FRAMING AND GALLERY TEN, 514 E. State St., Rockford IL 61104. (815)963-1113. President: Gary Pearson. Estab. 1986.

Exhibits: "We look for quality in presentation; will review any subject or style. However, we are located in a conservative community so artists must consider that when submitting. We may show it, but it may not sell if it is of a controversial nature." Interested in fine art. Example of exhibitions: "Johnson Center Series," by Beth Jersild. Number of exhibits varies. Shows last 6 weeks. Sponsors openings; provides publicity, mailer and opening refreshments. Photographer's presence at opening preferred.

Making Contact & Terms: Very receptive to exhibiting work of newer, lesser-known photographers. Charges 40% commission. General price range: $50-300. Reviews transparencies. Interested in mounted or unmounted work, matted work. "We prefer 20 × 24 or smaller." Send material by mail for consideration. SASE. Reports in 1 month.

Tips: "Quality in framing and presentation is paramount. We cannot accept work to sell to our clients that will self destruct in a few years."

CLEVELAND STATE UNIVERSITY ART GALLERY, 2307 Chester Ave., Cleveland OH 44114. (216)687-2103. Fax: (216)687-2275. Director: Robert Thurmer. Estab. 1973.

Exhibits: Requirements: Photographs must be of superior quality. Interested in all subjects and styles. Looks for professionalism, creativity, uniqueness. Examples of recent exhibitions: "Re-Photo Construct," with Lorna Simpson; "El Salvador," by Steve Cagan; "In Search of the Media Monster," with Jenny Holzer; and "Body of Evidence: The Figure in Contemporary Photography," by Dieter Appelt, Cindy Sherman, Joel Peter Witkin and others, curated by Robert Thurmer (1995). Presents 0-1 show/year. Shows last 1 month. Sponsors openings; provides publicity, catalog or brochure, wine and cheese. Photographer's presence at opening and during show preferred.

Making Contact & Terms: Interested in receiving work from newer, lesser-known photographers. Charges 25% commission. General price range: $100-1,000. Reviews transparencies. Interested in framed or unframed, mounted or unmounted, matted or unmatted work. Send material by mail for consideration. SASE. Reports within 3 months.

Tips: "Write us! Do not submit oversized materials. This gallery is interested in new, challenging work—we are not interested in sales (sales are a service to artists and public)."

COASTAL CENTER FOR THE ARTS, INC., 2012 Demere Rd., St. Simons Island GA 31522. Phone/fax: (912)634-0404. Executive Director: Mittie B. Hendrix. Estab. 1946.

Exhibits: Requirements: Unframed work must be shrink-wrapped for bin; framed work must be ready for hanging. Looking for "photo art rather than 'vacation' photos." Examples of recent exhibitions: "Eye on Nature," by Joan Hartzeel (nature studies); "Photo National/96" and "Photoworks." Presents 2 shows/year. Shows last 3 weeks. Sponsors openings.

Making Contact & Terms: Interested in receiving work from newer, lesser-known photographers. Charges 30% commission to members; 40% to nonmembers. General price range: $25-625. Reviews transparencies. Interested in framed or unframed work. "We have seven galleries and can show photos of all sizes." Send slides and résumé of credits. SASE. Reports in 3-4 weeks.

Tips: "In 1995 a national juror selected computer art to be hung in our 42nd Artists' National, considered the year's premiere exhibit for the region. If framed, use a simple frame. Know what the gallery mission is—more fine art (as we are) or walk-in tourists (as others in the area). Use a good printer. Do not substitute other work for work selected by the gallery."

‡COCONINO CENTER FOR THE ARTS, P.O. Box 296, Flagstaff AZ 86002. (520)779-6921. Fax: (520)779-2984. E-mail: cca@thecanyon.com. Exhibit Coordinator and Director: Keye McCulloch. Estab. 1981.

Exhibits: Requirements: "Guidelines vary for six annual exhibits each year and are primarily regional

and statewide, but some are national. Guidelines might be aimed at specific populations: River Runners, Cowboys, Native Americans, etc. No solo shows; only group shows." Interested in various styles, from manipulated and experimental, installation and performance-related to photo documentation and realism. Examples of recent exhibitions that included photography: "For Arts Sake" (juried, regional, fine arts); "Festival of Native American Arts" (national, varied media); and "Trappings of the American West" (national, juried, varied media). Shows last 6-8 weeks. "We have no monies to assist artists, but offer the community a reception with patrons and members." Photographer's presence at opening preferred.

Making Contact & Terms: Charges 35% commission, "but sales are not a primary area of our concern." General price range: $100-400. Reviews transparencies only if exhibit-related—absolutely no originals. Interested in unframed mounted work only. Send résumé and credits. "Call first to see if there are show possibilities." Reporting time varies. "We like to keep material on file for up to two years when possible to help as we design exhibit ideas."

Tips: "We are a not-for-profit agency and our needs and interests are different from for-profit galleries. I would hope that we can provide a venue for new, unkown artists with occasional contact with masters (contemporary). But funding is the issue—as always."

COLLECTOR'S CHOICE GALLERY, 20352 Laguna Canyon Rd., Laguna Beach CA 92651-1164. Phone/fax: (714)494-8215 (call before faxing). E-mail: canyonco@aol.com. Director: Beverly Inskeep. Estab. 1979.

Exhibits: Interested in portraiture (young, old, individual, groups); and surrealism and computer-enhanced works. Examples of recent exhibitions: "Deceptions," by Bruns Griffiths (photo magic); "Portraits," by Glenn Aaron and D. Richardson (faces around world).

Making Contact & Terms: Interested in receiving work from newer, lesser-known photographers. Charges 40% commission. Buys photos outright. General price range: $15-2,000. Interested in unframed, unmounted and unmatted work only. Accepts images in digital format for Windows. Send via compact disc or online (150). Works are limited to unmounted, 13′ × 16′ largest. No minimum restrictions. Send material by mail for consideration. SASE. Reports in 3 weeks.

‡COMMENCEMENT ART GALLERY, 902 Commerce, Tacoma WA 98402-4407. (206)593-4331. Fax: (206)591-5232. Gallery Coordinator: Benjamin Meeker. Estab. 1993.

Exhibits: Requirements: Must be Washington resident. Interested in all subjects including sculptural and installation presentations. Examples of recent exhibitions: Betty Sapp-Ragan (cut and hand-colored shaped photographs); Liz Birkholz (narrative personal sculptural installation with found photographs); and John Tylczak (documentary and personal studies of logging communities). Presents 2-3 shows/year. Shows last 1 month. Sponsors openings; sends full-color postcard to mailing list of 1,500, food and beverages catered. Photographer's presence at opening preferred.

Making Contact & Terms: Does not charge commission. General price range: $300-1,500. Work limited to those finished to the floor. Ready to hang. Send résumé, 10 slides and slide list for entry into juried competition held in June of every year. No fee. Reports upon completion of jury process.

Tips: "A photographer with bad slides will never get a show. Spend as much time on your slides as you do on your work."

CONCEPT ART GALLERY, 1031 S. Braddock, Pittsburgh PA 15218. (412)242-9200. Fax: (412)242-7443. Director: Sam Berkovitz. Estab. 1972.

Exhibits: Desires "interesting, mature work." Work that stretches the bounds of what is perceived as typical photography. Examples of exhibitions: "Home Earth Sky," by Seth Dickerman and "Luke Swank," selected photos.

Making Contact & Terms: Very interested in receiving work from newer, lesser-known photographers. Payment negotiable. Reviews transparencies. Interested in unmounted work only. Requires exclusive representation within metropolitan area. Send material by mail for consideration. SASE.

Tips: "Mail portfolio with SASE for best results. Will arrange appointment with artist if interested." Sees trend toward "crossover work."

THE CONTEMPORARY ARTS CENTER, Dept. PR, 115 E. Fifth St., Cincinnati OH 45202. (513)345-8400. Fax: (513)721-7418. Contact: Curator. Nonprofit arts center.

THE DIGITAL MARKETS INDEX, located in the back of this book, lists markets that use images electronically.

Exhibits: Requirements: Photographer must be selected by the curator and approved by the board. Interested in avant garde, innovative photography. Examples of recent exhibits: "It's Only Rock and Roll: Rock and Roll Currents in Contemporary Art"; "Humongolous: Works by Tim Hawkinson"; and "Is It Art: Transgressions in Contemporary Art." Presents 1-3 shows/year. Shows last 6-12 weeks. Sponsors openings; provides printed invitations, music, refreshments, cash bar. Photographer's presence at opening preferred.
Making Contact & Terms: Photography sometimes sold in gallery. Charges 15% commission. General price range: $200-500. Reviews transparencies. Send query with résumé and slides of work. SASE. Reports in 2 months.

THE COPLEY SOCIETY OF BOSTON, 158 Newbury St., Boston MA 02116. (617)536-5049. Gallery Manager: Jason M. Pechinski. Estab. 1879. A nonprofit institution.
Exhibits: Requirements: Must apply and be accepted as an artist member. Once accepted, artists are eligible to compete in juried competitions. Guaranteed showing once a year in small works shows. There is a possibility of group or individual shows, on an invitational basis, if merit exists. Interested in all styles. Examples of exhibitions: portraiture by Al Fisher (b&w, platinum prints); landscape/exotic works by Eugene Epstein (b&w, limited edition prints); and landscapes by Jack Wilkerson (b&w). Presents various number of shows/year. Shows last 3-4 weeks. Sponsors openings for juried shows by providing refreshments. Does not sponsor openings for invited artists. Photographer's presence at opening required. Photographer's presence during show required for invited artists, preferred for juried shows. Workshops and critiques offered.
Making Contact & Terms: Interested in receiving work from newer, lesser-known photographers. Charges 40% commission. General price range: $100-10,000. Reviews transparencies. Interested in framed work only. Request membership application. Quarterly review deadlines.
Tips: Wants to see "professional, concise and informative completion of application. The weight of the judgment for admission is based on quality of slides. Only the strongest work is accepted."

CREATIONS INTERNATIONAL FINE ARTS GALLERY, P.O. Box 492, New Smyrna Beach FL 32170-0492. Phone/fax: (904)673-8778. E-mail: 2bhy42a@peedigo. Website: http://ourworld.compuserve.com/homepages/creations-International-Gallery. Owner: Benton Ledbetter. Director: Vickie Haer. Estab. 1984.
Exhibits: Requirements: Submit bio indicating past shows, awards, collectors, education, and any other information that will help present the artist and the work. "There are no limits in the world of art, but we do keep it clean here due to the large numbers of children and families that visit Creations International each year." Recent exhibitions by Michael Starry, Benton Ledbetter and Gaetan Charbonneau. Presents 12 shows/year. Shows last 1 month. Sponsors openings; hosted by international award winner Benton Ledbetter along with the participating artists. Refreshments supplied. Photographer's presence at opening and during show preferred.
Making Contact & Terms: Interested in receiving work from newer, lesser-known photographers. Charges 25% commission. General price range: $50 and up. Reviews transparencies. Interested in framed or unframed, mounted or unmounted, matted or unmatted work. Accepts images in digital format (35mm). Send via compact disc, online, floppy disk or Zip disk. Send material by mail for consideration. Send in any way possible. SASE. Reports in 1 month.
Tips: "We currently have 30 Web pages and are up to date with the new computer trends. We represent work by slide registry and disk registry and train other businesses to use computers for their market needs. Be faithful to your work as an artist and keep working at it no matter what."

CROSSMAN GALLERY, University of Wisconsin-Whitewater, 950 W. Main St., Whitewater WI 53190. (414)472-5708. Director: Michael Flanagan. Estab. 1971.
Exhibits: Requirements: Résumé, artist's statement, list insurance information, 10-20 slides, work framed and ready to mount and have 4×5 transparencies available. "We primarily exhibit artists from the Midwest." Interested in all types, especially Cibachrome as large format and controversial subjects. Examples of recent exhibitions: "Color Photography Invitational," by Regina Flanagan, Leigh Kane and Janica Yoder. Presents 1 show biannually. Shows last 3-4 weeks. Sponsors openings; provides food, beverage, show announcement, mailing, shipping (partial) and possible visiting artist lecture/demo. Photographer's presence at opening preferred.
Making Contact & Terms: Call for application guidelines and deadlines for submitting proposals. Buys photos outright. General price range: $250-2,800. All media accepted. Reviews transparencies. Interested in framed and mounted work only. Send material by mail for consideration. SASE. Reports in 1 month.
Tips: "The Crossman Gallery's main role is to teach. I want students to learn about themselves and others in alternative ways; about social and political concerns through art."

DALLAS VISUAL ART CENTER, 2917 Swiss Ave., Dallas TX 75204. (214)821-2522. Fax: (214)821-9103. Executive Director: Katherine Wagner. Estab. 1981.
Exhibits: Requirements: a résumé, cover letter, slides and a SASE; photographer must be from Texas. Interested in all types. Examples of recent exhibitions: "World View" (group show of noted Dallas photographers); Mosaics series by Pablo Esparza (b&w/airbrushed). Presents variable number of shows (2-3)/year. Shows last 3-6 weeks.
Making Contact & Terms: Charges no commission (nonprofit organization). Reviews transparencies. Send material by mail for consideration. SASE. Reports in 1 month.
Tips: "We have funding from Exxon Corporation to underwrite exhibits for artists who have incorporated their ethnic heritage in their work; they should make a note that they are applying for the Mosaics series. (We have a Collector series which we underwrite expenses. All submissions are reviewed by committee.) Other gallery space is available for artists upon slide review. We have a resource newsletter that is published bimonthly and contains artist opportunities (galleries, call for entries, commissions) available to members (membership starts at $35)."

DE HAVILLAND FINE ART, 39 Newbury St., Boston MA 02116. (617)859-3880. Fax: (617)859-3973. Website: http://www.ArtExplorer.com. Gallery Director: Jennifer Gilbert. Estab. 1989.
Exhibits: Interested in mixed media, photo manipulation, Polaroid transfers, etc. Shows only New England artists. Presents 10 shows/year. Shows last 2 weeks. Sponsors openings. Photographer's presence at opening preferred.
Making Contact & Terms: Interested in receiving work from emerging and midcareer photographers. Charges 50% commission. General price range: $200-2,000. Reviews transparencies. Interested in framed, mounted or matted work. "We prefer work that is matted and framed. Shape and size is of no particular consideration." Submit portfolio for review. SASE. Reports in 1 month.
Tips: "The public is becoming more interested in photography. It must be unique, consistant and outstanding. Representation is very competitive. Located in the first block of Boston's exclusive Newbury Street, our gallery has been featured in dozens of publications as well as on NBC News for it's innovative support of emerging artists through video tapes."

TIBOR DE NAGY GALLERY, 724 Fifth Ave., New York NY 10019. (212)262-5050. Fax: (212)421-3731. Directors: Eric Brown and Andrew Arnot. Estab. 1950.
Exhibits: Interested in figures, nature, collages. Examples of recent exhibitions: "Photographs," by Allen Ginsberg and "A Photo Retrospective," by Rudy Burckhardt. Presents 2 shows/year. Shows last 1 month. Sponsors openings for gallery artists only. Photographer's presence at opening and during show preferred.
Making Contact & Terms: Charges 50% commission. General price range: $900-2,600. Not currently reviewing photographs. Requires exclusive representation locally. SASE.

‡EASTERN SHORE ART CENTER, 401 Oak St., Fairhope AL 36532. (334)928-2228. Fax: (334)928-5118. Director: B.G. Hinds. Estab. 1961.
Exhibits: Examples of recent exhibitions: Ken Cranton (color, primarily landscapes); Lee Owens (b&w portraits); and Todd Bertolet (b&w landscapes). Shows last 1 month. Sponsors openings on first Sunday of every month; provides food, beverages and publicity. Photographer's presence at opening preferred.
Making Contact & Terms: Charges 25% commission. General price range: $25-1,000. Reviews transparencies. Interested in framed work only Works are limited to 7'5" height, no width restriction. Send material by mail for consideration. SASE. Reports in 1 month.
Tips: "Be willing to schedule far in advance. If interested in sales, keep prices below $200 (good market for art, but photos don't sell terribly well here.)"

CATHERINE EDELMAN GALLERY, Lower Level, 300 W. Superior, Chicago IL 60610. (312)266-2350. Fax: (312)266-1967. Director: Catherine Edelman. Estab. 1987.
Exhibits: "We exhibit works ranging from traditional landscapes to painted photo works done by artists who use photography as the medium through which to explore an idea." Requirements: "The work must be engaging and honest." Examples of recent exhibitions: work of Joel-Peter Witkin; Michael Kenna; Lynn Geesman. Presents 9 exhibits/year. Shows last 4-5 weeks. Sponsors openings; free drinks. Photographer's presence at opening preferred.
Making Contact & Terms: Charges 50% commission. General price range: $500-8,000. Reviews transparencies. Requires exclusive representation within metropolitan area. Send material by mail for consideration. SASE. Reports in 2 weeks.
Tips: Looks for "consistency, dedication and honesty. Try to not be overly eager and realize that the process of arranging an exhibition takes a long time. The relationship between gallery and photographer is a partnership."

PAUL EDELSTEIN GALLERY, 519 N. Highland, Memphis TN 38122-4521. (901)454-7105. Director/Owner: Paul R. Edelstein. Estab. 1985.
Exhibits: Interested in 20th century photography "that intrigues the viewer"—figurative still life, landscape, abstract—by upcoming and established photographers. Examples of exhibitions: vintage b&w and color prints by William Eggleston; "Mind Visions," by Vincent de Gerlando (figurative); "Eudora Welty Portfolio," by Eudora Welty (figurative); and "Still Lives," by Lucia Burch Dogrell. Shows are presented continually throughout the year.
Making Contact & Terms: Interested in receiving work from newer, lesser-known photographers. Charges 30-40% commission. Buys photos outright. General price range: $400-5,000. Reviews transparencies. Interested in framed or unframed, mounted or unmounted, matted or unmatted work. There are no size limitations. Submit portfolio for review. Query with samples. Cannot return material. Reports in 3 months.

ELEVEN EAST ASHLAND (Independent Art Space), 11 E. Ashland, Phoenix AZ 85004. (602)257-8543. Director: David Cook. Estab. 1986.
Exhibits: Requirements: Contemporary only (portrait, landscape, genre, mixed media in b&w, color, non-silver, etc.); photographers must represent themselves, complete exhibition proposal form and be responsible for own announcements. Interested in "all subjects in the contemporary vein—manipulated, straight and non-silver processes." Examples of recent exhibitions: works by Colleen Rock (roctography); Neal Graham (b&w photos); and a Cook/Harris collaboration (hand-colored). Presents 13 shows/year. Shows last 3 weeks. Sponsors openings; two inhouse juried/invitational exhibits/year. Photographer's presence during show preferred.
Making Contact & Terms: Very receptive to exhibiting work of newer, lesser-known photographers. Charges 25% commission. General price range: $100-500. Reviews transparencies. Interested in framed or unframed, mounted or unmounted, matted or unmatted work. Shows are limited to material able to fit through the front door and in the $4' \times 8'$ space. Query with résumé of credits. Query with samples. SASE. Reports in 2 weeks.
Tips: "Sincerely look for a venue for your art, and follow through. Search for traditional and non-traditional spaces."

AMOS ENO GALLERY, 594 Broadway, #404, New York NY 10012. (212)226-5342. Director: Jane Harris. Estab. 1974.
Exhibits: "This is a nonprofit cooperative gallery. Generally, we only exhibit the work of our members except for our annual small works juried exhibition and selected exchanges and invitationals. We only represent 3 photographers out of 34 artists at this time." Open to all styles. Examples of recent exhibitions: "Watershed Investigations II," by Mark Abrahamson (aerial landscape, Cibachrome prints); "Paper" (group show of b&w photos); "Nothing Serious" (group show of b&w and color prints). Presents 1 photography show/year. Shows last 3 weeks. Photographer's presence at opening required.
Making Contact & Terms: Interested in receiving work from newer, lesser-known photographers. Charges 20% commission. General price range: $250-600. Interested in framed work only. Request information sheet first. If interested in applying for membership, send slides, résumé, statement and cover letter. Reviews slides on the third Saturdays of January, March, May, July and September.

‡**ETHERTON GALLERY**, (formerly Etherton/Stern Gallery), 135 S. 6th Ave., Tucson AZ 85701. (502)624-7370. Fax: (502)792-4569. Director: Terry Etherton. Estab. 1981.
• Etherton Gallery regularly purchases 19th Century, vintage, Western survey photographs and Native American portraits.
Exhibits: Photographer must "have a high-quality, consistent body of work—be a working artist/photographer—no 'hobbyists' or weekend photographers." Interested in contemporary photography with emphasis on artists in Western and Southwestern US. Examples of exhibitions: "The Sacred and Secular"; aerial photography by Marilyn Bridges; photographs by Paul Caponigro and Dick Arentz; and mixed-media photographs by Keith McElroy. Presents 10 shows/year. Shows last 6 weeks. Sponsors openings; provides wine and refreshments, publicity, etc. Photographer's presence at opening and during show preferred.
Making Contact & Terms: Does not accept unsolicited submissions. Charges 50% commission. Occasionally buys photography outright. General price range: $200-20,000. Reviews transparencies. Interested in matted or unmatted, unframed work. Please send portfolio by mail for consideration. SASE. Reports in 3 weeks.
Tips: "You must be fully committed to photography as a way of life. You should be familiar with the photo art world and with my gallery and the work I show. Please limit submissions to 20, showing the best examples of your work in a presentable, professional format; slides preferred."

FAVA (Firelands Association for the Visual Arts), New Union Center for the Arts, 39 S. Main St., Oberlin OH 44074. (216)774-7158. Fax: (216)774-7158. Gallery Director: Susan Jones. Estab. 1979. **Exhibits:** Open to all media, including photography. Presents 1 regional juried photo show/year ("Six-State Photography)." Open to residents of Ohio, Kentucky, West Virginia, Pennsylvania, Indiana, Michigan. Deadline for applications: February. Send annual application for 5 invitational shows by October 15 of each year; include 15-20 slides, résumé, slide list. Shows last 1 month. Sponsors receptions; produces and mails announcements and provides refreshments. Photographer's presence at opening preferred. **Making Contact & Terms:** Interested in receiving work from newer, lesser-known photographers. Charges 30% commission. General price range: $100-1,000. Interested in framed or unframed, mounted, matted work. Send SASE for "Exhibition Opportunity" flier or Six-State Show entry form. **Tips:** "As a nonprofit gallery, we do not represent artists except during the show."

‡**FIELD ART STUDIO**, 24242 Woodward Ave., Pleasant Ridge MI 48069-1144. (810)399-1320. Fax: (810)399-7018. Owner: Jerome S. Feig. Estab. 1950. **Exhibits:** Requirements: Gallery approval of subject matter. Presents 6-8 shows/year. Shows last 1 month. Sponsors openings; provides announcements and refreshments. Photographer's presence at opening and during show preferred. **Making Contact & Terms:** Charges 40% commission. Reviews transparencies. Interested in framed or unframed work. Requires exclusive representation locally. Works are limited to maximum 30×40. Query with samples. SASE. Reports in 1-2 weeks.

FOCAL POINT GALLERY, 321 City Island Ave., New York NY 10464. (718)885-1403. Photographer/ Director: Ron Terner. Estab. 1974. **Exhibits:** Open to all subjects, styles and capabilities. "I'm looking for the artist to show me a way of seeing I haven't seen before." Nudes and landscapes sell best. Examples of recent exhibitions: Judith Vejvoda (b&w landscapes); Richard Zoller (b&w); Dan McCormack (platinum nudes). Photographer's presence at opening preferred. **Making Contact & Terms:** Very receptive to exhibiting work of newer, lesser-known photographers. Charges 30% sales commission. General price range: $175-700. Artist should call for information about exhibition policies. **Tips:** Sees trend toward more use of alternative processes. "The gallery is geared toward exposure— letting the public know what contemporary artists are doing—and is not concerned with whether it will sell. If the photographer is only interested in selling, this is not the gallery for him/her, but if the artist is concerned with people seeing the work and gaining feedback, this is the place. Most of the work shown at Focal Point Gallery is of lesser-known artists. Don't be discouraged if not accepted the first time. But continue to come back with new work when ready."

ADRIENNE FORD GALLERY, 115 E. Mobile St., Florence AL 35630. (205)764-8366. Fax: (205)381- 1283. Art Consultant: Virginia Kingsley. Estab. 1993. **Exhibits:** Requirements: Must be under exclusive contract in Lauderdale, Colbert and Franklin counties in Alabama and must pass jury selection. Interested in all types of work appropriate for north Alabama market, including landmarks, landscapes, humor, people (with release only), animals and mixed media. Examples of recent exhibitions: "Handy Festival Musicians," by Shannon Wells; and "New Work," by Wayne Sides and work by various college age photographers plus one show for age 15 and under. Presents 1 show/year. Shows last 1 month. Sponsors openings; provides press, publicity, food, invitations for 50% show commission. Photographer's presence at opening preferred. **Making Contact & Terms:** Interested in receiving work from newer, lesser-known photographers. Charges 40% commission after show. General price range: $25-250. Pays within first 10 days of month following the sale. Reviews transparencies. Interested in framed, matted or unmatted work. Shrink wrap if accepted. Requires exclusive representation locally. No size limits. Arrange a personal interview to show portfolio. Submit portfolio for review. Query with résumé of credits. Query with samples. Send material by mail for consideration. Call before you send slides and send résumé with slides. Make an appointment with appropriate gallery personnel at least 1 week in advance to show work. Bring a good representation of work. Bring résumé and biography to appointment. SASE. Reports in 3 weeks.

THE SUBJECT INDEX, located at the back of this book, lists publications, book publishers, galleries, paper product companies and stock agencies according to the subject areas they seek.

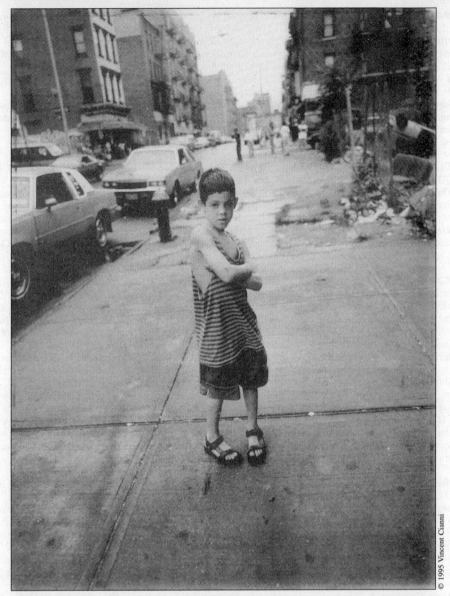

© 1995 Vincent Cianni

Focal Point Gallery's "The Southside Portraits" collection features Vincent Cianni's piece, *Young Homeboy, Bedford Avenue, Williamsburg, Brooklyn 1995*. The photo appeared in *Viewfinder*, Focal Point's catalog of exhibits spanning 1974-1996. "The face, clothing and posturing exude and communicate the pride, self-assuredness and inquisitiveness of this young version of a full-fledged male," says Cianni of his child subject. "He affects, at the same time, an arrogance and vulnerability, naivete and feigned maturity."

Tips: "We prefer to meet the photographer and see actual work, preferably a solid representation of a complete body of work." CD-ROM, video OK.

‡FOUNDRY GALLERY, 9 Hillyer Court NW, Washington DC 20008-1930. (202)387-0203. Fax: (202)387-2613. Director: Marcia M. Mayne. Estab. 1971.
Exhibits: Requirements: "We are a membership gallery." Example of recent exhibition: KB Basseches (Polaroid transfer photo collage). Shows last 3-4 weeks. Photographer's presence at opening required.
Making Contact & Terms: Charges 30% commission. General price range: maximum $300. Interested

in framed or unframed work. SASE. Reports in 1 month.

FRAGA FRAMING & ART GALLERY, 4532 Magazine St., New Orleans LA 70115. (504)899-7002. Fax: (504)834-5045. E-mail: fraga@mail.gnofn.org. President: Grace Fraga. Estab. 1992.
Exhibits: Requirements: Must be established for a minimum of 3 years. Interested in any kind of subject matter and style, especially unique, innovative styles. Examples of recent exhibitions: erotic photography by Michael White (distorted color images); Dorien Romer (11 × 14 color documentary images); "Nice Shots," by Steven Snyder, Michael White and Dorien Romer (documentary); and Steven Snyder (11 × 14 b&w nudes and documentary). Presents 1-3 shows/year. Shows last 1-2 months. Sponsors openings; artist provides announcements and gallery provides advertising and refreshments. Photographer's presence at opening and during show required.
Making Contact & Terms: Interested in receiving work from newer, lesser-known photographers. Charges 50% commission. General price range: $200-600. Reviews transparencies. Interested in framed or unframed work. Submit portfolio for review; call for appointment or mail with SASE. Requires exclusive representation locally. Works are limited to maximum 16 × 20 image. SASE. Reports in 2-3 months.

FREEPORT ARTS CENTER, (formerly Freeport Art Museum & Cultural Center), 121 N. Harlem Ave., Freeport IL 61032. Phone/fax: (815)235-9755. Director: Becky Connors. Estab. 1976.
Exhibits: Examples of recent exhibitions: "Art Bytes," group show (computer art and digitally composed photographs); "Au Naturel," group show (wildlife photos and carvings). Presents 1 or 2 shows/year. Shows last 2 months. Sponsors openings on Friday evenings. Pays mileage. Photographer's presence at opening required. All artists are eligible for solo or group shows.
Making Contact & Terms: Exhibits works by established or lesser-known photographers. Charges 20% commission. Reviews transparencies or photographs. Interested in framed work only. Send material by mail for consideration. SASE. Reports in 3 months.

FULLER LODGE ART CENTER AND GALLERY, 2132 Central Ave., Los Alamos NM 87544. (505)662-9331. Director: Gloria Gilmore-House. Estab. 1977.
Exhibits: Presents 10-11 shows/year, 3 of which are juried, one exclusively for photography. Shows last 4-5 weeks. For more information and prospectus send SASE. Examples of recent juried exhibitions: "Que Pasa: Art in New Mexico," T.K. Thompson (gelatin silver prints) and Marcia Reifman (photo transfer); "1995 Biennial: Regional Art (Texas, Oklahoma, Colorado, Arizona, Utah and New Mexico)," first prize and Grumbacher medal to photographer Virginia Lee Lierz (photo transfer). Annual exhibit exclusively for photography is "Through the Looking Glass." Initiated in 1993 as a national show. Cash awards and ribbons are presented. Exhibit juried from transparencies; awards decided upon actual pieces. Interested in all styles and genres.
Making Contact & Terms: Interested in receiving work from newer, lesser-known photographers. Charges 30% commission. General price range: $75-300. Interested in framed or unframed, mounted or unmounted work. Query with résumé of credits. SASE. Reports in 3 weeks.
Tips: "Be aware that we never do one-person shows—artists will be used as they fit into scheduled shows. Work should show impeccable craftsmanship."

GALERIA MESA, P.O. Box 1466, 155 N. Center, Mesa AZ 85211-1466. (602)644-2056. Fax: (602)644-2901. Website: http://www.artresources.com. Contact: Curator. Estab. 1980.
Exhibits: Interested in contemporary photography as part of its national juried exhibitions in any and all media. Examples of recent exhibitions: "Un-Portrait," by Donald Scavarda (autobiographical); "Image Conscious," by 35 artists (nationally juried); "Out and About Landscape," by Tom Strich, Chris Burkett, Laurie Lundquist (internationally juried); and "Reality Check," by several artists (nationally juried). Presents 7-9 national juried exhibits/year. Shows last 4-6 weeks. Sponsors openings; refreshments and sometimes slide lectures (all free).
Making Contact & Terms: Interested in receiving work from emerging photographers. Charges 25% commission. General price range: $300-800. Interested in seeing slides of all styles and aesthetics. Slides are reviewed by changing professional jurors. Must fit through a standard size door and be ready for hanging. Enter national juried shows; awards total $1,500. SASE. Reports in 1 month.
Tips: "We do invitational or national juried exhibits only. Submit professional quality slides."

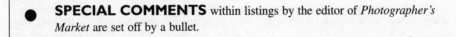

● **SPECIAL COMMENTS** within listings by the editor of *Photographer's Market* are set off by a bullet.

‡GALERIA SAN FRONTERAS, 1701 Guadalupe, Austin TX 78701. Phone/fax: (512)478-9448. Website: http://www.10.com/ngsf. Director: Susana Monteverole. Estab. 1986.
Exhibits: Requirements: Send contact sheets, working prints or slides for review; must include artist's statement and price list. Interested in photojournalism, especially work that documents Mexicans, Mexican-Americans, migrant workers, etc. Examples of recent exhibitions: "Holiday Extravaganza," by Alan Pogue (b&w documentary); "Hasta la Victoria," by Byron Brauchli (b&w photos of deforestation in Mexico). Presents 1 show/year. Shows last 10 weeks. Sponsors openings; provides b&w invitations, food and drink. Photographer's presence at opening required, presence during show preferred.
Making Contact & Terms: Interested in receiving work from newer, lesser-known photographers. Charges 50% commission. General price range: $100-1,000. Reviews transparencies. Requires exclusive representation locally. Query with samples. "Make an appointment. Don't expect to walk in and get an interview." Reports in 1 month.
Tips: The gallery deals in contemporary Mexican/Latino art."

‡GALLERY 825/LA ART ASSOCIATION, 825 N. La Cienega Blvd., Los Angeles CA 90069. (310)652-8272. Fax: (310)652-9251. Director: Amy Perez. Assistant Director: Rachel Pinto. Estab. 1924.
Exhibits: Requirements: Must "go through membership screening conducted twice a year; contact the gallery for dates. Shows are group shows." Interested in Southern Californian artists—all media. Examples of recent exhibitions: "Nature (re)Contained," by Bob Sanov (b&w nature); "Objects/Images/Ideas," by Nick Capito (sepia-toned b&w urban landscape); and Gary Rosenblum (color Polaroid abstracts). Presents 6-11 shows/year. Shows last 3-5 weeks. Sponsors openings; provides wine/cheese. Photographer's presence at opening and during show preferred.
Making Contact & Terms: Charges 33% commission. General price range: $150-7,500. Reviews transparencies on screening dates. Interested in framed or unframed, mounted or unmounted, matted or unmatted work. Works are limited to 100 lbs. Submit 3 pieces during screening date. Reports immediately following screening.

‡GALLERY OF ART, UNIVERSITY OF NORTHERN IOWA, Cedar Falls IA 50614-0362. (319)273-6134. Estab. 1976. Interested in all styles of high-quality contemporary art and photojournalistic works.
Exhibits: Example of recent exhibitions: Magic Silver Show (juried national show). Presents average of 4 shows/year. Shows last 1 month. Open to the public.
Making Contact & Terms: Work presented in lobby cases. "We do not often sell work; no commission is charged." Will review transparencies. Interested in framed or unframed work, mounted and matted work. May arrange a personal interview to show portfolio, résumé and samples. Send material by mail for consideration or submit portfolio for review. SASE. Reporting time varies.

‡GALLERY ONE, INC., 408½ N. Pearl St., Ellensburg WA 98926. (509)925-2670. Director: Eveleth Green. Estab. 1968.
Exhibits: Requirements: "Photographs must be framed and wired, ready to hang. We need to see slides or photos of work to be exhibited or displayed in one of our three sales rooms." Interested in "any subject that is in good taste. Patrons seem to enjoy b&w and color landscapes." Examples of recent exhibitions: Steve Solinsky from California (color photos); James Sahlstrand from Washington (variety of subject matter); and Rob Fraser from New York (rodeo action photographs). Shows last 3½ weeks. Sponsors openings. "We send exhibit announcements to our gallery members and to 12-15 friends of the artist. We serve punch and nuts and coffee (during cold weather)." Photographer's presence at opening preferred "but not absolutely necessary."
Making Contact & Terms: Charges 30% commission. General price range: $150-300. Reviews transparencies. Interested in framed work only. Requires exclusive representation locally. Submit portfolio for review. Query with résumé of credits. Query with samples. SASE. Reports in 1-2 weeks.

‡GALLERY 218/WALKER'S POINT ARTISTS, 218 S. Second St., Milwaukee WI 53204. (414)277-7800. E-mail: jhooks@omnifest.uwm.edu. President: Judith Hooks. Estab. 1990.
Exhibits: Requirements: Must be a member for 1 month before exhibiting. Membership dues: $45/year. Artists help run the gallery. Group and solo shows available. Interested in avante-garde and other type photos except commercial shots. Photography is shown alongside fine arts painting, printmaking, sculpture, etc. Examples of recent exhibitions: Fred Stein (hand-colored photographs); Andris Strazdiris (conceptual photo stats); and Waswo (sepia-toned travel diary from around the world). Presents 1 show/year. Show lasts 1 month. Sponsors openings. "If a group show, we make arrangements and all artists contribute if they wish. If a solo show, artist provides everything." Photographer's presence at opening and during show required.
Making Contact & Terms: Charges 25% commission. General price range: $100-650. Reviews trans-

parencies. Interested in framed work only. Query with samples. Send material by mail for consideration. Include membership application, or SASE. Reports in 1 month or "as soon as we can."
Tips: "Get involved in the process if the gallery will let you. We require artists to help promote their shows so that they learn what and why certain things are required. Have inventory ready."

GALMAN LEPOW ASSOCIATES, INC., Unit #12, 1879 Old Cuthbert Rd., Cherry Hill NJ 08034. (609)354-0771. Fax: (609)428-7559. Principals: Elaine Galman and Judith Lepow. Estab. 1979.
Making Contact & Terms: Interested in reviewing work from newer, lesser-known photographers. General price range is open. Reviews transparencies. Interested in seeing matted or unmatted work. No size limit. Query with résumé of credits. Visual imagery of work is helpful. SASE. Reports in 3 weeks.
Tips: "We are corporate art consultants and use photography for our clients."

FAY GOLD GALLERY, 247 Buckhead Ave., Atlanta GA 30305. (404)233-3843. Fax: (404)365-8633. Owner/Director: Fay Gold. Estab. 1981.
Exhibits: Contemporary fine art photography by established artists. Holds monthly photography exhibitions. In addition, the gallery maintains a major inventory of vintage and recent prints for beginning and advanced collectors, museums and institutions.
Making Contact & Terms: Send slides, résumé and artist's statement with SASE for weekly review. Terms discussed on an individual basis.
Tips: "Please do not send original material for review."

GOMEZ GALLERY, 836 Leadenhall St., Baltimore MD 21230. (410)752-2080. Fax: (410)752-2082. E-mail: walter@gomez.com. Website: http://www.gomez.com. Directors: Walter Gomez and Diane DiSalvo. Contact: Director. Estab. 1988.
Exhibits: Interested in work exploring human relationships or having psychological dimensions. Provocative work accepted. "Work must be contemporary, experimental, innovative. We will not accept traditional nude or portraiture work. Innovative figurative photography, male and female, is a particular direction." Photographers represented include: Connie Imboden, Robert Flynt, Stephen John Phillips, Jose Villarrubia, Mary Wagner, Frank Yamrus, Dan Burkholder, Stephen John Phillips and Geraldo Sutter. Presents 10 photo shows/year. Shows last 1 month. Sponsors openings; provides advertising, mailings, opening receptions.
Making Contact & Terms: Interested in reviewing work from newer, lesser-known photographers and from established photographers. Charges 50% commission. General price range: $150-3,000. "Initially will only review transparencies and résumé; may later request to see actual work." Requires exclusive representation within metropolitan area or Mid-Atlantic region." No "walk-ins" please. SASE. Reports 1-2 months.
Tips: "We currently are redesigning our gallery to devote a room exclusively to photography and are looking for new work. If it's already been done, or is traditional nudes, or lacks a focus or purpose, we are not the gallery to contact! We find that more provocative figurative work sells best."

WELLINGTON B. GRAY GALLERY, East Carolina University, Greenville NC 27858. (919)328-6336. Fax: (919)328-6441. Director: Gilbert Leebrick. Estab. 1978.
Exhibits: Requirements: For exhibit review, submit 20 slides, résumé, catalogs, etc., by November 15th annually. Exhibits are booked the next academic year. Work accepted must be framed or ready to hang. Interested in fine art photography. Examples of exhibitions: "A Question of Gender," by Angela Borodimos (color C-prints) and "Photographs from America," by Marsha Burns (gelatin silver prints). Presents 1 show/year. Shows last 1-2 months. Sponsors openings; provides invitations, publicity and a reception. Photographer's presence at opening and during show preferred.
Making Contact & Terms: Interested in receiving work from newer, lesser-known photographers. Charges 20% commission. General price range: $200-1,000. Reviews transparencies. Interested in framed work for exhibitions; send slides for exhibit committee's review. Send material by mail for consideration. SASE. Reports 1 month after slide deadline (November 15th).

HALLWALLS CONTEMPORARY ARTS CENTER, 2495 Main St., Suite 425, Buffalo NY 14214. (716)835-7362. Fax: (716)835-7364. E-mail: hallwall@pce.net.com. Visual Arts Director: Sara Kellner. Estab. 1974.
Exhibits: Hallwalls is a nonprofit multimedia organization. "While we do not focus on the presentation of photography alone, we present innovative work by contemporary photographers in the context of contemporary art as a whole." Interested in work which expands the boundaries of traditional photography. No limitations on type, style or subject matter. Examples of recent exhibitions: "Feed," by Heidi Kumao (zoetrope, mixed media); "Amendments," including Ricardo Zulueta (b&w performance stills); and "Altered Egos," including Janieta Eyre (Polaroid portraits). Presents 10 shows/year. Shows last 6 weeks.

Sponsors openings; provides invitations, brochure and refreshments. Photographer's presence at opening preferred.

Making Contact & Terms: Interested in receiving work from newer, lesser-known photographers. Photography sold in gallery. Reviews transparencies. Send material by mail for consideration. Do not send work. Work may be kept on file for additional review for 6 months.

Tips: "We're looking for photographers with innovative work; work that challenges the boundaries of the medium."

THE HALSTED GALLERY INC., 560 N. Woodward, Birmingham MI 48009. (810)644-8284. Fax: (810)644-3911. Contact: Wendy Halsted or Thomas Halsted.

Exhibits: Interested in 19th and 20th century photographs and out-of-print photography books. Examples of recent exhibitions: "Edna's Nudes," by Edna Bullock (nudes in landscapes); "JP Atterberry: A 15 Year Retrospective," by JP Atterberry; and "The Rouge," by Michael Kenna (the Rouge Steel Plant—industrial). Sponsors openings. Presents 5 shows/year. Shows last 2 months.

Making Contact & Terms: Charges 50% sales commission or buys outright. General price range: $500-25,000. Call to arrange a personal interview to show portfolio only. Prefers to see 10-15 prints overmatted. Send no slides or samples. Unframed work only.

Tips: This gallery has no limitations on subjects. Wants creativity, consistency, depth and emotional work.

LEE HANSLEY GALLERY, 16 W. Martin St., #201, Raleigh NC 27601. (919)828-7557. Fax: (919)834-0428. Website: http://www.citysearch.com/rdu/hansleygallery. Gallery Director: Lee Hansley. Estab. 1993.

Exhibits: Interested in new images using camera as a tool of manipulation; also minimalist works. Looks for top-quality work and a unique vision. Examples of recent exhibitions: "Nudes in Nature," by Ruth Pinnell (b&w photos); "Portrait of America," by Marsha Burns (large framed silver prints); "Landscapes," by Nona Short (b&w prints); "Paris at Night," by Ed Martin (8×10 silver prints). Presents 1 show/year. Show lasts 4-6 weeks. Sponsors openings; gallery provides everything. Photographer's presence at opening and during show preferred.

Making Contact & Terms: Interested in receiving work from newer, lesser-known photographers. Charges 50% commission. General price range: $250-800. Reviews transparencies. Interested in framed or unframed work. No mural-size works. Send material by mail for consideration. SASE. Reports in 1 month.

HAYDON GALLERY, 335 N. Eighth St., Suite A, Lincoln NE 68508. (402)475-5421. Fax: (402)472-9185. E-mail: ap63142@mail.itec.net. Director: Anne Pagel. Estab. 1987 (part of Sheldon Art & Gift Shop for 20 years prior).

Exhibits: Requirements: Must do fine-quality, professional-level art. "Interested in any photography medium or content, so long as the work is of high quality." Example of recent exhibition: "The Digital Show" (12 artists using computers). Presents 1 or 2 (of 9 solo exhibitions) plus group exhibitions/year. Shows last 1 month. Hors d'oeuvres provided by host couple, cost of beverages split between gallery and artist. (Exhibitions booked through 2000.) Artist presents gallery talk 1 week after the opening. Photographer's presence at opening required.

Making Contact & Terms: Interested in receiving work from newer, lesser-known photographers "if high quality." Charges 45% commission. General price range: $150-1,000. Reviews transparencies. Interested in seeing framed or unframed, mounted or unmounted, matted or unmatted work. "Photos in inventory must be framed or boxed." Requires exclusive representation locally. Arrange a personal interview to show portfolio. Submit portfolio for review. SASE. Reports in 1 month.

Tips: "Submit a professional portfolio, including résumé, statement of purpose and a representative sampling from a cohesive body of work." Opportunities for photographers through galleries is becoming more competitive. "The public is still very conservative in its response to photography. My observation has been that although people express a preference for b&w photography, they purchase color."

HEMPHILL FINE ARTS, 1027 33rd St. NW, Washington DC 20007. (202)342-5610. Fax: (202)342-2107. E-mail: hemphillfa@aol.com. Owner: George Hemphill. Estab. 1993.

Exhibits: Requirements: "Must present a quality product and make art that is innovative, fresh and interesting. Personality is a big factor as well." Interested in wide-ranging art of all periods. Examples of recent exhibitions: William Christenberry (color and b&w photos of rural Alabama); Robert Frank (street photography/gelatin silver); Colby Caldwell (hand-manipulated gelatin silver); and "Timeless Style: Ageless Photographs of Fashion from Bellocq to Newton." Shows last 5 weeks. Sponsors openings. Photographer's presence at opening and during show preferred.

Making Contact & Terms: Interested in receiving work from newer, lesser-known photographers. Receives variable commission. Buys photos outright. General price range: $400-200,000. Reviews transparen-

cies. Requires exclusive representation locally. Arrange a personal interview to show portfolio. Send material by mail for consideration. SASE. Reporting time varies.

HERA EDUCATIONAL FOUNDATION AND ART GALLERY, P.O. Box 336, Wakefield RI 02880. (401)789-1488. Director: Patti Candelari. Estab. 1974.
Exhibits: Requirements: Must show a portfolio before attaining membership in this co-operative gallery. Interested in all types of innovative contemporary art which explores social and artistic issues. The number of photo exhibits varies each year. Shows last 3-4 weeks. Sponsors openings; provides refreshments and entertainment or lectures, demonstrations and symposia for some exhibits. Call early in 1998 for prospectus on next juried show.
Making Contact & Terms: Interested in receiving work from newer, lesser-known photographers. Charges 25% commission. Prices set by artist. Reviews transparencies. Works must fit inside a 6' 6"×2'6" door. Reports in 2-3 weeks. Inquire about membership and shows. Membership guidelines mailed on request.
Tip: Hera exhibits a culturally diverse range of visual artists, particularly women and emerging artists.

HUGHES FINE ARTS CENTER, Dept. of Visual Arts, Box 7099, Grand Forks ND 58202-7099. (701)777-2906. Director: Brian Paulsen. Estab. 1979.
Exhibits: Interested in any subject; mixed media photos, unique technique, unusual subjects. Examples of exhibitions: works by James Falkofske and Alexis Schaefer. Presents 11-14 shows/year. Shows last 2-3 weeks. "We pay shipping costs."
Making Contact & Terms: Very interested in receiving work of newer, lesser-known photographers. Does not charge commission; sales are between artist-buyer. Reviews transparencies. "Works should be framed and matted." No size limits or restrictions. Send 10-20 transparencies with résumé. SASE. Reports in 2 weeks.
Tips: "Send slides of work . . . we will dupe originals and return ASAP and contact you later." Needs "fewer photos imitating other art movements. Photographers should show their own inherent qualities."

HUNTSVILLE MUSEUM OF ART, 700 Monroe St. SW, Huntsville AL 35801. (205)535-4350. Fax: (205)532-1743. Chief Curator: Peter J. Baldaia. Estab. 1970.
Exhibits: Requirements: Must have professional track record and résumé, slides, critical reviews in package (for curatorial review). Regional connection preferred. No specific stylistic or thematic criteria. Examples of recent exhibitions: "Still Time," by Sally Mann (b&w/color); "Salvation on Sand Mountain," by Melissa Springer/Jim Neel (b&w documentary); and "Encounters," by John Reese (b&w Alabama subjects). Presents 1-2 shows/year. Shows last 6-8 weeks. Sponsors openings; provides announcement card, mailing and food and drink at reception. Photographer's presence at opening and during show preferred.
Making Contact & Terms: Interested in receiving work from newer, lesser-known photographers. Buys photos outright. Reviews transparencies. Interested in framed or unframed, mounted or unmounted, matted or unmatted work. Send material by mail for consideration. SASE. Reports in 1-3 months.

HYDE PARK ART CENTER, 5307 S. Hyde Park Blvd., Chicago IL 60615. (312)324-5520. Contact: Exhibition Committee. Executive Director: Eva Olson. Estab. 1939.
Exhibits: Receptive but selective with new work. "The gallery has a history of showing work on the cutting edge—and from emerging artists. Usually works with Chicago-area photographers who do not have gallery representation." Examples of exhibitions: "Humor," curated by C. Thurow and E. Murray; "Private Relations," curated by Jay Boersma. Shows last 4-5 weeks. Photography included in 1-2 shows/year. Exclusively photo shows rare.
Making Contact & Terms: Charges 25% commission. Send up to 6 slides and résumé to exhibition committee. SASE. Reports quarterly.
Tips: "Don't make solicitations by phone; the exhibition committee does not have office hours. Please do not bring work in for review."

ICEBOX QUALITY FRAMING & GALLERY, 2401 Central Ave. NE, Minneapolis MN 55418. (612)788-1790. Contact: Howard Christopherson. Exhibition, promotion and sales gallery. Estab. 1988. Represents photographers and fine artists in all media. Specializes in "thought-provoking art work and photography, predominantly Minnesota artists." Markets include: corporate collections; interior decorators; museums; private collections.
Exhibits: Fine art and fine art photographs of "artists with serious, thought-provoking work who find it hard to fit in with the more commercial art gallery scene. A for-profit alternative gallery, Icebox sponsors installations and exhibits in the gallery's intimate black-walled space." Exhibit expenses and promotional materials paid by the artist.

Making Contact & Terms: Payment negotiable. Sliding sales commission. Send letter of interest telling why you would like to exhibit at Icebox. Include slides and other appropriate materials for review. "At first, send materials that can be kept at the gallery and updated as needed."
Tips: "We are also experienced with the out-of-town artist's needs."

ILLINOIS ART GALLERY, 100 W. Randolph, Suite 2-100, Chicago IL 60601. (312)814-5322. Director: Kent Smith. Assistant Administrator: Jane Stevens. Estab. 1985.
Exhibits: Must be an Illinois photographer. Interested in contemporary and historical photography. Examples of exhibitions: "Poetic Vision," by Joseph Jachna (landscape, large-format); "New Bauhaus Photographs 1937-1940," by James Hamilton Brown, Nathan Lerner, Gyorgy Kepes, Laszlo Moholy-Nagy and Arthur Siegel (photograms). Presents 2-3 shows/year. Shows last 2 months. Sponsors openings; provides refreshments at reception and sends out announcement cards for exhibitions.
Making Contact & Terms: Interested in receiving work from newer, lesser-known photographers, as well as established photographers. Reviews transparencies. Interested in mounted or unmounted work. Send résumé, artist's statement and slides (10). SASE. Reports in 1 month.

INDIANAPOLIS ART CENTER, 820 E. 67th St., Indianapolis IN 46220. (317)255-2464. Fax: (317)254-0486. E-mail: inartctr@inetdirect.net. Exhibitions Curator: Julia Moore. Estab. 1934.
Exhibits: Requirements: Preferably live within 250 miles of Indianapolis. Interested in very contemporary work, preferably unusual processes. Examples of exhibitions: works by Nancy Hutchinson (b&w hand-colored: surreal); Yasha Persson (altered using Adobe Photoshop: social commentary); Ken Gray (over-printed: social commentary); and Stephen Marc (documentary/digital montages). Presents 1-2 photography shows/year out of 13-20 shows in a season. Shows last 4-6 weeks. Sponsors openings. Provides food and mailers. "We mail to our list and 50 names from photographer's list. You mail the rest." Photographer's presence at opening and during show preferred.
Making Contact & Terms: Interested in receiving work from newer, lesser-known photographers. Charges 35% commission. General price range: $100-1,000. Reviews transparencies. Interested in framed (or other finished-presentation formatted) work only for final exhibition. Send material by mail for consideration. Send minimum 20 slides with résumé, reviews, artist's statement by December 31. No wildlife or landscape photography. Interesting color work is appreciated. SASE.

INTERNATIONAL CENTER OF PHOTOGRAPHY, 1130 Fifth Ave., New York NY 10128. (212)860-1777. Fax: (212)360-6490. Contact: Department of Exhibitions. Estab. 1974.
Making Contact & Terms: Portfolio reviews are held the first Monday of each month. Submit portfolio to the receptionist by noon and pick up the following afternoon. Call Friday prior to drop-off date to confirm. Include cover letter, résumé of exhibitions and publications, artist's statement and, if necessary, a project description. "Once reviewed by the Exhibitions Department Curatorial Committee, the portfolio can be picked up on the following day any time after noon. We would prefer that your portfolio not exceed 20×24 inches. The exterior of the portfolio must be labeled clearly with your name, address, and telephone number." Photos also can be submitted by mail. "We do not recommend sending prints through the mail due to the possibility of loss or damage. We suggest sending 20-40 slides, along with the other materials listed earlier. All slides should be labeled or accompanied by a slide list. Please allow 6-8 weeks for response. Video work should be submitted in ½-¾ inch format. Return postage must be included to ensure return of materials."

ISLIP ART MUSEUM, 50 Irish Lane, Islip NY 11730. (516)224-5402. Director: M.L. Cohalan. Estab. 1973.
Exhibits: Interested in contemporary or avant-garde works. Has exhibited work by Robert Flynt, Skeet McAuley and James Fraschetti. Shows last 6-8 weeks. Sponsors openings. Photographer's presence at opening preferred.
Making Contact & Terms: Interested in reviewing work from newer, lesser-known photographers. Charges 30% commission. General price range: $200-3,000. Reviews transparencies. Send slides and résumé; no original work. Reports in 1 month.
Tips: "Our museum exhibits theme shows. We seldom exhibit work of individual artists. Themes reflect

ideas and issues facing current avant-garde art world. We are a museum. Our prime function is to exhibit, not promote or sell work."

JACKSON FINE ART, 3115 E. Shadowlawn Ave., Atlanta GA 30305. (404)233-3739. Fax: (404)233-1205. President: Jane Jackson. Estab. 1990.
Exhibits: Requirements: "Photographers must be established, preferably published in books or national art publications. They must also have a strong biography, preferably museum exhibitions, either one-person or group." Interested in innovative photography and photo-related art: nudes, landscape, fashion, portraiture. Exhibition schedule includes mix of classic vintage work and new contemporary work. Examples of recent exhibitions: Sally Mann (20x24 silver prints); William Wegman (20x24 Polaroid); and John Dugdale (8x10 Cyanotype). Presents 14 shows/year in 2 gallery spaces. Shows last 6 weeks. Sponsors openings; provides invitations, food and beverages. Photographer's presence at opening preferred.
Making Contact & Terms: Only buys vintage photos outright. General price range: $600-150,000. Reviews transparencies. Requires exclusive representation locally. Send material by mail for consideration. "Send slides first. We will not accept unsolicited original work, and we are not responsible for slides. We also review portfolios on CD-ROM and sell work through CD-ROM." SASE. Reports in 2-3 months.
Tips: "Be organized. Galleries are always looking for exciting fresh work. The work should be based on a single idea or theme."

‡JADITE GALLERIES, 413 W. 50th St., New York NY 10019. (212)315-2740. Fax: (212)315-2793. Director: Roland Sainz. Estab. 1985.
Exhibits: Requirements: Artists and gallery divide equally the cost of exhibitions. Interested in b&w, color and mixed media. Examples of recent exhibitions: "Old World/New World," by Juliet Stelsman (b&w photographs); "Political Collages," by Brent James (mixed media photographs); and "Eros," by Luis Mayo (mixed media photographs). Presents 1-2 shows/year. Shows last 1 month. Sponsors opening; provides wine and cheese. Photographer's presence at opening preferred.
Making Contact & Terms: Interested in receiving work from newer lesser-known photographers. Charges 40% commission. General price range: $200-1,000. Reviews transparencies. Interested in un-framed work only. Arrange a personal interview to show portfolio. Submit portfolio for review. SASE. Reports in 2-5 weeks.

‡KALA INSTITUTE, 1060 Heinz Ave., Berkeley CA 94710. (510)549-2977. Fax: (510)540-6914. Programs Director: Patrick MacMenamin. Estab. 1974.
Exhibits: Usually required to be an artist in residence at the Kala Institute or part of group showing. Interested in photoetching and alternative photo processes. Examples of exhibitions: "Fellowship 1993," by Robin McCloskey (photoetching); "Monthly Salon," by Jan Kaufman (color abstract photography). Presents 1-2 shows/year. Shows last 6 weeks. Sponsors openings; usually provides publicity and installation. Photographer's presence at opening and during show preferred.
Making Contact & Terms: Interested in receiving work from newer, lesser-known photographers. Charges 50% commission. General price range: $100-500. Reviews transparencies. Interested in framed or unframed work, mounted or unmounted work, matted or unmatted work. Query with résumé of credits. SASE. Reports in 1 month.
Tips: "Normally, our gallery presents only work that is produced at our institute. We offer fellowships and artists in residencies to photographers and etchers to produce their work here."

‡KEARON-HEMPENSTALL GALLERY, 536 Bergen Ave., Jersey City NJ 07304. (201)333-8855. Fax: (201)333-8488. Director: Suzann McKiernan. Estab. 1980.
Exhibits: Interested in color and b&w prints. Example of recent exhibition: Keri Pampuch (16×20 color prints/landscapes). Presents 1 show/year. Shows last 1 month. Sponsors openings; provides food and beverages. Photographer's presence at opening preferred; presence during show preferred but not essential.
Making Contact & Terms: Charges 40% commission. General price range: $150-400. Reviews transparencies. Interested in mounted, matted work only. Requires exclusive representation locally. Send material by mail for consideration. Include résumé, exhibition listing, artist's statement and price of sold work. SASE. Reports in 1 month.
Tips: "Be professional: have a full portfolio; be energetic and willing to assist with sales of your work."

KENT STATE UNIVERSITY SCHOOL OF ART GALLERY, Dept. PM, KSU, 201 Art Building, Kent OH 44242. (330)672-7853. Director: Fred T. Smith.
Exhibits: Interested in all types, styles and subject matter of photography. Photographer must present quality work. Presents 1 show/year. Exhibits last 3 weeks. Sponsors openings; provides hors d'oeuvres, wine and non-alcoholic punch. Photographer's presence at opening preferred.

Making Contact & Terms: Photography can be sold in gallery. Charges 20% commission. Buys photography outright. Will review transparencies. Write a proposal and send with slides. Send material by mail for consideration. SASE. Reports usually in 4 months, but it depends on time submitted.

ROBERT KLEIN GALLERY, 38 Newbury St., Boston MA 02116. (617)267-7997. Fax: (617)267-5567. President: Robert L. Klein. Estab. 1978.
Exhibits: Requirements: Must be established a minimum of 5 years; preferably published. Interested in fashion, documentary, nudes, portraiture, and work that has been fabricated to be photographs. Examples of recent exhibitions: work by William Wegman, Tom Baril and Atget. Presents 10 exhibits/year. Shows last 5 weeks. Sponsors openings; provides announcements and beverages served at reception. Photographer's presence at opening and during show preferred.
Making Contact & Terms: Charges 50% commission. Buys photos outright. General price range: $600-200,000. Reviews transparencies. Interested in unframed, unmmatted, unmounted work only. Requires exclusive representation locally. Send material by mail for consideration. SASE. Reports in 2 months.

‡**JOHN MICHAEL KOHLER ARTS CENTER**, 608 New York Ave., P.O. Box 489, Sheboygan WI 53082. (414)458-6144. Fax: (414)458-4473. Curator of Exhibitions: Andrea Inselmann. Estab. 1969.
Exhibits: Requirements: "Exhibitors are emerging artists, MFA candidates; no commercial work." Interested in "all styles of innovative, expansive, cutting-edge photography." Examples of recent exhibitions: "Animal Magnetism," by Valerie Shaff (b&w medium format); and "Masculine Measures," including work by Huey Centz and Robert Flynt (color digital photography). Presents 1 show/year. Shows last 3 months. Photographer's presence at opening and during show preferred.
Making Contact & Terms: Charges 25% commission. General price range: $400. Reviews transparencies. Send slides, résumé, reviews, etc. Reports in 1-2 months.
Tips: "Be articulate, responsible and organized."

PAUL KOPEIKIN GALLERY, 170 S. La Brea Ave., Los Angeles CA 90036. (213)937-0765. Fax: (213)937-5974. Associate Director: Pilar Graves. Estab. 1990.
Exhibits: Requirements: Must be highly professional. Quality and unique point of view also important. No restriction on type, style or subject. Examples of recent exhibitions: Lee Friedlander (b&w 35mm); Karen Halverson (color landscapes); and Andrea Modica (platinum large format). Presents 7-9 shows/year. Shows last 1-2 months. Sponsors openings. Photographer's presence at opening and availability during show preferred.
Making Contact & Terms: Interested in receiving work from newer, lesser-known photographers, "if they're serious." Charges 50% commission. General price range: $400-4,000. Reviews transparencies. Interested in slides. Requires exclusive representation locally. Submit slides and support material. SASE. Reports in 1-2 weeks.
Tips: "Don't waste people's time by showing work before you're ready to do so."

‡**KUNTSWERK GALERIE**, 1800 W. Cornelia, Chicago IL 60657. (773)935-1854. Fax: (773)478-2395. Website: http://www.gorpnm.com/~fota. Co-director: Thomas Frerk. Estab. 1995.
Exhibits: Requirements: Photographer "must be interested in showing work in a more avant-garde setting." Interested in female/male figurative; landscapes (b&w preferably); experimental (i.e., layered images, Polaroid transfers, photography painting, etc.). Examples of recent exhibitions: "Legume du Jour," by Scott Mayer (b&w city photography); "Manhood," by Gina Dawden (layered b&w male figurative); and "Art Crawl," by Terry Gaskins (Chicago personalities). Presents 4-8 shows/year. Shows last 2-6 weeks. Sponsors openings; provides press releases, house lists for mailings, food, beverage and flowers. Further services vary per artist arrangement. Photographer's presence at opening required.
Making Contact & Terms: Charges maximum 25% commission; varies by artist. General price range: $50-500. Reviews transparencies. Interested in framed or unframed, matted or unmatted work. Send material by mail for consideration. SASE. Reports in 1 month.
Tips: "We encourage emerging artists. Go out and beat the bushes. Beginners should be wary of overpricing their work. To avoid this, don't bother framing or use simple framing to keep costs down. Also, find outlets to get your work published, i.e., bands who need album covers and free newspapers in search of artistic photos. We can arrange for an artist to put his portfolio on our website."

LA MAMA LA GALLERIA, 6 E. First Street, New York NY 10003. (212)505-2476. Director/Curator: Lawry Smith. Estab. 1982.
Exhibits: Interested in all types of work. Looking for "movement, point of view, dimension." Examples of exhibitions: "Jocks in Frocks," by Charles Justina; "Styles & Aesthetics," group show. Presents 2 shows/year. Shows last 3 weeks. Sponsors openings. Photographer's presence at opening required.

Making Contact & Terms: Very receptive to exhibiting work of newer, lesser-known photographers. Charges 20% commission. General price range: $200-2,000. Prices set by agreement between director/curator and photographer. Reviews transparencies. Interested in framed or unframed, mounted, matted or unmatted work. Requires exclusive representation within metropolitan area. Arrange a personal interview to show portfolio. Send material by mail for consideration. SASE. Reports in 1 month.
Tips: "Be patient; we are continuously booked 18 months-2 years ahead."

‡J. LAWRENCE GALLERY, 1435 Highland Ave., Melbourne FL 32935. (407)259-1492. Fax: (407)259-1494. Owner: Joseph L. Conneen, Jr. Estab. 1984.
Exhibits: Requirements: Must be original works done by the photographer. Interested in Cibachrome; hand-tinted b&w and b&w. Examples of exhibitions: works by Lloyd Behrendt (hand-tinted b&w), Chuck Harris (Cibachrome), and Clyde & Nikki Butcher (b&w and hand-tinted b&w). Most shows are group exhibits. Shows last 6 weeks. Sponsors openings; provides invitations, mailings, opening entertainment, etc. Photographer's presence at opening and during show preferred.
Making Contact & Terms: Interested in receiving work from newer, lesser-known photographers. Charges 40% commission. General price range: $200-1,000. Reviews transparencies. Interested in framed or unframed, mounted or unmounted, matted or unmatted work. Requires exclusive representation locally. Arrange a personal interview to show portfolio. Submit portfolio for review. Query with résumé of credits. Query with samples. Send material by mail for consideration. SASE. Reports in 1-2 weeks.
Tips: "The market for fine art photography is growing stronger."

LBW GALLERY, Northview Mall, 1724 E. 86th St., Indianapolis IN 46240-2360. (317)848-2787. Director: Linda B. Walsh.
Exhibits: Requirements: Must appeal to clients (homeowners, collectors). Interested in landscapes, flowers, architecture, points and places of interest. Examples of recent exhibitions: "Indiana Scenes," by Robert Cook; and "Indiana Scenery," by Robert Wallis. Presents 10 shows/year. Shows last 1 month. Sponsors openings; provides refreshments, press releases, direct mail. Photographer's presence at opening preferred, but not necessary.
Making Contact & Terms: Interested in receiving work from newer, lesser-known photographers. Charges 50% commission. General price range: $150-600. Reviews transparencies. Interested in framed and matted work only. Works are limited to up to 18×24. Query with résumé of credits. Query with samples. SASE. Reports in 1-2 weeks.
Tips: "Be realistic in dealing with subject matter that would be interesting and sell to the public. Also, be realistic as to the price you desire out of your work."

‡LE PETIT MUSÉE, 137 Front St., P.O. Box 556, Housatonic MA 01236. (416)274-1200. Director: Sherry Steiner. Estab. 1992.
Making Contact & Terms: Charges 50% commission. General price range: $50-500. Reviews transparencies. Interested in framed or unframed, mounted or unmounted, matted or unmatted work. Works are limited to no larger than 12×16 framed. Send material by mail for consideration. SASE. Reports in 1-2 weeks.

ELIZABETH LEACH GALLERY, 207 SW Pine, Portland OR 97204. (503)224-0521. Fax: (503)224-0844. Gallery Director: Miriam Rose.
Exhibits: Requirements: Photographers must meet museum conservation standards. Interested in "high quality and fine craftsmanship." Examples of recent exhibitions: Terry Toedtemeier (landscape/gelatin silver prints); Christopher Rauschenberg (landscape/gelatin silver print collage); and Richard Misrach (Extacolor photographs). Presents 1-2 shows/year. Shows last 1 month. Sponsors openings. "The gallery has extended hours every first Thursday of the month for our openings. Beer and wine are available for patrons and artists." Photographer's presence at opening and during show preferred.
Making Contact & Terms: Interested in receiving work from newer, lesser-known photographers. Charges 50% commission. General price range: $300-5,000. Reviews transparencies. Interested in framed or unframed, matted work. Requires exclusive representation locally. Submit slides with résumé, artist statement, articles and SASE. Reports every 4 months.

LEHIGH UNIVERSITY ART GALLERIES, 420 E. Packer Ave., Bethlehem PA 18015. (610)758-3615. Fax: (610)758-4580. Director/Curator: Ricardo Viera.
Exhibits: Interested in all types of works. The photographer should "preferably be an established professional." Presents 5-8 shows/year. Shows last 6-8 weeks. Sponsors openings. Photographer's presence at opening and during the show preferred.
Making Contact & Terms: Payment negotiable. Reviews transparencies. Arrange a personal interview

to show portfolio. SASE. Reports in 1 month.

Tips: Don't send more than 10 (top) slides.

LEWIS LEHR INC., Box 1008, Gracie Station, New York NY 10028. (212)288-6765. Director: Lewis Lehr. Estab. 1984. Private dealer. Buys vintage photos.

Exhibits: "American West" and "Farm Security Administration," both by various photographers; "Camera Work," by Stieglitz.

Making Contact & Terms: Charges 50% commission. Buys photography outright. General price range: $500 plus. Do not submit transparencies. Requires exclusive representation within metropolitan area. Query with résumé of credits. SASE. Member AIPAD.

Tips: Vintage American sells best. Sees trend toward "more color and larger" print sizes. To break in, "knock on doors." Do not send work or slides.

■LIGHT FACTORY, (formerly The Light Factory Photographic Arts Center), P.O. Box 32815, Charlotte NC 28232. (704)333-9755. Fax: (704)333-5910. E-mail: tlf@webserve.net. Website: http://www.lightfactor y.org. Executive Director: Bruce Lineker. Nonprofit. Estab. 1972.

Exhibits: Requirements: Photographer must have a professional exhibition record. Interested in light-generated media (photography, video, the Internet). Presents 8-10 shows/year. Shows last 2 months. Sponsors openings; reception (3 hours) with food and beverages, artist lecture following reception. Photographer's presence at opening preferred.

Making Contact & Terms: Artwork sold in the gallery. "Artists price their work." Charges 33% commission. No permanent collection. General price range: $500-12,000. Reviews transparencies. Query with résumé of credits and slides. Artist's statement requested. SASE. Reports in 2 months.

LIZARDI/HARP GALLERY, P.O. Box 91895, Pasadena CA 91109. (818)792-8336. Fax: (818)794-0787. Director: Grady Harp. Estab. 1981.

Exhibits: Requirements: Must have more than one portfolio of subject, unique slant and professional manner. Interested in figurative, nudes, "maybe" manipulated work, documentary and mood landscapes. Examples of exhibitions: "b-boy (sexual) fantasy series," by Erik Olson (male nudes); "Travels: India, Burma, Mexico," by Christopher James (mysterious light). Presents 3-4 shows/year. Shows last 4-6 weeks. Sponsors openings; provides announcements, reception costs. Photographer's presence at opening preferred.

Making Contact & Terms: Interested in receiving work from newer, lesser-known photographers. Charges 50% commission. General price range: $500-4,000. Reviews transparencies. Interested in unframed, unmounted and matted or unmatted work. Submit portfolio for review. Query with résumé of credits. Query with samples. Send material by mail for consideration. SASE. Reports in 1 month.

‡LOUISVILLE VISUAL ART ASSOCIATION, 275 Galleria, Louisville KY 40202. (502)581-1445. Gallery Manager: Janice Emery.

Exhibits: Requirements: "We focus on regional art. Any artists outside the area must have been trained in Kentucky, Indiana, Ohio, Tennessee, Illinois, Michigan or Wisconsin." Interested in contemporary work. Examples of recent exhibitions: Kenneth Hayden, Richard Pink and Bob Wells. Presents 1 show/year. Shows last 6 weeks. "We usually exhibit several artists simultaneously. Works are rotated every four months."

Making Contact & Terms: Charges 40% commission. General price range: $50-500. Reviews transparencies. Interested in seeing slides first. Query with résumé of credits. Query with samples. Send material by mail for consideration. SASE. Reports in 2 months.

Tips: "Call for an Internet review."

‡THE LOWE GALLERY, 75 Bennett St., Space A-2, Atlanta GA 30309. (404)352-8114. (404)352-0564. E-mail: lowegallery@indspring.com. Director: Courtney Maier. Estab. 1989.

Exhibits: Interested in psycho-spiritual and figurative photos. Examples of recent exhibitions: Maggie Hasbrouck (photo encaustic); Tamara Rafkin (large-scale color prints); and Rob Toedter (b&w-toned gelatin silverprints). Presents 2-5 shows/year. Shows last 4-6 weeks. Photographer's presence at opening preferred.

Making Contact & Terms: Charges 15% commission. General price range: $500-10,000. Reviews transparencies. Interested in framed work only. Requires exclusive representation locally. Send material by mail for consideration. SASE. Reports in 1 month.

Tips: "Know the aesthetic of the gallery before submitting."

M.C. GALLERY, 400 First Ave. N., Minneapolis MN 55401. (612)339-1480. Fax: (612)339-1480. Director: M.C. Anderson. Estab. 1984.

Exhibits: Interested in avant-garde work. Examples of recent exhibitions: works by Gloria Dephilips Brush, Ann Hofkin and Catherine Kemp. Shows last 6 weeks. Sponsors openings; attended by 2,000-3,000 people. Photographer's presence preferred at opening and during show.

Making Contact & Terms: Interested in receiving work from newer, lesser-known photographers. Charges 50% commission. General price range: $300-1,200. Reviews transparencies. Interested in framed or unframed work. Requires exclusive representation within metropolitan area. Submit portfolio for review. Query with résumé of credits. Send material by mail for consideration. Material will be returned, but 2-3 times/year. Reports in 1-2 weeks if strongly interested, or it could be several months.

MAINE COAST ARTISTS, P.O. Box 147, Rockport ME 04856. (207)236-2875. Fax: (207)236-2490. E-mail: mca@midcoast.com. Director: John Chandler. Estab. 1952.
- This gallery has received a National Endowment for the Arts grant.

Exhibits: Requirements: Photographer must live and work part of the year in Maine; work should be recent and not previously exhibited in the area. Examples of recent exhibitions: "Two Generations," by Paul and John Caparigro; "Belfast," by Patricia McLean and Liv Robinson; "Pothos," by Jonathan Bailey and "Tillman Crane." Number of shows varies. Shows last 1 month. Sponsors openings; provides refreshments. Photographer's presence at opening is preferred.

Making Contact & Terms: Interested in receiving work from newer, lesser-known photographers. Charges 40% commission. General price range: $200-2,000. Reviews transparencies. Accepts images in digital format for Mac. Send via compact disc or online. Query with résumé of credits. Query with samples. Send material by mail for consideration. SASE. Reports in 2 months.

Tips: "A photographer can request receipt of application for our annual juried exhibition (May 27-end of June), as well as apply for solo or group exhibitions. MCA is exhibiting more and more photography."

MARBLE HOUSE GALLERY, 44 Exchange Place, Salt Lake City UT 84111. (801)532-7332. Fax: (801)532-7338, "call first." Owner: Dolores Kohler. Estab. 1988.

Exhibits: Requirements: Professional presentation, realistic pricing and numerous quality images. Interested in painterly, abstract and landscapes. No documentary or politically-oriented work. No nudes. Examples of recent exhibitions: "Wildlife," by Paul Garvey; "Ducks and Cacti," by Dolores Kohler; and photographic scenes by Mark Smith. Presents 2 shows/year. Shows last 1 month. As a member of the Salt Lake Gallery Association, there are monthly downtown gallery strolls. Also provides public relations, etc.

Making Contact & Terms: Interested in receiving work from newer, lesser-known photographers. Charges 50% commission. Buys photos outright. General price range: $50-1,000. Reviews transparencies. Interested in framed or unframed, mounted or unmounted, matted or unmatted work. Requires exclusive representation within metropolitan area. No size limits. Arrange a personal interview to show a portfolio. Submit portfolio for review. Query with résumé of credits. Query with samples. Send material by mail for consideration. SASE. Reports in 1 month.

‡MARKEIM ART CENTER, Lincoln Ave. and Walnut St., Haddonfield NJ 08033. (609)429-8585. Executive Director: Danielle Reich. Estab. 1956.

Exhibits: Requirements: "Artists from New Jersey and Delaware Valley region are preferred. Work must be professional and high quality." Interested in all types work. Presents 1-2 shows/year. Shows last 6-8 weeks. "The exhibiting artist is responsible for all details of the opening." Photographer's presence at opening required, presence during show preferred.

Making Contact & Terms: Charges 20% commission. General price range: $75-1,000. Reviews transparencies. Interested in seeing framed, mounted or unmounted, matted or unmatted work. Send slides by mail for consideration. Include résumé and letter of intent. SASE. Reports in 1 month.

Tips: "Be patient and flexible with scheduling. Look not only for one-time shows, but for opportunities to develop working relationships with a gallery. Establish yourself locally and market yourself outward."

MARLBORO GALLERY, Prince George's Community College, 301 Largo Road, Largo MD 20772-2199. (301)322-0967. Gallery Curator: John Krumrein. Estab. 1976.

Exhibits: Not interested in commercial work. "We are looking for fine art photos, we need between 10 to 20 to make assessment, and reviews are done every six months. We prefer submissions during February-April." Examples of recent exhibitions: "Blues Face/Blues Places," John Belushi's blues collection photos (various photographers); "Blues Face/Blues Places," the David Spitzer collection of blues; and "Greek Influence," photos of Greece by various photographers. Shows last 3-4 weeks. Sponsors openings. Photographer's presence at opening required.

Making Contact & Terms: Interested in receiving work from newer, lesser-known photographers. General price range: $50-5,000. Reviews transparencies. Interested in framed work only. Query with samples. Send material by mail for consideration. SASE. Reports in 3-4 weeks.

Tips: "Send examples of what you wish to display and explanations if photos do not meet normal standards

(i.e., in focus, experimental subject matter)."

MARSH ART GALLERY, University of Richmond, Richmond VA 23173. (804)289-8276. Fax: (804)287-6006. E-mail: waller@richmond.edu. Website: http://www.urich.edu/. Director: Richard Waller. Estab. 1966.
Exhibits: Interested in all subjects. Example of recent exhibition: "Contemplating the Obvious," photographic studies by Susan Eder. Presents 8-10 shows/year. Shows last 1 month. Photographer's presence at opening preferred.
Making Contact & Terms: Charges 10% commission. Reviews transparencies. Interested in framed or unframed, mounted or unmounted, matted or unmatted work. Work must be framed for exhibition. Query with résumé of credits. Query with samples. Send material by mail for consideration. Reports in 1 month.
Tips: If possible, submit material which can be left on file and fits standard letter file. "We are a nonprofit university gallery interested in presenting contemporary art."

ERNESTO MAYANS GALLERIES LTD., 601 Canyon Rd., Santa Fe NM 87501. (505)983-8068. Fax: (505)982-1999. E-mail: arte2@aol.com. Website: http://www.arnet.com./mayans/html. Owner: Ernesto Mayans. Associate: Ava Ming Hu. Estab. 1977.
Exhibits: Examples of exhibitions: "Cholos/East L.A.," by Graciela Iturbide (b&w); "Ranchos de Taos Portfolio," by Doug Keats (Fresson), "A Diary of Light," by André Kertész (b&w), "Flores" by Willis Lee (iris prints); Manuel Alvarez Bravo; and Diane Kaye. Publishes books, catalogs and portfolios.
Making Contact & Terms: Charges 50% commission. Buys photos outright. General price range: $200-5,000. Interested in framed or unframed, mounted or unmounted work. Requires exclusive representation within area. Size limited to 11×20 maximum. Arrange a personal interview to show portfolio. Send inquiry by mail for consideration. SASE. Reports in 1-2 weeks.
Tips: "Please call before submitting."

R. MICHELSON GALLERIES, 132 Main St., Northampton MA 01060. (413)586-3964. Owner and President: Richard Michelson. Estab. 1976.
Exhibits: Interested in contemporary, landscape and/or figure, generally realistic work. Examples of exhibitions: Works by Michael Jacobson-Hardy (landscape); Jim Wallace (landscape); and Robin Logan (still life/floral). Presents 1 show/year. Show lasts 6 weeks. Sponsors openings. Photographer's presence at opening required, presence during show preferred.
Making Contact & Terms: Sometimes buys photos outright. General price range: $100-1,000. Reviews transparencies. Interested in framed or unframed, mounted or unmounted, matted or unmatted work. Requires exclusive representation locally. Send material by mail for consideration. SASE. Reports in 1-2 weeks.

PETER MILLER GALLERY, 740 N. Franklin, Chicago IL 60610. (312)951-0252. Fax: (312)951-2628. Directors: Peter Miller and Natalie R. Domchenko. Estab. 1979.
Exhibits: "We have not exhibited photography but we are interested in adding photography to the work currently exhibited here." Sponsors openings.
Making Contact & Terms: Interested in receiving work from newer, lesser-known photographers. Charges 50% commission. Reviews transparencies. Interested in framed or unframed, mounted or unmounted, matted or unmatted work. Requires exclusive representation locally. Send 20 slides of the most recent work with SASE. Reports in 1-2 weeks.
Tips: "We look for work we haven't seen before, i.e. new images and new approaches to the medium."

MINOT ART GALLERY, P.O. Box 325, Minot ND 58701. (701)838-4445. Executive Director: Jeanne Rodgers. Estab. 1970.
Exhibits: Example of exhibitions: "Wayne Jansen: Photographs," by Wayne Jansen (buildings and landscapes). Presents 3 shows/year. Shows last about 1 month. Sponsors openings.
Making Contact & Terms: Very receptive to work of newer, lesser-known photographers. Charges 30% commission. General price range: $25-150. Submit portfolio or at least 6 examples of work for review. Prefers transparencies. SASE. Reports in 1 month.
Tips: "Wildlife, landscapes and floral pieces seem to be the trend in North Dakota. The new director likes the human figure and looks for high quality in photos. We get many slides to review for our three photography shows a year. Do something unusual, creative, artistic. Do not send postcard photos."

MOBILE MUSEUM OF ART, P.O. Box 8426, Mobile AL 36689 or 4850 Museum Dr., Mobile AL 36608. (334)343-2667. Fax: (334)343-2680. Executive Director: Joe Schenk. Estab. 1964.
Exhibits: Open to all types and styles. Examples of recent exhibits: "Generations in Black and White:

"Photography by Carl Van Vechten" from the James Weldon Johnson Memorial Collection; and "Medicine's Great Journey: 100 Years of Healing." Presents 1-2 shows/year. Shows last about 6 weeks. Sponsors openings; provides light hors d'oeuvres and wine. Photographer's presence at opening is preferred.

Making Contact & Terms: Photography sold in gallery. Charges 20% commission. Occasionally buys photos outright. Reviews transparencies. Interested in framed work only. Arrange a personal interview to show portfolio; send material by mail for consideration. Returns material when SAE is provided "unless photographer specifically points out that it's not required."

Tips: "We look for personal point of view beyond technical mystery."

‡MONTEREY MUSEUM OF ART, (formerly Monterey Peninsula Museum of Art), 559 Pacific St., Monterey CA 93940. (408)372-5477. Fax: (408)372-5680. Director: Richard W. Gadd. Estab. 1969.

Exhibits: Interested in all subjects. Examples of recent exhibitions: "The Edge of Shadow," photographs from the Page Collection; "Peninsula People: Portraits," by John McCleary. Presents 4-6 shows/year. Shows last approximately 6-12 weeks. Sponsors openings.

Making Contact & Terms: "Very receptive" to working with newer, lesser-known photographers. Reviews transparencies. Work must be framed to be displayed; review can be by slides, transparencies. Send material by mail for consideration. SASE. Reports in 1 month.

Tips: "Send 20 slides and résumé at any time to the attention of the museum director."

MONTPELIER CULTURAL ARTS CENTER, 12826 Laurel-Bowie Rd., Laurel MD 20708. (301)953-1993. Director: Richard Zandler. Estab. 1979.

Exhibits: Open to all photography. Examples of exhibitions: "Photographs by Jason Horowitz" (panoramic b&w); "In The Shadow of Crough Patrick," photos by Joan Rough (color landscapes of Ireland); photos by Robert Houston (b&ws of urban life); "Images in Time," by Andrea Davidhazy. Shows last 1-2 months. Sponsors openings. "We take care of everything." Photographer's presence at opening preferred.

Making Contact & Terms: Interested in receiving work from newer, lesser-known photographers. "We do not sell much." Charges 25% commission. Reviews transparencies. Interested in framed work only. "Send 20 slides, résumé and exhibit proposal for consideration. Include SASE for return of slides. Work must be framed and ready for hanging if accepted." Reports "after scheduled committee meeting; depends on time of year."

MORGAN GALLERY, 412 Delaware, Suite A, Kansas City MO 64105. (816)842-8755. Fax: (816)842-3376. Director: Dennis Morgan. Estab. 1969.

Exhibits: Examples of recent exhibitions: photos by Holly Roberts; Dick Arentz (platinum); and Linda Conner (b&w). Presents 1-2 shows/year. Shows last 4-6 weeks. Sponsors openings.

Making Contact & Terms: Interested in receiving work from newer, lesser-known photographers. Charges 50% commission. General price range: $250-5,000. Reviews transparencies. Submit portfolio for review. Send material by mail for consideration. SASE. Reports in 3 months.

MORRIS-HEALY GALLERY, 530 W. 22nd St., New York NY 10011. (212)243-3753. Fax: (212)243-3668. Gallery Assistant: Joel Yoss. Estab. 1995.

Exhibits: "The photographers hopefully will have shown at some other galleries and have work that fits the conceptual ideology of our gallery. We are open to many different types and styles, however, the work must be provocative and strong technically." Examples of recent exhibitions: John Schabel, Esco Männikkö (representational). Presents 1-2 shows/year. Shows last 1 month. Sponsors openings; depending on situation, generally provides installation costs, shipping, reception and marketing. Photographer's presence at opening required; presence during show preferred.

Making Contact & Terms: Interested in receiving work from newer, lesser-known photographers. Commission depends on individual situation. General price range: $1,000-2,000. Reviews transparencies if requested. Interested in framed or unframed work. Requires exclusive representation locally. Arrange a personal interview to show portfolio. SASE.

Tips: "Get a contact person in the gallery, develop a relationship with that person and then invite him/her to your studio."

‡THE MUSEUM OF CONTEMPORARY PHOTOGRAPHY, COLUMBIA COLLEGE CHICAGO, 600 S. Michigan Ave., Chicago IL 60605-1996. (312)663-5554. Fax: (312)360-1656. Director:

THE DIGITAL MARKETS INDEX, located in the back of this book, lists markets that use images electronically.

Denise Miller. Assistant Director: Martha Alexander-Grohmann. Estab. 1984.

Exhibits: Interested in fine art, documentary, photojournalism, commercial, technical/scientific. "All high quality work considered." Examples of exhibitions: "Open Spain/Espana Abierta" (contemporary documentary Spanish photography/group show); "The Duane Michals Show," by Duane Michals (b&w narrative sequences, surreal, directorial); "Irving Penn: Master Images," by Irving Penn (b&w fashion, still life, portraiture). Presents 5 main shows and 8-10 smaller shows/year. Shows last 8 weeks. Sponsors openings, provides announcements.

Making Contact & Terms: "We do exhibit the work of newer and lesser known photographers if their work is of high professional quality." Charges 30% commission. Buys photos outright. General price range: $300-2,000. Reviews transparencies. Accepts images in digital format for Mac and Windows. Send via compact disc, floppy disk or SyQuest. Interested in reviewing unframed work only, matted or unmatted. Submit portfolio for review. SASE. Reports in 2 weeks. No critical review offered.

Tips: "Professional standards apply; only very high quality work considered."

MUSEUM OF PHOTOGRAPHIC ARTS, 1649 El Prado, Balboa Park, San Diego CA 92101. (619)238-7559. Fax: (619)238-8777. Director: Arthur Ollman. Curator: Diana Gaston. Estab. 1983.

Exhibits: "The criteria is simply that the photography be the finest and most interesting in the world, relative to other fine art activity. MoPA is a museum and therefore does not sell works in exhibitions. There are no fees involved." Examples of recent exhibitions featuring contemporary photographers from the U.S. and abroad include: "Current Fictions," by 8 emerging artists; "Republic: History of San Diego," by Richard Bolton (video-based installation); and "Points of Entry: A Nation of Strangers." Presents 6-8 exhibitions annually from 19th century to contemporary. Each exhibition lasts approximately 2 months. Exhibition schedules planned 2-3 years in advance. Holds a private Members' Opening Reception for each exhibition.

Making Contact & Terms: "For space, time and curatorial reasons, there are few opportunities to present the work of newer, lesser-known photographers." Send an artist's statement and a résumé of credits with a portfolio (unframed photographs) or slides. Portfolios may be submitted for review with advance notification and picked up in 2-3 days. Files are kept on contemporary artists for future reference. Send return address and postage. Reports in 2 months.

Tips: "Exhibitions presented by the museum represent the full range of artistic and journalistic photographic works." There are no specific requirements. "The executive director and curator make all decisions on works that will be included in exhibitions. There is an enormous stylistic diversity in the photographic arts. The museum does not place an emphasis on one style or technique over another."

MUSEUM OF THE PLAINS INDIAN & CRAFTS CENTER, Junction of Highways 2 and 89, Browning MT 59417. (406)338-2230. Fax: (406)338-7404. Curator: Loretta Pepion. Estab. 1941.

Exhibits: Requirements: Must be a Native American of any tribe within the 50 states, proof required. Shows last 6 weeks. Sponsors openings. Provides refreshments and a weekend opening plus a brochure. Admission charged June 1 to September 30.

Making Contact & Terms: Interested in receiving work from newer, lesser-known photographers. Charges 25% commission. Reviews transparencies. Interested in framed and matted work. Query with samples. Send material by mail for consideration.

‡**NEVADA MUSEUM OF ART**, 160 W. Liberty St., Reno NV 89501. (702)329-3333. Fax: (702)329-1541). Chairman of the Collections Committee: Kathleen Akers. Estab. 1931.

● Peter Pool is now in the process of developing an "Altered Landscape" collection for the museum concerning the interactive aspects of man with the modern landscape. That is the primary photographic concern for the museum.

Exhibits: Examples of recent exhibitions: "Through Their Own Eyes," by Edward Weston and Ansel Adams (personal portfolio); and "Nuclear Nevada," by Robert Del Tredici and Peter Goin. Presents 10-12 shows/year in various media. Shows last 6-8 weeks. Sponsors openings; provides catered reception for up to 400 people, book signings, etc. Photographer's presence at opening preferred.

Making Contact & Terms: General price range: $75-2,000. Reviews work in any form: original prints, work prints, slides. Call for interest and arrangements. Interested in framed or unframed work.

THE SUBJECT INDEX, located at the back of this book, lists publications, book publishers, galleries, paper product companies and stock agencies according to the subject areas they seek.

Tips: Museum exhibits "a wide variety of art, including photography. It is a tax-exempt, not-for-profit institution; primarily an art museum and not just a photography museum. We're not a commercial gallery."

NEW ORLEANS MUSEUM OF ART, Box 19123, City Park, New Orleans LA 70179. (504)488-2631. Fax: (504)484-6662. E-mail: noma@communique.net. Website: www.noma. Curator of Photography: Steven Maklansky. Collection estab. 1973.
Exhibits: Requirements: "Send thought-out images with originality and expertise. Do not send commercial-looking images." Interested in all types of photography. Examples of exhibitions: "Cameraderie," by 64 photographers and "Double Exposure," by 50 photographers. Presents shows continuously. Shows last 1-3 months.
Making Contact & Terms: Buys photography outright; payment negotiable. Present budget for purchasing contemporary photography is very small. Sometimes accepts donations from established artists, collectors or dealers. Query with color photocopies (preferred) or slides and résumé of credits. SASE. Reports in 1-3 months.

NICOLAYSEN ART MUSEUM & DISCOVERY CENTER, 400 E. Collins, Casper WY 82601. (307)235-5247. Fax: (307)235-0923. Director: Karen R. Mobley. Estab. 1967.
Exhibits: Requirements: Artistic excellence and work must be appropriate to gallery's schedule. Interested in all subjects and media. Examples of exhibitions: works by Gerry Spence (b&w); Devendra Shirkehande (color); and Susan Moldenhauer (color). Presents 2 shows/year. Shows last 2 months. Sponsors openings. Photographer's presence at opening and during show is preferred.
Making Contact & Terms: Interested in receiving work from newer, lesser-known photographers. Charges 40% commission. General price range: $250-1,500. Reviews transparencies. Interested in framed or unframed work. Send material by mail for consideration (slides, vita, proposal). SASE. Reports in 1 month.
Tips: "We have a large children/youth audience and gear some of what we do to them."

‡NORTHLIGHT GALLERY, School of Art, Arizona State University, Tempe AZ 85287-1505. (602)965-6517. Contact: Advisory Committee. Estab. 1972.
Exhibits: Requirements: Review by Northlight advisory committee for academic year scheduling. Interested in "any and all" photography. Examples of recent exhibitions: "Family Matters," by Sally Mann, Vince Leo, Melissa Shook, Phillip Lorca DiCorcia; Richard Bolton; Jay Wolke, Paul DaMato, Beaumont Newhall. Presents 6 shows/year. Shows last 1 month. Sponsors openings; provides travel honorarium. Photographer's presence at opening preferred.
Making Contact & Terms: Interested in receiving work from newer, lesser-known photographers. Reviews transparencies. SASE. Reports in 1 month.

‡NORTHWEST ART CENTER, 500 University Ave. W., Minot ND 58707. (701)858-3264. Fax: (701)839-6933. Director: Linda Olson. Estab. 1976.
Exhibits: Examples of recent exhibitions: "Images of an Idyllic Past," by Edward S. Curtis (photogravures); "Window Service," by Joe Rattie (color photos); and "Canyon," by Dr. Wayne Jansen (b&w photos). Presents 2 shows/year. Shows last 1 month. Sponsors openings; provides refreshments. Photographer's presence at opening preferred.
Making Contact & Terms: Charges 30% commission. General price range: $50-300. Reviews transparencies. Interested in framed work only, mounted or unmounted, matted or unmatted. Send material by mail for consideration. SASE. Reports in 1 month.

THE NOYES MUSEUM OF ART, Lily Lake Rd., Oceanville NJ 08231. (609)652-8848. Fax: (609)652-6166. Curator: Stacy Smith. Estab. 1983.
Exhibits: Works must be ready for hanging, framed preferable. Interested in all styles. Examples of recent exhibitions: "American Amusements," by David Ricci (silver dye-bleach); photographs by Dwight Hiscano (Cibachrome); "Dust-shaped Hearts: Photographic Portraits," by Don Camp (casein and earth pigment monoprints). Presents 2-3 shows/year. Shows last 6-12 weeks. Sponsors openings; provides invitations, public relations, light refreshments. Photographer's presence at opening preferred.
Making Contact & Terms: Interested in receiving work from newer, lesser-known photographers. Charges 10% commission. Infrequently buys photos for permanent collection. General price range: $150-1,000. Reviews transparencies. Any format OK for initial review. Send material by mail for consideration, include résumé and slide samples. Reports in 1 month.
Tips: "Send challenging, cohesive body of work. May include photography and mixed media."

O.K. HARRIS WORKS OF ART, 383 W. Broadway, New York NY 10012. (212)431-3600. Fax: (212)925-4797. Director: Ivan C. Karp. Estab. 1969.

• This gallery is closed from mid-July to after Labor Day.

Exhibits: Requirements: "The images should be startling or profoundly evocative. No rock, dunes, weeds or nudes reclining on any of the above or seascapes." Interested in urban and industrial subjects and cogent photojournalism. Examples of exhibitions: "Pine Ridge Reservation South Dakota," by John Lucas; "Tokyo: Theatrical Megalopolis," by Seiji Kurata; and "Dorset County Asylum," by Luca Zampedri. Presents 5-8 shows/year. Shows last 3 weeks.

Making Contact & Terms: Charges 40% commission. General price range: $350-1,200. Interested in matted or unmatted work. Appear in person, no appointment: Tuesday-Friday 10-6. SASE. Reports back immediately.

Tips: "Do not provide a descriptive text."

OLIN FINE ARTS GALLERY, Washington & Jefferson College, Washington PA 15301. (412)222-4400. Fax: (412)223-5271. Website: http://www.washjeff.edu. Contact: Paul Edwards. Estab. 1982.

Exhibits: Requirements: Photographer must be at least 18 years old, American citizen. Artists assume most show costs. Interested in large format, experimental, traditional photos. Examples of previous exhibitions: one-person show by William Wellman; "The Eighties," by Mark Perrott. Presents 1 show/year. Shows last 3 weeks. Sponsors openings; pays for non-alcoholic reception if artist attends. Photographer's presence at opening preferred.

Making Contact & Terms: Charges 20% commission. General price range: $50-1,500. Reviews transparencies. Interested in framed work only. Shows are limited to works that are no bigger than 6 feet and not for publication. Send material by mail for consideration. SASE. Reports in 1 month.

OLIVER ART CENTER-CALIFORNIA COLLEGE OF ARTS & CRAFTS, 5212 Broadway, Oakland CA 94618. (510)594-3650. Fax: (510)428-1346. Director-Exhibitions/Public Programming: Dyana Curreri. Estab. 1989.

Exhibits: Requirements: Must be professional photographer with at least a 2-year exhibition record. Interested in contemporary photography in all formats and genres. Examples of recent exhibitions: "Landscape: A Concept," by Andy Goldsworthy, Vito Accenci, Catherine Wagner, Judy Fiskin and others; "Cultural Identities and Immigration-Changing Images of America in the 90's," by Larry Sultan, Young Kim, Su-Chen Hung and others; and "Judy Dater: A Survey." Presents 1-2 exhibits/year. Shows last 6-8 weeks. Photographer's presence at opening and at show preferred.

Making Contact & Terms: Interested in receiving work from newer, lesser-known photographers. "All subjects and styles are accepted for our slide registry." Payment negotiable. Reviews transparencies. Query with résumé of credits. SASE. Reports in 1 month.

Tips: "Know the types of exhibitions we have presented and the audience which we serve."

ONLINEGALLERY, Internet Marketing Corporation, P.O. Box 280, Chalfont PA 18914-0280. (215)997-1234. Fax: (215)997-1991. Websites: http://www.OnLineGallery.com; http://www.art21.com; http://www.eroto.com. President: R.C. Horsch. Estab. 1996. Gallery that "exists only electronically on the Internet." Requirements: "The work must be artistically defensible and of the highest quality, must be available in a limited, signed edition, and, if possible, should have been previously exhibited or published by a gallery or museum." Needs all types and styles, including erotic.

Exhibits: "We are similar to traditional galleries in that we 'mount' cohesive one-man shows of artists' work. However, we differ considerably in that we exist only on the Internet. This confers some advantages by providing an unlimited amount of exhibition space and allowing our artists' shows to remain permanently mounted. Also, we breach the regional barriers of physical galleries by reaching a potential audience of 60 milliion in over 150 countries worldwide. We have two special gallery sections: FineArtPhoto and CommercialPhoto. Photographers can utilize either or both depending on the nature of their work. Each artist has an individual 'exhibition space' in the form of a dedicated OnLineGallery Webpage. Within that space, art is grouped and presented as a body of work by the individual artist along with biographical information, promotional material, reviews and other pertinent data."

Making Contact & Terms: "Contact us in any way you choose for information. Include your address and phone number, or the address and phone number of your gallery or representative. Your 'exhibition space' will contain an e-mail form that people browsing your work can use to leave comments, messages and to contact you electronically. Every image will contain your name and copyright information in both visible and encoded form and cannot legally be sold or distributed without violating Federal copyright law." Charges for a basic listing with 12 images: $24/month; additional images $1/month.

Tips: "We have taken over the traditional 'Rated X' photography show that has been an industry tradition hosted by Marjorie Neikrug of Neikrug Photographica, Ltd. in her New York gallery for the past 20 years. This show will continue with us and open this summer as a permanently mounted exhibition of the world's

finest erotic photography. Interested photographers may purchase exhibition space in this exhibition under the same terms as other OnLineGallery areas,"

ORGANIZATION OF INDEPENDENT ARTISTS, 19 Hudson St., #402, New York NY 10013. (212)219-9213. Fax: (212)219-9216. Website: http://www.arts-online.com/oia.htm. Program Director: Nadini Richardson. Estab. 1976.
- OIA is a non-profit organization that helps sponsor group exhibitions at the OIA office and in public spaces throughout New York City.

Exhibits: Presents 2 shows/year. Shows last 1 month. Photographer's presence at opening preferred.
Making Contact & Terms: Interested in receiving work from newer, lesser-known photographers. Payment negotiable. Submit slides with proposal. Send material by mail for consideration according to guidelines only. Write for information on membership. SASE. "We review 3 times/year."
Tips: "It is not required to be a member to submit a proposal, but interested photographers may want to become OIA members to be included in OIA's active slide file that is used regularly by curators and artists. You must be a member to have your slides in the registry to be considered for exhibits 'Selections from the Slide File' at the OIA office."

ORLANDO GALLERY, Dept. PM, 14553 Ventura Blvd., Sherman Oaks CA 91403. Phone/fax: (818)789-6012. Website: http://artsceneal.com.gotoorlando. Directors: Robert Gino, Don Grant. Estab. 1958.
Exhibits: Interested in photography demonstrating "inventiveness" on any subject. Examples of recent exhibitions: landscapes by Steve Wallace; personal images by Fred Skupenski; platinum prints by Joseph Orsillo; and landscapes and nudes by Kevin Lynch and Chris Voelken. Shows last 1 month. Sponsors openings. Photographer's presence at opening and during show is preferred.
Making Contact & Terms: Very receptive to work of newer photographers. Charges 50% commission. Price range: $600-3,000. Query with résumé of credits. Send material by mail for consideration. SASE. Accepts images in digital format. Framed work only. Reports in 1 month. Requires exclusive representation in area.
Tips: Make a good presentation. "Make sure that personality is reflected in images. We're not interested in what sells the best—just good photos."

PACEWILDENSTEINMACGILL, (formerly Pace/MacGill Gallery), 32 E. 57th St., 9th Floor, New York NY 10022. (212)759-7999. Contact: Laura Santaniello. Estab. 1983.
- PaceWildensteinMacGill has a second location in Los Angeles: 9540 Wilshire Blvd., Beverly Hills CA 90212. (310)205-5522. Contact: Chelsea Hadley.

Exhibits: "We like to show original work that changes the direction of the medium." Presents 18 shows/year. Shows last 6-8 weeks. Sponsors openings. Photographer's presence at opening preferred.
Making Contact & Terms: Photography sold in gallery. Commission varies. On occasion, buys photos outright. General price range: $1,000-300,000.
Tips: "Review our exhibitions and ask, 'Does my work make a similar contribution to photography?' If so, seek third party to recommend your work."

PALO ALTO CULTURAL CENTER, 1313 Newell Rd., Palo Alto CA 94303. (415)329-2366. Contact: Exhibitions Dept. Estab. 1971.
Exhibits: "Exhibit needs vary according to curatorial context." Seeks "imagery unique to individual artist. No standard policy. Photography may be integrated in group exhibits." Shows last 1-3 months. Sponsors openings. Photographer's presence at opening preferred.
Making Contact & Terms: Reviews transparencies. Interested in framed work only. Send material by mail for consideration; include transparencies, slides, bio and artistic statement. SASE.

THE PEORIA ART GUILD, 1831 N. Knoxville Ave., Peoria IL 61603. (309)685-7522. Fax: (309)685-7446. Director: Tyson Joye. Estab. 1969.
- The Guild has a successful annual Digital Photo Competition. Write for details.

Exhibits: Requirements: submit slides, résumé and artist's statement. Examples of recent exhibitions: "Digital Photography '97"; a Fine Art Fair and a Fine Art Show & Sale with photography included. Presents 1-2 shows/year. Shows last 1 month. Sponsors openings; provides food and drink, occasionally live music. Photographer's presence at opening preferred.
Making Contact & Terms: Interested in receiving work from newer, lesser-known photographers. Charges 40% commission. General price range: $75-500. Reviews transparencies. Interested in framed or unframed work. Submit portfolio for review. Query with résumé of credits. Send material by mail for consideration. SASE. Reports in 1 month.

PHILLIPS GALLERY, 444 E. 200 S., Salt Lake City UT 84111. (801)364-8284. Fax: (801)364-8293. E-mail: phillips@houghtport.com. Director/Curator: Meri Ploetz. Estab. 1965.
Exhibits: Requirements: Must be actively pursuing photography. Interested in all types and styles. Examples of recent exhibitions: "A Western View," by John Telford (color photography); "What I Did on My Summer Vacation," by Ruth Gier (b&w photography); and "What I Did on My Summer Vacation," by Laurel Casjens (b&w and color photography). Shows last 4-6 weeks. Sponsors openings; provides advertisement, half of mailing costs and refreshments. Photographer's presence at opening and during show preferred.
Making Contact & Terms: Interested in receiving work from newer, lesser-known photographers. Charges 50% commission. General price range: $300-700. Reviews transparencies. Interested in framed or unframed, matted or unmatted work. Requires exclusive representation locally. Submit portfolio for review. SASE. Reports in 1-2 weeks.

‡PHOENIX GALLERY, 568 Broadway, Suite 607, New York NY 10012. (212)226-8711. Fax: (212)343-7303. Website: http://www.gallery-guide.com/gallery/phoenix. Director: Linda Handler. Estab. 1958.
Exhibits: Requirements: "The gallery is an artist-co-operative and an artist has to be a member in order to exhibit in the gallery." Interested in all media. Examples of recent exhibitions: "Off the Wall," by Joel Springer (mixed media, computer manipulated). Presents 1-2 shows/year. Shows last 1 month. Exhibiting artists pay for wine, bartender and soda. Photographer's presence at opening preferred.
Making Contact & Terms: Charges 25% commission. General price range: $100-10,000. Reviews transparencies. Interested in framed work only. Ask for membership application. SASE. Reports in 1 month.
Tips: "The Gallery has a small works project room where nonmembers can exhibit their work. If an artist is interested he/she may send a proposal with art to the gallery. The space is free with a 25% commission to the gallery. The artist also shares in the cost of the reception with the other artists showing at that time."

THE PHOTO LOUNGE, Truckee Meadows Community College, 7000 Danoini Blvd, Reno NV 89512. (702)673-7084. Fax: (702)673-7221. E-mail: eml@scs.unr.edu. Director: Professor Erik Lauritzen. Estab. 1993.
Exhibits: Requirements: Send 15 slides of recent work, résumé, artist's statement and SASE for return of slides. "There is a $15 fee; checks to Board of Regents." Annual deadline February 1. Examples of recent exhibitions: "Nuclear History-Nuclear Destiny," by James Lenager; "20 Years in the Quest," b&w photos by Don Cameron. Presents 8-9 shows/year. Shows last 1 month. Sponsors openings; provides full color announcement and catered reception—wine, cheese, breads, fruit, etc. Photographer's presence at opening preferred.
Making Contact & Terms: Interested in receiving work from newer, lesser-known photographers. Charges 20% commission. General price range: $150-1,500. Reviews transparencies. Interested in matted work only. Works are limited to 30×40 maximum. Send material by mail for consideration. SASE. Reports in 2-4 months.
Tips: Slides submitted should be sharp, in focus, color correct and show entire image. "Ours is a nonprofit educational space. Students and community rarely purchase work, but appreciate images shown. In Reno, exposure to art is valuable as the community is somewhat removed from the artworld."

PHOTOGRAPHIC IMAGE GALLERY, 240 SW First St., Portland OR 97204. (503)224-3543. Fax: (503)224-3607. Director: Guy Swanson. Estab. 1984.
Exhibits: Interested in primarily mid-career to contemporary Master-Traditional Landscape in color and b&w. Examples of recent exhibitions: "Erotica," by Charles Gatewood; "Group," by Rowell, Neil, Ketchum (landscapes); "Nudes," by Jenny Velsmann. Presents 12 shows/year. Shows last 1 month. Sponsors openings. Photographer's presence at opening preferred.
Making Contact & Terms: Charges 50% commission. General price range: $300-1,500. Reviews transparencies. Requires exclusive representation within metropolitan area. Query with résumé of credits. SASE. Reports in 1 month.
Tips: Current opportunities through this gallery are fair. Sees trend toward "more specializing in imagery rather than trying to cover all areas."

■PHOTOGRAPHIC RESOURCE CENTER, 602 Commonwealth Ave., Boston MA 02215. (617)353-0700. Fax: (617)353-1662. Curator: Robert E. Seydel. "The PRC is a nonprofit gallery."
Exhibits: Interested in contemporary and historical photography and mixed-media work incorporating photography. "The photographer must meet our high quality requirements." Examples of recent exhibitions: "Between Spectacle and Silence: the Holocaust in Contemporary Photography"; "Anxious Libraries: Photography and the Fate of Reading"; and "Extended Play: Between Rock and an Art Space." Presents 5-6 group thematic exhibitions in the David and Sandra Bakalar Gallery and 5-6 one- and two-person shows

in the Natalie G. Klebenov Gallery/year. Shows last 6-8 weeks. Sponsors openings; provides receptions with refreshments for the Bakalar Gallery shows.
Making Contact & Terms: Interested in receiving work from newer, lesser-known photographers. Will review transparencies. Interested in matted or unmatted work. Query with samples or send material by mail for consideration. SASE. Reports in 2-3 months "depending upon frequency of programming committee meetings. We are continuing to consider new work, but because the PRC's exhibitions are currently scheduled into 1998, we are not offering exhibition dates."

PHOTOGRAPHY GALLERY, Dept. PM, % Park School of Communications, Ithaca College, Ithaca NY 14850. (607)274-3088. Fax: (607)274-1664. Director and Associate Professor: Danny Guthrie. Estab. 1980.
Exhibitions: "Open to all photo-based work; recent and contemporary work by known and emerging artists. No requirements, but most exhibitors are semi-established artists or artists/academics." Presents 10 shows/years. Shows last 1 month. "We do a national mailing of the annual calendar with one image from each selected photographer."
Making Contact & Terms: Interested in receiving work from newer, lesser-known photographers. Photography is occasionally sold. Does not charge commission. General price range: $300-1,500. "We review slides during the month of September for the next year." Interested in matted work only. No frames. Large unmatted work is OK. 4×8 maximum size. Send material by mail for consideration only in month of September. SASE. Reports in 1 month.
Tips: Send work in September. Submit good quality, labeled slides with statement, vitae and support material.

‡PHOTO-SPACE AT ROCKLAND CENTER FOR THE ARTS, 27 S. Greenbush Rd., West Nyack NY 10994. (914)358-0877. Fax: (914)358-0971. Executive Director: Julianne Ramos. Estab. 1947.
Exhibits: Requirements: Geographic Limits: Rockland, Westchester and Orange counties in New York and Bergen County in New Jersey. Interested in all types of photos. Examples of recent exhibitions: "Panoramic Photography," by Sally Spivak; "Tomorrow," new works by young photographers; and "Digital Photography." Presents 4-5 shows/year. Shows last 2 months. Photographer's presence at opening preferred.
Making Contact & Terms: Charges 33% commission. General price range: $250-2,500. Reviews transparencies. Interested in matted or unmatted work. Shows are limited to 32×40. Query with samples. Send material by mail for consideration. SASE. Reports in 3 months.

‡PLATTSBURGH ART MUSEUM, (formerly Suny Plattsburgh Art Museum), State University of New York, 101 Broad St., Plattsburgh NY 12901. (518)564-2813 or (518)564-2474. Director: Edward Brohel. Estab. 1969.
Exhibits: "Professional work only." Presents "about 7 shows per year." Shows last 7 weeks. Sponsors openings. "Generally 4 gallery spaces have openings on the same day. One general reception, or tea, is held. It varies as to which gallery hosts." Photographer's presence at opening preferred.
Making Contact & Terms: Interested in receiving work from newer, lesser-known photographers. General price range: $25-200. Reviews transparencies. Interested in framed work only. Requires exclusive representation to a degree within metropolitan area. Send material by mail for consideration or submit portfolio for review. Returns material "if requested—some are kept on file." Reporting time "varies with gallery pressures."
Tips: "Be serious, be yourself and think."

PRAKAPAS GALLERY, 1 Northgate 6B, Bronxville NY 10078. (914)961-5091. Fax: (914)961-5192. Director: Eugene J. Prakapas.
Making Contact & Terms: Commission "depends on the particular situation." General price range: $500-100,000.
Tips: "We are concentrating primarily on vintage work, especially from between the World Wars, but some as late as the 70s. We are not currently doing exhibitions."

‡PYRAMID ARTS CENTER, INC., 302 N. Goodman St., Rochester NY 14607. (716)461-2222. Fax: (716)461-2223. Executive Director: Elizabeth McDade. Estab. 1977.
Exhibits: Examples of recent exhibitions: "Upstate Invitational," by Vincent Borrelli (20×24 color prints); work by Margaret Wagner (16×20 toned b&w prints); and "Brazil: The Thinking Photography," by Luis Monforte (digitalized computer prints). Presents 2-3 shows/year. Shows last 4-6 weeks. Sponsors openings. Photographer's presence at opening preferred.
Making Contact & Terms: Charges 25% commission. General price range $100-500. Reviews trans-

parencies. Send slides, letter of inquiry, résumé and statement. Reports in 2-3 months.

QUEENS COLLEGE ART CENTER, Benjamin S. Rosenthal Library, Queens College, Flushing NY 11367-6701. (718)997-3770. Fax: (718)997-3753. E-mail: sb5qc@cunyvm.cuny.edu. Website: http://www. qc.edu/Library/Acpage.html. Director: Suzanna Simor. Curator: Alexandra de Luise. Estab. 1952.
Exhibits: Requirements: Open to all types, styles, subject matter; decisive factor is quality. Photographer must be ready to deliver all the work in ready-to-be-exhibited condition and is responsible for installation, removal, transportation. Examples of recent exhibitions: "Masks, Landscapes, Places of Light," by Krystyna Sanderson; "Photographs of Puerto Rico: 1940's & 1980's," by Jack Delano; "Tony Velez: Photographs." Shows last 1 month. Sponsors openings. Photographer is responsible for providing/arranging, refreshments and cleanup. Photographer's presence at opening required, presence during show preferred.
Making Contact & Terms: Charges 40% commission. General price range: $100-500. Interested in framed or unframed, mounted or unmounted, matted or unmatted work. Query with résumé of credits. Query with samples. Send material by mail for consideration. SASE. Reports in 3-4 weeks.

RANDOLPH STREET GALLERY, 756 N. Milwaukee Ave., Chicago IL 60622. (312)666-7737. Fax: (312)666-8966. E-mail:rsg@interaccess.com. Website: fileroom.aaup.uic.edu/RSG/rsghome.html. Exhibitions Director: Paul Brenner. Estab. 1979.
Exhibits: Exhibits work in all media, mostly in group exhibitions dealing with a specific topic, theme, social issue or aesthetic concept. Examples of exhibitions: "Telling. . . Stories," group show (photographic autobiography); "Lousy Fear," Andrew Bush, Harlen Wallach, et al. (marketing of fear); and "Minefield of Memory," Rosy Martin (lesbian identity). Presents 7 shows/year. Shows last 5 weeks. Sponsors openings; provides publicity brochure for exhibition. Photographer's presence at opening preferred.
Making Contact & Terms: Payment negotiable. Reviews slides. Interested in framed or unframed, mounted or unmounted, matted or unmatted work. Send material by mail for consideration. SASE. Reports in 1-4 months, depending on when the slides are received.
Tips: "We review quarterly and view slides only. We are a nonprofit arts center, therefore we do not represent artists, but can facilitate sales through the artist's gallery or directly through artist."

RED MOUNTAIN GALLERY, Truckee Meadows Community College, 7000 Dandini Blvd., Reno NV 89512. (702)673-7084. Fax: (702)673-7221. E-mail: eml@scs.unr.edu. Gallery Director: Erik Lauritzen. Estab. 1990.
Exhibits: Interested in all styles, subject matter, techniques—less traditional, more innovative and/or cutting edge. Examples of recent exhibits: "Tents," by Wendy Erickson (16×20 Cibachrome prints); "Other Spaces—Chaos to Zen," by Misako Akimoto; "Watershed Investigations," by Mark Abrahamson; and "Mackaig's Kafe Klatche," by Janet Mackaig (photo laser transfers/acrylic or canvas). Number of photography exhibits presented each year depends on jury. Shows last 1 month. Sponsors openings; catered through school food service. Photographer's presence at opening is preferred, but not mandatory.
Making Contact & Terms: Possible honorarium. Charges 20% commission; artist sets price. General price range: $100-4,000. Reviews transparencies. Interested in exhibiting matted work only. Send 15 slides, résumé and SASE for consideration (35mm glassless dupes). "There is a $15 fee; checks payable to Board of Regents." Work is reviewed once a year; deadline is February 1st.
Tips: "Slides submitted should be sharp, accurate color and clearly labeled with name, title, dimensions, medium—the clearer the vitae the better. Statements optional." Sees trend toward mixed media concerns and explorations.

ANNE REED GALLERY, P.O. Box 597, 620 Sun Valley Rd., Ketchum ID 83340. (208)726-3036. Fax: (208)726-9630. Director: Jennifer Gately. Estab. 1980.
Exhibits: Requirements: Work must be of exceptional quality. Interested in platinum, palladium prints, landscapes, still lifes and regional material (West). Example of recent exhibitions: "An Unerring Eye," by Kenro Izu (still life, floral). Presents 1-2 shows/year. Shows last 1 month. Sponsors openings; provides installation of exhibition, public relations and opening reception. Photographer's presence at opening preferred.
Making Contact & Terms: Interested in receiving work from newer, lesser-known photographers. Charges 50% commission. General price range: $400-4,000. Reviews transparencies. Interested in framed or unframed, mounted or unmounted, matted or unmatted work. Requires exclusive representation locally. Submit portfolio for review. Query with résumé of credits. Query with samples. Send material by mail for consideration. "It helps to have previous exhibition experience." SASE. Reports in 1-3 weeks.
Tips: "We're interested only in fine art photography. Work should be sensitive, social issues are difficult to sell. We want work of substance, quality in execution and uniqueness. Exhibitions are planned one year in advance. Photography is still a difficult medium to sell, however there is always a market for exceptional work!"

ROBINSON GALLERIES, 2800 Kipling, Houston TX 77098. (713)521-2215. Fax: (713)526-0763. E-mail: robin@wt.net. Website: http://web.wt.net/~robin. Director: Thomas V. Robinson. Estab. 1969.
● Robinson Galleries, through Art Travel Studies, has developed various travel programs whereby individual photographers provide their leadership and expertise to travel groups of other photographers, artists, museum personnel, collectors, ecologists and travelers in general. Ecuador and Mexico are the featured countries, however, the services are not limited to any one destination. Artists/photographers are requested to submit biographies and proposals for projects that would be of interest to them, and possibly to others that would pay the expenses and an honorarium to the photographer leader.
Exhibits: Requirements: Archivally framed and ready for presentation. Limited editions only. Work must be professional. Not interested in pure abstractions. Examples of recent exhibitions: works by Pablo Corral (Cibachrome); Ron English (b&w and hand-colored silver gelatin prints); and Blair Pittman (audiovisual with 35mm slides in addition to Cibachrome and b&w framed photographs). Presents 1 show every other year. (Photographs included in all media exhibitions 1 or 2 times per year.) Shows last 4-6 weeks. Sponsors openings; provides invitations, reception and traditional promotion.
Making Contact & Terms: Charges 50% commission. General price range $100-1,000. Reviews transparencies. Interested in framed or unframed, matted or unmatted work. Requires exclusive representation within metropolitan or state area. Arrange a personal interview to show portfolio. Submit portfolio for review. Query with résumé of credits. SASE. Reports in 1-2 weeks.
Tips: "Robinson Galleries is a fine arts gallery first, the medium is secondary."

THE ROLAND GALLERY, 601 Sun Valley Rd., P.O. Box 221, Ketchum ID 83340. (208)726-2333. Fax: (208)726-6266. Contact: Roger Roland. Estab. 1990.
Exhibits: Example of exhibitions: works by Al Wertheimer (1956 original Elvis Presley prints). Presents 5 shows/year. Shows last 1 month. Sponsors openings; provides advertising and reception. Photographer's presence at opening and during show preferred.
Making Contact & Terms: Interested in receiving work from newer, lesser-known photographers. Charges 50% commission. General price range: $100-1,000. Reviews transparencies. Interested in matted or unmatted work. Submit portfolio for review. SASE. Reports in 1 month.

THE ROSSI GALLERY, 2821 McKinney Ave., Dallas TX 75204. (214)871-0777. Fax: (214)871-1343. Owner: Hank Rossi. Estab. 1987.
Exhibits: Pays shipping both ways. Interested in b&w film noir. Challenging work and conceptual are preferred. Examples of recent exhibits: "Visions of the West," by Skeeter Hagler (b&w); photography by Natalie Caudill (mixed media photographs); "Spirit," by David Chasey (b&w). Presents 2 shows/year. Shows last 1 month. Sponsors openings; provides refreshments, invitations. Photographer's presence at opening required.
Making Contact & Terms: Interested in reviewing work from newer, lesser-known photographers. Charges 40% commission. General price range: $400-1,500. Reviews transparencies. Interested in mounted, matted, or unmatted work only. Query with samples. SASE. Reports in 1 month.
Tips: "Be responsible and prompt. Figurative work is very strong."

THE ROTUNDA GALLERY, 33 Clinton St., Brooklyn NY 11201. (718)875-4047. Fax: (718)488-0609. Director: Janet Riker.
Exhibits: Requirements: Must live in, work in or have studio in Brooklyn. Interested in contemporary works. Examples of previous exhibitions: "All That Jazz," by Cheung Ching Ming (jazz musicians); "Undiscovered New York," by Stanley Greenberg (hidden New York scenes); "To Have and to Hold," by Lauren Piperno (ballroom dancing). Presents 1 show/year. Shows last 5 weeks. Sponsors openings. Photographer's presence at opening preferred.
Making Contact & Terms: Interested in receiving work from newer, lesser-known photographers. Charges 20% commission. Reviews transparencies. Interested in framed or unframed, mounted or unmounted, matted or unmatted work. Shows are limited by walls that are 22 feet high. Arrange a personal interview to show portfolio. Send material by mail for consideration. Join artists slide registry, call for form. SASE.

 SPECIAL COMMENTS within listings by the editor of *Photographer's Market* are set off by a bullet.

SANGRE DE CRISTO ARTS CENTER, 210 N. Santa Fe Ave., Pueblo CO 81003. (719)543-0130. Fax: (719)543-0134. Curator of Visual Arts: Jennifer Cook. Estab. 1972.
Exhibits: Requirements: Work must be artistically and technically superior; all displayed works must be framed. It is preferred that emerging and mid-career artists be regional. Examples of exhibitions: Yousef Karsh (b&w, large format); Laura Gilpin (photos of the Southwest); James Balog ("Survivors" series and "Material World," international photographic project). Presents 3 shows/year. Shows last 2 months. Sponsors openings; provides hors d'oeuvres, cash bar and live musical entertainment. Photographer's presence at opening preferred.
Making Contact & Terms: Interested in receiving work from newer, lesser-known photographers, particularly regional. Charges 30% commission. General price range: $200-800. Reviews transparencies. Interested in framed or unframed, matted or unmatted work. Arrange a personal interview to show portfolio. Submit portfolio for review. Query with résumé of credits. Query with samples. Send material by mail for consideration. Reports in 2 months.

MARTIN SCHWEIG STUDIO AND GALLERY, 4658 Maryland Ave., St. Louis MO 63108. (314)361-3000. Gallery Director: Christine Flavin.
Exhibits: Requirements: Photographs must be matted to standard frame sizes. Interested in all types, expecially interested in seeing work that pushes the boundaries of photography, in technique and subject. Examples of recent exhibitions: "Celebrations," by Paul Dahlquist (20-year retrospective); "Emulsion Media," by various artists (annual alternative photographic processes); and "Redux," by Herb Wetman (retrospective, lifetime work). Presents 8 shows/year. Shows last 1 month. Sponsors openings. Photographer's presence at opening preferred.
Making Contact & Terms: Interested in receiving work from newer, lesser-known photographers. Charges 40% commission. General price range: $200-1,200. Interested in mounted or matted work. Submit portfolio for review. Query with samples. Usually a portfolio must be submitted twice. Portfolio should include 12-15 matted pieces. SASE. Reports in 1 month.
Tips: Looks for technical expertise, creativity and simplicity. "Ours is the longest continuing gallery in St. Louis. Our show schedule is decided by a panel of jurors (professional photographers and educators)."

SECOND STREET GALLERY, 201 Second St. NW, Charlottsville VA 22902. (804)977-7284. Fax: (804)979-9793. E-mail: fsg@cstone.net. Director: Sarah Sargent. Estab. 1973.
Exhibits: Requirements: Request exhibition guidelines. Examples of recent exhibitions: works by Anne Arden McDonald, Patricia Germain and Bill Emory. Presents 2-3 shows/year. Shows last 1 month. Sponsors openings. Photographer's presence at opening preferred.
Making Contact & Terms: Interested in receiving work from newer, lesser-known photographers. Charges 25% commission. General price range: $250-2,000. Reviews transparencies in fall. Submit 10 slides for review. SASE. Reports in 6-8 weeks.

SELECT ART, 10315 Gooding Dr., Dallas TX 75229. (214)353-0011. Fax: (214)350-0027. Owner: Paul Adelson. Estab. 1986.
● This market deals fine art photography to corporations and sells to collectors.
Exhibits: Interested in architectural pieces and landscapes.
Making Contact & Terms: Interested in receiving work from newer, lesser-known photographers. Charges 50% commission. General price range: $250-600. Retail price range: $100-1,000. Reviews transparencies. Interested in unframed and matted work only. Send material by mail for consideration. SASE. Reports in 1 month.
Tips: Make sure the work you submit is fine art photography, not documentary/photojournalistic or commercial photography. No nudes.

SHAPIRO GALLERY, 250 Sutter St., 3rd Floor, San Francisco CA 94108. (415)398-6655. Owner: Michael Shapiro. Estab. 1980.
Exhibits: Interested in "all subjects and styles. Superior printing and presentation will catch our attention." Examples of exhibitions: Aaron Siskind (b&w); Andre Kertesz (b&w); and Vernon Miller (platinum). Shows last 2 months. Sponsors openings.
Making Contact & Terms: Very interested in receiving work from newer, lesser-known photographers. General price range: $500-50,000. Weekly portfolio drop off for viewing on Wednesdays. No personal interview or review is given. "No slides please." SASE.
Tips: "Classic, traditional" work sells best.

NANCY SOLOMON GALLERY, 1037 Monroe Dr., Atlanta GA 30306. (404)875-7150. Fax: (404)875-0270. Gallery. Estab. 1994.

Exhibits: Requirements: Must supply full set (20 or more) of slides for review with biography and résumé. Interested in contemporary, large format, pin-hole and international work. Examples of recent exhibitions: "Fantastic Imagery," by Lawrence Beck (b&w large format); and works by "Skeet McAuley." Presents 3-4 shows/year. Shows last 5 weeks. Sponsors openings; provides invitations and food and drink. Photographer's presence at opening preferred.
Making Contact & Terms: Interested in receiving work from newer, lesser-known photographers. Charges 50% commission. General price range: $500-3,000. Reviews transparencies. Interested in framed or unframed work. Submit portfolio for review. Send material by mail for consideration. "Only portfolios reviewed." SASE. Reports in 3 weeks.

‡**SOUTH SHORE ART CENTER, INC.**, 119 Ripley Rd., Cohasset MA 02025. (617)383-2787. Fax: (617)383-2964. Executive Director: Laura Carleton. Estab. 1954.
Exhibits: Interested in "all types of fine arts photography." Example of recent exhibitions: "Color/Black & White" (all media, no theme), 100 selected from 350 entries. Presents at least 25 shows/year—juried and invitational. Shows last 4-5 weeks. Sponsors openings; cost of announcements; all opening costs of juried shows. Artists pay part of costs of an invitational show (gallery rental). Photographer's presence at opening is preferred.
Making Contact & Terms: Very interested in receiving work from newer, lesser-known photographers. Charges 40% commission. Charges $8/piece for juried shows; $100-150/person for invitational group shows. General price range: $100-500. Reviews transparencies. Interested in exhibiting framed work only. Limitations: work "must be framed in wood or metal—no bare glass edges." Send résumé and slide sheet, request call for entries.

B. J. SPOKE GALLERY, 299 Main Street, Huntington NY 11743. (516)549-5106. Coordinators: Marilyn Lavi, Debbie La Mantia.
Exhibits: Annual national/international juried show. Deadline November 30, 1997. Send for prospectus. Requirements: juried shows; send for prospectus or deadline. Interested in "all styles and genres, photography as essay, as well as 'beyond' photography." Examples of recent exhibitions: "Reflections on China"; "Photography '96, Invitational," by 8 photographers (varied subjects); "Photography '97 Invitational," by 20 photographers (varied subjects). Shows last 1 month. Sponsors openings. Photographer's presence at opening preferred.
Making Contact & Terms: Interested in receiving work from newer, lesser-known photographers. Charges 25% commission. General price range: $200-800; photographer sets price. Reviews transparencies. Interested in framed or unframed, matted or unmatted work. Arrange a personal interview to show portfolio. Query with résumé of credits. Send material by mail for consideration. SASE. Reports back in 2 months.
Tips: Offers biennial photography invitational in odd years. Curatorial fee: $50.

THE STATE MUSEUM OF PENNSYLVANIA, P.O. Box 1026, Third & North Streets, Harrisburg PA 17108-1026. (717)787-4980. Fax: (717)783-4558. Senior Curator, Art Collections: N. Lee Stevens. Museum established in 1905; current Fine Arts Gallery opened in 1993.
Exhibits: Requirements: Photography must be created by native or resident of Pennsylvania, or contain subject matter relevant to Pennsylvania. Art photography is a new area of endeavor for The State Museum, both collecting and exhibiting. Interested in works produced with experimental techniques. Examples of exhibitions: "Art of the State: PA '94," by Bruce Fry (manipulated, sepia-toned, b&w photo), and works by Norinne Betjemann (gelatin silver print with paint), and David Lebe (painted photogram). Number of exhibits varies. Shows last 2 months. Photographer's presence at opening preferred.
Making Contact & Terms: Interested in receiving work from newer, lesser-known photographers. Work is sold in gallery, but not actively. General price range: $50-3,000. Reviews transparencies. Interested in framed work. Send material by mail for consideration. SASE. Reports in 1 month.

‡**SWEET ART GALLERY**, 602 E. Ojai Ave., Ojai CA 93023. (805)646-5252. Owner: D. Sans Burke. Estab. 1989.
Exhibits: Requirements: "This is a child-oriented gallery. Be sensitive to a child's needs. No erotica." Example of recent exhibitions: photographs by Marisa Staker. Presents 1 show/year. Shows last 2 months.

THE SUBJECT INDEX, located at the back of this book, lists publications, book publishers, galleries, paper product companies and stock agencies according to the subject areas they seek.

Sponsors openings; shares expenses equally with photographer. Photographer's presence at opening required, presence during show preferred.

Making Contact & Terms Charges 50% commission. Sometimes buys photos outright. General price range: $150-250. Reviews transparencies. Interested in framed or unframed, mounted or unmounted, matted or unmatted work. Prefers smaller pieces. Send material by mail for consideration. "I can review portfolios on CD-ROM but I do not showcase online." SASE. Reports in 1 month.

Tips: "Keep prices reasonable; it helps me to sell your work."

THREAD WAXING SPACE, 476 Broadway, New York NY 10013. (212)966-9520. Fax: (212)274-0792. Executive Director: Ellen Salpeter. Estab. 1991.

Exhibits: "We are a nonprofit exhibition and performance space and do not sell or represent work. We have no set parameters, but, generally, we exhibit emerging artists' work or work that is not ordinarily accessible to the public." Examples of recent exhibitions: "Pence Springs Resort," by Stefan Roloff (photographic installation); "Solo Exhibition," by Pico Harnden; and "Collaboration B&W," by Nancy Spero and Abe Frapndlich. Shows last 6 weeks. Sponsors openings. Photographer's presence at opening and during show preferred.

Making Contact & Terms: Interested in receiving work from newer, lesser-known photographers. Reviews transparencies. Send slides with SASE.

UNIVERSITY ART GALLERY, NEW MEXICO STATE UNIVERSITY, Dept. 3572, P.O. Box 30001, Las Cruces NM 88003. (505)646-2545. Fax: (505)646-8036. Director: Charles M. Lovell. Estab. 1973.

Exhibits: Examples of recent exhibitions: "Breath Taken," by Bill Ravanesz (documentary of asbestos workers); "Celia Munoz," by Celia Munoz (conceptual); and "Nino Fidencio, A Heart Thrown Open," by Dore Gardner (documentary photographs of followers of a Mexican faith healer). Presents 1 show/year. Shows last 2 months. Sponsors openings; provides curatorial, registration and shipping. Photographer's presence at opening preferred.

Making Contact & Terms: Buys photos outright. General price range: $100-1,000. Interested in framed or unframed work. Arrange a personal interview to show portfolio. Submit portfolio for review. Query with samples. Send material by mail for consideration by end of October. SASE. Reports in 2 months.

Tips: Looks for "quality fine art photography. The gallery does mostly curated, thematic exhibitions. Very few one-person exhibitions."

URBAN PARK-DETROIT ART CENTER, 508 Monroe St., Detroit MI 48226-2944. (313)963-5445. Director: Dave Roberts. Estab. 1991.

Exhibits: Requirements: Artist or designate must assist in staffing gallery 32 hours over course of exhibition. Interested in landscape, still life, figurative. Examples of recent exhibitions: "Abstracts," by Ray Rohr (b&w photos); "A Girl's World," by youth. Presents 8 shows/year. Shows last 5 weeks. Sponsors openings; provides mailed announcements, refreshments. Photographer's presence at opening preferred; presence during show required.

Making Contact & Terms: Interested in receiving work from newer, lesser-known photographers. Charges 40% commission. General price range: $150-800. Reviews transparencies. Interested in framed work only. Arrange a personal interview to show portfolio. Submit portfolio for review. Query with résumé of credits. Query with samples. SASE. Reports in 1 month.

Tips: "Photographers should present a solid body of work with resolved ideas. Subjects can range from landscape still life or figurative to totally abstract. We are looking for comprehensive series within a particular style."

VALENCIA COMMUNITY COLLEGE EAST CAMPUS GALLERIES, P.O. Box 3028, Orlando FL 32802. (407)299-5000 ext. 2298. Fax: (407)299-5000 ext. 2270. Gallery Curator: Anita Wooten. Estab. 1982.

Exhibits: Interested in innovative, documentary, straight-forward style. Examples of recent exhibitions: "Figure/Ground Relationships," by Margaret Steward and Amelia Pierney (landscape/figurative paintings, drawings, photos); and "Picture Element," by Kenneth Sean Golden and others (electronic imaging). Shows last 6-8 weeks. Sponsors openings; provides food. Photographer's presence at opening required; presence during show preferred.

Making Contact & Terms: Interested in receiving work from newer, lesser-known photographers. Does not charge commission. General price range: $175-1,500. Reviews transparencies. Interested in matted work only. Send material by mail for consideration. SASE. Reports as needed.

Tips: Photography is usually exhibited with other mediums. Looks for "freshness and personal vision. Professional presentation is most helpful; display a willingness to participate in group shows." Sees a renewed interest in documentary photography, also in contemporary materials and methods.

‡**VERED GALLERY**, 68 Park Place, East Hampton NY 11937. (516)324-3303. Fax: (516)324-3303. Vice President: Janet Lehr. Estab. 1977.
Exhibits: Requirements: Submit slides with biography and SASE. Interested in avant-garde work. Examples of recent exhibitions: works by Edouard Baldus, Rober Fenton, Lewis Hine, Harold Edgerton. Shows last 3 weeks. Sponsors openings. Photographer's presence at opening preferred.
Making Contact & Terms: Charges 50% commission. General price range $750. Reviews transparencies. Interested in slides or transparencies, then exhibition prints. Requires exclusive representation within metropolitan area. Query with résumé of credits. SASE. Reports in 3 weeks.

VIRIDIAN GALLERY, 24 W. 57 St., New York NY 10019. (212)245-2882. Director: Joan Krawczyk. Estab. 1968.
Exhibits: Interested in eclectic. Member of Cooperative Gallery. Examples of recent exhibitions: works by Susan Hockaday, Glenn Rothman, Carol Crawford and Robert Smith. Presents 1-2 shows/year. Shows last 3 weeks. Photographer's presence at opening preferred.
Making Contact & Terms: Is receptive to exhibiting work of newer photographers, but they must pass board acceptance. Charges 30% commission. General price range: $300-600. Will review transparencies only if submitted as membership application. Interested in framed or unframed, mounted, and matted or unmatted work. Request membership application details. Send materials by mail for consideration. SASE. Reports in 3 weeks.
Tips: Opportunities for photographers in galleries are "improving." Sees trend toward "a broad range of styles" being shown in galleries. "Photography is getting a large audience that is seemingly appreciative of technical and aesthetic abilities of the individual artists."

‡**THE WAILOA CENTER GALLERY**, P.O. Box 936, Hilo HI 96720. (808)933-4360. Director: Mrs. Pudding Lassiter. Estab. 1967.
Exhibits: Requirements: Pictures must be submitted to director for approval. Examples of recent exhibitions: Cliff Panis (photography); Dennis Jones (photographic journal); and Diane McMillen (photographic flora studies). Presents 3 shows/year. Shows last 30 days. Sponsors openings; no charge to photographer for facilities. Photographer's presence at opening and during show preferred.
Making Contact & Terms: Gallery receives 10% "donation" on works sold. Reviews transparencies. Interested in framed work only. "Pictures must also be fully fitted for hanging. Expenses involved in shipping, insurance, etc. are the responsibility of the exhibitor." Submit portfolio for review. Query with résumé of credits. Query with samples. SASE. Reports in 3 weeks.
Tips: "The Wailoa Center Gallery is operated by the State of Hawaii, Department of Land and Natural Resources. We are unique in that there are no costs to the artist to exhibit here as far as rental or commissions are concerned. We welcome artists from anywhere in the world who would like to show their works in Hawaii. The gallery is also a visitor information center with thousands of people from all over the world visiting."

SANDE WEBSTER GALLERY, 2018 Locust St., Philadelphia PA 19103. (215)732-8850. Fax: (215)732-7850. E-mail: swgpa@aol.com. Contact: Gallery Director.
● The gallery will review the work of emerging artists, but due to a crowded exhibition schedule, may defer in handling their work.
Exhibits: Requirements: Interested in contemporary, fine art photography in limited editions. "We encourage the use of non-traditional materials in the pursuit of expression, but favor quality as the criterion for inclusion in exhibits." Examples of exhibitions: "Dust Shaped Hearts," by Don Camp (photo sensitized portraits); works by Norrine Betjemann (hand-tinted); Kevin Reilly (documentary landscape and automotive images) and "Just Jazz" (multimedia group show of jazz images). Presents 10 shows/year. Shows last 1 month. Sponsors openings; covers all costs for the event. The artist is responsible for travel and accommodations. Photographer's presence at opening and during show preferred.
Making Contact & Terms: Interested in receiving work from newer, lesser-known photographers. Charges 50% commission. General price range: $200-5,000. Reviews transparencies. Interested in framed or unframed work. Send material by mail for consideration. Include résumé, price list and any additional support material. SASE. Reports in 1 month.

 MARKETS USING AUDIOVISUAL MATERIAL, such as slides, film or videotape, are marked with a solid, black square.

"An uncertain relationship with the landscape" is the idea behind Norinne Betjemann's *Portrait*, shown at the Sande Webster Gallery. The work, composed of gelatin silverprints, canvas and paint, was the mailer image for London-based Betjemann's solo show "Breathing in Irrespirable Atmospheres."

WESTCHESTER GALLERY, 196 Central Ave., County Center, White Plains NY 10606. (914)684-0094. Fax: (914)684-0608. Gallery Coordinator: Christine Jewell.
Exhibits: Requirements: submit 10 slides or actual work to be juried by panel of artists. Example of exhibition: works by Tim Keating and Alan Rokach. Presents 2 photo shows/year (usually). Shows last 1 month. Sponsors openings; gallery covers cost of space, light, insurance, mailers (printing and small mailing list) and modest refreshments. Photographer's presence at opening preferred.
Making Contact & Terms: Interested in receiving work from newer, lesser-known photographers. Charges 33⅓% commission. General price range $150-3,750. Reviews transparencies. Interested in any presentable format ready to hang. Arrange a personal interview to show portfolio. Submit portfolio for review. Query with résumé of credits. Send material by mail for consideration. SASE. Reports in 1 month.
Tips: "Most sales are at low end, $150. Gallery space is flexible and artists are encouraged to do their own installation."

WHITE GALLERY-PORTLAND STATE UNIVERSITY, Box 751/SD Portland OR 97207. (503)725-5656 or (800)547-8887. Fax: (503)725-4882. Associate Director: Dulcinea Myers-Newcomb. Estab. 1969.
Exhibits: Examples of previous exhibitions: "Invisible No More," by Orville Robertson (b&w); "In the City Streets," by Edis Lurchis (b&w); and Collection of Opera Photographs," by Christine Sale (b&w). Presents 12 shows/year. Exhibits last 1 month. Sponsors openings. Photographer's presence at opening and during show is preferred.
Making Contact & Terms: Charges 30% commission. General price range: $175-400. Interested in unframed, mounted, matted work. "We prefer matted work that is 16×20." Send material by mail for consideration. SASE. Reports in 1 month.
Tips: "Best time to submit is September-October of the year prior to the year show will be held. We only go by what we see, not the name. We see it all and refrain from the trendy. Send slides. Do something different . . . view life upside down."

WYCKOFF GALLERY, 648 Wyckoff Ave., Wyckoff NJ 07481. (201)891-7436. Director: Sherry Cosloy. Estab. 1978.
Exhibits: Requirements: Prior exhibition schedule, mid-career level. Interested in all styles except depressing subject matter (e.g. AIDS, homelessness). Example of exhibitions: works by Jorge Hernandez (landscapes). Presents 1 exhibit/year. Shows last 1 month. Sponsors openings; arrangements discussed with photographer. Photographer's presence at opening is required, presence during show preferred.
Making Contact & Terms: General price range: $200-2,000. Reviews transparencies. Interested in framed or unframed, mounted or unmounted, matted or unmatted work. Requires exclusive presentation locally. Query with résumé of credits. Query with samples. SASE. Reports in 1-2 weeks.
Tips: "I am predominantly a fine arts (paintings and sculptures) gallery so photography is not the prime focus. People like photography that is hand-colored and/or artistic in composition and clarity."

YESHIVA UNIVERSITY MUSEUM, 2520 Amsterdam Ave., New York NY 10033. (212)960-5390. Fax: (212)960-5406. Director: Sylvia A. Herskowitz. Estab. 1973.

Exhibits: Seeks work focusing on Jewish themes and interest. Examples of recent exhibitions: "Sacred Realm: The Emergence of the Synagogue in the Ancient World"; "In a Golub: The Work of the Weavers in Color." Presents 3-4 shows/year. Shows last 4-8 months. Sponsors openings; provides invitations and light refreshments. Photographer's presence at opening preferred.

Making Contact & Terms: Interested in receiving work from newer, lesser-known photographers. Photography sold in museum shop. Payment negotiable; commission negotiable. General price range: $100 and up. Interested in framed work. Send material by mail for consideration. Reports following meeting of exhibits committee.

Tips: "We exhibit contemporary art and photography based on a Jewish theme. We look for excellent quality; individuality; and especially look for unknown artists who have not widely exhibited either in the New York area or at all. Send a slide portfolio of ten slides, an exhibition proposal, a résumé, and other pertinent information with a SASE. We conduct portfolio reviews three times a year."

Record Companies

The move away from traditional albums and toward CDs has not only changed the way music is packaged, but also affected the way it appears. Designers, for example, are using more photo and art collages to pump up the visual appeal of CDs and cassettes. Record producers want photos with odd angles and high-tech computer enhancements.

In many instances this signals a move meant to appeal to the Generation X crowd. As a photographer you have to adapt to this trend if you plan to market your work to the music industry. When working with record companies you will be asked to supply images for all kinds of uses. Assignments are made for album, cassette or CD covers, but frequently images are used in promotional pieces to sell the work of recording artists. As always, you should try to retain rights to images for future sales and the usage should help you establish a fair price during negotiations.

BUILDING YOUR PORTFOLIO

A good portfolio for record companies shows off your skills and style in an imaginative way, but especially illustrates your ability to solve creative problems facing art directors. Such problems may include coming up with fresh concepts for record art, working within the relatively limited visual format of the 5-inch compact disc liner sheet or assembling a complex shot on a limited budget. If you have not worked for a record company client, you still can study the needs of various companies in this section and shoot a series of self-assignments which clearly show your problem-solving abilities.

Photographers who go on to long-term, high-profile success often start working with smaller, independent music companies, or "indies." Larger companies typically rely on stables of photographers who are either on staff or work through art studios that deal with music companies. Because of this tendency, it can be difficult for newcomers to break in when these companies already have their pick of talented, reliable photographers. Start out slowly and develop a portfolio of outstanding images. Eventually the larger companies will become familiar with your work and they will seek you out when looking for images or handing out assignments.

Freelancers also must be alert when dealing with the independent market. When trying to attract new clients in this field, query prospective companies and request copies of their various forms and contracts for photographers. Seeing the content of such material can tell you a great deal about how well organized and professional a company is. Also talk to people within the music industry to get a better understanding of the company with which you want to do business.

For additional listings of record companies or more detailed information, check your library for *The Yellow Pages of Rock* (The Album Network) or the *Recording Industry Sourcebook* (Cardinal Business Media, Inc.).

A&M RECORDS, 1416 N. Labrea Ave., Hollywood CA 90028. Website: http://www.amrecords.com. Did not respond to our request for information.

■**AFTERSCHOOL PUBLISHING COMPANY**, P.O. Box 14157, Detroit MI 48214. (313)894-8855. President: Herman Kelly. Estab. 1977. Handles all forms of music. Freelancers used for portraits, in-concert shots, studio shots and special effects for publicity, brochures, posters and print advertising. Examples of recent uses: "Tell You What You're Going To Do," "Take A Journey," and "Love Letter-Dance to the Drummer" (all CD covers).
Needs: Buys 5-10 images annually. Offers 5-10 assignments annually. Interested in animation, love. Reviews stock photos. Model/property release preferred. Captions preferred.

Audiovisual Needs: Uses videotape, prints, papers for reproductions. Subjects include: love, fun, comedy, life, food, sports, cars, cultures.

Specs: Uses prints, all sizes and finishes, and videotape, all sizes. Accepts images in digital format for Windows (all file types).

Making Contact & Terms: Interested in receiving work from newer, lesser-known photographers. Submit portfolio for review. Keeps samples on file. SASE. Reports in 1 month. Pays $5-500/b&w photo; $5-500/color photo; $5-500/hour; $5-500/day; payment negotiable. Credit line given. Buys one-time, exclusive product and all rights; negotiable.

■♣**ALERT MUSIC, INC.**, 41 Britain St., Suite 305, Toronto, Ontario M5A 1R7 Canada. (416)364-4200. Fax: (416)364-8632. E-mail: alert@inforamp.net. Promotion Coordinator: Rose Slanic. Handles rock, pop and alternative. Freelancers used for cover/liner shots, inside shots and publicity.

Needs: Reviews stock photos. Model/property release preferred. Captions required.

Audiovisual Needs: Uses slides and videotape.

Specs: Uses color and b&w prints.

Making Contact & Terms: Query with résumé of credits. Works with local freelancers on assignment only. Keeps samples on file. SASE. Credit line given. Rights negotiable.

■♣**AQUARIUS RECORDS/TACCA MUSIQUE**, 1445 Lambert Closse, Suite 200, Montreal, Quebec H3H 1Z5 Canada. (514)939-3775. Fax: (514)939-2778. Production Manager: Rene LeBlanc. Estab. 1971. Handles rock, contemporary, alternative—English and French. Freelancers used for portraits, in-concert shots, studio shots, cover/liner shots, inside shots, publicity, brochures, posters and print advertising.

Needs: Buys 30 images annually; all supplied by freelancers. Offers 10 assignments annually. Model/property release required for photos of artists.

Audiovisual Needs: Uses slides and videotape glossies for promotion.

Specs: Uses 8×10 color and b&w prints; 2¼×2¼ transparencies.

Making Contact & Terms: Provide résumé, business card, self-promotion pieces or tearsheets to be kept on file for possible future assignments. Works with local freelancers only. Keeps samples on file. SASE. Reports in 1 month. Pays $400-750/job; $1.50-2/b&w photo. **Pays on acceptance**. Credit line given. Buys all rights.

ARISTA, 6 W. 57th St., New York NY 10019. Website: http://www.aristarec.com. Did not respond to our request for information.

ART ATTACK RECORDINGS/CARTE BLANCHE/MIGHTY FINE RECORDS, Dept. PM, Fort Lowell Station, P.O. Box 31475, Tucson AZ 85751. (602)881-1212. President: William Cashman. Handles rock, pop, country and jazz. Photographers used for portraits, in-concert shots, studio shots and special effects for album covers, inside album shots, publicity and brochures.

Needs: Offers 10-15 assignments/year.

Specs: "Depends on particular project."

Making Contact & Terms: Arrange a personal interview to show portfolio. Provide résumé, business card, self-promotion pieces or tearsheets to be kept on file for possible future assignments. Works on assignment only. "We will contact only if interested." Payment negotiable. Credit line given.

Tips: Prefers to see "a definite and original style—unusual photographic techniques, special effects" in a portfolio. "Send us samples to refer to that we may keep on file."

■**ASYLUM RECORDS/EEG**, 1906 Acklen Ave., Nashville TN 37212. (615)292-7990. Fax: (615)298-4385. Director/Creative Services: Kristi Brake. Estab. 1992. Handles country. Freelancers used for portraits, in-concert shots, studio shots, special effects, cover/liner shots, inside shots, publicity, brochures, event/convention coverage and print advertising. Examples of recent uses: "A Simple I Love You" (single CD packaging) and *Mandy Barnett* (album packaging), both by Mandy Barnett; and "Sittin' on Go," by Bryan White (single advertising).

♣ **CANADIAN LISTINGS** are marked with a maple leaf.

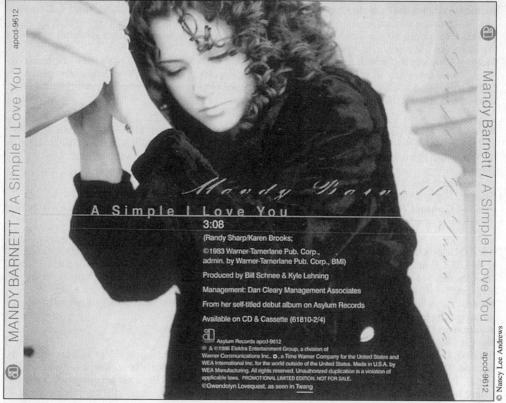

apcd 9612

MANDY BARNETT / A Simple I Love You

Mandy Barnett / A Simple I Love You

apcd-9612

© Nancy Lee Andrews

Mandy Barnett

A Simple I Love You

3:08

(Randy Sharp/Karen Brooks;

©1983 Warner-Tamerlane Pub. Corp.,

admin. by Warner-Tamerlane Pub. Corp., BMI)

Produced by Bill Schnee & Kyle Lehning

Management: Dan Cleary Management Associates

From her self-titled debut album on Asylum Records

Available on CD & Cassette (61810-2/4)

Asylum Records apcd-9612
℗ & ©1996 Elektra Entertainment Group, a division of
Warner Communications Inc. ♢, a Time Warner Company for the United States and
WEA International Inc. for the world outside of the United States. Made in U.S.A. by
WEA Manufacturing. All rights reserved. Unauthorized duplication is a violation of
applicable laws. PROMOTIONAL LIMITED EDITION. NOT FOR SALE.
©Gwendolyn Lovequest, as seen in Twang

This photo by Nancy Lee Andrews appeared in an article in *Twang* magazine on singer Mandy Barnett. Asylum records approached the photographer asking to use the image on Barnett's CD single package after seeing it in *Twang*. "We shot this in a cemetery in Nashville—the statuary and stone work were magnificent," says Andrews. "Mandy and I both happened to love the place. Once there, the ambiance seemed to envelope us . . . moody, introspective, and other-worldly." Asylum paid the photographer $200 to reprint her photo on the CD cover.

Needs: Reviews stock photos.
Audiovisual Needs: Uses slides, film and videotape.
Specs: Accepts images in digital format for Mac (Quark, Adobe). Send via compact disc, floppy disk, SyQuest, optical disk (high resolution preferred).
Making Contact & Terms: Interested in receiving work from newer, lesser-known photographers. Query with samples. Query with stock photo list. Provide résumé, business card, self-promotion pieces or tear-sheets to be kept on file for possible future assignments. Keeps samples on file. Will respond if interested in material for a current project. Payment negotiable.
Tips: "Send promotional samples that reflect/represent your portfolio. This helps me remember the contents of a portfolio when reviewing 'my sample box' for upcoming projects."

ATLANTIC RECORDING CORP., 9229 Sunset Blvd., 9th Floor, Los Angeles CA 90069. Did not respond to our request for information.

ATLANTIC RECORDING CORP., 1290 Avenue of the Americas, New York NY 10104. Website: http://www.atlantic~records.com. Did not respond to our request for information.

‡**AZRA INTERNATIONAL**, Dept. PM, 4343 E. 58 St., Maywood CA 90270. Phone/fax: (213)560-4223. President: David Richards. Estab. 1980. Handles rock, heavy metal, novelty and seasonal. Photographers used for special effects and "anything unique and unusual" for picture records and shaped picture records. Also needs photos for CD and album covers. Examples of recent uses: *Toe Suck* and *Mad Man Matt* (album covers).
Needs: Model release required. Property release preferred. Captions preferred.

Specs: Uses 8 × 10 b&w or color glossy prints and 35mm transparencies.

Making Contact & Terms: Interested in receiving work from newer, lesser-known photographers. Query with résumé of credits or send "anything unique in photo effects" by mail for consideration. Works with freelancers on assignment only; "all work is freelance-assigned." SASE. Reports in 2 weeks. Pays $50-250/b&w photo; $50-1,000/color photo; payment "depends on use of photo, either outright pay or percentages." Credit line given. Buys one-time rights; negotiable.

Tips: Wants to see unique styles or photo angles. "Query first, in writing or by phone. We have a wide variety of projects going at all times."

B-ATLAS & JODY RECORDS INC., 1353 E. 59th St., Brooklyn NY 11234. (718)968-8362. Vice President A&R Department: Vincent Vallis. Public Relations: Ron Alexander. Handles rock, rap, pop, country. Freelancers used for portraits, in-concert shots and studio shots for cover/liner shots.

Needs: Buys 10 images annually; 10 supplied by freelancers.

Making Contact & Terms: Interested in receiving work from newer, lesser-known photographers. Query with samples. SASE. Reports in 1-2 weeks. Payment negotiable; payment on assignment. Credit line given. Buys first rights; negotiable.

Tips: "Keep trying."

ROBERT BATOR & ASSOCIATES, 31 State St., Apt. 44D, Monson MA 01057. (413)267-5319. Art Director: Joan Bator. Estab. 1969. Handles rock and country. Photographers used for in-concert shots and studio shots for album covers, inside album shots, publicity and posters.

Needs: Buys 5,000 photos/year. Offers 400 assignments/year. Model release preferred. Captions preferred.

Specs: Uses 4 × 5 and 8 × 10 glossy ("mostly color") prints. "No slides."

Making Contact & Terms: Send unsolicited photos by mail for consideration. Provide résumé, business card, brochure, flier or tearsheets to be kept on file for possible future assignments. "You can submit female suggestive photos for sex appeal, or male, but in good taste." Works with freelancers on assignment only. SASE. Reports in 1 week. Pays $100-150/b&w photo; $150-250/color photo; $150-189/hour; $400-500/day; $375-495/job. Credit line given. Buys one-time rights; other rights negotiable.

Tips: Looks "for good clear photos of models. Show some imagination. Would like some sexually-oriented prints—because advertising is geared for it. Also fashion shots—men's and women's apparel, especially swimsuits and casual clothing."

■**BLACK DIAMOND RECORDS, INC.**, P.O. Box 8073, Pittsburg CA 94565. (510)980-0893. Fax: (510)432-4342. Associate Director of Marketing: Sherece Burnley. Estab. 1987. Handles rhythm & blues, rap, hip-hop, jazz hip-hop, rock dance, blues rock, jazz. Freelancers used for portraits and studio shots for cover/liner shots, publicity, brochures, posters, print advertising.

Needs: Buys 50 images annually; 10% supplied by freelancers. Offers 2-3 assignments annually. Interested in clean, creative shots. Reviews stock photos. Model release required. Property release preferred. Captions preferred.

Audiovisual Needs: Uses videotape for reviewing artist's work. Wants to see style, creativity, uniqueness, avant garde work.

Specs: Uses 8 × 11 b&w prints; 35mm transparencies.

Making Contact & Terms: Interested in receiving work from newer, lesser-known photographers. Submit portfolio for review. Provide résumé, business card, self-promotion pieces or tearsheets to be kept on file for possible assignments. Works on assignment only. Keeps samples on file. SASE. Reports in 1-2 weeks, possibly 2 months to one year. Payment negotiable. Pays upon usage. Credit line given. Buys all rights; negotiable.

Tips: "Be flexible. Look for the right project. Create a memory."

BLASTER-BOXX HITS, MARICAO RECORDS, HARD HAT RECORDS, BROADWAY SHOW MUSIC, 519 N. Halifax Ave., Daytona Beach FL 32118. Phone/fax: (904)252-0381. CEO: Bobby Lee Cude. Estab. 1978. Handles country, MOR, pop, disco and gospel. Photographers used for portraits, in-concert shots, studio shots and special effects for album covers, inside album shots, publicity, brochures, posters, event/convention coverage and product advertising. Examples of recent uses: "Broadway, USA!,"

 MARKETS USING AUDIOVISUAL MATERIAL, such as slides, film or videotape, are marked with a solid, black square.

CD Show Series album, Volumes 1, 2, 3 (cover art); "Times-Square Fantasy Theatre," CD audio shows (cover art).
Needs: Offers 12 assignments/year. Model/property release required. Captions preferred.
Specs: Uses b&w and color photos.
Making Contact & Terms: Interested in receiving work from newer, lesser-known photographers. Submit portfolio for review. Provide résumé, business card, self-promotion pieces, tearsheets or samples to be kept on file for possible future assignments. Works on assignment only. SASE. Reports in 2 weeks. Pays "standard fees." Credit line sometimes given. Buys all rights.
Tips: "Submit sample photo with SASE along with introductory letter stating fees, etc. Read *Mix Music* magazine."

BOUQUET-ORCHID ENTERPRISES, P.O. Box 1335, Norcross GA 30091. (770)497-9086. President: Bill Bohannon. Photographers used for live action and studio shots for publicity fliers and brochures.
Making Contact & Terms: Provide brochure and résumé to be kept on file for possible future assignments. Works on assignment only. SASE. Reports in 1 month. Pays $200 minimum/job.
Tips: "We are using more freelance photography in our organization. We are looking for material for future reference and future needs."

CANYON RECORDS PRODUCTIONS, 4143 N. 16th St., Suite 6, Phoenix AZ 85016. (602)266-7835. Fax: (602)279-9233. E-mail: canyon@canyonrecords.com. Website: http://www.canyonrecords.com. Executive Producer: Robert Doyle. Estab. 1951. Handles Native American. Freelancers used for portraits, studio shots, shots of pow-wows and traditional Native American dances, cover/liner shots, inside shots, publicity, brochures, posters and print advertising. Examples of recent products: "Kokopelli's Cafe," and "Naked in Eureka" (covers, interiors).
Needs: Buys 10-15 images annually; all supplied by freelancers. Offers 4 assignments annually. Reviews stock photos. Model/property release required.
Specs: Uses any size glossy color and b&w prints; 4×5 transparencies.
Making Contact & Terms: Interested in receiving work from newer, lesser-known photographers. Submit portfolio for review. Query with samples. Query with stock photo list. Keeps samples on file. SASE. Reports depending on current scheduling. Payment negotiable. Pays on usage. Credit line given. Buys one-time rights to reproduce on covers only; negotiable.

CAPITOL RECORDS, 1750 N. Vine St., Hollywood CA 90028. Website: http://www.hollywoodandvine.com. Did not respond to our request for information.

■**CAREFREE RECORDS GROUP**, Box 2463, Carefree AZ 85377. (602)230-4177. Vice President: Doya Fairbains. Estab. 1991. Handles rock, jazz, classical, country, New Age, Spanish/Mexican and heavy metal. Freelancers used for portraits, in-concert shots, studio shots and special effects for cover/liner shots, publicity, brochures, posters, event/convention coverage, print advertising, CD covers, cassette covers.
Needs: Buys 45-105 images annually. Offers 2-8 assignments/month. Interested in all types of material. Reviews stock photos. Model/property release required. Captions required.
Audiovisual Needs: Uses slides, film, videotape. Subjects include: outdoor scenes—horses, lakes, trees, female models.
Specs: Uses all sizes of glossy color or b&w prints; 8×10 transparencies; all sizes of film; all types of videotape.
Making Contact & Terms: Interested in receiving work from newer, lesser-known photographers. Submit portfolio for review. Works on assignment only. Keeps samples on file. SASE. Reports in 1 month. Payment negotiable. Pays upon usage. Credit line given. Buys all rights; negotiable.
Tips: "Keep your eyes and mind open to all types of photographs."

✽■**DEF BEAT RECORDS**, 38 Cassis Dr., Etobicoke, Ontario M9V 4Z6 Canada. (416)746-6205. Fax: (416)586-0853. Product Manager: Junior Smith. Estab. 1986. Handles R&B, hip hop, dance, Euro and soul. Freelancers used for portraits, in-concert shots, studio shots, cover/liner shots, inside shots, publicity, brochures, posters, event/convention coverage and print advertising.
Needs: Buys 25 images annually; 10 supplied by freelancers. Offers 30 assignments annually. Interested in concert and portrait shots. Reviews stock photos. Model/property release preferred.
Audiovisual Needs: Uses film and videotape for viewing and file. Subjects include: romantic settings, beaches, sunsets, ghetto streets.
Specs: Uses 5×7, 8×10 color and b&w prints; 8×10 transparencies; Beta SP/VHS videotape.
Making Contact & Terms: Interested in receiving work from newer, lesser-known photographers. Call first to arrange interview. Query with samples. Provide resume, business card, self-promotion pieces or

tearsheets to be kept on file for possible future assignments. Works with local freelancers only. Keeps samples on file. SASE. Reports in 1 month. Pays $150-400/job. **Pays on acceptance.** Buys all rights.
Tips: "Make sure you are presenting your best work at the interview because you only get one try."

DMP RECORDS, 175 Dolphin Cove, Stamford CT 06902. (203)327-3800. Fax: (203)323-9474. Marketing Director: Paul Jung. Estab. 1982. Handles jazz. Freelancers used for portraits and studio shots for cover/liner shots, inside shots and publicity.
Needs: Offers 10 assignments annually. Model/property release preferred. Captions preferred.
Audiovisual Needs: Uses slides.
Specs: Uses 2¼ × 2¼ transparencies.
Making Contact & Terms: Interested in receiving work from newer, lesser-known photographers. Query with samples. Keeps samples on file. SASE. Reports in 1-2 weeks. Pays $500/day. **Pays on acceptance**. Credit line given. Buys all rights; negotiable.
Tips: "The jazz industry is typically not a profitable one, especially for independent labels. While I realize that photographers aim to earn big money, there simply is not a big budget for photography."

EMA MUSIC, INC., P.O. Box 91683, Washington DC 20090-1683. (202)575-1774. President: J. Murphy. Estab. 1993. Handles gospel. Freelancers used for portraits, in-concert shots, studio shots and special effects for cover/liner shots, publicity, brochures, posters, event/convention coverage and print advertising.
Needs: Offers 2 assignments annually. Model/property release preferred.
Making Contact & Terms: Does not keep samples on file. Cannot return material. Payment negotiable. Pays on usage. Buys first, one-time and all rights; negotiable.

EMI RECORDS GROUP, 1290 Avenue of the Americas, New York NY 10104. Website: http://emirecord s.com. Did not respond to our request for information.

■GEFFEN RECORDS, INC., 9130 Sunset Blvd., Los Angeles CA 90069. (310)285-2780. Fax: (310)275-8286. Art Department Manager: Brit Davis. Estab. 1980. Handles rock, rap, alternative. Freelancers used for studio shots, location shots, cover/liner shots, inside shots, publicity, posters, event/convention coverage, print advertising and P-O-P displays.
Needs: Buys 100 images annually; all supplied by freelancers. Offers 40-45 assignments annually. Interested in "creative, new and different, yet classic, images." Reviews stock photos, "but arty, not run-of-the-mill stock images." Model/property release required for locations and people. Captions preferred; include where and when shot.
Audiovisual Needs: Uses video for promotional purposes.
Specs: Uses 8 × 10 color and b&w prints; 35mm, 2¼ × 2¼, 4 × 5 transparencies.
Making Contact & Terms: Interested in receiving work from newer, lesser-known photographers. Submit portfolio for review. Query with samples. Provide resume, business card, self-promotion pieces or tearsheets to be kept on file for possible future assignments. Keeps samples on file. SASE. Reports "only if we intend to hire." Pays $1,500-3,000/job; $100-500/color or b&w photo. Pays upon usage. Credit line given on package and poster. Buys all rights; negotiable.
Tips: "Be innovative with your pictures. Having perfect technique is not as important as being creative. Don't copy others; be true to your heart. Concepts are important—in your spare time, think of ideas."

GLOBAL PACIFIC RECORDS, 1275 E. MacArthur St., Sonoma CA 95476. (707)996-2748. Fax: (707)996-2658. Senior Vice President: Howard L. Morris. Handles jazz, World and New Age music. Photographers used for portraits, in-concert shots, studio shots and special effects for album covers, inside album shots, publicity, brochures, posters and product advertising.
Needs: Buys 12-18 images annually.
Specs: Uses 8 × 10 glossy b&w and color prints or transparencies.
Making Contact & Terms: Submit portfolio for review. Provide résumé, business card, self-promotion pieces or tearsheets to be kept on file for possible future assignments. SASE. Reports in 2 weeks. Payment negotiable. Buys all rights; negotiable.
Tips: Prefers "technically excellent (can be blown up, etc.), excellent compositions, emotional photographs. Be familiar with what we have done in the past. Study our music, album packages, etc., and present material that is appropriate."

 MARKETS NEW TO THIS EDITION are marked with a double dagger.

■HIT CITY RECORDS, P.O. Box 64895, Baton Rouge LA 70896. (504)925-0288. Fax: (504)383-9545 (call first). Owner: Henry Turner. Estab. 1984. Handles reggae, funk, country and rap. Freelancers used for portraits, in-concert shots, studio shots for cover/liner shots, publicity and posters.
Needs: Buys 25 images annually; all supplied by freelancers. Offers 30 assignments annually. Interested in clean b&w glossy prints. Property release required.
Audiovisual Needs: Uses film and videotape for promotion of artists. Subjects include music video.
Specs: Uses 8×10 prints; broadcast quality film for TV; Super 8 ¾″ videotape.
Making Contact & Terms: Interested in receiving work from newer, lesser-known photographers. Submit portfolio for review. "You must send a $5 fee. Attn: Reviewing Department for a review." Works on assignment only. Does not keep samples on file. Reports in 3 weeks. Payment negotiable; determined by the project. Pays on usage. Credit line given. Buys first rights, one-time rights, all rights; negotiable.
Tips: "Send a portfolio at least once every two months and be patient because we can only use photos as they are needed for projects."

■JAZZAND, 12 Micieli Place, Brooklyn NY 11218. (718)972-1220. President: Rick Stone. Handles jazz, acoustic and bebop. Freelancers used for portraits, in-concert shots and studio shots for cover/liner, publicity, brochures, posters, event/convention coverage and print advertising.
Needs: Buys 3-4 images annually; all supplied by freelancers. Offers 1-2 assignments annually. Interested in shots that have been used for covers. Good live and studio shots, portraits.
Audiovisual Needs: Uses videotape.
Specs: Uses 8×10 glossy color and b&w prints; VHS videotape.
Making Contact & Terms: Interested in receiving work from newer, lesser-known photographers. Arrange personal interview to show portfolio. Provide résumé, business card, self-promotion pieces or tearsheets to be kept on file for possible future assignments. Works with local freelancers only. Keeps samples on file. Cannot return material. Reports in 1 month. Pays $50-100/hour; $100-200/job; negotiable—depends on use. **Pays on acceptance.** Credit line given. Buys all rights; negotiable.
Tips: "We are a very small label with a miniscule budget. If you are good at location shots and want to establish a portfolio of cover shots, etc., we will be more than happy to supply you with copies of CD jackets, etc., which may help you to approach other labels."

‡L.R.J. RECORDS, Box 3, Belen NM 87002. (505)864-7441. Fax: (505)864-7442. President: Little Richie Johnson. Estab. 1959. Handles country and bilingual records. Photographers used for record album photos.
Making Contact & Terms: Send material by mail for consideration. Payment negotiable. Pays on receipt of completed job. Credit line given. Buys all rights, but may reassign to photographer.

PATTY LEE RECORDS, 6034 Graciosa Dr., Hollywood CA 90068. Phone/fax: (213)469-5431. 1920 Audubon St., New Orleans LA 70118. (504)866-4480. Assistant to the President: Susan Neidhart. Estab. 1985. Handles New Orleans rock & roll, cowboy poetry, bebop and eclectic. Freelancers used for cover/liner shots, posters. Example of recent uses: *Alligator Ball* (CD cover).
Needs: "We look for unique artwork that works best for the genre of music we are promoting."
Specs: Accepts images in digital format. Submit via SyQuest.
Making Contact & Terms: Interested in receiving work from newer, lesser-known photographers. Query with résumé of credits. "Send postcard query only; don't send actual art." Works with freelancers on assignment only. Keeps samples on file. Payment based on project. Credit line given. Buys one-time rights.

LIN'S LINES, 156 Fifth Ave., Suite 434, New York NY 10010. (212)691-5630. Fax: (212)645-5038. President: Linda K. Jacobson. Estab. 1983. Handles all types of records. Uses photos for portraits, in-concert shots, studio shots for album covers, inside album shots, publicity, brochures, posters and product advertising.
Needs: Offers 6 assignments/year.
Specs: Uses 8×10 prints; 35mm transparencies.
Making Contact & Terms: Query with résumé of credits. Provide résumé, business card, self-promotion pieces or tearsheets to be kept on file for possible future assignments. "Do not send unsolicited photos."

MARKET CONDITIONS are constantly changing! If you're still using this book and it's 1999 or later, buy the newest edition of *Photographer's Market* at your favorite bookstore or order directly from Writer's Digest Books.

Works on assignment only. SASE. Reports in 1 month. Pays $50-500/b&w photo; $75-750/color photo; $10-50/hour; $100-1,500/day; $75-3,000/job. Credit line given. Buys one-time rights; all rights, but may reassign to photographer.
Tips: Prefers unusual and exciting photographs such as holograms and 3-D images. "Send *interesting* material, initially in postcard form."

■**LEE MAGID**, P.O. Box 532, Malibu CA 90265. (213)463-5998. President: Lee Magid. Operates under Grass Roots Records label. Handles R&B, jazz, C&W, gospel, rock, blues, pop. Photographers used for portraits, in-concert shots, studio shots and candid photos for album covers, publicity, brochures, posters and event/convention coverage.
Needs: Offers about 10 assignments/year.
Specs: Uses 8×10 buff or glossy b&w or color prints and 2¼×2¼ transparencies.
Making Contact & Terms: Send print copies by mail for consideration. Works on assignment only. SASE. Reports in 2 weeks. Payment negotiable. Credit line given. Buys all rights.

MCA RECORDS, 1755 Broadway, 8th Floor, New York NY 10019. Did not respond to our request for information.

■**MIA MIND MUSIC**, 500½ E. 84th St., New York NY 10028. (212)861-8745. Fax: (212)861-4825. Promotions Director: Ashley Wilkes. Estab. 1982. Freelancers used for cover/liner shots, posters, direct mail, newspapers and videos.
Needs: Offers 3 assignments annually. Interested in photos of recording artists. Reviews stock photos appropriate for album/CD covers. Model/property release preferred. Captions preferred.
Audiovisual Needs: Uses slides and video to present an artist to record labels to obtain a record deal.
Specs: Uses 8×10 matte color and b&w prints.
Making Contact & Terms: Interested in receiving work from newer, lesser-known photographers. Please call first. Arrange personal interview to show portfolio. Submit portfolio for review. Provide résumé, business card, self-promotion pieces or tearsheets to be kept on file for possible future assignments. Contact through rep. Works with freelancers on assignment only. Keeps samples on file. SASE. Reports in 1-2 weeks. Pays $200-1,500/job; $200-500/color photo; $200-500/b&w photo. **Pays on acceptance**. Credit line given.
Tips: Looking for conceptual, interesting, edgy borderline-controversial photography. Seeing a trend toward conceptual, art photography.

■**MIRAMAR PRODUCTIONS**, 200 Second Ave. W., Seattle WA 98119. (206)284-4700. Fax: (206)286-4433. E-mail: miramarpd@halcyon.com. Website: http://www.uspan.com/miramar. Contact: Mike Boydstun. Estab. 1985. Handles rock and New Age. Freelancers used for portraits, in-concert shots and studio shots for cover/liner, inside shots, publicity, brochure, posters and print advertising. Example of recent uses: *Imaginit* (children's animated music video, photo of performer on back).
Needs: Buys 10-20 images annually; 10-20 supplied by freelancers. Offers 10-20 assignments annually. Reviews stock photos. Model/property release required. Captions preferred.
Audiovisual Needs: Uses slides, film and videotape.
Specs: Uses 35mm, 2¼×2¼, 4×5 transparencies; 35mm, 16mm film; no less than Betacam videotape. Accepts images in digital format for Mac (Photoshop, PICT, TIFF). Send via floppy disk or Zip disk.
Making Contact & Terms: Interested in receiving work from newer, lesser-known photographers. Query with samples. Works on assignment only. Keeps samples on file. SASE. Pays $100-2,500/job; negotiable. **Pays on acceptance.** Credit line given. Buys all rights; negotiable.

NUCLEUS RECORDS, 885 Broadway, #282, Bayonne NJ 07002-3032. President: Robert Bowden. Estab. 1979. Handles rock, country. Photographers used for portraits, studio shots for publicity, posters and product advertising.
 ● Nucleus Records has doubled its payment for photos.
Needs: Send still photos of people for consideration. Model release preferred. Property release required. Captions preferred.
Making Contact & Terms: Interested in receiving work from newer, lesser-known photographers. Works on assignment only. SASE. Reports in 3 weeks. Pays $100-150/b&w photo; $200-250/color photo; $200-250/job. Credit line given. Buys one-time and all rights.

PRO/CREATIVES, 25 W. Burda Place, New City NY 10956-7116. President: David Rapp. Handles pop and classical. Photographers used for record album photos, men's magazines, sports, advertising illustrations, posters and brochures.

Making Contact & Terms: Query with examples, résumé of credits and business card. SASE. Reports in 1 month. Payment negotiable. Buys all rights.

***R.T.L. MUSIC/SWOOP RECORDS**, White House Farm, Shropshire TF9 4HA England. (01630)647374. Fax: (01630)647612. Owner: Ron Lee. Estab. 1970. Uses portraits, in-concert shots, studio shots and special effects for album covers, inside album shots, publicity, brochures, posters, event/convention coverage and product advertising. Examples of recent uses: *Greatest Hits*, by Swoops; *Slam*, by Suburban Studs; and *Phobias*, by Orphan (all CD covers).
Needs: Wants to see all types of photos. Model/property release required. Photo captions required.
Specs: Uses 8×10 glossy or matte, b&w or color prints.
Making Contact & Terms: Interested in receiving work from newer, lesser-known photographers. Reports in 3 weeks. Payment always negotiated. Credit line given. Buys exclusive product and all rights; negotiable.
Tips: Depending on the photographer's originality, "prospects can be very good."

RCA RECORDS, 1540 Broadway, New York NY 10036. Did not respond to our request for information.

RELATIVITY RECORDINGS, INC., 79 Fifth Ave., New York NY 10003. (212)337-5300. Fax: (212)337-5374. Art Director: David Bett. Estab. 1979. Handles primarily rap and r&b, some gospel, and occasional pop and rock projects. Freelancers used for portraits, in-concert shots, studio shots and cover concepts for cover/liner, publicity, posters, print advertising.
Needs: Offers 30-50 assignments annually.
Specs: Uses "any and all."
Making Contact & Terms: Interested in receiving work from newer, lesser-known photographers as well as established professionals. Submit portfolio for review. Provide promo card or tearsheets to be kept on file for possible future assignments. Portfolio drop-offs accepted at any time, or send card to be kept on file. Works on assignment only. SASE. Reports "when we want to hire a photographer." Pays $500-2,500/publicity photo; $1,500-4,000/album cover photo; $1,500-2,500/back cover photo. "Depends on level of the recording artist, sales potential." Credit line given. Buys one-time rights; all rights; negotiable.
Tips: "We're always looking for photographers with imagination and good rapport with artists. We probably use photography on about 75% of our covers, and somewhere on all our albums."

ROCKWELL RECORDS, 227 Concord St., Haverhill MA 01830. (508)373-5677. President: Bill Macek. Produces top 40 and rock 'n' roll records. Photographers used for live action shots, studio shots and special effects for album covers, inside album shots, publicity, brochures and posters. Photos used for jacket design and artist shots.
Needs: Buys 1-2 images annually. Offers 1-2 assignments/annually. Freelancers supply 100% of photos. Interested in seeing all types of photos. "No restrictions. I may see something in a portfolio I really like and hadn't thought about using."
Making Contact & Terms: Arrange a personal interview. Submit b&w and color sample photos by mail for consideration. Submit portfolio for review. Provide résumé, business card or self-promotion pieces to be kept on file for possible future assignments. Local photographers preferred, but will review work of photographers from anywhere. SASE. Payment negotiable.

■SHAOLIN FILM & RECORDS, P.O. Box 58547, Salt Lake City UT 84158. President: Sifu Richard O'Connor. A&R: Don Dela Vega. Estab. 1984. Handles rock, New Age. Uses portraits, in-concert shots, studio shots, special effects for cover/liner, inside shots, publicity, brochures, posters, event/convention coverage, print advertising.
 • Shaolin Film & Records increased (by 50%) the number of images it buys annually and increased the number of images it buys from freelancers.
Needs: Buys 1,000 images annually; 90% supplied by freelancers. Offers 12 assignments annually. Subjects vary with project.
Specs: Uses mostly color and fiber b&w prints; 35mm, 2¼×2¼, 4×5, 8×10 transparencies; videotape.
Making Contact & Terms: Interested in receiving work from newer, lesser-known photographers. Query with samples. Provide résumé, business card, self-promotion pieces or tearsheets to be kept on file for possible future assignments. Works on assignment only. Keeps samples on file. SASE. Reports in 2 months. Each project is bid or negotiated with expenses and rates. **Pays on acceptance** and usage. "Occasionally the credit is not with the photo but elsewhere on product." Buys all rights; negotiable.
Tips: "Shoot for local magazines or just for the experience. Live is different than studio, which is different than locations . . . Shoot in all possible situations. Do what is right for the project or artist; not necessarily convenient for you. Groups seem to all be imitations of other successful artists. Meet the artists and develop an image that REALLY portrays them—not their aspirations."

SIRR RODD RECORD & PUBLISHING CO., 2453 77th Ave., Philadelphia PA 19150-1820. President/A&R: Rodney Jerome Keitt. Handles R&B, jazz, top 40, rap, pop, gospel and soul. Uses photographers for portraits, in-concert shots, studio shots and special effects for album covers, inside album shots, publicity, posters, event/convention and product advertising.
Needs: Buys 10 (minimum) photos/year.
Specs: Uses 8×10 glossy b&w or color prints.
Making Contact & Terms: Submit portfolio for review. Provide résumé, business card, self-promotion pieces or tearsheets to be kept on file for possible future assignments. SASE. Reports in 1 month. Pays $40-200/b&w photo; $60-250/color photo; $75-450/job. Credit line given. Buys all rights, negotiable.
Tips: "We look for versatility. Of course, you can show us the more common group photos, but we like to see new concepts in group photography. Remember that you are freelancing. You do not have the name, studio, or reputation of 'Big Time' photographers, so we both are working for the same thing—exposure! If your pieces are good and the quality is equally good, your chances of working with record companies are excellent. Show your originality, ability to present the unusual, and what 'effects' you have to offer."

SONY MUSIC, 51 W. 52nd St., New York NY 10019. Did not respond to our request for information.

***SOUND CEREMONY RECORDS**, 23 Selby Rd E11, London, England. (081)5031687. Managing Director: Ron Warren Ganderton. Handles rock. Uses photographers for portraits, in-concert shots, studio shots and glamour shots promotion for album covers, inside album shots, publicity, posters and product advertising.
Needs: Buys up to 75 photos/year. "Any interest welcomed. All types of material will be considered as we are involved in diverse, versatile events."
Specs: Uses various sizes; b&w and color prints.
Making Contact & Terms: Query with résumé of credits. Send unsolicited photos by mail for consideration. Provide résumé, business card, brochure, flier or tearsheets to be kept on file for possible future assignments. Does not return unsolicited material. Reports in 2 weeks; international, 3 weeks. "All pay depends on negotiation." Credit line given. Buys one-time rights, all rights; negotiable.
Tips: Prefers to see diverse samples.

UAR RECORD PRODUCTIONS, LTD., P.O. Box 1264, Peoria IL 61654. Phone/fax: (309)673-5755. E-mail: uarltd@united cyber.com. Website: http://www.unitedcyber.com/~uarltd. Owner: Jerry Hanlon. Estab. 1968. Handles country, country rock, Christian, Irish. Freelancers used for portraits for cover/liner shots and publicity. Example of recent uses: *Livin' on Dreams* (CD and cassette cover photo).
Needs: Reviews stock photos. Scenery (country scenes, water scenes), churches.
Specs: Uses color and/or b&w prints; 4×5 transparencies.
Making Contact & Terms: Interested in receiving work from newer, lesser-known photographers. Submit portfolio for review. Provide résumé, business card, self-promotion pieces or tearsheets to be kept on file for possible future assignments. Works on assignment only. Keeps samples on file. Cannot return material. Reports in 1 month. Payment negotiable. Pays upon usage.

VIRGIN RECORDS, 338 N. Foothill Rd., Beverly Hills CA 90210. Did not respond to our request for information.

WARNER BROS. RECORDS, 3300 Warner Blvd., Burbank CA 91505. Did not respond to our request for information.

WINDHAM HILL RECORDS, 8750 Wilshire Blvd., 3rd Floor, Beverly Hills CA 90211. (310)358-4800. Contact: Joanie Chan. Handles mostly jazz-oriented, acoustic and vocal music. Uses freelance photographers for portraits and art shots (including natural subjects) for album packaging.
Needs: Buys 20-30 freelance photos/year.
Specs: Uses 35mm, 2¼×2¼, 4×5 and 8×10 transparencies as well as b&w prints.
Making Contact & Terms: For portrait work, submit portfolio for review, including FedEx account number (or similar) if necessary for return. For album packaging imagery, send duplicate images only with SASE for eventual return of unwanted images; originals not accepted. NPI; payment varies. Credit given. Buys one-time rights or all rights.
Tips: "For both portrait photography and cover imagery, we are looking for something with a creative twist or unusual point of view. Become acquainted with our covers before submitting materials. Send materials that have personal significance—work with heart."

Resources

Art/Photo Representatives

As your photographic business grows you may find yourself inundated with office work, such as creating self promotions, billing clients, attending portfolio reviews and filing images. All of this takes time away from shooting, and most photographers would rather practice their craft. However, there are ways to remove the marketing burden that's been placed upon you. One of the best ways is to hire a photo rep.

When you sign with a photo rep you basically have hired someone to tote your portfolio around town to art directors, make cold calls in search of new clients, and develop promotional ideas to market your talents. The main goal is to find assignment work for you with corporations, advertising firms, or design studios. And, unlike stock agencies or galleries, a photo rep is interested in marketing your talents rather than your images.

For their time most reps charge 20-30 percent commission. They handle several photographers at one time, usually making certain that each shooter specializes in a different area. For example, a rep may have contracts to promote three different photographers, one that handles product shots, another that shoots interiors and a third who photographs food.

As you search for a rep there are numerous points to consider. First, how established is the rep you plan to approach? Established reps have an edge over newcomers in that they know the territory. They've built up contacts in ad agencies, magazines and elsewhere. This is essential since most art directors and picture editors do not stay in their positions for long periods of time. Therefore, established reps will have an easier time helping you penetrate new markets.

If you decide to go with a new rep, consider paying an advance against commission in order to help the rep financially during an equitable trial period. Usually it takes a year to see returns on portfolio reviews and other marketing efforts, and a rep who is relying on income from sales might go hungry if he doesn't have a base income from which to live.

And whatever you agree upon, always have a written agreement. Handshake deals won't cut it. You must know the tasks that each of you are required to complete and having your roles discussed in a contract will guarantee there are no misunderstandings. For example, spell out in your contract what happens with clients that you had before hiring the rep. Most photographers refuse to pay commissions for these "house" accounts, unless the rep handles them completely and continues to bring in new clients.

Also, it's likely that some costs, such as promotional fees, will be shared. For example, freelancers often pay 75 percent of any advertising fees (such as sourcebook ads and direct mail pieces).

If you want to know more about a specific rep, or how reps operate, contact the Society of Photographer and Artist Representatives, 60 E. 42nd St., Suite 1166, New York NY 10165, (212)779-7464. SPAR sponsors educational programs and maintains a code of ethics to which all members must adhere.

ANNE ALBRECHT AND ASSOCIATES, 405 N. Wabash, Suite 4410, Chicago IL 60611. (312)595-0300. Fax: (312)595-0378. Contact: Anne Albrecht. Commercial photography and illustration representative. Estab. 1991. President of C.A.R. (Chicago Artists Representatives). Represents 3 photographers and 7 illustrators. Markets include advertising agencies, corporations/clients direct, design firms, editorial/magazines, publishing/books and sales/promotion firms.

Handles: Illustration, photography.
Terms: Rep receives 25% commission. Advertises in *American Showcase*, *Creative Black Book* and *The Workbook*.
How to Contact: For first contact, send tearsheets. Reports only if interested. After initial contact drop off or mail materials for review. Portfolios should include photographs, tearsheets and/or photocopies.

ARF PRODUCTIONS, 59 Wareham St., Suite #8, Boston MA 02118. (617)423-2212. Fax: (617)423-2213. E-mail: arfhofohkl@aol.com. Contact: Amy R. Frith. Commercial photography and illustration representative. Estab. 1991. Member of SPAR. Represents 8 photographers, 2 illustrators. Specializes in photography, illustration, film directors, music production. Markets include: advertising agencies; corporations/clients direct; design firms; editorial/magazines.
Handles: Illustration, photography. Looking for portraitist images with a humorous slant.
Terms: Rep receives 25% commission. Exclusive area representation required. Talent pays 100% of advertising costs. For promotional purposes, talent must provide a minimum of 4 portfolios, 1 for show, 3 for shipping. New portfolio pieces must be provided at least 3 times a year. Advertises in *American Showcase*, *Creative Black Book*, *The Workbook*.
How to Contact: For first contact, send query letter, direct mail flier/brochure, tearsheets and SASE. Reports in 2 weeks. Portfolios should include a focused body of work that reflects who you are as an artist.
Tips: Obtains new talent through referrals and magazines.

ARTLINE, 439 S. Tryon St., Charlotte NC 28202. (704)376-7609. Fax: (704)376-0207. E-mail: artline1@ aol.com. Contact: Chris Omirly or Kate Caltis. Commercial photography and illustration representative. Estab. 1992. Represents 4 photographers, 6 illustrators and 1 multimedia artist. Staff includes Steve Murray (location/scenics and film); Steve Knight (still life); Alex Bee (still life); and Chris Rogers (fashion). Specializes in providing service as a resource center for commercial arts in the Southeast. Markets include: advertising agencies; corporations/clients direct; design firms; editorial/magazines; publishing/books.
Handles: Illustration, photography, fine art. Looking for digital photography.
Terms: Rep receives 25% commission. Charges photographers $300/month; once commissions exceed the total annual fee of $3,600, it is reduced to $100/month. Charges illustrators a flat fee of $50/month. Exclusive area representation required. Advertising costs are split: 75% paid by talent; 25% paid by representative. For promotional purposes, talent must provide 2 portfolios and 2 new promo pieces per year. Portfolios are to be updated every 4 months. Advertises in *Workbook*.
How to Contact: For first contact, send query letter, bio, direct mail flier/brochure, tearsheets. Reports in 2 weeks only if interested. After initial contact, call to schedule an appointment. Portfolios should include slides, transparencies or tearsheet copies.
Tips: Obtains new talent through recommendations, solicitations and inquiries. "Come forth with an open mind and a will to work. Just having a rep is not enough—both parties have to work together."

ROBERT BACALL REPRESENTATIVE, 350 Seventh Ave., 20th Floor, Suite 2004, New York NY 10011-5013. (212)695-1729. Fax: (212)695-1739. Contact: Robert Bacall. Commercial photography representative. Estab. 1988. Represents 6 photographers. Specializes in food, still life, fashion, beauty, kids, corporate, environmental, portrait, life style, location, landscape. Markets include: advertising agencies; corporations/clients direct; design firms; editorial/magazines; publishing/books; sales/promotion firms.
Terms: Rep receives 25% commission. Exclusive area representation required. For promotional purposes, talent must provide portfolios, cases, tearsheets, prints, etc. Advertises in *Creative Black Book*, *NY Gold*, *The Photographers DayBook*.
How to Contact: For first contact, send query letter, direct mail flier/brochure. Reports only if interested. After initial contact, drop off or mail materials for review.
Tips: "I usually get solicited and keep seeing new work until something interests me and I feel I can sell it to someone else. Seek representation when you feel your portfolio is unique and can bring in new business."

CECI BARTELS ASSOCIATES, 3286 Ivanhoe, St. Louis MO 63139. (314)781-7377. Fax: (314)781-8017. Contact: Ceci Bartels. Commercial illustration and photography representative. Estab. 1980. Member of SPAR, Graphic Artists Guild, ASMP. Represents 20 illustrators and 3 photographers. "My staff functions in sales, marketing and bookkeeping. There are 7 of us. We concentrate on advertising agencies and sales promotion." Markets include advertising agencies; corporations/client direct; design firms; publishing/books; sales/promotion firms.
Handles: Illustration, photography. "Photographers who can project human positive emotions with strength interest us."
Terms: Rep receives 30% commission. Advertising costs are split: 70% paid by talent; 30% paid by representative "after sufficient billings have been achieved. Artists pay 100% initially. We need direct mail

support and advertising to work on the national level. We welcome 6 portfolios/artist. Artist is advised not to produce multiple portfolios or promotional materials until brought on." Advertises in *American Showcase*, *Creative Black Book*, *RSVP*, *The Workbook*, *CIB*.

How to Contact: For first contact, send query letter, direct mail flier/brochure, tearsheets, slides, SASE, portfolio with SASE or promotional materials. Reports if SASE enclosed. After initial contact, drop off or mail in appropriate materials for review. Portfolio should include tearsheets, slides, photographs, 4×5 transparencies. Obtains new talent through recommendations from others; "I watch the annuals and publications."

BEATE WORKS, 2400 S. Shenandoah St., Los Angeles CA 90034-2026. (310)558-1100. Fax: (310)842-8889. E-mail: beateworks@aol.com. Contact: Beate Chelette. Commercial photography, illustration and graphic design representative. Estab. 1992. Represents 5 photographers, 2 illustrators and 2 designers. Staff includes Larry Bartholomew (fashion); Rick Steil (fashion); and Maura McCarthy (graphic design). A full service agency that covers preproduction to final product. Markets include advertising agencies, corporations/clients direct, design firms and editorial/magazines.

Handles: Photography. Only interested in established photographers. "Must have a client base."

Terms: Rep receives 25-30% commission. Exclusive area representation required. Advertising costs are split: 75% paid by talent; 25% paid by representative. For promotional purposes, talent must provide at least 3 portfolios.

How to Contact: For first contact, send query letter and direct mail flier/brochure. Reports in several days if interested. After initial contact, call to schedule an appointment. Portfolios should include tearsheets, photographs and photocopies.

Tips: Typically obtains new talent through recommendations and referrals. "Do your research on a rep before you approach him."

BERENDSEN & ASSOCIATES, INC., 2233 Kemper Lane, Cincinnati OH 45206. (513)861-1400. Fax: (513)861-6420. Contact: Bob Berendsen. Commercial illustration, photography, graphic design representative. Estab. 1986. Represents 24 illustrators, 4 photographers, 25 Mac designers/illustrators in the MacWindows Group Division. Specializes in "high-visibility consumer accounts." Markets include: advertising agencies; corporations/clients direct; design firms; editorial/magazines; paper products/greeting cards; publishing/books; sales/promotion firms.

Handles: Illustration, photography. "We are always looking for illustrators who can draw people, product and action well. Also, we look for styles that are unique."

Terms: Rep receives 25% commission. Charges "mostly for postage but figures not available." No geographic restrictions. Advertising costs are split: 75% paid by talent; 25% paid by representative. For promotional purposes, "artist must co-op in our direct mail promotions, and sourcebooks are recommended. Portfolios are updated regularly." Advertises in *RSVP*, *Creative Illustration Book*, *The Ohio Source Book* and *American Showcase*.

How to Contact: For first contact, send query letter, résumé, tearsheets, slides, photographs, photocopies and SASE. After initial contact, drop off or mail in appropriate materials for review. Portfolios should include tearsheets, slides, photographs, photostats, photocopies and SASE if materials need to be returned.

Tips: Obtains new talent "through recommendations from other professionals. Contact Bob Berendsen, president of Berendsen and Associates, Inc. for first meeting."

BERNSTEIN & ANDRIULLI INC., 60 E. 42nd St., New York NY 10165. (212)682-1490. Fax: (212)286-1890. Contact: Howard Bernstein. Photography representative. Estab. 1975. Member of SPAR. Represents 12 photographers. Staff includes Sam Bernstein; Tony Andriulli; Howard Bernstein. Markets include: advertising agencies; corporations/clients direct; design firms; editorial/magazines.

Handles: Photography.

Terms: Rep receives a commission. Exclusive career representation is required. No geographic restrictions. Advertises in *Creative Black Book*, *The Workbook*, *CA Magazine*, *Archive Magazine* and *Klik*.

How to Contact: For first contact, send query letter, direct mail flier/brochure, tearsheets, slides, photographs, photocopies. Reports in 1 week. After initial contact, drop off or mail in appropriate materials for review. Portfolio should include tearsheets and personal photos.

BROOKE & COMPANY, 4323 Bluffview Blvd., Dallas TX 75209. (214)352-9192. Fax: (214)350-2101. Contact: Brooke Davis. Commercial illustration and photography representative. Estab. 1988. Represents 10 illustrators, 3 photographers. "Owner has 18 years experience in sales and marketing in the advertising and design fields."

Terms: Rep receives 25% commission. Advertising costs are split: 75% paid by talent; 25% paid by representative.

How to Contact: For first contact, send bio, direct mail flier/brochure, "sample we can keep on file if

possible" and SASE. Reports in 2 weeks. After initial contact, write for appointment to show portfolio or drop off or mail in portfolio of tearsheets, slides or photographs.

Tips: Obtains new talent through referral or by an interest in a specific style. "Only show your best work. Develop an individual style. Show the type of work that you enjoy doing and want to do more often. We must have a sample to leave with potential clients."

CORCORAN FINE ARTS LIMITED, INC., 2915 Fairfax Rd., Cleveland Heights OH 44118. (216)397-0777. Fax: (216)397-0222. Contact: James Corcoran. Fine art representative. Estab. 1986. Member of NOADA (Northeast Ohio Art Dealers Association); ISA (International Society of Appraisers). Represents 5 photographers, 11 fine artists (includes 3 sculptors). Staff includes Meghan Wilson (gallery associate); Patrick Lafferty (office administrator); James Corcoran (owner/manager). Specializes in representing high-quality contemporary work. Markets include: architects; corporate collections; developers; galleries; interior decorators; museums; private collections.

Handles: Fine art.

Terms: Rep receives 50% commission. Exclusive area representation is required. Advertising costs are "decided case by case."

How to Contact: For first contact send a query letter, résumé, bio, slides, photographs, SASE. Reports back within 1 month. After initial contact, drop off or mail in appropriate materials for review. Portfolio should include slides, photographs.

Tips: Usually obtains new talent by solicitation.

CORPORATE ART PLANNING, 16 W. 16th St., 6th Floor, New York NY10011. (212)645-3490. Fax: (212)741-8608. E-mail: virtual2ads@infohouse.com. Contact: Maureen McGovern. Fine art consultant. Estab. 1986. Specializes in art management expertise, curatorial services. Markets include corporations/clients direct, advertising agencies. Fine art markets include architects, corporate collections.

Handles: Photography, fine art.

Terms: Rep receives 50% commission. Advertising costs are split: 50% paid by talent; 50% paid by the representataive. Advertises in *Art in America*, *Creative Black Book*, *Writer's Digest* and *The Workbook*.

How to Contact: For first contact, send query letter, résumé, bio, direct mail flier/brochure, tearsheets, SASE and color photocopies. Reports in 10 days. After initial contact, call to schedule an appointment. Portfolios should include tearsheets, slides, photographs and photocopies.

‡CREATIVE TALENT, (formerly Midwest Talent/Creative Talent), 1102 Neil Ave., Columbus OH 43201. (614)294-7827. Fax: (614)294-3396. Also 700 W. Pete Rose Way, Cincinnati OH 45203. (513)241-7827. Contact: Betty Aggas. Types of clients: talent and advertising agencies, production companies.

Needs: Recommends photographers to others. Subjects include portfolios and promotional shots of models and actors.

Specs: Uses 5×7 and 11×14 b&w prints; 35mm transparencies; and U-matic ¾" videotape.

Making Contact & Terms: Pays $4-10/b&w photo, $4-25/color photo, $25-65/hour and $100-275/job. **Pays on acceptance.** Buys all rights. Credit line given.

Tips: "Be concise, to the point and have good promotional package. We like to see well-lit subjects with good faces."

LINDA DE MORETA REPRESENTS, 1839 Ninth St., Alameda CA 94501. (510)769-1421. Fax: (510)521-1674. E-mail: ldmreps@aol.com. Contact: Linda de Moreta. Commercial photography and illustration representative; also portfolio and career consultant. Estab. 1988. Member of San Francisco Creative Alliance, Western Art Directors Club. Represents 4 photographers, 1 photodigital imager, 8 illustrators. Markets include: advertising agencies; design firms; corporations/client direct; editorial/magazines; paper products/greeting cards; publishing/books; sales/promotion firms.

Handles: Photography, digital imaging, illustration, calligraphy.

Terms: Rep receives 25% commission. Exclusive representation requirements vary. Advertising costs are split: 75% paid by talent; 25% paid by representative. Materials for promotional purposes vary with each artist. Advertises in *The Workbook*, *American Showcase*, *The Creative Black Book*.

How to Contact: For first contact, send direct mail flier/brochure, tearsheets, slides, photocopies, photostats and SASE. "Please do *not* send original art. SASE for any items you wish returned." Responds to any inquiry in which there is an interest. Portfolios are individually developed for each artist and may include prints, transparencies, tearsheets.

Tips: Obtains new talent primarily through client and artist referrals, some solicitation. "I look for a personal vision and style of photography or illustration and exceptional creativity, combined with professionalism, maturity and a willingness to work hard."

RHONI EPSTEIN/Photographer's Representative, 11977 Kiowa Ave., Los Angeles CA 90049-6119. (310)207-5937. Contact: Rhoni Epstein. Photography representative. Estab. 1983. Member of APA. Represents 5-8 photographers. Specializes in advertising/entertainment photography.
Handles: Photography.
Terms: Rep receives 25-30% commission. Exclusive representation required in specific geographic area. Advertising costs are paid by talent. For promotional purposes, talent must have a strong direct mail campaign and/or double-page spread in national advertising book, portfolio to meet requirements of agent. Advertises in *The Workbook*.
How to Contact: For first contact, send direct mail samples. Reports in 1 week, only if interested. After initial contact, call for appointment or drop off or mail in appropriate materials for review. Portfolio should demonstrate own personal style.
Tips: Obtains new talent through recommendations. "Research the rep and her agency the way you would research an agency before soliciting work! Remain enthusiastic. There is always a market for creative and talented people."

‡PAT FORBES REPRESENTS, 1332 Park Garden Lane, Reston VA 22054. (703)478-0434. Fax: (703)471-7546. Contact: Pat Forbes. Commercial photography representative. Estab. 1985. Represents 3 photographers. Current photographers specialize in studio, still life, location shots, portraiture. Markets include advertising agencies, corporations/clients direct, design firms, editorial/magazines, paper products/greeting cards, publishing/books and sales/promotion firms.
Will Handle: Photography.
Terms: Rep receives 15-30% commission. For promotional purposes, talent must provide portfolios, promo pages, etc. Advertises in *Creative Black Book* and *Washington Source Book*.
How To Contact: For first contact, send résumé, photos and promo pages. Reports only if interested. After initial contact call to schedule an appointment. Portfolios should include photographs, client list and résumé.

FORTUNI, 2508 E. Belleview Place, Milwaukee WI 53211. (414)964-8088. Fax: (414)332-9629. Contact: Marian Deegan. Commercial photography and illustration representative. Estab. 1990. Member of Graphic Artists Guild and ASMP. Represents 2 photographers and 6 illustrators. Fortuni handles artists with unique, distinctive styles appropriate for commercial markets. Markets include advertising agencies, corporations/clients direct, design firms, editorial/magazines, publishing/books.
Handles: Illustration and photography. "I am interested in artists with a thorough professional approach to their work."
Terms: Rep receives 30% commission. Exclusive area representation required. Advertising costs are split: 70% paid by the talent; 30% paid by the representative. For promotional purposes, talent must provide 4 duplicate transparency portfolios, leave behinds and 4-6 promo pieces per year. "All artist materials must be formatted to my promotional specifications." Advertises in *Black Book*, *Workbook*, *Single Image* and *Chicago Source Book*.
How To Contact: For first contact, send query letter, direct mail flier/brochure, tearsheets, photocopies, photostats and SASE. Reports in 2 weeks only if interested. After initial contact, call to schedule an appointment. Portfolios should include roughs, tearsheets, slides, photographs, photocopies and transparencies.
Tips: "I obtain new artists through referrals. Organize your work in a way that clearly reflects your style, and the type of projects you most want to handle; and then be professional and thorough in your initial contact and follow-through."

JEAN GARDNER & ASSOCIATES, 444 N. Larchmont Blvd., Suite 108, Los Angeles CA 90004. (213)464-2492. Fax: (213)465-7013. Contact: Jean Gardner. Commercial photography representative. Estab. 1985. Member of APA. Represents 6 photographers. Specializes in photography. Markets include: advertising agencies; design firms.
Handles: Photography.
Terms: Rep receives 25% commission. Exclusive representation is required. No geographic restrictions. Advertising costs are paid by the talent. For promotional purposes, talent must provide promos, *Workbook* advertising, a quality portfolio. Advertises in *The Workbook*.
How to Contact: For first contact, send direct mail flier/brochure.
Tips: Obtains new talent through recommendations from others.

‡ **MARKETS NEW TO THIS EDITION** are marked with a double dagger.

LITTLEHALES
PHOTOGRAPHER

BRETON LITTLEHALES, PHOTOGRAPHER
STUDIO: 202.291.2422 FAX: 202.291.2423

REPRESENTED BY GIANNINI & TALENT
703.534.8316
FAX: 703.534.8351
www.giannini-t.com

A Virginia design firm hired Breton Littlehales to shoot photos for a client's capabilities brochure. This shot appeared on the brochure's cover. Littlehales's agent, Judi Giannini of Giannini & Talent, chose the image for this promo piece. "We liked the fact that the picture was a strong environmental image," says Giannini. "It's warm and natural." To promote her talent Giannini advertises in several sourcebooks as well as offering images on the Internet—note the website listed on this piece.

‡**GIANNINI & TALENT**, 1932 Mcfall St., McLean VA 22101-5544. (703)534-8316. Fax: (703)534-8351. E-mail: gt@giannini~t.com. Website: www.giannini~t.com. Contact: Judi Giannini. Stock photography and photography representative. Estab. 1987. Member of ADCMW. Represents stock photography, 6 photographers. Specializes in talent that works in fine art and commercial arenas, or "who have singular personal styles that stand out in the market place." Markets include: advertising agencies; corporations/client direct; design firms; editorial/magazines; publishing/books; art consultants. Clients includes private collections.
Handles: Photography, select DC images, panoramic images.
Terms: Rep receives 25% commission. Charges for out-of-town travel, messenger and FedEx services, newsletter. Exclusive East Coast and Southern representation is required. Advertising costs are split: 75% paid by the talent; 25% paid by the representative. For promotional purposes, talent must provide leave-behinds and "at least have a direct mail campaign planned, as well as advertising in local and national sourcebooks. Portfolio must be professional." Advertises in *American Showcase*, *Creative Black Book*, *The Workbook* and *Creative Sourcebook*.

How to Contact: For first contact, talent should send query letter, direct mail flier/brochure. Reports in 1 week, only if interested. Call for appointment to show portfolio of slides, photographs.
Tips: Obtains new talent through recommendations from others. "Learn to be your own best rep while you are getting established. Then consider forming a co-op with other artists of non-competitive styles who can pay someone for six months to help them get started. Candidates for good reps have an art and sales background."

MICHAEL GINSBURG & ASSOCIATES, INC., 240 E. 27th St., Suite 24E, New York NY 10016. (212)679-8881. Fax: (212)679-2053. Contact: Michael Ginsburg. Commercial photography representative. Estab. 1978. Represents 7 photographers. Specializes in advertising and editorial photographers. Markets include advertising agencies, corporations/clients direct, design firms, editorial/magazines, sales/promotion firms.
Handles: Photography.
Terms: Rep receives 25% commission. Charges for messenger costs, Federal Express charges. Exclusive area representation is required. Advertising costs are split: 75% paid by talent; 25% paid by representative. For promotional purposes, talent must provide a minimum of 5 portfolios—direct mail pieces 2 times per year—and at least 1 sourcebook per year. Advertises in *Creative Black Book* and other publications.
How to Contact: For first contact, send query letter, direct mail flier/brochure. Reports in 2 weeks, only if interested. After initial contact, call for appointment to show portfolio of tearsheets, slides, photographs.
Tips: Obtains new talent through personal referrals and solicitation.

‡**TOM GOODMAN INC.**, 626 Loves Lane, Wynnewood PA 19096. (610)649-1514. Fax: (610)649-1630. Contact: Tom Goodman. Commercial photography and electronic/computer imaging and illustration representative. Estab. 1986. Represents 5 photographers. Specializes in commercial photography, electronic imaging. Markets include: advertising agencies; corporations/client direct; design firms; editorial/magazines; sales/promotion firms.
Handles: Photography, electronic imaging.
Terms: Rep receives 25% commission. Exclusive area representation is required. Advertising costs are split: 80% paid by talent; 20% paid by representative. For promotional purposes, representative requires portfolio of transparencies and printed samples. Requires direct mail campaigns. Optional: sourcebooks. Advertises in *American Showcase*.
How to Contact: For first contact, send query letter, direct mail flier/brochure. Reports in 2 weeks if interested. After initial contact, call for appointment to show portfolio of tearsheets, large transparencies.

BARBARA GORDON ASSOCIATES LTD., 165 E. 32nd St., New York NY 10016. (212)686-3514. Fax: (212)532-4302. Contact: Barbara Gordon. Commercial illustration and photography representative. Estab. 1969. Member of SPAR, Society of Illustrators, Graphic Artists Guild. Represents 9 illustrators, 1 photographer. "I represent only a small select group of people and therefore give a great deal of personal time and attention to the people I represent."
Terms: Rep receives 25% commission. No geographic restrictions in continental US.
How to Contact: For first contact, send direct mail flier/brochure. Reports in 2 weeks. After initial contact, drop off or mail in appropriate materials for review. Portfolio should include tearsheets, slides, photographs; "if the talent wants materials or promotion piece returned, include SASE."
Tips: Obtains new talent through recommendations from others, solicitation, at conferences, etc. "I have obtained talent from all of the above. I do not care if an artist or photographer has been published or is experienced. I am essentially interested in people with a good, commercial style. Don't send résumés and don't call to give me a verbal description of your work. Send promotion pieces. *Never* send original art. If you want something back, include a SASE. Always label your slides in case they get separated from your cover letter. And always include a phone number where you can be reached."

CAROL GUENZI AGENTS, INC., 865 Delaware, Denver CO 80204-4533. (303)820-2599. Fax: (303)820-2598. E-mail: cggiant@aol.com. Contact: Carol Guenzi. Commercial illustration, film and animation representative. Estab. 1984. Member of Denver Advertising Federation and Art Directors Club of Denver. Represents 25 illustrators, 5 photographers, 3 computer designers. Specializes in a "wide selection of talent in all areas of visual communications." Markets include: advertising agencies; corporations/clients direct; design firms; editorial/magazine, paper products/greeting cards, sales/promotions firms.
Handles: Illustration, photography. Looking for "unique style application" and digital imaging.
Terms: Rep receives 25-30% commission. Exclusive area representation is required. Advertising costs are split: 70-75% paid by talent; 25-30% paid by the representation. For promotional purposes, talent must provide "promotional material after six months, some restrictions on portfolios." Advertises in *American Showcase, Creative Black Book, The Workbook, Creative Options, Rocky Mountain Sourcebook.*
How to Contact: For first contact, send direct mail flier/brochure, tearsheets, slides, photocopies. Reports

in 2-3 weeks, only if interested. After initial contact, call or write for appointment to drop off or mail in appropriate materials for review, depending on artist's location. Portfolio should include tearsheets, slides, photographs.

Tips: Obtains new talent through solicitation, art directors' referrals, an active pursuit by individual. "Show your strongest style and have at least 12 samples of that style, before introducing all your capabilities. Be prepared to add additional work to your portfolio to help round out your style. We do a large percentage of computer manipulation and accessing on network. All our portfolios are on disk or CD-ROM."

PAT HACKETT/ARTIST REPRESENTATIVE, 1809 Seventh Ave., Suite 1710, Seattle WA 98101-1320. (206)447-1600. Fax: (206)447-0739. E-mail: pathackett@aol.com. Contact: Pat Hackett. Commercial illustration and photography representative. Estab. 1979. Member of Graphic Artists Guild. Represents 30 illustrators, 2 photographers. Markets include: advertising agencies; corporations/client direct; design firms; editorial/magazines.

Handles: Illustration.

Terms: Rep receives 25-33% commission. Exclusive area representation is required. No geographic restrictions, but sells mostly in Washington, Oregon, Idaho, Montana, Alaska and Hawaii. Advertising costs are split: 75% paid by talent; 25% paid by representative. For promotional purposes, talent must provide "standardized portfolio, i.e., all pieces within the book are the same format. Reprints are nice, but not absolutely required." Advertises in *American Showcase*, *The Workbook*, *New Media Showcase*.

How to Contact: For first contact, send direct mail flier/brochure. Reports in 1 week, only if interested. After initial contact, drop off or mail in appropriate materials: tearsheets, slides, photographs, photostats, photocopies.

Tips: Obtains new talent through "recommendations and calls/letters from artists moving to the area. We represent talent based both nationally and locally."

HALL & ASSOCIATES, 1010 S. Robertson Blvd, #10, Los Angeles CA 90035. (310)652-7322. Fax: (310)652-3835. Contact: Marni Hall. Commercial illustration and photography representative. Estab. 1983. Member of SPAR, APA. Represents 7 illustrators and 8 photographers. Markets include: advertising agencies; design firms. Member agent: Joy Asbury (artist representative).

Handles: Illustration, photography.

Terms: Rep receives 30% commission. Exclusive area representation is required. No geographic restrictions. Advertising costs are paid by talent. For promotional purposes, talent must advertise in "one or two source books a year (double page), provide two direct mail pieces and one specific, specialized mailing. No specific portfolio requirement except that it be easy and light to carry and send out." Advertises in *Creative Black Book*, *The Workbook*.

How to Contact: For first contact, send direct mail flier/brochure. Follow with a call before 7 days. After initial contact, drop off (always call first) or mail in appropriate materials for review. Portfolios should include tearsheets, transparencies, prints (4×5 or larger).

Tips: Obtains new talent through recommendations from clients or artists' solicitations. "Don't show work you think should sell but what you enjoy shooting. Only put in tearsheets of great ads, not bad ads even if they are a highly visible client."

HAMILTON GRAY, 3519 W. Sixth St., Los Angeles CA 90020. (213)380-3933. Fax: (213)380-2906. Contact: Maggie Hamilton. Commercial photography. Estab. 1990. Member of APA. Represents 8 photographers. Specializes in entertainment, editorial, advertising, annual reports. Markets include: advertising agencies; corporations/clients direct; editorial/magazines; design firms; music/entertainment.

Handles: Photography.

Terms: Rep receives 30% commission. Charges for messengers or FedEx if photographer has requested sending. Exclusive area representation required. Advertising costs are paid by talent. For promotional materials, talent must provide current portfolios (2-4 books), mailing pieces and be open to sourcebooks. Advertises in *American Showcase*, *Creative Black Book*, *The Workbook* and *California Sourcebooks* (Black Book Publishing), *Alternative Pick*.

How to Contact: For first contact, send query letter with direct mail flier/brochure. Reports in 1 week. After initial contact, call for appointment to show portfolio of tearsheets, slides, photographs.

Tips: "Obtain new talent through my own awareness and recommendations from others. Think about if you were a rep, what you would want in photographer? Portfolio—2-4 books; material—mailers, etc.; and a good sense of how hard it is to accomplish success without vision and commitment."

BARB HAUSER, ANOTHER GIRL REP, P.O.Box 421443, San Francisco CA 94142-1443. (415)647-5660. Fax: (415)285-1102. Estab. 1980. Represents 10 illustrators and 1 photographer. Markets include: primarily advertising agencies and design firms; corporations/clients direct.

Handles: Illustration and photography.

Terms: Rep receives 25-30% commission. Exclusive representation in the San Francisco area is required. No geographic restrictions.
How to Contact: For first contact, send direct mail flier/brochure, tearsheets, slides, photographs, photocopies and SASE. Reports in 3-4 weeks. After initial contact call for appointment to show portfolio of tearsheets, slides, photographs, photostats, photocopies.

THE TRICIA JOYCE CO., 80 Warren St., New York NY 10007. (212)962-0728. Send to: Tricia Joyce. Commercial photography representative. Estab. 1988. Represents 8 photographers and 4 stylists. Specializes in fashion, still life, architecture, interiors, portraiture. Markets include advertising agencies, corporations/clients direct, design firms, editorial/magazines and sales/promotion firms.
Handles: Photography and fine art.
Terms: Agent receives 25% commission. Advertising costs are split 75% paid by talent; 25% paid by the representative.
How to Contact: For first contact, send query letter, résumé, direct mail flier/brochure and photocopies. Reports only if interested. After initial contact "wait to hear—please don't call."
Tips: "Write/send work to reps whose clients' work you respect."

‡KIRCHOFF/WOHLBERG, ARTISTS REPRESENTATION DIVISION, 866 United Nations Plaza, #525, New York NY 10017. (212)644-2020. Fax: (212)223-4387. Director of Operations: John R. Whitman. Estab. 1930s. Member of SPAR, Society of Illustrators, AIGA, Assn. of American Publishers, Bookbuilders of Boston, New York Bookbinders' Guild. Represents over 50 illustrators. Artist's Represenative: Elizabeth Ford (juvenile and young adult trade book and textbook illustrators). Specializes in juvenile and young adult trade books and textbooks. Markets include: publishing/books.
Handles: Illustration and photography (juvenile and young adult). Please send all illustration correspondence to the attention of Elizabeth Ford and all photography correspondence to Judith Greene.
Terms: Rep receives 25% commission on all illustrations sold. Exclusive representation to book publishers is usually required. Advertising costs paid by representative ("for all Kirchoff/Wohlberg advertisements only"). "We will make transparencies from portfolio samples; keep some original work on file." Advertises in *American Showcase, Art Directors' Index; Society of Illustrators Annual*, children's book issue of *Publishers Weekly.*
How to Contact: For first contact, send query letter and "any materials artists feel are appropriate." Reports in 4-6 weeks. "We will contact you for additional materials." Portfolios should include "whatever artists feel best represents their work. We like to see children's illustration in any style."

ELLEN KNABLE & ASSOCIATES, INC., 1233 S. LaCienega Blvd., Los Angeles CA 90035. (310)855-8855. Fax: (310)657-0265. E-mail: peacezeka@aol.com. Contact: Ellen Knable. Commercial illustration, photography and production representative. Estab. 1978. Member of SPAR, Graphic Artists Guild. Represents 6 illustrators, 5 photographers. Markets include: advertising agencies; corporations/clients direct; design firms.
Terms: Rep receives 25-30% commission. Exclusive West Coast/Southern California representation is required. Advertising costs split varies. Advertises in *The Workbook.*
How to Contact: For first contact, send query letter, direct mail flier/brochure and tearsheets. Reports within 2 weeks. Call for appointment to show portfolio.
Tips: Obtains new talent from recommendations and samples received in mail. "Have patience and persistence!"

KORMAN & COMPANY, PHA, 135 W. 24th St., New York NY 10011. (212)727-1442. Fax: (212)727-1443. Contact: Alison Korman. Commercial photography representative. Estab. 1984. Member of SPAR. Represents 3 photographers. Markets include: advertising agencies; corporations/clients direct; editorial/magazines; publishing/books; sales/promotion firms.
Handles: Photography.
Terms: Rep receives 25-30% commission. "Talent pays for messengers, mailings, promotion." Exclusive area representation is required. Advertising costs are paid by talent "for first two years, unless very established and sharing house." For promotional purposes, talent must provide portfolio, directory ads, mailing pieces. Advertises in *Creative Black Book, The Workbook, Gold Book.*
How to Contact: For first contact, send direct mail flier/brochure. Reports in 1 month if interested. After initial contact, write for appointment or drop off or mail in portfolio of tearsheets, photographs.
Tips: Obtains new talent through "recommendations, seeing somebody's work out in the market and liking it. Be prepared to discuss how you can help a rep to help you."

ELAINE KORN ASSOCIATES, LTD., 2E, 372 Fifth Ave., New York NY 10018. (212)760-0057. Fax: (212)465-8093. Commercial photography representative. Estab. 1981. Member of SPAR. Represents 6

photographers. Specializes in fashion-related still life, children and family (lifestyle). Markets include: advertising agencies; editorial/magazines.

Handles: Photography.

How to Contact: For first contact, send promotional pieces. After initial contact, write for appointment to show portfolio.

JOAN KRAMER AND ASSOCIATES, INC., 10490 Wilshire Blvd., #1701, Los Angeles CA 90024. (310)446-1866. Fax: (310)446-1856. Contact: Joan Kramer. Commercial photography representative and stock photo agency. Estab. 1971. Member of SPAR, ASMP, PACA. Represents 45 photographers. Specializes in model-released lifestyle. Markets include: advertising agencies; design firms; publishing/books; sales/promotion firms; producers of TV commercials.

Handles: Photography.

Terms: Rep receives 30% commission. Advertising costs split: 50% paid by talent; 50% paid by representative. Advertises in *Creative Black Book*, *The Workbook*.

How to Contact: Call to schedule an appointment. Portfolio should include slides. Reports only if interested.

Tips: Obtains new talent through recommendations from others.

LEE + LOU PRODUCTIONS INC., 8522 National Blvd., #108, Culver City CA 90232. (310)287-1542. Fax: (310)287-1814. E-mail: leelou@earthlink. Commercial illustration and photography representative, digital and traditional photo retouching. Estab. 1981. Represents 10 illustrators, 5 photographers. Specializes in automotive. Markets include: advertising agencies.

Handles: Photography.

Terms: Rep receives 25% commission. Charges shipping, entertainment. Exclusive area representation required. Advertising costs are paid by talent. For promotional purposes, talent must provide direct mail advertising material. Advertises in *Creative Black Book*, *The Workbook* and *Single Image*.

How to Contact: For first contact, send direct mail flier/brochure, tearsheets. Reports in 1 week. After initial contact, call for appointment to show portfolio of photographs.

Tips: Obtains new talent through recommendations from others, some solicitation.

LEVIN•DORR, 1123 Broadway, Suite 1005, New York NY 10010. (212)627-9871. Fax: (212)243-4036. Contact: Bruce Levin or Chuck Dorr. Commercial photography representative. Estab. 1982. Member of SPAR. Represents 11 photographers. Markets include: advertising agencies; design firms; editorial/magazines; sales/promotion firms.

Handles: Photography.

Terms: Rep receives 25% commission. Exclusive area representation is required. Advertising costs are split: 75% paid by talent; 25% paid by representative. For promotional purposes, "talent must have a minimum of five portfolios which are lightweight and fit into Federal Express boxes." Advertises in *Creative Black Book*, *The Workbook*, *Gold Book*.

How to Contact: For first contact, send "portfolio as if it were going to advertising agency." After initial contact, call for appointment to show portfolio of tearsheets, slides, photographs.

Tips: Obtains new talent through recommendations, word-of-mouth, solicitation. "Don't get discouraged."

LORRAINE & ASSOCIATES, 2311 Farrington, Dallas TX 75207. (214)688-1540. Fax: (214)688-1608. E-mail: lorainel@airmail.net. Website: http://www.turntotexas.com. Contact: Lorraine Haugen. Commercial photography, illustration and digital imaging representative. Estab. 1992. Member of DSVC. Represents 3 photographers, 2 illustrators, 1 fine artist, 1 digital retoucher. "We have over eight years experience marketing and selling digital retouching and point-of-purchase advertising in a photographic lab." Markets include: advertising agencies; corporations/clients direct; design firms; interior decorators; high-end interior showrooms and retail.

Handles: Illustration, photography, digital illustrators and co-animators. Looking for unique established photographers and illustrators, CD digital animators and interactive CD-ROM animators.

Terms: Rep receives 25-30% commission, plus monthly retainer fee per talent. Advertising costs are split: 90% paid by talent; 10% paid by representative. For promotional purposes, talent must provide 2 show portfolios, 1 traveling portfolio, leave-behinds and at least 5 new promo pieces per year. Must advertise in *American Showcase*, *Black Book*, and participate in pro bono projects. Advertises in *American Showcase*, *Black Book*.

How to Contact: For first contact, send bio, direct mail flier/brochure, tearsheets. Reports in 2-3 weeks if interested. After initial contact, call to schedule an appointment. Portfolios should include photographs.

Tips: Obtains new talent through referrals and personal working relationships. "Talents' portfolios are also reviewed by talent represented for approval and complement of styles to the group represented.

Photographer should be willing to participate in group projects and be very professional in following instructions, organization and presentation."

MCCONNELL & MCNAMARA, 182 Broad St., Wethersfield CT 06109. (860)563-6154. Fax: (860)563-6159. E-mail: jack_mcconnell@msn.com. Contact: Paula McNamara. Commercial illustration, photography and fine art representative. Estab. 1975. Member of SPAR, Graphic Artists Guild, ASMP, ASPP. Represents 1 illustrator, 1 photographer and 1 fine artist. Staff includes Paula McNamara (photography, illustration and fine art). Specializes in advertising and annual report photography. Markets include: advertising agencies; corporations/client direct; design firms; editorial/magazines; paper products/greeting cards; publishing/books; sales/promotion firms; stock photography/travel; corporate collections; galleries.
Handles: Photography. "Looking for photographers specializing in stock photography of New England."
Terms: Rep receives 25-30% commission. Exclusive area representation is required. Advertising costs are split: 75% paid by talent; 25% paid by representative. For promotional purposes, talent must provide "professional portfolio and tearsheets already available and ready for improving; direct mail piece needed within three months after collaborating."
How to Contact: For first contact, send query letter, bio, résumé, direct mail flier/brochure, tearsheets, SASE. Reports in 1 month if interested. "Unfortunately we don't have staff to evaluate and investigate new talent or offer counsel." After initial contact, write for appointment to show portfolio of tearsheets, slides, photographs.
Tips: Obtains new talent through "recommendations by other professionals, sourcebooks and industry magazines. We prefer to follow our own leads rather than receive unsolicited promotions and inquiries. It's best to have repped yourself for several years to know your strengths and be realistic about your marketplace. The same is true of having experience with direct mail pieces, developing client lists, and having a system of follow up. We want our talent to have experience with all this so they can properly value our contribution to their growth and success—otherwise that 25% becomes a burden and point of resentment."

COLLEEN MCKAY PHOTOGRAPHY, 229 E. Fifth St., #2, New York NY 10003. (212)598-0469. Fax: (212)598-4059. Contact: Colleen McKay. Commercial editorial and fine art photography representative. Estab. 1985. Member of SPAR. Represents 4 photographers. "Our photographers cover a wide range of work from location, still life, fine art, fashion and beauty." Markets include: advertising agencies; design firms; editorial/magazines; retail.
Handles: Commercial and fine art photography.
Terms: Rep receives 25% commission. Exclusive area representation is required. Advertising costs are split: 75% paid by talent; 25% paid by representative. "Promotional pieces are very necessary. They must be current. The portfolio should be established." Advertises in *Creative Black Book, Select, New York Gold*.
How to Contact: For first contact, send query letter, résumé, bio, direct mail flier/brochure, tearsheets, slides, photographs. Reports in 2-3 weeks. "I like to respond to everyone but if we're really swamped I may only get a chance to respond to those we're most interested in." Portfolio should include tearsheets, slides, photographs, transparencies (usually for still life).
Tips: Obtains talent through recommendations of other people and solicitations. "I recommend that you look in current resource books and call the representatives who are handling the kind of work that you admire or is similar to your own. Ask these reps for an initial consultation and additional references. Do not be intimidated to approach anyone. Even if they do not take you on, a meeting with a good rep can prove to be very fruitful! Never give up! A clear, positive attitude is very important."

GARY MANDEL ARTISTS REPRESENTATIVE, 126 Fifth Ave., Suite 804, New York NY 10011. (212)727-1135. Fax: (212)727-2965. Contact: Hector Marcel. Commercial photography and makeup artists representatives. Member of ASMP. Represents 4 photographers. Staff includes Gary Mandel and Hector Marcel. Specializes in fashion, beauty, music and advertising. Markets include advertising agencies, corporations/clients direct, design firms and editorial/magazines.
Handles: Photography.
Terms: Rep receives 25-30% commission. Charges for messengers, Fed Ex, mail-outs, etc. Exclusive area representation required. Advertising costs are split: 75% paid by talent; 25% paid by representative. For promotional purposes, talent must provide portfolios, cards and mail-outs (once a year). Advertises in *American Showcase, Creative Black Book* and *Le Book*.
How to Contact: For first contact, send direct mail flier/brochure. After initial contact, call to schedule a folio drop off.
Tips: Obtains new talent through recommendations and solicitations based on material sent or seen.

MASLOV AGENT INTERNATIONAL, 608 York St., San Francisco CA 94110. (415)641-4376. Contact: Norman Maslov. Commercial photography, fine art and illustration representative. Estab. 1986. Member of APA. Represents 5 photographers, 10 illustrators. Markets include: advertising agencies; corporations/clients direct; design firms; editorial/magazines; paper products/greeting cards; publishing/books; private collections.
Handles: Photography. Looking for "original work not derivative of other artists. Artist must have developed style."
Terms: Rep receives 25% commission. Exclusive US national representation required. Advertising costs split varies. For promotional purposes, talent must provide 3-4 direct mail pieces a year. Advertises in *Single-Image*, *Archive*, *Workbook*, *Alternative Pick*.
How to Contact: For first contact, send query letter, direct mail flier/brochure, tearsheets. DO NOT send original work. Reports in 2-3 weeks only if interested. After initial contact, call to schedule an appointment or drop off or mail materials for review. Portfolio should include photographs.
Tips: Obtains new talent through suggestions from art buyers and recommendations from designers, art directors and other agents. "Enter your best work into competitions such as *Communication Arts* and *Graphis* photo annuals. Create a distinctive promotion mailer if your concepts and executions are strong."

‡FRANK MEO, 54 Morningside Dr., Suite 54, New York NY 10025. (212)932-9236. Fax: (212)932-3280. Contact: Frank Meo. Commercial photography representative. Estab. 1983. Member of SPAR. Represents 4 photographers. Markets include: advertising agencies; corporations/client direct; design firms.
Handles: Photography.
Terms: Rep receives 25% commission. Exclusive representation required. Advertising costs are split: 25% paid by talent; 75% paid by representative. Advertises in *Creative Black Book*.
How to Contact: For first contact, send query letter, photographs, direct mail flier/brochure. Reports in 5 days. After initial contact, drop off or mail in appropriate materials for review. Portfolio should include tearsheets, photographs.
Tips: Obtains new talent through recommendations and solicitations.

SUSAN MILLER REPRESENTS, 1641 Third Ave., Suite 29A, New York NY 10128. (212)427-9604. Fax: (212)427-7777. E-mail: futurelady@aol.com. Contact: Susan Miller. Commercial photography representative. Estab. 1983. Member of SPAR. Represents 8 photographers. "Firm deals mainly in advertising photography." Markets include: advertising agencies; sales/promotion firms, design firms, some editorial.
Handles: Photography.
Terms: Rep receives 25-30% commission in US; 33% in Europe. Advertising costs are paid by talent. "Talent must be able to self-promote in a directory page and other mailers if possible." Advertises in *Creative Black Book*, *The Workbook* and by direct mail.
How to Contact: For first contact, send query letter, direct mail flier/brochure, photocopies and SASE. May e-mail, but "no faxes, please." Reports in 3 weeks. After initial contact, call for appointment to show portfolio of slides, photographs.
Tips: "New talent comes to us through a variety of means; recommendation from art buyers and art directors, award shows, editorial portfolios, articles and direct solicitation. Photographers sending portfolio must pay courier both ways. Talent should please check directory ads to see if we have conflicting talent before contacting us. Most people calling us do not take the time to do any research, which is not wise."

MONTAGANO & ASSOCIATES, 401 W. Superior, 2nd Floor, Chicago IL 60610. (312)527-3283. Fax: (312)642-7543. E-mail: dmontag@aol.com. Contact: David Montagano. Commercial illustration, photography and television production representative and broker. Estab. 1983. Member of Chicago Artist Representatives. Represents 8 illustrators, 1 photographer, 8 directors. Markets include: advertising agencies; corporations/clients direct; design firms; editorial/magazines; paper products/greeting cards.
Handles: Illustration, photography, design. Looking for tabletop food photography.
Terms: Rep receives 30% commission. No geographic restrictions. Advertising costs are split: 70% paid by talent; 30% paid by representative. Advertises in *American Showcase*, *The Workbook*, *Creative Illustration Book*.
How to Contact: For first contact, send direct mail flier/brochure, tearsheets, photographs, disk samples.

THE DIGITAL MARKETS INDEX, located in the back of this book, lists markets that use images electronically.

Reports in 5 days. After initial contact, call to schedule an appointment. Portfolio should include original art, tearsheets, photographs.
Tips: Obtains new talent through recommendations from others.

MUNRO GOODMAN ARTISTS REPRESENTATIVES, 405 N. Wabash Ave., Chicago IL 60611. (312)321-1336. Fax: (312)321-1350. Contact: Steve Munro. Commercial photography and illustration representative. Estab. 1987. Member of SPAR, CAR (Chicago Artist Representatives). Represents 2 photographers, 22 illustrators. Markets include: advertising agencies; corporations/clients direct; design firms; publishing/books.
Handles: Illustration, photography.
Terms: Rep receives 25-30% commission. Exclusive area representation required. Advertising costs are split: 75% paid by talent; 25% paid by representative. For promotional purposes, talent must provide 2 portfolios, leave-behinds, several promos. Advertises in *American Showcase*, *Creative Black Book*, *The Workbook*, other sourcebooks.
How to Contact: For first contact, send query letter, bio, tearsheets and SASE. Reports in 2 weeks only if interested. After initial contact, write to schedule an appointment.
Tips: Obtains new talent through recommendations, periodicals. "Do a little homework and target appropriate rep."

‡THE NEIS GROUP, 11440 Oak Dr., Shelbyville MI 49344. (616)672-5756. Fax: (616)672-5757. Contact: Judy Neis. Commercial illustration and photography representative. Estab. 1982. Represents 30 illustrators, 7 photographers. Markets include: advertising agencies; design firms; editorial/magazines; publishing/books.
Handles: Illustration, photography.
Terms: Rep receives 25% commission. Advertising costs are split: 75% paid by talent; 25% paid by representative. Advertises in *The American Showcase*.
How to Contact: For first contact, send direct mail flier/brochure, tearsheets, photographs. Reports in 5 days. After initial contact, drop off or mail in appropriate materials for review. Portfolio should include non-returnable tearsheets, photographs.
Tips: "I am mostly sought out by the talent. If I pursue, I call and request a portfolio review."

MARIA PISCOPO, 3603 S. Aspen Village Way #E, Santa Ana CA 92704-7570. (714)556-8133. Fax: (714)556-8133. E-mail: mpiscopo@aol.com. Website: http://e~folio.com/piscopo. Contact: Maria Piscopo. Commercial photography representative. Estab. 1978. Member of SPAR, Women in Photography, Society of Illustrative Photographers. Markets include: advertising agencies; design firms; corporations.
Handles: Photography. Looking for "unique, unusual styles; handles only established photographers."
Terms: Rep receives 25-30% commission. Exclusive area representation is required. No geographic restrictions. Advertising costs are split: 50% paid by talent; 50% paid by representative. For promotional purposes, talent must provide 1 show portfolio, 3 traveling portfolios, leave-behinds and at least 6 new promo pieces per year. Plans advertising and direct mail campaigns.
How to Contact: For first contact, send query letter, bio, direct mail flier/brochure and SASE. Reports in 2 weeks, if interested.
Tips: Obtains new talent through personal referral and photo magazine articles. "Be very business-like, organized, professional and follow the above instructions!"

ALYSSA PIZER, 13121 Garden Land Rd., Los Angeles CA 90049. (310)440-3930. Fax: (310)440-3830. Contact: Alyssa Pizer. Commercial photography representative. Estab. 1990. Member of APCA. Represents 5 photographers. Specializes in entertainment (movie posters, TV Gallery, record/album); fashion (catalog, image campaign, department store). Markets include: advertising agencies, corporations/clients direct, design firms, editorial/magazines, record companies; movie studios, TV networks, publicists.
Handles: Photography. Established photographers only.
Terms: Rep receives 25% commission. Photographer pays for Federal Express and messenger charges. Talent pays 100% of advertising costs. For promotional purposes, talent must provide1 show portfolio, 2-3 traveling portfolios, leave-behinds and quarterly promotional pieces.
How to Contact: For first contact, send query letter or direct mail flier/brochure or call. Reports in a couple of days. After initial contact, call to schedule an appointment or drop off or mail materials for review.
Tips: Obtains new talent through recommendations from clients.

REDMOND REPRESENTS, 4 Cormer Court, Apt. #304, Timonium MD 21093. (410)560-0833. Fax: (410)560-0804. E-mail: sony@erols.com. Contact: Sharon Redmond. Commercial illustration and photog-

raphy representative. Estab. 1987. Markets include: advertising agencies; corporations/client direct; design firms.

Handles: Illustration, photography.

Terms: Rep receives 30% commission. Exclusive area representation is required. No geographic restrictions. Advertising costs and expenses are split: 50% paid by talent; 50% paid by representative. For promotional purposes, talent must provide a small portfolio (easy to Federal Express) and at least 6 direct mail pieces (with fax number). Advertises in *American Showcase, Creative Black Book.*

How to Contact: For first contact, send mailouts. Reports in 2 weeks if interested.

Tips: Obtains new talent through recommendations from others, advertisting in *Black Book*, etc. "Even if I'm not taking in new talent, I do want samples sent of new work. I never know when an ad agency will require a different style of illustration/photography, and it's always nice to refer to my files."

‡KERRY REILLY: REPS, 1826 Asheville Place, Charlotte NC 28203. Phone/fax: (704)372-6007. Contact: Kerry Reilly. Commercial illustration and photography representative. Estab. 1990. Represents 16 illustrators, 3 photographers. Markets include: advertising agencies; corporations/clients direct; design firms; editorial/magazines.

Handles: Illustration, photography.

Terms: Rep receives 25% commission. Exclusive area representation is required. No geographic restrictions. Advertising costs are split: 75% paid by talent; 25% paid by representative. For promotional purposes, talent must provide at least 2 pages printed leave-behind samples. Preferred format is 9 × 12 pages, portfolio work on 4 × 5 transparencies. Advertises in *American Showcase, Workbook.*

How to Contact: For first contact, send direct mail flier/brochure or samples of work. Reports in 2 weeks. After initial contact, call for appointment to show portfolio or drop off or mail tearsheets, slides, 4 × 5 transparencies.

Tips: Obtains new talent through recommendations from others. "It's essential to have printed samples—a lot of printed samples."

REPRESENTED BY KEN MANN INC., 20 W. 46th St., New York NY 10036. (212)944-2853. Fax: (212)921-8673. Contact: Ken Mann. Commercial photography representative. Estab. 1974. Member of SPAR. Represents 5 photographers. Specializes in "highest quality work!" Markets include: advertising agencies.

Handles: Photography.

Terms: Rep receives 25% commission in US; 30% international. Exclusive area representation is required. Advertising costs are split in US. 75% paid by talent; 25% paid by representative. International: photographer pays all advertising costs. Advertises in *Creative Black Book, The Work Book, N.Y. Gold.*

How to Contact: For first contact, send query letter, résumé, bio, direct mail flier/brochure, photocopies, photostats, "nothing that needs to be returned." Reports in 1 week if interested. After initial contact, call for appointment to show portfolio of tearsheets and photographs; drop off or mail materials for review.

Tips: Obtains new talent through editorial work, recommendations. "Put together the best portfolio possible because knowledgable reps only want the best!"

JULIAN RICHARDS, 262 Mott St., New York NY 10012. (212)219-1269. Fax: (212)925-7803. Contact: Juliette Consigny. Commercial photography representative. Estab. 1992. Represents 5 photographers. Specializes in portraits, still life, travel. Markets include: advertising agencies; design firms; editorial/magazines; publishing/books.

Terms: Rep receives 20% commission. Exclusive area representation required. Advertising costs are split: 80% paid by talent; 20% paid by representative.

How to Contact: For first contact, send direct mail flier/brochure.

Tips: Obtains new talent by working closely with potential representees over a period of months. "Be reasonable in your approach—let your work do the selling."

THE ROLAND GROUP INC., 4948 St. Elmo Ave., #201, Bethesda MD 20814. (301)718-7955. Fax: (301)718-7958. E-mail: rolandgrp@aol.com. Contact: Rochel Roland or Jason Bach. Commercial photography and illustration representatives as well as illustration and photography brokers. Estab. 1988. Member

MARKET CONDITIONS are constantly changing! If you're still using this book and it's 1999 or later, buy the newest edition of *Photographer's Market* at your favorite bookstore or order directly from Writer's Digest Books.

of SPAR, ASMP, Art Directors Club and Ad Club. Markets include advertising agencies; corporations/clients direct; design firms and sales/promotion firms.

Handles: Illustration, photography and videography. Searching for photographers, illustrators and videographers who are "computer oriented."

Terms: Agent receives 35% commission. For promotional purposes, talent must provide transparencies, slides, tearsheets or a digital portfolio. Advertises in *Print Magazine*, *American Showcase*, *The Workbook* and *Creative Sourcebook*.

How to Contact: For first contact, send résumé, tearsheets or photocopies and any other nonreturnable samples. Reports only if interested. After initial contact, drop off portfolio materials for review. Portfolios should include tearsheets, slides, photographs, photocopies.

Tips: "The Roland Group provides the National Photography Network Service in which over 200 photographers are assigned to specific geographic territories around the world to handle projects for all types of clients. Please call with questions."

LINDA RUDERMAN, 1245 Park Ave., New York NY 10128. Phone/fax: (212)369-7531. Contact: Linda Ruderman. Commercial photography representative. Estab. 1988. Represents 2 photographers. Specializes in children and still life photography. Markets include: advertising agencies; corporations/clients direct; design firms; sales/promotion firms.

Handles: Photography.

Terms: To be discussed. Advertises in *Creative Black Book* and *The Workbook*.

How to Contact: For first contact send bio, direct mail flier. Reports back only if interested.

Tips: Obtains new talent through recommendations, *Creative Black Book* portfolio review and by calling photographers who advertise in *The Creative Black Book* and *The Workbook*.

‡DARIO SACRAMONE, 302 W. 12th St., New York NY 10014. (212)929-0487. Fax: (212)242-4429. Commercial photography representative. Estab. 1972. Represents 3 photographers. Markets include: advertising agencies; design firms; corporations; editorial.

Handles: Photography.

Terms: Rep receives 25% commission. Exclusive area representation is required. For promotional purposes, talent must provide direct mail piece, minimum of 3 professionally-put-together portfolios.

How to Contact: For first contact, send bio, direct mail flier/brochure. After initial contact, drop off or mail in appropriate materials for review.

FREDA SCOTT, INC., 1015-B Battery St., San Francisco CA 94111. (415)398-9121. Fax: (415)398-6136. Contact: Freda Scott. Commercial illustration and photography representative. Estab. 1980. Member of SPAR. Represents 10 illustrators, 10 photographers. Markets include: advertising agencies; corporations/clients direct; design firms; editorial/magazines; paper products/greeting cards; publishing/books; sales/promotion firms.

Handles: Illustration, photography.

Terms: Rep receives 25% commission. No geographic restrictions. Advertising costs are split: 75% paid by talent; 25% paid by representative. For promotional purposes, talent must provide "promotion piece and ad in a directory. I also need at least three portfolios." Advertises in *American Showcase*, *Creative Black Book*, *The Workbook*.

How to Contact: For first contact, send direct mail flier/brochure, tearsheets and SASE. If you send transparencies, reports in 1 week, if interested. "You need to make follow up calls." After initial contact, call for appointment to show portfolio of tearsheets, photographs (4×5 or 8×10).

Tips: Obtains new talent sometimes through recommendations, sometimes solicitation. "If you are seriously interested in getting repped, keep sending promos—once every six months or so. Do it yourself a year or two until you know what you need a rep to do."

‡SHARPE + ASSOCIATES INC., 7536 Ogelsby Ave., Los Angeles, CA 90045. (310)641-8556. Fax: (310)641-8534. E-mail: sharpela@eastlink.net. Contact: John Sharpe (LA), Colleen Hedleston (NY): (212)595-1125). Commercial illustration and photography representative. Estab. 1987. Member of APA. Represents 5 illustrators, 5 photographers. Not currently seeking new talent but "always willing to look at work." Staff includes: John Sharpe, Irene Sharpe and Colleen Hedleston (general commercial—advertising and design), "all have ad agency marketing backgrounds. We tend to show more non-mainstream work." Markets include: advertising agencies; corporations/clients direct; design firms; editorial/magazines; music/publishing; sales/promotion firms.

Handles: Illustration, photography.

Terms: Agent recieves 25% commission. Exclusive area representation is required. Advertising costs are paid by talent. For promotional purposes, "promotion and advertising materials are the talent's responsibil-

ity. The portfolios are 100% the talent's responsiblity and we like to have at least three complete books per market." Advertises in *The Workbook* and through direct mail.

How to Contact: For first contact, call, then follow up with printed samples. Reports in 2 weeks. After initial contact, call for appointment to show portfolio.

Tips: Obtains new talent mostly through referrals, occasional solicitations. "Once they have a professional portfolio together and at least one representative promotional piece, photographers should target reps along with potential buyers of their work as if the two groups are one and the same. They need to market themselves to reps as if the reps are potential clients."

SULLIVAN & ASSOCIATES, 3805 Maple Court, Marietta GA 30066. (770)971-6782. Fax: (770)977-3882. E-mail: sullivan@atlcom.net. Contact: Tom Sullivan. Commercial illustration, commercial photography and graphic design representative. Estab. 1988. Member of Creative Club of Atlanta, Atlanta Ad Club. Represents 14 illustrators, 7 photographers and 7 designers, including computer graphic skills in illustration/design/production and photography. Staff includes Tom Sullivan (sales, talent evaluation, management), Debbie Sullivan (accounting, administration). Specializes in "providing whatever creative or production resource the client needs." Markets include: advertising agencies; corporations/client direct; design firms; editorial/magazines; publishing/books; sales/promotion firms.

Handles: Illustration, photography. "Open to what is marketable; computer graphics skills."

Terms: Rep receives 25% commission. Exclusive area representation in Southeastern US is required. Advertising costs paid by talent. For promotional purposes, talent must provide "direct mail piece, portfolio in form of $8\frac{1}{2} \times 11$ (8×10 prints) pages in 22-ring presentation book." Advertises in *American Showcase*, *The Workbook*.

How to Contact: For first contact, send bio, direct mail flier/brochure; "follow up with phone call." Reports in 2 weeks if interested. After initial contact, call for appointment to show portfolio of tearsheets, photographs, photostats, photocopies, "anything appropriate in nothing larger than $8\frac{1}{2} \times 11$ print format."

Tips: Obtains new talent through referrals and direct contact from creative person. "Have direct mail piece or be ready to produce it immediately upon reaching an agreement with a rep. Be prepared to immediately put together a portfolio based on what the rep needs for that specific market area."

TM ENTERPRISES, (formerly T & M Enterprises), 270 N. Canon Dr., Suite 2020, Beverly Hills CA 90210. (310)274-2664. Fax: (310)274-7957. Contact: Tony Marques. Commercial photography representative and photography broker. Estab. 1985. Member of Beverly Hills Chamber of Commerce. Represents 50 photographers. Specializes in women photography only: high fashion, swimsuit, lingerie, glamour and fine (good taste) *Playboy*-style pictures. Markets include: advertising agencies; corporations/clients direct; editorial/magazines; paper products/greeting cards; publishing/books; sales/promotion firms; medical magazines.

Handles: Photography.

Terms: Rep receives 50% commission. Advertising costs are paid by representative. "We promote the standard material the photographer has available, unless our clients request something else." Advertises in Europe, South and Central America and magazines not known in the US.

How to Contact: For first contact, send everything available. Reports in 2 days. After initial contact, drop off or mail in appropriate materials for review. Portfolio should include slides, photographs, transparencies, printed work.

Tips: Obtains new talent through worldwide famous fashion shows in Paris, Rome, London and Tokyo; participating in well-known international beauty contests; recommendations from others. "Send your material clean. Send your material organized (neat). Do not borrow other photographers' work in order to get representation. Protect—always—yourself by copyrighting your material. Get releases from everybody who is in the picture (or who owns something in the picture)."

‡TY REPS, 920¼ N. Formosa Ave., Los Angeles CA 90046. (213)850-7957. Fax: (213)850-0245. Contact: Ty Methfessel. Commercial photography and illustration representative. Specializes in automotive photography, portfolio reviews and marketing advice. Markets include advertising agencies; corporations/clients direct; design firms.

Handles: Illustration and photography.

Terms: Rep receives 25-30% commission. Exclusive area representation required. Advertising costs paid by talent. For promotional purposes, talent must provide a minimum of 3 portfolios, 4 new promos per year and a double-page ad in a national directory. Advertises in *American Showcase*, *Creative Black Book* and *The Workbook*.

How to Contact: For first contact, send query letter, direct mail flier/brochure and tearsheets. Reports in 2 weeks only if interested.

‡**ELYSE WEISSBERG**, 225 Broadway, Suite 700, New York NY 10007. (212)227-7272. Fax: (212)385-0349. Contact: Elyse Weissberg. Commercial photography representative, photography creative consultant. Estab. 1982. Member of SPAR. Markets include: advertising agencies; corporations/clients direct; design firms; editorial/magazines; publishing/books; sales/promotion firms.
Handles: Commercial photography. "I'm not looking for talent at this time."
Terms: "Each talent contract is negotiated separately." No geographic restrictions. No specific promotional requirements. "My only requirement is ambition." Advertises in *KIK*, *Creative Black Book*, *The Workbook*.
How to Contact: Send mailers.
Tips: Elyse Weissberg is available on a consultation basis. She reviews photography portfolios and gives direction in marketing and promotion.

■**WINSTON WEST, LTD.**, 204 S. Beverly Dr., Suite 108, Beverly Hills CA 90212. (310)275-2858. Fax: (310)275-0917. Contact: Bonnie Winston. Commercial photography representative (fashion/entertainment). Estab. 1986. Represents 8 photographers. Specializes in "editorial fashion and commercial advertising (with an edge)." Markets include: advertising agencies; client direct; editorial/magazines.
Handles: Photography.
Terms: Rep receives 25% commission. Charges for courier services. Exclusive area representation is required. No geographic restrictions. Advertising costs are split: 75% paid by talent; 25% paid by representative. Advertises by direct mail and industry publications.
How to Contact: For first contact, send direct mail flier/brochure, photographs, photocopies, photostats. Reports in days, only if interested. After initial contact, call for appointment to show portfolio of tearsheets.
Tips: Obtains new talent through "recommendations from the modeling agencies. If you are a new fashion photographer or a photographer who has relocated recently, develop relationships with the modeling agencies in town. They are invaluable sources for client leads and know all the reps."

JIM ZACCARO PRODUCTIONS INC., 315 E. 68th St., New York NY 10021. (212)744-4000. Contact: Jim Zaccaro. Commercial photography and fine art representative. Estab. 1961. Member of SPAR, DGA. Represents 4 photographers.
Terms: Rep receives 25% commission.
How to Contact: For first contact, send query letter, direct mail flier/brochure. Reports in 10 days. After initial contact, call for appointment to show portfolio.

Contests

Whether you're a seasoned veteran or a newcomer still cutting your teeth, you may consider entering contests to see how your work matches up against that of other photographers. The contests in this section range in scope from tiny juried county fairs to massive international competitions. When possible we've included entry fees and other pertinent information in our limited space. Contact sponsors for entry forms and more details.

Once you receive rules and entry forms, pay particular attention to the sections describing rights. Some sponsors retain all rights to winning entries or even *submitted* images. Be wary of these. While you can benefit from the publicity and awards connected with winning prestigious competitions, you shouldn't unknowingly forfeit copyright. Granting limited rights for publicity is reasonable, but never assign rights of any kind without adequate financial compensation or a written agreement. If such terms are not stated in contest rules, ask sponsors for clarification.

If you're satisfied with the contest's copyright rules, check with contest officials to see what types of images won in previous years. By scrutinizing former winners you might notice a trend in judging that could help when choosing your entries. If you can't view the images, ask what styles and subject matter have been popular.

ANNUAL INTERNATIONAL UNDERWATER PHOTOGRAPHIC COMPETITION, P.O. Box 2401, Culver City CA 90231. (310)437-6468. Cost: $7.50 per image, maximum 4 images per category. Offers annual competition in 9 categories (8 underwater, 1 water related). Thousands of dollars worth of prizes. Deadline mid-October.

AQUINO INTERNATIONAL, P.O. Box 125, Rochester VT 05767. (203)967-9952. Publisher: Andres Aquino. Ongoing photo contest in many subjects. Offers publishing opportunities, cash prizes and outlet for potential stock sales. Send SAE with 2 first-class stamps for details.

ART OF CARING PHOTOGRAPHY CONTEST, Caring Institute, 513 "C" St. NE, Washington DC 20002-5809. (202)547-4273. Director: Marian Brown. Image must relate to the subject of caring. Photos must be 8×10, color or b&w and must be submitted with a completed entry blank which may be obtained from Caring Institute.

ART ON THE GREEN, P.O. Box 901, Coeur d'Alene ID 83816. (208)667-9346. Outdoor art and crafts festival including juried show first August weekend each year.

ARTIST FELLOWSHIP GRANTS, % Oregon Arts Commission, 775 Summer St. NE, Salem OR 97310. (503)986-0086. Fax: (503)986-0260. (800)233-3306 (in Oregon). E-mail: vincent.k.dunn@state.or. us. Website: http://www.das.state.or.us/oac/. Assistant Director: Vincent Dunn. Offers cash grants to Oregon photographers in odd-numbered years.

‡BOOK OF THE YEAR COMPETITION, Maine Photographic Workshops, 2 Central St., P.O. Box 200, Rockport ME 04856. Send 2 copies of each book you wish considered. Enclose a letter listing the principal individuals responsible for the book—the author, photographer, editor, designer, publisher and printer. The book's specifications should also be included, detailing the number of pages, number of images, authors of the introduction, essays or any additional text. The printing specifications should be included as well. The entry letter should be signed by the individual making the submission with an address and phone number for notification. All books received become part of The Maine Photographic Workshops' Library and none are returned. Copies of all winning books are sold through The Workshops' book mail order catalog and retail store.

CASEY MEDALS FOR MERITORIOUS JOURNALISM, Casey Journalism Center for Children & Families, 8701-B Adelphi Rd., Adelphi MD 20783-1716. (301)445-4971. Administrative Director: Lori

Robertson. Honors distinguished coverage of disadvantaged and at-risk children and their families. Photojournalism category: Series of photos from daily or non-daily newspaper or general interest magazine. Deadline: early August. Contact for official entry form.

■THE CREATIVITY AWARDS SHOW, 456 Glenbrook Rd., Glenbrook CT 06906. (203)353-1441. Fax: (203)353-1371. Show Director: Dan Barron. Sponsor: *Art Direction* magazine. Annual show for photos and films appearing in advertising and mass communication media, annual reports, brochures, etc.

‡FINE ARTS WORK CENTER IN PROVINCETOWN, 24 Pearl St., Provincetown MA 02657. (508)487-9960. Contact: Visual Coordinator. Seven-month residency program for artists and writers. Housing, monthly stipend and materials allowance provided from October 1 through May 1. Send SASE for application. Deadline February 1.

49th EXHIBITION OF PHOTOGRAPHY, (formerly 48th International Exhibition of Photography), Del Mar Fair Entry Office, 2260 Jimmy Durante Blvd., Del Mar CA 92014-2216. (619)792-4207. Sponsor: Del Mar Fair (22nd District Agricultural Association). Annual event for still photos/prints. Pre-registration deadline: May 2, 1997. Send #10 SASE for brochure, available early March.

GALLERY MAGAZINE GIRL NEXT DOOR CONTEST, 401 Park Ave. S., New York NY 10016-8802. Contest Editor: Judy Linden. Sponsors monthly event for still photos of nudes. Offers monthly and annual grand prizes: $250 entry photo; $2,500 monthly winner; $25,000 yearly winner. "Must be amateurs!" Photographers: entry photo receives 1-year free subscription; monthly winner, $500; yearly winner, $2,500. Write for details or buy magazine.

GOLDEN ISLES ARTS FESTIVAL, P.O. Box 20673, Saint Simons Island GA 31522. (912)638-8770. Contact: Registration Chairman. Sponsor: Glynn Art Association. Annual 2-day festival for still photos/ prints; all fine art and craft. Deadline: August 30.

‡GOLDEN LIGHT & ERNST HAAS AWARDS, Maine Photographic Workshops, 2 Central St., P.O. Box 200, Rockport ME 04856. (207)236-8581. Fax: (207)236-2558. Website: http://www.MEWorkshops.com. An annual competition for the world's photographers. Awards include: The $10,000 Ernst Haas Award for personal photography, Photographer Support Awards of $1,000 each, the Print Competition in 6 categories. Entry fee: $30 for a portfolio, $5/print for the Print Competition. Also, Photography Student of The Year, Photography Educator of The Year and the Photographic Book of The Year Awards. Entry deadline: September 1. Awards made in New York City at VISCOM Trade Show. Request competition rules via phone, fax or Internet.

GREATER MIDWEST INTERNATIONAL XIV, CMSU Art Center Gallery, Clark St., Warrensburg MO 64093-5246. (816)543-4498. Gallery Director: Morgan Dean Gallatin. Sponsor: CMSU Art Center Gallery/Missouri Arts Council. Sponsors annual competition for 2-D and 3-D all media. Send SASE for current prospectus after June 1, 1998. Entry deadline October 15, 1998.

IDAHO WILDLIFE, P.O. Box 25, Boise ID 83707-0025. (208)334-3746. Fax: (208)334-2148. E-mail: dronayne@idfg.state.id.us. Editor: Diane Ronayne. Annual contest; pays cash prizes of $20-150. Rules in summer and fall issues of *Idaho Wildlife* magazine. Deadline October 15. Winners published. Freelance accepted in response to want list. Pays b&w or color inside $40; cover $80. Fax request for submission guidelines.

‡IMAGES CENTER FOR PHOTOGRAPHY, 1311 Main St., Cincinnati OH 45210. (513)241-8124. Cost: Up to 5 slides may be submitted along with a non-refundable $20 entry fee. Up to 5 additional slides may be submitted for $5 per slide. Annual juried exhibition. All work that utilizes any photographic process, from traditional silver printing techniques to the latest in technologically-generated imagery, are eligible. Artists must be members of IMAGES. Individual annual membership fees are $10 for students and $25 for individual members.

***INTERNATIONAL DIAPORAMA FESTIVAL**, Auwegemvaart 79, B-2800 Mechelen, Belgium. President: J. Denis. Sponsor: Koninklijke Mechelse Fotokring. Competition held every other year (even years) for slide/sound sequences.

‡ **CONTESTS NEW TO THIS EDITION** are marked with a double dagger.

INTERNATIONAL WILDLIFE PHOTO COMPETITION, 802 E. Front St., Missoula MT 59802. (406)728-9380. Chairman: Robin Lieb. Professional and amateur catagories, color and b&w prints. Pays $1,700 in cash and prizes. Entry deadline: March 10. Co-sponsored by the 20th Annual International Wildlife Film Festival.

‡*KRASZNA-KRAUSZ PHOTOGRAPHY BOOK AWARDS, 122 Fawnbrake Ave., London SE24 OBZ, England. (171)738-6701. Awards Administrator: Andrea Livingstone. Awards made to encourage and recognize outstanding achievements in the writing and publishing of books on the art, history, practice and technology of photography and the moving image. Entries from publishers only by July 1st.

LARSON GALLERY JURIED PHOTOGRAPHY EXHIBITION, Yakima Valley Community College, P.O. Box 1647, Yakima WA 98907. (509)574-4875. Director: Carol Hassen. Cost: $6/entry (limit 4 entries). National juried competition with approximately $2,500 in prize money. Held annually in April. Write for prospectus in January.

MAYFAIR JURIED PHOTOGRAPHY EXHIBITION, 2020 Hamilton St., Allentown PA 18104. (610)437-6900. Maximum 3 entries, $10 non-refundable fee to enter. May 21-June 21 juried exhibition open to all types of original photographs by artists within 75-mile radius of Allentown. Send for prospectus with SASE; entry deadline February 28.

‡■THE "MOBIUS"™ ADVERTISING AWARDS, 841 N. Addison Ave., Elmhurst IL 60126-1291. (630)834-7773. Fax: (630)834-5565. E-mail: 105464.2160@compuserve.com. Chairman: J.W. Anderson. Executive Director: Patricia Meyer. Sponsor: The United States Festivals Association. Annual international awards competition for TV and radio commericals, print advertising and package design. Annual October 1st entry deadline. Awards in early February each year.

MOTHER JONES INTERNATIONAL FUND FOR DOCUMENTARY PHOTOGRAPHY AWARDS, 731 Market St., Suite 600, San Francisco CA 94103. Fax: (415)665-6696. E-mail: photofund@motherjones.com. Contact: Hannah Frost. Sponsors awards programs for in-progress, in-depth (lasting more than 1 year) social documentary projects. Awards four grants of $7,000 each and the Leica Medal of Excellence worth $10,000. Write, fax or e-mail for guidelines.

‡NATIONAL JURIED COMPETITION, Phoenix Gallery, 568 Broadway, Suite 607, New York NY 10012. July 8. Juror: Laura Hoptman. Assistant Curator Museum of Modern Art. Award: solo/group show. Slides due May 2. Send SASE for Prospectus.

‡NAVAL AND MARITIME PHOTO CONTEST, U.S. Naval Institute, 118 Maryland Ave., Annapolis MD 21402. (410)295-1071. Contact: Picture Editor. Sponsors annual competition for still photos/prints and 35mm slides. December 31 deadline.

‡NEW YORK STATE FAIR PHOTOGRAPHY COMPETITION AND SHOW, 581 State Fair Blvd., Syracuse NY 13209. (315)487-7711, ext. 241 or 240. Program Manager: Marc C. Somerset. Fee: $5/entrant for 1 or 2 works. Open to amateurs and professionals in both b&w and color. Two prints may be entered per person. Prints only, no transparencies. Youth competition also featured. Entry deadline July 23.

■NEW YORK STATE YOUTH MEDIA ARTS SHOWS, Media Arts Teachers Association, 1401 Taylor Rd., Jamesville NY 13078. (315)469-8574. Co-sponsored by the New York State Media Arts Teachers Association and the State Education Department. Annual regional shows and exhibitions for still photos, film, videotape and computer arts. *Open to all New York state, public and non-public elementary and secondary students.*

‡NIKON SMALL WORLD COMPETITION, 1300 Walt Whitman Rd., Melville New York 11747. (516)547-8500. Advertising Manager: B. Loechner. International contest for photography through the microscope, 35mm—limit 3 entries. First prize $4,000.

1998 PHOTOGRAPHY ANNUAL, 410 Sherman, P.O. Box 10300, Palo Alto CA 94303. (415)326-6040. Executive Editor: Jean A. Coyne. Sponsor: *Communication Arts* magazine. Annual competition for still photos/prints. Write or call for entry forms. Deadline: March 16, 1998.

■NORTH AMERICAN OUTDOOR FILM/VIDEO AWARDS, 2017 Cato Ave., Suite 101, State College PA 16801-2768. (814)234-1011. Sponsor: Outdoor Writers Association of America. $125 fee/

entry. Annual competition for films/videos on conservation and outdoor recreation subjects. Two categories: Recreation/Promotion and Conservation/Natural History. Receiving deadline: January 10, 1998, for 1997 production date.

***NORTHERN COUNTIES INTERNATIONAL COLOUR SLIDE EXHIBITION**, 9 Cardigan Grove, Tynemouth, Tyne & Wear NE30 3HN England. (0191)252-2870. Honorary Exhibition Chairman: Mrs. J.H. Black, ARPS, APAGB. Judges 35mm slides—4 entries per person. Three sections: general, nature and photo travel. PSA and FIAP recognition and medals.

‡OUTDOOR GRANDEUR PHOTOGRAPHY CONTEST, Black River Publishing, P.O. Box 10091, Dept. 0T7, Marina del Rey CA 90295. (310)235-2602. After hours: (310)391-0717. Website: http://www.brpub.com. Contact: Paola Pastorino or Francis J. Nickels III. Annual outdoor scenic competition with 12 cash prizes including $1,000 to the first place winner. Winning images are also published in the the *Outdoor Grandeur* calendar. "Acceptable themes include images of outdoor scenery, such as waterfalls, snow covered mountains, scenic beaches and forests of changing leaves. Images reflecting all seasons of the year are needed. There is no limit to the number of 35mm slides submitted. Entries will be judged on their photographic quality, appeal and content. Entrants providing a SASE will have their slides returned. Winning images will be used on a nonexclusive basis." Deadline: June 30th. Cost: $5 entry fee, regardless of the number of slides submitted.

‡PACIFIC COAST UNDERWATER PHOTOGRAPHIC CHAMPIONSHIP, % San Diego Council of Divers, P.O. Box 9259, San Diego CA 92169-0259. (619)687-1492. Contact: PCUPC Chairperson or President of Council. Cost: $65. Call for brochure.

GORDON PARKS PHOTOGRAPHY COMPETITION, Fort Scott Community College, 2108 S. Horton, Fort Scott KS 66701. (316)223-2700. Chair, Lucile James Fine Arts Committee: Johnny Bennett. Cost: $15 for 2 photos; maximum of 2 additional photos for $5 each. Prizes of $1,000, $500, $250; winners and honorable mentions will be featured in annual nationwide traveling exhibition. Entry deadline September 30; write for entry form.

‡PHOTO COMPETITION U.S.A., 3900 Ford Rd., 18-Q, Philadelphia PA 19131. (215)878-6211. Publisher: Allan K. Marshall. Quarterly contests in 5 categories, sponsored by magazine for photographers. Cost: $18-36/entry. Write for more information.

‡PHOTO METRO MAGAZINE ANNUAL CONTEST, 17 Tehama St., San Francisco CA 94105. (415)243-9917. Photography contest with cash prizes, publication and exhibition. Send SASE for information after June. Call for entries goes out in July. Contest deadline is around September.

PHOTO REVIEW ANNUAL COMPETITION, 301 Hill Ave., Langhorne PA 19047. (215)757-8921. Editor: Stephen Perloff. Cost: $20 for up to 3 prints or slides, $5 each for up to 2 more. National annual photo competition; all winners reproduced in summer issue of *Photo Review* magazine. One entrant selected for 1-person show at the Print Center, Philadelphia, PA. Awards $1,000 cash prizes. Deadline: May 15-31.

PHOTOGRAPHIC ALLIANCE USA, 1864 61st St., Brooklyn NY 11204-2352. President: Henry Mass. FPSA, HonESFIAP. Sole US representative of the International Federation of Photographic Art. Furnishes members with entry forms and information regarding worldwide international salons (over 100 each year) as well as other information regarding upcoming photographic events. Recommends members for distinctions and honors in FIAP (Federation de la Art Photographique) as well as approves US international salons for patronage in FIAP.

PHOTOGRAPHY NOW, % the Center for Photography at Woodstock, 59 Tinker St., Woodstock NY 12498. (914)679-9957. Sponsors annual competition. Call or write for entries. SASE. Juried annually by renowned photographers, critics, museums. Deadline: February 14.

 INTERNATIONAL CONTESTS, those held outside of the United States and Canada, are marked with an asterisk.

‡**PHOTOGRAPHY 17**, Perkins Center for the Arts, 395 Kings Hwy., Moorestown NJ 08057. (609)235-6488. Director: Alan Willoughby. Regional juried photography exhibition. Past jurors include Merry Foresta, Curator of Photography at the National Museum of American Art (Smithsonian Institution); Willis Hartshorn, curator at the International Center for Photography (NYC) and photographer, Emmet Gowin.

‡**PHOTOMANIA**, (formerly Botamania), P.O. Box 705, Tucumcari NM 88401-0705. (505)461-6183. Fax: (505)461-6181. E-mail: botatogra@aol.com. Editor: William Johnson. Annual contest offered by *photoResource Magazine*. Cost: $15 for 5 slides. Open to all amateur photographers. Deadline December 1. Winners are published and awarded prizes. #10 SASE for prospectus.

PHOTOWORK 99, Barrett House Galleries, 55 Noxon St., Poughkeepsie NY 12601. (914)471-2550. Director: Ursula Nelson. National photography exhibition judged by New York City curator. Deadline for submissions: December 1998. Send SASE in September for prospectus.

POSITIVE NEGATIVE #12, P.O. Box 70708, East Tennessee State University, Johnson City TN 37614-0708. (423)439-7078. Gallery Director: Ann Ropp. Juried national show open to all media. Call or write for prospectus. Deadline for application: November 2.

PULITZER PRIZES, 702 Journalism, Columbia University, New York NY 10027. (212)854-3841 or 3842. Costs: $50/entry. Annual competition for still photos/prints published in American newspapers. February 1 deadline for work published in the previous year.

‡**CONSTANCE SALTONSTALL FOUNDATION FOR THE ARTS**, 120 Brindley St., Ithaca NY 14850. (607)277-4933. Offers summer residencies and grants to writers, painters and photographers who live in New York state. Contact the foundation for application information.

SAN FRANCISCO SPCA PHOTO CONTEST, SF/SPCA, 2500 16th St., San Francisco CA 94103. (415)554-3000. Coordinator: Frank Burtnett. Entry fee $5 per image, no limit. Photos of pet(s) with or without people. Color slides, color or b&w prints, no larger than 8×12 (matte limit 11×14). Make check payable to SF/SPCA. Three best images win prizes. Deadline for entry: December 15 each year; include return postage and phone number.

SISTER KENNY INSTITUTE INTERNATIONAL ART SHOW BY DISABLED ARTISTS, 800 E. 28th St., Minneapolis MN 55407-3799. (612)863-4630. Art Show Coordinator: Linda Frederickson. Show is held once a year in April and May for disabled artists. Deadline for entries: March 20. Award monies of over $5,000 offered.

‡**SOHO PHOTO GALLERY COMPETITION**, 15 White St., New York NY 10013. (212)799-4100. Contact: Wayne Parsons. Jurors: nationally known, varies yearly. Awards: one-month solo show; group show. Cost: $25 entry fee for a maximum of 6 slides. "Eligibility extends to any U.S.-resident photographer 18 years of age or older and to all photo-based images. Members of Soho Photo are not eligible; prior first-place winners at Soho Photo are not eligible for a first-place award, though they are eligible for the group show. There is no limitation as to subject matter; however, submitted work should show stylistic and thematic unity. Maximum dimension of any piece (including frame) is 48 inches." SASE for prospectus and deadline for 1998. For general information on the Gallery, contact Mary Ann Lynch, (212)929-2511.

‡**TAYLOR COUNTY FAIR PHOTO CONTEST**, P.O. Box 613, Grafton WV 26354-0613. Co-Chairman: K.M. Bolyard. Entry fee: $3 each print (maximum of 10). Color and b&w.

TEXAS FINE ARTS ASSOCIATION'S NEW AMERICAN TALENT, 700 Congress Ave., Austin TX 78701. (512)453-5312. Contact: Leslie Cox. A national all-media competition selected by a nationally prominent museum curator. Provides catalog and tour. Entry deadline: January 1998. Send SASE for prospectus.

‡■**U.S. INTERNATIONAL FILM AND VIDEO FESTIVAL**, 841 N. Addison Ave., Elmhurst IL 60126-1291. (630)834-7773. Fax: (630)834-5565. E-mail: 105464.2160@compuserve.com. Chairman: J.W. Anderson. Executive Director: Patricia Meyer. Sponsor: The United States Festivals Association. Annual international awards competition for sponsored and independently produced, business, television, industrial and informational film and video. Founded 1968. Annual March 1st entry deadline.

UNLIMITED EDITIONS INTERNATIONAL JURIED PHOTOGRAPHY COMPETITIONS, % Competition Chairman, P.O. Box 1509, Candler NC 28715-1509. (704)665-7005. President/Owner:

Gregory Hugh Leng. Sponsors juried photography contests offering cash and prizes. Also offers opportunity to sell work to Unlimited Editions.

VAL-TECH PUBLISHING INC., P.O. Box 25376, St. Paul MN 55125. (612)730-4280. Contact: Valerie Hockert. Cost: $3/entry. Deadlines: June 15 and November 30. Photos can be scenic, with or without people. Send SASE for guidelines.

‡■VISIONS OF U.S. HOME VIDEO COMPETITION, P.O. Box 200, Los Angeles CA 90078. (213)856-7707. Contact: Carla Sanders. No fee is required. Annual competition for home videos shot on 8mm video, Beta or VHS. Competition is open to anyone with a home format camera in the US.

WELCOME TO MY WORLD, P.O. Box 20673, Saint Simons Island GA 31522. (912)638-8770. Contact: Registration Chairman. Sponsored by the Glynn Art Association. Call or write for application. Cash awards. Deadline June.

YOUR BEST SHOT, % *Popular Photography*, P.O. Box 1247, Teaneck NJ 07666. Monthly photo contest, 2-page spread featuring 5 pictures: first ($300), second ($200), third ($100) and 2 honorable mention ($50 each).

■ **CONTESTS FOR AUDIOVISUAL MATERIAL**, such as slides, film or videotape, are marked with a solid, black square.

Workshops

Photography is headed in a new direction, one filled with computer manipulation, compact discs and online images. Technological advances are no longer the wave of the future—they're here.

Even if you haven't invested a lot of time and money into electronic cameras, computers or software, you should understand what you're up against if you plan to succeed as a professional photographer. Outdoor and nature photography are still popular with instructors, but technological advances are examined closely in a number of the workshops listed in this section.

As you peruse these pages take a good look at the quality of workshops and the level of photographers the sponsors want to attract. It is important to know if a workshop is for beginners, advanced amateurs or professionals, and information from a workshop organizer can help you make that determination.

These workshop listings contain only the basic information needed to make contact with sponsors and a brief description of the styles or media covered in the programs. We also include information on workshop costs. Write for complete information.

The workshop experience can be whatever the photographer wishes—a holiday from the normal working routine, or an exciting introduction to new skills and perspectives on the craft. Whatever you desire, you'll probably find a workshop that fulfills your expectations on these pages.

AERIAL AND CREATIVE PHOTOGRAPHY WORKSHOPS, P.O. Box 470455, San Francisco CA 94147. (415)563-3599. Fax: (415)771-5077. Director: Herb Lingl. Offers Polaroid sponsored seminars covering creative uses of Polaroid films and aerial photography workshops in unique locations from helicopters, light planes and balloons.

ALASKA ADVENTURES, P.O. Box 111309, Anchorage AK 99511. (907)345-4597. Contact: Chuck Miknich. Offers photo opportunities of Alaska wildlife and scenery on remote fishing/float trips and remote fish camp.

AMBIENT LIGHT WORKSHOPS, 5585 Commons Lane, Alpharetta GA 30202-6776. Contact: John Mariana. $45-125/day. In-the-field and darkroom. One-day and one-week travel workshops of canyons, Yosemite and the Southwest, 35mm, medium format and 4×5.

‡THE AMERICAN SAFARI, P.O. Box 485, Lisle IL 60532. (630)960-5314. Executive Director: Joe Speno. Cost: varies. Nature study and photography workshops from 1-14 days devoted to natural areas of the Midwest. Beginners are welcomed and encouraged to participate. "Groups study and observe everything from black bears to wildflowers."

AMERICAN SOUTHWEST PHOTOGRAPHY WORKSHOPS, 11C Founders, El Paso TX 79906. (915)757-2800. Director: Geo. B. Drennan. Offers intense field and darkroom workshops for the serious b&w photographer. Technical darkroom workshops limited to 5 days, 2 participants only.

❧AMPRO PHOTO WORKSHOPS, 636 E. Broadway, Vancouver BC V5T 1X6 Canada. (604)876-5501. Fax: (604)876-5502. Website: http://www.ampro-photo.com. Course tuition ranges from under $100 for part-time to $6,700 for full-time. Approved trade school. Offers part-time and full-time career courses in commercial photography and photofinishing. "Eighty-seven different courses in camera, darkroom and studio lighting—from basic to advanced levels. Special seminars with top professional photographers.

 CANADIAN LISTINGS are marked with a maple leaf.

Career courses in photofinishing, camera repair, photojournalism, electronic imaging and commercial photography." New winter, spring, summer and fall week-long field photography shoots.

‡**ARROWMONT SCHOOL OF ARTS AND CRAFTS**, P.O. Box 567, Gatlinburg TN 37738. (423)436-5860. Tuition is $260 per week. Room and board packages start at $185. Offers 1-week summer workshops in various techniques.

‡**ASSIGNMENT PHOTOGRAPHER**, 17171 Bolsa Chica #99, Huntington Beach CA 92649. (714)846-6471. Instructor: Stan Zimmerman. Assignment Photographer-Workshop. The workshop provides the instrluction necessary to taking professional quality photographs, marketing these skills, and earning money in the process.

NOELLA BALLENGER & ASSOCIATES PHOTO WORKSHOPS, P.O. Box 457, La Canada CA 91012. (818)954-0933. Fax: (818)954-0910. Contact: Noella Ballenger. Travel and nature workshop/tours, west coast locations. Individual instruction in small groups emphasizes visual awareness, composition and problem solving in the field. All formats and levels of expertise welcome. Call or write for information.

BIXEMINARS, 919 Clinton Ave. SW, Canton OH 44706-5196. (330)455-0135. Founder/Instructor: R.C. Bixler. Offers 3-day, weekend seminars for beginners through advanced amateurs. Usually held third weekend of February, June and October. Covers composition, lighting, location work and macro.

‡**BLACK CANYON PHOTOGRAPHY WORKSHOPS**, P.O. Box 2005, Lake Havasu City AZ 86405-2005. (520)453-5054. Coordinator: Don Althaus. Cost varies with workshop. Black Canyon Photography Workshops offers five-day and weekend workshops to help photographers develop visual awareness and personal expression.

HOWARD BOND WORKSHOPS, 1095 Harold Circle, Ann Arbor MI 48103. (313)665-6597. Owner: Howard Bond. Offers 1-day workshop: View Camera Techniques; and 2-day workshops: Zone System for All Formats, Refinements in B&W Printing and Unsharp Masking for Better Prints. Also offers b&w field workshop: 3 days at Colorado's Great Sand Dunes.

‡**NANCY BROWN HANDS-ON WORKSHOPS**, 6 W. 20th St., New York NY 10011. (212)924-9105. Fax: (212)633-0911. Contact: Nancy Brown. $1,500 for week, breakfast and lunch included. Offers two 1-week workshops in New York City studio; workshops held 1 week each month in August and September. Also offers one-on-one intensive workshops of shooting for one full day with Nancy Brown and professional models, hair and makeup artist and assistant.

*****BURREN COLLEGE OF ART WORKSHOPS**, Burren College of Art, Newton Castle, Ballyvaughan, County Clare Ireland. (353)65-77200. Fax: (353)65-77201. "These workshops present unique opportunities to capture the qualities of the west of Ireland landscape. The flora, prehistoric tombs, ancient abbeys and castles that abound in the Burren provide an unending wealth of subjects in an ever-changing light." For full brochure and further information contact Anne O'Brien at the above address.

JOHN C. CAMPBELL FOLK SCHOOL, Rt. 1, Box 14-A, Brasstown NC 28902. (704)837-2775 or (800)365-5724. Cost: $132-244 tuition; room and board available for additional fee. The Folk School offers weekend and week-long courses in photography year-round (b&w, color, wildlife and plants, image transfer, darkroom set-up, abstract landscapes). Please call for free catalog.

❧**A CANVAS WITHOUT AN EASEL IS LIKE A CAMERA WITHOUT A TRIPOD**, 10430 Hollybank Dr., Richmond, British Columbia V7E 4S5 Canada. (604)277-6570. Teacher: Dan Propp. Cost: $200/day (group of 5 maximum). "An old-fashioned scenic and postcard photographer will provide a fun day in scenic Vancouver showing you how to 'see' as opposed to simply 'look,' via the good old-fashioned, steady tripod!"

CANYONLANDS FIELD INSTITUTE PHOTO WORKSHOPS, P.O. Box 68, Moab UT 84532. (801)259-7750. Contact: Director of Programs. Program fees: $375-475. Offers programs in landscape photography in Monument Valley (Bluff, UT residential workshops for Elderhostel, age 55 and older).

‡**CAPE COD NATURE PHOTOGRAPHY FIELD SCHOOL**, P.O. Box 236, S. Wellfleet MA 02663. (508)349-2615. Program Coordinator: Melissa Lowe. Cost: $400 per week. Week long field course on Cape Cod focusing on nature photography in a coastal setting. Whale watch, saltmarsh cruise, sunrise,

sunset, stars, wildflowers, shore birds featured. Taught by John Green of Nature Ethics. Sponsored by Massachusetts Audubon Society.

VERONICA CASS ACADEMY OF PHOTOGRAPHIC ARTS, 7506 New Jersey Ave., Hudson FL 34667. (813)863-2738. President: Veronica Cass Weiss. Price per week: $410. Offers 8 one-week workshops in photo retouching techniques.

‡**CENTER FOR PHOTOGRAPHY**, 59 Tinker St., Woodstock NY 12498. (914)679-9957. Contact: Director. Offers monthly exhibitions, a summer and fall workshop series, annual call for entry shows, library, darkroom, fellowships, memberships, and photography magazine, classes, lectures. Has interns in workshops and arts administration.

CLOSE-UP EXPEDITIONS, 858 56th St., Oakland CA 94608. (510)654-1548 or (800)457-9553. Guide and Outfitter: Donald Lyon. Sponsored by the Photographic Society of America. Worldwide, year-round travel and nature photography expeditions, 7-25 days. Professional photography guides put you in the right place at the right time to create unique marketable images.

COASTAL CENTER FOR THE ARTS, 2012 Demere Rd., St. Simons Island GA 31522. Director: Mittie B. Hendrix.

CORY NATURE PHOTOGRAPHY WORKSHOPS, P.O. Box 42, Signal Mountain TN 37377. (423)886-1004 or (800)495-6190. Contact: Tom or Pat Cory. Small workshops/field trips with some formal instruction, but mostly one-on-one instruction tailored to each individual's needs. "We spend the majority of our time in the field. Cost and length vary by workshop. Many of our workshop fees include single occupancy lodging and some also include home-cooked meals and snacks. We offer special prices for two people sharing the same room and, in some cases, special non-participant prices. Workshops include spring and fall workshops in Smoky Mountain National Park and Chattanooga, Tennessee. Other workshops vary from year to year but include locations such as the High Sierra of California, Olympic National Park, Arches National Park, Acadia National Park, the Upper Peninsula of Michigan, Mt. Rainier National Park, Bryce Canyon/Zion National Park and Glacier National Park." Write or call for a brochure or more information.

CREATIVE ARTS WORKSHOP, 80 Audubon St., New Haven CT 06511. (203)562-4927. Photography Department Head: Harold Shapiro. Offers advanced workshops and exciting courses for beginning and serious photographers.

‡**DAUPHIN ISLAND ART CENTER**, 1406 Cadillac Ave., P.O. Box 699, Dauphin Island AL 36528. (800)861-5701. Director: Nick Colquitt. Offers workshops, seminars and safaris to amateur and professional photographers. The Center serves as a wholesaler of its student's work. Items sold include greeting cards, framed prints and wall decor. Free photography course catalog upon request.

FINDING & KEEPING CLIENTS, 3603 Aspen Village Way Apt. E, Santa Ana CA 92704-7570. Phone/fax: (714)556-8133. Website: http://e-folio.com/piscopo. Instructor: Maria Piscopo. "How to find commercial photo assignment clients and get paid what you're worth! Call for schedule and leave address or fax number."

FORT SCOTT COMMUNITY COLLEGE PHOTO WORKSHOP & TOURS, 2108 S. Horton, Fort Scott KS 66701. (800)874-3722. Photography Instructor: John W. Beal. Cost: $80-180 workshops. Weekend nature photo workshop in spring. Other workshops cover portrait, unframed photography, Zone System, color printing, b&w fine printing, etc.

FRIENDS OF ARIZONA HIGHWAYS PHOTO WORKSHOPS, P.O. Box 6106, Phoenix AZ 85005-6106. (602)271-5904. Offers photo adventures to Arizona's spectacular locations with top professional photographers whose work routinely appears in *Arizona Highways*.

FRIENDS OF PHOTOGRAPHY, 250 Fourth St., San Francisco CA 94103. (415)495-7000. Curator of Education: Julia Brashares. "One- and two-day seminars are conducted by a faculty of well-known photographers and provide artistic stimulation and technical skills in a relaxed, focused environment."

GETTING & HAVING A SUCCESSFUL EXHIBITION, 163 Amsterdam Ave., # 201, New York NY 10023. (212)838-8640. Speaker: Bob Persky. Cost: 1997/1998 tuition, $75 for 1-day seminar; course manual $27.95 postpaid.

THE GLACIER INSTITUTE PHOTOGRAPHY WORKSHOPS, P.O. Box 7457. Kalispell MT 59904. (406)755-1211. General Manager: Kris Bruninga. Cost: $130-175. Workshops sponsored in the following areas: nature photography, advanced photography, wildlife photography and photographic ethics. "All courses take place in beautiful Glacier National Park."

‡**GLAMOUR WORKSHOPS**, P.O. Box 485, Lisle IL 60532. (630)960-5314. Contact: Workshop Registrar. Cost: from $95. These are intensive glamour photo workshops and shoots in many various cities and locations. Beginners are welcomed. Length varies from half day to full weekends.

GLOBAL PRESERVATION PROJECTS, P.O. Box 30866, Santa Barbara CA 93130. (805)682-3398. Fax: (805)563-1234. Director: Thomas I. Morse. Offers workshops promoting the preservation of environmental and historic treasures. Produces international photographic exhibitions and publications.

‡**GOLDEN GATE SCHOOL OF PROFESSIONAL PHOTOGRAPHY**, 1251 Fifth Ave., Redwood City CA 94063-4019. (415)367-1265. Contact: Fred English. Offers short courses in photography annually.

GREAT PLAINS PHOTOGRAPHIC WORKSHOPS, (formerly Great Plains Photography Workshops), P.O. Box 705, Tucumcari NM 88401-0705. (505)461-6183. Fax: (505)461-6181. E-mail: grplphoto @aol.com. President: William Johnson. Cost: $125-250/workshop. Photographic workshops covering all types of outdoor subjects and techniques. 3 different locations every year in the Great Plains States: Kansas, Colorado, Montana, Nebraska, New Mexico, North and South Dakota, Oklahoma, Texas and Wyoming.

HALLMARK INSTITUTE OF PHOTOGRAPHY, P.O. Box 308, Turners Falls MA 01376. (413)863-2478. President: George J. Rosa III. Director of Admissions: Tammy Murphy. Tuition: $13,950. Offers an intensive 10-month resident program teaching the technical, artistic and business aspects of professional photography for the career-minded individual.

HEART OF NATURE PHOTOGRAPHY WORKSHOPS, 14618 Tyler Foote Rd., Nevada City CA 95959. (916)478-7778. Contact: Robert Frutos. Cost: $265/weekend workshop. Combines inspiration, proven techniques, creative activities, and in-depth instruction to provide participants with a full and well-rounded nature photo experience.

‡**HOLOGRAPHY WORKSHOPS, CENTER FOR PHOTONICS STUDIES**, Lake Forest College, 555 N. Sheridan Rd., Lake Forest IL 60045-2399. (708)735-5160, ext. 5163. Professor: Tung H. Jeong. Costs in 1997 ranged from $300 for tutorials to $900 for a Holography Workshop. The annual 5-day hands-on laboratory Holography Workshop I, designed for beginners on the techniques of producing many different kinds of holograms, is followed by a week of full-day Tutorials on Advanced Holography, traditionally held in July.

HORIZONS: THE NEW ENGLAND CRAFT PROGRAM, 108 N. Main St.-L, Sunderland MA 01375. (413)665-0300. Fax: (413)665-4141. Director: Jane Sinauer. Cross Cultural Art and Travel Programs: week-long workshops in Italy, The American Southwest, France and Mexico. Horizons intensives in Massachusetts: long weekend workshops (spring, summer, fall) and 2 3-Week Wummer Sessions for High School Students in b&w (July, August). Write for complete information and dates.

IN FOCUS WITH MICHELE BURGESS, 20741 Catamaran Lane, Huntington Beach CA 92646. (714)536-6104. Fax: (714)536-6578. President: Michele Burgess. Tour prices range from $4,000 to $6,000 from US. Offers overseas tours to photogenic areas with expert photography consultation, at a leisurely pace and in small groups (maximum group size 20).

INTERNATIONAL PHOTO TOURS (VOYAGERS INTERNATIONAL), P.O. Box 915, Ithaca NY 14851. (607)257-3091. Managing Director: David Blanton. Emphasizes techniques of nature photography.

IRISH PHOTOGRAPHIC & CULTURAL EXCURSIONS, Voyagers, P.O. Box 915, Ithaca NY 14851. (607)273-4321. Offers 12-day trips in County Mayo in the west of Ireland from May-October.

‡ **WORKSHOPS NEW TO THIS EDITION** are marked with a double dagger.

LIGHT FACTORY, (formerly The Light Factory Photographic Arts Center), P.O. Box 32815, Charlotte NC 28232. (704)333-9755. Executive Director: Bruce Lineker. Since 1972. The Light Factory is an art museum presenting the latest in light-generated media (photography, video, the Internet). Year-round education programs, community outreach and special events complement its changing exhibitions.

C.C. LOCKWOOD WILDLIFE PHOTOGRAPHY WORKSHOP, 8939 Jefferson Hwy., #2C, Baton Rouge LA 70809. (504)926-2100. Fax: (504)926-2180. Photographer: C.C. Lockwood. Cost: Atchafalaya Swamp, $95; Yellowstone, $1,500; Grand Canyon $1,695. Each October and April C.C. conducts a 2-day Atchafalaya Basin Swamp Wildlife Workshop. It includes lecture, canoe trip into swamp, critique session. Every other year C.C. does a 7-day winter wildlife workshop in Yellowstone National Park. C.C. leads an 8-day Grand Canyon raft trip photo workshop. May 8 and July 31.

JOE McDONALD'S WILDLIFE PHOTOGRAPHY WORKSHOPS AND TOURS, 73 Loht Rd., McClure PA 17841-9340. (717)543-6423. Owner: Joe McDonald. Offers small groups, quality instruction with emphasis on wildlife. Workshops and tours range from $400-2,000.

■THE MacDOWELL COLONY, 100 High St., Peterborough NH 03458. (603)924-3886. Website: http://www.macdowellcolony.org. Founded in 1907 to provide creative artists with uninterrupted time and seclusion to work and enjoy the experience of living in a community of gifted artists. Residencies of up to 2 months for writers, composers, film/video makers, visual artists, architects and interdisciplinary artists. Artists in residence receive room, board and exclusive use of a studio. Average length of residency is 6 weeks. Ability to pay for residency is not a factor. Application deadlines: January 15: summer (May-August); April 15: fall/winter (September-December); September 15: winter/spring (January-April). Please write or call for application and guidelines.

McNUTT FARM II/OUTDOOR WORKSHOP, 6120 Cutler Lake Rd., Blue Rock OH 43720. (614)674-4555. Director: Patty L. McNutt. 1994 Fees: $140/day/person, lodging included. Minimum of 2 days. Outdoor shooting of livestock, pets, wildlife and scenes in all types of weather.

■THE MAINE PHOTOGRAPHIC WORKSHOPS, 2 Central St., Box 200, Rockport ME 04856. (207)236-8581. Fax: (207)236-2558. Website: http://www.MEWorkshops.com. Director: David H. Lyman. More than 100 summer workshops for photographers, digital artists and designers. One-week courses for working pros, serious amateurs, artists and students. 60 Master Classes with renown faculty including Mary Ellen Mark, Arnold Newman, Eugene Richards and photographers from *National Geographic*, Magnum and Europe. Workshops in all areas of photography. Destination workshops in Tuscany and Venice, Italy; Provence, France; Oaxaxa, Mexico and the island of Martha's Vineyard. Tuition begins at $550. Lab fees $85. Room and meals $375-650/week. Also, professional fall and winter Resident Programs. New Associate of Art Degree and Master of Fine Art Degree available. Request current catalog by phone, fax or Internet.

MENDOCINO COAST PHOTOGRAPHY SEMINARS, P.O. Box 1629, Mendocino CA 95460. (707)937-2805. Program Director: Hannes Krebs. Offers a variety of workshops, including a foreign expedition to Chile.

MEXICO PHOTOGRAPHY WORKSHOPS, Otter Creek Photography, Hendricks WV 26271. (304)478-3586. Instructor: John Warner. Cost: $1,300. Intensive week-long, hands-on workshops held throughout the year in the most visually rich regions of Mexico. Photograph snow-capped volcanos, thundering waterfalls, pre-Columbian ruins, botanical gardens, fascinating people, markets and colonial churches in jungle, mountain, desert and alpine environments.

MIDWEST PHOTOGRAPHIC WORKSHOPS, 28830 W. Eight Mile Rd., Farmington Hills MI 48336. (248)471-7299. Fax: (248)542-3441. Directors/Instructors: Alan Lowy, C.J. Elfont and Bryce Denison. Workshops, seminars and lectures taught on landscape photography and including the Classical Nude Figure in the Environment (Ludington, Michigan sand dunes); also a week-long workshop in Grand Junction, Colorado and Moab, Utah. "We also teach the nude figure with studio lighting techniques, as well as workshops on boudoir and fashion photography." Other workshops include nature, still life and product photography, wedding and portraiture, as well as week-long workshops in the Smoky Mountains and weekend workshops in Tobermory, Canada on nature and macro photography.

MISSISSIPPI VALLEY WRITERS CONFERENCE, 3403 45th St., Moline IL 61265. Director: David R. Collins. Registration $25, plus individual workshop expenses. Open to the basic beginner or polished

professional, the MVWC provides a week-long series of workshops in June, including 5 daily sessions in photography.

MONO LAKE PHOTOGRAPHY WORKSHOPS, P.O. Box 29, Lee Vining CA 93541. (760)647-6595. Website: http://www.monolake.org. Contact: Education Director. Cost: $100-250. "The Mono Lake Committee offers a variety of photography workshops in the surreal and majestic Mono Basin." 2- to 3-day workshops take place from June to October. Call or write for free brochure.

NATURE IMAGES, INC., P.O. Box 2037, West Palm Beach FL 33402. (407)586-7332. Director: Helen Longest-Slaughter. Photo workshops offered in Yellowstone National Park, North Carolina Outer Banks, Costa Rica and Everglades National Park and New England. 1-day seminars in various cities in the US covering how-to and marketing.

NATURE PHOTOGRAPHY EXPEDITIONS, 418 Knottingham Dr., Twin Falls ID 83301. (800)574-2839. Contact: Douglas C. Bobb. Cost: $1,200/person, includes room, meals and transportation during the tour; requires a $300 deposit. Offers week-long trips in Yellowstone and the Tetons from June to October.

‡NATURE PHOTOGRAPHY WORKSHOPS, (formerly Great Smoky Mountains Photography Workshops), 108 Enchanted Lane, Franklin NC 28734. (704)369-6044. Instructor: Bill Lea. Offers programs which emphasize the use of natural light in creating quality scenic, wildflower and wildlife images.

NEVER SINK PHOTO WORKSHOP, P.O. Box 641, Woodbourne NY 12788. (212)929-0008; (914)434-0575. Fax: (212)929-2689. Owner: Louis Jawitz. Offers weekend workshops in scenic, travel, location and stock photography from late July through early September in Catskill Mountains.

NEW ENGLAND SCHOOL OF PHOTOGRAPHY, 537 Commonwealth Ave., Boston MA 02215. (617)437-1868. Academic Director: Martha Hassell. Instruction in professional and creative photography.

NEW VISIONS SEMINAR, (formerly Iowa Seminars), 10 E. 13th St., Atlantic IA 50022. Director: Jane Murray. Offers workshops in developing personal vision for beginning and intermediate photographers.

NEW YORK CITY COLOR PRINTING WORKSHOPS, 230 W. 107th St., New York NY 10025. (212)316-1825. Joyce Culver, professional photographer and color printer, offers 1-day, 6-hour Saturday workshops in color printing. Attendees make 8×10 and larger prints from color negatives or internegatives in a professional New York City lab. Cost: $250. Classes of 4-5. Call or write for registration form and description.

NORTHEAST PHOTO ADVENTURE SERIES WORKSHOPS, 55 Bobwhite Dr., Glemont NY 12077. (518)432-9913. President: Peter Finger. Price ranges from $99 for a weekend to $600 for a week-long workshop. Offers over 20 weekend and week-long photo workshops, held in various locations. Recent locations have included: Cape Cod, Maine, Acadia National Park, Vermont, The Adirondacks, The Catskills, Block Island, Martha's Vineyard, Nantucket, Prince Edward Island, Nova Scotia and New Hampshire. "Small group instruction from dawn till dusk." Write for additional information.

OHIO INSTITUTE OF PHOTOGRAPHY AND TECHNOLOGY, 2029 Edgefield Rd., Dayton OH 45439. (513)294-6155. Director of Education: Helen Morris. Convenient, affordable, intense workshops. Summer weekend workshops in still photography offer a variety of topics including nature, fashion/glamour, photographing people, color printing, darkroom effects, Adobe Photoshop and more. Cost $195.

‡OSPREY PHOTO WORKSHOPS & TOURS, 2719 Berwick Ave., Baltimore MD 21234-7616. (410)426-5071. Workshop Operator: Irene Hinke-Sacilotto. Cost: varies with program. Programs for '97/'98 include: The Falkland Islands; South Texas/Rio Grande; Mexico; Brigantine NJ; Alaska by Boat; North West Territory/Caribou; and Canaan Valley WV. Classes are small with personal attention and practiccal tips.

OZARK PHOTOGRAPHY WORKSHOP FIELDTRIP, 40 Kyle St., Batesville AR 72501. (501)793-4552. Conductor: Barney Sellers. Retired photojournalist after 36 years with *The Commercial Appeal*, Memphis. Cost for 2-day trip: $100. Participants furnish own food, lodging, transportation and carpool. Limited to 12 people. No slides shown. Fast moving to improve alertness to light and outdoor subjects. Sellers also shoots.

❖**FREEMAN PATTERSON/ANDRÉ GALLANT PHOTO WORKSHOPS**, (formerly Freeman Patterson/Doris Mowry Photo Workshops), Rural Route 2, Clifton Royal, New Brunswick E0G 1N0 Canada. (506)763-2189. Cost: $650 (Canadian) for 6-day course plus accommodations and meals. All workshops are for anybody interested in photography and visual design from the complete novice to the experienced amateur or professional. "Our experience has consistently been that a mixed group functions best and learns the most."

PHOTO ADVENTURE TOURS, 2035 Park St., Atlantic Beach NY 11509-1236. (516)371-0067. Fax: (516)371-1352. Manager: Richard Libbey. Offers photographic tours to Iceland, India, Nepal, China, Scandinavia and domestic locations such as New Mexico, Navajo Indian regions, Hawaiian Islands, Albuquerque Balloon Festival and New York.

PHOTO ADVENTURES, P.O. Box 591291, San Francisco CA 94159. (415)221-3171. Instructor: Jo-Ann Ordano. Offers practical workshops covering creative and documentary photo technique in California nature subjects and San Francisco by moonlight.

PHOTO EXPLORER TOURS/CHINA PHOTO WORKSHOP TOURS, 2506 Country Village, Ann Arbor MI 48103-6500. (800)315-4462 and (313)996-1440. Director: Dennis Cox. Specialist since 1981 in annual photo tours to China's most scenic areas and major cities with guidance to special photo opportunities by top Chinese photographers. Program now includes tours to various other countries, for example Turkey, India and Peru with emphasis on travel photography and photojournalism.

PHOTO FOCUS/COUPEVILLE ARTS CENTER, P.O. Box 171 MP, Coupeville WA 98239. (360)678-3396. Director: Judy Lynn. Cost: $235-330. Locations: Whidbey Island, Olympic Peninsula, Mt. Rainier, North Cascades in Washington, Canadian Rockies and Alaska. Held April through September. Workshops in b&w, photojournalism, stock photography, portraiture, human figure, nature photography and more with outstanding faculty.

‡**PHOTO METRO MAGAZINE AND DIGITAL WORKSHOPS**, 17 Tehama St., San Francisco CA 94105-3109. (415)243-9917. E-mail: jo@idiom.com. Website: http//www.photometro.com. Publisher: Jo Leggett. Photo magazine published 6 times yearly. Now available in bookstores and on newsstands throughout the US. Subscription $20. Computer workshops for Adobe Photoshop, QuarkXPress, Illustrator, Director, etc. Call for dates, prices. Yearly contest in fall; SASE after July for information.

PHOTOCENTRAL, (formerly PhotoCentral/Infrared Workshop), 1099 E St., Hayward CA 94541. (510)881-6721. Fax: (510)881-6763. E-mail: photcentrl@aol.com. Coordinators: Geir and Kate Jordahl. Cost: $60-200/workshop. PhotoCentral offers workshops and classes for all levels of photographers with an emphasis on small group learning, development of vision and a balance of the technical and artistic approaches to photography. Special workshops include panoramic photography, infrared photography and handcoloring. Workshops run 1-4 days and are offered year round.

‡**PHOTOGRAPHIC ARTS WORKSHOPS**, P.O. Box 1791, Granite Falls WA 98252. (206)691-4105. Director: Bruce Barnbaum. Offers wide range of workshops across US, Mexico and Canada. Workshops feature instruction in composition, exposure, development, printing, photographic goals and philosophy. Includes critiques of student portfolios. Sessions are intense, held in field, darkroom and classroom with various instructors. Ratio of students to instructor is always 8:1 or fewer, with detailed attention to the problems the student wants to solve.

PHOTOGRAPHY AT THE SUMMIT: JACKSON HOLE, Denver Place Plaza Tower, 1099 18th St., Suite 1840, Denver CO 80202. (303)295-7770 or (800)745-3211. Administrator: Rich Clarkson. A week-long workshop and weekend conferences with top journalistic, fine art and illustrative photographers and editors.

*****PHOTOGRAPHY COURSES**, Dillington House, Ilminster Somerset TA19 9DT England. (0460)55866. Booking Secretary: Helen Howe. Weekend and week-long practical photography courses in the sixteenth century setting of Dillington House.

 INTERNATIONAL WORKSHOPS, those held outside of the United States and Canada, are marked with an asterisk.

PHOTOGRAPHY INSTITUTES, % Pocono Environmental Education Center, RR2, Box 1010, Dingmans Ferry PA 18328. (717)828-2319. Attention: Tom Shimalla. Offers weekend and week-long institutes throughout the year focusing on subjects in the natural world.

PT. REYES FIELD SEMINARS, Pt. Reyes National Seashore, Pt. Reyes CA 94956. (415)663-1200. Director: Julie Milas. Fees range from $50-350. Offers 1-5 day photography seminars taught by recognized professionals.

PORT TOWNSEND PHOTOGRAPHY IMMERSION WORKSHOP, 1005 Lawrence, Port Townsend WA 98368. (604)469-1651. Instructor: Ron Long. Cost: $470. Six-day workshops include lectures, critiques, overnight processing, individual instruction, field trips and lots of shooting. All levels welcome.

PROFESSIONAL PHOTOGRAPHER'S SOCIETY OF NEW YORK PHOTO WORKSHOPS, 121 Genesee St., Avon NY 14414. (716)226-8351. Director: Lois Miller. Cost is $475. Offers week-long, specialized, hands-on workshops for professional photographers.

PUBLISHING YOUR PHOTOS AS CARDS, POSTERS, & CALENDARS, #201, 163 Amsterdam Ave., New York NY 10023. (212)362-6637. Lecturer: Harold Davis. 1997/1998 cost: $150 including course manual. Course manual alone $22.95, postpaid. A one-day workshop.

‡BRANSON REYNOLDS' PHOTOGRAPHIC WORKSHOPS, P.O. Box 3471, Durango CO 81302. (970)247-5274. Fax: (970)247-1441. Website: http://www.simwell.com/reynolds. Owner: Branson Reynolds. Cost: varies with workshop. Offers a variety of workshops including, Southwestern landscapes, Native Americans, and "Figure-in-the-Landscape." Workshops are based out of Durango, Colorado, and are taught by nationally published photographer Branson Reynolds.

‡ROCHESTER INSTITUTE OF TECHNOLOGY ADOBE PHOTOSHOP IMAGE RESTORATION AND RETOUCHING, 66 Lomb Memorial Dr., Rochester NY 14623. (800)724-2536. Cost: $895. This learn-by-doing workshop demystifies the process for digitally restoring and retouching images in Photoshop. This intensive 3-day hands-on workshop is designed for imaging professionasl who have a solid working knowledge of Photoshop and want to improve their digital imaging skills for image restoration and retouching.

ROCHESTER INSTITUTE OF TECHNOLOGY DIGITAL PHOTOGRAPHY, 66 Lomb Memorial Dr., Rochester NY 14623. (800)724-2536. Cost: $975. A three-day, hands-on exploration of this new technology. Through lectures, practice, evaluation and discussion, learn hot to use digital photography in your own work. Create and produce images in the "electronic darkroom."

‡ROCKY MOUNTAIN PHOTO WORKSHOPS, % Latigo Ranch, Box 237, Kremmling CO 80459. (800)227-9655. (303)724-9008. Director: Jim Yost. Cost (1994): $1,465 (wildflower workshop), $1,465 (round-up workshop); price includes meals, lodging, taxes, gratuities and instructions. Offers workshops in photography featuring western cattle round-ups and wildflowers.

ROCKY MOUNTAIN SCHOOL OF PHOTOGRAPHY, 210 N. Higgins, Suite 101, Missoula MT 59802. (406)543-0171 or (800)394-7677. "RMSP offers professional career training in an 11-week 'Summer Intensive' program held each year in Missoula, Montana. Program courses include: basic and advanced color and b&w, studio and natural lighting, portraiture, marketing, stock, intro to digital, portfolio and others. We also offer over 20 workshops year-round with Galen Rowell, Bruce Barnbaum, John Shaw, Alison Shaw, David Middleton and others. Locations all across U.S. and abroad—including New Zealand."

ROCKY MOUNTAIN SEMINARS, Rocky Mountain National Park, Estes Park CO 80517. (970)586-1258. Seminar Coordinator: Kris Marske. Cost: $45-175, day-long to 6-day seminars. Workshops covering photographic techniques of wildlife and scenics in Rocky Mountain National Park. Professional instructors include David Halpern, Perry Conway, Wendy Shattil, Bob Rozinski, Andrew Beckham, Joe Berke and James Frank.

RON SANFORD, P.O. Box 248, Gridley CA 95948. (916)846-4687. Contact: Ron or Nancy Sanford. Travel and wildlife workshops and tours.

PETER SCHREYER PHOTOGRAPHIC TOURS, P.O. Box 533, Winter Park FL 32790. (407)671-1886. Tour Director: Peter Schreyer. Specialty photographic tours to the American West, Europe and the backroads of Florida. Travel in small groups of 10-15 participants.

THE SEATTLE WORKSHOP, P.O. Box 481, Ivy VA 22936. (206)322-6886 or (804)987-1923. Contact: Glenn Showalter. Cost: $200-500, depending on curriculum and length of program. Course projects include downtown Seattle markets and piers, cruises to the San Juan Islands, aerial photography, field visits to winerys, the Washington seacoast and various areas in the Cascade Mountains. All camera formats, primarily 35mm. "Emphasis is on the art of seeing, composition, visual communication and camera work for the productive scientist and businessman as well as the artist. Glenn Showalter has degrees in photography and education and has worked at Gannett Rochester Newspapers, UPI, AP and DuPont Corporation." Send for information. "Would like to see a 3×5 postcard with a photograph you have produced."

"SELL & RESELL YOUR PHOTOS" SEMINAR, by Rohn Engh, Pine Lake Farm, Osceola WI 54020. (715)248-3800. Fax: (715)248-7394. E-mail: psil@ix.netcom.com. Seminar Coordinator: Sue Bailey. Offers half-day workshops in major cities. 1997 cities included: Philadelphia, Washington DC, Detroit, Minneapolis, San Francisco, Atlanta, Charlotte, Orlando, St. Louis, Las Vegas, Denver and Houston. Workshops cover principles based on methods outlined in author's best-selling book of the same name. Marketing critique of attendee's slides follows seminar. Phone for free 1998 schedule.

JOHN SEXTON PHOTOGRAPHY WORKSHOPS, 291 Los Agrinemsors, Carmel Valley CA 93924. (408)659-3130. Director: John Sexton. Offers a selection of intensive workshops with master photographers in scenic locations throughout the US and abroad. All workshops offer a combination of instruction in the aesthetic and technical considerations involved in making expressive prints.

SIERRA PHOTOGRAPHIC WORKSHOPS, 3251 Lassen Way, Sacramento CA 95821. (800)925-2596. In Canada, phone: (916)974-7200. Contact: Sierra Photographic Workshops. Offers week-long workshops in various scenic locations for "personalized instruction in outdoor photography, technical knowledge useful in learning to develop a personal style, learning to convey ideas through photographs."

BOB SISSON'S MACRO/NATURE PHOTOGRAPHY, P.O. Box 1649, Englewood FL 34295. (941)475-0757. Contact: Bob Sisson (Former Chief Natural Sciences Division, *National Geographic Magazine*.) Cost: $200/day. Special one-on-one course; "you will be encouraged to take a closer look at nature through the lens, to learn the techniques of using nature's light correctly and to think before exposing film."

‡SITKA CENTER FOR ART AND ECOLOGY, P.O. Box 65, Otis OR 97368. (503)994-5485. Contact: Executive Director. Offers 1- to 5-day workshops during summer months. Write for photography workshop information.

SNAKE RIVER INSTITUTE PHOTO WORKSHOPS, P.O. Box 128, Wilson WY 83014. (307)733-2214. Program Coordinator: Dana McDaniel. Offers nature and landscape photography workshops.

SOUTHAMPTON MASTER PHOTOGRAPHY WORKSHOP, % Long Island University-Southampton College, Southampton NY 11968-9822. (516)287-8349. E-mail: info@southampton.liunet.edu. Contact: Carla Caglioti, Summer Director. Offers a diverse series of 1-week and weekend photo workshops during July and August.

SOUTHEAST MUSEUM OF PHOTOGRAPHY AT DAYTONA BEACH COMMUNITY COLLEGE, (formerly Portraiture with Wah Lui), 1200 W. International Speedway Blvd., Daytona Beach FL 32118. (904)254-4475. Fax: (904)254-4487. Website: http://www.dbcc.cc.fl.us/dbcc/smp/welcome.htm. Director/Senior Curator: Allison Devine Nordström. Photographic exhibitions, workshops and lecture series.

SPECIAL EFFECTS BACKGROUNDS, P.O. Box 1745, San Marcos TX 78667. (512)353-3111. Director of Photography: Jim Wilson. Offers 3-day programs in background projection techniques. Open to all levels of photographic education; participants are limited to 12/workshop.

STONE CELLAR DARKROOM WORKSHOPS, 51 Hickory Flat Rd., Buckhannon WV 26201. (304)472-1111. Photographer/Printmaker: Jim Stansbury. Master color printing and color field work. Small classes with Jim Stansbury. Work at entry level or experienced level.

SUPERIOR/GUNFLINT PHOTOGRAPHY WORKSHOPS, P.O. Box 19286, Minneapolis MN 55419. Director: Layne Kennedy. Prices range from $585-785. Write for details on session dates. Fee includes all meals/lodging and workshop. Offers wilderness adventure photo workshops twice yearly.

Winter session includes driving your own dogsled team in northeastern Minnesota. Summer session includes kayak trips into border waters of Canada-Minnesota and Apostle Islands in Lake Superior. All trips professionally guided. Workshop stresses how to shoot effective and marketable magazine photos.

SYNERGISTIC VISIONS WORKSHOPS, P.O. Box 2585, Grand Junction CO 81502. Phone/fax: (970)245-6700. E-mail: synvis@gj.net. Website: http://www.apogeephoto.com/synvis.html. Director: Steve Traudt, ASMP. Costs vary. Offers a variety of classes, workshops and photo trips including Galapagos, Costa Rica, Slot Canyons, Colorado Wildflowers and more. All skill levels welcome. Author of *Heliotrope-The Book* and creator of *Hyperfocal Card*, "Traudt's trademark is enthusiasm and his classes promise a true synergy of art, craft and self." Call or write for brochures.

TAOS INSTITUTE OF ARTS, 5280NDCBU, Taos NM 87571-6155. (505)758-2793. Director: Judith Krull. Cost: $350. Workshops: In you quest for the image, explore northern New Mexico.

TEN MANAGEMENT NUDE FIGURE PHOTOGRAPHY WORKSHOPS, 5666 La Jolla Blvd., Suite 111, La Jolla CA 92037. (619)459-7502. Director: Bob Stickel. Cost: $100-185/day. Ten Management offers a range of studio and location (mountain, beach, desert, etc.) workshops on the subject of photographing the male nude figure.

TOUCH OF SUCCESS PHOTO SEMINARS, P.O. Box 194, Lowell FL 32663. (352)867-0463. Director: Bill Thomas. Costs vary from $250-895 (US) to $5,000 for safaris. Offers workshops on nature scenics, plants, wildlife, stalking, building rapport and communication, composition, subject selection, lighting, marketing and business management. Workshops held at various locations in US. Photo safaris led into upper Amazon, Andes, Arctic, Alaska, Africa and Australia. Writer's workshops for photographers who wish to learn to write.

UNIVERSITY OF WISCONSIN SCHOOL OF THE ARTS AT RHINELANDER, 726 Lowell Hall, 610 Langdon St., Madison WI 53703. (608)263-3494. Coordinator: Kathy Berigan. One-week interdisciplinary arts program held during July in northern Wisconsin.

JOSEPH VAN OS PHOTO SAFARIS, INC., P.O. Box 655, Vashon Island WA 98070. (206)463-5383. Fax: (206)463-5484. Director: Joseph Van Os. Offers over 50 different photo tours and workshops worldwide.

VENTURE WEST, P.O. Box 7543, Missoula MT 59807. (406)825-6200. Owner: Cathy Ream. Offers various photographic opportunities, including wilderness pack and raft trips, ranches, housekeeping cabins, fishing and hunting.

MARK WARNER NATURE PHOTO WORKSHOPS, P.O. Box 142, Ledyard CT 06339. (860)376-6115. Offers 1-day workshops on nature and wildlife photography by nationally published photographer and writer at various northeast locations.

WILD HORIZONS, INC., P.O. Box 5118-PM, Tucson AZ 85703. (520)743-4551. Fax: (520)743-4552. President: Thomas A. Wiewandt. Average all-inclusive costs: domestic travel $1,400/week; foreign travel $2,000/week. Offers workshops in field techniques in nature/travel photography at vacation destinations in the American West selected for their outstanding natural beauty and wealth of photographic opportunities. Customized learning vacations for small groups are also offered abroad.

WILDERNESS ALASKA, Box 113063, Anchorage AK 99511. (907)345-3567. Fax: (907)345-3967. E-mail: macgill@alaska.net. Website: http://www.gorp.com/wildak. Contact: MacGill Adams. Offers custom photography trips featuring natural history and wildlife to small groups.

WILDERNESS PHOTOGRAPHY EXPEDITIONS, 402 S. Fifth, Livingston MT 59047. (406)222-2302. President: Tom Murphy. Offers programs in wildlife and landscape photography in Yellowstone Park and special destinations.

WOMEN'S PHOTOGRAPHY WORKSHOP, P.O. Box 3998, Hayward CA 94540. (510)278-7705. E-mail: kpjordahl@aol.com. Coordinator: Kate Jordahl. Cost: $160/intensive 2-day workshop. Workshops dedicated to seeing more through photography and inspiring women toward growth in their image making and lives through community and interchange. Specializing in women's concerns in photography.

‡**WOMEN'S STUDIO WORKSHOP**, P.O. Box 489, Rosendale NY 12472. (914)658-9133. Program Director: Laura Moriarty. WSW offers weekend and week-long classes in our comprehensive fully-equipped studios throughout the summer. Photographers may also spend 2-4 weeks here November-May as part of our fellowship program. SASE for specific information.

‡**WOODSTOCK PHOTOGRAPHY WORKSHOPS**, 59 Tinker St., Woodstock NY 12498. (914)679-9957. Fax: (914)679-6337. Offers annual lectures and workshops in creative photography from June through October. Faculty includes numerous top professionals in fine art and commercial photography. Interviews workshop interns each April. Topics include still life, landscape, portraiture, lighting, alternative processes. Offers 1-, 2- and 3-day events as well as travel workshops in the US and overseas.

WORKSHOPS IN THE WEST, P.O. Box 1261, Manchaca TX 78652. (512)295-3348. Contact: Joe Englander. Costs: $275-3,650. Photographic instruction in beautiful locations throughout the world, all formats, color and b&w, darkroom instruction.

YELLOWSTONE INSTITUTE, P.O. Box 117, Yellowstone National Park WY 82190. (307)344-2294. Registrar: Pam Gontz. Offers workshops in nature and wildlife photography during the summer, fall and winter. Custom courses can be arranged.

YOUR WORLD IN COLOR, % Stone Cellar Darkroom, P.O. Box 253, Buckhannon WV 26201. (304)472-1111. Director: Jim Stansbury. Offers workshops in color processing, printing and related techniques. Also arranges scenic field trips. Work at entry or advanced level, one-on-one with a skilled printmaker. "Reasonable fees, write for info on variety of workshops."

Schools

Whether you are a long-time professional or a newcomer to photography, continuing education is very important to your success. Earlier in this book we listed dozens of workshops. This section lists schools that specialize in photography. Because of space constraints we chose not to include the numerous colleges and universities throughout the world that offer academic degrees in photography. For information about university degrees in photography, check your local library for the most recent edition of *Peterson's Guide to Four-Year Colleges*.

ANTONELLI COLLEGE OF ART AND PHOTOGRAPHY, 124 E. Seventh St., Cincinnati OH 45202. (513)241-4338.

ANTONELLI INSTITUTE, 300 Montgomery Ave., Erdanheim PA 19038. (610)275-3040.

BROOKS INSTITUTE OF PHOTOGRAPHY, 801 Alston Rd., Santa Barbara CA 93108. (805)966-3888.

CENTER FOR IMAGING ARTS & TECHNOLOGY, 4001 de Maisonneuve Blvd. W., Suite 2G2, Montreal, Quebec H3Z 3G4 Canada. (514)933-0047.

CREATIVE CIRCUS, 1935 Cliff Valley Way, Suite 210, Atlanta GA 30329. (800)704-4150 or (404)633-1990.

HALLMARK INSTITUTE OF PHOTOGRAPHY, P.O. Box 308, Turners Falls MA 01376. (413)863-2478.

INTERNATIONAL CENTER OF PHOTOGRAPHY, Education Dept., 1130 Fifth Ave. at 94th Street, New York NY 10128. (212)860-1776.

THE MAINE PHOTOGRAPHIC WORKSHOPS, 2 Central St., Rockport ME 04856. (207)236-8581.

NEW ENGLAND SCHOOL OF PHOTOGRAPHY (NESOP), 537 Commonwealth Ave., Kenmore Square, Boston MA 02215. (617)437-1868.

OHIO INSTITUTE OF PHOTOGRAPHY AND TECHNOLOGY (OIPT), 2029 Edgfield Rd., Dayton OH 45439. (513)294-6155.

PORTFOLIO CENTER, Admissions Department, 125 Bennett St., Atlanta GA 30309. (800)255-3169 or (404)351-5055.

ROCHESTER INSTITUTE OF TECHNOLOGY, Bausch & Lomb Center, 60 Lomb Memorial Dr., Rochester NY 14623-5604. Admissions Office: (716)475-6631.

THE WESTERN ACADEMY OF PHOTOGRAPHY, 755A Queens Ave., Victoria, British Columbia V8T 1M2 Canada. (250)383-1522. Fax: (250)383-1534.

WINONA INTERNATIONAL SCHOOL OF PROFESSIONAL PHOTOGRAPHY, 57 Forsyth St. NW, Suite 1500, Atlanta GA 30303. (404)522-3030.

Professional Organizations

The organizations in the following list can be valuable to photographers who are seeking to broaden their knowledge and contacts within the photo industry. Typically, such organizations have regional or local chapters and offer regular activities and/or publications for their members. To learn more about a particular organization and what it can offer you, call or write for more information.

ADVERTISING PHOTOGRAPHERS OF NEW YORK (APNY), 27 W. 20th St., Room 601, New York NY 10011. (212)807-0399.

AMERICAN SOCIETY OF MEDIA PHOTOGRAPHERS (ASMP), 14 Washington Rd., Suite 502, Princeton Junction NJ 08550-1033. (609)799-8300.

AMERICAN SOCIETY OF PICTURE PROFESSIONALS (ASPP), ASPP Membership, 2025 Pennsylvania Ave. NW, Suite 226, Washington DC 20006. (202)955-5578. Executive Director: Cathy Sachs.

BRITISH ASSOCIATION OF PICTURE LIBRARIES AND AGENCIES, 18 Vine Hill, London EC1R 5DX England. (0171)713-1780. Fax: (0171)712-1211.

CANADIAN ASSOCIATION OF JOURNALISTS, PHOTOJOURNALISM CAUCUS, 2 Mullock St., St. Johns, Newfoundland A1C 2R5 Canada. (709)576-2297. Contact: Greg Locke.

CANADIAN ASSOCIATION OF PHOTOGRAPHERS & ILLUSTRATORS IN COMMUNICATIONS, 100 Broadview Ave., Suite 322, Toronto, Ontario M4M 2E8 Canada. (416)462-3700. Fax: (416)462-3678. http://www.capic.org.

THE CENTER FOR PHOTOGRAPHY AT WOODSTOCK (CPW), 59 Tinker St., Woodstock NY 12498. (914)679-9957. Fax: (914)679-6337). Executive Director: Colleen Kenyon.

EVIDENCE PHOTOGRAPHERS INTERNATIONAL COUNCIL (EPIC), 600 Main St., Honesdale PA 18431. (717)253-5450. President: Bob Jennings.

THE FRIENDS OF PHOTOGRAPHY, 250 Fourth St., San Francisco CA 94103. (415)495-7000.

INTERNATIONAL CENTER OF PHOTOGRAPHY (ICP), 1130 Fifth Ave., New York NY 10128. (212)860-1781.

INTERNATIONAL SOCIETY OF FINE ART PHOTOGRAPHERS, P.O. Box 440735, Miami FL 33144.

THE LIGHT FACTORY (TLF) PHOTOGRAPHIC ARTS CENTER, 809 W. Hill St., Charlotte NC 28208. Mailing Address: P.O. Box 32815, Charlotte NC 28232. (704)333-9755.

NATIONAL PRESS PHOTOGRAPHERS ASSOCIATION (NPPA), 3200 Croasdaile Dr., Suite 306, Durham NC 27705. (800)289-6772. NPPA Executive Director: Charles Cooper.

NORTH AMERICAN NATURE PHOTOGRAPHY ASSOCIATION (NANPA), 10200 W. 44th Ave., Suite 304, Wheat Ridge CO 80033-2840. (303)422-8527. President: Jane S. Kinne. Executive Director: Jerry Bowman.

PHOTOGRAPHIC SOCIETY OF AMERICA (PSA), 3000 United Founders Blvd., Suite 103, Oklahoma City OK 73112. (405)843-1437.

PICTURE AGENCY COUNCIL OF AMERICA (PACA), P.O. Box 308, Northfield MN 55057-0308. (800)457-7222.

PROFESSIONAL PHOTOGRAPHERS OF AMERICA (PPA), 57 Forsyth St. NW, Suite 1600, Atlanta GA 30303. (404)522-8600.

SOCIETY OF PHOTOGRAPHER AND ARTIST REPRESENTATIVES, INC. (SPAR), 60 E. 42nd St., Suite 1166, New York NY 10165. (212)779-7464.

VOLUNTEER LAWYERS FOR THE ARTS, 1 E. 53rd St., 6th Floor, New York NY 10022. (212)319-2787.

WEDDING & PORTRAIT PHOTOGRAPHERS INTERNATIONAL (WPPI), P.O. Box 2003, 1312 Lincoln Blvd., Santa Monica CA 90406. (310)451-0090.

WHITE HOUSE NEWS PHOTOGRAPHERS' ASSOCIATION, INC. (WHNPA), P.O. Box 7119, Ben Franklin Station, Washington DC 20044-7119. (202)785-5230.

WORLD COUNCIL OF PROFESSIONAL PHOTOGRAPHERS, 654 Street Rd., Bensalem PA 19020.

Websites for Photographers

There are numerous sites on the World Wide Web related to photography. The websites below are the most useful ones we've found—quick and easy sources of information and ideas on both the craft and the business of the industry. We didn't include Web addresses for magazines, book publishers, stock agencies and other markets. This information is included within the listings in this book. Keep in mind that due to the dynamic nature of the Internet, sites may come and go quickly. We'd appreciate hearing from you if you run across other quality sites that spring up. (E-mail us at photomarket@fwpubs.com.)

INFORMATIONAL SITES
These websites provide general information on anything from copyright and taxes to the ins and outs of the stock photo industry:

Focal Point Industry's Media Yellow Pages: http:www.fpointinc.com
Lists retail stores, photolabs, repair and rental service, and photographers all over the world.

Internal Revenue Service: http://www.irs.ustreas.gov/basic/cover/html
Visit this site for links to IRS help, IRS forms and IRS publications.

Stockphoto: http://www.s2f.com/
This site provides information on the stock photo industry including answers to frequently asked questions, lists of photo organizations, workshops and market leads.

Taking Stock: http://www.pickphoto.com
This is the online version of stock industry guru Jim Pickerell's newsletter.

U.S. Copyright Office: http://www.loc.gov/copyright
This homepage gives you access to copyright forms, information, and a list of other Internet resources related to copyright.

PROFESSIONAL ORGANIZATIONS
Visit these sites for information about organizations for photographers as well as industry information:

Advertising Photographers of America: http://www.apanational.com

American Society of Media Photographers: http://www.asmp.org

Canadian Association of Photographers & Illustrators in Communication:
http://www.capic.org

North American Nature Photographers Association: http://www.mcs.net/~rjacods/nanpa.htm

National Press Photographers Association: http://www.sunsite.unc.edu/nppa/

Picture Agency Council of America: http://www.indexstock.com/pages/paca/htm

Professional Photographers of America: http://www.ppa-world.org

Wedding & Portrait Photographers International: http://www.wppi-online.com

RETAILERS

These sites of photography retailers provide information on new products as well as technical advice:

Agfa Film: http://www.agfahome.com

Canon: http://www.usa.canon.com

Fuji: http://www.fujifilm.co.jp/index.html

Kodak: http://www.Kodak.com

Nikon: http://www.niKonusa.com/index.htm

Pacific Coast Software: http://www.pacific-coast.com

Helpful Resources for Photographers

Photographer's Market recommends the following additional reading material to stay informed about market trends as well as to find additional names and addresses of photo buyers. Most are available either in a library or bookstore or from the publisher. To insure accuracy of information, use copies of these resources that are no older than a year.

PERIODICALS

AMERICAN PHOTO, 1633 Broadway, 43rd Floor, New York NY 10019. (212)767-6086. Monthly magazine, emphasizing the craft and philosophy of photography.

ART CALENDAR, P.O. Box 199, Upper Fairmont MD 21867-0199. (410)651-9150. Monthly magazine listing galleries reviewing portfolios, juried shows, percent-for-art programs, scholarships and art colonies, among other art-related topics.

ASMP BULLETIN, 14 Washington Rd., Suite 502, Princeton Junction NJ 08550-1033. (609)799-8300. Monthly newsletter of the American Society of Media Photographers. Subscription comes with membership in ASMP.

THE COMMERCIAL IMAGE, PTN Publishing, 445 Broad Hollow Rd., Melville NY 11747. (516)845-2700. Monthly magazine for photographers in various types of staff positions in industry, education and other institutions.

COMMUNICATION ARTS, 410 Sherman Ave., Box 10300, Palo Alto CA 94303. Website: http://www.commarts.com. Magazine covering design, illustration and photography. Published 8 times a year.

EDITOR & PUBLISHER, The Editor & Publisher Co., Inc., 11 W. 19th St., New York NY 10011. (212)675-4380. Website: http://www.mediainfo.com. Weekly magazine covering latest developments in journalism and newspaper production. Publishes an annual directory issue listing syndicates and another directory listing newspapers.

F8 and BEING THERE, P.O. Box 8792, St. Petersburg FL 33738. (813)397-3013. A bimonthly newsletter for nature photographers who enjoy travel.

FOLIO, 911 Hope St., P.O. Box 4949, Bldg. 6, Stamford CT 06907-0949. (203)358-9900. Monthly magazine featuring trends in magazine circulation, production and editorial.

GRAPHIS, 141 Lexington Ave., New York NY 10016-8193. (212)532-9387. Fax: (212)213-3229. Website: http://www.pathfinder.com. Magazine for the visual arts.

GREETINGS TODAY, The Greeting Card Association, 810 E. 10th St., Lawrence KS 66044. (800)627-0932.

GUILFOYLE REPORT, AG Editions, 41 Union Square West, #523, New York NY 10003. (212)929-0959. Website: http://www.ag-editions.com/report.html. Quarterly market tips newsletter for nature and stock photographers.

HOW, F&W Publications, 1507 Dana Ave., Cincinnati OH 45207. (800)289-0963. Website: http://www.howdesign.com. Bimonthly magazine for the design industry.

NEWS PHOTOGRAPHER, 1446 Conneaut Ave., Bowling Green OH 43402. (419)352-8175. Monthly news tabloid published by the National Press Photographers Association.

OUTDOOR PHOTOGRAPHER, 12121 Wilshire Blvd., Suite 1220, Los Angeles CA 90025. (310)820-1500. Monthly magazine emphasizing equipment and techniques for shooting in outdoor conditions.

PETERSEN'S PHOTOGRAPHIC MAGAZINE, 6420 Wilshire Blvd., Los Angeles CA 90048-5515. (213)782-2200. Monthly magazine for beginning and semi-professional photographers in all phases of still photography.

PHOTO DISTRICT NEWS, 1515 Broadway, New York NY 10036. Website: http//www.pdn-pix.com. Monthly trade magazine for the photography industry.

PHOTOSOURCE INTERNATIONAL, Pine Lake Farm, 1910 35th Rd., Osceola WI 54020. (715)248-3800. This company publishes several helpful newsletters, including PhotoLetter, PhotoMarket, Photo-Bulletin *and* PhotoStockNotes.

POPULAR PHOTOGRAPHY, 1633 Broadway, New York NY 10019. (212)767-6000. Monthly magazine specializing in technical information for photography.

PRINT, RC Publications Inc., 104 Fifth Ave., 19th Floor, New York NY 10011. (212)463-0600. Fax: (212)989-9891. Bimonthly magazine focusing on creative trends and technological advances in illustration, design, photography and printing.

PROFESSIONAL PHOTOGRAPHER, Professional Photographers of America (PPA), 57 Forsyth St. NW, Suite 1600, Atlanta GA 30303. (404)522-8600. Website: http://www.ppa-world.org. Monthly magazine, emphasizing technique and equipment for working photographers.

PUBLISHERS WEEKLY, Bowker Magazine Group, Cahners Publishing Co., 249 W. 17th St., New York NY 10011. (212)645-0067. Weekly magazine covering industry trends and news in book publishing, book reviews and interviews.

THE RANGEFINDER, 1312 Lincoln Blvd., Santa Monica CA 90401. (310)451-8506. Monthly magazine on photography technique, products and business practices.

SHUTTERBUG, Patch Communications, 5211 S. Washington Ave., Titusville FL 32780. (407)268-5010. Monthly magazine of photography news and equipment reviews.

TAKING STOCK, published by Jim Pickerell, Pickerell Services, 110 Frederick Ave., Suite A, Rockville MD 20850. (301)251-0720. Website: http://www.pickphoto.com. Newsletter for stock photographers; includes coverage of trends in business practices such as pricing and contract terms.

BOOKS & DIRECTORIES

ASMP COPYRIGHT GUIDE, 14 Washington Rd., Suite 502, Princeton Junction NJ 08550 (609)799-8300.

ASMP PROFESSIONAL BUSINESS PRACTICES IN PHOTOGRAPHY, 5th Edition, published by Allworth Press, distributed by Writer's Digest Books, 1507 Dana Ave., Cincinnati OH 45207. (800)289-0963.

ASMP STOCK PHOTOGRAPHY HANDBOOK, by Michal Heron, 14 Washington Rd., Suite 502, Princeton Junction NJ 08550 (609)799-8300.

BLUE BOOK, AG Editions, 41 Union Square West, #523, New York NY 10003. (212)929-0959. Website: http://www.ag-editions.com. Annual directory of geographic, travel and destination stock photographers for use by photo editors and researchers.

CHILDREN'S WRITERS & ILLUSTRATOR'S MARKET, Writer's Digest Books, 1507 Dana Ave., Cincinnati OH 45207. (800)289-0963. Annual directory including photo needs of book publishers, magazines and multimedia producers in the children's publishing industry.

CREATIVE BLACK BOOK, 10 Astor Place, 6th Floor, New York NY 10003. (800)841-1246. Sourcebook used by photo buyers to find photographers.

DIRECT STOCK, 10 E. 21st St., 14th Floor, New York NY 10010. (212)979-6560. Sourcebook used by photo buyers to find photographers.

ENCYCLOPEDIA OF ASSOCIATIONS, Gale Research Inc., 645 Griswold St., 835 Penobscot Building, Detroit MI 48226-4094.(313)961-2242. Annual directory listing active organizations.

GREEN BOOK, AG Editions, 41 Union Square West, #523, New York NY 10003. (212)929-0959. Website: http://www.ag-editions.com. Annual directory of nature and stock photographers for use by photo editors and researchers.

GUIDE TO TRAVEL WRITING & PHOTOGRAPHY, by Ann and Carl Purcell, published by Writer's Digest Books, 1507 Dana Ave., Cincinnati OH 45207. (800)289-0963.

HOW TO SELL YOUR PHOTOGRAPHS & ILLUSTRATIONS, by Elliot & Barbara Gordon, published by Writer's Digest Books, 1507 Dana Ave., Cincinnati OH 45207. (800)289-0963.

HOW TO SHOOT STOCK PHOTOS THAT SELL, by Michal Heron, published by Allworth Press, distributed by Writer's Digest Books, 1507 Dana Ave., Cincinnati OH 45207. (513)531-2222.

HOW YOU CAN MAKE $25,000 A YEAR WITH YOUR CAMERA, by Larry Cribb, published by Writer's Digest Books, 1507 Dana Ave., Cincinnati OH 45207. (800)289-0963. Newly revised edition of the popular book on finding photo opportunities in your own hometown.

KLIK, American Showcase, 915 Broadway, 14th Floor, New York NY 10010. (212)673-6600. Sourcebook used by photo buyers to find photographers.

LIGHTING SECRETS FOR THE PROFESSIONAL PHOTOGRAPHER, by Alan Brown, Tim Grondin and Joe Braun, published by Writer's Digest Books, 1507 Dana Ave., Cincinnati OH 45207. (800)289-0963.

LITERARY MARKET PLACE, R.R. Bowker Company, 121 Chanlon Rd. New Providence NJ 07974. (908)464-6800. Directory that lists book publishers and other book industry contacts.

MARKETING PHOTOGRAPHY IN THE DIGITAL ENVIRONMENT, by Jim Pickerell and Andrew Child, Pickerell Services, 110 Fredereck Ave., Suite A, Rockville MD 20850 (800)868-6376. Website: http://www.pickphoto. com.

NEGOTIATING STOCK PHOTO PRICES, by Jim Pickerell. Available through American Society of Media Photographers, 14 Washington Rd., Suite 502, Princeton Junction NJ 08550-1033. (609)799-8300. Hardbound book which offers pricing guidelines for selling photos through stock photo agencies.

NEWSLETTERS IN PRINT, Gale Research Inc., 645 Griswold St., 835 Penobscot Building, Detroit MI 48226-4094. (313)961-6083. Annual directory listing newsletters.

O'DWYER DIRECTORY OF PUBLIC RELATIONS FIRMS, J.R. O'Dwyer Company, Inc., 271 Madison Ave., New York NY 10016. (212)679-2471. Annual directory listing public relations firms, indexed by specialties.

PHOTO MARKETING HANDBOOK, by Jeff Cason, Images Press, 7 E. 17th St., New York NY 10003.

THE PHOTOGRAPHER'S MARKET GUIDE TO PHOTO SUBMISSIONS & PORTFOLIO FORMATS, by Michael Willins, Writer's Digest Books, 1507 Dana Ave., Cincinnati OH 45207. (800)289-0963.

PHOTOGRAPHER'S SOURCE, by Henry Horenstein, Fireside Books, ℅ Simon & Schuster Publishing, Rockefeller Center, 1230 Avenue of the Americas, New York NY 10020. (212)698-7000.

PRICING PHOTOGRAPHY: THE COMPLETE GUIDE TO ASSIGNMENT & STOCK PRICES, by Michal Heron and David MacTavish, published by Allworth Press, 10 E. 23rd St., New York NY 10010. (212)777-8395.

PROFESSIONAL PHOTOGRAPHER'S GUIDE TO SHOOTING & SELLING NATURE & WILDLIFE PHOTOS, by Jim Zuckerman, Writer's Digest Books, 1507 Dana Ave., Cincinnati OH 45207. (800)289-0963.

PROFESSIONAL PHOTOGRAPHER'S SURVIVAL GUIDE, by Charles E. Rotkin, Writer's Digest Books, 1507 Dana Ave., Cincinnati OH 45207. (800)289-0963. A guide to becoming a professional photographer, making the first sale, completing assignments and earning the most from photographs.

SELL & RESELL YOUR PHOTOS, by Rohn Engh, Writer's Digest Books, 1507 Dana Ave., Cincinnati OH 45207. (800)289-0963. Newly revised edition of the classic volume on marketing your own stock images.

STANDARD DIRECTORY OF ADVERTISING AGENCIES, Reed Reference Publishing Co., 121 Chanlon Rd., New Providence NJ 07974. (908)464-6800. Annual directory listing advertising agencies.

STANDARD RATE AND DATA SERVICE (SRDS), 1700 Higgins Rd., Des Plains IL 60018. (847)375-5000. Website: http://www.srds.com. Monthly directory listing magazines, plus their advertising rates.

STOCK PHOTOGRAPHY: The Complete Guide, by Ann and Carl Purcell, published by Writer's Digest Books, 1507 Dana Ave., Cincinnati OH 45207. (800)289-0963.

THE STOCK WORKBOOK, Scott & Daughters Publishing, Inc., 940 N. Highland Ave., Suite A, Los Angeles CA 90038. (213)856-0008. Annual directory of stock photo agencies.

SUCCESSFUL FINE ART PHOTOGRAPHY, by Harold Davis, published by Images Press, distributed by Writer's Digest Books, 1507 Dana Ave., Cincinnati OH 45207. (800)289-0963.

WRITER'S MARKET, Writer's Digest Books, 1507 Dana Ave., Cincinnati OH 45207. (800)289-0963. Annual directory listing markets for freelance writers. Lists names, addresses, contact people and marketing information for book publishers, magazines, greeting card companies and syndicates. Many listings also list photo needs and payment rates.

Glossary

Absolute-released images. Any images for which signed model or property releases are on file and immediately available. For working with stock photo agencies that deal with advertising agencies, corporations and other commercial clients, such images are absolutely necessary to sell usage of images. Also see Model release, Property release.

Acceptance (payment on). The buyer pays for certain rights to publish a picture at the time he accepts it, prior to its publication.

Agency promotion rights. In stock photography, these are the rights that the agency requests in order to reproduce a photographer's images in any promotional materials such as catalogs, brochures and advertising.

Agent. A person who calls upon potential buyers to present and sell existing work or obtain assignments for his client. A commission is usually charged. Such a person may also be called a *photographer's rep*.

All rights. A form of rights often confused with work for hire. Identical to a buyout, this typically applies when the client buys all rights or claim to ownership of copyright, usually for a lump sum payment. This entitles the client to unlimited, exclusive usage and usually with no further compensation to the creator. Unlike work for hire, the transfer of copyright is not permanent. A time limit can be negotiated, or the copyright ownership can run to the maximum of 35 years. (See Taking Care of Business.)

All reproduction rights. See All rights.

All subsidiary rights. See All rights.

ASMP member pricing survey. These statistics are the result of a national survey of the American Society of Media Photographers (ASMP) compiled to give an overview of various specialties comprising the photography market. Though erroneously referred to as "ASMP rates," this survey is not intended to suggest rates or to establish minimum or maximum fees.

Assign (designated recipient). A third-party person or business to which a client assigns or designates ownership of copyrights that the client purchased originally from a creator, such as a photographer. This term commonly appears on model and property releases.

Assignment. A definite OK to take photos for a specific client with mutual understanding as to the provisions and terms involved.

Assignment of copyright, rights. The photographer transfers claim to ownership of copyright over to another party in a written contract signed by both parties. Terms are almost always exclusive, but can be negotiated for a limited time period or as a permanent transfer.

Audiovisual. Materials such as filmstrips, motion pictures and overhead transparencies which use audio backup for visual material.

Automatic renewal clause. In contracts with stock photo agencies, this clause works on the concept that every time the photographer delivers an image, the contract is automatically renewed for a specified number of years. The drawback is that a photographer can be bound by the contract terms beyond the contract's termination and be blocked from marketing the same images to other clients for an extended period of time.

AV. See Audiovisual.

Betacam. A videotape mastering format typically used for documentary/location work. Because of its compact equipment design allowing mobility and its extremely high quality for its size, it has become an accepted standard among TV stations for news coverage.

Bimonthly. Occurring once every two months.

Biweekly. Occurring once every two weeks.

Bleed. In a mounted photograph it refers to an image that extends to the boundaries of the board.

Blurb. Written material appearing on a magazine's cover describing its contents.

Body copy. Text used in a printed ad.

Bounce light.
Light that is directed away from the subject toward a reflective surface.

Bracket. To make a number of different exposures of the same subject in the same lighting conditions.

Buyout. A form of work for hire where the client buys all rights or claim to ownership of copyright, usually for a lump sum payment. Also see All rights, Work for hire.

Capabilities brochure. In advertising and design firms, this type of brochure—similar to an annual report—is a frequent request from many corporate clients. This brochure outlines for prospective clients the nature of a company's business and the range of products or services it provides.

Caption. The words printed with a photo (usually directly beneath it) describing the scene or action. Synonymous with *cutline*.

Catalog work. The design of sales catalogs is a type of print work that many art/design studios and advertising agencies do for retail clients on a regular basis. Because the emphasis in catalogs is upon selling merchandise, photography is used heavily in catalog design. There is a great demand for such work, so many designers, art directors and photographers consider this to be "bread and butter" work, or a reliable source of income.

CD-ROM. Compact disc read-only memory; non-erasable electronic medium used for digitized image and document storage and retrieval on computers.

Cibachrome. A photo printing process that produces fade-resistant color prints directly from color slides.

Clip art. Collections of copyright-free, ready-made illustrations available in b&w and color, both line and tone, in book form or in digital form.

Clips. See Tearsheets.

CMYK. Cyan, magenta, yellow and black—refers to four-color process printing.

Collateral materials. In advertising and design work, these are any materials or methods used to communicate a client's marketing identity or promote its product or service. For instance, in corporate identity designing, everything from the company's trademark to labels and packaging to print ads and marketing brochures is often designed at the same time. In this sense, collateral design—which uses photography at least as much as straight advertising does—is not separate from advertising but supportive to an overall marketing concept.

Commission. The fee (usually a percentage of the total price received for a picture) charged by a photo agency, agent or representative for finding a buyer and attending to the details of billing, collecting, etc.

Composition. The visual arrangement of all elements in a photograph.

Copyright. The exclusive legal right to reproduce, publish and sell the matter and form of a literary or artistic work. (See Understanding the Basics of Copyright.)

C-print. Any enlargement printed from a negative. (Any enlargement from a transparency is called an R-print.)

Credit line. The byline of a photographer or organization that appears below or beside published photos.

Crop. To omit parts of an image when making a print or copy negative in order to focus attention on one area of the image.

Cutline. See Caption.

Day rate. A minimum fee which many photographers charge for a day's work, whether a full day is spent on a shoot or not. Some photographers offer a half-day rate for projects involving up to a half-day of work. This rate typically includes mark-up but not additional expenses, which are usually billed to the customer.

Demo(s). A sample reel of film or sample videocassette which includes excerpts of a filmmaker's or videographer's production work for clients.

Disclaimer. A denial of legal claim used in ads and on products.

Dry mounting. A method of mounting prints on cardboard or similar materials by means of heat, pressure, and tissue impregnated with shellac.

EFP. Abbreviation for Electronic Field Processing equipment. Trade jargon in the news/video production industry for a video recording system that is several steps above ENG in quality. Typically, this is employed when film-like sharpness and color saturation are desirable in a video format. It requires a high degree of lighting, set-up and post-production. Also see ENG.

ENG. Abbreviation for Electronic News Gathering equipment. Trade jargon in the news/video production industry for professional-quality video news cameras which can record images on videotape or transmit them by microwave to a TV station's receiver.

Exclusive property rights. A type of exclusive rights in which the client owns the physical image, such as a print, slide, film reel or videotape. A good example is when a portrait which is shot for a person to keep, while the photographer retains the copyright.

Exclusive rights. A type of rights in which the client purchases exclusive usage of the image for a negotiated time period, such as one, three or five years. May also be permanent. Also see All rights, Work for hire.

Fee-plus basis. An arrangement whereby a photographer is given a certain fee for an assignment—plus

reimbursement for travel costs, model fees, props and other related expenses incurred in filling the assignment.

First rights. The photographer gives the purchaser the right to reproduce the work for the first time. The photographer agrees not to permit any publication of the work for a specified amount of time. (See Understanding the Basics of Copyright.)

Format. The size, shape and other traits giving identity to a periodical.

Four-color printing, four-color process. A printing process in which four primary printing inks are run in four separate passes on the press to create the visual effect of a full-color photo, as in magazines, posters and various other print media. Four separate negatives of the color photo—shot through filters— are placed identically (stripped) and exposed onto printing plates, and the images are printed from the plates in four ink colors.

Gaffer. In motion pictures, the person who is responsible for positioning and operating lighting equipment, including generators and electrical cables.

Grip. A member of a motion picture camera crew who is responsible for transporting, setting up, operating, and removing support equipment for the camera and related activities.

Holography. Recording on a photographic material the interference pattern between a direct coherent light beam and one reflected or transmitted by the subject. The resulting hologram gives the appearance of three dimensions, and, within limits, changing the viewpoint from which a hologram is observed shows the subject as seen from different angles.

In perpetuity. A term used in business contracts which means that once a photographer has sold his copyrights to a client, the client has claim to ownership of the image or images forever. Also see All rights, Work for hire.

Internegative. An intermediate image used to convert a color transparency to a b&w print.

IRC. Abbreviation for International Reply Coupon. IRCs are used instead of stamps when submitting material to foreign buyers.

Leasing. A term used in reference to the repeated selling of one-time rights to a photo; also known as *renting*.

Logo. The distinctive nameplate of a publication which appears on its cover.

Model release. Written permission to use a person's photo in publications or for commercial use. (See Taking Care of Business.)

Ms, mss. Manuscript and manuscripts, respectively. These abbreviations are used in *Photographer's Market* listings.

Multi-image. A type of slide show which uses more than one projector to create greater visual impact with the subject. In more sophisticated multi-image shows, the projectors can be programmed to run by computer for split-second timing and animated effects.

Multimedia. A generic term used by advertising, public relations and audiovisual firms to describe productions using more than one medium together—such as slides and full-motion, color video—to create a variety of visual effects. Usually such productions are used in sales meetings and similar kinds of public events.

News release. See Press release.

No right of reversion. A term in business contracts which specifies once a photographer sells his copyrights to an image or images, he has surrendered his claim to ownership. This may be unenforceable, though, in light of the 1989 Supreme Court decision on copyright law. Also see All rights, Work for hire.

Offset. A printing process using flat plates. The plate is treated to accept ink in image areas and to reject it in nonimage areas. The inking is transferred to a rubber roller and then to the paper.

One-time rights. The photographer sells the right to use a photo one time only in any medium. The rights transfer back to the photographer on his request after the photo's use.

On spec. Abbreviation for "on speculation." Also see Speculation, Assignment.

Page rate. An arrangement in which a photographer is paid at a standard rate per page. A page consists of both illustrations and text.

Panoramic format. A camera format which creates the impression of peripheral vision for the viewer. It was first developed for use in motion pictures and later adapted to still formats. In still work, this format requires a very specialized camera and lens system.

Pans. See Panoramic format.

PICT. The saving format for bit-mapped and object-oriented images.

Picture Library. See Stock photo agency.

Point-of-purchase, point-of-sale. A generic term used in the advertising industry to describe in-store

marketing displays which promote a product. Typically, these colorful and highly-illustrated displays are placed near check out lanes or counters, and offer tear-off discount coupons or trial samples of the product.

P-O-P, P-O-S. See Point-of-purchase.

Portfolio. A group of photographs assembled to demonstrate a photographer's talent and abilities, often presented to buyers. (See How to Put Together a Winning Portfolio.)

Press release. A form of publicity announcement which public relations agencies and corporate communications staff people send out to newspapers and TV stations to generate news coverage. Usually this is sent in typewritten form with accompanying photos or videotape materials. Also see Video news release.

Property release. Written permission to use a photo of private property or public or government facilities in publications or for commercial use.

Publication (payment on). The buyer does not pay for rights to publish a photo until it is actually published, as opposed to payment on acceptance.

Release. See Model release, Property release.

Rep. Trade jargon for sales representative. Also see Agent.

Query. A letter of inquiry to an editor or potential buyer soliciting his interest in a possible photo assignment or photos that the photographer may already have.

Résumé. A short written account of one's career, qualifications and accomplishments.

Royalty. A percentage payment made to a photographer/filmmaker for each copy of his work sold.

R-print. Any enlargement made from a transparency. (Any enlargement from a negative is called a C-print.)

SAE. Self-addressed envelope.

SASE. Self-addressed stamped envelope. (Most buyers require SASE if a photographer wishes unused photos returned to him, especially unsolicited materials.)

Self-assignment. Any photography project which a photographer shoots to show his abilities to prospective clients. This can be used by beginning photographers who want to build a portfolio or by photographers wanting to make a transition into a new market.

Self-promotion piece. A printed piece which photographers use for advertising and promoting their businesses. These pieces usually use one or more examples of the photographer's best work, and are professionally designed and printed to make the best impression.

Semigloss. A paper surface with a texture between glossy and matte, but closer to glossy.

Semimonthly. Occurring twice a month.

Serial rights. The photographer sells the right to use a photo in a periodical. Rights usually transfer back to the photographer on his request after the photo's use.

Simultaneous submissions. Submission of the same photo or group of photos to more than one potential buyer at the same time.

Speculation. The photographer takes photos on his own with no assurance that the buyer will either purchase them or reimburse his expenses in any way, as opposed to taking photos on assignment.

Stock photo agency. A business that maintains a large collection of photos which it makes available to a variety of clients such as advertising agencies, calendar firms, and periodicals. Agencies usually retain 40-60 percent of the sales price they collect, and remit the balance to the photographers whose photo rights they've sold.

Stock photography. Primarily the selling of reprint rights to existing photographs rather than shooting on assignment for a client. Some stock photos are sold outright, but most are rented for a limited time period. Individuals can market and sell stock images to individual clients from their personal inventory, or stock photo agencies can market a photographer's work for him. Many stock agencies hire photographers to shoot new work on assignment, which then becomes the inventory of the stock agency.

Stringer. A freelancer who works part-time for a newspaper, handling spot news and assignments in his area.

Stripping. A process in printing production where negatives are put together to make a composite image or prepared for making the final printing plates, especially in four-color printing work. Also see Four-color printing.

Subagent. See Subsidiary agent.

Subsidiary agent. In stock photography, this is a stock photo agent which handles marketing of stock images for a primary stock agency in certain US or foreign markets. These are usually affiliated with the primary agency by a contractual agreement rather than by direct ownership, as in the case of an agency which has its own branch offices.

SVHS. Abbreviation for Super VHS. Videotape that is a step above regular VHS tape. The number of lines of resolution in a SVHS picture is greater, thereby producing a sharper picture.

Table-top. Still-life photography; also the use of miniature props or models constructed to simulate reality.

Tabloid. A newspaper that is about half the page size of an ordinary newspaper, and which contains many photos and news in condensed form.

Tearsheet. An actual sample of a published work from a publication.

TIFF. Tagged Image File Format—a computer format used for saving or creating certain kinds of graphics.

Trade journal. A publication devoted strictly to the interests of readers involved in a specific trade or profession, such as dancers, beekeepers, pilots or manicurists, and generally available only by subscription.

Transparency. A color film with positive image, also referred to as a slide.

Tungsten light. Artificial illumination as opposed to daylight.

U-Matic. A trade name for a particular videotape format produced by the Sony Corporation.

Unlimited use. A type of rights in which the client has total control over both how and how many times an image will be used. Also see All rights, Exclusive rights, Work for hire.

VHS. Abbreviation for Video Home System. A standard videotape format for recording consumer-quality videotape; the format most commonly used in home videocassette recording and portable camcorders.

Video news release. A videocassette recording containing a brief news segment specially prepared for broadcast on TV new programs. Usually, public relations firms hire AV firms or filmmaker/videographers to shoot and produce these recordings for publicity purposes of their clients.

Videotape. Magnetic recording tape similar to that used for recording sound, but which also records moving images, especially for broadcast on television.

Videowall. An elaborate installation of computer-controlled television screens in which several screens create a much larger moving image. For example, with eight screens, each of the screens may hold a portion of a larger scene, or two images can be shown side by side, or one image can be set in the middle of a surrounding image.

VNR. See Video news release.

White Paper. An article on a specific subject that, once written, is considered an industry standard.

Work for hire, Work made for hire. Any work that is assigned by an employer and the employer becomes the owner of the copyright. Copyright law clearly defines the types of photography which come under the work-for-hire definition. An employer can claim ownership to the copyright only in cases in which the photographer is a fulltime staff person for the employer or in special cases in which the photographer negotiates and assigns ownership of the copyright in writing to the employer for a limited time period. Stock images cannot be purchased under work-for-hire terms.

World rights. A type of rights in which the client buys usage of an image in the international marketplace. Also see All rights.

Worldwide exclusive rights. A form of world rights in which the client buys exclusive usage of an image in the international marketplace. Also see All rights.

Zone System. A system of exposure which allows the photographer to previsualize the print, based on a gray scale containing nine zones. Many workshops offer classes in Zone System.

Zoom lens. A type of lens with a range of various focal lengths.

Digital Markets Index

The growth in computer technology has created a need among buyers for digitally stored images. The trend is easy to spot by the number of markets in this book that list website addresses. This index contains those companies that have shown an interest in working with freelancers who can supply photos on CD-ROM, computer disk or via online services. A double dagger (‡) before a listing in this index signifies that the market is new.

Subject Index

This index can help you find buyers who are searching for the kinds of images you are producing. Consisting of markets from the Publications, Book Publishers, Paper Products, Stock Photo and Galleries sections, this index is broken down into 46 different subjects. If, for example, you shoot landscape/scenics and want to find out which markets purchase this material, turn to that category in the index. A double dagger (‡) before a listing in this index signifies that the market is new.

Adventure

AAIMS Publishers Company 236; Adventure Photo 302; Adventure West Magazine 44; Alaska Stock Images 303; ‡American Survival Guide 49; Arnold, Inc., Peter 306; ‡Au Juice 52; BC Outdoors 55; ‡Bears Magazine 55; ‡Fox Magazine 89; Gallery Magazine 89; ‡High Range Graphics 287; Hillstrom Stock Photo, Inc. 328; International Sports 333; Mountain Pilot 219; Mushing Magazine 220; Rock & Ice 146; Sportslight Photo 361; ‡Stock Broker, The 362

Agriculture/Rural

Agritech Publishing Group 238; ‡AGStockUSA 303; Alabama Living 45; American Agriculturist 197; Biological Photo Service 307; Bryant Stock Photography (DDB Stock), D. Donne 308; Charlton Photos, Inc. 311; Country 75; Country Woman 75; Cranberries 204; Delta Design Group, Inc. 205; Envision 320; Europe 209; Farm & Country 185; Farm Chemicals 209; ‡Ferguson Publishing Company 251; Ford New Holland News 211; Frozen Images, Inc. 325; F/Stop Pictures Inc. 325; Grain Journal 212; Hemphill Fine Arts 484; Hereford World 214; Holt Studios International, Ltd. 328; ‡Hutchison Library, The 329; ‡Levy Fine Art Publishing, Inc., Leslie 291; Llamas Magazine 218; Olson & Co., C. 265; Ozark Stock 345; Picture Cube Inc., The 352; Produce Merchandising 226; ‡Reiman Publications, L.P. 268, 295; Rural Heritage 148; Tropix Photographic Library 367; Voice of South Marion 173; Weigl Educational Publishers Limited 274; Western Producer, The 195

Animals

Adventure West Magazine 44; Agritech Publishing Group 238; Alpine Publications, Inc. 238; ‡America West Airlines Magazine 47; American Agriculturist 197; American Farriers Journal 198; Animal Sheltering 198; Animals 50; Animals Animals/Earth Scenes 304; Appaloosa Journal 50; ‡Aquarium Fish Magazine 51; Avanti Press Inc. 279; Backpacker Magazine 54; Beautyway 279; Bird Watcher's Digest 56; Blackbirch, Inc. 243; Bowhunter 58; Bugle Magazine 60; Caged Bird Hobbyist 61; Caller, The 183; Calypso Log 62; Canada in Stock Inc. 310; ‡Canadian Rodeo News 63; Cat Fancy 66; Cedco Publishing Co. 281; Charlton Photos, Inc. 311; Chickadee Magazine 68; Chronicle of the Horse, The 70; ‡Concord Litho Co. Inc. 282; Country Woman 75; Crabtree Publishing Company 248; ‡Crystal Tissue Company, The 282; ‡Cyr Color Photo Agency 313; Das Fenster 78; Deer and Deer Hunting 78; Defenders 78; Delta Design Group, Inc. 205; Devaney Stock Photos, 315; Dinodia Picture Agency 316; Dog Fancy 79; Dolphin Log, The 80; Ducks Unlimited 81; Earth Images 317; Eclipse and Suns 318; Environmental Investigation Agency 320; Envision 320; ‡Event 83; Faces: The Magazine About People 84; Farm & Country 185; Farm & Ranch Living 84; ‡Ferguson Publishing Company 251; ‡Fishing and Hunting News 185; Flashcards, Inc. 285; Florida Wildlife 87; Ford Gallery, Adrienne 479; Ford New Holland News 211; FPG Interna-

Architecture/Interiors

Art/Fine Art

Photography (DDB Stock), D. Donne 308; Canton Museum of Art, The 471; Carolina Quarterly 65; Catholic Near East Magazine 66; Center Press 246; Charlene's Framing & Gallery Ten 474; Chinastock 311; ‡Christianity and the Arts 70; Coastal Center for the Arts, Inc. 474; Collages & Bricolages 71; Confrontation: A Literary Journal 74; Crabtree Publishing Company 248; Crafts Report, The 204; Cream City Review, The 76; Edelman Gallery, Catherine 477; Encyclopaedia Britannica 251; ‡Event 83; ‡50/50 Magazine 85; Foto Expression International 322; Gold Gallery, Fay 483; Grand Rapids Magazine 91; ‡Graphique Du Jour, Inc. 286; Gray Gallery, Wellington B. 483; Hemphill Fine Arts 484; Hera Educational Foundation and Art Gallery 485; Holt, Rinehart and Winston 255; Hyde Park Art Center 485; Icebox Quality Framing & Gallery 485; Jackson Fine Art 487; Kalliope, A Journal of Women's Art 101; ‡Kohler Arts Center, John Michael 488; ‡Lawrence Gallery, J. 489; ‡Magic Realism 110; Marble House Gallery 491; Marcel Schurman Company 292; Marlboro Gallery 491; Mediphors 111; ‡Milkweed Editions 262; Museum of Contemporary Photography, Columbia College Chicago, The 493; Museum of Photographic Arts 494; National Rural Letter Carrier 116; Native Peoples Magazine 117; ‡Nevada Museum of Art 494; Northern Ohio Live 123; ‡Nova Media Inc. 293; ‡Palm Court Press 131; Peoria Art Guild, The 497; Phoenix Magazine 133; Photographic Arts Center, The 266; Photographic Resource Center 498; Pittsburgh City Paper 190; ‡Portfolio Graphics, Inc. 294; Renaissance Greeting Cards, Inc., 296; Rockford Review 147; ‡Rossi Gallery, The 501; Russian Life Magazine 148; ‡South Shore Art Center, Inc. 503; ‡Sub-Terrain Magazine 162; Swanstock Agency Inc. 365; Tampa Review 163; ‡Thin Air Magazine 165; Thread Waxing Space 504; Vermont Magazine 171; Waite Group Press 274; Webster Gallery, Sande 505; Westart 195; With 177; Woodmen 178; World and I, The 178

Automobiles
‡Auto Sound & Security 52; Auto Trim & Restyling News 52; Automotive Service Association (ASA) 53; British Car 60; Car & Travel 64; Car Craft Magazine 64; ‡Class Publications, Inc. 282; Classic Auto Restorer 71; ‡Collector Car & Truck Prices 72; Collision 203; Dune Buggies and Hot VWs Magazine 81; Four Wheeler Magazine 89; Franklin Photo Agency 323; "In The Fast Lane" 98; Inside Automotives 216; Land Line Magazine 217; Landmark Calendars 291; Landmark Stock Exchange 336; Midwest Motorist, The 113; Mopar Muscle Magazine 114; Moving World, The 188; National Bus Trader 220; Open Wheel Magazine 126; Planning 135; ‡Portal Publications Ltd. 293; Reflexion Phototheque 356; ‡Reiman Publications, L.P. 295; Southern Motoracing 191; Speedway Scene 231; Stock Car Racing Magazine 162; Super Ford 163; Teldon Calendars 297; ‡Thorson & Associates 271; Traffic Safety 167; Transport Topics 168; Truck Accessory News 232; Utility and Telephone Fleets 232; Utility Construction and Maintenance 232; Vehicle Leasing Today 234

Avant Garde
A.O.I. Gallery 461; Akron Art Museum 462; ‡Art Center of Battle Creek 464; ‡Artemisia Gallery 465; Center for Exploratory and Perceptual Art 473; Collector's Choice Gallery 475; Concept Art Gallery 475; Contemporary Arts Center, The 475; Crossing Press 249; Edelstein Gallery, Paul 478; ‡Gallery of Art, University of Northern Iowa 482; ‡Gallery 218/Walker's Point Artists 482; ‡Gomez Gallery 483; Hera Educational Foundation and Art Gallery 485; Hughes Fine Arts Center 485; Hyde Park Art Center 485; Islip Art Museum 486; Jackson Fine Art 487; ‡Kohler Arts Center, John Michael 488; ‡Kuntswerk Galerie 488; M.C. Gallery 490; Marble House Gallery 491; PaceWildensteinMacGill 497; Red Mountain Gallery 500; Schweig Studio and Gallery, Martin 502; State Museum of Pennsylvania, The 503; ‡Vered Gallery 505

Business/Industry
AAA Image Makers 302; ABA Banking Journal 196; Accounting Today 197; Ace Photo Agency 302; Adams-Blake Publishing 237; Air Line Pilot 45; Allyn and Bacon Publishers

Celebrities

Players Press Inc. 266; ‡Portal Publications Ltd. 293; ‡Pre-Vue Entertainment Magazine 138; ‡Q San Francisco Magazine 141; Rangefinder 356; Real People 142; Recreational Hair News 142; ‡Reedproductions 295; ‡Request Magazine 145; Retna Ltd. 357; Rex USA Ltd. 357; Rolling Stone 147; Saturday Evening Post Society, The 151; Senior Voice of Florida 190; Silver Image Photo Agency, Inc. 360; Singer Media Corp., Inc. 191; Skating 155; Soap Opera Digest 158; SportsCar 161; Star 161; Stock Car Racing Magazine 162; ‡Strain, The 162; Sun 192; Tennis Week 163; Today's Model 166; Total TV 166; Vanity Fair 171; Vista 173; World and I, The 178; Wrestling World 180; Writer's Digest/Writer's Yearbook 235; Your Health 180

Children/Children's

AAP News 196; ‡Abbeville Press 237; ‡American School Health Association 240; ‡(APL) Argus Photoland, Ltd. 305; AppaLight 305; Arjuna Library Press 241; Atlanta Parent 51; Avanti Press Inc. 279; ‡Baby's World Magazine 53; Behrman House Inc. 243; Black Child Magazine 56; Blackbirch Press, Inc. 243; Bureau for At-Risk Youth, The 245; Child Care Focus 184; Child of Colors 68; Childhood Education 69; Crabtree Publishing Company 248; ‡Crystal Tissue Company, The 282; ‡Cyr Color Photo Agency 313; Devaney Stock Photos, 315; Dial Books for Young Readers 249; Education Week 206; ‡Elegant Greeting 285; Flashcards, Inc. 285; ‡Flavia Studios 285; Glencoe Publishing/McGraw Hill 253; Grand Rapids Parent Magazine 91; Gryphon House 254; Highlights for Children 95; Home Education Magazine 95; ‡Hutchison Library, The 329; Jeroboam 334; Kidstock 335; Ladies Home Journal 106; ‡Levy Fine Art Publishing, Inc., Leslie 291; Light Sources Stock 336; Long Island Parenting News 188; Megapress Images 339; Metamorphous Press 262; New England Stock Photo 343; New Moon Publishing 121; Olson & Co., C. 265; Owen Publishers, Inc., Richard C. 265; Ozark Stock 345; Pediatric Annals 223; Photo Agora 346; Pictor International, Ltd. 352; ‡Portal Publications Ltd. 293; ‡Porterfield's Fine Art in Limited Editions 293; ‡Pratt & Austin Co., Inc. 294; Rainbow 355; San Diego Family Magazine 150; School Mates 151; Science and Children 151; Sharpshooters, Inc. 359; ‡Silver Visions 360; Speech Bin Inc., The 270; ‡Sporting Pictures (UK), Ltd. 361; Stack & Associates, Tom 362; Sunrise Publications, Inc. 296; Victory Productions 273

Cities/Urban

AppaLight 305; Beautyway 279; Bryant Stock Photography (DDB Stock), D. Donne 308; Empire State Report 208; Envision 320; ‡Ferguson Publishing Company 251; Foto Expression International 322; Frozen Images, Inc. 325; ‡Kuntswerk Galerie 488; New England Stock Photo 343; O.K. Harris Works of Art 495; ‡Q San Francisco Magazine 141; Recommend Worldwide 228; Ro-Ma Stock 358; Silver Image Photo Agency, Inc. 360; ‡Silver Visions 360; Unicorn Stock Photo Library 367; ‡Vintage Images 298

Documentary/Journalistic

‡A.R.C. Gallery 461; AAP News 196; American Bar Association Press 239; American Chamber of Commerce Executives 198; American Farriers Journal 198; Art Institute of Philadelphia 465; ‡Baltimore 54; ‡Bannister Gallery 468; Bostonia Magazine 58; Camera Press Ltd. 309; Catholic News Service 310; Chess Life 67; Christian Century, The 69; ‡Coconino Center for the Arts 474; Commercial Carrier Journal 203; Compix Photo Agency 312; Construction Equipment Guide 203; ‡Currents 77; Daily Business Review 185; Dog Fancy 79; Doubletake Magazine 80; Emergency, The Journal of Emergency Services 208; Encyclopaedia Britannica 251; Eye Ubiquitous 321; Fire Chief 209; Fire Engineering 209; Fire-Rescue Magazine 210; Frontline Photo Press Agency 324; ‡Galeria San Fronteras 482; ‡Gallery of Art, University of Northern Iowa 482; Grand Rapids Magazine 91; Grand Rapids Parent Magazine 91; Helicopter International 213; Image Works, The 330; Images Pictures Corp. 331; Jeroboam 334; Jewish Exponent 187; Junior Scholastic 101; Keystone Press Agency, Inc. 334; Klein Gallery, Robert 488; Kyodo Photo Service 335; Lerner Publications Company 258; Life 108; Lizardi/

Harp Gallery 490; Long Island Parenting News 188; Lutheran, The 109; Maclean's Magazine 109; Mattei Productions, Michele 338; ‡Mill Creek View 188; Mississippi Publishers, Inc. 188; Musclemag International 115; Museum of Contemporary Photography, Columbia College Chicago, The 493; National Rural Letter Carrier 116; Natural History Magazine 117; Network Aspen 342; New Haven Advocate 189; New York Times Magazine 189; News Photographer 122; NFPA Journal 122; 911 Magazine 221; O.K. Harris Works of Art 495; O&A Marketing News 222; Ohio Magazine 124; ‡Omega News Group/USA 344; Open Wheel Magazine 126; Other Side, The 127; Out Magazine 127; Outline 345; Phoenix Magazine 133; ‡Photo Associates News Service 347; ‡Photoweb Inc. 351; Pittsburgh City Paper 190; Police Magazine 225; Police Times/Chief of Police 225; ‡Professional Photographer 226; ‡Progressive, The 140; Public Citizen News 140; Rangefinder 356; Recreational Hair News 142; Rex USA Ltd. 357; Runner's World 148; Russian Life Magazine 148; Scholastic Magazines 151; Sentinel, The 154; Silver Image Photo Agency, Inc. 360; Society 159; Southern Motoracing 191; Sovfoto/Eastfoto, Inc. 361; Spy 161; Stack & Associates, Tom 362; Stock Car Racing Magazine 162; Streetpeople's Weekly News 192; Sun 192; Sunshine: The Magazine of South Florida 192; Syracuse Cultural Workers 297; Today's Model 166; Toronto Sun Publishing 192; Tribune-Review 194; ‡Uno Mas Magazine 170; Valencia Community College East Campus Galleries 504; VeloNews 194; Vermont Life 171; Washingtonian 174; Watertown Public Opinion 195; With 177; World and I, The 178; Yachtsman 195; Yankee Magazine 180

Education
AAA Image Makers 302; AIM Magazine 45; Allyn and Bacon Publishers 238; ‡American School Health Association 240; Black Child Magazine 56; Childhood Education 69; Christian Ministry, The 202; Crafts Report, The 204; Dance Teacher Now 205; Devaney Stock Photos, 315; Education Week 206; Entry Publishing, Inc. 251; First Opportunity 86; Folio, Inc. 322; Grand Rapids Parent Magazine 91; Home Education Magazine 95; Image Works, The 330; Jeroboam 334; Jr. High Ministry Magazine 217; Light Sources Stock 336; Lightwave 336; Manitoba Teacher, The 110; Monkmeyer 340; Owen Publishers, Inc., Richard C. 265; Photo Agora 346; Prakken Publications, Inc. 267; Reading Today 142; Scholastic Magazines 151; Speech Bin Inc., The 270; Tropix Photographic Library 367; U. The National College Magazine 169; Unicorn Stock Photo Library 367; Visions 173

Entertainment
Advanced Graphics 278; Ardsley House Publishers Inc. 241; Atlantic City Magazine 52; Camera Press Ltd. 309; Casino Journal 201; ‡Comesana-Agencia De Prensa, Eduardo 312; Devaney Stock Photos, 315; Down Beat Magazine 81; ‡50/50 Magazine 85; Fotos International 323; ‡Globe Photos, Inc. 327; Images Pictures Corp. 331; Keyboard 103; ‡Keystone Pressedienst GmbH 335; Mattei Productions, Michele 338; ‡Metropolis Publications 112; National News Bureau 189; ‡New Choices Living Even Better After 50 120; Northern Ohio Live 123; Photophile 351; ‡Photoweb Inc. 351; Pittsburgh City Paper 190; Players Press Inc. 266; ‡Pre-Vue Entertainment Magazine 138; ‡Q San Francisco Magazine 141; ‡Reedproductions 295; Relix Magazine 144; ‡Request Magazine 145; Retna Ltd. 357; Rex USA Ltd. 357; Rolling Stone 147; Senior Voice of Florida 190; Soap Opera Digest 158; Today's Model 166; Toronto Sun Publishing 192; Total TV 166; Travel & Leisure 168; Vanity Fair 171; Washington Blade, The 194; Washingtonian 174; Where Chicago Magazine 176

Erotica/Nudity
‡Alfresco Publications 278; ‡Amelia Magazine 46; Banc Gallery, Tamara 468; Benham Studio Gallery 469; ‡Book Beat Gallery 470; Center Press 246; ‡Class Publications, Inc. 282; Cleis Press 247; Comstock Cards 282; Cupido 76; ‡Event 83; Fine Press Syndicate 321; ‡Firsthand Ltd. 86; Flashcards, Inc. 285; Focal Point Gallery 479; ‡Fox Magazine 89; Gallery Magazine 89; Gent 90; Greetwell 287; Image Factory, The 330; Jackson Fine Art 487; Klein

Gallery, Robert 488; LIBIDO: The Journal of Sex and Sensibility 108; Lizardi/Harp Gallery 490; Lusty Letters, Options, Beau 109; Model Image Resources 340; Naturist Life International 119; Naughty Neighbors 119; Nugget 124; Onlinegallery 496; ‡Palm Court Press 131; ‡Provocateur Magazine 140; Rockshots, Inc. 296; S.K. Stock 359; Score 152; ‡Thin Air Magazine 165; AAP News 196

Families
African American Child Magazine 44; American Bar Association Press 239; ‡(APL) Argus Photoland, Ltd. 305; Atlanta Parent 51; ‡Baby's World Magazine 53; Black Child Magazine 56; Bureau for At-Risk Youth, The 245; Catholic News Service 310; Child of Colors 68; ‡Cyr Color Photo Agency 313; Devaney Stock Photos, 315; Frozen Images, Inc. 325; F/Stop Pictures Inc. 325; Grand Rapids Parent Magazine 91; Great Quotations Publishing Co. 253; ‡Group Magazine 93; Guide for Expectant Parents 93; Hillstrom Stock Photo, Inc. 328; Image Works, The 330; Index Stock Photography 331; Jeroboam 334; Jr. High Ministry Magazine 217; Light Sources Stock 336; Long Island Parenting News 188; Mach 2 Stock Exchange Ltd. 337; Nawrocki Stock Photo 342; New England Stock Photo 343; Our Family 127; Ozark Stock 345; Papier-Maché Press 266; Photo Agora 346; Photo Network 348; Photo Search Ltd. 349; Photobank, Inc. 350; Pictor International, Ltd. 352; Picture Cube Inc., The 352; San Diego Family Magazine 150; Sharpshooters, Inc. 359; ‡Silver Visions 360; Snow Country Magazine 158; Speech Bin Inc., The 270; Unicorn Stock Photo Library 367; Woodmen 178

Fashion/Glamour
‡Aboard Magazine 43; ‡Alfresco Publications 278; Art Center, The 464; Atlantic City Magazine 52; Beauty Handbook: National Women's Beauty Magazine 55; Bride's 60; Complete Woman 74; Cosmopolitan 75; ‡50/50 Magazine 85; Folio, Inc. 322; Genre 89; Gent 90; Golfer, The 90; Grand Rapids Magazine 91; Health & Beauty Magazine 94; Hemphill Fine Arts 484; Image Factory, The 330; Indianapolis Woman 99; Jackson Fine Art 487; Klein Gallery, Robert 488; Landmark Stock Exchange 336; ‡Latina Magazine 107; Mississippi Publishers, Inc. 188; ‡Mode Magazine 113; Model Image Resources 340; Model News, Show Biz News 188; Musclemag International 115; National News Bureau 189; Old West 125; Out Magazine 127; ‡Photoweb Inc. 351; Playboy 135; Polo Magazine 136; Prime Time Sports & Fitness 139; Recreational Hair News 142; Retna Ltd. 357; Rex USA Ltd. 357; Seventeen Magazine 154; Singer Media Corp., Inc. 191; Today's Model 166; Vanity Fair 171; Victoria Magazine 172; Washingtonian 174

Food/Drink
AAA Image Makers 302; ‡Abbeville Press 237; Allyn and Bacon Publishers 238; ‡America West Airlines Magazine 47; American Bee Journal 197; American Fitness 47; Association of Brewers, Inc. 242; ‡Atlanta Homes & Lifestyles 51; ‡Au Juice 52; ‡Baltimore 54; Bartender Magazine 200; Behrman House Inc. 243; Better Nutrition 55; Beverage & Food Dynamics 200; Cephas Picture Library 311; Colonial Homes Magazine 72; Cosmopolitan 75; Crossing Press 249; Delta Design Group, Inc. 205; ‡Diggin Photography, Michael 315; Dinodia Picture Agency 316; Diversion Magazine 79; Dockery House Publishing Inc. 249; Energy Times 83; Envision 320; Florida Keys Magazine 86; Food & Service 210; Food & Wine 88; Food Distribution Magazine 211; Food Product Design Magazine 211; Guest Informant 93; Health & Beauty Magazine 94; Howell Press, Inc. 256; IGA Grocergram 215; Kashrus Magazine 103; Landmark Calendars 291; ‡Latina Magazine 107; Layla Production Inc. 258; Marketing & Technology Group 218; Mississippi Publishers, Inc. 188; ‡Natural Life Magazine 118; ‡Natural Living Today 118; ‡Natural Way 118; Nawrocki Stock Photo 342; ‡New Choices Living Even Better After 50 120; Olson & Co., C. 265; Over the Back Fence 129; Pelican Publishing Co. 266; Playboy 135; Pool and Spa Living Magazine 136; ‡Portal Publications Ltd. 293; Positive Images 354; Produce Merchandising 226; ‡Restaurant Hospitality 229;

Images Inc. 338; Medichrome 339; Mediphors 111; Megapress Images 339; Metamorphous Press 262; ‡Metropolis Publications 112; Musclemag International 115; ‡Natural Life Magazine 118; ‡Natural Way 118; ‡New Choices Living Even Better After 50 120; 911 Magazine 221; Olson & Co., C. 265; Ozark Stock 345; Pediatric Annals 223; ‡Phototake, Inc. 351; PN/Paraplegia News 135; Positive Images 354; Prime Time Sports & Fitness 139; Public Citizen News 140; ‡Push! 141; Saturday Evening Post Society, The 151; Science Photo Library, Ltd. 359; Secure Retirement 154; Singer Media Corp., Inc. 191; ‡Street Skills 231; Surgical Technologist, The 163; ‡Ulysses Press 272; Women's Sports and Fitness Magazine 177; Woodmen 178; Your Health 180

History/Historical

Aloha, The Magazine of Hawaii and the Pacific 46; ‡Anchor News 49; Ardsley House Publishers Inc. 241; Arnold Publishing Ltd. 241; Autograph Collector Magazine 52; Back Home in Kentucky 53; ‡Bluewood Books 244; B'Nai B'Rith International Jewish Monthly, The 57; Bryant Stock Photography (DDB Stock), D. Donne 308; California Views/Mr. Pat Hathaway Historical Collection 309; Calliope 61; Chinastock 311; Cobblestone: The History Magazine for Young People 71; Colonial Homes Magazine 72; Crumb Elbow Publishing 249; Delta Design Group, Inc. 205; ‡Diggin Photography, Michael 315; Encyclopaedia Britannica 251; ‡Fifth House Publishers 252; Graphic Arts Center Publishing Company 253; Holt, Rinehart and Winston 255; ‡Hot Shots Stock Shots, Inc. 329; Howell Press, Inc. 256; Jewish Exponent 187; Junior Scholastic 101; Klein Publications, B. 257; ‡Lucent Books 261; ‡Lynx Images Inc. 261; Midwest Motorist, The 113; Nawrocki Stock Photo 342; New England Stock Photo 343; Oklahoma Today 125; Old West 125; Oliver Press, The 264; Over the Back Fence 129; Pennsylvania 131; Persimmon Hill 132; Photographic Resource Center 498; Planning 135; Reminisce 144; Retired Officer Magazine, The 145; Rex USA Ltd. 357; Russian Life Magazine 148; Texas Highways 164; ‡Transportation Trails 271; True West 169; Unicorn Stock Photo Library 367; Visuals Unlimited 369; ‡Wisconsin Trails Books 275; Woodmen 178; World and I, The 178

Human Interest/Lifestyle

AAA Image Makers 302; Accent on Living 43; American Stock Photography Inc. 304; ‡American Survival Guide 49; ‡Atlanta Homes & Lifestyles 51; Atlantic Publication Group Inc. 199; Aware Communications, Inc. 53; Back Home in Kentucky 53; ‡Baltimore 54; ‡Birds & Blooms 56; Bodyboarding Magazine 58; Camera Press Ltd. 309; Capper's 184; Charlton Photos, Inc. 311; Climate Business Magazine 202; Coast Magazine 71; Cornerstone Productions Inc. 248; Envision 320; Ewing Galloway, Inc. 320; First Image West, Inc. 321; ‡Fisher House Publishers 252; Flashcards, Inc. 285; Food Distribution Magazine 211; ‡Gomez Gallery 483; Grand Rapids Parent Magazine 91; Guernica Editions, Inc. 254; ‡Hot Shots Stock Shots, Inc. 329; ‡Hutchison Library, The 329; I.G. Publications Ltd. 256; Index Stock Photography 331; Indianapolis Monthly 98; JII Sales Promotion Associates, Inc. 288; Life 108; Mach 2 Stock Exchange Ltd. 337; Maclean's Magazine 109; Monkmeyer 340; Mountain Stock Photo & Film 340; ‡Natural Life Magazine 118; New England Stock Photo 343; O&A Marketing News 222; ‡Omega News Group/USA 344; Ozark Stock 345; Palm Beach Illustrated Magazine 131; Photo Index 347; Photo Network 348; Photo Search Ltd. 349; Photobank, Inc. 350; Photographic Resources Inc. 350; Photophile 351; Picture Cube Inc., The 352; Picture Perfect 353; Picturesque Stock Photos 354; ‡Progressive, The 140; Rangefinder 356; Retired Officer Magazine, The 145; Rex USA Ltd. 357; Rider 146; Saturday Evening Post Society, The 151; Sentimental Sojourn 154; ‡Silver Visions 360; Social Policy 230; Society 159; Southern Lumberman 230; Star 161; State, The 161; ‡Stock Broker, The 362; Stockhouse, Inc., The 364; Sun, The 163; Superstock Inc. 364; Take Stock Inc. 365; Third Coast Stock Source 366; Unicorn Stock Photo Library 367; Victoria Magazine 172; Virginia Wildlife 172; Visual Contact 369; Visuals Unlimited 369; Weigl Educational Publishers Limited 274

Humor

Accent on Living 43; Ace Photo Agency 302; American Motorcyclist 49; Avanti Press Inc. 279; BePuzzled 280; Business Credit Magazine 201; Camera Press Ltd. 309; Campus Life 62; Catholic News Service 310; ‡Centric Corporation 281; ‡Class Publications, Inc. 282; Comstock Cards 282; Crossing Press 249; Design Design, Inc. 284; ‡Dream Publishing 285; Flashcards, Inc. 285; Ford Gallery, Adrienne 479; Grand Rapids Magazine 91; Great Quotations Publishing Co. 253; ‡Grit Magazine 93; Image Factory, The 330; Indianapolis Monthly 98; Kogle Cards, Inc. 290; Life 108; Marcel Schurman Company 292; Marketers Forum 218; Midwest Motorist, The 113; Mother Earth News 114; Musclemag International 115; National Rural Letter Carrier 116; Our Family 127; Palm Press, Inc. 293; Photri Inc. 352; Police Magazine 225; ‡Portal Publications Ltd. 293; Psychology Today 140; ‡Recycled Paper Greetings, Inc. 295; ‡Reiman Publications, L.P. 295; Renaissance Greeting Cards, Inc., 296; Rockshots, Inc. 296; Rural Heritage 148; Shooter's Rag—The Practical Photographic Gazette 229; Spy 161; State, The 161; Sun 192; Vermont Life 171; With 177; Woodmen 178

Landscapes/Scenics

Acme Graphics, Inc. 277; ‡Adirondack Life 44; Adventure Photo 302; Adventure West Magazine 44; ‡Aerial Photography Services 237; Alabama Living 45; Aloha, The Magazine of Hawaii and the Pacific 46; ‡America West Airlines Magazine 47; American & World Geographic Publishing 238; American Banker 197; American Bible Society 239; American Forests Magazine 48; Appalachian Trailway News 50; Art Center, The 464; ‡Art Independent Gallery 465; Back Home in Kentucky 53; Backpacker Magazine 54; Balloon Life 54; Barlett Fine Arts Gallery 468; Bassin' 54; ‡Bears Magazine 55; Beautiful America Publishing Company 243; Beautyway 279; Benham Studio Gallery 469; Bible Advocate, The 56; Bodyboarding Magazine 58; Bristol Gift Co. Inc. 280; Caller, The 183; Camerique Inc. International 309; Capper's 184; ‡Capstone Press 245; ‡Central California Art League Gallery 473; ‡Centric Corporation 281; Charlton Photos, Inc. 311; Chatham Press 246; ‡Concord Litho Co. Inc. 282; Copley Society of Boston, The 476; Cornerstone Productions Inc. 248; Crumb Elbow Publishing 249; ‡Crystal Tissue Company, The 282; ‡Currents 77; ‡Diggin Photography, Michael 315; Dockery House Publishing Inc. 249; ‡Down the Shore Publishing Corp. 250; ‡Dream Publishing 285; E Magazine 81; Edelman Gallery, Catherine 477; Edelstein Gallery, Paul 478; Eleven East Ashland (I.A.S.) 478; First Image West, Inc. 321; ‡Fisher House Publishers 252; ‡Flavia Studios 285; Florida Keys Magazine 86; Focal Point Gallery 479; Ford Gallery, Adrienne 479; Foto-Press Timmerman 322; Franklin Photo Agency 323; Frozen Images, Inc. 325; ‡Galison Books/Mudpuppy Press 286; ‡Gallery 825/LA Art Association 482; ‡Gallery One, Inc. 482; Glacier Bay Photography 327; ‡Goes Calendars 286; Graphic Arts Center Publishing Company 253; ‡Graphique Du Jour, Inc. 286; Greetwell 287; Holt Studios International, Ltd. 328; Horizons Magazine 95; ‡Hutchison Library, The 329; I.G. Publications Ltd. 256; Impact 288; InLine: The Skater's Magazine 99; International Wildlife 99; Jackson Fine Art 487; JII Sales Promotion Associates, Inc. 288; Kaplan Co., Inc., Arthur A. 289; ‡Kearon-Hempenstall Gallery 487; Kregel Publications 258; ‡Kuntswerk Galerie 488; Landmark Calendars 291; LBW Gallery 489; Leach Galllery, Elizabeth 489; ‡Levy Fine Art Publishing, Inc., Leslie 291; Light Sources Stock 336; Lizardi/Harp Gallery 490; ‡McGaw Graphics, Inc., Bruce 292; Marble House Gallery 491; Michelson Galleries, R. 492; Minot Art Gallery 492; ‡Modern Art 292; Moon Publications, Inc. 262; ‡Mountain Living 114; Mountain Stock Photo & Film 340; National Parks Magazine 116; National Wildlife 117; Nevada Magazine 120; New Leaf Press, Inc. 264; ‡New York Graphic Society 292; Nor'westing 123; Outdoor America 128; Outdoor Canada 128; Outdoor Traveler Mid-Atlantic 128; Ozark Stock 345; Pacific Union Recorder 129; Painet 346; Paper Age 223; Personal Selling Power, Inc. 224; Photographic Image Gallery 498; Planet Earth Pictures 354; ‡Portal Publications Ltd. 293; ‡Prairie Dog 138; ‡Product Centre-S.W. Inc., The Texas Postcard Co. 294; ‡Quality Artworks, Inc. 295; Reed Gallery, Anne 500; ‡Reiman Publications, L.P. 268, 295; Roanoker, The 146; Ro-Ma Stock 358; Rotarian, The 147; S.K. Stock 359; Scuba Times

Magazine 153; Select Art 502; Sharpshooters, Inc. 359; ‡Silver Visions 360; Snow Country Magazine 158; Speech Bin Inc., The 270; Strang Communications Company 270; Sunrise Publications, Inc. 296; Take Stock Inc. 365; Teldon Calendars 297; Texas Realtor Magazine 164; Thanatos 165; ‡Thin Air Magazine 165; Third Coast Stock Source 366; Travel & Leisure 168; ‡Ulysses Press 272; Unity School of Christianity 272; Valencia Community College East Campus Galleries 504; ‡Vintage Images 298; Virginia Wildlife 172; Waterway Guide 175; Weigl Educational Publishers Limited 274; Where Chicago Magazine 176; Whitecap Books Ltd. 275; ‡Wisconsin Trails 176, 299; ‡Wisconsin Trails Books 275

Manipulated

‡Art Center of Battle Creek 464; Art Forms 464; ‡Bannister Gallery 468; ‡Campbell Contemporary Art, William 471; ‡Coconino Center for the Arts 474; Collector's Choice Gallery 475; De Havilland Fine Art 477; Hansley Gallery, Lee 484; Indianapolis Art Center 486; ‡Kala Institute 487; ‡Kuntswerk Galerie 488; Lizardi/Harp Gallery 490; Renaissance Greeting Cards, Inc., 296; State Museum of Pennsylvania, The 503; Watercraft World 174

Medicine

‡American Survival Guide 49; ‡Anchor News 49; Aware Communications, Inc. 53; ‡Baby's World Magazine 53; Biological Photo Service 307; Contemporary Dialysis & Nephrology 204; Cornerstone Productions Inc. 248; ‡Custom Medical Stock Photo 313; Dental Economics 205; Emergency, The Journal of Emergency Services 208; Encyclopaedia Britannica 251; ‡Firefighters News 210; Fire-Rescue Magazine 210; Guide for Expectant Parents 93; ‡Hutchison Library, The 329; Index Stock Photography 331; JEMS Communications 216; Jeroboam 334; Journal of Psychoactive Drugs 217; Light Sources Stock 336; Medical Images Inc. 338; Medichrome 339; Megapress Images 339; New Methods 221; Ocular Surgery News 222; Pediatric Annals 223; Photo Network 348; Photo Researchers, Inc. 348; Photophile 351; ‡Phototake, Inc. 351; Ro-Ma Stock 358; Saturday Evening Post Society, The 151; Science Photo Library, Ltd. 359; ‡Street Skills 231; Surgical Technologist, The 163; Tropix Photographic Library 367; Unicorn Stock Photo Library 367; Visual Contact 369; Visuals Unlimited 369

Memorabilia/Hobbies

‡Collecting Toys Magazine 72; ‡Collector Car & Truck Prices 72; Doll Reader 80; Finescale Modeler 85; Front Striker Bulletin, The 185; Kite Lines 104; Muzzle Blasts 115; Reminisce 144; Sports Card Trader 160

Military

Arms Communications 306; Foto Expression International 322; Howell Press, Inc. 256; Olson & Co., C. 265; Proceedings/Naval History 140; Retired Officer Magazine, The 145; Soldier of Fortune Magazine 159; U.S. Naval Institute 368; V.F.W. Magazine 171

Outdoors/Environmental

Ace Photo Agency 302; Acme Graphics, Inc. 277; Adirondack Lakes Center for the Arts 462; ‡Adirondack Life 44; ‡AGStockUSA 303; Alabama Living 45; ‡Alaska 46; Alaska Stock Images 303; Aloha, The Magazine of Hawaii and the Pacific 46; ‡America West Airlines Magazine 47; American Agriculturist 197; American Banker 197; American Bee Journal 197; American Forests Magazine 48; American Gardener, The 48; AppaLight 305; Arnold, Inc., Peter 306; Back Home in Kentucky 53; Backpacker Magazine 54; Bassin' 54; BC Outdoors 55; Beacon Press 242; ‡Bears Magazine 55; Beautiful America Publishing Company 243; Beautyway 279; Bible Advocate, The 56; Biological Photo Service 307; Bird Watcher's Digest 56; ‡Birds & Blooms 56; Blackbirch Press, Inc. 243; Blue Ridge Country 57; Bowhunter 58; Briarpatch 59; Bristol Gift Co. Inc. 280; Bugle Magazine 60; Caller, The 183; Calypso Log 62; Canada in Stock Inc. 310; Canoe & Kayak 63; Cape Cod Life including

Earth Pictures 354; Planning 135; Polo Magazine 136; ‡Popular Photography 136; ‡Portal Publications Ltd. 293; Positive Images 354; ‡Prairie Dog 138; Produce Merchandising 226; ‡Product Centre-S.W. Inc., The Texas Postcard Co. 294; ‡Progressive, The 140; Psychology Today 140; ‡Quality Artworks, Inc. 295; Rag Mag 142; Rainbow 355; Reflexion Phototheque 356; ‡Reiman Publications, L.P. 295; Relay Magazine 144; Reptile & Amphibian Magazine 145; Resource Recycling 228; Rock & Ice 146; Rockford Review 147; Ro-Ma Stock 358; S.K. Stock 359; Sailing 150; Salt Water Sportsman 150; San Diego Family Magazine 150; Sandlapper Magazine 151; Science and Children 151; Scientific American 152; Scuba Times Magazine 153; Sea Kayaker 153; Sentinel, The 154; Sharpshooters, Inc. 359; Signpost for Northwest Trails Magazine 155; Silver Image Photo Agency, Inc. 360; ‡Silver Visions 360; Skipping Stones 156; Snow Country Magazine 158; Spy 161; Stack & Associates, Tom 362; ‡Stock Broker, The 362; Stock Options® 363; Stockhouse, Inc., The 364; Straight 162; ‡Strain, The 162; Strang Communications Company 270; Sunrise Publications, Inc. 296; Syracuse Cultural Workers 297; Teldon Calendars 297; Terraphotographics 366; Texas Gardener 164; Texas Highways 164; Texas Realtor Magazine 164; Third Coast Stock Source 366; Tide Magazine 165; Total TV 166; Travel & Leisure 168; Tropix Photographic Library 367; True West 169; Turkey Call 169; Unicorn Stock Photo Library 367; Unity Magazine 170; Unity School of Christianity 272; Up Here 170; Vermont Life 171; Vermont Magazine 171; Virginia Wildlife 172; Visuals Unlimited 369; Voyageur Press 273; War Cry, The 173; Washingtonian 174; Waterway Guide 175; Weigl Educational Publishers Limited 274; Western Outdoors 175; Western Producer, The 195; Where Chicago Magazine 176; Wildlife Collection, The 370; Wisconsin Trails 299; ‡Wisconsin Trails Books 275; With 177; Woodmen 178; World and I, The 178; Yankee Magazine 180; Your Money Magazine 180

People

AAA Image Makers 302; AAP News 196; ABA Banking Journal 196; A/C Flyer 196; Accent on Living 43; Ace Photo Agency 302; Adams-Blake Publishing 237; ‡Adirondack Life 44; African American Child Magazine 44; AIM Magazine 45; Air Line Pilot 45; Alive Now Magazine 46; Aloha, The Magazine of Hawaii and the Pacific 46; Alpine Publications, Inc. 238; ‡America West Airlines Magazine 47; American Agriculturist 197; American & World Geographic Publishing 238; American Bible Society 239; ‡American Survival Guide 49; Animal Sheltering 198; ‡(APL) Argus Photoland, Ltd. 305; Appalachian Trailway News 50; Association of Brewers, Inc. 242; ‡Atlanta Homes & Lifestyles 51; Atlanta Parent 51; Australian Picture Library 307; Autograph Collector Magazine 52; Aware Communications, Inc. 53; Back Home in Kentucky 53; Backpacker Magazine 54; Balloon Life 54; Bartender Magazine 200; BC Outdoors 55; Beauty Handbook: National Women's Beauty Magazine 55; Better Nutrition 55; Better Roads 200; Bible Advocate, The 56; Black Child Magazine 56; ‡Bloomsbury Review, The 57; Blue Ridge Country 57; ‡Bluewood Books 244; Bodyboarding Magazine 58; Bostonia Magazine 58; ‡Brazzil 59; Briarpatch 59; Brigade Leader 60; Bryant Stock Photography (DDB Stock), D. Donne 308; Buildings 201; Business in Broward 61; Business NH Magazine 201; ‡California Nurse 61; Calliope 61; Camera Press Ltd. 309; Camerique Inc. International 309; Campus Life 62; Canada in Stock Inc. 310; Canada Lutheran 62; Cape Cod Life including Martha's Vineyard and Nantucket 64; Cape Rock, The 64; Capper's 184; Car & Travel 64; Career Focus 65; Careers & Colleges Magazine 65; Caribbean Travel and Life Magazine 65; Casino Player 66; Cat Fancy 66; Catholic Library World 66; Catholic Near East Magazine 66; Catholic News Service 310; CEA Advisor 67; Charlton Photos, Inc. 311; Chesapeake Bay Magazine, The 67; Chess Life 67; Child Care Focus 184; Child of Colors 68; Childhood Education 69; Children's Digest 69; ‡Children's Ministry Magazine 69; Chinastock 311; Christian Home & School 70; Christian Ministry, The 202; Chronicle of Philanthropy, The 202; ‡Class Publications, Inc. 282; Cleaning & Maintenance Management Magazine 202; Coast Magazine 71; ‡Coconino Center for the Arts 474; Coleman Photo Library, Bruce 312; College Preview 72; ‡Comesana-Agencia De Prensa, Eduardo 312; Company 74; Compix Photo Agency 312; Complete Woman 74; Construction Comment 203;

354; Playboy 135; Plumbing & Mechanical 225; Police Magazine 225; Police Times/Chief of Police 225; Pool and Spa Living Magazine 136; Population Bulletin 138; Powerline Magazine 225; Princeton Alumni Weekly 139; Principal Magazine 139; Proceedings/Naval History 140; Prorodeo Sports News 190; Public Citizen News 140; Purchasing Magazine 227; ‡Q San Francisco Magazine 141; Rag Mag 142; Rainbow 355; Referee 228; Reflexion Phototheque 356; ‡Restaurant Hospitality 229; Retired Officer Magazine, The 145; Rex USA Ltd. 357; Ristorante Magazine 229; Rock & Ice 146; Roll Call Newspaper 190; Ro-Ma Stock 358; Runner's World 148; Rural Heritage 148; ‡Salem Press 269; San Diego Family Magazine 150; Sandlapper Magazine 151; Saturday Evening Post Society, The 151; Scholastic Magazines 151; ‡Science Scope 152; Scientific American 152; Seafood Leader 229; Secretary, The 153; Secure Retirement 154; Sharpshooters, Inc. 359; Signpost for Northwest Trails Magazine 155; Silver Image Photo Agency, Inc. 360; ‡Silver Visions 360; Skipping Stones 156; Slide File, The 361; ‡Slo-Pitch News, Varsity Publications 191; Society 159; Southern Lumberman 230; Stack & Associates, Tom 362; Star 161; ‡Stock Broker, The 362; Stock Options® 363; Straight 162; Strang Communications Company 270; Sun, The 163; Superstock Inc. 364; Take Stock Inc. 365; Thanatos 165; Third Coast Stock Source 366; Tobacco International 232; Touch 166; Transitions Abroad 167; U. The National College Magazine 169; Unicorn Stock Photo Library 367; Unity Magazine 170; Unity School of Christianity 272; Up Here 170; Utility and Telephone Fleets 232; Vanity Fair 171; Vermont Magazine 171; Victor Books 273; Visions 173; Visual Contact 369; Visuals Unlimited 369; Warner Books 274; Washington Blade, The 194; Washingtonian 174; Waterski Magazine 174; Weigl Educational Publishers Limited 274; Wine & Spirits 176; Womenwise 178; Woodshop News 235; Word Publishing 276; World and I, The 178; Yachtsman 195; Your Money Magazine 180; Youth Update 182

Political
Andes Press Agency 304; B'Nai B'Rith International Jewish Monthly, The 57; Briarpatch 59; Center for Exploratory and Perceptual Art 473; Climate Business Magazine 202; Collages & Bricolages 71; Empire State Report 208; Europe 209; Farm & Country 185; Fellowship 85; Florida Underwriter 210; Foto Expression International 322; Government Technology 212; Image Works, The 330; ‡Keystone Pressedienst GmbH 335; Network Aspen 342; News Flash International, Inc. 343; Oliver Press, The 264; Other Side, The 127; Pennsylvanian Magazine 132; ‡Photoweb Inc. 351; ‡Progressive, The 140; Rangefinder 356; Reform Judaism 144; Retna Ltd. 357; Roll Call Newspaper 190; Rolling Stone 147; Scholastic Magazines 151; Social Policy 230; Southern Exposure 160; Spy 161; Stack & Associates, Tom 362; Tikkun 165; V.F.W. Magazine 171; Vermont Magazine 171; Womenwise 178; World and I, The 178

Portraits
ABA Banking Journal 196; American Banker 197; American Gardener, The 48; Arizona Business Gazette 183; Art Center, The 464; Atlantic City Magazine 52; Berman Fine Arts, Mona 469; Casino Journal 201; Collector's Choice Gallery 475; Cranberries 204; Daily Business Review 185; Electrical Wholesaling 206; Eleven East Ashland (I.A.S.) 478; Futures Magazine 211; Guernica Editions, Inc. 254; Holt, Rinehart and Winston 255; Horse Illustrated 96; IEEE Spectrum 215; Income Opportunities 98; Indianapolis Business Journal 98; Jackson Fine Art 487; Kiplinger's Personal Finance Magazine 103; Klein Gallery, Robert 488; Landscape Architecture 107; ‡Latina Magazine 107; Lawyers Weekly, The 187; Log Home Living 108; Minority Business Entrepreneur 219; Mississippi Publishers, Inc. 188; Mother Earth News 114; National Casino Journal 221; Nation's Business 221; Open Wheel Magazine 126; Our Family 127; Out Magazine 127; Outline 345; Personal Selling Power, Inc. 224; Polo Magazine 136; ‡Popular Photography 136; Psychology Today 140; Quick Frozen Foods International 227; Registered Representative 228; ‡Request Magazine 145; Retna Ltd. 357; Runner's World 148; ‡Sport Magazine 160; SportsCar 161; Spy 161; Stock Car Racing

Magazine 162; ‡Strain, The 162; Successful Meetings 231; Vanity Fair 171; Vermont Magazine 171; Washingtonian 174; With 177

Product Shots/Still Lifes

Ace Photo Agency 302; American Agriculturist 197; American Bar Association Press 239; American Bee Journal 197; American Farriers Journal 198; Art Center, The 464; Association of Brewers, Inc. 242; ‡Atlanta Homes & Lifestyles 51; Atlantic City Magazine 52; Auto Trim & Restyling News 52; Bartender Magazine 200; Blackbirch Press, Inc. 243; ‡Book Beat Gallery 470; Bristol Gift Co. Inc. 280; Buildings 201; Cosmopolitan 75; Delta Design Group, Inc. 205; Devaney Stock Photos, 315; Edelstein Gallery, Paul 478; Energy Times 83; ‡Event 83; Farm Chemicals 209; ‡Fishing and Hunting News 185; ‡Flavia Studios 285; Food Distribution Magazine 211; FPG International Corp. 323; Gas Industries 211; Golfer, The 90; ‡GunGames Magazine 94; Hearth and Home 213; Heating, Plumbing & Air Conditioning (HPAC) 213; Ideals Magazine 97; InLine: The Skater's Magazine 99; International Ground Water Technology 216; Kaplan Co., Inc., Arthur A. 289; Kitchen & Bath Business 217; ‡McGaw Graphics, Inc., Bruce 292; Marcel Schurman Company 292; Marketers Forum 218; Marketing & Technology Group 218; Masonry Magazine 218; ‡Mode Magazine 113; Modern Drummer Magazine 113; Moving Publications Limited 114; Nailpro 220; National Bus Trader 220; National Casino Journal 221; National Rural Letter Carrier 116; New Methods 221; O&A Marketing News 222; Ohio Tavern News 222; Pacific Fishing 223; Plumbing & Mechanical 225; ‡Portal Publications Ltd. 293; ‡Prairie Dog 138; Produce Merchandising 226; Quick Frozen Foods International 227; Reed Gallery, Anne 500; Resource Recycling 228; Security Dealer 229; Signcraft Magazine 230; ‡Slo-Pitch News, Varsity Publications 191; Stock Car Racing Magazine 162; Tobacco International 232; Travel & Leisure 168; Underground Construction 232; Utility Construction and Maintenance 232; Vermont Life 171; Vermont Magazine 171; Warner Books 274; Washingtonian 174; Watercraft World 174; With 177; Women's Sports and Fitness Magazine 177; Woodmen 178; World and I, The 178; Writer's Digest/Writer's Yearbook 235

Regional

Adirondack Lakes Center for the Arts 462; ‡Adirondack Life 44; Adventure West Magazine 44; Agritech Publishing Group 238; Alabama Living 45; ‡Alaska 46; Alaska Stock Images 303; ‡Albany Center Galleries 462; American Agriculturist 197; American Stock Photography Inc. 304; ‡Anchor News 49; Andes Press Agency 304; AppaLight 305; Arnold Publishing Ltd. 241; Australian Picture Library 307; Back Home in Kentucky 53; ‡Blue Dolphin Publishing, Inc. 244; Bromfield Art Gallery 471; Bryant Stock Photography (DDB Stock), D. Donne 308; Canada in Stock Inc. 310; Capitol Complex Exhibitions 472; Central Bank Gallery, The 473; ‡Central California Art League Gallery 473; Chatham Press 246; Chinastock 311; ‡Coconino Center For the Arts 474; ‡Commencement Art Gallery 475; Corporate Detroit Magazine 204; Crossman Gallery 476; Dallas Visual Art Center 477; Delta Design Group, Inc. 205; ‡Diggin Photography, Michael 315; Dinodia Picture Agency 316; ‡Down the Shore Publishing Corp. 250; DRK Photo 316; Eastern Press, Inc. 250; Eclipse and Suns 318; ‡Etherton Gallery 478; ‡Fifth House Publishers 252; First Image West, Inc. 321; Florida Keys Magazine 86; Florida Mariner 86; Food & Service 210; Ford Gallery, Adrienne 479; France Magazine 89; F/Stop Pictures Inc. 325; ‡Gallery 825/LA Art Association 482; Geoslides & Geo Aerial 326; Glacier Bay Photography 327; Grand Rapids Magazine 91; ‡Greece Travel Magazine 91; Gulf Coast Golfer 187; Horizons Magazine 95; ‡Hot Shots Stock Shots, Inc. 329; Huntsville Museum of Art 485; Illinois Art Gallery 486; Image Factory, The 330; Image Finders, The 330; Impact 288; Indianapolis Art Center 486; Interpress of London and New York 333; ‡Levy Fine Art Publishing, Inc., Leslie 291; Light Sources Stock 336; Lineair Fotoarchief B.U. 336; ‡Louisville Visual Art Association 490; Maine Coast Artists 491; ‡Markeim Art Center 491; Mexico Events & Destinations 219; Midwestock 339; Moon Publications, Inc. 262; Museum of the Plains Indian & Crafts Center 494; Mushing Magazine

Religious

Science

Technology/Computers

Teens

Travel

AAIMS Publishers Company 236; ‡Abbeville Press 237; ‡Aboard Magazine 43; Accent on Living 43; Ace Photo Agency 302; Adventure Photo 302; Adventure West Magazine 44; African American Child Magazine 44; Alabama Living 45; Aloha, The Magazine of Hawaii and the Pacific 46; ‡America West Airlines Magazine 47; American Motorcyclist 49; Anchorage Daily News 183; ‡(APL) Argus Photoland, Ltd. 305; AppaLight 305; ‡Atlanta Homes & Lifestyles 51; Blue Ridge Country 57; Bostonia Magazine 58; Bride's 60; Bryant Stock Photography (DDB Stock), D. Donne 308; Camera Press Ltd. 309; Cape Rock, The 64; Car & Travel 64; Caribbean Travel and Life Magazine 65; Chinastock 311; Civitan Magazine 71; Climate Business Magazine 202; Coast Magazine 71; Cruising World Magazine 76; ‡Currents 77; Das Fenster 78; Davis Travel Photography, James 314; Delta Design Group, Inc. 205; Devaney Stock Photos, 315; Dinodia Picture Agency 316; Diversion Magazine 79; Empire State Report 208; Envision 320; Europe 209; ‡Event 83; Family Motor Coaching 84; ‡First Light Associated Photographers 321; Five Corners Publications 252; Food & Wine 88; ‡For Seniors Only 88; Foto-Press Timmerman 322; Four Wheeler Magazine 89; France Magazine 89; F/Stop Pictures Inc. 325; General Aviation News & Flyer 212; Gent 90; Geoslides & Geo Aerial 326; Golfer, The 90; Grand Rapids Magazine 91; ‡Greece Travel Magazine 91; Guest Informant 93; Hadassah Magazine 94; Hillstrom Stock Photo, Inc. 328; Hollow Earth Publishing 255; Images Pictures Corp. 331; Impact 288; Index Stock Photography 331; Jaywardene Travel Photo Library 334; Kansas 101; Kashrus Magazine 103; Lake Superior Magazine 106; Landmark Calendars 291; ‡Latina Magazine 107; Leisure World 107; Light Sources Stock 336; ‡Lynx Images Inc. 261; Mainstream 110; Mexico Events & Destinations 219; Michigan Natural Resources Magazine 112; Midwest Motorist, The 113; ‡Mountain Living 114; Mountain Pilot 219; Moving Publications Limited 114; Muir Publications, John 263; National Geographic Traveler 116; National Rural Letter Carrier 116; Nawrocki Stock Photo 342; Network Aspen 342; Nevada Magazine 120; ‡New Choices Living Even Better After 50 120; New England Stock Photo 343; Northwest Travel 123; Nor'westing 123; Ohio Magazine 124; Oklahoma Today 125; Old West 125; ‡Omni-Photo Communications 344; Oregon Outside 126; Outdoor Traveler Mid-Atlantic 128; Ozark Stock 345; Pacific Stock 346; Pacific Union Recorder 129; Palm Beach Illustrated Magazine 131; Pelican Publishing Co. 266; Pennsylvania 131; Photo Network 348; Photo Researchers, Inc. 348; Photophile 351; Picture Cube Inc., The 352; Picture Perfect 353; Playboy 135; Polo Magazine 136; ‡Portal Publications Ltd. 293; ‡Prairie Dog 138; ‡Q San Francisco Magazine 141; Rainbow 355; Recommend Worldwide 228; Recreational Hair News 142; Recreational Ice Skating 144; Retired Officer Magazine, The 145; Rider 146; Roanoker, The 146; San Diego Family Magazine 150; Saturday Evening Post Society, The 151; Scuba Times Magazine 153; Senior Voice of Florida 190; Showboats International 155; Silver Image Photo Agency, Inc. 360; ‡Silver Visions 360; Ski Canada 155; ‡Skin Diver 156; Skipping Stones 156; Southern Boating 159; Sportslight Photo 361; State, The 161; ‡Stock Broker, The 362; Stockhouse, Inc., The 364; Superstock Inc. 364; Teldon Calendars 297; Texas Highways 164; Transitions Abroad 167; Travel & Leisure 168; Traveller 168; Tribune-Review 194; True West 169; ‡Ulysses Press 272; Unicorn Stock Photo Library 367; Vermont Life 171; Vermont Magazine 171; ‡Vernon Publications 172; Visual Contact 369; Washingtonian 174; Watercraft World 174; Waterski Magazine 174; Where Magazine 176; Windsurfing 176; Wine & Spirits 176; With 177; Woodmen 178; World and I, The 178; Yachtsman 195; Yankee Magazine 180

Vintage

‡Benrubi Gallery, Bonni 469; ‡Collecting Toys Magazine 72; Gold Gallery, Fay 483; Halsted Gallery Inc., The 484; Illinois Art Gallery 486; Jackson Fine Art 487; Lehr Inc., Lewis 490; Picture Cube Inc., The 352; ‡Reiman Publications, L.P. 268; Victoria Magazine 172

Wildlife

Adventure Photo 302; Adventure West Magazine 44; Alabama Living 45; Alaska Stock Images 303; American & World Geographic Publishing 238; American Forests Magazine 48;

American Hunter 48; Animals 50; Animals Animals/Earth Scenes 304; Appalachian Trailway News 50; Arnold, Inc., Peter 306; Backpacker Magazine 54; BC Outdoors 55; ‡Bears Magazine 55; Caged Bird Hobbyist 61; Caller, The 183; Canada in Stock Inc. 310; Cedco Publishing Co. 281; Children's Digest 69; Crumb Elbow Publishing 249; Defenders 78; DRK Photo 316; Earthviews 318; ENP Images 319; Environmental Investigation Agency 320; Florida Keys Magazine 86; Florida Wildlife 87; Foto Expression International 322; Glacier Bay Photography 327; ‡Goes Calendars 286; Greetwell 287; Healthy Planet Products Inc. 287; ‡Hot Shots Stock Shots, Inc. 329; Idaho Wildlife 97; Impact 288; International Wildlife 99; Landmark Stock Exchange 336; Minot Art Gallery 492; Mushing Magazine 220; National Parks Magazine 116; National Wildlife 117; Natural Science Photos 341; Nevada Magazine 120; Northwoods Publications Inc. 123; Outdoor America 128; Outdoor Canada 128; ‡Outdoor Empire Publishing, Inc. 265; ‡Outdoor Life Magazine 128; Pacific Union Recorder 129; Palm Press, Inc. 293; ‡Pennsylvania Game News 131; Photo Researchers, Inc. 348; Planet Earth Pictures 354; Reflexion Phototheque 356; Scuba Times Magazine 153; Sharpshooters, Inc. 359; Stack & Associates, Tom 362; Stock Options® 363; Sunrise Publications, Inc. 296; Teldon Calendars 297; ‡Thin Air Magazine 165; Unicorn Stock Photo Library 367; ‡Vernon Publications 172; Virginia Wildlife 172; Visual Contact 369; Voyageur Press 273; Weigl Educational Publishers Limited 274; Whitecap Books Ltd. 275; Wildlife Collection, The 370; Wisconsin Trails 299

Women's

Camera Press Ltd. 309; Complete Woman 74; Indianapolis Woman 99; Ladies Home Journal 106; Papier-Maché Press 266; ‡Push! 141; Southern Exposure 160; Spinsters Ink 270; Victoria Magazine 172; Warner Books 274; Women's Sports and Fitness Magazine 177; Womenwise 178

General Index

You'll notice as you flip through this index that more than 400 double daggers (‡) appear. This symbol denotes markets that are new to this edition. We also list companies that appeared in the 1997 edition of *Photographer's Market*, but do not appear this year. Instead of page numbers beside these markets you will find two-letter codes in parentheses that explain why these markets no longer appear. The codes are: (**ED**)—Editorial Decision, (**NS**)—Not Accepting Submissions, (**NR**)—No (or late) Response to Listing Request, (**OB**)—Out of Business, (**RP**)—Business Restructured or Sold, (**RR**)—Removed by Market's Request, (**UC**)—Unable to Contact, (**UF**)—Uncertain Future.

More Great Books to Help You Sell What You Shoot!